·Masters of 17th-Century Dutch Landscape Painting·

The exhibition and catalogue are supported
by grants from the
National Endowment for the Arts,
a federal agency, and the
Algemene Bank Nederland N.V.
Additional support for the exhibition is
provided by an indemnity from the
Federal Council on the Arts and Humanities
and by KLM Royal Dutch Airlines.

The catalogue is made possible in part
by grants from
Coopers & Lybrand,
Dutch Institutional Holding Company,
and Nutter, McClennen & Fish
in association with the
Netherlands-American Amity Trust.

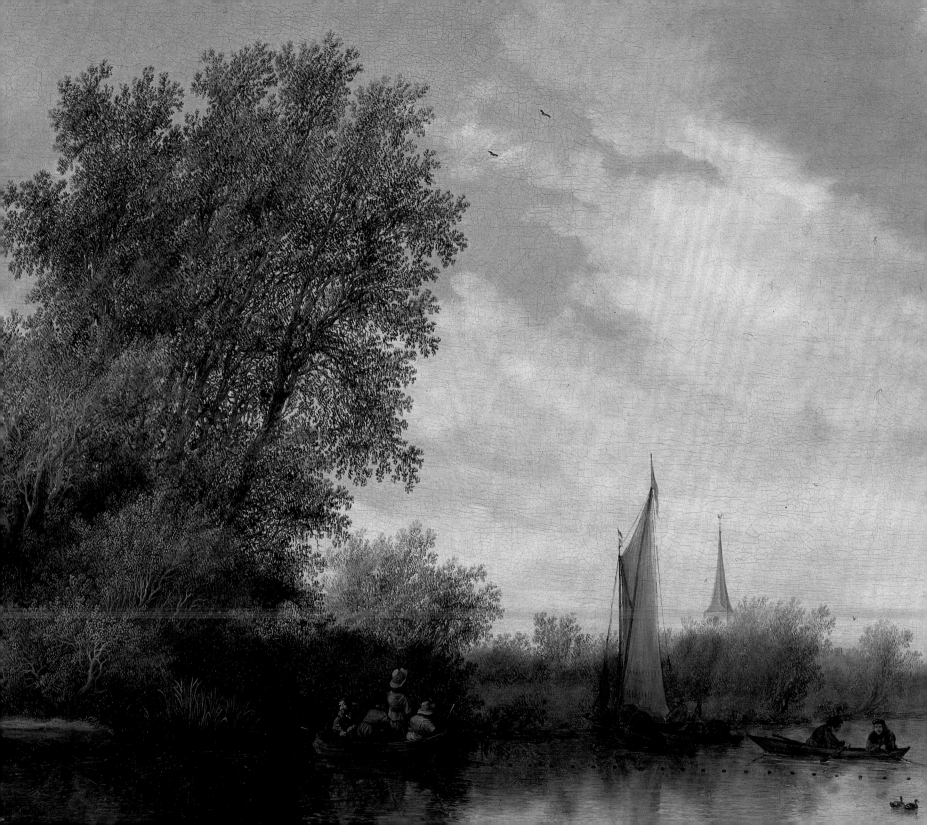

·Masters of 17th-Century Dutch Landscape Painting·

Peter C. Sutton

with contributions by
Albert Blankert
Josua Bruyn
C.J. de Bruyn Kops
Alan Chong
Jeroen Giltay
Simon Schama
Marjorie Elizabeth Wieseman

This exhibition was organized by
Peter C. Sutton and P.J.J. van Thiel

Rijksmuseum, Amsterdam Museum of Fine Arts, Boston Philadelphia Museum of Art

Library of Congress Catalog Card no. 87-43078
ISBN 0-87846-282-1 (paper)
ISBN 0-8122-8105-5 (cloth)

Designed by Carl Zahn

Color printing supervised by Nancy Robins

Cover (jacket) and frontispiece:
SALOMON VAN RUYSDAEL (1600-03–1670),
River View, 1645 (cat. 93).
Lent by Mr. and Mrs. George M. Kaufman

Exhibition dates:

RIJKSMUSEUM, AMSTERDAM
October 2, 1987–January 3, 1988

MUSEUM OF FINE ARTS, BOSTON
February 3–May 1, 1988

PHILADELPHIA MUSEUM OF ART
June 5–July 31, 1988

Contents

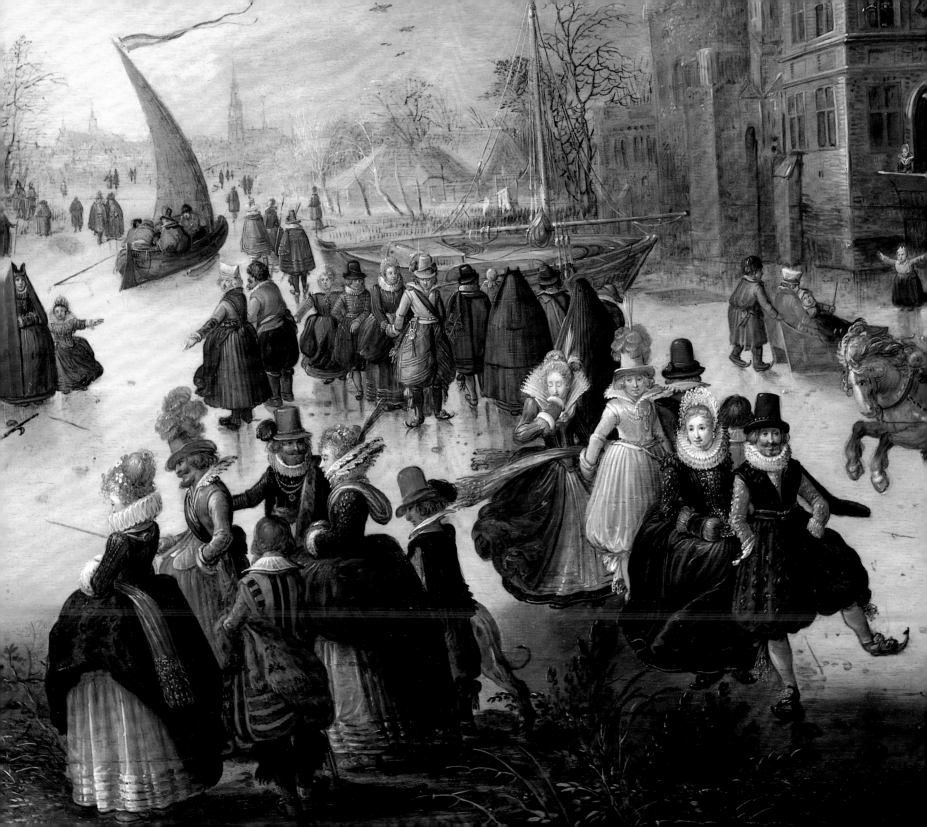

Lenders to the Exhibition

Amsterdam, Rijksmuseum

Antwerp, Koninklijk Museum voor Schone Kunsten

Baltimore, Walters Art Gallery

Berlin, Gemäldegalerie Staatliche Museen Preussischer Kulturbesitz

Bonn, Rheinisches Landesmuseum

Boston, Isabella Stewart Gardner Museum

Boston, Museum of Fine Arts

Braunschweig, Herzog Anton Ulrich-Museum

Budapest, Szépművészeti Múzeum

Cambridge, Fogg Art Museum, Harvard University Art Museums

Chicago, The Art Institute of Chicago

Cincinnati, The Taft Museum

Cleveland, Cleveland Museum of Art

Copenhagen, Statens Museum for Kunst

Detroit, The Detroit Institute of Arts

Dublin, The National Gallery of Ireland

Edinburgh, Torrie Collection, University of Edinburgh

Haarlem, Frans Halsmuseum

The Hague, Mauritshuis, Koninklijk Kabinet van Schilderijen

The Hague, Rijksdienst Beeldenden Kunst

Hannover, Niedersächsisches Landesmuseum

Hartford, Wadsworth Atheneum

Indianapolis, Indianapolis Museum of Art

Kassel, Staatliche Kunstsammlungen

London, The National Gallery

Malibu, The J. Paul Getty Museum

Munich, Bayerische Staatsgemäldesammlungen, Alte Pinakothek

New York, The Metropolitan Museum of Art

Paris, Musée du Louvre

Philadelphia, John G. Johnson Collection at the Philadelphia Museum of Art

Philadelphia, Philadelphia Museum of Art

Richmond, Virginia Museum of Fine Arts

Rotterdam, Boymans-van Beuningen Museum

Speyer, Historisches Museum der Pfalz

Utrecht, Centraal Museum

Vienna, Gemäldegalerie der Akademie der bildenden Künste

Vienna, Kunsthistorisches Museum

Washington, D.C., The Corcoran Gallery of Art

Worcester, Massachusetts, Worcester Art Museum

Zurich, Foundation E.G. Bührle Collection

Zurich, Galerie Bruno Meissner

Her Majesty Queen Elizabeth II

The Duke of Westminster

The Earl of Yarborough

The Marquess of Bute

Lady Teresa Agnew

Maida and George Abrams, *Boston*

The Benjamin Trust

Mr. and Mrs. Edward William Carter, *Los Angeles*

Mr. and Mrs. George M. Kaufman, *Norfolk, Virginia*

Thyssen-Bornemisza Collection, *Lugano*

< DAVID VINCKBOONS, *Landscape with Frozen Canal, Skaters and Ice Boats* (detail), cat. 111

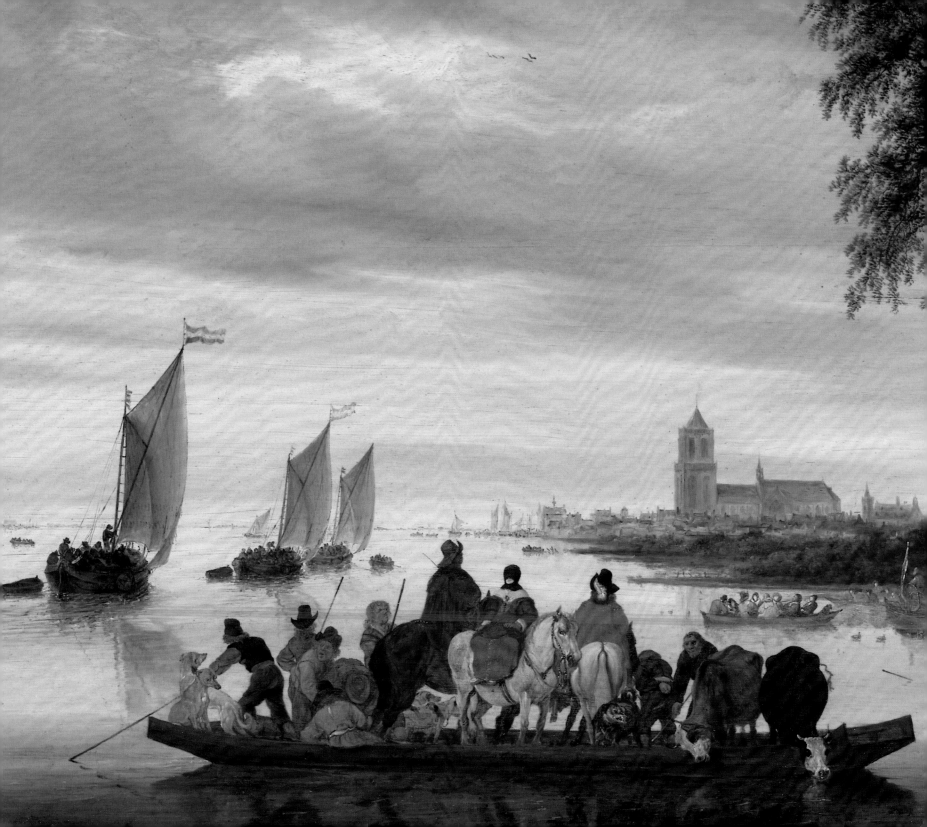

Foreword

The pleasures to be found in seventeenth-century Dutch landscape painting have long been savored by museum visitors on both sides of the Atlantic. Innovative naturalism and great diversity of style and subject established its uncontested position as one of the most remarkable chapters in the history of Western art. These diverse views of a diminutive country – dunes and polders, majestic forests, craggy escarpments and serene fields, and, above all, the grand skies that wordlessly remind their viewers of the fundamental limitations of our earthbound perspective – offer a constant source of renewal and delight. Yet it has been too long since this rich and surprisingly varied province of Dutch painting has been surveyed in a major exhibition, and we are particularly proud of the present gathering of works and the accompanying catalogue, which explore the terrain more fully than ever before, assaying its mixture of topographical fact and artistic fiction, as well as calculating its currency for Dutch culture.

There is no clearer measure of the degree to which this aspect of Dutch achievement has been treasured by museums and collectors than the impressive distances that many of the pictures have traversed over the past two centuries to reach their present owners. We are deeply indebted to the lenders to this exhibition, whose keen interest in the subject has been matched by their generosity in sharing their paintings with new audiences.

Elsewhere in this volume, Peter C. Sutton has expressed his gratitude to the many people who have been indispensable to the realization of this project, and we most warmly underscore his thanks. As dependent as our three institutions have been upon the help of a wide circle of colleagues and friends during every phase of the development of this exhibition, we must also note that central to its achievement were the great affection and attention that Peter Sutton brought to bear on his subject and his energetic persistence as an organizer. First conceived while Dr. Sutton was on the staff of the Philadelphia Museum of Art, as a sequel to the exhibition "Masters of Seventeenth-Century Dutch Genre Painting" (1984), the idea of an exhibition devoted to Dutch landscape was taken up with zest by Jan Fontein, director of the Museum of Fine Arts, at the time of Dr. Sutton's appointment in Boston. From the earliest stages of the project, colleagues in all three museums, and particularly the staff of the Rijksmuseum, have participated in its development with enthusiasm. As this catalogue and the exhibition itself bear witness, it has been a deeply gratifying collaboration between our institutions.

In turn, the support and confidence extended to us have made the exhibition possible. We are most grateful to the National Endowment for the Arts, to the Federal Council for the Arts and Humanities, for an indemnity that substantially reduces the cost of borrowing important pictures, to Algemene Bank Nederland N.V., which also contributed to the catalogue, and to KLM Royal Dutch Airlines. In Philadelphia, participation in the exhibition has been made possible by the continuing support of the Pew Memorial Trust. The catalogue owes much of its handsome and substantial format to generous grants from Coopers & Lybrand, Dutch Institutional Holding Company, and Nutter, McClennen & Fish in association with the Netherlands-American Amity Trust.

SIMON LEVIE
Director, Rijksmuseum, Amsterdam

ALAN SHESTACK
Director, Museum of Fine Arts, Boston

ANNE D'HARNONCOURT
The George D. Widener Director,
Philadelphia Museum of Art

< SALOMON VAN RUYSDAEL, *River Landscape with Ferry* (detail), cat. 94

So rich and varied was the production of Dutch artists in the seventeenth century that exhibitions of Dutch landscape still form a perennial staple of commercial galleries and smaller museums. However, more than thirty-five years have now passed since a major show has been mounted reviewing the full achievement of this art; the exhibitions in Paris in 1950–51 and, on a less ambitious scale, in Dordrecht in 1963 were the last to attempt a true survey of Dutch landscape's range and qualitative accomplishments. More recent shows (notably those in Utrecht in 1965, The Hague and Cambridge, Massachusetts, in 1981–82, and London in 1986) have taken monographic approaches, investigated individual artists' works, restricted periods or types of landscape, or landscape themes. This exhibition casts its net more broadly, highlighting the achievements and diversity of Dutch landscape, reviewing its development and investigating some of its meanings and functions for Dutch culture.

Reconnoitering in such well-traveled terrain, one invariably crosses the paths of those who went before. Wolfgang Stechow's pioneering *Dutch Landscape Painting of the Seventeenth Century* (1966) stands as a milestone in the field. Yet it is a measure of the distance that scholarship has traversed since that work appeared that Stechow's appeal in his Epilogue ("We need monographs on Esaijas van de Velde, Jan van Goyen, Jan Porcellis, Hercules Seghers, Aelbert Cuyp, Jan van de Capelle, Aert van der Neer and Jan Both") has already been answered. Stechow's bold methodological experiment of arranging his material thematically

proved his premise that subject matter was more important than style in determining the appearance of Dutch landscapes but resulted in a curiously episodic history, which can be at times rigid or redundant. Individual artists' achievements tend to be obscured, especially when they treated a variety of themes, and the author is often forced to repeat trends in formal development (the familiar progression from the multiform, to the "tonal," to the structural phase of landscape). With less rigor but greater flexibility, the present exhibition addresses the material variously, identifying highpoints, acknowledging invention and unusual achievements, and seeking patterns in the selection of themes and styles that clarify the art's beauty, origins, and uses. The catalogue tests the presumed connections between the rise of landscape and the socioeconomic climate of the Dutch "Golden Age" and investigates studio practices, the art market, and patronage. Following the example of J.G. van Gelder's ground-breaking work *Jan van de Velde* (1933), it also explores parallels between Dutch art and literature and seeks to clarify the role of metaphor and symbol in Dutch landscape.

For the purposes of this exhibition, when limning the parameters of Dutch landscape, we have parted company with Stechow – again not without misgivings – in excluding marines and cityscapes. Though intimately allied with landscape, these subdivisions, as it were, of the painting type had their own history and specialists, hence have been discretely investigated in past exhibitions (Amsterdam and Toronto 1977) and may be

reserved for future shows. One may therefore expect to encounter among the paintings exhibited here river, coastal, and beach scenes, but no views of the open sea; vistas with city profiles but no inner city or architectural paintings. It also may not be self-evident that the paintings in this show have figural elements that are less prominent than the landscape motifs, though not necessarily less significant or diminutive in any colloquial sense of the nineteenth-century term "staffage." Though intimately, indeed seminally, related to Dutch landscape paintings, drawings and prints have also been excluded only because of limitations of space. However, adjunct exhibitions of graphic arts will appear in all three of the show's venues.

The material in the catalogue and exhibition is arranged roughly chronologically, with an introduction offering discussions of the cultural context, the theory and concept of Dutch landscape, its pioneers and champions, and the general lines of both its formal and iconographic development. In responding to the argument that developmental studies are too Darwinian in their implication of a progressive, perfectible art, we concur with Stechow, who observed that it is only through such studies that one can discover what is possible in a given place at a certain moment.

P.C.S.

Introduction

Peter C. Sutton

The harvest of landscape painters, as I shall refer to those who paint woods, fields, mountains and villages, is so great and famous in our Netherlands that anyone attempting to name them all would fill a small book. . . . It can even be said, as far as naturalism is concerned, that in the works of these clever men, nothing is lacking but the warmth of the sun and the movement caused by the gentle breeze.

Constantijn Huygens (c.1629/1630)[1]

Dutch painting, it is quickly perceived, was and could only be the portrait of Holland, its exterior image, faithful, exact, complete and without embellishment. Portraits of men and places, citizen habits, squares, streets, country places, the sea and sky, such was to be reduced to its primitive elements, the program of the Dutch school. Outwardly nothing could be more simple than the discovery of this art of earthly aim; but until [the Dutch] tried to paint it, nothing had been imagined equally vast and more novel.

Eugène Fromentin (1875)[2]

As no other people before them, the Dutch in the seventeenth century compiled a remarkably comprehensive record in paint of their land, people, and possessions. What nineteenth-century art historians like Eugène Fromentin called the "probity" of Dutch art — its record of fact and compelling truth to life — was perhaps more clearly expressed in landscape than in any other genre; the Dutch, for all intents and purposes, invented the naturalistic landscape. Though at first view an unpromising subject, the small, watery, and predominantly flat nation known as the Netherlands was studied minutely and adoringly by her artists. They produced its likeness in images of a richly diverse landscape of blond dunes, limitless panoramas, and bosky glens. Artists painted the vaulted sky above the plain, damp and dank river views, the opulent ripening of summer, the heavy stillness of evening, agreeable cornfields, regular canals, and the hoarfrost of winter. At no other time have such modest geographical resources inspired such varied interpretations of nature. Great travelers, the Dutch also lent form to the plunging valleys of the Rhine, the cliffs and cataracts of Tirol and Scandinavia, the sunny Italian campagna, and the emerald plains of Brazil. Yet for all its inventory of fact and observation, Dutch landscape was neither a literal *speculum naturae* (mirror of reality) nor a topographically exact traveler's journal. The Dutchman's painterly imagination reformed nature, whether by conjuring up lunar remoteness as in Hercules Segers's fantasy landscapes or simply by rerouting a river or relocating a church spire as in the background of a country scene by Jan van Goyen or Salomon van Ruysdael. We no longer rest easy with uncomplicated notions of a naive Dutch realism chronicling the countryside with the literalness of a camera lens. Nor can we accept the view of Dutch landscape as a portrait of the land, unless one acknowledges the portraitist's license to editorialize, recast, and flatter.

Surveying 300-year-old Dutch landscape paintings from the vantage point of the late twentieth century, we are likely to misconstrue their outward accessibility or ignore the inevitable effects on our own vision of the intervening centuries' changing concepts of landscape. As Stechow noted, "A Dutch landscape is as far removed from a Caspar David Friedrich as it is from a Cézanne."[3] Antithetical to Dutch art, for example, is the nineteenth century's romantic, anthropomorphized view of nature with its implicit projection of human emotion onto the landscape. No less inconsistent is the instantaneous naturalism of impressionism, reality caught in the blink of a camera's shutter. There is nothing momentary or fragmented about Dutch landscape; nature is conceived as complete and, notwithstanding its specificity, exemplary. Although some Dutch landscapists shared with their Italian counterparts a taste for the classical, timeless aspect of nature or an ideal steeped in nostalgia for the antique, more revolutionary were the many Dutch landscapes in which time is perceived as passing in the present, the locale unapologetically local, and space a continuum.

Lands Liberated, Lands Reclaimed

Beginning with Hegel, much has been written in search of relationships between the social and economic history of the Netherlands and content and style in Dutch art.[4] To many writers the naturalism of Dutch art, its detailed attention to simple, unelevated themes, has seemed an appropriately "democratic" style for the permissive little bourgeois country that Fromentin characterized as "a nation of burghers, practical, unimaginative, busy, not in the least mystical, of anti-Latin mind, with traditions destroyed, with a worship without images, and parsimonious habits."[5] That Dutch art was an expression of the people's pride in their newly won independence from Spain, an assertion of democratic values, of the Protestant faith, and of the Dutchman's renowned practicality, self-reliance, and materialism has become conventional wisdom but touches on many truths. No doubt the Dutch painted landscapes in part out of a sense of pride in their own newly liberated land; the fact that naturalistic landscapes were first painted during the Twelve-Year Truce scarcely seems a matter of chance. It also is undoubtedly significant that this art arose in a period of unprecedented prosperity and urban growth in the Netherlands. With fewer than two million souls, the country was less than one-third the size of England and one-tenth that of France. However, between 1500 and 1660 the population of the Dutch maritime provinces tripled, while the city of Amsterdam achieved a similar order of magnitude of growth in only a fifty-year period (1570-

1622).[6] By contrast, elsewhere in Europe this was a period of stagnation or limited population growth. Most of the Netherlands' increases resulted from immigration; the skilled and unskilled, titled and disenfranchised, scorned and celebrated – all were drawn to that country's promise of religious and political tolerance and economic opportunity.

The great philosopher René Descartes wrote from Amsterdam in 1631, "What other place in the world could one choose, where all the commodities of life and all the curiosities to be desired are as easy to come by as here? What other land where one could enjoy such complete freedom."[7] The Dutch prospered; indeed, they became the richest folk in Christendom and remained so throughout the seventeenth century. Estimates made in 1688 and 1695 by the English accountant Gregory King rank per capita income in Holland as the highest in northern Europe and probably anywhere on earth.[8] The tiny country was the center of a far-flung seafaring empire, which transformed Amsterdam into Europe's banker and the world's emporium. More important than the exotic trade with the East and West Indies was the Baltic grain trade, which fed Holland's burgeoning cities.[9] The Polish connection unburdened Dutch farmers of the task of growing staples and enabled them to turn to more profitable pursuits, usually horticulture, animal husbandry, dairy farming, and industrial and specialized crops.

This was also a period of intensive land reclamation, when the Dutch literally saw their land grow daily through massive drainage projects.[10] Between 1590 and 1650,

for example, the land area of the province of North Holland increased by one-third. Yet for all the geographical engineering, the rural population, especially in the inland provinces, grew very little. Since much of the money used for these projects came from the city, the urban investor and his property were often widely separated. However, with the vast inland communication and transportation system provided by a new network of canals, the city and country in fact were brought closer together.[11] The dunes stretched to the very thresholds of cities like The Hague, Leiden, and Haarlem, while for Amsterdamers still closer at hand were the inviting banks of the gentle Amstel, offering a ready outing and reprieve. If one sought a rougher, more rural world, the Gooi, Veluwe, and Achterhoek were quickly reached. Over the course of the century, rich men also made a fashion of building country houses, preferably along the Amstel or Vecht rivers.[12] Constantijn Huygens had his Hofwyck, and Jacob Cats his Sorghvliet as retreats from the importunate world of affairs. For the merely prosperous, a converted farmhouse was as good as a villa for knitting up "the ravell'd sleave of care." To be sure, there was a good deal of posturing at seigneurial roles – the feudal system of land ownership had never taken hold in Holland and Zeeland, and the Dutch nobility had married into the patriciate or been absorbed largely by the urban oligarchies – but the notion of the rural environment as a place of mental refreshment and occasional recreation is surely linked to the rise of landscape painting.

Markets and Specialists

More than sixty percent of Holland's popu-
lation was centered in cities, which in turn
provided the chief market places for Dutch
art. In a real statistical sense, therefore,
Dutch landscape is a reflection of an urban
ideology: images of the countryside com-
pensating a busy city folk. To judge from
the many Dutch landscapes in seventeenth-
century inventories, to say nothing of the
astounding numbers that have survived, the
appetite for this art must have been formid-
able, but the ranks and reserves of artists
more than equal to the task of its satisfac-
tion. Some of these works were evidently
commissioned by public or private patrons.
Stechow cites the case of Jan Porcellis's
agreement in 1615 to provide for a set fee
forty seascapes in twenty weeks, assistant
included, and Jan van Goyen's commission
from the city fathers in 1651 to paint his
View of The Hague for the very sizable sum of
fl.650.[13] The landscapist Pieter van Asch was
paid fl.100 for a painting to hang in the
Prinsenhof, in Delft.[14] In 1637 Simon de
Vlieger signed a long-term contract with the
Rotterdam dealer Volmarijn, requiring the
artist to produce paintings as installment
payments on the purchase of a house.[15] A
still more colorful case concerning barter is
the arrangement between the landscape
painter Peter Stael (d. by March 1621) and a
garment worker named IJselsteyn, in which
the latter was to provide the artist with
fancy trousers, described as "coral red,
striped, and trimmed with passementerie"
in exchange for paintings. The settlement of
a dispute that arose obligated Stael to paint

a "winter" and a "summer" landscape for
IJselsteyn of the "same quality as the piece
that he had painted for the burgomaster"; if
the pair of paintings arrived on time, Stael
was to receive forty-eight ells of imitation
gold galloon and a pearl for his wife.[16]

Most Dutch landscapists, however, were
probably painting for the open market. To
judge from sales prices and inventory ap-
praisals, the average Dutch painter realized
a very small margin of profit for his efforts.
Reviewing fifty-two inventories in the city
of Delft from 1617 to 1672, Montias de-
termined that the average price of a painting
with an attribution to an artist was fl.16.6,
while unattributed paintings brought only
fl.7.2.[17] The municipal commissions of van
Asch and van Goyen were surely windfalls
for artists more accustomed to receiving
fl.10–20 for their paintings, or the equiva-
lent of about two weeks' wages for a skilled
worker. It has often been observed that the
low prices paid for their art encouraged
Dutch painters to specialize, since once they
hit upon a successful subject in this com-
petitive marketplace, they were likely to
stick to it. Thus Ambrosius Bosschaert
painted still lifes, Pieter Codde genre scenes,
and Bartholomeus van der Helst portraits,
while Jan van Goyen, Allart van Everdingen,
Jacob van Ruisdael, and Meindert Hobbema
specialized in landscapes. Art theorists of the
period justified these trends, advising artists
to discover and pursue their own natural
talents. Philips Angel commented, "It is
better to do one thing excellently than many
things only passably," offering a quotation
from Cicero: "He who cannot become a
lutenist can learn to play the pipes."[18] In

1678 Samuel van Hoogstraeten could even
joke about this curious Dutch compulsive-
ness, citing the case of a specialist in the
painting of cypress trees who, when asked to
paint a shipwreck by one of its survivors,
inquired whether his patron would like a
cypress in his "sad sea-accident."[19]

Some artists who specialized in other
types of painting depicted the occasional
landscape; for example, Jan Baptist Weenix
was primarily a figure painter, as was
Rembrandt, by whom fewer than ten land-
scape paintings are known. By the same
token some landscape specialists tried their
hand occasionally at other genres; Salomon
van Ruysdael painted still lifes with dead
birds and Philips Koninck, portraits and low-
life genre. Some landscape painters might
combine their talent with another specialty,
as Adriaen van de Velde did in his *Portrait of
a Family in a Landscape* (see p. 112, fig. 10).
More common, however, were the painters
who practiced specialties allied to landscape,
such as Jan van der Heyden, who was prin-
cipally a cityscapist, and Simon de Vlieger
and Jan van de Cappelle, who were primarily
marine painters. The tendency to specialize
extended even to specialties within land-
scape: Hendrick Avercamp painted winter
scenes almost exclusively, Allart van
Everdingen specialized in Scandinavian
views, Aert van der Neer in his maturity
painted mostly twilight and nocturnal
views, Philips Koninck painted panoramas,
and Frans Post made a career of painting
South America even long after he had re-
turned from that continent. There were, of
course, exceptional cases. The cameleons
Antonij van Borssom and Herman Saftleven

painted in a wide variety of styles and treated different subjects. But as Gerard de Lairesse observed in 1707, the general tendency was to specialize. "It is not unusual that each landscape painter has a special inclination . . . ; the one to wild and desolate views, the other to still and calm; still a third to nordic and cold, sun or moonshine, waterfalls and dunes, water and woody views."[20]

The value that the Dutch placed on landscape can be gauged from authors' comments, biographies of landscapists, the social status of collectors, and the relative prices brought by landscapes. Karel van Mander (whose comments are discussed later at length) spoke admiringly of the sixteenth-century Flemish landscapists Patenir, Herri met de Bles, Abel Grimmer, and the newly expatriated Gillis van Coninxloo. Visiting Amsterdam and Rotterdam in 1640, Peter Mundy noted the abundance of paintings on sale in the streets and hanging in every house and shop, even those of the blacksmith and cobbler.[21] Mundy's fellow Englishman John Evelyn remarked the following year on the many Dutch "Landscips and Drolleries, as they call those clownish representations."[22] Even allowing for foreign observers' exaggerations, landscape paintings were undoubtedly owned by a broad cross section of the Dutch citizenry. Montias's extensive survey of the seventeenth-century *boedels* (estates) in the Delft archives discredits the myth that peasants and the lower classes owned large quantities of art; it proves, however, that an extraordinary abundance of paintings hung in Dutch homes and, further, that while the

majority of paintings were purchased by "clients in the top third of the wealth distribution . . . paintings by guild-registered masters did penetrate into the middle and lower strata."[23]

Still more significant for our inquiry are Montias's statistics proving a change in the content of Delft inventories, with the largest increases in the proportional representation of landscape paintings. Between 1610 and 1679 the percentage of landscapes rose from about 25 to 40 percent of the collections, while the share of history painting shrank in about inverse proportion, declining from 46 to 17 percent in the same period.[24] This broadening base of support presumably was a strong factor in the rise of naturalistic landscape painting. However, we no longer immediately assume, as did our nineteenth-century predecessors, that Dutch landscape's appeal to an increasingly secularized, middle-class audience was coupled with a taste for purely visual rather than conceptual values. As we shall see, the decline of history painting and the rise of landscape meant not that traditional symbolism and allegory were discarded but that these were supplemented or superseded by new forms of conceptualizing.

Although our understanding of these patterns is still very limited, different social strata apparently bought different kinds of Dutch landscapes. Virtually the only landscapes to appear in inventories of the stadtholder's various residences were the classical Italianate landscapes of Poelenburch and his circle.[25] Typical of the courtly taste for the pastoral was the commission in about 1633 that Poelenburch, Abraham

Bloemaert, Herman Saftleven, and Dirck van der Lisse received from Frederick Henry to paint a series of four representations from Guarini's *Il Pastor Fido*, for Amalia van Solms's *cleedcamer* (dressing room) in the new palace of Honselaersdijk.[26] Specialized and hierarchical tastes are also borne out by major inventories, such as the famous record compiled on June 27, 1657, of the stock of the Amsterdam dealer Johannes de Renialme.[27] The highest values in that inventory were reserved for Italian and Flemish painting, for what were then "old masters" (Bassano, Jacopo Palma, Rubens, Van Dyck, Holbein, and Jan Swart van Groningen) and the history paintings of Rembrandt. Supporting what will emerge as an ongoing critical bias toward idealized Italian art, the most valuable landscape painting in the collection was a Claude Lorrain valued at fl.500; also awarded high values were Flemish (Grimmer fl.60, Paulus Bril fl.90, Govaert Jansz fl.50 and 150, Jan Brueghel fl.48, Jan Lievens fl.120) or *flamisant* landscapes (Roelant and Jacques Savery, respectively, fl.150 and fl.120) and Dutch Italianate paintings (Thomas Wyck fl.72, Poelenburch fl.60; even a copy by Poelenburch after Elsheimer brought fl.50). Among the "indigenous" Dutch school, the highest estimates were reserved for Hercules Segers's fantasy landscapes, one of which (possibly the painting now in the Uffizi, Florence; fig. 46) brought fl.300 (!), while others were estimated at fl.72, 60, and 30, and for one of Philips Koninck's only very recently completed panoramas ("een verschiet van Philips Konink", fl.130). However, the painters of simple dunes and

country roads, Pieter de Molijn (fl.24 and 30) and Jan van Goyen (fl.40 and 12 for "a Heath" [*heyken*]) received some of the lowest valuations in the inventory. In the light of these low values for the native Dutch school, it is notable that within the limited sampling available no record exists of a painting by Jacob van Ruisdael ever selling for, or being valued at, higher than fl.100 in his lifetime.[28] But the stories once told about Ruisdael dying a pauper have proven to be a case of mistaken identity. Four years before he died he was able to make a loan of fl.400, and at his death his estate was valued at fl.2,000, not the *boedel* of a rich man but that of a respectably middle-class burgher.

Given the limited profits they could expect for their paintings, it is scarcely surprising that many Dutch landscapists seem to have "moonlighted," supplementing their incomes with extra-artistic ventures. Aert van der Neer and Jan Wijnants kept inns, and Jan van Goyen speculated ruinously in tulips and real estate, ventures that left him in permanent debt. At his death in 1656, the sale of van Goyen's unsold art and six houses barely covered his debts. Van Goyen had also worked as an art appraiser and auctioneer. Naturally, many Dutch painters were also active in the art market; Segers was mentioned as an art dealer in Utrecht in 1631 and The Hague in 1633. We no longer assume that Hobbema stopped painting, but he seems to have curtailed his activity after a prosperous marriage and appointment to the Amsterdam octroi. Koninck, on the other hand, evidently set aside his brushes when in the last ten years of his life he knew more

financial security as "Waerd op het Rotterdamer Veer" (owner of the boat connection between Amsterdam and Rotterdam). Aelbert Cuyp, too, stopped painting after marrying into the regent class. On the other hand, the wealthy Jan van de Cappelle, who ran the family dye-works, and the well-born Dirck van der Lisse, who became burgomaster of The Hague in 1660, seem to have painted simply for the joy of it. Undoubtedly the most surprising report of a second career, however, is that Jacob van Ruisdael became a surgeon in later life; someone of this name apparently took a degree at Caen in 1676, and Houbraken claimed that Ruisdael performed successful surgical operations in Amsterdam.

Studios and Staffage

Dutch landscape paintings theoretically began as drawings made out of doors on the spot that were later transferred to canvas, panel, or (rarely) copper supports in the studio (fig. 1). Thousands of Dutch landscape drawings have survived, but the number of preparatory or auxiliary sketches is surprisingly small.[29] Although nearly seven hundred paintings and twelve etchings by Ruisdael are known, only about twenty of his drawings can be characterized as preparatory. None of Philips Koninck's more than eighty drawings are preparatory studies, only two by Aert van der Neer are known,[30] and not a single sheet of any kind can be assigned with certainty to Salomon van Ruysdael. On the other hand, the oeuvres of Jan van Goyen and Aelbert Cuyp include numerous studies for paintings, and more than a quarter of the graphic pro-

Fig. 1. Michiel van Musscher, *A Painter (Willem van de Velde?) in His Studio*, signed and indistinctly dated, panel, 47.6 x 36.8 cm., Lord Northbrook, London.

duction (about two hundred drawings) of Adriaen van de Velde is related to his paintings, comprising studies made from life *en plein air*, compositional, figure, and animal studies, as well as finished *modelli*.[31] However, it is unclear whether these were the exceptions or the rule. Attesting to the loss of a great deal of this important but ephemeral material is the fact that Jan van de Cappelle's estate lists about eight hundred drawings by his hand but probably fewer than fifteen have survived.[32]

Important developments for Dutch landscape painting were the spread in popularity of chalk drawings and the rise of the sketchbook. Chalk drawings had been produced in Haarlem by Goltzius, Jacob Matham, and Cornelis van Haarlem, and in Utrecht by

Abraham van Bloemaert, but when Esaias van de Velde produced his first chalk sketchbook in 1618–20, he helped to spread the concept of recording landscape subjects rapidly and succinctly on the spot.[33] The sketchbook and sketching from life in chalk soon became standard practices; van Goyen, Pieter de Molijn, and Pieter de Neyn were among the first to follow Esaias in producing chalk landscape drawings. Virtually all the following generation of landscapists sketched in chalk: Simon de Vlieger, Aelbert Cuyp, Jacob van Ruisdael, Antonie Waterloo, Joris van der Haagen, Meindert Hobbema, Philips Wouwermans, and Jan van der Cappelle. Although Rembrandt, like Cornelis Vroom and Aert van der Neer, preferred pen and brush, he too sketched in the speedy, versatile medium of chalk.

Our understanding of Dutch studio practices and the progressive procedure of making a landscape painting is incomplete. However, we have come to know something about artists' practices from guild records and other documentary sources, notebooks and treatises, modern technical analyses, as well as genre scenes of artists' studios.[34] The average artist probably had one or two apprentices who ground and mixed the artists' pigments, placed them in bladders, stretched his canvases, prepared the palettes, and generally looked after the maintenance of the studio. Ideally, the studio would have had northern exposure to reduce glare and been kept scrupulously neat. Wooden supports were purchased from joiners and tended to be radially sawn oak panels that came in fairly standardized sizes, often taking their names from the coins used

to purchase them.[35] The wording of Lendert Hendricx Volmarijn's request to the Municipality of Leiden in 1643 to open an artists' supplies store suggests that the practice of buying prepared colors and supports may have been more widespread than we have previously supposed.[36] Van der Wetering has concluded from his study of Rembrandt's canvases and the mention of *plumuyrders* (primers) in documents that Dutch painters as a rule bought their canvases already prepared.[37] Canvases were often first laced or tacked within an oversized stretcher for painting (see fig. 8) and stretched to their final dimensions only after completion of the work. Most landscapes had colored grounds, ranging from light gray to yellowish white or tan, composed mostly of a mixture of chalk in an oil medium or glue, or of oil, chalk, and lead white. Sometimes double-layer grounds were used. Artists often worked up their compositions with black chalk or other dark material directly on the ground. Artists' manuals record the various pigments. Unfortunately for landscape painters, the most troublesome colors were blues and greens. Although the Dutch generally escaped the problems suffered by their Italian counterparts who used copper resonate greens (which can go a muddy brown with age), they encountered other difficulties. Lapis was expensive, and although scarce azurite was fairly durable, cheap blue smalt, which was most commonly used, often turned a dull opaque gray or even became transparent. Poor aging properties of pigments were noticed early; in 1719 Houbraken claimed that Jan van Goyen's use of the pigment called "Haarlem

blue" accounted for the increased transparency of his paint layers. The author believed that this made the wood grain of the panel more pronounced and created a disconcerting monochrome.[38] Since the secret of making from verdigris Memling's deep rich green had been forgotten, Hoogstraeten lamented, "Terra verde is too weak, verdigris too crude and green bice is not durable."[39] Green could be made by glazing blue with a yellow lake pigment known inexplicably as "Dutch pink" or *schietgeel* (a contraction of *vershietgeel* [fading yellow], which accurately describes its limitations). This practice accounts for the curious blue foliage that one often encounters in the works of artists like Adam Pijnacker and Adriaen van de Velde.

With advances of technology we have learned a great deal more about the structure and materials of Dutch landscapes. For example, with the aid of infra-red reflectography (a technique that has the advantages over simple infra-red photography of enabling us to see through not only the upper end of the color spectrum but also blues and greens), we can now see the underdrawing on the light-colored grounds of Dutch panels. Glimpses of underdrawing can be seen without technical assistance in many landscapes, but Bomford recently obtained a clear image of extensive underdrawing in a river scene by Salomon van Ruysdael (see cat. 93, fig. 1), a find that may in part explain the absence of any certain drawings by Ruysdael. Recent studies of the ground layers of landscapes by Jan van Goyen and Salomon van Ruysdael suggest that the artists deliberately exploited the transparen-

cies of upper layers of paint and the colors of lower ground layers in achieving their effects. Indeed, Gifford suggests that Houbraken may have misunderstood deliberate effects of late van Goyens, where the transparency of this ground layer made the paintings appear to be painted directly on wood.[40] Another new find is the unusually large proportion of crushed glass-like particles in the ground layer of Adriaen van de Velde's *Winter Scene* (cat. 104).[41] Whether this technique was designed simply as a drying agent or possibly to enhance the luminosity of this brilliant little picture awaits, as do so many technical queries about Dutch landscapes, further comparative studies.

It has often been observed that Dutch landscapes almost always include some figures, whether historical characters or anonymous "genre" figures.[42] The rare figureless landscapes by Joachim Camphuysen and Alexander Keirincx (see fig. 2) are the exceptions. The effect of the figures' presence is not only to animate the scene and provide a human index and proportion to the landscape but also to imply that man is an integral part of nature. The human element ensures, in Stechow's words, that "The wide panorama, tall tree, wild sea, never grows beyond man's compass and comprehension."[43] The tendency to specialize also applied to the staffage of Dutch landscapes: some artists (David Vinckboons, Adriaen van de Venne, Jan Pynas, Aert van der Neer, Salomon van Ruysdael, Philips Wouwermans, and Adriaen van de Velde) always painted their own staffage figures, while others (Jan van Goyen, Jan Both,

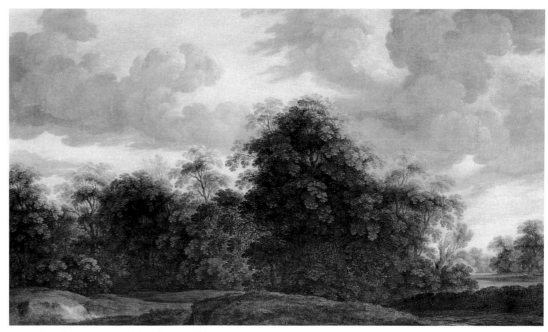

Fig. 2. Alexander Keirincx, *Wooded Landscape*, panel, 29.5 x 50.5 cm., Galerie Hoogsteder, The Hague.

Alexander Keirincx, Jacob van Ruisdael, Philips Koninck, Meindert Hobbema, and Allart van Everdingen) occasionally used a staffage painter, and an artist like Jan Wijnants apparently collaborated virtually all the time. Although none of the paintings have been identified, van Goyen provided staffage for landscapes by his first teacher, Coenraet van Schilperoort.[44] Among the most popular staffage painters were the Dutch Italianate painters Cornelis van Poelenburch, Claes Berchem, Adriaen van de Velde, and Johannes Lingelbach. Perhaps surprisingly, even naturalistic landscapists like Ruisdael collaborated with Italianate

staffage painters.

The historical subjects popularly depicted by landscapists included biblical themes intrinsically suited to depictions out of doors in the countryside, such as the Rest on the Flight or Flight into Egypt (cat. 69, 70, 78), the *Parable of the Tares and the Thistles* (cat. 12 and 112), and scenes from mythology, such as *Mercury and Battus* (cat. 75), *Hermaphroditus and Salamacis* (cat. 123), *Cephalus and Procris* (cat. 51), and the *Judgment of Midas* (cat. 30). The pastoral tradition of landscape also naturally placed a premium on arcadian, bucolic figures (cat. 55). The majority of Dutch landscapes, however, include anony-

mous "everyday" staffage. One frequently encounters herdsmen (cat. 2, 8, 10, 22, 40, 45, 49, 58, 65, 71, 92), hunters (cat. 11, 19, 42, 50, 52, 96, 99), and fishermen (cat. 9, 53, 93), but generally there are many more images of leisure and relaxation than of work. This is especially true among winter landscapes and scenes with upper-class figures; however, it is not exclusively the case (see cat. 103). In contrast to sixteenth-century landscapes, agrarian images with figures working the land are not plentiful (see cat. 47); even cultivated fields are not common (see cat. 82 and 83). Far more plentiful are views of the unarable dunes. The peculiar nature of the Dutch geography and rural economy that has been discussed above may, of course, have been a factor in these developments, but we must also consider these patterns within the context of pictorial and literary tradition. It is primarily to the pictorial tradition, for example, that we must look for the inspiration for the most popular theme for secular figures in Dutch landscape: travelers.[45] These themes range from figures en route to the local market (cat. 108), stopping by an inn (cat. 92), ferrying across a river (cat. 33, 94, 106), or moving through foreign or fantastic scenery (cat. 14, 27, 57). Some travel on foot or rest heavily by the side of the road (cat. 36, 43, 90, 98), while others travel in the luxury of carriages through vast panoramas (cat. 37 and 54). To the goals and associations of these many travelers we must return.

Concept, Theory, and the Mud of Ludius

For all their formidable production of landscapes, the Dutch were surprisingly taciturn on the subject; in seventeenth-century books on art only a few slim chapters assist us in understanding the concept and perception of landscape.[46] Many of the ideas that were expressed, however, had roots in Italian Renaissance art theory and, in turn, classical sources. Gombrich determined that landscape first achieved theoretical legitimacy in Italy in the writings of Alberti and Leonardo and, perhaps more unexpectedly, was vindicated in theory before it became a widespread practice in art or a discrete genre of painting.[47] Before the sixteenth century the term landscape was used in connection with neither literature nor the visual arts. It first gained familiar usage not in the North but in Venice, where it appears in early sixteenth-century inventories.[48] More than fifty years earlier, Alberti, in his *Ten Books on Architecture* (c.1450; published 1486; book 9, chap. 4), had compared painting and poetry in their range of subject matter, thus recalling Horace's famous dictum "ut pictura poesis."[49] In the context of discussing landscape decoration for architecture, he correlated these subjects with the lowest echelons of society but commended their soothing and diverting effects on the mind. As in Renaissance still life, landscape was a theoretical reconstruction of a category of art only fleetingly mentioned by the classical authors Pliny and Vitruvius. Paolo Giovio, who inspired Vasari's *Lives*, referred in the late 1520s to landscape backgrounds in

Dosso Dossi's paintings as "*parerga*," a term borrowed from Pliny, who applied it to pictorial accessories.[50] Thus landscape was acknowledged as a type of painting, albeit an adjunctive and lesser category of art.

Though never fully codified until the third quarter of the seventeenth century in the writings of André Félibien,[51] this hierarchy of subject matter was implicit in most fifteenth- and sixteenth-century art theory. At the core of these ideas was the notion that landscape appealed to the eyes, not to the intellect. In remarks that Francisco da Hollanda attributed to Michelangelo, the prejudice is clear: "in Flanders they paint with a view to external exactness of such things as may cheer you and of which you cannot speak ill. . . . They paint stuffs and masonry, the green grass of the fields, the shadow of trees and rivers and bridges, which they call landscapes, with many figures on this side and many figures on that"; but he added that they paint "without reason or art, without symmetry or proportion, without skillful choice or boldness."[52] In verses appended to a portrait of Jan van Amstel, Lampsonius patronizingly claimed that the landscape painter had his "brains in his hands," an anatomical disorder never suffered by Italians who painted mythologies and histories.[53] The artist's noblest calling was history painting: the depiction of literary (biblical, mythological, historical, etc.) or allegorical subjects.

Though obviously a passionate admirer of landscape painting, Karel van Mander, like the later seventeenth-century Dutch art theorists Samuel van Hoogstraeten and Gerard de Lairesse, accepted as an article of

faith the notion that history painting was the highest form of art.[54] In his *Den Grondt der edel vry schilder-const* (1603), van Mander devoted his entire eighth chapter to landscape but implied within the larger context of his *leerdicht* (chapter 9, for example, is devoted to the painting of "Beasts, Animals and Birds," chapter 10, to drapery) that landscape was only one of several subdisciplines of art that must necessarily be mastered by a successful figure painter.[55] Similarly, in Hoogstraeten's *Inleyding* (1678), in the first sentence of the chapter on landscape, the author underscores landscape's supportive role: "Landscapes and prospects greatly enhance Histories."[56] Ironically, for all the legions of Dutch painters who earned their bread painting landscapes, it is unclear, at least in theory, that landscape was regarded a separate genre of painting.

Statistics suggest, however, that theoretical texts on art were not widely disseminated among Dutch artists; indeed, we may legitimately question to what extent they were read at all.[57] While van Mander might practice what he preached, inasmuch as wooded or mountainous landscapes are usually but not exclusively (see fig. 24) at the service of figural elements in his paintings, the vast majority of Dutch painters apparently felt little constraint from theoretical orthodoxy. So easy and unrestrained was the Dutch manufacture of landscapes, in fact, that not only the product but also the word (*landschap*) was exported. In 1606 Henry Peacham acknowledged the Dutch origins of the term "landtskip,"[58] and another Englishman, Edward Norgate, remarked in his *Miniatura* of c.1650 that

landscape was "an art so new in England and so lately come ashore, as all the Language within our Seas cannot find it a Name but [uses] a borrowed one and that from a people that are no great lenders but upon good Securitie, the Dutch. Perhaps to say the truth the Art is theirs, the best in that kind that ever I saw speake Dutch."[59] Noting the recent invention of landscape and, perhaps more important, acknowledging its full recognition as a separate genre through the professional landscapist's devoted efforts, Norgate wrote, "But to reduce this part of painting to an absolute and intire Art, and to confine a man's industry for the tearme of Life to this onely, is as I conceave an Invencon of these later times, and though a Noveltie, yet a good one, that to the Inventors and Professors hath brought both honor and profitt."[60] The *pictor vulgaris* thus had won his place.

The discrepancies between Dutch art theory and practice reflect not only the fact that relatively few art theoretical texts were written or disseminated but also the fact that those few were often inspired by literary models. Whether one assigns it to chance, a natural sympathy among the sister arts, or a fulfillment of the Horatian *ut pictura poesis*, the fact is that quite a few Dutch landscapists were also poets. These included among the artists exhibited here Adriaen van de Venne and the minor versifiers Philips Koninck and Gerbrand van den Eeckhout. But it can scarcely be accidental that van Mander composed his treatise in verse, while Hoogstraeten, who wrote in prose, often reverted to rhyme for his landscape descriptions. Both authors make

abundant use of literary allusions. Indeed, to the modern reader, Hoogstraeten's flourishes of erudition and invocations of classical authorities may appear pretentiously cloying.

Unsystematic as van Mander's descriptions of exemplary landscapes may be, they convey much practical advice for artists and a keen sense of observation. In describing a landscape with hunters walking through "green, dewy fields," van Mander admonishes the young painter to observe "how the trodden dew turns a lighter tone of green, showing their footprints." Or elsewhere (verses 8–10), discussing the differences between linear and aerial perspective, he would have us "note how the ditches and furrows in the field taper and converge at the same vanishing point, looking like a tiled floor . . . , [and] take into account the thickness of the air which contains a blue substance obscuring sight and forming a haze, through which it is impossible to see clearly." Seemingly describing Pieter Bruegel the Elder's or Roelandt Savery's Tirolian views, his prescription for mountains and waterfalls (verses 33–34) is that "the cascade tumbles circuitously hither and thither like a drunken man, and arriving at the bottom follows a tortuous path like a snake." Trees are also to be highly individualized (verse 39): "Show a distinction between the pale, thin beeches and limes, and let the wrinkled oak bark be overgrown with creeper and green ivy." Van Mander's call for an arboreal portraitist was answered forty years later by the great Jacob van Ruisdael, whose art, as Slive and his colleagues have shown, had an unrivaled

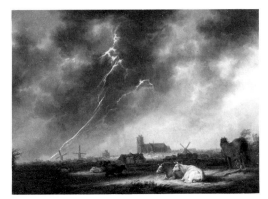

Fig. 3. Aelbert Cuyp, *Dordrecht in a Thunderstorm*, signed, panel, 75 x 105 cm., Bührle Collection, Zurich.

botanical accuracy.[61] The specifics of weather and season also must not be neglected. Van Mander recalls that the classical painter Apelles could even paint thunder and lightning – a challenge later taken up spectacularly by, among others, van Goyen and Aelbert Cuyp (see fig. 3) – and encourages his readers to "try to express in paint, the snow, hail, rainy squall, ice, hoarfrost and impenetrable fog" (verse 14). Hoogstraeten, too, poetically inventories the features of the exemplary winter scene of the type painted earlier in the century so triumphantly by Hendrick Avercamp and his successors: "Dress the woodcutter in warm attire, but let the trees be barren and the frozen brook covered with snow and frost. Let the fair swan swim in the hole in the ice, have a man cross a bridge: Let all the chimneys smoke against a dazzling sky. Have the city slicker's nose drip, his hair and beard full of icicles as he meets the cutting Northwind."[62] Even the most ephemeral of

meteorological phenomena, namely, clouds, must be studied, according to both van Mander (verse 11) and Hoogstraeten, in all their subtle variations.[63] But here Hoogstraeten reminds his reader that the landscapist's role is not only empirical but interpretive as well: "Observe the lovely gliding of the clouds, and how their drift and shapes are related to one another, because the eye of the artist must always recognize things by their essence while the common folk see only weird shapes."[64]

In van Mander's assessment Gillis van Coninxloo was the greatest living landscapist, and one readily detects in the theorist's recommendations (for example, the use of designs with strong *repoussoirs* in the foreground [verse 19], oscillating patterns of recession [verse 21], and details such as the painting of leaves from one's imagination rather than first-hand observation [verse 40]) the mannerist conventions of his day. But his writings also anticipate and vindicate the naturalistic observation that distinguished so much Dutch seventeenth-century landscape painting. Particularly telling is van Mander's reference to the ancient authority of Ludius (and here, as so often, Hoogstraeten dutifully repeats van Mander), whose story Pliny recounts in the *Historia naturalis*. The original landscapist, Ludius was not renowned for painting some heroic or exotic subject, such as a view of a castle, great mountain, or panoramic river valley; rather, his greatest achievement was a simple painting of a low-lying piece of land with a couple of farms and muddy, almost impassable roads, traveled by figures who include women slipping and falling down

(verses 44–46). Reading van Mander's account of the story, one may think of the unpretentious dunescapes that Pieter de Molijn, Pieter Santvoort, Jan van Goyen, and Salomon van Ruysdael were painting two and three decades later (see fig. 48 and cat. 56, 98, 35).

Country Walks and "Hofdichten"

According to Van Mander, Ludius populated his landscapes with "people who were enjoying themselves by going for a walk" (verse 44). The author's poetic tribute to landscape painting had also begun with his advice to the young painter not to work constantly indoors but, whenever possible, to go out early in the morning into the countryside (verses 1–3). Van Mander urges the artist into the open air, where he is enjoined to observe nature at first hand, recording it ("naar het leven") in drawings that will subsequently be translated into paint back in the studio. With rare exceptions, as recorded, for example, in Lievens's drawing of a tiny figure with large easel painting in a forest (fig. 4), it was not the general practice in the Netherlands in the seventeenth century to paint *en plein air*.[65] But Dutch landscapes frequently depict artists sketching out of doors (see fig. 5, cat. 15, and p. 81, fig. 13). The famous chronicler of artists' lives Arnould Houbraken specifically stated that Paulus Potter and Adriaen van de Velde went out regularly into the countryside to sketch.[66] Rembrandt's graphic oeuvre thoroughly documents his custom, especially in the 1640s, of taking walks along the Amstel to sketch by the river's bank and in the countryside outside

Fig. 4. Jan Lievens, *Forest Landscape with a Painter*, pen and ink drawing, Städelsches Kunstinstitut, Frankfurt, inv. 3289.

Fig. 5. Allart van Everdingen, *Draftsmen in Scandinavia*, etching.

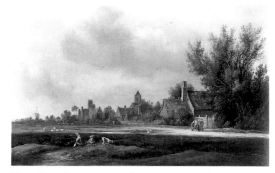

Fig. 6. Pieter de Neyn, *Meadow beside a Village*, signed and dated 162[9], panel, Landesmuseum, Mainz, inv. 725.

Amsterdam. Indeed, so exact is this record of Rembrandt's walks that Frits Lugt's charming book has virtually retraced the artist's steps.[67] In the unpredictable Dutch climate, the roving artist might of course be victimized by the weather. The poet Joachim Oudaen wrote a poem about the painter Neun (probably the Jan van Goyen follower, Pieter de Neyn [1597–1639]), who was caught in a downpour:

> Neun, who likes to draw landscapes sets out
> for the open field,
> But soon the sun becomes pale and the air
> loses its sweetness.
> He watches the clouds mount (harbingers of a
> heavy downpour)
> And shortly he feels drop upon little drop:
> (the threat of a rain shower)
>
> .
>
> He gets home so thoroughly soaked, dirty and
> wet
> That he resembles a big friendly dog without
> a tail or a drowned cat.
> This time he remembers something better
> than the appearance of meadows and fields,
> And, so that he may show it, he takes his
> brush and paints
> And he depicts his adventure, how the wind
> and rain beat him,
> How swiftly his legs moved, just as it appears
> before you.[68]

This "Neun" fulfills the prescription that one should only compose in paint upon returning to the studio (fig. 6). Though scarcely Wordsworth's "recollections in the

tranquility" and still little understood, the practice, which had the effect of editing and reforming nature, was perhaps best expressed by Hoogstraeten's phrase *keurlijke natuerlijckheyt* (selective naturalism).[69] The goal was a plausible fiction, at once harmonious and agreeable. In his excellent discussion of the often quoted expression "naar het leven," Freedberg has observed that, rather than meaning simply "from life," like the phrase "uyt den gheest," it is a concept rooted in the imagination. Instead of a literal record of reality, the work should give the impression of being lifelike; natural phenomena should be depicted as if drawn from life.[70]

Noting the new urban taste for country walks, Freedberg observed that the Dutch could even take a stroll without leaving home; leafing through series of naturalistic landscape prints, such as those of C.J. Visscher, was like taking an imaginary walk in the country.[71] What has often been ignored in discussing van Mander's invitation to young artists to take a walk in the country is its implication of release from toil ("lay aside the yoke and go out") and recommendation to seek nature's recreational and restorative effect. Nature for van Mander and his contemporaries even had curative powers. According to the author, Goltzius, whose extraordinarily precocious drawings of the outskirts of Haarlem initiated the naturalistic landscape tradition, was consumptive and took long constitutionals in the countryside.[72] The Rembrandt pupil Heiman Dullaert in old age had to have descriptions of landscapes read to him to satisfy his desire for the walks he no

longer could take.[73] We have seen that Alberti commended the soothing effects of landscape painting, which he felt was well-suited to the decorations of a villa, in itself a place of retreat. Writing at virtually the same moment as van Mander, the patron and the most important advocate of seicento Bolognese landscape painting, Giovanni Battista Agucchi, refers in letters of 1602 to the restorative powers of landscape painting for harried men of affairs.[74]

The roots of the pastoral idea of nature as a place for mental relaxation and emotional release has, of course, primeval origins but can be traced from classical literature – Theocritus's idylls, Horace's *Epodes*, and Virgil's highly influential *Georgics* and *Eclogues* – to medieval Latin literature and finally to vernacular Dutch literature and poetry. On the threshold of the seventeenth century, Virgil's *Georgics*, a didactic poem on farming that stressed the rustic charms of landscape, was not a remote, ancient text but a living poem that had just been translated into Dutch in 1597 by van Mander himself.[75] From the 1590s onwards, Dutch poets also deliberately sought to show that their own surroundings were no less worthy of poetic tribute than the classical landscape. Jacob Cats's "Shepherd" poems of 1618 express the classical yearning for the pastoral life but, despite the arcadian names of the shepherds and shepherdesses, the locale is the island of Walcheren in Zeeland.[76] Hendrick Laurensz Spieghel, in his *Hertspieghel*, also wrote, "Parnassus is too far away, here is no Helicon – only dunes, woods, and brooks. Our subject is this country's brooks, meadows, streams, and

tree goddesses – and it is these that we love so helplessly."[77]

The clearest expression of the georgic revival was the *hofdicht* (literally, country house poem), a popular seventeenth-century Dutch literary form that praised rural living from a country gentleman's point of view.[78] Many of the greatest Dutch poets of the period composed *hofdichten*, including Petrus Hondius, Joachim Oudaan, Constantin Huygens, Jacob Westerbaen, and Jacob Cats.[79] The poem had three purposes: to describe – often in considerable naturalistic detail – the grounds of the estate, to teach horticulture, and to moralize. A literary form distinct from the pastoral, the *hofdicht* often emphasized the four seasons, local references, and patriotic sentiments. As a rule, the naturally virtuous and constant way of life of the countryside was opposed to the unsettling realm of the city, where one was forever set upon by contentious solicitors, corrupt businessmen, and craven souls of every stripe. The country life was also to be preferred to the dangers and covetousness of a seafaring career, then, of course, a popular vocation for ambitious gentlemen seeking their fortune. The seigneurial gardener identified with the virtuous, self-reliant farmer, who lived with the rhythms of the seasons far from the obsequiousness of court and the bugles of war. But this was not a romantic retreat into the peasantry, since the country gentleman was a cultured, erudite figure, whose library and study were always close at hand, offering an edifying book in Latin or French for a winter afternoon.[80]

The chief poetic conceit of the *hofdicht* is the country walk, on which the narrator conducts the reader on a tour of the property. As the name *hofdicht* implies, the narrator is chiefly concerned with cultivated as opposed to wild nature. While rarely great poetry, these verses attest to an intense aesthetic response to nature that parallels the rise of Dutch landscape painting. The practical landowner delights in poetic catalogues of plants and vegetables and tips on pruning and manuring. Huygens, in his famous *Hofwyck* of 1653, for example, can look on a stand of great oaks and simultaneously see their idyllic and commercial value: "It is pleasing to see four wondrous lanes of oak trees with their valuable wood" (Den tammen lust voldoen vier wonderlicke dreven van Eicken saegbaer hout [line 153]).[81] But the overriding theme of the country walk is nature's restorative psychological and spiritual effects. As early as 1613 Philibert van Borsselen wrote sensitively of these feelings in the first true *hofdicht*: "In the evening what a joy to take in the cool air,/ To hasten with hurried step out of the anxious house into the open field,/ To look at the heavens and to lose earth's vain care to the stars,/ Permitting one's inner spirit to soar up."[82]

God's Two Books

Invariably these poems also have a religious orientation and often expatiate on nature as divine revelation. Petrus Hondius in his *Moufe-scans* of 1621 wrote, "And each flower that he saw/ Offered to him God's wonder-works" (Een yder Bloemken dat he siet/ Godts wonder wercken hem aenbiet), while

Huygens, who wrote, "God's goodness appears on every dune's top" (Des Heeren goedheit blijckt aen elcken Duijn syn' top), likened nature to a book.[83] Referring to "Gods een en ander Boeck" (*Hofwyck*, line 1524), he alluded to the Bible and nature as the two sources of divine understanding. Jacob Cats also takes up this metaphor in his own *Tachtig Jarig Leven, en huyshouding, of kort begryp van het buyten leven op zorg vliet* (Amsterdam, 1684), where the two "books" are respectively interpreted as expressions of God's will and power.[84] Cats even suggests that in the fields and countryside one can come closer to a biblical world and the Old Testament times of Isaac and Jacob. The recurrent idea in Dutch poetry and literature on landscape and gardening that each tree and plant, however small, is divinely instructive was illustrated by Adriaen van de Venne for his *Zeeusche Nachtegael* (Middelburgh, 1623) with an engraving by Crispijn van den Queborne entitled *Ex minimas patet Deus* (fig. 7). The verses that the print illustrates explain that the old man is teaching his elegantly dressed young companion that everything on earth, regardless of size, is good because it is created by God. All natural things point to their Creator, and one can be assured of his presence simply by touching his creations.

On one level, all Dutch landscape paintings also embody the idea that nature is the mirror of God, the reflection of divinity. Recent iconographic studies of Dutch landscape, however, claim to have identified a much fuller program of Christian symbolism, primarily in the art of Jacob van Ruisdael.[85] In assessing the validity of these

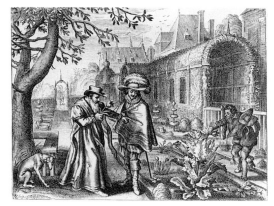

Fig. 7. Crispijn van den Queborne after Adriaen van de Venne, *Ex Minimus Patet Ipse Deus*, illustration in A. van de Venne, *Zeeusche Nachtegael* (Middelburg, 1623).

interpretations, one of the greatest challenges is gauging whether a moralistic message was uppermost in the Dutchman's mind, only one of several meanings, or merely an associative footnote to the overall meaning and appreciation of the landscape. Early seventeenth-century print series were often given charming subtitles like C.J. Visscher's *Plaisante Plaetsen* (*Pleasant Places*) of 1611–12: "For Nature Lovers who have no time to travel far." The notion of landscape as *delectatio*, or *amoenae regiunculae* (pleasant little regions), without a didactic or moralistic aspect, is even expressed in theological treatises. In the 1545 edition of Calvin's *Institutes of the Christian Religion* (Dutch edition 1560), he distinguished between two types of subjects in painting: "The first consists of histories, and the second of trees, mountains, rivers, and persons that one paints without meaningful intention. The first kind provides instruc-

tion, the second exists only to afford us pleasure."[86]

While there can be little question that a painting like the *Jewish Cemetery* (cat. 86) is richly symbolic, it would be profoundly misleading to assume that every tree, shrub, and stream in a Dutch landscape had a specific, isolable symbolic meaning. This is not to suggest that Dutch landscapes were executed for purely descriptive or aesthetic ends, as pleasurable as those features may have been for Dutch viewers. Rather, it is to draw attention to a misunderstanding that arises from premises of twentieth-century criticism, which contrast "imitative realism" and "creative abstraction" and often labor under the residue of academic theory in a tendency to equate "meaning" solely with isolable literary content. To the modern viewer the absence of an identifiable narrative or allegorical dimension signals that the work of art deliberately draws attention to its own means, thus offers pleasures only of a purely aesthetic sort.[87] But seventeenth-century Dutch naturalism was neither a purely aesthetic phenomenon nor a visual substitute for conceptual meaning; rather, it was a new way of conceptualizing. The richness and variety of Dutch landscapes' meanings are intimated only through studies that address the larger context of Dutch culture.[88]

Music, Paysages moralisés, and Modes

Stechow, who concluded that Dutch landscapes "did not display – and hardly hid – symbolic elements,"[89] was fond of music and musical metaphors. He qualified Max J. Friedländer's remark ("what music is in the

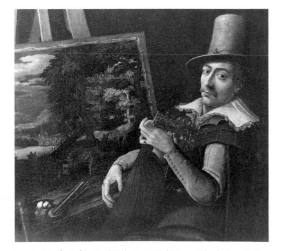

Fig. 8. Attributed to Paul Bril, *Artist (Self-Portrait?) Playing a Lute*, canvas, 71 x 77 cm., Museum of Art, Rhode Island School of Design, Providence, no. 39.046.

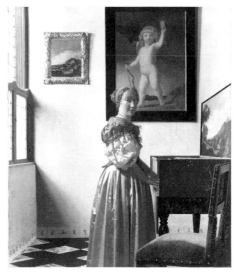

Fig. 9. Johannes Vermeer, *Woman Standing at a Virginal*, monogrammed, canvas, 51.7 x 45.2 cm., National Gallery, London, no. 1383.

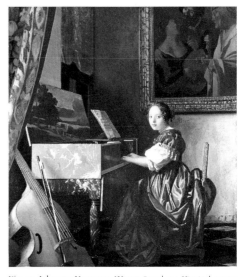

Fig. 10. Johannes Vermeer, *Woman Seated at a Virginal*, monogrammed, canvas, 51.5 x 45.5 cm., National Gallery, London, no. 2568.

categories of art, landscape is in the categories of painting"),[90] likening Dutch landscapes to chamber music, since "no one should look to them for the message of vocal music or, for that matter, the dimensions of a symphony".[91] Netherlandish artists depicted themselves in the role of musicians, and music often found a place in the studio (see fig. 8).[92] Musical analogies in landscape have, of course, a long history and can be discovered, for example, in the tradition of decorating keyboard instruments with landscapes. These decorations could have general associations with pastoral lyricism or more specific meanings. A recent interpretation of Johannes Vermeer's *Woman Standing at a Virginal* and *Woman Seated at a Virginal* (figs. 9 and 10) suggests that they are pendants opposing virtue and vice, with the

Fig. 9a. Detail of fig. 9.

Fig. 10a. Detail of fig. 10.

landscapes on the virginals (see figs. 9a and 10a) embodying the hard, steep road of the former and the easy, wide road of the latter.[93] This type of *paysage moralisé*, as it has been called, has been discussed by Panofsky, particularly in the case of subjects like the classical theme of Hercules at the Crossroads but also generally in religious paintings where the *aera sub lege* is contrasted with the *aera sub gratia*.[94] For the Dutch poet Roemer Visscher, an emblem depicting a landscape with two trees, one rotted and the other in full bloom (fig. 11), is enough to prompt anxious thoughts about life's choices and the dangers of being misled by false appearances or the lack of knowledge.[95] In the case of the Vermeers, the landscapes' opposing symbolism is clarified by the pictorial context, which includes two large figures, one standing and the other seated, and accessories such as the paintings within the paintings contrasting Dirck van Baburen's *Procuress* (dated 1622, Museum of Fine Arts, Boston, 50.2721) and a lost painting of a putto holding up a card, or placard, that has been interpreted through emblems as embodying fidelity to one love.[96]

Figures have, of course, the expository and narrative advantage over landscape of a repertoire of gesture, action, and costume. Van Mander acknowledged these expressive differences when he noted in *Den Grondt* (verse 41), that it is useful (but not necessary!) to know beforehand what kind of figures and what type of narrative is to be included "so that you may adapt your landscape accordingly."[97] While van Mander never systematized the necessary adaptations, Italian and French art theorists

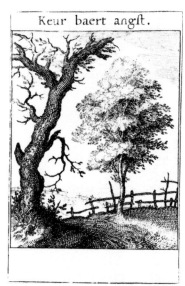

Fig. 11. Roemer Visscher, *Keur baert angst* (*Choosing Causes Anxiety*), emblem from *Sinnepoppen* (Amsterdam, 1614), p. 11.

attempted to codify a modal view of landscape, in effect, categorizing the moods of nature according to analogies with the theater or music.[98] The classical author Vitruvius had observed, in his seventeenth book, that the walls of antique rooms were often painted in imitation of theatrical stage decorations, with long galleries painted with naturalistic landscapes.[99] The three different types of dramatic poetry – tragedy, comedy, and satire – were characterized by different types of scenery, with the last mentioned composed principally not of architectural elements but of trees, grottos, mountains, and other landscape elements. Gombrich argued that Vitruvius's precedent was a starting point for Lomazzo, who in 1585 fashioned a crude subsystem of landscape

that anticipates the distinctions between the heroic landscapes of Poussin, the pastorals of Claude, and the dramatically romantic works of Salvator Rosa.[100] Later, Poussin, in a now famous letter of 1647 to his friend Chantelou, outlined a system of five expressive categories for landscape based on music, differentiating, for example, between joy, gravity, and lamentation.[101] Subsequent art history shows that such systems usually congealed into academic conventions.

The fact that a modal system of landscape was never codified by the Dutch no doubt contributed to the splendid diversity of their landscapes (Stechow wrote, "it varied from decoration to cabinet piece, from stateliness to intimacy, from sociability to reticence, from gaiety to melancholy") but also denies us the syntax for deciphering the landscape "adaptations" of the artists who came after van Mander. Spickernagel has argued, however, that the residue of Vitruvius's notion of landscapes as "satyrica" may have persisted into the seventeenth century.[102] In Sebastiano Serlio's well-known treatise on architecture, the woodcut illustrations of "satyric" scenery take the form of a proscenium with a naturalistic landscape featuring low cottages and trees (fig. 12) that resembles some of the earliest Netherlandish drawings and prints of naturalistic landscapes (see fig. 17). More pertinent is the appearance on the title pages of the highly naturalistic landscape print series by Jan van de Velde of decorative satyrs' heads, in one case holding up a theatrical-looking curtain with a painter's palette, peasants, and more elegantly dressed figures arranged as props and players below (fig. 13).[103] Notwith-

Fig. 12. *Satyric Scene*, woodcut illustration from Sebastiano Serlio, *Treatise on Architecture.*

Fig. 13. Jan van de Velde, title page for landscape series, 1616.

standing the seventeenth-century humanistic notion of the rural worker as the ideal of the *beatus ille*, the common peasant was regarded as coarse, boorish, and downright funny. Van Mander saw not only the naturalism in the peasants by Bruegel ("Pier den drol") but also their humor; similarly he speaks of Bloemaert's "aerdighe landschappen met aerdighe en drollighe Boerenhuysen" ("pretty landscapes with pretty and amusing [droll] farm houses").[104] The notion expressed in the inscriptions and on the title pages of so many print series that landscapes are *plaesanten plaetsen*, the seventeenth-century equivalent of the antique's *locus amoenus*, suggests that, like a comedy, they should entertain and give pleasure, an idea consistent with the classical "satyric" mode. Bredero, we recall, stressed in the preface to his *Groot lied-boeck* of 1622 that his low-life songs and plays were intended to amuse as well as to instruct.

Origins and Allegories

The origins of Northern landscape painting have been traced to early fifteenth-century miniatures, notably the *Très riches heures du Duc de Berry* by the Limbourg brothers, in which landscape settings accompany depictions of activities appropriate to the months. Early Netherlandish painting, inspired by Jan van Eyck's exacting, even microscopic attention to naturalistic detail, often included carefully observed landscape backgrounds in religious paintings. Gerard David's two *Views of a Forest* (Rijksmuseum, Amsterdam, inv. A 3134, A 3135, on loan to Mauritshuis, The Hague) are not independent landscapes but integral parts of a larger religious program as the outer wings of a triptych depicting *The Nativity with Saint Jerome, Catherine, and Donors* (The Metropolitan Museum of Art, New York, nos. 49.7.20 a–c).[105] The landscapes, which once featured the figures of Adam and Eve (now overpainted), were thus images conducive to devotional meditation.

The artist commonly regarded as the first specialist in landscape and the inventor of the so-called Flemish world landscape was Joachim Patinir (c.1475–1524).[106] While several types of landscape were to emerge in Europe during the sixteenth century, the Flemish variety developed by Patinir in Antwerp between 1515 and his death in 1524 was characterized by vast panoramas with elevated horizon, high, often multiple points of view, and an encyclopedic profusion of detail: mountains, sheer rocky outcroppings, plains and valleys, castles and villages, paths and highways, rivers, seas, and harbors. These vast "bird's-eye" landscapes are naturalistic only in isolated details; the overall effect is highly stylized, offering a compilatory and comprehensive segment of the earth rather than a specific record of locale or native topography. Together with Herri met de Bles (c.1500–1550-59), Cornelis Massys (c.1505-12–after 1557), and Lucas Gassel (c.1500–c.1570), Patinir established the Flemish world landscape as the dominant landscape form for nearly a century.[107] Dürer was inspired to make a pilgrimage to Patinir's studio, and Pieter Bruegel the Elder was schooled in this tradition.

Commending the individuality of Patinir's "excellent and clever" landscapes, van Mander noted how effectively the artist placed his tiny figures in the landscape.[108] The religious subjects that invariably appear in these paintings are well suited to landscape settings: the Rest on the Flight into Egypt, Saint John Preaching, Saint Jerome in the Wilderness, and other hermit saints. Since these religious figures are often diminutive in scale, modern art historians have often concluded that they were a mere pretext for the painting of landscape. The religious elements of sixteenth-century painting seemed to somehow atrophy as the secular aspects (landscape, genre, and still life) burgeoned forth. However, we no longer assume that the "lesser" genre evolved out of religious painting. Emmens showed that the theory that genre subjects and still life were "emancipated" for naturalism was an idea born of nineteenth-century concepts of realism.[109] Similarly, Falkenburg has now argued that the landscapes in Patinir's art reinforced their religious themes, acting as devotional aides in the tradition of late medieval *Andachtsbilder*.[110] Thus Patinir's images of an isolated Madonna and Child seated in a landscape (fig. 14) are associated with Rest on the Flight through the subsidiary scenes in the landscape alluding to events in the story, such as the Massacre of the Innocents, the Miraculous Wheatfield, and the Toppling of the Idols. The landscape symbolically assists in the viewer's meditation on the religious theme. The author also interprets Patinir's landscapes with tiny figures of Saint Jerome (see, for example, Prado, Madrid, inv. 1614) as alluding to the

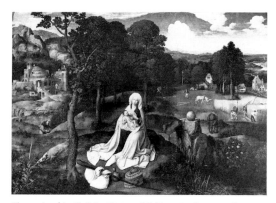

Fig. 14. Joachim Patinir, *Virgin and Child in a Landscape*, panel, 121 x 177 cm., Museum de Prado, Madrid, inv. 1611.

Fig. 15. Pieter Bruegel the Elder, *The Alps*, pen and ink drawing, Pierpont Morgan Library, New York, inv. 1952.25.

two paths of the "pilgrimage of life"; every Christian must choose between the hard path of virtue, Jerome's path, which leads to the mountains, and the path of vice, which leads through the lowlands.[111] Rejecting Falkenburg's theory, Gibson argues that these landscapes, rather than contrasting wicked and righteous realms, show us the wonders of the world from which Saint Jerome averts his gaze to pursue a spiritual path, the highlands and lowlands possibly contrasting the contemplative and active life.[112] These and other theories suggest that late medieval religious ideas persisted in landscape even after the advent of the new *Weltlandschaften*.[113]

The greatest Netherlandish artist of his day, Pieter Bruegel the Elder (c. 1525-30–1569) quickly absorbed Patinir's landscape formulas. On a visit to Italy in 1551–54, Bruegel brought a new grandeur and even more exacting standards of observation to the panoramic world landscape in drawings that he made of the Alps (fig. 15). No longer the backdrop of a story, these sheets celebrate the scenery itself, recording the wonders of the natural world with unprecedented power. Van Mander acknowledged their importance when he wrote of Bruegel with the now famous words: "it was said of him, that while he visited the Alps, he had swallowed all the mountains and cliffs, and, upon coming home, spat them forth upon his canvases and panels."[114] More revolutionary than Bruegel's world landscapes were his drawings of woodland views (see, for example, *Landscape with Bears*, Národní Galerie, Prague), which inaugurated a new type of landscape, the forest interior, and

Fig. 16. Master of the Small Landscapes, *Village Landscape*, 1561, etching.

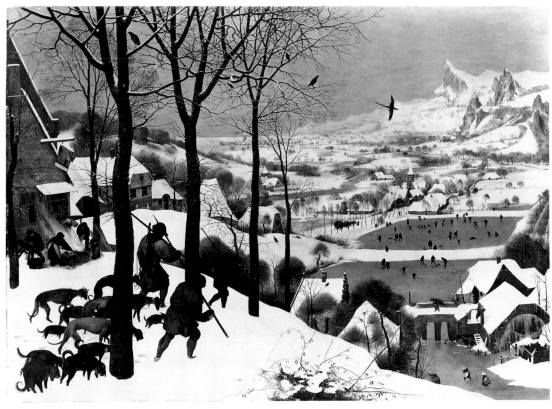

Fig. 17. Pieter Bruegel the Elder, *Hunters in the Snow*, 1565, panel, 117 x 162 cm., Kunsthistorisches Museum, Vienna, inv. 1838.

later became popular among Netherlandish artists around 1600. Bruegel's ideas were broadcast through the engravings made after his designs by Hieronymous Cock and others.[115]

Cock was also the publisher of two series of landscape prints that appeared in 1559 and 1561 entitled, respectively, *Numerous and exceedingly beautiful examples of various village dwellings* and *Depictions of estates, country houses, and peasant cottages.* These little views of villages and hamlets outside Antwerp (see fig. 16) by the Master of the Small Land-scapes (Joos van Liere?)[116] no doubt were stimulated by Bruegel's new practice of drawing from life but took their own highly original approach to naturalistic obser-vation. They abandoned the bird's-eye view in favor of a conventional eye level and exchanged Bruegel's heroic Alpine valleys for unpretentious images of rural scenery. The series later was copied and reissued in

Amsterdam in 1612 by Claes Jansz Visscher as *Regiunculae et villae (Comely Districts and Dwellings)*. In this way the designs of the Master of the Small Landscapes were to have a direct impact on the early seventeenth-century "realist" school of Dutch landscape painting.

Visscher's series carried a false attribution to Pieter Bruegel, a fact that both reflects the admiration that the great Flemish artist then enjoyed and acknowledges that his ideas were chiefly publicized through prints. Bruegel's paintings, on the other hand, were for a more elite circle of private collectors. Despite his penchant for depicting low-life scenes, Bruegel undoubtedly was a learned man who kept abreast of topical religious and political issues, moved in scholarly, humanistic circles frequented by the great cartographer Abraham Ortelius, and knew the patronage of wealthy clients. No doubt one such privileged patron first owned Bruegel's famous landscape series of the Months, dated 1565, of which five paintings have survived (see fig. 17; and p. 65, fig. 1);[117] indeed, the series is probably identical with the one owned by the wealthy merchant Nicolaes Jonghelinck of Antwerp in 1566.

The practice of depicting allegories of the months or seasons grew out of the tradition of the medieval Books of Hours, which first appeared as illuminated manuscripts, like that of the Duc de Berry mentioned above, and later were widely disseminated in printed form in the sixteenth and seventeenth centuries.[118] In these books the calendar of feast and saints' days were usually decorated with scenes of the labors or occupations of

Figs. 18–21. Jacob Grimmer, *Four Seasons Series*, 1577, panels, each approx. 36 x 60 cm., Szépművészeti Múzeum, Budapest, nos. 555–558.

the months, reflecting the seasonal activities of the peasantry and the pastimes of feudal lords. Thus December often was depicted with pig killing, January with feasting, and April with a view of workers in a garden.[119] These illuminated calendars later served as models for printed and painted depictions of the months and seasons, which might even be certified by zodiac symbols appearing in the images. In other cases, however, the seasons were more loosely joined; Bruegel's series, for example, may originally have included only six instead of twelve scenes.[120] A typical example of a Flemish sixteenth-

century depiction of the Four Seasons is Jacob Grimmer's series of paintings from 1577, preserved in Budapest (figs. 18–21).[121] The cycle of the seasons naturally provided a metaphor for life's passage, with the result that the Ages of Man were often linked with the changing seasons.[122] In addition, the seasons could be linked allegorically in the late medieval metaphorical mind with the Four Temperaments or the Seven Planets.[123] The Five Senses and Four Elements also were occasionally provided with landscape settings.[124]

The landscape formulae developed by Bruegel and Cock, which coupled unprecedented naturalistic detail with a relatively high horizon and clear spatial divisions (the darkened foreground abruptly falling away to the lighter, lower middle ground, which then rose steadily to a distant prospect) were adapted and developed by artists who were active in Mechelen (Malines) and later had an influence on Dutch landscape painting. The city's native son, Hans Bol (1534–1593), after traveling in Germany in his youth, became a master in 1560 at Mechelen, where he was active as a painter, miniaturist, and printmaker.[125] He executed a series of influential prints in 1562 that illustrate his personal interpretation of the Flemish world landscape and, the year after fleeing from wartime hostilities to Antwerp in 1572, designed a series of Bruegelian engravings of the months. While in Antwerp, Bol executed his extraordinary *Panorama with a View of the Scheldt River*, dated 1572 (Los Angeles County Museum, no. 46.16.16), and *Panorama of Antwerp*, dated 1575 (fig. 22), works that anticipate later Dutch panoramas. Like so many other Flemish painters of the period, Bol found no peace in Antwerp from the disturbances of war and again fled, this time to the Northern Netherlands, first to Bergen op Zoom, then to Dordrecht and Delft, and finally to magnetic Amsterdam. There he helped to communicate the lessons of Bruegel, especially with drawings of forest interiors like his pen and wash drawing dated 1588 (cat. 110, fig. 1).

Another gifted Mechelen-born artist, Lucas van Valckenborch (1540–1597), also executed paintings of dense forest scenery

Fig. 22. Hans Bol, *Panorama of Antwerp*, signed and dated 1575, canvas on panel 34.5 x 54 cm., Musées Royaux des Beaux-Arts, Brussels, inv. 2960.

such as the painting *Angler at a Woodland Pool*, dated 1590 (fig. 23).[126] However, since he worked for Archduke Matthias, stadholder of the Netherlands, from 1577 onward in Linz, Austria, and after 1593 in Frankfurt, it is unclear to what extent Valckenborch's works, including his extraordinarily powerful mountain landscapes and rocky coastal views, could have been known in the Netherlands.

Emigrés and "Art-Hating Mars"

According to van Mander, Bol immigrated to Holland to escape "the malevolence of the art-hating Mars."[127] The religious persecution and economic upheaval visited on Flanders by the Spanish foe drove scores of artists north in those years. Typical of this group was the poet-painter van Mander, whose detailed biography was appended to the second edition of *Het Schilderboek* (1618; posthumous). Returning to Flanders from a journey to Italy and Austria, van Mander

soon found the country in chaos. In 1581 his village was attacked and his parental house burned. Anarchy reigned as the "malcontents" (as van Mander referred to Alva's unpaid mercenary troops) pillaged the countryside and brutalized the peasantry. Only with great difficulty did van Mander succeed in rescuing his family; after again being victimized in Bruges, he made his way in 1583 to the "old and honorable city of Haarlem," where he first made a living painting signboards. Van Mander's own landscapes (fig. 24) are scarcely revolutionary, adopting the familiar schema of the Flemish world landscape but populating them with elegantly mannered little figures in the style of the influential Bartolomeus Spranger.[128] He also painted a few sketchily conceived village landscapes in the tradition of Bruegel's followers (e.g., *Rustic Landscape*, Allen Art Museum, Oberlin College, Oberlin, no. 59.43). As we shall see, van Mander's ability to work simultaneously in more than one style was shared with his fellow Haarlemers Hendrik Goltzius and Jacques de Gheyn.

Other newly arrived Flemish émigrés had a more profound effect than van Mander on Dutch landscape: Jacob Savery arrived in Amsterdam from Kortrijk in 1591, and his brother Roelandt probably joined him four years later; the father of David Vinckboons of Mechelen obtained Amsterdam citizenship in 1591; and Gillis van Coninxloo arrived in 1595. During this extraordinary "brain drain," Flemings made contributions in all fields: the de la Court, de Geer, and Trip families prospered in commerce and finance; Lodewijk Elzevier and Jodicus

Hondius moved their publishing and cartography concerns north; the great Vondel, Daniel Heinsius, Constantijn Huygens, and Jeremias de Decker immeasurably enriched Dutch poetry and literature; and, of course, the lengthy roll call of Flemish-born artists includes such distinguished painters as Frans Hals and Adriaen Brouwer.[129]

Coninxloo arrived in Amsterdam only after having first fled in 1587 to the Rhineland town of Frankenthal, Germany, another haven for Protestants from the Southern Netherlands. There he joined other immigrant artists to form the so-called Frankenthal School.[130] Coninxloo's greatest achievement in landscape painting were his dense, leafy forest interiors (see fig. 25 and cat. 19). These works employ highly mannered designs with undulating coulisses and dark, tunneling recesses. They nonetheless achieve a more naturalistic effect than the sparser wooded views that preceded them. The compositions are dominated by huge, writhing trees, pervaded with an atmosphere of shadowed seclusion, and filled with lavish details of flora. The sources and rise of these forest landscapes are still imperfectly understood. In the past, Coninxloo's achievements have been thought to evolve from his Frankenthal experience (1587–1595). However, none of his Frankenthal landscapes abandon the conventions of Antwerp landscape painting. Rather, his accomplishments are better understood within the context of the circle of innovative artists that he joined in Amsterdam, which included Bol (cf. cat. 110, fig. 5), who provided a more direct link with the forest landscape's true founder, Pieter Bruegel the

Fig. 23. Lucas van Valckenborch, *Angler at a Woodland Pool*, dated 1590, panel, 47 x 56 cm., Kunsthistorisches Museum, Vienna, inv. 1073.

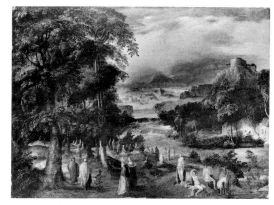

Fig. 24. Karel van Mander, *Saint John the Baptist Preaching*, signed and dated 1597, Niedersächsisches Landesmuseum, Hannover, inv. PAM 907.

Elder. Wooded interiors that Pieter's son, Jan Brueghel the Elder, drew and painted (see his *Forest Landscape* of c.1595–96; cat. 19, fig. 2) and the more inaccessible forest scenes of Lucas van Valckenborch (see fig. 23) may also have been important factors. Whether Coninxloo also consulted Cornelis Cort's engravings after Girolamo Muziano's forest scenes and the woodcuts with great twisting trees by Titian and Domenico Campagnola, or was content to confine his research to the descendants of Bruegel's own interpretations of the earlier Italian sources, is unclear.

The forest views of David Vinckboons (cat. 110) followed those of Conninxloo, dating mostly from the first and second decades of the seventeenth century. Indeed, they so closely resemble Coninxloo's works that some scholars have assumed without documentation that he studied under the older artist. The early woodland landscapes

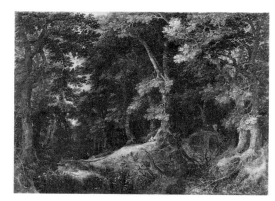

Fig. 25. Gillis van Coninxloo, *Forest Landscape with Resting Hunter*, signed and dated 1598, panel, 44 x 63 cm., Prince of Liechtenstein Collection, Vaduz, inv. 751.

with tiny staffage gradually yielded after c.1605 to paintings in which the figures assume a larger presence relative to the setting; however, he continued to paint some forest views in later years (Leningrad, Hermitage, no. 457 [dated 1618]; Bayerische Staatsgemäldesammlungen, Munich [dated 1624]).[131] In Mechelen, Vinckboons's father

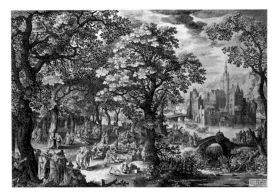

Fig. 26. Nicolaes de Bruyn after David Vinckboons, *Feast in a Forest*, 1601, engraving.

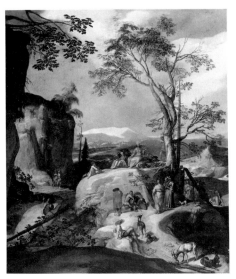

Fig. 27. Abraham Bloemaert, *The Sermon on the Mount*, c.1610, canvas, 115 x 99.5 cm., Chaucer Fine Arts, London.

had been a painter of imitation tapestries, which were executed on cloth in watercolor or tempera. Something of this decorative impulse survives in Vinckboons's forest views, with their lacy foliage and sinuous trunks. As van Mander observed, these works often contain "modern figures,"[132] frequently hunters or elegant members of the *jeunesse dorée* who visit the wood to picnic or play music. As we shall see, Vinckboons also executed winter scenes (see cat. 111), which again may attest to his contact with his fellow Flemings in Amsterdam, Bol and Jacob Savery. The forest idylls and skating scenes of Vinckboons received good prices, were often copied, and achieved wide renown through engravings made after them by Nicolaes de Bruyn (fig. 26), Johannes van Londerseel, Hessel Gerritsz, Hendrick Hondius, and Claes Jansz Visscher.

As treated by Coninxloo and his followers, the woods assumed many forms and meanings, from the dangerous wilderness inhabited by bandits, highwaymen, and wild animals, to the setting for dramatic biblical or mythological events (*Samson and the Lion, The Prophet Elias with Children of Bethel Consumed by Bears, The Meeting of Jacob and Esau, The Temptation of Christ,* and *The Judgment of Paris*), the preserve of aristocratic hunting parties, a secluded retreat for hermits, penitents, or their secular analogues (see fig. 25), or even a hiding place for lovers.[133] In representations of Hercules at the Crossroads, the path of *voluptas* might lead through a darkened wood, while the road to virtue passes through a lighter grove.[134] A moral admonition no doubt was intended in Vickboons's inclusion of a scene of the Dance of Mary

Magdalene in the lower left of his *Feast in the Forest* (fig. 26).[135] However, the variety of figure subjects encountered in these leafy realms obviates any single meaning for Coninxloo's forests.[136] Indeed, Vinckboons even used the same forest interior for a wide variety of religious and secular themes (see cat. 110). As with other types of scenery, it is only through the landscape's context that one may specify the forest's associations and determine whether it functions as a *paysage moralisé*.

The early works of Roelandt Savery clearly reflect his Flemish legacy and training under his brother Jacob; Jan Brueghel, Bol, and Coninxloo also left their mark on the artist. After Jacob's death in 1603, Roelandt left Amsterdam and traveled to Prague, where he entered the service of the erratic and unstable emperor Rudolf II. In 1606–1608 Rudolf sent Roelandt to Tirol to sketch views of his mountain properties and the imperial flora and fauna. Joachim von Sandrart reported in 1675 that Savery's charge was to seek out the "rare marvels of nature," adding insightfully that these drawings "proved very useful when he produced his later landscapes."[137] Some of Savery's finest achievements were Tirolian drawings (see cat. 28, fig. 3); rarer are the paintings, like the pair dated 1608 in the Niedersächsisches Landesmuseum, Hannover (inv. VAM 933 and KA 154/1967), that preserve something of the intimacy and immediacy of the sketches. More typically, the paintings executed in Prague or, after Rudolf's death in 1612, in Amsterdam grandly attest to mannerist complexity, with their splintered pine forests bristling

like burrs on a magnet (see cat. 99, fig. 2) or imaginary mountain scenes stocked with the menagerie of animals that Savery had studied in the emperor's famous zoo. The degree to which these works represent Tirolean scenery has rightly been questioned by both Stechow and Sip.[138] However stylized they are, they successfully evoke a primeval wilderness that embodied an ideal that had had great appeal for German rulers from at least the time of Altdorfer — an untamed realm far from the intrigues of court.[139] The frequency with which hermit saints, such as Anthony (see cat. 99, fig. 1),[140] appear in Savery's wilderness scenes not only attests to the persistence of the Flemish tradition of religious staffage but also underscores the wilderness's role as a place of retreat and contemplation.[141] Apparently Savery's subjects also found a ready audience in the Netherlands, since for more than two decades he continued to ring the changes on these themes with little new invention. Indeed, Savery's later works are deliberately retardataire. After moving to Utrecht in 1619, Savery had a profound effect on Gillis de Hondecoutre, who closely imitated his mannered style for several years before gradually developing a style and subject matter based more on the direct observation of his Dutch surroundings (see cat. 48).

Like Coninxloo and van Mander, Abraham Bloemaert was an artist of the mannerist generation whose early landscapes are mostly fantastic mountain views and panoramic vistas. His *Sermon on the Mount* of around 1610 (fig. 27), for example, addresses a biblical subject (not based on scripture and

virtually unique in Dutch art) in an imaginary mountain landscape that may acknowledge Jacques de Gheyn's drawings but is closer in its fantasy to mannerist Italian and Flemish landscapes.[142] A native of Utrecht, Bloemaert worked in closer proximity to the country's rural areas than did his counterparts in the maritime cities of Amsterdam and Haarlem and made a specialty of farm landscapes. His splendid draftsmanship focused on cunningly picturesque motifs: calligraphic trees, cluttered barnyards, and artfully tattered peasants. Not the whole but the stuff and parts of landscapes attracted him. Nonetheless, Bloemaert's designs were excellently suited to his landscape print series (see fig. 50), which enjoyed a broad dissemination and influence, especially in the second and third decades of the century. A Methusela among artists, Bloemaert taught generation upon generation of Utrecht painters and, to his enduring credit, always sought to respond in his fashion to new ideas. Thus a painting like *Landscape with the Parable of the Tares of the Field* of 1624 (cat. 12) still depicts a traditional biblical landscape theme in a highly picturesque setting, but in a less stylized, calmer, and spatially more coherent manner. However, Bloemaert always subordinated the unity of his landscapes to the linear elaboration and beauty of motifs: the knotted roots of an oak, the studied disarray of farm utensils, or the foreshortened forms of exhausted field hands. Proof of his devotion to these ideals is *The Farm*, dated 1650 (Staatliche Museen Berlin [DDR]), an undiminished, indeed, outstanding work painted when Bloemaert was eighty-seven years old.

Fig. 28. Hendrick Goltzius, *Panoramic Landscape near Haarlem*, 1603, pen and ink drawing, 87 x 153 mm., Museum Boymans-van Beuningen, Rotterdam, inv. no. H-253.

Plausible Fictions: Esaias van de Velde and the "Early Realists"

The graphic arts frequently precede the pictorial tradition in addressing new subjects and styles. This was clearly the case in the rise of the naturalistic landscape. The drawings and prints executed in the first two decades of the century by the Haarlem and Amsterdam artists Hendrick Goltzius (1558–1617), Jan Claesz Visscher (1587–1652), Willem Buytewech (c.1591/92–1624), Jan van de Velde II (1593–1641), and his cousin, Esaias van de Velde, inaugurated a new concept of naturalistic landscape. To be sure, these artists followed a tradition that germinated in the Southern Netherlands, as attests a comparison of Visscher's drawings and the prints by the Master of the Small Landscapes.[143] But a drawing like Goltzius's extraordinarily precocious *Panoramic Landscape near Haarlem*, dated 1603 (fig. 28),

documents a new commitment to the record of the native Dutch scene. For Goltzius, naturalism was, of course, a style, with its implications of artifice and imagination, to be practiced alongside his more fantastic styles in a refined or alternatively broad manner.[144] But with its evocation of the "here and now," naturalism was an eminently topical manner for the people of a young country impassioned by pride of place and a desire for self-esteem.

Like Goltzius's drawing and the poems that van Mander hymned about his adopted home ("Twee Beelden van Haarlem" [1596]),[145] Visscher's popular print series dated 1611 celebrates the unpretentious beauty of Haarlem's environs, portraying simple hamlets and country woods without artistic fanfare. That a large portion of Visscher's publishing business in those years was devoted to topographic and cartographic prints, the latter sometimes embellished with landscape vignettes, surely reflects in part patriotic sentiments. Similarly, the heroization of recent national history is expressed in the landscape print series by Buytewech, Jan van de Velde, and others with the many depictions of ruined castles, including Brederode and Huis te Kleef outside Haarlem and Spangen near Rotterdam. Destroyed by the Spanish in 1572, these buildings were associated with the vicissitudes of Holland's immediate past. Representations of the ruins of Roman antiquity had a long tradition in Northern landscapes,[146] but the inscriptions on Jan van de Velde's etchings (after Pieter Saenredam) of Brederode and Huis te Kleef (see fig. 29) for Samuel Ampzing's famous

Fig. 29. Jan van de Velde after Pieter Saenredam, *Ruins of the Huis te Kleef*, etching.

Fig. 30. Esaias van de Velde, *Two Riders in a Dune Landscape*, signed and dated 1614, panel, 25 x 32.5 cm., Rijksmuseum Twenthe, Enschede, inv. 79.

book on Haarlem of 1628 suggest that the sites were associated with two specific themes: the brevity and impermanence of man's efforts and the Dutch struggle for independence.[147] Paradoxically, the remains of ancient buildings might also connote the durability of man's works;[148] and, of course, ruins were implicitly commended in landscape print series as sites for the enjoyment of sylvan pleasures.

While Buytewech and Jan van de Velde apparently did not much concern themselves with the painting of landscapes, Esaias van de Velde worked in oils throughout his career. That career spanned little more than seventeen years, but Esaias was probably the single most innovative and influential painter among the group often referred to as the "Early Realists." He joined the Haarlem guild in the banner year 1612, which also saw the enrollment of Buytewech and Hercules Segers. Two years later he first dated his pictures, which include *Two Riders in a Dune Landscape* of 1614 (fig. 30). Its unpretentious subject, a dirt road in the open countryside with travelers on horseback and on foot, had been anticipated to a degree by Flemish artists, notably Jan Brueghel (see *Country Road*, dated 1603, Prado, Madrid, inv. 1433). But not only was Esaias the first Dutchman to paint the rural Dutch landscape in a simple, direct fashion, stripped of the traditional clutter of accessories and picturesque motifs; in addition he brought a new spatial unity to his work with a lower horizon line, more continuous recession, and a subdued palette. Gone is the emphatic, decorative coloring of earlier mannerist landscapes. Esaias's landscapes celebrate the

Fig. 31. Esaias van de Velde, *View of Zierikzee*, signed and dated 1618, canvas, 27 x 40 cm., Staatliche Museen Preussischer Kulturbesitz, Berlin (West), inv. 1952.

Fig. 32. Esaias van de Velde, *Hilly Landscape with Antique Ruins*, signed and dated 1624, panel 37 x 59 cm., Národní Galerie, Prague, inv. O-1481.

commonplace and prosaic in an appropriately candid, unembellished style.[149]

Although the number of Esaias's landscapes in which water plays an important role is not large, he also made significant contributions to the river-view landscape. *The View of Zierikzee* (Zeeland) of 1618 (fig. 31) couples the urban-profile view popularized by topographic engravings with the seaport view from the water favored by marine painters like Haarlem's own Hendrick Vroom (1566–1640). But in typical reductive fashion, Esaias banned the complexity of shipping from the foreground and introduced the suggestion of the spectator's riverbank in the lower left corner, thus conferring on this tiny work an unexpected spaciousness and subtle diagonal sweep.[150] *The Ferry* of 1622 (cat. 106), one of Esaias's largest and most ambitious compositions (in spite of a later addition in the sky; see commentary), is also distinguished by its spatial continuity and serene horizontality; compare, once again, Jan Brueghel's earlier treatment of virtually the same theme in *River Landscape with Landing and Ferry*, dated 1603 (cat. 94, fig. 1).[151] But *The Ferry* is typical of Esaias's later Hague period (1618–1630) in its reintroduction of a richer multiplicity of detail and greater wealth of local color. The painting's reasoned treatment of space and clear subordination of figures to nature ensures that Esaias's mature style was not a reversion to sixteenth-century conventions. Moreover, his many mountain views (see, for example, *Mountain Path with a Cascade*, signed and dated 1625, Museum of Fine Arts, Riga)[152] and hilltops studded with classical Roman temples (fig. 32) prove

Fig. 33. Cornelis Vroom, *Hunters in a River Landscape*, signed, canvas, 86 x 125 cm., Czartoryski Collection, Muzeum Narodowe, Krakow, inv. 157888.

that this stay-at-home, archetypal "realist" drew as much from artistic tradition as from observation. Indeed, one revisionist view argues somewhat perversely that the relatively short period during which landscape was at its most naturalistic was the exception rather than the rule in Dutch art.[153]

Among the many artists who came under Esaias van de Velde's spell in Haarlem were Jan van Goyen (to whom we will return), Pieter de Neyn (see fig. 6), Gerrit Bleker (see cat. 11) and Cornelis Vroom. Vroom began his career painting busy marines in the exacting style of his father, Hendrick Vroom. When, before 1622, he turned to landscapes, he originated a highly personal style that mixed Northern and Southern elements. Apparent in *Hunters in a River Landscape* (fig. 33) is his admiration for Esaias's art, as well as for the tall trees with curi-

ously tufted foliage that appear in Buyte-wech's prints. But the scenery of Vroom's haunting *River Landscape with Imaginary Ruins* (cat. 114) is neither Dutch nor Italian, existing only in a poetically conceived region of intersection. Vroom's sensitively detailed rendering of trees and foliage was unprecedented and foreshadows Jacob van Ruisdael's early works.

Wintry Contentments: Avercamp, van de Venne, and Vinckboons

Two years Esaias's senior, Hendrick Avercamp began dating his richly detailed winter landscapes in 1608 (fig. 34). Called "de Stomme van Kampen" (the Mute of Kampen) because of his disability, Avercamp worked for much of his life in Kampen on the eastern side of the Zuider Zee, relatively far from major centers of artistic activity. He nonetheless became the first Dutch landscapist to specialize in winter scenes, which, together with the panorama, are generally regarded as the most typically Dutch of all the Netherlandish landscape specialties. Favoring horizontal compositions with high horizons, Avercamp filled his scenes with broad, frozen rivers with bare trees, snow-covered cottages, pastel-colored villas, ice-locked boats, and a multitude of brightly colored, nimble little figures. Some skate while others converse, play games, fish, or carry home the groceries or kindling. Avercamp's wintry ant farms of humanity naturally appeal as much to social historians as to art lovers.

Although he explored the pictorial possibilities of the flat landscape and a more comprehensive treatment of space, Aver-

Fig. 34. Hendrick Avercamp, *Winter Landscape*, monogrammed and dated 1608, panel, 33 x 55.5 cm., Billedgalleri, Bergen, Norway, no. 43.

Fig. 35. Hendrick Avercamp, *Winter Landscape*, monogrammed, panel, 25 x 27.5 cm., sale, New York (Sotheby's), Jan. 15, 1986, no. 30.

camp remained wedded to sixteenth-century formal conventions. The traditional high-horizon line accommodated his additive approach to composition, which piled up the skaters' crisp little silhouettes and maximized the account of sundry details. This approach followed logically from the pioneering winter scenes of Pieter Bruegel (fig. 17) and later Flemish artists, such as Valckenborch, Pieter van der Borcht, Jacob Grimmer (fig. 21), Hans Bol (see, especially, his circular etching, *Skaters*),[154] and Jacob Savery.[155] David Vinckboons may also have inspired Avercamp;[156] however, his only surviving painted winter landscape, datable before 1611, employs larger, though equally diverting figures (cat. 111). Larger figures tend to characterize Avercamp's paintings of c. 1620, which include his masterful picture in the Carter Collection (cat. 7). Although Avercamp's works are notoriously difficult to date, Blankert has recently proposed a chronology based on the dated works of 1608, 1609, and 1620.[157] Before 1608 (see, for example, Wallraf-Richartz Museum, Cologne, no. 607156), Avercamp painted in a looser and more additive manner than in the Bergen painting of 1608 (fig. 34), where the touch is already refined and the figures clustered in groups (cf. cat. 5). By 1609,[158] the horizon has begun to descend, and a suggestion of atmosphere appears in the hazy distance, trends that continue in the undated painting of c.1609–10 in The Hague (cat. 6). The Carter painting's (cat. 7) compact, horizontal groupings of larger figures, low horizon, and freedom from any lateral framing devices, or "wings," are features shared with Avercamp's dated

painting of 1620 (cat. 7, fig. 3). These qualities may also have appeared some years earlier. After 1620 the figures again are diminished in scale, but unlike those in the crisply drawn works of the early years, they tend to merge with their more atmospheric surroundings.

The charming gaiety of Avercamp's scenes of multicolored skaters has been compared by Stechow to verses from Bredero's spirited *Boeren gezelschap* of 1622.[159] There were, of course, moments of minor tragedy: figures falling down or even breaking though the ice (see cat. 5 and 7). Bruegel's print *Ice Skating before Saint George's Gate, Antwerp* carried an inscription in three languages, alluding to the wise and foolish ways in which people conduct their lives, some "slipping and slithering their way through a life whose basis is more ephemeral and fragile than ice." Other prints also allude to the "slibberachtigheyt van 's menschen leven" ("the slipperiness of human life"), but van Straaten wisely warned that fallen skaters need not always encode moral admonitions.[160] A still darker side to Avercamp's winter scenes is the lugubrious detail of a half-rotted carcass of a dead animal gnawed by a dog on the right of a painting recently on the art market (fig. 35). The detail appears just above the figure of an old bearded man wearing a fur cap and seated on a log with a basket beside him. This figure repeatedly appears in Avercamp's works and descends from medieval personifications of the month of February.[161] In a print by Jan Sadeler after Hans Bol of *Winter*, dated 1580 (fig. 36), the "old man of winter" says grace at a full table before a winter land-

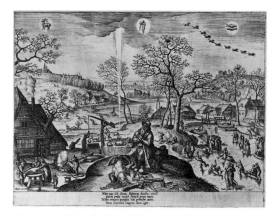

Fig. 36. Jan Sadeler after Hans Bol, *Winter*, 1580, engraving.

scape with the slaughtering of fattening pigs to one side and festive skaters on the other. The accompanying inscription warns, "Winter takes the pleasant dish provided by earlier effort with virile hand. Whoever in such a way provides for himself while his years are intact, will pass happily the hard times of old age." Captions on prints often likened winter to old age. In contrast to the well-stocked table in Bol's print, Avercamp's old man has an empty marketing basket, perhaps an admonition to those who have not provided for the cruelest of seasons or for the adversity of old age. While dead animals no doubt were a more common sight in seventeenth-century Holland than today and, indeed, regularly appear in Dutch landscapes,[162] in this particular conjunction, the carcass is probably a *memento mori*, with its implicit reminder of the fleeting nature of life. Gibbets and gallows were a familiar feature of public justice in the Nether-

lands,[163] but, just as in sixteenth-century works by Bosch and Bruegel, when these details appear in a landscape like Esaias van de Velde's *Panorama with Gallows*, of 1619 (see p. 73, fig. 6), they probably carried *vanitas* associations.[164]

The persistence of seasonal allegories in early seventeenth-century landscapes is illustrated in the works of Adriaen van de Venne and several of the other leading figures, including Vinckboons (two print series, see cat. 111, note 2), Esaias van de Velde, Jan van de Velde (a print series of 1617), and Avercamp.[165] Van de Venne juxtaposed Winter and Summer in his earliest dated landscapes of 1614 (cat. 108 and 109), two works that reflect Jan Brueghel's influence in conception and design but achieve a splendid new subtlety of aerial perspective. When van de Venne returned to the subject of the Seasons in 1625 (Rijksmuseum, Amsterdam, inv. A 1771–A 1774), he illustrated all four but dominated the landscapes with the genre figures that he employed so effectively in his illustrations of sayings and proverbs. Indeed, in the same year he depicted the Seasons in conjunction with a print series illustrating the progressive stages of a woman's life for Jacob Cats's *Houwelyck* (*Marriage*, 1625). Van de Velde painted pendants of Summer and Winter, the latter, like the remarkable Cambridge painting of a year earlier (cat. 107, fig. 2), offering a more naturalistic image of "Hyems" than any of Avercamp's or van de Venne's works from those early years. However, Esaias's earliest pendants juxtaposing Summer and Winter (Allen Memorial Art Museum, Oberlin, and [for-

merly] Lucca Collection, Mansi)[166] reflect their sixteenth-century origins in supplementing the scenes with the time-honored biblical travel subjects of, respectively, the Road to Emmaus and the Flight into Egypt. As late as 1629 Esaias executed designs for a series of Months.[167] His gifted pupil Jan van Goyen also painted pendants of Winter and Summer in his youth (cat. 31 and 32). But the revolutionary feature of the art of Esaias and van Goyen is that the vast majority of their landscapes are not seasonal allegories, the backdrops of religious imagery, or typological images in any conspicuous way. Indeed, the precise hour, place, and season of most seventeenth-century landscapes are indeterminate. The new companion pieces offer juxtapositions and complementarities of a subtler sort, such as in Esaias's little tondos *Village Landscape* and *Hilly Landscape with Waterfall* (figs. 37 and 38);[168] the one perhaps celebrating the local scene, with its farms and church spire, and the other contrasting a wider world of travel, offering cascades, arcadian hillside pastures, and, just discernible on the summit, noble buildings.

"The Capital of Pictura's School":
The Pre-Rembrandtists, Poelenburch, and Breenbergh

Dutch artists traveled widely, but the most common trip and the one constantly recommended by art theorists and connoisseurs such as Huygens was the journey that led across the Alps to Italy. The goal of the pilgrimage was Rome, the city that van Mander called "the capital of Pictura's school," where an artist could study the

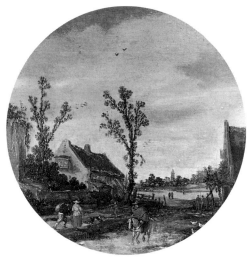

Fig. 37. Esaias van de Velde, *Village Landscape*, signed and dated 1627, panel, diam. 21.4 cm., Kurpfälzisches Museum, Heidelberg, no. G 705.

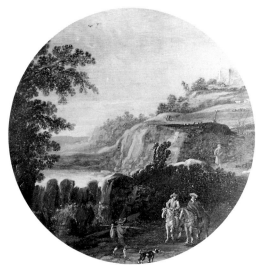

Fig. 38. Esaias van de Velde, *Hilly Landscape with Waterfall*, signed and dated 1627, panel, diam. 21.4 cm., Kurpfälzisches Museum, Heidelberg, no. G 704.

achievements of antiquity, the Renaissance, as well as the contemporary art community. As we have seen, the Italians were happy to cede honors in landscape, a lesser discipline, to the *oltramontani*, and many of the leading landscapists active in Italy at the turn of the seventeenth century were Northerners, including Paulus Bril (1554–1626) and Adam Elsheimer (d. 1610).

A native of Antwerp, Bril arrived in Rome around 1580 and first painted landscape frescoes in the style of Muziano before beginning to date small easel paintings in 1590.[169] Around 1605–10 these landscapes gradually developed away from the rhythmic surface patterns of later Flemish mannerist landscapes – a style still very evident in his works dated 1600 (see Gemäldegalerie, Dresden, no. 858) – toward a calmer, simpler art inspired not only by his surroundings but also by the stay in Rome, shortly before 1600, of the great Annibale Carracci. Carracci and his Bolognese followers (Albani, Domenichino, Lanfranco, Badalocchio) created landscapes of such lucid structure, of such permanence, lyrical repose, and harmonious integration as to define for all time the ideal of the timeless, classical landscape (see fig. 39). The ideal grew out of the literary and historical values of the Roman aristocracy, who nurtured a retrospective utopia, a backward-looking dream of the classical past.

True to his Flemish origins, Bril's landscapes of c.1610 (fig. 40) show a greater concern than the works of his Italian counterparts with vegetable, animal, and architectural detail, as well as with bustling anecdote. But Bril's Italian experience is

already apparent in the more natural transition between planes. His mature works depicting the open landscape (see *Landscape with Fishermen*, 1627, Louvre, Paris, inv. 1117) are still more classicized, achieving a serene calm. In the limited discussions of Northern landscape painting found in the writings of Italian seicento theorists, such as Mancini and Baglione, Bril is singled out for praise for having "modernized" his style under the influence of Bolognese painting – for being, as it were, the Northern Protestant who had converted to the True Faith.[170] Yet, Bril's own original contributions to landscape were many. His early easel paintings were some of the first to employ genre figures, mostly casual groupings of herdsmen and shepherds rather than religious themes. He also originated the Italianate harbor landscape and helped to establish such popular motifs as waterfalls and fords.

The German expatriate Adam Elsheimer had arrived in Rome by April 1600 and became a personal friend of Bril's.[171] At his death in 1610, Elsheimer was impoverished but enjoyed such renown as to be eulogized by Rubens in faraway Antwerp. Primarily a history painter in miniature on small copper panels, Elsheimer executed very few paintings in which landscape played an important role. Indeed, only four certain compositions are now known: the *"Small" Tobias and the Angel* (Historisches Museum, Frankfurt, no. B789), which may only be a damaged copy; the *"Large" Tobias*, known only in copies and the engravings by Hendrick Goudt; the *Aurora* (see p. 94, fig. 16); and the nocturnal *Flight into Egypt* (cat. 78, fig. 2). Even allowing for the wide dissemination of Elsheimer's

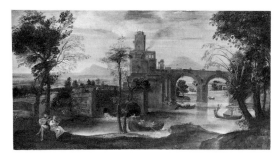

Fig. 39. Annibale Carracci, *River Landscape with Castle and Bridge*, c.1595, canvas, 73 x 143 cm., Staatliche Museen Preussischer Kulturbesitz, Berlin (West), inv. 372.

Fig. 40. Paul Bril, *Imaginary Roman Landscape with Waterfall*, signed and dated 16[..], probably c.1610, canvas, 84 x 112 cm., Herzog Anton Ulrich-Museum, Braunschweig, inv. 60.

ideas through Goudt's prints, his personal influence on Dutch landscape has probably been overstressed. His inventions nonetheless were revolutionary. Chief among these was a new design, seen in the *Tobiases* and *Aurora*, of a wedge-shaped diagonal of land gently receding into the distance. This schema replaced the traditional sixteenth-century practice of organizing space into a series of planes with overlapping coulisses and zigzagging recessions. Elsheimer also exhibited a splendidly refined sense of the mood of landscape, effecting fine nuances by subtle adjustments of light. He was fascinated by different kinds of light, both natural (daylight, twilight, moonlight, even starlight) and artificial (firelight, torchlight, and so forth). Elsheimer's reputation for intellectual curiosity would seem to be confirmed by the presence for the first time in his painting of the Milky Way and a cratered moon, two celestial phenomena that had only just been confirmed by Galileo.

Pieter Lastman was in Italy at the time of van Mander's writing, hence, by 1603–1604, and probably first became acquainted with Elsheimer's art in Rome. Like Elsheimer, Lastman was almost exclusively a figure painter, but he had begun to produce history paintings with landscapes reminiscent of Elsheimer's no later than a year after his return to Amsterdam in or before 1607. (No certain paintings from Lastman's Italian sojourn are known.) *Pastoral Landscape* of around 1609–14 (cat. 55) employs a wedge-shaped, Elsheimerian composition as well as the robust but finely articulated little figures for which the German artist was admired. But, while Lastman's format, like Els-

heimer's, is intimate, his touch is thicker, scarcely disguised, and his colors are less acrid. Despite the arcadian theme, the effect is of greater naturalism. As the Tümpels have shown, Lastman's approach to narration in his history paintings stressed a new expository clarity and an almost archeological concern with the evocation of the past.[172] His more naturalistic arcadian landscapes thus were the complement to his clumsily tussling lovers. Lastman's arcadian image is one of the earliest Dutch paintings to reflect the new enthusiasm for the pastoral that followed closely on the appearance of P.C. Hooft's play *Granida*, published in 1605. Lastman was Rembrandt's teacher and thus provides a direct link between Elsheimer and the Dutch master. The group of which Lastman was a leader has become known, unfortunately, as the Pre-Rembrandtists, a term incorrectly implying that their achievements were only prefatory.

Though less innovative than Lastman in terms of subject matter, the most important landscapist among the Pre-Rembrandtists was Jacob Pynas, who visited Italy in 1605–1608. Pynas's accomplishments were obscured until about a generation ago by misattributions to Elsheimer. His quite Mediterranean landscapes, with small mythological or biblical figures often secreted in the foreground corners (see fig. 41), share features with Elsheimer: their strong diagonal compositions, the rounded cauliflower trees, the low vantage point, and fluid recession. But Pynas had a dryer touch, without Elsheimer's concern for atmosphere. He favored blunt, beige-colored mountains and sharp contrasts or striations of light and

Fig. 41. Jacob Pynas, *Landscape with the Good Samaritan*, copper, 27 x 34 cm., Musée des Beaux-Arts, Nancy, no. 225.

Fig. 42. Cornelis van Poelenburch, *Roman Ruins*, signed and dated 1620, copper, 40 x 59 cm., Musée du Louvre, Paris, inv. 1084.

shade (see cat. 75). While Bril's influence may account for some of these differences, Pynas never shared Bril's penchant for fastidious detail. Since his first dated paintings are only from 1617, Pynas's early development is still hypothetical. The majority of his work seems to date from the late teens and twenties, but he only departed from his Pre-Rembrandtist manner about 1640, when he adopted a looser style, occasionally painting in grisaille. Pynas's importance is still under appraisal, but with the possible exception of the obscure Godfried Wals, he was probably the most innovative landscapist to emerge from that group of close Elsheimer followers which included Johan Konig, Thomas von Hagelstein, and David Teniers the Elder.

Like the history painter Claes Moeyaert, Moyses van Wtenbrouck was a later artist who dated an etching in 1615 but was only admitted to the guild in The Hague in 1620. Both painters nevertheless are usually considered to be Pre-Rembrandtists. Wtenbrouck's works have only one foot in this camp, the other in the circle of the Italianizing landscapists Poelenburch and Breenbergh. Wtenbrouck's dark, fan-like trees and thickly painted classical architecture recall Pynas's interpretations of Elsheimer's legacy (although there is no proof of a trip to Italy), but his taste, particularly in his later works, for broader more open compositions, as well as an early preference for mythological subjects, point to the Dutch Italianate camp. Lastman and his followers were more likely to paint biblical themes, including obscure Old Testament subjects. Wtenbrouck often substituted genre-like arcadian and bacchic

scenes for specific mythological subjects. His robust, frisky figures and lush settings – often a pool by a wooded bank (see cat. 123) – are well suited to his boisterous pagan themes and assert a strong, independent artistic personality. A successful artist, he won the praise of Huygens in his memoirs of 1629–30 and the patronage of the stadtholder by 1632/33, with repeated commissions for Honselaersdijk Palace acknowledged from 1638–1646. Thus Wtenbrouck's career again proves that Dutch artists who worked in international styles often were better rewarded for their efforts than painters practicing indigenous styles.

Surely the clearest example of these trends in landscape is provided by Cornelis van Poelenburch, who not only worked in the Netherlands for Prince Frederick Henry, the "Winter King," and Baron van Wttenhorst but in addition enjoyed the patronage abroad of Grand Duke Cosimo II de' Medici in Florence and Charles I of England. The appeal, especially among noble and upper-class patrons, of Poelenburch's idyllic little landscapes with historical or arcadian figures proves that the classical ideal cultivated by the Italian aristocracy was successfully exported, taking root not only in the Netherlands but also throughout Europe. Poelenburch was Roman Catholic and probably born in the ancient bishopric of Utrecht, which had long-standing ties to Rome. Like so many other promising local artists, he seems to have studied under the long-lived Abraham Bloemaert. Following their apprenticeship, Utrecht painters traditionally made the artistic pilgrimage to Italy. Poelenburch arrived in Rome in 1617

and dated his first painting three years later (fig. 42). These early "Forum pieces" depict ruins, only sometimes identifiable as the Roman Forum, in a flat landscape populated with tiny, carefully painted herdsmen and animals. Even in these very early works Poelenburch's style is assured, his brushwork virtually invisible, his feathered technique velvety soft. Cool tonal harmonies of silvery grays, beiges, and soft greens prevail.

The chief influence on these works are Bril's art and possibly Filippo Napoletano's, but Poelenburch's Italian views show a far greater concern with classical restraint and repose than his sources and a new ability to paint landscape and architecture bathed in full sunlight. Among his early landscapes, there are also more dramatic views such as the tiny, highly detailed but exceptionally fresh little *Waterfalls at Tivoli* (cat. 68), where the hillside with cascading water fills four-fifths of the composition, dwarfing the herdsmen below. Like his views of peasants grazing their livestock in the Forum, this is not an arcadian vision. Rather, it is partly topographical, partly an imaginary rendering of a famous landmark and tourist attraction peopled by contemporary, that is to say, seventeenth-century staffage. A different use is put to the diagonally silhouetted hillside in the *Rest on the Flight* of 1625 (cat. 69), where the dramatic spatial effects set off the lighted vista beyond, recalling mannerist conventions. Despite the dramatic space, the effect is still of peace and idyllic tranquility.

Poelenburch returned to the Netherlands no later than April 1627. The absence of dates on his works after 1625 makes it virtually impossible to establish a chronology for the years 1625–1667. While his figures apparently became more robust and the tonality shifted to a lower key, often with browns predominating, he seems to have been content to repeat his favored themes, above all, small, hilly landscapes with ruins and biblical or mythological figures (genre-like staffage appear only in the Italian period, before c.1625) or the ever popular bathing nymphs and satyrs. Unlike Elsheimer and the Pre-Rembrandtists, Poelenburch favored time-honored landscape themes such as the Rest on the Flight (see cat. 70) or themes from the story of Diana, fewer of which have survived but which inspired his many anonymous nymphs. The artist's popularity was measured both by his personal success and by his many imitators, principal among whom were Dirck van der Lisse, David Vertangen, Johan van Haensbergen, and Abraham van Ceulenborch.

Arriving in Rome in 1619 and probably remaining there until 1629/30 (but no later than 1635), Bartholomeus Breenbergh was influenced by Poelenburch but functioned as an independent colleague with his own distinctive personal style. His earliest dated painting is the *Finding of Moses* of 1622 (Hallwylsk Museet, Stockholm), which attests to his beginnings in the Pre-Rembrandist circle, primarily under the influence of Jacob Pynas. Unfortunately, since there are no dates on Breenbergh's paintings between 1622 and 1630, his development in the early Roman period is still imperfectly under-

stood. By the 1620s mannerist conventions in Rome were fast disappearing, as Poelenburch, Napoletano, and Wals developed simpler compositional schemes and changing lighting effects. No doubt Breenbergh was influenced by Bril in this period, but the other younger artists, above all Poelenburch, had a more important impact. The latter's views of the Italian countryside with ruins and tiny figures are recollected in Breenbergh's *Voyage of Eliezer and Rebecca* of 1630 (cat. 17), as well as in related compositions from 1631. Breenbergh had a greater interest than Poelenburch in panoramic effects and expressive juxtapositions of scale, with Roman ruins often towering over his tiny figures. More innovative than Breenbergh's paintings of the Italian period were a series of pen and wash drawings that he executed of the environs of Rome in 1625–27, employing techniques that had been in use for several decades but never exploited to such advantage. These extraordinary drawings even presage Claude's.

Poelenburch remained a strong influence on Breenburgh even after he had returned to Amsterdam, as a comparison of his *Rest on the Flight* of 1634 (cat. 69, fig. 1) with Poelenburch's painting of nine years earlier (cat. 69) clearly attests. However, Breenburgh's touch tends to be harder, more polished, and his colors more assertive. Testifying to the ongoing popularity of Guarini's *Il Pastor Fido*, the *Landscape with Silvio and Dorinda* of 1636 (fig. 43) treats the landscape elements in softer focus, anticipating the later Dutch Italianate landscapists but retaining his tighter figure style. Little is known about the life of Carel Cornelisz de Hooch apart

Fig. 43. Bartholomeus Breenbergh, *Landscape with Silvio and Dorinda*, signed and dated 1636, panel, 54.8 x 78.4 cm., Musée Municipal, Brest, inv. 64-3-1.

Fig. 44. Carel Cornelisz de Hooch, *Italian Landscape with Duck Hunters*, signed and dated 1630, panel, 42.5 x 63.3 cm., Centraal Museum, Utrecht, inv. 11032.

Fig. 45. Hercules Segers, *River Valley*, panel, 30 x 53.5 cm., Rijksmuseum, Amsterdam, inv. A 3120.

from his probable presence in Haarlem in 1628, when Ampzing mentions a "de Hooch" in his chronicle of the city, and in Utrecht from 1633 until the painter's death in 1638. De Hooch based his style on the art of Breenbergh and Poelenburch but asserted his own boldly monumental sense of design, a highly ordered approach to composition that Blankert has characterized as "pre-Claudian" (fig. 44).[173]

"The Violence of Fortune": Hercules Segers

Among the most original artists of the century, Hercules Segers was both a painter and printmaker. The son of Flemish immigrants, he was apprenticed to Gillis van Coninxloo and, as noted above, joined the Haarlem guild in 1612. Hoogstraeten confected an elaborate melodrama of Segers's life in his chapter entitled "How an artist should defend himself against the violence of Fortune."[174] He recounted how the artist's contemporaries misunderstood and ignored his talents, reducing him to penury and a drunken death. The documented facts, however, suggest that, at least in his early years, Segers knew some success, when, for example, one of his paintings was presented to King Christian of Denmark in 1621, and two others were in Frederick Henry's collection by 1632. While Segers seems to have had financial difficulty in later years, Hoogstraeten's anecdote about his being forced to use the family linen to print his "paintings" only attests to the writer's misunderstanding of Segers's innovative and at times idiosyncratic approach to printmaking. The artist's methods were extraordinarily daring, involving unconventional etching tech-

niques, colored papers and inks, brushed color, and more. Indeed, almost every print by Segers is unique, with the result that of 54 etchings only 183 impressions are known. Hoogstraeten spoke evocatively of "drukte schildery" (printed paintings).[175]

Scarcely less visionary and considerably less numerous are Segers's rare paintings, which number less than one dozen. These mostly depict fantastic images of mountain valley scenery. None are dated, but they have ancestry in Flemish landscapes of Alpine scenery, beginning with Bruegel but surviving into the second decade of the seventeenth century in the fantastical, gigantic mountain views of Kerstiaen de Keuninck (d. 1635) and Joos de Momper (1564–1635) (see cat. 57, fig. 1). As a student of Coninxloo, Segers would have been introduced to this tradition; indeed, Coninxloo's private collection of paintings is known to have included works by Bruegel the Elder, Joachim Patenir, and Paulus Bril.

Begemann plausibly reasoned that Segers's paintings developed from the mountain landscape tradition, the Flemish legacy of his training, to views of valley floors, and finally, around 1630, to the panorama.[176] A painting like the Rijksmuseum's *River Valley* (fig. 45) is probably an early work, still offering a dramatized view of nature – a hostile, windswept region of great desolate rocks, precipices, and the blackened stumps of trees. In the smaller of the two Segers paintings in Rotterdam (cat. 100), the valley floor has broadened, the trees and hillside now wear a soft down of mossy vegetation, and the human presence, by way of both the figures and the architecture in the center

Fig. 46. Hercules Segers, *Mountain Valley*, canvas on panel, 55 x 99 cm., Uffizi, Florence.

distance, has become more assertive. The painting in the Uffizi (fig. 46) establishes a new spatial grandeur and a dramatic new use of light and shade. Some of these changes, however, are the results of reworkings by a later hand, which, on stylistic grounds and the strength of the appearance of a large work by Segers in his inventory of 1656, has been identified as the work of Rembrandt. (To this fascinating probability we must return.) While the chronology and even the sequence of these paintings cannot be certainly specified, Segers may then have

executed his second painting in Rotterdam, the *Houses near Steep Cliffs* (cat. 101). This painting brings the willful shuffling and restructuring of nature in Dutch landscape to a marvelous new standard of arbitrariness by relocating the houses that Segers could see from his house on the Lindengracht to the base of a great cliff. There is no proof that Segers ever personally saw cliffs and precipices of the magnitude depicted here or in his other mountain valley paintings.

There is better reason, however, to assume that he would have seen the city and

broad plain around Rhenen (see cat. 37, fig. 1). Since the Winter King's Palace is omitted from his panoramic view of the city, Segers probably visited the city prior to 1630, thus providing us with the artist's only provisionally datable work. This painting and Segers's other panoramas, in Berlin (Staatliche Museen Preussischer Kulturbesitz, no. 808A) and in the Borthwick Norton collection, offer a new simplicity and calm following the imaginary tumult of his early mountain views. The Dutch panorama has Flemish origins (Bruegel to Bol; see fig. 22) and first made its appearance in the Netherlands in Goltzius's drawings (fig. 28) and Esaias van de Velde's prints. Segers probably, then, was the first Dutchman to paint panoramas.[177] The *View of Rhenen* exhibits the restrained choice of a few motifs, the straightforward paint application, and great economy of means that characterize Dutch painting at its most naturalistic. As in Segers's other two panoramas, however, the original long, horizontal format was probably altered, perhaps as early as the 1640s, to add the greater expanse of sky that became popular in panoramas of a decade or two later.

Following closely on Segers's heels were Pieter Post (1608–1669) and Cornelis Vroom, who had both begun investigating panoramic compositions by 1631 (see cat. 115, note 2). Vroom's *Estuary Viewed through a Screen of Trees* (cat. 115) and *Panorama*, in Heino (fig. 47), illustrate his achievements of the later 1630s, which brought a more idyllic mood to the panorama by subtle applications of a shadowed atmosphere and an expressive new use of the silhouettes of

Fig. 47. Cornelis Vroom, *Panorama*, signed, panel, 73 x 105 cm., Hannema-de Stuers Foundation, Kasteel het Nijenhuis, Heino, no. 358.

massive trees and their delicate leaves. The poetic atmosphere of Vroom's mature works has rightly been compared by Biesboer to the idylls of contemporary Dutch literature.[178] Inspired by Tasso and Guarini, P.C. Hooft (see *Granida*, 1605), Samuel Coster (*Itys*, 1615), and Huygens sought to bring arcadia to Holland. As in the poetry of the period, Latin *bucolica* are translated by Vroom into a native Dutch idiom.

Tonalities and Associations: Pieter de Molijn, Jan van Goyen, and Salomon van Ruysdael

Born in Leiden, Jan van Goyen was an enormously prolific artist whose catalogue raisonné lists more than 1,200 paintings and 800 drawings. He obliged later art historians by dating paintings and drawings in virtually every year of his career, beginning in 1620.[179] According to his earliest bio-

grapher, Jan Orlers (1640), van Goyen had five teachers and toured France (1615/1616) before studying with Esaias van de Velde in c.1616–18. We could have deduced this tutelage even without Orlers's confirmation, so clear is van Goyen's debt to Esaias in his gay and colorful little paintings of country roads, villages, and winter scenes dating from c.1620–25. Indeed, van Goyen's *Ferry* of 1625 (cat. 33) is probably based directly on van de Velde's painting dated three years earlier (cat. 106). But, as a close comparison of these two works attests, van Goyen in his early years remained more committed than his teacher to a compilatory mode of composition with old-fashioned coulisses and local coloration. His art still has a highly constructed, multiform appearance, whereas Esaias had achieved a more informal vision of landscape as early as 1614 (see fig. 30). Similarly van Goyen's little circular pendants *Summer* and *Winter*, dated 1625 (cat. 31 and 32) not only retain the sixteenth century's iconographic traditions but also employ additive designs that have not been significantly altered since those of Avercamp and even Bol. (Circular compositions are restricted almost exclusively to van Goyen's Leiden years; ovals appear only in his Hague period.) Van Goyen's pen and wash drawings of the years 1620–25 make advances in the unification of space, but it was not until c.1625/27 in Leiden that similar developments began to appear in his paintings. These changes were modest at first: a small reduction in the number of motifs, a subtle darkening of the tonality, and more browns and grayish greens in his palette. It has rightly been assumed that the probable

inspiration for these changes came from the great painter of silvery gray, atmospheric marines, Jan Porcellis (c.1584–1632), who moved to the village of Zoeterwoude near Leiden in 1626. We know at any rate that van Goyen had become acquainted with Porcellis by 1629, when he sold him a house in Leiden called "De vergulde troffel" (The Gilt Trowel).

The first two artists to create landscapes that were unified in terms of both composition and tonal values, Pieter van Santvoort in 1625 (cat. 98) and Pieter de Molijn in 1626 (cat. 56), have scarcely become household names, yet their achievement in formalistic terms was remarkable and of lasting influence. In paintings of simple roads in the dunes, both these artists employed unifying diagonal compositions with a more restricted "monochromatic" palette of tans, browns, and grayish greens. By reducing the range of values and hues in their works, they produced some of the first "tonal" paintings. The works of Santvoort and de Molijn preceded comparable paintings by either van Goyen or Salomon van Ruysdael, the two preeminent masters of "tonal" landscapes. The rugged painting by Santvoort, who may only have been an occasional artist, is unaccompanied in his small oeuvre by works of comparable originality, making it the odd exception. However, de Molijn was an artist of considerable invention who, though still painting forest scenes in the style of Jan Wils and Gerrit Bleker as late as 1625 (see cat. 56, fig. 1), made a sustained contribution to the dune landscape in the latter half of the 1620s. Imbued throughout with a grayish

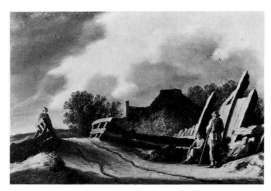

Fig. 48. Salomon van Ruysdael, *Road and Bridge in the Dunes*, signed and dated 1626, panel, formerly with dealer H. Katz, The Hague.

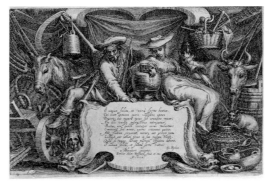

Fig. 49. Boethius à Bolswert, after Abraham Bloemaert, title page to a series of landscape prints, 1614, engraving.

green tonality, his brilliant picture in Braunschweig slopes away rapidly from right to left, achieving a sense of sweep that belies the picture's tiny scale.

Grosse, Stechow, and others have repeatedly analyzed van Goyen's formal development in the later 1620s, demonstrating that between 1626 and 1629 he moved from multiplicity of design and color to a unified structure and overall tonality.[180] The latter qualities are nascent by 1628 (see Rijksmuseum Twenthe, Enschede, inv. 271), clearly evident in paintings of the following year in West Berlin (no. 865) and the Städelsches Kunstinstitut, Frankfurt (cat. 35, fig. 1), and attain full tonal fruition by 1631 in the beautifully understated dunescape with a ramshackle fence, goats, and goatherds in Braunschweig (cat. 35). A similar progression can be traced at this time in Salomon van Ruysdael's dunescapes, which tend, however, to use a low, raking light, broader technique nearer to the bold manner of de Molijn and Santvoort, and a closer focus in the arrangements of his designs. These qualities are already evident in a painting that was reported to be dated 1626 (fig. 48).[181] The daringly cropped and occluded compositions of 1628 in Pasadena (see p. 67, fig. 3) offers a further variation on the sidelit design with shadowed foreground that was brought to a more spacious solution in Ruysdael's painting of 1631 in Vienna (cat. 90).

It is difficult to say what seventeenth-century viewers made of these dun-colored images of sandy tracks in the dune with peasants or goatherds lounging at the side of the road or before crudely thatched cottages

(cat. 34). Would the viewer have perceived in the rundown farmhouse an admonition against sloth and carelessness (see p. 86) or regarded it, as van Mander clearly saw Bloemaert's "drollig" farms, with a mixture of admiration for the artist's skill and a slightly bemused condescension toward his subject? Or would the scene have prompted thoughts similar to those expressed in the poem that G. Ryckius appended to the title page (fig. 49) of the twenty landscape prints with farmhouses and peasants (fig. 50) engraved by Boethius à Bolswert after Abraham Bloemaert's designs in 1614? Ryckius's poem celebrates the security and contentment of country life in the true georgic spirit:

Most happy is he and truly blessed is the one
Who may spend his years free of burgher cares,
So long as he lives securely under the
 thatched roof of his hut;
His spirit does not wrestle in a heart filled
 with doubt,
But remains happy, content with the pos-
 sessions of his fathers;
He collects either the golden crop, or the ripe
 apples of the tree
Or drives his fruitful cow toward the meadow
 which he may call his own.
But if he has a wife who helpfully takes her
 part in the work,
Most happy is he and in the highest measure
 blessed.[182]

According to the title page of another series of prints, dated 1627, by Cornelis Bloemaert after Abraham's designs depicting peasants, shepherds, and herdsmen, images of dozing peasants might occasion poetic moralizing on idleness but also might acknowledge the

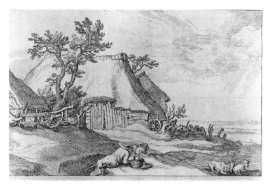

Fig. 50. Boethius à Bolswert, after Abraham Bloemaert, *Farmhouse with Peasants*, 1614, engraving.

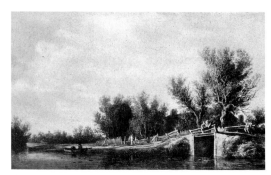

Fig. 51. Jan van Goyen, *River View with a Low Bridge*, signed and dated 1629, panel, 32 x 52 cm., J.H. van Roijen, Washington, D.C., c.1953.

positive aspect of leisure as a restorative interlude between periods of productivity.[183] Indeed, the admiration for the carefree simplicity of rustic life is constantly reiterated in the captions on prints of leisurely peasants. In the same series of 1627, beneath the image of two peasants slumbering under an open sky, is the inscription "Aspice quam placidos sumnos largitur egestas, / Ducere quos magnae non patiuntur opes" (Look at how poverty bestows peaceful sleep, which great wealth does not permit one to enjoy).[184]

The style of subtle tonal and coloristic adjustments that Salomon van Ruysdael and van Goyen had perfected by 1631, and that is epitomized in Salomon's *Halt before the Inn* of that year (cat. 91), was also successfully applied in these years to the two artists' river views and scenes of canals and ponds. As in their dunescapes, the compositions of their river views are organized diagonally with the entire foreground filled with water. The bank is usually covered with trees and reflected in the shimmering water below. Boats carrying fishermen or a ferry laden with passengers frequently ply the water. As in the "tonal" views of country roads, a palpably moist atmosphere and a palette of grayish greens, muted yellows and browns prevail. Van Goyen apparently took a slight lead in these investigations; as Stechow observed, his *River View with a Low Bridge*, dated 1629 (fig. 51), inspired the diagonal design of Salomon's painting of 1631 in London (see cat. 93, fig. 1).[185] But the two artists' works were extremely close in these years. Their achievement of an atmospheric and compositional cohesiveness in river

views is made clear by a comparison with
the works of a decade earlier by Esaias and
van Goyen himself (cat. 106 and 33).
Although van Goyen was living in these
years in Leiden (1627–32) and after the
summer of 1632 in The Hague, his close
association with the Ruysdael family in
Haarlem is proven by a fine that he received
from the Haarlem guild for painting illegally
at the house of Salomon's brother, Izaack
van Ruysdael.

During the height of the "tonal period,"
van Goyen painted a wide variety of sub-
jects, including dunescapes, country roads,
river scenes, marines, strands, and coastal
views, as well as some distant views of cities,
but very few winter scenes. As Stechow
concluded, a landscape style could oc-
casionally dictate subject matter;[186] in its
purest form in the thirties, the "tonal"
palette apparently was not considered well
suited to bright ice skating and snow scenes.
However, around 1638–1640 van Goyen
took up snow scenes again and embarked on
several new subjects, including the pan-
orama. He had experimented with a "single
wing" panorama by 1632 and after around
1638/39 frequently employed this design
with a stand of trees nestled to one side of a
broad expanse of plain.[187] Perhaps his most
successful work of this type is the painting of
1641 in the Rijksmuseum (Amsterdam, inv.
A 2133), while the true "wingless" pan-
orama is achieved in his wonderfully fresh
View of Haarlem with the Haarlemmer Meer,
1646 (fig. 52). Unlike Segers's earlier pan-
oramas, van Goyen's painting gives over
more than three-quarters of the composition
to sky. No sooner, however, did he arrive at

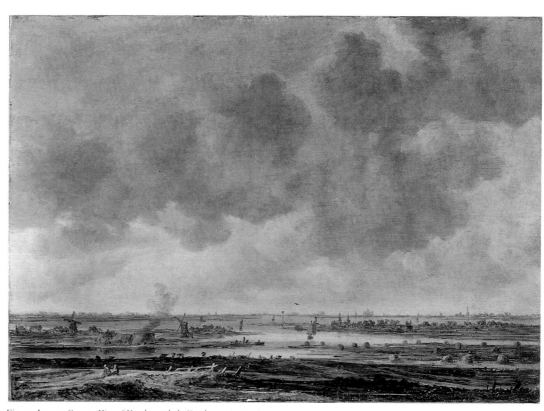

Fig. 52. Jan van Goyen, *View of Haarlem with the Haarlemmer Meer*,
signed and dated 1646, panel, 34.6 x 50.5 cm., The Metropolitan
Museum of Art, New York, no. 71.62.

this eminently reductive, atmospheric solution than van Goyen pierced the horizon with the elegant spire of Saint Cunera's Church in his *View of Rhenen*, also dated 1646 (cat. 37). This reassertion of an emphatic vertical accent could be viewed as the first step in the move to a greater emphasis on form and structure, which occurred throughout Dutch painting shortly after midcentury. But it also reminds us that the panorama's development was neither linear nor driven simply by the conquest of space; Segers, after all, had surmounted that obstacle nearly twenty years earlier. Rather, van Goyen clearly experimented with variations on the panoramic convention, especially when it might be applied to as promising a subject as the city of Rhenen (see commentary to cat. 37).

Views of distant cities, like those of ruins discussed above, no doubt elicited strong historical associations in seventeenth-century minds. Cities like Rhenen and Nijmegen (see cat. 22) were depicted repeatedly, not only because of their picturesque skylines or beautiful situations but also because they must have stirred recollections of national origins and historical vicissitudes. Had Salomon van Ruysdael omitted the two elegant coaches with their matching trains of blue and red footmen from the foreground of his *View of The Hague*, dated 1647 (fig. 53),[188] the glimpse of the Saint Jacobskerk in the distance probably still would have sufficed for viewers to identify the scene as situated near the seat of the Dutch court, and perhaps to further reflect on the city as the polis of great men and the site of momentous events. This too was

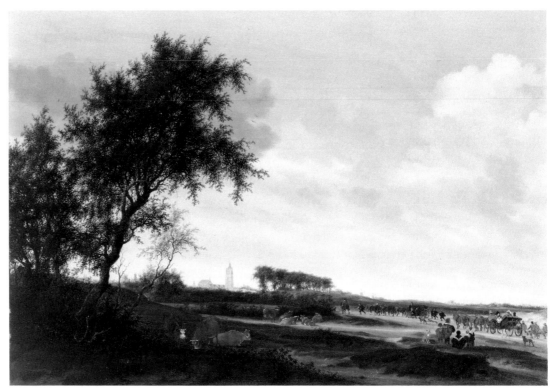

Fig. 53. Salomon van Ruysdael, *View of The Hague*, signed and dated 1647, panel, 75 x 110 cm., Shickman Gallery, New York.

Huygens's pretentious Hague, an "uneasy city of overcivilized people."[189]

While van Goyen and Ruysdael clearly had a great mutual influence on one another in the 1630s, in the following decade their styles diverged. Van Goyen continued to work in a warmer palette, painting more freely and directly, while Salomon gradually adopted brighter colors viewed in a clearer light and applied with a finer touch. Ruysdael also reduced the number of trees in his works and permitted them to grow taller. Vroom's example may have exerted some influence here, but Ruysdael's mature style from around 1645 onward is distinctively original. His splendidly fresh skies, always windswept at the horizon, and majestic trees, delicately flecked with new spring growth, convey a unique sense of pacific well-being, whether in one of his many views of the theme of stopping by the inn (cat. 92) or the equally favored river views with companionably overbooked ferry boats (cat. 94). Storms and natural inclemency were unknown to Salomon. But in 1650, or soon thereafter, he again took up the winter view (see cat. 120, fig. 1) after a hiatus of more than twenty years. His late paintings of winter (cat. 95) often depict cheerful skating scenes on frozen rivers, with the receding banks covered by stately buildings recalling the earlier topographic tradition.

Salomon's later winter views were preceded by those of Isack van Ostade and Aert van der Neer. Isack began his lamentably short career painting peasant interiors and doorway scenes in the style of his brother, the genre painter Adriaen van Ostade. In 1643 he joined the Haarlem guild and began painting winter scenes. Some are intimately scaled, light-toned panels executed with a subtle attention to detail and atmosphere (cat. 64), while others of the same period (c.1643–47) are large-scale canvases (cat. 63) painted in deeper tones and in a more expansive style.[190] Most of Isack's winter scenes, however, employ a diagonal composition with a large river bank, cottages, and figures set off against the pale expanse of the ice. True to his artistic beginnings, Ostade often included prominent and expertly characterized figures and animals; a favorite motif was a white workhorse dragging a sleigh, sledge, or other burden up the bank. Particularly successful was his evocation of the faun-colored, frosted surfaces of bare, frozen earth.

Nocturnes and Colored Light: Aert van der Neer

The mature winter scenes of Aert van der Neer are usually viewed from a greater distance than Ostade's, his small figures making no claims to the province of genre and tall trees sprouting on the banks. Van der Neer had begun painting winter scenes by 1641 in a style descended from Avercamp. These first works depict a canal with tiny skaters to one side of a snow-covered landscape. By 1643 the first signs had appeared of his favored and formalized "two-bank" design,[191] which offer a centralized view down a frozen canal with both banks visible and a tall sky overhead. The colorful painting of 1645 in the Corcoran Gallery, Washington (fig. 54), illustrates the emerging formal schema but has yet to achieve the

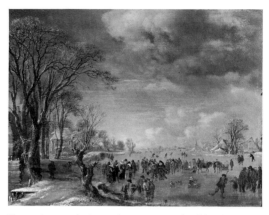

Fig. 54. Aert van der Neer, *Skating Scene*, signed and dated 1645, panel, 54.5 x 70 cm., The Corcoran Gallery of Art, Washington, D.C., no. 26.148.

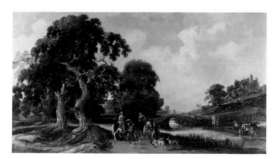

Fig. 55. Aert van der Neer, *River Landscape with Riders*, signed and dated 1635, panel, 100 x 186 cm., Galerie Edel, Cologne.

subtly tinted atmospherics and full luminosity of the Rijksmuseum's skating scene (cat. 60) of about a decade later. So exacting are the adjustments of hue and value that create this sense of an envelope of moist air that Stechow was tempted to compare the effort to differential calculus.[192] Daring, too, if intrinsically doomed, were van der Neer's efforts to paint falling snow (cat. 61); he evoked the driving wind, threatening clouds, then lightly daubed the scene with meteorological measles.

Van der Neer apparently began as an amateur painter in Gorinchem under the influence of the local Camphuysen brothers. He tried his hand as early as 1632 at genre painting in the style of Pieter Quast (National Galerie, Prague),[193] and about this time moved to Amsterdam. His first dated landscapes from 1633–35 (see fig. 55)[194] attest to the influence of Gillis de Hondecoutre (cf. cat. 48), Keirincx, and Bleker (cf. cat. 11), who, like Keirincx, helped to translate the Flemish forest view into a local idiom. Keirincx, who trained in Antwerp, painted wooded scenes in his early years in a highly decorative manner derived from Coninxloo and Flemish artists like Abraham Govaerts and Jan Brueghel the Elder (see cat. 51). This ornamental impulse, most evident in the gnarled trunks and lacy foliage of his trees, remained strong even in the pictures of Keirincx's later Amsterdam period, around 1640–45 (see cat. 52). The latter reveal the persistence of an alternative *flamisant* landscape style that offered a third alternative to the indigenous Dutch and Dutch Italianate traditions.

In the early 1640s van der Neer painted a few river views with diagonal designs recalling those of van Goyen and Salomon van Ruysdael.[195] We detect in these works the first hint of a colored light but as yet without atmospheric nuance. Kauffmann discussed the importance of van der Neer's colored light for his poetic intimations of twilight and nocturnal illumination.[196] These effects are best observed in the mature works painted during van der Neer's period of greatest achievements, about 1646–1660.

The history of nocturnal landscapes in religious paintings can again be traced from medieval manuscript illumination, to early Netherlandish painting (Hugo van der Goes and Geertgen tot Sint Jans), to sixteenth-century artists such as Albrecht Altdorfer, Mabuse, Cornelis Massys, Pieter Bruegel, Gillis van Valckenborch, and Kerstiaen de Keuninck. But it was Elsheimer who stimulated a new interest in nocturnes in the early seventeenth century with works like the *Flight into Egypt* of 1613 (cat. 78, fig. 1). As already mentioned, Elsheimer was curious not only about nocturnal celestial light but about various types of artificial light as well, combining them in a single picture in a virtuoso display. Esaias van de Velde and Pieter de Molijn painted a few night scenes with fires in the 1620s, and in the 1630s the great Flemish artists Rubens (see especially *Moonlight Landscape*, Count Seilern Collection, Courtauld Gallery, London) and Brouwer painted night scenes. But it fell to van der Neer to perfect the Dutch nocturne.

Whether van der Neer was inspired in these efforts by the example of Jan Lievens (1607–1674),[197] who conveniently moved from Antwerp to Amsterdam in 1644, is debated,[198] but if, as seems probable, a work like the *Countryside at Evening* (Staatliche Museen Preussischer Kulturbesitz, Berlin [West], no. 816) is to be dated around 1640, Lievens may have served as the conduit for Rubens's ideas. Van der Neer's earliest dated night scene is the painting in Gotha of 1643 (cat. 59, fig. 1), which presages the *Moonlit View on a River* of the following — indeed, the last — year in which van der Neer regularly dated his pictures (cat. 59). The extraordinarily subtle use of layers and tints of color (the hue of burnt cork, brownish reds, slate grays, and a whole range of accents in black, rust, blue, and pink) creates a luminous atmosphere wedding earth and sky in an unprecedented nocturnal harmony. More than his Flemish predecessors, van der Neer reduced the local hues of objects to achieve a new coloristic unity. Although there is little evidence to support the parallels that Kauffmann purported to see with the research of Christiaan Huygens (1629–1695) in optics and refraction,[199] van der Neer's new sensitivity to the spatial effects of color is another expression of the era's empirical faith in observation. In addition to large scale-works of the type exhibited here, van der Neer produced small, finely executed twilight and night scenes that sacrifice nothing in poetic effect for the reduced scale. Indeed, van der Neer's moonlit scenes may remind us of Philibert van Borsselen's lines quoted above (p. 12) or the verses of the anonymous poet of *Roemster van den Amstel*.

Rembrandt and His Circle

Van der Neer's more famous contemporary in Amsterdam and fellow painter of at least one nocturne (see cat. 78), was Rembrandt van Rijn. Numbering fewer than ten, landscape paintings form only a small portion of Rembrandt's oeuvre. Far more numerous are his many landscape drawings and etchings, executed primarily in the later 1640s and early 1650s. The majority of these works on paper were drawn from life and depict the environs of Amsterdam that Rembrandt encountered on his country walks. Rembrandt's landscape paintings precede in date his drawings and rather than recording actual sites, offer mostly fantasized, highly dramatic views in the tradition of Segers. We recall that Rembrandt apparently added the deep brown washes and glazes to Segers's landscape in the Uffizi (fig. 46). In what may seem by modern standards a brashly obtrusive act but surely constituted artistic homage of a sort, he also later reworked one of Segers's etching plates.[200]

Like his reworked version of Segers's painting (fig. 46), Rembrandt's *Landscape with a Thunderstorm* in the Herzog Anton Ulrich-Museum, Braunschweig (p. 97, fig. 20) depicts a rough mountain scene but adopts a more dramatic, less visionary approach, especially in the treatment of light and shade. The fascination with nature's theatrical moments is also encountered in two less exotic paintings by Rembrandt depicting landscapes with water and bridges (fig. 56 and cat. 76). Over the native Dutch countryside of *The Stone Bridge*

Fig. 56. Rembrandt van Rijn, *Landscape with Long Arched Bridge*, panel, 28.5 x 39.5 cm., Staatliche Museen Preussischer Kulturbesitz, Berlin (West), no. 1932.

(cat. 76) the thunderclouds are just retreating. A shaft of light sets the central tree ablaze and outlines a highlight on the low arch of the bridge. Rembrandt did not neglect religious subjects in landscape, addressing two time-honored landscape themes, the *Good Samaritan* (see p. 96, fig. 19) and the *Rest on the Flight* (cat. 78). The latter painting, of 1647, is the artist's last dated landscape and has often been linked with its source in Goudt's print after Elsheimer (cat. 78, fig. 2), but its more painterly, atmospheric treatment of nocturnal effects parallels van der Neer's art in this period. While the Dublin painting thus appropriates and recasts a well-known prototype, Rembrandt's only winter landscape is a tiny work of 1646 executed with such astonishing freshness and immediacy as to seem to deny any artistic precedent. Indeed, among seventeenth-century Dutch paintings that appear to have

been painted on the spot, the Kassel painting (cat. 77) takes the palm; but it, too, of course, nods to forebears, principally the unpretentious little scenes of Esaias van de Velde (cf. cat. 107). The Kassel painting's only offspring, however, were Rembrandt's own landscape drawings, which began to multiply about this time, striving for a similar artistic shorthand.

How close Rembrandt's students and followers could come to his landscape style is illustrated by the case of the *Landscape with Obelisk* (cat. 29), which was long assigned to the master but bears remnants of Govaert Flinck's signature. The aspect of Rembrandt's landscape style that Flinck emulated was not the fresh, economical style of the Kassel painting but his dramatic, emotional conception of nature. Flinck and Gerbrand van den Eeckhout (see cat. 26) both worked in Rembrandt's studio and painted only a handful of landscapes, but these acknowledge their teacher's influence. Roeland Roghman (see cat. 79) and Philips Koninck also owed a debt to Rembrandt, but unlike Flinck and Eeckhout, they emerged as fully independent landscapists. Whereas many of Roghman's greatest achievements were in the field of drawing and therefore lie outside the boundaries of this study, the accomplishment of Philips Koninck will concern us further.

Birds of a Feather:
The Second Generation of Dutch Italianates

Shortly after 1620 Poelenburch and Breenbergh helped establish a fraternity of Northern painters in Rome called the

"Bentvueghels" (Birds of a Feather), the "Schildersbent," or simply the "Bent."[201] Their official purpose was to challenge the authority of the local Accademia di San Luca and the demand of Pope Urban VIII that all foreigners pay dues to the guild whether enrolled in it or not. But the unofficial activities of the Bent – raucous festivities, drinking bouts, and the mock baptism before Bacchus of each new "bird" – brought them greater notoriety. At the baptism each painter was given a demeaning nickname based on his appearance or personality; Poelenburch was the "Satyr" and Breenbergh the "Ferret." The Bent survived nearly a century until Pope Clement XI finally banned it in 1720 for heretical behavior.

Many of the leading artists among the second generation of Dutch Italianate painters became members of the Schildersbent. Jan Both may have encountered Poelenburch in Utrecht and Breenbergh in Amsterdam (the former had returned to the Netherlands in 1626, the latter in 1630) before he departed for Italy. Unlike his brother Andries, the genre painter of low-life subjects, who was in Rome in 1630, Jan probably did not make the journey until 1635, or at the latest 1638. In Rome, Both met Herman van Swanevelt from Woerden, whose calm, monumentally conceived landscapes (see cat. 102, fig. 1) form an important link between the first and second generations of Italianates. Both, Swanevelt, and Claude Lorrain worked together on the decorative commission for landscapes with religious subjects for Buen Retiro, the palace of Philip IV in Madrid, which were installed between

1636 and 1640 and are now preserved in the Prado.[202] The works by these artists from this series share a concern with compositional structure and a golden light, qualities that had already appeared in Swanevelt's painting of 1630. The mutual influences of Swanevelt, Both, and Claude are many and difficult to disentangle. But, as Blankert observed, despite repeated assertions beginning with the biographies of Sandrart (1675) and Houbraken (1718–1721), it is not clear that Claude was the chief innovator in the group. Nor is it clear that he was the decisive influence on the youthful Both, Claes Berchem, or Jan Baptist Weenix.[203]

With only one, relatively late dated work (see *Landscape with Mercury and Argus* of 1650; cat. 16, fig. 1) Both's development is hard to trace. His early works for Buen Retiro already show a characteristic interest in majestic trees, dramatic *contrajour* illumination, and a taste for the meticulous details of foliage and foreground vegetation. But there are also a softer touch and more glazes than in the later works. An important influence on the young Both in Italy no doubt was Pieter van Laer (1599–after 1642), known as "Bamboccio" (clumsy puppet), because he was a cripple. Though better known as a painter of genre-like Roman street scenes, van Laer was also active as a landscapist and probably influenced his fellow Dutchmen both in this capacity and as a figure painter. Both returned to Utrecht in 1641, where, despite his removal from his subject, he went on to perfect the painting of the Italian campagna. While in his mature works, Both shares with Claude a taste for golden atmosphere, his sunlight is clearer,

more brilliant, and he eschews Claude's aching nostalgia for the classical past. Both's landscapes are populated not by arcadian shepherds but by seventeenth-century herdsmen, travelers (cat. 14), artists sketching (cat. 15), even banditti (cat. 16). Usually his prominent trees have twisting, slightly wooly trunks and spread their delicate foliage against the light. A rich, deep green with accents of yellow and blue establishes the palette. Weaving roads and brooks unite the richly detailed foregrounds with the hillsides and mountain vistas beyond. In later years, he painted on a squarer and larger format than his fellow Italianates (see cat. 15 and 16). He also rarely depicted Roman ruins, monuments, or religious or mythological staffage. The history figures that appear in his landscapes are usually by other hands, such as Poelenburch and Nicolaes Knupfer (c.1603–1655). J.B. Weenix also added animals to Both's works, and Berchem occasionally contributed figures.

Jan Asselijn began his career painting cavalry skirmishes in the style of Esaias van de Velde's later works and the paintings of Esaias's nephew and Asselijn's probable teacher, Jan Martszen de Jonge. Sometime between 1635 and 1642 he traveled to Italy, where he was known as "Krabbetje" (the Crab) on account of his deformed hand. No dated works are known between 1635 and 1646. The *Landscape with Ruins, Riders, and Herdsmen* of 1646 (Galleria Nazionale dell'Accademia de San Luca),[204] which was probably painted in France during his return journey to the Netherlands depicts ruins recalling Poelenburch's work but with the

contrasting light and shadow popularized by Pieter van Laer. No works are known from the period of Asselijn's Italian sojourn. He was in Amsterdam again in 1647 and in the remaining five years of his life emerged as one of the most important Italianate land-scapists. His dated works of 1647 attest to his interest in architecture as a means of establishing monumental compositional structure and reveal a taste for pliantly picturesque figures and supple animals.[205] In the undated *Landscape with Herdsmen and Cattle in a Ford* in the Vienna Akademie (cat. 2) of two or three years later, these elements are successfully combined in a spacious view of the campagna with glowing, cloud-flecked sky. The motif of the cattle train fording a river was one of Asselijn's favorites. It re-appears on a tinier scale in the middle dis-tance of the hushed and luminous *Moun-tainous Landscape with Traveling Herdsmen*, also in the Vienna Akademie (cat. 1). The vast expanse of plain, which slopes gently away then rises again to tall mountains, is un-fettered by lateral boundaries. This stately painting inaugurates the Italian panoramic landscape, later notably practiced by Berchem (see cat. 1, fig. 1), Karel du Jardin (see *Le Diamant*; cat. 49, fig. 2), and Jan Hackert (see cat. 41). Around 1650 Asselijn's style grew slicker and more polished, as seen in the *View of the Tiber with Ponte Rialto*, dated that year (C.L. David, Copenhagen).[206] The artist's late style may then be studied in the *View of the Muiderdijck* (cat. 4), probably dating from 1652 or later. This is one of several paintings in which the local calamity of a broken dike drew Asselijn's attention after returning from the sunny south to the

Fig. 57. Jan Asselijn, *Winter Landscape with Hunters Crossing a Bridge*, signed, canvas on panel, 49.7 x 35.8 cm., Frits Lugt Collection, Fondation Custodia, Institut Néerlandais, Paris, inv. 6611.

local scene. In his variegated and fluent oeuvre, however, Asselijn had also trans-ported features of the northern climate to the south, as, for example, in his rare but beautiful winter scenes, which include the early work in the Lugt Collection (fig. 57) and a very differently conceived mature painting in Worcester (cat. 3). The noc-turnes and waterfalls by Asselijn are also notable departures from his better-known themes.

Though less important than either Both or Asselijn for the subsequent development of Italianate landscape painting, Jan Baptist Weenix was a highly innovative artist. He is known to have been in Italy from 1642 to 1647, and his mature works with large

Roman ruins and prominent genre figures are dated in the year of his return; see *The Ford* (Leningrad, Hermitage, inv. 820) and the *Hunting Party Resting among the Ruins* (cat. 116, fig. 1), both dated 1647. His early works exhibit a brilliant sense of color and a broad-ly assured manner that tightened by the mid-1650s. In the years immediately follow-ing his return, Weenix also turned his Italianate vision to a time-honored, native Dutch landscape theme, the river with a ferry (cat. 116; cf. cat. 106, 33, and 94). Like so many other Italianate landscapes, this work mixes northern and southern elements. In addition to depicting landscapes with Roman ruins (the Temple of Vespasian often appears), Weenix was an innovator in the painting of imaginary harbor views. He and Asselijn collaborated on one such port scene (Vienna Akademie, inv. 761), and he worked with Berchem on a religious painting (Mauritshuis, The Hague, inv. 1058).

Berchem is often assumed to have accom-panied Weenix on his trip to Italy in the mid-1640s, but there is no documentation for the journey at this or any other time. Blankert concluded on stylistic grounds that 1653–55 was the most likely time for Berchem's visit.[207] Since he was a highly prolific artist (Hofstede de Groot lists 857 paintings, and attributed to Berchem are over 500 drawings and 50 etchings), there is no single typical Berchem; however, as a landscapist, he is best known for his scenes of pastoral, harbor, winter, battle, and hunting subjects. Ber-chem's earliest landscapes of about 1644–46 are pastoral views with shepherdesses and their flocks.[208] These works have darkened foregrounds somewhat uncertainly con-

nected with the lighter vistas beyond and dark tree trunks with rather insubstantial foliage. They combine figure motifs inspired by van Laer with compositions derived from Both. Blankert concluded that it was not until around 1653 that Berchem arrived at his mature Italianate manner, executing paintings of greater compositional assurance, atmospheric subtlety, and sunnier overall lighting (see the *Landscape with Tall Trees*, dated 1653, Louvre, Paris, inv. 1037).[209] Both and Asselijn had died in the previous year, but Berchem continued to draw inspiration from their works. For example, Asselijn's legacy appears not only in Berchem's panorama of 1655 in the British Royal Collection (cat. 1, fig. 1) but also in his *Landscape with Cattle Fording a Stream* of 1658 (?) (Louvre, Paris, inv. 1038), and possibly again in his splendid nocturnal image of crab catchers (see cat. 9). The last work attests to Berchem's splendid facility as a painter of genre figures. An excellent example of his mature style of the mid- to later 1650s is the painting from Braunschweig (cat. 8). But as catalogue 10 demonstrates, by the 1660s Berchem's style had turned darker in tonality, more decorative, and given to a fluttering, restive animation that may acknowledge Pijnacker's influence. Pijnacker was also the source for the tall bridge on the right of Berchem's upright *Landscape with a Waterfall and Temple at Tivoli* of around 1670 (fig. 58), a work that shows Berchem recycling one of his own compositions of 1656 (Rijksmuseum, Amsterdam, inv. C 97). While there was, then, some repetitiveness in his countless variations on the Italian pastoral, Berchem showed no

Fig. 58. Claes Berchem, *Landscape with a Waterfall and Temple at Tivoli*, signed, canvas, 105.5 x 94.3 cm., Frits Lugt Collection, Fondation Custodia, Institut Néerlandais, Paris, inv. 7670.

diminution of his artistic faculties even in his later career.

It is not known when Adam Pijnacker went to Italy; it is certain only that he spent three years there, probably in the mid-1640s. His earliest dated paintings of 1654 (see Staatliche Museen, Berlin [East], no. 897) clearly attest to the influence of Both and Asselijn, as do his paintings from the 1650s of mountain landscapes, lakes, and harbor scenes. But the exceptional simplicity and quietude of his paintings of coastal views and river banks (cat. 65 and 67) ex-

ceed the classical harmony and repose of his mentors' works, just as his lighting exceeds in radiance their golden atmosphere. A sudden change, however, is signaled by *The Falling Bridge* of 1659 (cat. 66, fig. 1), which brings a new interest in dramatic effects, sinuous, flapping forms, and visual turbulence. The twisting, curling bark of the trees and cabbage-like foliage in the foreground of his later work in the Dulwich Picture Gallery (fig. 59) take on a life of their own. In these years Pijnacker's tonality became cooler, his colors more insistent, and his brushwork tighter. There also were abrupt changes of scale. Indeed, the willfully artificial elegance of Pijnacker's late draftsmanship has even been called in this century "manneristic." But the seventeenth-century appreciation of Pijnacker's art was eloquently expressed in poetry by Pieter Verhoek (see commentary to cat. 66).

Nicknamed "Bokkebaart" (Goat's Beard) by the Schildersbent, Karel du Jardin probably visited Rome in the late 1640s. He was in Amsterdam again in 1650 but soon left for Paris, where he appeared in 1650 and 1652 and no doubt became an admirer of the velvety brushwork of Sébastien Bourdon. Pieter van Laer undoubtedly also had an influence on du Jardin's figure and animal style, as he did on the early works of Paulus Potter. Potter in turn seems to have inspired du Jardin's paintings of c.1655 of livestock at pasture (see Louvre, Paris, inv. 1397, dated 1655). However, du Jardin's little paintings have a more fluid, softer touch than Potter's and a warmer treatment of light. Toward the end of the 1650s the genre elements of his paintings began to dominate the land-

Fig. 59. Adam Pijnacker, *Landscape with Sportsmen and Game*, signed, canvas, 137.8 x 198.7 cm., Dulwich Picture Gallery, London, no. 86.

scapes. But on a return trip to Rome in 1675 du Jardin again addressed landscape subjects with a new enthusiasm, evidently under the inspiration not only of Asselijn's much earlier panoramic views but also of the works of local followers of Carracci (see cat. 49 and 50).

A "Pure and Bright" Manner of Painting; Aelbert Cuyp

Most Dutch Italianate masters produced the majority and best of their works not in Italy but after returning to the Netherlands. Indeed, in a large measure the tradition of depicting the Italian campagna was a Dutch rather than an Italian accomplishment. Moreover, particularly after 1640 the most important developments in Italianate painting took place not on Italian but on Dutch soil. It must be stressed that, unlike modern art historians, seventeenth-century Dutch art theorists made no categorical distinction between a national and Italianate school of landscape painting. However, Blankert has noted that Houbraken spoke of Asselijn's having imported "a pure and bright manner of painting, like that of Claude, to Holland".[210] While we now question Claude's invention of this style, its identification is significant. Elsewhere Houbraken also referred to Karel du Jardin as preferring the "bright" manner of painting to the "brown manner" of Jacob van der Does (1623–1673).[211] Thus, the light tonality, colorful palette, and smoother technique that we associate with the Italianate manner were acknowledged, if only in passing, as a distinctive style. Some of the greatest accomplish-

ments of this tradition were made around and soon after midcentury, in parallel and through cross-fertilization with native styles.

As Pieter Jansz Saenredam's *Landscape with Santa Maria della Febbre, Rome* (fig. 60) clearly attests, the presence of Italian motifs in a Dutch landscape is no proof that the artist ever set foot in Italy. Just as Saenredam based his work on a drawing by Heemskerk, so later Dutch landscapists scarcely required personal experience of Mediterranean scenery and light to paint in an Italianate manner or derivation thereof. This was true not only of minor talents, like Jacobus Sibrandi Mancadan (c.1602–1680), but also of painters of the first rank, such as Aelbert Cuyp, Paulus Potter, and Adriaen van de Velde.

Cuyp's earliest paintings date from around 1639–41 and seem to reflect his initial artistic education under his father, the Dordrecht portraitist Jacob Gerritsz Cuyp (1594–1651/52; see cat. 20). By 1641 he had begun to paint broad pastoral views and river scenes with a yellow-brown overall tonality and lemony or light green accents. Both in their style and choice of subject matter, these works (see fig. 61) acknowledge Jan van Goyen's paintings of the 1630s. During the 1640s Cuyp must have ventured from his native Dordrecht and come in contact with Amsterdam and Utrecht painters, including Aert van der Neer, who probably inspired his moonlight views, Gijsbert de Hondecoeter, who influenced his animal and poultry paintings, and Poelenburch and Jan Both, who introduced him to the Italianate manner. Since very few of Cuyp's paintings are dated, it is

Fig. 60. Pieter Jansz Saenredam, *Santa Maria della Febbre, Rome*, signed and dated 1629, panel, 37.8 x 70.5 cm., National Gallery of Art, Washington, D.C., no. 1396.

Fig. 61. Aelbert Cuyp, *Pastoral Landscape near Utrecht*, signed, panel, 49 x 74 cm., Czernin Collection, Residenzgalerie, Salzburg.

difficult to pinpoint changes in his art. But around 1646 he seems to have exchanged the pale blond light and malleable dunes of his early works for the sturdier rock formations and tectonic compositions of Poelenburch. Toward the end of the decade, he added the golden atmosphere, long shadows, and more majestic designs of Both. But Cuyp was scarcely content to imitate Both or any of the other Italianates. His own originality is apparent in his painting in Budapest of around 1650 (cat. 21), where the great placid forms of the cows, the expanse of shallow water, low point of view, and tall upswept sky achieve an unprecedented monumentality and repose. No doubt such images evoked a sense of well-being and prosperity in seventeenth-century viewers; indeed, the common milk cow, so central to the Dutch rural economy, was employed as a symbol in Dutch art of earth, spring, fecundity, trade, moderation, and even of the Dutch nation itself (see commentary to cat. 21). Thus, it had a whole series of reassuring connotations.

Though an apposite and amenable beast, the cow was only one player in Cuyp's soothing, classicized imagery. Merwede or Ubbergen Castle, the Valkhof in Nijmegen (cat. 22), and even the Mariakerk in Utrecht (Toledo Museum of Art, no. 60.2) might be conscripted as architectural members or signposts (again, ripe with associations) in the open landscape of Cuyp's artfully constructed, Northern idylls. The preferred hour is eventide, when the angled sun sets the air and ragged clouds aglow. Yet Cuyp's atmosphere is not the amber lens of Both, but a shimmering, luminous envelope. In his

compositions on a small scale with a quiet stretch of water, Cuyp will cover the resonant browns demarcating river banks, mountains, and other terrestrial forms with a scrim of flecked highlights to set the moist air skittering. On a grander scale, as in catalogue 24 and 25, the brilliant refinement of his mature technique is fully appreciated. The transition from the detailed reeds and creeper in the foreground to the roads with tall trees, riders, and herdsmen beyond, and finally to the gentle aspect of the distant spires and mountains attests to Cuyp's unrivaled command of tonal gradations, ever at the service of spatial recession. Fromentin wrote of Cuyp, "He had the uncommon power of first imagining an atmosphere and then making it not only the vanishing, fluid and breathable element, but also the law and, so to speak, the ruling principle of his pictures."[212] Cuyp's severe and luminous art won many admirers and imitators, both in his own time, among artists like Abraham van Calraet (1642–1722), and especially in the late eighteenth century, when Jacob van Strij (1756–1815) produced so many works in Cuyp's manner that the Rotterdam collector Gerrit van der Pot van Groneveld complained in 1797 of a "Cuyp factory."[213] The height of the famous English infatuation with Cuyp came in the San Donato sale in Paris in 1868, when the *Avenue at Meerdervoort* (cat. 47, fig. 1) sold to Lord Hertford for frs.140,000, then the highest price ever paid for a landscape at auction.

Though primarily and triumphantly an animal painter, Paulus Potter distinguished himself also as a painter of meadows, pastures, farmyards, and hunt scenes. Like

Cuyp, he adopted a bright manner, but in Potter's works the air is cooler, atmospheric only in the distance. There are no fuzzy effects here; his probing, meticulous portraits of livestock demand scrutiny. Potter's early works reflect the influence of his father, Pieter Potter (c.1600–1652), his teacher, the Pre-Rembrandtist Claes Moeyaert (1592/93–1655), and Gerrit Claesz Bleker. Important links with the Italianate tradition were the influences of Pieter van Laer's paintings and animal prints and the pastoral landscapes of Jan Both. Potter was only twenty-two years old in 1647 but already at the height of his artistic powers when he painted his famous *Young Bull* (Mauritshuis, The Hague, no. 136) and some of his finest farm landscapes (see cat. 73). In these years his smaller, cabinet-size paintings of animals at pasture probably influenced the subjects and designs of contemporary paintings by Karel du Jardin, but Potter's touch is always more descriptive. A greater elegance appeared in his later art, when he was persuaded to move to Amsterdam to work for the wealthy Dr. Nicolaes Tulp (also Rembrandt's early patron) in the year that he painted his *Departure for the Hunt* of 1652 (fig. 62). The park-like setting in this work recalls the Bosch near The Hague. As Stechow observed, Potter's painting probably was the inspiration for Adriaen van de Velde's later forest glades of 1658 (see Städelsches Kunstinstitut, Frankfurt, inv. 1048; National Gallery, London, no. 982).[214] Potter's *Hawking Party* of 1653 (Duke of Bedford, Woburn Abbey) also shares a favored subject and design, if not the delicate manner and harmonized coloring, of Philips Wouwermans.

Fig. 62. Paulus Potter, *Departure for the Hunt*, signed and dated 1652, canvas, 60 x 76 cm., Staatliche Museen Preussischer Kulturbesitz, Berlin (West), inv. 872A.

Travels Far and Near: Frans Post and Allart van Everdingen

The eminent humanist Justus Lipsius (1574–1606) wrote in a letter to a friend, "Small and narrowminded souls stay at home in their own country; more elevated is the person who follows the sky and who loves movement. In former times and still today, men who have traveled are almost always men of substance."[215] Though sanctioned and ever popular, the trip to Italy was only one of the journeys undertaken by Dutch artists. Most exotic of all was the trip to Northeast Brazil, the colony that had been taken by the Dutch from the Portuguese in 1630. Frans Post, the younger brother of the architect-painter Pieter Post, traveled to

Brazil in 1637 with the figure painter Albert Eckhout (c.1610–1666) in the retinue of the new governor-general Johan Maurits of Nassau-Siegen. While Eckhout made life-size portraits of Tupi and Tapuya Indians, as well as paintings of the local fauna, Post recorded the landscape. Only six of Post's works executed in Brazil have survived, but the Louvre's painting dated 1638 (cat. 71) shows his application of Esaias van de Velde's diagonal composition schema and a subdued tonality (cf. fig. 31) not to the Zierikzee but to São Francisco River, with Fort Maurits in the distance, and cactus and a capybara (a large Brazilian rodent) in the foreground. Upon his return to Haarlem in 1644, Post continued to specialize in Brazilian landscapes, even after the Dutch had returned the colony to its former owners in 1654. These later paintings were based on drawings Post had done in Brazil but also reflect an ample investment of imagination. Replacing the somber palette and homogeneous tonality are more brilliant colors and stronger contrasts of value. New, as well, is the decorative brown-green-blue compositional schema familiar to us from the earlier mannerists, Coninxloo and Savery. In the darkened foreground, precisely articulated Brazilian plants and animals permit study and identification of species while forming a sharply silhouetted and, by this time, old-fashioned *repoussoir*. Indeed, Post often seems to have reverted to Vroom's earlier manner (cf. cat. 114). Post's Brazilian panoramas are often filled with houses, churches, sugar plantations and mills, as well as tiny native figures. A painting like Post's monumental *View of Olinda*, dated

1662 (see cat. 72), would not only have satisfied curiosity about faraway wonders, both natural and social, but also have served to verify and legitimize national pride in Holland's global reach.

For the Dutchman, accustomed to wide beaches, rolling dunes, and "mountains" no higher than the Vaalserberg, in Maastricht (1,050 feet), Scandinavia's geography was scarcely less exotic than Brazil's. Annotated drawings indicate that Allart van Everdingen traveled to the southern coast of Norway and the area around Göteborg in Sweden in 1644. He returned home no later than February of the following year, but his Scandinavian experience, like Post's South American tour, provided him with subject matter throughout his career. Like the works of the Italianates, Everdingen's greatest paintings of Northern mountains, cataracts, and pine forests were executed in the Netherlands. It was only in 1647, two years after joining the Haarlem guild, that Everdingen perfected his Scandinavian views (see cat. 27). These owe a debt to the Tirolean scenes of Roelandt Savery – who, Houbraken informs us, was Everdingen's teacher – but dispense with the earlier artist's mannered surface pattern. Everdingen's massive cliffs, sheer rock faces, and crashing waterfalls capture the harsh beauty of the Scandinavian landscape without indulging in the picturesque. In 1648 he began painting upright views of waterfalls, which, by virtue of their high horizon, low viewpoint, and thundering water, loom ever more immediately before the viewer (see cat. 28). These impressive paintings later had an important impact on Jacob van

Ruisdael. After 1650 dates are scarce in Everdingen's oeuvre, but he apparently continued to repeat his waterfalls to the slackening of their dramatic effect, at times adding Dutch motifs or even Italianate staffage (see Rijksmuseum, Amsterdam, inv. A 691, dated 1655). Less numerous but no less beautiful than Everdingen's waterfalls or boulder-strewn mountains are his few panoramic views of the rolling Scandinavian countryside (see *Hilly Landscape*, Kunsthalle, Hamburg, no. 56). Though better known for quiet marines and atmospheric, silvery-gray beach scenes (see Mauritshuis, The Hague, inv. 558, dated 1643), the versatile Simon de Vlieger painted a few Northern coastal views (see cat. 113) in the last years of his life, about 1650–53. Like Everdingen's contemporary works but also harkening back to much earlier Flemish models, these paintings convey the rough grandeur of the Scandinavian coastline, complete with a few intrepid explorers perched on the rocky cliffs.

In addition to painting Italian, Brazilian, and Scandinavian views, some Dutch landscapists (Claude de Jongh, Hendrick Danckaerts, and Jan Griffier, for example) painted English scenes. Jan Hackert made three trips to Switzerland, executing topographical drawings for Joan Blaeu's famous *Atlas Major* (1662) as well as a major painting of the Lake of Zurich (see cat. 41). In the light of the hostilities with the Spanish-occupied Southern Netherlands, the scarcity of Flemish subjects (Segers and Jan van der Heyden depicted Brussels) is perhaps not surprising, and the virtual absence of any views of Spain is understandable. The most

common foreign landscapes after Italian views were German subjects, above all Rhenish scenes. Especially following the appointment of Johan Maurits as stadtholder of the Great Electorate in 1647, Dutch artists traveled to the area around Kleve (see cat. 40). The travel diaries of Vincent Laurensz van de Vinne record his enthusiastic response to Rhenish scenery.[216] Venturing up the Rhine, especially in the area of the Siebengebirge and the Rheingaugebirge, Herman Saftleven made a specialty after around 1650 of "imaginary Rheinland" views (see cat. 97), as Jan Griffier the Elder (see cat. 39) did later (while mostly residing in England!) in a more decoratively mannered style. As Nieuwstraten demonstrated, however, the earlier career of the protean Saftleven attests to remarkable versatility, indeed, reflects a broad cross section of Dutch landscape painting.[217] He responded by turns to van Goyen; to the Utrecht painters Bloemaert, Breenbergh, Poelenburch, and Both; and to the Amsterdam artist Keirincx. But his skills were not derivative. Saftleven's own originality is appreciated in works like his wooded mountain valleys of 1641 in Vienna (cat. 96, fig. 1), the *Hillside with Sleeping Hunter* of 1642 in the Abrams Collection (cat. 96), and the *Hunters Resting in a Forest* of 1647 (cat. 96, fig. 3).

Koninck and a Grander Panorama

Like his predecessors in this specialty, Philips Koninck traveled no farther than Gelderland to discover the subjects of his art, but through fresh notions of scale, design, and technique he opened a new chapter in the history of the panorama. Settling in Amsterdam in 1640/41 after studying with his brother, Jacob, Koninck entered Rembrandt's circle at an age too old for the traditional master-pupil relationship. But Rembrandt's influence is clear, particularly in the dark, sonorous palette of Koninck's early paintings as well as in his first drawing style. While Rembrandt's landscape paintings are mostly fantastic subjects, Koninck's invariably are naturalistic, if rarely topographically identifiable, depicting a broad, flat plain coursed by rivers, with cottages nestled among trees and entire cities viewed in the distance.

Koninck had begun his panoramas by 1647 and painted most of the finest ones in the period 1654 to 1665 (see cat. 53 and 54). In these works, he invariably adopted a high point of view and divided the compositions at the horizon roughly in half. These horizons are scarcely ever intersected by trees, buildings, or other motifs. Rather, the crucial transition between earth and sky is facilitated by the pale forms of dunes or a muted mountain range. Thus, the horizon is never a straight line but an intimation, glimpsed in the hazy distance. Earth and air are united in a painterly atmosphere. Parallel strata of trees and cast shadows on the illuminated plain are subtly interwoven by rivers or highways snaking into the distance, ever disappearing and reappearing. Koninck's broad technique scrubs in bushes, russet cottages, and yellow meadows, while his brightly colored, almost miniaturistic figures seem to make his huge canvases all the larger. No doubt a calculated effect in this choice of scale is the viewer's awe and absorption. Like the larger, more highly structured canvases that Cuyp and Jacob van Ruisdael painted in those years, Koninck's grander panoramas are part of the "classical phase" of Dutch landscape paintings.

Noble Specifics: Ruisdael and Hobbema

Jacob van Ruisdael has rightly come to be regarded as the greatest and most versatile landscapist of the heroic age of Dutch painting, namely, the third quarter of the century. His production was extensive (over 700 landscapes, as opposed to only about 110, for example, by Koninck) as well as highly varied. He made contributions in virtually all of Stechow's thirteen categories of landscape, omitting only Italianate views. Born in Haarlem to an artistic family, Jacob was the son of Isack van Ruysdael, a frame maker, dealer, and occasional painter, and the nephew of the distinguished landscapist Salomon van Ruysdael. He could scarcely have chosen a more auspicious time to be coming of age as a landscapist in Haarlem. In his recent survey of Dutch painting, Haak observed, "in the years 1645–55, as in 1612–13, Haarlem became a mecca for a group of first-rate landscape painters."[218] In addition to Salomon, there were the older painters de Molijn and Vroom; Everdingen was back from Scandinavia and, like Claes Berchem, was just embarking on his career.

In the midst of this extraordinary concentration of talent, Ruisdael quickly asserted himself. His first dated works of 1646,

which total thirteen, were executed when he was a youth of only seventeen or eighteen but attest to astonishing precociousness. There is nothing tentative or halting about Ruisdael's first efforts. The painting in Hamburg (fig. 63) of dunes with a cottage, tumbledown outhouse, low oak tree, flowering elder, and a pollard willow by a stream is confidently composed and recorded with loving botanical detail. As the willow's idiosyncratic form, exposed trunk, and tufted spray of dead branches attest, Ruisdael was already a great observer of trees. By the next year he had addressed the flat landscape (see *Panoramic View of Naarden*, dated 1647, Thyssen Bornemisza Collection, Lugano, no. 246) and in 1649 painted a far grander panoramic view of the *Banks of a River* (fig. 64). Particularly effective here is the lighted sandy track that unifies the middle distance beyond the glassy stretch of water. As Slive has observed, the treatment of the trees, both on the left and in the distance, the still water, as well as the landscape's poetic mood – all recall Cornelis Vroom's art (cf. cat. 114 and 115).[219] Vroom no doubt was a decisive influence on Ruisdael in the period 1648–49. However, in paintings on a smaller scale dating from this early period and a few years later, Ruisdael displayed his own distinctive invention in enlarging details of nature into the central motifs of his pictures, were it only a bushy tree (see *Le Buisson*, c.1647/48, Louvre, Paris, inv. 1819) or the crest of a dune (cat. 80).

Probably in 1650 but no later than 1651, Ruisdael embarked on his *Wanderjahr*, traveling the 175 kilometers to Bentheim, a small German town in Westphalia. In all

Fig. 63. Jacob van Ruisdael, *Cottage in the Dunes*, signed and dated 1646, panel, 71 x 101 cm., Kunsthalle, Hamburg, inv. 159.

Fig. 64. Jacob van Ruisdael, *Banks of a River*, signed and dated 1649, canvas, 134 x 193 cm., Torrie Collection, University of Edinburgh, on loan to National Gallery of Scotland, Edinburgh, no. 75.

likelihood he made his journey in the company of Berchem, who made a drawing of Bentheim Castle, dated 1650 (Städelsches Kunstinstitut, Frankfurt). At least a dozen landscapes by Ruisdael include views of Bentheim Castle, the earliest of which is dated 1651 (private collection),[220] and the justifiably most famous – the painting in the Beit Collection (see p. 99, fig. 23) – 1653. Most of these works, and particularly the dated paintings of 1651 and 1653, tend to exaggerate the site and prominence of the castle, which, in fact, is a more squat structure resting on a low hill. In a characteristic move, Ruisdael has monumentalized the scene, investing nature and man's works with an imagined grandeur, no less plausibly "true to life" for its reformation. This emphasis on structure and monumentality coupled with a recognizable view of nature are the features that distinguish Ruisdael's works as the preeminent classical Dutch landscapes. He sought heroic effects without sacrificing the individuality of each oak, coppice, and clod of earth.

Ruisdael and Berchem undoubtedly journeyed on to Steinfurt, the birthplace of Berchem's father, the still life painter Pieter Claesz (c.1597–1660). The "Buddenturm" of Steinfurt Castle appears in several of Ruisdael's works, including the *Hilly Landscape with Large Oak* (cat. 82), of the early 1650s. Anticipating Sandrart's remark about trees being the "muscles" of the landscape, a giant oak tree writhes in the center of the picture, its twisted trunk and flutter of lush foliage the embodiment of natural vitality and organic growth. Other giant, gesticulating trees appear in Ruisdael's paintings as

well as an etching of this period, all hinting at their ancestry in Savery's undulating forests. While there are few dated works by Ruisdael after 1653, his later trees, such as those in the great *Forest Pool* (cat. 87), have a more majestic calm and stillness. Similarly, yellow grainfields, like the one at the right in the Braunschweig picture, reappeared in more tranquil compositions of the 1660s (cat. 83). No less evocative of rural prosperity than Cuyp's cows, Ruisdael's grainfields are traditional emblems of the summer's abundance.

Yet another landscape theme that Ruisdael first encountered in Westphalia was undershot watermills, a subject that his student, Meindert Hobbema, developed and made his own. Ruisdael's painting now in the Getty Museum (cat. 81) well illustrates the young master's technique – pastose yet vigorously assured, accenting the vegetation in the foreground and the thatched mill beyond with sparkling highlights. The roiling water of Ruisdael's watermills presaged his crashing waterfalls (see for example, cat. 85). The latter, as many authors have observed, have much in common with Everdingen's waterfalls, which were inspired by the latter's trip to Scandinavia, a region apparently never visited by Ruisdael. Ruisdael may have been inspired by Everdingen's examples as early as their years in Haarlem together (1645–52) but probably responded more directly after around 1656/57, when both painters resided in Amsterdam. Ruisdael's earliest dated Northern landscape is of 1659 (formerly the Hermitage, Leningrad).

After moving to Amsterdam, Ruisdael's designs opened up, eliminating the compositional crutch of prominent motifs in the immediate foreground and seeking new spaciousness and power. To the scenes of heroically massed woods developed in the mid-1650s, he added a complex of clearings, screens, and open vistas, which scarcely undermine the forest's monumentality but add tectonic and visual interest. The *Marsh in the Woods* of around 1665 (cat. 87, fig. 1) and the later but related *Forest Pool* (cat. 87) are the fruition of these trends, richly evoking the dark interior life of the forest but intimating much more about the natural cycle of all life and death. Ruisdael's famous *Mill at Wijk* (cat. 88) also takes up a theme that he had treated earlier, namely, the windmill, but now gives it its definitive form, not merely within Ruisdael's oeuvre but for all time. The stately cylinder of the mill stands out powerfully against the airy sky; more than a heroic motif, it serves as an icon of preindustrial Holland, an image rich with social, political, and spiritual meanings (see commentary to cat. 88). But for sheer density of symbolic program, Dutch landscape never surpassed Ruisdael's famous *Jewish Cemetery* (cat. 86), with its multiple and richly layered allusions to the transience of life and all things of this earth. In this exceptional picture, the painter offered an accurate account of tombs at the cemetery at Ouderkerk, but their immediate conjunction not only with the distant ruins of Egmond Abbey but also with a blasted tree, threatening sky, rainbow, and running brook, creates a context that announces, indeed advertises, their allegorical intent. This context has

repeatedly been characterized as "romantic," but such a latter-day notion would have been as anachronistic for Ruisdael as, for example, for a seventeenth-century Dutch painter of *vanitas* still lifes. The triumph of Ruisdael's picture is not a projection of a melancholic mood but the intellectual rigor and coherence, in both style and iconography, with which he encoded symbols.

In the same years that Ruisdael was producing these dramatically ambitious canvases, he also made innovative contributions to several other traditional categories of landscape: the panorama, beach scenes, and winter scenes. Following logically on the recent panoramas with tall skies by van Goyen, Rembrandt, and Koninck, Ruisdael converted the traditional horizontal panorama to an upright format in a series of images with the profile of his native Haarlem (see fig. 65) or the city of Alkmaar (see cat. 89) on the horizon. In Ruisdael's *haerlempjes* the pattern of the broad plain is mirrored in the cloud-filled sky, enhancing the sense of recession and majesty. Indeed Ruisdael's images of Haarlem seen from the dunes seem the ultimate fulfillment not only of the panorama but also of van Mander's early odes to that city; having traveled far and wide in his youth, van Mander concluded "but such a beautiful city, so beautifully situated as Haarlem in Holland, I have never found."[221]

Ruisdael's beach scenes all apparently date from the 1660s and 1670s and follow in a tradition that began with a pronounced narrative interest (the scenes of beached whales by Goltzius et al. and the embar-

Fig. 65. Jacob van Ruisdael, *View of Haarlem with Bleaching Fields*, signed, canvas, 62.2 x 55.2 cm., Ruzicka Stiftung, Kunsthaus, Zurich, inv. R 32.

kations of notable people by painters like Adam Willaerts) and turned gradually toward the subject of the beach itself in the works of van Goyen (see cat. 38) and Simon de Vlieger. One of Ruisdael's first beach scenes (Ruzicka Stiftung, Kunsthaus, Zurich) simply depicts the top of grassy dunes with the beach and ocean stretching away below and tiny boats racing for shore as a menacing storm blows up. This work shares the subdued but luminous gray tonality of many of Ruisdael's winter scenes (see cat. 84), none of which are dated but were probably begun by 1658 and continued through the 1660s. Ruisdael's winter scenes

invariably represent an overcast, forlorn day, the very opposite of Avercamp's festive gaiety. In his later beach scenes of c.1670 and thereafter he adopted much broader, open designs while retaining cool harmonies of gray, pale blue, and pink (see, for example, National Gallery, London, no. 1390). Whereas Ruisdael's later forest scenes sometimes suffer from a static vacancy, this peculiar emptiness ironically was well suited to the beachscape.

This is perhaps the moment to mention the contributions to these subjects by Jan van de Cappelle, whose innovations in both beach scenes (see Mauritshuis, The Hague, no. 820) and snow scenes were less significant in theme and design than in atmospherics. Van de Cappelle brought to his works an unprecedented sensitivity to aerial perspective, saturating his scenes with moist air. The effect is of a reduction in the draftsman-like character and a commensurate increase in the painterly qualities of his art. Van de Cappelle's vaporous winter scenes (cat. 18), mostly dating from about 1652–53, thus preceded Ruisdael's paintings but scarcely anticipated the latter's hauntingly somber essays on the subject.

Of Ruisdael's various direct followers, including Jan van Kessel (see cat. 47, fig. 3), Adriaen Verboom (c.1628–c.1670), Cornelis Decker (1623–1678), and Meindert Hobbema, only the last supports comparison with the master. In 1660 Jacob van Ruisdael testified that Hobbema had studied with him in Amsterdam for several years. Hobbema's early works occasionally recall the more slender forms of Salomon van Ruysdael's wooded scenes and acknowledge Vroom's art

in the treatment of foliage, but by 1662 (see cat. 44) they reflect a clear reliance on Ruisdael's more substantial forests. In the following year, Hobbema had already begun to diversify his forest designs, opening sunlit clearings, and introducing screens of trees and multiple perspectives receding on different levels. Hobbema's trees tend to stand out distinctly against the lighted posterior plane of his wooded landscapes. Ruisdael also opened up his designs in the 1660s, but Hobbema's results are more dilative, airier, and generally more vivacious. Rosenberg observed that, while an impulse to concentration dominates Ruisdael's compositions, an urge to decentralization prevails in Hobbema's work.[222] If he thereby escaped any heaviness or lack of cheer, Hobbema also sacrificed something of Ruisdael's power and depth of feeling. More than an epigone, Hobbema suffers unduly from this traditional comparison with his teacher, but in truth he had little of Ruisdael's versatility, specializing almost exclusively throughout his career in wooded landscapes. Even in his river scenes and occasional city views, Hobbema always awarded trees prominence. The reappearance of the same clusters of trees, the same bushes and buildings prove that he worked from a repertoire of studies.

Although Hobbema was a specialist, he developed one theme, the water mill (see cat. 46), with great subtlety and expressiveness. Like virtually all of his other outstanding works, Hobbema's paintings of this subject were executed mostly in the years c.1662 to 1669 and usually depict the mill in a sparsely forested, flat landscape with a still pond and dirt roads. Blue skies and the mill's red-tiled

roofs offer cheerful notes in a palette dominated by deep mossy greens, chocolate browns, and lighter tans. Hobbema's later production, as noted, was sporadic and for the most part disappointing. A flabbiness saps the early turgor of his trees, and a hardness stiffens the vitality of his brushwork. But his justifiably famous *Avenue at Middelharnis* of 1689 (cat. 47) gives the lie, if only momentarily, to accusations of decline. This extraordinary canvas readdresses a time-honored design – the central perspective down a road lined with trees – in the elegant new idiom of the late baroque. It now seems hard to understand the incredulity of Hofstede de Groot and others who questioned the late date on this picture, since the painting's style is consistent with that of the period. The slender, streaming forms of the lopped alders recall the attenuated trunks of Hackaert's trees (cf. cat. 42), while their few feathery leaves might be likened to Moucheron's wispy foliage (cf. cat. 58). It is also a picture that treads a narrow path between the excessive formal discipline of the later advocates of international classicism (the stragglers in the entourage of Poussin and Dughet) and the more casual appearance of earlier Dutch naturalism. Indeed, the painting's enduring appeal surely acknowledges its resolution of timeless dichotomies: country life in the foreground contrasting with the village beyond and hinting at a still broader world with masts of ships just glimpsed over the trees; and man's orderly plantation on one side contrasting with a wilder region opposite. Indeed, the alders themselves embody these ironies, at once part of nature

but, like poplars, also one of man's traditional means of demarcating his own property.

Wouwermans, Wijnants, and Adriaen van de Velde

The most successful Dutch painter of horses, Philips Wouwermans was also a gifted landscapist. Receptive to a wide variety of influences, especially in his early years, Wouwermans was always creative in his absorption of ideas. His earliest dated painting is of 1639 (sale, London [Christie's] October 20, 1972, no. 13), and his three paintings of 1646[223] have been compared to earlier works by van Laer, the horse painter Pieter Verbeecq (1610/15–1652), and exactly contemporary paintings by Ruisdael. By 1649 Wouwermans had responded to Asselijn's new, more monumental Italianate compositions but mixed this Southern vision with atmospheric Northern motifs in *Travelers Awaiting a Ferry* (cat. 119). Paintings of the early 1650s include airy dunescapes with tall, slender trees and a low horizon (see *Dunes and Horsemen*, dated 1652, L.F. Koetser, London, 1966)[224] or broad mountain panoramas with villages (cat. 120, fig. 3), the latter offering an unlikely but functional marriage between Asselijn and the Ostades. The landscapes of these years already employ a bright, clear palette and tiny, agile figures, often clad in brilliantly colored attire. Naturally, Wouwermans sought out equestrian subjects to display his talents; these include landscapes with village diversions, such as *Riding at the Herring* (cat. 120), travelers at rest, hunt scenes (see

Fig. 66. Philips Wouwermans, *Dune Landscape*, signed and dated 1660, panel, 35 x 31 cm., Museum Boymans van-Beuningen, Rotterdam, inv. 2537.

cat. 122 and cat. 122, figs. 1 and 2), riding schools, horse fairs, bivouacking cavalry, and pitched battles on horseback. At times, Wouwermans even revived old mannerist compositions, including picturesquely silhouetted bridges (see cat. 121), retooling them in his own charmingly elegant idiom. But he could also paint an image of travelers in the dunes with extraordinary directness and simplicity. The Rotterdam dunescape (fig. 66) closely resembles and predates most of Jan Wijnants's favored upright compositions of dunes, adding a vaulted sky worthy of Ruisdael. The winter scenes of

Wouwermans (see *The Snowy Day*, The New-York Historical Society, New York,[225] or the painting in the Johnson Collection, Philadelphia, no. 615) also adopt a more naturalistic, matter-of-fact manner. In Wouwermans's mature works, however, from the decade preceding his early death in 1668, the landscape often becomes secondary to the numerous figures and incidents. The latter are increasingly centered on upper-class pastimes: horseback courtship *à la mode*, displays of equitation, and hunt scenes (stag hunts, coursing, hawking, even wild boar and wolf hunts – activities never or rarely encountered in the Netherlands). The landscapes now frequently adopt a broad oblong format and offer a spacious view in blue tints of vaguely Italian river valleys (see cat. 122). Viewing these brilliantly rendered, aristocratic fantasies, one can well understand how Wouwermans became the darling of the rococo.

Jan Wijnants was not such a versatile artist as Wouwermans, specializing mostly in dunescapes. However, his early works are views of farmhouses under high trees reminiscent of Emanuel Murant (1622–c.1700). About 1657–58 he adopted a softer manner and began painting dunes recalling the works from the late 1640s and early 1650s by Ruisdael and Wouwermans. Often a large rise of sandy soil skirted by a rutted track forms the central motif, with gnarled trees to one side and staffage figures, usually travelers, by a collaborator (see cat. 117). The later works appear on both a large and an intimate scale but invariably are more decorative (see cat. 118). Only occasionally did Wijnants depart from his loving record

Fig. 67. Jan Wijnants, *Dune Landscape*, signed and dated 1660, copper, 66 x 95 cm., Private Collection (on loan to Kunsthaus, Zurich).

Fig. 68. Adriaen van de Velde, *The Farm*, signed and dated 1666, canvas on panel, 63 x 78 cm., Staatliche Museen Preussischer Kulturbesitz, Berlin (West), inv. 922C.

of Dutch dunes, painting, for example, a finely rendered, open Italianate landscape in 1660 on copper in a manner that may have been influenced by Karel du Jardin (fig. 67; compare cat. 49, fig. 2). We detect here the collaboration of Wijnants's young pupil, Adriaen van de Velde, who undoubtedly painted the figures and who also painted similar landscapes in these and following years (cf. Rijksmuseum, inv. A 444, dated 1663). Still a more remarkable departure is Wijnants's *View of the Heerengracht, Amsterdam*, datable to around 1660–62 (Cleveland Museum of Art, no. 64.419),[226] a work that suggests Wijnants may have played an important role in the rise of the cityscape.

Adriaen van de Velde took an equal interest in Italian and native Dutch subjects. According to Houbraken, he was a pupil of Wijnants, but his earliest works of around 1655–56 attest to a greater admiration for Potter's landscapes with animals, and, as we have noted, his forest glades of 1658 recall Potter's *Departure for the Hunt* of six years earlier (fig. 62). By 1666 van de Velde had perfected his own more atmospheric and dramatically contrasted style in scenes like the so-called *Farm* (fig. 68), which feature pastures bordered by large trees. Particularly effective here is the low shaft of light that illuminates the trees and section of meadow in the middle distance. Open landscapes like *A Farm by a Stream* of 1661 (National Gallery, London, no. 2572) and *Hilly Landscape with a High Road* of 1663 (Rijksmuseum, Amsterdam, inv. A 444) seem to acknowledge, in addition to Potter, Wouwermans's earlier dunescapes and possibly du Jardin's art. Van

de Velde's mature works are distinguished by a splendid surety of tone and a pure, clear light. These qualities are well appreciated in his beach scenes, of around 1658–70, and his few winter scenes, which all date from around 1668–70. A gifted painter of figures who provided staffage for other landscapists, van de Velde often introduced tenderly observed everyday details into his landscapes, whether it be a simple fisherman's family on a picnic (cat. 103) or a couple pushing a sledge in tandem (cat. 104).

The Century's Twilight

The last quarter of the seventeenth century witnessed the passing of many of the greatest Dutch landscapists with little replenishment of their ranks. In our revisionist age, it is unfashionable to speak of an era of decline or historical swan songs, but the obituaries militate against much relativistic reappraisal of late Dutch landscape. These casualties began even before 1672, the calamitous *rampjaar* that witnessed the invasion by Louis XIV of the Netherlands; Wouwermans died in 1668, Salomon van Ruysdael in 1670, Adriaen van de Velde in 1672, Pijnacker in 1673, Everdingen in 1675, van der Neer in 1677, du Jardin in 1678, Jacob van Ruisdael in 1682, and his friend Berchem in the following year. Koninck lived until 1688 and Cuyp until 1692, but both had apparently stopped painting long before; the *Avenue at Middelharnis* of 1689 by Hobbema, who survived into the new century, dying in 1709, remained the great exception in that master's diminished and enfeebled later production.

There were, of course, a few notable talents. Jan Hackert, who was still dating pictures in 1685, painted the splendid *Lake of Zurich* in the early 1660s (cat. 41), a worthy successor to Asselijn's Italianate mountain panoramas. Hackert's beautiful views from the seventies and eighties of curving alleys with very tall trees (see cat. 42) or forest views – again on an upright format, with trees stretching to the very top of the picture plane – offer an elegant new interpretation of Both's golden wooded views. Complementing Hackert's graceful forests are his aristocratic staffage: gallant riders, fancy carriages, and stag hunts. Another talented but underrated later Italianate painter was Frederick de Moucheron, whose works are never as logically composed as those of his teacher, Asselijn, or those of Both, but with their streaming tree trunks and wispy foliage can achieve a splendidly refined, decorative beauty (see cat. 58). Less talented were the Both imitator, Willem de Heusch (1625–1692), and the Berchem follower, Hendrick Mommers (c.1623–1697).

A gifted but limited talent was Hendrick ten Oever, who dated his remarkable sunset scene, *Canal with Bathers*, in 1675 (cat. 62) and continued to date works until at least 1705. The town of Zwolle, where ten Oever apparently worked in relative isolation for much of his life, appears in the distance of his picture. Not unlike Joris van der Haagen's earlier works (see cat. 40), his paintings have a fastidious surface and make expressive use of shadows contrasting with the brilliance of his skies. But there is also a charming hint of what is now popularly known as "naive realism" in ten Oever's

style, which no doubt reflects his relatively provincial situation. We also should mention the protean Jacob Esselens (1626–1687), whose varied paintings of woods, beaches, and classical landscapes in both the native and Italianate manner are more diverse than distinguished.

The one significant new movement that appeared among both Dutch and Flemish landscapists in the last quarter of the century was the rise of the idealized classical landscape. The primary inspiration for the movement was the paintings of Gaspard Dughet (1615–1675), which in turn were inspired by Dughet's teacher and brother-in-law, Nicolas Poussin. Dughet offered a milder, less conspicuously composed, hence more naturalistic interpretation of the clear, tectonic landscape constructions of Poussin. With his more rhythmic designs, warmer colors, and greater feeling for atmosphere, Dughet greatly appealed to Northern artists working in Rome. Johannes Glauber and Frederik de Moucheron's son, Isaac (1667–1744), even made etchings after Dughet. Together with the Antwerp painters Abraham Genoels (1640–1723) and Jan Frans van Bloemen (1662–1749), the Dutch painters Glauber (see cat. 30), Albert Meyeringh (1645–1714),[227] and Jacob de Heusch (1656–1701)[228] fashioned their own variations on the idealized Dughet landscape (see figs. 69 and 70).[229] These artists won the praise of Houbraken and their contemporary Gerard de Lairesse; indeed, after returning to Amsterdam in 1684, Glauber joined Lairesse's literary circle "Nil Volentibus Arduum" (Nothing is Difficult for Those Who Are Willing) and seemed intent

Fig. 69. Albert Meyeringh, *Ideal Landscape with Mercury and Herse*, signed and dated 1689, canvas, 82 x 104 cm., Herzog Anton Ulrich-Museum, Braunschweig, inv. 397.

Fig. 70. Jacob de Heusch, *Idealized Landscape*, signed and dated 1693, panel, 82 x 120 cm., Centraal Museum, Utrecht, inv. 10580.

upon illustrating the writer's classicizing theories of decorum in paint. The art of Glauber, Meyeringh, and de Heusch later inspired the idealized wall decorations executed for patricians' homes in Amsterdam and for the Soesdijk and Het Loo palaces, as well as the works of early eighteenth-century *vedute* painters in Rome.

What is striking about these developments is that the art of the "third generation" of Dutch Italianate painters did not grow out of the work of the preceding generation – Asselijn, Both, Berchem, and Pijnacker – but took their lead from French and Italian painters. Thus, at the close of the century, there was scarcely anything identifiably Dutch about Dutch landscape paintings. Like the mannerists at the beginning of the century, later Dutch painters were once again more international than local in their artistic orientation.

"Modern Landscapes"

Lairesse drew a distinction between "antique" and "modern" landscapes. He concluded that "Nature is modern, that is, imperfect, [because] in her objects she appears the same as she was a thousand years ago; woods, fields, mountains, and water are always the same. . . . But she is Antique and perfect, when we judiciously adorn her with uncommon and magnificent buildings, tombs and other remains of antiquity; which, in conjunction with the ornaments above-mentioned [*bywerken* (accessories), including classical staffage, such as wood nymphs, river-gods, shepherds, and bacchanals] compose an antique landscape."[230] Though

an avowed admirer of Genoels, Dughet, and Glauber, Lairesse allowed that the modern landscape, as practiced by "the famous Everdingen, Pynakker, Ruysdael, Moucheron and others," was a sanctioned alternative, which did "not call for the aforesaid Embellishments, as having other sufficient Matter, *viz.* cottages, fishermen, hay wagons and hunting carriages, and such daily rural occurrences which are as proper to it as the antique; for the decorations (*stoffagie*) alone, in my opinion, make a landscape either *Antique* or *Modern*."[231]

What Lairesse could not see from his own historical vantage point was that this "modern landscape" was his countrymen's most revolutionary and lasting contribution to the art form. Moreover, the Dutch landscape's "modernity" was not simply a matter of staffage or "embellishments" but its evocation of specificity in nature, its ability to make the spectator reflect on the character of place, the *genius loci*. Indeed, the optimistic naturalism of Dutch landscape is so compelling that we tend to forget the formal discipline and intellectual effort that went into them. But this *werkelijkheidgetrouw* is born of more than mere devotion to observation and the contrivance of a plausibly "random" view of nature. It reflects a new, unprecedentedly modern notion of the countryside. While both the Middle Ages and the sixteenth century had represented the countryside as a place of agriculture, rural industry, and aristocratic leisure – the setting for the sweat of one's brow, Labors of the Months, and the backdrop of the feudal community – the seventeenth century freed the countryside of its associations with

work, celebrating instead its role as the site of occasional recreation and mental refreshment. The pictorial metaphor for this modern view of nature was a more casual, naturalistic landscape that more closely conformed to one's own experience of walking in the countryside. Hughes has recently written of the "artfully discomposed views" of Dutch landscapists.[232] In seventeenth-century Holland, the human order came to be pictorially dominated by the uncultivated and random elements of nature; in place of seasonal variations, effects of weather superimpose arbitrary patterns of sunlight and shadow on the structure of cultivation (see cat. 53 and 83). Yet the fortuitousness is always artfully calculated, the unheroic aspect selectively conceived.

Seasonal typologies continued to occasionally appear,[233] but only winter remained a discrete painting tradition as the old allegorical cycles receded. Eddy de Jongh has characterized the gradual retreat of the allegorical and emblematic aspect in landscape as a process of *verdamping* (evaporation).[234] These trends no doubt were related to the enormous popularity of landscapes among a much broader public than the elite circles of sixteenth-century collectors who enjoyed deciphering obscure emblems. This is not to deny, however, the metaphorical cast of the average burgher's mind. Religious views of landscape, for example, persisted. Nature as *solitudo rustica* was still regarded as a refuge, a stimulus to meditation, a therapeutic place where man might measure his own smallness against God's creations. And, as we have seen, landscapes also elicited a whole spectrum of other historical, socio-

economic, and political associations, be it through the appearance of ruins, a canal laden with commercial and civil traffic, a view of the site of colonial conquests, or simply the perennial glimpse of a town on the horizon.[235] These associations embody "meanings" in Dutch landscapes that are distinguished from the nineteenth century's "art for art's sake"; thus, landscape is no more *sui generis* than any other category of Dutch art.

Acknowledging these "meanings," however, does not preclude landscape's traditional function as delectation. Notwithstanding the concept's moral ambivalence for seventeenth-century *predikants* or their secular twentieth-century counterparts, landscape painting was also a record of pleasure in nature. Far from expressing any uneasiness about this enjoyment, Lairesse prefaced his discussion of the "innermost secrets of this branch of painting" with the assertion that "landscape is the most delightful subject in painting . . . it diverts and pleases the eye. What can be more satisfactory than to travel the world without going out of doors . . . without danger of incommodity from sun or frost? . . . how relieving must be the sight [of landscapes] to those of the most melancholy temper."[236]

NOTES

1. Huygens's autobiography, the manuscript of which is preserved in the Koninklijk Bibliothek, The Hague, was first published in the original Latin by J.A. Worp (Utrecht 1897). In this essay I have referred to the modern Dutch translation by A.H. Kan (Huygens, Kan 1946).

2. Fromentin 1963, p. 131. Fromentin's *Les Maîtres d'autrefois: Belgique – Hollande*, was first published in serialized form in *Revue des deux-mondes* in 1875. The French edition cited in this catalogue was published in 1876 (Fromentin 1876).

3. Stechow 1966, p. 8.

4. For a brief history of the nineteenth century's concept of Dutch art, particularly as it was applied to the defense of realism, see Peter Demetz, "Defenses of Dutch Painting and Theory of Realism," *Comparative Literature* 15 (1963), pp. 97–115.

5. Fromentin 1963, p. 130.

6. On Dutch demographics, see A.M. van der Woude, "Demografische ontwikkeling van de Noordelijke Nederlanden 1500–1800," in *Algemene Geschiedenis der Nederlanden*, vol. 5 (Haarlem, 1980), pp. 123–139; J. de Vries 1974, pp. 89–90; J. de Vries, "The Dutch Rural Economy and the Landscape: 1590–1650," in London 1986, pp. 79–80.

7. Descartes, *Oeuvres complètes*, 12 vols. (Paris 1897–1913), vol. 1, p. 203.

8. See J. de Vries 1974, p. 242.

9. On the Baltic grain trade, see J.G. van Dillen, in *Algemene Geschiedenis der Nederlanden*, vol. 4 (Haarlem, 1980); J.A. Faber, "The Decline of the Baltic Grain Trade," *Acta Historiae Neerlandica* 1 (1966), pp. 108–131; J. de Vries 1974, pp. 171, 237.

10. On land reclamation, see A.M. van der Woude, *Het Noorderkwartier*, 3 vols. (Wageningen, 1972); Jan de Vries, "Landbouw in de Noordelijke Nederlanden, 1490–1650," in *Algemene Geschiedenis der Nederlanden*, vol. 7 (Haarlem, 1980), pp. 36–37; and J. de Vries, in London 1986, pp. 80–82.

11. On the Dutch canal system, see J. de Vries, *Barges and Capitalism: Passenger Transportation in the Dutch Economy, 1632–1839* (Utrecht, 1981); and J. de Vries, in London 1986, pp. 82–83.

12. On the country house, see Amsterdam, Amsterdamsch Historisch Museum, *Het Land van Holland*, 1978, pp. 122ff.

13. Stechow 1966, p. 6.

14. Montias 1982, p. 189.

15. See Floerke 1905, pp. 36–37; see also Montias 1982, pp. 190–91.

16. Montias 1982, pp. 192–93. For the only certain works by Stael, who worked in a style reminiscent of Esaias van de Velde and Jacob Pynas, see Keyes 1984, no. Rej. 79, fig. 119.

17. Montias 1982, p. 259.

18. Angel 1642, pp. 49–50. In discussing this passage, Beatrijs Brenninkmeyer-de Rooij (in Haak 1984, p. 64) observes that there would have been an implicit qualitative judgment in this remark since in the seventeenth century the pipes were considered less musically distinguished than the lute.

19. Cited by Brenninkmeyer de Rooij (in Haak 1984, p. 506, note 23); Hoogstraeten 1678, p. 76.

20. See de Lairesse 1701, vol. 1, p. 344.

21. *The Travels of Peter Mundy in Europe and Asia, 1608–1667*, vol. 4: *Travels in Europe: 1639–1647*, ed. Richard Carnac Temple (London, 1925), p. 70.

22. *The Diary of John Evelyn*, ed. E.S. de Beer (Oxford, 1935), p. 39.

23. Montias 1982, pp. 269–70.

24. Ibid., pp. 241–43.

25. See Drossaers, Lunsingh Scheuleer 1974–76. See also Sluijter-Seiffert 1984, appendix 3, pp. 267–69.

26. See Utrecht 1965, pp. 13–14; Sluijter-Seiffert 1984, p. 31.

27. See Bredius 1915–22, vol. 1, pp. 228–38.

28. A landscape by Ruisdael was valued at fl.100 in the Amsterdam inventory of Wulfraet, 1673; works valued at fl.60 were reported in 1664 and 1671.

29. On the rarity of preparatory studies for Dutch landscapes, see Slive 1973, p. 274; Stechow 1966, p. 6; and especially Robinson 1979, pp. 3–4.

30. Bachmann 1972, pp. 7–12.

31. See Robinson 1979, pp. 3–17.

32. Russell 1975.

33. See Keyes 1984, pp. 73–74.

34. Martin 1905–1908; Delft, Stedelijk Museum "het Prinsenhof," *De Schilder en zijn wereld*, 1964–65 (also shown at Antwerp, Koninklijk Museum voor Schone Kunsten, 1965); Joyce Plesters, "The Materials and Techniques of Seventeenth-Century Dutch Painting," in London 1976a, pp. 5–7; Ernst van de Wetering "De jonge Rembrandt aan het werk," *Oud Holland* 91 (1977), pp. 27–74; Ernst van de Wetering, "Painting Materials and Working Methods," in *Rembrandt Research Project* 1982, vol. 1, pp. 11–33; Ernst van de Wetering, *Studies in the Workshop Practice of Early Rembrandt*, diss. (Amsterdam, 1986); David Bomford, "Techniques of Early Dutch Landscape Painters," in London 1986, pp. 45–56.

35. J. Bruyn, "Een onderzoek naar 17de-eeuwse schilderijformaten, voornamelijk in Noord-Nederland," *Oud Holland* 93 (1979), pp. 96–115; van de Wetering, *Early Rembrandt* pp. 12–17. Note, however, that M.L. Wurfbain's study of van Goyen's Leiden period panels, in Amsterdam 1981b, pp. 24–26, indicated that they deviated from the standard formats posited by Bruyn.

36. W. Martin, "Een 'Kunsthandel' in een Klapperwachthuis," *Oud Holland* 19 (1901), pp. 86–88. Volmarijn proposed to sell "various prepared and unprepared paints, panels, canvases, brushes and other utensils useful and necessary for the art of painting."

37. Van de Wetering, *Early Rembrandt*, pp. 25, 30.

38. Houbraken 1718–21, vol. 2, p. 135. The identity of the pigment "Haarlem blue" has been debated. Mansfield Kirby Tally, *Portrait Painting in England: Studies in the Technical Literature before 1700* (London, 1981), pp. 194–96, suggested it was a blue clay earth, while Gifford (see note 40, below) proposed smalt.

39. Translated from Hoogstraeten 1678, p. 221, by Joyce Plesters, in London 1976a, p. 6.

40. E. Melanie Gifford, "A Technical Investigation of some Dutch 17th Century Tonal Landscapes," a paper presented to the eleventh annual meeting of the American Institute for Conservation of Historic and Artistic Works, May 25–29, 1983. For another technical study of van Goyen's landscapes, see Alexandru Efremov, "Van Goyen in Colectia Muzeului de Arta al Republicii Socialiste Rominia," *Studii Muzeale* 3 (1966), pp. 106–17.

41. Report of pigment samples taken by Marigene H. Butler and Karen Ashworth, Jan. 6, 1987.

42. Stechow 1966, p. 7. Albert Blankert (1967–68, pp. 105–106) points out that Stechow's example of a figureless *Dunescape* by Jan Wijnants (dated 1667?, Staatliche Gemäldegalerie, Kassel; Stechow 1966, fig. 1), is only a fragment of a larger composition that may once have included figures.

43. Stechow 1966, p. 7; see also Beening 1963, p. 453.

44. Inventory of Jan Orlers, 1640; see Leiden, de Lakenhal, *Geschildert tot Leyden anno 1626*, 1976–77, p. 12.

45. On the popularity of travelers as staffage, see Raupp 1980, pp. 93ff.

46. Van Mander 1604, *Grondt*, chap. 8; Hoogstraeten 1678, pp. 135–41; Lairesse 1707, vol. 1, pp. 343–72.

47. Gombrich 1966, pp. 107–21 (first published in a collection of essays presented to Hans Tietze, 1950).

48. Ibid., p. 109, where it is noted that as early as 1521, Marc Antonio Michiel mentioned "molte tavolette de paesi" by "Albert (Ouwater?) of Holland" in the collection of Cardinal Grimani. On the origins of the term "landscape" (*landschap, landschaft, paesaggio*, etc.), see Rainer Gruenter, "Landschaft: Bemerkungen zur Wort- und Bedeutungsgeschichte," *Germanisch-romanische Monatschrift* 34, n.s. 3 (1953), pp. 110–20.

49. Gombrich 1966, p. 111.

50. Ibid., p. 133; see Tiraboschi, *Storia della letteratura italiana* (Florence, 1712), vol. 8, p. 1722.

51. See André Félibien, *De l'origine de la peinture* (Paris, 1660); and especially, *Conférences de l'académie de peinture et de sculpture: Pendant l'année 1667* (Paris, 1669), pp. 14–15. Later in the eighteenth century, Quatremère de Quincy (*Considération sur les arts du dessin en France* [Paris, 1791], pt. 2, pp. 30–32), codified subject matter based on the traditional philosophical hierarchy: "thinking and animate nature" (history themes, bourgeois scenes, portraits, battles, engraved figure compositions), "vegetable and changeable nature" (landscapes, marines, fires, tempests, perspectives, ruins, theater decorations, and engravings of like subjects), and "dead and inanimate nature" (still life).

52. Francesco da Hollanda, *Four Dialogues on Painting*, trans. A.F.G. Bell (London, 1928), First Dialogue, pp. 15–16.

53. Quoted in full by Gombrich 1966, p. 115: "Pictorum aliquot celebrium Germanicae inferioris effigies" (Antwerp, 1572), *De Ioanne Hollando pictore*.

54. For example, Hoogstraeten 1678, vol. 3, includes a chapter on the "Three Grades of Art," pp. 75–85, in which a subject's rank was (very!) loosely determined by the demands that it made on the painter's imagination. Ranked beneath the "poetic histories" but above still lifes at the lowest grade is a confused assemblage of secular genre and landscape themes for "cabinet paintings of every type."

55. For commentary and analysis, see van Mander, Miedema 1973, vol. 2, pp. 538–58. An English translation by Willemien de Konige and Christopher Brown of van Mander's chapter on landscape appears in London 1986, pp. 35–42.

56. Hoogstraeten 1678, p. 135.

57. Brenninkmeyer-de Rooij (in Haak 1984, p. 63) reviewed the approximately 280 inventories of artists' estates dating from the sixteenth to the eighteenth century and published by Bredius (1915–22) and discovered that van Mander was listed only twelve times, Francesco Junius four times, Hoogstraeten once, and Philips Angel not at all.

58. See Ogden, Ogden 1955, pp. 5–6 (also quoted by Simon Schama, p. 67, in this catalogue).

59. Edward Norgate, *"Miniatura"; or the Art of Limning*, ed. Martin Hardie (Oxford, 1919), pp. 41ff.

60. Ibid.

61. See Peter Ashton, Alice I. Davies, and Seymour Slive, "Jacob van Ruisdael's Trees," *Arnoldia* 24 (winter 1982), pp. 2–31.

62. "steek dan den houtkliever vry in een warmen dos, maer laet het Bosch bladerloos en met rijp en sneeuw beladen zijn, en de bevrore beek, schoon de zwaen in de bijt zwemme, den huisman tot een brug strekken: Laet de locht dyzich zijn, en alle schoorsteenen rooken, den steeling vry de neus druipen, en zijn hair en baert vol yskegels hangen, wanneer hy de snippige noordewindt te gemoet treet." Hoogstraeten 1678, p. 124.

63. Marek Rostworowski, "L'atlas des nuages en peinture hollandaise," *Ars auro prior: Studia Ioanni Bialostocki sexagenario dictata* (Warsaw, 1981), pp. 459–63, has recently argued that Dutch landscapes comprise a virtual atlas of the sky, while John Walsh ("Clouds: Function and Form," lecture delivered at the meeting of the College Art Association, Boston, Feb. 1987) has rightly stressed the creative invention of Dutch cloud formations.

64. "Men moet ook zijn vliet aenleggen in den geestigen zwier der wolken wel waer te nemen, en hoe haere drift en gedaente in een zekere evenredenheyt bestaet; want het ooge des konstenaers moet de dingen ook zelfs uit haerse oorzaken kennen, en van de zotte waen des gemeenen volx vry zijn." Hoogstraeten 1678, p. 140.

65. Knab 1960, p. 67; Blankert (in Utrecht 1965, pp. 143–44); and Philip Conisbee, "Pre-Romantic Plein-Air Painting," *Art History* 2 (Dec. 1974), pp. 413–428, all concluded that the practice of painting out of doors was known in seventeenth-century Italy and probably practiced by the "Bentvueghels." Sandrart (Sandrart, Peltzer 1925, p. 184) claimed that he and Poussin, Claude, and Pieter van Laer painted landscapes from life, and there exists an etching by Claude of the Roman Forum with painters with a canvas. See also Jan Asselijn's drawing in Berlin (see cat. 15, fig. 2) of artists working out doors, with one using a large easel. But, with the exception of the drawing by Jan Lievens, there is no proof that it was a Northern practice.

66. Houbraken 1718–21, vol. 2, p. 125, vol. 3, p. 90.

67. Lugt 1915.

68. "Neun, die gare landschap teikent, geeft sig naer het open velt: / Strak siet hy de Son verbleiken, en de soete lugt ontstellt: / Strak siet hy de wolken klimmen (voorspook van een sware buy): / Met soo voelt hy drop op dropje: (dreiging van een regen-ruy) . . . Dus soo raekt hy tuis, bedropen, well-deur-weekt, begaed, en nat; / Dat hy

lykt een lobbes, sonder staert, of een verdronke kat: / Dese reis onthout hy beter, dan de stand, van land, en beemt, / En, op dat se iets te sta koom; hy pinceel en verruw neemt, / En hy maelt zyn wedervaren, hoe hem wind en regen slaet, / Hoe hy kan syn kootjes reppen, even als 't hier voor U staet". Quoted by Beening 1963, p. 233; see also Fuchs 1973, p. 288.

69. Hoogstraeten 1678, p. 238.

70. Freedberg 1980, p. 10.

71. Ibid., pp. 15–16.

72. Van Mander 1604, fol. 284.

73. See Freedberg 1980, p. 16.

74. See Battisti 1962; and Eskridge 1979, p. 17.

75. P. Vergilius Maro, *Bucolica en Georgica, dat is Ossen-stal en Landt-werck, Nu eerst in rijm-dicht vertaelt, door K.V. Mander* (Haarlem, 1597). Joost van den Vondel also translated the *Georgics*.

76. See Haak 1984, p. 138.

77. Quoted and translated by Freedberg 1980, p. 12.

78. See van Veen 1960; and the review by H. van de Waal, in *Tijdschrift voor Nederlandse taal en Letterkunde* 80 (1964), pp. 213–17. The *hofdicht*'s relationship to Dutch art has recently been discussed by Freedberg 1980, p. 19; Vergara 1982, pp. 167–70; Kettering 1983, pp. 26–27, 73–75; and Walsh 1985, chap. 7, pp. 278ff.

79. See Petrus Hondius, *Dapes inemptae, of de Moufe-schans dat is de soeticheydt des buytenlevens, verghselschapt met de boucken* (Leiden, 1621); Joachim Oudaen, *Hof-zang over de Hofs-tede aan't Spare, aan myn Heer Geeraard Bas* (1650); Constantijn Huygens, *Vitalium: Hofwyck: Hofstede van den Heere van Zuylichem onder Voorburgh* (The Hague, 1653); Jacob Westerbaen, *Arctoa Tempe: Ockenburgh* (1653), in *Gedichten*, vol. 1 (The Hague, 1672); and Jacob Cats, *Ouderdom, buyten leven en hof-gedacht, op Sorghvliet* (1656).

80. See van Veen 1960, pp. 14, 33. Snouckaert, the owner of the estate in Philibert van Borsselen's *Den Binckhorst* (1611), spends winter days reading the Bible and books in Latin, while Jacob Cats, in his *Ouderdom*, versifies on the contents of the country-house library, likening a bookshelf in a country home to a pearl in a golden ring (Geen peerel voeght so wel oock in een gouden ringh).

81. Van Veen 1985, p. 30.

82. "'s avonts o wat een vreucht de coele lucht te scheppen / End ut het bange huys na 't open veld te reppen / sijn haestigen voetstap, om den geschickten loop. / Des Hemels aen te sien end met der Sterren loop / Ut 's Aerdrijckts ydel sorch verdwaelt om hooch te / stijgen sijn innerlycken geest." P. van Borsselen, *Den Binckhorst; ofte het lof des*

gelucsalighen ende gerustmoedighen land-levens [Binckhorst; or, In Praise of Felicitous and Tranquil Country Life] (Amsterdam, 1613). See van Veen 1985, pp. 14–16.

83. Van Veen 1985, p. 19. The subtitle of Hondius's *hofdicht*, whence van Veen titled his own study, is translated "The Sweetness of Country Life, Accompanied by Books."

84. Van Veen 1985, p. 34. In his "Shepherd" poems of 1618, the arch moralist Cats found lessons to be learned throughout nature: "When I walk through the woods / And see the young and growing trees, / And I find one a poplar, / One a tall oak; one a low elder, / A linden, an elm, a beech, an ash, / At once I am taught a lesson: / For while I stand alone and try / To feed my spirit through my eye, / Just so I always find / Something useful for my mind." Translated by Haak 1984, p. 138.

85. Wiegand 1971; Fuchs 1973, pp. 281–91; Raupp 1980, pp. 85–110; Walford 1981. See also Josua Bruyn's essay in this catalogue, "Toward a Scriptural Reading of Seventeenth-Century Dutch Landscape Paintings."

86. Quoted and translated by Keith P.F. Moxey, *Pieter Aertsen, Joachim Beuckelaer, and the Rise of Secular Painting in the Context of the Reformation* (Diss., University of Chicago, 1974; New York, 1977), p. 166. "En la première sont contenues les histoires, et en la seconde, les arbres, montaignes, rivières, et personnages qu'on peint sans aucune signification. La première espèce emporte enseignement, la seconde n'est que pour donner plaisir."

87. Hughes 1984, p. 579, has discussed this problem in relation to Dutch landscape prints, where the "technical brilliance . . . , together with the relative semantic emptiness of their landscape subjects has led to the view that, 'to put it modishly, the medium is the message'. . . . Meaning, though, does not disappear so easily."

88. Though also occasionally overreading the imagery, the study of de Klijn (1982) is more successful than Wiegand (1971) in evoking the broader cultural context that enriched the meanings of Dutch landscape. See also Simon Schama's essay in this catalogue.

89. Stechow 1966, p. 11.

90. Friedlander 1950, p. 143.

91. Stechow 1966, p. 11. For discussion, see Ella Snoep-Reitsma 1967–68, who, as van Gelder (1933), Beening (1963), van Veen (1960, 1985), and Reznicek (1961) before her, stressed the importance of Dutch seventeenth-century literature in evoking what she has called the "mentality" of Dutch landscapes.

92. See H.J. Raupp, "Musik im Atelier: Darstellungen musizierender Künstler in der niederländischen Malerei des 17. Jahrhunderts," *Oud Holland* 92 (1978), pp. 106–29.

93. Lecture presented by Christine Armstrong at the Frick Collection, New York, 1976. See London 1976, p. 93.

94. Erwin Panofsky, *Hercules am Scheidewege und andere antike Bildstoffe in der neueren Kunst* (Leipzig and Berlin, 1930), pp. 47ff.; see also Panofsky, *Studies in Iconology: Humanistic Themes in the Art of the Renaissance* (New York, 1972), pp. 64, 150.

95. "Daerme kiesen mach voor beste uyt twee ofte meer dinghen, daer valt terstondt bekommeringh in 't oordeel, soo dat men altemet bedroghen is door valsche voorbeeldinghe en ghebreck van kennisse, kiesende het quaedste voor 't beste: soo sietmen dat die te keurboom gaen mach, diewils tot vuyboom komt" ("When one must make a choice of the best of two or more things, there soon arises anxiety, which often causes one to be confused by false appearances and lack of knowledge, choosing the worst for the best. This is why he who could have had the choice tree often ends up with the rotted one"). Roemer Visscher, *Sinnepoppen* (Amsterdam, 1614), p. 11.

96. Mario Praz, *Studies in Seventeenth Century Imagery* (Rome, 1964), p. 54.

97. *Den Grondt*, chap. 8, verse 41: "Het is wel goed als je van te voren het geschiedenisje kent [dat je er in aan gaat brengen] – volgens de Schrift of uit de 'poëten,' al naar het je belieft – om je landschap daar beter naar te [kunnen] schikken."

98. See Bialostocki 1961, pp. 128–41; J. Bialostocki, *Stil und Ikonographie* (Dresden, 1966), pp. 9–35; Fuchs 1973, p. 286; Thomas da Costa Kaufmann, in The Art Museum, Princeton, *Drawings from the Holy Roman Empire (1540–1680)* (1982), pp. 22–25.

99. See Gombrich 1966, p. 119 (Vitruvius, book 7, chap. 5).

100. Gombrich 1966, p. 120. G.P. Lomazzo, *Trattato dell' arte della pittura, scultura ed architettura* (1585), book 6, chap. 62. However, Falkenburg (1985, p. 164, note 38) debates this conclusion since the three types of landscape are discussed only as accessories to Lomazzo's seven *modi* of painting generally.

101. See Nicolas Poussin, *Lettres et propos sur l'art*, ed. Anthony Blunt (Paris, 1964), pp. 121–24; Anthony Blunt, "The Heroic and the Ideal of Nicolas Poussin," *Journal of the Warburg and Courtauld Institutes* 7 (1944), pp. 154–55; Bialostocki 1961, p. 130; Fuchs 1973, p. 286.

102. See Spickernagel 1979, pp. 133–48.

103. Spickernagel (1979, p. 142, fig. 11) also draws attention to the heads of satyrs that appear on the triumphal arch on the title page of Jan van de Velde's landscape print series *Amenissimae aliquot regiunculae*.

104. See van Mander (1604) on Bruegel and Bloemaert, respectively, fols. 233a-234 and 297a-298.

105. Max J. Friedländer, *Early Netherlandish Painting*, vol. 6b: *Hans Memlinc and Gerard David* (New York, 1971), no. 160.

106. On Patinir see Max J. Friedländer, *Early Netherlandish Painting*, vol. 9; L. von Baldass, "Die niederländische Landschaftsmalerei von Patinir bis Brueghel," *Jahrbuch der kunsthistorischen Sammlungen in Wien* 34 (1918), pp. 113–22; Koch 1968; Franz 1969, pp. 29–50; D. Zinke, *Patinirs "Weltlandschaft": Studien und Materilien zur Landschaftsmalerei im 16. Jahrhundert* (diss., Frankfurt, 1977); and Falkenburg 1985.

107. On Herri met de Bles, Cornelis Massys, and Lucas Gassel, see Franz 1969, pp. 78–98, 108–14.

108. Van Mander 1604, fol. 219a.

109. J.A. Emmens, "Eins aber ist nötig: Zu Inhalt und Bedeutung von Markt- und Küchenstücken des 16. Jahrhunderts," *Album Amicorum J.G. van Gelder* (The Hague, 1973), pp. 93–101. Discussing the kitchen and market scenes of Pieter Aertsen and Joachim Bueckelaer, Emmens showed that the large still-life and genre elements in the foregrounds symbolically embodied and reiterated the moral truths expressed in the smaller religious subjects in the backgrounds.

110. Falkenburg 1985, pp. 14–81.

111. Ibid., pp. 82–129.

112. Walters Gibson, "Patiner and St. Jerome: The Origins and Significance of a Landscape Type," lecture delivered at the meeting of the College Art Association, Boston, Feb. 1987.

113. See, for example, A.P. de Mirimonde, "Le symbolisme du rocher et de la source chez Joos van Cleve, Dirk Bouts, Memling, Patinir, C. van den Broeck (?), Sustris et Paul Bril," *Jaarboek van het Koninklijk Museum voor Schone Kunsten* (Antwerp), 1974, pp. 73–100.

114. Van Mander 1604, fol. 233 (trans. C. Van de Wael), p. 153.

115. On Hieronymous Cock, see Franz 1969, pp. 145–54.

116. See E. Haverkamp Begermann, "Joos van Liere," in *Pieter Bruegel und seine Welt* (Berlin, 1978), pp. 17–28.

117. See Novotny 1948; E. van der Vossen, "De 'Maandenreeks' van Pieter Bruegel den Ouden," *Oud-Holland* 66 (1951); Fritz Grossmann, *Bruegel: Die Gemälde* (Cologne, 1955), pp. 197ff.; Franz 1969, pp. 173–177.

118. See John Harthan, *The Book of Hours* (New York, 1977).

119. On the Labors of the Months, see James Fowler, "On Mediaeval Representations of the Months and Seasons," *Archaeologia* 44 (1873), pp. 137–224; Julien le Sénécal, "Les Occupations des mois dans l'iconographie du moyen âge," *Bulletin de la Société des Antiquaires de Normandie* 35 (1921–23),

pp. 1–218; Raimond van Marle, *Iconographie de l'art profane au Moyen-Age et à la Renaissance* (The Hague, 1932), vol. 2, pp. 314–40; J. Willard, "The Occupations of the Months in Mediaeval Calendars," *Bodleian Quarterly Record* 7 (1932), pp. 33–39; John Carson Webster, *The Labors of the Months in Antique and Medieval Art* (Princeton, 1938); Otto Pächt, "Early Italian Nature Studies and the Early Calendar Landscape," *Journal of the Warburg and Courtauld Institutes* 13 (1950), pp. 13–47.

120. Archduke Ernst made a gift of a series of six paintings by Bruegel of the Months to the stadtholder of the Netherlands in 1594, and the inventory compiled between 1665 and 1692 of the court at Brussels included six paintings by Bruegel representing the Months.

121. See Franz 1969, pp. 244–46.

122. See, for example, the print series of 1563 with male personifications in landscapes by Philip Galle after Maerten van Heemskerck (Hollstein, nos. 353–56) and by Jacob Matham after Goltzius (Hollstein, nos. 300–303).

123. For a discussion of their interrelationships, see Ilja M. Veldman, "Seasons, Planets and Temperaments in the Work of Maerten van Heemskerck: Cosmo-astrological Allegory in Sixteenth-century Netherlandish Prints," *Simiolus* 11 (1980), pp. 149–76.

124. See, for example, Jan van de Velde's series of Elements, Franken, van der Kellen 1883, nos. 138–41.

125. On Hans Bol see Franz 1969, pp. 182–97.

126. On Lucas van Valckenborch see Franz 1969, pp. 198–208; see also Allan Ellenius, "The Concept of Nature in a Painting by Lucas van Valckenborch," in Nationalmuseum, Stockholm, *Netherlandish Mannerism* (1985), pp. 109–16, which relates the rise of the woodland landscape to contemporary literature and social attitudes.

127. Van Mander 1604, fol. 260 (trans. C. van de Wael), p. 270.

128. See also *Cavalry in Winter*, dated 1599, Bury St. Edmonds, ill. in George Kauffman, ed., *Die Kunst der 16. Jahrhunderts* (Berlin, 1970), fig. 87. On van Mander as a landscapist, see Franz 1969, pp. 288–91.

129. See Briels 1976.

130. See Plietzsch 1910; Franz 1969, pp. 270–88.

131. Goossens 1977, pls. 26 and 28.

132. Van Mander 1604, fol. 268.

133. See the works by and after Coninxloo, ill. in Franz 1969, vol. 2, figs. 413–37. On the love-garden associations of Vinckboons's *Forest Scene* in the Akademie, Vienna, see Philadelphia/Berlin/London 1984, no. 121. Anticipating Coninxloo's wooded views are Adriaen Collaert's prints

after Marten de Vos entitled *Solitudo*, depicting saints in retreat.

134. Panofsky, *Hercules am Scheidewege*.

135. See, for discussion, Kahren Jones Hellerstedt, in Frick Art Museum, Pittsburgh, *Gardens of Earthly Delight: Sixteenth and Seventeenth Century Netherlandish Gardens* (1986), pp. 42–43.

136. See Raupp 1980, p. 95. Following Wiegand (1971), Raupp (1980), and Falkenburg (1985), in discussing landscape as it relates to the "pilgrimage of life" and other spiritual themes, Catherine M. Levesque ("God, Man and Nature: Dutch Landscape, 1560–1660," abstract of a Columbia University diss., in *Center 4. Research Reports and Records of Activities* [Washington, D.C., National Gallery of Art, 1984], pp. 51–52) proposes to relate Coninxloo's forest landscapes to ideas current among the Calvinist exiles in Frankenthal. As examples she cites forest settings alluding to the "wilderness of the world" in depictions of themes from the Psalms, Prophets, and the Exile of Israel; further, the commentary to biblical illustrations depicting forests with hunters and dogs explains that it symbolizes Nebuchadnezzar and his soldiers hunting the defeated Israelites (2 Kings 25:1–8). It seems unlikely, however, that such allegorical meanings displaced the association of hunting with aristocratic leisure in a work like Coninxloo's painting in Speyer (see cat. 19).

137. See Spicer 1979, vol. 1, pp. 360–61; Sandrart, Peltzer 1925, pp. 175–76.

138. Stechow 1966, pp. 142–43; Sip 1973, pp. 69–75.

139. See Walter Liedtke, in New York 1985–86, p. 283; and Larry Silver, "Forest Primeval: Albrecht Altdorfer and the German Wilderness Landscape," *Simiolus* 13 (1983), pp. 4–43.

140. London 1986, no. 27, ill.

141. The fact that several of the landscapes with mountains, wilderness views, and ruins that Jan Brueghel painted for Cardinal Federico Borromeo around 1596–97, included hermits and saints Anthony and Fulgentius (Ambrosiana, Milan; Ertz 1979, nos. 11, 18, 21, 30, and 34) also points to landscape's compensaton for worldly pressures. Pamela M. Jones ("Federico Borromeo as a Patron of Flemish Landscapes," lecture delivered at the meeting of the College Art Association, Boston, Feb. 1987) quoted a letter written by the cardinal in 1599, "Today I have been in a garden, as if outside Rome, solitary and almost a hermit. I want do do this frequently . . . because it cheers up the spirit," in support of her belief that the more than twenty Flemish landscapes in the cardinal's collection "must have served as outlets for his spiritual needs." See also the inscriptions on prints of Anchorites with huge, gnarled trees by Abraham Bloemart.

142. Marcel Roethlisberger ("The Landscapes of Abraham Bloemaert: Types and Meanings," lecture delivered at the meeting of the College Art Association, Boston, Feb. 1987) suggested that the landscape in this painting might again allude symbolically to the two roads of virtue and vice, respectively, with the rising path on the left and the wide road to perdition opposite.

143. On Visscher see M. Simon 1958.

144. See Reznicek 1961; see also E.K.J. Reznicek, "Hendrick Goltzius and His Conception of Landscape," in London 1986, pp. 57–62. Goltzius was familiar with and probably espoused the art theory of Federigo Zuccaro (*Idea de' pittori scultori ed architetti* [1607]), whose portrait Goltzius drew. Zuccaro posited that the application of poetic imagination and the deceptive emulation of nature were the proper goals of painting.

145. Published in Rutgers van der Loeff 1911.

146. See, for example, Hieronymus Cock's series of 1551; Hollstein, nos. 22–47.

147. Ampzing 1628; Utrecht 1961.

148. See Haverkamp Begemann 1973, p. 38.

149. See Stechow 1966, pp. 19–22; Keyes 1984, p. 47.

150. See Stechow 1966, pp. 52–53; Keyes 1984, p. 66.

151. Ertz 1979, no. 94, fig. 22.

152. Keyes 1984, no. 178, fig. 150.

153. See E.K.J. Reznicek, "Realism as a Side Road or By Way in Dutch Art," in *The Renaissance and Mannerism: Studies in Western Art*, Acts of the Twentieth International Congress of the History of Art, vol. 2 (Princeton, 1963), pp. 247–53.

154. Hollstein, no. 22; Stechow 1966, fig. 162.

155. See *Ice Scene*, dated 1595, pen drawing, Ashmolean Museum, Oxford; Franz 1969, fig. 470.

156. See discussion by C. Welcker (1933, p. 88) of Hessel Gerritsz's print after Vinckboon's *Winter with a View of Castle Zuylen* (her fig. XII).

157. See Albert Blankert, "Hendrick Avercamp," in Amsterdam 1982, pp. 15–36.

158. See C. Welcker 1933, no. S4, pl. 8.

159. Quoted by Stechow 1966, p. 84: "Maer Mieuwes, en Lientjen, en Jaapje, Klaes en Kloen, / Die waren ekliedt noch op het ouwt fitsoen, / In't root, in't wit, in't groen, / In't grijs, in't grauw, in't paers, in't blaeuw, / Gelijck de Huysluy doen."

For many other literary references, as well as an account and illustrations of winter's diverse activites, see van Straaten 1977; see also J.G. van Gelder, in Amsterdam 1932; Blankert, in Amsterdam 1982, pp. 29–31; and The

Taft Museum, Cincinnati, *Skating in the Arts of Seventeenth-Century Holland*, cat. by Laurinda S. Dixon (1987).

160. Van Straaten 1977, p. 58. On Bruegel's print, see A. Montballieu, "Pieter Bruegel's Schaatenrijden bij de St. Jorispoort te Antwerpen," *Jaarboek van het Koninklijk Museum voor schone Kunsten*, 1981, pp. 17–19. See also L. Baver and G. Baver, "The Winter Landscape with Skates and Bird Trap by Pieter Bruegel the Elder," *Art Bulletin* 66 (1984), pp. 145–50.

161. See Blankert 1982, pp. 30, 89, no. 7, detail B.

162. See, for example, Salomon van Ruysdael, *Alkmaar in Winter*, 1647, panel, 53.1 x 89.3 cm. National Gallery of Ireland, Dublin, no. 2, which includes animals devouring a carcass in the foreground.

163. See H.G. Jelgersma, *Galgebergen en Galgevelden* (Zutphen, 1978).

164. Having recorded in a drawing the gruesome scene of the *Display on the Gallows of Gerret van Leedenberg's Coffin* (1619, Teyler Stichting, Haarlem; Keyes 1984, no. D 5) and etched the *Execution of Jan van Wely's Murderers* (Keyes 1984, no. E 2), van de Velde was, of course, well acquainted with public executions. The specific associations of the gallows with crime and punishment are underscored in a drawing dated 1627 by Esaias (Rijksprentenkabinet, Amsterdam; Keyes 1984, no. D 22), which, like the Göteborg painting, includes an open countryside with gallows but adds a bandit attacking travelers in the foreground.

165. See C. Welcker 1933, nos. S99, S119, S168, and 68 a, b.

166. See Keyes 1984, nos. 7 and 14, figs. 1 and 2.

167. See Keyes 1984, under no. D 61.

168. Keyes 1984, nos. 119 and 169.

169. On Bril see Mayer 1910; Baer 1930; Utrecht 1965; Faggin 1965; Bodart 1970a, pp. 212–38; Salerno 1977–80, vol. 1, pp. 12–29.

170. See Eskridge 1979, p. 9.

171. Andrews 1977.

172. Sacramento 1974, pp. 15–23, 127–147.

173. On Carel de Hooch, see Flugi van Aspermont 1899; Utrecht 1965, pp. 19, 89–92; Rüdiger Klessmann, "Betrachtungen zu einem Relief auf holländischen Gemälden," *Spiegelungen* 12 (1986), pp. 91–104.

174. Hoogstraeten 1678, p. 312.

175. Ibid. However, Haverkamp Begemann (1973, p. 49) points out that Hoogstraeten's phrase can be interpreted as "printed paintings," "painted colors," or "printed with painterly means."

176. E. Haverkamp Begemann in Rotterdam 1954.

177. See Gerson 1936, pp. 20–21; Stechow 1966, pp. 33–38.

178. Biesboer 1979, pp. 104–112; and Biesboer 1972.

179. See Beck 1972–73, vol. 2, no. 99.

180. Grosse 1925, pp. 64–78; Stechow 1966, pp. 26–28.

181. First published by Nieuwstraten 1965b, p. 83, note 3, who noted that the date could be certified only with the aid of photography.

182. See Hollstein, nos. 420–438. Ryckius's poem was translated by Kettering (1983, p. 158): "O nimium felix, et vere sorte beatus, / Cui licet immunes curis ciuilibus annos / Degere, dum tugur I tutus sub arundine viuut! / Non illi variis anfractibus intricator / Pectus, non dubio lactatur corde voluntas: / Composita sed mente, opibus contentus auitis, / Aut flauman segetem, matura aut arbore poma / Colligit, aut laetum pecus in sua pascua ducit. / Quod si uxor subeat partem officiosa laboris, / O nimum felix, et summa sorte beatus!"

183. See Kettering 1983, p. 83. Hollstein, nos. 212–215. On the title page beneath the image of a sleeping shepherd boy is a poem by H. de Roij (trans. by Kettering): "Otia delectant faciuntque labouribus aptos, / Robore quae firmant lanquida membra novo / Ast ignava Quies frangit torpedine Corpus, / Enervatque Animum, nec sinit esse probum. / Ergo mihi Socors segni torpore sepultus, / Non homo, sed vivus triste Cadaver erit" ("Leisure gives pleasure and makes us fit for work. / But worthless laziness weakens the body with sluggishness, / It dulls the mind and does not allow it to be virtuous. / So for me a lazy man buried in his slothful torpor / Is not a man but while he lives will be regarded as a sad cadaver").

184. Hollstein, no. 15, trans. by Kettering (1983, p. 86). See also the inscription on the print of the contemplative goatherd discussed under cat. 35.

185. Stechow 1938, p. 42; see Beck 1972–73, vol. 2, no. 432.

186. Stechow 1966, pp. 88–89, 184.

187. See Stechow 1966, p. 39; and Beck 1972–73, vol. 2, p. 435, nos. 968ff.

188. Stechow 1938 p. 90, no. 193, suggested that the figure in the first coach was Amalia van Solms, widow of the stadtholder Prince Frederik Hendrik, and in the second coach, the young Prince William II. However, J.G. van Gelder suggested that the youth in the second carriage might be the young Elector of Brandenburg, who visited The Hague in 1647.

189. "ick bann den heelen Haegh, / Met all sijn achter-klapp, ick bann de vuyle plaegh / Van loose pleiterij, ick bann d'onstuymigheden / Van over-heerigh volck in ongeruste Steden." Constantijn Huygens, *Hofwryck* (1653), verses 1449–1453; quoted in van Veen 1985, p. 29.

190. See Stechow 1966, p. 90.

191. See Bachmann 1982, p. 43, fig. 26, *Winter Landscape with Skaters*, dated 1643, canvas, 88 x 116 cm., formerly P. Saltmarshe collection.

192. Stechow 1966, p. 94.

193. See Bachmann 1982, fig. 1; and Seifertova-Korecka 1962, p. 57.

194. See also Bachmann 1982, figs. 2–4.

195. See Städelsches Kunstinstitut, Frankfurt, inv. 1090, dated 1642; Bachmann 1982, fig. 14.

196. Kauffmann 1923, pp. 106–10.

197. On Lievens see H. Schneider 1932; and Braunschweig 1979.

198. Kauffmann 1923, p. 110; Stechow 1966, p. 179.

199. Kauffmann 1923, p. 108.

200. Hind 1915–31, no. 266; White, Boon 1969, no. B 56.

201. See Hoogewerff 1952; Utrecht 1965.

202. See Waddingham 1960; Roethlisberger 1961; Waddingham 1964; Blankert in Utrecht 1965.

203. Blankert in Utrecht 1965, pp. 22–23.

204. Steland-Stief 1971, no. 102.

205. See *Ruins with Animals and Herdsmen*, formerly Semenov collection, St. Petersburg (Steland-Stief 1971, no. 63); a *bambocciate* street scene, formerly Gemäldegalerie, Dresden, inv. 1592; a *Port Scene with a View of SS. Giovanni e Paolo in Rome*, Staatliche Museum, Schwerin, inv. 406 (cat. 119, fig. 3); and *Haven with Towered Wall*, sale, Sticker, Cologne (Lempertz), Oct. 29, 1932, no. 523 (Steland-Stief 1971, no. 211).

206. Steland-Stief 1971, no. 178.

207. Utrecht 1965, pp. 147–49.

208. See Koninklijk Museum voor Schone Kunsten, Antwerp, inv. 637 (dated 1645); Kunsthalle, Bremen, inv. 17 (dated 1646); and Allen Memorial Art Museum, Oberlin, no. 59.125. For discussion see Gerson 1946b, p. 346.

209. Utrecht 1965, p. 154.

210. Ibid., p. 41; Houbraken 1718–21, vol. 3, p. 64.

211. Utrecht 1965, p. 41; Houbraken 1718–21, vol. 2, p. 108.

212. Fromentin 1963, p. 210.

213. Moes, van Biema 1909, p. 185.

214. Stechow 1966, p. 80.

215. J.G. van Gelder 1933, p. 27, note 4.

216. See van de Vinne, Sliggens 1979; see also Bonn 1960–61; and Dattenberg 1967.

217. Nieuwstraten 1965b.

218. Haak 1984, p. 381.

219. The Hague/Cambridge 1981–82, under no. 44.

220. Ibid., no. 12.

221. "Ick hebbe gereijst, geloopen, gevaren, / Mijn jonge jaren, meest alder wegen, / In landern in rijken, daer schoon steden waren, / . . . Maer soo lustighen stadt, noch soo wel gelegen / En vant ick als Haerlem in Hollant fijn." Rutgers van der Loeff 1911, p. 19.

222. Rosenberg 1928, p. 142.

223. See Museum der bildende Künste, Leipzig, inv. 825; National Gallery, London, no. 6263; and Assheton Bennett collection, City Art Gallery, Manchester.

224. Stechow 1966, fig. 41.

225. Ibid., fig. 193.

226. See Stechow 1965a; van Eeghen 1966.

227. On Meyeringh see Zwollo 1973, pp. 19–27.

228. On de Heusch see Zwollo 1973, pp. 57–76.

229. Pendant to *Ideal Landscape with Youths beside Water*, dated 1686, Herzog Anton Ulrich-Museum, Braunschweig, inv. 398.

230. Quoted from *The Art of Painting* (London, 1738), p. 206; Lairesse 1707, p. 349: "Want de Natuur is in haare voorwerpen nu even als zy over duizen jaaren geweest is: bosschen, velden, bergen, en water, blyven altyd het zelve. Derhalven is de Natuur *modern*, dat is te zeggen onvolmaakt; maar weder *antieks* en volmaakt, wanneer men het verstandig weet te schikken met vreemde en uitmuntende gebouwen, tombes, en diergelyke overblysfselen van de aloudheid, welke met de voornoemde stoffagie te samen een antieksch landschap uitmaaken."

231. *Art of Painting*, p. 270; Lairesse 1707, p. 349: "Belangende de stoffagie van modern of hedendaagsch landscap, gelyk door die vermaarde schilders, Everdingen, Pynakker, Ruysdaal, Moucheron, en meér diergelyke die de moderne trant volgden, is geschilderd, dezelve behoeven de genoemende stoffagie niet; maar konnen zonder aan boerenhutten, vissers, voerlug met hoog-, jacht- en endere lastwagens, aan diergelyke dagelyksche landgevallen genoegsaame rykdom van stoffe en voorvallen vinden, die daar toe zo wel als het antiek eigen zyn; want de stoffagie maakt, myn's oordeels, alleen een Landscap *antiek* of *modern*."

232. Hughes 1984, p. 579.

233. See, for example, Davies 1978.

234. De Jongh, in Brussels 1971, p. 151.

235. See Haverkamp Begemann, Chong 1985, esp. pp. 56–57, the discussion of the range of response to nature illustrated by the artist van der Vinne's travel diaries.

236. *Art of Painting*, p. 266; Lairesse 1707, p. 344: "Laet ons nu eens, eêr wy tot het binnenste geheim dezer oeffening der Konst indringen, noch eenige omstandigheden verhandelen, en zeggen zeker te zyn, dat een Landschap het vermaakelyste voorwerp in de Schilderkonst is, en in der daad met zeer vermogende hoedanigheden omtrent het gezicht voorzien, wanneer het door een lieffelke samensmelting van koleuren, en met een cierlyke schikking gepaard, de aanschouwers vermaakt en verlustigt. Wat kan een mensch meer vergenoegen, dan dat hy, zonder een voet uit zyn kamer te zetten de geheele waereld doorwandelt . . . zonder in het minste gevaarte vervallen, bevryd van de hitte der zon, of koude en alle andere ongemakken des winters, ende moeijelyke bejegeningen die onze ligchaamen treffen? Wat is vermaakelyker dan een [landschap] in welke te zien de zwaarmoedigste geesten stoffe genoeg vinden om hunne kommerlykheden te verdryven?"

Dutch Landscapes:
Culture as Foreground

Simon Schama

Three great transformations occurred in the Northern Netherlands between 1590 and 1650. A type of landscape painting, wholly new to Western art, made its first appearance; the physical geography of northern Holland was dramatically altered by the reclamation of about two hundred thousand acres from inland seas; and the United Provinces detached itself from the body of international monarchy and became, rather suddenly, a self-conscious, independent, culture.[1] The contemporaneity of these developments was not accidental. They were related in complicated and indirect ways that preclude any one of the phenomena "explaining" the other. But that there was *some* connection between the peculiarities of Dutch geography and history and the revolutionary peculiarities of its landscape painting between 1620 and 1640 is very likely.[2] Just what that connection was needs to be discerned a little more clearly through the fog of references to "atmospherics" that has settled damply on accounts of landscapes in this period.

It has become fashionable recently to gloss over the radical discontinuity represented by what has been conventionally (though, I shall argue, unhelpfully) classified as "the rise of Dutch realism."[3] The emergence of landscape in its own right in the sixteenth-century Southern Netherlands and the survival of imaginary landscapes into the seventeenth century have been emphasized as integrating Dutch painting more closely within international European styles (first mannerist, then classical) rather than divorced from them. "Italianate" painters like Jan Asselijn, Claes Berchem, Jan Both, and

Adam Pijnacker have been, in effect, repatriated from the stigma of having been in some preconceived way "un-Dutch" and, by virtue of that, relegated to the second rank. Certainly this reappraisal was overdue, and it now seems beyond dispute that those landscapists who have been stereotyped as "least Dutch" produced some of the most spectacular paintings in all of Netherlandish art. But the issue (at least for a cultural historian) is not the qualitative reshuffling of reputations according to some brownie-point index of superlatives. Nor does it turn on a fruitless attempt to adjudicate what constitutes authentically Dutch landscape. A more challenging response would be to reassert the truism that much of the landscape painting of the late 1620s and 1630s was of a type, in subject matter as well as form, that had never before been essayed by *any other European culture*. Once restated, what then needs explaining is how such a dramatic shift in sensibilities and expression came about.

Even the most cursory glance at a sample of Netherlandish landscape before, and after, this alteration ought to silence doubts about its magnitude. Pieter Bruegel the Elder's *Gloomy Day* (fig. 1), painted in 1565, is one in a series representing the months of the year, or possibly the seasons, commissioned by the Antwerp merchant Jonghelinck. Accordingly, it corresponds to the armchair Renaissance cosmology that one would expect to find favored by a humanist patrician. The city merchants of Antwerp were also investors in land, and as such they had inherited a vested interest in the calendrical order established in Books of Hours by the

Fig. 1. Pieter Bruegel the Elder, *The Gloomy Day* (February), dated 1565, panel, 118 x 163 cm., Kunsthistorisches Museum, Vienna, inv. 1837.

seigneurial nobility. In that order, the labor of man, its festive punctuation, and the behavior of the elements were all synchronized in predictable tempo, so that Bruegel's painting had to do double duty. On one level, it had the lexicographic function of assembling and representing the work and pastimes distinctive to a particular moment in the passing year (pruning, faggot gathering, and carnival hats for Shrove Tuesday). But it had also the obligation to express in its overall composition the neo-Platonic assumption that the particularities of the natural world were all precisely fitting mosaic pieces of a harmonious Creation.[4]

While Bruegel's landscape (like his "swarming paintings") may be read sequentially, traveling through the details, it is through formidable compositional techniques that the artist succeeded in representing a universe that was more than the sum of its parts. That meant gluing together landscape features that were naturalistically incompatible: the snow-covered Alpine ranges acting as a background for a domestic Flemish village, the two joined by a torrential river that belonged, in reality, to neither landscape. The foundering ships, together with a church spire puncturing the horizon in the remote distance (a favorite Bruegel device), acted as a visual reminder of February, carrying the Christian calendar from peril to redemption. This kind of landscape, then, could not, by its nature, be separated from the code of associations, allusions, and metaphors embedded in the Renaissance view of nature. Its calendar was not a mere measurement of time or a weather report but the meeting place of spiritual

messages and material cycles. The same
process by which landscape functioned, not
as an analogue but as the primary message-
carrier, is evident in Bruegel's *Fall of Icarus*
(fig. 2). There, too, one element of the
Renaissance cultural personality, the
Mediterranean world of the pagan classics, is
abruptly joined to the northern humanist
milieu of bucolic piety. Or, more accurately,
the landscape and figures of the Ovidian
narrative are reduced to a perfunctory anec-
dote while the plowman signifying Christian
hope, patience, faith, and redemption (the
vernal resurrection of the crop redeeming
the fall from grace) dominates the fore-
ground.[5]

 The obligation to report and to editorial-
ize in these kinds of landscapes imposed
certain constraints of form, but it also of-
fered special opportunities, at least to artists
of the inventiveness of Bruegel. It dictated a
high horizon and a lofty point of view, both
to contain the mass of visual information
offered and at the same time to encompass,
as it were, the alpha and the omega of the
universal topography. Much of the success
with which Bruegel enables the beholder to
see his painting, simultaneously as a col-
lection of details and as a unified whole,
comes from the bullying toughness of his
draftsmanship that commands the eye
through the corridor of bare trees toward
the river and out toward the horizon along
its course. As in the even more famous
Hunters in the Snow and the summer painting
of *Haymaking* in the Metropolitan Museum of
Art, New York (cat. 83, fig. 3), vertiginous
extremes of depth and height and abruptly
angled planes are used to push the eye

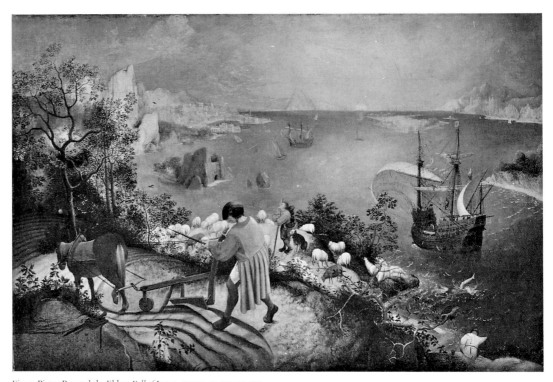

Fig. 2. Pieter Bruegel the Elder, *Fall of Icarus*, canvas, 73.5 x 112 cm.,
Musées Royaux des Beaux-Arts, Brussels, inv. 4030.

through the panorama. Bruegel and those
Dutch artists of the following century who,
like Hercules Segers, worked with the imag-
inary landscapes that had been first created
by Joachim Patinir and Herri met de Bles in
the fifteenth century used space sculp-
turally, carving great arcs of depth and
recession, and working the paint (in
Rembrandt's case) or the etching instru-
ment (in Segers's) intensively to generate
additional drama in expressively modeled
rock surfaces. They also remained faithful to
the omnipresent prospects that the Jacobean
writer Henry Peacham described as defining
such "landskips": "hills woodes, Castles,
seas, valleys, ruines, hanging rocks, Citties,
Townes &c. as farre as may bee shewed
within our Horizon."[6]

To go from Bruegel's dizzy prospects to
Salomon van Ruysdael's dunescape of 1628
(fig. 3) is to experience a drastic coming
down to earth. If the visual language of the
heirs of Patinir is hyperbole, that of the
inventors of native Dutch landscape is plain
diction. The horizon and point of view have
descended toward the surface, and if there is
a raised prospect, it is on the scale of an
authentically Netherlandish dune or hum-
mock, not a spuriously Flemish Alp.
Grandeur has been replaced by intimacy,
universality by locality, a Platonic vision of a
unified creation by an Aristotelian one of
randomly scattered things. It is a world that
has been deprogrammed. Figures and the
elements no longer march about their busi-
ness or issue in angry eruptions: they labor,
they idle, or they trudge. The cultural
fixtures of the Renaissance calendar have
virtually disappeared so that seasonality no

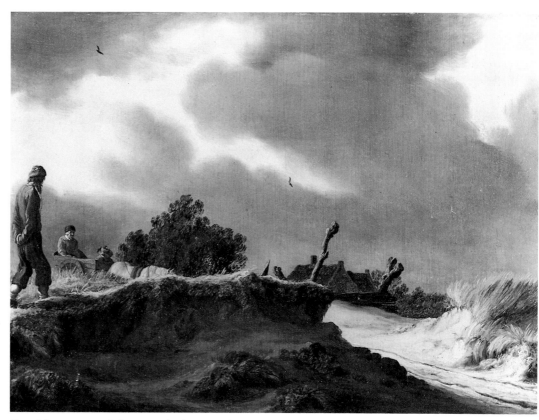

Fig. 3. Salomon van Ruysdael, *Dunescape*, dated 1628, panel,
27.3 x 38.1 cm., Norton Simon Foundation, Pasadena.

longer represents a whole cultural system of human and religious activity but merely a response to the climate.

In works of this modesty, all the formidable compositional problems of yoking the particular to the universal vanish because there is *only* the particular, expanded to make up the whole subject matter of the painting. Equally important, nothing of the least cosmic significance, no second-order set of allusions (like the redemptive plowman), no narrative interposes between the beholder and the bald observation of humble matter. If anything, these repeated images of sand, scrubby vegetation, bleak, wind-torn trees, and tattered dwellings are excessively miserable; well-being is grudgingly intimated in the cornfield that is set below road level in Pieter de Molijn's little panel of 1626 (cat. 56). By the late 1620s, the anecdotal congestion that had characterized Esaias van de Velde's ferry paintings (see cat. 106 and the many variants of that theme by van Goyen, e.g., cat. 33) had been wiped out, together with the applied local color that formed their chromatic grammar. A minimalist palette – ochres, dun browns, metallic grays, and aqueous greens – monopolized the canvas. Van Goyen's thinly laid-on free brushstrokes in fact belied considerable preparation in sketches (and led Fromentin to the conclusion that his works were often half-finished),[7] but this appearance of painterly spontaneity reinforced a tone of transparent plainness. Rough art had been invented for rough country in rough times. The "tonal" hues that came to be discussed so lyrically in the eighteenth century exactly corresponded to the prepon-

derant minerals of the subject matter. Landscape had become a world of sand, mud, and weed. It had once been mountainous; now it was amphibious.

The alteration could hardly have been more dramatic. It is, to be sure, not the whole story. Many of the very best Dutch artists continued to paint in the earlier tradition or to develop a new effulgently lit Italianate arcadia. Many of the later paintings of Esaias van de Velde, it should be recalled, were more, rather than less, fanciful and synthetic. But on the other hand, confronted with the vast output by van Goyen in the more somber manner, amounting by the end of his career to nearly twelve hundred paintings,[8] one can hardly avoid the fact that a truly new idiom had been firmly established. That he virtually manufactured many of these landscapes on formulaic lines might reasonably suggest to the connoisseur a serious dessication of the creative juices. But for the cultural historian, it suggests the servicing of a broad market and a popular taste.

How has this momentous change been accounted for? If nature abhors a vacuum, art history takes even greater exception to awkward breaks in the continuum of its "traditions" (a term sometimes used with excessive reverence). An apparently unheralded leap of representational convention seems almost in itself an affront to the axioms of "influence" that carry the baton generation to generation, master to pupil, and in so doing proclaim the sovereignty of the studio over that of the world. In the case of Dutch landscape there has been something of an intense search for "missing links"

that could repair a continuity so rudely broken by the appearance of the likes of Esaias van de Velde, de Molijn, Salomon van Ruysdael, and van Goyen. And, predictably, they have been discovered in three sources.[9] The first is the graphic work of Hendrick Goltzius, Claes Jansz Visscher, and Jan van de Velde II between 1600 and 1615. The second is the painting of Protestant southern exiles like Gillis van Coninxloo, Roelandt Savery, and David Vinckboons, all of whom emigrated north and settled in Amsterdam in the 1590s. And finally, most frequently cited, there is what might be called the Elsheimer Syndrome.

To take the last first, Adam Elsheimer's little copper panels, or more specifically the seven engravings made after them by Hendrick Goudt (see cat. 78, fig. 2), are now seen in a peculiarly instrumental way as being virtually *the* key transitional influence that moved Dutch artists away from an imaginative to a realistic manner of representation.[10] And in support of this view, Elsheimer's diagonal composition and his characteristically shrub-like tree vegetation is shown turning up in, for example, Esaias van de Velde's famous *Ferryboat* of 1622 (cat. 106). There is no question that this distinctive modeling is apparent in these works and that the famous diagonal was indeed an important compositional device freely used by the artists of the 1620s and 1630s. But to suppose that this kind of formal matching is all we need to account for the immense alteration of *virtually everything else* seems aridly mechanical. Elsheimer's vegetation, as it happens, so far from being "realistically" rendered, seems rather styl-

ized, even mannered, in its representation; and it is that mannerism, not realism, that is therefore rather jarringly transposed in, for example, de Molijn's *Dune Landscape* (cat. 56). Interestingly, in the chapter on landscape in Karel van Mander's *Den grondt der edel vry schilder-konst*, first published in 1604, artists are urged to avoid making the tops of their trees over-rounded "as though they had been trimmed short" – perhaps a comment on over-slavish imitation of the Elsheimer manner. When the Elsheimerian overgrown shrubs were replaced by the scrawnier, weather-beaten trees favored by van Goyen and Salomon in the 1630s, the treatment of subject matter became more of a piece. But even were his details to be faithful reports from nature, it is evident that for Elsheimer (as for van Eyck and Patinir and Herri met de Bles) landscape, however prominent, played the part of a scenic device in a scriptural narrative (*Tobias and the Angel* being the most famous). So that it is more properly said that Elsheimer's legacy was to those Dutch artists like Rembrandt's teacher, Pieter Lastman, who saw themselves first and foremost as history painters.

Something of the same may be said against invoking Coninxloo and Vinckboons as candidates for the role of "missing link." For most of Coninxloo's career, there is no question of his loyalty to mannerist narratives, in which landscapes appear (as they had always done) as decorative setting rather than primary motif (see cat. 19, fig. 1). But it is the late Coninxloo, following his arrival in Amsterdam in 1595, in whom some art historians see the authentic beginning of naturalistic landscape. By way of reinforcement, rather

slender evidence connects this artist with Esaias van de Velde, who may have studied with him and who is mentioned by Arnold Buchelius as having supplied the figures for one of his paintings.[11] This may be so, but to look at the "breakthrough" paintings of Esaias of 1614 – the winterscape in the Fitzwilliam Museum, Cambridge, with its bald, hard surfaces, raw blue sky, and casually gathered figure groups (cat. 107, fig. 1) – one sees nothing whatsoever to suggest a debt to Coninxloo's luxuriant moss-strangled forest interiors, except a backhanded compliment extended to the point of outright revolt. (Esaias's panel even marked a departure from the conventional markers of seasonality, for this is evidently a winterscape without snow, a February image without the least suggestion of carnival.) Coninxloo did of course leave an important legacy: to the powerful strain of Dutch landscapists who (like Jacob van Ruisdael and Allart van Everdingen) followed him into the arboreal depths and played cunningly with brilliantly speckled effects of light, vegetation, and water. But their great achievements were two generations ahead. In the meantime, Coninxloo remained less of a woodland naturalist and more of a sylvan poet, using trees and rocks with the same architectural effects as the Renaissance lyrics that worked them into a form of alternative dwelling.

Deep woodland was the primal location for the birth of free nations, according to northern Renaissance history. But the first generation of self-consciously native artists left the realm of universal myth for that of local topography. To go from Coninxloo's

bosky tunnels to the raw spaces of the dune and beach scenes of the late 1620s is to be expelled from a kind of cultural womb into a new world of indeterminately open space. It is to travel from enclosure to exposure. The comfort of the great Renaissance prospects (as in the Dutch panoramas of the 1650s by Philips Koninck) is that they are immediately all-encompassing, serving up all the imaginary eye can take in from foreground to horizon. The disturbing features of the dunescapes of the late 1620s and 1630s are their ambiguity: their indeterminacy, their lack of reassuring reference points. Defining fences are broken or pierced by rudimentary paths and tracks; figures emerge half-sunken from below ground level; others shuffle downward over the horizon. Beyond the dunes are, what: more dunes, sea, the empty, cold air? Where there are sandy roads we see neither beginnings nor destinations, only straggling groups of cottagers and fishers caught in actions that are desultory and incomplete. Conversations seem to take place, but those who conduct them do so without expression, and their substance is discursively unintelligible to the beholder. It is a plotless place.

Describing these kinds of paintings as "realistic" is, conventionally, to offer both classification and explanation in one semantic bundle. And, the assumption that we should somehow *expect* a "realistic eye" to open and a hand to follow that eye in the early seventeenth century has proved even more influential in minimizing the sense of surprise that should greet the appearance of these paintings (and the graphic art that was their immediate precedent). What is

being offered here is, in effect, an argument about history, the premises of which lie in an unexamined teleology on the nature of progress in Western culture. Modern sensibilities under the thrall of Weberian assumptions about the disenchantment of early modern culture, the rise of empirical Baconian science, and post-Galilean optics assume somehow the inevitability of a vision of nature that moves from imagination to observation, irrational to rational vision. And this may be why enthusiasts of French Realism in the nineteenth century, like the critic Théophile Thoré, recruited Dutch landscape as an honorable ancestor.[12] In other words, realism was an ethos hanging around waiting for a group of painters to catch on. And the Dutch were the first to catch on.

Why? Because they and their patrons were "bourgeois." This is the standard explanation offered by accounts like Kenneth Clark's *Landscape into Art*,[13] where seventeenth-century Holland is said to constitute the "heroic epoch of bourgeoisie" and, as such, to have generated a taste for the "*recognisable.*" This egregiously crude historical generalization is another product of the same anachronistic timetable that features in the "Realism as *Zeitgeist*" school of thought. For the claim that a nonaristocratic culture necessarily opts for the prosaic over the poetic, the plain over the embellished, simplicity over symbolism tells us more about nineteenth- and twentieth-century assumptions than those of the seventeenth. In fact, of course, there is no reason to suppose that the social identity of those who commissioned or bought Bruegel

and, before him, Patinir and, after him, Vinckboons was any different from those who would buy van Goyen and Salomon van Ruysdael. "Bourgeois taste" – for the early modern period at any rate – has become one of those terms that is so elastic as to have become virtually meaningless.

Part of the problem lies with the casual and unexamined use of the term "realism" itself to describe these paintings. Looking at Goltzius's famous drawings of the countryside around Haarlem in 1603 (see Introduction, fig. 28), where the lowered horizon and informal sketches from nature suggest a kind of suburban excursion, one need have no doubts that this is indeed a work of record where data are made beautiful. The same probably goes for the other major "documents" in the "rise of realism": in particular, the Claes Jansz Visscher series of landscape etchings published between 1605 and 1612 (Simon, nos. 127–38). But these very artists are emphatically not part of some sort of protomodern culture where the aim of art could be thought to be pure resemblance. The philosopher Nelson Goodman has brilliantly pointed out, in *Languages of Art*, the intrinsic absurdity of the notion that "a picture is realistic just to the extent that it is a successful illusion leading the viewer to suppose that it is, or has the characteristics of what it represents."[14] Even the most seductive practitioners of *trompe l'oeil*, like Cornelis Norbertus Gijsbrechts (active 1659–75), required that the beholder would quickly distinguish between painting as object and the painted subject for the wit of the piece to take effect.

It is difficult, if not impossible, to find a

seventeenth-century Dutch word adequately conveying what we usually mean by "realism." *Naer het leven*, the most commonly used term, merely signifies "a good likeness" but generally referred to individual details and figures, rather than any new overall conception of a composition as a whole aspiring to naturalistic verisimilitude. The closest equivalent might be the term used by Samuel van Hoogstraeten in his manual for artists (1678): *keurlijke natuurlijkheid*, meaning "the selective naturalism."[15] It referred to the difference between sketching from nature, which became habitual for artists like Esaias van de Velde and Jan van Goyen, and constructing the composition in the studio. Nowhere was it presumed that the exclusive goal of such a construction was to reach the closest possible likeness to an objectivised vision of the landscape. Van Mander's detailed advice in his 1604 manual on the representation of trees, animals, water, and figures (which he conspicuously ignored in his own paintings) offered a technique for the naturalistic rendering of individual elements in a work, rather than urging mechanical resemblance – visual reportage – as the painter's goal. And, in fact, many of the characteristic formal devices used by painters of that generation – the abrupt movement from a band of darkened foreground to a brightly lit middle ground that we see in Santvoort and de Molijn's dunescapes, for example, or the suppression of local color in favor of virtually monochromatic hues used in van Goyen and Salomon van Ruysdael's riverscapes – are highly artificial and expressive conventions. The word "atmospheric" is rather lazily

used to describe the aim of this radical contraction of chromatic range without appreciating that "atmosphere" had to be a concept, an ideal type, before it could possibly be an image.

What happened in the late 1620s and 1630s, then, was not so much the replacement of subjective by objective landscape, as the substitution of one kind of subjectivity by another. If they were not an imaginary landscape, nor were the riverbanks, ferryboats, dunes, and beaches simply an arbitrary inventory of topographical data. Rather, they were a highly selective and value-laden presentation of a particular kind of native habitat. It might even be possible to describe their characteristic form as poetic, although it is the poetry of the aggressive localism of Gerbrand Adriaansz Bredero, rather than the international style of the sonnets of Pieter Cornelisz Hooft. Bredero's preface to his bawdy vernacular comedy *The Spanish Brabander* specifically praised the beauties and pleasures of the Dutch language. And it was another humanist poet-scholar, H.L. Spieghel, coauthor of the first Dutch dictionary, who in his 1599 *Hertspiegel* recommended artists to turn their attention away from classical and imaginary landscapes and toward native scenery.[16]

Claes Jansz Visscher, an impeccably local type (the son of an Amsterdam ship's carpenter), in 1611 made the first series of prints recording "Pleasant Places" in the countryside and coastal villages of Holland. And given that, at the same time, Visscher was closely associated with writers like Roemer Visscher (Spieghel's coauthor on the dictionary), it is hard not to see his own

enthusiasm for local scenery as part of their self-conscious effort to promote a pride of place. As such, it was related to the contemporary coining of a new symbolic visual vocabulary that emphasized the modest virtues of the homeland. So, as a response to the traditional bestiary of dynastic heraldry, Roemer Visscher and others offered the cow as the standard symbol for *Hollands Welvaren* (Holland's Prosperity) or the fenced garden (*Hollands Tuin*) as the providentially abundant land.[17] Thus, it is the emergence of a native aesthetic, poetically expressed but normative in its associations, rather than any a-historical "discovery of realism" that marks the innovations in landscape of these years.

Most explanations of this phenomenon, when not leaning heavily on the genealogy of influence, have swung wildly from rigid formalism to naive sociology. But more surprisingly still, even the most powerful and exhaustive accounts of landscape, such as Wolfgang Stechow's *Dutch Landscape Painting of the Seventeenth Century*, have shown remarkably little curiosity about subject matter in general and the relationship of figures to landscape setting in particular. Stechow's famous book is organized according to a topographical typology: "The Beach," "The Sea," "Winter," etc. But each of these categories is discussed purely in terms of their disembodied formal qualities, as though the artists were oblivious of human subject matter. This is particularly bizarre, since it is precisely the alteration of view of what constitutes a pleasing scene – humans, animals, and all – that undergoes such a radical change at this time. And it is a

Fig. 4. Esaias van de Velde, *Three Men Conversing before a Dune*, dated 1628, chalk and wash, 198 x 308 mm., Gemeentearchief, The Hague, inv. Atlas, no. 120.

mistake to suppose that, in the new view, figures simply evaporate into the "atmospheric" landscape. (If trees become protagonists, it is at least probable that they are heroically anthropomorphized.)

Both Esaias van de Velde and the less sophisticated Arent Arentsz "Cabel" (born on the Zeedijk in Amsterdam in 1585 and very much of the Bredero generation) produced large-scale images of fishermen and farmers that dominated as well as populated their landscapes and that were, moreover, deliberately stripped of any conventionally picturesque qualities (figs 4, 5). The same goes for the uncompromisingly earthy figures in Salomon van Ruysdael's bleak dunescape (fig. 3). But even where the figures are not so obviously dominant, it would be a fallacy to equate size with significance, for it is not uncommon in Northern art for small, rudimentarily sketched shapes, glimpsed on the horizon to set tone to the whole composition – as in the famous case of the blind

Fig. 5. Arent Arentsz, *Polder Landscape with Fishermen and Farmers*, panel, 27 x 52 cm., Rijksmuseum, Amsterdam, inv. A 1448.

leading the blind in Bruegel's *Flemish Proverbs*. In this tradition the eye is meant to search such little meanings out. In the van Goyen *Farmhouses with Peasants* (cat. 34), the foreground group of figures, dressed in the impoverished rags of the cotters, are slumped on the sandy earth like their barely supported, sagging dwelling, while on the horizon a hunched figure makes his way along a path.

The axiom that such figures are mere "staffage" belies their crucial importance in giving both tone and feeling to the composition and, more urgently, overlooks the crucial fact that these *misérables* are deliberately stripped of any of the "picturesque" qualities deemed proper for landscape in the southern tradition. Indeed, "staffage" is itself a purely modern term, coined by the terminology of German *Kunstgeschichte* in the 1870s. There is no inkling from any contemporary art historical writing at all that figures should be seen as gratuitous accessories in formal arrangements of space and color. Van Mander, in fact, spends several paragraphs giving instruction about the inclusion of figures, "strolling or wandering about . . . or taking their pleasure on the water" or more modest types "seen in fields and paths and next to the houses and huts of farmers."[18] And the types he describes, along with old hovels collapsing into muddy water, are evidently not the stock figures from mannerist or narrative landscapes of the kind produced by Bloemaert but the common people of the Dutch countryside. And so far from being a gratuitous accessory to those landscapes, they were to be an intrinsic and important feature.

The same may be said for rural buildings. When van Goyen uses new and striking techniques to dramatize ramshackle huts and hovels, it does not mean that he is interested merely in the visually arresting qualities of rotting wood or wispy thatch. Cottages, country inns, ruined churches, and swinging gibbets, as well as characteristic kinds of transport – ferryboats, fishing boats, laden wagons, mounted horses, or little carts (like the one seen in the Norton Simon Ruysdael) – all bear the weight of cultural associations and values that rose from the identity of the native community at a specific time and place. To suppose these things are decorative is to invoke an aesthetic of the prettily down-at-heel, which was absolutely unknown to the seventeenth century. It follows, then, that the introduction and even fixation with images of the poor, the humble, and the modest carried with them a whole world of values and associations that, so far from being incidental to a new kind of landscape, actually supplied their organizing motifs.

These are images, then, of a peculiar type of culture, not merely so many aesthetically pleasing effects that have chosen the Netherlands countryside arbitrarily for their location. Nothing, to my mind, could be further from the truth than the comment offered in a recent monograph, that the development of "realistic landscape" was owed to Dutch artists wishing to "express the integrity and universal appeal of nature by representing their native countryside that metaphorically could embrace the universe."[19] On the contrary, these paintings were insistently parochial, and in their constant references to recognizable insignia of the patriotic community – windmills, fisherfolk, watchtowers, river bastions, church spires projecting from the horizon – created exactly the album of benign visual clichés that we now think of as "characteristically Dutch."

Why should the Dutch, who bought the many hundreds of van Goyen's paintings that recapitulated these visual themes over and again, have (presumably) been pleased by this topographical self-portrait? To understand that, it is necessary to go beyond formal aesthetics (the property of a small elite) and grasp the ways in which Dutch social geography shaped cultural self-consciousness. And if these issues seem really peripheral to comprehending the distinctiveness of the landscapes of Esaias van de Velde or van Goyen, it should always be borne in mind that these artists were not unknown daubers toiling away in modest anonymity. Van Goyen may indeed have died poor (partly as the result of foolish speculation, not least in the tulip mania of 1636–37). But his move to The Hague in

1618 and a pair of commissions for which he was paid hundreds of guilders testify to his ambitions to become the most important as well as the most prolific landscapist of his time. Esaias's relatively brief career was even more directly connected with the founding history of the republic. He was among the select list of artists (who mostly included history landscapists like Moyses van Wtenbrouck and Cornelis van Poelenburch) singled out for praise by Constantijn Huygens, the virtuoso poet, scientist, and secretary to Stadtholder Frederik Hendrik.[20] At the same time that he was producing images of an ostensibly peaceful Dutch world, he was turning out battle scenes of implacably ferocious quality that link him to the expressly war-propagandist work of Jacques de Gheyn and Willem Buytewech. Occasionally, even his landscapes themselves incorporated ostensibly jarring details of pillaging soldiers. One remarkable painting of 1619, now in the Konstmuseum, Göteborg, is built around the grim spectacle of a wayside gibbet that looms over the ostensibly innocent figure of a man lounging by a path (fig. 6). Fromentin could not have been more wrong in supposing that in what he took to be the imperviously placid nature of the countryside there was no history and "not a trouble, not an anxiety, existed."[21]

Landscape painting in the 1620s and 1630s *was* often a kind of history painting, though not in the sense in which the term is traditionally used in art history. It was without narrative structure but emphatically not without historical reference. Often it approximated to a kind of generalized

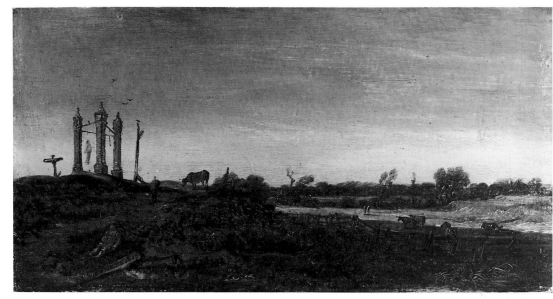

Fig. 6. Esaias van de Velde, *Panorama with Gallows*, 1619, panel, 13.5 x 27 cm., Konstmuseum, Göteborg, no. 1698.

patriotic geography. And the first element from which such a patriotic self-image was formed was, of course, the water. The Northern Netherlands was a flood culture. Its earliest chronicles and their reiteration in the Renaissance histories like the *Oude Chronycke van Holland* recorded the dates of the great inundations as other cultures recorded the visitations of war and pestilence.[22] And the later sixteenth century had seen a number of disastrous floods in the heartland of Holland at the same time that they had also endured invasion and economic hardship. The perennially grim reality of a water-logged history carried with it, however, certain important sociopolitical

consequences. It meant that feudalism in its classic European form was deprived of its principal rationale. For although peasants accepted the inferior status of serfdom in return for protection from the violence of casual pillage (that is, *our* horsemen guaranteed the peasant safety from *their* horsemen), the primary danger in the wetland estuaries of the Rhine, Maas, and Schelde was sea and storm, not the feudal host. Since cavalry, by definition, could not be aquatic, the vulnerability of peasant communities before feudal intimidation increased in exact proportion to their distance from the great river deltas. Gelderland, for example, became a more classic European landscape of castles, moats,

and arable farms. Zeeland, at the other extreme, perforce lived exclusively from coastal shipping and fishing, importing its grain from farther afield.

The peasant farmers of Holland, then, were mercifully exempt from the coercive system in which legal inferiority (vassalage) was signified through the tributary supply of goods and services to the protecting lord. In fact the village communities were the beneficiaries of incentives, rather than the victims of threats. To make their title to land anything more than an empty formality, seigneurial overlords like the Counts of Holland needed to attract prospective settlers on wetlands by waiving many of the dues and burdens that normally went with occupancy in feudal territory. So that, in the Northern Netherlands, relatively free communities grew up whose prosperity benefited their lord through indirect taxes and higher rents. Instead of a relationship where the lord profited from the violently secured lowering of status, the Netherlands witnessed one where he profited from its amelioration.

This system was benevolently self-reinforcing to a surprising degree. Relieved of having to supply lords with goods and services before raising crops and animals for themselves, these more independent farmers could specialize in the farming for which their ecology was best suited. And as specialization in turn meant a labor-extensive use of manpower, the population was free to migrate to the towns, which in turn became the farmers' market. Ease of water transportation from country to town lowered the price of those goods, making

real incomes go further and offering a variety and quantity of food rarely available in the "other Europe" dominated by seigneurs and subsistence peasants.[23] Farmers assured of customers could manage to accumulate modest surpluses that in turn could be plowed back into their holdings in technical improvements (another drainage ditch or pumping mill, another herd of cows). Division of function and labor became more marked. The Netherlands farmers left to long-distance trade the business of grain importing while they concentrated on the rural activities for which their particular milieu was best suited: pastoral cattle and stock rearing, dairy production, and intensive horticulture. All parts of the system dovetailed neatly with the others. Even the dung produced by well-fed urban populations could be taken by night-soil barges back into the rural hinterland to enrich the meadows and market gardens, raising yields that in turn fed growing populations.[24]

There were, moreover, political implications in the peculiarities of the Dutch landscape. Defense against flooding – the maintenance of dikes, ditches, and pumps – had long been devolved by the lord to the community itself. The local hydraulics administration (*heemraadschap*) was itself responsible for raising the taxes and appointing the dikereeves and laborers necessary to safeguard the villages and towns in its jurisdiction. Where the lord had the formal right to make such appointments, in reality it was reduced to a power of assent to names presented by the local councils. And when, under Emperor Charles V, an attempt was made to bring in centrally appointed out-

siders to the *hoogheemraadschappen*, it provoked a great deal of ill-feeling, especially in northern Holland.[25]

Liberty, locality, and prosperity all converged to make up a peculiar success story of the Netherlands countryside. And as a result, town and country were complementary rather than adversarial cultures. Toward the end of the sixteenth century and into the early seventeenth, urban patricians (often but not always merchants) began to take a more aggressive interest in land, buying up titles to farms and villages and releasing them to successful tenants. The most entrepreneurially minded of them like the Cromhout and Bardesius clans went even further and sunk enormous quantities of capital into great reclamation projects in the Wormer, Beemster, and Purmer inland seas in the Noorderkwartier peninsula of Amsterdam. Dirk van Os alone invested the titanic sum of a million and a half guilders in one such project and the total sums involved may have risen as high as twenty million in all. In less than twenty years rich pasture was providing a twenty percent return in increased rents and very much higher yields for those who decided to sell their appreciated land.

When one bears in mind that in the more densely populated parts of the republic, like Holland and Zeeland, no town was farther away from another than fifteen or so miles, it seems a safe conjecture that most of the buyers of early native landscapes were urban. And it also seems likely that the idiosyncrasies of that art were in conformity with the image of the countryside that most gratified that clientele. It was an image that

stressed modesty and rugged labor, punc-
tuated by periodically merited leisure. Not
the great outbursts of festive glut and drink
that had become stylized in the Flemish
boerenkermis (and that were perpetuated in
some seventeenth-century low-life painting
like that of Adriaen van Ostade); rather, the
more quotidian forms of leisure, above all
fishing, skating, and rabbit hunting. Where
"low-life" festive scenes by definition in-
creased the distance between urban be-
holder (sometimes shown in the paintings as
a spectator) and rustic participant, the
demotion of feast to pastime brought to-
gether the different social groups, all of
whom could enjoy the same sort of recre-
ation. It was difficult to assert patrician
superiority on skates.

This, then, was a rural world where
boundaries, both social and topographical,
were made deliberately indistinct. Hendrick
Avercamp's winterscapes, for example,
reflect two types of ambiguity. It is often
happily unclear whether skating scenes are
taking place in small towns or villages. But
more important is the social inclusiveness of
the paintings. Nothing could be further
removed from the iconic power structure of
court painting than an image of the princely
house – the stadtholder swallowed up by the
festivities of the Valkenburg horse fair! I
don't want to claim that this is a pictorial
democracy. The attributes of social rank are
very clearly marked in costume. But in view
of the much more clearly delineated division
of classes visible in, for example, van der
Heyden's townscapes in the 1660s, it is
striking that patricians in Avercamp's and
Esaias van de Velde's works are rarely given

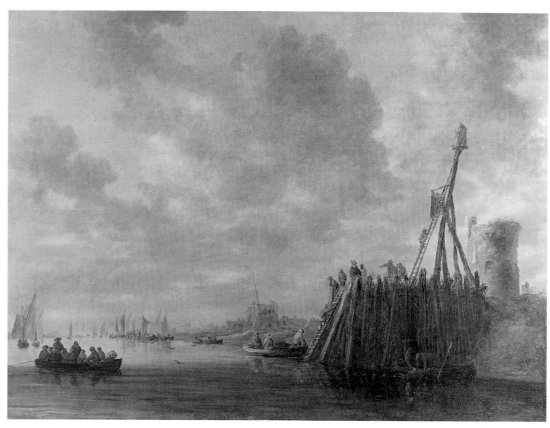

Fig. 7. Jan van Goyen, *Riverscape with Bastion*, canvas, 95.3 x 132.1 cm.,
Fogg Art Museum, Cambridge, Mass., no. 1969.54.

space and prominence that privilege them over common burghers, tradesmen, children, and dogs.

Water did not have to be frozen to imply commonalty. What Huizinga called the "hydrographic" element in Dutch culture was seen by the first generation of Dutch patriots as having acted as a powerful dissolvent of the dynastic empire. And given that water, both fresh and briny, was allotted this patriotic role in early histories, it is to be expected that in at least some paintings where wateriness dominates, there are to be found striking images of defense and protection against both human and elemental threats to the peace and safety of the community. Bastions, watchtowers, forts, tollgates were not accidental features of the scenic view. Van Goyen often showed bastions in large format, their cannon jutting from timber piles, parallel to the picture plane for maximum emphasis (see fig. 7). Nor should one be deluded into supposing that the peaceful activities proceeding before them in some way rob those more forbidding elements of their historical power. In fact, they reinforce them, since images of the community going about its business seem contingent on (not oblivious of) the duties indicated by the structures looming over fishermen and ferryboats.

It is a sense of frontier, of communal membrane, that simultaneously incorporates and excludes, that defines nations, and a historian cannot help but be struck by how many landscapes of the early period were frontier pieces: the dunes, the great fortified river estuaries being cases in point. But there was another scenic type facing the

Fig. 8. Esaias van de Velde, *Village by the Sea*, dated 1627, chalk and wash, 190 x 294 mm., Rijksprentenkabinet, Amsterdam, inv. A 4007.

Fig. 9. Salomon van Ruysdael, *Market by a Seashore*, signed and dated 1629, panel, 40.6 x 59.4 cm., The Metropolitan Museum of Art, New York, no. 60.55.4.

elemental frontier of the ocean where local values were so sentimentally bonded together that its repetition through the work of many artists and through a number of generations into the 1650s constituted a kind of idyllic myth of the homeland. And that was the fishing village.

At the same time that Esaias van de Velde was increasingly preoccupied with the tastes and demands of "high culture" in The Hague, he produced drawings of just such idealized villages by the sea: modest cottages huddled together near a church facing the sea, the perfect setting for the figure studies of fishermen he was also preparing in 1627–28 (fig. 8). I find it difficult to believe that it was entirely fortuitous that this was also a period in which, with the war with Spain renewed since 1621, the herring fleets of the North Sea coast had become the selected targets for the devastatingly successful onslaughts of the Armada of Flanders and hired privateers, operating out of Ostend, Nieuwpoort, and Dunkirk. In 1626–27 alone eighty herring boats were taken; in 1635 an even greater number and with them over nine hundred fishermen taken prisoner.[26] Whole villages had seen their boats and their livelihood destroyed; and their fortitude in the face of this adversity was represented in commentaries of this time as a kind of primitive *exemplum virtutes* — a model for pious, patriotic conduct.

I don't wish to argue that each time a fishing village was painted it was meant to bring these explicitly patriotic associations into the mind of the beholder. But rather that this difficult time had lodged in the collective mentality of the Dutch an idealized

version of villages like Scheveningen and Katwijk as embodying the kind of modest indomitability that humanists liked to believe was characteristic of the nation as a whole. And it was in the light of that self-flattering stereotype that the fishing village pictures of the 1630s were produced. A Salomon van Ruysdael from the early 1630s in the Metropolitan Museum, rather misleadingly titled *Market by the Seashore* (fig. 9), incorporates most of the standard features of the genre: references in the herring boat and nets to industry of the fisherfolk; a church in the right background endorsing their famous (and often quite aggressively Calvinist) piety; and, most important, the absence of any formal social ranking in the relation between the burghers (on horseback and on foot) and the fishwives. This corresponded exactly to a number of literary stereotypes, not in the high "pastoral poetry" of the humanist regents (for which the Italianate landscapes would be a better pictorial equivalent), but in the popular, relentlessly moralizing verses of Jacob Cats, himself a Zeelander, who became Grand Pensionary of Holland. To the qualities of fortitude and piety were added a kind of no-nonsense leveling bluntness that, paradoxically, the patricians from The Hague who periodically descended on Scheveningen for the herring (as they still do) affected to admire. In one poem, for example, Cats has a Scheveningen fishwife contrast the functional basket of fish set on her head with the useless gewgaws that ornamented the bonnets and hair of fine ladies from The Hague.[27]

The austere hues in which the fishing villages were painted were a perfect chromatic fit for the expression of these local homilies. Like the Valkenburg horse fair, the beach could even function as a kind of processional milieu where high-ups established a prominent presence yet were incorporated representationally with a teeming crowd. Van Goyen painted just such a picture (now in the Bute Collection), and it is one of the most grandiose of all his works. It is not at all accidental that the repertoire of other related genres – the "monochromatic" still-life paintings that prominently feature herring, oysters, and bread and the maritime paintings of Porcellis – uses the same tonal register.

Other villages like Katwijk, Noordwijk, and Beverwijk were all within easy reach of some of the major centers of artistic activity like Haarlem, Leiden, and The Hague. And it was on the shore, confronted with stranded whales or Simon Stevin's extraordinary wind chariot, that some of the graphic artists most responsible for taking landscape forward (Goltzius, Buytewech, and Claes Jansz Visscher, for example) found some of their most adventurous imagery. In one particular fishing village, Egmond aan Zee with its ruined abbey church choir, painters found sufficient inspiration to return over and again to rework what is, in effect, an idealized vision of the perfect Dutch community: sacred, simple, and free. Visscher himself produced a lottery card that depicted fisherfolk not as pathetic supplicants for charity but as heraldic supporters of a new lay morality: riches contingent on charity (fig. 10). Van Goyen went to Egmond aan Zee many times to convey something of the same atmosphere, painting

Fig. 10. Claes Jansz Visscher, *Lottery Card, Egmond aan Zee*, 1615, etching.

the abbey church from every possible perspective. The late version of 1653 (cat. 38) is one of the richest of these views, full of boats, fishermen, and even a fishwife with her basket of fish on her head in the standard posture described in Cats's verse. In about 1646 Jacob van Ruisdael produced the most self-consciously brilliant consummation of the theme with a supernal light playing on the water (fig. 11). It was left to the more modest and old-fashioned landscapist Adriaen van de Velde to add, in the 1660s beach painting in the Mauritshuis, The Hague (cat. 103), yet one more homiletic quality to this catalogue of model virtues: that of family affection. It is this kind of painting that most clearly bears out Fromentin's observation that Dutch art was characterized by "the transportation of domestic virtues from private life into the practice of art, serving equally well for good conduct and good painting."[28]

Ruisdael's painting of Egmond aan Zee, with its shimmering light and operatic sky, simultaneously rehearses the old themes of

the founders of native landscape and departs
radically from them. He had begun his
career manifestly affected by both the motifs
and the handling of them in the works of his
uncle Salomon and the latter's generation.
But after 1650, Ruisdael produced one heroic
variation after another on ostensibly native
subjects: bleaching grounds, windmills,
cornfields (the last actually not a common
sight in a country that imported most of its
grain). In all these great compositions, the
orchestration of light and shadow, the re-
turn to a lofty point of view, and the ex-
pressive modeling of features like pollarded
or dead trees were such that the ostensibly
local and native were, indeed, overwhelmed
by a more universal aesthetic. The same
perhaps could be said of Philips Koninck's
obsessively horizontal panoramas. In these
large-scale paintings of the 1650s, figures do
indeed shrink to incidental significance, and
although the Dutch landscape is in some
abstract, map-like sense "faithfully" ren-
dered, Koninck's paintings in effect freeze a
rural world into a predetermined spatial
frame that has the kind of cartographic-
survey quality observed by Svetlana Alpers
in her study of this genre.[29]

Meticulous cartography was, of course, a
specialty of Amsterdam's print culture, and
there is no shortage of evidence to suggest
that maps were displayed in the grander
patrician houses almost interchangeably
with paintings. As cultural items they were
at the same time reflexive and outward-
looking, embodying both a pride in place
and a curiosity to situate the Netherlands
within a wider order of things. In the 1650s,
both Koninck and Jacob van Ruisdael were

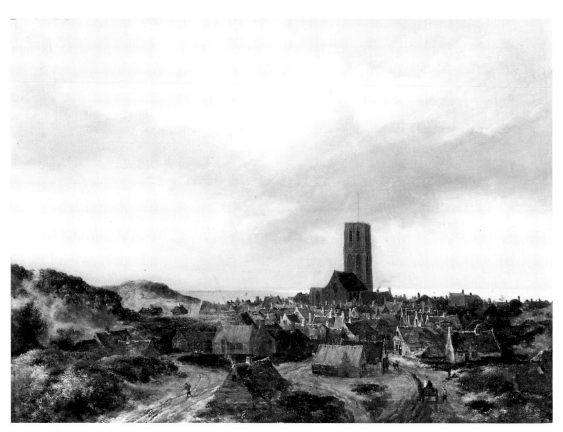

Fig. 11. Jacob van Ruisdael, *Egmond aan Zee*, c.1646, panel,
49.5 x 67.3 cm., Glasgow City Art Gallery, no. 34.

working the same Amsterdam market and, it may be argued, producing exactly the kind of art that recalled the simplicity and distinctiveness of the Dutch milieu but at the same time gave it heroic treatment and scale. And that kind of taste was witness to the end of the more defensive nativism that had characterized the earlier generation. Even by the 1640s, the theater of war had receded far from the immediate frontiers of the provinces of Holland and Zeeland to the perennially disputed territories of Brabant. In 1648 at the Peace of Münster, after eighty years of futile efforts at reconquest, Spain finally conceded Dutch independence. The pictorial equivalent of the siege mentality gradually faded and was replaced by a new expansiveness that reflected itself in the subject matter of landscape painting. Just as the cargo of commercial empire – Ming blue and white porcelain and Persian rugs – began to modify the austerity of still-life painting with sensuously rendered luxuries, an imperialist landscape began to find a clientele among a more sophisticated patriciate in cities like Amsterdam with pretentions to cosmopolitan cultivation. Frans Post's startling views of Dutch Brazil were more of a visual inventory than a document in imperial self-congratulation. But the emphasis on genteel travel and on scenic itinerary in the work of Jan Both or Jan Asselijn speaks of a new spatial freedom replacing the watery parochialism of the 1630s.

There had always been Dutch painters, some of whom had settled in Rome, who had rejected the more rugged local idiom in favor of the radiant classicism of a southern manner. But what is revealing about the 1650s and 1660s is to find in some works a peculiar and uneasy hybrid of native and exotic themes. Asselijn's painting of about 1652 (cat. 4) of the repairs to the St. Anthonis dike – a theme of the utmost local importance following a catastrophic flood – incorporates, as one might expect from this adamantly "Southern" painter, human types that more obviously belong in a Roman rather than a Dutch landscape. More significantly, painters whose background was essentially in the native style became restive about the limited repertoire of Low Country scenery, tonal coloration, and coarse human types that had made up its characteristic stock-in-trade.

This was most obviously the case for Jacob van Ruisdael. A trip to Westphalia with Claes Berchem in 1651 produced the motif that may reasonably be called pre-romantic: Bentheim Castle on its crag, seen from below (see p. 99, fig. 23).[30] And it was from that "other" Dutch world, a world of castles (some ruined, some intact), more majestically flowing rivers, and – *mirabile dictu* – hills, in the land provinces that a new kind of repertoire was created. Subsequently Ruisdael turned to landscapes of a natural drama, such as Scandinavian waterfalls and northern pines, that stressed their difference from the local; heavily symbol-laden allegories like the Jewish Cemetery, where local topography was altered in the interest of poetic drama; or ostensibly native themes (like the Mill at Wijk bij Duurstede), where the local was given a monumentalism that transformed it out of all recognition (cat. 88).

This aggrandizement of the native habitat does not mean that Ruisdael was necessarily investing his mills, his cornfields, and his bleaching fields with directly symbolic meanings. Discontent with a purely formalist reading of his art has recently brought about an attempt to apply the techniques of iconographic decoding to some of his works in an effort to establish them as visual sermons.[31] This has led in some instances to exercises in pure supposition worthy of the ripest nineteenth-century imaginative writing. A recent textbook on Dutch art, for example, turns Ruisdael's *Mill at Wijk* into a psychologized weather report, half genre painting, half Hitchcock movie: "The weather is about to change; grey clouds are gathering. Soon the sun will disappear completely; the women will hurry home as the wind freshens into a gale. Suddenly the strong mill which looks like a fortress as it towers over the land, the pride of man's ingenuity, in using the forces of nature, looks curiously small against the sky."[32] Emblem books are sometimes also introduced where they feature rustic images such as cattle, windmills, or trees to lend support to the notion that painted depictions of these themes were meant to convey the morals supplied in the emblems' textual inscriptions. But this kind of routine transposition from text to painting is actually as mechanical an exercise as the stylistic formalism it opposes. A more subtle approach might be to regard these stock elements as part of a generalized repertoire of native associations that had lodged in Dutch culture and were now being reworked into forms that could reconcile loyalty to the

homely with thirst for the grandiose.

An even more eloquent example of the revision of Dutch landscape types away from the homespun and the local to the polished and the cosmopolitan was the famous career of Aelbert Cuyp. Cuyp's earliest paintings of the 1640s, like those of van Ruisdael, betray the debt to van Goyen. But the contrast between the latter's treatment of another popular theme – the imposing bulk of the Valkhof castle at Nijmegen – with Cuyp's version immediately points up the distance that Cuyp had traveled from the older master (cat. 22 and cat. 22, fig. 2). For van Goyen, the Valkhof remained part of native architecture, rough-hewn and unidealized, not unlike some other of the river bastions: a rather grim item from contemporary history. Through backlighting and a lower vantage point (similar to the steep angle used for the Bentheim views) it is transformed into a romanticized image of the knightly past. Along with the idealization of architectural forms came the prettification of the human landscape. What had become, for a more cultivated generation of patrons, the unpleasing image of coarsely represented peasants and fisherfolk was replaced by figures drawn more from pastoral lyric poetry than seashore and duneland doggerel. And these more ingratiating images were produced by Cuyp at a time when the wealthiest of the Amsterdam patriciate, like the Huydecopers and the de Graeffs, were creating their own rural arcadias: Palladian villas complete with Latin-inscribed doorways, urns on the gateposts, and well-tended hunting estates.

One source for this kind of ethos was the

Fig. 12. Peter Paul Rubens, *Autumn Landscape with Het Steen*, panel, 132 x 229 cm., National Gallery, London, no. 66.

mellow landscapes painted by Peter Paul Rubens toward the end of his career in the 1630s (fig. 12). These celebrated the artist's bucolic retreat away from the professional world of the studio and the public world of court diplomacy (in which Rubens had been much embroiled). But they also recorded the long-cherished dream of *Sir* Peter Paul Rubens (like *Sir* Constantijn Huygens) to become a landed gentleman. Consequently, the landscape itself, as Alpers has pointed out, is dominated by the proprietorial presence of Castle Steen.[33] And its relationship to the figures in the painting derives directly from the seigneurial traditions of Books of Hours: a rural calendar determined by the expression of lordly control, with an emphasis on the knightly pursuit of surrogate war – hunting – and with agricultural labor that is scenic rather than functional. What Rubens creates here is not a working countryside but, rather, the landscape as park. And in this sense of its appropriation he lays out the representational plan that Gainsborough would perfect.[34]

To an even more marked degree, many of Cuyp's late landscapes were at the service of a social process that transformed commercial oligarchs into landed gentry.[35] Not surprisingly, many of these paintings were highly esteemed and bought by the eighteenth-century British Hanoverian elite engaged in much the same mutation. The most spectacular of all, however, was acquired by that bugbear of the Whigs, the Marquess of Bute, who was something of an arbiter of taste in painting as well as political ideas to the young George III (cat. 25).

The Bute Cuyp is a collation of all the motifs that turned their back on those of the earlier generation of "native" landscapists. In this sense they serve to reintegrate Dutch culture with the international manner (in this case aristocratic) against which it had defined itself in the 1620s and 1630s. Even Cuyp's characteristic backlighting suffuses his works with a kind of sentimental radiance that is precisely antithetical to the inexpressive wetness of van Goyen and Salomon Ruysdael's riverscapes. The trees are manicured, the water still, the air sweet. With Cuyp we return to boundaries, emphatically restated: the boundary of a river across which is set a castle, the enduring repository of landed power. And the relation between mounted figure and those on foot no longer has the social indifference of the beach scenes. The boy herdsman is unmistakably deferential. He and the shepherds with their perfectly groomed fat stock are the decorative accessories of an order governed by land and hierarchy. This is the Rest of the Seventeenth Century.

And it was a world that, without any

question, Cuyp himself yearned to join. From the time when, as a youngster, he had witnessed the stadtholder Frederik Hendrik's entry into Dordrecht, he had been drawn to the dynastic and chivalric culture that, notwithstanding the periodic dominance of the patriciate, remained exceptionally potent in the Dutch republic. Indeed, on at least two occasions Cuyp painted near-contemporary histories of Frederik Hendrik at Nijmegen and Dordrecht that celebrated dynastic paternalism, at a time when it was politically unfashionable. His images of the artist at work, like that of the sketching figure in the collection of the Duke of Bedford (aptly enough), offer an upwardly mobile version of the gentleman-artist, dressed accordingly and accompanied by elegantly groomed horses (fig. 13). In this, as in so many other aspects, Cuyp prefigured the scenic dilettantism of the Grand Tour.

Like a good apprentice patrician, Cuyp obviously knew how to cultivate the connections necessary for his own social elevation. Repeated commissions for one particular Dordrecht clan, the van Beverens and the Pompe van Meerdevoorts, suggest in their familiarity much more than the tug of the forelock. Whether the family insisted or Cuyp suggested, the artist went overboard in presenting every kind of status emblem necessary to hoist the sitters over and above the common run of burghers. Country houses are indicated, but as often as not, their architecture is deliberately Italian rather than local, to suggest their pretentions to cosmopolitan taste. The van Beveren clan took special pride in the

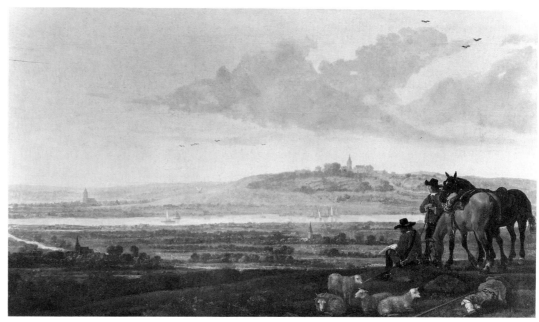

Fig. 13. Aelbert Cuyp, *Artist Sketching*, panel, 47.5 x 80 cm., Duke of Bedford, Woburn Abbey.

knightly order that had been bestowed on them by Louis XIII, and Cuyp's paintings are careful to incorporate the *fleur-de-lis* heraldic device that signified that honor on horse brasses and saddlecloths. Equitation is of exceptional importance, as it was in all courtly cultures. In Cuyp's riding subjects, figures are often dressed in the quasi-oriental or "Polish" manner favored by the very uppermost crust, and adopt postures that were taught at riding academies in France. Such institutions were not merely intended to produce sportsmen; they were deemed (by Richelieu and Louis XIV, for example)

the most proper school for all forms of social and political etiquette.

In that kind of world, pedigree was everything. And as its pictorial doyen, Cuyp celebrated the merits of pure blood like no other Dutch artist. The dogs were bred for perfect hunting form; the horses that he painted were *expressly* bred for the sleek appearance of their disproportionately small heads. The Pompe van Meerdevoort children were shown being schooled in these genteel pursuits (see p. 110, fig. 8). And not least, black servants were displayed (for one of the first times in landscape portraits) as

another kind of exquisitely groomed creature, bred and purchased for show (cat. 25, fig. 3).

There could be only one outcome of all this strenuous and profitable sycophancy. In due course, Cuyp the painter and the son of a painter became Cuyp the patrician and the father of patricians, dissolving into the cultural landscape of his own invention. Marrying the granddaughter of the implacable Calvinist theologian Gomarus was not a sign of the ardor of his own Calvinism, for in the third generation the family had lost much of their conspicuous zeal. But the alliance did hoist him into the patriciate whence Cuyp duly became a member of the highly restricted town regency, "The Forty."

Like Hobbema, whose successful marriage also spelled an end to his career as a painter, Cuyp more or less gave up his art following this ascent. But late in his career, as if in gratitude for all this good fortune, he paid Dordrecht back by producing an image of its harbor that corresponded in its cosmetic extravagance to the horsey gentry he had portrayed. His views of the Maas and the harbor are drenched in a supernal, golden aura; van Goyen's views were of brown, slapping water against gray, wind-driven skies. Cuyp's boats (somewhat like his cattle) are immense stationary objects, generally becalmed and loftily disengaged from any recognizable human labor. Van Goyen's boats on the Maas are generally seen in hectic, beleaguered sail, tacking as urgently as they can to their destination. When Cuyp's breezes blow, they are zephyrs; when van Goyen's winds blow, they are

stiff gales. Cuyp's Dordrecht is history; van Goyen's is business.

It would be a mistake to conclude from this that van Goyen's landscapes are to be preferred to Cuyp's in the interests of historical realism. Both idioms inhabit the realm of visual fictions, imaginatively reworked to create their own coherence and integrity. As alternative idioms in Dutch culture, they complement rather than contradict each other. Indeed, the afterlife of the two styles also suggests that both manners could find acceptance from the same taste. From the middle of the eighteenth century van Goyens found their way into the collections of the Hanoverian gentry and nobility in phenomenal numbers. Christie's catalogues record sales of no less than 172 van Goyens between 1768 and 1778 to such buyers, and the import flood went on unabated until the 1790s.[36] And if Cuyps were bought by the most powerful of the Hanoverian magnates like the Cavendishes and the Spencers, they also decorated the London saloons of more parvenu Scottish clans like the Dundases. Their pictorial legacy was perhaps more variable. Predictably, van Goyen and Salomon van Ruysdael appealed to John Crome (who owned a painting by the former) and the Norwich school, themselves searching for some sort of new expressive manner to treat a low, fenny landscape. Crome's last words are said to have been "Oh Hobbima, my dear Hobbima, how I have loved you,"[37] while those already succumbing to Burke's prescriptions for the sublime were more likely to see it anticipated in the cloud symphonies of Jacob van Ruysdael and Cuyp's lightning bolts.

While Ruskin thought the effect of all Dutch landscapes was "so totally for evil" that he recommended burning the lot, his own model artist, Turner, admired both, paying tribute to Cuyp in his versions of the Dordrecht packet boat and harbor and offering an idiosyncratic pictorial account of *Van Goyen Searching for a Subject in Antwerp*.

They are not, then, mutually exclusive styles of landscape – the vernacular and the guttural on the one hand and the classical and lyrical on the other. But Dutch landscape painting has become an inadvertent accomplice in the process of cultural stereotyping, which in the day of its own creation it defied. Fromentin's elegant condescension about a culture that he saw as technically accomplished but morally bovine has worked its deadly power. So much of this painting is now embalmed in expected arrays on museum walls as a festival of "charm." But charm is the enemy of artistic shock, and in its very best sense, a great deal of Dutch landscape painting is shocking, especially when set down without apology amongst the harmonies and disciplines of classical painting. For centuries now, Dutch landscape painting has been used (as it was perhaps by its first patrons) as therapeutic: an idyllic repose from commerce and from history. But as all students of Vermeer know, Clio was never far from the hand of the Dutch painter. And if she has returned to haunt the muse of landscape, it is as a celebrant, not as a scold.

NOTES

1. On the cultural process by which this separation occurred, see Simon Schama, *The Embarrassment of Riches: An Interpretation of Dutch Culture in the Golden Age* (New York and London, 1987), chap. 2.

2. This was first argued by J.G. van Gelder in his brilliant study of Jan van de Velde (van Gelder 1933, p. 15). Until relatively recently, however, there have been few attempts to trace the connections between history, geography, and landscape painting. For one interesting attempt see Bergvelt 1978. Bengtsson 1952, esp. pp. 33–66, provides a good deal of information about the sociology of artists in Haarlem in this period but, rather peculiarly, fails to integrate this historical data with any kind of explanatory interpretation.

3. An extreme case is E.K.J. Reznicek, "Realism as a Side-Road or Byway in Dutch Art," in *Renaissance and Mannerism: Studies in Western Art*, Acts of the 20th International Congress of the History of Art, vol. 2 (Princeton, 1963), pp. 247–53.

4. See Otto Benesch, *The Art of the Renaissance in Northern Europe* (Cambridge, Mass., 1947), pp. 97–99.

5. On the virtuous associations of the plowman, see Robert Baldwin, "Peasant Imagery and Bruegel's 'Fall of Icarus.'" *Konsthistorisk Tidskrift* 55 (1986), pp. 101–14.

6. Cited in Ogden, Ogden 1955, p. 5.

7. "Van Goyen is too uncertain, volatile, airy, and woolly; one feels in him the light and rapid trace of a fine intention; the sketch is charming; the work did not succeed because it was not substantially nourished by preparatory studies, patience, and labor." Fromentin 1963, p. 188.

8. See the catalogue raisonné in Beck 1972–73.

9. The best account is in van Gelder 1933. See also Stechow 1966; de Groot 1979.

10. See, for example, Stechow 1966, p. 52; Rosenberg et al. 1966, pp. 31–32.

11. See Keyes 1984, p. 11. Buchelius mentions a painting by Coninxloo with figures by Esaias.

12. On Thoré's "discovery" of Dutch art as protodemocratic in form as well as content, see Francis Haskell, *Rediscoveries in Art* (Ithaca, 1980), pp. 146–51.

13. Clark 1976, p. 59.

14. Nelson Goodman, *Languages of Art* (Indianapolis, 1976), pp. 34–35.

15. The concept is discussed in van de Waal 1941, pp. 27–28; and by David Freedberg, *Dutch Landscape Painters of the 17th Century* (London, 1980), pp. 9–20. Freedberg's essay is an acutely perceptive commentary on the problem of "naturalism."

16. See Beening 1963, p. 56.

17. For the general understanding of the cow emblem of "Hollands Welvaren," see van de Waal 1952, vol. 1, p. 21.

18. Van Mander 1604; van Mander, Miedema 1973, vol. 1.

19. Keyes 1984, p. 75.

20. Cited in Keyes 1984, pp. 12–13.

21. Fromentin 1963, p. 149.

22. On the iconographic tradition of the Saint Elizabeth's Flood of 1421, see van de Waal 1952, vol. 1, p. 255; see also Schama, *Embarrassment of Riches*, chap. 1.

23. On the difference between these two patterns of rural society, and for a superlative account of Dutch agriculture and land in general, see J. de Vries 1974.

24. J. de Vries 1974, pp. 150–51.

25. On the institutional aspects of Dutch hydraulic administration, see the excellent essay by H. van der Linden, "Iets over wording, ontwikkeling en landschappelijk spoor van de Hollandse waterschappen," in *Land en Water* (Amsterdam, 1978), pp. 101–13; see also S.J. Fockema Andreae, *Het hoogheeemraadschap van Rijnland: Zijn recht en bestuur van vroegsten tijd tot 1867* (Leiden, 1934), vols. 1–2; idem, *Overzicht van de Nederlandse waterschapsgeschiedenis* (Leiden, 1952).

26. For an assessment of the damage, see J.I. Israel, "Spain and the Netherlands: A Conflict of Empires, 1618–1648," in *Past and Present* 76 (1977), pp. 45–47.

27. Jacob Cats, "Op de gelegentheyt van een Schevenings vroutje dat een benne visch op haar hooft draaght . . . ," in *Invallende Gedachten op Voorvallende Gelegentheyden* (Amsterdam, 1656).

28. Fromentin 1963, p. 135.

29. Alpers 1983, chap. 4.

30. On the importance of this period, see The Hague/Cambridge 1981–82, pp. 20–21.

31. In particular Wiegand 1971; see also in this vein, Fuchs 1973. De Klijn 1982 is much less mechanically iconographical and very perceptive on some of the links between Dutch literature, sensibility, and painting, but he quite unnecessarily ties the emergence of a native style to expressly Calvinist features of the culture.

32. Fuchs 1978, p. 133.

33. Alpers 1983, pp. 150–52.

34. For a path-breaking account of the social implications of English landscape painting, see John Barrell, *The Dark Side of the Landscape* (Cambridge, 1980). It will be immediately apparent how indebted I am to this work for my general approach to the relation between culture and landscape.

35. On this process, see Peter Burke, *Venice and Amsterdam: A Study of Seventeenth Century Elites* (London, 1974), pp. 101–12; H. van Dijk and D.J. Roorda, "Sociale mobiliteit onder regenten van de Republiek," *Tijdschrift voor Geschiedenis* 84 (1971), pp. 306–28; see also D.J. Roorda, *Partijenfactie* (Groningen, 1961), passim.

36. See Christopher Wright, "Van Goyen: A History of British Taste," in London 1976b, p. 14.

37. For the relationship between English preromantic and romantic painting and seventeenth-century Dutch landscape, see The Hague/London 1971.

Toward a Scriptural Reading of Seventeenth-Century Dutch Landscape Paintings

Josua Bruyn

Fig. 1. Abraham Bloemaert, *Landscape with Tobias and the Angel*, canvas, 65 x 54.5 cm., private collection, on loan to Centraal Museum, Utrecht.

It has been said that technical inventions appear just when the human mind most needs them. This certainly seems to be true of the invention of photography, which evolved through different phases in the second quarter of the nineteenth century. It corresponded no doubt to a growing interest in the kind of reality that could be captured visually. Since then photography has had an enormous influence on visual art and, to this day, on our way of seeing. It has contributed to the notion that realism was a characteristic of an art whose chief aim was the reproduction of visual reality. It stands to reason that this characteristic is readily applied to a great part of Dutch seventeenth-century painting: to all still lifes, genre scenes, landscapes, and seascapes that appear neither to call for nor even to admit any other explanation but a "realistic" impulse. This view, incidentally, was already widespread in the eighteenth century, although the word "realism" did not yet exist, and the old, not exactly favorable term "imitation of nature" was used instead. It was not until the second half of the nineteenth century that, thanks to the aesthetic and ideological admiration evinced toward Dutch painting by such writers as Eugène Fromentin and Thoré-Bürger, the "realism" of this art could be appreciated in fully positive terms. Realism thus became the basis for the lasting high esteem in which this art was held and has remained so almost indisputably to this day, certainly insofar as landscape painting is concerned. This is quite extraordinary because in other areas – to some extent in still life, but especially in genre painting – Dutch realism has been if not exactly exposed, then certainly seen through and qualified. The joyful, often coarse domestic and tavern scenes have been convincingly established as instructive lessons, warning against sin, recalling death, challenging the viewer to lead a God-fearing life. As the exhibitions "Tot lering en vermaak" in Amsterdam (1976) and "Die Sprache der Bilder" in Braunschweig (1978) showed, the choice of subjects was fairly limited, the moral message virtually unchanging.

One can hardly expect it should be fundamentally different with regard to landscape. Yet it has long been supposed so. Even as late as the fall of 1986 in London an exhibition of Dutch landscapes took place whose catalogue contained contributions from a literary and an economic historian – in the hope that this would produce an understanding of the images – but otherwise attention was given only to the formal and technical aspects of the exhibited works. This bias is to some extent understandable. First, not only photography but also impressionism had a profound effect on our way of conceiving of landscape; although we have long known that the seventeenth century was unacquainted with "open air" painting and, in general, did not strive for topographical accuracy,[1] we must admit that our view of seventeenth-century painting, as if it were a slice of nature, has been lastingly shaped by impressionism. Second, we are still bound to the earlier conceptions of the landscape painter stemming from romanticism, according to which the artist projected his state of mind into the landscape and thereby created his own, independent representation of the environment. The

most renowned examples of such premature romantics would be Jacob van Ruisdael as the melancholic and Rembrandt as the inconsolable widower.[2] Third, the few valuable attempts at a more adequate approach, that is, an interpretation based on a historical structure, have sometimes seen the light in remote places and have therefore been easily overlooked. What first comes to mind is an important contribution in Wilfried Wiegand's Hamburg dissertation of 1971,[3] and an article published in 1980 by Hans-Joachim Raupp, which has also received too little attention.[4] Both studies are in no way unimpeachable, but I believe in many respects they point in the right direction, which I endeavor to pursue further in this essay. Finally, there is yet a fourth, deeper cause for the neglect until recently of the problem of levels of meaning beyond those which are strictly realistic. This consists in the relative paucity of unambiguous contemporary statements on this matter. When there is no compelling evidence for deeper meanings, why then should one exert oneself further? I hope to be able to give a satisfactory answer to this question in the following essay.

First, I should emphasize that in the seventeenth century the painted landscape, like the genre painting, the still life, and even, to some degree, the portrait, raises the question of "visual language." It remains for us to understand this language. As I have already indicated, the fields of literary or socioeconomic history have occasionally been expected to shed light on the experience of nature or on, for example, agrarian topics or provide information about the life of certain groups of the population that are shown in landscape painting. Such expectations, however, are rooted in the old and, to my mind, outdated assumption that the world represented in images is identical to the reality of a historical past and therefore rooted in the kind of realism defined by the last century. The confusion here can be traced, of course, to the special sense in which seventeenth-century art was indeed very "realistic": it strove with increasing success for a naturalistic reproduction of reality, its painters were praised for the "naturalness" of their work, the artists themselves doubtless regarded the imitation of nature as the goal of their craft, and for the viewer – then as now – the pleasure derived from the picture was determined by its painterly qualities. This is all indisputable. Nevertheless, we should not let it sway us. There are too many indications that this naturalism was not a goal in itself but rather could blossom only in the service of a very specific program. This program, really this "visual language," found its point of departure partly in the spoken word, since the general relationship between word and image in the sixteenth and seventeenth centuries was very close. Proverbs, sayings, and quotations from the classical writers and especially from the Bible were not only suitable for expressing a chiefly religious and always moralistically colored maxim but could also, either literally or allegorically conceived, give rise to the creation of images, which could in turn bring to mind the proverb or the edifying quotation. The language of images was therefore in no way an undifferentiated whole. On the contrary, it was a blend of very different elements. These were, however, all subject to a common structure, in which a figurative use of motifs was the norm and a transmission of meaning at several levels could take place. The meaning itself could change quite drastically, and it was considered creditable to discover new meanings in well-known motifs. This is apparent to us from emblems that, with their varying combinations of inscription and image, show clearly – if in a peculiar and intellectually pointed form – just where the image was thought to stand.

What this will say about the meaning, or we should say about our interpretation, of the image I should like to show through an example: that of the dove and the dovecote. The dove was traditionally a symbol of fertility and could be regarded as such in the good sense – as a symbol of matrimonial fidelity or even of peace – as well as in the bad – as an attribute of Venus or, from the late fourteenth century, of Lust.[5] One should not imagine that these meanings played a considerable role in everyday life. Only when the dove appeared in a certain context did one of the potential meanings become, as it were, activated, and the context determined which it would be. Thus it cannot be doubted that a representation of two doves in a family portrait referred to matrimonial fidelity.[6] The incorporation of a dovecote in a landscape image, however, indicates an entirely different purpose. This becomes especially clear when one sees the young Tobias with the angel Raphael passing by on their journey. Tobias, with his mysterious companion, was in fact an exemplary

traveler – as were, for example, the Holy Family on the flight into Egypt, Christ and two disciples on their way to Emmaus, or the Good Samaritan – shunning on his dangerous journey the sins of the world, mindful of his old father's admonition. One can gather which sins these are from a landscape by Abraham Bloemaert of about 1610 in Utrecht (fig. 1). The dovecote and goats in the foreground evidently represent Lust (*luxuria*), the sleeping lad, Sloth (*acedia*). To the latter one may ascribe the decayed condition of the farmhouse (not, as was once believed,[7] to the ravages of the Eighty Years' War). Bloemaert on several occasions treated in his stylish way the theme of slothful and unchaste country life;[8] sometimes, however, as in a picture dated 1624 (cat. 12), Sloth and Lust are emphasized in even stronger terms through the shamelessly nude sleepers in the foreground, while the devil, according to the parable in Matthew (13:24–30), sows tares among the wheat.

Already in a drawing of 1603 Jacques de Gheyn had renounced every biblical staffage and created a scene containing what has been called "a highly animated synopsis of farm life."[9] Hans Mielke rightly could not be satisfied with this:

> Is the broken wheel, which looms large in the foreground, really just a nostalgic moodsetter in the boutique idiom of today? . . . Let us take a closer look: most of the house's roofing tiles have fallen off; the door has come off its hinges; a shutter rots away; a barrel lies overturned; a tub sits on the ground – the overall impression is of neglect. And yet the house is inhabited, for smoke rises from the chimney. Most of the trees are willows, whose emblematic significance is clear: rooted in swampy soil, they grow too easily and too fast and this effortless ease ensures they will never bear ripe fruit. Youth misspent on pleasure, therefore, unable to achieve anything in life. Let us now look at the young couple beneath the large willow: he leans against the tree, one leg casually crossing the other, while she looks up at him with idly folded arms and an unladen yoke on her shoulders. The yoke evidently signifies the burden of duty. The young couple . . . refuse to bear it, wasting their time instead of working; their indolence has brought about the farmhouse's ruin. The vice of Sloth was frequently represented by a sluggish, idle person who left his house to decay, and evidently our drawing must be interpreted in this sense.[10]

Mielke's interpretation appears to me essentially correct. I should merely like to add a remark about the orderly and well-tended fields and the small church in the distance to the right, which stand in contrast to the derelict grounds in the foreground, and about the two dovecotes, one of them a true dovecote. It follows from this last motif that the genesis of the pastoral was bound up not only with Sloth but also with Lust, a fact we recognize to this day in the expression "shepherd's hour." It seems to have been Abraham Bloemaert in particular who, stimulated apparently by De Gheyn II (see fig. 2), carried on and transmitted the pastoral theme. It was to play an important role in the work of several of his disciples, in that of Jacob Gerritz Cuyp, who handed it down to his son Aelbert, as well as in that of the Italianate landscape painters, among them several of Bloemaert's disciples.

Fig. 2. Jacques de Gheyn II, *Landscape with Dilapidated Farmhouse*, signed and dated 1603, drawing, 195 x 311 mm., Rijksprentenkabinet, Amsterdam.

Now that the reader has been introduced into the landscape, the sins, and the problems connected with them, some evidence will have to be brought forward in support of the views just sketched, first in the form of contemporary confirmation in word and image. There are few examples of this. But those I have come across concur so well with each other and contribute so much to a coherent interpretation of numerous images that it may be assumed they represent a broad tradition.

My first source is a well-known engraving executed by Jacob Matham in 1599 after a design by Karel van Mander (fig. 3).[11] Van Mander was also responsible for the inscriptions in Dutch (not the Latin one). These verses, paraphrases of over thirty biblical texts, all refer to the transitory nature of earthly life, the inevitability of death, the renunciation of worldly pleasure, and the quest after eternal bliss. In the center of the composition there is a great

Fig. 3. Jacob Matham after Karel van Mander, *The Transience of Human Life*, 1599, engraving.

bouquet of flowers, a motif that already in the fifteenth century was used as a symbol of *vanitas* on the strength of several biblical passages. More important for our purpose are the landscapes flanking the bouquet and the accompanying texts. "Oh man, you are only a wandering stranger on the earth," declares the text on the left; and in fact one sees a pilgrim, recognizable by his hat and stick, and farther in the background, a lake with boats and a fisherman. (The last two motifs are not explained in the text; we should, however, bear them in mind.) Under the leafy tree in the foreground lies a globe whose purpose is made clear in the poem in the right half. Above the image of a nearly defoliated tree, at the foot of which again lies a globe, the text begins as follows: "This world is like a tree, you, man, are like the leaf that grows and falls and vanishes," a variation on a text from Ecclesiasticus (or Jesus Sirach 14:9). Just as significant is an inscription on a slate held by a skeleton that begins: "Mend the roof of your house for the sake of virtue." This is to me an otherwise unknown saying, presumably not borrowed from the Bible, a fact that suggests that the run-down farmhouse in Bloemaert's and De Gheyn's works was not an arbitrary motif but a quite literal illustration of a well-known maxim. The same inscription closes with the words, "No continuing city befits you here, man; therefore seek one to come," a metaphor borrowed from Paul's Letter to the Hebrews (13:14) and illustrated by the city situated high on a hill, approached by a winding path. At the foot of the hill to the right is a waterfall, a theme that is not mentioned in the accompanying text but

will be discussed later in this essay. All in all, word and image in this engraving offer an entire repertoire of landscape motifs and a coherent system in which they acquire the meaning of *vanitas*. The question remains whether this system was incidental, improvised by a devout poet, or whether it corresponded to a tradition in which the metaphorical use of landscape was rooted. The latter possibility should be considered the likelier by far. Metaphors like those represented in Matham's engraving came into play much earlier in landscape painting, in fact formed its basis. Recently it has been suggested that the earliest examples of Flemish landscape painting in the early sixteenth century served apparently as guides to religious meditation.[12] In this context one often speaks of *paysage moralisé*—wrongly, in fact, because this does not concern an autonomous landscape based on reality, to which a spiritual significance is attached, but rather the illustration of religious metaphors to aid meditation. Matham's engraving is bound up with this tradition not only through the structure of its meaning but also through its content. The theme of earthly life as a perilous pilgrimage toward eternal bliss became widespread in the Middle Ages and the Renaissance,[13] and the travelers one often comes across in sixteenth-century landscapes whether they are anonymous or biblical figures like Tobias and the angel, stem from this concept. Pictorial motifs that occur in Matham's print can also be found in even earlier paintings. One example of this is a view through a window in a double portrait of 1541, possibly of Amsterdam origin (fig.

Fig. 4. Anonymous, *Portrait of a Couple* (detail), dated 1541, panel, Amsterdams Historisch Museum, inv. A 84.

4).[14] Above the inscription "Cedit mors nemini" ("Death gives way to no one") there is a skull, and between a partly defoliated tree and a crucifix in the distance is an illuminated city on the slope of a hill — motifs that evidently represent death, faith, and salvation, as the nearly identical motifs did in the print of 1599. I venture to conclude from this that the *vanitas* print, which the Mennonite Karel van Mander designed and the Catholic Jacob Matham executed in 1599, was not an isolated case but rather represents one stage in a long tradition.

That this tradition was still alive in 1700 follows from the evidence of a man who, like van Mander, was a writer and artist at the same time and one of the few who has left

behind his views in images and accompanying texts. I am referring to Jan Luyken, who converted and became an ascetic Pietist and a tireless illustrator, not least of his own emblematic rhymed couplets. Some of his widely read, late pious booklets, especially, correspond closely in overall character as well as specific content to the views and modes of expression of Karel van Mander, so much so that a common tradition, rooted in medieval piety, can be assumed. Like van Mander, Luyken drew upon biblical texts for commentary on his depictions (which were accompanied by mottoes, as was proper to emblemata), and to his own edifying verses he once again added a series of biblical quotations. Of the numerous texts he quoted from the Bible several can be found that appear also in van Mander's depiction of *vanitas*, but the two authors had pictorial motifs in common as well. A page from the booklet *De onwaardige Wereld* (*The Unworthy World*), published in 1710, may serve as an example (fig. 5). Under the legend *Transience*, it shows once again the tree with globe as the image of the passing world: the leaves are said to flutter in the wind, only a few fruits — the true faithful — are pleasing to God.[15] The recurrence of this image appears to be significant: it corresponds to an ancient conception that apparently held its own and was, as we shall see, perpetuated as a traditional sermon motif. Still more important than these and other particularities is the identical, all-encompassing conception of life on earth as a pilgrimage. Luyken actually provided a frontispiece for a Dutch translation of Bunyan's *Pilgrim's Progress* in 1682.

Fig. 5. Jan Luyken, *Transience*, 1710, etching from *De onwaardige Wereld*.

Fig. 6. Jan Luyken, *The Old Building*, 1711, etching from *De bykorf des gemoeds*.

Fig. 7. Jan Luyken, *The Alps*, 1711, etching from *De bykorf des gemoeds*.

"O Man! Whatever happens to you on your life's journey, / May everything be a sign to you / To point you to the straight path to your happiness; / So will you always avoid your misfortune." So wrote Luyken in the foreword to his *De bykorf des gemoeds* (*The Beehive of the Spirit*), of 1711.[16] I should like to give two examples here first. *Het oud gebouw* (*The Old Building*) also gathers Bible quotations like those to be found in van Mander's selection – "For all flesh is as grass" (Peter 1:24), for example – and devotional reflections on the frailness of human achievements (fig. 6).[17] The motif is based directly on the significance of *vanitas* that the ruin had already acquired in sixteenth-century art and poetry. Apparently just as traditional,

though more difficult to verify as such, is the image of the high mountain with its steep and narrow ascent (fig. 7): "Though the ascent be high and steep, / It is done for one's eternal salvation."[18] Clearly, Jan Luyken's message is not remarkably different from van Mander's. The renunciation of all worldly pleasures, reflection on death, the love of God – these are the familiar motifs of all Christian asceticism, including that of Western European puritanism, according to the shape already given to Netherlandish piety by Thomas à Kempis and the *devotio moderna* in the fourteenth and fifteenth centuries.

If, therefore, Luyken's views were firmly rooted in this tradition, whether the same holds for his visual language is, of course, another question. In the field of emblemata, to which his works belong, new interpretations, new combinations of motto and image were certainly, as mentioned earlier, especially popular, and Luyken himself in many instances spared no pains to provide all possible motifs with a pious significance. In other instances, however, he demonstrably drew upon much older images. Among these belong several already mentioned here, which followed from a comparison with van Mander's engraving; but it is possible to cite several more examples, which show how much at least some elements of the visual language applied by Luyken fit the internal logic of certain images of the seventeenth century.

To show this, I should like first to point out several examples of "pictures within pictures." The "picture within the picture" – a

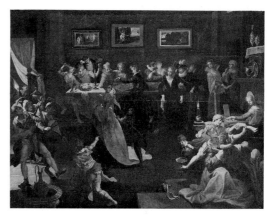

Fig. 8. Anonymous, after Joos van Winghe, *Nocturnal Banquet*, panel, 117.5 x 154.5 cm., Rijksmuseum, Amsterdam, inv. A 473.

picture portrayed as hanging on the wall of an interior – has certainly been discussed in art history[19] but has not always been appreciated as a significant element.[20] As such it appears to have been used regularly after about 1615. An early example is a *Nocturnal Banquet* by an unknown Dutch artist (fig. 8). The figures in this scene are taken from a much earlier engraving after Joos van Winghe, where the dissolute character of the gathering is explained by biblical texts.[21] In the painting, however, this function has been taken over by the pictures on the back wall: landscapes with biblical or mythological subjects. In the middle, *Salmacis with Hermaphroditus* exemplifies unbridled desire; to the left, *Lot with His Daughters*, woman's power to arouse lust; and to the right, *Tobias with the Angel*, the conduct of the God-fearing life. In this manner "pictures within pictures" contribute to an explanation of the

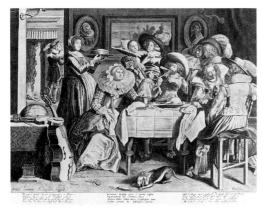

Fig. 9. Cornelis van Kittensteyn after Dirck Hals, *Merry Company*, engraving.

Fig. 10. Pieter Codde, *Merry Company*, signed and dated 1627, panel, 39.5 x 53 cm., Musée du Louvre, Paris, inv. MNR 452.

Fig. 11. Jacob Duck, *Merry Company*, signed, panel, 38 x 67 cm., Musée des Beaux-Arts, Nîmes, no. IP-1363.

scene. For the moment we are interested particularly in landscapes because the context in which the landscape image appears can shed light on its significance.

There are a number of merry company scenes that emerged from Frans Hals's Haarlem circle, among them works by his younger brother Dirck, that show a landscape, and indeed almost always a landscape with trees. This can be seen, for instance, in an engraving after Dirck Hals, whose inscription informs us of the nature of the gathering represented (fig. 9).[22] Here too we are dealing with careless and corrupt youths, who waste their time in unchaste and vain activity, thereby endangering the salvation of their souls ("Verslyten haeren tyt met ydelheyt onkuys"). The concept of *vanitas* is expressed in different pictorial motifs: not only in sensual pleasures, the musical instruments, and the smoke of the chimney, but also in the large painting on

the wall, in which, significantly, only trees are partly visible. We have already been introduced to the tree as a symbol of the transience of earthly life through van Mander and Jan Luyken; in fact, the tree had long been considered as such earlier in patristic tradition and later in the practice of the sermon. This we may conclude from a sermon by John Chrysostom (XIX. Ad Eutropium), held up as a model for preachers in the sixteenth century. In this the tree, along with a number of well-known *vanitas* symbols, is described as an image of transience: "Omnia vanitas – all is vanity, all floats away as through the breath of the Spirit, as the leaves are all shaken off and the tree is left shorn, and not only shorn but ripped from its roots."[23] Thus, trees appear in landscapes behind the "merry companies," as Dirck Hals so often depicted them, serving as an imminent warning against the dissipation represented. Just as engravings are occasionally provided with exactly the same legend, "Vanitas," so the image on the wall acts like an inscription to the scene represented in the foreground. That this text could be replaced by a landscape attests how closely word and picture were linked in general and especially how well known was the significance of the landscape.

The work of Pieter Codde, who lived in Amsterdam but was somewhat influenced by the Haarlem School, offers several illuminating examples from the same period. A painting dated 1627 given the euphemistic title *The Dance Lesson* in the Louvre (fig. 10)[24] in reality deals with a house of doubtful repute, where young people squander their time in idle pleasures. The large painting on the

wall (which carries the artist's signature) shows a landscape in which three figures pass by a ruin and an old tree. Whether the three figures could be Christ and the two Emmaus pilgrims is hard to determine. But that the tree and the ruin in this context serve again to emphasize the *vanitas* character of idleness appears to be undeniable and is confirmed by yet another noteworthy circumstance. A painting by Jacob Duck obviously portrays a brothel scene (fig. 11);[25] one of the men is being undressed in a young woman's lap – "Een hoeren schoot is duyvels boot" ("A whore's lap is the devil's boat"), versified Johan de Brune in 1624.[26] Three pictures hang on the wall. On the left, above the head of a young man grinning and pointing, Salome, her dance over, receives John the Baptist's head, as depicted by Leonard Bramer in a painting that has survived. Duck apparently held up this scene as an ideal representation of the fatal power of female lasciviousness. On the right, next to the door, we find Codde's picture again (fig. 10), which here, with the *vanitas* landscape omitted, becomes in itself a symbol of wantonness. This landscape, too – or at least a very similar one – has taken its place on the wall, doubtless with the same meaning. And, finally, on the right, above a young man looking morosely out of the painting, hangs a map, symbol of the world or of worldly life.[27] Beware of idleness and vain pleasure, especially of the female power that rules the world – so, more or less, goes the message of the entire scene, and the landscape image has its share in conveying this ever recurring moral.

In portraits, the *memento mori* had of old

Fig. 12. Jan Luyken, *The Horizon*, 1711, etching from *De bykorf des gemoeds*.

been a customary ingredient. We may suspect from the outset that the landscape paintings incorporated in them had a similar significance, even if this is not apparent at first glance. The *Portrait of a Young Woman*, also by Pieter Codde and dated 1627 (National Gallery, London, no. 2584), is an example of this. The woman is obviously holding a mirror, a well-known symbol of *vanitas*, and the cat watching a mouse is depicted here to denote sinful human nature. The pictures on the wall appear to fall in with this iconographic "program." The one on the back wall presents a wide landscape, in the front right corner of which a figure moves diagonally into the space. Here I should like once more to cite an emblem from Jan Luyken's *De bykorf des gemoeds* (fig.

12), which appears to hold the key to understanding Codde's wall decoration. *Het verschiet* (*The Horizon*) is the title of this emblem, by which is meant life's end, with reference to Psalm 39:4–5 ("Lord, make me to know mine end, and the measure of my days, what it is. . . . Behold, thou hast made my days as an handbreadth; and mine age is as nothing before thee"). "Certain death awaits on everyman's horizon"[28] is the theme expressed here by two figures, one pointing in the distance, the other peering. That a related concept is the basis for the landscape in Codde's portrait is highly probable in view of the emphasis given to the traveler. The sitter might naturally have possessed such a painting; but it is not necessary to assume this: the artist may well have adopted an appropriate current type. The same can be said for the forest landscape, which hangs on the side wall to the right and was depicted with the unmistakable intention of contributing further to the iconographic program of the image. That the reflection of death comes into play in this image as well is not unlikely when one considers the significance of the tree.

The forest, however, had yet another meaning, which related particularly well to the pilgrim and his life's journey. Luyken wrote in a booklet printed in 1708: "Oh World! You very dangerous forest!"[29] For him the forest was full of dangers, as the world is full of sins that threaten the unsuspecting traveler. This interpretation, however, must be much older, as Hans-Joachim Raupp has demonstrated,[30] and it is not difficult to find many images from throughout the seventeenth century to

which this interpretation can be applied. Some of these images illustrate the dangers of the forest through the staffage: through the violence of highwaymen or the deceit of fortune-telling gypsies or through the activities of hunters, anglers, or lovers, all of whom, as we know from different sources,[31] represent the vices of Lust and Sloth. In the most noteworthy instances the dangerous forest is evoked as the symbol of the sinful life not as much by the figures – an almost invisible traveler or hunter – as by the fantastic shapes of trees, their branches and roots, which have become the protagonists. Works of Gillis van Coninxloo (cat. 19), Roelandt Savery (cat. 99), Alexander Keirincx (cat. 52), and Jacob van Ruisdael (cat. 87) spring to mind. If we conceive of the edifying significance of the forest image in this manner, the painting to the right in Codde's portrait fits quite well in the program on which the entire scene appears to be based. The young woman is surrounded by wise admonitions and warnings, reminders of certain death and the sinfulness of the world.

One can say something similar about the young man whose portrait Pieter Codde painted in 1625 (Ashmolean Museum, Oxford). There a seascape on the wall shows a ship on the open sea. It does not refer to the man's profession, as one perhaps might imagine, but contains another quite common illustration of human life as *navigatio vitae*. Neither van Mander nor Jan Luyken used this image, but both cited Psalm 39:6, which has it that all men are moved by "Vanity alone" and on which Augustine gave this commentary: "this world is like a sea"

Fig. 13. Jacob Bellevois, *Ships in a Storm*, signed, 1664, canvas, 105 x 148 cm., Herzog Anton Ulrich-Museum, Braunschweig, inv. 396.

("hoc saeculum mare est").[32] Practically all the important Christian writers of the Middle Ages appear to have used this metaphor: the sea is the world; all storms and other dangers that threaten the ship are the sinful temptations to which man is exposed during his lifetime. The fact that the emblemata (beginning with Alciati) appropriated this motif and applied it more specifically to politics and love[33] in no way changed its basic religious significance. That this is so can be inferred sometimes plainly from painted seascapes. In *Ships in a Storm* by Jacob Bellevois (fig. 13), for example, not only are there three ships weathering the storm near a cliff-lined coast on which a fourth ship already lies wrecked, but there is also a castle perched on top of an exceptionally

steep cliff that can only be reached by a suspension bridge. We recognize it as the eternal city on Mount Zion, symbol of salvation; and to emphasize this symbolism, two shipwreck survivors are portrayed on a cliff in the right foreground, one of them praying, the other one kneeling and holding a crucifix. We may therefore assume that the seascape in Pieter Codde's *Portrait of a Young Man* is an exact equivalent of the landscape with a forest in his *Portrait of a Woman* and that the two "pictures within pictures" served the same end: to show that both sitters were aware that only a God-fearing life could protect them from the temptations of sin.

After midcentury one can observe a new wave of "pictures within pictures," among them many landscapes, as in works by Gabriel Metsu, Frans van Mieris, Jan Steen, and Jan Vermeer. Most of these works are not portraits – although the *Regents* by Frans Hals naturally ranks among the best known – but amorous scenes that barely disguise allusions to affairs of the heart. Two examples must suffice. *A Young Man Writing a Letter* by Metsu (fig. 14) shows a pastoral on the wall, which, as we have already seen, serves to elucidate the young lover's intentions. The magnificent carved and gilt frame appears to underscore this meaning; its crown is (lo and behold!) in the shape of a dove. (It is possible, though not certain, that the motifs on the tiles, too, contain erotic allusions.) The companion piece (fig. 15) shows a young lady absorbed in reading a letter; her innocence is expressed through her momentarily interrupted domestic activities. Whether she will also pay heed to

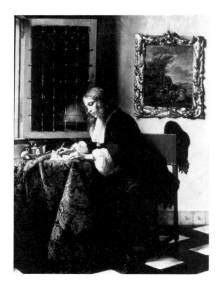

Fig. 14. Gabriel Metsu, *A Young Man Writing a Letter*, signed, panel, 52.5 x 40.2 cm., Alfred Beit Foundation, Russborough, Co. Wicklow.

Fig. 15. Gabriel Metsu, *A Young Woman Reading a Letter*, signed, panel, 52.5 x 40.2 cm., Alfred Beit Foundation, Russborough, Co. Wicklow.

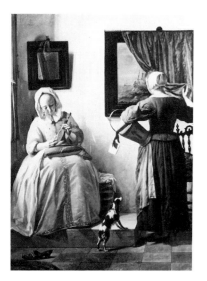

the admonition of the painting on the wall appears doubtful; the presence of a curtain, which only for an instant is pulled aside by a servant girl, should warn us against optimism on this score. Again the image is a seascape showing a choppy sea and, understandably, without a splendid frame but in a plain, dark molding. In this context this difference, too, appears to be significant!

These examples could be amplified by numerous others, and their interpretation could no doubt be considerably refined and extended. Instead, I should like to return to the question of contemporary statements about landscape, this time drawing on literary texts.

It must be said that only faint traces of the views on landscape images outlined above appear in Dutch literature. The literary paraphrases of biblical texts by various religious poets – like Dirck Raphaelsz Camphuysen, who was for some time a Reformed pastor, or the Calvinist pastor Jacob Revius – cleaved too closely to the biblical text to result in imagery with a figurative meaning of its own. With other writers the account of a natural landscape follows classical models or even, as occasionally with Joost van den Vondel, turns it into an allegory in the classical idiom. It is characteristic that even van Mander shows no trace of the piety that appeared in the engraving of 1599 in his literary descriptions of landscape but, as one can expect of the translator of Virgil's *Bucolica* and *Georgica* (1597), described a landscape in arcadian terms, drawing on a classical typology.[34] In general one must suppose that many writers

wrote for an audience oriented toward humanist ideas and therefore gave little place to the pietistic conception of the world. Only in a few cases, such as that of the extremely pious pastor Jodocus van Lodensteyn, does one recognize a nearly absolute flight from the world and the view that everything, including nature, is vanity. That this view was not thought of as extreme at the time is evident from the fact that his songs and poems, published under the title *Uyt-spanningen* (*Relaxations* [perhaps for the ascetic pastor but hardly for the reader!]), went to seventeen editions between their first appearance in 1676 and the late eighteenth century![35] Van Lodensteyn was a cultivated man, not without literary pretensions, but his purpose must have differed from that of a Hooft or Vondel. He was admired and read by faithful churchgoers, and one must assume that his pious views were the basis of his sermons and those of his Reformed colleagues. One may suspect that some of the statements important for our understanding of landscape depictions are buried in the sermons of the time and thence exercised their influence on the language and visual fantasy. Knowledge of the old biblical metaphors and those coined by the Church fathers appears to have been disseminated mainly in this way. This hypothesis is supported by the already mentioned quotation in a sixteenth-century manual for preachers of a number of current symbols of *vanitas*, which stem from an early Christian patristic source. It may be hoped that closer study of the Dutch seventeenth-century sermon will provide further corroboration of this idea.

No Dutch writer seems to have conceived of the landscape as the illustration of a religious truth in quite so clearly articulated a manner as the German Andreas Gryphius. Born in Glogau in 1616, he traveled widely as a young man and remained for a while in Leiden from 1638 to 1643, at first as a student of theology, then as a teacher. Whether the approach that is to be found in his poetry should be considered as bearing a special kinship to the kind of piety predominating in the Netherlands is difficult to say. If this were so, his years at the University of Leiden could be responsible. In any case it can be stated that a striking relationship exists, both in the overall idea and the specific nature of the imagery used. Concerning the overall idea, one finds that the *hominis fragilitas et mundi vanitas* ("the frailty of man and the vanity of the world")[36] is so often the leitmotif in Gryphius's writings that it was once believed to derive from his personality, and the poet – like Jacob van Ruisdael! – was deemed a melancholic. But, as Wiegand remarked with reference to Ruisdael, "in the baroque there was no confessional or expressionistic art."[37] Especially interesting is the way Gryphius first descriptively suggests the subject of his sonnets and odes and then interprets it in terms of a biblical metaphor without explicitly identifying the biblical source – somewhat the way a recitative is followed by a lyrical aria in Bach's church cantatas. An example is provided by verses from a sonnet on the morning, which opens a group of sonnets dedicated to the hours of the day. It begins with a description of dawn and midway turns into a prayer:

. . . O threefold highest power
Enlighten him, who bows before your feet!
Drive away the thick night, which besieges my soul,
The darkness of the pain, which troubles heart and spirit,
Restore my soul, and strengthen my confidence.
Grant, that I spend this day serving you alone:
And if my end and that day is coming
[Grant,] That I should forever behold you, my sun, my light.[38]

Thus, morning becomes a morning prayer, and the rising sun, God's light, which the poet hopes on dying to look upon. The sources for this image were, of course, a number of biblical passages (especially John 1:9), but the entire medieval tradition had used and elaborated it, and there is even known to have been a hymn in which Christ was called "Aurora." If one is familiar with these facts, it becomes easier to understand how Adam Elsheimer could paint so astonishing a picture as the Braunschweig *Aurora* (fig. 16) in the first decade of the seventeenth century, which was subsequently engraved by Hendrick Goudt. The picture's modern character is due above all to its being seemingly without any subject, but Gryphius's spiritual interpretation of the visible world, which follows a long tradition, makes it doubtful whether this idea can be maintained.

Some verses from another sonnet by Gryphius may be quoted here, because it corresponds perfectly to the conception we have found to exist of the sea and of the ship:

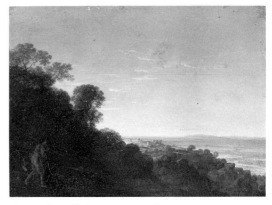

Fig. 16. Adam Elsheimer, *Aurora*, panel, 17 x 22 cm., Herzog Anton Ulrich-Museum, Braunschweig, inv. 550.

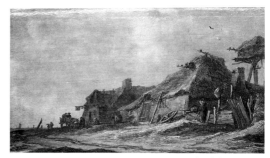

Fig. 17. Jan van Goyen, *Cottages near the Sea*, signed and dated 1631, panel, 30 x 50 cm., Musée des Beaux-Arts, Carcassonne, no. 893.1.355.

To the world
My oft besieged ship, plaything of the cruel winds
Toy of the nasty waves, oh ship that was nearly split,
Run over cliff after cliff, and foam, and sand;
 Puts in to harbor early, for which my soul longs.
. .
Alight you tired soul, alight! We are ashore!
Why fear you the port, now you are free of all bonds
 And fear, and bitter pain, and heavy sorrows.
Goodbye, cursed world: you sea full of rough storms!
Blessings to my fatherland, hold the steady calm in refuge
 And shelter and peace, you eternally illuminated castle![39]

Once again there is an image fully derived from the Bible and medieval exegesis, in a text one could use without changes as a commentary on Pieter Codde's *Portrait of a Young Man* or on numerous seascapes, with or without cliff-lined coasts and castles perched on high.

It may have become clear by now that the conceptions of the landscape image encountered in the words and images of van Mander and Jan Luyken, in several "pictures within pictures," and in the writings of van Lodestyn and especially of Gryphius were not the notions of a few isolated personalities but corresponded to a widespread tradition rooted in medieval ideas. Quite another question is whether the system, this "visual language," can also really contribute to a

deeper understanding of Dutch landscape painting. It would be premature to claim that one can "read" any given landscape painting in precise detail as long as the meaning of some important motifs is still unexplained. However, it seems reasonable to maintain that the "language" as such existed and that, drawing on the interpretations set forth above, one can understand numerous images better than before. Following is a selection from the works of three artists of different generations and very different nature that may be used to demonstrate this: Jan van Goyen (b. 1596), Rembrandt (b. 1606), and Jacob van Ruisdael (b. 1628/29). This selection does not of course result in a systematic overview of the motifs and their development (which would in time certainly be desirable), since much more extensive groundwork would be required than has yet been accomplished. Nevertheless, it may be said that the examples chosen are to be taken not as exceptional cases but as representing entire groups of pictures, including works by other artists.

Despite the thematic diversity of Jan van Goyen's enormous production, it is possible to extract a limited number of subject types and motifs that constitute the iconographic skeleton, so to speak, of his work. His *Cottages near the Sea*, dated 1631 (fig. 17),[40] belongs to a group of paintings that also includes the 1630 *Farmhouses with Peasants* (cat. 34), whose constituents are often analyzed and esteemed for their diagonal spatial effects and their play of light and shadow. From the thematic point of view, however, one recognizes a striking similarity to the depiction of idle country life by De

Gheyn II or Abraham Bloemaert's versions of the same theme. A dilapidated farm with a broken wheel and two chatting figures, behind them a dovecote – all of this indicates the same idleness and lasciviousness that are suggested in the works of the older artists. A new element in van Goyen's painting is the humble tavern, identified by its sign, which was described as the embodiment of depravity in medieval sermons; here a carriage has paused rather than continued toward the journey's goal. Tobias and the angel are not there; but perhaps two tiny figures with their backs turned, one of whom carries a long stick with a sack, may be seen as substitutes for them. They seem to be the only travelers in the picture with a goal in mind and recur as such in a great many other van Goyen works, including the 1630 *Farmhouses with Peasants*. It can hardly be fortuitous that the pilgrim on his life's journey toward heavenly paradise was described during the late Middle Ages as carrying a sack containing his sins on his right shoulder.[41] In the light of this, the contrast between the idle figures in the foreground and the purposeful travelers appears to be deliberate. In other works by van Goyen, Raupp could detect similar contrasts between the sinners (sometimes portrayed in a ferry as personifications of the Five Senses) and the pious (sometimes represented praying).[42] The goal of the travelers is not depicted in the two pictures mentioned; often, however, it is suggested by a church or only a steeple in the distance. Such motifs belong to what may be considered as stock motifs, and so does the carriage. The latter is obviously associated

with the image of the journey through life and was described by Luyken as such: "By rolling wheels of day and night / On life's wagon we are / Brought seated on our way / And carried toward eternity."[43] Provided, of course, that the driver follows the straight path, "the way of all the truly pious." Hence Luyken's legend for this emblem: *Prudence*.

The freedom with which artists of the seventeenth century treated topographical subjects has often been noted but never satisfactorily explained. It would seem that these subjects could be handled freely, because they were adopted on account of their thematic meaning and their symbolic function in an iconographically determined context. Like many others, van Goyen transplanted repeatedly identifiable topographical subjects, especially churches and city gates, to an imaginary setting. His rendering from nature of the never completed Hooglandse Kerk, or Saint Pancras's Church, in Leiden, shows it towering above the roofs of the surrounding houses.[44] A similar drawing must have been the basis for his depiction of the same church in a painting of 1643 (fig. 18).[45] Here, however, it stands almost isolated within narrow ramparts on the banks of a broad river and, moreover, has been robbed of its chancel. In this new context the Leiden church appears to have become a symbol of the eternal city, of heavenly Jerusalem, just as more or less remote cities assume this role in the works of many artists, among them (as will be shown) Rembrandt. Furthermore, it seems that the river illustrates the transitoriness of life, a theme alluded to by several biblical passages along with later interpretations.[46]

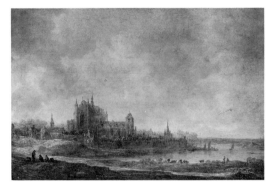

Fig. 18. Jan van Goyen, *Landscape with Saint Pancras's Church, Leiden*, signed and dated 1643, panel, 39.8 x 59.5 cm., Alte Pinakothek, Munich, inv. 4892.

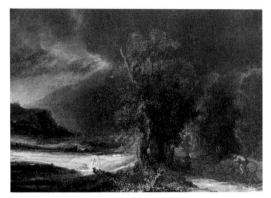

Fig. 19. Rembrandt, *Landscape with the Good Samaritan*, signed and dated 1638, panel, 46.5 x 66 cm., Muzeum Narodowe, Kraków.

The group of idle and chatting figures in the left foreground, like the herdsmen with their cows on the riverbank, have become familiar as representatives of Sloth and Lust. It may come as a surprise that van Goyen's images should have dealt so often – or even as a rule – with the transience of a vain world. That they did so can be demonstrated, however, by numerous examples, among them the well-known *Landscape with Two Oaks* of 1641 (cat. 36).[47] As in several other works by van Goyen, the weather-beaten trees are treated as protagonists, thus emphasizing their symbolization of *vanitas*. Equally clear is the meaning of the idle, chatting figures, and perhaps the interpretation of the horizon as the end of life, which appears in Luyken (fig. 12), could be applied to such a panorama. The traveler descending a hill with his back to the viewer might well be the pilgrim, approaching the church in the distance to the left. One may even wonder whether a thematic significance may be attached to the play of light and dark, especially in the *Saint Pancras's Church*, and to the color scheme, virtually restricted to gray and ochre hues, in the *Two Oaks*, which evokes the absence of sunlight. In view of the symbolism of light, then, van Goyen and Rembrandt may not have been such different artists, as we have been accustomed to assume.

Rembrandt differed from van Goyen in that he was not a typical landscape painter. If he had never produced a landscape, he would scarcely seem another kind of artist. But he did paint landscapes whose place in his oeuvre or in the pictorial production of his time is not easily assessed. The *Landscape with the Good Samaritan*, dated 1638 (fig. 19), is

linked to a surprising degree with the Flemish tradition of the early seventeenth century. The incidence of biblical staffage appears already antiquated, and the division of space into a lowland and a higher forested area can be ultimately traced to the style of Bruegel. Hence one is less inclined here than in van Goyen's case to believe in a "realistic" depiction. This does not seem to make any significant difference to the iconographic program. Already in the sixteenth century the Good Samaritan, like the young Tobias, was one of the prototypes of the pious soul on the pilgrimage of life. His path takes him first through a dark forest, where a hunter and a pair of lovers represent the sinful temptations, as does a scarcely visible angler to the left in the lowlands. At the end of the forest the road bends left toward the plain, where in sunlight under a largely gray sky a carriage, this time a coach-and-four, approaches a bridge; next to the bridge a river flowing toward the front creates a waterfall. In the distance a city is bathed in twilight. One might not seek an iconographic program in these motifs if the same combination were not found in other works of Rembrandt and his school and a coherent interpretation based on several texts did not offer itself. As for analogies, in Rembrandt's *Landscape with a Thunderstorm* (fig. 20) one sees, as before, a carriage, this time midway up a mountain, approaching a bridge; next to the bridge there is again a waterfall, and behind it a city raised high and in sunlight. These similarities can scarcely be coincidences. We have seen already that the river can stand for the transitoriness of life; the waterfall, as will be discussed later with

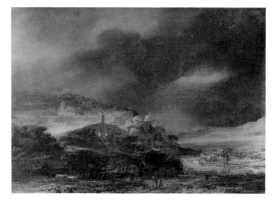

Fig. 20. Rembrandt, *Landscape with a Thunderstorm*, signed, panel, 52 x 72 cm., Herzog Anton Ulrich-Museum, Braunschweig, inv. 236.

reference to Ruisdael, had the same meaning. The bridge is explained by Luyken as a symbol of Christ, on the grounds, strangely, of John 14:6: "I am the way, the truth, and the life."[48] Luyken, however, did not invent this. Picinelli had already written in 1635, with reference to the same Bible passage: "The bridge, which leads over the river to the city, carries the [emblematic] heading 'For You to Cross' ('Ut transeas'). Christ said of himself: 'I am the way.' Therefore one cannot help but tirelessly follow the path to perfection and eternal salvation."[49]

No doubt the Luyken and Picinelli commentaries were based on a common tradition, which appears, incidentally, to have found expression already in landscapes of the sixteenth century. Furthermore the interpretation of the city as symbol of salvation confirms the reading given earlier with reference to van Goyen's Saint Pancras's Church (fig. 18). The interpretation of the bridge is sometimes emphasized

in pictures by the addition of a cross or, as in Rembrandt's *Landscape with a Thunderstorm*, of a tabernacle. Finally, the wagon has already been encountered in van Goyen as an image of the soul in search of salvation. Both these landscapes by Rembrandt thus show the human soul on its way through the sinful and transient world, at the end of which eternal salvation is accessible to "all the truly pious." However, not only in these fantastic pictures by Rembrandt but also when the character of the scene is closer to reality, the underlying program is determined by the same message. *The Stone Bridge* (cat. 76) shows a carriage pausing at an inn in the shadows to the left; we now know its meaning. To the left, in the middle ground, directly illuminated by the sun, a lone traveler with a staff over his shoulder approaches a bridge. Beyond the bridge stands a fence, likewise fully illuminated, in front of several old trees, which suggest transitoriness. The fence as a conspicuous motif has been seen already in van Goyen's *Cottages near the Sea* (fig. 17; see also cat. 34 and 35); here, however, it assumes – just as in Salomon van Ruysdael (cat. 90) – so central a place that it appears to constitute a significant grouping with the trees. If we are to believe Roemer Visscher, the fence in fact evoked death; he linked the motif with the following verses: "Fear the day / Which no one can pass by."[50] Therefore, whosoever should bypass the sinful tavern, the picture implies, and reach death by way of Christ's bridge, is assured arrival at the church visible to the extreme right; it must be supposed that the latter means salvation, as in De Gheyn II, van Goyen, and so many others. Whether

Fig. 21. Rembrandt, *A Cottage behind a White Paling*, drawing, 170 x 255 mm., Rijksprentenkabinet, Amsterdam.

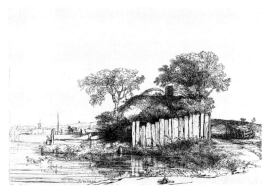

Fig. 22. Rembrandt, *A Cottage behind a White Paling*, 1646, etching.

Rembrandt's painting can be viewed as a topographically exact representation of a real situation, as was once assumed, seems extremely doubtful. Like his contemporaries' landscapes, it is, rather, the depiction of a conceivable view, not taken from reality but devised on the basis of an iconographic program. In his etchings, Rembrandt remained occasionally somewhat closer to reality. If one supposes at least that the drawing *A Cottage behind a White Paling* (fig. 21) is based on on-the-spot observation, the corresponding etching (fig. 22) is to be viewed virtually as a rendering of nature; but the slight additions made by the artist betray here again his intention of giving the picture a meaning of its own. The dilapidated farmhouse among the trees and the conspicuous fence by themselves represented death and transience, a horse's skull only reinforced this meaning, and a tiny traveler with his sack, approaching the farm by following the dike, now assumes the role fulfilled in the *Stone Bridge* by the lone traveler who goes to meet his death.

It is interesting to note that Rembrandt's own landscape paintings and those by his pupils (or former pupils) are not only of the same type but also present the same iconographic features. The *Landscape with an Obelisk* in the Isabella Stewart Gardner Museum, Boston (cat. 29), recently attributed to Govaert Flinck, is a case in point. The composition is obviously modeled on that of Rembrandt's *Landscape with the Good Samaritan*. As in the latter, the shattered tree and tree trunk in the foreground speak clearly of transience, and so does the river meandering through the plain, forming no

less than three waterfalls. In the left foreground there is a stone bridge and a man pulling a horse and cart over it with some difficulty. On the strength of Rembrandt's *Stone Bridge* we would expect a symbol of death behind the bridge – and that is exactly what the obelisk meant according to medieval belief and Renaissance imagery! A horse-drawn coach is moving away from a distant city – no doubt the heavenly Jerusalem – apparently in deliberate contrast to the humble man who makes an effort to pull his cart over the bridge in the foreground. In the meantime, two men in the center foreground, obviously hunters (since one of them is carrying a falcon), represent sin, not only because of their activity but also because they are going the wrong way.

However markedly Jacob van Ruisdael differs as an artist from Rembrandt – he was almost exclusively a landscape painter and belonged to a much younger generation – iconographically the distinction between them is not as great as one might imagine, and in Ruisdael the relationship to nature is scarcely less problematical. It has long been recognized that the *Wooded Landscape with Bentheim Castle*, dated 1653 (fig. 23) is not based on a real situation;[51] the castle in fact merely stands on a low hill in flat Westphalian country. Why then has Ruisdael, like his traveling companion Claes Berchem, depicted in this and in other pictures with the same motif a forested hill with the castle as a dramatic climax? Relatively vague artistic considerations have always been adduced to explain this and other similar liberties. Artistic considerations evidently determined the composition and color

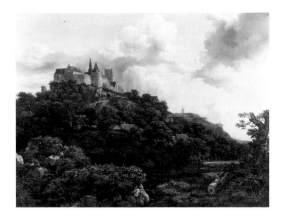

Fig. 23. Jacob van Ruisdael, *Wooded Landscape with Bentheim Castle*, signed, 1653, canvas, 110.5 x 144 cm., Alfred Beit Foundation, Russborough, Co. Wicklow.

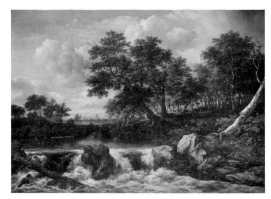

Fig. 24. Jacob van Ruisdael, *Landscape with Waterfall*, signed, canvas, 142 x 195 cm., Rijksmuseum, Amsterdam, inv. C 210.

scheme of the picture to a large extent, but the conscious and recurring deviations from reality are governed without a doubt by the iconographic program. Bentheim Castle does not appear here for the sake of the topographic motif – which anyway must have been scarcely recognizable to a Dutch audience! – but as the castle on the mountain, the eternal city on Mount Zion.[52] Felled trees in the foreground and lacerated or nearly dead trees emphasize the *vanitas* symbolism of the forested area, through which the tiny travelers must move in order to reach their goal. An almost identical program is the basis for a group of pictures in which a forested area is seen over a wide waterfall and, in the distance, a small church (see fig. 24).[53] That the waterfall, especially, should play an important role in Ruisdael's work is explained surely by the iconographic attraction of this motif, which is nowhere to be found in Dutch reality. The old tradition that I mentioned earlier in referring to the river in van Goyen appears to find even stronger expression in the motif of the waterfall.[54] A text by Augustine, cited by Picinelli under the heading "Flumen" ("River"), worded it as follows: "As the river swells from rainwater, overflows, rages, flows and in flowing slides down – so is the course of mortality: Humans are born, they die, and while some die others are born and supersede them, step forth, but do not long remain. What remains in place here? What does not vanish in the abyss as if it were swollen from rain?"[55] And even in 1711 Jan Luyken wrote: "Away water all of vanity, / That steadily glides downward."[56] We may therefore view the waterfall and

trees as an expression of the same idea. The church in the distance, which has displaced the castle as a symbol of salvation, is situated behind orderly cornfields, which appear to stand in deliberate contrast to the barren foreground, as found already in De Gheyn II and in many other works by Ruisdael. Ruisdael's numerous depictions of waterfalls in vertical format must have been especially esteemed (cat. 85).[57] As has been rightly assumed, they were based on pictures by Allart van Everdingen, who had himself been in Sweden and could have observed such motifs there. But this is not the only reason that Ruisdael's paintings of this subject are often similar to each other; it is also explained by the way in which the composition is determined by the iconographic program: the now familiar *vanitas* motif in the foreground and the steep cliffs with a raised castle beyond, a scheme that (as we shall see) could already be found in Everdingen.

The most renowned case in which Ruisdael treated topographical motifs with extreme liberty consists, of course, in the two versions of the *Jewish Cemetery*, the larger of the two (with the ruin of Egmond Abbey Church in the background) in Detroit (cat. 86) and the smaller one (with the ruin of Egmond Castle) in Dresden.[58] A drawing of his in Haarlem's Teylers Museum is enough to persuade us that the cemetery, which is near Amsterdam in Ouderkerk, appeared more or less as it does today; it was not in any case divided by a brook, nor was one of its boundaries a forested hill with dead trees and a ruin. Ruisdael's rearrangement of the graves is

only a minor point. The nature of his important changes and the effect of the menacing, cloudy gray sky were such that Goethe, unfamiliar with the "language of images" but in consonance with his classical artistic ideal, felt in 1816 that here "the pure-feeling, clear-thinking artist, showing himself a poet, has achieved a perfect symbolism."[59] Since then the Dresden *Jewish Cemetery*, like the version in Detroit, has been deemed an exceptional case in Ruisdael's work, and indeed (what for Goethe was not yet acceptable) a representation of the vanity of worldly life. We now know, it seems reasonable to say, that in this respect both pictures are not at all exceptions but, on the contrary, in an especially impressive manner show the iconographic essence of Ruisdael's work. Wiegand has explained the individual motifs, including the Jewish graves, in an exemplary way, and even the rainbow in the Detroit version, which could also be interpreted as a sign of God's blessing, turns out to have been used as a *vanitas* symbol in the seventeenth century on the strength of its fugitive nature.[60]

There is one thematic feature that all the pictures mentioned above, from those by Bloemaert and his contemporaries to those by Jacob van Ruisdael, would seem to have in common. None of them are as concerned with an incidental subject – even when a particular building or topographical situation may be recognized – as with an image of human life in general. In this respect seventeenth-century landscape painting continued what had been initiated in the works of Patinir, Bruegel, and their contemporaries and followers in the sixteenth century. It is

the image of a transient world, where the lonely traveler, beset by sinful temptations, may hope for eternal bliss after death. Whether biblical figures take part is of minor importance: if they do, they merely exemplify the pious soul without bringing any substantial change to the idea underlying the scene. It is mainly this idea and the limited number of stereotyped motifs that represent it that give expression to an ever recurring, essentially religious belief.[61]

If we review the somewhat fragmentary results of this discussion, a question arises about the credibility of this religio-literary interpretation of an art that still seems to us so natural and matter-of-fact. Is there no contradiction in this? I believe not. The problem is a typically modern one; it lies in our reception of a work of art and has nothing to do with the aesthetic intentions of the artist or the social meaning of his work in the seventeenth century. How we, as modern viewers, relate to the landscape painting of the seventeenth century was addressed at the beginning of this essay, and of course it is not easy for us to free ourselves in this regard from our historical conditioning. We can only try to imagine roughly what the situation was in that period.

The "imitation of nature," that is, the realistic reflection, based on observation, of an invented reality, was demonstrably a requirement in the painter's training. It was imperative as a technical device for creating a picture. The picture's value, incidentally, was dependent not only on its technical success – its quality – but also to a great degree on its size and subject. According to

old inventories, landscape was not among the expensive kinds of painting.[62] One has the impression that typical landscape painters often made a living in other ways or sank into poverty. Landscape paintings were popular as well as relatively inexpensive. Foreigners were surprised by the paintings owned by humble people and the rich supply in fairs. The English diarist John Evelyn, for example, remarked particularly on landscapes ("Landscips") and their low prices.[63]

This documentation supports the view that the landscape picture contained a message (without which the landscape in the seventeenth century would not have become a landscape picture!) that was accessible not only to a limited group of the humanistically educated but also to a broad segment of the population, the faithful of various denominations. This was possible because both the structure and the content of this message were determined, as in the sixteenth century, far more by long-standing conceptions than by denominational differences. The structure of this tradition consisted in the metaphorical use of biblical and other texts, its content in the strict moralistic views of a puritanical society.

Fig. 25. Corridor in the Trippenhuis, Amsterdam (now the Royal Netherlands Academy of Arts and Sciences).

Fig. 26. Allart van Everdingen, *Landscape with Waterfall*, canvas, 110.3 x 100.3 cm., Trippenhuis, Amsterdam.

We who are saturated every day with virtually meaningless images can hardly imagine how paintings addressed their owners from the walls of town and country dwellings. We know from several "pictures within pictures" how small and middle-sized paintings were framed and hung on the wall; such paintings could also be set into the wainscotting, either over the door or the fireplace or on a great stretch of a wall. Landscape pictures were used for all these ends. Sketches by Jan van Goyen show how in the 1640s overdoors could be framed with luxuriant baroque decoration;[64] some of his paintings appear to have been destined for such a use, judging by their coarse execution and unusual format. In only a few instances have such pictures remained in place. The two corridors on the second floor of the palatial double house built around 1660 in Amsterdam for the brothers Trip, arms merchants of international stature, may give some idea of the original arrangement (fig. 25).[65] Each contains two of Allart van Everdingen's painted overdoors with Swedish motifs, for the Trip family maintained its gun foundries in that country. Two of these pictures depict waterfalls, which, as mentioned earlier, van Everdingen (and after him Ruisdael) often painted (see fig. 26). Here again the *vanitas* symbolism is unmistakable, as is the intimation of heavenly bliss, this time in the shape of a small church on the steep cliff to the right. Death spares no one; our salvation is not of this world. This held too for the inhabitant of this house, the fabulously rich Louys Trip, and he even wanted to be reminded of this each time he entered his room. Those who

consider such a thought odd, underestimate the characteristic tension for a puritanical cast of mind between renunciation and worldly life, between pious anticipation of heavenly salvation and social success. The idea of *vanitas* ubiquitous in the Netherlands of that time appears almost banal to us, its profession again and again almost senseless. But then our own historical conditioning must be responsible for this attitude; we are simply unable to imagine the vitality of such a morality. This, then, is our inadequacy, if understanding the "visual language" of that time is our aim. But perhaps it is necessary to be something of a puritan in order to be able to admit this.

The text of this essay was originally written as a lecture in German. The English translation is by Michael Armstrong Roche.

NOTES

1. See, for example, Stechow 1938b and Niemeijer 1959.

2. For quotations concerning Ruisdael, see Wiegand 1971, pp. 23–28.

3. See note 2. Walford 1981 unfortunately remains unknown to me.

4. Raupp 1980.

5. Tervarent 1958, s.v. "colombe," cols. 104–106; Emile Mâle, *L'Art religieux de la fin du moyen âge en France* (Paris, 1908), fig. 171 (Bibliothèque Nationale, Paris, MS. franç. 400).

6. On the harpsichord depicted in Frans Floris, *Family Group*, in Lier (Van de Velde 1975, no. 150, fig. 78).

7. Müller 1927a. Bloemaert's 1629 version of the subject in Berlin, reproduced there, shows the same dovecote as the Utrecht picture, apparently on the basis of the same model drawing.

8. The significance of these scenes is borne out by the Latin inscriptions accompanying a series of sixteen pastoral scenes engraved by Cornelis Bloemaert after his father's design (Hollstein, vol. 2, nos. 212–215), which clearly identify Sloth as the central theme. The same meaning was attached to a pastoral scene by Rubens, as is clear from an inscription on an engraving after this artist's *Landscape with Shepherds and a Rainbow* in Leningrad. That such an interpretation would have run counter to Rubens's own intentions seems to me an anachronistic assumption (see L. Vergara, *Rubens and the Poetics of Landscape* [New Haven and London, 1982], p. 60).

9. Van Regteren Altena 1983, vol. 1, p. 93.

10. Hans Mielke, Review of K.G. Boon, *Netherlandish Drawings of the Fifteenth and Sixteenth Centuries* (The Hague, 1978), *Simiolus* 11 (1980), p. 46.

11. See E. de Jongh's introduction to Amsterdam 1976, figs. 1 and 2; Hollstein, vol. 11, no. 344. A simplified anonymous copy was used to illustrate a New Year's poem in 1604; see H.E. Greve, *De tijd van den Tachtigjarigen Oorlog in beeld* (Amsterdam, 1908), p. 113.

12. Falkenburg 1985.

13. See, for example, S.C. Chew, *The Pilgrimage of Life* (New Haven, 1962). On the transmission of this theme through sermons, see G.R. Owst, *Literature and Pulpit in Medieval England* (Oxford, 1961), esp. pp. 97ff.

14. Amsterdam Historical Museum (attributed to Dirck Jacobsz); see Haarlem 1986, no. 11.

15. J. Luyken, *De onwaardige Wereld vertoond in zinnebeelden* (Amsterdam, 1710), p. 192.

16. "ô Mensch! Wat u ontmoet, op Uwe levens reizen, / Dat zulks u altemaal als tot een vinger zy, / Om u den rechten weg, tot uw Geluk te wyzen, / Zo gaat gy al gestaag Uw ongeluk voorby."

17. Luyken 1711, p. 6.

18. "Als is den opgang hoog en steil, / Men doet het om een Eeuwig Heil." Ibid. p. 248.

19. Wadsworth Atheneum, Hartford, *Pictures within Pictures* (1949); Stechow 1960c; and A. Chastel, "Le Tableau dans le tableau," in *Stil und Überlieferung in der Kunst des Abendlandes. Akten des 21. Internationalen Kongresses für Kunstgeschichte in Bonn 1964* (Berlin, 1967), vol. 1, pp. 15–29.

20. See, however, for example, Eddy de Jongh, *Zinne- en minnebeelden in de schilderkunst van de zeventiende eeuw* (Amsterdam, 1967), pp. 48–52; and Amsterdam 1976, nos. 4, 18, 23, 25, 29, 30, 39, 41, 42, 47, 53, 54, 60, 61, 63, and 71.

21. See R.-A. d'Hulst, "Nieuwe gegevens betreffende J. van Winghe als schilder en tekenaar," *Bulletin Koninklijke Musea voor Schone Kunsten Brussel* 4 (1955), pp. 239–48.

22. See de Jongh, *Zinne- en minnebeelden*, pp. 6–8.

23. Quoted after Alardus Amstelredamus, *Selectae similitudines, sive collationes . . .* (Cologne, 1539), p. 285: "Omnia vanitas, omnia repente spiritus flatu, tanquam folia cuncta decussa sunt, & arbor nuda derelicta est, & non solum nuda, sed ab ipsis convulsa radicibus. Omnia nox sunt, & somnium, & die orto nusquam comparuerunt. Umbra erat, & pertransiit. Fumus fuit, & dissolutus est. Bullae aquarum fuerunt, & disruptae sunt. Araneae telae erant, & discussae sunt." This text is remarkable in that it mentions besides the tree a number of other *vanitas* motifs that were still current in the seventeenth century: the shadow, the smoke, the soap bubble, and the cobweb. This makes its frequent use by preachers all the more likely.

24. Paris 1970–71, no. 39.

25. Ibid., no. 69; Amsterdam 1976, no. 18.

26. J. de Brune, *Emblemata of Zinne-werck* (Amsterdam, 1624; reprint ed., Soest, 1970), no. XXXII.

27. J.S. Kunstreich, *Der geistreiche Willem: Studien zu Willem Buytewech 1591–1624* (Cologne, 1959), p. 68.

28. "De wisse dood, is ider eens verschiet." Luyken, *De bykorf*, pp. 30–32.

29. J. Luyken, *Beschouwing der Wereld* (Amsterdam, 1708), p. 66: "ô Wereld! zeer gevaarlijk Woud! / Met veelerhande lof bewassen, / Waar achter zich 't verderf onthoud, / Om 't acht'loos leeven t'overrassen."

30. Raupp 1980, p. 95.

31. See, for example, Eddy de Jongh, "Erotica in vogelperspectief," *Simiolus* 3 (1968–69); Amsterdam 1976, nos. 13, 46, and 56.

32. Quoted, along with many references to other church fathers, by D.W. Jöns, *Das "Sinnen-Bild": Studien zur allegorischen Bildlichkeit bei Andreas Gryphius* (Stuttgart, 1966), pp. 191ff. On the role of the symbolic ship in English medieval sermons, see Owst, *Literature and Pulpit*, pp. 67–76; for its occurrence in Petrarca and Michelangelo, see *Die Dichtungen des Michelangiolo Buonarroti*, ed. C. Frey (Berlin, 1897), pp. 236, 486.

33. See W.J. Müller in Braunschweig 1978, no. 2; Bentkowska 1982.

34. Beening 1963, pp. 50–59. This study gives a useful anthology of landscape descriptions from works by Dutch poets c.1570–1700.

35. J. van Lodensteyn, *Uyt-spanningen* (Utrecht, 1676). See in particular pp. 141–52: "Niet en Al, dat is, Des Werelds Ydelheyd, en Gods Algenoegsaamheyd" (from 1654); the title refers to the world (which is nothing: "Niet") and God (who is all: "Al").

36. I borrow the phrase from Jöns, *Das "Sinnen-Bild,"* p. 235.

37. Wiegand 1971, p. 34.

38. ". . . O dreymal höchste Macht / Erleuchte den, der sich itzt beugt vor deinen Füssen! / Vertreib die dicke Nacht, die meine Seel umbgibt, / Die Schmerzen Finsternüss, die Hertz und Geist betrübt, / Erquicke mein Gemütt, und stärcke mein Vertrauen. / Gib, dass ich diesen Tag, in deinem Dienst allein / Zubring: und wenn mein End' und jener Tag bricht ein / Dass ich dich, meine Sonn, mein Licht mög ewig Schauen." For text and comments see Jöns, *Das "Sinnen-Bild,"* pp. 91ff.

39. "An die Welt / Mein offt bestürmbtes Schiff der grimmen Winde Spil / Der frechen Wellen Baal, das schir die Flut getrennet, / Das uber Klip auf Klip', undt Schaum, und Sandt gerennet; / Komt vor der Zeit an Port, den meine Seele wil. / . . . Steig aus du müder Geist, steig aus! wir sind an Lande! / Was graut dir für den Port, itzt wirst du aller Bande / Und Angst, und herber Pein, und schwerer Schmertzen loss. / Ade, verfluchte Welt: du See voll rauher Stürme! Glück zu mein Vaterland, das stette Ruh' im Schirme / Und Schutz und Frieden hält, du ewig-lichtes Schloss!" For text and comments see Jöns, *Das "Sinnen-Bild,"* pp. 191ff., esp. pp. 197–98. Also quoted by Raupp 1980, p. 99.

40. Beck 1972–73, vol. 2, no. 998. Closely connected with the group of landscapes of this type is *Dune Landscape* from the early 1630s at Braunschweig (ibid., no. 1140), included in the exhibition (cat. 35, in Amsterdam only). That the

goats were here a later addition, as suggested by Beck, is highly unlikely from the iconographical as well as the stylistic point of view.

41. In a treatise entitled "Weye to Paradys," of c.1400 (British Museum, London, Ms. Harley 1671, fol. 5); see Owst, *Literature and Pulpit*, pp. 105–106.

42. Raupp 1980, pp. 101–104.

43. "Door 't draaijend rad van dag en nacht, / Zo worden wy op 's levens wagen, / Al zittende over weg gebragt, / En na de Eeuwigheid gedraagen." Luyken, *De bykorf*, pp. 82–85; see also pp. 284–87 ("De reizende man"), an image of the traveler's return to his Creator in heaven.

44. Beck 1966b, pl. 27; Beck 1972–73, vol. 1, no. 845/27.

45. Beck 1972–73, vol. 2, no. 333.

46. See, for example, Ph. Picinelli, *Mundus symbolicus . . .* (Milan, 1635) [Latin trans., Cologne, 1681, 1695.], book 2, chap. 24, no. 448 (s.v. "flumen"). See also note 55 below.

47. Beck 1972–73, vol. 2, no. 1144 (with the unlikely suggestion that this would be a view of the Rhine with Wageningen).

48. Luyken, *De bykorf*, pp. 10–13.

49. Picinelli, *Mundus symbolicus*, book 16, chap. 14, no. 129: "Pons, per flumen ad urbem stratus, epigraphen tenet: UT TRANSEAS. Christus de se ipso pronunciavit: *Ego sum via*. Superest ergò, ut hanc viam ad perfectionem & aeternam beatitudinem indefesè incedas."

50. "Vreest voor den dagh, / Die niemandt verby en magh." Roemer Visscher, *Sinnepoppen* (Amsterdam, 1614; The Hague, 1949), p. 67. See also Lotte Brand Philip, "'The Pedler' by Hieronymus Bosch," *Nederlands Kunsthistorisch Jaarboek* 9 (1958), pp. 72–73.

51. The Hague/Cambridge 1981–82, nos. 12–14, pp. 50–55.

52. Wiegand 1971, pp. 93–98, followed by Raupp 1980, pp. 92–93, interpreted the elevated castle, wrongly in my opinion, as an image of Pride (*superbia*) mainly on the basis of emblematic material. On the symbolic use of the castle in various meanings – including that of "the Celestial Fortress" – by English preachers during the Middle Ages, see Owst, *Literature and Pulpit*, pp. 77–85. "In the fourteenth and fifteenth centuries, such symbolic castles were clearly nothing less than commonplaces of the pulpit" (ibid., p. 84).

53. The Hague/Cambridge 1981–82, no. 35, pp. 106–107.

54. This interpretation of the waterfall motif was already given by Wiegand 1971, pp. 87–91.

55. Picinelli, *Mundus symbolicus*, book 2, chap. 24, no. 448, quoting Saint Augustine's commentary on Psalm 109: "Sicut torrens pluvialibus aquis colligitur, redundat, perstrepit, currit, & currendo decurrit: sic est omnis iste cursus mortalitatis: nascuntur homines, moriuntur, & aliis morientibus alii nascuntur: succedunt, accedunt, non manebunt. Quid hic tenetur? quid non, quasi de pluvia collectum, it in abyssum?" See also Jöns, *Das "Sinnen-Bild*," pp. 244–46.

56. "Weg water aller idelheid, / Dat stadig na beneden glyd." Luyken, *De bykorf*, p. 87.

57. The Hague/Cambridge, Mass. 1981–82, no. 34, pp. 102–105.

58. Ibid., nos. 20–21, pp. 67–77.

59. "Ruysdael als Dichter," in *Goethes Werke*, 5th ed. (Hamburg, 1963), vol. 12, pp. 138–42 (comments by H. von Einem, pp. 611–13).

60. Wiegand 1971, pp. 57–85.

61. It is worth mentioning in this context that landscapes with or without religious staffage were frequently used to decorate Catholic churches in the Southern Netherlands during the seventeenth century (not to mention sixteenth-century Rome: Polidoro da Caravaggio in S. Silvestro al Quirinale, Paul Bril in S. Maria Maggiore!). In 1769 J.-B. Descamps described landscapes by such artists as Lucas Achtschellinck, Jacques d'Arthois, Daniel van Heil, and Cornelis Huysmans as hanging in churches in, e.g., Brussels: the chapel of Our Lady in the then collegiate church of SS. Michel et Gudule, the parish church of Notre-Dame de la Chapelle, and the conventual church of the Annonciades (*Voyage pittoresque de la Flandre et du Brabant* [Paris, 1838; 1st ed. 1769], pp. 58, 47, and 80); Malines: the conventual churches of Notre-Dame de la Vallée de Lys (Leliëndaal) and Notre-Dame de Hanswyck (ibid., pp. 126 and 128); Antwerp: the churches of the Augustinians, the Shod Carmelites, and the Unshod Carmelites (ibid., pp. 168, 172, and 173); and Bruges: the parish church of Saint Anne, the Abbaye des Dunes, the Jesuits' and the Dominicans' churches (ibid., pp. 277, 278, 280–81, and 283). Only rarely are these paintings still *in situ* – as in the Chapel of the Sacrament, Notre-Dame de la Chapelle, Brussels, and in Notre-Dame de la Vallée de Lys, Malines – or to be found elsewhere in the same church – as in what is now Saint Michael's Cathedral, Brussels, where they were still in their place in the Lady Chapel until 1882 (G. des Marez, *Guide illustré de Bruxelles* [Brussels, 1918], p. 296) and have since been distributed over the transept and sacristies (E. de Callatay, "Etudes sur les paysagistes bruxellois du XVIIe siècle," *Revue belge d'archéologie et d'histoire de l'art* 29 [1960], pp. 171–77). Sometimes they ended up in the local

museum, as did works by d'Arthois, Pieter van Bredael, and Achtschellinck from the Abbaye des Dunes and the Dominicans' church in the Musée Communal at Bruges. This use of the landscapes has never (to my knowledge) been satisfactorily explained but becomes understandable if one sees them as images of the sinful world and ultimate salvation. It should be added that the iconographic types found in these paintings closely correspond to those used in the Northern Netherlands.

62. While dealing with the value of works of art, Montias (1982, pp. 259ff.) does not go into the question of the relative prices of various genres. It appears from his investigation of Delft inventories, "that the subject matter of the paintings collected underwent a gradual but profound change in the course of the century. Religious and mythological 'histories,' as well as allegories, receded in importance; landscapes . . . gained most of the ground 'histories' had lost." The author adds, somewhat prematurely, that these landscapes "were gradually shorn of their earlier religious or otherwise symbolic significance" (p. 270; cf. pp. 241–42). One might, on the contrary, argue that the changing proportion bears out the "religious or otherwise symbolic significance" that was attached to landscapes.

63. Quoted in Rosenberg et al. 1966, p. 9. See, however, the critical comments in Montias 1982, p. 269: "The evidence in this chapter suggests that the buyers of master painters' works were mainly in the top third of the wealth distribution" – which still would be no mean number!

64. Beck 1966b, pls. 98–108; Beck 1972–73, vol. 1, nos. 845/98–108.

65. See D.P. Snoep, "Het Trippenhuis, zijn decoraties en inrichting," in *Het Trippenhuis te Amsterdam*, ed. R. Meischke and H.E. Reeser (Amsterdam, 1983), pp. 187–211, esp. 206.

The Market for Landscape Painting in Seventeenth-Century Holland

Alan Chong

The faires are full of pictures, especially Landscips, and Drolleries, as they call those clownish representations. The reason of this store of pictures and their cheapness proceede from their want of Land, to employ their Stock; so 'tis an ordinary thing to find, a common Farmor lay out two, or 3000 pounds in this Commodity, their houses are full of them, and they vend them at their Kermas'es to very great gaines.

John Evelyn, 1641[1]

As For the art off Paintings and the affection off the people to Pictures, I thincke none other goe beyond them . . . All in generall striving to adorne their houses, esp. the outer or street roome, with costly peeces, Butchers and bakers not much inferiour in their shoppes which are Fairely set Forth, yea many tymes blacksmithes, Coblers, etts., will have some picture or other by the Forge and in their stalle, Such is the generall Notion, enclination and delight that these Countrie Natives have to Paintings.

Peter Mundy, 1640[2]

The democratic distribution of paintings among the various levels of Dutch society caught the attention of many foreign visitors. Unlike the rest of Europe, the Netherlands abounded with collectors spanning the social spectrum; even citizens of modest means possessed pictures (simple prints or small paintings), as inventories and sales records indicate. The growth in art collecting accompanied the expansion of the so-called middle class, a burgeoning group that swelled in Holland as nowhere else.[3] The total number of paintings as well as the proportion of landscapes in inventories increased rapidly from 1600 to midcentury. As their prices decreased, landscapes became the most common type of painting (see table 1). Indeed, the prices and availability of landscape paintings made them the art form of the middle classes. The significance of wealthy and government patrons should not be underestimated, however. Not only did very rich collectors, dealers in art, and government organizations spend a much higher percentage of their income than the middle class on art, but their large expenditure also ensured that they played an important role in the patronage of landscape painting.[4]

A comprehensive survey of the patronage of Dutch landscape painting has not yet been attempted; conclusions have frequently been based on random pieces of evidence garnered from auctions or inventories. An examination of the major groups of patrons and a statistical analysis of the prices of landscape paintings reveal that the seventeenth-century Dutch art market was sharply divided between government and private patronage. Government organizations – the court, the States-General, and the city governments – paid vastly inflated prices, in effect honoraria or compensation for long-term services.[5] Among private collectors, three distinct groups with divergent motives and economic power can be identified: dealers (including many painters), serious collectors (members of a small affluent group who bought many works, often at high prices), and more casual collectors.[6]

Government Patrons

Though of overwhelming importance in the rest of baroque Europe, the royal court played a comparatively minor role in Holland, partly because the stadtholder's court, for all its pretentions, lacked exceptional power or social status. In addition, the office of stadtholder remained vacant for long periods, further diminishing its influence in art circles. Nonetheless, the decoration of the royal palaces of Honselaarsdijk (1630s) and Huis ten Bosch (c.1648–55), directed chiefly by Amalia van Solms, wife of Frederik Hendrik, was among the largest artistic undertakings of the century. Not surprisingly, the bulk of art assembled and commissioned by the court consisted of portraits and history painting. The ambitious decoration of the Oranjezaal at Huis ten Bosch employed the most prominent Flemish history painters as well as their Dutch colleagues who worked in an international classicizing style.[7] In these projects, landscape painting played a small role. Cornelis Vroom and Moyses van Wtenbrouck were employed in decorative schemes at Honselaarsdijk, but these seem

Fig. 1. Cornelis van Poelenburch, *Amaryllis Crowning Mirtillo*, monogrammed, canvas, 116 x 148.3 cm., Staatliche Museen, Berlin (DDR), inv. 956.

to have been in collaboration with other artists and probably included large figures.[8] Several other paintings by Wtenbrouck were destined for Honselaarsdijk; indeed, he appears to have been the highest-paid landscapist at court.

Around 1635 four Utrecht painters – Abraham Bloemaert, Cornelis van Poelenburch, Herman Saftleven, and Dirck van der Lisse – were commissioned to paint a cycle illustrating Guarini's *Il pastor fido*, which was installed in a room in Amalia van Solms's suite at Honselaarsdijk, along with a mantelpiece by Poelenburch and a set of flower paintings. The works show the strong classical and humanist orientation of the court (see fig. 1); these are figural paintings as much as landscapes, inspired by van Dyck's painting of the crowning of Mirtillo that the court had acquired earlier. Below each of the four large pieces were installed four panels depicting various activities in landscapes: shepherds by Dirck van der Lisse (fig. 2), a hunt by Gijsbert de Hondecoeter, a fish

market on a beach by Adam Willaerts, and a scene of "agriculture" (now lost).[9] The selected themes for these unusually shaped decorative paintings represent a programmatic concept of landscape otherwise unknown in Holland.

Poelenburch, one of the most popular painters at court, made his debut in the form of a gift to Amalia van Solms from the States of Utrecht in 1627. This painting of the Banquet of the Gods, for which the artist was paid 575 guilders, includes a subsidiary landscape. Despite the high price and importance of the purchase, the work was probably not specifically painted for the court since there are many similar works in Poelenburch's oeuvre, some of earlier date.[10] By 1632 no less than eleven paintings by Poelenburch hung in the Noordeinde Palace, in The Hague, although most were religious or historical works.[11] That Poelenburch and Wtenbrouck were the most important Dutch landscapists at the royal court reveals the court's taste for ideal landscape with classical figures.

Fig. 2. Dirck van der Lisse, *Landscape with Shepherd*, monogrammed, panel, 52.3 x 171 cm., Staatliche Museen, Berlin (DDR), inv. III/467.

A painting by Roelandt Savery of a menagerie was also in the 1627 Utrecht gift (fl.700; now in the Staatliche Museen, Berlin [DDR], inv. 710), and two other works by Savery were soon added.[12] The commissioning of the panels by de Hondecoeter and Willaerts already mentioned, together with the presence of works by Joos de Momper, Denys Alsloot, Jan Brueghel, and Paul Bril, indicates the interest of the court in Flemish landscape. The acquisition of two landscapes by Hercules Segers in 1632 is not in the least surprising if one considers the *flamisant* character of the artist's work.

In addition, the court appears to have commissioned landscapes of topographic interest to the stadtholder: naval battles (by Hendrick Vroom and Cornelis van Wieringen), views of royal palaces in Holland and abroad (by Frans Post, Abraham de Verwer, and Antonie Croos),[13] as well as two Brazilian landscapes by Post. The situation changed very little in later years, although at the Palace Het Loo in 1712 there were landscapes by Philips Wouwermans, Rubens, Poelenburch, and one attributed to Claude Lorrain, which all seem to have been purchased late in the seventeenth century.[14]

Given the court's taste for a refined international style, the absence of later Italianate painting (with the exception of Wouwermans) is especially curious. The court owned no landscapes by Asselijn, Both, Swanevelt, van Laer, Berchem, Pijnacker, du Jardin, or Adriaen van de Velde – all successful, well-known landscapists. Also surprising is the almost total exclusion of native Dutch landscapes; no

paintings by Avercamp, de Molijn, Salomon van Ruysdael, van Goyen, Jacob van Ruisdael,[15] Philips Koninck, or Hobbema can be found in the royal collection.

A clearer sense of the royal taste may be deduced from the experience of one "Dutch" landscapist, Paulus Potter, with the court. Potter's *The Farm*, dated 1649 (Hermitage, Leningrad, inv. 820), was owned by Amalia van Solms but, according to Houbraken, was returned by a courtier who objected to its low and indecorous subject. Much celebrated in its time, this landscape was probably the picture seen by a Swedish agent in 1652, when it was valued at 400 guilders.[16]

In truth, landscapes were never as prevalent at court as among private collections (see table 1). In 1632 landscapes made up 16 percent of the works on display at Noordeinde Palace, compared with 41 percent for portraits and 20 percent for history paintings; in a priced inventory of 1676, landscapes constituted only 12 percent of the total.[17]

Peripheral members of the royal family were also active in the art market. The Winter King and Queen of Bohemia commissioned a landscape portrait of their children from Poelenburch in 1628 (Szépművészeti Múzeum, Budapest, inv. 381) and owned several works by Savery and Hendrick Vroom. More significant as a patron was Prince Johan Maurits of Nassau-Siegen, who took Frans Post along on his Brazilian expedition in 1636. The numerous landscapes that Post painted in Brazil constitute the largest single landscape commission in seventeenth-century Holland. Post seems to have been one of the few landscape painters

employed specifically to depict scenery. Ironically, Post's works made in Brazil (such as cat. 71) were never displayed in Holland; they were stored in the Mauritshuis for nearly forty years when Jan Maurits was stadtholder of Kleve, after which they were sent to Paris. Post continued, however, to receive the patronage of the court, and his later landscapes enjoyed wide circulation.[18]

Although Prince Jan Maurits rebuilt and refurbished his residence at Kleve, he does not seem to have employed any of the numerous landscapists who journeyed there, such as Cuyp, van Borssom, and van der Haagen (see cat. 40). In 1653, however, Paulus Potter painted an equestrian portrait of Jan Maurits in a landscape with a view of Kleve (Six Collection, Amsterdam).[19]

Following the court in rank were the national political bodies: the States-General and the admiralties. Relatively active patrons, these organizations decorated their chambers and, more significantly, presented art works to various dignitaries. Landscape paintings rarely figured in these prestigious gifts, although marine paintings were well represented. In 1607 the Amsterdam Admiralty presented Prince Maurits with a *Battle of Gibraltar* by Cornelis van Wieringen. The "Dutch gift" to Henry, Prince of Wales, in 1610 included a depiction by Hendrick Vroom of the same battle (the artist had asked for fl.2,400 but was eventually given about fl.1,800). In 1636 Charles I of England received four sixteenth-century Netherlandish paintings but no landscapes. On the understanding that Charles II preferred Italian art, the States-General procured in 1660 the famous Reynst collection

of Italian paintings, which happened to include two landscapes by Pieter van Laer; Dutch paintings by Saenredam and Dou (the latter singled out for praise by Charles II himself) were added, but, again, there were no Dutch landscapes.[20]

The most important public sponsors of landscape were the wealthy and jealously independent municipal governments, which, from the fifteenth century, had decorated town halls and other public chambers (as well as churches after the overthrow of the Spanish). Naturally, city fathers were most interested in procuring art works of civic or patriotic importance. Landscape painters played a considerable role in providing illustrations of major battles, ceremonies, or, indeed, of the city itself. In the sixteenth century civic bodies in Haarlem commissioned other types of landscapes. Paintings by Jan van Scorel of the Baptism of Christ and of Mary Magdalen contain prominent landscape settings.[21] In 1611 Haarlem paid Hendrick Vroom fl. 200 for a painting of the Fall of Damiate, a proud chapter in Haarlem's history (also illustrated in tapestries designed by Cornelis Claesz van Wieringen).[22] Most significant, however, was the commission in 1629 for a depiction of the Battle of Haarlemmermeer from Hendrick Vroom for fl. 750, the highest price Haarlem ever paid for a work of art. While ostensibly a representation of a historic event, the result is, in fact, a sweeping landscape with a city profile (fig. 3). About ten years later, Hendrick's son, Cornelis Vroom, presented to the city a landscape valued at fl. 325, for which fl. 200 was taken in lieu of military service, leaving fl. 125 for the

Fig. 3. Hendrick Vroom, *Battle of Haarlemmermeer, 1573*, signed, canvas, 190 x 268 cm., Rijksmuseum, Amsterdam, inv. A 602.

artist.[23] Ironically, Haarlem, regarded as the birthplace of Dutch landscape, owned no other landscapes.

Hendrick Vroom was something of an expert in securing commissions from government agencies. He also sold works to Lord Howard of England, the admiralty, and the towns of Hoorn, Vianen, and Veere. In 1621, he attempted to sell a work to the city of Amsterdam for the astounding price of fl.6,000. Vroom's offer was justifiably refused, the commission being granted instead to Cornelis van Wieringen (in the Nederlands Scheepvaart Museum, Amsterdam) and Abraham de Verwer (now lost), for the still very substantial sum of fl.2,450 each.

Not only was Vroom one of the highest paid artists, but his official commissions, because of their prominence, had considerable effect on the development of landscape painting. Particularly important are two views of Delft he presented to that city in 1634 (fig. 4), for which he received fl.150. Actually, the two large canvases were not made specifically for the city since they are dated 1615 and 1617, almost twenty years before they were "given" to Delft. A strangely worded document states that Vroom gave the paintings to the city because his mother was buried in the Oude Kerk and he had been taught art there.[24] A wily salesman, Vroom apparently encouraged remuneration through such gifts. Swanevelt similarly presented Baron van Wyttenhorst with a landscape in 1649 before receiving a commission the following year. Such gifts could also benefit painters by broadening public exposure of their work, since prestige and value often accrued to

Fig. 4. Hendrick Vroom, *View of Delft from the Northwest*, dated 1617, canvas, 71 x 162 cm., Stedelijk Museum het Prinsenhof, Delft, inv. S 131.

Fig. 5. Jan van Goyen, *View of The Hague*, monogrammed, canvas, 170 x 438 cm., Gemeentemuseum, The Hague, no. 106.

pieces displayed in public rooms. A good example is the large landscape-marine painted by Carel Fabritius and Daniel and Nicolaes Vosmaer that was exhibited for many years in Delft's Prinsenhof. Later legal efforts by private parties to retrieve the painting were inspired by Fabritius's posthumous reputation and the work's public visibility.[25]

Generally, marine painters won the lion's share of landscape commissions. A monumental depiction of Dordrecht was commissioned from Adam Willaerts in 1628 (Dordrechts Museum), Jan Blanckerhoff worked for the town council of Hoorn, and Simon de Vlieger was paid fl. 700 in 1640 for a decorative cycle of unknown theme in the Delft Town Hall. In 1665 Amsterdam paid Ludolf Bakhuizen fl. 1,327 for a view of the city as a gift to Hugues de Lionne, foreign minister to Louis XIV (Louvre, Paris, inv. 988, dated 1666).[26] The marine artists' talent for accurately depicting ships, battles, and harbors, as well as their interest in cartography, no doubt commended them as portrayers of cities.

One of the only landscape specialists to work directly for a town government was Jan van Goyen, who was paid by The Hague in 1651 for a view of the city (fig. 5). Not only was the price, fl. 650, extraordinary — more than ten times higher than van Goyen had received before — but the painting itself is also unlike any other in the artist's oeuvre. In fulfilling this commission, Jan van Goyen completely altered his style, creating a highly finished, carefully detailed panorama of The Hague. The composition closely echoes Vroom's *View of Delft* (fig. 4). A river

curves diagonally from the lower left toward the towered city beyond, while a variety of agricultural and shipping activities enliven the foreground. Van Goyen either was enjoined or felt compelled to emulate Vroom's manner of painting.

These well-paid commissions, however, were reserved for an elite of artists.[27] Other landscapists who are famous today for their portrayals of certain cities — Aelbert Cuyp for Dordrecht, Jacob van Ruisdael for Haarlem and Amsterdam, and Salomon van Ruysdael for numerous towns — never worked for town governments.

Private Patrons

Though not produced for a civic authority, Jan Vermeer's *View of Delft* (fig. 6), was painted for a specific Delft patron, Pieter Claesz van Ruijven, and is imbued with civic associations. As Montias discovered, van Ruijven owned about half of Vermeer's documented oeuvre, probably buying works regularly on a retainer basis.[28] This arrangement was conducive to Vermeer's painstaking production and further ensured that the work of art had specific local associations.[29]

Vermeer's virtually exclusive connection with a single collector is similar to Gerrit Dou's arrangement with Petter Spiering and Frans van Mieris's with François de la Boe Silvius for the right of first refusal for an annual fee, but patronage of this sort was rare among landscapists. Frans Post traveled to Brazil as an employee in Jan Maurits's retinue, but only Poelenburch, who in a sense also qualifies as a *fijnschilder* (fine paint-

Fig. 6. Jan Vermeer, *View of Delft*, canvas, 98 x 117.5 cm., Mauritshuis, The Hague, inv. 92.

er), enjoyed the patronage of a single important collector.

The wealthy and dedicated collector in Holland (see my note 6) was no more disposed to collecting landscapes than was the court. The most prestigious collections of paintings in the seventeenth century were devoted primarily, if not exclusively, to Italian painting, perhaps including as well a few examples by Rubens and van Dyck or some early Netherlandish painters. The most celebrated collection, that of the Reynst brothers in Amsterdam, contained only Italian paintings and classical sculpture, with the exception of three works (including two landscapes) by Pieter van Laer.[30] The expatriate Duke of Arundel's collection contained no Dutch landscapes, only a view of Livorno harbor by Jan Lingelbach and two genre pieces after van Laer. Huygens, who wrote admiringly of a few Dutch land-

scapists but valued the Italians above all others, seems to have owned a work by Paulus Bor with the landscape by Cornelis Vroom (Rijksmuseum, Amsterdam, inv. A 852). Other major collections, including those of Joan Huydecooper, Marten Kretzer, Lucas van Uffelen, Joan Uitenbogart, and Jan Six, consisted mostly of Italian and Flemish works, together with works by Holbein, Rembrandt, and Lievens, and a few Italianate landscapes by van Laer, Poelenburch, and Both (in descending order of frequency).[31]

Among the few major collectors who favored landscapes was Herman Becker, a wealthy Amsterdam merchant, who owned an impressive collection of paintings, including seventeen paintings by Rembrandt and several by Rubens. The landscapes, which made up about a third of the collection, presented a wide-ranging survey. Becker owned six landscapes by Jan Lievens, three by Ruisdael (including a view of the Dam and a beach scene), as well as works by Jacob Pynas, Porcellis, de Vlieger, Esaias van de Velde, Segers, Potter, Everdingen, and Koninck. Italianate landscapes were also well-represented by works of Bril, Poelenburch, Both, Asselijn, Berchem, Weenix, Wouwermans, and a rare painting by Claude. Indeed, Becker appears to have assembled the broadest selection of landscapes in seventeenth-century Holland.[32]

Baron Vincent van Wyttenhorst of Utrecht was also a major patron of landscape painters, with a special passion for Poelenburch, who provided him with numerous portraits and religious works as well as twenty-three landscapes. Although Wyttenhorst ignored Utrecht Caravaggesque figural

painting, he favored local landscapists such as Abraham Bloemaert, Jan Both, Alexander Keirincx, Herman Saftleven, Roelandt Savery, Hercules Segers (temporarily in Utrecht), and Jan Baptist Weenix. Since he also owned landscapes by Berchem, Breenbergh, Potter, Swanevelt, and Wouwermans, Wyttenhorst appears to have sought out masters from other towns who worked in an elegant Italianate style.[33] Although Swanevelt apparently approached Wyttenhorst first, he probably did so because of the collector's reputation. Wyttenhorst's inventory of paintings also indicates that artists were often commissioned to work in collaboration on projects of the collector's conceiving.

The wealthy could afford to commission landscapes of personal significance. Allart van Everdingen painted several Scandinavian landscapes for the Trip family, who owned important industries in Sweden. In addition to executing several overdoors installed in the Trippenhuis, Amsterdam (see p. 101, figs. 25, 26), Everdingen depicted the Trips' Julitabroeck cannon foundry in Sweden in a finer and more detailed style than was usual for him (fig. 7), no doubt because of the need for topographic accuracy in fulfilling the commission. However, it is doubtful that Everdingen's voyage to Sweden in 1645–46 was financed by the Trips, as has often been supposed. Rather, the view in figure 7 was based on a map of 1649, and it was probably Everdingen's already well-established reputation as a painter of Scandinavian landscapes that brought him to the attention of the Trips.[34] Although Dutch landscapists were inveter-

Fig. 7. Allart van Everdingen, *Cannon Foundry, Julitabroeck, Sweden*, canvas, 192 x 254 cm., Rijksmuseum, Amsterdam, inv. A 1510.

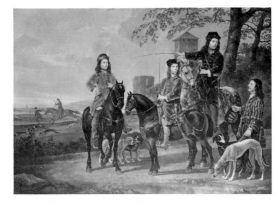

Fig. 8. Aelbert Cuyp, *Michiel and Cornelis Pompe van Meerdervoort*, signed, canvas, 108 x 154 cm., The Metropolitan Museum of Art, New York, no. 32.100.20.

ate travelers, Frans Post's voyage to Brazil was one of the only journeys directly sponsored by a patron.[35]

Aelbert Cuyp appears to have had a close association with a handful of patrician families in Dordrecht. Around 1652 he portrayed Michiel and Cornelis Pompe van Meerdervoort setting off for a hunt (fig. 8). The landscape background, based on scenery near Elten with fictitious architecture, has no demonstrable connection with the family, although in another work Cuyp depicted the family castle at Meerdervoort across the Maas from Dordrecht (cat. 47, fig. 1). The family also owned other paintings by Cuyp, including a Conversion of Saul.

Later in the century, landscapists were frequently commissioned to portray country seats. In Gerrit Berckheyde's view of the house and gardens of Elswout, owned by the Amsterdam trader Gabriel Marselis, an active patron of the arts,[36] the assistants to the hunt and the sketching artist add to the sense of aristocratic grandeur and elegance (fig. 9). Of similar seigneurial character are the numerous landscape portraits by Cuyp, Paulus Potter, and Adriaen van de Velde (fig. 10). Ruisdael provided the landscape setting for Thomas de Keyser's portraits of the Amsterdam burgomaster Cornelis de Graeff and his family arriving at Soestdijk (fig. 11) and painted two more views of the family's estates, which hung alongside others by Frederik de Moucheron.[37]

The landscapes by Everdingen for the Trips and by Ruisdael for the de Graeff family were meant to be set into specific positions in rooms. No doubt many surviving Dutch landscapes originally served a

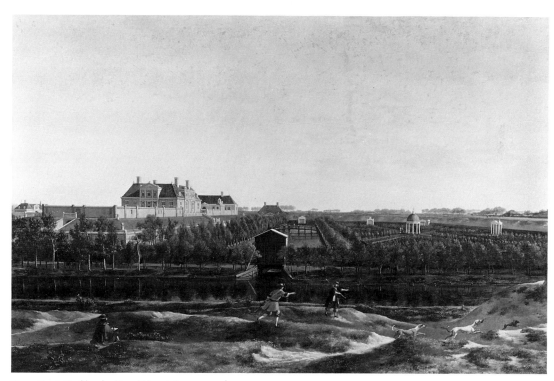

Fig. 9. Gerrit Berckheyde, *View of Elswout, Overveen*, panel, 52 x 80 cm., Frans Halsmuseum, Haarlem, no. 464b.

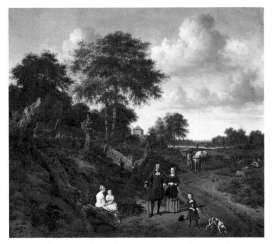

Fig. 10. Adriaen van de Velde, *Portrait of a Family in a Landscape*, signed and dated 1667, canvas, 148 x 178 cm., Rijksmuseum, Amsterdam, inv. C 248.

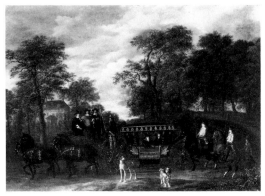

Fig. 11. Jacob van Ruisdael and Thomas de Keyser, *Cornelis de Graeff and His Family Arriving at Soestdijk*, canvas, 118 x 170.5 cm., National Gallery of Ireland, Dublin, no. 144.

decorative function in patrician houses. A poem by Pieter Verhoek describes a room in the house of Cornelis Backer decorated with landscapes by Adam Pijnacker, which allowed the patron to "relax and enjoy contemplating them" (see cat. 66). Verhoek specifically refers to the decorative role of such paintings by commending them as better suited than tapestries for decorating walls. Certain other paintings, such as an arched work by Post (cat. 72, fig. 1), were probably commissioned specifically for rooms, just as some very large landscapes by Cuyp or Italianate artists (cat. 15, 25, 116) are unlikely to have been executed for the open market.

The Open Market

Little is known precisely about the selling of art in the seventeenth century. Many collectors bought paintings from artists' studios, dealers' shops, or bookstores (see fig. 12), as well as at fairs and open stalls. In the early years of the century, history paintings (religious, mythological, and allegorical works) were the most common type, but after 1650 landscapes exceeded them. On average, history paintings and architectural pictures were the highest priced throughout the century. From the first quarter of the century through the next fifty years, there was a vast increase in the production of landscapes, as indicated by the decline in their price and the commensurate rise in their proportion in collections (see table 1). Landscapes had a wide distribution among middle-class collections in part because they were affordable. The majority of them were undoubtedly sold on the open market.

Fig. 12. Salomon de Bray, *Collectors in a Bookshop*, pen and wash, 76 x 76 mm. each, Rijksprentenkabinet, Amsterdam, inv. A 290.

Although landscapes in the collections of wealthy patrons tended to be cheaper than nearly all other categories, in middle-class collections they were costlier than either portraits or still lifes.

Inventories indicate that the patterns of bourgeois consumption varied widely. Among the inventories of poorer families, a small religious image is as likely to appear as a landscape. Nearly all those who could afford to commission portraits did so. Some burghers owned no landscapes, while others collected them almost exclusively. Carel Martens of Utrecht is an example of a casual, well-to-do collector from midcentury. In addition to portraits, he bought four still lifes, a large painting of Bacchus and Venus, a Rembrandt, a very expensive work by David Teniers, but among possible landscapes, only a small piece by "Hondecooter" and four works by Joost Droochsloot (including a battle and a kitchen scene).[38]

The increased demand for landscapes from the 1620s onward coincided with the appearance of the "tonal" landscapes by Jan van Goyen, Pieter de Molijn, and Salomon van Ruysdael – moderately priced pictures

that occur with great frequency in inventories. These works appear to have been painted quickly, as van Goyen's production of about twelve hundred works would seem to indicate. Thus, the large numbers of tonal landscapes seem to parallel rising market forces, while, conversely, finely painted landscapes by Coninxloo, de Hondecoutre, and Savery declined in frequency and price after 1600–25.

Examination of middle-class inventories in the middle of the century reveals several trends: Italianate landscapes, which appear with some frequency in wealthy collections, though not as public commissions, are rare in comparison with works by van Goyen, Porcellis, de Molijn, Everdingen, Ruisdael, and Steven van Goor (today almost unknown), in descending order. Artists like Wtenbrouck, Hendrick and Cornelis Vroom, and even Poelenburch, who were popular and well paid by elite collectors, are virtually unknown in middle-class collections. Landscapes by Asselijn, Both, van Laer, and especially Pijnacker appear only in large, expensive collections. Segers's work was almost invariably in upper-class hands or with dealers. Wouwermans, on the other hand, appears to have been broadly distributed (but perhaps through copies), despite the aristocratic nature of his imagery.

Protestants (Calvinists) owned proportionally twice as many landscapes as Catholics did, primarily because of the presence of large numbers of religious (especially New Testament) subjects in Catholic inventories.[39] Preliminary evidence indicates that buyers in Amsterdam, Delft, The Hague, and Dordrecht accumulated landscapes in similar proportions, while Utrecht residents seem to have bought fewer landscapes in relation to historical and religious works, perhaps because of the large and more open Catholic community there.

How then did patronage affect the making of the pictures themselves? The government and rich private collectors could afford to commission landscapes of special relevance or meaning. Some seemingly anonymous landscapes – Italianate scenes, waterfalls, and hunting landscapes – were, in fact, specifically commissioned. Hobbema's *Avenue at Middelharnis* (cat. 47), for example, may have been commissioned by a local resident. Collectors could, of course, select from common motifs or views that satisfied their taste, thus exerting the power of patronage. Of great importance were the indirect roles played by the different groups of collectors: the wealthy serious collector, the dealer, the burgher each collected different sorts of landscapes, and landscape painters seem to have restricted their work to the needs and habits of a particular segment of the market. In addition, there is little indication that seventeenth-century Dutch collectors acquired landscapes in accordance with then-current academic theories of collecting.[40]

Dutch Landscapists Abroad

Dutch landscapists traveled to every corner of Europe but only on rare occasions for the purpose of fulfilling commissions. Rather, artists were lured abroad by unusual scenery and culture, business ventures, or the intrinsic joy of travel. Some painters, however, served important foreign patrons. Hendrick

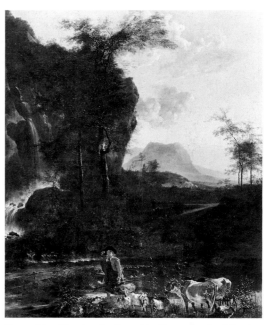

Fig. 13. Adam Pijnacker, *Landscape with a Hunter*, signed and dated 1654, canvas, 206.7 x 174.8 cm., Staatliche Museen, Berlin (DDR), inv. 897.

Vroom and his sons worked for a variety of English clients. Charles I specifically requested the presence of Poelenburch and Keirincx at his court, as he did of Rubens, van Dyck, Daniel Mijtens, and others.[41] Roelandt Savery spent ten years in Bohemia at the court of the Holy Roman Emperor and later received a commission from the Prince of Liechtenstein. In 1654 Adam Pijnacker was employed at the Brandenburg court, painting an Italianate hunting scene (fig. 13). Two other Italianate artists, Herman van Swanevelt and Jan Asselijn, worked on a decorative project at the Hôtel

Lambert in Paris along with French painters, proof of the demand for elegant Dutch Italianate landscapes in foreign capitals.[42]

Most Dutch artists, however, probably traveled with the hope of occasionally selling works along the way to support themselves. Van Mander recounted Hendrick Vroom's wanderings through the Mediterranean, his temporary employment, occasional triumphs, and the fact that he "moved on when he found no work."[43] The diary of the landscape artist Vincent Laurensz van de Vinne also indicates that he was able to sell pictures while journeying through Germany and France. The situation in Italy was probably much the same despite the sizable and better-organized community of Netherlandish artists working there.

ITALY

The market forces brought to bear on Dutch landscapists who went to Italy differed from both those at home and those affecting their Italian colleagues. From the sixteenth century, Netherlandish artists had made the pilgrimage to Rome. Landscapists such as Lodewijk Toeput, Paolo Fiammingo, Paulus Franck, and Paul and Matthijs Bril enjoyed long careers in Italy. These artists, who received important commissions and became fully integrated into the Italian artistic community, experienced a situation entirely different from that of most seventeenth-century Dutch artists who went to Rome.

The Flemish artist Paul Bril, mentor of Willem van Nieulandt, Poelenburch, and Breenbergh, received major commissions for fresco cycles in the Vatican and the palaces of the principal Roman families; his works are found in many seventeenth-century inventories, testifying to his success in the Roman market. Poelenburch also played a prominent role in Italian art circles, and his paintings are recorded in Roman collections as early as 1624.[44] More significant is his work for Grand Duke Cosimo II in Florence (see cat. 69, fig. 1), also documented in contemporary sources.[45] By contrast, only the Orsini family (the Dukes of Bracciano) can be positively identified as patrons of Bartholomeus Breenbergh, even though the artist lived in Rome for more than ten years.[46] Pieter van Laer's landscapes and genre scenes seem to have achieved a wide circulation in Rome and were highly valued in Holland.[47]

Jan Both and Herman van Swanevelt achieved some renown in Rome, participating with Claude, Poussin, Dughet, and others in the most important landscape commission of the period: the decoration of the Buen Retiro Palace in Madrid. Saints and religious figures feature prominently in these works; Both's landscapes for the project (fig. 14) suggest that the artists were closely restricted by the terms of the commission with respect to format, subject, and motif, presumably in the interest of the overall unity of the series.[48] Swanevelt was the only Dutch seventeenth-century landscape artist to spend his career almost entirely abroad. By far the most successful Dutch landscapist in Rome, he worked for virtually every major aristocratic family in the city. His *Landscape with the Legend of Latona* (fig. 15), made for the Giustiniani family (and recorded in a 1638 inventory, no. 118), illustrates his successful marriage of a classical

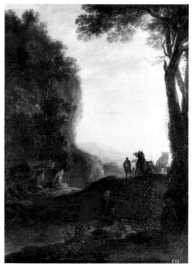

Fig. 14. Jan Both (figures by Andries Both), *Landscape with the Baptism of the Eunuch*, canvas, 212 x 155 cm., Museo del Prado, Madrid, inv. 2060.

Fig. 15. Herman van Swanevelt, *Landscape with the Legend of Latona*, canvas, 130.3 x 199.5 cm., Staatliche Museen, Berlin (DDR), inv. 432.

figure style with atmospheric Italian land-scapes. Swanevelt always had close con-nections with France and eventually moved to Paris, repeating some of his success there.

But other Dutch painters caused scarcely a ripple in Italy. Italianate landscapists such as Moyses van Wtenbrouck, Carel de Hooch, Jan Asselijn, Thomas Wijck, Claes Berchem, Adam Pijnacker, Adriaen van de Velde, Jan Hackaert, and Frederik de Moucheron cannot even be positively documented in Italy. Johannes Lingelbach and Karel du Jardin are recorded in Rome, but only Jan Baptist Weenix is known to have had a major patron.[49] Not until Gaspar van Wittel (1652/53–1736) took up residence in Rome did a Dutch landscapist return to the main-stream of artistic life in Italy. In sum, the majority of Italianate landscape paintings had no role whatsoever in the Italian art market; most Dutch artists sold their paint-ings, if at all, on an irregular basis.

Prices

As mentioned earlier, government bodies paid far higher prices for paintings than private citizens did, even the wealthy among them. Those landscapists who received com-missions from the state or whose works were purchased by it were the highest paid. The largest sum paid for marine paintings (by Cornelis van Wieringen and Abraham de Verwer) was fl.2,450; fl.1,375 was paid for a city view (by Bakhuizen), fl.850 for an Wtenbrouck landscape, and fl.700 for works by Poelenburch and Savery. Van Goyen, Cornelis Vroom, and Frans Post also re-ceived substantial sums (see table 3).

In the private sector, the following land-scape painters were the highest paid in their own lifetimes: (in descending order) Jan Porcellis, Coninxloo, Potter, du Jardin, Poelenburch, van der Lisse, Savery, Weenix, Hendrick Vroom, Lievens, Rembrandt, Asselijn, Wouwermans, Pijnacker, Koninck, Everdingen, Post, Bloemaert, and Ruisdael. Prices increased markedly in the last fifteen years of the century, especially for Italianate landscapes. A work by van Laer attained fl.500; one by Both with figures by Poelen-burch, fl.415; works by Vermeer, Weenix, Asselijn, and Lingelbach all exceeded fl.170. Landscapes by foreign artists were naturally of higher average price since they were rarer, except perhaps for the works of Flemish artists such as Joos de Momper and Jan Brueghel. It is also likely that only the finest foreign works would have been im-ported. Of the several works recorded as by Claude, the highest price was fl.500 (in Renialme's stock, 1657); a Poussin landscape was valued at fl.270, Jan Brueghel at fl.210 (or fl.500 in the royal collection), and Pieter Breugel (?) at fl.103.

In general, as mentioned, history paint-ings were considerably more expensive than landscapes, although governmental organi-zations paid roughly comparable prices for commissioned landscapes from the most prestigious painters.[50] Genre and still-life paintings commanded prices similar to landscapes. However, in rare cases fine painters like Frans van Mieris and Gerard Dou received fl.2,500 and 1,000, respec-tively, for genre scenes, while works by Vermeer and Baburen were appraised at fl.600. In comparison, the ceiling on prices for Italian paintings was normally around fl.400 for works attributed to Titian and other Venetian painters. Exceptional was Raphael's *Baldassare Castiglione* (Louvre, Paris), the most expensive easel painting in seventeenth-century Holland, which was sold for fl.3,500 in 1639.

The average prices shown in table 3 generally confirm the reputations that artists had in official circles. Variations must be allowed for different sizes of paintings, although inventories only occasionally note whether paintings are small or large. Size often affected price, large works being va-lued higher. However, "fine" paintings – highly detailed and finished works – were often small in scale but of extremely high value.

Marine paintings were consistently awar-ded high values despite a variety of styles ranging from Hendrick Vroom and Jan Porcellis to Simon de Vlieger, Abraham de Verwer, Ludolf Bakhuizen, and Johannes Lingelbach (see table 2). Early in the cen-tury mannerist artists such as Gillis van Coninxloo, Gillis de Hondecoutre, Karel van Mander, and especially Roelandt Savery were highly valued. Works by Savery kept their value in later periods, but the prices of other Flemish-inspired fine painters dropped precipitously. The work of Avercamp, though uncommon, was also well valued. Paintings by Poelenburch, always expensive, increased in value steadily into the early 1700s, but Breenbergh, also a "fine" painter specializing in landscapes with mythological and religious figures, received low values on the few occasions that he is recorded in inven-tories. Nonetheless, he seems to have been favored by Charles I. Second-generation

Italianates generally achieved high values only at the very end of the century. Among these, works by Both and van Laer fetched the highest prices. Landscapes by van Laer possessed a certain cachet even among collectors who did not otherwise favor Dutch landscapes, perhaps because they included prominent genre elements.

At midcentury, works by Lievens, Wouwermans, Segers, and Post were comparatively well-valued. These artists are not related stylistically, nor would any of them now be considered a typical Dutch landscape painter. Ruisdael was also respectably priced, indeed, higher on average than Everdingen (although the latter received higher individual prices). In contrast, Jan van Goyen's works were cheap, probably because many of his paintings were small or sketchy, and perhaps also because of the proliferation of imitators and copyists. His fellow painters in the "tonal" manner, de Molijn and Salomon van Ruysdael, were similarly priced. The work of Cuyp, also surprisingly inexpensive, is remarkable for its extremely limited circulation; not a single work can be located outside Dordrecht in the seventeenth century. More unexpected is the almost total absence in seventeenth-century inventories of works by Hobbema, although he spent a productive career in Amsterdam.

TABLE I

Paintings by genre, 1600–1700

Genre	1600–25		1626–50		1651–75		1676–1700	
	Average price (fl.)	Attrib. works (%)	Average price (fl.)	Attrib. works (%)	Average price (fl.)	Attrib. works (%)	Average price (fl.)	Attrib. works (%)
Landscapes	30.31	24.79	21.77	33.12	24.29	38.21	43.99	40.74
Religious	33.03	26.37	43.26	20.41	70.26	13.36	52.13	13.54
History	47.60	8.17	38.39	6.04	44.09	5.93	65.29	3.89
Portraits	5.99	14.57	10.74	15.23	23.03	13.94	37.05	9.65
Genre	27.79	6.13	22.07	5.66	30.79	5.84	88.23	14.33
Still life	27.39	4.81	30.13	12.33	23.84	15.87	41.33	11.31
Architectural	41.43	1.65	59.34	6.00	52.71	1.45	22.50	1.17
Other/Unknown	10.55	13.51	17.25	1.20	20.99	5.40	33.00	5.36

Sources: Published complete inventories from Bredius 1915–22, Obreen 1877–90, early issues of *Oud Holland*, and various other sources; also manuscript material transcribed by Michael Montias from Delft and Amsterdam archives, and by the author from Amsterdam, Dordrecht, The Hague city archives, the Algemeen Rijksarchief, and the Hoge Raad van Adel, The Hague.

Note: A total of 6,684 attributed paintings were surveyed, of which 2,709 were priced. Prices fluctuated in the seventeenth century; inflation of approximately 25 percent occurred between the 1620s and 1650s. Thereafter prices were more or less stable until the end of the century (N.W. Posthumus, *Inquiry into the History of Prices in Holland*, 2 vols. [Leiden, 1946–64]; J. de Vries 1974, pp. 183–89). Percentages of genres were derived from inventories in which at least half the paintings listed could be identified by type. Unattributed works, copies, grisailles, drawings, and prints have been omitted. Included in the category of landscapes are marines as well as religious and history subjects described as being in landscapes.

TABLE 2

Average prices of landscapes by motif, 1625–75

Motif	Attributed		Unattributed	
	Average price (fl.)	Number surveyed	Average price (fl.)	Number surveyed
All landscapes	23.03		11.23	
Marines	45.02	51	6.28	63
Italianate landscapes	58.14	54		
With mythological figures	58.22	27	14.23	38
With animals	22.71	38	11.82	35
Waterfalls	35.73	29		
Winter scenes	35.17	46		
Battle scenes	37.12	19		
Night scenes	23.83	8		

Sources: See sources for Table 1.

LANDSCAPE MOTIFS

Among the various subjects of landscape pictures, marine views by known artists were almost twice as expensive as other types of landscape, although unattributed seascapes were much cheaper than un-attributed landscapes (see table 2). Italianate landscapes and those with myth-ological figures were even more expensive than marines. Landscapes that were identi-fied as including animals were almost exactly the same average price as landscapes overall, as were night scenes. Paintings of waterfalls were priced slightly higher than average, but about the same as winter and battle scenes. This seems to suggest that Scandi-navian or Alpine scenes were not especially prestigious and were certainly less in de-mand than Italian views or seascapes.[51]

The immense variety of landscape types in Holland was possible in large measure because patrons were so numerous and diverse. For most of the seventeenth cen-tury, the Netherlands lacked a single power-ful group of collectors. The influence and power of individual buyers, though some-times specific and identifiable, were never of overwhelming importance in the production of the work of art. Instead, individual tastes and demands were subsumed by the vast market for landscapes in Holland, although collectors of different social and economic class seem to have preferred particular styles and subjects of landscapes, as well as different artists.

TABLE 3

Prices for landscape paintings, 1600–1725

The first figure is the average price in guilders; the number in parentheses refers to the number of paintings surveyed. In some cases, prices from adjacent years have been combined. The column at the far right lists examples of the artists' most expensive works, with the year of the inventory or sale in parentheses. Prices are for described landscapes only, even though some artists worked in other genres.

Artist	1600–25	1626–50	1651–75	1676–1700	1701–25	Highest Prices
Jan Asselijn			20 (2)	133.2 (8)		154 (1692), 194 (1694)
Hendrick Avercamp	24.7 (3)	49.5 (4)				75 (1628, 1637), 150 (1716)
Ludolf Bakhuizen				57 (3)		1,275* (1665), 100 (1680)
Claes Berchem			33.7 (4)	91.6 (7)	53.3 (3)	48 (1666), 190 (1692)
Abraham Bloemaert						33 (1613), 100 (1637) [620 (1628) unspec.]
Jan Both			57.7 (8)	132.2 (10)		70 (1649), 415, 182 (1692)
Bartolomeus Breenbergh				10.7 (5)		25 (1693)
Gillis van Coninxloo	58.5 (25)	38 (3)	20.3 (8)			350 (1607), 400 (1612), 120 (1620)
Aelbert Cuyp			26.6 (5)	13.5 (12)		80 (1675), 31 (1688)
Allart van Everdingen			36.1 (23)	8.5 (18)		150 (1657), 100 (1670, 1671)
Steven van Goor			25.9 (22)	18.6 (10)		130 (1657)
Jan van Goyen		16.8 (37)	17.0 (11)	7.7 (9)		32 (1647), 650* (1651), 48 (1657)
Jan Hackaert				33.3 (3)		55 (1682)
Meindert Hobbema			14 (2)			20 (1664, 1693)
Gillis de Hondecoutre	54 (4)	34.3 (19)	35.8 (6)	14.4 (6)		90 (1621, 1657), 150 (1647)
Karel du Jardin			85.8 (5)	55 (6)		330 (1657), 90 (1695)
Philips Koninck			74.9 (10)	7 (3)	6.2 (3)	130 (1657), 199 (c. 1670)
Pieter van Laer				210.1 (4)		500 (twice in 1692), 371 (1692)
Pieter Lastman						42 (1657)
Jan Lievens			100.4 (5)	18.4 (5)		200 (1657)
Johannes Lingelbach				57.3 (6)		170 (1687), 75 (1694)
Karel van Mander	52.7 (7)					40 (1612), 221 (1614)
Pieter de Molijn		18.1 (10)	13.9 (15)		6 (4)	50, 26.5 (1647)
Frans de Momper			7.2 (16)			23 (c. 1650)
Frederik de Moucheron				21.7 (30)		70 (1673)
Aert van der Neer			20.2 (9)	9.2 (12)		36 (1670, 1673)
Adam Pijnacker				73 (12)		150 (1670), 98 (1692)
Cornelis van Poelenburch		30 (13)	92.4 (10) 322.5* (4)	106.7 (7)	215 (7)	575* (1627), 120 (1637), 300 (1649), 700* (1673), 360 (1692)

(Continued on next page)

Artist	1600–25	1626–50	1651–75	1676–1700	1701–25	Highest Prices
Jan Porcellis		87.2 (12)	84.7 (13)	26.1 (10)	6 (4)	450 (1649), 300 (1657)
Frans Post				59 (5)		180* (1650), 130 (1679)
Paulus Potter			106.5 (4)	28.1 (4)		400* (1652), 80 (1687)
Jacob Pynas						59 (1625), 42 (1693)
Rembrandt						166 (1644)
Roeland Roghman				19.9 (6)		30 (1669, 1681)
Jacob van Ruisdael			42.3 (18)	28.1 (7)		60 (1664), 100 (1673), 80 (1699)
Salomon van Ruysdael			8.7 (6)	12.4 (5)		15.5 (c. 1640)
Herman Saftleven		32.8 (5)	28.7 (2)	26.5 (3)		60 (1648, 1687)
Pieter van Santvoort		43.2 (5)			7 (2)	78 (1654)
Roelandt Savery	68.4 (6)	75.5 (10), 533.3* (3)	38.6 (6)	34 (2)		225 (1625), 700* (1626), 150 (1627, 1657)
Hercules Segers		18.5 (36)	70.1 (10)			60 (1654), 300, 100 (1657)
Adriaen van de Velde				62.6 (8)		70 (1649), 54 (1671), 120 (1687)
Esaias van de Velde		22.4 (7)		10 (2)		70 (1649)
Abraham de Verwer						2,450 (1622), 200* (twice in 1639)
David Vinckboons		41.7 (3)	39.6 (5)			52 (1637), 100 (1675)
Simon de Vlieger		18.8 (18)	23.6 (8)			110 (1649), 80 (1669)
Daniel Vosmaer			16.7 (15)			130 (1650s)
Cornelis Vroom				88.3 (6)		325* (1639), 175 (1675)
Hendrick Vroom	46.2 (5), 1,000* (2)	23.2 (4), 287.5* (4)	21 (2)			1,800* (1610), 200 (1616), 750* (1629)
Jan Baptist Weenix			116.4 (5)	100.2 (6)		225 (1653), 100 (1678), 200 (1692)
Thomas Wijk			25.6 (7)			136 (1649), 72 (1657)
Jan Wijnants				18.2 (5)		33 (1671), 80 (1713)
Philips Wouwermans			47.3 (13)	60.1 (20)	195 (4)	90 (1652), 150 (1669), 355 (1687), 255* (1712)
Moyses van Wtenbrouck		314.2* (4)	34 (3)			850* (1646), 110 (1692)
Foreign Artists						
Jan Brueghel	99.9 (5)	86.7 (5)	258.6 (5)			141 (1613), 210 (1620), 500* (1676)
Claude Lorrain			269.2 (4)			500 (1657)
Joos de Momper	22.1 (35)	32.6 (9)	21.3 (4)			71 (1640), 48 (1643)
Poussin (?)						270 (1692)

Sources: See sources for Table 1.

*Prices paid by government organizations.

I am grateful to Michael Montias for sharing much of his work on seventeenth-century inventories and for his assistance with many problems involved in this study.

NOTES

1. *The Diary of John Evelyn*, ed. E.S. de Boer (Oxford, 1935), p. 39.

2. *The Travels of Peter Mundy in Europe and Asia*, ed. R.C. Temple, vol. 4 (London, 1925), p. 70. De Monconys (1665–66, p. 149) also reported seeing a Vermeer painting in the house of a baker, Hendrik van Buyten.

3. There arose in seventeenth-century Holland an unprecedentedly large portion of the population that was sandwiched between unskilled or semiskilled laborers (who made fl.300–400 a year) and the regents and wealthy property owners. Though not a "middle class" in the twentieth-century sense, skilled craftsmen, shopkeepers, tradesmen, and small-scale investors, who typically made fl.500–1,500 annually, constitute for our purposes "middle-class" collectors.

4. Montias 1982. The basic study on the Dutch art market is Floerke 1905. Haak (1984, pp. 33–60) provides a good survey of patrons. See also Martin 1905–1908, pt. 6.

5. In 1618 Rubens wrote that the nobility was normally charged more than ordinary collectors (*The Letters of Peter Paul Rubens*, ed. R. Magurn [Cambridge, 1955], p. 55). See also Haak 1984, p. 53.

6. The typical "casual" collector in the inventories surveyed owned eighty paintings or less and left an estate of movable goods worth approximately fl.500–1,500. These inventories rarely contained a single painting worth more than fl.75. The "serious" collector, usually leaving a substantial estate, owned a hundred paintings or more or possessed works of very high value. See Montias 1982, pp. 262–63.

7. The Flemish artists included Jacob Jordaens, Thomas Willeboirts Bosschaert, and Theodoor van Thulden; among the Dutch were Caesar van Everdingen, Gerrit Honthorst, Jan Lievens, Salomon de Bray, and Christiaen van Couwenbergh. See J.G. van Gelder, "De schilders van de Oranjezaal," *Nederlands Kunsthistorisch Jaarboek* 2 (1948–49), pp. 118–64.

8. In Dec. 1638 Cornelis Vroom was paid fl.450 for landscapes in a hall and stairway. At the same time, Wtenbrouck was paid fl.800 for "cornucopia" paintings in a staircase and fl.520 for other works; he had earlier been paid fl.400 for four works on stone (D.F. Slothouwer, *De paleizen van Frederik Hendrik* [Leiden, 1943], pp. 269–72). In 1641 Wtenbrouck received a further fl.950 for two paintings; the inventory of 1707 lists a large landscape and a large "Bacchanal" by Wtenbrouck (Drossaers, Lunsingh Scheurleer 1974–76, vol. 1, pp. 522, 529).

9. The Honselaarsdijk inventory of 1707 seems to record the original arrangement of the works (Drossaers, Lunsingh Scheurleer 1974–76, vol. 1, pp. 524–25). On the *Il pastor fido* theme at court, see J.G. van Gelder, "Pastor Fido-voorstellingen in de Nederlandse kunst van de zeventiende eeuw," *Oud Holland* 92 (1978), pp. 227–63; and Kettering 1983, pp. 107–13. Van Dyck's painting is now in Schloss Schönborn, Pommersfelden. The three other primary scenes for Honselaarsdijk are by Saftleven, dated 1635, with figures probably by another artist (Staatliche Museen, Berlin [DDR], inv. 958); Bloemaert; and van der Lisse (both Schloss Grunewald, Berlin, inv. 3833 and 5295). The subsidiary landscape by de Hondecoeter represents hunters (Staatliche Museen, Berlin [DDR], inv. 985); that by Willaerts shows a market on a beach (Schloss Grunewald, Berlin). All are reproduced in van Gelder, "Pastor Fido-voorstellingen"; and Kettering 1983.

10. Poelenburch's painting is now in the Schloss Georgium, Dessau, inv. 804 (panel, 39 x 69 cm.). Sluijter-Seiffert (1984, nos. 14–21) lists eight works of the same theme; one formerly with the Alan Jacobs Gallery, London, is dated 1624.

11. Drossaers, Lunsingh Scheurleer 1974–76, vol. 1, pp. 183–84, 192, nos. 59, 67, 69, 71, 74, 75, 79, 232–234. Of these, only two are described as landscapes: one with the Virgin and Child, the other with Tobias and the Angel. There were also works by Keirincx and Savery with figures by Poelenburch (nos. 81, 241, 1246).

12. Briels (1976, p. 293) records the payment to Savery in Dec. 1626; also included in the gift from Utrecht were a shepherd and a shepherdess by Paulus Moreelse. The two other works by Savery in the stadtholder's collection were an *Orpheus* and a landscape with fish with figures by Poelenburch (Drossaers, Lunsingh Scheurleer 1974–76, vol. 1, p. 192).

13. Drossaers, Lunsingh Scheurleer 1974–76, vol. 1, p. 522. No. 24 in the 1707 inventory of Honselaarsdijk, a view of the Huis ten Bosch by Antonie Croos, is the only example in the royal collection of an artist associated with the Dutch "tonal" school of painting. There was also an "Italiaens kroegje" by Jan Both, probably a genre scene, as well as two works described as in the manner of du Jardin and Asselijn (ibid., vol. 1, pp. 522, 528–29).

14. Hoet 1753, pp. 149–54; Drossaers, Lunsingh Scheurleer 1974–76, vol. 1, pp. 695–700.

15. A work by Jacob van Ruisdael is recorded at Honselaarsdijk in 1755–58 (Drossaers, Lunsingh Scheurleer 1974–76, vol. 2, p. 511, no. 197), but this is very likely a later acquisition since it does not occur in earlier lists.

16. Houbraken 1718–21, vol. 2, p. 127. See also Olof Granberg, "Une revue d'art du XVIIe siècle," *Oud Holland* 4 (1886), p. 270 (4 x 3½ feet).

17. In the Noordeinde inventory of 1632, of a total of 256 Dutch and Flemish works: landscapes 16%, portraits 41.1%, religious and history paintings 19.9%, marines 8.2%, still lifes 6.2%, genre 4.6%, architectural works 2.7%. At Honselaarsdijk in 1676, of a total of 141 works: landscapes 12% (average value fl.152), portraits 56% (fl.102), religious and history paintings 15.6% (fl.695), still lifes 4.3% (fl.262), genre 2.8% (fl.112), others 9.2% (fl.232).

18. In 1650 Frans Post was paid fl.300 by the court for an unspecified number of views of towns in Burgundy. There were also several views of foreign palaces (Fontainebleau, Escorial, and Hampton Court) by Frans (or Pieter?) Post (Honselaarsdijk 1707, nos. 116, 117; Honselaarsdijk 1755–58, nos. 266, 267, 275).

19. The sitter has traditionally been identified as Dirck Tulp, son of Dr. Nicolaes Tulp, whom Houbraken gave as Potter's principal patron in Amsterdam, but the identifying inscription and the face are much later additions, as x-radiographs confirm (Gorissen 1964, nos. 15, 16; Walsh 1985). On Jan Maurits as a patron, see The Hague 1979–80; and Kleve 1979.

20. See Anne-Marie Logan, *The "Cabinet" of the Brothers Gerard and Jan Reynst* (Amsterdam, 1979). The Reynst collection of twenty-four paintings and twelve statues was purchased for fl.80,000 – an astounding sum. The States-General lavished large amounts on state gifts that included tapestries, furnishings, and even a yacht, as well as paintings; see D. Mahon, "Notes on the 'Dutch Gift' to Charles II," *Burlington Magazine* 91 (1949), pp. 303–305, 349–50; 92 (1950), pp. 12–18, 238.

21. Frans Halsmuseum, Haarlem, no. I-312, and Rijksmuseum, Amsterdam, inv. A 372. See Biesboer 1983, figs. 2, 6.

22. Van Wieringen was paid fl.225, plus fl.25 in "beer money" for the designs in 1630. The artist also painted the Fall of Damiate (Frans Halsmuseum, Haarlem, inv. I-355); see E.J. Kalf, "De 'Val van Damiate' of het nut van vergissingen," *Haarlem Jaarboek*, 1980, pp. 7–24; and Biesboer 1983.

23. Bredius 1915–22, vol. 7, p. 282.

24. On Hendrick Vroom, see Russell 1983, chap. 3. On the 1621 commission from the Amsterdam admiralty and the "gift" to Delft in 1634, see Bredius 1915–22, vol. 7, pp. 670–79.

25. See Christopher Brown, *Carel Fabritius* (Oxford, 1986), pp. 154–56. Earlier, in 1620, a painting displayed in the States-General was purchased outright for the Prinsenhof (Bleyswijck 1674, p. 127).

26. E.W. Moes, "Een geschenk van de stad Amsterdam aan den Marquis de Lionne," *Oud Holland* 11 (1893), pp. 30–33 (400 ducatons and 1 gold ducat); see also Houbraken 1718–21, vol. 2, p. 240; Amsterdam 1985, no. s8, ill.

27. Frans Post was commissioned to paint a chimney piece for the Spaarndam Town Hall (for fl.180). Other landscape commissions include one of 1684 for a view of Gouda by Christoffel Pierson worth fl.113 (Obreen 1877–90, vol. 6, p. 73).

28. J. Michael Montias, "Vermeer's Patrons and Clients," *Art Bulletin* 69 (1987), pp. 68–76. Van Ruijven also owned Vermeer's *Het Straatje* (Rijksmuseum, Amsterdam, inv. A 2860). At the sale of the estate of van Ruijven's son-in-law, Jacob Dissius (Amsterdam, May 16, 1696), the *View of Delft* sold for fl.200, more than any of the other twenty paintings by Vermeer.

29. See Haverkamp Begemann, Chong 1985; and a paper given by the present writer at the University of Pittsburgh, 1986. The view painted by Vermeer, never before depicted, was the site of the greeting of Charles II by the magistracy and the States-General in 1660.

30. Logan. *"Cabinet" of Gerard and Jan Reynst.* The collection was acquired for the most part in Italy then transplanted to Amsterdam.

31. On collecting in Amsterdam, see A. Bredius, "De kunsthandel te Amsterdam in de XVIIe eeuw," *Amsterdamsch Jaarboekje*, 1891, pp. 54–71; A. Heppner, "Amsterdamsche Verzamelaars," in *Zeven Eeuwen Amsterdam*, ed. A.E. d'Ailly, vol. 6 (Amsterdam, 1950), pp. 227–64. On the collecting of Italian art specifically, see Frits Lugt, "Italiaansche kunstwerken in Nederlandsche verzamelingen van vroeger tijden," *Oud Holland* 63 (1936), pp. 97–135. Kretzer's collection, for example, contained works by Lastman, Poelenburch, Pynas, Honthorst, ter Brugghen, Both, Weenix, Porcellis, and van Laer, besides Titian, Bassano, and del Sarto.

32. A. Bredius, "De nalatenschap van Harmen Becker," *Oud Holland* 28 (1910), pp. 195–201.

33. M.J. Friedlaender, "Das Inventar der Sammlung Wyttenhorst," *Oud Holland* 23 (1905), pp. 63–68; de Jonge 1932. Much of the collection is now in the Schloss Herdringen, Germany. Wyttenhorst also owned seascapes by de Molijn, Mulier, and Willaerts, demonstrating again that seascapes of all styles were in constant demand.

34. See Davies 1978, pp. 101, 191–96. Everdingen probably never saw Julitabroeck (fig. 7); indeed, the Trips did not even own the foundry when Everdingen visited Sweden.

35. Echoing Post's South American experience, Dirck Valkenburg went to Surinam in 1706 under the sponsorship of the plantation owner Jonas Witsen; see A. van Schendel, "Een still plantage door Dirck Valkenburg," *Bulletin van het Rijksmuseum* 11 (1963), pp. 80–86. On the other hand, it is doubtful that trips by other artists such as Willem Schellinks, Jan Hackaert (see under cat. 41), and Reinier Nooms were financed entirely by Laurens van der Hem; see H. de la Fontaine Verwey, "De atlas van Mr. Laurens van der Hem," *Maandblad Amstelodamum* 38 (1951), pp. 85–89.

36. See G. Schwartz, in Vancouver 1986, no. 86. Jan van der Heyden also depicted Elswout.

37. The 1709 inventory of Pieter de Graeff lists views of Zuidpolsbroek and Soestdijk by Ruisdael (The Hague/Cambridge 1981–82, pp. 23–24). Ruisdael may also have painted other specific estates (ibid., no. 54, p. 151).

38. "Het kasboek van Mr. Carel Martens," *Oud Utrecht*, 1970, pp. 154–219.

39. This conclusion is based on a survey by Montias (unpublished) of inventories in Amsterdam and Delft 1620–79, in which the religion of the owner could be deduced with a high degree of probability (524 entries in Catholic inventories; 591 for Calvinists).

40. Samuel van Quicchelberg set down the outlines of an encyclopedic *kunstkammer* in 1565, which included landscapes in its sections on paintings and prints. See Julius von Schlosser, *Die Kunst- und Wunderkammern der Spätrenaissance* (Braunschweig, 1978; 1st ed. Leipzig, 1908); O. Impey and A. MacGregor, *The Origins of Museums: The Cabinet of Curiosities in 16th and 17th Century Europe* (New York, 1986). Rembrandt assembled such a universal art cabinet, although his landscape paintings do not appear to represent a deliberate variety of subject matter (R.W. Scheller, "Rembrandt en de encyclopedische verzameling," *Oud Holland* 84 (1969), pp. 1–81).

41. At least six works by Poelenburch, sixteen by Keirincx, and six by Breenbergh are recorded in the inventories of Charles I, as well as single examples by Savery, Porcellis, Bril, de Momper, Nieulandt, van Goyen (?), and several by the "old" and "young" Vroom. See Oliver Millar, "Abraham van der Doort's Catalogue of the Collections of Charles I," *Walpole Society* 37 (1960); idem, "Inventories and Valuations of the King's Goods, 1649–1651," ibid. 43 (1970–72).

42. Other Dutch landscape painters who worked extensively in foreign countries include Johannes Ruisscher, who

was employed briefly in Berlin before becoming *Hofmaler* in Dresden in 1662, and Frans de Momper, who worked in Hamburg. For a full discussion of the Dutch painter abroad, see Gerson 1942.

43. Van Mander 1604, fol. 287.

44. The 1624 inventory of Costanzo Patrizi, Rome, contained eight landscapes by Poelenburch, valued between thirty and eighty scudi (fl.108–288), plus two works by Bril with figures by Poelenburch (Sluijter-Seiffert 1984, p. 271). Vincenzo Giustiniani owned four canvases by Poelenburch by 1638; there were five in the Palazzo Rondanini by 1662. The Pamphili had four works by the 1680s, the Colonna, ten by 1714. The Orsini family had the largest collection of Poelenburch paintings. See Salerno 1977–80, vol. 3, pp. 121–40; Rubsamen 1980.

45. The 1638 inventory of the "guardaroba" of the Grand Duke lists four landscapes by Poelenburch, still in the Pitti Palace, Florence (inv. 1200, 1203, 1220, 1221); see Schaar 1959, p. 40.

46. Seven works by Breenbergh are recorded in the 1655–56 inventory of the Orsini family's Palazzo Monte Giordano in Rome (Rubsamen 1980, pp. 9, 10, 15). Many of Breenbergh's drawings were made at the Bomarzo estate of the Duke of Bracciano. In addition, two small landscapes (one with fishermen) are listed in a Pamphili inventory of 1709 as by "Brainbergh Olandese" (Salerno 1977–80, vol. 3, p. 1138).

47. Van Laer's landscapes were owned by the Giustiniani, Chigi, and Rondinini families; other works, probably genre scenes, are listed in Barberini and Spada inventories (Salerno 1977–80, vol. 3, pp. 1121–40).

48. On the Buen Retiro commission see Burke 1976; von Barghahm 1979; Brown, Elliot 1980; Madrid, Museo del Prado, *Claudio de Lorena y el ideal clássico*, 1984; and Brown, Elliot 1987. In 1642 Both was paid sixty scudi by Cardinal Antonio Berberini for two landscapes, which were valued at forty scudi each in 1671 (Lavin 1975, pp. 8, 173, 292–93).

49. Schloss 1983a.

50. Examples of high-priced history paintings include a work by van Dyck valued at fl.3,000 and a Rubens at fl.2,600 in a royal inventory of 1676. The largest pieces in the Oranjezaal by Honthorst and Theodor van Thulden cost fl.2,000. Large group portraits could also be expensive; the fl.1,600 Rembrandt received for the *Nightwatch* was not unusual.

51. Waterfalls were not among the most expensive landscape categories, as had been supposed by Davies (1976, pp. 42–43; repeated in The Hague/Cambridge 1981–82, pp. 21–22).

Gillis van Coninxloo
(Antwerp 1544 1607 Amsterdam)

Plate I (CAT. 19)

Hunters in a Landscape, 1605
Signed and dated
Panel, 23 x 32⅞ in. (58.4 x 83.5 cm.)
Historisches Museum der Pfalz, Speyer, HM 1957/122

David Vinckboons
(Mechelen 1576–c.1632 Amsterdam?)

Plate 2 (CAT. 110)

Forest with a Hunt, 1602
Signed and dated
Panel, 20⅛ x 22⅝ in. (51 x 57.5 cm.)
Private Collection

Roelandt Savery
(Kortrijk c.1576/78–1639 Utrecht)

Plate 3 (CAT. 99)

Forest Scene with Hunters, c.1617–20
Panel, 20½ x 33⅜ in. (52 x 85.3 cm.)
Private Collection, The Netherlands

Alexander Keirincx
(Antwerp 1600–1652 Amsterdam)

Plate 4 (CAT. 51)

Landscape with Cephalus Receiving the Gifts from Procris,
c.1620/21
Panel, 18¾ x 31¾ in. (48 x 80.6 cm.)
Virginia Museum of Fine Arts, Richmond, The Williams
Fund, 1984, 87.77

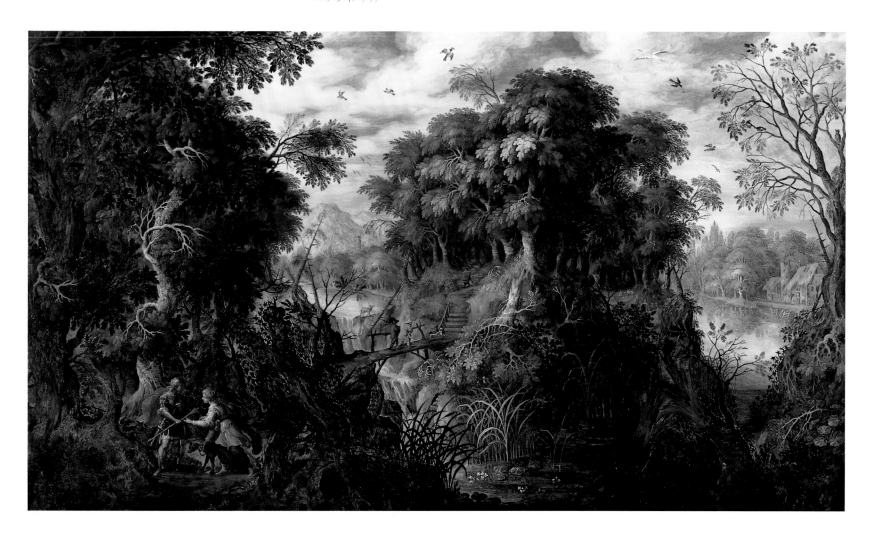

Adriaen van de Venne
(Delft 1589–1662 The Hague)

Plate 5 (CAT. 109) *Amsterdam only*

Winter Landscape, 1614
Signed and dated
Panel, 16½ x 26¾ in. (42 x 68 cm.)
Gemäldegalerie, Staatliche Museen Preussischer
Kulturbesitz, Berlin (West), no. 741B

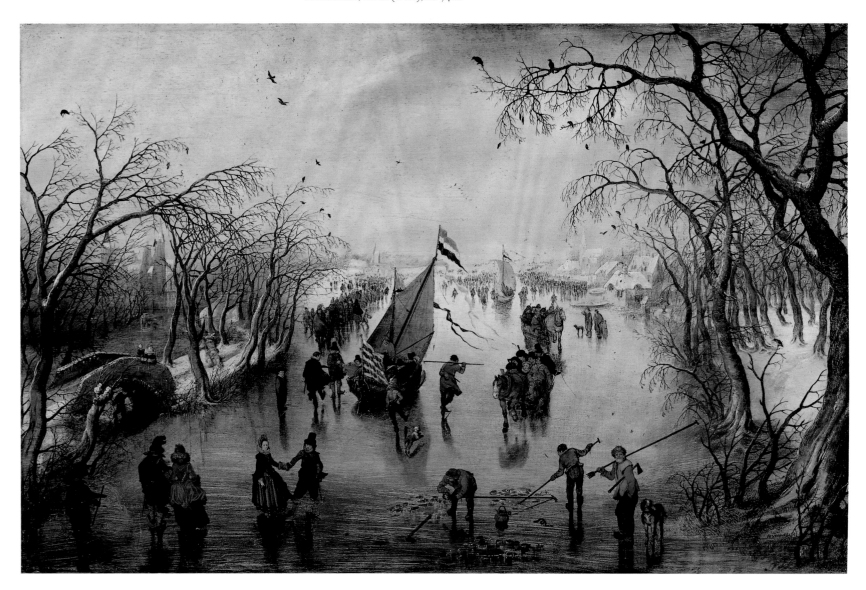

Adriaen van de Venne

Plate 6 (CAT. 108) *Amsterdam only*

Summer Landscape, 1614
Signed and dated
Panel, 16⅝ x 26¾ in. (42.2 x 68 cm.)
Gemäldegalerie, Staatliche Museen Preussischer
Kulturbesitz, Berlin (West), no. 741A

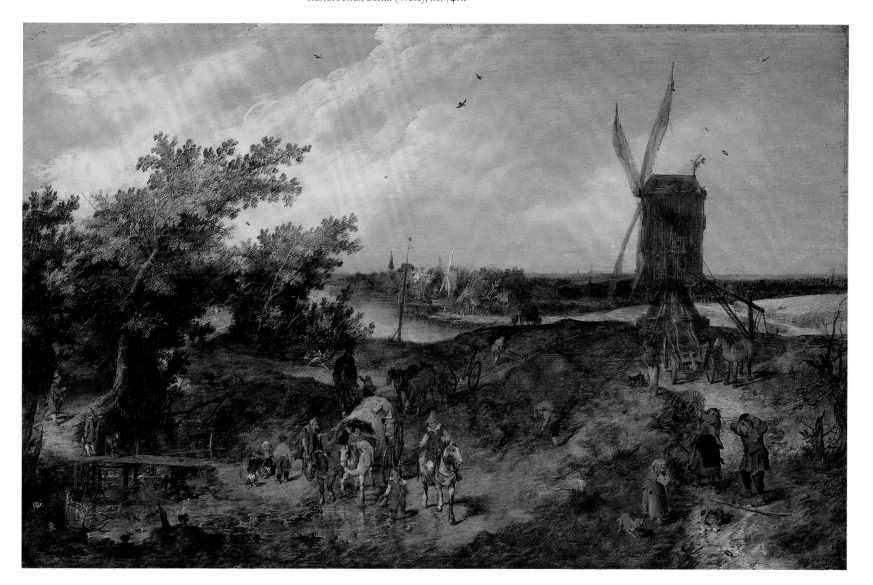

Hendrick Avercamp
(Amsterdam 1585–1635 Kampen)

Plate 7 (CAT. 5) *Amsterdam only*
Winter Landscape with Skaters, c.1608
Signed
Panel, 30½ x 52 in. (77.5 x 132 cm.)
Rijksmuseum, Amsterdam, inv. A 1718

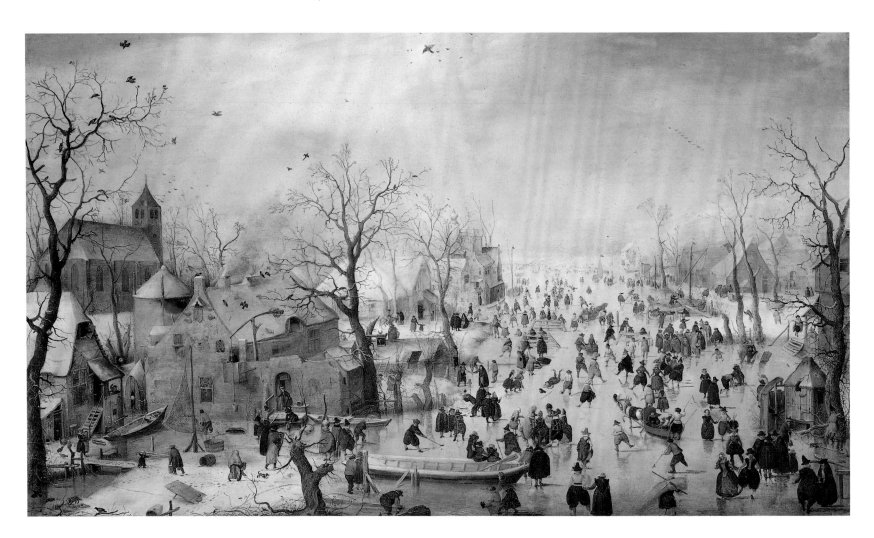

Hendrick Avercamp

Plate 8 (CAT. 6) *Boston and Philadelphia only*

Skaters by a Village, c.1609–10
Monogrammed
Panel, 14⅛ x 28 in. (36 x 71 cm.)
Koninklijk Kabinet van Schilderijen, Mauritshuis, The
Hague, inv. 785

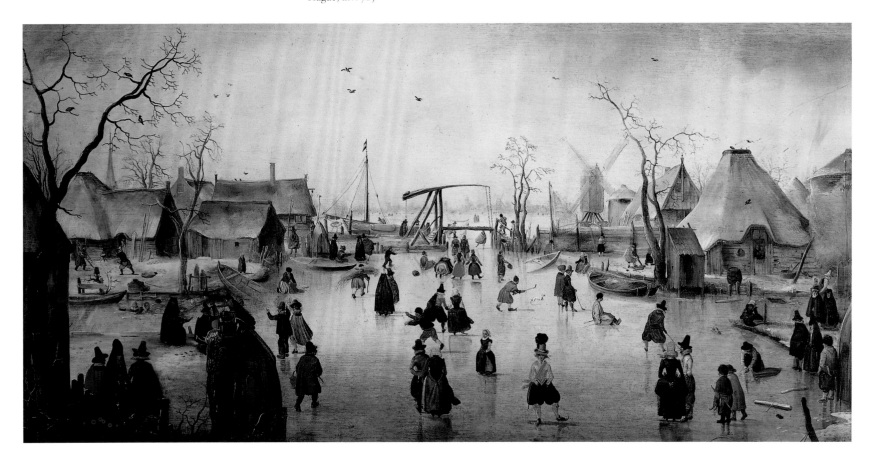

David Vinckboons
(Mechelen 1576–c.1632 Amsterdam?)

Plate 9 (CAT. III)

Landscape with Frozen Canal, Skaters and Ice Boats, c.1610
Panel, 20½ x 39⅜ in. (52 x 100 cm.)
Private Collection

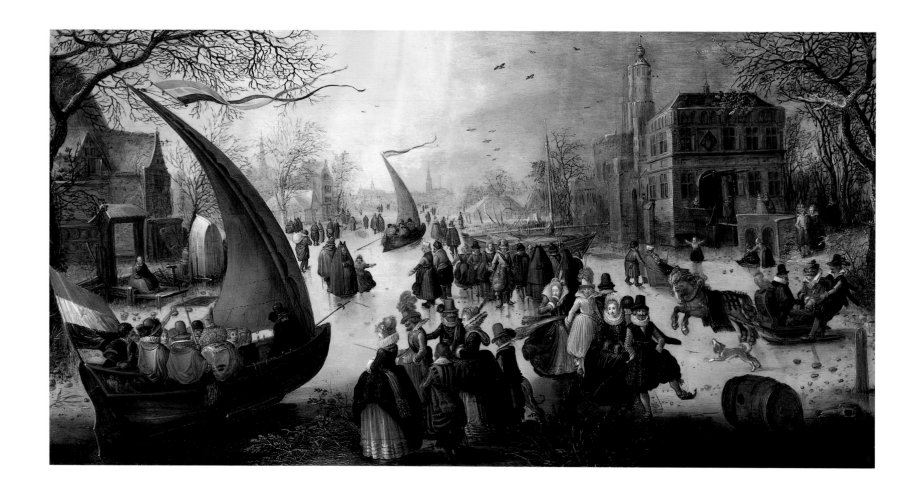

Hendrick Avercamp
(Amsterdam 1585–1635 Kampen)

Plate 10 (CAT. 7)

Winter Scene with a Frozen Canal, c.1620
Monogrammed
Panel, 14½ x 25¾ in. (36.8 x 65 cm.)
From the Private Collection of Mr. and Mrs. Edward
William Carter, Los Angeles, California

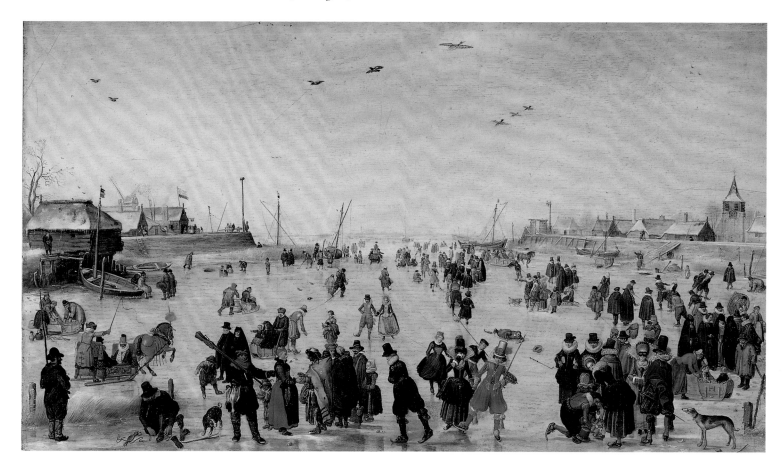

Pieter Lastman
(Amsterdam c.1583–1633 Amsterdam)

Plate 11 (CAT. 55)

Landscape with Pastoral Figures, c.1609–14
Signed
Panel, 15 x 21¼ in. (38 x 54 cm.)
Private Collection

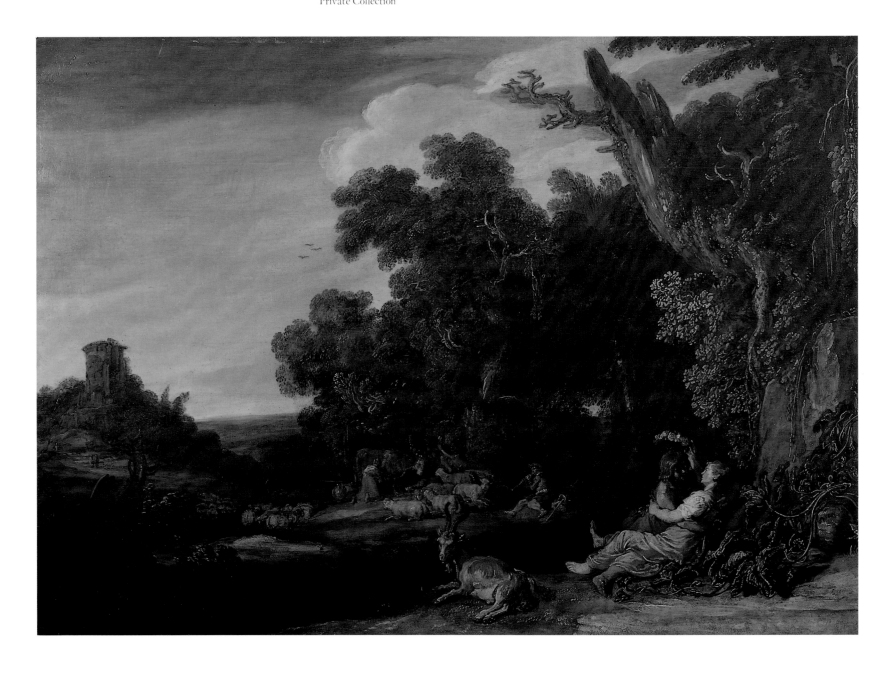

Jacob Pynas
(Haarlem c.1585–after 1656 Haarlem)

Plate 12 (CAT. 75)

Landscape with Mercury and Battus, 1618
Monogrammed and dated
Panel, 15¼ x 20¾ in. (38.7 x 52.7 cm.)
Private Collection, New York

Moyses van Wtenbrouck

(c.1590?–c.1647 The Hague)

Plate 13 (CAT. 123)

Forest Pool with Hermaphroditus and Salmacis, 1627
Monogrammed and dated
Panel, 17 x 26 in. (43 x 66 cm.)
Rijksdienst Beeldende Kunst, The Hague, inv. NK 2532

Abraham Bloemaert

(Gorinchem 1564–1651 Utrecht)

Plate 14 (CAT. 12)

Landscape with the Parable of the Tares of the Field, 1624
Signed and dated
Canvas, 39½ x 52¼ in. (100.3 x 137.8 cm.)
Courtesy, Walters Art Gallery, Baltimore, Maryland,
gift of the Hon. Francis D. Murnaghan, no. 37.2505

Esaias van de Velde
(Amsterdam 1587–1630 The Hague)

Plate 15 (CAT. 105)

Riders Resting on a Wooded Road, 1619
Signed and dated
Panel 15 x 19⅝ in. (38 x 50 cm.)
Private Collection, Boston

Esaias van de Velde

Plate 16 (CAT. 107)

Landscape with Cottages and a Frozen River, 1629
Signed and dated
Paper on panel, 8⅜ x 13¼ in. (21.2 x 33.5 cm.)
From the Private Collection of Mr. and Mrs. Edward
William Carter, Los Angeles

Gillis de Hondecoutre

(Antwerp c.1575-80–1638 Amsterdam)

Plate 17 (CAT. 48)

Entrance to a Village with Hunters, c.1615–18
Monogrammed
Panel, 16 x 29⅛ in. (40.5 x 72 cm.)
Rijksmuseum, Amsterdam, inv. A 1502

Gerrit Claesz Bleker

(?c.1600–1656 Haarlem)

Plate 18 (CAT. 11) *Amsterdam only*

Stag Hunting in the Dunes, c.1627
Signed and indistinctly dated
Panel, 30⅞ x 53½ in. (78.5 x 136 cm.)
Frans Halsmuseum, Haarlem, inv. 550

Cornelis Vroom
(Haarlem c.1591–1661 Haarlem)

Plate 19 (CAT. 114)

River Landscape with Imaginary Ruins, c.1622–30
Signed
Panel, 11⅝ x 23⅝ in. (29.5 x 60 cm.)
Frans Halsmuseum, Haarlem, inv. 499

Cornelis Vroom

Plate 20 (CAT. 115)

Estuary Viewed through a Screen of Trees, c.1638
Signed
Panel, 19¾ x 26½ in. (50 x 67.3 cm.)
Private Collection, on loan to Frans Halsmuseum, Haarlem

Cornelis van Poelenburch
(Utrecht 1594/95–1667 Utrecht)

Plate 21 (CAT. 68) *Amsterdam only*

Waterfalls at Tivoli, c.1622
Monogrammed
Copper, 9½ x 13⅛ in. (24.1 x 33.3 cm.)
Bayerische Staatsgemäldesammlungen, Alte Pinakothek,
Munich, inv. 5273

Cornelis van Poelenburch

Plate 22 (CAT. 70) *Boston only*
Rest on the Flight into Egypt, 1640s
Monogrammed
Copper, 13 x 17 in. (33 x 42 cm.)
Harvard University Art Museums (Fogg Art Museum).
Purchase from the Louise Haskell Daly and Alpheus Hyatt Funds, 1965.523

Cornelis van Poelenburch
(Utrecht 1594/95–1667 Utrecht)

Plate 23 (CAT. 69)
The Flight into Egypt, 1625
Monogrammed and dated
Canvas, 18⅞ x 28 in. (48 x 71 cm.)
Centraal Museum, Utrecht, inv. 8391

Bartholomeus Breenbergh
(Deventer 1598–1657 Amsterdam)

Plate 24 (CAT. 17)

The Voyage of Eliezer and Rebecca, 1630
Signed and dated
Panel, 19⅛ x 31½ in. (48.5 x 80 cm.)
Private Collection, Montreal

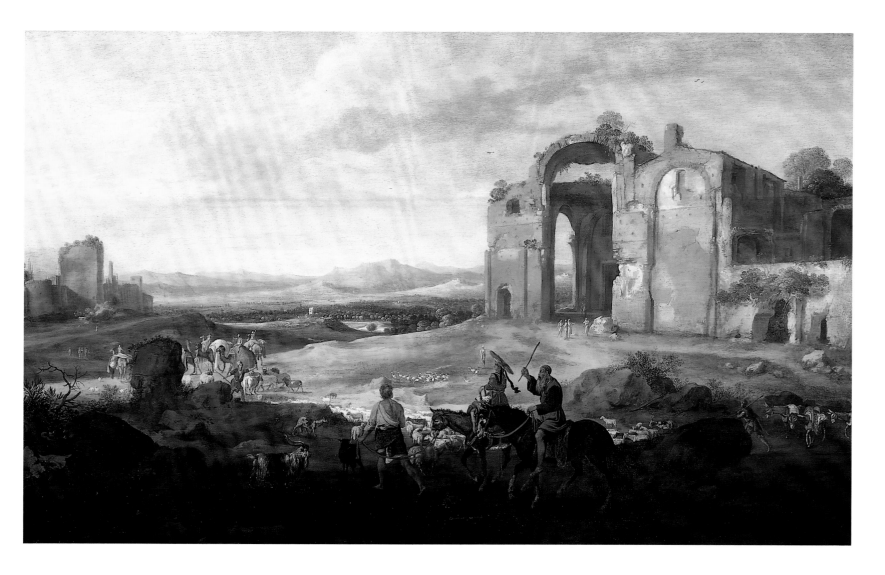

Jan van Goyen
(Leiden 1596–1656 The Hague)

Plate 25 (CAT. 31)

Summer, 1625 (pendant of Plate 26)
Signed and dated
Panel, diam. 13⁵⁄₁₆ in. (33.5 cm.)
Rijksmuseum, Amsterdam, A 3945

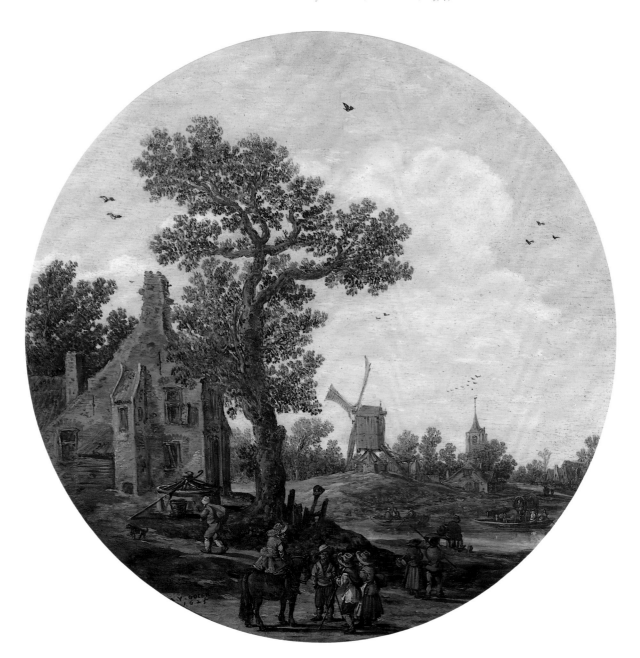

Jan van Goyen

Plate 26 (CAT. 32)
Winter, 1625 (pendant of Plate 25)
Signed and dated
Panel, diam. 13³⁄₁₆ in. (33.5 cm.)
Rijksmuseum, Amsterdam, inv. A 3946

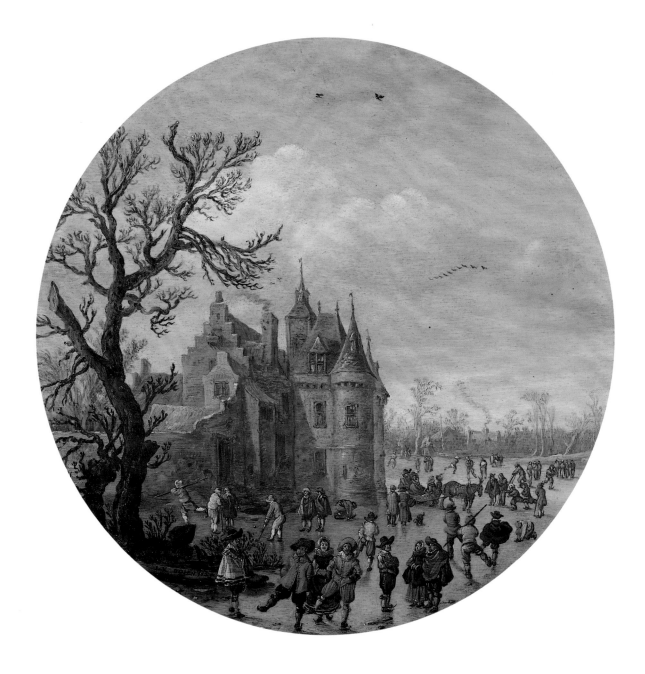

Esaias van de Velde
(Amsterdam 1587–1630 The Hague)

Plate 27 (CAT. 106) *Amsterdam only*
The Ferryboat, 1622
Signed and dated
Panel, 29¾ x 44½ in. (75.5 x 113 cm.)
Rijksmuseum, Amsterdam, inv. A 1293

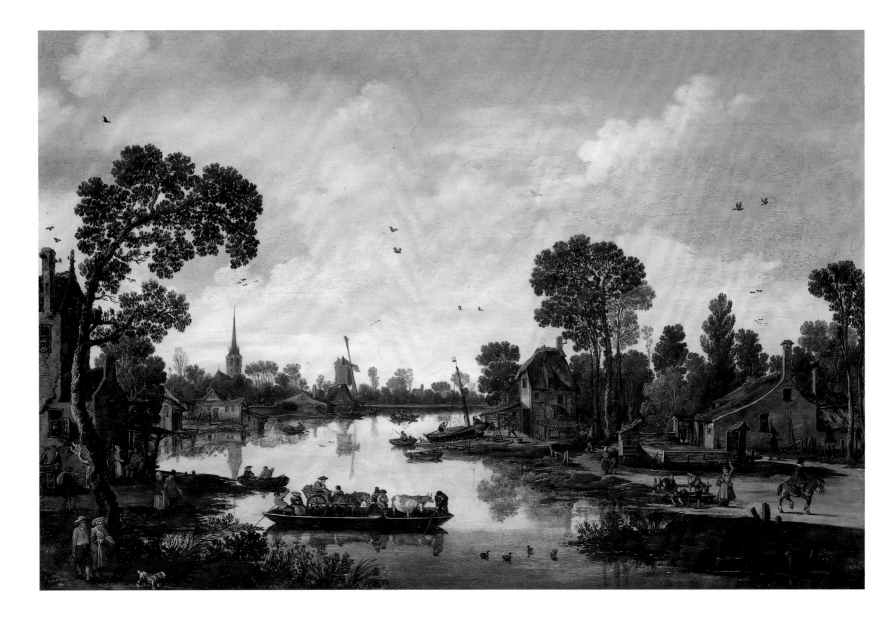

Jan van Goyen
(Leiden 1596–1656 The Hague)

Plate 28 (CAT. 33)

River Landscape with Ferry and Windmill, 1625
Signed and dated
Panel, 16⅜ x 25¼ in. (41.5 x 64 cm.)
Foundation E.G. Bührle Collection, Zurich, no. 152

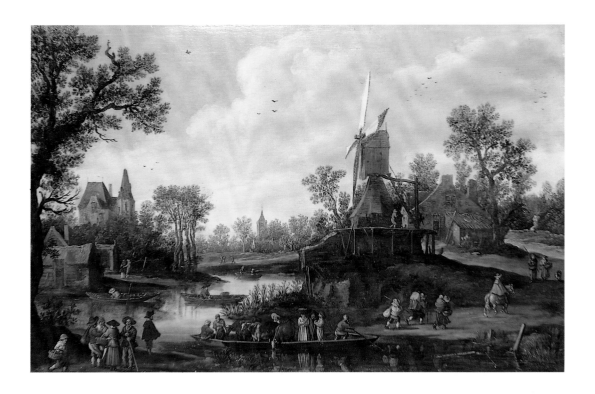

Pieter van Santvoort

(Amsterdam 1604/05–1635 Amsterdam)

Plate 29 (CAT. 98)

Landscape with a Road and Farmhouse, 1625
Signed and dated
Panel, 11⅞ x 14⅝ in. (30 x 37 cm.)
Gemäldegalerie, Staatliche Museen Preussischer
Kulturbesitz, Berlin (West), no. 1985

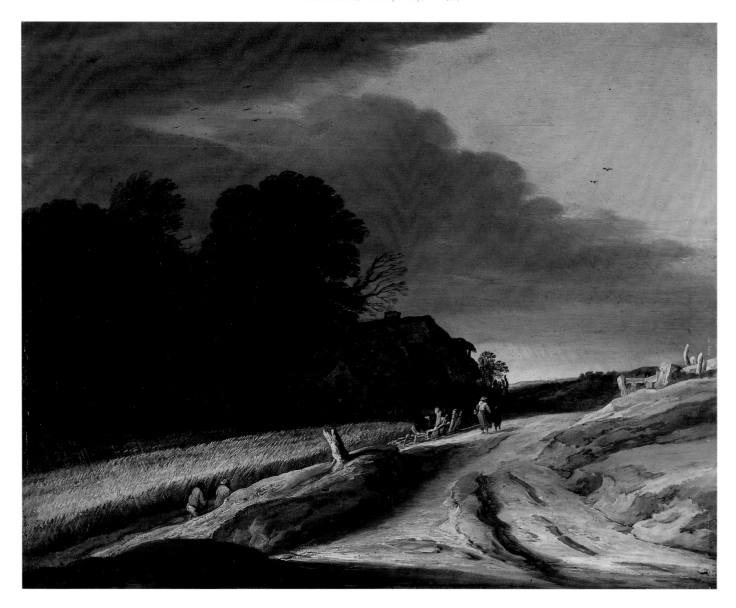

Pieter de Molijn
(London 1595–1661 Haarlem)

Plate 30 (CAT. 56)

Dune Landscape with Trees and Wagon, 1626
Signed and dated
Panel, 10¼ x 14⅛ in. (26 x 36 cm.)
Herzog Anton Ulrich-Museum, Braunschweig, inv. 338

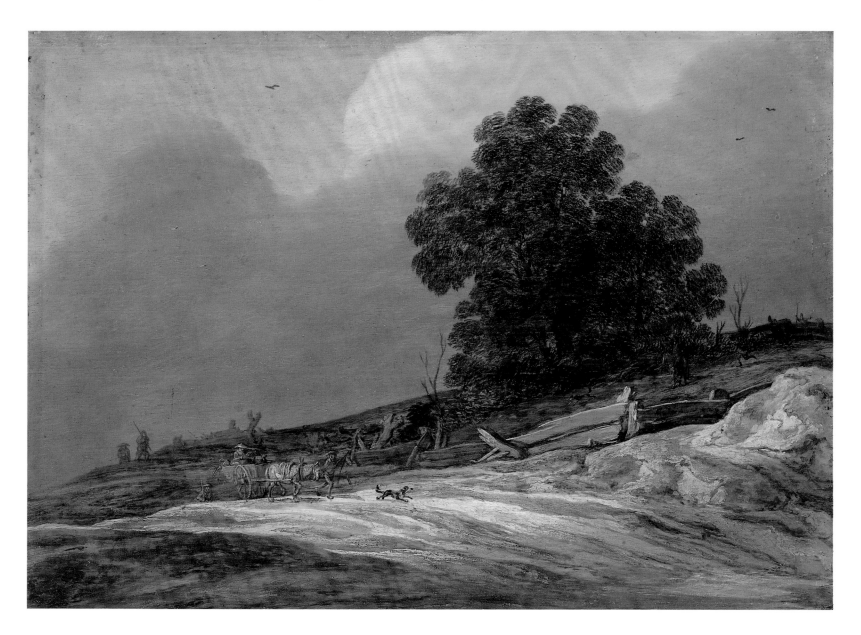

Salomon van Ruysdael
(Naarden 1600-03–1670 Haarlem)

Plate 31 (CAT. 90) *Amsterdam only*

Landscape with a Fence, 1631
Signed and dated
Panel, 14⅞ x 21⅜ in. (37.8 x 54.3 cm.)
Kunsthistorisches Museum, Vienna, inv. 6972

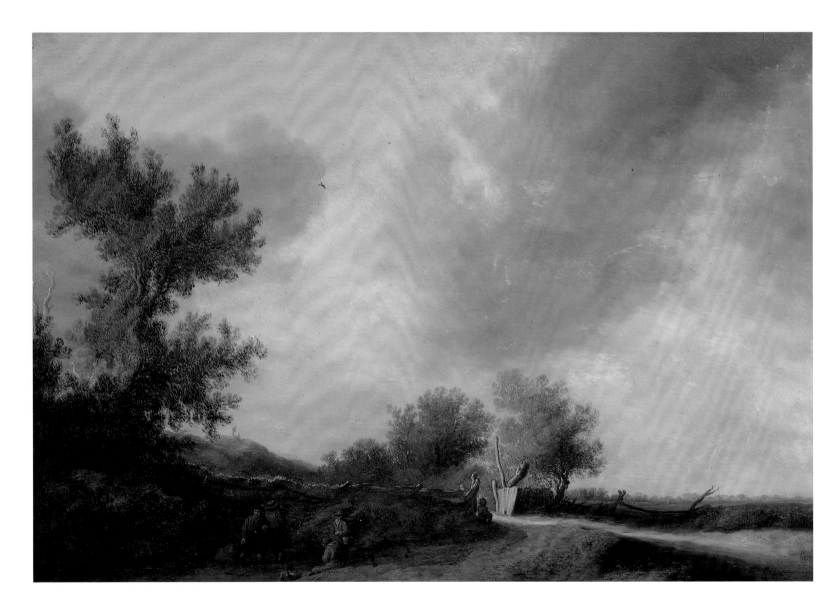

Salomon van Ruysdael

Plate 32 (CAT. 91)
Road in the Dunes with a Passenger Coach, 1631
Monogrammed and dated
Panel, 22 x 34 in. (56 x 86.4 cm.)
Szépművészeti Múzeum, Budapest, inv. 260

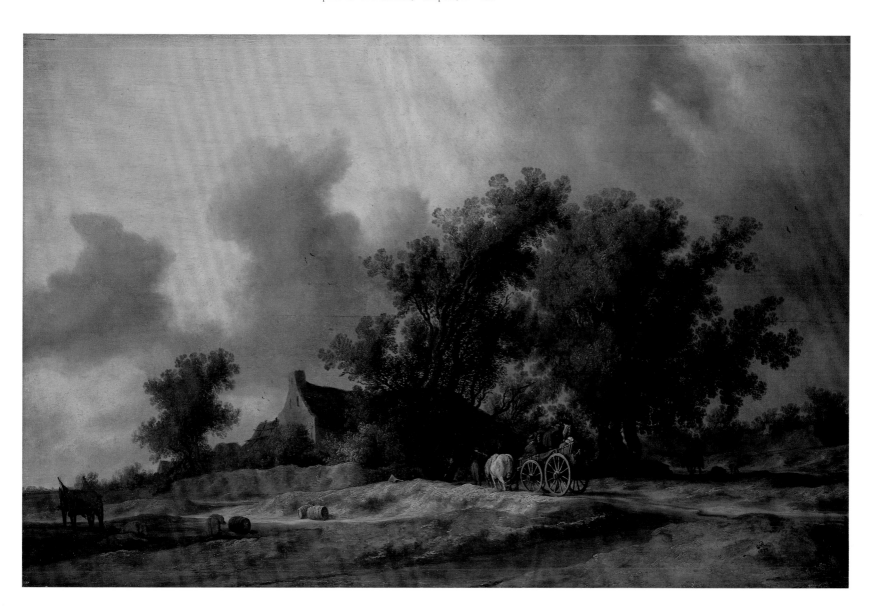

Jan van Goyen
(Leiden 1596–1656 The Hague)

Plate 33 (CAT. 35) *Amsterdam only*

Dune Landscape, 1631
Monogrammed and dated
Panel, 15½ x 24¾ in. (39.5 x 62.7 cm.)
Herzog Anton Ulrich-Museum, Braunschweig, no. 340

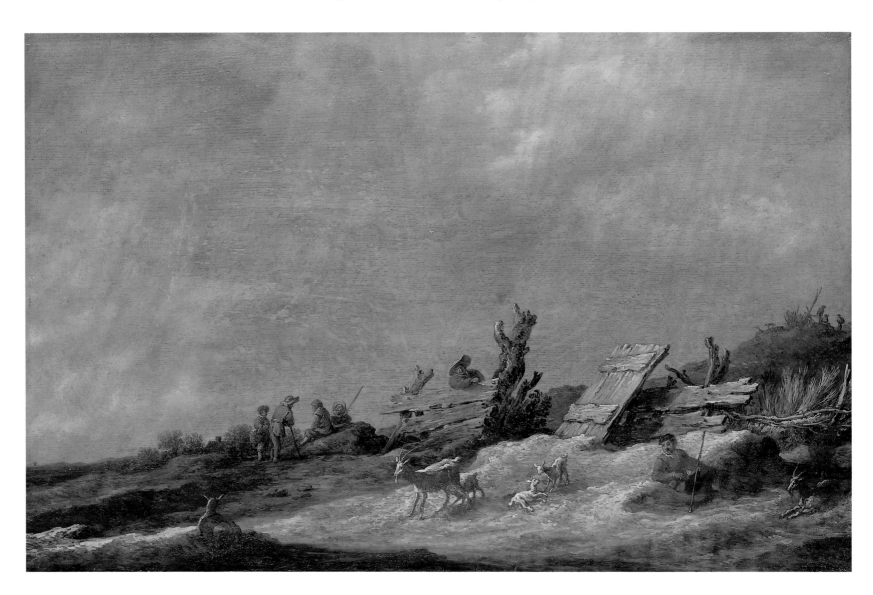

Jan van Goyen

Plate 34 (CAT. 34)
Farmhouses with Peasants, 1630 or 1636
Monogrammed and dated
Panel, 14⅛ x 20¼ in. (36 x 51 cm.)
Private Collection, New York

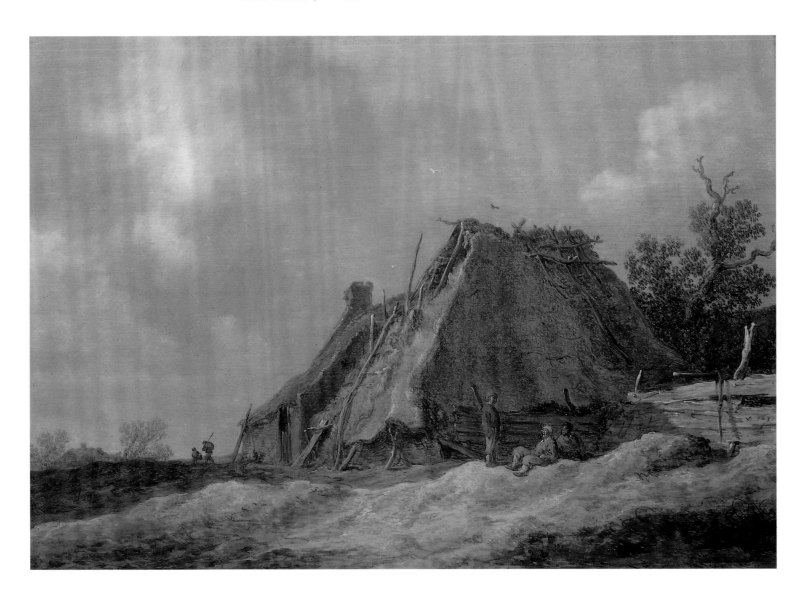

Jan van Goyen

Plate 35 (CAT. 36)
Landscape with Two Oaks, 1641
Monogrammed and dated
Canvas, 34⅞ x 43½ in. (88.5 x 110.5 cm.)
Rijksmuseum, Amsterdam, inv. A 123

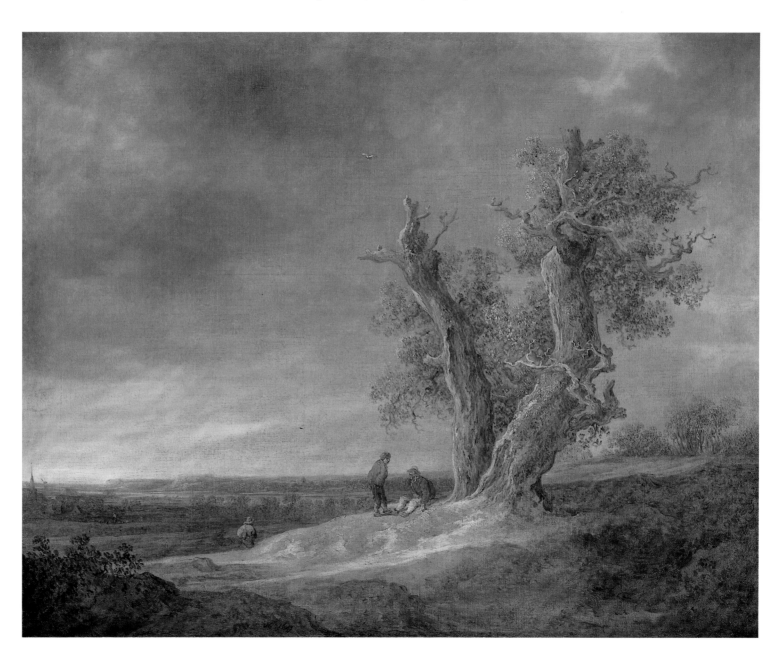

Aelbert Cuyp

(Dordrecht 1620–1691 Dordrecht)

Plate 36 (CAT. 20)

Farm Scene with Cottages and Animals, c.1641
Signed
Canvas, 41½ x 61 in. (105 x 155 cm.)
Private Collection

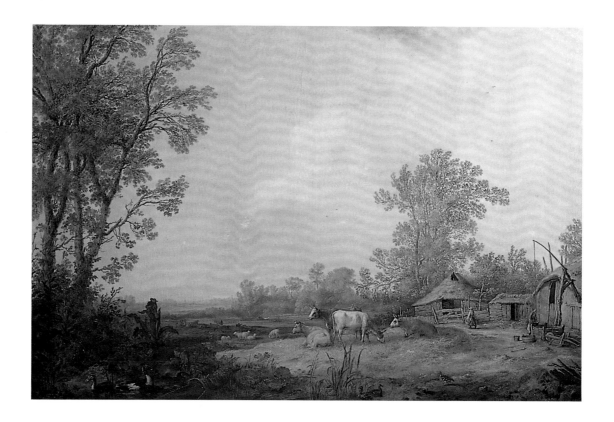

Jan van Goyen
(Leiden 1596–1656 The Hague)

Plate 37 (CAT. 37)

View of Rhenen, 1646
Signed and dated
Canvas, 40 x 53½ in. (101.5 x 136 cm.)
The Corcoran Gallery of Art, Washington, D.C.; William
A. Clark Collection, 26.95

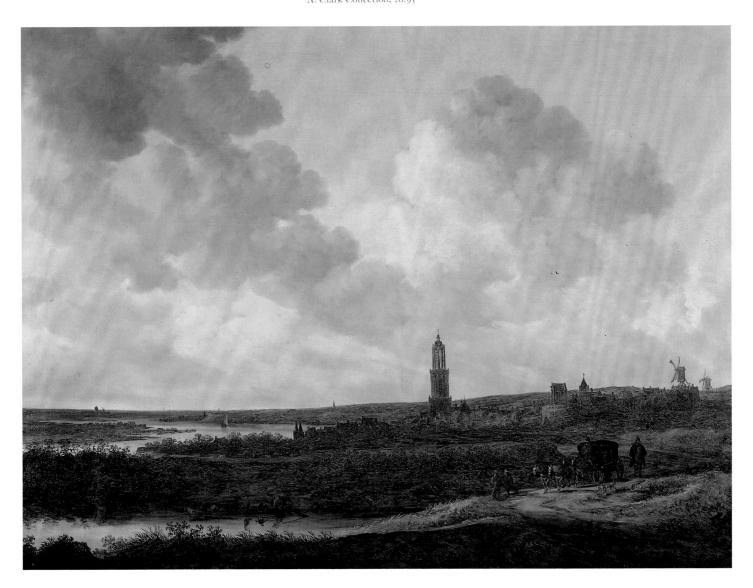

Jan van Goyen

Plate 38 (CAT. 38)

The Beach at Egmond aan Zee, 1653
Monogrammed and dated
Panel, 19 x 29¼ in. (48 x 74.5 cm.)
Private Collection

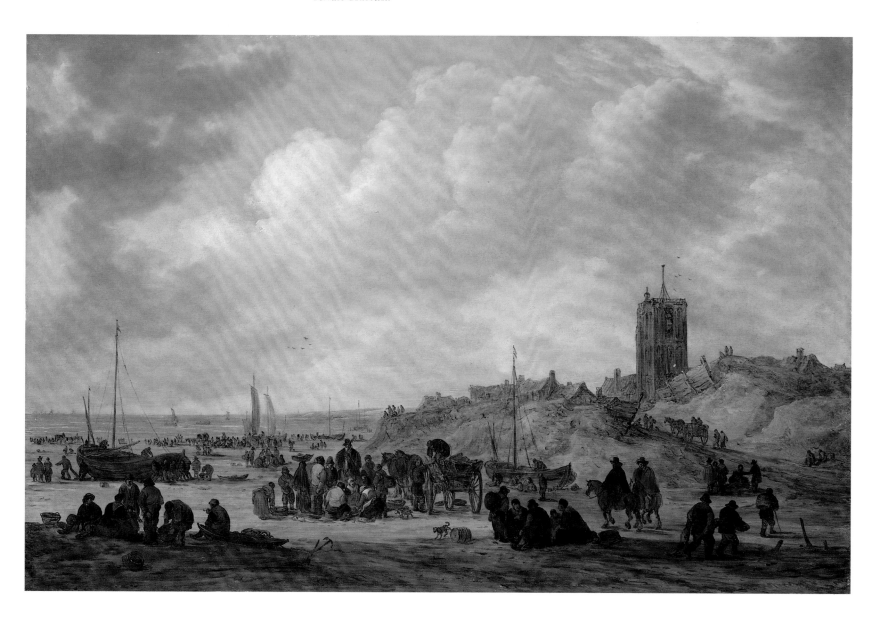

Hercules Segers
(Haarlem 1589/90–1633-38 The Hague?)

Plate 39 (CAT. 100) *Boston and Philadelphia only*
Landscape with a Lake and a Round Building, 1620s
Signed
Canvas on panel, 11½ x 18 in. (29.3 x 45.7 cm.)
Museum Boymans-van Beuningen, Rotterdam, inv. 2383

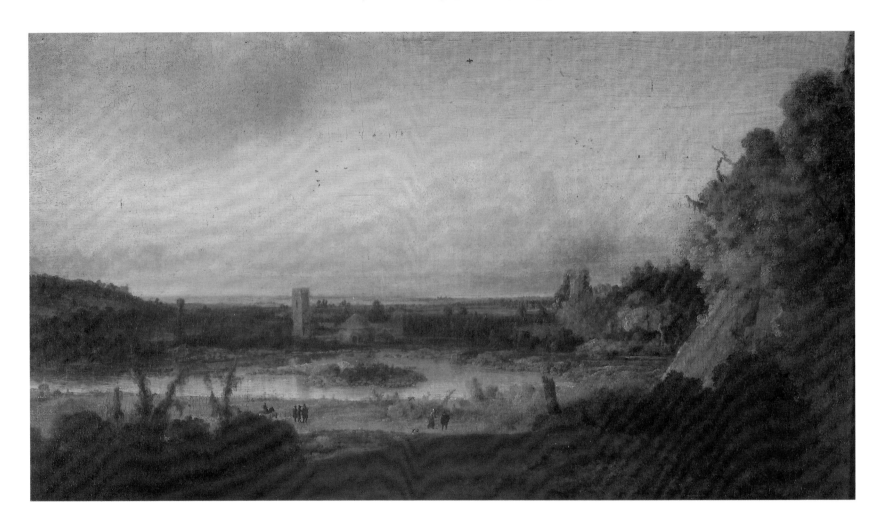

Hercules Segers

Plate 40 (CAT. 101) *Amsterdam only*
Houses near Steep Cliffs, 1620s
Canvas, 27½ x 34⅛ in. (70 x 86.6 cm.)
Museum Boymans-van Beuningen, Rotterdam, inv. 2525

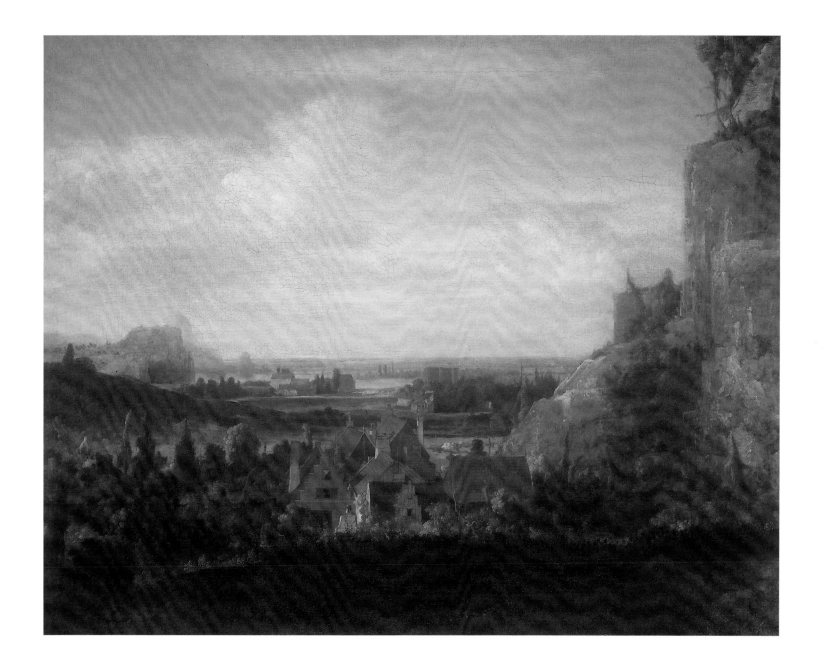

Frans de Momper
(Antwerp 1603–1660 Antwerp)

Plate 41 (CAT. 57)

Valley with Mountains, c.1640–50
Signed
Panel, 14¾ x 25⅛ in. (37.5 x 63.5 cm.)
Philadelphia Museum of Art, The Henry P. McIlhenny
Collection, in memory of Frances P. McIlhenny, no. 1986-26-276

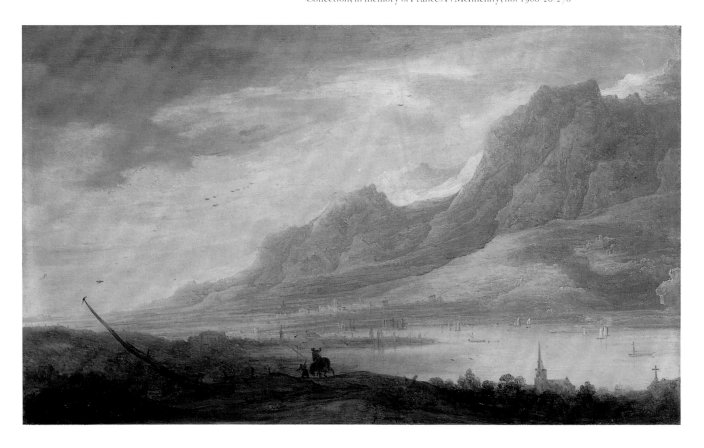

Aert van der Neer

(Amsterdam 1603/04–1677 Amsterdam)

Plate 42 (CAT. 59)

Moonlit View on a River, 1647
Monogrammed and dated
Panel, 22⅝ x 35 in. (57.5 x 89 cm.)
Private Collection, Montreal

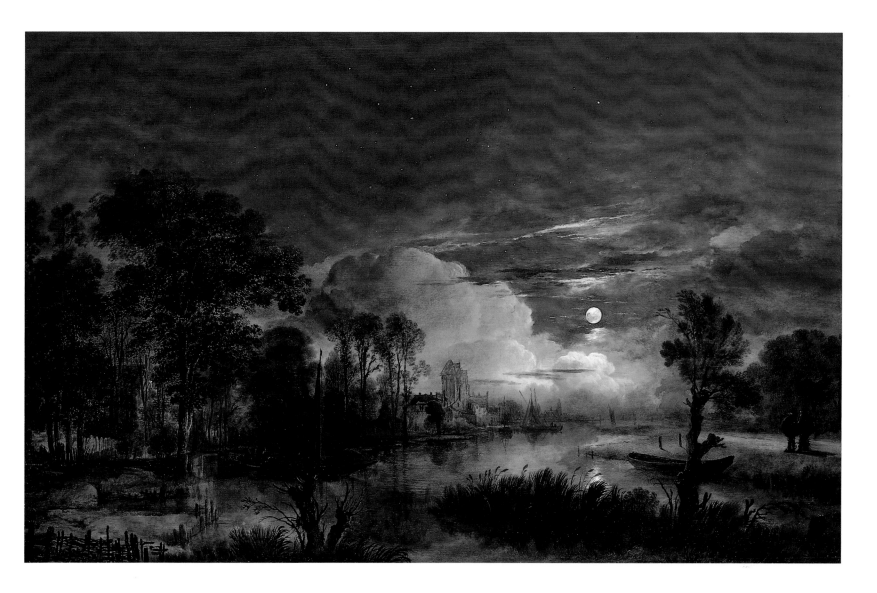

Aert van der Neer

(Amsterdam 1603/04–1677 Amsterdam)

Plate 43 (CAT. 61)

Winter Landscape in a Snowstorm, c.1655–60
Signed
Canvas, 24 x 29⅞ in. (61 x 76 cm.)
Private Collection

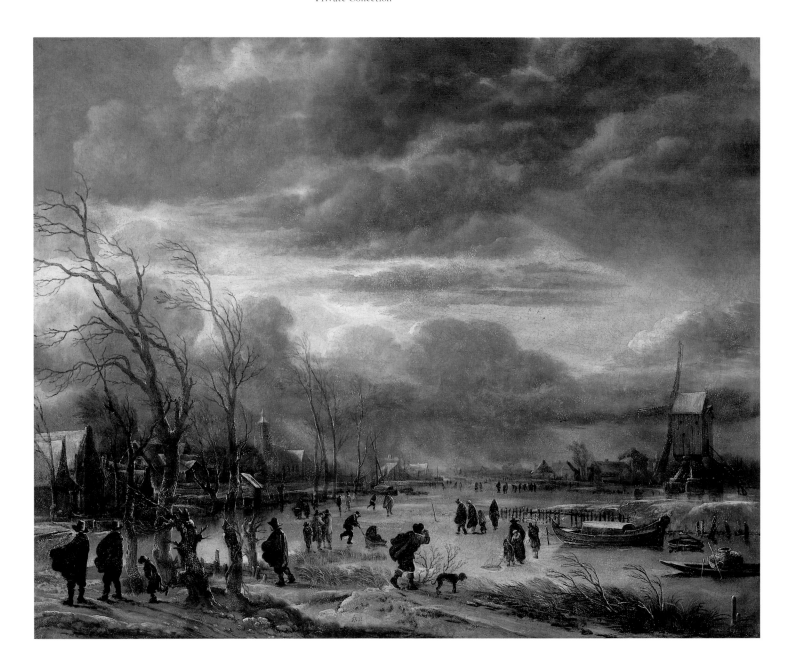

Aert van der Neer

Plate 44 (CAT. 60)
View of a River in Winter, 1655–60
Monogrammed
Canvas, 25¼ x 31⅛ in. (64 x 79 cm.)
Rijksmuseum, Amsterdam, inv. C 191

Isack van Ostade

(Haarlem 1621–1649 Haarlem)

Plate 45 (CAT. 63)

A Frozen Canal with Skaters, c.1644
Signed
Canvas, 39¾ x 58⅝ in. (101 x 149 cm.)
Musée du Louvre, Paris, inv. 1688

Isack van Ostade

Plate 46 (CAT. 64)

Ice Scene before an Inn, 1644
Signed and dated
Panel, 26 x 36 in. (63.5 x 88.5 cm.)
Private Collection

Salomon van Ruysdael
(Naarden 1600-03–1670 Haarlem)

Plate 47 (CAT. 93)

River View, 1645
Monogrammed and dated
Canvas, 38½ x 52 in. (98 x 132 cm.)
Mr. and Mrs. George M. Kaufman

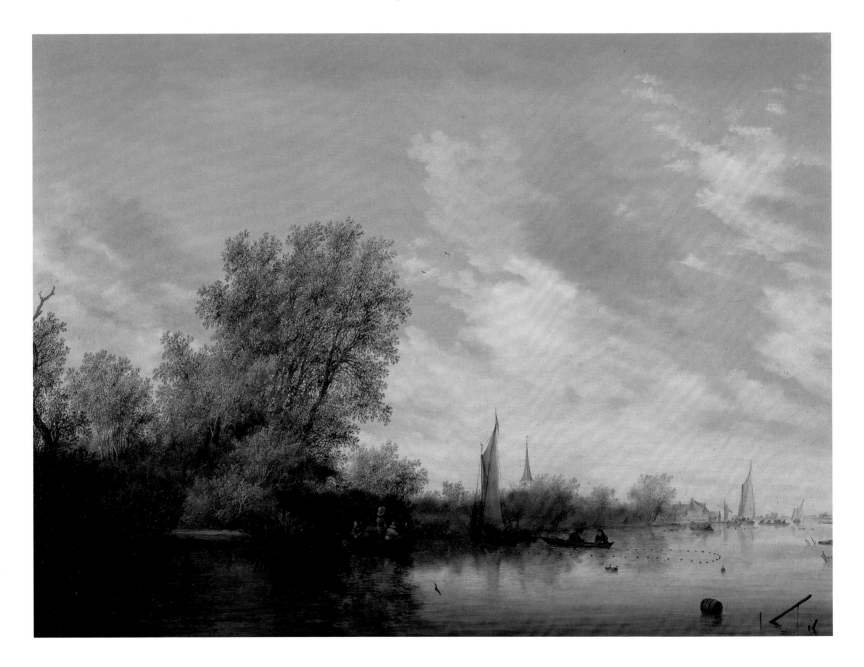

Salomon van Ruysdael

Plate 48 (CAT. 94) *Boston and Philadelphia only*

River Landscape with Ferry, 1649
Signed and dated
Panel, 35⅞ x 49⅝ in. (91 x 126 cm.)
Private Collection

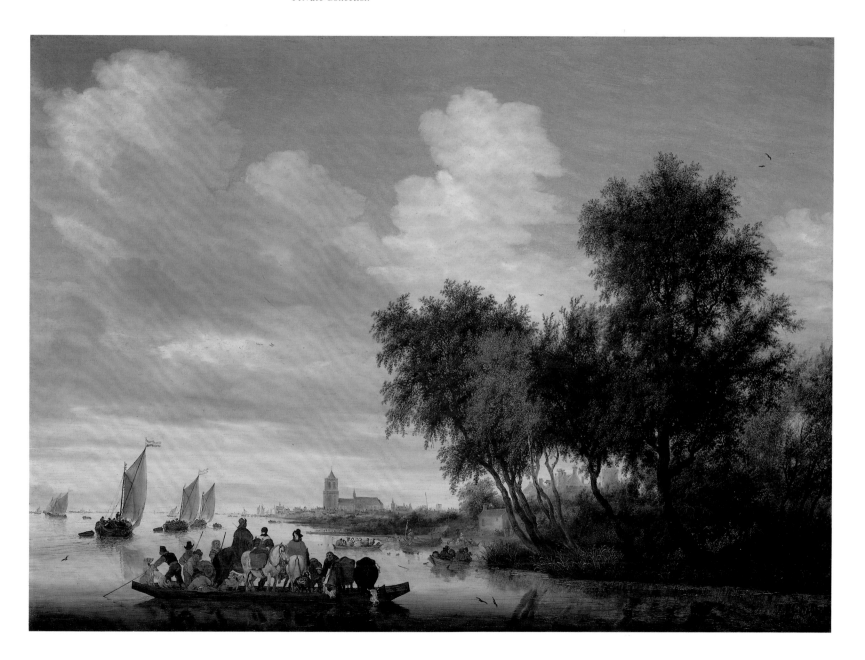

Salomon van Ruysdael
(Naarden 1600-03– 1670 Haarlem)

Plate 49 (CAT. 92)
Travelers before an Inn, 1645
Signed and dated
Panel, 27¼ x 36½ in. (69.5 x 92.5 cm.)
Private Collection

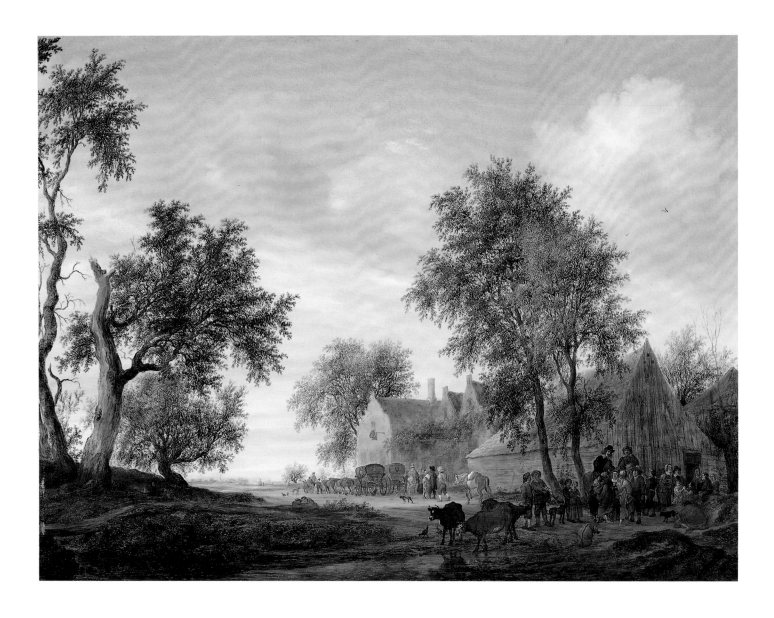

Salomon van Ruysdael

Plate 50 (CAT. 95)
Winter View outside Arnhem, 1653
Monogrammed and dated
Panel, 22 x 31½ in. (56 x 80 cm.)
Dutch Private Collection

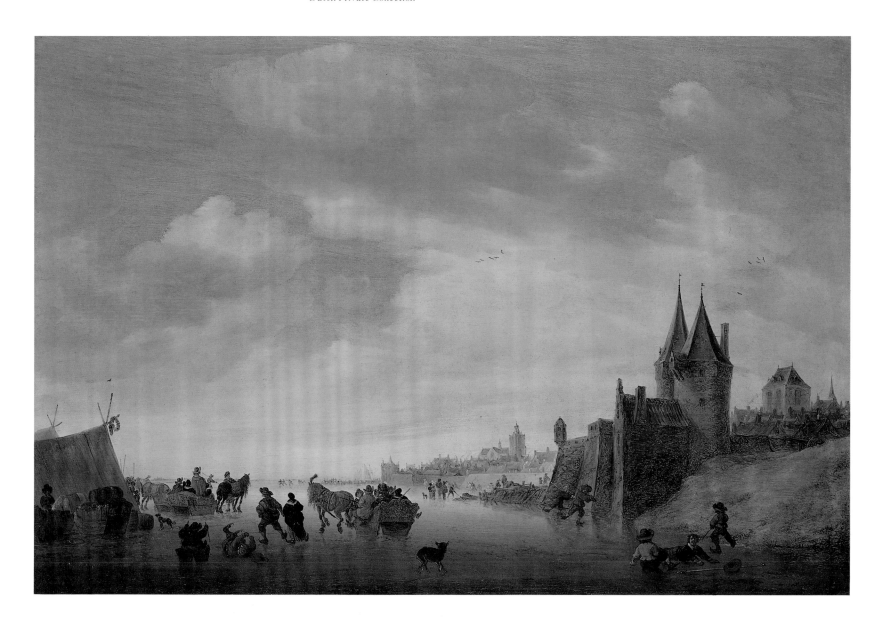

Herman van Swanevelt
(Woerden 1600–1655 Paris)

Plate 51 (CAT. 102)

Landscape with Tall Rocks, 1643
Signed and dated
Canvas, 22 x 27⅛ in. (56 x 69 cm.)
Rijksmuseum, Amsterdam, inv. A 2497

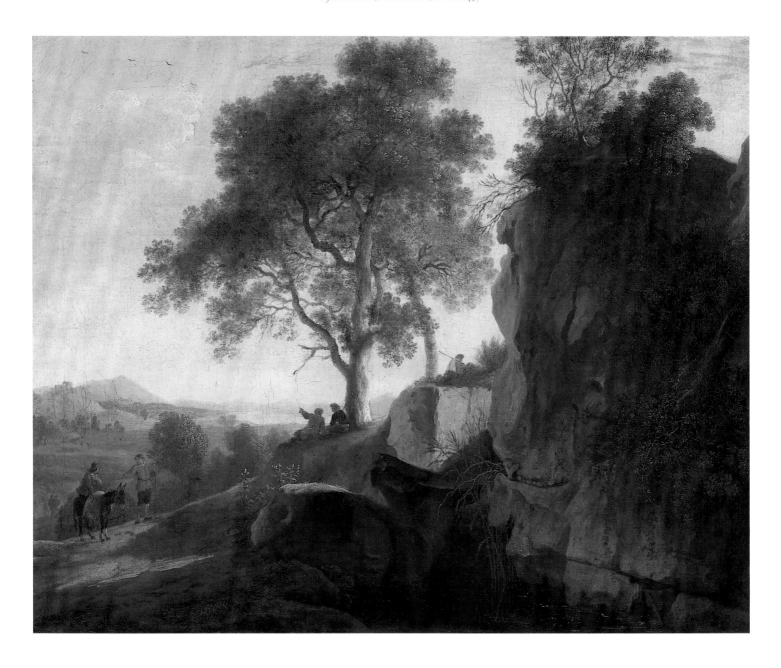

Jan Both
(Utrecht? c.1615–1652 Amsterdam)

Plate 52 (CAT. 14)

Mountain Pass with Large Fir Tree, c.1647–50
Panel, 16¾ x 24 in. (42.5 x 61 cm.)
The Detroit Institute of Arts, gift of James E. Scripps, no. 89.31

Jan Both
(Utrecht? c.1615–1652 Amsterdam)

Plate 53 (CAT. 16)

Landscape with Bandits Leading Prisoners, c.1650
Signed
Canvas, 65⅛ x 85⅝ in. (165.5 x 217.5 cm.)
Museum of Fine Arts, Boston, Seth K. Sweetser Fund,
34.239

Jan Both

Plate 54 (CAT. 15)
Italian Landscape with Draftsmen, c.1650
Signed
Canvas, 73⅜ x 94½ in. (187 x 240 cm.)
Rijksmuseum, Amsterdam, inv. C 109

Jan Asselijn
(Diemen? c.1615–1652 Amsterdam)

Plate 55 (CAT. 2)
Herdsman and Cattle at a Ford, c.1649
Monogrammed
Canvas, 40¼ x 51½ in. (102.4 x 130.7 cm.)
Gemäldegalerie der Akademie der bildenden Künste,
Vienna, inv. no. 810

Jan Asselijn

Plate 56 (CAT. 1)
Mountainous Landscape with Traveling Herdsmen, c.1648–50
Monogrammed
Panel, 16⅞ x 26⅜ in. (43 x 67 cm.)
Gemäldegalerie der Akademie der bildenden Künste,
Vienna, inv. no. 836

Jan Asselijn
(Diemen? c.1615–1652 Amsterdam)

Plate 57 (CAT. 3)

Frozen Moat outside City Walls, 1647–52
Monogrammed
Canvas, 26½ x 41¾ in. (67.4 x 106 cm.)
Worcester Art Museum, Massachusetts; Eliza S. Paine Fund
in memory of William R. and Frances T.C. Paine, 1969.24

Aelbert Cuyp
(Dordrecht 1620–1691 Dordrecht)

Plate 58 (CAT. 23) *Amsterdam only*
Ice Scene before the Huis te Merwede near Dordrecht, 1650s
Signed
Panel, 25½ x 35½ in. (64 x 89 cm.)
The Earl of Yarborough, Brocklesby Hall

Jan Asselijn
(Diemen? c.1615–1652 Amsterdam)

Plate 59 (CAT. 4)
View of the Reconstruction of the St. Anthonis Dike, c.1652
Monogrammed
Canvas, 25½ x 38¼ in. (64 x 97 cm.)
Gemäldegalerie, Staatliche Museen Preussischer
Kulturbesitz, Berlin (West), no. 2/58

Claes Berchem
(Haarlem 1620–1683 Amsterdam)

Plate 60 (CAT. 8)

Peasants near a River (The Kicking Donkey), 1655
Signed and dated
Canvas, 32¼ x 39¼ in. (82 x 100 cm.)
Herzog Anton Ulrich-Museum, Braunschweig, inv. 793

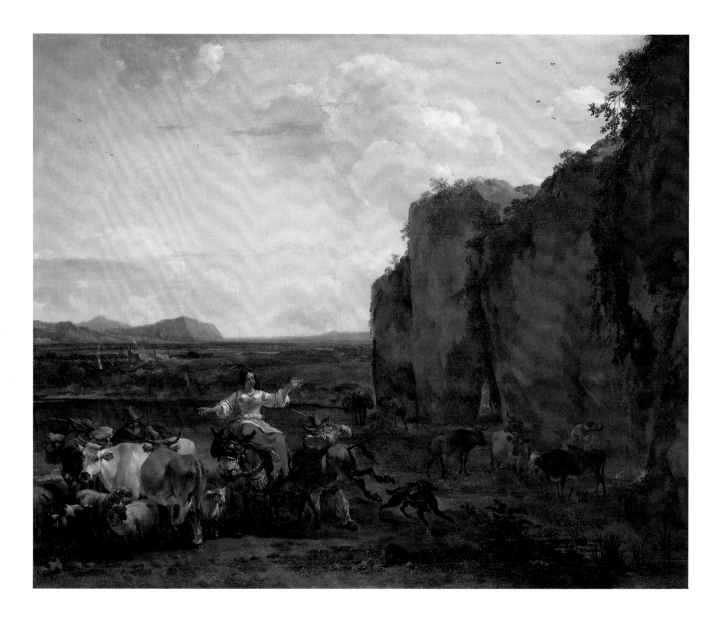

Claes Berchem
(Haarlem 1620–1683 Amsterdam)

Plate 61 (CAT. 9)
Landscape with Crab Catchers by Moonlight, c.1655?
Signed
Canvas, 23¾ x 31½ in. (60.3 x 80 cm.)
Trafalgar Galleries, London, on behalf of a trust

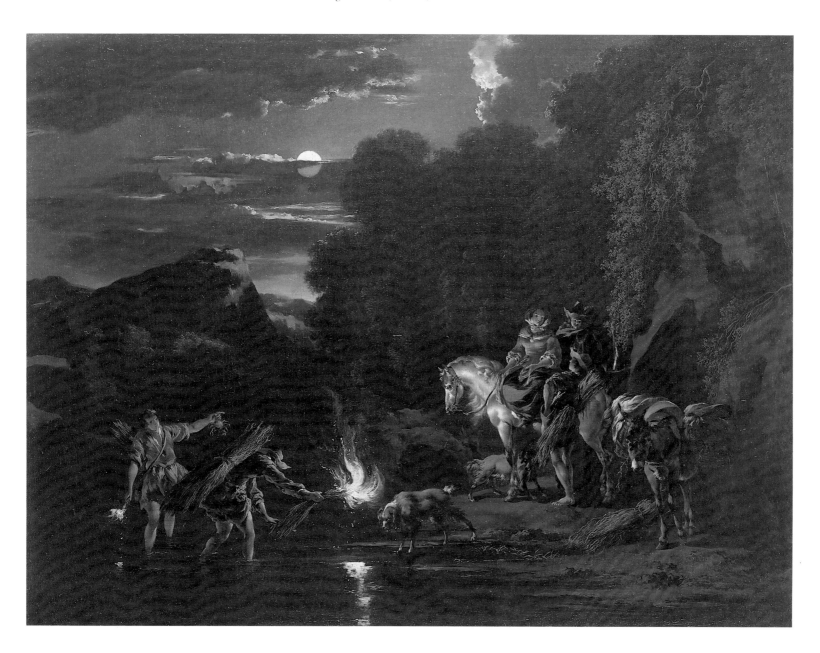

Jan Baptist Weenix
(Amsterdam 1621–1660/61 Utrecht)

Plate 62 (CAT. 116)

River View with a Ferry, c.1647–50
Signed indistinctly
Canvas, 60 x 80 in. (152.4 x 203.2 cm.)
French & Company, New York

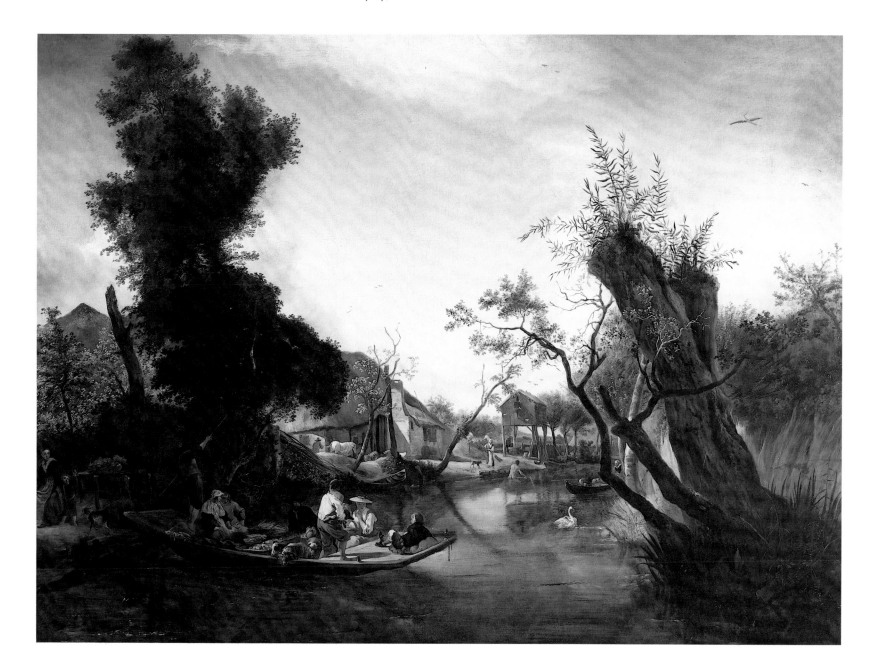

Adam Pijnacker
(Schiedam c.1620–1673 Amsterdam)

Plate 63 (CAT. 65)

Barges on a Riverbank, c.1654–57
Signed
Canvas on panel, 19 x 17 in. (48.5 x 44.5 cm.)
Gemäldegalerie der Akademie der bildenden Künste,
Vienna, inv. 828

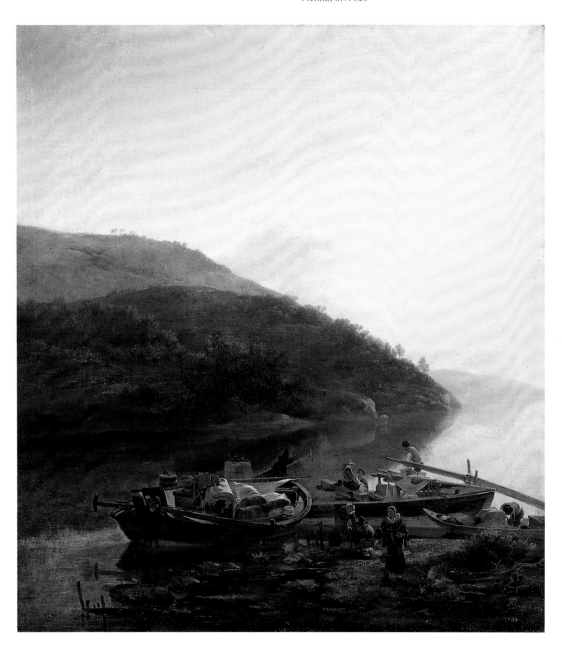

Adam Pijnacker

Plate 64 (CAT. 67)
Barges and Ships on a Coast, c.1665–70
Signed
Canvas, 17⅛ x 22⅞ in. (43.5 x 58.5 cm.)
Wadsworth Atheneum, Hartford, The Ella Gallup Sumner
and Mary Catlin Sumner Collection, 1952.51

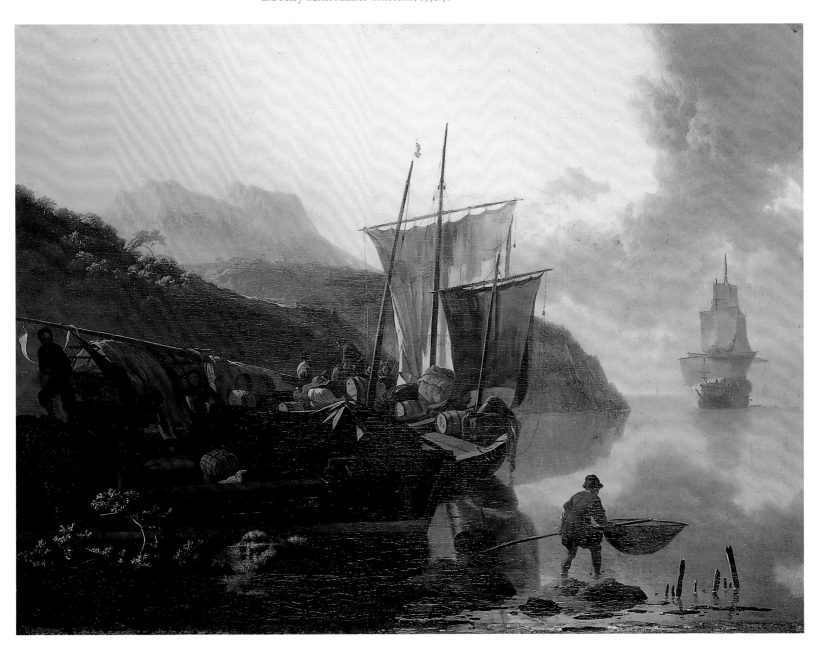

Adam Pijnacker
(Schiedam c.1620–1673 Amsterdam)

Plate 65 (CAT. 66)

Boats on the Bank of a Lake, c.1660
Signed
Canvas on panel, 38 x 33 in. (96.5 x 83.8 cm.)
Rijksmuseum, Amsterdam, inv. A 321

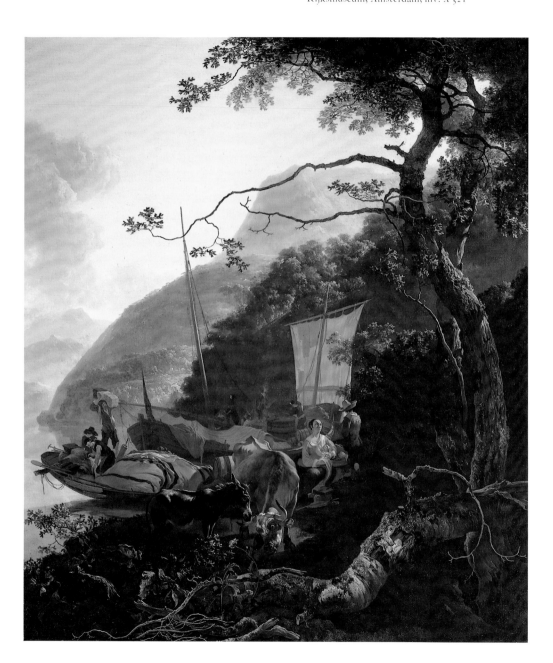

Claes Berchem
(Haarlem 1620–1683 Amsterdam)

Plate 66 (CAT. 10)

Mountainous Landscape with Herders Gathering Wood,
c.1665–75
Canvas, 55½ x 68½ in. (141.1 x 173.9 cm.)
The J. Paul Getty Museum, Malibu, 86.PA 731

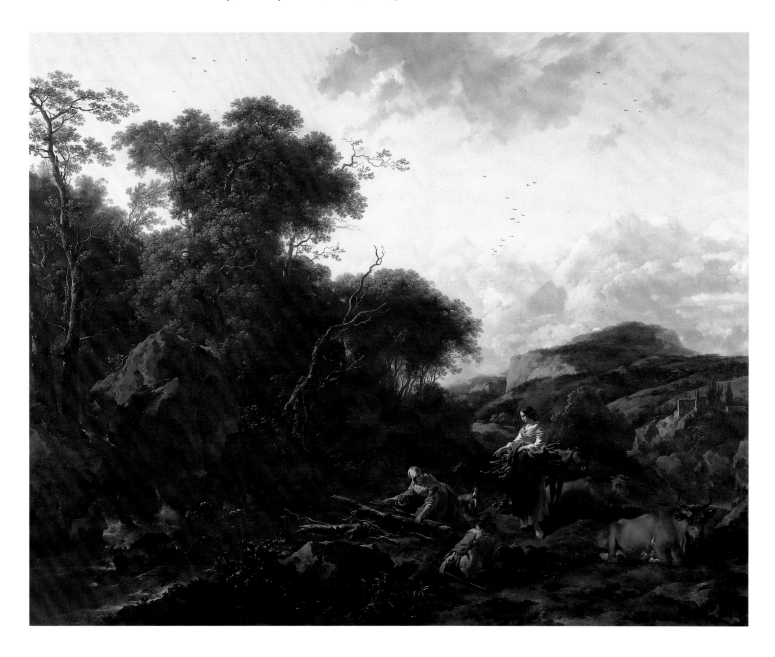

Aelbert Cuyp
(Dordrecht 1620–1691 Dordrecht)

Plate 67 (CAT. 21)

Cattle in a River, c.1650
Signed
Panel, 23½ x 29½ in. (59 x 74 cm.)
Szépművészeti Múzeum, Budapest, inv. 408

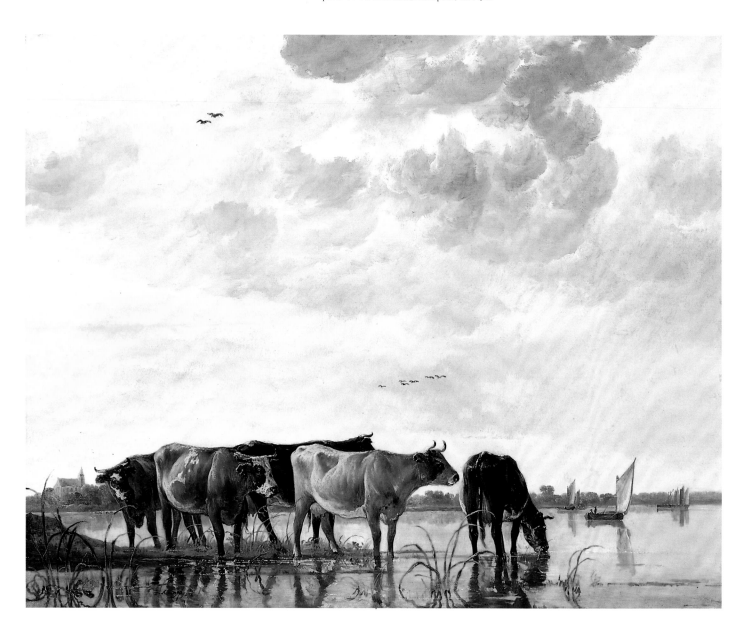

Aelbert Cuyp

Aelbert Cuyp
(Dordrecht 1620–1691 Dordrecht)

Plate 69 (CAT. 24) *Amsterdam and Boston only*
Hilly Landscape with Shepherds and Travelers, late 1650s
Signed
Canvas, 40 x 60½ in. (101.5 x 153.6 cm.)
Her Majesty Queen Elizabeth II, Buckingham Palace, no. 314

Aelbert Cuyp

Plate 70 (CAT. 25) *Amsterdam only*
Landscape with a Rider and Peasants, late 1650s
Signed
Canvas, 49 x 96 in. (123 x 241 cm.)
The Marquess of Bute, on loan to the National Museum of
Wales, Cardiff

Karel du Jardin
(Amsterdam c.1622–1678 Venice)

Plate 71 (CAT. 49)

Peasant Travelers, 1675
Signed and dated
Canvas, 33½ x 42 in. (85 x 107 cm.)
Koninklijk Museum voor Schone Kunsten, Antwerp, inv. 965

Karel du Jardin

Plate 72 (CAT. 50)
Elegant Riders on a Hilltop Overlooking a Lake, c.1675–78
Canvas, 20⅞ x 27 in. (53 x 68.5 cm.)
Gemäldegalerie der Akademie der bildenden Künste,
Vienna, inv. 827

Frans Post
(Haarlem c.1612–1680 Haarlem)

Plate 73 (CAT. 71)
The São Francisco River with Fort Maurits, 1638
Signed and dated
Canvas, 24⅜ x 37⅜ in. (62 x 95 cm.)
Musée du Louvre, Paris, inv. 1727

Frans Post

Plate 74 (CAT. 72)
Ruins of the Cathedral of Olinda, Brazil, 1662
Signed and dated
Canvas, 42⅜ x 68 in. (107.5 x 172.5 cm.)
Rijksmuseum, Amsterdam, inv. A 742

Alexander Keirincx
(Antwerp 1600–1652 Amsterdam)

Plate 75 (CAT. 52)

Landscape with Deer Hunt, c.1640–45
Canvas, 33⅛ x 43¼ in. (84 x 110 cm.)
Private Collection

Herman Saftleven
(Rotterdam 1609–1685 Utrecht) and
Cornelius Saftleven
(Gorinchem c.1607–1681 Rotterdam)

Plate 76 (CAT. 96)

Hunter Sleeping on a Hillside, 164(2)
Signed and dated
Panel, 14½ x 20½ in. (36.8 x 52 cm.)
Collection of Maida and George Abrams, Boston

Paulus Potter
(Enkhuizen 1625–1654 Amsterdam)

Plate 77 (CAT. 73) *Boston and Philadelphia only*
Farm near The Hague, 1647
Signed and dated
Panel, 15⅝ x 19¾ in. (39.7 x 50.2 cm.)
By the kind permission of His Grace The Duke of
Westminster, Eaton Hall, Chester

Paulus Potter

Plate 78 (CAT. 74) *Amsterdam only*
Herdsmen with Cattle, 1651
Signed and dated
Canvas, 32 x 36 in. (81 x 97.5 cm.)
Rijksmuseum, Amsterdam, inv. A 318

Simon de Vlieger

(Rotterdam? c.1601–1653 Weesp)

Plate 79 (CAT. 112)

Wooded Landscape with Sleeping Peasants (The Parable of the Tares of the Field)
Signed and dated 165[0–3]
Canvas, 35⅝ x 51⅜ in. (90.4 x 130.4 cm.)
The Cleveland Museum of Art, Mr. and Mrs. William H. Marlatt Fund, 75.76

Jan van der Heyden
(Gorkum 1637–1712 Amsterdam)

Plate 80 (CAT. 43)

Wooded Landscape with Crossroads, 1660s
Signed
Panel, 17½ x 21⅝ in. (44.5 x 55 cm.)
Thyssen-Bornemisza Collection, Lugano, Switzerland, no. 131

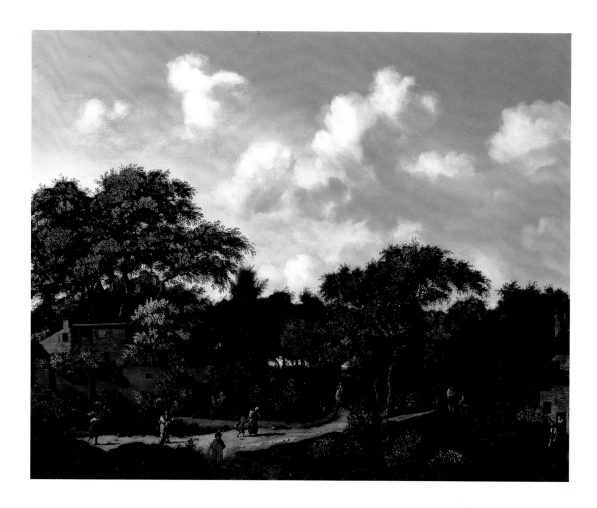

Rembrandt van Rijn
(Leiden 1606–1669 Amsterdam)

Plate 81 (CAT. 76)

The Stone Bridge, late 1630s
Panel, 11⅝ x 16¾ in. (29.5 x 42.5 cm.)
Rijksmuseum, Amsterdam, inv. A 1935

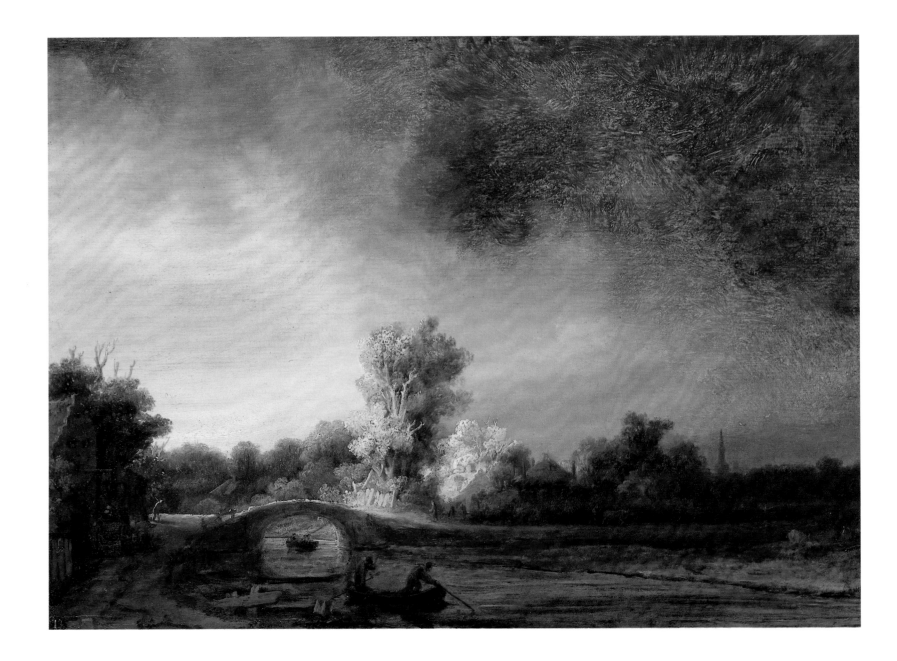

Rembrandt van Rijn

Plate 82 (CAT. 78) *Boston only*

Landscape with the Rest on the Flight into Egypt, 1647
Signed and dated
Panel, 13⅜ x 18⅞ in. (34 x 48 cm.)
The National Gallery of Ireland, Dublin, no. 215

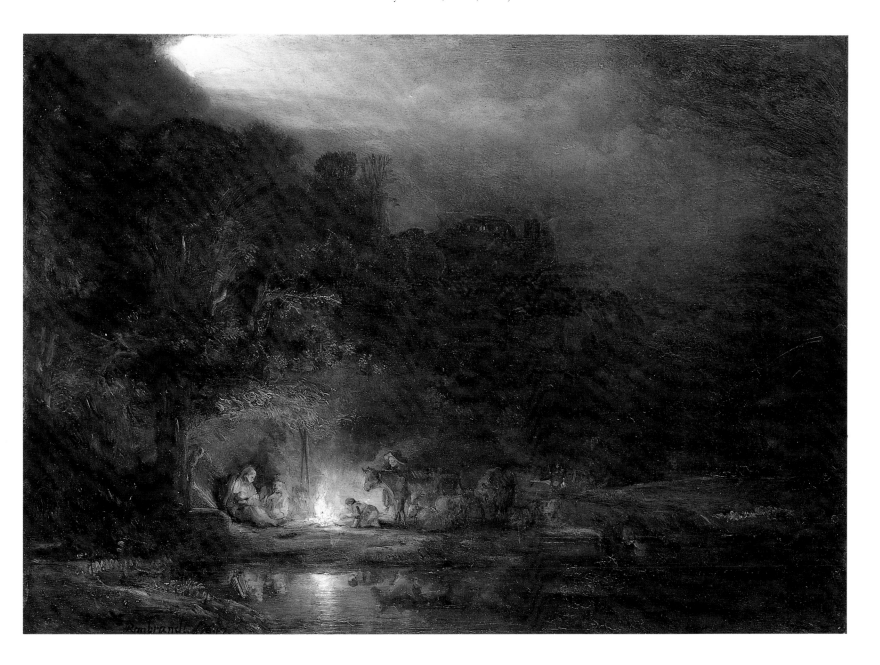

Rembrandt van Rijn

Plate 83 (CAT. 77) *Amsterdam and Boston only*

Ice Scene near Farm Cottages, 1646
Signed and dated
Panel, 6½ x 8¾ in. (16.7 x 22.4 cm.)
Gemäldegalerie Alter Meister, Staatliche
Kunstsammlungen, Kassel, no. GK 241

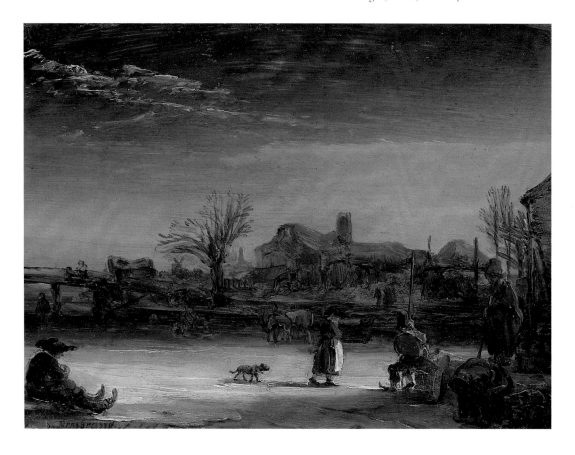

Govaert Flinck
(Kleve 1615–1660 Amsterdam)

Plate 84 (CAT. 29)
Landscape with an Obelisk, 1638
Signed (falsely) and dated
Panel, 21⅝ x 28⅛ in. (55 x 71.5 cm.)
Isabella Stewart Gardner Museum, Boston, no. 2P1W24

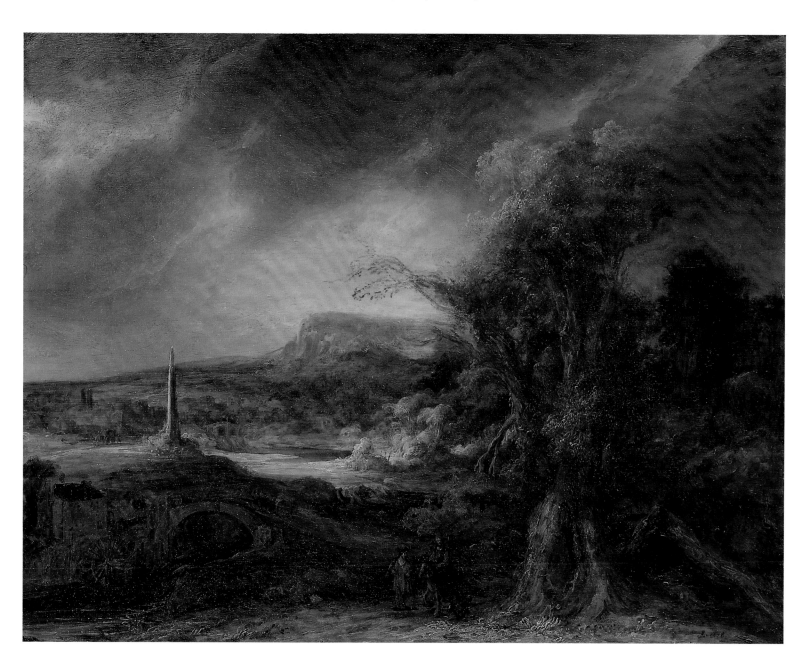

Roeland Roghman

(Amsterdam 1627–1692 Amsterdam)

Plate 85 (CAT. 79)

Valley with Travelers, 1660s
Canvas, 44⅞ x 65¾ in. (114 x 167 cm.)
Galerie Bruno Meissner, Zurich

Gerbrand van den Eeckhout

(Amsterdam 1621–1674 Amsterdam)

Plate 86 (CAT. 26)

Mountain Landscape, 1663
Signed and dated
Canvas, 20⅝ x 25⅝ in. (52.5 x 65 cm.)
Private Collection

Philips Koninck
(Amsterdam 1619–1688 Amsterdam)

Plate 87 (CAT. 53)
Panorama with Cottages Lining a Road, 1655
Signed and dated
Canvas, 52⅜ x 66 in. (133 x 167.6 cm.)
Rijksmuseum, Amsterdam, inv. A 4133

Philips Koninck

Plate 88 (CAT. 54)
Distant View in Gelderland, 1655
Signed and dated
Canvas, 33⅛ x 54 in. (84 x 137 cm.)
Thyssen-Bornemisza Collection, Lugano, no. 156

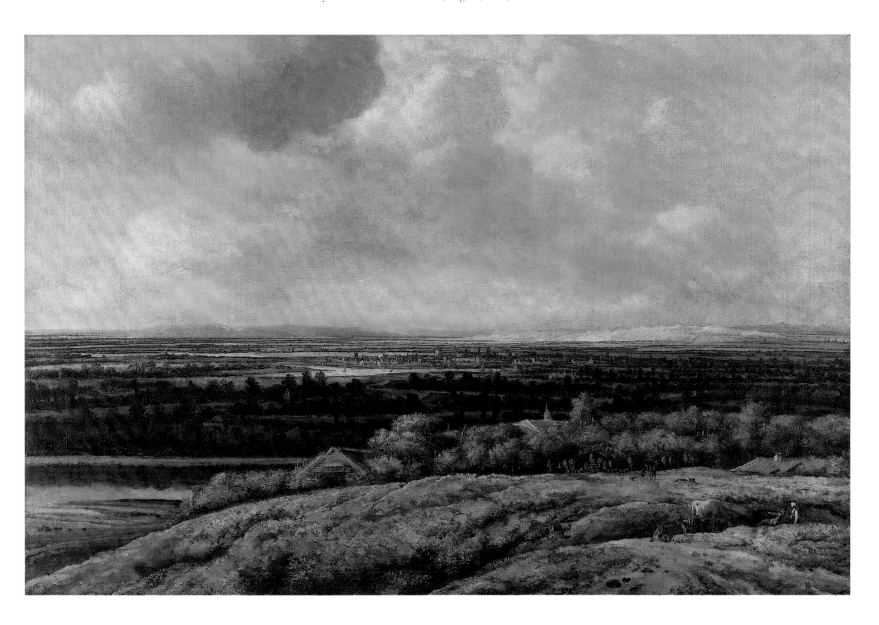

Simon de Vlieger

(Rotterdam? c.1601–1653 Weesp)

Plate 89 (CAT. 113)

Landing Party on a Rugged Coast, 1651
Signed and dated
Panel, 30 x 43 in. (76 x 109 cm.)
Private Collection, Montreal

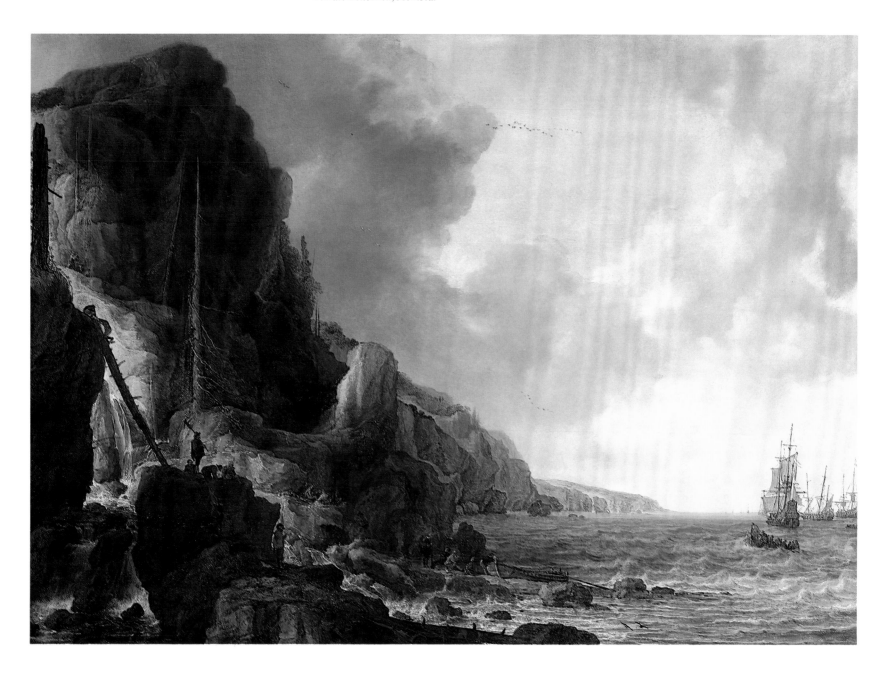

Allart van Everdingen
(Alkmaar 1621–1675 Amsterdam)

Plate 90 (CAT. 27)
Mountain Landscape with River Valley, 1647
Signed and dated
Canvas, 32½ x 42¾ in. (82.5 x 111 cm.)
Statens Museum for Kunst, Copenhagen, no. SP. 513

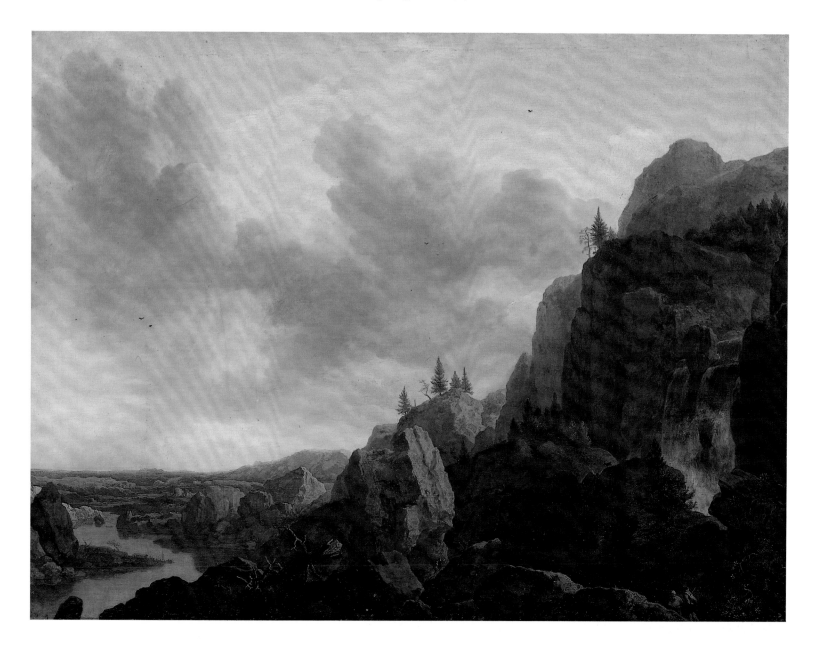

Philips Wouwermans
(Haarlem 1619–1668 Haarlem)

Plate 91 (CAT. 119)
Travelers Awaiting a Ferry, 1649
Monogrammed and dated
Canvas, 26 x 32 in. (66 x 81.3 cm.)
Private Collection, New York

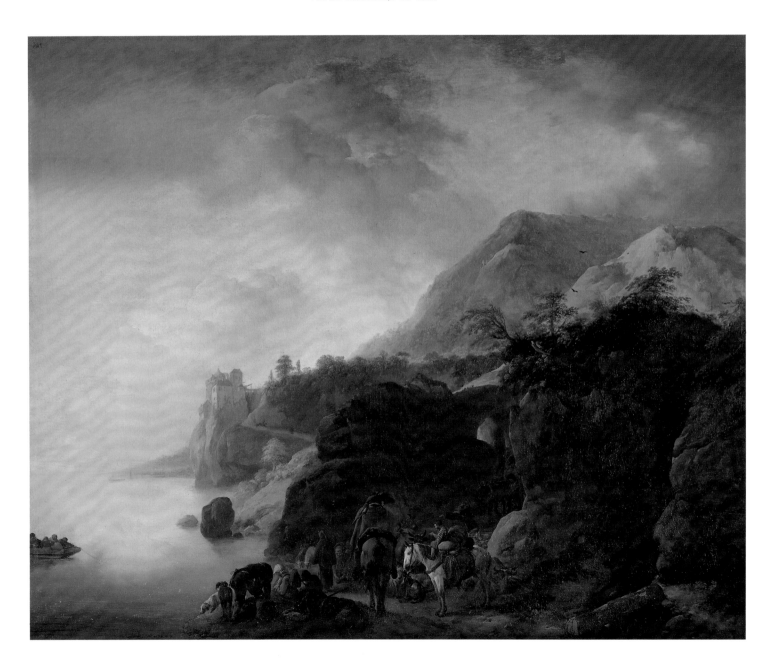

Herman Saftleven
(Rotterdam 1609–1685 Utrecht)

Plate 92 (CAT. 97)

Rhineland Fantasy View, 1650
Signed and dated
Canvas, 21 x 28 in. (53.3 x 71 cm.)
Private Collection, New York

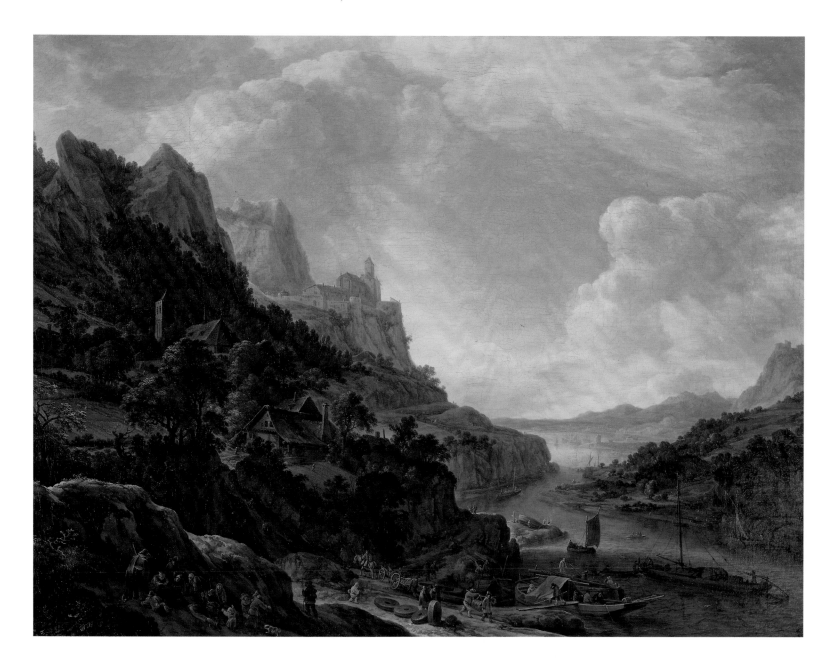

Anthonij van Borssom
(Amsterdam 1630-33–1677 Amsterdam)

Plate 93 (CAT. 13)

A Broad River View with a Horseman, 1660s
Signed
Canvas, 21⅞ x 28⅜ in. (55.5 x 72 cm.)
Szépművészeti Múzeum, Budapest, inv. 187

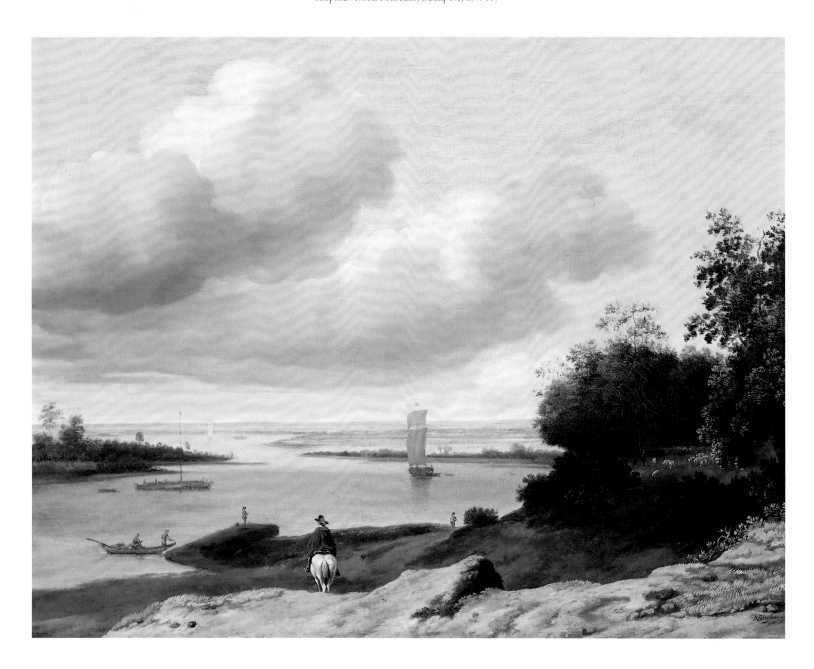

Jacob van Ruisdael
(Haarlem c. 1628/29–1682 Amsterdam)

Plate 94 (CAT. 80)

Dune Landscape, c. 1651–55
Monogrammed
Panel, 13⅜ x 19 in. (34 x 48.3 cm.)
John G. Johnson Collection at the Philadelphia Museum of
Art, no. 563

Allart van Everdingen
(Alkmaar 1621–1675 Amsterdam)

Plate 95 (CAT. 28)
Scandinavian Waterfall with a Watermill, 1650
Signed and dated
Canvas, 44⅛ x 34⅝ in. (112 x 88 cm.)
Bayerische Staatsgemäldesammlungen, Alte Pinakothek,
Munich, inv. no. 387

Jacob van Ruisdael

(Haarlem c.1628/29–1682 Amsterdam)

Plate 96 (CAT. 85)

Waterfall with Castle and a Hut, c.1665
Signed
Canvas, 39¼ x 34 in. (99.7 x 86.3 cm.)
Harvard University Art Museums (Fogg Art Museum).
Gift of Helen Clay Frick, 1953.2

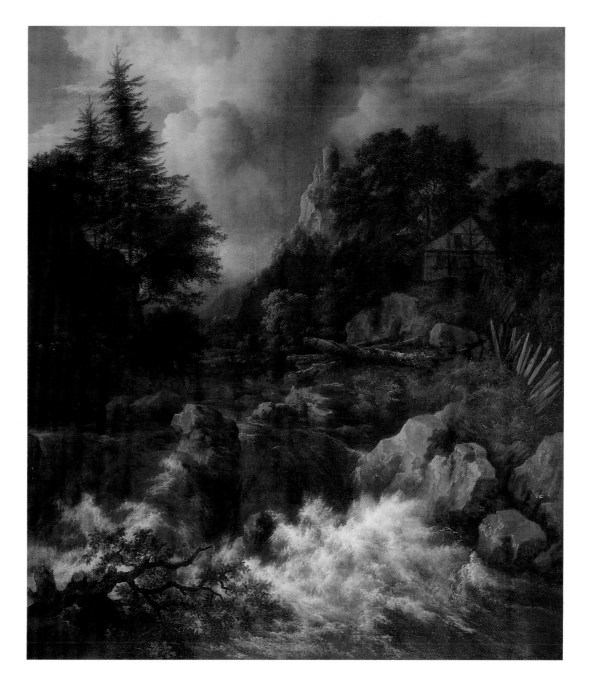

Jacob van Ruisdael

(Haarlem c.1628/29–1682 Amsterdam)

Plate 97 (CAT. 81)

Two Watermills with an Open Sluice, 1653
Signed and dated
Canvas, 26 x 33¼ in. (66 x 84.5 cm.)
The J. Paul Getty Museum, Malibu, no. 82.PA.18

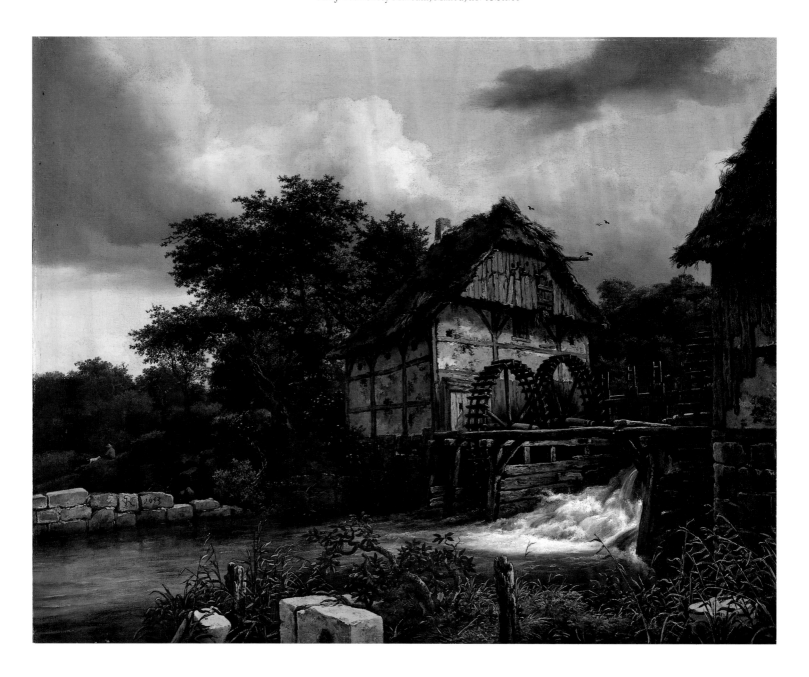

Meindert Hobbema
(Amsterdam 1638–1709 Amsterdam)

Plate 98 (CAT. 46)

Wooded Landscape with a Water Mill, c.1662–64
Signed
Canvas, 32 x 43⅛ in. (81.3 x 109.6 cm.)
The Art Institute of Chicago, Gift of Mr. and Mrs. Frank G.
Logan, 94.1031

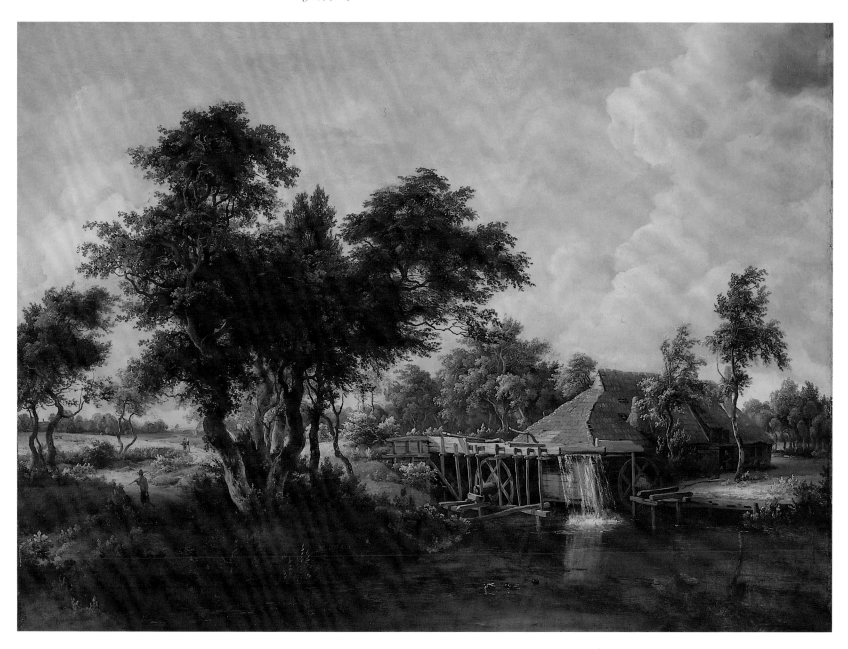

Jacob van Ruisdael

(Haarlem c. 1628/29–1682 Amsterdam)

Plate 99 (CAT. 83)

Grainfields, 1660s
Signed
Canvas, 18½ x 22½ in. (47 x 57.2 cm.)
The Metropolitan Museum of Art, New York, bequest of
Michael Friedsam, The Friedsam Collection, no. 32.100.14

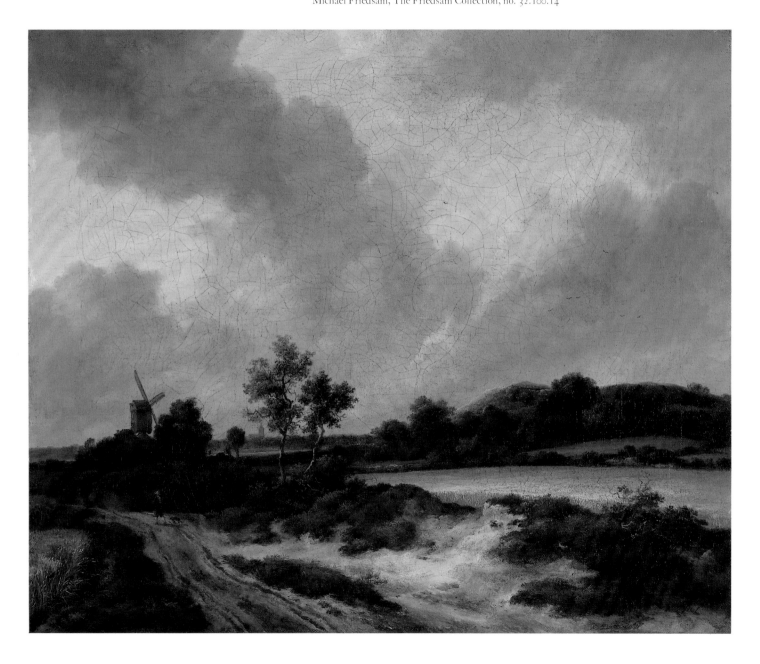

Jacob van Ruisdael

Plate 100 (CAT. 89)
View of Alkmaar, c.1670–75
Signed
Canvas, 17½ x 17⅛ in. (44.4 x 43.5 cm.)
Museum of Fine Arts, Boston, Ernest Wadsworth
Longfellow Fund, 39.794

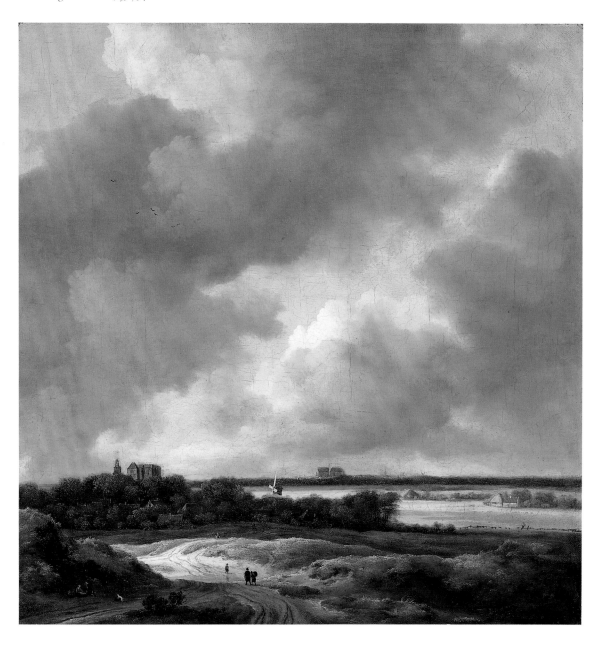

Jacob van Ruisdael

(Haarlem c.1628/29–1682 Amsterdam)

Plate 101 (CAT. 82)

Hilly Landscape with Large Oak, after 1652
Canvas, 41¾ x 54⅜ in. (106 x 138 cm.)
Herzog Anton Ulrich-Museum, Braunschweig, inv. 376

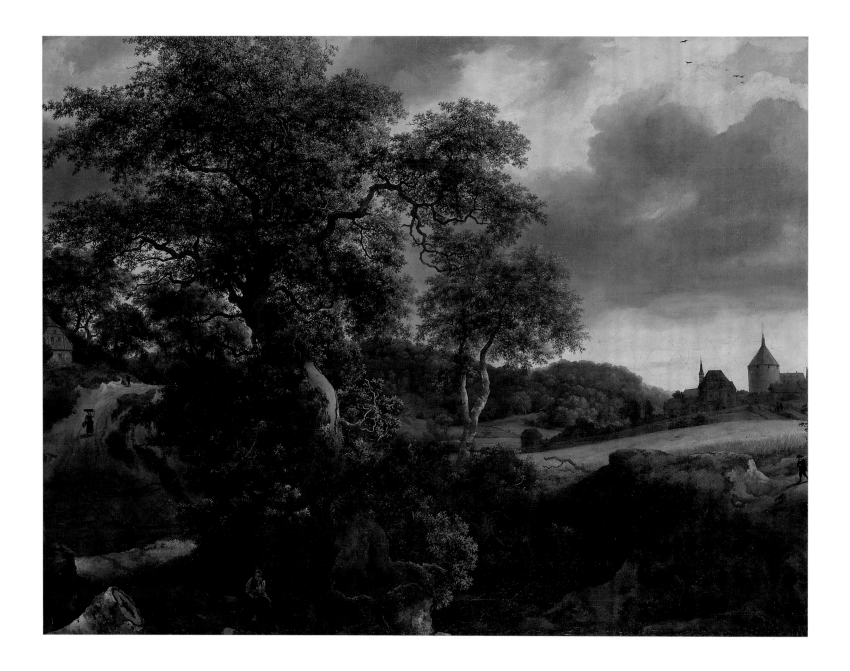

Jacob van Ruisdael

Plate 102 (CAT. 87)
Oaks beside a Pool, mid-1660s
Signed
Canvas, 44⅞ x 55½ in. (114 x 141 cm.)
Gemäldegalerie, Staatliche Museen Preussischer
Kulturbesitz, Berlin (West), no. 885G

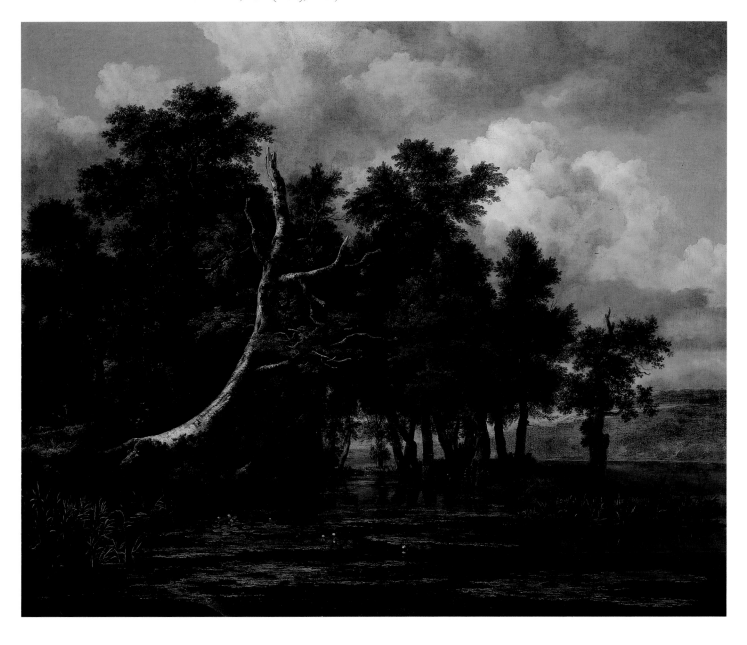

Jacob van Ruisdael

(Haarlem c.1628/29–1682 Amsterdam)

Plate 103 (CAT. 88)

The Mill at Wijk, c.1670
Signed
Canvas, 32¾ x 39¼ in. (83 x 101 cm.)
Rijksmuseum, Amsterdam, inv. C 211

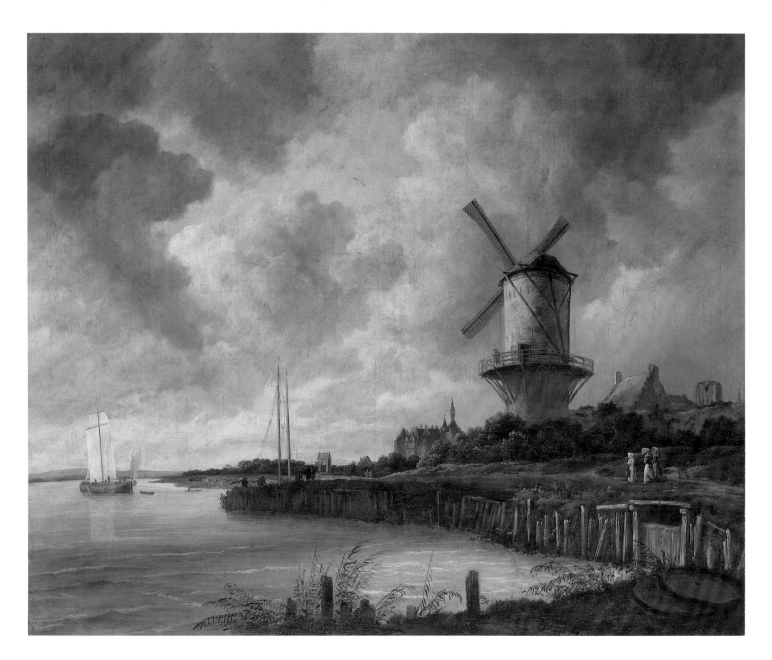

Jacob van Ruisdael

Plate 104 (CAT. 86) *Philadelphia only*
The Jewish Cemetery, 1668–72
Signed
Canvas, 55½ x 72 in. (141 x 182.9 cm.)
The Detroit Institute of Arts, Gift of Julius H. Haass, in
memory of his brother Dr. Ernest W. Haass, no. 26.3

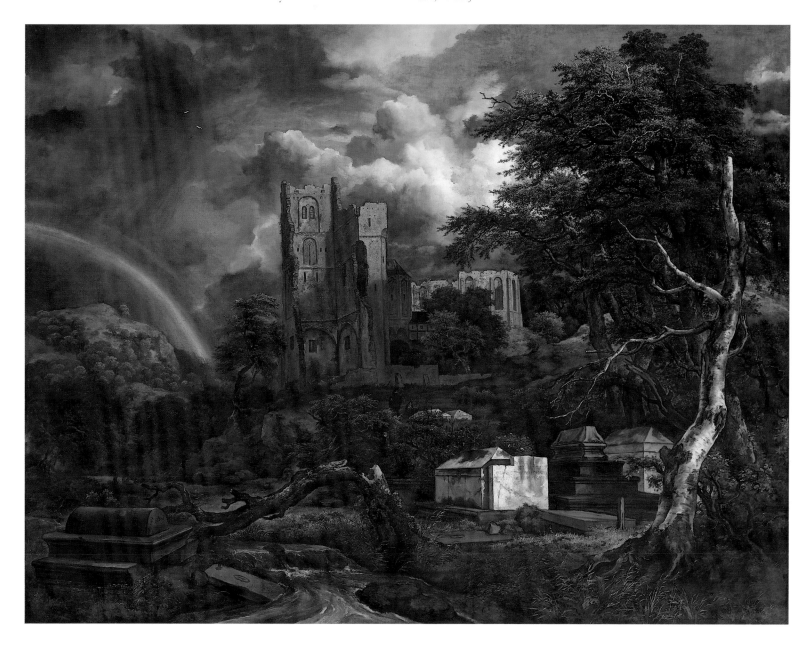

Jacob van Ruisdael
(Haarlem c.1628/29–1682 Amsterdam)

Plate 105 (CAT. 84)
A Village in Winter, mid-1660s
Signed
Canvas, 14⅛ x 12¼ in. (36 x 31 cm.)
Bayerische Staatsgemäldesammlungen, Alte Pinakothek,
Munich, inv. 117

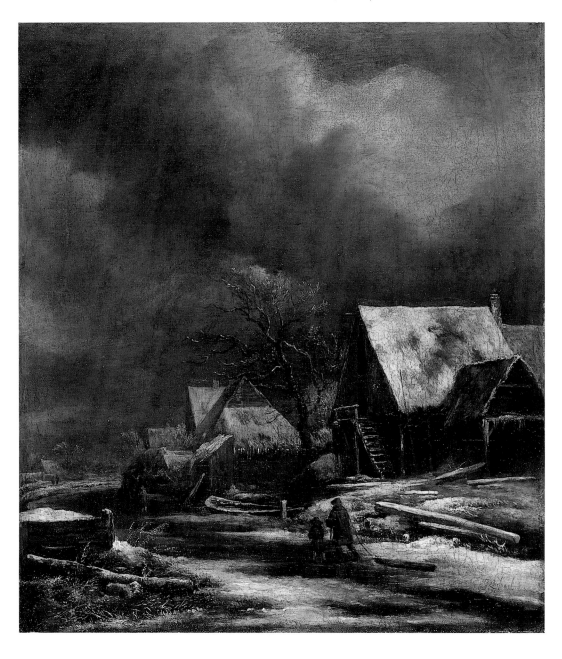

Jan van de Cappelle
(Amsterdam 1626–1679 Amsterdam)

Plate 106 (CAT. 18)

Winter Landscape, 1653
Signed and dated
Canvas, 20⅜ x 24⅜ in. (51.8 x 61.8 cm.)
Koninklijk Kabinet van Schilderijen, Mauritshuis, The
Hague, inv. 567

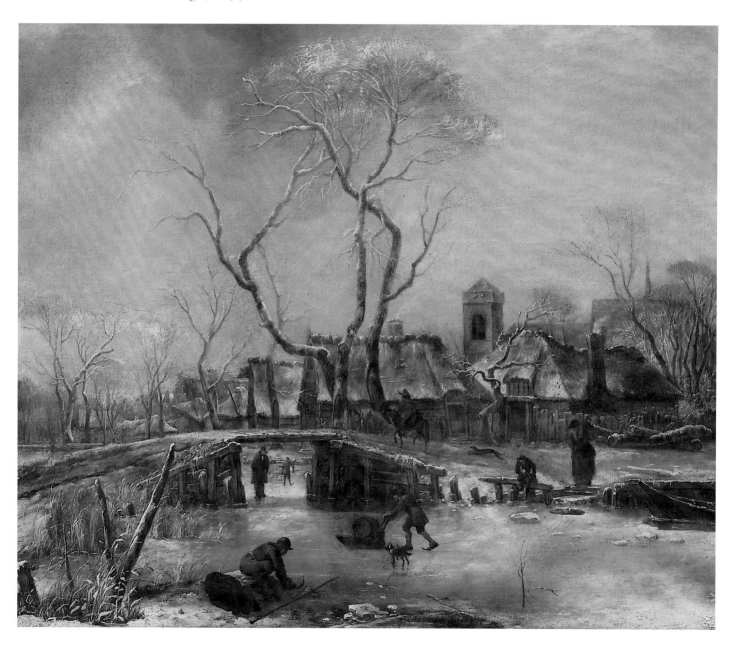

Meindert Hobbema

(Amsterdam 1638–1709 Amsterdam)

Plate 107 (CAT. 44)

Wooded Road with Cottages, 166[2]
Signed and dated
Canvas, 42⅛ x 51½ in. (107 x 130.8 cm.)
Philadelphia Museum of Art, the William L. Elkins
Collection, E'24-3-7

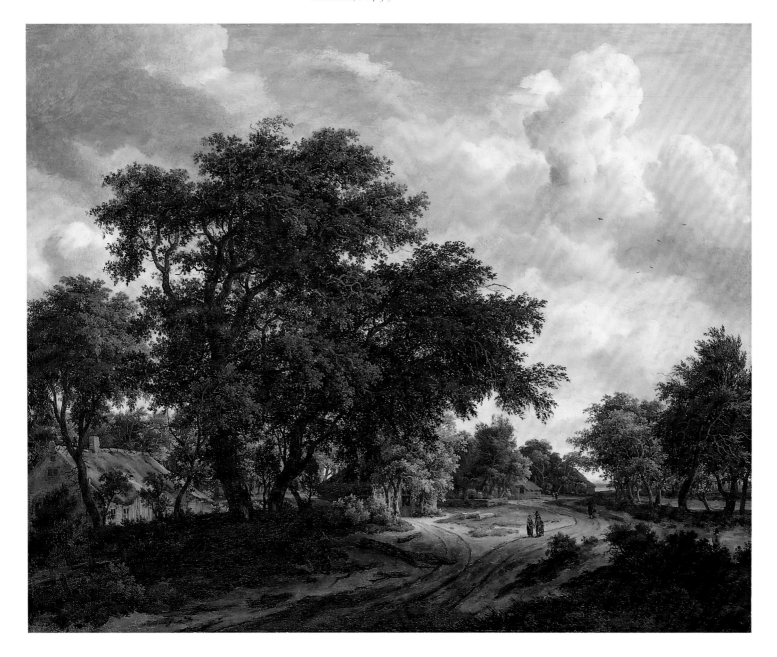

Meindert Hobbema

Plate 108 (CAT. 45)
Wooded Landscape with a Pool and Water Mills, c.1663
Signed
Canvas, 38 x 50½ in. (96.5 x 128.3 cm.)
The Taft Museum, Cincinnati, Ohio, Gift of Mr. and Mrs.
Charles Phelps Taft, 1931.407

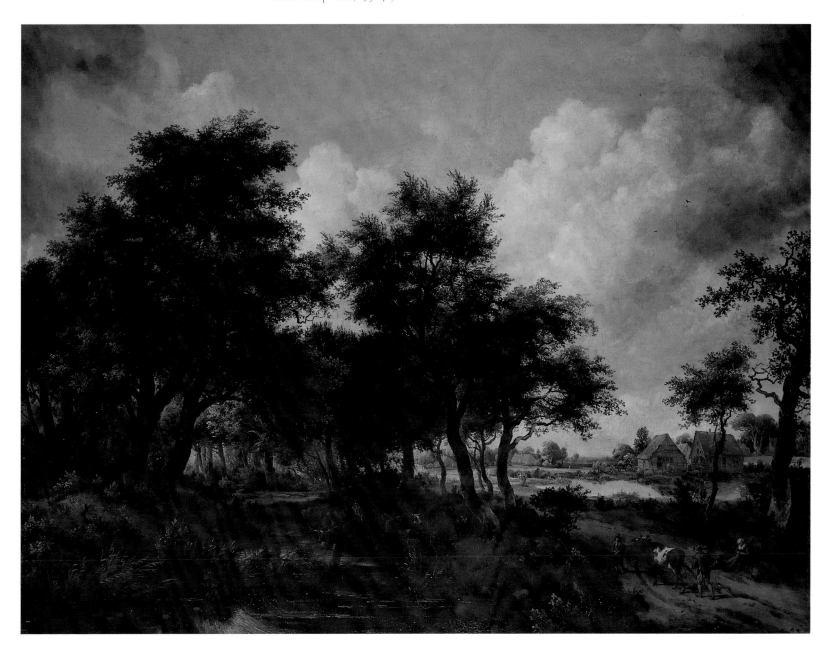

Joris van der Haagen

(Arnhem? 1613-17–1669 The Hague)

Plate 109 (CAT. 40)

View of the Swanenturm in Kleve, 1660s
Signed
Canvas, 35½ x 44⅛ in. (90 x 112 cm.)
Private Collection, Boston

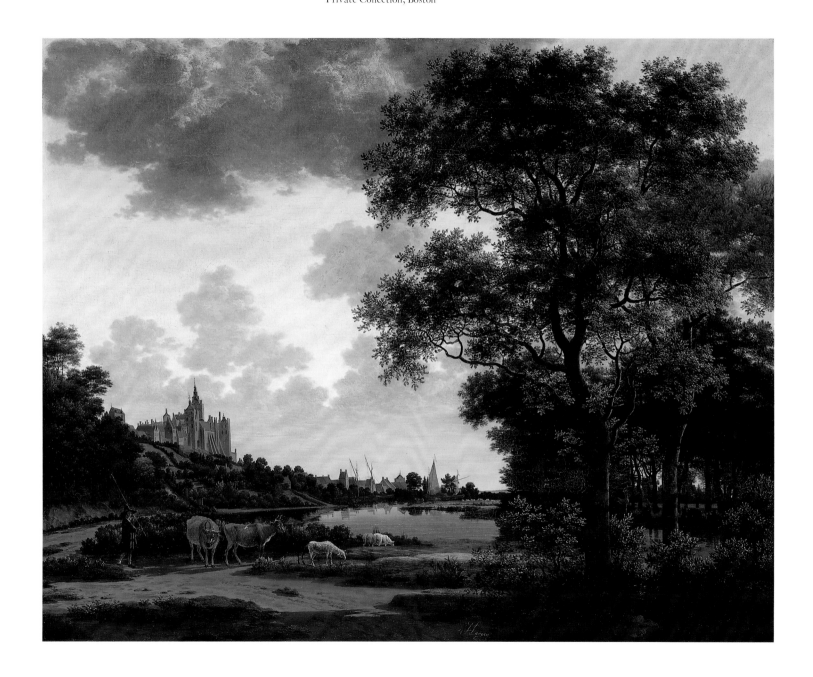

Hendrick ten Oever

(Zwolle 1639–1716 Zwolle)

Plate 110 (CAT. 62)

View of Zwolle, 1675
Signed and dated
Canvas, 26¼ x 34¼ in. (66.5 x 87 cm.)
Torrie Collection, University of Edinburgh

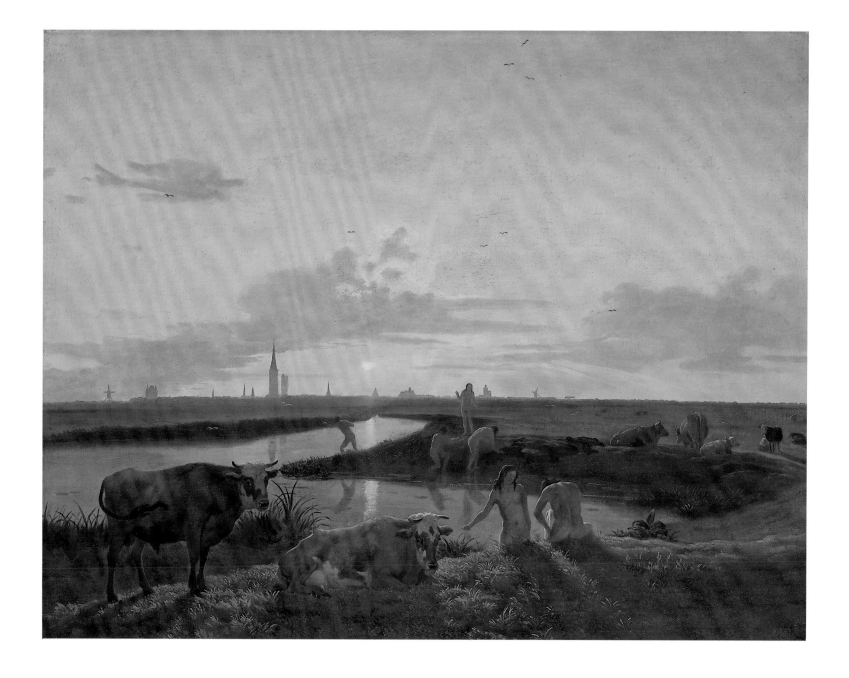

Adriaen van de Velde
(Amsterdam 1636–1672 Amsterdam)

Plate 111 (CAT. 103)

Beach View, c.1664
Signed and dated indistinctly
Panel, 16½ x 21¼ in. (42 x 54 cm.)
Koninklijk Kabinet van Schilderijen, Mauritshuis, The
Hague, inv. 198

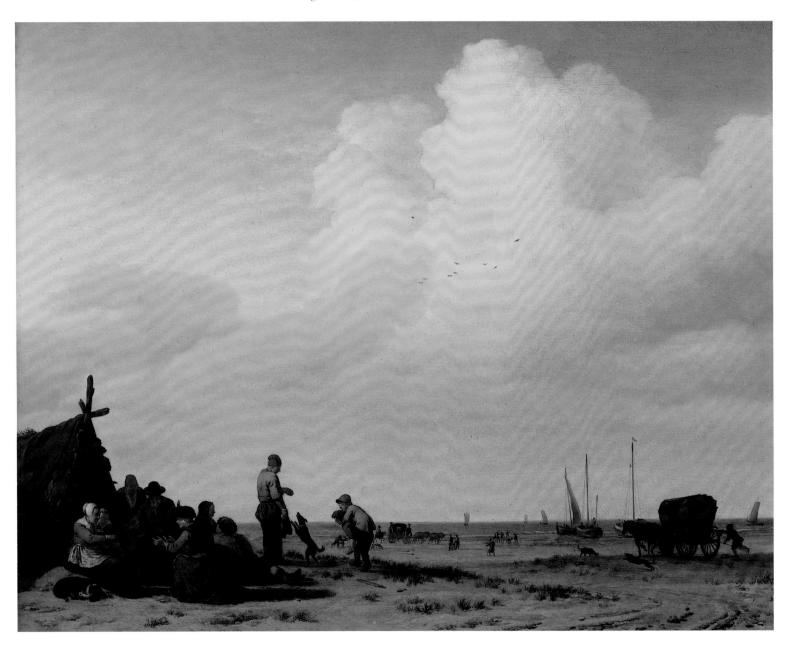

Adriaen van de Velde

Plate 112 (CAT. 104)
Winter Scene, c.1668–69
Panel, 12 x 14½ in. (30.5 x 36.8 cm.)
John G. Johnson Collection at the Philadelphia Museum of
Art, no. 603

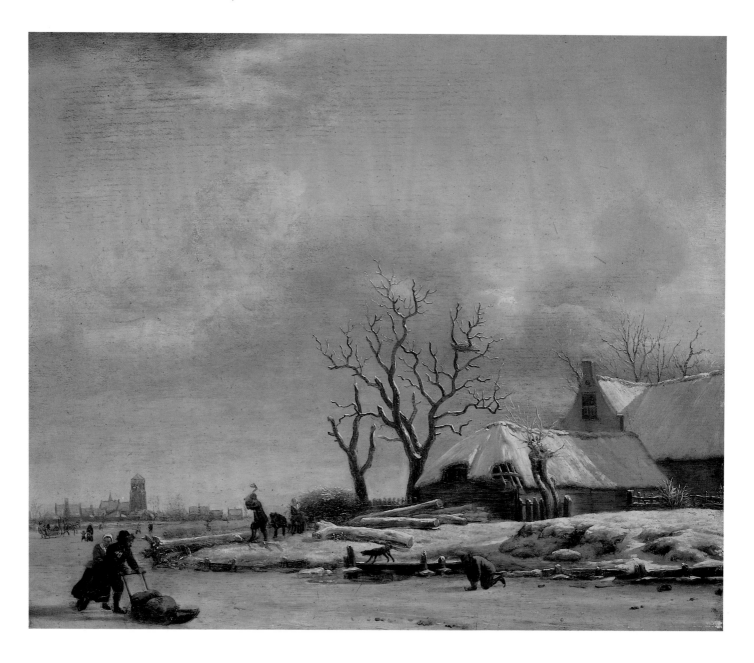

Philips Wouwermans
(Haarlem 1619–1668 Haarlem)

Plate 113 (CAT. 120)

Riding at the Herring, c.1650
Monogrammed
Canvas, 25⅜ x 32¼ in. (64.5 x 82 cm.)
Private Collection

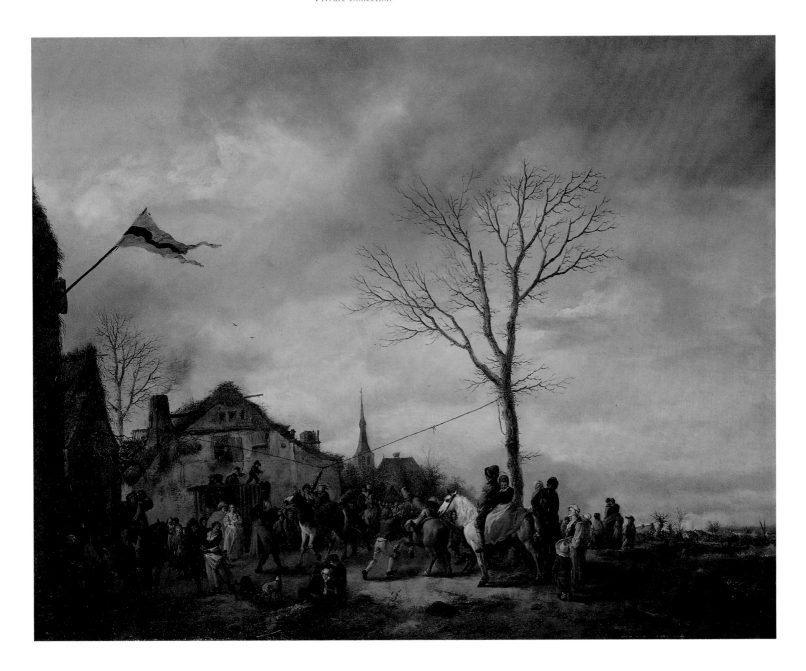

Philips Wouwermans

Plate 114 (CAT. 121)
Rest by a Stream with a Wooden Bridge, c.1655–60
Monogrammed
Canvas, 22⅞ x 26¾ in. (58 x 68 cm.)
Musée du Louvre, Paris, inv. 1952

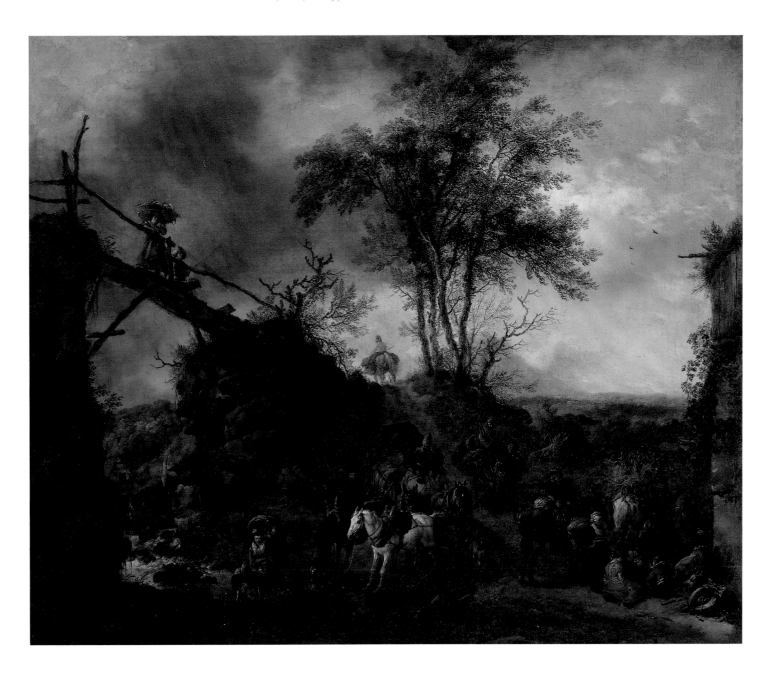

Philips Wouwermans

(Haarlem 1619–1668 Haarlem)

Plate 115 (CAT. 122)

Stag Hunt, c.1665
Monogrammed
Canvas, 32¼ x 55⅛ in. (82 x 140 cm.)
Bayerisches Staatsgemäldesammlungen, Staatsgalerie,
Schleissheim, inv. 408

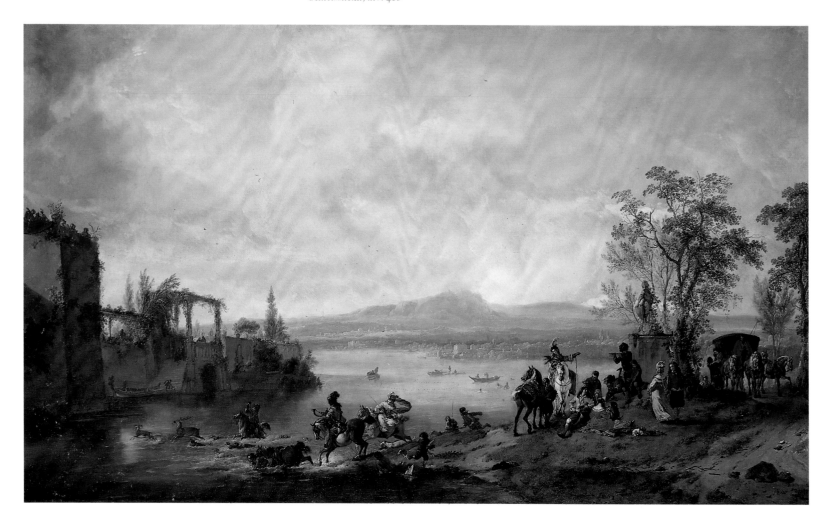

Jan Hackaert
(Amsterdam 1628–after 1685 Amsterdam?)

Plate 116 (CAT. 41)

The Lake of Zurich, early 1660s
Signed
Canvas, 32¼ x 57⅛ in. (82 x 145 cm.)
Rijksmuseum, Amsterdam, inv. A 1709

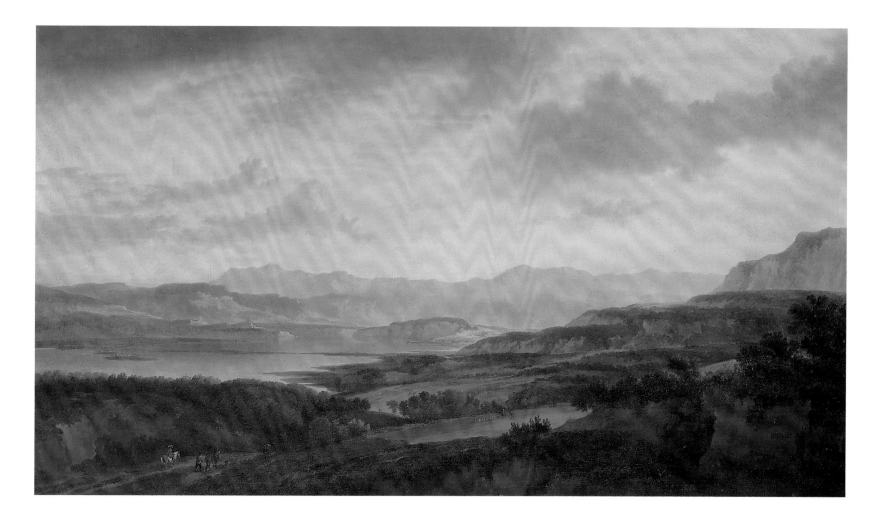

Jan Wijnants

(Haarlem? 1631/32–1684 Amsterdam)

Plate 117 (CAT. 117)

Dune Landscape with Hunters, c.1665–70
Canvas, 14⅝ x 13⅜ in. (37 x 34 cm.)
Rijksmuseum, Amsterdam, inv. A 490

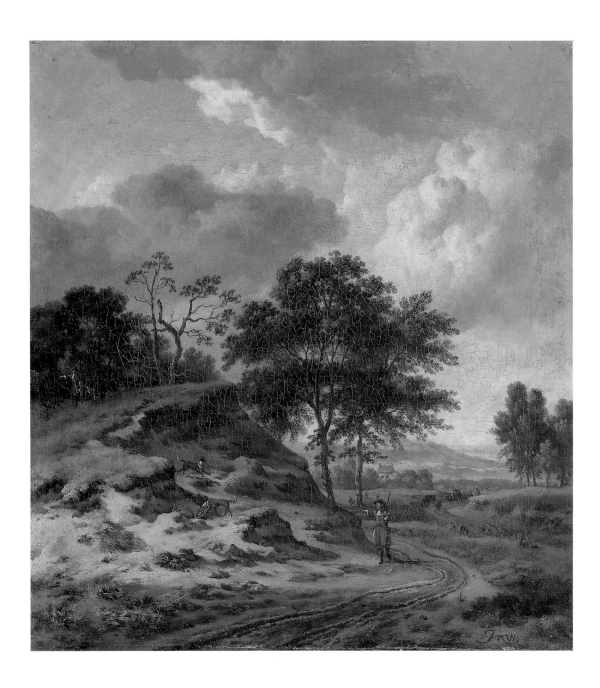

Jan Wijnants

Plate 118 (CAT. 118)
Wooded Landscape with a River, c.1668–75
Signed
Canvas, 37 x 45⅝ in. (94 x 116 cm.)
The National Gallery of Ireland, Dublin, no. 508

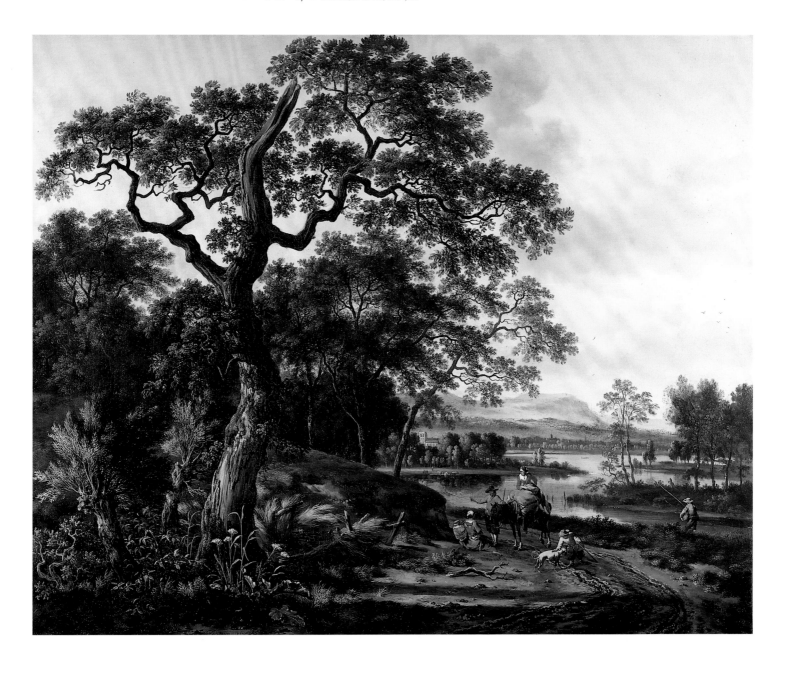

Jan Hackaert

(Amsterdam 1628–after 1685 Amsterdam?)

Plate 119 (CAT. 42)

River Bend with Hunting Party on a Road, c.1675–80
Canvas, 26⅛ x 21 in. (66.2 x 53.5 cm.)
Rijksmuseum, Amsterdam, inv. A 130

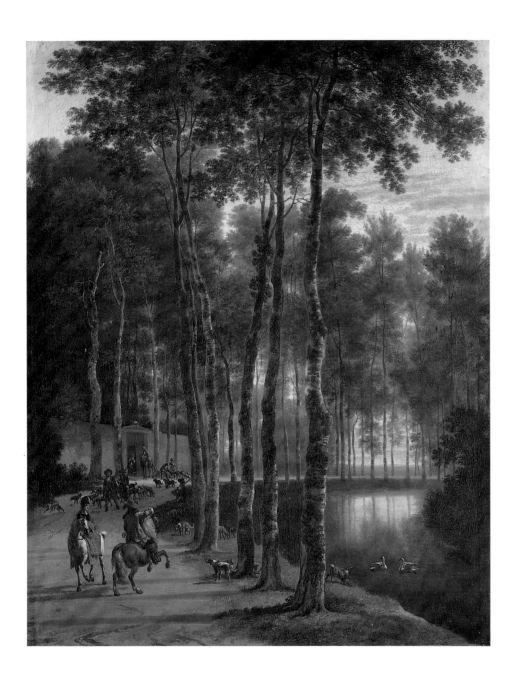

Meindert Hobbema

(Amsterdam 1638–1709 Amsterdam)

Plate 120 (CAT. 47) *Amsterdam only*

The Avenue, Middelharnis, 1689
Signed and dated
Canvas, 40¾ x 55½ in. (103.5 x 141 cm.)
The Trustees of The National Gallery, London, no. 830

Frederick de Moucheron
(Emden 1633–1686 Amsterdam)

Plate 121 (CAT. 58)

Italianate Landscape, 1670s
Signed
Canvas, 34⅝ x 37¼ in. (88 x 96 cm.)
Niedersächsisches Landesmuseum, Hannover, inv. PAM 821

Jan Griffier
(Amsterdam c.1646–1718 London)

Plate 122 (CAT. 39)

Rheinland Landscape, c.1705
Monogrammed
Panel, 21 x 24⅛ in. (53.5 x 64.3 cm.)
Rheinisches Landesmuseum, Bonn, inv. 54.17

Johannes Glauber
(Utrecht 1646–1726 Schoonhoven)

Plate 123 (CAT. 30)
Landscape with King Midas Judging the Musical Contest
between Pan and Apollo, 1690s
Signed
Canvas, 26½ x 35¾ in. (67.3 x 90.8 cm.)
Museum of Fine Arts, Boston, Juliana Cheney Edwards Collection, 1979.287

Catalogue

Jan Asselijn

(Diemen? c.1615–1652 Amsterdam)

Rembrandt, *Portrait of Jan Asselijn*, signed, c.1647, etching.

Jan Asselijn was probably born around 1615. He was inscribed on the Amsterdam citizens' rolls in 1652 as being from "Diepen" which has been interpreted as Diemen, a village near Amsterdam, or Dieppe, in France. His earliest dated paintings are six mounted battle and ambush scenes of 1634, which indicate that he probably trained with Jan Martszen the Younger (c.1609–after 1647), a pupil of Esaias van de Velde.

While there is no documentary proof of a trip to Italy, both Sandrart and Houbraken say he went to Rome, where he was called "Crabbetje" (Little Crab) by his fellows among the Bentveughels, in reference to his deformed left hand, although he was probably nicknamed before he went to Italy. Asselijn probably left for Italy sometime after 1635, the year of his last dated painting in a purely Dutch manner. In Italy he was inspired by Pieter van Laer (1599–1642), who specialized in depictions of Italian street life. No dated works from the Italian years are known. On his return north, Asselijn was married no later than the end of 1644 in Lyon to Antonetta Houwaart whose older sister was married to the painter Nicolaes de Helt Stockade (1614–1669). The two painters also worked in Paris, leaving that city by August of 1646, when the painter Willem Schellinks (1627–1678) recorded in his diary his unsuccessful attempt to visit them. While in Paris, Asselijn had been commissioned, together with Herman van Swanevelt, Pierre Pastel (d. 1676), and Eustache le Sueur (1617–1655), to decorate the Cabinet de l'Amour of the Hôtel Lambert (Louvre, Paris, inv. 984–986).

From Paris, Asselijn may have briefly visited Antwerp, but was certainly back in Amsterdam by July 11, 1647. Around 1648 Rembrandt etched his portrait (Bartsch no. 277). As noted above, on January 24, 1652, Asselijn purchased Amsterdam citizenship, and on September 28 of that year made a will. In Amsterdam, he lived on the Singel near the Heiligewegspoort, and was buried in the Nieuwezijdskapel there on October 3, 1652.

The absence of dated works between 1635 and 1646 obscures Asselijn's development in the very years that he created and perfected his distinctive Italianate manner. Many of his pictures depict riders or shepherds with their animals among ruins in the Italian campagna, often with mountains or distant vistas. His broad, open views, without framing devices, are an innovation in Italianate landscape painting. A still atmosphere and light palette prevail, accented with bright highlights. Asselijn's mature landscape style shows the influence of Pieter van Laer, Herman van Swanevelt, and Jan Both. The influence of French painting, including the work of Claude, remains doubtful despite Houbraken's claim that Asselijn was one of the first to bring the French painter's style north. After his return to Amsterdam, Asselijn continued to absorb influences; he was one of the only Italianate landscapists to paint native Dutch scenes. In turn, Asselijn influenced Claes Berchem, Aelbert Cuyp, Willem Schellinks, Karel du Jardin, and Adam Pijnacker. Houbraken reports that Frederik de Moucheron was a pupil. On at least one occasion, Asselijn collaborated on a painting with Jan Baptist Weenix (Akademie, Vienna, inv. 761).

P.C.S., A.C.

Literature: Sandrart 1675, p. 182; Houbraken 1718–21, vol. 2, p. 327, vol. 3, p. 64; Nagler 1835–52, vol. 1, p. 177; Immerzeel 1842–43, vol. 1, pp. 15–16; Kramm 1857–64, vol. 1, p. 29; Obreen 1877–90, vol. 3, p. 300, vol. 7, pp. 191–92; A.D. de Vries 1885–86, vol. 4, p. 302; Bredius 1890–95, vol. 8, p. 231; Wurzbach 1906–11, vol. 1, pp. 31–32; E.W. Moes in Thieme, Becker 1907–50, vol. 1 (1907), p. 198; Martin 1935–36, vol. 2, pp. 324–25; van den Berg 1942, p. 21; Steland-Stief 1963; Steland-Stief 1964; Utrecht 1965, pp. 129–44; Stechow 1966, pp. 91–92, 153, 157–63; Steland-Stief 1967; Steland-Stief 1970; Steland-Stief 1971; P. Rosenberg, Schnapper 1971; Paris 1972; Salerno 1977–80, vol. 2, pp. 438–49, vol. 3, pp. 984–85; Steland-Stief 1980.

Mountainous Landscape with Traveling Herdsmen, c.1648–50

Monogrammed lower center: JA
Oil on panel, 16⅞ x 26⅜ in. (43 x 67 cm.)
Gemäldegalerie der Akademie der bildenden
Künste, Vienna, inv. 836

Provenance: Count Anton Lamberg-Sprinzenstein,
Vienna; presented in 1822.

Exhibitions: Zurich 1953, no. 4; Utrecht 1965, no. 66,
ill.; Minneapolis/Houston/San Diego 1985, no. 4, ill.;
Salzburg/Vienna 1986, pp. 35–36, no. 8, ill.

Literature: Vienna, Akademie cat. 1866, no. 447;
Vienna, Akademie cat. 1889, no. 836; Frimmel 1901,
p. 187; Ledermann 1920, p. 44; Eigenberger 1927,
p. 14, pl. 160; Schaar 1958, p. 47; Vienna, Akademie
cat. 1961, p. 53, no. 72; Stechow 1966, p. 158, pl. 318;
Waddingham 1966, p. 3, pl. 1; Steland-Stief 1971,
p. 85, no. 110, pl. 59; Vienna, Akademie cat. 1972, no.
95; Vienna, Akademie cat. 1982, pp. 61–64, ill.; Haak
1984, p. 303, fig. 645.

From a lofty viewpoint a vast, uneven plain
extends to the foot of the high mountains and, at
the left, a sea. Enormous banks of clouds float in
the sky above. Figures travel through the
countryside; herders descend with their cattle to
a ford and proceed on the other side through a
gap in the rocks.

Dutch Italianate landscapes have often been
called "idyllic,"[1] although the term seems out of
place in a work such as this. Few paintings
display such a penetrating understanding of the
vastness, monumentality, and desolate barren-
ness of the Southern landscape. The picture
makes a convincing, coherent impression, even
though it is impossible to determine whether
Asselijn was inspired by the southern reaches of
the Alps, the Apennines, or some other moun-
tainous area.

Since the painting is unique in Asselijn's
oeuvre, it cannot be compared in kind with
dated works, but the consensus is that it was
painted about 1648–50. Asselijn created a new
type of landscape in this work that was broadly

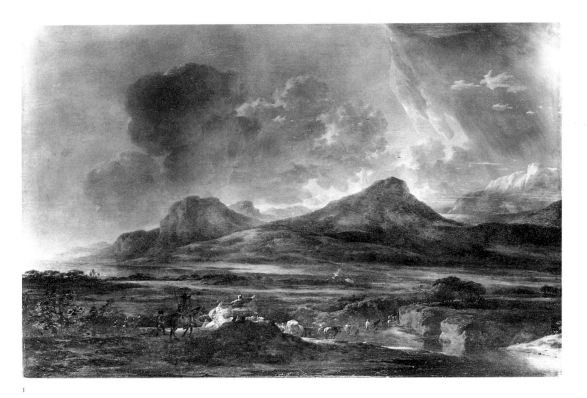

I

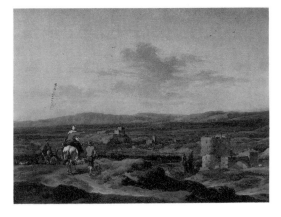

Fig. 1. Claes Berchem, *Panorama*, signed and dated 1655, panel, 33 x 44.1 cm., Collection of H.M. Queen Elizabeth II, Windsor Castle, no. 3213.

2 (PLATE 55)

Herdsman and Cattle at a Ford, c.1649

influential for later Italianate painters. A feeling of great depth has been created by placing a succession of horizontal bands one behind the other, without resorting to vertical repoussoirs or framing devices. This type of landscape is encountered in the work of Claes Berchem in 1655 (fig. 1), Karel du Jardin in about 1660 (cat. 49, fig. 2), and Jan Hackaert (cat. 41). These works appear in parallel with the native Dutch panoramic landscapes of Philips Koninck and Jacob van Ruisdael (cats. 53, 54, 89). The overwhelming spatial effects of the exhibited work are the more astonishing for the picture's modest size.

A.Bl.

1. Budde 1929.

Monogrammed at right: JA
Oil on canvas, 40¼ x 51½ in. (102.4 x 130.7 cm.)
Gemäldegalerie der Akademie der bildenden Künste, Vienna, inv. 810

Provenance: Count Anton Lamberg-Sprinzenstein, Vienna; presented in 1822.

Exhibitions: Vienna 1951, no. 5, fig. 1; Utrecht 1965, no. 65, ill.; Brussels 1971, no. 2, ill; Minneapolis/ Houston/San Diego 1985, no. 2, ill.; Salzburg/Vienna 1986, no. 6, ill.

Literature: Parthey 1863–64, p. 43, no. 46; Vienna, Akademie cat. 1866, p. 11, no. 102; Vienna, Akademie cat. 1889, no. 810; T. von Frimmel, *Repertorium für Kunstwissenschaft* 14 (1891), p. 78; Frimmel 1901, vol. 4, p. 185; Ledermann 1920, pp. 40, 43; Eigenberger 1927, p. 14, pl. 159; Schaar 1958, p. 12; Plietzsch 1960, p. 135, fig. 227; Vienna, Akademie cat. 1961, no. 69, pl. 7; Waddingham 1966, pl. 2; Knab 1969, p. 135, note 16; Steland-Stief 1971, pp. 74, 139, no. 101, pl. 48; Vienna, Akademie cat. 1972, no. 101; Vienna, Akademie cat. 1982, pp. 56–58, ill.

From a bank in the immediate foreground a herdsman drives his cattle across a small branch of a river. On the other side tall ruins rise behind some shrubbery. A waterfall appears in the river at the right and behind it in the distance are mountains. The details of the terrain, river, vegetation, architecture, and atmosphere have been studied and rendered with almost scientific precision. However, Asselijn has unified his components into a single sweeping structure. The foreground ledge, the waterfall, and mountains have been reduced to a few boldly outlined forms. Even the massive clouds have harder contours than nature would confer. The pervasive warmth of the golden evening light imbues the scene with a stillness broken only by the herdsman, who prods his limber, long-horned cattle into the water. Only the white of the herdsman's sleeve and a single cow in the center chasten the warm tones of the composition.

The balance that Asselijn attained in this painting was not achieved in a single stroke. Pentimenti of other shrubs and a second herdsman on horseback are visible under the ruin, attesting to a different original conception of the picture. Asselijn simplified the composition by painting the structure over these figures afterward.[1]

The classicized monumentality of this painting, the polished rendering of details, and the unusually large scale all indicate that this is a late work. In 1891 Frimmel proposed a date of around 1647;[2] a slightly later date, about 1649,[3] appears more likely. In any case, the work was painted long after Asselijn's stay in Italy, which had ended in 1644 at the latest. The motifs, atmosphere, and lighting, all so convincingly Italian, were produced in Asselijn's studio in Holland from memory and drawings. In this respect Asselijn worked in the same way as the other Italianate painters of his generation; Jan Both, Claes Berchem, Adam Pijnacker and Jan Baptist Weenix also created their best Italian landscapes after their sojourns to the south.

The theme of a herdsman with his cattle at a ford originated with the fountainhead of Netherlandish Italian landscape painting, Paul Bril (1554–1626) (Palazzo Barberini, Rome, inv. 1982);[4] the theme also makes an early appearance in Domenichino's *Ford*, of about 1605, in the Galleria Doria Pamphili in Rome (inv. 305).

The ruin at the left has always been called an aqueduct. A drawing by Asselijn in Munich (fig. 1)[5] is similar in composition and in fact represents such a structure. An aqueduct consists of open arches through which light can fall, but the two arches seen in the exhibited painting appear as dark niches and seem to be based, instead, on Roman baths. Asselijn's landscapes, like the work of Dutch Italianate artists, were once thought to have been influenced by Claude

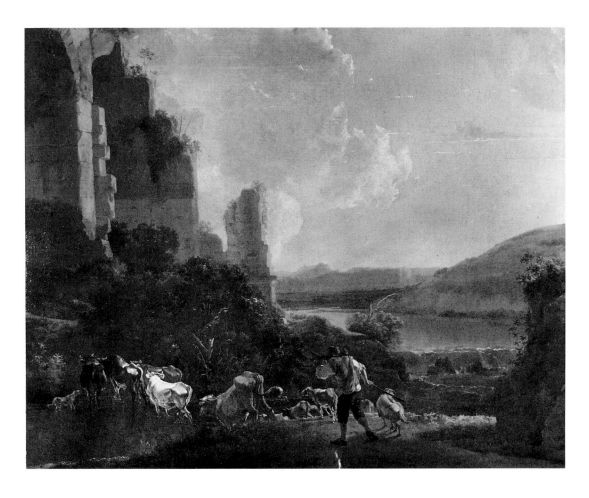

Fig. 1. Jan Asselijn, *Landscape with Aqueduct*, drawing, 204 x 186 mm., Staatliche Graphische Sammlung, Munich, inv. 1922.

Lorrain, a belief supported by the testimony of Sandrart and Houbraken. However, it has been clearly demonstrated that they have their roots in the Netherlandish tradition.[6]

A.Bl.

1. L. Münz in Vienna 1951, no. 5.
2. Frimmel, *Repertorium für Kunstwissenschaft* 14 (1891), p. 78.
3. Steland-Stief 1971, as c. 1648; Blankert in Utrecht 1965 as c.1649; Trnek in Vienna, Akademie cat. 1982, as 1648/49.
4. Blankert 1978, p. 14, fig. 175.
5. Knab 1969.
6. Utrecht 1965, pp. 19–20, 43–45.

Frozen Moat outside City Walls, 1647–52

Monogrammed at lower right: JA
Oil on canvas, 26½ x 41¾ in. (67.4 x 106 cm.)
Worcester Art Museum, Massachusetts; Eliza S.
Paine Fund in memory of William R. and
Frances T.C. Paine, 1969.24

Provenance: Johannes Jansz Verkolje; sale, Amsterdam,
October 24, 1763, no. 34 (fl.305 to Fouquet); sale,
London (Christie's), July 26, 1935, no. 190; sale,
London (Sotheby's), June 23, 1937, no. 92 (£20); sale,
Lady Frances Vyvyan, London (Christie's), June 23,
1950, no. 1 (24 gns. to V. Bloch); Duits, London;
private collection, England; Gooden and Fox,
London; purchased in 1969.

Literature: Swillens 1949; Steland-Stief 1963, pp.
174–75, no. 237; Steland-Stief 1964, pp. 101–102, fig.
1; Stechow 1966, p. 203, note 37; Steland-Stief 1970,
pp. 62–63, fig. 5; Steland-Stief 1971, pp. 77–78,
103–104, 107–108, 164, no. 237, pl. 51; *Worcester Art
Museum Annual Report*, 1969, pp. x, xii; Worcester,
cat. 1974, vol. 1, pp. 77–79, ill.

The structure in this painting has sometimes
been thought to be a fortress, but it seems to be
a walled city. Although Asselijn is considered an
Italianate landscapist, this winter landscape
contains no identifiable Italian ruins or scenery
and is decidedly un-Italian in light and tone;
compare, for example, Cuyp's skating scenes
(cat. 23). Intense cool light breaks through a
dramatic parting of the gray clouds, casting a
band of light on the walls and the snow. The
seventeenth-century Dutch viewer probably
regarded the landscape as a plausible Dutch or
Northern winter scene. The perspective of the
receding city walls echoed by the bank at the
right, which leads to a smoking lime kiln,[1] forms
a bold, unified composition.

 Unusual for an Italianate painter is the num-
ber of winter landscapes Asselijn painted.
Similar in style and composition to the
Worcester painting is a winter ice scene with
moored barges and piles of masonry (fig. 1). At
the left is a round tower based on the tomb of

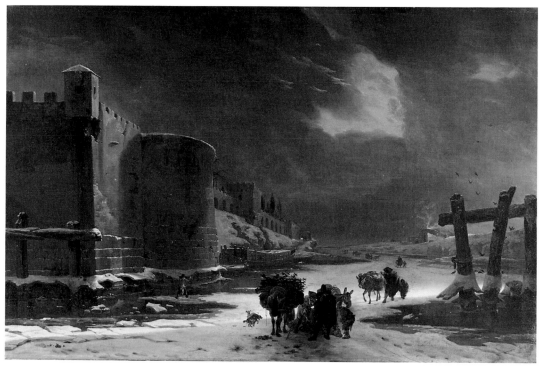

3

Fig. 1. Jan Asselijn, *Frozen River*, signed, canvas, 66.8 x 81.5 cm., formerly Staatliches Museum, Schwerin, inv. 2638 (lost in 1945).

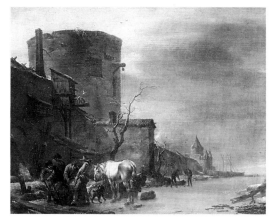

Fig. 2. Claes Berchem, *Winter Landscape*, signed and dated 1647, panel, 39.5 x 48.5 cm., Rijksmuseum, Amsterdam, inv. A 27.

Caecilia Metella, which in this context is almost unrecognizable as a Roman ruin and scarcely adds an Italian flavor to the scene.

The stylistic sources and dating of the Worcester picture are difficult to determine. Steland-Stief assigns two other winter land-scapes to Asselijn's stay in Paris, about 1644–47 (Hermitage, Leningrad, inv. 1115; and see Introduction, fig. 57), and stresses the French sources of the Worcester painting.[2] While Steland-Stief seems correct in dating the Hermitage and Lugt paintings before the ex-hibited work, it is difficult to see any stylistic influence from French painting in these winter landscapes. After his return to Holland in 1647, Asselijn must have been affected instead by currents then prevalent in Dutch landscape painting. A winter landscape by Claes Berchem (fig. 2), very similar in composition and tone to Asselijn's, is dated 1647 and is the source for the present painting, rather than the other way around, as Steland-Stief proposed.[3] Asselijn's composition is an extension and refinement of Berchem's composition – the diagonal city wall made bolder and more regular, perhaps under the inspiration of the paintings of Roman city walls by Jan Both (National Gallery, London, no. 958); however, as early as 1618, Esaias van de Velde painted an ice scene outside a diagonally arranged city wall (Alte Pinakothek, Munich, inv. 2884).[4]

Willem Schellinks's *Winter Landscape* in the Rijksmuseum, Amsterdam (inv. A 2112), once attributed to Asselijn, is not a pastiche or copy of the Worcester painting, as Steland-Stief suggested, but another derivation of Berchem's painting.[5]

A.C.

1. The lime kiln is based on a motif by Pieter van Laer; see paintings in the Szépművészeti Múzeum, Budapest (inv. 493) (Utrecht 1965, no. 37, ill.), and in a private collection, Rome. The motif is also known through a print by Cornelis Visscher (Briganti et al. 1983, fig. 12). Asselijn depicted a lime kiln in another painting, now lost (Steland-Stief 1971, no. 243).

2. Steland-Stief 1971, pp. 55–56, nos. 232, 233. The winter landscape in Leningrad is paired with a summer scene (inv. 1116).

3. Steland-Stief 1971, pp. 78, 107. In general, Steland-Stief's chronology is conjectural and probably assigns too many paintings to the artist's period in France; there is no clear reason to date the Leningrad and Lugt collection winter scenes to c.1645. Steland-Stief's conclusion that the undated Worcester painting is the source for Berchem's winterscape of 1647 (fig. 2) was already doubted by Seymour Slive (Worcester, cat. 1974, p. 77), who also noted that the composition might be derived from the river scenes by van Goyen and Ruysdael from the 1640s (see also Stechow 1966, p. 56). As with most second-generation Italianate painters, the bulk of Asselijn's work was pro-bably done after his return to Holland.

4. Esaias' composition is close to a print by Jan van de Velde (Franken, van der Kellen 1883, no. 186). Herman Saftleven also used a diagonally arranged city wall with a moat in his print of 1646 of the Wittevrouwenpoort, Utrecht (Schulz 1982, pl. 86). A print by Frans Huys after Pieter Bruegel the Elder of 1553 shows a frozen canal with skaters outside the walls of Antwerp (St. Jorispoort) (Lebeer 1979, no. 51.)

5. Steland-Stief 1971, pp. 102–103, pl. 72 (who identified the painting as by Schellinks). Another version by Schellinks is in a Dutch private collection.

View of the Reconstruction of the St. Anthonis Dike, 1652

Monogrammed at left (on barrel): JA
Oil on canvas, 25½ x 38¼ in. (64 x 97 cm.)
Gemäldegalerie, Staatliche Museen Preussischer
Kulturbesitz, Berlin (West), no. 2/58.

Provenance: Gerrit Braamcamp, Amsterdam; sale,
Amsterdam, July 31, 1771, no. 4 (fl.800 to Fouquet);
Mrs. Charles Cope; sold in 1872 for £330 15s. to Sir
Frederick Cook, Bart., Doughty House, Richmond
(in the Long Gallery, no. 56); by descent to Sir
Francis Cook, Bart.; sale, London (Sotheby's), June
25, 1958, no. 71 (£1,400 to Dr. Scharf); acquired in
1958.

Exhibitions: London, Royal Academy, 1872, no. 65
(lent by Mrs. Charles Cope); London 1938, no. 183;
London, Guildhall Art Gallery, 1948, no. 42; London
1952–53, no. 611; Sheffield, Graves Art Gallery, 1956,
no. 1.

Literature: Cook collection, cat. 1914, vol. 2, no. 202;
Berlin (West), cat. 1959, no. 2/58; Bille 1960, pp.
210–11, fig. 4; Steland-Stief 1963, pp. 140–41, no.
231; Stechow 1966, p. 196, note 63; Steland-Stief
1971, pp. 84, 162–63, no. 231, pl. 58; Berlin (West),
cat. 1975, p. 32, ill.; Haak 1984, pp. 303–304, fig. 646.

In the late winter of 1651 there was considerable
flooding in the countryside of north Holland,
stemming primarily from the Diemermeer, with
the farms and villages in low-lying areas around
Amsterdam being particularly affected. Finally,
on the night of March 5–6, 1651, a combination
of strong northwesterly winds and very high
tidal waters caused the St. Anthonis dike east of
Amsterdam to break in two places, flooding
much of the center of the city.[1] This catastrophe
was widely reported and also illustrated by
several artists. There exist numerous drawings
of the event and the site by Willem Schellinks
(1627–1678)[2] and Jan van Goyen, who seems to
have traveled from The Hague just to see and
sketch the site of the disaster.[3] Asselijn himself
depicted the break of the dike in a painting in
Schwerin (fig. 1). The interest in the event is
easily understandable, since it occurred so close

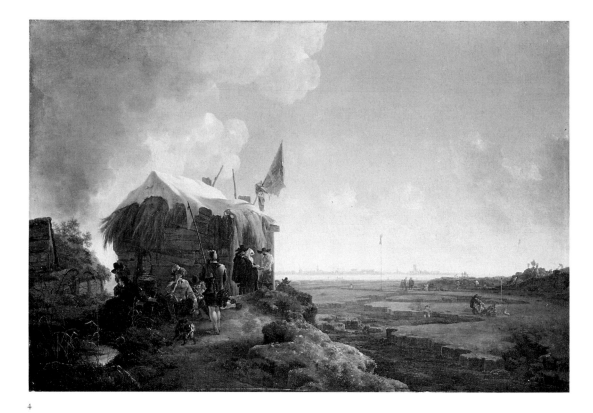

4

to Amsterdam. Vondel wrote about the floods in
a poem celebrating the inauguration of the
Amsterdam Town Hall in 1655, although he did
not actually mention the breaking of the St.
Anthonis dike, nor the flooding of the city.[4]
Vondel compares the flooding with three other
disasters that befell Amsterdam at about the
same time: the Stadtholder Willem II's attack on
the city in 1650, the start of the first Anglo-
Dutch war in 1652, and the burning of the old
Town Hall also in 1652. It is interesting that the
destruction of the Town Hall (or its aftermath)
was also frequently depicted, evidence of the
widespread taste for pictures showing natural or

man-made catastrophes, including floods, burn-
ings of buildings, and explosions (most notably
that of the gunpowder magazine at Delft in
1654).

In the exhibited painting, perhaps meant as a
pendant to a lost painting of the dike break
similar to figure 1, Asselijn depicts the rebuild-
ing of the St. Anthonis dike in the summer of
1652. The project attracted the attention of
other artists.[5] Pieter Nolpe (c.1613–c.1653)
engraved drawings made by I. Colin and
J. Esselens showing the rebuilding of the two
breaks in the dike (fig. 2).[6] Roeland Roghman
issued a four-part print showing the same sub-

Fig. 1. Jan Asselijn, *Break of the St. Anthonisdijk, 1651*, canvas, 55.5 x 67.5 cm., Staatliches Museum, Schwerin, inv. 2697.

Fig. 2. Pieter Nolpe after I. Colin and J. Esselens, *The Dike at Jaaphannes and Houtewael after the Break of 1651*, etching (2 plates).

Fig. 3. Esaias van de Velde, *The Repair of the Dike after the Flood of Vianen, 1624*, etching.

jects as well as the initial disasters.[7] Asselijn's painting appears to show the rebuilding of the break at Houtewael, rather than that near Jaaphannes. Perhaps the most important visual source for this group of images is Esaias van de Velde's print of the cleanup and rebuilding activities of the flood of Vianen in 1624 (fig. 3), which established the pictorial tradition for the subject.

Unlike these graphic artists, Asselijn did not pay much attention to the complexities of dike reconstruction, nor to the absolute topographical accuracy of his landscape. The exact point of view cannot be identified; the buildings seen across the water refer neither to Amsterdam nor to surrounding villages. Instead, the scene is dominated by a ramshackle hut on an elevated ledge in the foreground. The figures gathered here are derived from the rowdy types of Pieter van Laer which Asselijn often placed in his more pure Italian landscapes. Indeed, the entire landscape, especially the sharp drop to flat

expansive plains and the clear, warm light, is wholly Italianate, resembling Asselijn's own depictions of the Italian countryside (cat. 2) and later ones by Claes Berchem and Karel du Jardin (cat. 8 and 50). The exhibited painting is especially important because Asselijn has here brought to a native Dutch scene an Italianate sensitivity to light, color, and dramatic composition, almost exactly as Paulus Potter and Aelbert Cuyp (cat. 73 and 22) were doing at the same moment.

A.C.

1. This account is based on a contemporary description in the annual *Hollantsche Mercurius*, 1652, pp. 31–34. See also Bille 1960 and Beck 1966a.

2. A drawing by Schellinks in the British Museum (inv. Oo 10–202; Hind 1915–22, no. 1) is the basis of a print by Pieter Nolpe (F. Muller 1863–82, no. 2017; Hollstein, no. 208) which was meant to accompany the two prints illustrated in fig. 2. Another drawing of the flood by Schellinks is in the Institut Néerlandais, Paris (inv. 401); a painting of the same subject is in the Amsterdams Historisch Museum. Schellinks's drawings seem to be the basis of Asselijn's painting.

3. Beck 1966a.

4. J. Vondel, *Inwydinge van 't Stadhuis t'Amsterdam*, 1655, lines 221–38, ed. S. Albrecht et al. (Muiderberg, 1982), p. 64. M.A. Schenkeveld-van der Dussen (in an essay in London 1986, p. 75) is therefore not entirely correct in comparing Vondel to a drawing by Schellinks of the dike break, since they treat different events. She compares Vondel's classicist allusions with the drawing, concluding, "Schellinks simply intended to put this tragic event on record."

5. Lugt 1915, pp. 131–49; Benesch 1973, vol. 6, nos. 1261, 1262. Rembrandt made many sketches of the area, although he does not seem to have returned after the flood of 1651.

6. F. Muller 1863–82, no. 2020; Hollstein, nos. 209, 210.

7. Hollstein, no. 39, ill., based on sketches in the same direction in the British Museum (inv. 1836.8.11.471) and Brussels (de Grez, no. 3061).

Hendrick Avercamp

(Amsterdam 1585–1635 Kampen)

Baptized in the Oude Kerk in Amsterdam on January 27, 1585, Hendrick Avercamp was born in a house on the west side of the Nieuwe Dijk next to the Nieuwe Kerk. His father, Barent Hendricksz Avercamp (c.1557–1603), was the Frisian schoolmaster of the Latin school on the Nieuwezijds Burgwal. Barent Hendricksz was married in the Nieuwe Kerk in Amsterdam in 1583 to Hendrick's mother, Beatrix Pietersdr Vekemans (1560/62–1634), the daughter of the Latin school's headmaster. The following year Avercamp's father was recorded as an "apothecary from Friesland," with citizenship in Amsterdam. In 1586 the family moved to Kampen where Avercamp's father set up his apothecary business in the Oude Straat. Avercamp's brother Lambert eventually succeeded his father as town apothecary. Another brother studied medicine. Hendrick's family was well educated and well traveled; their members continued to be prominent Kampen citizens after Barent's death.

The young Hendrick Avercamp was sent to Amsterdam to live and study with the history and portrait painter Pieter Isacksz (1569–1625), who in 1607 was recalled to his native Denmark by Christiaan IV. The Antwerp painters Adriaen (1587–1658) and Willem van Nieulandt (1584–1635) were fellow pupils under Isacksz. In the auction that preceded his teacher's departure, Avercamp was identified among the buyers as "de stom tot Pieter Isacqs" (Pieter Isacksz's mute); in another document of 1622 he was also called "Hendrick Avercamp de Stomme." When Hendrick's mother drew up her will in 1633 she expressed concern for her eldest son, who not only was unmarried but also being "mute and miserable," might be unable to live off his portion of the inheritance; thus she stipulated that Hendrick receive an annual sum of one hundred guilders from the family capital for the rest of his life. There is no indication, however, that Hendrick was deaf as well as dumb.

Avercamp's earliest dated works are of 1601. During his formative years in Amsterdam he was influenced by the landscape tradition as practiced in that city by the expatriot Flemish painters, Gillis van Coninxloo and David Vinckboons; the latter has been proposed, on stylistic grounds, as another of Avercamp's teachers. There is also a strong connection between Avercamp's earliest Flemish-style landscape designs and works by his fellow Kampen artist Gerrit van der Horst (1581/82–1629). On January 28, 1614, Avercamp was again living in Kampen. Further travels are undocumented, although both Welcker and Plietzsch speculate improbably that he journeyed to the Mediterranean. On May 15, 1634, he was buried in the St. Nicolaaskerk in Kampen.

A painter of richly populated winter landscapes, his early works show a strong interest in narrative and genre-like anecdote in the tradition of Pieter Bruegel. His mature paintings are more concerned with evoking a wintry atmosphere. As no other early Dutch realist, he made a specialty of the ice view. Avercamp's low viewpoints and flat expansive scenes across the ice are regarded as crucial for the development of Dutch landscape painting, and are closely paralleled by the winter landscapes of Adriaen van de Venne. Avercamp also made numerous figure and landscape drawings, many of which served as preparatory studies. Hendrick's nephew, Barent Avercamp (c.1612–1679) was his pupil and follower. Other followers include Arent Arentsz (called Cabel) (1585/86–1635) and Dirck Hardenstein II (1620–after 1674).

P.C.S.

Literature: van Eynden, van der Willigen 1816–40, vol. 1, pp. 32–34; Nagler 1835–52, vol. 1, p. 207; Immerzeel 1842–43, vol. 1, p. 17; Kramm 1857–64, vol. 1, p. 35; Nagler 1858–79, vol. 1, no. 97, vol. 3, nos. 584, 852; Obreen 1877–90, vol. 2, pp. 195–234, 270; de Roever 1885; de Jongh 1903–04; Wurzbach 1906–11, vol. 1, pp. 35–36, vol. 3, p. 14; E.W. Moes in Thieme, Becker 1907–50, vol. 2 (1908), p. 276; Poengsen 1923–24; Grosse 1925, pp. 21–23; Juynboll 1933; van Gelder 1934; Martin 1935–36, vol. 1, pp. 244–46; Hoogendoorn 1946; Hennus 1949; Kampen 1949; C. Welcker 1950; Maclaren 1960, pp. 3–5; Stechow 1960d, p. 79; Stechow 1966, pp. 85–87; van Straaten 1977; C. Welcker 1979; Amsterdam/Zwolle 1982; Blankert 1982; Haak 1984, pp. 197–98; Wiersma 1985.

Winter Landscape with Skaters
c.1608

Signed at right on wooden shed:
HAENRiCVS.AV [H ligated with A]
Oil on panel, 30½ x 52 in. (77.5 x 132 cm.)
Rijksmuseum, Amsterdam, inv. A 1718

Provenance: Sale, G. de Clercq, Amsterdam, June 1,
1897, no. 1, ill.; purchased for the museum with the
aid of the Vereeniging Rembrandt.

Exhibitions: Amsterdam, Rijksmuseum, *Vereeniging
Rembrandt*, 1923, no. 15; London 1929, no. 71;
Brussels 1946, no. 2, fig. 41.

Literature: Roh 1921, p. 72, fig. 120; Havelaar 1931,
p. 64, ill.; F. Schmidt-Degener, *Gedenkboek Vereeniging
Rembrandt, 1883–1933* (Amsterdam, 1933), p. 46, ill.;
Bernt 1948, vol. 1, pl. 28; Plietzsch 1960, p. 86, fig. 143;
E. van Uitert, *Openbaar Kunstbezit (televisie cursus)* 3,
no. 20 (1965); *Van tijd tot tijd* 73 (1965–66) ill.;
Dobrzycka 1966, p. 20, fig. 2; Bernt 1969, vol. 1,
pl. 37; van Straaten 1977, p. 100, fig. 135; Bergvelt
1978, p. 144, fig. 15; C. Welcker 1979, p. 204, no. 10,
pl. III, fig. XV; Amsterdam/Zwolle 1982, p. 27;
C. Brown 1984, pp. 192, 201, ill.

This large panel from around 1608 is not only
Avercamp's most ambitious winter landscape
but also one of his earliest known works.[1] He
was the first in the northern Netherlands to
paint winter landscapes featuring such diver-
sions upon the ice and had been inspired by
earlier drawings and prints produced by the
circle of Flemish landscape artists who had
immigrated to Amsterdam.[2]

On a frozen waterway that extends past a
church, between farmhouses, and into the
distance, crowds of people from all walks of life
disport themselves. Further on, in the middle of
the scene is a castle with a graceful tower.
Beneath a tree displaying a signboard with a
crescent and another crescent on top, the build-
ing in the left foreground can be identified as a
brewery by the lever for drawing water, here
used by a man to haul water out of a hole hacked
in the ice.

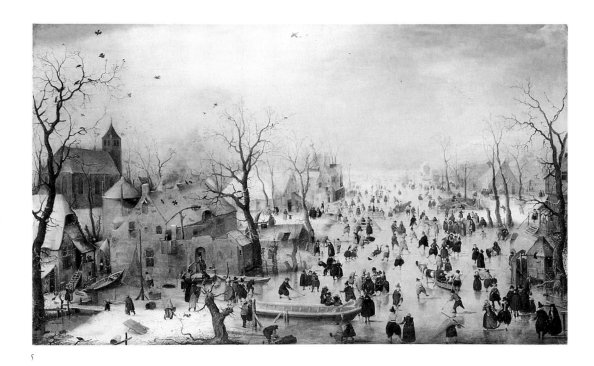

5

Fig. 1. Pieter Bruegel the Elder, *Winter Landscape with Skaters and
Bird Trap*, signed and dated 1565, panel, 38 x 56 cm., Musées
Royaux des Beaux-Arts, Brussels, inv. 8724.

It is noteworthy that in addition to depicting
recreational ice sports, Avercamp typically
included a variety of people going about every-
day business. To the left of the brewery, for
example, we see a discarded barge set upright in
the water being used as a privy. Such "ne-
cessaries" are frequently seen along the edge of
the water in Avercamp's winter scenes. Just
beyond, we catch a glimpse of an amorous couple
atop a haystack. The attention lavished upon
such earthy narrative details harks back to the
spirit of the Flemish tradition that evolved from
the art of Pieter Bruegel the Elder. In the left
foreground a man carrying two heavy buckets
crosses a snowy farmyard already tracked with
many footprints; a toddler runs delightedly to
meet him, while the mother watches, holding

another child in her arms. On the loading dock before the door of the brewery a woman hands a pair of skates to a man, while his companion straps his skates on. One can continue endlessly cataloguing the entertaining vignettes Avercamp has painted: a great variety of events and trivial activities, described to the smallest detail. Some typical motifs in Avercamp's paintings include the man in the right foreground carrying a bundle of reeds, freshly cut with the scythe that is tied to them. An eel fisher, walking by the shed at the right, carries a bag of eels and an axe with which he has hacked a hole in the ice, while over his shoulder rests the *elger* or "eel spear" (a trident at the end of a long pole) with which the eel is caught by rooting around and stabbing into the mud under the ice.[3] Elsewhere along the middle of the left bank, we see another man chopping a hole in the ice.

Equal attention has been given the lively recreation of the villagers, burghers, and nobles with their women, whom they gallantly assist in tying on skates. They glide quickly over the ice, singly or hand in hand, and are sometimes surprised by a sudden fall. There are games of *kolf*, horse-drawn sleighs, and in the distant background ice sailing. And, as always, there are plenty of spectators. The small vessels frozen in the ice near the brewery are exactly like the punts still used in the waterways around Kampen.[4]

Avercamp effectively evokes a wintery atmosphere through his rendering of tempered sunlight, strong enough to cast shadows next to figures, and reflections in the ice, but filtered through a haze that dissolves the distant view. From these subtle atmospheric effects, as well as the minute narrative details, it appears that Avercamp was an extraordinarily painstaking observer.

It is unlikely, however, that he depicted a real brewery named "The Half Moon," as suggested

by its signboard.[5] The painter probably never or only very rarely sought to represent buildings or places strictly according to reality. It is interesting to note that Avercamp placed on the gable of the brewery the coat of arms of the city of Antwerp flanked by two lions.[6] This may be interpreted as an eloquent homage on the part of the artist to the Flemish tradition that had been an example and inspiration early in his career.

Although not alone, the Rijksmuseum painting is the most convincing example of this influence. Flemish in character are the bird's-eye perspective and the high horizon, the exaggerated height of the framing trees to either side with their decorative lacework of branches and twigs, the rhythmic progression of spatial divisions from the foreground into the distance, and finally, the many accents of color scattered throughout the composition. Moreover, Avercamp's thin and draftsman-like brushwork is reminiscent of Pieter Bruegel the Elder's technique.

Avercamp must have known Bruegel's *Winter Landscape with Skaters and Bird Trap* of 1565, famous even in the seventeenth century (fig. 1), which is the source for the independent winter landscape in Netherlandish painting. It is even possible that the original painting was in Amsterdam at this time, although this is not certain.[7] Nevertheless, numerous close copies existed, "best sellers" from the workshop of Pieter Brueghel the Younger; the earliest known example, from 1601, is in Vienna (Kunsthistorisches Museum, inv. 625).[8] In any case, Avercamp's familiarity with Bruegel's painting is proven by a curious and otherwise inexplicable similarity: a bird trap in the left of Avercamp's painting repeats the motif from the right foreground in the Bruegel (fig. 1). Bruegel clearly detailed the function of the old door, which, by a tug on the rope, slams to the ground

and crushes the unsuspecting birds that have come to take the bait. But Avercamp leaves no room for doubt as to the purpose of the contraption, tying a long rope to the prop and adding a couple of stones atop the door; all birds, moreover, stay conspicuously out of the area. Bruegel may have been hinting at a deeper meaning by including the bird trap. According to Marlier, the motif may be interpreted as an admonition against the dangers that deceive us in life, establishing a parallel between the risks inherent in carefree diversion on the fragile ice and the treacherous trap that threatens the very lives of innocent, foraging birds.[9] This interpretation is confirmed by the unambiguous inscription of the print *Ice Skating before St. Joris Gate at Antwerp*, engraved in 1558 by Frans Huys after a drawing by Pieter Bruegel the Elder. The significance of the title *The Slipperiness of Human Life* (*De slibberachtigheyt van 's menschen leven*) is further elucidated by several verses under the print.[10] It is tempting to conclude, but unfortunately difficult to prove, that Avercamp concealed the same message in his painting.

C.J.d.B.K.

1. The clothing of the figures can be dated to about 1608 by comparison with prints; see, among others, the figures in the border of the map *Comitatus Hollandia: 't Graefschap Hollandt*, published by Willem Jansz Blaeu in 1608 (exh. cat. Amsterdam, Amsterdams Historisch Museum, *The World on Paper*, 1967, no. 119, ill.). The winter landscape of 1608 in Bergen, one of Avercamp's few dated works (C. Welcker 1979, no. 83), has much in common with the Amsterdam panel, which Blankert supposed was earlier (Amsterdam/Zwolle 1982, p. 27).

2. No date has been fixed to the anonymous etching *Winter Scene with Ice Sports near a Castle*, published in Amsterdam after a design by David Vinckboons, which figures as one of Avercamp's pictorial sources (Amsterdam/Zwolle 1982, p. 40, fig. 13). A date in or shortly after 1602, however, can be deduced from a drawing signed and dated 1602 by Vinckboons that is a model or a preliminary study for the etching (Boerner, Düsseldorf, cat. 38, 1964, no. 132, pl. 55; cat. 44, 1966, no. 106, pl. 57).

6 (PLATE 8)

Skaters by a Village, c.1609–10

3. Wiersma 1985, p. 8.

4. Verbal communication from G.L. Berk, Kampen, 1986.

5. Avercamp also depicted a brewery in his painting in London (National Gallery, no. 1479), which Welcker called *The Brewery "Half Moon" at Kampen*, without stating her proof (C. Welcker 1979, no. 855). Maclaren doubted this identification (Maclaren 1960, p. 5), as did Christopher Brown (London 1986, no. 83). The breweries in the London and Amsterdam paintings are not identical.

6. See the arms of Antwerp depicted on two maps of the city, the engraving of Hieronymus Cock from 1557 and Pauwels van Overbeke's woodcut of 1568.

7. "Een Wintertje van den ouden Breughel" included in the 1687 inventory of the Amsterdam art dealer Hendrik Meyeringh, if formerly in the collection of one of the many families from Antwerp resident in Amsterdam, could have been in the city eighty years earlier; see G. Marlier, *Pierre Brueghel le jeune* (Brussels, 1969), p. 240.

8. For the many copies, see Marlier, *Pierre Brueghel*, pp. 239–50.

9. Brussels, Musées Royaux des Beaux-Arts, *De eeuw van Bruegel*, 1963, no. 50; Marlier, *Pierre Brueghel*, p. 140. See also Linda and George Bauer, "The Winter Landscape with Skaters and Bird Trap by Pieter Bruegel the Elder," *Art Bulletin* 66 (1984), pp. 145–50.

10. Amsterdam/Zwolle 1982, p. 30; C. Brown 1984, p. 190.

Signed left on a tree: HA [in monogram]
Oil on panel, 14⅛ x 28 in. (36 x 71 cm.)
Koninklijk Kabinet van Schilderijen,
Mauritshuis, The Hague, inv. 785

Provenance: Sale, P. Opperdoes Alewijn (Hoorn), Amsterdam, April 28, 1875, no. 1; sale, M.M. Snouck van Loosen, Enkhuizen, April 29, 1886, no. 5; purchased by the Rijksmuseum, Amsterdam (inv. A 1320), from whom it has been on loan since 1924.

Exhibitions: Kampen 1949, no. 6; Zurich 1953, no. 7, pl. 3; Milan 1954, no. 5, fig. 5; Rome 1954, no. 5, fig. 6; Breda/Ghent 1960–61, no. 4; Amsterdam/Zwolle 1982, no. 5, ill.; Paris 1986, no. 5, ill.

Literature: A. Bredius, *Zeitschrift für bildende Kunst* 21 (1886), p. 644; Havelaar 1931, p. 65, ill.; Bernt 1948, vol. 1, pl. 27; E. Haverkamp Begemann, *Openbaar Kunstbezit* 2, no. 1 (1958), ill.; Plietzsch 1960, p. 86, fig. 144; A.B. de Vries 1963, fig. 2; Bernt 1970, vol. 1, pl. 36; Amsterdam, Rijksmuseum cat. 1976, no. A 1320, ill.; C. Welcker 1979, p. 206, no. S16, pl. IV, fig. XVI; Amsterdam/Zwolle 1982, p. 27; The Hague, Mauritshuis cat. 1985, no. 4, ill.; Wiersma 1985, pp. 24–25, ill.; Dublin, cat. 1986, pp. 3–4.

Under a pale, overcast winter sky, a frozen canal with densely populated banks provides a stage for lively diversions upon the ice. The thatched houses, barns, haystacks, and a few bare trees form a coulisse; in the background to the left is the spire of a village church and to the right a windmill. Along both sides of the canal are boats frozen fast in the ice. Beyond a drawbridge, banks, and a ship flying the flag of the Netherlands stretches a broad expanse of ice, where more people may be vaguely discerned. In the hazy distance we can make out the far side of the water, with the ghosts of houses, a windmill, and a church.

There is a flurry of detailed activity on this side of the drawbridge, including skaters, *kolf* players, and a man on a sledge propelled by hand-held cleats, with the customary spectators arrayed around the sides of the ice. As always

with Avercamp, there are villagers involved in ordinary daily activities. A woman kneels by a hole in the ice to do her wash; a man carries a great bundle of reeds on his back across the ice; on the right bank a man chops wood; and behind him someone pisses against the fence. Few painters appreciate and express the carefree and genial mood in which people experience the pleasures of winter or perform their everyday tasks as well as Avercamp. The burdensome inconveniences of the bleak winter play no role here; the imperturbable calm is unbroken even by the treacherous fall of a man and woman just in front of the drawbridge. The woman's rather embarrassing discomfort appears to attract no one's attention. Nor does the hazardous incident at the left, where several people have fallen through the ice, arouse the general concern that one might expect. A man slides on his belly to lend a hand to the drowning people, while others are dashing up, and a man approaches across the farmyard with the rescue ladder; otherwise, there is scarcely any reaction to the incident.

The framing of the composition on the left side by a tree stretching to the panel's full height is reminiscent of traditional Flemish models, but the high horizon has here been replaced by a much more natural evocation of space. The spectator is now more closely involved with the activity of the landscape. Only a few steps down the bank, we could easily mix with the crowd of skaters. This feeling would be strengthened in Avercamp's later works, in which he made the foreground figures even larger and closer to the picture plane.

Blankert's chronology for Avercamp's undated works places this painting shortly after the *Winter Diversions by an Old Fortress*, dated 1609, thus about 1609–10.[1] Confirmation of this dating can be found in a winter view of 1611 by Avercamp's follower Adam van Breen,[2] which includes a copy of the solitary girl roughly in the

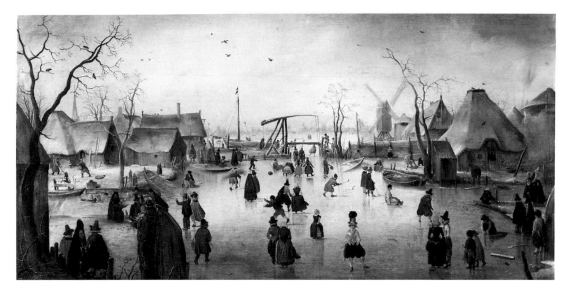

6

Fig. 1. Master of the Small Landscapes, *Farmhouses near the Water*, 1561, etching.

Fig. 2. Claes Jansz Visscher, *Iceboat*, etching from the top border of the map *Comitatus Hollandia*, 1608.

center of the exhibited work, who warms her numb hands beneath her apron.

The centrally placed drawbridge provides a visual focus for this winter scene and maintains an open connection between foreground and the space beyond, which insures a sense of spatial recession. According to Blankert, Avercamp was the first to apply this motif in such an ingenious fashion.[3] He repeated it later more emphatically in his *Scene on the Ice* in Dublin,[4] dated after 1620 by Blankert.[5] Avercamp's drawing of a similar drawbridge[6] probably originated well after 1610 and thus cannot have served as a preliminary study for our painting, as was once supposed.[7]

The question is, however, whether Avercamp himself invented the use of the drawbridge as a central motif. New pictorial forms in painting frequently appear to be inspired by prints. Often cited as a model for Dutch landscapes is Hieronymus Cock's print series published in Antwerp in 1559 and 1561 of native Netherlandish villages and farms, after drawings by the anonymous Master of the Small Landscapes (fig. 1).[8] The influence that these popular prints had upon the development of realism in seventeenth-century Dutch landscape painting can hardly be overstated, especially since the series was reprinted by Theodor Galle (Antwerp 1601), and by Claes Jansz Visscher (Amsterdam, 1612).[9] Since Avercamp painted this winter landscape around 1610, he must have been familiar with one of the Antwerp editions. The modern way he has represented the farmhouses and barns clearly shows the importance of the prints in the genesis of this work.

Avercamp probably also borrowed the use of the drawbridge as a central motif from a print. In 1610 Pieter van den Keere published in Amsterdam a map of the province of Holland, the top border of which is composed of several scenes etched by Claes Jansz Visscher.[10] One of these is a winter view with skaters and ice

sailing, with a drawbridge precisely in the center of the background (fig. 2).[11]

In 1618 Esaias van de Velde painted the same sort of drawbridge as in Avercamp's painting in the center of his *Winter Landscape* in the Alte Pinakothek, Munich (inv. 2884). As Keyes has already noted, Avercamp's influence can be recognized in many different aspects of this painting.[12] The drawbridge may have been borrowed from Avercamp's work but could also have its origin in Visscher's print (fig. 2).

Visscher placed large figures of fishermen, farmers, and country women from different districts, as well as burghers and nobles, each in their appropriate garb, in the foreground of his series of border illustrations, which he designed not only for the above-mentioned map of 1610 but also for the map of Holland published by Willem Jansz Blaeu in 1608.[13] These border illustrations may have provided Avercamp with examples for his varied figures.

C.J.d.B.K.

1. Amsterdam/Zwolle 1982, no. 2, ill., and p. 27, no. 5; see also Stechow 1960d, pp. 80–83, ill., and Stechow 1966, p. 85, fig. 166.

2. Amsterdam/Zwolle 1982, no. 27, ill.

3. Ibid., p. 27.

4. National Gallery of Ireland, Dublin, inv. 496; Dublin, cat. 1986, p. 3, fig. 4.

5. Amsterdam/Zwolle 1982, p. 27, fig. 9.

6. Museum Boymans-van Beuningen, Rotterdam, inv. H95; C. Welcker 1979 no. T 50, pl. XIII, fig. XXVIII.

7. C. Welcker 1979, p. 263, no. T 62.2. Possibly the Rotterdam drawing, in which the structure of the draw-bridge is incorrectly recorded, is a copy after an earlier, lost sketch executed directly after nature, which could have served as a model for the motif in both the painting in The Hague and the Dublin painting.

8. Van Bastelaer 1908, nos. 19–32, 34–63.

9. See de Groot 1979, p. 7, fig. 2; see also Amsterdam 1983, p. 4, and London 1986, pp. 18–19, 110, nos. 18a–d, ill. Even before Claes Jansz Visscher published his series of prints after the Antwerp examples in 1612, the prints had

influenced his sketches of rural sites in the area of Haarlem (c.1607), which he published as a series of prints in 1611. See de Groot 1979, nos. 23–34, ill.; also London 1986, nos. 74–75, ill.

10. De Groot, Vorstman 1980, nos. 30–32, ill.

11. Visscher's drawing for this etching, in the Ingram collection, was made at the latest in 1610 but probably somewhat earlier, so it is unlikely that Visscher had observed the motif in Avercamp's painting. See exh. cat. Rotterdam/Amsterdam, *150 teekeningen uit vier eeuwen, uit de verzameling Sir Bruce en Lady Ingram*, 1961–62, no. 109, fig. 18.

12. George S. Keyes, "Hendrik Avercamp and the Winter Landscape," in Amsterdam/Zwolle 1982, p. 50, fig. 21. The drawbridge is not specifically mentioned here as borrowed from Avercamp.

13. See cat. 5, note 1.

7 (PLATE 10)

Winter Scene with a Frozen Canal, c.1620

Monogrammed on the sled at right: HA [ligated]
Oil on panel, 14½ x 25¾ in. (36.8 x 65 cm.)
From the Private Collection of Mr. and Mrs. Edward William Carter, Los Angeles, California

Provenance: Graaf Jan Carel Elias van Lynden, The Hague; by descent to Ridder Johan Willem Frederik Huyssen van Kattendijke, The Hague; by descent to Graaf J.M.D. van Lynden, Lisse, by 1929; by descent to Gravin A.E. van Limburg Stirum, Lisse; S. Nijstad Antiquairs, Lochem; Sidney J. van den Bergh, Wassenaar; G. Cramer, The Hague, 1972.

Exhibitions: The Hague 1881, no. 70; The Hague 1929, no. 1, ill.; London 1929, no. 81, ill.; Brussels, Exposition Universelle, *Cinq siècles d'art*, 1935, vol. 1, no. 701; Rotterdam 1955, no. 40, pl. 44; Laren 1959, no. 24, fig. 15; Leiden 1965, no. 4, fig. 1; New York, Metropolitan Museum of Art, 1972; Los Angeles/Boston/New York 1981–82, no. 1, ill.

Literature: Bredius et al. 1897–1904, vol. 3, p. 96, ill. p. 98; *Beeldende Kunst* 17 (1930), nos. 43, 43a, ill.; A.B. de Vries 1959, pl. 6; Plietzsch 1960, p. 86, fig. 146; A.B. de Vries 1964, pp. 355–57, pl. iii; van den Bergh collection, cat. 1968, p. 16, ill.; C. Welcker 1979, pp. 87, 207, no. S23, p. 214, no. S58.1, pl. X; A. Blankert in Amsterdam/Zwolle 1982, p. 28.

This well-preserved painting is one of the most successful winter scenes from Avercamp's mature career. On a broad frozen canal beneath an overcast winter sky, people of various classes disport themselves with a wealth of genre-like anecdote. Some tie on their skates while others skim over the ice or climb aboard horse-drawn sleighs or human-powered sleds. On the left a gypsy tells a woman's fortune while a stolid hunter gestures nearby. At the center an elegantly clad skating couple draws curious glances from a second pair in provincial costume; on the right an elegant party, including a fashionable young woman with a mask, don their skates. In the distance the riot of minor incident continues – figures play *kolf* (predecessor of modern golf

and ice hockey), trudge to and fro with their wares and groceries, or take a tumble on the ice. Not all is wintry gaiety – one skater has had a bad fall, lying prone and bleeding on the ice. On the horizon are the pink and brown indications of cottages, boats, and distant church spires; the specter of skaters dissolving in the icy mist.

The man with his back turned and the woman with the mask on the far right have been identified by Welcker[1] as the "Winter King and Queen" of Bohemia on the basis of their resemblance to figures in a drawing (without any inscription) by Avercamp in the Teylers Museum in Haarlem (fig. 1). Avercamp's design was engraved in 1766 by Cornelis Ploos van Amstel (1726–1798) with the inscription "H.A. 1621 fe. dit is Frederik de 5de: Koning van Bohemen en vrouw na het leven getykent" (H[endrick] A[vercamp] 1621 fe. this is Frederik the 5th: King of Bohemia and his wife drawn from life).[2] The exiled king of Bohemia, Frederick V, took refuge in Holland in 1620. The same group that appears in the Carter picture, but typically altered with minor changes of design and pose, also figures on the right side of a similar winter scene recently with the Waterman Gallery in Amsterdam (fig. 2). However, as A.B. de Vries and later Walsh and Schneider have observed, there is little reason to believe Ploos van Amstel's inscription.[3] His print dates more than a century and a half after the event that it purports to record, and as Blankert noted (in rejecting the identification for the figures in the Waterman picture), Ploos van Amstel worked at a time when there was a fashion for fictional, anachronistic identifications.[4] This group, to judge from their clothing, are members of the patrician class and thus are probably anonymous types like the picture's middle-class burghers and peasants.

Welcker dated this painting to 1626 or later because of her belief that it depicted the royal

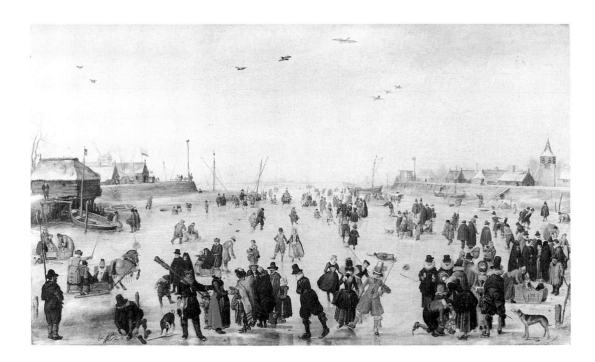

7

Fig. 1. Hendrick Avercamp, *Elegant Figures on the Ice*, pen and ink drawing with watercolor, 189 x 241 mm., Teylers Museum, Haarlem, no. T 46.

Fig. 2. Hendrick Avercamp, *Winter Landscape near Utrecht or Kampen*, panel, 46.9 x 89 cm., formerly Waterman Gallery, Amsterdam.

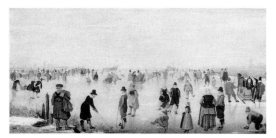

Fig. 3. Hendrick Avercamp, *Winter Landscape*, signed and dated 1620, panel, 33 x 53 cm., private collection.

couple on their visit to Kampen in that year.[5] Walsh and Schneider, however, rightly pointed to the painting's stylistic resemblance to a picture dated 1620 in a private collection (fig. 3);[6] that work also depicts many relatively large-scale, sharply delineated figures spread across the foreground with smaller figures beyond and a faint horizon situated across the midpoint of the panel's height. Completing this stylistic group is the *Winter Landscape near Utrecht or Kampen* formerly with the Waterman Gallery (fig. 2). These works are the first to completely eliminate flanking trees or buildings, thus permitting the figures and horizontal expanse of ice to dominate the landscape. Avercamp's earlier landscapes (see Introduction and cats. 5 and 6) recall in their use of smaller figures and landscape motifs in the foreground the tradition of Pieter Bruegel and his Flemish followers. This later group of paintings with larger figures has more in common with David Vinckboons's art of c.1610 (see cat. 111). The date of about 1620 for the Carter picture is further corroborated by the figures' costumes. Blankert, who believed that the Carter painting and figure 2 might predate the picture of 1620 (fig. 3), related the compact groupings of figures to Avercamp's undated painting in Schwerin (Gemäldegalerie, inv. 2678) and dated the entire group c.1615–20.[7]

Fig. 4. Hendrick Avercamp, *Skater*, pen and ink drawing, 171 x 115 mm. Royal Library, Windsor Castle, no. 6477.

Avercamp's working method evidently involved the reuse of a repertoire of figure studies, since many of the figures in this and other paintings recur. In some cases, specific drawings are known; for example, the jaunty foreground skaters in red appear in a drawing in Windsor Castle (fig. 4), and the hunter at the left recurs in a slightly altered pose in a drawing in the Rijksprentenkabinet, Amsterdam.[8] Like Jacques de Gheyn (1565–1629) and others before him, Avercamp had earlier depicted gypsies in

their crude encampments or fleecing the gullible with their fortunetelling.[9] Here, however, there is little beyond the hunter's gesture to suggest an admonition against credulity — no cutpurse or wily accomplice. The small boy with brazier of coals who appears beside this incident recalls instead medieval depictions of February in a series of Months of the Year in which a figure (albeit usually an old man) often was shown warming his hands. But such potential symbolism scarcely seems uppermost in the artist's approach to his subject. For Avercamp, the painting of a winter landscape is not so much an occasion for the illustration of seasonal typologies, for social commentary, or for moral admonishments as it is a celebration of the diversity of human response to nature: the bracing chill of the weather and the novelty of an expansive, ice-covered terrain. The success of his efforts is reflected in the fact that his pictures are as attractive to collectors and museum-goers as to social historians.

P.C.S.

1. C. Welcker 1979, p. 87.

2. Ibid., no. T 46; I.Q. van Regteren Altena, in Paris, Musée du Louvre, *Cent dessins du Musée Teyler*, Haarlem, 1972, no. 63.

3. Van den Bergh collection, cat. 1968, no. 16; Walsh and Schneider in Los Angeles/Boston/New York 1981–82, pp. 5–6.

4. Blankert 1982, p. 611.

5. C. Welcker 1979, pp. 87, 89.

6. Walsh and Schneider in Los Angeles/Boston/New York 1981–82, p. 6.

7. Blankert in Amsterdam/Zwolle 1982, p. 28.

8. C. Welcker 1979, no. T 18; Rijksprentenkabinet, Amsterdam, inv. A 3738.

9. See Walsh and Schneider in Los Angeles/Boston/New York 1981–82, p. 7, note 3, and especially Avercamp's drawing in the Kunsthalle, Hamburg, no. 21647 (C. Welcker 1979, no. T 118, pl. XXVIII).

Claes Berchem

(Haarlem 1620–1683 Amsterdam)

Baptized in Haarlem on October 1, 1620, Claes Berchem was the son of the still-life painter Pieter Claesz (1596/97–1661). Born in Burgsteinfurt, near Enschede, Pieter Claesz had lived in Holland for three years prior to Claes's birth. In 1634 the Haarlem guild records report Pieter Claesz "teaching drawing to his son." According to Houbraken, after training with his father, Berchem became a pupil, successively, of Jan van Goyen, Claes Moeyaert (1592/93–1655), Pieter de Grebber (c.1600–1653), Jan Wils (c.1610–1666), and his cousin Jan Baptist Weenix. The last-mentioned is unlikely, since Weenix was Berchem's junior. On May 6, 1642, Berchem entered the Haarlem guild and took on three pupils in the same year. Paintings of 1645 depict Netherlandish scenery and prove that he began his career painting in the indigenous Dutch landscape style. In 1646 he married in Haarlem. On March 22, 1649, Berchem made a will in Haarlem with his wife, Catrijne Claes de Groot. Around 1650 he traveled with Jacob van Ruisdael near the German border. He was mentioned in 1656 and 1657 in Haarlem, 1660 in Amsterdam, and in 1670 again in Haarlem. In 1677 he moved permanently to Amsterdam, where he died in 1683 and was buried on February 23 in the Westerkerk. On May 4, 1683, the paintings left in his estate were auctioned.

It has been suggested that Berchem accompanied Jan Baptist Weenix to Italy in 1642, but despite the fact that Weenix was in Rome from 1642 to 1645, there is no proof that Berchem was also there. No early written sources mention such a trip; however, Sick, Schaar, and Blankert all hypothesized on the basis of style that Berchem traveled to Italy around 1653 (the first two authors wrongly assumed for the second time). Berchem was certainly back by 1656.

A productive painter, draftsman, and etcher of Italianate landscapes as well as a history painter, Berchem was a member of the second generation of Dutch Italianate painters. His early works before about 1650 show the influence of Pieter van Laer (1599–1642), Jan Both, and Jan Asselijn, while there are still parallels with the "indigenous" Dutch landscape school. Asselijn's example becomes still more important in his mature works, and Adam Pijnacker also makes an impact in the 1660s. In addition to landscapes, Berchem painted imaginary Mediterranean harbor scenes, allegories, religious and mythological subjects, and genre scenes. He apparently provided the figures in the landscape compositions of other artists, including Jacob van Ruisdael, Meindert Hobbema, Willem Schellinks (1627–1678) and Jan Hackaert. Berchem also certainly collaborated with Gerrit Dou (1613–1675), Jan Wils (1600–1666), and Jan Baptist Weenix. Berchem etched more than fifty plates, the majority of which were animal subjects. In the eighteenth century, largely through the numerous engravings after his works, Berchem became the best known of all the Dutch Italianate landscapists. Although the 850 works listed by Hofstede de Groot include many misattributions, Berchem was one of the most productive, versatile, and, notwithstanding his virtuosity, consistently inspired Dutch painters of his age.

During his more than thirty years of activity, Berchem had many pupils, including the following listed by Houbraken: Karel du Jardin, Abraham Begeyn (c.1635–1697), Willem Romeyn (c.1624–1694), Hendrick Mommers (c.1623–1693), Johannes van der Bent (c.1650–1690), and Dirck Maes (1659–1717), as well as the genre painters Pieter de Hooch (1629–1684) and Jacob Ochtervelt (1634–1682).

P.C.S.

Literature: de Bie 1661, p. 385; Houbraken 1718–21, vol. 2, pp. 109–14; Descamps 1753–64, vol. 2, pp. 340–47; de Winter 1767; Bartsch 1803–21, vol. 5, pp. 245–83; van Eynden, van der Willigen 1816–40, vol. 1, pp. 408–12; Smith 1829–42, vol. 5, pp. 1–111, vol. 9, pp. 593–619; Nagler 1835–52, vol. 1, pp. 430–34; Goethals 1837; Immerzeel 1842–43, vol. 1, pp. 41–42; Kramm 1857–64, vol. 1, pp. 76–78; Nagler 1858–79, vol. 1, no. 1749, vol. 4, nos. 44, 2328, 2337; de Brou 1863; van der Willigen 1870, pp. 76–77, 252–253, 256; Obreen 1877–90, vol. 5, pp. 304, 317, vol. 7, pp. 190, 310; Wurzbach 1906–11, vol. 1, pp. 82–85, vol. 3, p. 23; Hofstede de Groot 1907–28, vol. 9 (1909), pp. 51–292; E.W. Moes in Thieme, Becker 1907–50, vol. 3 (1909), pp. 370–73; von Sick 1930; Hoogewerff 1931; Martin 1935–36, vol. 2, pp. 350–54; Heppner 1940; Schaar 1954; Schaar 1956a; Schaar 1956b; Schaar 1958; Kuznetsov 1960; Maclaren 1960, pp. 20–24; Plietzsch 1960, pp. 147–52; Hagels 1964; Stechow 1965b, pp. 113ff.; Utrecht 1965, pp. 147–71; Stechow 1966, pp. 153–55, 157, 159–60; Haverkamp Begemann 1972; Müllenmeister 1973–81, vol. 2, pp. 23–27; Schatborn 1974; Salerno 1977–80, vol. 2, pp. 716–33, vol. 3, pp. 988–89; Duparc 1980; The Hague, Mauritshuis cat. 1980, pp. 8–11; Schapelhouman 1982; Schloss 1982; Haak 1984, pp. 382–84; Philadelphia/Berlin/London 1984, pp. 136–37; Jansen 1985.

8

8 (PLATE 60)

Peasants near a River (The Kicking Donkey), 1655

Signed and dated indistinctly: Berchem 1655
Oil on canvas, 32¼ x 39¼ in. (82 x 100 cm.)
Herzog Anton Ulrich-Museum, Braunschweig,
inv. 793

Provenance: Sale, Amsterdam, April 29, 1732, no. 7
(fl. 290); sale, de Montribloud, Paris, Feb. 9, 1784,
no. 51 (frs. 6,452 to Tolozan); Lapeyrière sale, Paris,
April 19, 1825 (frs. 12,130); Bousault collection,
Paris, 1834; dealer Artaria, 1838; Edmund Higginson,
Saltmarshe Castle; sale, Higginson, London
(Christie's), June 4, 1846, no. 206 (£593 5s., bought
in); sale, Higginson, London (Christie's), June 16,
1860 (£299 to Cooper); sale, W.D. Cooper, London
(Christie's), April 27, 1861 (£157 10s. to Pearce);
sale, E.W. Anderson, London (Christie's), May 7,
1864 (£294 to Colnaghi); art market, the
Netherlands; acquired in 1967, gift of the Fritz-
Behrens Stiftung Hannover.

Literature: Hoet 1752, vol. 1, p. 373; Smith 1829–42,
vol. 5, no. 81, vol. 9, no. 34; Higginson collection, cat.
1842, no. 135; Blanc 1857–58, vol. 2, pp. 88, 185;
Hofstede de Groot 1907–28, vol. 9, no 571; Schaar
1958, p. 67, note 51; Braunschweig, cat. 1969, p. 33,
fig. 71; Salerno 1977–80, vol. 2, p. 718, pl. 121.11;
Braunschweig, cat. 1983, p. 24, ill.

In the foreground is an itinerant band of herders
with assorted animals. As a woman watches, a
herdsman is about to whack a kicking donkey.
Behind this group is a pool and at the right a
vertical escarpment. In the left half of the com-
position is open countryside. Berchem infuses
the scene with an air of theatrical artifice:
emphatically framed by cliffs, the woman reacts
with a gracefully studied gesture of surprise to
the vigorous beating of the donkey. Here
Berchem has mixed Pieter van Laer's caricatured
peasant types with figures of aristocratic grace,
just as the rich brown tonality of the cliffs, also
typical of van Laer, is combined with brilliantly
lit scenery.[1] In the combination of a lofty
structure and sweeping plains separated by a
body of water, Berchem's landscape resembles

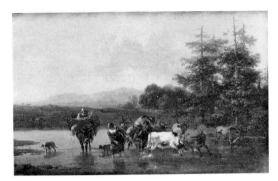

Fig. 1. Claes Berchem, *Herd of Cattle Crossing a Ford*, signed and dated 1656, panel, 38 x 62.5 cm., Rijksmuseum, Amsterdam, inv. A 30.

Fig. 2. Claes Berchem, *Italian Landscape with Herdsmen*, signed, canvas, 114.5 x 165 cm., whereabouts unknown.

Jan Asselijn's work (cat. 1). Berchem's idealized, wandering rustics (see also fig. 1) had great influence on later Italianate landscapists, not only Karel du Jardin (cat. 49 and 50) and Philips Wouwermans (cat. 122) but also eighteenth-century painters, especially in France.

Berchem was highly innovative in the 1650s, developing several types of landscape composition almost simultaneously.[2] A painting dated 1656 (fig. 1), similar in many respects to the exhibited work, contains trees of a non-Italian character, perhaps derived from Berchem's trip along the German border around 1650 with Jacob van Ruisdael. From 1655 is a broad, open landscape (cat. 1, fig. 1) similar to the left side of the exhibited work, executed in the same year. *The Education of Jupiter on Mount Ida* of 1654 (cat. 10, fig. 1) introduced a composition that Berchem continued to use for more than two decades. Similarly, the exhibited painting was repeated in a work that, to judge from its smooth, crisp handling, probably dates from the 1670s (fig. 2). Even the staffage is similar – the gesture of the woman on the donkey is virtually reversed in the later work.

A.C.

1. See van Laer's painting in the Kunsthalle, Bremen (inv. 69); or in a private Dutch collection (Blankert 1978, no. 35 and fig. 196).

2. Schaar (1958, pp. 44–63) describes several types of Berchem compositions, including river landscapes, harbors, hilly scenes, and banded compositions; see also Utrecht 1965, nos. 78–84.

Landscape with Crab Catchers by Moonlight, 1655?

Signed and dated lower right: N Berghem 1645
Oil on canvas, 23¾ x 31½ in. (60.3 x 80 cm.)
Trafalgar Galleries, London, on behalf of a trust

Provenance: Jacques Philippe Le Bas, Paris, 1762 (when the painting was engraved with the title *Pêche aux ecrévices* by François Denis Née [c.1739–1817]); sale, Vassal de St. Hubert, Paris, January 17, 1774, no. 38 (frs. 381);[1] Kleinberger's Gallery, New York, 1957; sale, London (Sotheby's), June 27, 1962; on loan to the Cleveland Museum of Art.

Literature: Smith 1829–42, vol. 5, no. 208; Hofstede de Groot 1907–28, vol. 9, no. 168 (the description corresponds but not the measurements, 36.4 x 51.3 cm.); Stechow 1966, pp. 176, 220, note 14, fig. 352.

In the foreground of a hilly landscape beneath a night sky, fishermen catch crabs. A full moon is partly obscured by clouds. Two men in the left foreground stand ankle deep in a stream, using bright torches of blazing reeds to spy their prey; on their backs are other bundles of reeds. One of the men triumphantly holds up his catch. A third crab fisherman on the bank at the right pauses for casual conversation with a more elegantly attired man and woman on horseback. At the far right is a heavily laden burro and, in the center, two dogs.

Like Adam Elsheimer (1578–1610) before him (see cat. 78, fig. 1), Berchem delighted in the challenge of representing in a nocturne two different types and sources of light, in this case the blazing torchlights of the fishermen and the colder, steely blue light of the moon. As much a genre scene as a landscape, this work gives special prominence to the foreground figures, who are sharply contrasted with the foil of dark rocks and trees behind. Characteristic of Berchem are the figures' graceful, almost balletic, attitudes and an elegant *soigné* technique. Stechow asserted that it was not Elsheimer but Pieter van Laer who inspired Berchem in this instance;[2] the latter painted a similar nocturne,

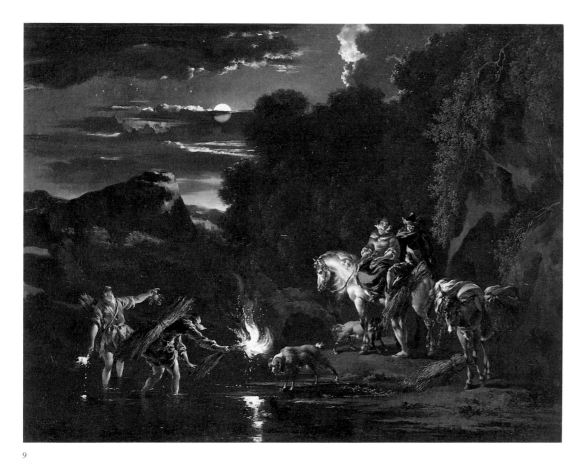

9

Fig. 1. Pieter van Laer, *Nocturne*, 35.5 x 49.5 cm., Galleria Spada, Rome, inv. 302.

now in the Galleria Spada, Rome (fig. 1).[3] Van Laer had returned to Haarlem in 1639, and his works made perhaps the strongest impact on the youthful Berchem, both in terms of staffage figures and an overall conception of landscape.

Dating the painting to 1645 would place the *Crab Catchers* among Berchem's earliest dated works.[4] However, on the basis of style, Albert Blankert questioned the reading of the date, observing that it would be more logically de-

ciphered as 1675.[5] Berchem's rather halting early pastoral scenes in Antwerp (inv. 637, dated 1645) and Bremen (inv. 17, dated 1646) are utterly different in technique and conception. The Cleveland Museum of Art closely examined the signature and date and reaffirmed the reading of 1645,[6] but the painting must date at least a decade later. The elegant figures, splendidly polished execution, and assured touch all anticipate a more mature point in Berchem's

career. Indeed, a dating of c.1655 finds support in comparison with another nocturne by Berchem, the *Moonlit Landscape* of 1652, recently acquired by the Niedersächsisches Landesmuseum, Hannover (fig. 2).[7]

Crab fishermen also appear in the foreground of a daylight scene by Berchem of a brightly lit Mediterranean coast with high rocks, now preserved in the City Art Gallery, York (fig. 3).[8] Stechow believed that Jan Asselijn's *Crab Fishing by Night* in the Statens Museum for Kunst, Copenhagen (fig. 4) was slightly later in date than Berchem's work, but given Asselijn's death in 1652, the opposite must be the case.[9] Asselijn's painting gives more of the composition over to the landscape and adopts a looser design and freer handling, but with sparser application of highlights. This is Asselijn's only surviving night scene, but others are recorded in early sales.[10]

The iconographic tradition of night fishing in a landscape may be traced back to medieval calendar illustrations, where it appeared as a typical occupation for the month of March.[11]

Fig. 2. Claes Berchem, *Moonlit Landscape with Herdsmen*, signed and dated 1652, canvas, 32 x 34 cm., Niedersächsisches Landesmuseum, Hannover, inv. PAM 1005.

Fig. 3. Claes Berchem, *Mediterranean Coast Scene with Crab Fishermen*, panel, 31.5 x 40 cm., City Art Gallery, York, no. 778.

Fig. 4. Jan Asselijn, *Crab Fishing by Moonlight*, monogrammed, canvas, 59 x 49 cm., Statens Museum for Kunst, Copenhagen, inv. Sp. 267.

A print after the *Crab Catchers by Moonlight* by Dancker Danckerts (1634–1666) also served as the illustration of Night in a series of the Four Times of the Day as illustrated by four paintings by Berchem.[12] Whether Berchem himself interpreted the work in this metaphorical fashion is unclear, since inscriptions appended to prints after artists' works even in their own time need not reflect the work's original meaning.

A copy of the *Crab Catchers by Moonlight* by Nicolaes Berchem the Younger (1649–1672) is preserved in the Konstmuseum, Göteborg.[13]

P.C.S.

1. Hofstede de Groot 1907–28, vol. 9, no. 168, as 36.4 x 51.3 cm. According to Hofstede de Groot, the painting fitting this work's description in the sale, W. Smits et al., The Hague, May 18, 1785, no. 167 (canvas on panel, 31 x 40.5 cm.), which sold to Spruyt for fl.14.5, was probably only a copy.

2. See Stechow 1966, pp. 176, 220, note 15.

3. See Federico Zeri, *La Galleria Spada in Roma* (Rome, 1952), no. 302, pl. 113; and Briganti 1950, p. 197, pl. CCIX. While landscapes of any type by van Laer are rare today, they are mentioned in early inventories and sales and include the night piece that was stolen from Swanevelt in 1636.

4. See Schaar 1958, pp. 13ff.; and Utrecht 1965, under no. 73, *Woman Milking at the Edge of the Wood*, Koninklijk Museum voor Schone Kunsten, Antwerp, inv. 637.

5. Utrecht 1965, p. 105.

6. Letter from Ann Lurie, November 26, 1986.

7. See Hannover, Niedersächsisches Landesmuseum, *Von Cranach bis Monet: Zehn Jahre Neuerwerbungen 1976–1985*, 1985, no. 2, ill. Compare also Berchem's undated nocturnes in the Bayerische Staatsgemäldesammlungen, Munich (inv. 2168), and the Hermitage, Leningrad (inv. 1917). See also Stechow 1966, p. 220, note 14.

8. In the City Art Gallery, York, cat. 1971, p. 46, no. 776, as dating from the 1670s, but Blankert (Utrecht 1965, p. 159, no. 81) more persuasively argues for a date of 1658. A copy or replica of this work, but with an upright format, is in the Muzeum Narodowe, Warsaw, cat. 1969, no. 80, ill. (panel, 45 x 43.5 cm.). The subject of fishermen talking with an elegant couple also figures in Berchem's painting of 1656 in the Gemäldegalerie, Staatliche Kunstsammlungen, Dresden, no. 1482.

10 (PLATE 66)

Mountainous Landscape with Herders Gathering Wood, c.1665–75

9. Stechow 1966, p. 176. Blankert (Utrecht 1965, p. 105) rightly disputes the claim that the Berchem served as model for the Asselijn. See also Steland-Stief 1971, p. 62, no. 238, pl. 36, who notes that crab fishing appears in Frans de Momper's *Mountain Landscape by Moonlight* (panel, 61 x 97 cm., Museum der bildenden Künste, Leipzig, inv. 1239).

10. See Steland-Stief 1971, nos. 239–41.

11. See Stechow 1966, p. 220, note 16.

12. See de Winter 1767, no. 71; Wurzbach 1906–11, vol. 1, p. 377, under series no. 8; Hollstein, vol. 5, p. 130, nos. 22–25. However, by the time that Née engraved the work in 1762, its allegorical title had been replaced by the more purely descriptive title *Pêche aux écrévices*.

13. *Göteborgs Konstmuseum Malerisamlingen* (1979), p. 22, no. 1032, signed, canvas, 72 x 86.5 cm.

10

Oil on canvas, 55½ x 68½ in. (141.1 x 173.9 cm.) The J. Paul Getty Museum, Malibu, 86.PA.731

Provenance: Sale, Hendrik Twent, Leiden, August 11, 1789, no. 2, (fl.2,000 to Fouquet); sale, Pierre Grand-Pré, Paris, February 16, 1809, no. 90 or 91 (frs.30,000, bought in); sale, Alexis Delahante, London (£892 10s.); sale, Edward Hollond, London (Christie's), May 22, 1830, no. 104 (£787 10s., bought in); sale, Edward Hollond, London (Squibb), July 9, 1831, no. 67 (£367 10s.); Gosling, 1834; sale, London (Christie's), July 27, 1976, no. 61; private collection, Germany; private collection, New York; purchased 1986.

Literature: Smith 1829–42, vol. 5, no. 144; Blanc 1857–58, vol. 2, p. 363; Hofstede de Groot 1907–28, vol. 9, no. 341.

Fig. 1. Claes Berchem, *The Education of Jupiter on Mount Ida*, signed and dated 1654, canvas, 61 x 83 cm., Wallace Collection, London, no. P 256.

A brook flows past a tree-covered hill. To the right appears a view of a wide mountainous landscape. By the brook a woman kneels to gather wood. She looks over her shoulder toward another woman standing by a donkey; a boy wearing a wide-brimmed hat and carrying a stick sits in the foreground. These figures are accompanied by a dog and two resting cows.

This type of landscape composition had been fully developed by Berchem early in his career. In his painting *The Education of Jupiter on Mount Ida*, dated 1654 (fig. 1), the foreground is bordered by a stream near a hill covered with trees in exactly the same way. That painting also offers a view of a similarly expansive mountainous landscape. On the other hand, fundamental differences between the two paintings are also apparent. In *The Education of Jupiter* the trees are of a single species, while in the exhibited painting there is a variety of trees – some bare, others richly verdant. The hills in figure 1 undulate gently, while in the Getty picture the outlines of the mountains zigzag with sharp edges, creating an agitated, dynamic effect characteristic of Berchem's late works. The picture must, therefore, date about 1665–75.[1]

The Getty painting was once considered one of Berchem's masterpieces at a time when the artist himself was reckoned one of the most eminent masters of the Dutch school. The auction catalogue of 1789 termed the landscape "one of the most vigorous and artful of the master"; at the 1830 and 1831 sales it was called "a noble chef d'oeuvre." But after Smith's catalogue raisonné was published in 1834, it disappeared from public sight, resurfacing only a few years ago.

A.Bl.

1. See Utrecht 1965, pp. 31–32, nos. 85–93.

Gerrit Claesz Bleker

(c.1600–1656 Haarlem)

Although the date and place of Gerrit Claesz Bleker's birth remain unknown, he had already earned some reputation as a landscapist and portraitist in Haarlem by 1628, when Samuel Ampzing mentioned him in his *Beschryvinge van Haerlem*. Theodoor Schrevelius also mentioned him in his own account of the city. A painting of the *Wives of Weinsberg* was said to be signed and dated 1624 (sale, Amsterdam, October 14, 1884), but the earliest verifiable date is 1625 on the *Adoration of the Kings* (Rijksmuseum "Het Catherijneconvent", Utrecht). In 1640 three little-known Amsterdam artists – Pieter Adelaer, Paulus van der Goes, and David Decker – were apprenticed to Bleker in Haarlem. Three years later he was named *vinder* of the Haarlem Guild. His address was recorded as the corner of the Groote Houtstraat and Paardesteeg when he was buried on February 8, 1656, in the St. Bavo Kerk in Haarlem. He was probably the father of the Haarlem portrait and history painter Dirk Bleker (c.1622–after 1672).

Bleker's surviving paintings are rare but include landscapes, portraits, and history paintings. He was also active as a draftsman and etcher; prints of animal subjects bear the dates 1638 and 1643.

P.C.S.

Literature: Ampzing 1628, p. 372; Schrevelius 1648, pp. 390, 487; Houbraken 1718–21, vol. 2, p. 124; Bartsch 1803–21, vol. 4, pp. 103–113; van Eynden, van der Willigen 1816–40, vol. 1, pp. 63–64, vol. 4, p. 95; Nagler 1835–52, vol. 1, pp. 527–28; van der Willigen 1870, pp. 81–82; Obreen 1877–90, vol. 1, p. 231; Bode 1883, pp. 348–51; Wurzbach 1906–11, vol. 1, pp. 104–105, vol. 3, p. 28; E.W. Moes in Thieme, Becker 1907–50, vol. 4 (1910), pp. 111–12; Bettink 1937; Hollstein, vol. 2; Gudlaugsson 1953; Bol 1969, pp. 246–47; Müllenmeister 1973–81, vol. 2, pp. 29–30.

Stag Hunting in the Dunes, c. 1627

Signed and dated: BLE . . . 162[?]
Oil on panel, 30⅞ x 53½ in. (78.5 x 136 cm.)
Frans Halsmuseum, Haarlem, inv. 550

Provenance: Sale, Petit Collection, Amsterdam
(Muller), June 19, 1913, no. 4; sale, F. Muller,
Amsterdam, November 21, 1933, no. 4; acquired in
1934 from dealer D. Katz, Dieren.

Literature: Haarlem, cat. 1960, p. 8, no. 550, fig. 22 (as
Bleker, the figures by Willem Cornelisz Duyster);
Keyes 1984, p. 114, note 144.

In the foreground of a marshy landscape with
low hills and coppices of trees, hunters on foot
and mounted on horseback pursue two stags. In
the distance other figures hunt, and in the
central background a castle with turrets is
visible through the trees.

In the Frans Halsmuseum's catalogue, the
figures in this work are attributed to the
Haarlem genre painter Willem Duyster
(1599–1635), but S.J. Gudlaugsson rightly
asserted that they too are probably by Bleker's
hand.[1] Both the figures and the approach to
landscape are close in style to two other hunting
scenes in forests by Bleker – the signed and
dated *Raid on a Village* (panel, 74 x 135 cm.) of
1628 in the National Gallery of Ireland, Dublin
(no. 246), and the unsigned *Forest with Stag Hunt*
in the Frits Lugt Collection (fig. 1).[2] As Saskia
Nystad observed of the latter picture,[3] the
Haarlem painting exhibits a strong Flemish in-
fluence and is particularly reminiscent of the art
of Jan Wildens (1586–1653). While stag hunts in
forests had been popular subjects among Flemish
and German sixteenth-century landscapists, this
painting is close in conception to those land-
scapes with low horizons, tall, full trees, and
distant glimpses of bright prospects that Jan
Wildens first painted in 1615/16 in Genoa (fig. 2)
and later made a specialty after his return to
Antwerp in 1616.[4] Wildens's earlier painting
owes a debt to Paul Bril and forms part of a

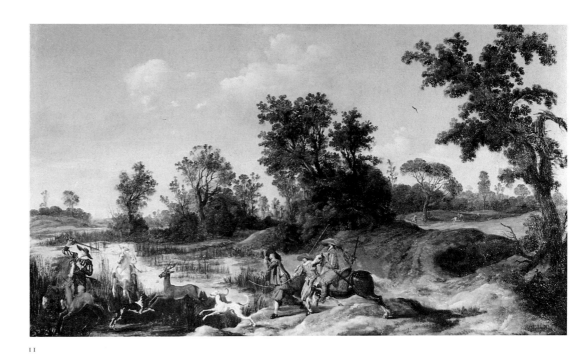

11

Fig. 1. Gerrit Claesz Bleker, *Forest with Stag Hunt*, panel, 43.5 x
74.2 cm., Fondation Custodia, Collection Frits Lugt, Institut
Néerlandais, Paris, inv. 5242A.

Fig. 2. Jan Wildens, *Forest with Stag Hunt (September)*, c.1615/16,
canvas, 123 x 192 cm., Galleria di Palazzo Bianco, Genoa, inv.
280-P.R. (damaged by fire in World War II).

Abraham Bloemaert

(Gorinchem 1564–1651 Utrecht)

series of illustrations of the Months; whether Bleker's work retains any similar allegorical associations is unclear. Certainly the coloring and treatment of the foliage recall his Flemish prototypes, only the touch has become harder and more exacting. The treatment of the figures, trees, and hillocks may acknowledge Esaias van de Velde's precedents.

P.C.S.

1. Annotation on the photo mat at the Rijksbureau voor Kunsthistorisch Documentatie, The Hague.

2. See also the *Landscape with Riders*, panel, 64 x 97.5 cm., in the Girardet collection; ill. in Cologne/Rotterdam 1970, no. 59, wrongly as Esaias van de Velde, but, according to the catalogue, attributed by S.J. Gudlaugsson to Bleker.

3. Paris 1983, p. 16, no. 8, pl. 5.

4. See Wolfgang Adler, *Jan Wildens, der Landschaftsmitarbeiter des Rubens* (Fridingen, 1980), p. 98, no. G19, fig. 34.

Paulus Moreelse, *Portrait of Abraham Bloemaert*, signed and dated 1609, panel, 63.5 x 50 cm., Centraal Museum, Utrecht, inv. 12489.

According to Houbraken, Abraham Bloemaert was born in Gorinchem in 1564. His father, Cornelis Bloemaert (1525–c.1595), was a sculptor, painter, architect, and engineer who left his native Dordrecht for political reasons. As a child, Bloemaert moved with his family from Gorinchem to 's Hertogenbosch and then to Utrecht. Bloemaert first studied with his father, then briefly with the Utrecht artist Gerrit Splinter (active c.1569–1589) before being apprenticed, together with Joachim Wtewael (1566–1638), to Joos de Beer (d.1599), a former pupil of Frans Floris (c.1520–1570). In de Beer's studio he was introduced to the work of Anthonis Blocklandt (1532–1583).

Bloemaert visited Paris between 1580 and 1583, where he studied with, among others, the Antwerp painter Hieronymous Francken (1540–1610). Back in Utrecht in 1583, he had left again by October, 1591, for Amsterdam, where his father had been appointed municipal architect. It was probably during this period (1591–93) that he first became acquainted with the form of mannerism practiced in nearby Haarlem. On May 2, 1592, he married Judith Schonenberg in Amsterdam. By 1593 Bloemaert had returned to Utrecht, where he remained for most of his career. Bloemaert, however, retained his ties to Amsterdam, where he married his second wife, Geertruida de Roy, in 1601, and executed a commission for a glass window in the Zuiderkerk in 1603. In 1611 he was one of the founding members of the Utrecht St. Luke's Guild and in 1618 became its dean. No doubt under the influence of the younger Utrecht painters Hendrick ter Brugghen (1588–1629) and Gerrit van Honthorst (1590–1656), Bloemaert adopted a Caravaggesque manner of painting for a period in the 1620s. Bloemaert died in Utrecht on January 27, 1651, and was buried in the Catharijnekerk.

Bloemaert was primarily a painter and draftsman of religious, mythological, and allegorical subjects; fewer in number are his landscapes, genre scenes, and portraits. The visits made to his studio by Peter Paul Rubens (1577–1640) and Queen Elizabeth of Bohemia attest to his renown. One of the most sought-after teachers, Bloemaert instructed, among others, Hendrick ter Brugghen, Gerrit van Honthorst, Wybrand de Geest (1592–c.1661), Jacob Gerritsz Cuyp (1594–1651), Jan van Bijlert (1597–1671), Nicolaes Knüpfer (c.1603–1655), Willem van Honthorst (1604–1666), Andries Both (1612/13–1641), and the Italianate landscapists Cornelis van Poelenburch, and Jan Baptist Weenix. A productive artist, his works were widely dis-

12 (PLATE 14)

Landscape with the Parable of the Tares of the Field, 1624

seminated through engravings. Bloemaert's *Fondamenten der Teecken-Konst (Foundations of the Art of Drawing),* engraved by his son Frederick, was a standard model book until well into the nineteenth century.

P.C.S.

Literature: van Mander 1604, pp. 297–98; de Bie 1661, pp. 43–46; Sandrart 1675, vol. 2, p. 291; Baldinucci 1686, pp. 44, 61; de Piles 1699, pp. 397–98; Houbraken 1718–21, vol. 1, pp. 43–44; Weyerman 1729–69, vol. 1, pp. 224–27; Bloemaert 1740; Descamps 1753–64, vol. 1, pp. 246–48; van Eynden, van der Willigen 1816–40, vol. 1, pp. 369–70; Nagler 1835–52, vol. 1, pp. 533–34; Immerzeel 1842–43, vol. 1, pp. 60–61; Blanc 1854–90, vol. 1, p. 373; Kramm 1857–64, vol. 1, pp. 101–103; S. Muller 1880, p. 146; de Kruyff 1882–83; Wurzbach 1906–11, vol. 1, pp. 109–11, vol. 3, p. 29; E.W. Moes, in Thieme, Becker 1907–50, vol. 4 (1910), pp. 125–26; Grosse 1925, pp. 12–16; Sandrart, Peltzer 1925, pp. 153, 157, 164, 172–75, 184, 248; Müller 1927a; Antal 1928–29; Buchelius 1928, pp. 31, 51, 74–76, 93–95; Delbanco 1928; Bodkin 1929; Schneider 1933; Bredius 1937; Kamenskaja 1937; Hollstein, vol. 2, pp. 60–69; Philipsen 1957–59; Stechow 1966, pp. 25–28, 149–50, 192, no. 27; Roethlisberger 1967; Bol 1969, pp. 158–59; Nicolson 1979, pp. 23–24; Washington, D.C./Detroit/Amsterdam 1980–81, pp. 86–91; Kettering 1983, pp. 84–87; Haak 1984, pp. 172, 208, 313–15; Utrecht/Braunschweig 1986–87, pp. 208–12; Roethlisberger, forthcoming.

Signed and dated lower right: A. Bloemaert fe:/1624
Oil on canvas, 39½ x 52¼ in. (100.3 x 137.8 cm.)
Courtesy, Walters Art Gallery, Baltimore, gift of the Hon. Francis D. Murnaghan. 37.2505

Provenance: Earl of Portarlington, Emo Court, Ireland; Justice James Murnaghan, Dublin.

Literature: Bodkin 1929, pp. 101–102, fig. 1; Bowron 1973; *Gazette des beaux-arts* 83 (1974), p. 121, fig. 392.

Five figures, two of them nude, slumber before a landscape with a picturesque farmhouse, dovecote, and, on the right, a distant prospect of hills and mountains. The painting's biblical subject is revealed only by the tiny figure of the devil sowing the field in the middle distance; the painting illustrates the Parable of the Tares (Matthew 13:24–30, 36–39) in which "the Kingdom of Heaven is likened unto a man who sowed good seed in his field. But while the man slept his enemy came and sowed tares among the wheat, and went his way." Christ offered an unusually full symbolic interpretation of the parable: "He that soweth the good seed is the son of man; the field is the world; the good seed are the children of the kingdom; but the tares are the children of the wicked one; the enemy that saved them is the devil; the harvest is the end of the world; and the reapers are the angels. As therefore the tares are gathered and burned in the fire, so shall it be in the end of the world."

As Bodkin observed, Bloemaert had treated the subject in a design engraved by Jacob Matham as early as 1605 (fig. 1).[1] The print already includes many of the principal motifs of Baltimore's painting – the sleepers in the foreground, the devil beyond, and the farmhouse at the left – but introduces a screen of two large trees as the central element of the design. Bowron, too, compared the Walters' painting with another undated painting of the subject in Denys Sutton's collection (fig. 2).[2] There the

slumbering peasants are fully clothed, situated in the central foreground, the tree moved to the left, while a smaller screen of slender trees reminiscent of Buytewech's prints figures in the middle distance. Finally, there is a drawing by Bloemaert of this subject in Brussels; in that sketchy little sheet, however, the figures and not the landscape dominate.[3]

Cornelis Müller sought to characterize Bloemaert's stylistic development as a landscapist but largely without relationship to other painters' work.[4] Grosse assigned Bloemaert a leading role in the development of an indigenous Dutch landscape art, but Stechow rightly saw him as dependent upon the younger generation – Esaias van de Velde, Pieter de Molijn, and Jan van Goyen.[5] Bloemaert's many drawings of picturesque landscape details were subsumed by a unified landscape vista only in his later works. This painting of 1624 is a transitional work in his career. It still employs the mannerist convention of an "inverted" narrative, as well as many picturesque, additively composed details, such as the dovecote. There is a drawing of this dovecote in reverse in the Ecole des Beaux-Arts, Paris (fig. 3).[6] A similar dovecote also appears in the *Tobias and the Angel* (see p. 84, fig. 1). The Baltimore work eschews the deep funneling space, dramatic tonal contrasts, and imaginary mountains of earlier works, examples of which are his *Landscape with the Rest on the Flight into Egypt* of c.1605 (canvas, 112 x 160 cm., Centraal Museum, Utrecht, inv. 5570), which again includes the dovecote, and the *Prophet Elijah in a Landscape* (canvas, 72 x 97 cm., Hermitage, Leningrad, inv. 6802). Other horizontal compositions, which share with the Baltimore painting the use of a foreground foil of reclining figures, a diagonal recession, and tiny religious figures beyond, include two landscapes dominated by cottages and unidentified peasants with distant figures of Tobias and the Angel dated

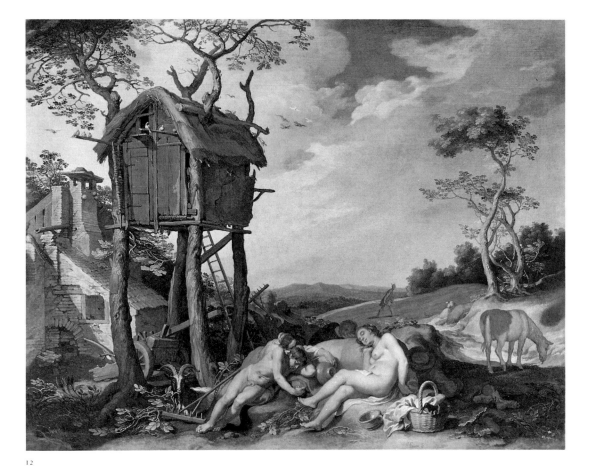

12

Fig. 1. Jacob Matham, after Abraham Bloemaert, *Parable of the Tares*, engraving, 1605.

Fig. 2. Abraham Bloemaert, *Parable of the Tares*, signed and dated (indistinctly), canvas, 97 x 121.9 cm., collection of Denys Sutton, London.

1629 (canvas, 91.5 x 135.5 cm., Kunsthalle, Hamburg, inv. 732) and 1650 (canvas, 91.2 x 134.2 cm., Gemäldegalerie, Staatliche Museen zu Berlin, DDR, inv. 1995). The latter work, a very late painting by Bloemaert, illustrates the strong stylistic continuity of his art.

Representations of the Parable of the Tares had enjoyed some popularity with earlier Netherlandish artists, including Jan Mandijn, Ambrosius Brueghel, Abel Grimmer, Pieter

Baltens, Hans Bol, and Jacques de Gheyn (see cat. 112, fig. 1).[7] The theme was also to attract later artists, such as Simon de Vlieger (see cat. 112), but no one embraced it as fully as Bloemaert and his school. Something of the medieval practice of interpreting the Parable of the Tares as an allegorical allusion to the Fall of Man apparently persists in Bloemaert's decision to depict two of the laborers nude. The only case of this practice in his art, this is probably an

Fig. 3. Abraham Bloemaert, *Dovecote*, pen and ink with wash, 181 x 201 mm., Cabinet des Dessins, Ecole Nationale Supérieure des Beaux-Arts, Paris, inv. M1539.

allusion to Adam and Eve. The connecting element between the themes is the thistle, or tare, which was a symbol of earthly sorrow and sin because of the curse against Adam by God (Genesis 3:17–18): "Cursed is the ground for thy sake, in sorrow shalt thou eat of it all the days of thy life; thorns also and thistles shall it bring forth to thee; and thou shalt eat the herb of the field." In early illustrated Dutch and German Bibles the Parable of the Tares was also often illustrated together with the Parable of the Sower. The latter precedes the tares parable in the Gospel of Saint Matthew (13:5–8) and, like it, alludes to the various fates of mankind: "Some seeds fell by the way-side and the fowls came and devoured them up . . . some fell upon stony places, where they had not much earth . . . and some fell among the thorns . . . but others fell into good ground."

The etymology of the English word "tare" is disputed,[8] but the basic biblical texts refer to the Aramaic word *zizania*, which is identified as the common Near Eastern weed, darnel (*Lolium temulentum*). Darnel resembles wheat in its early growth, but its kernels can carry a poisonous fungus causing dizziness. Hence the French term for darnel is *ivraie*, a word related to *ivress*, or drunkenness. In modern French slang, the saying *semer la zizanie* means "to sow discord or dissension," the very deed performed by the devil in the parable.

No catnap, the sleep of Bloemaert's laborers is suggestive of the heavy slumber of the inebriated. Whether other elements of the picture offer eschatological symbolism is unclear: The goat is a traditional symbol of the damned in the Last Judgement (Matthew. 25:33–34); the peacock is a traditional symbol of pride and of immortality, since its flesh was believed never to decay. According to van Mander (*Wtbeeldinge*, fol. 131),[9] the peacock also symbolized the indecency of riches, since, with its tail raised, the bird is beautiful only from the front; that is to say, wealth is attractive but often hides immoral means of gain. Finally, the dove is the emblem of love and the Holy Spirit. For additional associations of the dove and the dovecote, see J. Bruyn's essay in this volume.

P.C.S.

1. Bodkin 1929, p. 102. For Matham's engraving, see Hollstein, vol. 2, no. 67.488. See also John Barra's engraving after Bloemaert (Hollstein, no. 65.2).

2. Bowron 1973, note 5. The painting in Denys Sutton's collection (fig. 2; exh. Hazlitt Gallery, *Vasari to Tiepolo* [London, 1952], no. 2; not in Delbanco), sold in London (Christie's), December 8, 1950, no. 108.

3. Pen and ink, 62 x 94 mm., Musées Royaux des Beaux-Arts, Brussels; De Grez collection, cat. 1913, no. 343.

4. Müller 1927, pp. 193–208.

5. Grosse 1925, p. 7; Stechow 1966, pp. 25–26.

6. The discovery (letter, April 22, 1974) of François Viatte, Conservateur du Cabinet des Dessins, Ecole des Beaux-Arts, Paris. As Bowron observed (1973, note 3), the dovecote appears repeatedly in Bloemaert's work and precisely as here in the *Landscape with Dovecote* engraved by Frederik Bloemaert after his father's design (Hollstein, no. 94.266). See also de Groot 1979, no. 80, illustrating Jan van de Velde's landscape print *Two Fishermen near a Dovecote*. The cottage reappears in the *Prodigal Son* (sale, London [Christie's], Oct. 15, 1972, no. 46) and the house appeared in the 1605 engraving; see fig. 1.

7. See, respectively, panel, 79 x 111 cm., Koninklijk Museum voor Schone Kunsten, Antwerp, inv. 881; panel, 56 x 81 cm., private collection, reproduced in *Brueghel: Een dynastie van schilders* (Brussels, Palais des Beaux-Arts, 1980), p. 244, no. 179; panel, 49 x 45.5 cm., on Amsterdam art market, c.1940; panel, 98 x 140 cm., sale, Paul Delaroff, Paris, April 23, 1914, no. 16; drawing dated 1573(?), 194 x 301 mm., Rijksprentenkabinet, Amsterdam, inv. A 3353; drawing dated 1603, Kupferstichkabinett, Berlin (West), inv. 3102. See also the other examples listed and illustrated in Pigler 1956, vol. 1, pp. 356, 358, and DIAL 73C81.2, and a series of four prints by Hans Bol illustrated in Hollstein, vol. 3, p. 41.

8. See W. van der Zweep, "Golden Words and Wisdom about Weeds," chap. 6 in *Biology and Ecology of Weeds* (ed. W. Holzner and N. Numata, The Hague, 1982), pp. 61–69; and W. van der Zweep, "Linguistic, Artistic and Folklore Aspect of Tares in the Biblical Parable," lecture presented at the Conference on Plants in Folklore, University of Sussex, Folmer (Brighton), April 8–10, 1983. The English word "tare" probably derives from the Middle-Dutch word "taruwe" (modern Dutch *tarwe*), which simply means "wheat." "Wilde Tare" apparently originally referred to weed grasses similar to wheat, such as darnel.

9. Van Mander 1604, fol. 131.

Anthonij van Borssom
(Amsterdam 1630/31–1677 Amsterdam)

I3 (PLATE 93)

A Broad River View with a Horseman, 1660s

Anthonij van Borssom was baptized on January 2, 1631, in Amsterdam, the son of Cornelis van Borssom, a mirror maker from Emden. On October 24, 1670, he was living on the Rozengracht in Amsterdam with his father when he married Anna Crimping, also of Emden. A year later, when he made his will, he was living on the Prinsengracht. He moved again to the Beerenstraat. On March 19, 1677, he was buried in the Westerkerk.

Little is known of van Borssom's training or career. He seems to have studied with Rembrandt or members of his circle. His earliest drawings recall those of Philips Koninck. Van Borssom also visited Kleve and the area along the Rhine and made drawings and paintings based on sites there. Van Borssom was an eclectic landscapist. Besides panoramas influenced by Koninck, the artist painted animal scenes influenced by Paulus Potter as well as night and fire scenes under the influence of Aert van de Neer. Occasionally the effects of Vroom, Ruisdael, Wijnants, and others can be felt. Van Borssom also executed church interiors, still lifes, and Rembrandtesque history paintings and made a few etchings of animals.

A.C.

Literature: Bartsch 1803–21, vol. 4, pp. 215–20; A.D. de Vries 1885–86, p. 69; Wurzbach 1906–11, vol. 1, pp. 142–43, vol. 3, p. 33; E.W. Moes in Thieme, Becker 1907–50, vol. 4 (1910), p. 378; Hollstein, vol. 3, pp. 112–15; Gorissen 1964; Dattenberg 1967, pp. 50–53; Bol 1969, pp. 230–31; Müllenmeister 1973–81, vol. 2, p. 35; Sumowski 1979, vol. 2, pp. 617–779; Sumowski 1983, vol. 1, pp. 426–56; Haak 1984, p. 468.

Signed lower right: AVBorssom – f [AVB in monogram]
Oil on canvas, 21⅞ x 28⅜ in. (55.5 x 72 cm.)
Svépművészeti Múzeum, Budapest, inv. 187

Provenance: Prince Nikolaus Esterházy von Galantha (at Laxenburg before 1815, in Vienna 1815–65, in Pest Academy of Sciences from 1865); purchased by the Hungarian government in 1870; in the National Gallery, Pest, 1872; transferred to the Svépművészeti Múzeum, 1906.

Literature: Esterházy, cat. 1812, XIII, no. 18; Esterházy, cat. 1869, XIII, no. 18; Bredius 1880, pp. 285, 374; Frimmel 1892, p. 188; Budapest, cat. 1906, no. 535, ill.; Wurzbach 1906–11, vol. 1, p. 143; E. Moes in Thieme, Becker 1907–50, vol. 4 (1910), p. 378; Martin 1935–36, p. 309; Budapest, cat. 1937, p. 44, no. 187, pl. 192; Bernt 1948, vol. 1, pl. 113; Budapest, cat. 1954, p. 74, no. 187, pl. 240; Czobor 1967, pl. 39; Budapest, cat. 1968, p. 87, no. 187, pl. 280; Garas 1977, p. 267; ill.; Bernt 1980, vol. 1, pl. 166; Sumowski 1983, no. 195, ill.

Anthonij van Borssom visited Emmerich, Kleve, and the surrounding area sometime between 1651 and 1656, according to the topographical evidence of the sketches made on the journey.[1] Many artists traveled through this area in the 1650s, including Aelbert Cuyp, Herman Saftleven, Jan van Goyen, Joris van der Haagen, Gerrit Berckheyde, Jan van der Heyden, Gerbrand van den Eeckhout and Vincent Laurensz van de Vinne (1629–1702).[2] The sketches van Borssom made in the Rhineland provided the basis for a handful of paintings: *View of the Huis ter Leede* (Carter collection, Los Angeles),[3] and a *View of Schenkenschanz and Elten*, dated 16(5?)6 in Dusseldorf (fig. 1), which exists in a second version.[4] The displayed painting must date from sometime after both these works, probably from the 1660s; it also closely resembles a landscape in Hamburg (fig. 2), which shows the additional influences of Wijnants and Wouwermans.

The exhibited painting is not a precise topographical rendering of any site but a landscape based on the type of scenery found in the Rhineland.[5] The panorama and the broad winding river are very similar to presumably earlier, more geographically specific landscapes (fig. 1), but van Borssom has added more picturesque elements such as the high sloping foreground, the strong vertical accents of the rider in a bright red jacket on horseback, and the prominent sailboat on the river.[6] Indeed the well-dressed horseman in the exhibited painting (like riders in Cuyp's landscapes, cat. 22 and 25) evokes a sense of travel along the Rhine, echoing the artist's own experiences. The prevailing atmosphere is one of peace and calm, despite the bank of clouds which filter a gray, diffuse light onto the landscape. A shepherd tends his flock on a high clearing at the right as boaters and fishermen go about their activities. Such an assemblage of idealized and idyllic elements closely resembles Philips Koninck's river panoramas (see cat. 53) which must have influenced van Borssom profoundly, although this type of landscape has its roots in sixteenth-century panoramic painting.

A.C.

1. The dating is established by Gorissen, who identified sites in two of van Borssom's drawings: *A View of Emmerich*, made after the reconstruction of c.1651–53 (van Eeghen collection, The Hague; Gorissen 1964, pl. 67 [as attributed to Koninck], and Sumowski 1979, no. 365xx [as van Borssom]); *View of Kleve* made before 1656 (Stichting Hannema-de Stuers, Heino; Gorissen 1964, no. 80; Sumowski 1979, no. 289). A drawing of the amphitheater at Kleve in the Rijksprentenkabinet, Amsterdam (inv. 705), which is the basis of a painting, was once attributed to van Borssom (Diedenhofen 1973) but has now been convincingly reassigned to Gerbrand van den Eeckhout by Sumowski (1979, vol. 3, no. 802).

Fig. 1. Anthonij van Borssom, *View of Schenkenschanz and Elten*, dated 16[5?]6, canvas, 90.5 x 126 cm., Staatliche Kunstsammlungen, Dusseldorf, inv. 121.

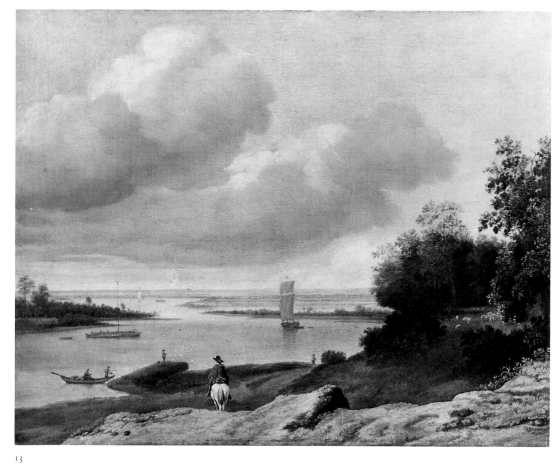

13

Fig. 2. Anthonij van Borssom, *Rider near a River*, canvas, 42.2 x 61.3 cm., Kunsthalle, Hamburg, inv. 138.

Jan Both

(Utrecht? c.1615–1652 Utrecht)

2. It has been suggested that the Peace of Münster of 1648 allowed artists the freedom to travel to Cologne and other areas in Germany for the first time (Paris 1986, p. 222). However, this is only a partial explanation, since artists always had some degree of freedom to cross the eastern borders. More importantly, the appointment of Prince Johan Maurits of Nassau-Siegen as Stadtholder of Kleve in 1647, and the close traditional ties between Kleve and the Dutch Republic since the sixteenth century ensured that the area was a major attraction for travelers.

3. Los Angeles/Boston/New York 1981–82, no. 3, ill. Walsh and Schneider suggest that the painting in the Carter collection must date between 1666 and 1671, the latter being the date on a painting in Copenhagen, Statens Museum for Kunst (inv. 997). However the painting in Copenhagen is in a wholly different style, heavily influenced by Jan Vermeer van Haarlem (Sumowski 1983, no. 190), and therefore provides no real indication of the dating of the Rhineland panoramas.

4. Gorissen 1964, pl. 36. Although Sumowski (1983, no. 191) reads the date on the Dusseldorf painting as 1666, the third digit could well be a 'five' (van Borssom returned from his Rhineland trip by 1656 at the latest). Almost the same view can be found in a painting in the Philadelphia Museum of Art, no. W 01-1-2 (Sumowski 1983, no. 192).

5. Sumowski (1983, no. 195) believes that the Budapest painting may represent the area around Arnhem and compares the view with drawings by Lambert Doomer and Gerbrandt van den Eeckhout (Sumowski 1979, vol. 2, no. 488, ill.; vol. 3, no. 683, ill.).

6. A drawing of a Rhineland landscape with an elegantly dressed party and sailboats may anticipate the development of the Budapest painting (Sumowski 1979, pl. 321). See also a drawing in Berlin (West), inv. 12962 (ibid., pl. 335).

Cornelis van Poelenburch, *Portrait of Jan Both*, 1648(?), panel, 16.5 x 13 cm., Freiherr von Fürstenberg Collection, Herdringen, no. 34.

The birthdate of Jan Both is as yet unknown, although he was probably born in Utrecht. Apprenticeship fees for a son of the glass painter Dirck Both (or Boot) were paid to the Utrecht guild between 1634 and 1637. This must have been Jan, because his brother, Andries (c.1612–c.1642), had already been apprenticed to Abraham Bloemaert in 1624–25. There is no reason to believe Sandrart's statement that Jan as well as Andries studied with Bloemaert. Jan Both was probably born around 1615–18, although some authors have estimated that he was born as early as 1610. Jan and Andries were recorded in Rome at a meeting of artists on July 12, 1638, although Andries had been in the city since 1635. Jan probably traveled to Italy separately to join his brother. The two were living together in Rome in the parish of San Lorenzo in Lucina in 1639 and 1641. In 1639 Both received a commission from Spanish agents to paint four landscapes for the Buen Retiro Palace in Madrid (now in the Prado), a project in which Herman van Swanevelt, Nicolas Poussin, Gaspard Dughet, and Claude also participated. Otherwise, only a few drawings can be reliably assigned to Jan Both's stay in Italy. He must have still been in Rome in 1642, since in that year he was paid sixty scudi by Cardinal Antonio Barberini for two paintings. Probably in the same year, Jan and Andries Both began their journey home to Holland. Andries, however, drowned in Venice, and Jan returned alone.

In Utrecht, Hendrick Verschuuring (1627–1690) was apprenticed to Both around 1642. Barend Bispinck and Willem de Heusch (1625–1692) were also pupils. Both had demonstrable influence on Claes Berchem, Aelbert Cuyp, and Adam Pijnacker.

In 1644 Both painted the landscape in a portrait of Baron van Wyttenhorst, while the figure itself was done by Cornelis van Poelenburch and Bartholomeus van der Helst (c.1613–1670). Wyttenhorst again bought works from Both in 1649 and 1651. In 1649, along with Jan Baptist Weenix and Poelenburch, Both was elected an *overman* of the St. Luke's Guild in Utrecht. The only dated work by Jan Both is of 1650, *Landscape with Mercury and Argus* from a series of three (Staatsgalerie, Bayreuth; cat. 16, fig. 1). On August 9, 1652, Both was buried in the Buurkerk, Utrecht.

Jan Both was a painter, draftsman, and etcher of Italian landscapes and street scenes. His golden-toned landscapes often depict river valleys with ferries or open mountainous vistas.

14 (PLATE 52)

Mountain Pass with a Large Fir Tree, c.1647–50

His work was inspired by the work of Pieter van Laer (c.1592–1642), Herman van Swanevelt, and, to a lesser extent, by Paul Bril (1554–1626) and Cornelis van Poelenburch. There appears to be little stylistic evidence for Sandrart's assertion that Both was influenced by Claude. Andries and Jan Both collaborated on a few works, namely the paintings for the Buen Retiro and a series of prints of the five senses. In Utrecht, artists such as Nicolaes Knüpfer (c.1603–1655), Weenix, and Poelenburch often contributed staffage to Both's landscapes. Poelenburch also painted Both's portrait (see p. 276).

A.C.

Literature: Meyssens 1649; de Bie 1662, pp. 156–57; Félibiens 1666–68, p. 92; Sandrart 1675, p. 312; Félibiens 1679, p. 50; de Piles 1699, pp. 313, 416–17; Houbraken 1718–21, vol. 2, pp. 35, 114, 193, vol. 3, p. 362; Dézallier d'Argenville 1745–52, vol. 3, p. 128; Bartsch 1803–21, vol. 5, pp. 199–213; Smith 1829–42, vol. 6, pp. 165–223, vol. 9, pp. 730–37; Nagler 1835–52, vol. 1, pp. 75–76; S. Muller 1880, pp. 122, 129; Obreen 1887–90, vol. 2, p. 82; Wurzbach 1906–11, vol. 1, pp. 156–57, vol. 3, p. 34; Hofstede de Groot 1907–28, vol. 9, pp. 421–518; E.W. Moes in Thieme, Becker 1907–50, vol. 4 (1910), pp. 410–11; Hoogewerff 1913–17, vol. 2, p. 53; Ledermann 1920, pp. 82–86; Molkenboer 1926–27; de Jonge 1932, pp. 123, 129; Hoogewerff 1933a; Martin 1935–36, vol. 2, p. 517; Gerson 1942; Hoogewerff 1942–43, pp. 108, 110; Hollstein, vol. 3, pp. 158–64; de Bruyn 1952; Willnau 1952; Stechow 1953; Stechow 1955; Maclaren 1960, pp. 50–57; Knab 1962; Waddingham 1964; Utrecht 1965, pp. 112–28; Stechow 1966, pp. 150–65; Müllenmeister 1973–81, vol. 2, pp. 35–37; Lavin 1975, pp. 8, 173, 292–93, 308, 310, 394; Tilanus 1975; Burke 1976; de Hoop Scheffer 1976; Salerno 1977–80, vol. 2, pp. 424–37, vol. 3, pp. 994–96; von Barghahm 1979, pp. 314–28; Brown, Elliot 1980, pp. 125–27; Briganti et al. 1983, pp. 194–221; Brown, Elliot 1987.

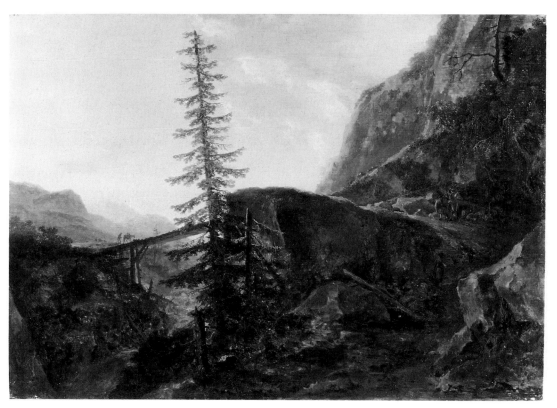

14

Oil on panel, 16¾ x 24 in. (42.5 x 61 cm.) The Detroit Institute of Arts, Gift of James E. Scripps, no. 89.31

Provenance: Sale, Tence (Rijssel), Paris, December 12, 1881, no. 10 (frs.1,200 to Feral); acquired in 1889.

Exhibitions: Ann Arbor 1964, no. 15; Utrecht 1965, no. 55, ill.

Literature: Hofstede de Groot 1907–28, vol. 9, no. 162; Detroit, cat. 1930, no. 14, ill.; Stechow 1966, p. 157, fig. 316; Burke 1976, p. 194, no. 20, ill.

In 1926 Hofstede de Groot reported that this painting was fully signed at the lower right; however, since no other source has noticed a signature, Hofstede de Groot was probably mistaken. Yet the painting's technique is so indisputably like Both's that the attribution cannot be doubted.[1] The subject nonetheless is unique in Jan Both's oeuvre. Most of his landscapes are overgrown with verdant trees and vegetation, whereas this painting is dominated by bare or sparsely covered rocks. A small wooden bridge spans a rugged crevice through

Fig. 1. Allart van Everdingen, *Scandinavian Mountain Landscape*, signed and dated 1647, panel, 64.3 x 89 cm., Herzog Anton Ulrich-Museum, Braunschweig, inv. 364.

Fig. 2. Gillis de Hondecoutre, *Mountainous Landscape*, monogrammed, panel, 65 x 99.5 cm., Kunsthandel Schneeberger, Bern, 1946.

which a mountain stream rushes. A solitary fir tree rises from the cliffs, its alternately lush and bare branches silhouetted against the sky. It appears that Both was inspired by the young Allart van Everdingen. Everdingen's *Scandinavian Mountain Landscape* in Braunschweig (fig. 1) is a cold, northern view when compared with the warm golden-orange evening of Both's painting; indeed, since it appeared at auction in 1881 the Detroit picture has been called *A Pass in the Apennines* (i.e., Italy). In other respects, the Detroit and Braunschweig paintings show striking similarities: both consist of a bare, rocky valley from which a fir tree rises starkly against the sky. Everdingen's painting is dated 1647; Both's must date shortly thereafter, since the artist died in 1652.[2]

It should be noted that all of these motifs could have been found in the work of Both's fellow Utrecht landscapists Roelandt Savery and Gillis de Hondecoutre (see cats. 99 and 48). Savery was probably Everdingen's teacher and influenced his mountain subjects.[3] However Savery and de Hondecoutre still presented these motifs in crowded "mannerist" compositions (fig. 2). Everdingen and Both after him gave classical form to these themes, affecting their generation of Dutch landscape painters. Jan Both "cultivated" the savage mountains by arranging the landscape around a few bold forms. The sparseness of these bare rocks created stronger outlines than were available to Both in his lush, overgrown landscapes. The top of the large rock in the center consists of a tight contour which extends to the profile of the mountain at the right. Among all these massive forms, small figures are almost unnoticed: on the bridge a man walks behind his donkey, while at the right two shepherds converse.

A.Bl.

1. Arthur Wheelock in the forthcoming Detroit Institute of Arts catalogue of paintings proposes an attribution to Jan Wils (1600–1666). A signed mountain landscape by Wils in the F.C. Butôt collection (Bernt 1980, vol. 3, pl. 1488) is of a similar type, but its composition is more cluttered and incoherent.

2. In Utrecht 1965 (no. 55) the present author proposed a date in the second half of the 1640s on other grounds. Stechow (Ann Arbor 1964, no. 15) thought that the painting might date from Both's Italian period, as did Burke (Burke 1976, p. 194).

3. On Savery as probable teacher of Everdingen, see Davies 1978, p. 34. The Everdingen family probably came from Utrecht (Utrecht/Braunschweig 1986–87, p. 252).

Italian Landscape with a Draftsman, c.1650

Signed lower right: JBoth fe [JB ligated]
Oil on canvas, 73⅝ x 94½ in. (187 x 240 cm.)
Rijksmuseum, Amsterdam, inv. C 109

Provenance: Sale, Quirijn van Biesum, Rotterdam, October 18, 1719, no. 127 (fl.225); sale, Richard Pickfatt, Rotterdam, April 12, 1736, no. 57 (fl.45); Thomas Hamlet, Denham Court by 1829; sale, London (Robins), July 27–August 3, 1833, no. 201 (£1260, bought in); sold in 1834 to John Smith, who sold it for £1179 13s. 6d. to A. van der Hoop, Amsterdam; given in 1854 to the city of Amsterdam; Museum van der Hoop; on loan to the Rijksmuseum since 1885.

Exhibitions: London, British Institution, 1829, no. 127; Utrecht 1965, no. 56, ill.

Literature: Hoet 1752, vol. 1, pp. 233, 469; Smith 1829–42, vol. 6, no. 1; Amsterdam, Rijksmuseum cat. 1885, van der Hoop no. 22; Amsterdam, Rijksmuseum cat. 1887, no. 163; Amsterdam, Rijksmuseum cat. 1903, 1960, no. 591; Martin 1905–1908, p. 363; Ledermann 1920, p. 97; Plietzsch 1960, p. 152, fig. 269; *Van tijd tot tijd* 74 (1965–66), ill.; Rosenberg et al. 1966, p. 176, fig. 153A; Stechow 1966, pp. 155, 158, fig. 304; Waddingham 1966, vol. 1, pls. 14, 15; Burke 1976, pp. 167–68, 180–81, no. 1, ill.; Amsterdam, Rijksmuseum cat. 1976, no. C 109, ill.; Salerno 1977–80, vol. 2, p. 424, pl. 66.5; Broos 1979, p. 40, pls. 9, 10; Amsterdam/Washington, D.C. 1980–81, p. 64, figs. 4, 5.

The theme of an artist drawing in a landscape can be found in other Both paintings (see fig. 1),[1] and occurs frequently in Netherlandish Italianate landscapes beginning in the sixteenth century. The theme may have been derived from artists' self-portraits or representations of Saint Luke painting the Virgin found in early Netherlandish painting. Maerten van Heemskerk's self-portrait of 1553 includes in the background an artist sketching the Colosseum in Rome.[2] In this context the artist (actually a second self-portrait) fulfills the exhortation to study antiquity. A drawing by Pieter Bruegel

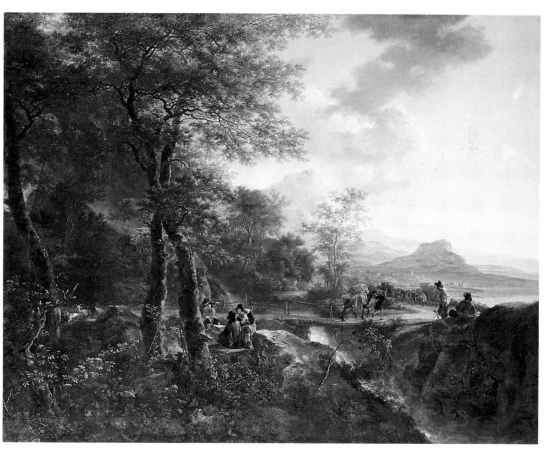

15

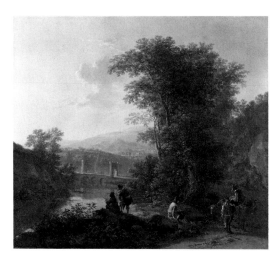

Fig. 1. Jan Both, *Landscape with the Ponte Lucano*, signed, canvas, 107 x 120 cm., Mr. and Mrs. Edward William Carter, Los Angeles.

Fig. 2. Jan Asselijn, *Artists Working Out of Doors*, signed, chalk and brush, 187 x 237 mm., Kupferstichkabinett, Staatliche Museen Preussischer Kulturbesitz, Berlin (West), inv. 144.

the Elder of almost exactly the same date shows an artist sketching a pure landscape – the Alps (Seilern Collection, Courtauld Institute, London).[3]

Burke suggests that Both derived the motif from Claude's *Mill on a River* of 1631 (Museum of Fine Arts, Boston, no. 44.72) or other similar works,[4] but Both probably knew the motif from the work of Paul Bril, as seen in a print of Tivoli (by Nieulandt after Bril, cat. 68, fig. 1) and a drawing formerly in the Perman collection. Both helped introduce this theme to Dutch landscapes; it later occurs in paintings by Aelbert Cuyp, Adriaen van de Velde, Ludolf Bakhuizen, Gerrit Berckheyde, and Willem van de Velde,[5] and is even more common in prints and drawings.[6] It is uncertain whether Dutch landscape paintings were ever executed out of doors, although a drawing by Jan Asselijn (fig. 2) appears to show artists working at easels in a landscape (also see Introduction, figs. 4 and 5); certainly no known landscape painting has the appearance of having been done on the spot, with the possible exception of catalogue 77.

More than these other examples, Both's painting (and figure 1, with the Ponte Lucano and Tomb of the Plautii near Tivoli) evokes for the viewer the suggestion of travel – of the itinerant artist. His sketcher has not walked out for the day from a nearby city, as is the feeling in many Dutch landscapes, including Rembrandt's etching of a draftsman before farm buildings (Bartsch no. 219). Nor is he sketching antique ruins. Rather, his subject is the vast landscape through which he journeys. Both's painting shows both the artist at work and the subject of his attentions, thus distinguishing it from traditional representations of artists' studios or self-portraits.[7]

The other travelers in Both's landscapes – a peasant with a heavily laden mule and a sedan chair – further enhance the sense of an expe-

dition in the Italian countryside. This was an important and popular idea in seventeenth-century Holland, since the overland journey to Italy and the various perambulations therein were well described in contemporary travel books and diaries.[8] The poetry of Six van Chandelier specifically evoked the delights of travel in Bolzano and Tirol in the company of an artist.[9] Pieter Verhoek, in describing Italianate landscape paintings, referred particularly to the pleasure of descending from the Alps to discover the beauty of Italy for the first time (see under cat. 66). That most of the Italianate landscapists were Catholic suggests the notion of pilgrimage to Rome, although this is clearly a secondary association of their Italian landscapes.[10]

This largest of Jan Both's paintings seems to have been painted in the last few years of the artist's life. The intensity of its coloring and the broadness of the brushwork, especially in the silvery highlights on the tree trunks, are similar to Both's painting of *Mercury and Argus* in Bayreuth dated 1650 (cat. 16, fig. 1), part of a series of three (other works are in Vienna and Schleissheim). Similarly monumental landscapes include catalogue 16 and a painting in Copenhagen (Statens Museum for Kunst, inv. Sp.430).[11] Both's chronology after his return to Utrecht around 1642 until his death ten years later is problematic, since only a single work is dated. His lighter-toned landscapes with simpler, more open compositions, including his landscapes before city walls (National Gallery, London, no. 958), appear to predate the Rijksmuseum's painting.

The exhibited work is a highly complex and innovative landscape organized around a rocky ravine and a rushing torrent that divide a shady slope from the open countryside. This is mountainous Italy, perhaps the Apennines, as Smith suggested, or the lower reaches of the Alps. High blue peaks surrender to lower hills and sweeping plains. Lush vegetation in the im-

mediate foreground and a screen of leafy trees frame the draftsman and shepherds, who sit on a rocky ledge. The spray of another mountain stream can be seen against the dark hill at the left. The combination of fine detail and the spatial complexity of paths, rocks, and trees seems almost to revive mannerist practices, but also reflects Both's familiarity with the work of Bloemaert and Poelenburch (cat. 69). On the other hand, the distant view closely resembles a painting by Asselijn in Vienna (cat. 1). The balancing of rich foreground foliage and tall trees against a mountainous panorama was to influence Adam Pijnacker (cat. 66).

For John Smith, writing in 1835, this was Jan Both's most splendid painting: "It is impossible not to feel the most intense delight; for such is the exhilarating beauty of the morning, the grandeur and wildness of the scenery, the rich luxuriance of the vegetation, the cooling freshness of the roaring cataract, and the enchanting prospect of the lake and the surrounding hill."[12] While some of this enthusiasm is self-serving, since Smith had just sold the picture, it also is a testament to the work's monumentality and richness, as well as to Both's high regard in the years before John Constable's diatribe against Both's "bastard style of landscape, destitute of sentiment or poetic feeling."[13]

A.C.

1. Also a work in the Petit Palais, Paris. Hofstede de Groot lists several others not traceable (1907–28, vol. 9, nos. 88–95).

2. Cambridge, Fitzwilliam Museum, cat. 1960, no. 103, ill.

3. De Tolnay 1952, no. 21, pl. 12 (as c.1555).

4. Detroit Institute of Arts; Cincinnati Art Museum, inv. 1946.102. See Roethlisberger 1961, nos. 12, 22, 44, fig. 48. The motif also occurs in a drawing, *Liber Veritatis* no. 12.

5. A draftsman can be seen in van Goyen's beach scene of 1634 (Hermitage, Leningrad, inv. 2820; Beck 1972–73, vol. 2, no. 927, ill.); Aelbert Cuyp, *Sketchers near Elten,*

Woburn Abbey (cat. 23, fig. 1); the theme is also included in several school works (Reiss 1975, pls. 69, 70); Adriaen van de Velde, *Sketchers before Ruins,* dated 1665, Staatliche Kunstsammlungen, Dresden, no. 1657 (Salerno 1977–80, vol. 2, pl. 125.3); Ludolf Bakhuizen, *'Lejonet' in the IJ,* Kunsthistorisches Museum, Vienna, inv. 473 (Amsterdam 1985, no. s 16, ill.); Gerrit Berckheyde, *Elswout,* Frans Halsmuseum, Haarlem (see p. 111, fig. 9); Willem van de Velde the Elder, *Battle of Terheide,* Rijksmuseum, Amsterdam, inv. A 1365; Hobbema, *Landscape with Draftsman,* Berlin, inv. 886.

6. See drawings by Roelandt Savery (Keyes 1984, fig. 27; also Aegidius Sadeler after Savery, Hollstein no. 226), Hans Savery (da Costa Kauffmann 1986, fig. 1), Herman Saftleven (Schulz 1982, no. 1017, pl. 72; also a print of Utrecht, Hollstein no. 17), Jacob van Ruisdael (Giltay 1980, no. 92); also an etching by Rembrandt, Bartsch no. 219.

7. The most famous examples in Dutch art are Rembrandt's *Artist in his Studio* (Museum of Fine Arts, Boston, 38.1838), Adriaen van Ostade's *Studio* (Rijksmuseum, Amsterdam, inv. A 298), and for landscape painting, M. van Musscher depicting Willem van de Velde the Younger(?) at work (Introduction, fig. 1). See Delft/Antwerp 1964; Raupp 1983 (who, however, does not treat the theme of sketchers in landscapes).

8. See A. Frank-van Westreinen, *De Groote Tour* (Diss., Amsterdam, 1984); and L. Schudt, *Italienreisen im 17. und 18. Jahrhundert* (Vienna, 1959).

9. *Op de reise door Tirool, met Michiel Soetens schilder* (ed. G. van Es [Zwolle, 1953]). I am grateful to Ilana Dreyer for this reference. Van Mander urged young painters to go to Italy (1604, *Grondt,* chap. 1, lines 66–75) but not specifically to study the countryside.

10. Falkenburg 1985 discusses Patinir's landscape paintings as evocations of pilgrimages. It is doubtful whether such an interpretation had primary significance for seventeenth-century viewers.

11. Burke 1976, pp. 164–68, 180. Salerno (1977–80, vol. 2, p. 424) places the exhibited painting among Both's early work produced under the influence of Claude's style of the 1630s. However, the work is clearly from Both's Dutch period, with little specific indebtedness to Claude. A close variant of the exhibited work was sold in London (Christie's), February 1, 1957, no. 165, as by Both and Wils, which Burke (1976, p. 174, note 38) believes could be an earlier version.

12. Smith 1829–42, vol. 6, pp. 171–72.

13. C.R. Leslie, *Memoirs of the Life of John Constable* (London, 1937), pp. 392–93.

16 (PLATE 53)

Landscape with Bandits Leading Prisoners, c.1650

Signed lower left: JBoth f [J and B ligated]
Oil on canvas, 65⅛ x 85⅝ in. (165.5 x 217.5 cm.)
Museum of Fine Arts, Boston, Seth K. Sweetser Fund, 34.239

Provenance: The Clifford Family, Amsterdam (for whom the painting was made); sale, N. Tjark et al., Amsterdam, November 10, 1762, no. 17, bought by Fouquet; Sir Thomas Dundas Collection, 1794; sale, Sir Lawrence Dundas, Bart., Greenwood, London, May 31, 1794, no. 34 (bought in); in the Dundas collection until 1838, when he was made Earl of Zetland; Marquis of Zetland, Aske Hall near Richmond, Yorkshire; sale, Marquis of Zetland, London (Christie's), April 27, 1934, p. 22, no. 113; bought by P. and D. Colnaghi, London, from whom it was purchased in 1934.

Exhibitions: London, British Institution, 1815, no. 55; London, British Institution, 1845, no. 16; London, British Institution, 1864, no. 59; Ann Arbor 1964, no. 14, pl. v.

Literature: Smith 1829–42, vol. 6, no. 26; Wurzbach 1906–11, vol. 1, p. 156; Hofstede de Groot 1907–28; vol. 9, no. 82; *Art News* 33, no. 4 (Oct. 27, 1934), p. 10; Stechow 1953, p. 133, ill.; Gerson 1964b, fig. 5; Burke 1976, pp. 168, 174, note 37, cat. no. 12, fig. 12; Boston, MFA cat. 1985, p. 26, ill.

This ambitious picture is characteristic of Jan Both's mature or later style. With its tall trees, distant mountain prospect and avid attention to botanical detail in the foreground, as well as anecdotal staffage, it combines a stateliness in scale and design with an intimate concern with everyday fact. The tender treatment of the spreading branches and sinuous but soft tree trunks complement the painting's light tonality and Both's renowned "golden" atmosphere.

The large scale of this work, the lush verdure of the foliage, and the prominence of deep green in the palette are all qualities associated with Both's works of c.1650; compare, for example, the *Landscape with Mercury and Argus* dated 1650 (fig. 1) and *Italian Landscape with a Draftsman*

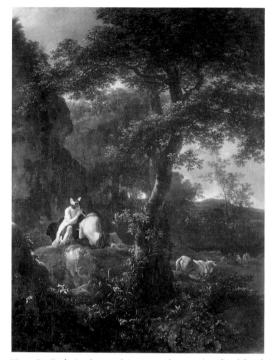

Fig. 1. Jan Both, *Landscape with Mercury and Argus*, signed and dated 1650, canvas, 169 x 129 cm., Bayerische Staatsgemäldesammlungen, Staatsgalerie, Bayreuth, no. 140.

16

(cat. 15).[1] The last-mentioned employs a similar single wing composition with a near view of woods and expansive vista beyond. Burke considered the Boston painting an enlarged variation on the design of the painting in Indianapolis (fig. 2), which also shows a winding road on the left and a screen of trees on the right.[2]

Smith claimed that the staffage in the Boston painting was by the painter's brother Andries Both;[3] however, the latter's death in about 1642 precludes such an attribution. Like the many

other paintings by Dutch Italianate painters showing brigands attacking travelers (see, for example, Berchem's painting, *Travelers Attacked by Brigands*, Mauritshuis, The Hague, no. 14), these staffage figures of banditti conducting prisoners vividly remind us of the dangers of travel in the seventeenth century.

The appearance of the painting in Sir Lawrence Dundas's collection in 1794 confirms the often cited English taste for Dutch Italianate works. Smith further noted that Dundas paid

Bartholomeus Breenbergh

(Deventer 1598–1657 Amsterdam)

Fig. 2. Jan Both, *Landscape in the Roman Campagna*, c.1647, canvas, 68.9 x 85.4 cm., Indianapolis Museum of Art, no. 55.225.

the substantial sum of £504 for the picture, adding that at the time of his writing in 1835, it was "now worth double that sum."[4] The painting was engraved by the English artist John Browne (1741–1801), and two copies are known.[5]

P.C.S.

1. Stechow (1953, p. 133) dated the work c.1650. Burke (1976, cat. no. 12) concurs in this dating and compares the work specifically with Both's painting in Amsterdam (cat. 15) and Copenhagen (Statens Museum for Kunst, no. Sp. 430). He also notes the similarity of a central tree group in Both's drawing in the Nationalmuseum, Stockholm, inv. NMH 196/1916.

2. Burke 1976, p. 168. "The Boston example is a large scale remake of the painting in Indianapolis, with intensified color, wider tonal effects, more heroic scale, refined composition and without repoussoirs."

3. Smith 1829–42, vol. 6, no. 26.

4. Ibid.

5. Measuring 81.5 x 105.5 cm., private collection, Cornwall; a reversed copy in the collection of N.G. Harmer, Hastings, Sussex. See Burke 1976, under no. 12.

Bartholomeus Breenbergh was baptized in the Reformed Church of Deventer on November 13, 1598. In 1607, after the death of his father, the city's apothecary, the family probably moved to Hoorn and then to Amsterdam, where Breenbergh received his initial instruction as an artist. He is documented in Amsterdam in October 1619, but later that same year was in Rome, where he stayed for nearly a decade. His earliest surviving work is a *Finding of Moses* dated 1622 (Hallwyl Gallery, Stockholm). Although only a handful of paintings can be reliably attributed to his Roman period, large numbers of sketches of ruins and landscapes dated 1624 through 1628 attest to the artist's activity in Rome and nearby Tivoli. Breenbergh worked for the Duke of Bracciano at the Orsini estate at Bomarzo; seven landscapes by the artist are recorded in the Orsini inventory of 1655–56. Together with Cornelis van Poelenburch and several other Dutch painters, Breenbergh was portrayed at a ceremony of the Roman *Schildersbent* in 1623; his nickname was "Het Fret" (the ferret).

While in Rome, Breenbergh was closely associated with and influenced by Poelenburch and Paul Bril (1554–1626), although he displayed strong originality in his landscape drawings.

By 1630 Breenbergh was back in the Netherlands. Under the influence of Pieter Lastman, Claes Moeyaert, and other artists of the so-called Pre-Rembrandtist school, the bulk of Breenbergh's later production comprises religious and mythological scenes set in landscapes. Breenbergh arrived in Amsterdam at almost the same moment as Rembrandt; both moved in the same artistic circles and often painted similar subjects. Breenbergh's work is eclectic and original. He produced a number of etchings and portraits. Only very few paintings by Breenbergh are recorded in Dutch inventories, although Charles I of England owned six of his paintings.

On September 11, 1633, Breenbergh married Rebecca Schellingwou, whose father was a wealthy Protestant cloth merchant, her mother a member of a prominent Catholic family. Whether Breenbergh or his wife were actually Catholic is difficult to determine: he was baptized and buried a Protestant, although he is listed as a communicant in Rome. From 1648 the Breenbergh family rented a house on the Lauriersgracht from the collector Joan Huydecoper. He is recorded in Amsterdam in 1649 and 1653, when he is called a *coopman* (trader); one of his two sons was involved in foreign shipping. In 1654 he was living on the Prinsengracht, by 1657 on the more elegant Herengracht. Breenbergh was buried in the Oude Kerk in Amsterdam on October 5, 1657.

A.C.

Literature: Félibien 1666–88, vol. 2, p. 273; Houbraken 1718–21, vol. 1, p. 369; Dézallier d'Argenville 1745, pp. 81ff.; Descamps 1753–64, vol. 2, pp. 299–301; Bartsch 1803–21, vol. 4, pp. 157–81; Nagler 1835–58, vol. 2, p. 123; Immerzeel 1842–43, vol. 1, p. 94; Kramm 1857–64, vol. 1, p. 156; Obreen 1877–90, pp. 150–51, 153; Havard 1879–81, vol. 4, pp. 8ff.; Bode 1883, pp. 335–37; Doorninck 1883–86; Wurzbach 1906–11, vol. 1, pp. 178–80; E.W. Moes in Thieme, Becker 1907–50, vol. 4 (1910), pp. 565–66; Budde 1929; Stechow 1930; Naumann 1931; Juynboll 1935; Gerson 1942, pp. 149–53; Hoogewerff 1942–43, p. 88; Feinblatt 1949; Hollstein, vol. 3, pp. 205–16; Hoogewerff 1952, pp. 48, 50; Aschengreen 1953; Schaar 1959; Knab 1960; Maclaren 1960, pp. 58–60; Chiarini 1964; Utrecht 1965; Nieuwstraten 1965a; Stechow 1966, pp. 150–51, 153; Waddingham 1966; Roethlisberger 1969; Chiarini 1972b; Nalis 1972–73; Müllenmeister 1973–81, vol. 2, pp. 18–20, p. 39; Roethlisberger 1977; Salerno 1977–80, vol. 1, pp. 238–59; Blankert 1978, pp. 75–87, 257–58; Rubsamen 1980, pp. 9, 10, 15; Roethlisberger 1981; Sluijter-Seiffert 1982; Ekkart 1983; Haak 1984, pp. 144, 302; Roethlisberger 1985.

The Voyage of Eliezer and Rebecca, 1630

Signed and dated lower left: BBreenborch 1630
[BB in monogram]
Oil on panel, 19⅛ x 31½ in. (48.5 x 80 cm.)
Private Collection, Montreal

Provenance: Probably sale, Wissel-Geldt, Brussels, July 23, 1767, no. 57; sale, Clavière de Bellegarde, Paris, December 1, 1810, no. 8;[1] sale, c.1900, Paris; private collection, Paris; sale, Paris (Drouot), December 4, 1970, no. 13; Bruno Meissner, Zurich.

Literature: Hoet 1770, vol. 3, p. 625; Roethlisberger 1981, no. 134, ill. and color pl. II.

The painting probably represents the meeting of Isaac and Rebecca, described in Genesis 24:61–64. Isaac's party has halted in the left middle distance. Seeing Rebecca riding on a mule in the foreground, Isaac runs toward her. It was much more common in the sixteenth and seventeenth centuries to show Eliezer and Rebecca at the well with Rebecca offering him water from a pitcher. This is the moment represented by such Amsterdam history painters as Claes Moeyaert, Pieter Potter, Jacob de Wet, and Gerbrand van den Eeckhout,[2] as well as by Breenbergh himself on at least two other occasions.[3] Even though they are motifs sketched by Breenbergh in Italy, the ruins and exotic landscape are meant to evoke the Holy Land, since Roman ruins were regarded as links with the biblical past.[4]

Breenbergh seems to have painted few works during his residence in Italy. On his return to Amsterdam around 1629, his production and creativity flourished. His frequent choice of unusual Old Testament subjects (which make up about half of his painted oeuvre) reflects contacts with the so-called Pre-Rembrandtists. No doubt as a result of these contacts, and as an expression of the artist's desire to establish a reputation in a new art market, Breenbergh's work of the early 1630s is varied and innovative.

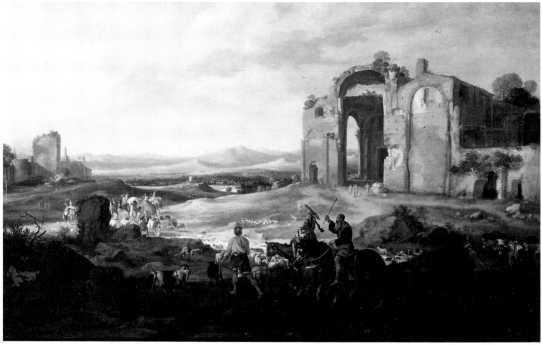

17

In these paintings Breenbergh made frequent use of his numerous sketches of Roman ruins and scenery. The wall at the left in the present work is derived from a sketch in Frankfurt,[5] while the central building is based on a drawing that he made of the Baths of Diocletian in Rome.[6] Breenbergh depicted the same building in a slightly earlier painting at Pommersfelden,[7] although in that work it was the primary subject of the picture. In the exhibited painting, the structure is a diagonal backdrop for the figures. Thus it acts as a foil for the narrative, which depends on the distribution of staffage between the foreground and middle distance. Much the same composition occurs in a work of 1631, *Atalanta and Hippomenes* in Kassel (fig. 1). Once again, large, diagonally situated ruins frame two

sets of interacting figures in the landscape. Related compositions are also found in two other paintings of 1631, *Moses and Aaron Turning the Nile into Blood* in the J. Paul Getty Museum and a landscape in the Girardet collection.[8]

In the year of the exhibited painting, Breenbergh explored a very different type of historical landscape in a representation of the *Disobedient Prophet* (fig. 2).[9] The largest of Breenbergh's paintings, it is a variation of a landscape by Paul Bril of the same subject, which Willem van Nieulandt etched.[10] Bril, perhaps Breenbergh's most important mentor in Rome, was the conduit for the influence of Annibale Carracci, which can be seen in the contrast between the clearing in the foreground and the small forest through which the distant landscape

Jan van de Cappelle
(Amsterdam 1626–1679 Amsterdam)

Fig. 1. Bartholomeus Breenbergh, *Atalanta and Hippomenes*, signed and dated 1631, panel, 49 x 79.5 cm., Staatliche Kunstsammlungen, Kassel, no. 207.

Fig. 2. Bartholomeus Breenbergh, *The Disobedient Prophet*, signed and dated 1630, canvas, 99 x 171.5 cm., whereabouts unknown.

appears (see Introduction, fig. 39).

After his return to Amsterdam, Breenbergh's handling of figures was strongly affected by the work of Pieter Lastman and his followers, particularly Jan and Jacob Pynas. There is also a mannerist quality to Breenbergh's figures, in the exaggeration of color, proportion, and scale, that reveals his acquaintance with the history paintings of Bril, Cornelis van Poelenburch, and Abraham Bloemaert.

A.C.

1. The description of figures in both of these sales closely matches the present painting, although there are discrepancies in size.

2. For Moeyaert, see A. Tümpel 1974, no. 21, fig. 219 (see also no. 23, fig. 115). Two of van den Eeckhout's versions are dated 1661 and 1663 (Sumowski 1983, vol. 2, pls. 431, 439, 477). Gillis de Hondecoutre also depicted the subject; see Jan Londerseel's print, cat. 123, fig. 1.

3. One dated from about 1625 (Roethlisberger 1981, pl. 82); another of about ten years later in a private French collection (ibid., pl. 181).

4. The *Calling of Saint Matthew* by Claes Berchem and Jan Baptist Weenix (Mauritshuis, The Hague, inv. 1058) employs Roman ruins and buildings as its setting. The biblical past and Roman antiquity were often linked by Dutch descriptions of the Holy Land, such as those by M. de Villamont (1596), P. Dan (1637), Jacob Spon (1678), and Cornelis de Bruijn (1698).

5. Städelsches Kunstinstitut, inv. 3796 (Roethlisberger 1969, no. 24, ill.).

6. Christ Church College, Oxford, inv. 1065 (ibid., no. 49, ill.).

7. Roethlisberger 1981, pl. 95. Similar ruins occur in a painting attributed to Breenbergh in the National Gallery of Ireland, Dublin, no. 700 (ibid., pl. 96).

8. Ibid., pls. 135 and 137, respectively.

9. This rare subject (1 Kings 13:25) was also treated by Gillis de Hondecoutre; see Jan Londerseel's print, Hollstein, no. 14.

10. No. 27 of Nieulandt's series, Hollstein, nos. 76–111 (incompletely described).

Baptized on January 25, 1626, in Amsterdam, Jan van de Cappelle was the son of Franchoys van de Cappelle (1592–1674), the owner of a thriving Amsterdam dye-works called "de gecroonde handt," and Anneken Mariens. Jan carried on his father's business and is described in documents as a carmosin-dyer (*carmosynverwer*), merchant, and painter. On February 2, 1653, Jan married Anna Grootingh. From his wife's family, Jan inherited two houses in the Karthuizerskerkstraat and one in the Lindenstraat. Until 1663 he lived in the Keizersgracht, among some of the richest citizens of Amsterdam. Thereafter he lived on the north side of the Koestraat in a house that he purchased for the substantial sum of 9,600 guilders. On April 24, 1664, and again on September 19, 1666, he was mentioned in Amsterdam. In June of that year he had been sick and made a will. It was not until December 22, 1679, that he died. The following year the inventory of his estate was completed and proves that he not only had compiled a fortune (approximately fl.92,000) but also owned one of the largest private art collections of his time, including two hundred paintings and six thousand drawings. Among the landscapists whose works he owned were Hendrick Avercamp (nine hundred drawings), Jan and Esaias van de Velde, Hercules Segers, Cornelis Vroom, Pieter de Molijn, Pieter van Santvoort, Jan van Goyen (four hundred drawings), Allart van Everdingen (five hundred drawings), Rembrandt, Herman van Swanevelt, Simon de Vlieger (thirteen hundred drawings), and Adam Elsheimer, but not a single work by Jacob van Ruisdael, Salomon van Ruysdael, or Aelbert Cuyp was in his possession.

Van de Cappelle's teacher is not known, and the artist may have been self-taught; a four-line verse by Gerbrand van den Eeckhout lauding his art begins, "In praise of the art of Johannes van de Capelle who taught himself to paint out of his

18 (PLATE 106)

Winter Landscape, 1653

own desire." The verse appears in the Album Amicorum of the Amsterdam poet and rector of the Gymnasium Jacob Heyblocq (Koninklijk Bibliotheek, The Hague). Among other contributors to the Album were some of the most prominent Dutch scholars and literary figures of the day, suggesting that van de Cappelle moved in learned as well as wealthy circles. His portrait was painted by Rembrandt, Frans Hals, and Gerbrand van den Eeckhout (all these works are lost).

Van de Cappelle was active as a painter and draftsman of seascapes, beach scenes, and winter landscapes. He is most admired for his marines, which owe a debt to the seascapist Jan Porcellis, sixteen of whose paintings he owned. His winter and beach scenes are less numerous than his marines.

P.C.S.

Literature: van Eynden, van der Willigen 1816–40, vol. 1, p. 163, vol. 4, p. 117; Nagler 1835–52, vol. 6, p. 527; Immerzeel 1842–43, vol. 2, p. 96; van der Willigen 1870, p. 107; Obreen 1877–90, vol. 5, p. 12; Bredius 1892; Wurzbach 1906–11, vol. 1, pp. 242–243; E.W. Moes in Thieme, Becker 1907–50, vol. 5 (1911), p. 549; Hofstede de Groot 1908–27, vol. 7, pp. 177–233; Martin 1935–36, vol. 2, pp. 228, 386–88; Valentiner 1941, pp. 272–296; Maclaren 1960, pp. 72–78; Meijer 1961, pp. 47, 54, 55, 64; Rosenberg et al. 1966, p. 165; Stechow 1966, pp. 95–98, 106–108, 116–21; Bol 1973, pp. 218–228; Russell 1975; Haak 1984, pp. 475–77.

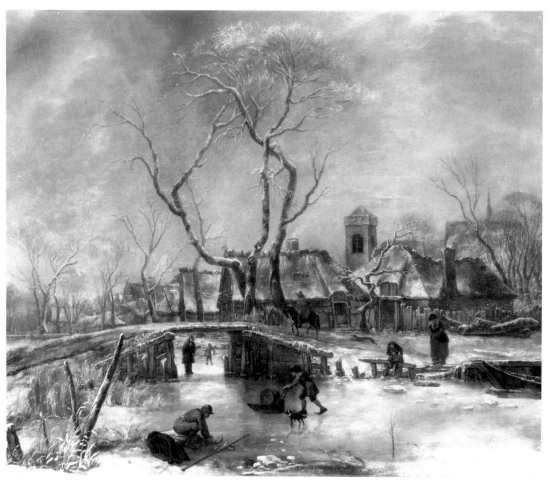

18

Signed and dated: I. v. CAPPELLE fe. 1653
Oil on canvas, 20⅜ x 24⅜ in. (51.8 x 61.8 cm.)
Koninklijk Kabinet van Schilderijen, Mauritshuis, The Hague, inv. 567

Provenance: Possibly Sir Joshua Reynolds (1723–92), London (but not in either of his sales: London [Christie's], March 11, 1795, or May 8, 1798); sale, London, October 20, 1838 (as Isack van Ostade); possibly William Hardman, Manchester; sale, London (Christie's), May 9, 1865; acquired from the dealer Colnaghi, London, 1893.

Exhibitions: Eindhoven 1948, no. 13.

Literature: Wurzbach 1906–11, vol. 1, p. 242; E.W. Moes in Thieme, Becker 1907–50, vol. 5, p. 549; Hofstede de Groot 1908–27, vol. 7, no. 148; Martin 1935–36, p. 311, fig. 168; Bernt 1948, vol. 1, fig. 176;

Fig. 1. Jan van de Cappelle, *Frozen Canal*, signed and dated 165[2], canvas, 60 x 54 cm., Rijksmuseum Twenthe, Enschede, no. 396.

Fig. 2. Jan van de Cappelle, *Frozen Canal with Kolf Players*, brush drawing with watercolor, Kunsthalle, Hamburg, inv. 21790.

Martin 1950, p. 65, no. 83, fig. 83; Stechow 1966, p. 96, fig. 188; Russell 1975, pp. 30, 34, 84, no. 148, fig. 24; The Hague, Mauritshuis cat. 1980, p. 18, no. 567, ill.; Paris 1983, p. 34; Paris 1986, p. 341, fig. 2.

A low bridge crosses a frozen canal on which figures are skating. In the center, large leafless trees reach almost to the upper edge of the canvas. A row of cottages and a village church form the backdrop. In the foreground a boy ties on his skates while another skater pushes a sledge loaded with a cask. A horseman is crossing the bridge.

Fewer than two dozen winter landscapes by van de Cappelle are known. A painting that appeared in a 1791 sale was said to be dated 1644,[1] but all the other dated winter scenes by van de Cappelle are of either 1652 or 1653. In the painting of 165(2) in the Rijksmuseum Twenthe, Enschede (fig. 1), the chilled landscape dominates the figures, who lurk in the shadows beside boats frozen in the ice. In the Enschede painting the stillness and calm for which van de Cappelle's marines are so admired is conveyed by the atmosphere of wintry quiet. In the Mauritshuis painting of the following year, the bustle of village life enlivens the scene, and one sees more clearly van de Cappelle's debt to the earlier winter scenes that Aert van der Neer painted in the preceding decade. Though a noted collector, van de Cappelle ironically owned no works by this master.

A winter scene by van de Cappelle, also dated 1653, in the Institut Néerlandais, Paris, is more finely executed and opens the composition up with a long view down the frozen canal on which the figures again become secondary.[2] A drawing attributed to van de Cappelle in the Kunsthalle, Hamburg (fig. 2), depicts virtually the same scene from the same angle as the Mauritshuis painting but replaces the skaters with *kolf* players, like those that figure in the Lugt collection painting.[3] The composition, with skaters in the foreground and a low bridge in the middle distance, recalls earlier designs favored by Jan and Esaias van de Velde (see cat. 77, fig. 3).

P.C.S.

1. Hofstede de Groot 1908–27, vol. 7, no. 159.

2. Canvas, 45.5 x 53.5 cm., inv. 528; Paris 1983, no. 19, pl. 28. See also the closely related *Winter Scene* dated 1653 in the collection of Mrs. Rudolf Heinemann, New York; Russell 1975, p. 85, no. 157, fig. 25.

3. Russell 1975, p. 35, fig. 44a, considers this drawing "a rather doubtful attribution." Compare also the *Winter Landscape* dated 1662, wash drawing, in the Kupferstich-kabinett, Berlin (West), inv. 2425 (Russell 1975, fig. 44).

Gillis van Coninxloo

(Antwerp 1544–1607 Amsterdam)

Hunters in a Landscape, 1605

Born on January 24, 1544, Gillis van Coninxloo was the son of Jan van Coninxloo and Elisabeth Hassaert. Van Mander reports that Gillis studied with Pieter Coecke van Aelst (1527–1559), but this is a confusion with Gillis van Coninxloo II (1581–1619/20), who had no known relationship with the present artist, who is sometimes called Gillis III. After his training Gillis traveled to France. In 1570 he joined the Antwerp guild and married Maeyken Robroeck. The religious persecution of Protestants in Flanders drove Coninxloo in 1585 from Antwerp to Zeeland. Two years later he moved to Frankenthal (Germany). In 1595 he resettled in Amsterdam. In April 1597 he paid *poorterrecht* (citizenship fee) in Amsterdam and remarried there in 1603. Coninxloo was a member of the Brabant Rederijkerskamer "Het Wit Lavendel." On January 4, 1607, he was buried in Amsterdam.

Coninxloo's earliest surviving dated work is a landscape with Midas, executed in Frankenthal in 1588 (cat. 19, fig. 1). Dated paintings indicate that he was active throughout his life.

Coninxloo was the teacher of Hercules Segers; Buchelius reports that Esaias van de Velde painted staffage in a painting by Coninxloo. Further, the influence of Coninxloo was essential to an entire generation of Dutch landscape painters, especially those who emigrated from Flanders, including Karel van Mander (1548–1606), Jacob Savery (1545–1602), David Vinckboons, Gillis de Hondecoutre, Alexander Keirincx, and Roelandt Savery. The posthumous sale of Coninxloo's works held by his widow on March 1, 1607, testifies to the extent of his influence and importance. Buyers included Segers, Vinckboons, Pieter Lastman, Hans van de Velde (father of Esaias), Claes Jansz Visscher (1550–1612), Adriaen van Nieulandt (1587–1658), Pieter Isaacsz (1569–1625), and Cornelis Ketel (1548–1616). Nicolaes de Bruyn etched

numerous landscape designs by Coninxloo.

A.C.

Literature: van Mander 1604, fol. 267b; Sandrart 1675, vol. 1, pp. 278–79; Descamps 1753–64, vol. 1, pp. 172–73; de Roever 1885a; Starcke 1898; Wurzbach 1906–11, vol. 1, pp. 326–27; Zoege van Mantueffel in Thieme, Becker 1907–50, vol. 7 (1912), pp. 302–304; Plietzsch 1910, pp. 24–74; Raczyński 1937, pp. 27–36; Laes 1939; Białostocki 1950; Thiéry 1953; Wellensieck 1954a; Wellensieck 1954b; Münch 1960; Mannheim 1962; Franz 1963; Arndt 1965–66; Stechow 1966, pp. 65–67; Wegner 1967; Franz 1968; Franz 1968–69; Franz 1969, pp. 270–88; Briels 1976, pp. 94–95, 220–54; Gerszi 1976a; Genaille 1983; Haak 1984, pp. 174–75; Thiéry 1986.

Monogrammed and dated 1605 on the tree trunk at left
Oil on panel, 23 x 32⅞ in. (58.5 x 83.5 cm.)
Historisches Museum der Pfalz, Speyer, inv. HM 1957/122

Provenance: Curt Glaser, Berlin; V.J. Mayring, Nuremberg; acquired in 1957.

Exhibitions: Berlin, Galerie Gottschenski, 1921; Berlin, Kaiser-Friedrich-Museums-Verein, 1925; Nuremberg, Germanisches Nationalmuseum, 1952, no. 33; Mannheim 1962, no. 4, fig. 5; Frankfurt 1966–67, no. 65, fig. 54; Cologne/Utrecht 1985–86, no. 80, ill.; London 1986, no. 21, ill.

Literature: Wellensieck 1954a, p. 52, no. 17; Münch 1960; Franz 1963, p. 76, fig. 16; Franz 1968, p. 15; Stechow 1966, p. 66; Franz 1969, vol. 1, pp. 279–83, vol. 2, fig. 437; K. Schultz, "Frankenthal in der Kunstgeschichte," *Pfälzer Heimat* 2 (1972), p. 63, note 65; Gerszi 1976a, p. 211; G. Stein, *Museen in Rheinland-Pfalz* (Speyer, 1983), vol. 1, pp. 134–35; Haak 1984, p. 175, fig. 362.

Hunters and their dogs move through a dense wood. On the left, behind the darkened coulisse of a broken tree, a sunlit clearing appears. In the left foreground a hunter fires his weapon from a low wooden bridge at herons on the banks of a stream while a second hunter stands at ease. Further back a third hunter makes his way along the path toward a lighted clearing. On the right a stream with a low waterfall appears in the darkened undergrowth beneath a leafy canopy of embroidered foliage.

This is a very late work by Coninxloo, painted just two years before his death. It is typical of the near views of dense woods with huge trees that the artist began painting soon after moving to Amsterdam in or before June 1595. Prior to that date, during his period in Frankenthal as the leader of the so-called Frankenthal School, Coninxloo painted more open landscapes often with wooded "wings," huge panoramic valleys, and rocky mountains in the tradition of the

19

Fig. 1. Gillis van Coninxloo, *Landscape with the Judgment of Midas*, signed and dated 1588, panel, 120 x 204 cm., Staatliche Kunstsammlungen, Dresden, no. 857.

Fig. 2. Jan Brueghel, *Forest Landscape*, copper, 25 x 32 cm., Pinacoteca Ambrosiana, Milan, inv. 74, f-20.

Flemish world landscape. A good example of these earlier works by Coninxloo and the artist's earliest dated painting is the *Landscape with the Judgment of Midas* of 1588 (fig. 1). After moving to Amsterdam Coninxloo joined the circle of artists around the Flemish émigrés Hans Bol and Jacob Savery, and soon began his forest interiors with huge writhing trees and tunneling vistas. The earliest dated example of these forest landscapes is the painting in Vaduz of 1598 (Introduction, fig. 25). No doubt it was paintings like the lush works in Vaduz and Speyer that inspired van Mander's comment, "I have noticed that Gillis now has followers in Holland. The trees, that have always been rather bare, in pictures of other artists, now begin to grow a little, according to the style of Gillis. But nursery men and planters [e.g. artists] hardly dare acknowledge this."[1]

There can be no doubting Coninxloo's influence on artists like David Vinckboons (see cat. 110), Roelandt Savery, and Gillis de Hondecoutre, but his role has recently emerged as more that of a conduit of Flemish ideas than as a

Aelbert Cuyp

(Dordrecht 1620–1691 Dordrecht)

prime innovator. Both Franz and Gerszi have demonstrated that many of Coninxloo's ideas were inherited, chiefly via prints, from Hans Bol, Jacob Savery, Jan Brueghel the Elder and Paul Bril, and ultimately stem from the art of Pieter Bruegel the Elder.[2] Discussing the extraordinary "Bruegel revival" that took place in the late sixteenth and early seventeenth centuries, Gerszi compared the Vaduz painting to Jan Brueghel's *Forest Landscape* of about 1595/96 in the Pinacoteca Ambrosiana, Milan (fig. 2).[3] The Speyer picture also bears comparison with these earlier woodland scenes of Jan Brueghel and Bril, as well as with those of Lucas van Valckenborch (see Introduction, fig. 23).

P.C.S.

1. Translated by Constant van de Wall, *Carel van Mander. Dutch and Flemish Painters* (New York, 1936), p. 308.

2. See Franz 1963; Franz 1968; Franz 1968–69; Franz 1969; Gerszi 1976a.

3. Gerszi 1976a, p. 227. Jan Brueghel's earliest dated forest interior is of 1599, *Forest Scene with Sacrifice of Abraham*, panel, 49.5 x 64.7 cm., private collection, New York (Ertz 1979, no. 56, ill.).

Baptized in the Dordrecht Reformed Church in October 1620, Aelbert Cuyp was the son of Jacob Gerritsz Cuyp (1594–1652) and Aertken van Cooten of Utrecht. Aelbert was born into a family of active artists. His grandfather, Gerrit Gerritsz (c.1565–1644), was a prominent glass painter originally from Venlo; his father's half brother Benjamin Cuyp (1612–1650) was a history and genre painter in Rembrandt's circle. Aelbert's first teacher was his father, an accomplished history, genre, portrait, and still-life painter. Father and son collaborated on a number of paintings in 1641 and occasionally in the mid-1640s, primarily portraits or pastoral figures in landscapes. Aelbert Cuyp's earliest paintings are dated 1639. By 1641 he was working in a style very close to Jan van Goyen and Salomon van Ruysdael. Around 1642 the artist made an extensive sketching tour of various towns and villages in Holland and Utrecht. The family's connections with Utrecht seem to have been particularly strong, and Aelbert came under the influence of various Italianate landscape artists based there, most notably Herman Saftleven and Jan Both. In 1651 or 1652 Cuyp made a journey up the Rhine as far as Nijmegen, Emmerich, Elten and Kleve. At almost the same time, the death of his father and uncle left him with the patronage of the most prominent Dordrecht patrician families, such as the Pompe van Meerdervoort, van Beyeren, de Roovere, and Berck. Cuyp embarked upon an ambitious series of aristocratic equestrian portraits, large-scale expansive landscapes, and town views.

In July 1658, Aelbert Cuyp married Cornelia Boschman, widow of a wealthy regent, Johan van den Corput; she already had three children. Cuyp's only child, Arendina, was born in 1659. The family moved to a larger house in the Wijnstraat in 1663. The financial and social position of his wife catapulted Cuyp into public prominence; he became deacon and elder of the

Reformed Church, a regent of a major charity, and a member of the Tribunal of South Holland. Records reveal him to be one of the wealthiest men in Dordrecht at the time of his death in November 1691. He was buried on November 15 in the Augustinian church.

There is no firm evidence that Cuyp painted at all after about 1660. Further, his work appears to have been almost entirely unknown outside Dordrecht in his own lifetime; no record exists of his paintings in other towns until the eighteenth century. Besides landscapes, Cuyp also painted a handful of portraits and interior scenes but probably no still lifes, as was once thought. He displayed an innovative use of watercolor in some of his numerous landscape sketches.

A.C.

Literature: van Balen 1677, pp. 186, 909; Houbraken 1718–21, vol. 1, p. 248; van Eynden, van der Willigen 1816–40, vol. 1, pp. 382–89; Smith 1829–42, vol. 5, pp. 279–368, vol. 9, pp. 649–67; Nagler 1835–52, vol. 3, pp. 230–31; Kramm 1857–64, vol. 1, pp. 308–10, vol. 66, p. 39; van der Kellen 1866, p. 98; Veth 1884; Bode 1885a; Veth 1888, pp. 142–48; Cundall 1891, pp. 63–103, 159–67; Michel 1892b; Hofmann 1906; Wurzbach 1906–11, vol. 1, pp. 364–69, vol. 3, pp. 70–71; Hofstede de Groot 1907–28, vol. 2, pp. 1–248; Bredius 1913b; K. Lilienfield in Thieme, Becker 1907–50, vol. 8 (1913), pp. 227–29; Hofstede de Groot 1915–16a; Bredius 1917; J. Holmes 1930; J. Holmes 1933; Martin 1935–36, vol. 2, pp. 340–49; Gerson 1942; Hollstein, vol. 4, pp. 100–103; Reiss 1953; Staring 1953; Stechow 1960d, pp. 86–90; Gorissen 1964; de Bruyn Kops 1965; Nieuwstraten 1965c; Utrecht 1965, pp. 171–74; Stechow 1966, pp. 27, 61–64, 119, 161–62, 181–82; Dattenberg 1967, pp. 64–82; Burnett 1969; van Gelder, Jost 1969; van Gelder, Jost 1972; London 1973; Somerville 1973; Reiss 1975; Dordrecht 1977–78; Müllenmeister 1973–81, vol. 2, pp. 51–54; Reiss 1978; Chong, forthcoming; van Gelder, Jost, forthcoming.

Farm Scene with Cottages and Animals, c.1641

Signed lower center: A cuÿp
Oil on canvas, 41½ x 61 in. (105 x 155 cm.)
Private Collection

Provenance: Possibly sale, The Hague, Hendrik
Vershuuring, September 17, 1770, no. 39 (fl.385);
sale, J. Blackwood, London, February 21, 1778, no. 77
(£99 15s. to the Earl of Ilchester).

Exhibitions: London 1973, no. 5, ill.; Dordrecht
1977–78, no. 18, ill.

Literature: Ilchester collection, cat. 1883, p. 6, no. 10
(as brought from Redlynch); Hofstede de Groot
1907–28, vol. 2, nos. 228b, 699; Haak 1973,
pp. 713–15, fig. 1; *Burlington Magazine* 115 (1973),
p. 132, fig. 92; Reiss 1975, no. 7, ill., color pl. 1; J.M.
de Groot, "Een vroeg landschap van Aelbert Cuyp in
een Dordtse expositie," *Antiek* 12 (1977), pp. 373–74;
Plomp 1986, pp. 146–47, note 7.

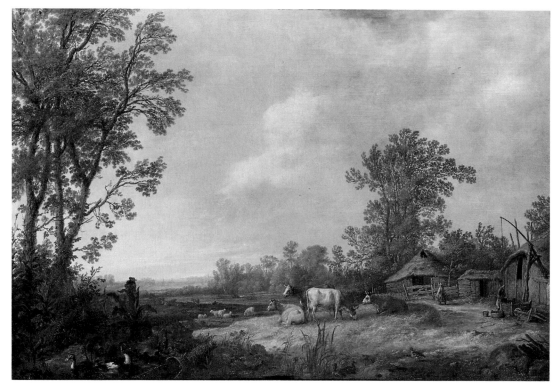

20

This straightforward depiction of a simple farm
is the largest and most assured of Aelbert Cuyp's
early paintings. The artist's development in the
late 1630s and early 1640s is unclear despite
several dated works. Paintings from 1639 reveal
an eclectic artist who painted farm landscapes
(fig. 1), mountainous scenes, and harbor views,[1]
a surprisingly wide range of landscape themes
for an artist in the first year of his career. The
recent appearance of a landscape dated 1639[2]
showing the influence of Esaias van de Velde, and
perhaps even of Cornelis Vroom, indicates that
Cuyp was experimenting with a number of
different styles at this time. The next available
dates in Cuyp's oeuvre are two group portraits
signed by his father Jacob Gerritsz Cuyp in 1641
(fig. 2), in which Aelbert painted the landscapes
in a monochromatic, blond impasto derived from
the work of Jan van Goyen and Salomon van
Ruysdael.[3] What remains of the 1639 paintings
(see fig. 1) is a hardness in the crinkled foliage of
the foreground, in the trees, and in the drawing
of the cattle.

The present landscape differs in its graceful
flowing trees and variety of repoussoir foliage.
The handling of paint is not as flat and awkward
as in the Besançon picture (fig. 1) and its con-
temporaries, nor as monochromatic and calli-
graphic as in the works of 1641. These differ-
ences in style make it unlikely that the painting
dates from 1640.[4] On the other hand, the paint-
ings of 1641 inaugurate a series of works in a
van Goyenesque style which Cuyp developed
and refined until about 1644.[5] Cuyp gradually
suffused this style with brighter, more colorful
lighting effects derived from Italianate artists.[6]
Some of these later works share with the present
painting the treatment of foliage, particularly in
the foreground; several of these foreground
motifs are taken from a drawing.[7] The exhibited
painting would appear to date from after 1641,
when the artist was capable of working simul-
taneously in two styles—the present one and a
more monochromatic manner derived from van
Goyen (see Introduction, fig. 61).[8] Closest in
handling to the exhibited work is a landscape
with the Baptism of the Eunuch in the de Menil
collection, Houston.[9]

Flat, simple farm scenes began to appear in
Netherlandish art with the Master of the Small
Landscapes (Joos van Liere), whose drawings
were etched by Hieronymus Cock (see Intro-

Fig. 1. Aelbert Cuyp, *Farm Scene*, signed and dated 1639, panel, 37 x 47 cm., Musée des Beaux-Arts, Besançon.

Fig. 2. Aelbert and Jacob Gerritsz Cuyp, *Portrait of a Family in a Landscape*, signed and dated 1641, canvas, 62 x 100 cm., Israel Museum, Jerusalem, inv. 166.4.65.

Fig. 3. Herman Saftleven, *Farm Landscape*, etching.

duction, fig. 16),[10] and continued with the work of Abraham Bloemaert and Jan van de Velde's drawings (Albertina, Vienna, inv. 8083) and etchings.[11] Cuyp's immediate sources for this type of landscape were probably François Rijckhals and Herman Saftleven, although the influence of Gijsbert de Hondecoeter[12] and of the artist's father, Jacob Gerritsz, can also be detected. Rijckhals was an early source for Cuyp, especially in his stable interiors, although the exhibited landscape also resembles Rijckhals's paintings and drawings of farms.[13] More important are the farm scenes of Herman Saftleven, especially a print of a milkmaid in an unembellished, flat farm scene sheltered by trees on one side (fig. 3).[14] Cuyp's detailed foliage in the foreground and the gradual transition to the distant view may also have been influenced by Cornelis van Poelenburch (cat. 69).[15] Cuyp had many important ties to Utrecht early in his career; his mother was from Utrecht and his father studied there.[16] These early relationships with Bloemaert, Saftleven, and Poelenburch, make Cuyp's later involvement with the work of Jan Both around 1650 much less unexpected.

A.C.

1. The paintings dated 1639 are Musée des Beaux-Arts, Besançon (fig. 1); formerly Brunner Gallery, Paris, 1919 (Reiss 1975, pl. 4); and note 2.

2. Sale, London (Sotheby's), April 6, 1977, no. 52.

3. The second portrait group of 1641 is in a private Swiss collection (Reiss 1975, pl. 17).

4. As Reiss (ibid., p. 33) and J.M. de Groot (Dordrecht 1977–78, p. 64) suggest.

5. Reiss 1975, nos. 8–15, 18–22, 25, 29–30.

6. Ibid., nos. 26–27, 62.

7. Hind 1915–31, vol. 3, no. 24.

8. The trees in the present entry, as well as the transition from foreground to distance, resemble the landscape in the Residenzgalerie, Salzburg, although the tonality of the painting is quite different.

9. Ibid., pl. 6.

10. Van Bastelaer 1908, no. 59.

11. Van Gelder 1933, nos. 69, 117, figs. 26, 34. See also etchings dated 1615–16 (Franken, van der Kellen 1883, nos. 227, 229, 295).

12. The painting in the de Menil foundation is particularly close to Gijsbert de Hondecoeter, as Reiss has noted. Compare a painting by de Hondecoeter in a private collection (Bol 1969, pl. 117).

13. See a painting of a farm landscape by Rijckhals sold at Christie's December 4, 1931, no. 74, and a drawing in the Gemeente Archief, Haarlem (L.J. Bol "Goede onbekende," *Tableau* 2 (1980), p. 307, fig. 10).

14. Based on a drawing in the British Museum (Hind 1915–31, vol. 4, no. 1; Schulz 1982, no. 336, pl. 67). Such farm scenes occur as early as 1627 in Herman Saftleven's prints (Schulz 1982, nos. I–III, pls. 59–61; Hollstein, nos. 1–3). Saftleven's painting dated 1630 can also be compared with Cuyp's landscape (Schulz 1982, no. 20, pl. 1).

15. A painting by Cuyp recently in the art market shows the influence of Poelenburch in the treatment of rocks and cliffs (Reiss 1975, pl. 68). The drawing of cattle in early paintings by Cuyp also shows Poelenburch's influence.

16. Van Gelder, Jost 1972.

2 I (PLATE 67)

Cattle in a River, c.1650

Signed lower right: A. cuijp.
Oil on panel, 23½ x 29½ in. (59 x 74 cm.)
Szépművészeti Múzeum, Budapest, inv. 408

Provenance: John Barnard, London; Thomas Hankey,
London; sale, London (Christie's), June 8, 1799, no.
35 (£115 10s. to Bryan); Prince Miklós Esterházy von
Galántha, by 1810 (at Laxenburg before 1815, in
Vienna 1815–65 [1820 inventory, no. 175], in Pest
Academy of Sciences from 1865); purchased by the
Hungarian government, 1870; National Gallery, Pest,
1872; transferred to the Szépművészeti Múzeum,
1906.

Exhibitions: Budapest 1967, no. 15; Lugano 1985, no.
28, ill.

Literature: Smith 1829–42, vol. 5, no. 170; Parthey,
1863–64, vol. 1, p. 723; Keleti 1871, pp. 5–8; Bredius
1880, p. 375; Tschudi, Pulszky 1883, p. 18; *Graphischen
Künste* 8 (1886), p. 102; Frimmel 1892, p. 196; Michel
1892, p. 236; Wurzbach 1906–11, vol. 1, p. 366;
Budapest, cat. 1906, no. 587; Bode 1907, p. 162, 167;
Hofstede de Groot 1907–28, vol. 2, no. 390; van
Dyke 1914, p. 126; L. Herman, *Magyar Művészet* 10
(1934), pp. 203–205; Martin 1935–36, pp. 339, 346;
Budapest, cat. 1937, p. 80, no. 408, pl. 193; Budapest,
cat. 1954, no. 408; Czobor 1967, pl. 38; Budapest, cat.
1968, p. 174, no. 408, pl. 278; Reiss 1975, no. 85, ill;
Garas 1977, p. 186, ill. p. 187.

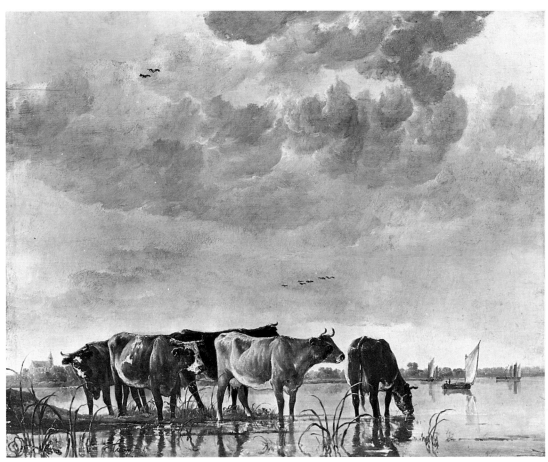

21

In shallow water a herd of cows grazes and
drinks. Almost no dry ground can be seen in the
foreground; the distant bank across the river is
punctuated by a church and a few sailboats. In
the sky a vigorous group of clouds is painted in
thick gray strokes. Cuyp has radically reduced
the elements of his landscape to concentrate on
the unified tones of water and sky, which set off
the brown architectonic shapes of the cattle.
Always attentive to light, Cuyp has carefully
depicted the rippling reflections in the water
with rich buttery passes of the brush.

Cuyp must have considered this composition
particularly satisfying and successful, since he
painted four closely related versions, some with
pendants of different designs: Robarts collection,
Great Britain (fig. 1), with a pendant (fig. 2);
Marquess of Bute, Scotland, with a pendant;[1]
Lord Samuel, England;[2] National Gallery,
London (no. 823).[3] In terms of size, support,
handling of paint, and composition, the exhib-
ited work most closely resembles the paintings
in the Robarts and Bute collections, both of
which have pendants. The painting of cows and
bulls in the pendant are based on Roelandt
Savery's works of 1616.[4] The pendant to the
Robarts picture (fig. 2), which shows a herd of
bulls lying and standing on a riverbank, in-
dicates the type of composition that the artist
considered a suitable companion to a design like
that of the exhibited work. The pendant to the

Fig. 1. Aelbert Cuyp, *Cows in a River*, signed, panel, 59.7 x 73.7 cm., Robarts collection, Great Britain.

Fig. 2. Aelbert Cuyp, *Bulls on a Riverbank*, signed, panel, 59.7 x 73.7 cm., Robarts collection, Great Britain.

Bute painting also includes more evidence of *terra firma*: on a grassy knoll are cows, a horse, and a shepherd boy.

In many respects the Robarts painting is the reverse of the Budapest composition. The drinking cow, inserting an incisive angled bracket in the herd, is not only reversed but also seen from the front rather than from behind, as in the Budapest painting. In figure 1 Cuyp eliminated the church at the left and the sailboats in order to concentrate on the flat horizon that divides water and sky, and the cows themselves. Even the heads of the cattle have been brought into line to create a more unified silhouette than in the Budapest picture. Since the Robarts painting has a pendant, is more highly finished, and contains far fewer pentimenti than the exhibited picture (where Cuyp changed the outlines of the legs and backs of the cattle), the Budapest painting may be supposed to be the earlier version.

A midpoint between the Budapest and Robarts paintings may be the version belonging to the Marquess of Bute, which, though sharing with the Budapest painting the same church and sailboat, has already reversed the composition. The version in Lord Samuel's collection is close in design to the Robarts painting and must date from about the same time, although Reiss placed it earlier.[5] The earliest of all the versions would seem to be the picture in the National Gallery, London, which contains a more traditional arrangement of a boat with fishermen and depicts more of the riverbank.

All of these paintings are executed in the same general style and must date about 1650, that is, before Cuyp journeyed to the Rhineland in 1651 or 1652. The vigorous brushwork in the clouds is found in an equestrian portrait in the Maurits-huis, The Hague (inv. 25) that can be dated before 1652 on documentary evidence.[6] Remnants of this painting technique can also be

Fig. 3. Hendrick Hondius, *Cows in a River*, etching, dated 1644.

detected in the sky of the somewhat later *View of Nijmegen* (cat. 22). At about the same time as the Budapest painting, Cuyp executed several other paintings showing groups of cattle. Similar in handling are a painting belonging to the British Rail Pension Fund (on loan to the J. Paul Getty Museum, Malibu) and a recent acquisition of the National Gallery of Art, Washington, D.C.

Cuyp's depictions of dairy cows reflect the pride of the Dutch in their milk industry. Dutch dairy herds were world renowned for their prodigious milk production and were in great demand throughout Europe. The Dutch were only too eager to brag about the productivity and commercial value of their cattle.[7] In

View of Nijmegen, c. 1652–54

seventeenth-century texts and emblems, a variety of different meanings were attached to the cow, ranging from the cow as *terra*[8] to being a symbol of spring, fecundity, wealth, loyalty, and moderation. However, the most prominent popular meaning attached to the cow was as a symbol, or representative, of Holland itself. As early as the sixteenth century, the cow was frequently employed in political allegories – in prints, drawings, and paintings – as a symbol of the Dutch nation.[9] Jan Saenredam's allegory of the prosperous Netherlands (1603) uses a milk cow to represent national wealth.[10] Particularly important in this regard is Hendrick Hondius's print of 1644 (fig. 3), part of a series of five landscapes with patriotic themes. The caption reads, "Watchmen, do your best to see that the Dutch cow is not stolen from us." The concern with vigilance over cows, and therefore over Dutch wealth, is a common theme in these images. The combination of commercial and patriotic associations in the cow was a natural one, since the cow was a linchpin in the agricultural productivity and prosperity of Holland.[11] Karel van Mander's poem in praise of his native Haarlem (c.1596) describes the surrounding landscape and its production of "cheese, milk and rich butter" and many "fattened cows and plump bulls."[12] The associations of a painting such as the exhibited work were clear and resonant. Like Potter's famous *Bull* (Mauritshuis, The Hague, inv. 136), the picture embodies seventeenth-century social and economic ideas as well as patriotic feelings.

A.C.

1. Panel, 59.7 x 71 cm. Its pendant, in the same collection, shows cows, a horse, and a shepherd boy on a hillside (Hofstede de Groot 1907–28, vol. 2, nos. 392, 349; ill. in London 1978, pls. 29, 31).

2. Panel, 38 x 58.4 cm. (Reiss 1975, pl. 87). Reiss gave the location as the Hermitage, Leningrad, from which it was

sold in the 1930s, and questioned the attribution, considering it "weaker both in design and chiaroscuro" than the Robarts painting. The attribution to Cuyp is undoubtedly correct.

3. *Cows on a Bank with Fishing Boat*, panel, 45.7 x 75 cm. (Reiss 1975, pl. 88).

4. Spicer 1983, p. 255, figs. 5, 6.

5. Reiss 1975, p. 124.

6. The sitter, Pieter de Roovere, died in 1652 (Dordrecht 1977–78, no. 25, pp. 78–80).

7. For example, see Wouter van Gouthoeven, *D'oude chronijcke end historien van Holland* (The Hague, 1636); and Kaerle Stevens and Jan Libaut, *De veltbouw* (Amsterdam, 1622). For a general discussion, see Hengeveld 1865–70; for economic aspects of the seventeenth-century dairy industry, see J. de Vries 1974, pp. 137–44 and 166–68.

8. See Spicer 1983; Walsh 1985; and P. Sutton 1987. Van Mander (1604, fol. 125) states explicitly that the cow represents earth; prints by Cornelis Bloemaert (after Abraham Bloemaert, Hollstein, no. 309) and Jan van de Velde (after Willem Buytewech; Franken, van der Kellen 1883, no. 134) use the cow in representations of *terra* in series of the Four Elements. The limits of such an interpretation can be seen in the caption to Jan van de Velde's print (see note 11 below) and indeed in the present painting by Cuyp, where almost no *terra* – solid ground – is included.

9. See van de Waal 1952, pp. 21–22, and Haverkamp Begemann, Chong 1985, pp. 63–64, 67. A sixteenth-century allegorical painting of Holland and Spain (Rijksmuseum, Amsterdam, inv. A 2684) employs a cow as a symbol of Holland. See also an allegory of the Netherlands by Jan Tengnagel (Prinsenhof, Delft), a drawing attributed to Pieter Quast (Crocker Art Gallery, Sacramento, inv. 578), and a political print on Willem III of 1672 (F. Muller 1863–82, no. 2309).

10. F. Muller 1863–82, no. 1174.

11. The caption to Jan van de Velde's print of *Terra* (Franken, van der Kellen 1883, no. 134, Rotterdam 1974–75, no. 177, pl. 126) reads "The earth proudly displays her wealth and gifts of the field, swine . . . and cattle in the meadows." See also cat. 92, fig. 2, for van de Velde's print *The White Cow* of 1622, which bears an inscription describing a farmer taking his cows and goats to market.

12. Van Mander, "Twee beelden van Haarlem," in Rutgers van der Loeff, 1911, p. 20.

Signed lower right: A. cuijp.
Oil on panel, 19¼ x 29 in. (48.9 x 73.7 cm.)
Indianapolis Museum of Art, Gift in commemoration of the sixtieth anniversary of the Art Association of Indianapolis in memory of Daniel W. and Elizabeth C. Marmon, 43.107

Provenance:[1] Dukes of Saxe-Coburg-Gotha, Schloss Friedenstein, Gotha; Herzogliche Gemäldegalerie, Gotha; sold by 1937; Cassirer Gallery, Amsterdam; dealer Heinemann, New York; A. Seligman, Rey and Co., New York; John Heron Art Institute, Indianapolis, purchased in 1943.

Exhibitions: San Francisco, California Palace of the Legion of Honor, *Seven Centuries of Paintings*, 1939–40, no. 54, ill.; Toronto Art Gallery, *An Exhibition of Paintings in Aid of the Canadian Red Cross*, 1940, no. 17.

Literature: Parthey 1863–64, vol. 1, p. 722; Gotha, Herzogliches Museum, cat. 1883, p. 6, no. 55; cat. 1890 and 1910, no. 293 (as falsely signed); Hofstede de Groot 1907–28, vol. 2, no. 196; *Art News* 46, no. 16 (1944), ill., p. 6; *Art Quarterly* 17 (1944), pp. 69–71, ill.; B. Stillson, *Bulletin of the Art Association of Indianapolis* 31 (April 1944) pp. 7–9; Indianapolis, cat. 1948, pp. 10–13, ill.; Stechow 1960a; P. Sliepenbeek, ed., *Het Valkhof* (Brugge, 1961), p. 68, ill.; Stechow 1966, pp. 61–62, fig. 102; Indianapolis, cat. 1970, pp. 92–94, ill.; Reiss 1975, no. 130, ill.; Fuchs 1978, p. 140, fig. 121; Indianapolis, cat. 1980, p. 106, ill; Washington, D.C. 1985–86, p. 385.

On the south side of the Waal River appears the town of Nijmegen, capital of the province of Gelderland, near the German border. The fortified town had long played an important role in the region as a stronghold of the Batavians, the Romans, Charlemagne, the Holy Roman Empire, and finally the Dutch Republic. The mass of fortifications surrounding the high tower on the hill is the Valkhof (falcon court), rebuilt in the middle of the twelfth century. Cuyp has bathed the entire scene in rich golden sunlight, and it is this light, rather than a system of perspective or foreshortening that gives the architectural features their assertive three-

dimensionality. Highlights and shadows have been minutely articulated and balanced at intervals with unusual gray-white strokes which lend the painting its solidity. This luminous vision can also be seen in Cuyp's contemporary depictions of his hometown of Dordrecht and is paralleled by the "pointillism" of Vermeer's *View of Delft* (see p. 109, fig. 6).

Cuyp made an extensive tour of the area around Nijmegen and Kleve in 1651 or 1652, making numerous sketches en route. Since many of these drawings are continued on adjacent pages in a sketchbook – and on the reverses of some drawings – Cuyp's steps can be retraced. Certain architectural features in views of Kleve permit an exact dating of his journey.[2] The drawing on which the exhibited painting is based is an accurate transcription of the topographical features of Nijmegen (fig. 1).[3] Most of the details are identical in both drawing and painting, including the general arrangement of the sailboats and even the right edge of the composition which cuts off the view. The boat with suspended fishnets at the left in the painting is taken from another drawing of Nijmegen.[4] The idealized qualities of Cuyp's painting, in particular the warm light and idyllic staffage, have led to the assumption that Cuyp's view of Nijmegen is less accurate than topographic prints or the work of Jan van Goyen (fig. 2).[5] However, comparison with contemporary sources indicates that the Indianapolis painting closely approximates the actual appearance of Nijmegen in the seventeenth century (see fig. 3).

Jan van Goyen painted a large number of Nijmegen views from 1633 to about 1650.[6] Van Goyen's most common composition (fig. 2) provides the basic model for Cuyp's paintings, although the differences between the two are also significant. Van Goyen's point of view is closer and further to the right, so that the Valkhof is seen at a steeper angle. Van Goyen

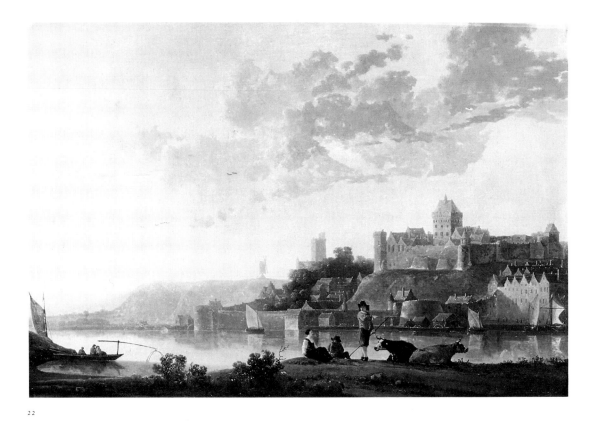

22

emphasizes the vertical thrust of the buildings while Cuyp presents a more distant and horizontally balanced view, with a greater effect of repose and resolution. Van Goyen's diagonal, foreshortened composition recurs in Salomon van Ruysdael's views of Nijmegen (which, as Stechow suggested, are based on van Goyen's paintings rather than firsthand observation)[7] as well as in other "Haarlem school" landscapes, such as those by Jacob van Ruisdael. In its particular viewpoint, Aelbert Cuyp's painting more closely resembles another widely circulated image of Nijmegen, the print that appeared in Joan Blaeu's *Toonneel der Steden van de Vereenighde*

Nederlanden of 1649 (fig. 3).[8] Numerous other Dutch artists sketched or painted Nijmegen, including Lambert Doomer (1624–1700), Willem Schellinks (1627–1678), Roeland Roghman, Anthonie Waterloo (c.1610–1690), and Abraham Rademaker (1675–1735).

Cuyp painted a second version of this view that is slightly larger and on canvas (Woburn Abbey).[9] In addition, there are small but significant differences in the composition and handling of paint. The exhibited painting sparkles with a more crystalline atmosphere, in part because of its panel support but also because the picture at Woburn Abbey is more broadly

Fig. 1. Aelbert Cuyp, *View of Nijmegen from the Northeast*, drawing, 170 x 249 mm., sale, Amsterdam (Sotheby-Mak van Waay), April 25, 1983, no. 73.

Fig. 2. Jan van Goyen, *View of Nijmegen*, canvas, 94 x 124.5 cm., Ponce Museum of Art, Puerto Rico, inv. 63.0358.

Fig. 3. Joan Blaeu, *Profile of Nijmegen*, etching.

executed, with fewer highlights. The figures and details in the foreground of the Indianapolis landscape are indicated in black paint by quick calligraphic passes of the brush, a technique recalling Cuyp's van Goyenesque style of the 1640s. Moreover, the vigorous gray brushwork in the sky, some of which covers lighter blue areas, is related to Cuyp's technique of about 1650, as seen in cat. 21. These factors suggest that the Indianapolis painting is the first version of the composition, probably executed shortly after Cuyp's visit in 1651 or 1652 to Nijmegen. The painting at Woburn Abbey appears to date from several years later.

The composition of the Woburn Abbey picture is more deliberately formal: the point of view farther away, the staffage now including two aristocratic riders along with the shepherds. Both landscapes apparently have a companion piece. The exhibited painting is paired with a view of Nijmegen from the east (fig. 4), painted in precisely the same style and adorned with a similar type of staffage.[10] The painting at Woburn Abbey has as its pendant a view of the Valkhof from the southwest (National Gallery of Scotland, Edinburgh, no. 2314).[11] The transformations of the staffage seen in the two later paintings on canvas, from purely pastoral figures to a combination of upper-class horsemen and simpler rustics, reflect changes in imagery anticipating Cuyp's last paintings (cats. 24 and 25).

Cuyp painted yet another view of Nijmegen from a point slightly farther to the right of the position of the Indianapolis painting, that is, from almost the identical position seen in van Goyen's works (see fig. 2). This work, in the collection of the Duke of Sutherland, depicts the Dutch fleet anchored before the town.[12]

Nijmegen was one of the most important historic and patriotic sites in the Netherlands in the seventeenth century. Dutch independence, officially confirmed in 1609, turned writers and

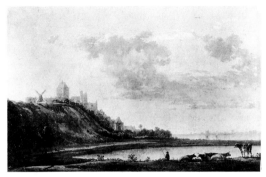

Fig. 4. Aelbert Cuyp, *View of Nijmegen from the East*, panel, 48.3 x 74 cm., private collection, United States.

politicians of the time to the historic and ancient past in attempts to legitimize their new country. The writing of national and civic histories took on a special importance, with Nijmegen playing a prominent role because Tacitus specified it as the seat of Claudius (more properly Julius) Civilis, leader of the Batavian revolt against the Romans. The Batavian legend was essential to the mythologizing associated with the development of Dutch nationalism and patriotism. Charlemagne and his immediate successors made Nijmegen a major stronghold in the Middle Ages. These tales of historic glory were then considerably embroidered in the sixteenth and seventeenth centuries, beginning with Guicciardini's very popular description of the Netherlands, first published in 1526, later translated and republished numerous times in the 1600s.[13] The account by Johannes Smetius is probably the most influential of several histories of Nijmegen, since it was frequently republished, most notably in Joan Blaeu's atlas. Smetius wrote that "Nijmegen, or Noviomagnum, is the first and oldest city, not only of Gelderland and Batavia, but of all the lands in the area to the sea" and further that Nijmegen,

founded by the Celts, was named for Magus, one of the first kings of the Gauls.[14] In chronicles or lists of the cities of the Netherlands, Nijmegen is traditionally named first because of its antiquity; it is repeatedly hailed as the "mother-city," "capital of the world north of the Alps,"[15] and the seat of Claudius Civilis, ancient model of the Dutch struggle for independence.

The extent to which Nijmegen was popularly associated with the ancient Batavians, forefathers of the Dutch, can be seen in Rembrandt's painting of the *Oath of the Batavians*, made in 1661 for the new Amsterdam Town Hall (now preserved only as a fragment, Nationalmuseum, Stockholm). Instead of setting the event in a sacred grove, as described by Tacitus (and depicted by Flinck),[16] Rembrandt situated it in a Romanesque apse based on the chapel in the Valkhof at Nijmegen, as can be seen in Rembrandt's preparatory sketch (Staatliche Graphische Sammlung, Munich, inv. 1097; Benesch 1973, vol. 5, no. 1061).

With more indirect means than Rembrandt, Cuyp too evokes the glory of Holland's patriotic past. Any view of Nijmegen could, of course, have been associated with Holland's first capital and the locus of the most ancient struggle of the Dutch for freedom; but Cuyp complements these associations with a timeless, idealized treatment of the city. The light, so clearly that of the Italian campagna, and the pastoral figures contemplating the scene evoke an idyllism that transcends the quotidian.

A.C.

1. Stechow 1960 and Indianapolis, cat. 1980 report a spurious provenance of King George V of Hannover.
2. Gorissen 1964, nos. 13, 14, 141.

3. The drawing is continued on the back of a sheet preserved in the Musée des Beaux-Arts, Besançon (inv. D 513), the recto of which is a view of the Belvedere of Nijmegen from the northwest. In turn, the verso of fig. 1 is continued on a drawing of Nijmegen from the south in a private collection, Brussels.

4. In the Museum Commanderie van St. Jan, Nijmegen (Dordrecht 1977–78, no. 72).

5. This is the opinion of Stechow (1960a, p. 4) and Burnett (1969, p. 379, who says Cuyp "was little concerned with topographical accuracy").

6. Beck 1973, nos. 342–70.

7. Stechow 1960, p. 6. For Salomon van Ruysdael's various views of Nijmegen, see Stechow 1938a, nos. 70, 354.

8. The print accompanied a map and description of Nijmegen. Blaeu's city profiles are influenced by earlier prints, in particular those of Pieter Bast, whose views of various Dutch cities of 1593–97 were well known. An early view of Nijmegen appears in Braun, Hogenberg 1572–1617, vol. 2, pl. 26.

9. Canvas, 106 x 165 cm.; Reiss 1975, pl. 127.

10. The view is based on a drawing in the British Museum, London (Hind 1915–31, vol. 3, no. 19, pl. xxxviii). This important painting, now in a private American collection, had long been missing.

11. Illustrated in Reiss 1975, pl. 128. The view is derived from a sketch by Cuyp in the Pierpont Morgan Library, New York (inv. I 122); see Vassar College Art Gallery, *Seventeenth Century Dutch Landscape Drawings*, 1976, no. 49, ill.

12. Reiss 1975, pl. 103 (canvas, 114 x 166 cm.), based on a drawing (Dordrecht 1977–78, no. 72). The painting apparently is identical to the one recorded in the 1673 inventory of A. Dichters, "rendevou van schepen leggende voor Nummegen" (Dordrecht 1977–78, p. 19). An eighteenth-century version of this composition, without ships, is in a private collection (Reiss 1975, pl. 109).

13. Francesco Guicciardini, in his *Beschryvinghe van alle de Neder-Landen* (Amsterdam, 1616; reprint, Haarlem, 1979), pp. 137–39, describes Nijmegen as the former capital of the kingdom of the Gauls and the seat of Charlemagne.

14. Johannes Smith, *Oppidum Batavorum, seu Noviomagnum* (Amsterdam, 1644; translated into Dutch in Blaeu 1649).

15. Nijmegen is discussed first in such accounts as Jan Laet, *Belgii Confoederati Respublica* (Leiden, 1630) and Blaeu 1649. Other histories of Nijmegen include: P. Scriverius, *Beschrijvinghe van Out Batavien* (Arnhem, 1612); I. Pontanus, *Noviomagnum Gelriae* (1628; later eds. 1639, 1653–54).

16. Sumowski 1983, vol. 2, no. 641, ill.

Ice Scene before the Huis te Merwede near Dordrecht, 1650s

Signed lower right: A cuijp
Oil on panel, 25½ x 35½ in. (64 x 89 cm.)
The Earl of Yarborough, Brocklesby Hall

Provenance: J. van der Linden van Slingeland, Dordrecht, by 1752 (according to Hoet); sale, J. van der Linden van Slingeland, Dordrecht, August 22, 1785, no. 78 (fl.1,705 to Fouquet); Sir Richard Worsley, by descent to Henrietta Simpson, who married in 1806 Charles, 2nd Baron Yarborough; Earls of Yarborough, London and Brocklesby Hall.

Exhibitions: London, British Institution, 1832, no. 47; London, British Institution, 1847, no. 55; London, British Institution, 1849, no. 18; Manchester 1857, no. 1035; London, Royal Academy, 1875, no. 145; London, Royal Academy, 1890, no. 96; London 1929, no. 268; London, Slatter Gallery, 1949, no. 5; London 1952–53, no. 340; London 1976a, no. 26, ill.; Hull 1981, no. 27, ill.

Literature: Hoet 1752, vol. 2, p. 496; Smith 1829–42, vol. 5, no. 19; Yarborough, cat. 1851, p. 2, no. 20; Waagen 1854–57, vol. 2, p. 86, supplement p. 68; Thoré 1860, p. 271; Michel 1892, pp. 228–29; Wurzbach 1906–11, vol. 1, p. 367; Hofstede de Groot 1907–28, vol. 2, no. 737; Bode 1921, p. 217; Reiss 1953, p. 46; Stechow 1966, p. 205, note 63; Reiss 1975, no. 111, ill.; *Kindlers Malerei-Lexikon* 1976, vol. 1, ill. p. 861.

Cuyp painted only two other winter scenes, a similar ice scene at Woburn Abbey (fig. 1) and a landscape with a still life of dead fowl in the Staatliche Museen, Berlin (DDR, inv. 861 K), although there are numerous school pieces and copies.[1] Reiss considered the present painting to be earlier than the one at Woburn Abbey because it is broader in handling. In fact, there is little difference in the handling of paint. Rather, the more anecdotal quality of the figures in the Woburn Abbey picture and their more contrived placement may indicate that it is earlier. The sensitivity to light and its reflections distinguish the exhibited painting as one of Cuyp's most brilliant, similar in technique and date to the

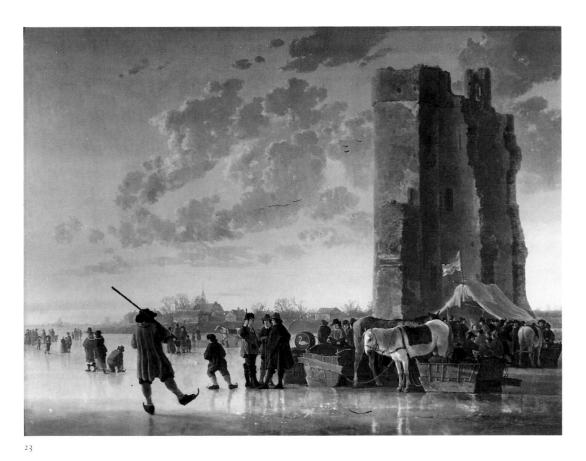

23

Fig. 2. Aelbert Cuyp, *Huis te Merwede*, drawing, 187 x 123 mm., British Museum, London, inv. 1836.8.11.101.

View of Nijmegen (cat. 22) and a *View of Dordrecht* at Ascot,[2] dating from a period after catalogue 21 and before Cuyp's final paintings (cat. 24, 25).

The sources of this type of winter landscape are difficult to determine. Ironically, winter scenes by Italianate artists like Claes Berchem (dated 1647; cat. 3, fig. 2) and Jan Asselijn (cat. 3) have nothing of the brilliant, warm light of Cuyp's ice scenes. Indeed, no artist before Cuyp was able to combine the golden light effects of Italianate painting with such a charac-

Fig. 1. Aelbert Cuyp, *Ice Scene near Dordrecht*, panel, 57 x 115 cm., Woburn Abbey.

teristically northern scene. Cuyp also carefully observed and depicted light reflecting off the ice in an innovative way. Although sunlight clearly enters the picture from the left, the shadows are softened and diffused by the reflections: the darker corners of the ruins are warmly modulated, and the white horse at the right is partially lit from below.

Cuyp's composition is also innovative in its very simplicity. The very low point of view and high sky area are contrasted with the towering

ruins of the Huis te Merwede, near Dordrecht. The closest compositional parallel comes from Esaias van de Velde's etching of ice skaters in front of a tall, oversized windmill at Penninccks-veer (Keyes 1984, no. E 13). Unusual for Cuyp is the placement of the skating figures close to the picture plane, which is even more pronounced in the winter landscape at Woburn Abbey. This recalls certain compositions employed by the patriarch of Dutch winter landscapes, Hendrick Avercamp.[3] Cuyp, however, eschews an expansive panoramic view across the ice, as favored by such artists as Avercamp, Adriaen van de Venne, and Jan van Goyen (cat. 5, 109, and 32). The bright mood of Cuyp's picture is a function of the play of sunlight and color as well as of the jaunty pose of the skater with a pole, caught in mid-glide. A crowd has gathered around the tent flying the Dutch flag for food and refreshment. This *koekenzoopie* is well stocked with beer for the skaters, judging by the barrels on the sleds. One is clearly marked with the swan of Dordrecht's main brewery. The row of leafless trees silhouetted against the sky is a vivid reminder of the bitter cold.

The view of the Huis te Merwede from the south is derived from a sketch by Cuyp in the British Museum (fig. 2), one of several made from different points of view.[4] The ruins appear in other Cuyp paintings and those of his followers.[5] The fifteenth-century fortress of the lords of Merwede was a famous landmark just east of Dordrecht. It occurs in the work of several landscapists,[6] but most frequently in Jan van Goyen's paintings, including his winter scenes.[7] The town of Dordrecht appears in numerous winter landscapes by van Goyen in the 1640s.[8] Cuyp's father, Jacob Gerritsz, also used Dordrecht as the setting for a skating scene featured in Jacob Cats's *'s Weerelts begin* (1647).[9]

A.C.

1. Versions and pastiches of the exhibited painting, with the ruins seen from various angles, include Polesden Lacey (inv. 34); sale, London (Sotheby's), July 12, 1985, no. 8; Bayerische Staatsgemäldesammlungen, inv. 1221 (probably by Jacob van Strij); sale, London (Christie's), November 26, 1976, no. 86.

2. Reiss 1975, pl. 98.

3. See esp. C. Welcker 1979, nos. S52.1, S14, pls. VA, XI.

4. Hind 1915–31, vol. 3, no. 23. Other drawings of the ruins by Cuyp include another in the British Museum from the west (ibid., no. 22), and one in the Institut Néerlandais, Paris (inv. 579), from the northeast.

5. The ruins are shown from approximately the same angle in a painting attributed to Cuyp in Montpellier (Musée Fabre, inv. 204; Reiss 1975, pl. 40). The ruins are seen from a position lower than in the present painting; doubts remain as to the attribution of the work. Another painting with the same view, also of doubtful authenticity, is in Strasbourg (Reiss 1975, pl. 70).

6. For example, the sea painters Jan Porcellis (Rouen, inv. 462) and Abraham van Beyeren (private collection; Atlanta 1975, no. 8).

7. See paintings in de Lakenhal, Leiden, dated 1638; National Gallery, London, no. 1327; Louvre, Paris, inv. RF 3726, dated 1649 (Beck 1973, nos. 51, 63, 80).

8. For van Goyen's winter scenes showing Dordrecht, see Beck 1973, nos. 28, 61, 69 (dated 1642–44). Salomon van Ruysdael also depicted Dordrecht with skaters: Kunsthalle, Zurich, dated 1653 (Stechow 1975, no. 6, fig. 47).

9. Etched by Jan van Bremden, ill. in van Straaten 1977, fig. 107.

24 (PLATE 69)

Hilly Landscape with Shepherds and Travelers, late 1650s

Signed lower right: A. cuijp.
Oil on canvas, 40 x 60½ in. (101.5 x 153.6 cm.)
Her Majesty Queen Elizabeth II

Provenance: Sale, J. van der Linden van Slingeland, Dordrecht, August 22ff., 1785, no. 22 (fl. 1,250 to Fouquet); sale, Jan Gildemeester, Amsterdam, June 11–13, 1800, no. 30 (fl. 3,200, to Telting); Sir Francis Baring; Sir Thomas Baring; bought by George IV in 1814, Carlton House; Buckingham Palace, London, no. 314.

Exhibitions: London, British Institution, 1826, no. 74; London, British Institution, 1827, no. 28; London, Royal Academy, 1885, no. 101; London 1946–47, no. 391; London 1971–72, no. 17, pl. 20.

Literature: Smith 1829–42, vol. 5, no. 22; Waagen 1838, vol. 2, p. 371; London, Royal collection cat. 1841, no. 30; Jameson 1844, no. 22; London, Royal collection cat. 1852, no. 23; Waagen 1854–57, vol. 2, p. 20; Wurzbach 1906–11, vol. 1, p. 366; Hofstede de Groot 1907–28, vol. 2, no. 432; Rosenberg et al. 1966, p. 159, pl. 142; Burnett 1969, p. 380, fig. 22; Reiss 1975, no. 133, ill.; J.H. Plumb, *Royal Heritage* (London, 1977), ill. p. 232; White 1982, no. 35, pl. 35.

Undulating ridges and hilly knolls divide a pool in the foreground from a wider river or lake in the background. In the foreground two riders converse with rustics. A boy on a donkey, silhouetted on a ridge, rides into the distance. Farther back a shepherd and shepherdess tend their flock. Warm golden sunlight casts long shadows through the scene and gilds the edges of plants in the foreground. Sunlight streams diagonally into the picture at the lower left.

Cuyp's ability to dramatically and convincingly illuminate the various parts of his landscapes drew the attention of early British critics. Smith in 1834 wrote, "some buildings are faintly seen through the sultry haze on the receding hills. The beauty of a fine summer's evening gives value to the scene."[1] Smith was also able to identify the landscape correctly as the environs of the Rhine. The sloping hill at the right

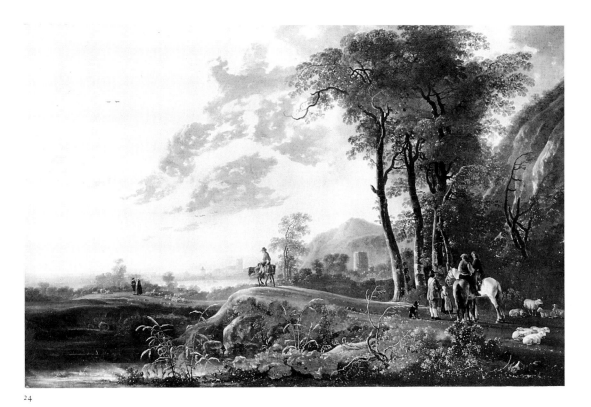

24

Fig. 1. Aelbert Cuyp, *Wijlermeer between Nijmegen and Kleve*, black chalk, 162 x 245 mm., formerly Duits and Co., London.

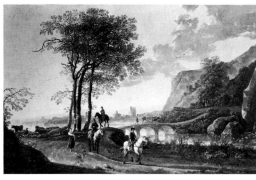

Fig. 2. Aelbert Cuyp, *River Landscape*, signed, canvas, 100 x 164 cm., private collection, Great Britain.

and much of the view into the distance recall Cuyp's sketch of 1651–52 of the area around the Wijlermeer between Nijmegen and Kleve (fig. 1). From this original sketch made on the spot, Cuyp prepared another drawing with different figures (Städelsches Kunstinstitut, Frankfurt, inv. 3721)[2] which became the basis of a painting (Rijksmuseum, Amsterdam, inv. A 4118). But in the exhibited painting, rather than closely following the topographic details of the drawings, Cuyp freely varied the type of landscape recollected from his travels. The tall trees, which mitigate the steep slope and frame the figures in the foreground, are part of Cuyp's response to Jan Both's work (see cat. 15, where trees similarly screen a hillside and shelter figures) and perhaps even to that of Adam Pijnacker. Although Cuyp had been influenced by Jan Both since the late 1640s, especially in his use of brilliant Italianate sunlight, only in later works such as this and catalogue 25, which probably date from after 1655, would Cuyp employ Both's trees and characteristic compositions. The combination of trees and a silhouetted ridge is derived from a print by Both (cat. 66, fig. 2). The exhibited work, together with that in Amsterdam (inv. A 4118) and catalogue 25, are probably Aelbert Cuyp's last paintings. The fidelity of the painting in Amsterdam to Cuyp's sketches from nature

25 (PLATE 70)

Landscape with a Rider and Peasants,
late 1650s

would suggest that it is the earliest of the three, while the composition of the Queen's painting is a midpoint in the artist's formulation of a more thoroughly imaginary landscape.

Cuyp painted several other similar variations of the Rhineland view recorded in the drawing illustrated in figure 1 – a sloping hill at the right, with a castle on a misty lake at the left. Closest to the Bute painting is a work in a British private collection (fig. 2), which shows similar pastoral and equestrian figures on a road. Other variations include those at Waddesdon Manor,[3] and several works by followers of Cuyp.[4] The Queen's painting is also closely related in handling and tone to a painting at Dulwich (cat. 25, fig. 2). A boy on a donkey, similar to that found in the exhibited landscape but seen from a different angle, rides along a road now shaded by a row of tall trees which organize the landscape differently. Cuyp had earlier depicted travelers on horseback in a landscape with ridges (Cleveland Museum of Art, no. 42.637).[5]

A.C.

1. Smith 1829–42, vol. 5, p. 293.

2. Gorissen identified the site (Dattenberg 1967, no. 71C). See also de Bruyn Kops 1965, pp. 164–65, note 3. D.G. Burnett (1969, p. 378) incorrectly suggested that the drawing in fig. 1 is a studio composition derived from another sketch from nature.

3. Reiss 1975, pl. 137.

4. National Gallery, London, no. 53 (Reiss 1975, pl. 143); Petworth House (Reiss 1975, pl. 145). A copy of the left and middle portions of the exhibited work was sold in London (Christie's), June 5, 1953, no. 161. A watercolor copy by A. Schelfhout was sold in Amsterdam (Mak van Waay), January 15, 1974, no. 766.

5. Ibid., pl. 46.

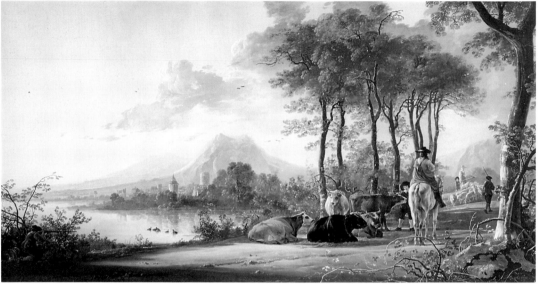

25

Signed lower right: A. cuijp
Oil on canvas, 49 x 96 in. (123 x 241 cm.)
The Marquess of Bute, on loan to the National Museum of Wales, Cardiff

Provenance: Capt. William Baillie, who bought it in Holland; sold to John Stuart, Earl (later Marquess) of Bute, by 1764; Marquesses of Bute, Luton Hoo, and Mount Stuart (Luton Hoo cat. [MS] 1799, no. 118); on loan to the National Museum of Wales, Cardiff, since 1975.

Exhibitions: London, British Institution, 1818, no. 85; London, British Institution, 1819, no. 37; London, British Institution, 1847, no. 66; London, Royal Academy, 1870, no. 102; London 1883, no. 38; Glasgow, 1884; Manchester 1885, no. 56; London, Guildhall, 1894, no. 45; Edinburgh 1949, no. 7, ill.; London 1973, no. 14, ill.; London 1976a, no. 31, ill.

Literature: Boydell 1769, pl. 12; Farington 1793–1821, vol. 15, p. 5203; Smith 1829–42, vol. 5, no. 264; Waagen 1854–57, vol. 3, pp. 40, 479–80; Wurzbach 1906–11, vol. 1, p. 367; Hofstede de Groot 1907–28, vol. 2, no. 433; Burnett 1969, p. 380; *Burlington Magazine* 115 (1973), pp. 132–35, fig. 88; Reiss 1975, p. 183, pl. 140; Hull 1981, p. 7, fig. 4; D. Sutton, "Aspects of British Collecting," *Apollo* 96 (1982), p. 377, fig. 10; Haak 1984, p. 415, fig. 906.

Perhaps the grandest of Cuyp's landscapes, and certainly a pinnacle in the Dutch art of landscape, this painting appears to date from the very end of the artist's career. An elegantly dressed horseman stops near a herdsman tending a group of cattle. Beyond are more peasants with their flocks. In the distance at the left are a group of towers and buildings – a castle or fortified town nestled beneath a tall peak. Strong, warm sunlight bathes the entire scene, casting long shadows in the foreground and providing almost incandescent reflections on the lake. The hazy atmosphere in the extreme

Fig. 1. William Elliot after Aelbert Cuyp, *A View on the Maese near Maestricht*, dated 1764, engraving.

Fig. 2. Aelbert Cuyp, *Landscape with a Rocky Path*, canvas, 113 x 167.6 cm., Dulwich Picture Gallery, London, no. 124.

distance and the essentially Italian light, which lend an elegiac and classicizing feeling to the scene, are products of Cuyp's contact with Jan Both's work.

This painting is the largest that Cuyp ever executed. Indeed, it was once about ten inches higher; a print by William Elliot made in 1764 shows the picture with a higher sky and gives its dimensions as sixty by ninety-six inches (fig. 1). Like many Dutch paintings in English collections, it was cut down in the late eighteenth or early nineteenth century.

Fig. 3. Aelbert Cuyp, *Landscape with Portraits and a Negro Page*, signed, canvas, 140 x 222.5 cm., Buckingham Palace, London, no. 311.

Closest in style and expansiveness of vision are catalogue 24 and a painting in Amsterdam (inv. A 4118), the latter derived directly from sketches Cuyp made around Nijmegen and Kleve in 1651–52 (cat. 24, fig. 1). In 1764 the exhibited painting was identified as a view on the Maas near Maastricht, which, though not strictly accurate, correctly describes the sources of Cuyp's landscapes. In the Bute painting, Cuyp was scarcely constrained by topographical accuracy in creating a grander, more imaginary landscape. The emphatic profile of the mountain in fact looks nothing like the Rhineland, nor any other identifiable site, but recalls mountainous scenes from almost the same date by Jacob van Ruisdael.[1]

The closest precedent in Cuyp's work is a landscape at Dulwich (fig. 2), which contains similar peaked hills as well as a rocky path with peasants. As in the Bute painting, a screen of trees divides the landscape. While this is a device borrowed directly from Jan Both (see cat. 15), Cuyp employed it rather timidly prior to these late works when the trees became a major part of the composition. Even here the screen does not advance to the immediate foreground,

as in Both's work. The buildings on the other side of the lake, which seem to refer to no identifiable site but rather evoke in a general way a glorious feudal past, also occur in a slightly earlier equestrian portrait in Buckingham Palace, London (fig. 3).[2]

Reiss dates the Bute painting around the same time as a portrait of a couple on horseback in the National Gallery of Art, Washington, D.C. (no. 1942.9.15).[3] However, Cuyp worked on that painting on two different occasions; even at its reworking, it must date considerably before the Bute landscape, with which it shares only a few general characteristics.[4]

Cuyp awarded prominence to the elegant aristocrat who travels through the countryside, a common theme in Cuyp's mature works. Although the patron of this particular landscape is not known, Cuyp worked for members of the regent and aristocratic classes of Dordrecht, many of whom commissioned landscape portraits.[5] These share with the Bute painting elegantly attired upper-class horsemen set in brilliantly lit Italianate landscapes. The status and rank of such equestrian figures are underscored by the deferential peasants or servants who surround them. In the Bute picture, the lone rider assumes a seigneurial status relative to the rural peasants, while in the painting illustrated in figure 3, the riders are supported by a fancily dressed black page. It is likely that the Bute painting was destined for one of Dordrecht's patrician houses and served to verify aristocratic ambitions similar to those expressed in his many equestrian portraits.

Such imagery, as well as Cuyp's artistic prowess as a landscapist, no doubt appealed to English eighteenth-century upper-class collectors. The exhibited work was one of the first paintings to be celebrated in England. John Boydell, describing it in 1769, said it was "entirely painted from nature, is inexpressibly

bright, clear and sunny; the choice of scene is elegant and picturesque."[6] The painter Benjamin West reported that Captain Baillie brought it to England before 1764, and it "was the first picture by that Master known in England. Having been seen, pictures by Cuyp were eagerly sought for & many were introduced & sold to advantage!"[7] On the other hand, Noel Desenfans, a dealer who assembled the core of what is now the Dulwich Picture Gallery, wrote that the first works by Cuyp were imported to England in 1740 by a Swiss merchant, spawning a demand for Cuyp among English and French dealers.[8] In any case, Cuyp, who had been virtually unknown even in Holland until the mid-1700s, became one of the most popular old masters in Britain.

A.C.

1. Compare the two similar mountainous scenes by Ruisdael in Leningrad (inv. 932) and Capetown (ill. in The Hague/Cambridge 1981–82, no. 52 and fig. 59).

2. Reiss (1975, p. 154) dated the Buckingham Palace painting to the late 1640s. However, the river landscape, its long shadows, and naturally integrated rather than stiffly posed portrait figures place it in Cuyp's mature period, after 1652.

3. Reiss 1975, pp. 165, 183.

4. The landscape portrait in the National Gallery of Art, inv. 611 (Reiss 1975, pl. 124) was at some point reworked by Cuyp, who repainted the costumes and faces and eliminated hunting elements in the landscape (i.e., dogs and pages). Much of the painting is damaged and worn. Reiss states that the signature is the only one in Cuyp's oeuvre with a capital C; however, it is almost certainly falsified or heavily repainted. This landscape is related in style to a group portrait in the Metropolitan Museum of Art, New York, which can be dated c.1653 (see p. 110, fig. 8). The portrait in Washington is probably a little later.

5. Examples of such portraits, besides fig. 3, include those in the Metropolitan Museum, New York; Barber Institute, Birmingham; a private collection, Germany; National Gallery of Art, Washington, D.C. (Reiss 1975, pls. 121–24).

6. Boydell 1769, vol. 1, no. 12.

7. Account of Joseph Farington (1747–1821), who recorded in his diary on May 18, 1818, his tour of the British Institution exhibition with Benjamin West; Farington 1793–1821, vol. 15, p. 5203.

8. Desenfans 1802, vol. 2, pp. 142–45. Desenfans reports that a "Grand Jean," a Swiss merchant, imported several paintings by Cuyp, some of which were sold to Mr. Blackwood who in turn sold a major landscape to Laurence Dundas (now in the National Gallery, London, no. 53). The first paintings by Cuyp to appear in a London auction were in Glover's sale, March 16–17, 1741, nos. 58 (a landscape with cattle) and 115 (a seaport).

Gerbrand van den Eeckhout

(Amsterdam 1621–1674 Amsterdam)

The son of a goldsmith, Jan Pietersz van den Eeckhout, and Grietie Claes Lydeckers, Gerbrand was born in Amsterdam on August 19, 1621. According to Houbraken, he was one of the best pupils and a "great friend" of Rembrandt. The dates of this period of study have not been pinpointed, but most writers suggest the later 1630s. His earliest dated paintings are of 1640/41. Little is known of his life; he served as an appraiser of art works in 1659, 1669, and 1672 and seems to have been an amateur poet. In 1654 he sent a poem to the Amsterdam poet Jacob Heyblock and in 1657 composed a hymn of praise to his friend the Amsterdam landscape painter Willem Schellinks (1627–1678). Van den Eeckhout never married and evidently remained his entire life in Amsterdam, where he was buried in Oudezijds Kapel on September 29, 1674.

Primarily a painter of history subjects, van den Eeckhout also executed landscapes, genre scenes, portraits, and *portraits-historiés*. His history painting style owes much to Rembrandt in its chiaroscuro effects, broad execution, and approach to narration. The last mentioned is also indebted to the narrative techniques of Pieter Lastman, Rembrandt's teacher. Van den Eeckhout's biblical paintings tend to be more Rembrandtesque than his mythological subjects. His portraits reflect Rembrandt's impact in lighting and the handling of paint but adopt the more conventional poses of Amsterdam portraiture of the period. Noteworthy among his group portraits are two large paintings of the *Officers of the Amsterdam Coopers and Wine-Rackers Guild* dated 1657 (National Gallery, London, no. 1459) and 1673 (Rijksdienst Beeldende Kunst, The Hague). Van den Eeckhout's genre scenes are more innovative. While his scenes dating from 1651 onward of soldiers relaxing in interiors owe something to the guardroom painters of the 1630s and possibly early Gerard Ter Borch

Gerbrand van den Eeckhout, *Self-Portrait*, signed and dated 1647, black chalk and wash, 265 x 202 mm., Institut Néerlandais, Paris, inv. 854A.

(1617–1681), they anticipate features of Pieter de Hooch's (1629–1684) earliest works. His scenes of elegant companies on terraces and in rich halls also look ahead to the greater elegance that Dutch genre adopted in the third quarter of the century. Besides painting and drawing, van den Eeckhout was active as an etcher and designed pattern books for gold- and silversmiths.

P.C.S.

Literature: Houbraken 1718–21, vol. 1, p. 174, vol. 2, p. 100; Immerzeel 1842–43, vol. 1, p. 215; Kramm 1852–64, vol. 2, p. 415; *Algemeene Nederlands Familieblad* 1 (1882–83), nos. 104, 105; A.D. de Vries 1885, p. 141; R. Bangel in Thieme, Becker 1907–50, vol. 10, pp. 355–57; Wurzbach 1906–11, vol. 1, pp. 481–83; Maclaren 1960, pp. 117–19; Plietzsch 1960, pp. 180–81; Sumowski 1962, pp. 11–37; Roy 1972; Sumowski 1979; Washington, D.C./Detroit/ Amsterdam 1980–81, pp. 141, 174–77; Sumowski 1983, vol. 2, pp. 719–909; Philadelphia/Berlin/ London 1984, pp. 200–201.

Mountain Landscape, 1663

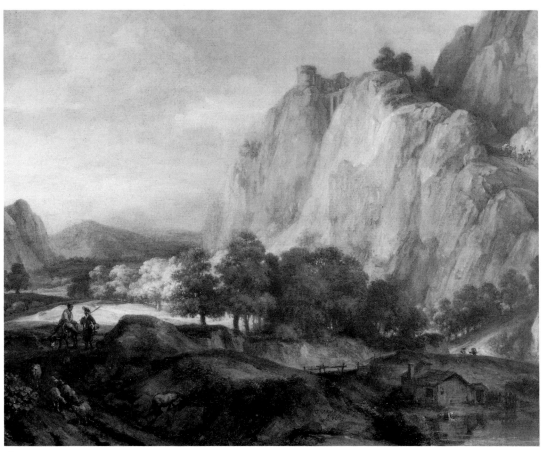

26

Signed and dated lower center: G.V. Eeckhout fe./A°1663
Oil on canvas, 20⅝ x 25⅝ in. (52.5 x 65 cm.)
Private Collection

Provenance: Sale, A.W. Mensing, Amsterdam (Frederik Muller), November 15, 1938, no. 31, ill.; H.W.O. Niewenhuys; van Heer collection; sale, Amsterdam (Mak van Waay), April 7, 1970, no. 40, ill.

Exhibitions: The Hague, Gemeente Museum, *Het landschap door Hollanders gezien*, 1922; Amsterdam 1970, no. 27, ill.; Brussels 1971, no. 29, ill.; London 1976a, no. 37, ill.; Yokohama/Fukuoka/Kyoto, *Rembrandt and the Bible*, 1986–87, no. 22, ill.

Literature: Isarlov 1936, p. 49; Roy 1972; pp. 198–225, no. 95; Sumowski 1983, vol. 2, no. 546, ill.

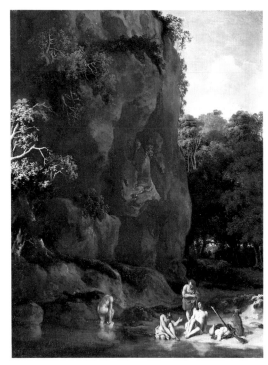

Fig. 1. Gerbrand van den Eeckhout, *Landscape with Men Bathing*, signed, panel, 45.5 x 33 cm., Rijksmuseum, Amsterdam, inv. A 1612.

A landscape with sheer mountains on the right and a screen of backlighted trees in the valley in the middle distance includes two travelers with sheep moving along a road on the left. The road reemerges on the right and ascends the mountain. In the lower right is a small cottage beside a lake.

Gerbrand van den Eeckhout executed numerous landscape drawings but few paintings.[1] His earliest dated landscape in oils is of 1642.[2] The *Landscape with Men Bathing* (fig. 1) in the Rijksmuseum, Amsterdam, bears a perhaps unexpected stylistic resemblance to the work of

Asselijn and the Italianate landscapists and has been related to van den Eeckhout's *Ruth and Boaz* of 1651 in the Kunsthalle, Bremen.[3] The exhibited work is dated 1663, hence was probably painted almost a decade later than the Amsterdam painting. Its darkened palette, dramatic contrasts of light and shade, and broad, painterly touch recall Rembrandt's landscapes, but the primary source of inspiration, as noted in the Amsterdam exhibition catalogue of 1970, was probably Roeland Roghman.[4] Houbraken mentioned Roghman and van den Eeckhout in the same breath as Rembrandt's "great" friends.[5] Sumowski correctly noted in the exhibited painting the general stylistic and compositional resemblance to Roghman's *Mountain Landscape with Waterfall* in the Rijksmuseum (fig. 2); he also related the work to two drawings that van den Eeckhout executed in 1661.[6]

In his dissertation on van den Eeckhout, Roy likened the motif of the massive peak with sheer rock face to the art of the Flemish landscapist Joos de Momper (1569–1635) while rightly characterizing the muted palette of browns and yellow earth colors as Rembrandtesque.[7] Although the treatment of the mountains surely descends from Flemish conventions, an intermediary may have been Esaias van de Velde, who painted several broadly executed mountain views.[8] Among Rembrandt's landscapes, those which provide the most significant precedents for van den Eeckhout's work are the mountain views in Paris and Kassel.[9] Though undated, a *Mountain Landscape* by van den Eeckhout formerly with Newhouse Galleries, New York (canvas, 66.5 x 82.5 cm.), and very similar to the present painting in its expansive design and painterly touch is probably also from the early 1660s.[10] Several of van den Eeckhout's history paintings from these years include extensive landscapes in a related style; see, for example, *Elisha and the Shunamite Woman*, dated 1664

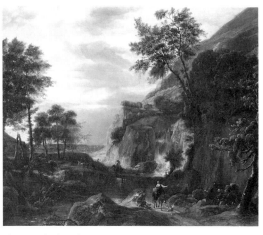

Fig. 2. Roeland Roghman, *Mountain Landscape with Waterfall*, canvas, 123 x 151 cm., Rijksmuseum, Amsterdam, inv. A 760.

(Szépművészeti Múzeum, Budapest, inv. 5610).[11]

P.C.S.

1. For van den Eeckhout's landscape drawings, see Sumowski 1979, vol. 3, nos. 670–695.

2. See sale, Higgins, London, June 14, 1928, no. 185.

3. See Sumowski 1983, vol. 2, no. 544.

4. Amsterdam 1970, p. 38, no. 27.

5. Houbraken 1718–21, vol. 1, p. 174. "Hy [Roghman] was in zyn tyd, met Gerbrant van den Eeckhout, een groot vriend van Rembrant van Ryn."

6. Sumowski 1983, vol. 2, under no. 544. See the *View of the Rhine near Arnhem*, Fitzwilliam Museum, Cambridge, no. PD 283-1963; and *Wooded Dune with Sunken Road*, British Museum, London; respectively Sumowski 1979, vol. 3, nos. 683 and 684.

7. Roy 1972, pp. 198, 225, no. 95 ("Mompers Felswande und Rembrandts Farbigkeit").

8. Compare Esais's *Landscape with Judah and Tamar* (not Ruth and Boaz), dated 1625, panel, 26.5 x 33 cm., private collection, United States (Keyes 1984, no. 2, pl. 151).

9. Bredius 1935, nos. 450, 454.

10. Sumowski 1983, vol. 2, no. 545, ill.

11. Ibid., no. 440, ill.

Allart van Everdingen

(Alkmaar 1621–1675 Amsterdam)

Baptized on June 18, 1621, in Alkmaar, Allart van Everdingen was the son of a notary and the brother of the history painter Caesar van Everdingen (1616/17?–1678). According to Houbraken, he was a pupil of Roelandt Savery in Utrecht and of Pieter de Molijn in Haarlem; both artists apparently influenced him. His earliest dated painting, a marine, is of 1640 (*Stormy Sea*, whereabouts unknown). In 1644 he annotated drawings of the southern coast of Norway, probably visiting Risor and Langesund, and the area around Göteborg, in Sweden. There is no proof, however, for Houbraken's claim that Everdingen was shipwrecked on the Norwegian coast.

Everdingen returned to the Netherlands by early 1645 and in February wed Janneke Cornelis Brouwers in Haarlem. At that time he was living in Alkmaar. On October 13, 1645, he became a member of the Reformed Church in Haarlem; only in the following year did he join the Haarlem guild. Also in 1646 he testified on behalf of his brother, Caesar, against Pieter Molijn regarding payment for a painting. In 1648 he and Caesar joined the Civic Guard of St. George. Four of Allart's children were baptized in Haarlem: Cornelis (1646), Aagje (1647), who died soon thereafter, Aagje (1648), and Elizabeth (1651). Houbraken also mentions two sons, Pieter and Jan, who apparently were not baptized in Haarlem. In 1652 Allart moved to Amsterdam and in 1657 became a citizen. A document of 1660 states that he had been living on the Coninxstraat for the past five years. He was still at that address in 1663, but by the time of his death in 1675 had moved to the Bantammerstraat. In 1661 Allart, Jacob van Ruisdael, Willem Kalff and Barend Kleeneknecht were requested to judge the authenticity of a seascape by Jan Porcellis (before 1584–1632). Drawings, etchings, and a painting by Everdingen of Montjardin Castle and other motifs in and around Spa (see Mauritshuis, The Hague, inv.

Jacob Houbraken, *Allart van Everdingen*, from Arnold Houbraken, *De groote schouburgh*, 1718–21, engraving.

953) and in the Southern Netherlands suggest an otherwise unrecorded visit to the Ardennes that Davies (1978, p. 39) would date around 1660 and Duparc (1980, p. 31) before 1654, both on stylistic grounds. Everdingen executed several landscapes for the Trip family house in Amsterdam.

Dead at the age of fifty-four, Everdingen was buried in the Oude Kerk in Amsterdam on November 8, 1675. A sale of a portion of his estate was held on March 3, 1676. However, the sale of his widow's estate on April 16, 1709, suggests that Everdingen, like many of his colleagues, may have had a second career as an art dealer; the sale purported to include works by Raphael, Giorgione, Annibale Carracci, Titian, Veronese, Holbein, Savery, Porcellis, Bueckelaer, Frans Hals, and Rembrandt.

A productive painter, draftsman, and etcher, Allart van Everdingen specialized in marine paintings and Scandinavian landscapes. He introduced the drama of Northern waterfalls, rocky escarpments, and wooden huts to Dutch landscape art, which influenced, among others, Jacob van Ruisdael, Jan van Kessel, and to a lesser extent Pieter de Molijn and Claes Berchem. Everdingen's only known pupil was the seascape painter Ludolf Bakhuizen (1631–1708), but he had followers, notably Jan van Kessel (1641–1680). His many etchings included Scandinavian landscapes, as well as a set of illustrations for the poem "Renard the Fox" and some of the earliest Dutch mezzotints.

P.C.S.

Literature: Houbraken 1718–21, vol. 2, pp. 95–96; Weyerman 1729–69, vol. 2, pp. 178–79; Dézallier d'Argenville 1745–52, vol. 3, p. 133; Gottsched 1752; Descamps 1753–64, vol. 2, pp. 319–21; Bartsch 1803–20, vol. 2, pp. 157–246; van Eynden, van der Willigen 1816–40, vol. 1, p. 407; Nagler 1835–52, vol. 4, pp. 167–71; Immerzeel 1842–43, vol. 1, pp. 225–26; Frenzel 1855; Kramm 1857–64, vol. 2, p. 445; Thoré 1858–60, vol. 1, p. 150, vol. 2, pp. 136–38; van der Willigen 1870, pp. 126–29; Drugulin 1873; Bruinvis 1899; Granberg 1902; Bruinvis 1903; Gothe 1903; Wurzbach 1906–11, vol. 1, pp. 497–500; Caffin 1911; E. Plietzsch in Thieme, Becker 1907–50, vol. 11 (1915), pp. 106–107; Hofmann 1920; Kalff 1922; Marguery 1926; van der Kellen 1928; Martin 1935–36, vol. 2, p. 310; Held 1937; Hollstein, vol. 6, pp. 153–204; Steneberg 1953; Steneberg 1955; Maclaren 1960, pp. 119–20; Hos 1961; Stechow 1966, pp. 121, 128, 143–46; Bol 1969, pp. 204–208; Davies 1972; Müllenmeister 1973–81, vol. 2, pp. 64–65; Davies 1978; The Hague, Mauritshuis cat. 1980, pp. 29–30; Snoep 1983; Boston/St. Louis 1980–81, pp. 180, 181, 185, 186; Haak 1984, p. 464.

Mountain Landscape with River Valley, 1647

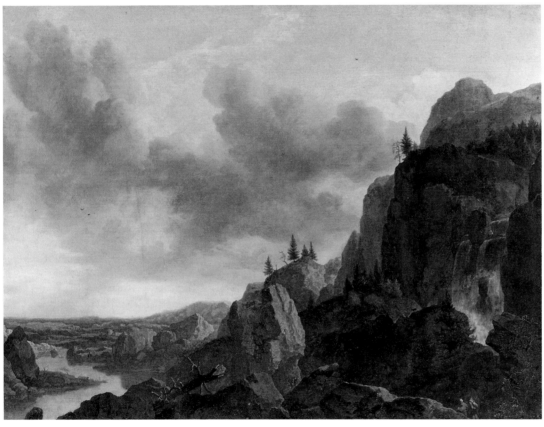

27

Signed and dated lower right center on rock:
A:EVERDINGEN/1647
Oil on canvas, 32½ x 43¾ in. (82.5 x 111 cm.)
Statens Museum for Kunst, Copenhagen,
no. SP. 513

Provenance: Purchased in Amsterdam in 1763.

Literature: Copenhagen, MS. cat. (eighteenth century), p. 133, no. 108; J.C. Spengler, *Catalog over Det kgl. Billedgalleri paa Christiansborg*, 1827, no. 513; Granberg 1902, no. 10; Sthyr 1929, pp. 14–15, 45, ill.; Copenhagen, cat. 1951, no. 210, ill.; Stechow 1966, p. 144; Davies 1978, pp. 114–18, no. 26, fig. 78.

In 1644, the year that van Everdingen traveled to Scandinavia, he dated two paintings – a Dutch dunescape in the style of van Goyen and de Molijn (with dealer A. van der Meer, 1964)[1] and the *Mountain Landscape with Water* (formerly Palmer collection, London),[2] a view of a placid lake and sheltered village with mountains and castles beyond. Fully three years separate these paintings from the next dated works by the painter: four paintings, executed, presumably with the aid of drawings, following his return to the Netherlands. These offer a far rougher and, paradoxically, more naturalistic image of the mountainous northern terrain than did the Palmer collection picture. Copenhagen's painting of a boulder-strewn river valley with steep rock cliffs, rushing cataracts on the right, and a twisting river at the left is typical of this pioneering group. For Everdingen, 1647 was a watershed year in which he made innovative advances not only in his technique but also in his subject matter, firmly establishing for the first time the favored Northern themes of his career: views of mountains, rocks, valleys, cataracts, and waterfalls. The staffage in the Copenhagen painting – two tiny travelers at the lower right, another pair almost undetected at the lower center, and a boat plying the river – typically are dwarfed by their dramatic surroundings. As

Fig. 1. Allart van Everdingen, *Mountain Landscape with Small Waterfall*, signed and dated 1647, panel, 48.2 x 60.3 cm., Niedersächsisches Landesgalerie, Hannover, inv. PAM 784.

Davies observed, this work is the painter's "mountain landscape *par excellence* . . . a reverent [and] awesome view of the Nordic high country."[3]

Very similar in conception and style but painted on smaller panels are two of Everdingen's other mountain views signed and dated 1647 in Hannover and Braunschweig (fig. 1 and cat. 14, fig. 1). In the former, the influence of the Tirolean views by Everdingen's teacher, Roelandt Savery, is especially apparent in motifs like the silhouetted elk, but both works by Everdingen are indebted to the earlier artist for their massing of huge dark rock forms that bristle with pine trees against the stormy sky.[4] Despite these debts, Savery's idyllic art is traded for a more untamed, forbidding view of nature. The only earlier Dutch artist who concentrated on desolate mountainous terrain was Hercules Segers (see Introduction, figs. 45, 46), but despite certain points of comparison between the two painters' designs, Segers's visionary,

primordial landscapes expose Everdingen's devotion to observed fact supplemented by picturesque detail.

The cascades in the Copenhagen and Hannover paintings also remind us that Savery undoubtedly stimulated Everdingen's interest in waterfalls; but in Everdingen's work of this early period the great cataracts and smaller torrents have a new naturalistic fidelity. Like his carefully modeled rock forms, the rushing, foaming water is recorded with a delicate hand. The triumph of Everdingen's early efforts in this regard is the *Waterfall*, the fourth dated work of 1647, in Leningrad (cat. 28, fig. 1). Everdingen's later mountain views and waterfalls develop a far more painterly touch and expressionistic vision; the landscapes become an internalized, private northern vision.

P.C.S.

1. Panel, 30 x 50 cm., photo in the RKD; not in Davies 1978.

2. Davies 1978, no. 21, fig. 63; with Bruno Meissner in Zurich, 1976.

3. Ibid., p. 108.

4. Davies (1978, p. 115) has related the Copenhagen painting to Savery's drawing *Mountain Landscape with Travelers*, dated 1608, in the Kunsthistorisches Museum, Vienna (her fig. 79), suggesting that Everdingen in this painting may have borrowed "the height of the slopes from his master . . . [but] the isolation and savagery of [Everdingen's] landscape separates it from Savery's."

28 (PLATE 95)

Scandinavian Waterfall with a Water Mill, 1650

Signed and dated lower right: A.v. Everdingen/1650

Oil on canvas, 44⅛ x 34⅝ in. (112 x 88 cm.)

Bayerische Staatsgemäldesammlungen, Alte Pinakothek, Munich, inv. 387

Provenance: Purchased by de Vigneux in 1792 for the Electoral Gallery; Hofgarten Gallery; transferred to the Alte Pinakothek in 1836.

Literature: Granberg 1902, no. 73; Wurzbach 1906–11, vol. 1, p. 498; Stechow 1966, pp. 144–45, 213, note 12, fig. 287; Davies 1978, pp. 32, 137, 153, 158, 221, 235, no. 58, fig. 8.

A Scandinavian waterfall descends from right to left with large darkened boulders in the foreground and a pine-covered hillside on the far bank. Also on the opposite bank is a water mill constructed of heavy logs. Three men and a dog stand on the near rocks looking down at the foaming water. Goats and sheep appear on both banks. Tall mountains rise in the distance.

Although the date on this painting was correctly deciphered in 1909 by Wurzbach as 1650,[1] it has sometimes been misread as 1656.[2] Stechow and Davies both certified the date of 1650 and related the painting to the *Northern Waterfall* dated three years earlier in the Hermitage (fig. 1).[3] The Leningrad painting is Everdingen's earliest dated treatment of the waterfall theme, the subject for which he is best known. However, the Leningrad painting still employs a horizontal composition. Davies noted that the upright design of the Munich picture is anticipated by a waterfall painting dated 1648 that was with the Leger Gallery in 1972 and is now on loan to the Niedersächsisches Landesgalerie, Hannover (fig. 2).[4] This vertical design was to become Everdingen's preferred and most influential composition type. He continued to repeat it until at least 1670 (Musée des Beaux-Arts, Rouen, inv. 850–2), and it had a formative effect on Jacob van Ruisdael's waterfalls (see cat.

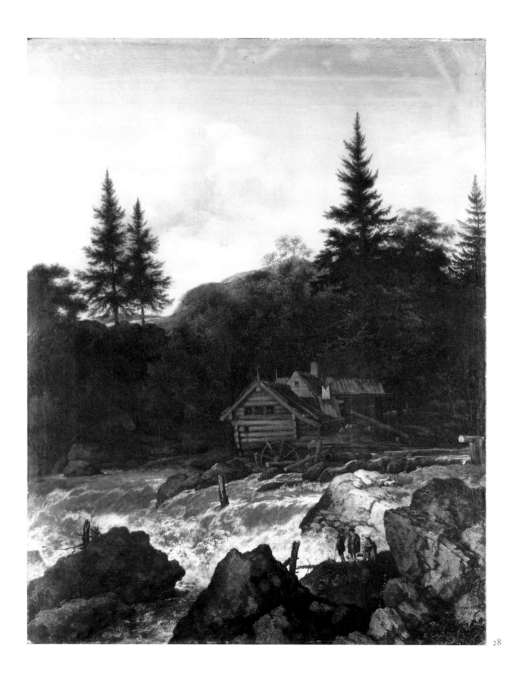

28

85). The Leningrad, Hannover, and Munich paintings share elements (the crashing water, huge foreground rocks, spiky pines, wooden buildings, and broken and decaying logs), but the two upright paintings employ a lower point of view that moves the spectator closer to the subject. The horizon ascends to nearly three-quarters of the design, the roaring water and spray loom ever larger; the effect is of greater immediacy. Everdingen achieved a similar immediacy through comparable adjustments of design in his marine paintings in this period.[5]

Although Everdingen actually depicts a tiny draftsman sketching the dramatic scene in the Hermitage's painting and occasionally recorded actual waterfalls in his own Scandinavian drawings (see, for example, the *Waterfall at Mölndal*, signed, black chalk and ink, 197 x 194 mm., Mölndal Museum),[6] his paintings of waterfalls were all executed from memory after he had returned to the Netherlands. The staffage usually is also by his own hand, although occasionally (see Rijksmuseum, Amsterdam, inv. A 641, dated 1655, with the figures possibly by Claes Berchem) he apparently collaborated. In this imaginary reconstruction of waterfalls, Everdingen naturally consulted artistic tradition. Steland has traced the development of paintings of waterfalls back to Northern artists working in Rome.[7] According to her, the theme originated with Paul Bril's paintings around the turn of the seventeenth century and developed around 1640 into the first paintings in which the waterfall became the primary pictorial motif in the art of Herman van Swanevelt, Jan Both, and Jan Asselijn (see, especially, Asselijn's *Mountain Landscape with Waterfall*, Galleria Palatina, Florence, inv. 1045, which Steland compares with Everdingen's *Waterfall* in Leningrad).

At least as important for Everdingen, however, were the waterfall studies by his teacher, Roelandt Savery, and possibly also the art of

Fig. 1. Allart van Everdingen, *Northern Waterfall*, signed and dated 1647, canvas, 111 x 115 cm., Hermitage, Leningrad, inv. 1901.

Fig. 2. Allart van Everdingen, *Waterfall*, signed and dated 1648, canvas, 85 x 70 cm., private collection, on loan to the Niedersächsisches Landesgalerie, Hannover.

Esaias van de Velde. Just as Everdingen journeyed to Norway to study the mountainous scenery, Savery traveled forty years earlier to Tirol to record the dramatic scenery for Rudolf II of Prague. As Davies has observed, Savery's drawing in the Rijksprentenkabinet (fig. 3), which actually bears a false Everdingen monogram, is a logical point of departure for Everdingen's Scandinavian scenes.[8] The fir trees, rock formations, log buildings, and stepped falls already anticipate the main motifs of Everdingen's painting in Munich. Just as Everdingen would reduce the mannered artifice of Savery's waterfalls, so Ruisdael made naturalistic advances over Everdingen's achievement.[9] Ruisdael's refinements, which solidify the designs and clarify surfaces and textures while heightening the dramatic effect, are all the more remarkable given the fact that he never seems to have traveled to Scandinavia. Wiegand has interpreted Ruisdael's waterfalls and fast-moving streams as symbols of transitoriness and mortality;[10] however, it seems likely that if Everdingen intended a moral message, it was supplemental to the primary theme of the exotic drama of these Northern scenes.

In addition to Ruisdael, Jan van Kessel (1641/42–1680) and Roeland Roghman apparently were influenced by Everdingen's waterfalls. His works of this type also seem to have brought relatively good prices in their day; two waterfalls by Everdingen in the inventory (January 18, 1669) of Laurens Mauritsz Douci appraised by Ferdinand Bol and Gerrit Uylenburgh were estimated respectively at sixty and twenty-five guilders, while two other waterfalls by Jacob Ruisdael ("de jonge Ruysdale") were appraised respectively at forty-two and thirty-six guilders.[11] Everdingen's prices and regard fell in the eighteenth century, when Dutch Italianate landscapes were favored. But he was singled out for praise by Goethe in 1784 (the

Fig. 3. Roelandt Savery, *Mountain Landscape with Waterfall*, crayon, watercolor, and gouache, 381 x 410 mm., Rijksprentenkabinet, Amsterdam, inv. 31 182.

poet actually copied several of Everdingen's landscapes) and began to come back into fashion as early as about 1820.[12] The close resemblance to Everdingen's Scandinavian scenes with waterfalls of the art of the Norwegian painter Johan Christian Dahl (1788–1857) attests to the nineteenth century's revival of interest in the Dutch painter.

P.C.S.

1. Wurzbach 1906–11, vol. 1, p. 498.

2. See the Munich, Alte Pinakothek catalogues, and Roh 1921, fig. 152.

3. Stechow 1966, p. 144; Davies 1973, p. 137.

4. Davies 1973, pp. 137–38.

5. See Davies 1973, pp. 62–63, and esp. the *Stormy Sea*, Museum der bildenden Künste, Leipzig, inv. 1007.

Govaert Flinck

(Kleve 1615–1660 Amsterdam)

6. See Davies 1973, fig. 137. The sheet is inscribed "molen-dael buyten Gothenburgh na 't leven." For discussion, see Held 1937. In her thorough study of Everdingen's oeuvre, Davies found very little correlation between his Scandinavian drawings and paintings, suggesting that he rarely worked directly from his sketchbooks.

7. Ann Charlotte Steland, "Wasserfälle: Die Emanzipation eines Bildmotivs in der holländischen Malerei um 1640," *Niederdeutsche Beiträge zur Kunstgeschichte* 24 (1985), pp. 85–104.

8. See Davies 1973, p. 117.

9. For a detailed contrast of the waterfalls of Everdingen and Ruisdael, see Stechow 1966, p. 145.

10. See Wiegand 1971, pp. 87ff. See also Raupp 1980, p. 90, who quotes 2 Samuel 14:14.

11. Bredius 1915–22, vol. 2, pp. 422ff. "A painting [*stuck*] by Everdingen" (but possibly by Allart's brother, Caesar) brought the sizable sum of fl.150 in the famous inventory of the art dealer Johannes de Renialme of 1657; see ibid., vol. 1, p. 232.

12. See Hofmann 1920, p. 189; for the history of Everdingen's appreciation, see Davies 1973, pp. 1–27.

Govaert Flinck, *Self-Portrait*, c.1640, black chalk and wash, 109 x 98 mm., Prentenkabinet der Rijksuniversiteit, Leiden, inv. AW 387.

Govaert Teunisz (Antonisz) Flinck was born in Kleve on January 25, 1615. Houbraken states that he was sent to Leeuwarden in Friesland to study with Lambert Jacobsz (c.1600–1637) and afterward went with Jacob Backer (1608–1651) to Amsterdam. Flinck probably moved permanently to Amsterdam around 1633, where he studied with Rembrandt until about 1636. He fully absorbed Rembrandt's style and approach to design, producing works – above all portraits and history paintings – in the 1630s and early 1640s that have often been confused with Rembrandt's works. It is also probable that he participated in the execution of some of Rembrandt's paintings from these years (e.g., *The Sacrifice of Abraham*, 1636, Alte Pinakothek, Munich, no. 438). Flinck received important commissions for militia company portraits in Amsterdam in the 1640s and also won patrons in his native Germany. In 1645 he married Ingertje Thoveling. Three years later he painted the militia banquet in celebration of the Peace of Münster of 1648 (Rijksmuseum, Amsterdam, inv. C 1).

Flinck built a large studio and collected classical sculpture as well as paintings and decorative arts. As his painting manner grew more elegant in the manner of van Dyck and Flemish painters, he won still more important commissions, including decorations for the Huis ten Bosch and the new Town Hall in Amsterdam in 1656 and later. In November 1659 he was asked to paint twelve additional compositions (on the struggles of the Batavians under Claudius Civilis and the Romans, and depictions of ancient heroes) for the Town Hall, surely the most prestigious commission of his career. After executing four of these works provisionally in watercolor, he died unexpectedly at the height of his fame at only age forty-five in Amsterdam on February 2, 1660. The Town Hall commission was divided among other artists, including Jan Lievens (1607–1674), Jacob Jordaens (1593–1678), and Rembrandt. One of Flinck's unfinished compositions eventually was completed by Juriaen Ovens (1623–1678) and replaced Rembrandt's *Conspiracy of Claudius Civilis* (Nationalmuseum, Stockholm, inv. 578).

Praised by leading poets such as Joost van den Vondel and Jan Vos, Flinck was one of the most successful artists of his age. His early works – portraits and *tronien*, history paintings, allegorical subjects, and landscapes – are very close in manner to Rembrandt's paintings, while over the course of the 1640s he developed a more elegant, international style closer to the fashionable portraitists Bartholomeus van der Helst (c.1613–1670) and Adriaen Hanneman (1601–1671). Though active both as a draftsman and

painter of landscapes, his landscapes are rare. Johannes Spilberg (1619–1690) was Flinck's pupil.

P.C.S.

Literature: Wagenaer, vols. 7 and 11; de Bie 1661, p. 280; van Zesen 1664, p. 360; Sandrart 1675, p. 319; Houbraken 1718–21, vol. 2, pp. 18–21; van Eynden, van der Willigen 1816–40, vol. 1, p. 402; Kramm 1857–64, vol. 2, pp. 492–94; Havard 1879–81, vol. 2, pp. 71–174; Wurzbach 1906–11, vol. 1, pp. 537–39; Hofstede de Groot in Thieme, Becker 1907–50, vol. 12 (1916), pp. 97–100; H. Schneider 1925, pp. 216–17; Welcker 1940, pp. 115–22; Maclaren 1960, pp. 131–32; von Moltke 1965; Sumowski 1979, vol. 4, pp. 1883–2166; Washington, D.C./Detroit/Amsterdam 1980–81, pp. 164–67; Dudok van Heel 1982, pp. 70–90; Sumowski 1983, vol. 2, pp. 998–1151; C. Schneider 1984a.

Landscape with Obelisk, 1638

29

Signed (falsely) and dated: R. 1638
Oil on panel, $21\frac{5}{8}$ x $28\frac{1}{8}$ in. (55 x 71.5 cm.)
Isabella Stewart Gardner Museum, Boston,
2PIW24

Provenance: Ducal collection, Kassel, 1775 inventory, no. 390 (as Flinck) and cat. 1783, no. 46 (as Flinck); Jérôme Bonaparte; possibly sale, Woodburn, London (Christie's), May 15–19, 1854, no. 77 (£9); sale, Baron de Beurnonville, Paris, May 9, 1881, no. 434, May 21, 1883, no. 84 (probably bought in), and June 2, 1884, no. 292 (to dealer A. Posonyi, Vienna, for frs.4,690); Georg von Rath, Budapest; purchased from P. & D. Colnaghi, London, in 1900 (through Bernard Berenson).

Exhibitions: Amsterdam, Stedelijk Museum, *Rembrandt*, 1898, no. 41 (as Rembrandt).

Literature: Kassel, cat. 1783, no. 46 (as Flinck); Dutuit 1883–85, p. 22 (as not by Rembrandt); Michel 1893, pp. 314, 559; Bode, Hofstede de Groot 1908–27, vol. 4, no. 230, ill.; Hofstede de Groot 1908–27, vol. 6, no. 941; Valentiner 1908, p. 231, ill.; Eisler 1918, p. 190, fig. 116; Bode 1925 (as not by

Rembrandt); Boston, Gardner cat. 1931, p. 297; Benesch 1935, p. 26; Bredius 1935b, no. 443, ill.; H. Gerson, *Burlington Magazine* 98 (1956), p. 280; Knuttel 1956, pp. 113, 279; von Moltke 1965, no. 154 (as wrongly attributed to Flinck); Bauch 1966, no. 546, ill. (c.1639?); Rosenberg et al. 1966, p. 58; Stechow 1966, p. 136, ill.; Gerson 1968, no. 198, ill.; Bredius, Gerson 1969, p. 589, ill.; Haak 1969, p. 148, fig. 231; Hamann 1969, p. 298; Sumowski 1969, pp. 298, 453; Chicago/Minneapolis/Detroit 1969–70, p. 704; Boston, Gardner cat. 1974, pp. 204–206, ill.; Kahr 1978, p. 117; Larsen 1983, pp. 65–66, pl. 6; Sumowski 1983, vol. 2, no. 719, ill. (as Flinck); C. Schneider 1984a (as Flinck); Schwartz 1985, p. 251, fig. 284 (as Flinck); C. Tümpel 1986, p. 226, no. A 121, ill. (as Flinck).

In a stormy landscape a fabulous gnarled and broken tree rises in the right foreground beside a road that weaves back over a bridge to a dramatically lit obelisk. Two travelers in fanciful dress, one mounted and the other on foot carrying a hawk move toward the viewer in the foreground. A small water mill appears beside the river on the left. A cart and, in the left distance, a coach travel along the road. Distant mountains rise above the central horizon.

This painting appears in virtually all of the Rembrandt literature as the work of that master and until recently was catalogued and labeled as such. Now, however, it is again recognized as the work of Rembrandt's pupil Govaert Flinck. The painting appeared in a 1775 inventory and 1783 catalogue of collections of the Hessian Dukes of Kassel as the work of Flinck.[1] Moreover, it bears remnants of that artist's signature, which was altered by a later (probably nineteenth-century) hand – the final *k* being transformed into an *R*.[2] Dutuit in 1885 questioned the attribution to Rembrandt, as did Bode in 1925,[3] but it was not until 1975 that P.J.J. van Thiel of the Rembrandt Research Project (privately) noted the connection with the ducal inventories and the possibility of reassignment to Flinck.[4] Peter

Fig. 1. Govaert Flinck, *Landscape with a Bridge and Ruins*, signed and dated 1637, panel, 49.5 x 74.9 cm., Musée du Louvre, Paris.

Fig. 2. Rembrandt van Rijn, *Obelisk at Halfweg*, etching.

Schatborn then discovered the remnants of the original Flinck signature in 1981.[5]

The work's reassignment to Flinck is further supported by the recent appearance of a second landscape by Flinck dated 1637 and acquired by the Louvre (fig. 1).[6] That work also depicts a dramatically lit landscape with silhouetted ruins, bridge, figures, and carts moving along a road. The blond palette of browns and earth colors is also comparable. X-rays of the Louvre painting indicate that the tree on the right once was twice its present height and breadth, and, like the dominant motif in the Gardner painting, extended tendril-like branches toward the

center. Thus the painting originally was even closer in character to the Gardner picture. At present these two works are the only known landscapes by Flinck, but other landscapes appear in early references cited by Moltke and Dudok van Heel,[7] and still others may carry misattributions. At least one certain landscape by Flinck appears in the background of his double portrait *Dirck Graswinckel and His Wife, Geertruyt van Loon* (signed and dated 1646, Museum Boymans-van Beuningen, Rotterdam, inv. 1206), where a tree not unlike that in the Gardner painting rises behind the couple. In the background of Flinck's early *Return of the Prodigal Son* (North Carolina Museum of Art, Raleigh, no. 52.9.41), there also appears a landscape with an obelisk.[8]

According to Houbraken, within a year of his arrival in Rembrandt's studio Flinck had so thoroughly absorbed Rembrandt's style that his works often passed or sold as authentic paintings by the master.[9] How close Flinck's rare landscapes could come to those of Rembrandt's is borne out by a comparison of the *Landscape with Obelisk* and Rembrandt's *Landscape with the Good Samaritan* dated the same year (see p. 96, fig. 19). The design, with large tree in the foreground and threatening, theatrically contrasted vista beyond, is very similar, as are the treatment of individual motifs and details such as the foliage and staffage. Flinck also apparently followed his master in his limited production of landscapes in oils; not more than ten authentic landscape paintings are known by Rembrandt, and all of them seem to date from about a ten-year period, 1636–46. Rembrandt also may have helped to pique Flinck's interest in such exotic architectural motifs as obelisks. As Lugt noted in discussing Rembrandt's well-known etching the *Obelisk at Halfweg (Spieringhorn)* (fig. 2), there were two obelisks in the vicinity of Amsterdam, one in Sloten and one halfway between Amster-

Johannes Glauber

(Utrecht 1646–1726 Schoonhoven)

dam and Haarlem.[10] As boundary markers and milestones, obelisks in the Netherlands probably had strong associations. They constituted juridical signposts, which alerted travelers when they were entering or leaving zones governed by municipal law. Egbert Haverkamp Begemann has speculated that among the obelisk's associations in Flinck's work was the idea that it separated the cultivated landscape from the exotic, imaginary scenery beyond.[11]

P.C.S.

1. *Inventarium B*, c.1775, no. 390, as well as in the First Supplement of the Inventory of 1749, no. 390, compiled c.1817–19. These documentary citations, as well as a full account of the work's reassignment to Flinck were first published by Cynthia Schneider (1984a).

2. See detail photo, C. Schneider 1984a, fig. 16. As Sumowski (1983–86, no. 719) observed, this same devious alteration was performed on Flinck's signature on the *Portrait of the Forty-Four-Year-Old Man*, Mauritshuis, The Hague, inv. 866. However, many earlier authors, including Bode and Hofstede de Groot (1897–1906, vol. 4, no. 230), Valentiner (1908), Hofstede de Groot (1915, no. 941), Knuttel (1956, pp. 113, 279), Bauch (1966, no. 546), Haak (1969, p. 148), had doubted the putative Rembrandt monogram.

3. Dutuit 1883–85, p. 22; Bode 1925, p. 159.

4. Letter of February 1975; see C. Schneider 1984a, p. 18, note 7.

5. See Sumowski 1983, no. 719; and C. Schneider 1984a, p. 18, note 8.

6. Sumowski 1983, no. 718.

7. Von Moltke 1965, no. D229. Dudok van Heel (1982, pp. 118, 119) refers to landscapes by Flinck in Amsterdam inventories of 1647 and 1653.

8. Sumowski 1983, vol. 2, no. 616.

9. Houbraken 1718–21, vol. 2, pp. 20–21: "Vond hy zig geraden een jaar by Rembrant te gaan leeren; ten einde hy zig die behandeling der verwen en wyze van schilderen gewende, welke hy in dien korten tyd zoodanig heeft weten na te bootsen dat verschieden van zyne stukken voor eghte penceelwerken van Rembrant wierden aangezien en verkogt."

10. Lugt 1915, pp. 152–55; Bartsch, no. 227.

11. Recorded by C. Schneider (1984a, p. 11, note 29).

Johannes Glauber, son of German émigrés, was baptized in the Lutheran church in Utrecht on May 18, 1646. He studied with Claes Berchem in Amsterdam for about nine months in the mid-1660s, then worked for the Amsterdam dealer Gerrit Uylenburgh, as one of many young artists employed in manufacturing copies of Italian paintings. Accompanied by his sister Diana (1650–after 1721) and brother Jan Gottlieb (1656–1703), who were also painters, Glauber embarked on a prolonged journey to Italy in 1671. After working for a dealer in Paris for a year, he studied with the expatriate Dutch landscape painter Adriaen van der Cabel (1631–1705) in Lyon for two years. Glauber was in Rome by 1675 and joined the Schildersbent, using the nickname "Polidor" in recognition of his debt to the Italian landscapist Polidoro da Caravaggio. During his two or more years in Rome, Glauber became close friends with Karel du Jardin and Albert Meyeringh (1645–1714); the latter accompanied him on his subsequent travels to Padua, Venice, Hamburg, and finally Copenhagen, where Glauber worked for the Danish count Ulrik Gyldenlove.

In 1684 Glauber returned to Amsterdam, where he shared a residence with the history painter and theoretician Gerard de Lairesse (1641–1711). With Lairesse he presided at meetings of the classicizing literary society Nil Volentibus Arduum. The two artists also collaborated on decorative commissions for the stadtholder's palaces Soestdijk and Het Loo, as well as other commissions from the wealthy bourgeoisie of Amsterdam and Rotterdam. Glauber joined the painters' confraternity in The Hague in 1678, although there is no record of his having moved to that city. His only dated painting is of 1686 (Louvre, Paris, inv. 1301). He married Susannah Vennekool, sister of the architect Steven Vennekool, on March 28, 1704. He retired to the Proveniershuis in Schoonhoven

in 1721 and died there in 1726.

Together with Jacob de Heusch (1656–1701) and Jan Frans van Bloemen (1662–1749), Glauber was a leader of the "third generation" of Dutch Italianate landscape painters. His pleasant campagna landscapes in the manner of Gaspard Dughet (1615–1675) are accented with small-scale mythological or biblical figures. Their popularity in the late seventeenth and early eighteenth centuries is evidence of the Dutch taste for an international style of academic classicism. Gerard de Lairesse sometimes painted the figures in Glauber's landscapes, and Glauber in turn provided landscape backdrops for many of Lairesse's history paintings. The two artists worked together on the Amsterdam house of Jacob de Flines, about 1687 (Rijksmuseum, Amsterdam, inv. A 4213-16). Glauber was a prolific printmaker, producing etchings after his own designs, as well as those by Dughet and Lairesse.

M.E.W.

Literature: de Monconys 1665–66, p. 179; Houbraken 1718–21, vol. 3, pp. 66, 210, 216–19; Weyerman 1729–69, vol. 3, pp. 55–57; Dézallier d'Argenville 1745–52, vol. 3, p. 173; Descamps 1753–64, vol. 3, pp. 187–90; Bartsch 1803–21, vol. 5, pp. 377–99; Nagler 1835–52, vol. 5, pp. 232–34; Immerzeel 1842–43, vol. 1, p. 280; Kramm 1857–64, vol. 2, p. 575; Nagler 1858–79, vol. 3, no. 2405; Michiels 1865–76, vol. 10, pp. 222, 226, 241–43; Obreen 1877–90, vol. 4, pp. 109, 156, 211; Cazenove 1888, p. 38; Upmark 1900, p. 125; Wurzbach 1906–11, vol. 1, p. 587; W. Dirksen in Thieme, Becker 1907–50, vol. 14 (1921), pp. 243–44; Gerstenberg 1923, p. 137; Martin 1935–36, vol. 2, p. 452; Hoogewerff 1942–43, pp. 59–60, 216, 470; Stechow 1966, pp. 164–65; Snoep 1970, pp. 194–97; Kaemmerer 1975, pp. 81–100; Zwollo 1973, pp. 10–19; Salerno 1977–80, vol. 2, pp. 826–29, vol. 3, pp. 1052–53; New York 1985b, pp. 195–97.

Landscape with King Midas Judging the Musical Contest
between Pan and Apollo, 1690s

30

Signed lower right: I GLAUB . . .
Oil on canvas, 26½ x 35¾ in. (67.3 x 90.8 cm.)
Museum of Fine Arts, Boston, Juliana Cheney
Edwards Collection, 1979.287

Provenance: Purchased from Somerville and Simpson,
Ltd., London, 1979.

Literature: Boston, MFA cat. 1985, p. 119, ill.

Although the Judgment of Midas is a popular
and well-illustrated episode from the *Meta-*
morphoses, the usual title is something of a
misnomer, for it does not reflect the actual se-
quence of events in Ovid's narrative. Pan, over-
confident and boasting of his musical prowess,
was invited by the mountain god Tmolus to
test his skill in a contest against Apollo. First
Pan played his pipes, then Apollo his lyre.
Tmolus decided in favor of Apollo, a judgment
accepted by all except King Midas, who was
rewarded with ass's ears as a consequence of his
stupidity.[1]

Glauber has placed the scene in a sunny
clearing framed by a brook in the foreground and
a grove of trees beyond. Although Pan is seen to
be playing his pipes, Midas invites Apollo to
begin his piece. The final judgment has not yet
been rendered, for the king's ears are still in
their human form. Several listeners are grouped
around the three main protagonists, and, in the
foreground, a river god and nymph disport
themselves in the water. The remainder of the
landscape is an idealized view of the Roman
campagna, a gently rolling land accented with
classical ruins and monuments and bounded by a
mountain range.

While continuing a long tradition of Northern
Italianate landscape painting, the Italianate
scenes of Glauber and other late seventeenth-
century landscapists such as Jacob de Heusch,
Albert Meyeringh, and Isaac de Moucheron
(1667–1744) are quite different from those of
their predecessors. Rather than illustrating the
picturesque Italy of the seventeenth century or
the remnants of its glorious past, these artists
evoke the dreamlike serenity of a mythical
golden age completely removed from reality.
Stylistically, this group of painters favored an
internationally fashionable classicism heavily
influenced by the arcadian landscapes of Claude,
Gaspard Dughet, and Nicolas Poussin; through
conscious effort, there is little in their work that
is recognizably Dutch. Glauber's debt to
Poussin's landscape compositions is particularly
evident, notable in the measured order of land-
scape forms, the clear midday light giving a
sense of arrested time, and the vivid accent of
primary colors placed against the subdued green
tones of the landscape.

In addition to these purely formal influences,
however, Glauber has attempted a union of
landscape and narrative in which the forms of
the landscape are clearly related to the illus-
trated theme, a concept developed in the land-
scapes of Poussin and Claude.[2] In the exhi-
bited work, for example, the rugged mountain

dominating the center of the composition is probably a reference to Tmolus, the god incarnate as a mountain: "Tmolus, looking far out upon the sea, stands stiff and high, with steep sides extending along one slope to Sardis and on the other reaches to little Hypaepae."[3] Most earlier representations of the Judgment of Midas include Tmolus as a bearded old man, actively involved in the scene, and place little emphasis upon the landscape setting. Although a mountain is included in a few versions – such as Pieter Lastman's *Judgment of Midas* in Kassel (Gemäldegalerie, no. 188) – it is always in conjunction with the god present in human form. Glauber's composition is therefore unusual in including the mountain as a symbol for, rather than as an attribute of, the god. His incorporation of Tmolus into the extensive landscape is not only a subtle interpretation of Ovid's text but also an evocation of an actual landscape in Asia Minor.

Glauber's classical landscapes are in many respects visual expressions of the theories outlined in Gerard de Lairesse's *Het Groot Schilderboek*. The two artists worked closely together after Glauber's return to Amsterdam in 1684, and both were members of the classicizing literary society Nil Volentibus Arduum. In the *Schilderboek*, Lairesse stresses the importance of choosing a landscape setting appropriate to a scene from antiquity and of selecting the correct staffage and buildings with which to fill the landscape. To illustrate his point, he gives an example of a "laughable" juxtaposition of a classical scene set within a Rhineland landscape.[4] In a general context, Lairesse also applauds the originality of such paintings as Glauber's *Judgment of Midas*. While he recognizes the knowledge to be gained through the study of paintings and prints, he urges artists not to derive all their ideas from other artists' representations of a certain theme but to return to the text and read it carefully for new and correct

interpretations. In short, he concludes, the goal of the artist should be twofold: to educate and enlighten the art lover through the beautiful representation of a didactic tale and to amuse the scholar through a sensitive and accurate depiction of a familiar theme.[5]

These requirements are amply met in Glauber's painting, which depicts a well-known tale within a fashionable arcadian setting and, in addition, presents a subtle reading of Ovid's narrative to the knowledgeable seventeenth-century eye. It is not surprising that Lairesse recommended Glauber in his *Schilderboek* as one of the few modern landscape painters whose works were worthy of study and emulation by younger artists.[6]

M.E.W.

1. Ovid, *Metamorphoses* 11.146–79.

2. For more detailed investigations of landscape theory in the works of these artists, see Blunt 1967, vol. 1, pp. 268–300; and Roethlisberger 1961, vol. 1, pp. 23–26.

3. Ovid, *Metamorphoses* 11.150–52.

4. Lairesse 1707, p. 343. Earlier landscape painters, of course, had no such compunctions. For example, Gillis van Coninxloo's *Landscape with the Judgment of Midas* (cat. 19, fig. 1) places the scene from Ovid in just such a Rhineland landscape as Lairesse cautioned against, complete with medieval castles and fortresses.

5. Ibid., p. 131.

6. Ibid., p. 419. The other landscapists recommended were Francesco Albani, Abraham Genoels, and Gaspard Dughet.

Jan van Goyen
(Leiden 1596–1656 The Hague)

Gerard ter Borch, *Portrait of Jan van Goyen*, panel, 20 x 15 cm., Schloss Vaduz, Liechtenstein.

Jan Josephsz van Goyen, the son of a shoemaker, was born in Leiden on January 13, 1596. According to J.J. Orlers (1641), he was a pupil from 1606 onward in Leiden, successively, of Coenraet van Schilperoort (c.1577–1635/36), Isaack van Swanenburch (c.1538–1614), Jan de Man (active early seventeenth century), and the glass painter Hendrick Clock, and later worked for two years under Willem Gerritsz at Hoorn. Orlers further claimed that van Goyen subsequently returned to Leiden, traveled in France for a year, and finally returned to Haarlem, where he became a pupil of Esaias van de Velde. He married Annetje Willemsdr van Raelst at Leiden in 1618, was still living there the following year, and in 1625 bought a house on the St.

Summer, 1625

Peterskerkstraat, which he sold in 1629 to Jan Porcellis (before 1584–1632), the marine painter. He is mentioned regularly in Leiden documents of 1627–32. Van Goyen probably moved to The Hague in the summer of 1632, and he became a citizen two years later. Sometime in 1634 he was painting in Haarlem at the house of Isaack van Ruisdael (1599–1677), the brother of Salomon. In 1635 he bought a house in The Hague on the Veerkade and the following year built the house on the Dunne Bierkade in which the animal and landscape painter Paulus Potter lived from 1649 to 1652. Until his death van Goyen was regularly mentioned in The Hague as living in his house on the Wagenstraat. He was named *hoofdman* of The Hague guild in 1638 and 1640. In 1649 his two daughters were married: Maria to the still-life painter Jacques de Claeuw (died after 1676?), and Margarethe to Jan Steen (1625/26–1679). In 1651 van Goyen painted a panoramic view of The Hague for the city's Town Hall. He died at The Hague on April 27, 1656, and was buried in the Grote Kerk. Throughout his life van Goyen had speculated with little success in various businesses, including real estate and tulips.

Jan van Goyen was one of the greatest and most prolific seventeenth-century Dutch landscapists. His early works (prior to 1626) closely resemble those of his teacher Esaias van de Velde. Thereafter he developed a new "to-nal" manner with three other gifted Haarlem painters, Pieter de Molijn, Salomon van Ruys-dael, and Jan Porcellis. He made many drawings in the countryside around The Hague, Leiden, Haarlem, and Amsterdam, and on trips to the Southern Netherlands, Gelderland, and the area around Kleve. Claes Berchem was his student but reflected little or nothing of his style.

P.C.S.

Literature: Orlers 1641, vol. 1, p. 373; Hoogstraeten 1678, p. 273; Houbraken 1718–21, vol. 1, pp. 166, 170, vol. 2, pp. 111, 235, vol. 3, p. 13; Weyerman 1729–69, vol. 1, pp. 393–96; Descamps 1753–64, vol. 1, pp. 419–22; van Eynden, van der Willigen 1816–40, vol. 1, p. 378; Nagler 1835–52, vol. 5, pp. 308–309; Immerzeel 1842–43, vol. 1, p. 290; Kramm 1857–64, vol. 2, pp. 596–97; Nagler 1858–79, vol. 3, no. 2406, vol. 4, no. 581, vol. 5, nos. 1170, 1191; Westrheene 1866; Vosmaer 1874a; Vosmaer 1874b; Mantz 1875; Bredius 1896; Alfassa 1903; Amsterdam 1903; Martin 1903; Steenhoff 1903; Frimmel 1906; Wurzbach 1906–11, vol. 1, pp. 607–10; O. Hirsch-mann in Thieme, Becker 1907–50, vol. 14 (1921), pp. 460–63; Hofstede de Groot 1908–27, vol. 8, pp. 1–324; Bredius 1916; Dodgson 1918; Bredius 1919; Bremmer 1920–21; Steenhoff 1922–23; Hofstede de Groot 1923; Reynolds 1923; Grosse 1925, pp. 64–78; Volhard 1927; van der Kellen 1928; Steenhoff 1930; Martin 1935–36, vol. 2, pp. 276–79; Romanow 1936; van Gelder 1937a; Stechow 1938b; Bremmer 1939; van de Waal 1941; Willemsen 1946; Renckens 1951; Bengtsson 1952; Beck 1957; Filla 1959; Beck 1960; Leiden/Arnhem 1960; Maclaren 1960, pp. 134–40; J.C. Brown 1961; Beck 1966a; Beck 1966b; Dobrzycka 1966; Stechow 1966; Dattenberg 1967, pp. 142–81; Beck 1972–73; Bol 1973, pp. 119–32; van Regteren Altena 1974; London 1976b; Haverkamp Begemann 1978; Quarles van Ufford 1978; The Hague, Mauritshuis cat. 1980, pp. 31–38; Amsterdam 1981a; Amsterdam 1981b; Haak 1984, pp. 224, 243–45, 269, 336–37.

Signed and dated lower left: I.V.GOIEN.1625
Panel, diam. 13¼₁₆ in. (33.5 cm.)
Rijksmuseum, Amsterdam, inv. A 3945
(Pendant of cat. 32)

(*Provenance*, *Exhibitions*, and *Literature* apply to both cat. 31 and cat. 32.)

Provenance: Count Woronzoff; Paul Delaroff, Leningrad, 1905; Kilian Hennessy, Paris, 1956; dealer William Hallsborough, London; purchased in 1958 and presented to the museum by the Photo-commissie.

Exhibitions: London, William Hallsborough Galleries, April–May 1958, nos. 12 and 13, ill.; Leiden/Arnhem 1960, nos. 7 and 8, figs. 4 and 5.

Literature: Frimmel 1906, p. 74, ill.; Hofstede de Groot 1908–27, vol. 8, no. 357, and no. 1172; Dobrzycka 1966, pp. 24, 86, nos. 13, 14; Bauch, Eckstein and Meyer-Siem in *Nederlands Kunsthistorisch Jaarboek* 23 (1972), p. 488; Beck 1972–73, vol. 2, nos. 108, 9, ill.; van Straaten 1977, p. 106, figs. 142–43; Amsterdam 1981b, p. 34; Haak 1984, p. 224, figs. 472, 473.

A stone house stands atop a rise by the bank of a river, behind a majestic oak tree and a well covered by a wagonwheel. A man with a sack on his back walks toward the house, preceded by a dog. On the road in the foreground a rider has paused to speak with two men and a woman. Another man and woman approach the river-bank, where a villager sits on a bench with his basket beside him, waiting to be ferried across the river. The ferryboat has just pushed off from the opposite bank, carrying a wagon drawn by two horses. Three men in a small boat row nearby. On the far side of the water, the road circles a windmill situated on top of a rise and continues past several farmhouses toward a village church with its steeple towering above the trees.

32 (PLATE 26)

Winter, 1625

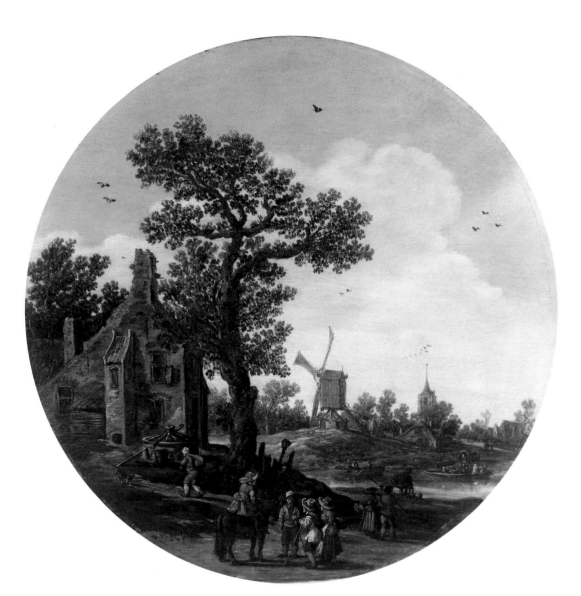

31

Signed and dated lower left: I.V.GOIEN.1625
Panel, diam. 13¾₆ in. (33.5 cm.)
Rijksmuseum, Amsterdam, inv. A 3946
(Pendant of cat. 31)

On a frozen moat surrounding a castle crowned
with various towers, stepped gables, and a
smoking chimney, a crowd of people amuse
themselves with skating, *kolf* playing, and sleigh
riding, while others stand by, watching the
spectacle. In the left foreground is a bare tree,
and in the distance some farmhouses are grouped
along the bank of a canal between a stand of
trees. High above, a flock of geese flies past.

Viewed in the context of more conventional
rectangular paintings from the seventeenth
century, these small circular paintings appear to
us as exceptional deviations. However, this
probably was not the case in van Goyen's day,
when such charming roundels, with their small-
scale figures and vibrant accents of color, en-
joyed considerable popularity. That there was,
in fact, a regular demand for such paintings may
be inferred from the approximately sixty little
roundels in van Goyen's oeuvre that are cata-
logued by Beck.[1] The paintings in this group
vary in diameter from 10 to 68.5 cm.; the ear-
liest dated example is of 1620, the latest is of
1650. Thus van Goyen returned to this parti-
cular format periodically for at least thirty years,
although the vast majority of these works were
produced before 1630. Similar roundels occur as
early as 1616 in the work of Esaias van de Velde,
to whom van Goyen was apprenticed around
1617 and who had a great influence upon his
early work.[2] The concept of emulation should
not be taken too literally, but the landscapes of
the two painters and particularly their circular
formats greatly resemble each other in design
and style.

The small round variant of the cabinet paint-
ing had already been popular in sixteenth cen-
tury Flanders; in Antwerp, for example, Abel

Grimmer (d. 1619) specialized in series of the Twelve Months or the Four Seasons and not infrequently painted them on round panels. Hendrik Avercamp painted several round winter landscapes and was perhaps the first Dutchman to adopt these innovations, probably before 1610 (fig. 1). The roundel format, first introduced by Flemish immigrants, was not exclusively popular with landscapists, as can be seen in the cheerful children's heads by Frans Hals of the 1620s.[3] A good example of the latter's work is in the Mauritshuis, The Hague; see also Dirck Hals's 1636 series of the Five Senses in the same museum.[4]

Following the example of Esaias van de Velde, van Goyen distilled the traditional serialized depiction of the Twelve Months or Four Seasons to paired representations of summer and winter. Such seasonal pendants occur repeatedly in his small circular landscapes from 1621 onward.[5] Apart from these, he also painted pendants that are united not by time of year but, for example, by the paired motifs of a roadway and a water-way.[6] In some instances, the pendants correspond to or complement one another in composition, as, for example, in the placement of dominant motifs, such as buildings or trees, respectively, on the left and right of the composition. But these refinements of design were certainly not fixed or standardized, as the *Summer* and *Winter* from 1625 attest. Here the dominant forms in both paintings are on the left side.

The castle situated in the midst of winter games upon a frozen moat had long been a popular motif in winter landscape. It was imported to Amsterdam by the Flemish immigrants Hans Bol and David Vinckboons and was soon taken over by Dutch painters. Hendrik Avercamp was the first to integrate the motif of the castle into his paintings. His round winter scene in London (fig. 1) is one of the many that adopts the formal characteristics of the Flemish

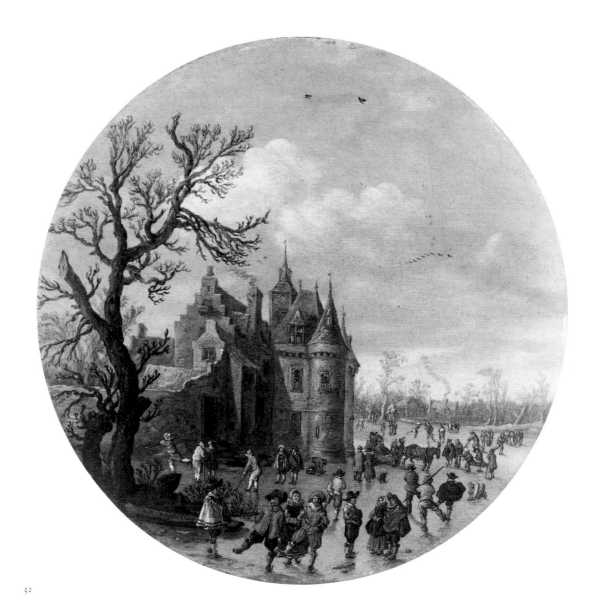

32

Fig. 1. Hendrik Avercamp, *Winter Scene with Skaters near a Castle*, monogrammed, panel, diam. 40.7 cm., National Gallery, London, no. 1346.

tradition in the high horizon and the large tree in the left foreground with its decorative network of branches and twigs. Almost twenty years after Avercamp's example, the Flemish formula is still recognizable in van Goyen's round *Winter*. But through his use of a relatively low horizon, the distance between the viewer and the action on the ice is greatly diminished, and we feel more a part of the scene.

Van Goyen's sunny, colorful winter scene is not as complex or as entertaining as Avercamp's; it is less rich in anecdotal details and lacks the subtle misty winter atmosphere that is so characteristic of Avercamp. In marked contrast to the earlier artist, there is no snow in van Goyen's *Winter*, no misty distance where everything dissolves; nor is there any suggestion of Avercamp's pale winter light. Van Goyen's

early *Winter* is more matter-of-fact, still far removed from the atmospheric winter landscapes that he painted later in his career.

In the pendant *Summer*, van Goyen was chiefly inspired by the works of Esaias van de Velde. In all details, such as the shape of the tree, the house, and background motifs, he consciously imitated van de Velde's style. He also successfully assimilated the sense of tranquil activity, well-being, and unconcern that attends the simple countryfolk in his former teacher's paintings, but the proportions and movements of his figures are less natural and easy. In this early work the motifs are still borrowed gratuitously and, quite unlike his later landscapes, do not appear to be supported by direct study from nature. After 1625 van Goyen developed independently from his early masters and was able to make his own significant contribution to the art of landscape painting. The tasteful arrangement of forms and the easy vitality of the brushstrokes that enliven the painting are characteristic of van Goyen's work throughout his career and confer an unmistakable charm on this early and still rather naive work.

C.J.d.B.K.

1. Beck 1972–73, vol. 2, nos. 1–20 and 99–138.
2. Keyes 1984, no. 130, fig. 79, no. 101, fig. 419.
3. Seymour Slive, *Frans Hals* (London, 1970–74), vol. 3, nos. 27–29.
4. Frans Hals, *Laughing Boy*, c.1620–25, panel, diam. 29.5 cm. (inv. 1032); and Dirck Hals, *The Five Senses*, 1636, panels, diam. 12 cm. (inv. 771–775).
5. Beck 1972–73, vol. 2, nos. 1/130, 3/103, 6/105, 7/106, 8a/107a, 9/108, 11/109, 12/110, 14/131, 16/132, 17/100, and 18/101.
6. Ibid., nos. 114/15, 118/34, and 120/21.

River Landscape with Ferry and Windmill, 1625

Signed and dated in the lower right: J.V.Goyen 1625
Oil on panel, 16⅜ x 25¼ in. (41.5 x 64 cm.)
Foundation E.G. Bührle Collection, Zurich, no. 152

Provenance: Possibly sale, J. van der Linden van Slingeland, Dordrecht, August 22, 1785, no. 164 (fl.11, to Fouquet); sale, London (Christie's), January 18, 1946, no. 144 (to Slatter); dealer E. Slatter, London; G.H. Kennedy, Heathfield Cottage, Rotherfield, Sussex; acquired in England in 1954 by Emil G. Bührle, Zurich.

Exhibitions: London, Eugene Slatter's Gallery, 1946, no. 34, ill.; London 1952–53, no. 246; Jegenstorf 1955 no. 5, ill.; Zurich 1958, no. 72, ill.

Literature: Hofstede de Groot 1908–27, vol. 8, no. 633e(?); Gerson 1953, p. 48; Dobrzycka 1966, no. 22; Beck 1972–73, vol. 2, no. 234, and possibly no. 234a; Zurich, Bührle cat. 1973, pp. 350–51, no. 152; Raupp 1980, pp. 100–102.

In the foreground of a river landscape, a ferry boat situated parallel to the picture plane carries seven passengers and three cows across the narrow expanse of water. On the left bank rural folk wait to board, and in the distance cottages and a villa appear. On the right bank the travelers disembark and proceed up a dirt road that passes by a large windmill. Three other boats ply the river, which meanders back left of center to a distant village.

Although van Goyen studied with Esaias van de Velde in Haarlem in 1616–17, his art most reflected his teacher's influence in the early and mid-1620s. The Bührle collection's *River Landscape with Ferry* of 1625, for example, is an abridged adaptation of Esaias's larger and more grandly conceived *Ferry* dated three years earlier (cat. 106). Not only the general design of this river landscape, with the darkened ferry viewed broadside and the water retreating into the center distance, but also the handling of in-

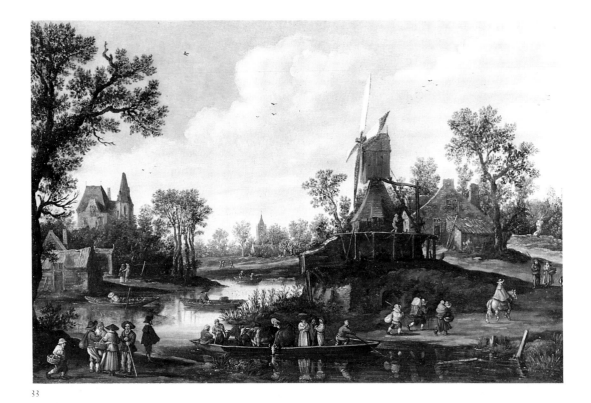

33

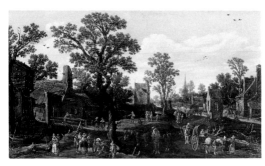

Fig. 1. Jan van Goyen, *Street Scene in the Village of de Bilt Near Utrecht*, signed and dated 1623, panel, 39.5 x 69.6 cm., Herzog Anton Ulrich-Museum, Braunschweig, no. 339.

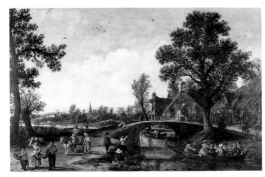

Fig. 2. Jan van Goyen, *River Landscape with Rowboat and Bridge*, signed and dated 1625, panel, 78 x 124 cm., Kunsthalle, Bremen, inv. 48-1827.

dividual motifs, figures, and the subdued palette accented with local colors recall Esaias. In 1953 Horst Gerson thought the resemblance to Esaias's work so compelling that he wrongly declared van Goyen's signature false and re-assigned the work to van de Velde.[1] Typically, van Goyen condensed Esaias's composition, making it more intimate; indeed, the distance traversed by the young van Goyen's ferry hardly seems worth the wait.

Esaias's influence on van Goyen's works of about 1623–25 is readily detected in his winter landscapes, village scenes (see, for example, fig. 1), and his river landscapes; among the last

mentioned, the *River Landscape with Rowboat and Bridge*, dated 1625, in Bremen (fig. 2) is among the finest and closely resembles the Bührle picture in style and conception.[2] Esaias's influence is also apparent in the work of another of his Leiden pupils, Pieter de Neyn, whose *Sandy Road with a Boat on a Canal* of 1626 (Stedelijk Museum "de Lakenhal", Leiden) may be compared with the Bührle collection's van Goyen of the preceding year.

The Bührle collection's painting may have been the *River Landscape*, dated 1625 and closely conforming to its dimensions, that was in the distinguished eighteenth-century collection of

34 (PLATE 34)

Farmhouses with Peasants,
1630 or 1636

J. van der Linden van Slingeland; however, the cursory description of that work in the 1785 sale catalogue does not permit certain identification.[3]

P.C.S.

1. Gerson 1953, p. 48, note 6.
2. Van Goyen made many other river landscapes on a broad, horizontal format in these years. Compare Beck 1972–73, vol. 2, nos. 216 (dated 1622), 218 (dated 162[3?]), 219 (dated 1623), 225 (dated 1624), 237 (dated 1625), 240 (dated 1626), 242 (dated 1626), 243 (dated 16[2]6), and especially 233 (dated 1625, Museum der bildenden Künste, Leipzig, inv. 1475) and 235 (dated 1625, Národní Galerie, Prague, inv. DO-6031).
3. See Hofstede de Groot 1908–27, vol. 8, no. 633e; and Beck 1972–73, vol. 2, no. 234a.

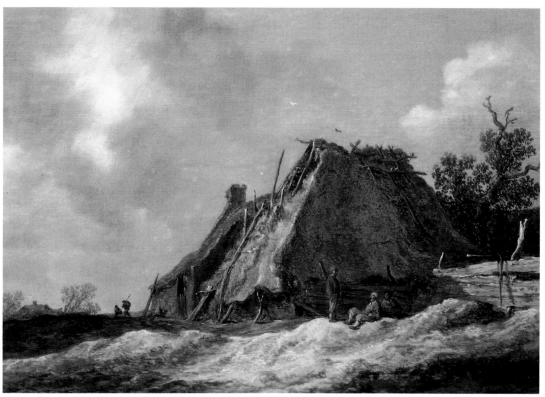

34

Monogrammed and dated lower right on the fence: VG 1630 [or 6]
Oil on panel, 14⅛ x 20¼ in. (36 x 51 cm.)
Private Collection, New York

Provenance: British art market; dealer A.S. Drey, Munich; W. Duschnitz, Vienna; private collection, France; collecting point, Munich, 1945–46; dealer A. Brod, London, spring 1962; dealer S. Nystad, The Hague, 1962; Sidney J. van den Bergh, Wassenaar.

Exhibitions: Leiden 1965, no. 18.

Literature: Hofstede de Groot 1908–27, vol. 8, no. 385a; van den Bergh collection, cat. 1968, pp. 46–47, ill.; Beck 1972–73, vol. 2, no. 1141, ill.

A farmhouse with loosely thatched roof stands in the center of a dune landscape receding to the left. Three peasants, two of them seated, converse before the farmhouse, and in the distance are two silhouetted travelers. A crude fence appears at the far right, and in the left distance are other trees and farmhouses.

This painting is typical of a group of dune landscapes with a unified structure and palette that van Goyen developed shortly before 1630 in his archetypal "tonal" phase. The motifs are few in number and of the simplest nature, the diagonal design moves precipitously into space, and

Fig. 1. Attributed to van Goyen, *Landscape with Thatched Farmhouse*, chalk and wash, 101 x 204 mm., Musée des Beaux-Arts, Besançon, inv. 775.

Fig. 2. Jan van Goyen, *Landscape*, chalk and watercolor, 155 x 271 mm., Musée des Beaux-Arts, Besançon, inv. 776.

the earth colors are muted and limited in their range of value. The tumbledown farmhouse with precariously buttressed roof is not some picturesque arcadian accessory but an unembellished fact of the rural scene. Mottled by passages of light and shadow, the loamy, blond landscape seems to shift and sidle as the light breaches the ceiling of clouds overhead.

The last digit of the date has been deciphered as either a zero or a six.[1] The composition with the diagonally receding thatched farmhouse closely resembles paintings such as van Goyen's work dated 1631 in the Musée des Beaux-Arts,

Carcassonne (see p. 94, fig. 17).[2] Compare also the paintings of similar subjects and designs from the late 1620s and early 1630s in the Rijksmuseum Twenthe, Enschede (dated 1628, inv. 271); sale, E. Huybrechts, Antwerp, May 12, 1902 (dated 1631, no. 81); Kunsthalle, Hamburg (dated 1632, inv. 607); Niedersächsisches Landesmuseum, Hannover (dated 1632, inv. PAM 752); Staatliche Kunstsammlungen, Dresden (dated 1633, no. 1338A); and formerly in the Girardet collection, Kettwig (dated 1633, Cologne/Rotterdam 1970, no. 21).[3] Thus the work probably dates from 1630; however, the delicate and slightly more colorful palette may uphold a later reading. As Beck observed, the same thatched cottage appears in a drawing attributed to van Goyen in the Musée des Beaux-Arts, Besançon (fig. 1). Also very close in conception is another chalk drawing by van Goyen in the same museum (fig. 2).[4]

An interesting feature of the painting, especially from the standpoint of van Goyen's working methods, technique, and materials, is the lively underdrawing that is visible throughout the panel.

P.C.S.

1. See Beck 1972–73, vol. 2, no. 1141.
2. Panel, 30 x 50 cm., ibid., no. 998.
3. See respectively Beck 1972–73, vol. 2, nos. 1057, 1099, 1003, 1104, 1015, and 1012.
4. Ibid., vol. 1, no. 615, ill.

35 (PLATE 33) *Amsterdam only*

Dune Landscape, 1631

Monogrammed and dated on the door on the right: VG 1631
Oil on panel, 15½ x 24¾ in. (39.5 x 62.7 cm.)
Herzog Anton Ulrich-Museum, Braunschweig, inv. 340

Provenance: Acquired in 1738 for the Galerie in Salzdahlum (in inventory of 1744, as "Cornelis Molinar"); removed by Napoleon to Paris, 1807–15.

Exhibitions: Schaffhausen 1949, no. 35.

Literature: Salzdahlum 1776, p. 315, no. 22 (as "Johan van der Goyen"); Braunschweig, cat. 1836, p. 189, no. 518 (as unknown); Braunschweig, cat. 1868, p. 84, no. 677 (as Cornelis Molenaer); Bode 1872, p. 169; Schmidt 1873b; Riegel 1882, pp. 352ff.; Schmidt 1883; Hofstede de Groot 1908–27, vol. 8, no. 294; Grosse 1925, p. 70, pl. 40; Volhard 1927, pp. 88, 174; Havelaar 1931, p. 126, ill.; van de Waal 1941, p. 28, ill.; Filla 1959, p. 31, fig. 10; Dobrzycka 1966, pp. 39, 96, no. 74, fig. 38; Stechow 1966, pp. 26–27, fig. 28, p. 193, note 34; Beck 1972–73, vol. 2, no. 1110, ill.; Schmidt 1981, pp. 102ff., fig. 31; Braunschweig, cat. 1983, p. 75, no. 340, ill.

Under an overcast sky, a view of the dunes with a low horizon line falls away into the distance to the left. In the foreground a goatherd looks after several goats and their kids. The darkened form of a goat seated on a mound in the foreground serves as a *repoussoir*. A crude fence, composed of tree stumps, old planks, and a broken door hastens the design's diagonal recession. In the middle distance four peasants pause to chat. A gray-green palette enhances the atmospheric effects, while the highlights on the sparse motifs are a bright lemon yellow.

Owing to a second, false monogram and date "CM 1591," this painting was wrongly identified in the eighteenth and nineteenth centuries as the work of the Flemish painter Cornelis Molenaer (1540–1589?); however, it was already recognized as a work by Jan van Goyen in the 1776 catalogue of the ducal collection at Salzdahlum. The date has also been incorrectly deciphered in

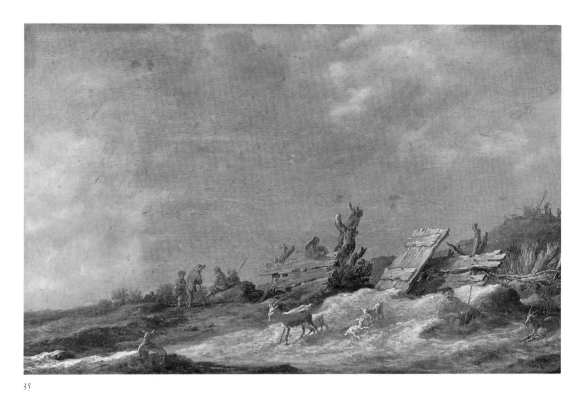

35

the past as 1632 or 1635. Beck's erroneous reading of the date (1632) as well as his false assumption that the goats and goatherd were by a later hand were corrected by Klessmann.[1]

The painting's formal structure has been discussed repeatedly. Grosse correctly recognized the work's resemblance in design to the painting of 1629 in Frankfurt (fig. 1) and noted Pieter de Molijn's anticipation of both of these unified, diagonal compositions (see cat. 56).[2] Stechow compared the picture with the *Dune Landscape with Resting Peasants*, also of 1629, in Berlin (West), characterizing it as the fulfillment of "the development from multiplicity of design and color to tonality and more unified structure of composition."[3] He further characterized these achievements as a function of the progressive reduction of the number and complexity of details, the fuller integration of local colors, and the harmonious limitation of the range of tones. In addition to the earlier works in Braunschweig and Berlin, several other paintings dated 1631 depict sandy roads in the dunes with or without buildings and employ similar diagonal compositions; see particularly the paintings in the Musée des Beaux-Arts, Carcassonne (p. 94, fig. 17); the Museum Ridder Smidt van Gelder, Antwerp (inv. Sm 880/2); formerly the H. Nigh collection, Rotterdam; and formerly in the Schlossmuseum in Gotha.[4] None of these works, however, has the charming intimacy or compositional sweep of the Braunschweig painting.

There are also several drawings by van Goyen from this period employing similar angled designs that prominently feature sections of broken fences (see fig. 2).[5] Yet, none of these sheets can be identified as a preparatory study for this painting. Typically, van Goyen continued to paint variations and elaborations of this work's design in the years immediately following, and aspects of the composition even reappear in his art more than a decade later.[6]

Fig. 1. Jan van Goyen, *Dune Landscape*, monogrammed and dated 1629, panel, 32 x 56.5 cm., Städelsches Kunstinstitut, Frankfurt, inv. 1271.

Fig. 2. Jan van Goyen, *Landscape with Fence*, monogrammed, black chalk, 154 x 263 mm., Ecole des Beaux-Arts, Paris, inv. M.I. 659.

Fig. 3. Cornelis Bloemaert after Abraham Bloemaert, *Goatherd beneath a Tree*, engraving.

The subject of a goatherd resting in a landscape may recall an engraving (fig. 3) executed before about 1627 by Cornelis Bloemaert after a design by his father, Abraham. Beneath the scene of the quietly contemplative goatherd is the inscription "Non adeas aulum, qui diligis otia mentis: / Haec nemus umbrosum, vel tibi caula dabunt" (Do not go to court, you who are fond of the leisure of the mind; / A shady grove or sheepfold will give you this). For additional references praising the contemplative and peaceful life of the country, with landscapes featuring peasants and shepherds, see the Introduction.

P.C.S.

1. Beck 1972–73, vol. 2, no. 1110; Klessmann, in Braunschweig, cat. 1983, p. 75, no. 340.

2. Grosse 1925, p. 70; Beck 1972–73, vol. 2, no. 1077.

3. Stechow 1966, p. 27. See Staatliche Museen Preussischer Kulturbesitz, Berlin (West), inv. 865; Beck 1972–73, vol. 2, no. 1074.

4. See, respectively, Beck 1972–73, vol. 2, nos. 998, 1087, 1095, 1092.

5. Beck 1972–73, vol. 1, no. 613. Compare also the related drawing in the sketchbook of 1627–35 in the British Museum, London, inv. 1946.7.13.1076 (104) (Beck 1972–73, vol. 1, no. 844/104). See also the drawings of dune landscapes in this sketchbook and in the National Gallery of Ireland, Dublin (no. 2125), respectively Beck 1972–73, vol. 1, nos. 844/77 and 614.

6. See the dune landscapes in Louvre, Paris, inv. RF 1961-85 (dated 1632); Niedersächsisches Landesmuseum, Hannover, inv. 110 (dated 1632); Reformiertes Waisenhaus, Haarlem (dated 163[3]); and formerly with Bruno Meissner, Zurich (dated 1642); respectively Beck 1972–73, vol. 2, nos. 1107, 1104, 1122, and 1147.

Landscape with Two Oaks, 1641

Monogrammed and dated center bottom: VG 1641
Oil on canvas, 34⅞ x 43½ in. (88.5 x 110.5 cm.)
Rijksmuseum, Amsterdam, inv. A 123

Provenance: Probably sale, A. Lacoste, Dordrecht, July 10, 1832 (not in the sale catalogue); collection J. Rombouts, Dordrecht, 1850; bequest of L. Dupper Wzn., Dordrecht, 1870.

Exhibitions: Brussels 1946, no. 35, fig. 43; Paris 1950–51, no. 30, fig. 6; Zurich 1953, no. 37; Rome 1954, no. 39; Milan 1954, no. 46; New York 1954–55, no. 26, ill.; Leiden/Arnhem 1960, no. 28, fig. 14; Osaka, Expo 1970, *The March Towards Freedom*, 1970, no. 213, ill.

Literature: Hofstede de Groot 1908–27, vol. 8, no. 267; *Jaarverslag 1917, Rijksmuseum Amsterdam*, p. 12; Volhard 1927, p. 111; Havelaar 1931, p. 128, ill.; Martin 1935–36, vol. 1, p. 99, fig. 57; Romanow 1936; Knuttel 1938, p. 224; Gerson 1950–52, vol. 2, p. 42, fig. 118; H.E. van Gelder 1959a, pl. II; Filla 1959, fig. 12; A.H. Tiemens, *Gelders Dagblad*, September 14, 1960; *Van tijd tot tijd*, 1961–62, no. 44, ill.; A.B. de Vries 1963, fig. 4; Stechow 1966, pp. 39, 43, fig. 60; Dobrzycka 1966, pp. 43, 100, no. 93, fig. 48; Beck 1972–73, vol. 2, no. 1144, ill.; A.L. Jones in *Bulletin of The Krannert Art Museum, University of Illinois* 2 (1978), p. 16, fig. 2; Kahr 1978, pp. 206–207, fig. 156; Amsterdam 1981b, p. 33.

The right half of the landscape is dominated by two massive old oaks rooted in a rugged, sloping terrain. The left half is taken up by a wide panoramic view over an extensive river basin bounded by a distant range of hills. Exactly at the junction of these two motifs the painter has marked the midpoint of the composition by introducing the colorful accent of a standing man in a red jacket. He is in conversation with another man, who rests at the foot of the oaks. Farther to the left a third man descends the hill on his way to a village lying below and to the left. Nearby is a river, behind a rise in the terrain over which a shepherd drives his flock.

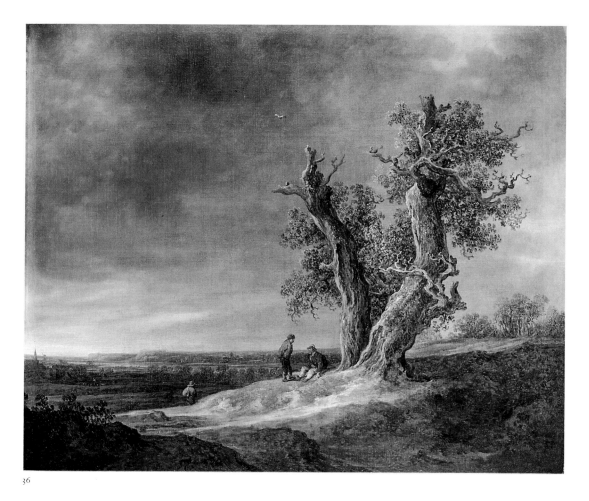

36

Fig. 1. Jan van Goyen, *Landscape with Two Old Oaks*, signed and dated 1627, black chalk, 169 x 266 mm., private collection, London.

Fig. 2. Jan van Goyen, *View of a River Valley*, signed and dated 1639, panel, 26.5 x 44 cm., whereabouts unknown.

The sky is covered by gray clouds, thinning to a translucent veil in the background, which admits filtered sunlight. A weak glimmer of sunlight breaks through in the foreground and passes over the old trees, the two men underneath, and a bird high in the sky.

The attention van Goyen has given to the depiction of space, light, and atmosphere, and the subordinate role reserved for the few human figures, form a stark contrast to his earliest paintings of the 1620s (see cat. 31 and 32). In the

latter, all emphasis is on the lively activity of a crowd of people, placed in a painterly and descriptive but neutral setting, without an indication of a particular mood or real experience of nature. In the exhibited work, by contrast, van Goyen has applied himself to rendering a recognizable type of landscape, seen and experienced under specific weather conditions.

The change in van Goyen's approach to landscape design came about gradually during his associations with a group of landscape painters, primarily from Haarlem, who rejected old formulas to develop a new, more realistic vision of their own familiar rural surroundings. These developments in Dutch landscape painting, characterized by a simplified compositional scheme and an extremely restricted palette, have recently been reviewed again in an exhibition.[1] They can also be studied in the present show (see cat. 98, 56, and 35); van Goyen's monumental Amsterdam painting represents the culmination of these vital new developments.

The motif of the paired old oaks, with their stout trunks weathered and misshapen, their branches broken and partially withered, recurs frequently in van Goyen's oeuvre. He began his long series of paired oaks with a drawing of 1627 (fig. 1).[2] By the time he executed this painting, he had already used the motif many times in both small and large formats and would again return to it. The powerful continuity of his work, admitting of minor variations, is clearly demonstrated by comparing the exhibited landscape with a much earlier and a later example of similar oaks in related compositions: an equally extensive landscape from 1632 in Moscow[3] and a somewhat smaller painting from 1645 in a private collection.[4]

Throughout his career van Goyen recorded his outdoor observations in chalk sketches that he frequently later worked up into more complete drawings. In his sketches van Goyen built up an image from countless lively, continually interrupted, little strokes of chalk. His painting technique echoes his manner of drawing (fig. 1). As in the chalk sketches, the trees and other elements of the image are "sketched" with a restless hand that links up the thin, nervous brushstrokes into an irregular network spread upon the light brown ground. So loose and airy is the technique that the ground is never completely covered but becomes an important component in the final tonality of the painting.[5] Samuel van Hoogstraeten's description of a competition between Jan van Goyen and two colleagues, in which the differences between their painting techniques are intimated, gives an impression of van Goyen's peculiar approach.[6]

When this landscape was painted, the distant panorama was not yet such a well-tried motif as the paired oaks, but was one that van Goyen would return to many times, frequently with recognizable cities or villages viewed nearby or at a distance. Locations along the Rhine, such as Elten, Arnhem, Wageningen, and Rhenen (see cat. 37), appear more than once. In these paintings the painter often took artistic liberties in deviating from the existing topographical site. Van Goyen's two fairly accurate paintings dated 1636 and 1638 of the town of Wageningen[7] suggest that in the exhibited work he has probably made a very free rendering of that town, which is recognizable by its site and church steeple. The distant view thus offers a free interpretation of the Rhine landscape in the area of Wageningen. As spectators standing on the hill to the northeast of the town, we see far before us to the west the lengthy profile of the Grebbeberg, which the painter has here arbitrarily doubled.[8] In 1639 van Goyen had painted a somewhat different version of this same landscape, omitting the town of Wageningen (fig. 2).[9] With the river winding through a plain, the range of hills beyond, and the rise in the right foreground on which two oaks stand, it offers a foretaste of the Amsterdam painting on a small scale.

This monumental painting is evidence of the important role Jan van Goyen played in the long tradition of painted panoramic landscapes, which originated about 1630 in the work of Hercules Segers and which was later brought to fruition by Philips Koninck and Jacob van Ruisdael.

C.J.d.B.K.

1. London 1986.

2. Beck 1972–73, vol. 1, no. 80, ill.

3. Ibid., vol. 2, no. 1112, ill.; Romanow 1936, pp. 187–88, fig. 1.

4. Beck 1972–73, vol. 2, no. 1151, ill.

5. See also David Bomford, "Techniques of the Early Dutch Landscape Painters," in London 1986, p. 51.

6. Hoogstraeten 1678, p. 274, repeated in Houbraken 1718–21, vol. 1, pp. 166–68.

7. Beck 1972–73, vol. 2, nos. 1138, ill., and 968, ill.; see also Enschede 1980, pp. 36–37 and 44–45. Hercules Segers and Aelbert Cuyp also painted Wageningen in a comparable manner; see *Duits Quarterly* 1 (1963), pp. 4–5, where the town is incorrectly identified as Niederelten.

8. In his description of the painting, Beck (1972–73, vol. 2, no. 1144) calls the two ranges of hills in the distance the "Wageningse berg and Grebbeberg". However, it is probably a capriccio of the artist's own conception.

9. Beck 1972–73, vol. 2, no. 969, ill.

View of Rhenen, 1646

Signed and dated lower right: VGoyen 1646 [VG ligated]
Oil on canvas, 40 x 53½ in. (101.5 x 136 cm.)
The Corcoran Gallery of Art, Washington, D.C., William A. Clark Collection, 26.95

Provenance: Probably H. Smith Wright, Nottingham, 1878: T. Wright, Apton Hall, Nottinghamshire; purchased by William A. Clark of New York (Senator from Montana) from Sir G. Donaldson, London; given by Senator Clark in 1926 to the Corcoran Gallery of Art.

Exhibitions: Probably Nottingham 1878, no. 48; Washington, D.C., Corcoran Gallery of Art, 1908; New York 1909, no. 18, ill.; New York 1959, p. 11; Richmond, Virginia Museum of Fine Arts, *Twenty-Fifth Birthday Exhibition*, 1961; Utica 1963; Washington, D.C., Corcoran Gallery of Art, *The William A. Clark Collection*, 1978.

Literature: Breek 1910, p. 59; Hofstede de Groot 1908–27, vol. 8, no. 210; Washington, D.C., Corcoran cat. 1932, p. 47, no. 2095; Washington, D.C., Corcoran cat. 1955, p. 21, ill.; Stechow 1966, p. 41, fig. 71; Beck 1972–73, vol. 2, p. 188, no. 387; Haverkamp Begemann 1978, fig. 40; Deys 1981, p. 30, fig. 68.

Jan van Goyen depicted the city of Rhenen repeatedly. Somewhat surprisingly, there appear to be no certain drawings of the subject by his hand, although at least twenty-six of his paintings, ranging in date from 1636 to 1655, offer a view of the city or a glimpse of its distinctive skyline.[1] Van Goyen was only one of the many Dutch landscapists who were drawn to Rhenen as a subject. As Egbert Haverkamp Begemann has observed, van Goyen was preceded in his treatment of this subject by Hercules Segers, whose *View of Rhenen* in the Gemäldegalerie in West Berlin (fig. 1) is probably the earliest painting of the town; this work probably dates from the latter half of the 1620s.[2] Among the artists listed by Begemann who made drawings of Rhenen were Rembrandt

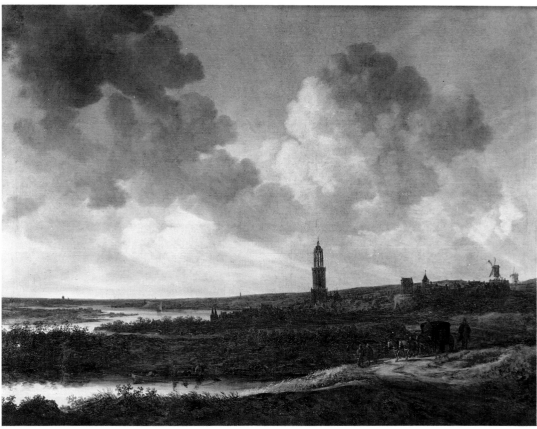

37

and his pupils Lambert Doomer (c. 1622/23–1700) and Gerbrand van den Eeckhout, Jacob van Ruisdael, Johannes Ruyscher (c. 1625–after 1675), Aelbert Cuyp, Daniel Schellinks (1627–1701), and Anthonie Waterloo (c. 1610–1690).[3] Salomon van Ruysdael painted views of Rhenen in 1648 (National Gallery, London, no. 6348), 1651 (Bührle Collection, Zurich), and 1660 (Barnes Foundation, Merion, Penn.), and Philips Koninck depicted it in 1670 (Konstmuseum, Göteborg).[4] Various draftsmen, including Pieter

Saenredam, Abraham de Verwer, and Jan de Bisschop, also recorded Rhenen.

The appeal of Rhenen as a landscape subject must have stemmed in part from its attractive situation: the beautiful walled town is on the hilly northern bank of the Rhine to the southeast of Utrecht. But it offered the landscapist more than a picturesque site and impressive profile; the town had an august history. With its massive walls and heavy gates, Rhenen had served in the Middle Ages to defend the bishop-

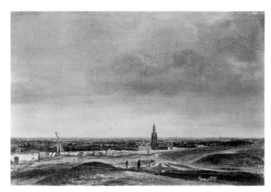

Fig. 1. Hercules Segers, *View of Rhenen*, panel, 42.6 x 66.5 cm. (originally 21.9 x 66.5 cm.; the upper part of the sky is an addition of c.1640), Gemäldegalerie, Staatliche Museen Preussischer Kulturbesitz, Berlin (West), inv. 808A.

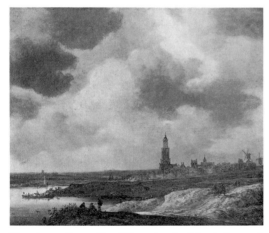

Fig. 2. Jan van Goyen, *View of Rhenen*, signed and dated 1640, panel, 43 x 54 cm., formerly Richard Green Gallery, London, 1974.

ric of Utrecht. The presiding tower of the church of St. Cunera (built between 1442 and 1531) was one of the tallest and most elegant late-Gothic structures in the Netherlands. The large building adjoining the tower on the right in van Goyen's painting is probably the palace of the King of Bohemia (built by Bartholomeus van Bassen in 1631; destroyed in 1812), who was residing in the Netherlands in 1646 when this painting was executed. Silhouetted against the river at the center left are the towers of the Rijnpoort; at the upper right a windmill marks the northern border of the town. In the foreground a coach drawn by four horses moves away from the town on a road leading to Wageningen and Arnhem. As Begemann has aptly written, "with its medieval appearance and crumbling walls, the town, particularly when approached from the East [as here depicted by van Goyen], must have been associated . . . with the past of the country, with its glories and vicissitudes."[5]

Typically, van Goyen has represented the overall features of the town correctly but deviated from reality in details: the tower's height is exaggerated, as is its distance from the Rijnpoort, and he has not represented the nave of the church or the Winter King's palace accurately. Moreover, the Rhine winds around more energetically and the foreground is wilder and rougher than in reality. The low hills beyond the town are also the artist's invention.

The general design of the Clark Collection painting had already been worked out by van Goyen in a small panel painting dated 1640 (fig. 2).[6] However, in his larger version of a half-dozen years later van Goyen greatly enhanced the panoramic effect. His use of a panorama design, with a high foreground followed by a backdrop in the middle distance, is inherited from Segers (see fig. 1) and anticipates Koninck's later compositions. The brown and dark green tones of the Corcoran painting are characteristic of van Goyen's works from the early and mid-1640s.

P.C.S.

1. See Beck 1972–73, vol. 2, nos. 374 (dated 1636, formerly The Metropolitan Museum of Art, New York) to 400a. The latest dated painting of this subject (Beck 1972–73, vol. 2, no. 396) is the *View of Sailboats with a Distant View of Rhenen* dated 1655 (formerly van Aalst collection, Hoevelaken).

2. See Haverkamp Begemann 1978, p. 53.

3. Rembrandt's drawing is in the Museum Bredius, The Hague (Benesch 1973, no. 825); van den Eeckhout: Kupferstichkabinett, Berlin (West) (inv. 1320); Jacob van Ruisdael: sale, Leipzig (Boerner), April 29, 1931, no. 40; Cuyp: Teylers Museum, Haarlem, inv. P42; Schellinks: Kunsthalle, Hamburg, inv. 2250; Waterloo: National Gallery of Scotland, Edinburgh, no. D 1183; Musées Royaux des Beaux-Arts, Brussels, inv. A 18163.

4. See respectively, London, National Gallery cat. 1973, no. 6348, ill.; Stechow 1938a, no. 309, fig. 46; Gerson 1936, no. XI.

5. Haverkamp Begemann 1978, p. 53. Lugt (1915, pp. 159–62) suggested that Rembrandt would have had a similar response to the city.

6. Beck 1972–73, vol. 2, no. 377.

The Beach at Egmond aan Zee, 1653

Monogrammed and dated at left: VG 1653
Oil on panel, 19 x 29¼ in. (48 x 74.5 cm.)
Private Collection

Provenance: Frederick C. Dickson; sale, London
(Sotheby's), December 8, 1971, no. 44 (as S. van
Ruysdael); dealer H. Terry Engell, London (cat. 1973,
no. 6); J.H. Bakker; Noortman and Brod Gallery.

Literature: Beck 1972–73, vol. 2, no. 963, ill.

In this late work done a few years before his
death, Jan van Goyen continued to employ the
techniques and themes he had perfected earlier
in his career. Noteworthy is the spontaneity
with which he painted the many figures on the
beach – a transformation into paint of the sug-
gestive calligraphy of his black-chalk drawings
and a feat otherwise equaled only by Rembrandt
in his winter landscape from Kassel (cat. 77).
The figures and boats on the beach are described
in fluid, dark strokes set against the lighter
monochromatic background comprising the
beach and dunes. This tonality, already in use
for several decades by the 1650s, is here com-
bined with innovations: the sky is enriched with
gray clouds and a light blue sky, probably under
the influence of Salomon van Ruysdael; the cool,
bluish-green tones of the sea are also new de-
velopments in van Goyen's work and directly
anticipate Jacob van Ruisdael's later beach
scenes. Ruisdael painted Egmond aan Zee
several times;[1] his beachscape in the National
Gallery, London (no. 1390) is close in com-
position to the exhibited work and may have
been derived from it.

 The large square-towered church seen just
beyond the dunes is the church at Egmond aan
Zee, a beach town near Alkmaar that Claes Jansz
Visscher depicted in a print of 1615 (see p. 77,
fig. 10). The fishing fleet has just returned.
Several boats have been pulled onto the sand (at
the left we see several men with their backs
against a boat, pushing it into position), while in

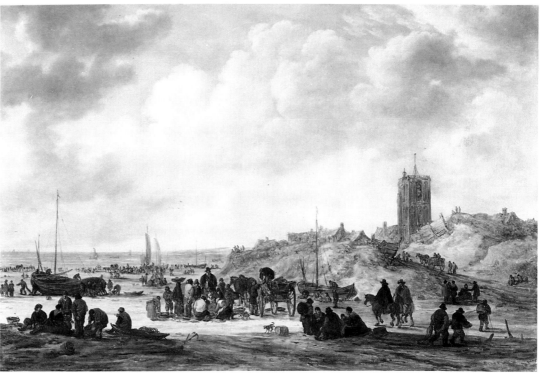

38

the foreground, fish are sorted and loaded onto
carts. This is not a true fish market since there
are no buyers from the city. In the seventeenth
century the beaches of Holland were often
recommended as tourist attractions for city
dwellers; travel descriptions state that the
fishing fleets can be observed and that one may
buy fish on the beach. (See the essay in this
catalogue by S. Schama.)

 Jan van Goyen depicted beaches with the
unloading of fish as early as 1623 and produced
such scenes frequently in the early 1640s.[2]
Although van Goyen more often depicted the
beach at Scheveningen, which was near The
Hague, where he lived, he occasionally painted

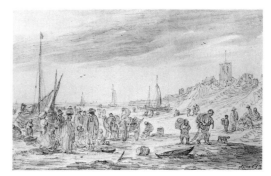

Fig. 1. Jan van Goyen, *Beach at Egmond aan Zee*, black chalk, signed
and dated 1653, 170 x 272 mm., Pierpont Morgan Library, New
York, inv. III, 72.

the beach at Egmond. A work dated 1641 already utilized the composition of the exhibited work.[3] In 1653, van Goyen made two series of drawings of beach motifs.[4] This renewed interest in the seashore may have been the result of a visit to Scheveningen or Egmond aan Zee, although the sketches appear to be studio constructions. One sheet now preserved in the Pierpont Morgan Library, also dated 1653 (fig. 1), is closely related to the exhibited painting and may be considered a preparatory stage in van Goyen's thinking. The composition of the sketch is similar to the painting, but the figures are larger. To some extent, van Goyen's painting style reiterates the rippling lines of the drawing.

Fish markets beside the sea occur in late sixteenth-century Flemish painting, particularly in the work of Jan Brueghel the Elder, where they are often coupled with religious subjects.[5] However, this tradition, continued by painters such as Adam Willaerts (1577–1664) (cat. 113, fig. 2), had limited impact on the development of the beach scene in Dutch art. Scenes of fishing on the beach have a thematic source in Goltzius's allegorical image of Diana presiding over fishing, of 1597 (print by Jan Saenredam; Bartsch, no. 79). Stechow traced the origins of the genre to Hendrick Goltzius's drawing of a beached whale (1598),[6] which engendered a whole tradition of reporting events on the beach, whether beached whales, "sandboats," or the departure or arrival of dignitaries.[7] Beaches in Dutch art became the setting for various activities, including fish markets and the arrival of fishing vessels, as in the present painting. Indeed, van Goyen may be credited with having first placed peasant genre activities in the naturalistic setting of the beach, although Salomon van Ruysdael also made important contributions to the tradition. Artists such as Simon de Vlieger, Benjamin Cuyp (1610–1650), and Willem Kool (1608/09–1666) were

quick to follow.[8] Jan van Goyen also set the stage for the work of Jacob van Ruisdael and Adriaen van de Velde, whose beach scenes are clearly dependent on those of van Goyen (see cat. 103).

A.C.

1. See The Hague/Cambridge 1981–82, nos. 2, 7, figs. 8, 14, 58.

2. Beck 1972–73, vol. 2, nos. 222 (dated 1623), 923–62.

3. Formerly with Thos. Agnew & Son, London (Beck 1972–73, vol. 2, no. 933, ill.). For other views of Egmond aan Zee, see Beck 1972–73, vol. 2, nos. 925, 943, 951, 954, 956.

4. Beck 1972–73, vol. 1, nos. 358–671 (all dated 1653); in addition, no. 372 (of a different size) shows a beached whale. True beach drawings by van Goyen date as early as 1626 (Beck 1972–73, vol. 1, no. 59).

5. Ertz 1979, nos. 29, 46 (dated 1596 and 1598).

6. Stechow 1966, pp. 101–102.

7. For the numerous prints of beached whales, see Stechow 1966, pp. 101–102; Boston/St. Louis 1980–81, nos. 24, 56. For sandboats, see de Groot/Vorstman 1977, nos. 31, 31a, ill. The arrival of dignitaries on beaches was also commonly depicted, as for example by Adam Willaerts (Stechow 1966, fig. 199), Jan van Goyen (Beck 1972–73, vol. 2, no. 959), Jan Lingelbach (Rijksmuseum, Amsterdam, inv. C 1224), and Ludolf Bakhuizen (Mauritshuis, The Hague, inv. 6).

8. For de Vlieger, see a painting dated 1633 in the National Maritime Museum, Greenwich (Stechow 1966, fig. 206). For Benjamin Cuyp, see, for example, Walters Art Gallery, Baltimore (inv. 37.335). There is a beach scene by Kool in the Frans Halsmuseum, Haarlem (Bol 1969, fig. 184).

Jan Griffier

(Amsterdam c.1645–1718 London)

Jan Griffier was born in Amsterdam, probably about 1645. He studied first with a flower painter, then with Roeland Roghman in Amsterdam. He traveled around 1667 to London, where he completed his training with the Dutch landscape painter Jan Looten (1618–c.1681). Griffier remained in England for several years, living on a boat on the Thames from which he painted both topographical and imaginary views of London and its environs. Griffier and his family returned to the Netherlands in 1695 with a large collection of paintings which he hoped to sell there, but a shipwreck off the coast near Rotterdam thwarted his plans. While in Rotterdam regaining his fortune, he became much influenced by the Rhenish landscapes of Herman Saftleven. According to Houbraken, Griffier purchased another boat as soon as he was able and, using Amsterdam as a base, traversed the inland waterways of Holland for ten to twelve years. A Johannes Griffier, aged 27 (thus possibly Griffier's son, Jan II), was listed in the *Album Studiosorum* of the Leiden Academy for July 14, 1700, as living on the Breestraat in that city. The elder Griffier returned to England and rented a house in Millbank, London, where he died in 1718, aged seventy-two.

Griffier was a prolific and versatile landscape painter, reflecting the influences of Roghman, Saftleven, Cornelis van Poelenburch, Rembrandt, Jacob van Ruisdael, and Adriaen van de Velde. Best known for his fantastic Rhine valley scenes, Griffier also painted topographical prospects and landscapes with Italianate ruins, the latter often peopled with nude bathers in the manner of Poelenburch. As a printmaker, he etched several views of birds and animals. He was one of the most highly esteemed landscapists in contemporary England, where he enjoyed the patronage of the Duke of Beaufort, among others. His two sons, Jan II (c.1673–c.1750) and Robert (1688–c.1760), painted in a

39 (PLATE 122)

Rhineland Landscape, c.1705(?)

similar fashion, and their works are not wholly distinguishable from those of their father.

M.E.W.

Literature: Houbraken 1718–21, vol. 3, pp. 357–60; Weyerman 1729–69, vol. 3, pp. 191–95; Descamps 1753–64, vol. 3, pp. 352–56; Walpole 1828, vol. 3, pp. 91–94; Nagler 1835–52, vol. 5, pp. 373–74; Immerzeel 1842–43, vol. 1, pp. 295–96; Kramm 1857–64, vol. 2, p. 604; Nagler 1858–79, vol. 3, nos. 10, 2381; Obreen 1877–90, vol. 5, p. 272; Wurzbach 1906–11, vol. 1, pp. 616–17; H. Schneider in Thieme, Becker 1907–50, vol. 15 (1922), pp. 26–27; Vertue 1929–42, vol. 18, pp. 50–51, vol. 26, p. 69; Gerson 1942, pp. 402–404; Ogden, Ogden 1955, pp. 121, 138–39, 141, 143, 154; Stechow 1966, pp. 165, 168; Schulz 1982, pp. 44–46.

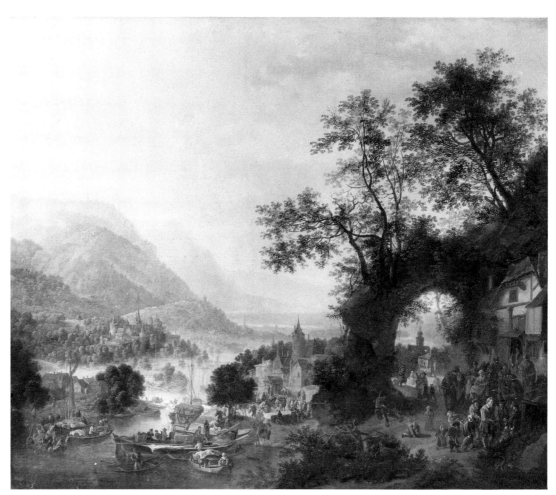

39

Monogrammed on largest boat: J.G.
Oil on panel, 21 x 25⅜ in. (53.5 x 64.3 cm.)
Rheinisches Landesmuseum, Bonn, inv. 54.17

Provenance: Duke of Newcastle; sale, London (Christie's), October 25, 1946, no. 67 (as R. Griffier), purchased by Ellis and Smith; Major Edward Harris-St. John, by 1951; acquired from Galerie Abels, Cologne, 1954.

Exhibitions: Newcastle-upon-Tyne, King's College, Hatton Gallery, *Pictures from Collections in Northumberland*, May 8–June 15, 1951, no. 16; Bonn 1960–61, no. 37.

Literature: Bonn, cat. 1959, p. 22; Stechow 1966, p. 168; Bonn, cat. 1977, pp. 128–29; Bonn, cat. 1982, pp. 200–201; Schulz 1982, p. 45.

Several clusters of lively human activity are scattered across the fore- and middleground of this detailed panoramic view. A colorful group of peasants and travelers gathers by an inn at the right, where a man's pocket is picked while his attention is diverted by the man before him. A boy plays a violin as children romp and play nearby, and at the foot of the rocky arch, a weary traveler rests by the side of the road. On the riverbank at the center of the composition, passengers and goods are busily shuttled to and from the boats gathered at the shore, while a similar scene transpires at the left. Beyond this anecdotal activity an expanse of river valley unfolds, framed by a low mountain range characteristic of the lower Rhine valley. The rich panoply of color and detail in the landscape is enhanced by the extraordinary preservation of the panel.

Although Rhineland scenes such as this were his specialty, the well-traveled Griffier may in fact never have visited the Rhine valley. He did produce a number of accurate topographical views developed from observation of specific English sites, but his invented Rhineland scenes were most likely based upon close study of paintings by Herman Saftleven (see cat. 97). He would have had an ample opportunity to study these works during his stay in Rotterdam in the 1690s.[1] There are obvious formal similarities between the Rhenish landscapes of the two artists: a slightly elevated view of a river valley enlivened by river traffic and numerous figures. However, while Saftleven's views frequently represent identifiable locations, Griffier's imaginary views are skillful compilations of the most salient and most recognizable features of the area: picturesque castles and villages, nestled among densely forested mountains that slope down to a broad and winding river. His imaginative recombinations of these elements produced a stream of pleasant Rhineland fantasies

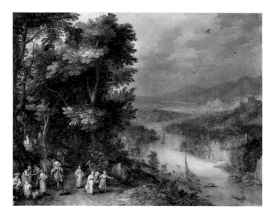

Fig. 1. Jan Brueghel, *River Landscape*, signed and dated 1602, copper, 33.3 x 45.8 cm., Staatsgalerie, Aschaffenburg, inv. 829.

that delighted his English audience.[2] With their liberal sprinkling of buildings, Griffier's paintings present a much more agreeable and domesticated land than Saftleven's craggy, naturalistic mountain valleys.

In many respects, Griffier's orderly paintings affect a return to the artificial view of nature presented in similar landscapes by late sixteenth–early seventeenth-century Flemish artists such as Jan Brueghel (fig. 1), Lucas van Valckenborch, and Joos de Momper.[3] This development in Griffier's art may be a result of both his personal interest in carefully structured topographical views and a more general tendency in late seventeenth-century landscape painting toward the representation of nature as a manicured garden rather than as an untamed wilderness.[4] The topographical view and the garden were important influences in the structure of earlier landscape painting as well. The compositional parallels between Griffier's Rhenish fantasies and earlier Flemish landscapes are enhanced by Griffier's use of minute detail and rich enamel-like colors, as well as the typical

blue-green gradation of the distant landscape. A more specific instance of influence from sixteenth-century landscapes may be the view framed by a natural rock arch, seen at the right of the Bonn painting. As a compositional device, it can be traced back to ancient Roman wall painting. Similar examples appear in landscapes by Joachim Patinir, Cornelis van Dalem, and Lucas van Valkenborch.[5]

A variant of the Bonn painting, signed by Griffier's son Robert, is in the Galleria Nazionale (Palazzo Corsini), Rome (copper, 62 x 78 cm., inv. 916). Although it echoes the basic composition and copies individual motifs such as the rock arch and several of the boats in the river, the buildings and figure groups are different, and the distant landscape view is not so dramatic.

M.E.W.

1. For a further discussion of the artistic relationship between Saftleven and Griffier, see Schulz 1982, especially pp. 44–46.
2. Griffier's extraordinary popularity among his English patrons is documented in Ogden, Ogden 1955, p. 121. Saftleven's Rhineland views were also highly prized by English collectors.
3. Stechow 1966, p. 168.
4. This tendency can also be seen in works by Italianate landscape painters of the late seventeenth century, most notably Isaac de Moucheron.
5. For example, Joachim Patinir's *Landscape with Saint Jerome* (Museo del Prado, Madrid); Cornelis van Dalem's *Landscape with the Flight into Egypt* of 1565 (destroyed; formerly Kaiser Friedrich-Museum, Berlin), and *Landscape with the Beginning of Civilization* (Dr. G.P.R.A. Bouvy collection, Bussum, panel, 88 x 165 cm.); and Valckenborch's *Landscape with the Road to Emmaus*, dated 1597 (Kunsthalle, Hamburg, panel, 26.7 x 35.8 cm., inv. 786).

Joris van der Haagen

(Arnhem? 1613-17–1669 The Hague)

Joris van der Haagen, *Self-Portrait*, panel, 25 x 20.5 cm., formerly M.J.F.W. van der Haagen Collection, The Hague.

The son of the painter Abraham van der Haagen (d. 1639) and Sophia Ottendr van der Laen, Joris van der Haagen was born between 1613 and 1617, probably in Arnhem but possibly in Dordrecht. He apparently studied with his father. Van der Haagen moved to The Hague around 1639, where he built a house on the Amsterdamse Veerkade, the street where Paulus Potter and Pieter Post also lived. On July 6, 1642, van der Haagen married Magdalena Thijmansdr de Heer, widow of Lodewijck Hasepoot. On January 30, 1643, he became a member of the guild in The Hague and in 1644 a citizen. A lost landscape (sale, Wurster,

Cologne, June 15, 1896, no. 124) was said to be dated 1636, but the earliest certain date is 1649 on the *Landscape outside the Rijnpoort of Arnhem* (Mauritshuis, The Hague, inv. 46). He was named deacon in 1651 and headman (*hoofdman*) in 1653 of The Hague guild. On October 16, 1656, he was one of the founders of the Confrerie Pictura in The Hague; two years later he exhibited a landscape of The Hague at the Confrerie. Jan Jansz Smidt was listed in the Confrerie's records of 1656 as a pupil of van der Haagen. In 1650 and 1657 van der Haagen was mentioned in Amsterdam, but it is unlikely that he ever lived there. He died in his house on the Amsterdamse Veerkade in The Hague on May 20, 1669. In the inventory of the estate of van der Haagen's widow compiled on January 5, 1676, there were twenty-eight landscapes by her late husband, nine by their son Cornelis (1651–1688), and thirty-four works by other artists; there also was a chest of ninety drawings. Joris's son Jacobus (1657–1715) and grandson Joris Cornelisz (1676–c.1745) were also artists.

A painter and draftsman of topographic views, woodlands, and panoramas, van der Haagen employed an exacting, delicate touch and subdued palette in his mature works. Among the identifiable Dutch subjects in his works are sites in and around Arnhem, Amsterdam, Nijmegen, Rosendaal, Ilpendam, Delft, The Hague, Wassenaar, Overveen, Maastricht, Rhenen, and Overschie; he also painted and drew sites near Brussels, the mountains near Elten, and views of Kleve. The staffage figures in his works were sometimes contributed by Claes Berchem (see Rijksmuseum, Amsterdam, inv. A 33) and Adriaen van de Velde, while Dirck Wyntrack (c.1625–1678) painted waterfowl and animals in his landscapes.

P.C.S.

Literature: Houbraken 1718–21, vol. 3, p. 203; Weyerman 1729–69, vol. 3, pp. 39–40; Descamps 1753–64, vol. 3, p. 25; Immerzeel 1842–43, vol. 2, p. 8; Kramm 1857–64, vol. 2, pp. 616–17; Nagler 1858–79, vol. 3, no. 1864; Obreen 1877–90, vol. 4, p. 149, vol. 5, p. 101; Bredius 1890–95, pp. 168–70; Wurzbach 1906–11, vol. 1, p. 633; F. van der Haagen 1915; M. van der Haagen 1917; H. Schneider in Thieme, Becker 1907–50, vol. 15 (1922), pp. 463–64; J. van der Haagen 1932; M. van der Haagen 1932; Martin 1935–36, vol. 2, p. 309; Gorissen 1964; Stechow 1966, p. 49; Dattenberg 1967, pp. 188–206; Bol 1969, pp. 224–25; The Hague, Mauritshuis cat. 1980, pp. 38–40; Haak 1984, p. 459.

View of the Swanenturm, Kleve, 1660s

Signed in the lower middle: JHagen [JH ligated]
Oil on canvas, 35½ x 44⅛ in. (90 x 112 cm.)
Private Collection, Boston

Provenance: Sale, N. de Bruyn, Leiden, May 10, 1775,
no. 27 (not sold); sale, K.R. Mackenzie, London, June
4, 1917, no. 127; in 1919 sold by the dealer
Thompson, to M.J.F.W. van der Haagen, The
Hague; sale, Amsterdam (Sotheby-Mak van Waay),
March 14–15, 1983, no. 20; S. Nijstad, The Hague,
1985.

Exhibitions: The Hague, *Het Hollandse waterlandschap,*
1932, no. 26; Arnhem, Gemeentelijk Museum, *Twee
eeuwen kunst in en om Arnhem, 1600–1800,* 1952, no. 10.

Literature: H. Schneider in Thieme, Becker 1907–50,
vol. 15 (1922), p. 463; J. van der Haagen 1932, p. 42,
no. 143S, fig. XXIV; Gorissen 1964, no. 109, ill.;
Dattenberg 1967, no. 197, ill.

The painting offers a fairly accurate depiction of
the Swanenturm in Kleve, viewed from the
Kermisdal. In the foreground a drover and his
cattle and sheep move along a sandy road. At the
right, tall trees flank the river that curves back
into the distance.

Between about 1660 and 1666 van der Haagen
repeatedly depicted the area around Kleve and
Elten in the Lower Rhine.[1] Houbraken specifi-
cally commended van der Haagen for his draw-
ings of Kleve on blue or white paper, noting that
"most were dated 1650, 1660 and 62" and that
they brought very good prices when a group was
sold in Amsterdam in 1715.[2] A topographical
drawing by van der Haagen (fig. 1) of virtually
the same view as the left side of this painting
is preserved in the Musée des Beaux-Arts,
Besançon;[3] this carefully executed sheet or a
similar drawing undoubtedly provided the
original conception for van der Haagen's more
elaborate painted views of the site. With minor
alterations of design and staffage, the same view,
with the Swanenturm on the left, the road in the
foreground, and the trees at the right, appears in

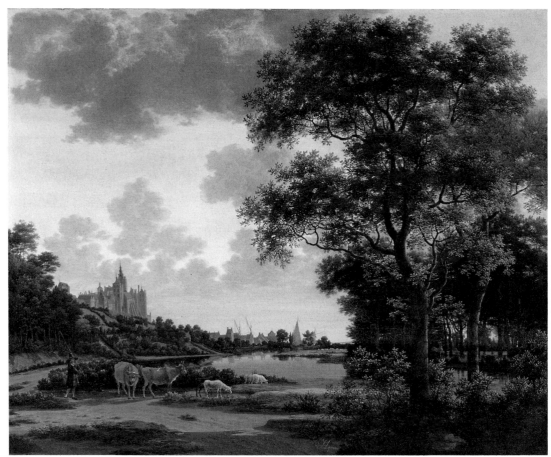

40

Fig. 1. Joris van der Haagen, *View of the Swanenturm, Kleve*, drawing, 255 x 395 mm., Musée des Beaux-Arts, Besançon.

Fig. 2. Joris van der Haagen, *View of the Swanenturm, Kleve*, signed, canvas, 109 x 120 cm., Rijksmuseum, Amsterdam, inv. C 138.

a painting in the Rijksmuseum (fig. 2).[4] A variant of the composition, which more closely resembles the Besançon drawing in its viewpoint and omission of the trees on the right, included a ferry with horse-drawn carriage in the foreground.[5] This variant may constitute a transitional stage between the drawings and van der Haagen's creation of the larger versions in the Rijksmuseum and the picture exhibited here. Van der Haagen made a practice of working up his painted compositions from his detailed and often fully annotated and numbered topographical drawings. In addition to these closely related paintings, van der Haagen's nearer view of the Swanenturm is preserved in the Konstmuseum, Göteborg (canvas, 86 x 119 cm., inv. 703), and his distant view of Kleve from Mühlenberg is in the Rijksmuseum Twenthe, Enschede (canvas, 147.5 x 187 cm.).[6]

Although van der Haagen's landscape subjects prove that he traveled in the Netherlands and the Lower Rhine, his special attraction to Kleve may have been related to the fact that in 1647 Johan Maurits of Nassau had been named the stadtholder. Among the Dutch artists that Johan Maurits employed in Kleve was the accomplished Hague architect and landscape painter Pieter Post (1608–1669). Van der Haagen repeatedly depicted Post's buildings, not simply his most famous structures, such as the Mauritshuis and Huis ten Bosch, but also those like Constantijn Huygens's Hofwijk and the royal villa, Honselaarsdijk – two buildings rarely depicted by artists specializing in architectural views. J.K. van der Haagen, who wrote a modern monograph on his distant relative, noted personal ties between the two artists' families: the artists lived on the same street in The Hague, and Joris's sons studied art under Pieter's son.[7] While there is no proof of J.K. van der Haagen's hypothesis that van der Haagen accompanied

Post on his trips to Kleve, the painter undoubtedly shared Post's interest in architecture; in van der Haagen's cityscapes proper, topographical drawing, and landscape paintings, architecture often plays an important role. Van der Haagen also shared stylistic features with Pieter Post's brother, the painter Frans Post, including a taste for carefully delineated foliage, striated compositions with strong contrasts of light and shade, and rather airless spaces. Some of these qualities in van der Haagen's works harken back to the silhouetted woods of Cornelis Vroom's silent river views (see cat. 114, 115), but his sense of scale and dramatic grandeur, albeit with more prosaic results, is indebted to Ruisdael.

P.C.S.

1. See J. van der Haagen 1932, pp. 41–42. A lost drawing of the Park at Kleve with the Eltenberg was dated 1660 (ibid., no. 135T; sale, Feitema, Amsterdam, October 16, 1758, no. E50). *A View of Kleve* in the Rijksprentenkabinet, Amsterdam, inv. A 1950, is dated 1661.

2. Houbraken 1718–21, vol. 3, p. 203.

3. J. van der Haagen 1932, no. 148T, fig. XXII. The drawing is inscribed "Cleef van de zijde van Berg en Daal."

4. Ibid., no. 142.

5. Canvas, 46 x 65 cm., Back collection, after c.1920 on loan to the Szépművészeti Múzeum, Budapest (J. van der Haagen 1932, p. 41, no. 144, fig. XXIII). See also Dattenberg 1967, no. 198, ill.

6. Respectively, Dattenberg 1967, nos. 199 and 201.

7. J. van der Haagen 1932, pp. 16, 41.

Jan Hackaert

(Amsterdam 1628–after 1685 Amsterdam?)

Jan Hackaert was baptized in Amsterdam in February 1628. Little is known of the artist's early training. Between 1653 and 1656 he traveled to Switzerland (see cat. 41), making numerous sketches of the country, but probably not as far as Italy, as was once thought. He also appears to have visited Kleve (see cat. 41, fig. 1). Dated paintings begin in 1657. On January 1, 1658, he was recorded living on the Keizersgracht, Amsterdam. As his latest known dated work is of 1685, Hackaert must have died in that year or later.

Houbraken reports that Adriaen van de Velde was a friend of Hackaert's and often painted staffage in his work. These figures are often also attributed to Claes Berchem and Johannes Lingelbach. However, only one painting, in the National Gallery, London (no. 829), bears a second signature (that of Berchem), and Hackaert may have frequently painted his own staffage.

Hackaert's paintings are strongly influenced by the tradition of Italianate landscapes, especially those of Jan Asselijn and Jan Both, although his scenes of deep woods are a more original creation. The artist also made a few landscape etchings.

A.C.

Literature: Houbraken 1718–21, vol. 3, pp. 46–48; Bartsch 1803–21, vol. 4, pp. 285–94; Wurzbach 1906–11, vol. 2, pp. 627–28; G.J. Hoogewerff in Thieme, Becker 1907–50, vol. 15 (1922), p. 407; Hofstede de Groot 1907–28, vol. 9, pp. 1–47; Stelling-Michaud 1937; Maclaren 1960, pp. 141–43; Utrecht 1965, pp. 217–19; Stechow 1966, pp. 81, 156, 158; Pfister 1972; Pfister 1973; Weber 1974; Salerno 1977–80, vol. 2, pp. 710–15; Stelling-Michaud 1979; The Hague, Mauritshuis cat. 1980, pp. 40–43; Solar 1981; Schulz 1983; Bregenz 1984; Solar 1984.

41 (PLATE 116)

The Lake of Zurich, early 1660s

41

Signed lower right: HACKAERT
Oil on canvas, 32¼ x 57⅛ in. (82 x 145 cm.)
Rijksmuseum, Amsterdam, inv. A 1709

Provenance: Collection Count von Sierstorpff, Schloss Driburg, 1863; sale, Sierstorpff, Berlin (Lepke), April 19, 1887, no. 9; collection A. von Beckerath, Berlin; sale, G. de Clercq, Amsterdam, June 1, 1897, no. 31; purchased for the museum with the aid of the Vereeniging Rembrandt.

Exhibitions: Paris 1950–51, no. 33; Warsaw 1958, no. 40, fig. 38; Utrecht 1965, no. 138, ill.; Tokyo, *The Age of Rembrandt*, 1968, no. 20, ill.

Literature: Parthey 1863–64, vol. 1, p. 538, no. 7; Bredius 1887–89, p. 55; Hofstede de Groot 1907–28, vol. 9, no. 8; G.J. Hoogewerff, in Thieme, Becker 1907–50, vol. 15 (1922), p. 408; Ledermann 1920, p. 119; Gerstenberg 1923, p. 152, pl. LVI; Waetzoldt 1927, pp. 70 and 214, ill. p. 66; Havelaar 1931, p. 14; Martin 1935–36, vol. 2, pp. 321 and 323, fig. 174; Martin 1950, p. 77, ill. 110; Hoogewerff 1952, pp. 96–97; Stechow 1953, p. 135; Plietzsch 1960, p. 137, fig. 233; Nieuwstraten 1963, p. 227; Rosenberg et al. 1966, p. 179; Stechow 1966, p. 158, fig. 321; Bol 1969, p. 270, fig. 259; Pfister 1972; Pfister 1973; Weber 1974; Amsterdam, Rijksmuseum cat. 1976, no. A 1709, ill.; Blankert 1978, pp. 218–19, 263, fig. 138; Zurich 1979, p. 17, ill.; Solar 1981, p. 15, ill.; Vienna, Akademie cat. 1982, p. 64; Haak 1984, p. 270, ill.; Salzburg/Vienna 1986, p. 36.

Seen from an elevated view, a range of mountains encircles a large lake; the terraced erosion of the land down to the water's edge is particularly evident in profile at the right. Golden sunlight spreads diagonally across the scene from the right in an almost palpable wave, imparting

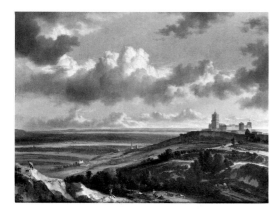

Fig. 1. Jan Hackaert, *View of Kleve*, canvas, 88 x 120 cm., Groninger Museum, Groningen, inv. 1931-124.

rich gold and amber tonalities to the land, vegetation, and clouds. In counterpoint to the majestic expanse of the scene, buildings and staffage are kept to a minimum and dwarfed by distance. Some travelers on the road at the left provide an accent of color; in the center are a woman on horseback, a herder with his flock, and some figures reclining by the side of the road. Along the far side of the lake sunlight glints on the minute terra-cotta roofs of a distant town.

As in Hackaert's *View of Kleve* (fig. 1),[1] the panoramic view in *The Lake of Zurich* is unusual in its depiction of a specific location within the conventions of an idealized Italianate style, paralleled by the work of Potter, Cuyp, and ten Oever. The emphasis on the formal sculptural qualities of the Alpine terrain to the almost complete exclusion of staffage is also exceptional. *The Lake of Zurich* was probably painted in the early 1660s,[2] shortly after Hackaert's return to the Netherlands, from a drawing of the site made during his Swiss travels in the mid-1650s.[3]

Parthey, in the earliest known description of the painting (1863), called it a "mountain land-scape" without reference to a specific location. In 1887, however, Bredius noted that the painting was apparently a representation of Lake Trasimeno in the Apennines, a suggestion that was repeated as fact in subsequent literature. Not until 1972 was the scene correctly identified by Pfister as the Lake of Zurich.[4]

Hackaert made three trips to Switzerland between 1653 and 1656. Although the reasons for his trips are not completely known, he was employed by the Amsterdam lawyer Laurens van der Hem as a draftsman, one of twelve artists commissioned to execute detailed topographical drawings in various parts of the world.[5] Van der Hem's extensive collection of topographical drawings, engravings, maps, and documents formed the basis of Joan Blaeu's *Atlas Major* in 1662. Hackaert's views of Switzerland – thirty-eight of which were included in the *Atlas* – were done mostly over a four-month period in 1655 during a journey southwest from Zurich into the canton of Graubünden. The route was probably suggested by van der Hem, who may have been representing the concerns of a group of Dutch merchants interested in developing regular overland trade routes between the Netherlands and Switzerland via the Rhine, with connections south to Italy.[6] Whatever the motivation, it is interesting to note that a number of significant sites along these proposed trade routes are represented in Hackaert's precisely detailed drawings.

In addition to these accurate and factual drawings, Hackaert's graphic oeuvre includes many imaginary landscape views, and almost all of his painted landscapes – both Dutch and Italianate – are of imaginary scenes. The one great exception to this is the magnificent *Lake of Zurich*, which, as noted above, combines topographical fidelity with an idealized format characteristic of Dutch Italianate landscapes. The influence of Jan Both and Jan Asselijn is

particularly evident in the flood of golden light spreading across the landscape, which un-doubtedly contributed to the consistent mis-identification of the scene as the Italian Lake Trasimeno.

Although mountain panoramas occur in the works of many other Northern Italianate artists, such as Claes Berchem and Karel du Jardin,[7] *The Lake of Zurich* is most closely related to Asselijn's panoramic landscape (cat. 1). Both artists have concentrated on the abstract formal composition of their horizontal landscapes and included only incidental staffage. However, while Asselijn's daring composition is a product of his own imagination, Hackaert has achieved equally dramatic results in the depiction of a specific locale by careful selection of viewpoint and atmospheric effects. It is certainly possible that he was aware of Asselijn's painting and applied the earlier artist's innovations to his representation of the Swiss lake. Alternatively, a common source has been postulated for both works, perhaps the fantastic mountain landscapes of Hercules Segers.[8] In its attenuated horizontality, Hackaert's *Lake of Zurich* is particularly close to Segers's panoramic views.

M.E.W.

1. Earlier attributed to Adriaen van de Velde and J. Esselens (see Dordrecht 1963, no. 126).

2. Stechow 1966, p. 158.

3. On Hackaert's drawings in Switzerland, see Solar 1981. Although no extant drawing corresponds exactly to the painting, Hackaert's *Lake of Zurich with the Rapperswil, from the Northwest* (Österreichisches Nationalbibliothek, Vienna) shows a different aspect of the same area.

4. See Parthey 1863–64, vol. 1, p. 538, no. 7; Bredius 1887–89, p. 55; Pfister 1972. Stechow (1966, p. 216, note 58) retains the traditional title of the scene but notes the lack of proof for such an identification.

5. The other artists perhaps engaged by van der Hem included Lambert Doomer, Jacob Esselens, Frederic de Moucheron, Bonaventura Peeters, Herman Saftleven, Roelandt Savery, Willem Schellinks, and Reiner Nooms.

River Bend with Hunting Party on a Road, c.1675–80

For an account of van der Hem's topographical collection, see H. de la Fontaine Verwey, "De Atlas van Mr. Laurens van der Hem," *Amstelodamum* 38 (1951), pp. 85–89. For a more detailed discussion of Hackaert's role in the project, see Solar 1981.

6. See Stelling-Michaud 1979.

7. For Berchem, compare the *Panorama*, British Royal Collection (cat. 1, fig. 1); for du Jardin, compare the *Landscape with Ford* (Louvre, Paris, inv. 1395).

8. See Vienna, Akademie cat. 1982, p. 64; Stelling-Michaud 1979, p. 614.

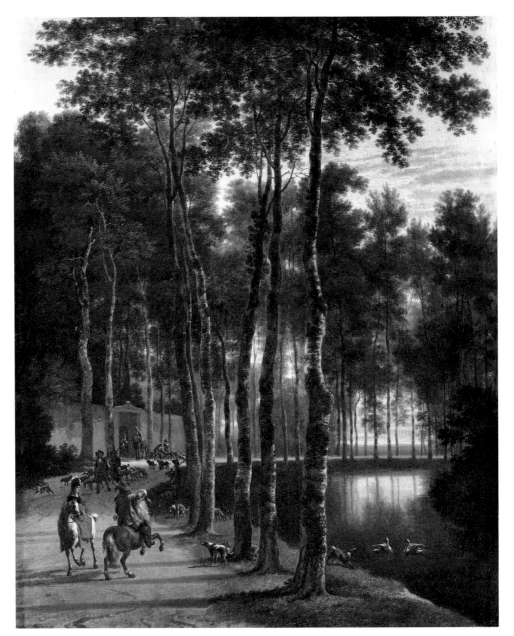

42

Oil on canvas, 26⅛ x 21 in. (66.25 x 53.5 cm.)
Rijksmuseum, Amsterdam, A 130

Provenance: Sale, J. Clemens, Ghent, June 21, 1779,
no. 117; with dealer J.D. Nijmans, Amsterdam,
purchased by G. van der Pot for fl.550 in 1781;[1] sale,
G. van der Pot van Groeneveld, Rotterdam, June 6,
1808, no. 47 (fl.3,005 to J. Eck & Son, for the
Rijksmuseum).

Literature: *Zeitschrift für bildende Kunst* 10 (1875),
p. 320; Hofstede de Groot 1907–28, vol. 9, no. 32;
Moes, van Bierma 1909, pp. 113, 181, and 196;
Wiersum 1931, p. 209, fig. 5; Martin 1935–36, vol. 2,
pp. 322–23, fig. 175; Plietzsch 1960, p. 137, fig. 232;
Utrecht 1965, pp. 218–219, note 3; Rosenberg et al.
1966, p. 179; Blankert 1978, p. 81, fig. 160; Bol 1969,
p. 269; Amsterdam, Rijksmuseum cat. 1976,
no. A 130, ill.; Burke 1976, p. 159; Salerno 1977–80,
vol. 2, p. 710, pl. 120.5; Sullivan 1984, p. 45.

A road bordered by tall and graceful birch trees
curves gently to the right around a still canal or
stream; two white swans glide through the
water in the foreground. At the left side of the
road is a high wall with a pedimented gateway.
Gathered on the road leading from the gate is a
hunting party, including an elegantly dressed
couple on horseback and servants bearing fal-
cons, guns, and other accoutrements of the hunt.
A pack of hounds prowls the area, restlessly
awaiting the call to action. The entire scene is
bathed in a hazy golden sunlight that emanates
from behind the slender trunks of the trees at
right, casting long shadows across the road and
creating the languid aura of a warm late
afternoon.

 The figures in the painting have been attri-
buted to Adriaen van de Velde, who sometimes
added staffage to Hackaert's landscapes, as did
Johannes Lingelbach.[2] Such collaborations are
difficult to prove, however, since no paintings
bear the signatures of both artists.

 Hackaert's many hunt scenes within a native
Dutch landscape form nearly as large a group

Fig. 1. Jan Hackaert, *Hunting in a Wood*, Earl of Crawford and
Balcarres, Scotland.

within his oeuvre as his Italianate landscapes.
Horizontal or vertical compositions, with active
or passive pursuit of the quarry, they are usually
set in the shady, secluded interior of a wood yet
given a feeling of airiness by the sunlight passing
between slender and evenly spaced trees
crowned with lacy foliage. Sometimes Hackaert
painted denser forests (see fig. 1), but even these
are richly textured with light. Hackaert was
probably most directly influenced by Jan Both in
this sort of Dutch forest motif. Both composed
several such intimate wooded scenes illuminated
by a soft, glowing light, frequently with a view

down a tree-lined road.[3] Although this format
was adopted and popularized by other artists
through the 1650s – for example, Joris van der
Haagen, Paulus Potter, and Herman Saftleven[4] –
it was Hackaert who most successfully adopted
Both's distinctive sensitivity for light and
atmosphere.

 Hunting was a popular and multifaceted
theme in Dutch landscape painting. Tra-
ditionally an aristocratic sport in the Nether-
lands, hunting was strictly regulated and in
theory restricted to the nobility.[5] During the
latter part of the seventeenth century it grew in
importance, chiefly because of its recognized
identification with the leisured class. The pas-
sion for hunting was associated with the grow-
ing trend for wealthy nobles and patricians to
establish fashionable country homes (*buiten-
plaatsen*) outside the cities, where they could
pursue such leisure activities as hunting and
horticulture. Contemporary *hofdichten* extol the
rich and diverse opportunities for hunting as a
part of the overall fruitfulness of the country
estate.[6]

 Concurrent with these events, a new type of
Dutch hunt scene developed in landscape paint-
ing after about 1660, in which the vigorous
athletic pursuit of birds or game popular in
earlier paintings (see, for example, cat. 11) is
supplanted by the more decorous, parenthetical
acts of setting out for or returning from the
hunt. The well-dressed hunting parties often
include women; a significant proportion of the
paintings feature hunting with falcons or other
birds of prey, considered the most gentlemanly
and sportsmanlike manner of hunting.[7] The
scene is frequently composed in a vertical format
graced with tall, slender trees that emphasize
the static elegance of the event. Quite often a
country estate or its gateway is included in the
view, alluding to the affluent and privileged
status expected of participants in the hunt.

Jan van der Heyden

(Gorkum 1637–1712 Amsterdam)

In addition to Hackaert, several Dutch artists specialized in depicting the departure for or return from the hunt; the works of Frederic de Moucheron and Adriaen van de Velde in this genre are particularly close to Hackaert's in both composition and mood.[8] Similar views by Gerrit Berckheyde and Jan van der Heyden place more emphasis on architecture in the landscape and often represent identifiable estates.[9] The number of artists producing such scenes suggests that the market for paintings of the hunt was not limited to the nobility eligible to conduct such hunts from their country estates. The acquisition of these paintings, in fact, probably afforded wealthy burghers the vicarious enjoyment of a sport denied them by position or birth.[10]

There are variants of the Rijksmuseum painting in the Wallace Collection, London; formerly with Lady Wantage; and in the collection of Broadlands, Romsey.[11] A replica or copy of the painting was sold in Paris in 1942,[12] and a reversed copy of the Wallace Collection painting was in Zurich in 1985.[13]

M.E.W.

1. An engraving after the painting by R. Daudet, as part of the cabinet of M. Le Brun, is dated 1786; Hofstede de Groot placed the painting in Le Brun's collection around 1780.

2. Similar paintings with staffage attributed to van de Velde include fig. 1 and formerly in the Alte Pinakothek, Munich (inv. 1039). A hunt scene with figures attributed to Lingelbach was sold in Amsterdam, October 17, 1905, no. 52, ill.

3. See Both's drawing of a tree-lined road, c.1645 (collection P. Brandt, Amsterdam; Burke 1976, no. D-2, fig. 126). Hackaert may have been a pupil of Both and was in any event familiar with drawings from his studio, as evidenced by Hackaert's 1661 copy of a Both drawing (J. Bolten, *Dutch Drawings from the Collection of Dr. C. Hofstede de Groot* [Utrecht, 1967], pp. 70–73, ill. p. 162; Both's signed original is in the Kupferstichkabinett, Berlin [West]).

4. See Burke 1976, pp. 155–59.

5. Sullivan 1984, pp. 33–34; the main sources for hunting in seventeenth-century Holland cited by Sullivan are Paullus Merula, *Placaten ende Ordonnancien op 'tstuck vande Wildernissen* (The Hague, 1605); and *Jacht-Bedryff* (1636), an anonymous work attributed to Cornelis Jacobsz van Heernvliet (ed. A.E.H. Swaen [Leiden, 1948]), the original manuscript of which is in the Koninklijk Bibliotheek, The Hague.

6. See Beening 1962, pp. 374–87; and van Veen 1960, p. 145, passim.

7. Sullivan 1984, p. 37.

8. Compare de Moucheron's hunt scene (Schloss Mosigkau, Dessau, inv. 116) and van de Velde's *Hawking Party Setting Out* (Buckingham Palace, London; White 1982, no. 206).

9. For example, van der Heyden's *Maarsen, Huis Harteveld* (Louvre, Paris, inv. RF 3723) and Berckheyde's series of hunting processions around the Hofvijver in The Hague (examples in the Mauritshuis, inv. 797; and the Gemeentemuseum, The Hague, cat. 1935, no. 55).

10. Sullivan 1984, p. 45; L. de Vries 1984, p. 36.

11. Listed in London, Wallace Collection, cat. 1968, p. 143.

12. As "replica with important variations," sale, Paris June 15, 1942, no. 24, ill.

13. With Galerie Bruno Meissner; sale, London, July 5, 1984, no. 301, ill.

Originally from Flanders, the van der Heyden family settled in Bommal in the beginning of the seventeenth century. Jan van der Heyden's parents married in Utrecht in 1631 and soon thereafter moved to Gorkum. The couple was Mennonite; Jan's father was by turns an oil mill owner, a grain merchant, and a broker. The third of eight children, Jan was born March 5, 1637, in Gorkum. His oldest brother Goris made and sold mirrors. Jan first studied with a glass painter in Gorkum before moving to Amsterdam, where he married Sara ter Hiel of Utrecht on June 26, 1661. By this date he was already a practicing artist, but no dated works are known before 1664. Between 1668 and 1671, Jan van der Heyden and his brother Nicolaes developed a pumping mechanism that greatly improved firefighting techniques; in 1673 he was appointed overseer of the city's fire departments. Further, in 1670 Jan was named overseer of Amsterdam street lighting. In 1679 he bought land on the Koestraat with the intention of building a house and fire engine factory. In 1690, Jan and his eldest son, Jan van der Heyden the Younger, published a large book on fire-fighting. The artist died in his house on the Koestraat at the age of seventy-five on March 28, 1712. His substantial estate was appraised at 84,000 guilders. In his possession at the time of his death were more than seventy of his paintings.

Jan van der Heyden was primarily a cityscape painter and draftsman and only rarely produced still lifes and landscapes. He occasionally collaborated with figure painters, such as Adriaen van de Velde and Jan Lingelbach (1622–1674). The sites depicted in his works indicate that he traveled to the Rhineland and Southern Netherlands. The precision and specialized visual effects in his cityscapes suggest the use of lenses, mirrors, and very possibly the camera obscura; however, these effects cannot be deduced in his landscapes. These number only about forty

paintings but are varied in subject, including river valleys, hills, mountains, and woods. His colleague Adriaen van de Velde apparently influenced him. Landscapes also figure among his few surviving paintings on glass (see Rijksmuseum, Amsterdam, inv. A 2511). Although no students are recorded, van der Heyden had numerous followers and imitators.

P.C.S.

Literature: Houbraken 1718–21, vol. 3, p. 800; Weyerman 1729–69, vol. 2, pp. 391–92; Descamps 1753–64, vol. 3, pp. 48–52; Reynolds 1781; de Bosch 1807; Smith 1829–42, vol. 5, pp. 369–411, vol. 9, pp. 668–79; Nagler 1835–52, vol. 6, pp. 168–69; Immerzeel 1842–43, vol. 2, pp. 37–38; Kramm 1857–64, vol. 3, pp. 687–88; Nagler 1858–79, vol. 3, no. 1647, vol. 4, nos. 570, 586; ter Gouw 1872; Obreen 1877–90, vol. 4, p. 266; Bredius 1880; A.D. de Vries 1885–86, vol. 3, p. 149; Wurzbach 1906–11, vol. 16, pp. 685–87; vol. 3, p. 101; Hofstede de Groot 1908–27, vol. 8, pp. 325–426; Bredius 1912; Breen 1912; 't Hooft 1912; Bredius 1913a; Breen 1913; Bode 1915; C. Hofstede de Groot, in Thieme, Becker 1907–50, vol. 17 (1924), pp. 22–24; Rijckevorsel 1933; Martin 1935–36, vol. 2, pp. 398–402; Amsterdam 1937; van Eck 1937; van Gelder 1937b; Heppner 1937; Richardson 1939–40; Dattenberg 1940; Kleyn 1944; Maclaren 1960, pp. 156–63; Stechow 1966; Dattenberg 1967, pp. 210–33; Wagner 1970; Wagner 1971; Haak 1972–73; van Eeghen 1973a; van Eeghen 1973b; Haverkamp Begemann 1973b; Sluijter 1973; L. de Vries 1976; Schwartz 1983; Haak 1984, pp. 483–85; L. de Vries 1984.

43 (PLATE 80)

Wooded Landscape with Crossroads

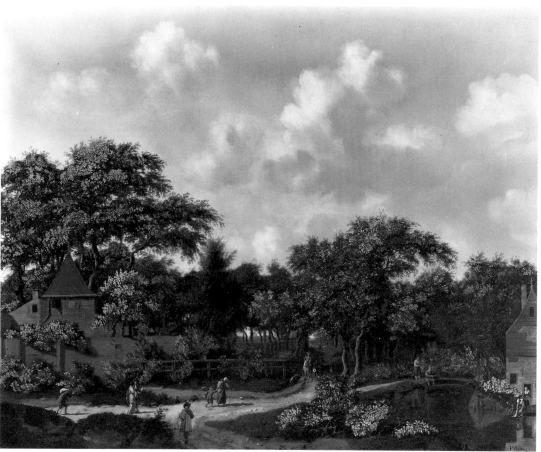

43

Signed lower right: VHeijde [VH ligated]
Oil on panel, 17½ x 21⅝ in. (44.5 x 55 cm.)
Thyssen-Bornemisza Collection, Lugano, no. 131

Provenance: Sale, Amsterdam, September 25, 1743, no. 54 (fl.30.5); sale, Leboeuf, Paris, April 8–12, 1782 (frs.3420); Duke of Westminster, London; Lady Theodora Guest; R. Langton Douglas, London; dealer J. Goudstikker, Amsterdam (1918 cat., no. 22, pl. VI); acquired by the Thyssen Collection, 1938.

Exhibitions: Rotterdam/Essen 1959–60, no. 83, fig. 93; The Hague/London 1970–71, no. 65.

Literature: Hoet 1752, vol. 2, p. 127; Smith 1829–42, vol. 5, no. 37; Hofstede de Groot 1907–28, vol. 8, no. 295; Lugano, cat. 1958, no. 190a; Lugano, cat. 1969, vol. 1, no. 131, vol. 2, pl. 195; Wagner 1971, pp. 48, 109, no. 189, ill.; Lugano, cat. 1986, no. 131, ill.

Fig. 1. Jan van der Heyden, *View of the Wood*, verre églomisé, 34 x 42.5 cm., Rijksmuseum, Amsterdam, inv. A 2511.

Fig. 2. Jan van der Heyden, *Wooded Landscape with Bathers*, monogrammed, panel, 21 x 30 cm., Rijksmuseum Twenthe, Enschede, inv. 414.

Beneath a bright sky, a sandy road running parallel to the picture plane and bordered by woods divides in the foreground. On the left it passes by a country house with tall trees and a fence; on the right it crosses a low bridge spanning a pond and leading to a smaller house.

In the right center the main branch of the road curves back into the distance along a tree-lined alley. The several travelers on the road include a man with a white sack on his shoulder; an elegantly attired couple; a woman carrying a child on her back and leading a small boy; in the middle distance, a horseman with companions on foot; and, in the immediate foreground, a man walking toward the viewer on a branch of the road. On the right boys fish from the bridge as a woman washes clothes.

This work is one of only about forty landscapes proper that the cityscapist van der Heyden painted.[1] Landscape nonetheless often was an important feature of his views of cities, parks, and country houses. In addition to executing wooded views such as this painting, he painted river scenes, views of valleys, mountains, and hills, the edges of villages, meadows and pastures bordered by woods, and a few southern landscapes. With only two dated landscapes,[2] this portion of his oeuvre reveals no clear chronology or consistent development. An extraordinary group of his landscapes, which are presumed without foundation to be early works, are his several landscapes painted behind glass (fig. 1).[3] This painstaking and highly deliberate art form – which permits of no changes once the artist has begun his work, as it were, in reverse – is today regarded as little more than a curious display of virtuosity but is consonant with van der Heyden's exacting approach to technique. The care with which he has built up the enamel-like foliage in the Thyssen-Bornemisza Collection's painting attests to a similar love of finish and resolution.

The figures in this painting have probably correctly been attributed to Adriaen van de Velde,[4] with whom van der Heyden seems to have often collaborated. As with other designs by van der Heyden (see, for example, *Farm among Trees*, National Gallery, London, no. 993),

this work's horizontal composition, with the mass of trees disposed parallel to the picture plane and rising to about two-thirds the height of the picture, recalls arrangements favored by Adriaen van de Velde (see Städelsches Kunstinstitut, Frankfurt, inv. 1048; dated 1658).[5] Finally, the painting's combination of great clarity of tone and a relatively thick, assured touch may also owe a debt to Adriaen. Although the subject is very different, a comparable technique is employed in van der Heyden's *Landscape with a Castle* (Herzog Anton Ulrich-Museum, Braunschweig, inv. 394).

Another view by van der Heyden of a road in a wood with water and a bridge is preserved in Enschede (fig. 2). While that site has not been identified, the location of the exhibited painting is believed by Wagner to be the woods at The Hague.[6] She refers to a similar view in a painting by Joris van der Haagen that was in the Spanish Embassy in Paris in 1971, but the similarity of the two works is not compelling.[7]

There appears to be little support for Hofstede de Groot's assumption that the Thyssen-Bornemisza painting is the pendant to the so-called *Garden in a Convent*,[8] correctly identified by Wagner as St. Cäcilien (Pannwitz Collection, Heemstede), Cologne.[9] While the dimensions are close, the two works' supports are different, and their subjects would seem to have little in common. Moreover, descriptions in the 1743 Amsterdam sale that purportedly links these two works do not mention pendantship and are too cursory to permit positive identification with either work.[10]

P.C.S.

Meindert Hobbema

(Amsterdam 1638–1709 Amsterdam)

1. See Wagner 1971, pp. 47–50, nos. 177–208.

2. See *River Landscape with Cottages*, signed and dated 1668, panel, 22 x 33 cm., private collection (Wagner 1971, no. 179, ill.); and *River Landscape with Hills*, signed and dated 1666, Godsfield Manor, Arlesford (ibid., no. 198, ill.).

3. See *View of the Wood*, (fig. 1); and *River Valley*, 17.5 x 27.5 cm., J.E.M. Kramer, Paris (respectively Wagner 1971, nos. 192 and 195, ill.). Wagner assumes that the latter work is a youthful effort because it employs designs favored by the earlier Flemish artists Joos de Momper and Tobias Verhaecht. However, these Flemish compositions were revived by many Dutch painters in the third quarter of the seventeenth century and need not indicate an early date.

4. Hofstede de Groot 1908–27, vol. 8, no. 295, and later authors.

5. Wagner 1971 (p. 48) cited the Frankfurt painting. Compare also Adriaen van de Velde's *Edge of the Wood*, signed and dated 1658, National Gallery, London, no. 982.

6. Wagner (1971, p. 48) refers to the painting as "die Landschaft 'im Haagschen Bosch'." Her assumption, however, that Adriaen van de Velde may have also had a hand in painting some of the landscape elements and foliage seems unlikely.

7. Ibid. See J. van der Haagen 1932, p. 108, no. 196s, as in the collection of Madame A. Schlosz, Paris.

8. Hofstede de Groot 1908–27, vol. 8, no. 219, canvas, 40 x 55.5 cm.

9. Wagner 1971, no. 53, ill.

10. Hoet 1752, vol. 2, p. 127, no. 54, "Een landschap in de manier van Jan van der Heyden. 30–5"; and no. 55, "Een Thuyngezigt agter een Kloster, waar in komt een Processie, door denzelven. 33–0" (without dimensions in either case). The two paintings apparently later reappeared together in the collection of Theodora Guest but, according to Hofstede de Groot, had different intervening and later provenances.

The son of Lubbert Meyndertsz, Meindert (or Meijndert) was baptized in Amsterdam on October 31, 1638. At an early age he adopted the surname "Hobbema," which his father evidently never used. In July 1660 Jacob van Ruisdael claimed that Hobbema, who was then living in Amsterdam, had been his apprentice for "some years." Hobbema's work, which is often based on Ruisdael's, seems to confirm this contact. In 1668 Hobbema became one of the wine gaugers for the Amsterdam octroi, a post he held until the end of his life. He was married in the same year to Eeltje Vinck, then thirty years old, with Ruisdael serving as a witness. It was previously believed that Hobbema gave up painting after getting married and assuming his new job, but a handful of later works, some of high quality (see, for example, *The Avenue at Middelharnis* of 1689, cat. 47), have been identified. It nevertheless seems clear that his activity as a painter was sharply curtailed after 1668. Hobbema lived on the Rozengracht in Amsterdam throughout his later years. He died on December 7, 1709, in that city.

Hobbema was active as a painter and draftsman of landscapes, above all wooded scenes, in the manner of Jacob van Ruisdael. Though sometimes wrongly thought of as a dilettante, he was a highly productive painter with a large oeuvre. The earliest dated work is of 1658 (Institute of Arts, Detroit, no. 89.38). His early paintings recall the style of Salomon van Ruysdael and Cornelis Vroom. It was only around 1662 that the influence of Ruisdael's art became particularly pronounced in his work. Already by about 1663–64, however, he had asserted his independence from Ruisdael. His art became lighter, more colorful and expansive, his compositions gained a new spatial freedom, and his touch became more fluid. The majority of Hobbema's best works date from about 1662 to 1668 and are usually horizontal scenes of woods

with houses, water mills, and sandy roads. He is distinguished from Ruisdael by his livelier view of nature, yet in achieving this effect he sacrificed something of his teacher's power and intensity.

P.C.S.

Literature: van Eynden, van der Willigen 1816–40, vol. 1, pp. 122–28, vol. 4, p. 101; van der Willigen 1831–32; Smith 1829–42, vol. 6, pp. 109–63, vol. 9, pp. 719–29; Nagler 1835–52, vol. 6, pp. 201–203; Koppius 1839–40; Héris 1839–40; Immerzeel 1842–43, vol. 2, p. 41; Héris 1854; Steinmetz et al. 1854–60; Kramm 1857–64, vol. 3, pp. 693–98; Nagler 1858–79, vol. 2, nos. 105, 3040, vol. 3, no. 1311; Thoré 1859; Veegens 1860; Rammelman Elsevier 1861–62; de Brou 1862; Scheltema 1863; von Lützow 1875; van Vloten 1875; Scheltema 1876; de Roever 1882; de Roever 1883–85; Michel 1886; Michel 1890a; Cundall 1891, pp. 39–62, 154–59; Hofstede de Groot 1893; Rooses 1894; Thieme 1896; Wurzbach 1906–11, vol. 1, pp. 690–92, vol. 3, pp. 101–102; C. Hofstede de Groot in Thieme, Becker 1907–50, vol. 17 (1924), pp. 160–61; Hofstede de Groot 1908–27, vol. 4, pp. 350–451; Bredius 1910–15; Hofstede de Groot 1917–18; Havelaar 1924; Rosenberg 1927; Martin 1935–36, vol. 2, pp. 310–18; Grautoff 1936; Broulhiet 1938; Maclaren 1938; Oldewelt 1939; van Regteren Altena 1939a; Oldewelt 1942b; Brière-Misme 1946; Gerson 1947a; Stechow 1959; Maclaren 1960, pp. 163–76; Rosenberg et al. 1966, pp. 157–59; Stechow 1966, pp. 76–80, 127–28; Maschmeyer 1978; Hagens 1982; Haak 1984, pp. 465–67; Wright, forthcoming.

Wooded Road with Cottages, 166[2]

Signed and dated lower left: m. hobbema f
166[2]
Oil on canvas, 42⅛ x 51½ in. (107 x 130.8 cm.)
Philadelphia Museum of Art, the William L.
Elkins Collection, acc. no. E'24-3-7

Provenance: Sir Richard Ford, London, by 1851 and,
according to Waagen in 1854, in "the possession of
Mrs. Ford's family for four generations"; sale,
London, 1871 (£3,100); Sir John Fowler, Thornwood
Lodge, Campden Hill, by 1872; sale, Fowler, London
(Christie's), May 6, 1899, no. 89 (£9,555 to
A. Wertheimer); William L. Elkins, Philadelphia.

Exhibitions: London, British Institution, 1851, no. 83;
probably London, British Institution, 1863, no. 74
(*Woody Landscape* lent by Clare Ford); London, Royal
Academy, 1872; New York 1909, no. 50, ill.;
St. Louis, City Art Museum, 1947, no. 21, ill.;
Philadelphia 1950–51, no. 40, ill. (signed and dated
1662).

Literature: Waagen 1854–57, vol. 2, p. 225;
Philadelphia, Elkins cat. 1900, vol. 2, no. 101, ill.;
Hofstede de Groot 1908–27, vol. 4, no. 46;
Philadelphia, Elkins cat. 1924, no. 7; Philadelphia
Museum of Art, *Picture Book*, 1931, p. 5, fig. 6;
Broulhiet 1938, no. 197, ill.; *Philadelphia Museum of
Art Bulletin* 193 (March 1942), p. 19, ill.; Stechow
1959, pp. 3, 10, fig. 8; Philadelphia, PMA cat. 1965,
p. 33; Cleveland, cat. 1982, p. 240; J. Rishel, "Dutch
Painting: An Overlooked Aspect of the Collection,"
Apollo 100 (1974), p. 29, fig. 3; P. Sutton 1986, p. 225,
fig. 327.

A road winds away through a wood from the left
center foreground. At a fork in the middle
distance a smaller road branches off to the door
of a cottage on the left. Two other cottages
appear farther down the main road and a fourth
is seen in the foreground at the far left. All of
these structures are partly hidden among the
trees. The largest and loftiest group of trees in
the left center shades a peasant couple beneath
it. Farther along the alternately sunlit and
shaded road are additional staffage figures
situated at intervals.

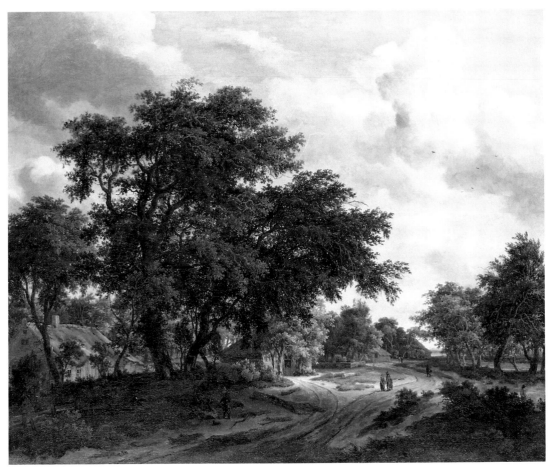

The date on this painting has been read variously: Waagen in 1854 and the compilers of the Elkins collection catalogue in 1900 deciphered it as 1652; when exhibited in New York in 1909, it was said to read "166–," and the cataloguers suggested a date of about 1665; Hofstede de Groot in 1912 preferred to see "16–2" and suggested "the illegible figure most probably was a six, and not a five as some have suggested"; Broulhiet in 1938 accepted the Hudson-Fulton exhibition catalogue's reading of 1665; and, finally, Stechow in 1959 concurred with Hofstede de Groot's reading of 1662. The third digit now appears to be a six, a reading corroborated by the facts that no dates earlier than 1658 have been discovered and that the form of the signature, with the first initial separated from the last name ("m. hobbema"), occurs only after 1660.[1] The last digit is the most heavily drawn and appears with the naked eye, microscope, and infrared photography to be a "2." A reading of 1662 for the date is most convincing given the work's stylistic resemblance to other pictures of this date.

Stechow, who accepted the date 1662 without reservations, discussed the picture as a milestone in Hobbema's early career, stressing that it was one of several compositions from 1662 that reveal the very pointed influence of Ruisdael, indeed the strongest of Hobbema's career.[2] Several other works from this year – *The Farm*, in the Louvre, Paris (fig. 1); two views of water mills;[3] and *The Old Oak*, National Gallery of Victoria, Melbourne[4] also reflect his teacher's impact; the last mentioned is even based on an early Ruisdael etching. In the present work the Ruisdaelian elements include the design with a road running diagonally through a wood of enormous oaks, the lighting system that artfully distributes patches of sunlight and silhouettes the tree trunks, and the color scheme of rich greens and earth hues (compare the palette, for

Fig. 1. Meindert Hobbema, *The Farm*, signed and dated 1662, canvas, 82 x 103 cm., Musée du Louvre, Paris, inv. R.F. 1526.

Fig. 2. Meindert Hobbema, *Village among Trees*, signed and dated 1665, canvas, 76 x 110.5 cm., Frick Collection, New York, inv. 02.1.73.

example, in cat. 82). The heavy trees with their compact contours and the rather closed composition are typical of Hobbema's art of 1662; only one year later he would adopt a freer approach (see cat. 45). Stechow wrote that the palette was "heavier and of deeper brown than the pictures of 1663, but that it foreshadows the mature style of the middle sixties in composition and numerous details".[5] Two paintings, also in American collections, and both dated 1665 employ virtually the same design: the *Village among Trees* (fig. 2) in the Frick Collection in New York and *View on a High Road* in the National Gallery of Art, Washington, D.C. (no. 62). Hobbema often repeated compositions and motifs. While his repertory, therefore, was limited, comparison of these three closely related designs proves that his variations never produce mechanical results. The artist achieved surprising variety with great economy of means.

P.C.S.

1. See Stechow 1959, p. 18.

2. Ibid., pp. 3, 10.

3. Collection Nivaa, Hage cat. 1908, no. 29, and with dealer D. Katz, Dieren, c.1937; see, respectively, Hofstede de Groot nos. 88, 108; Broulhiet 1938, figs. 33, 34.

4. Inv. no. 2253/4; Hofstede de Groot 1908–27, no. 132; Broulhiet 1938, no. 225. A signed variant is in the Thyssen-Bornemisza collection, Lugano (Hofstede de Groot, no. 264; Broulhiet 1938, no. 224), cat. 1969, no. 132, pl. 188. Also dated 1662 is the *Wooded Landscape with Wagon Fording a Stream*, with dealer M. Porkay, Zurich, 1965 (Hofstede de Groot, no. 117; Broulhiet 1938, no. 85) and (possibly) the *Wooded Landscape with Riders*, with dealer Knoedler, New York, before 1946 (Hofstede de Groot, no. 129).

5. Stechow 1959, p. 10.

Wooded Landscape with a Pool and Water Mills, c.1663–68

Signed lower right: m. hobbema.
Oil on canvas, 38 x 50½ in. (96.5 x 128.3 cm.)
The Taft Museum, Cincinnati, Gift of Mr. and
Mrs. Charles Phelps Taft. 1931.407

Provenance: Sale, Lady Holderness, London, March 6,
1802, no. 76 (to Tracy £264); Charles Hanbury
Tracy, London, 1835; sale, Demidoff, San Donato,
March 15, 1880, no. 1103, ill.; sale, E. Secrétan,
London, July 13, 1889, no. 6 (£5,460); Baron Samuel
Cunliffe-Lister; Scott and Fowles, New York; ac-
quired by Mr. and Mrs. Charles Phelps Taft,
Cincinnati, October 26, 1907.

Exhibitions: London, British Institution, 1821, no. 129;
London, British Institution, 1832, no. 56; New York,
Scott and Fowles, 1909 and 1914.

Literature: Buchanan 1824, vol. 1, p. 318, no. 76;
Smith 1829–42, vol. 6, p. 117, no. 10; Cundall 1891,
p. 158; Hofstede de Groot 1908–27, vol. 4, no. 106;
Cincinnati, Taft cat. 1920, p. 71; Broulhiet 1938,
pp. 41–42, 469, no. 239, ill.; Cincinnati, Taft cat.
1945, p. 159, no. 470; P. Sutton 1986, p. 61, ill.

In the left foreground is a sedgy pool surrounded
by tall trees, while on the right a road leads back
to a sunlit meadow and water mills. A herdsman
blowing his horn drives a bull on the right. To
his left stands a boy, and to the right a woman
sits beneath a lofty tree by the roadside, cleaning
a man's hair. In the shadow of the trees beside
the pool, another herdsman tends two cows, and
near them are a sheep, a goat, and a dog. The
photographs reproduced here show the painting
before its recent cleaning, which revealed an
area of damage around the herdsman with two
cows in the left center.

After painting river landscapes in his early
career, Hobbema made a specialty of woodland
views, at first with slender trees and airy vistas
reminiscent of Salomon van Ruysdael, and later
with more monumental stately forests derived
from Jacob van Ruisdael. As Stechow has shown,
the Philadelphia painting of 1662 (cat. 44) marks
the period of Hobbema's greatest indebtedness

45

to Ruisdael's wooded scenes.[1] Already by the
following year he had struck out more asser-
tively on his own, producing several large,
ambitiously conceived woodland scenes with
more open compositions. His indisputable
masterpiece is the Beit collection painting
(fig. 1), which, like his other works of 1663,
introduces a new variety into his design, offering
a view of a high road on the right separated by a
group of tall trees in the center from a low

pathway and pond beneath it on the left.[2]
The diversity not only of the motifs but also
in the treatment of space that characterizes
Hobbema's art of about 1663–68 is well illus-
trated by the Taft Museum's painting. The dual
view, over a low pond and under a screen of
trees on the left, and with a slightly ascending
roadway and sunlit prospect on the right,
achieves a more varied and open effect than the
conspicuously contained and more heavily

Fig. 1. Meindert Hobbema, *Wooded Landscape with Cows*, signed and dated 1663, canvas, 108 x 128.3 cm., collection of Sir Alfred Beit, Blessington, Ireland.

Fig. 2. Jacob van Ruisdael, *Edge of a Forest*, signed, canvas, 103.8 x 146.2 cm., Worcester College, Oxford.

constructed works Hobbema painted during his most Ruisdaelian phase. Even the staffage have more spring in their step. As in the Beit picture, they were probably painted by Adriaen van de Velde, who often collaborated with Hobbema, Ruisdael, and others. The first to assign the figures to van de Velde was Smith, who judged the painting a "capital picture."[3]

A close unsigned variant of the Taft Museum painting's composition is illustrated by

Broulhiet,[4] who claims that both works were inspired by Jacob van Ruisdael's *River in a Forest* (sale, Maurice Kann, Paris, 1911).[5] While there is some general resemblance in design, especially in the configuration of the trees on the left, it is unclear that this specific Ruisdael was Hobbema's point of departure. Hobbema's works of this group (see also Musée du Louvre, inv. 1342; Statens Museum for Kunst, Copenhagen, inv. 4947; and Allen Memorial Art Museum, Oberlin College, no. 44.52, signed and dated 166[8 or 9]) have thoroughly digested their sources in Ruisdael's forest scenes from the mid-1650s (see, for example, fig. 2).[6] In the latter works the artist's teacher first developed a variation on the traditional design of a pool in the foreground with a diagonally receding grove of trees by opening a glimpse through the darkened screen of trunks to a lighted vista beyond. In the Taft painting Hobbema opens the composition still further by spacing his trees more liberally, adding a road at the right and a prospect of meadows beyond. He continued to do variations of this design until at least 1669.[7]

P.C.S.

1. Stechow 1959, p. 10; 1966, pp. 76–77.

2. Hofstede de Groot 1908–27, vol. 4, no. 136; Broulhiet 1938, no. 304. Compare also the other dated paintings of 1663, including National Gallery of Art, Washington, no. 1937.1.61 (Hofstede de Groot, no. 171), and the Musées Royaux des Beaux-Arts, Brussels, inv. 2616 (ibid., no. 127).

3. Smith 1829–42, vol. 6, no. 10. Broulhiet (1938, p. 409, no. 239) also commended it as a work as "de la série des grands chefs-d'oeuvre de l'apogée."

4. *Pool in the Woods*, canvas, 88 x 119 cm., probably Porgès collection, sale, Paris (Drouot), January 22, 1936; Madame Max Botten (see Broulhiet 1938, no. 238, ill.).

5. Hofstede de Groot, 1908–27, no. 505; Broulhiet 1938, no. 236, ill.

6. Rosenberg 1928a, no. 89, fig. 55.

7. See Broulhiet 1938, no. 438, signed and dated 1669, panel, 24 x 32.5 cm., ex-Drummond Libbey, Toledo.

46 (PLATE 98)

Wooded Landscape with a Water Mill, c. 1662–64

Signed lower left, on mound: hobbema
Oil on canvas, 32 x 43⅛ in. (81.3 x 109.6 cm.)
The Art Institute of Chicago, Gift of Mr. and Mrs. Frank G. Logan, no. 94.1031.

Provenance: John Ellis, 1755; Lord Mount Temple, 1870–90; Durand Ruel, Paris; Prince Anatole Demidoff, San Donato; Prince Paul Demidoff, Pratolino, 1890; presented 1903.

Exhibitions: Chicago, Art Institute, *A Century of Progress*, 1933, no. 66, pl. 38; Chicago, 1934, no. 93; New York, World's Fair, *Masterpieces of Art*, 1939, no. 193.

Literature: Smith 1829–42, vol. 6, no. 105; Thieme, Becker 1907–50, vol. 17 (1924), p. 160; Hofstede de Groot 1908–27, vol. 4, no. 71; Chicago, Art Institute, *Catalogue of Paintings and Sculpture*, 1933, no. 66, ill.; Broulhiet 1938, p. 378, no. 13, ill.; *Art Quarterly*, Winter 1939, fig. 10; The Hague, Mauritshuis cat. 1980, pp. 46–49; P. Sutton 1986, p. 51, ill.

A water mill on the right feeds a pool that fills much of the foreground. The millstream passes through a sluice with two waterwheels beneath it. The large red tile roof of the mill stands before trees beyond. An additional clump of tall trees appears on the left beside a road with travelers.

In 1835 Smith described the painting from a drawing;[1] Hofstede de Groot offered a more detailed description of the work, judging it "a very good picture," and noting that the same water mill appears in at least six other paintings by Hobbema.[2] The closest of these, viewing the mill from the same side and almost the same angle, are the undated paintings in the Wallace Collection, London (fig. 1),[3] and the Rijksmuseum, Amsterdam (inv. c 144).[4] The mill appears from another point of view in the Rijksmuseum, Amsterdam (inv. A 156, on loan to the Mauritshuis, The Hague, inv. 884), and in a painting dated 1664 that was in Lady Wantage's collection in 1905 and later in the H.E. ten Cate collection (fig. 2).[5] Several drawings by

Fig. 1. Meindert Hobbema, *Water Mill*, signed, panel, 69 x 92 cm., Wallace Collection, London, no. P99.

46

Fig. 2. Meindert Hobbema, *Water Mill*, signed and dated 1664, canvas, 92.7 x 127.6 cm., formerly H.E. ten Cate, Almelo.

Hobbema of this mill are also preserved.[6] Yet another painting by Hobbema of a different water mill is also dated 1664 (National Gallery of Art, Washington, new inv. no. 627).[7] The Washington painting's composition and a picture by Hobbema dated 1662 (C.P. Fisher collection, Detroit, 1938)[8] are based on a painting by Jacob van Ruisdael of 1661 (Rijksmuseum, Amsterdam, inv. C 213). The dates on these related works by Hobbema suggest that the Chicago *Water Mill* probably can be dated about 1662–64.

Hobbema executed nearly three dozen paintings of water mills; indeed he, more than any other Dutch landscapist, is associated with the theme. The inspiration for these works surely came from his teacher, Jacob van Ruisdael, who had begun painting water mills by 1653 (cat. 81). Ruisdael discovered the theme during a trip to Bentheim when he visited the estate of Singraven near Denekamp, a village in the eastern part of the province of Overijssel, not far from the Dutch–German border. As Döhmann and Dingeldein first observed,[9] Hobbema's

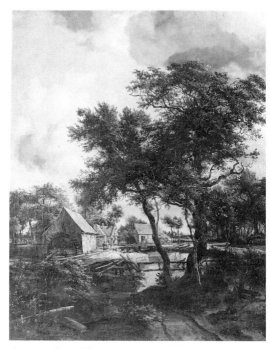

Fig. 3. Meindert Hobbema, *Water Mill*, signed, canvas, 80 x 66 cm., Musée du Louvre, Paris, inv. M.I. 270.

Fig. 4. J.B. Collaert after Johan Stradanus, *Water Mill*, from *Nova Reperta*, engraving.

depictions of a water mill in the Louvre (fig. 3)[10] and the National Gallery, London (no. 832)[11] are identifiable as the water mills owned by the manor house at Singraven.[12] The specific mill in the Chicago painting has not been identified but could have existed in the same region. No doubt, however, Hobbema has taken artistic liberties with the site; comparisons of the different variations of the theme (compare the left side, for example, of fig. 1) reveal his changes and adjustments.

Ruisdael's rushing streams and waterfalls have been interpreted as *vanitas* allusions to life's swift passage (see cat. 81). Similarly, water wheels appear in early seventeenth-century emblems as symbols of the vicissitudes of life, which can change from a position of favor to disgrace as easily as the wheel turns.[13] Water mills could also be regarded as modern industrial wonders; J.B. Collaert executed a print of a water mill after Johan Stradanus (fig. 4) that was included in a series, *Nova Reperta*, of new discoveries (for example, America) and new inventions (such as the astrolabe).[14] Whether Hobbema intended his water mill paintings to evoke such associations, however, is unclear.

P.C.S.

1. Smith 1829–42, vol. 6, no. 105.

2. Hofstede de Groot 1908–27, vol. 4, p. 376 under no. 66, and p. 377, no. 71.

3. Ibid., no. 85; Broulhiet 1938, no. 14.

4. Hofstede de Groot 1908–27, vol. 4, no. 67; Broulhiet 1938, no. 17.

5. Wantage collection, cat. 1905, no. 103, ill.

6. See The Hague, Mauritshuis cat. 1980, pp. 46–47. Hobbema's drawings of this water mill include Teylers Museum, Haarlem, inv. R-38; British Museum, London (Hind 1915–31, vol. 3, pl. LXII); Rijksmuseum, Amsterdam, cat. 1963, no. 73. It also appears in a drawing in the Petit Palais, Paris (Lugt 1927, no. 42, pl. XIX) alternatively attributed to Hobbema or to Jacob van Ruisdael, which Duparc (The Hague, Mauritshuis cat. 1980, p. 47, under inv. 884) believed could be a preparatory drawing for the Rijksmuseum's painting on loan to the Mauritshuis.

7. Hofstede de Groot 1908–27, vol. 4, no. 67; Broulhiet 1938, no. 32, ill.

8. Hofstede de Groot 1908–27, vol. 4, no. 108; Broulhiet 1938, no. 34, ill.

9. K. Döhmann, *Singraven, de Geschiedenis van een Twentsche Havezate*, vol. 3 (1934), pp. 144–45.

10. Hofstede de Groot 1908–27, vol. 4, no. 89; Broulhiet 1938, no. 441.

11. Hofstede de Groot 1908–27, vol. 4, no. 76; Broulhiet 1938, no. 220.

12. As Slive observed (The Hague/Cambridge 1981–82, p. 79), Ruisdael's *Two Water Mills* formerly in the Habich collection, Kassel (Hofstede de Groot 1908–27, vol. 4, no. 170), and known also in a smaller version (sale, Mensing, Amsterdam [Muller], November 15, 1938, no. 88), may also depict water mills at Singraven. However, see commentary to cat. 81.

13. See Sebastian de Covarrubias Orozco, *Emblemas Morales* (Madrid, 1610), III, no. 55; Henkel, Schöne 1967, col. 1429.

14. Hollstein, vol. 4, no. 139. See cat. 88, note 28.

The Avenue at Middelharnis, 1689

Signed and dated lower right of center:
M. hobbema/f 1689.
Oil on canvas, 40¾ x 55½ in. (103.5 x 141 cm.)
The Trustees of The National Gallery, London,
no. 830

Provenance: Theodorus Kruislander, clerk of the
Council of Sommelsdijk, near Middelharnis (d. 1782);
acquired from Kruislander estate in 1783, or more
probably at his sale, Sommelsdijk(?), October 15–22,
1782, no. 31, for fl.25, by the Middelharnis Council for
the Town Hall, where it remained until 1822, when it
was exchanged for a copy and a view of the village of
Renkum, both by Adrianus van der Koogh of
Dordrecht; "van der Pots" (R. Pott?), Rotterdam,
whose paintings were purchased (in 1824?) by
Charles Galli and taken to Edinburgh; offered for sale
by Galli in Edinburgh, 1826, no. 23; sale, James
Stuart of Dunearn, Edinburgh, February 9–11, 1829,
no. 120 (195 gns.); brought to London, "much
improved by cleaning" (Smith), and sold by Ewing
for £800; Sir Robert Peel, London, by 1834; pur-
chased with the Peel collection, 1871.

Exhibitions: London, British Institution, 1835, no. 19.

Literature: Smith 1829–42, vol. 6, no. 88;
C.J. Nieuwenhuys, *A Review of the Lives of Some of the
Most Eminent Painters* (London, 1834), p. 143;
Waagen 1854–57, vol. 1, pp. 410–11; Alois Riegl,
*Abhandlungen und Forschungen zur niederländische Kunst-
geschichte* (Berlin, 1882), p. 78; Hofstede de Groot
1893b, p. 62; Uldo J. Mijs, *De Nieuwe Rotterdamsche
Courant*, Jan. 17, 1893; C.G. 't Hooft, *De Amsterdammer*
947 (Aug. 18, 1895), pp. 5–6; F. Avenarius, *L'art à
l'école et au foyer* 1 (1906), p. 4; Bode 1906b, pp. 146,
149; Wurzbach 1906–11, vol. 1, pp. 690, 691; Hof-
stede de Groot 1908–27, vol. 4, pp. 350–51, no. 13;
Bredius 1910–15, p. 125; Blokhuis 1917–18; Rosen-
berg 1927, p. 151; *Eigen Haard* 62 (1934), p. 716;
Martin 1935–36, vol. 2, pp. 310, 315–17, fig. 170;
H.J.C. Grierson, ed., *The Letters of Sir Walter Scott,
1828–1831* (London, 1936), pp. 121–22; Broulhiet
1938, pp. 16, 29, 30, 45, 50, no. 375, ill.; *Studio* 115
(1938), pp. 80–81; H. Nauta, *Maandblad Amstelodamum*
26 (1939), pp. 51–52; J. Pope-Hennessy, "The
Avenue at Middelharnis," *Burlington Magazine* 74
(1939), p. 67; Maclaren 1960, pp. 165–68; Imdahl

47

1961; Rosenberg et al. 1966, p. 158, fig. 137; Stechow
1966, p. 32, fig. 47; Haak 1984, p. 467, fig. 1027;
Hughes 1984, p. 578.

At the center of the composition a road lined
with tall lopped trees recedes perpendicularly
from the picture plane toward the village of
Middelharnis. On either side of the road is a
ditch, with plantations in the right foreground
and at the back left. A small path on the left

leads to the road in the immediate foreground,
and farther back on the right the road branches
off in front of a farm. On the right a man fixes a
stake to a tree, a hunter and his dog move
toward the viewer on the road, and a man and
woman pause before the farm on the right.

The scene depicts the village of Middelharnis
on the northern coast of the island of Over
Flakee (Province of South Holland) from the
Boomgaardweg (now Steene Weg). Blokhuis

Fig. 1. Aelbert Cuyp, *Avenue at Meerdervoort*, signed, canvas, 72 x 100 cm., Wallace Collection, London, no. P51.

Fig. 2. Attributed to Adriaen van de Venne, *Avenue of Trees with Country Villa* (Slot Heemskerk? known as Marquette), panel, 26 x 36 cm., Kunsthalle, Hamburg, inv. 182.

showed that Hobbema depicted the scene very accurately, including the fifteenth-century St. Michael's Church on the left, the smaller tower of the Middelharnis Town Hall (1639), even the barn on the right that stood until about 1879.[1] The damaged third digit of the painting's date was misread as a six by Hofstede de Groot, who did not believe that the painting could have been executed as late as 1689.[2] However, the latter date was read as early as 1822 and has been repeatedly confirmed.[3] The reading is further supported by Uldo Mijs's observation that the beacon visible beside the masts of ships in the right distance was not erected until 1682; and, further, that the avenue of trees along the Boomgaardweg were planted in 1664, hence they could not have reached such a height by 1669.[4] Moreover, Maclaren pointed out that the costume of the hunter is better suited to the 1680s than to the 1660s.[5] It may be added that the highly ordered design with slender, attenuated trees is also stylistically more typical of the late period and may be compared with works by Hackaert and others (see cat. 42). Hobbema also dated a view of the Bergkerk and Bergpoort at Deventer in 1689 (Duke of Sutherland's collection).[6] The fact that the *Avenue* came from a collection in Sommelsdijk, near Middelharnis, suggested to Maclaren that the work might have been commissioned by a local patron.[7]

Although never treated so majestically, the design with the road receding perpendicularly between an avenue of trees was a time-honored design. Martin compared it with Aelbert Cuyp's *Avenue at Meerdervoort* (fig. 1),[8] and Imdahl cited the precedent of an early seventeenth-century painting tentatively attributed to Sebastian Vrancx of an avenue of trees with a country house (Rijksmuseum, Amsterdam, inv. A 2699).[9] A painting in Hamburg offering a variant of the latter design is attributed improbably to

Fig. 3. Jan van Kessel, *Avenue*, canvas, 87 x 111 cm., Staatsgalerie, Stuttgart, inv. 360.

Adriaen van de Venne (fig. 2). Stechow differentiated this traditional design from the one represented by the *Avenue* (fig. 3) by Jan van Kessel, whose death in 1680 proves that his work preceded Hobbema's *Avenue*.[10] Whereas the trees in the van Kessel extend over the entire front plane of the picture, permitting glimpses of the background only through the screen of trunks and foliage, the success of Hobbema's design depends on the compensating effects of the spacious views to either side of his precipitously retreating perspective. Hobbema only arrived at this solution by judicious self-editing; x-radiographs (to be published in the National Gallery's forthcoming catalogue) reveal that Hobbema originally placed another tree on either side of the avenue in the foreground but subsequently painted them out. The artist's changes have contributed to preservation problems in the painting's sky.

Jan de Vries[11] and Anthony Hughes[12] have both pointed to the contrasts established in the painting between nature and nurture, the

Gillis Claesz de Hondecoutre

(Antwerp? c.1575-80–1638 Amsterdam)

uncultivated grove on the left and the "well-drilled nursery of saplings" on the right.[13] The painting is unusual in seventeenth-century Dutch landscape painting not only for depicting figures actively working the land but also for its conspicuous dialectical symmetry. Its orderly appearance may call to mind the many Dutch prints of formal gardens,[14] the park-like perspectives by artists like Hoogstraeten, and the increasingly popular genre of the country house portrait, especially as practiced by Jan van der Heyden and Gerrit Berckheyde (1636–1698). The painting in Hamburg (fig. 2) is an early example of this tradition, which attained a high point with works like Berckheyde's *View of Elswout in Overveen* (see p. 111, fig. 9), painted in the 1660s. In profound contrast to the earlier "tonal" dunescapes, these works stressed how intensively the Dutch landscape was ordered, worked, and engineered. The lands reclaimed from sea and peat bogs were only the most conspicuous aspect of this very active human restructuring of the landscape – a feature of the Dutch countryside that still strikes visitors today.

When the Hobbema was offered for sale in 1829, the Duke of Buccleuch asked Sir Walter Scott for his judgment of the picture, which the latter considered "fitter for an artist's studio than a nobleman's collection." Scott continued, "Your Grace may be reconciled to it by the figure of a shooter and a Spanish pointer who are coming down the road in quest of waterfowl. . . . It is the last thing I would buy from my own taste, yet they seem to think it capital."[15] But Hobbema's painting has also had many admirers. When it was in Sir Robert Peel's collection in 1854, Waagen remarked, "Such daylight I have never before seen in any picture. The perspective is admirable, while the gradation, from the fullest bright green in the foreground, is so delicately observed, that it may be considered a

masterpiece in this respect, and is, on the whole, one of the most original works of art with which I am acquainted."[16] Hofstede de Groot was even more complimentary: "The finest picture, next to Rembrandt's *Syndics* (Rijksmuseum, Amsterdam, inv. C 6), which has been painted in Holland."[17]

P.C.S.

1. Blokhuis 1917–18, pp. 277–84.

2. Hofstede de Groot 1908–27, vol. 4, p. 350.

3. See Maclaren 1960, p. 167, note 5. From the minutes of the Middelharnis Council's resolution of May 8, 1822, approving the exchange of the *Avenue* for a copy by van der Koogh.

4. The research of Ulbo J. Mijs (burgomaster of Middleharnis, 1891–1917), was published by C.G. 't Hooft in *De Amsterdammer* 947 (Aug. 18, 1895), pp. 5–6.

5. Maclaren 1960, p. 166.

6. Hofstede de Groot 1908–27, vol. 4, no. 77.

7. Maclaren 1960, p. 166.

8. Martin 1935–36, p. 317.

9. Imdahl 1961, p. 175.

10. Stechow 1966, p. 194, note 61.

11. Lecture delivered at Dutch Genre Painting symposium, London, November 1984.

12. Hughes 1984, p. 578.

13. Ibid.

14. See Pittsburgh, Frick Art Museum, *Gardens of Earthly Delight: Sixteenth and Seventeenth Century Netherlandish Gardens*, 1986 (catalogue by Kahren Jones Hellerstedt).

15. See Pope-Hennessy, *Burlington Magazine* 74 (1939), p. 67.

16. Waagen 1854–57, vol. 1, p. 411.

17. Hofstede de Groot 1908–27, vol. 4, p. 351.

Jacob Houbraken, *Gillis de Hondecoutre*, from Arnold Houbraken, *De groote schouburgh*, 1718–21, engraving.

The place and date of Gillis de Hondecoutre's birth are unknown. His father, Nicolaes Jansz de Hondecoutre (d. 1609), and his brother Hans were also painters. The family moved to Delft before 1601. On September 22, 1602, Gillis, then living in Utrecht, married Maritgen van Heemskerk in Delft. The couple had nine children, including two who later became painters: Gijsbert (1604–1653) and Nicolaes II (1605–c.1671). Although Gillis and his father used the French or Flemish form of their name, de Hondecoutre, his son Gijsbert and grandson Melchior (1636–1695) adopted the Dutch spelling d'Hondecoeter. Gillis's daughter, Josina,

48 (PLATE 17)

Entrance to a Village with Hunters, c.1615–18

married Jan Baptist Weenix. In 1610 Gillis de Hondecoutre moved to Amsterdam, where he is recorded in 1615 and 1635. On March 19, 1628, he married his second wife, Anna Spierinx. He was dean of the Amsterdam guild in 1636. A year later he attended the wedding of his son Nicolaes in Delft. On October 17, 1638, he was buried in the Westerkerk.

De Hondecoutre's landscapes show the influence of Gillis van Coninxloo, Roelandt Savery, and David Vinckboons. His earliest painting is dated 1602 (National Gallery of Canada, Ottawa; cat. 48, fig. 1). His landscapes frequently incorporate mythological or religious scenes. Jan van Londerseel made several prints after de Hondecoutre in 1614.

A.C.

Literature: Houbraken 1718–21, vol. 3, pp. 69–75; Weyerman 1729–69, vol. 2, pp. 387–89; Nagler 1858–79, vol. 1, no. 2456, vol. 2, no. 2850, vol. 3, nos. 32, 1167; Obreen 1877–90, vol. 1, p. 7, vol. 4, p. 70, vol. 6, p. 42; A.D. de Vries 1885–86, p. 152; Haverkorn van Rijsewijk 1901, p. 61; Wurzbach 1906–11, vol. 1, p. 703, vol. 3, p. 102; Plietzsch 1910, p. 68; Bredius 1915–22, vol. 4, pp. 1213–40; H. Schneider in Thieme, Becker 1907–50, vol. 17 (1924), pp. 431–34; Hoogewerff 1954, p. 108; Stechow 1966, pp. 67, 69–70; Bol 1969, pp. 123, 128–31; Müllenmeister 1973–81, vol. 2, pp. 74–76; London 1986, nos. 23, 24.

48

Monogrammed lower left: G.DH [DH ligated]
Oil on panel, 16 x 29⅜ in. (40.5 x 72 cm.)
Rijksmuseum, Amsterdam, inv. A 1502

Provenance: Sale, Fedor Zschille (Dresden), Cologne, May 27–28, 1889, no. 50 (as Gabriel de Heusch).

Exhibitions: London 1986, no. 24, ill.

Literature: Amsterdam, Rijksmuseum cat. 1976, no. A 1502, ill.

On the road leading into a small village, several hunters are shooting birds. The landscape has been divided into several smaller elements: calm pools of water, sunlit clearings, groups of thatched cottages. In typical mannerist fashion, a very tall tree divides the composition.

This type of simple village scene, screened by trees and seen from a low viewpoint, occurred occasionally in sixteenth-century prints and drawings. De Hondecoutre's composition is based ultimately on prints after Pieter Bruegel and the work of the Master of the Small Landscapes (Joos van Liere?).[1] The paintings of Jan Brueghel the Elder, which often represent peasant cottages along country roads, may have influenced de Hondecoutre.[2] However, de Hondecoutre's painting is distinguished by a new simplicity and naturalness. There is more open space in the foreground, which recedes diagonally into the distance. The point of view is much lower than in sixteenth-century village landscapes, and de Hondecoutre's palette is more restrained, limited to related tones of brown, red, and green. Both the content and style of the exhibited work reflect a transitional

Fig. 1. Gillis de Hondecoutre, *Forest Scene with Musicians*, signed and dated 1602, panel, 46.5 x 67 cm., National Gallery of Canada, Ottawa, inv. 17001.

Fig. 2. Gillis de Hondecoutre, *Farm Cottages*, signed and dated 1620, panel, 40 x 65.5 cm., with P. de Boer, Amsterdam, 1965.

phase between Flemish sixteenth-century painting and the so-called tonal landscapes of Esaias van de Velde, Jan van Goyen, Pieter de Molijn, and Pieter van Santvoort. The drawings and prints of Claes Jansz Visscher, especially a series of views near Haarlem of about 1607, probably inspired some of the features of de Hondecoutre's landscape.[3]

De Hondecoutre's earliest work, a forest scene with musicians, dated 1602, in Ottawa (fig. 1) was produced under the influence of Gillis van Coninxloo (see cat. 19). In the 1610s de Hondecoutre began to paint more spacious views of villages and country roads. Works dated 1613, 1615, 1617, and 1618 show strong compositional and stylistic similarities with the exhibited painting.[4] About 1618 the artist also began to paint landscapes with tall rocks and fir trees, which are inspired by the Alpine scenes of Roelandt Savery (see cat. 14, fig. 2).[5] During the 1620s, de Hondecoutre painted both mountainous views of this type as well as simple village roads and farm cottages (see fig. 2). These later works are distinguished by new features: in particular, brightly highlighted foliage scattered throughout the scene. Comparison with de Hondecoutre's dated village scenes indicates that the exhibited painting probably dates from around 1615–18.[6] The period immediately preceding 1620 was one of great change and innovation in Dutch landscape painting, which incorporated elements of old and new. Despite the traditional features of its design, de Hondecoutre's painting has a directness of approach and simplicity of color that parallel developments in the work of artists more readily associated with Dutch realism, such as Esaias van de Velde, Willem Buytewech, and Jan van Goyen.

A.C.

1. For example, a print by Hieronymous Cock after Bruegel, showing a muddy road leading into a village, entitled *Pagus Nemorosus* (van Bastelaer 1908, no. 16; Lebeer 1979, no. 11, ill.). The prints after the Master of the Small Landscapes of 1559–61 also closely resemble the exhibited work, as Christopher Brown noted (London 1986, p. 120). See van Bastelaer 1908, nos. 32, 34, 55, 56, ill.

2. Ertz 1979, nos. 196 (dated 1609), 206 (as c.1609–14), 307, figs. 31, 282, 263.

3. A series of twelve villages and sites near Haarlem, M. Simon 1958, nos. 127–38; de Groot 1979, pls. 25–33.

4. Landscapes dating 1613 show similar village roads (Museum voor Schone Kunsten, Antwerp, inv. 828; and with Koetser, Nov. 1964), as does a work dated 1615 formerly in Leipzig (Stechow 1966, fig. 120). Works dated 1617 (with J. Hoogsteder, The Hague, 1983) and 1618 (with Abels, Cologne, 1938) are similar to the exhibited work.

5. The earliest such landscape appears to be a painting in Schloss Wilhelmshöhe, Kassel, dated 1618 (inv. 176). See also a work in the Rijksmuseum, Amsterdam (inv. A 1740), dated 1620.

6. De Hondecoutre's late paintings of village roads include a work in a private collection dated 1623 (London 1986, no. 23, ill.) and another dated 1630 (sale, London [Christie's], July 17, 1986, no. 1). Similar in composition to the present work, these paintings show a very different handling of foliage.

Karel du Jardin

(Amsterdam c. 1622–1678 Venice)

Karel du Jardin, *Self-Portrait*, signed and dated 1662, copper,
28.5 x 22 cm., Rijksmuseum, Amsterdam, inv. A 190.

Karel du Jardin (the artist also spelled his name
"du Iardin" but only on rare occasions as one
word) was probably born around 1622, as he is
said to be "about 50" in a document of 1672.
Nothing is known of his family, although it is
possible that his father was the painter Guillaum
du Gardyn of Amsterdam. Houbraken states
that the artist studied with Claes Berchem. His
first dated painting is from 1646 (formerly
Cramer, The Hague). Du Jardin traveled from
Amsterdam to Paris in 1650 as a merchant and,
according to Houbraken, married Suzanne van
Royen in Lyon. Du Jardin may have made an
early trip to Italy around 1650–52, but the

evidence is unclear. In any case, he was back in
Amsterdam and married in 1652, when he made
a will. About 1655 he moved to The Hague,
where he is listed as a member of the Confrerie
Pictura in 1656–58. By 1659 he had returned to
Amsterdam, where he is documented again in
1670, 1671, and 1674. Ferdinand Bol portrayed
the artist in 1658, although the painting is now
known only through an eighteenth-century
drawing.

In 1653 he published a series of prints and
continued to make etchings through the 1650s.
In 1661 du Jardin began to paint religious and
history pictures with more monumental figures.
In May 1672 du Jardin, along with several other
Amsterdam artists, was asked to appraise Italian
pictures from the Reynst collection.

In 1675 du Jardin sailed to Italy with Jan
Reynst, probably stopping in Tangiers in
October 1675. A painting in Antwerp (cat. 49)
signed "Roma. 1675" initiated a period of
renewed activity in landscape painting. His
nickname in Rome was "Bokkebaert" (Goatee).
He died in Venice in 1678.

A versatile artist, du Jardin painted religious
and history paintings, genre scenes, animal
pieces, and portraits, as well as Italian land-
scapes.

A.C.

Literature: de Bie 1661, p. 377; Sandrart 1675, p. 366;
Houbraken 1718–21, vol. 2, pp. 108, 273, 352, vol. 3,
pp. 56–61, 201, 218, 327; Weyerman 1729–69, vol. 2,
p. 378, vol. 4, p. 39; Descamps 1753–64, vol. 3, pp.
111–15; Bartsch 1803–21, vol. 1, pp. 159–96; Smith
1829–42, vol. 5, pp. 227–77, vol. 9, pp. 638–48;
Nagler 1835–52, vol. 6, pp. 419–22; Immerzeel
1842–43, vol. 2, pp. 81–82; Weigel 1843, p. 22; de
Belloy 1844; Kramm 1857–64, vol. 3, p. 805; Obreen
1877–90, vol. 1, p. 166, vol. 4, pp. 60, 127, vol. 5,
pp. 16, 136, 144; Dutuit 1881–88, vol. 4, p. 106,
vol. 5, p. 586; A.B. de Vries 1885–86, p. 157; Bredius
1890–95, pp. 232–33; Bredius 1906; Wurzbach
1906–11, vol. 1, pp. 435–37, vol. 3, p. 77; E. Plietzsch
in Thieme, Becker 1907–50, vol. 10, pp. 102–104;
Marguery 1925; Hofstede de Groot 1907–28, vol. 9,
pp. 295–411; Martin 1935–36, vol. 2, pp. 354–58;
Hoogewerff 1940; Gerson 1942, pp. 51, 165–66, 186;
Hollstein, vol. 6, pp. 27–44; Hoogewerff 1952,
pp. 93–94, 100, 135; Brochhagen 1957; Brochhagen
1958; Schaar 1958, p. 18; Hardenberg 1960, p. 30;
Maclaren 1960, pp. 201–205; Utrecht 1965,
pp. 195–212; Rosenberg et al. 1966, pp. 178–79;
Stechow 1966, p. 159; Steland-Stief 1967; Müllen-
meister 1973–81, vol. 2, pp. 60–62; Tilanus 1975;
Salerno 1977–80, vol. 2, pp. 738–49, vol. 3,
pp. 1021–23; Bartsch 1978, vol. 1, pp. 171–211;
Blankert 1978, pp. 195–212; Boston/St. Louis
1980–81, pp. 208–209, 212–15, 218; Amsterdam/
Washington 1981–82, pp. 70–71; Briganti et al. 1983,
pp. 286–93; Haak 1984, pp. 468–69.

49 (PLATE 71)

Peasant Travelers, 1675

Signed and dated lower right: K. DV. IARDIN.
FEC. ROMA 1675
Oil on canvas, 33½ x 42 in. (85 x 107 cm.)
Koninklijk Museum voor Schone Kunsten,
Antwerp, inv. 965

Provenance: Weduwe K. Ooms-van Eersel; presented
1922

Exhibitions: Utrecht 1965, no. 129, ill.

Literature: Hofstede de Groot 1907–28, vol. 9, no.
255; Antwerp, cat. 1948, 1958, no. 956; Brochhagen
1957, pp. 236–40, fig. 2; Brochhagen 1958, pp.
123–26; Plietzsch 1960, p. 159; Salerno 1977–80, vol.
2, p. 740, pl. 124.11; The Hague, Mauritshuis, cat.
1980, p. 50; Vienna, Akademie cat. 1982, p. 83; New
York 1985, p. 178; Salzburg/Vienna 1986, p. 86.

A group of men and women with sheep and
beasts of burden, including horses and donkeys,
have stopped on a high plateau on their journey.
A chasm with a river separates them from hills
and mountains on the far side. Strong sunlight
bathes the whole, creating bright highlights and
deep shadows.

Karel du Jardin, alone among the Dutch
Italianate landscapists, traveled late in his career
to Italy, where he spent the last three years of
his life. It is possible that he had made a trip
there earlier, around 1650–52.[1] In 1675, at fifty-
three years of age, he sailed to Italy with the
collector Jan Reynst.[2] The signature on the
exhibited painting proves that du Jardin was at
work in Rome in 1675. It is also reported that in
October 1675 du Jardin was in Tangiers, prob-
ably a stop on the sea voyage.[3] Several other
paintings inscribed "Rome" and bearing dates
1675, 1676, and 1678 (see fig. 1) testify to the
artist's productivity in Italy.[4]

The exhibited painting is significantly dif-
ferent from du Jardin's landscapes done in the
Netherlands, such as a work in the Fitzwilliam
Museum, Cambridge (fig. 2), datable about
1660.[5] Both paintings are brightly lit and com-

49

posed simply and directly without framing
devices. The striated pattern of clouds also
remains basically identical. In the Antwerp
painting, however, du Jardin abandoned his
brilliant, buttery technique in favor of heavy,
rough strokes with fewer glistening highlights.
The composition and the contrasts are now
bolder, the gentle diagonals of the Cambridge
picture replaced by broad bands of landscape

that stretch from one side of the composition to
the other.

Blankert has pointed out that the brushwork
of du Jardin's late works is no longer typical of
the Dutch Italianates but resembles that of the
Italian landscape painters following Annibale
Carracci.[6] Blankert also relates the thickly
painted, strongly lit figures to those of
Michelangelo Cerquozzi (1602–1660). These

Fig. 1. Karel du Jardin, *A Riding School*, signed and dated 1678, canvas, 60.2 x 73.5 cm., National Gallery of Ireland, Dublin, no. 544.

Fig. 3. Claes Berchem, *Italian Landscape*, 1658, signed, panel, 50 x 70.5 cm., Musée du Louvre, Paris, inv. 1040.

Fig. 2. Karel du Jardin, *Italian Landscape*, signed, panel, 20.6 x 27 cm., Fitzwilliam Museum, Cambridge, no. 1099.

Fig. 4. Karel du Jardin, *View of a Waterfall*, dated 1673, canvas, 64.2 x 69.5 cm., Mauritshuis, The Hague, inv. 73.

features appear to be the principal changes to du Jardin's style in Italy, combining an emphatic technique and increasingly schematic compositions with the sensitivity to brilliant light that he had perfected in the 1660s.

Compositionally, the exhibited painting relates directly to late works by Claes Berchem, who had previously inspired du Jardin.[7] Especially important is a Berchem painting of 1658 (fig. 3), which shows a group of peasants on a high plateau overlooking a hilly landscape. Drawing on Jan Asselijn's landscapes, Berchem developed a composition consisting of a dark chasm or river that stretches across the picture plane, dividing a ledge in the foreground from a distant panorama. Other paintings by Berchem with such an arrangement include landscapes in Buckingham Palace (inv. 175), the Northbrook collection, and formerly in the London art market.[8] Such innovative compositions without trees or rocks framing the view on the side strongly affected du Jardin's late landscapes. In these paintings, Berchem's broad, thick handling and sharply lit figures are also very similar to du Jardin's picture in Antwerp.

Brochhagen first identified a group of du Jardin paintings, including catalogue 50,[9] on the basis of similarities to the exhibited painting. He contrasted this late style with du Jardin's *View of a Waterfall*, dated 1673 (fig. 4). That work, however, is not wholly typical of du Jardin in the late 1660s and early 1670s since it is actually a setting for classically inspired staffage rather than a true landscape. It is clear that under Berchem's influence, du Jardin had already begun to develop compositions similar to the Antwerp painting before he left for Italy.

A.C.

1. In 1650 a "Carel du Gardin" was recorded in Amsterdam preparing to travel to Paris (Bredius 1906, pp. 223–24; Brochhagen 1958, p. 3). Houbraken reports that du Jardin married in Lyon, which was on a principal route to Italy (Houbraken 1718–21, vol. 3, p. 60). When du Jardin made a will in Amsterdam in 1652, he was already married (Bredius 1890–95, pp. 232–33). If he did go to Italy, he must have done so between 1650 and 1652. Brochhagen (1958, pp. 2, 19) believes that drawings and the atmosphere of du Jardin's paintings provide confirmation of an early journey to Italy, but this is speculative.

2. Houbraken 1718–21, vol. 3, p. 60. He is recorded in November 13, 1674, in Amsterdam (Bredius 1890–95, pp. 232–33). Brochhagen believed that an allegory in Bamberg (inv. 141), signed by both du Jardin in 1675 and Gerard de Lairesse, was left unfinished by du Jardin when he departed for Italy (Brochhagen 1957, p. 236).

3. Hardenberg 1960, p. 30; reported in Utrecht 1965, p. 197.

4. Hofstede de Groot 1907–28, vol. 9, no. 234, sold in London (Christie's), July 10, 1931, no. 57, is also dated 1675. A landscape in Turin is reportedly dated 1676 (ibid., no. 262). Among other works inscribed "Rome" is a painting in the Musée des Beaux-Arts, Lyon, inv. 129 (ibid., no. 72).

5. Brochhagen 1958, pp. 51–53; Blankert 1978, pp. 206–207, 263.

6. Utrecht 1965, p. 209.

7. Brochhagen's suggestion (1957, p. 237) that du Jardin's Italian compositions were derived from Gaspard Dughet was rejected by Blankert, who proposed the general models of Asselijn and Berchem (Utrecht 1965, p. 209).

8. Hofstede de Groot 1908–27, vol. 9, no. 250, Northbrook collection no. 31, signed lower left, panel, 29.2 x 44.5 cm.; ibid., no. 476, formerly Brod Gallery, exhibited Cardiff 1960, no. 4.

9. Brochhagen 1957.

50 (PLATE 72)

Elegant Riders on a Hilltop Overlooking a Lake, c.1675–78

50

Oil on canvas, 20⅞ x 27 in. (53 x 68.5 cm.)
Gemäldegalerie der Akademie der bildenden Künste, Vienna, inv. 827

Provenance: Count Anton Lamberg-Sprinzenstein, Vienna; presented in 1822.

Exhibitions: Amsterdam/Brussels 1947, no. 15 (as Berchem); Vienna 1951, no. 2 (as van Laer); Vienna 1963, no. 8; Utrecht 1965, no. 130, ill.; Vienna 1969, no. 67; Salzburg/Vienna 1986, no. 27, ill.

Literature: Vienna, Akademie cat. 1873, no. 619; Vienna, Akademie cat. 1889, no. 21 (as Berchem); Frimmel 1891, p. 79 (as A. de Cooghe); Frimmel 1899–1901, vol. 4, p. 186 (as A. de Cooghe); Eigenberger 1927, vol. 1, p. 28, vol. 2, pl. 166 (as Berchem); von Sick 1930, p. 12 (as Berchem); Hoogewerff 1932–33, p. 111 (as van Laer); Gerson 1947, p. 179 (as J. Esselens); Brochhagen 1957, p. 240, fig. 3; Brochhagen 1958, p. 125; Vienna, Akademie cat. 1972, no. 101; Salerno 1977–80, vol. 2, p. 740; Vienna, Akademie cat. 1982, pp. 83–86, pl. 28.

An elegantly dressed couple on horseback have paused atop a hill overlooking a broad lake. A hunting party, they are accompanied by a black page and attendants with dogs. On a peninsula in the lake is a towered castle. The painting's apparent pendant, also preserved in the Akademie (fig. 1), includes figures of a different class – simple peasant travelers rather than aristocratic hunters. The landscapes are similarly composed around foreground ridges that partially obscure some of the figures; both paintings show women riding sidesaddle.

The exhibited painting is executed in the same technique and style as catalogue 49, which was painted in Rome in 1675. Du Jardin's late Italian landscapes are characterized by bold contours, dazzling sunlight, and vast open space. Stechow aptly characterized them as a synthesis of the Italian South and the American West.[1] The striking figures provide the only darker passages in the scene. Their faces are indicated by unmodulated strokes of white paint set down onto darker tones, resulting in a mask-like appearance. Such figures are generally derived from the work of Pieter van Laer, although his influence seems to have been filtered through Italian painters such as Michelangelo Cerquozzi.[2] The brilliant light that subsumes the colors of the costumes and the sky, as well as the simple shapes of the distant hills, lends the painting an artificial quality, heightened by the woman's frozen scarf suspended manneristically in midair.

It has been suggested that direct knowledge of Italy helped du Jardin avoid "the clichés of his Netherlandish colleagues."[3] Italian painting surely inspired his summary brushwork and deeply shadowed lighting, so different from earlier Dutch Italianate painting. On the other hand, du Jardin does not appear to have been concerned with the specifics of the Italian scene, and his late work remains allied to established

Fig. 1. Karel du Jardin, *Italian Landscape with Peasants*, canvas, 53 x 68.5 cm., Akademie der bildenden Künste, Vienna, inv. 829.

Fig. 3. Karel du Jardin, *Landscape with Ford*, panel, 36.5 x 28.7 cm., Institut Néerlandais, Paris, inv. 6462.

Fig. 2. Karel du Jardin, *Italian River Scene*, canvas, 39 x 42 cm., formerly Galerie Sanct Lucas, Vienna.

conventions, especially the striated compositions of Asselijn (see cat. 1) and Berchem. His figures are reformulations of the aristocratic imagery associated with the equestrian hunting scenes of Berchem, Wouwermans, and Cuyp.

Brochhagen assigned almost thirty paintings to du Jardin's residency in Italy, 1675–78, to which recent writers have added others,[4] making this period the artist's most productive. A work similar to the exhibited landscape (fig. 2) shows du Jardin adopting a squarish format and abandoning the introductory foreground ridge altogether. Several of the landscapes thought to be from du Jardin's Roman period, such as a work in the Institut Néerlandais, Paris (fig. 3), may in fact have been executed earlier in Holland.[5] The painting in Paris, though similar in many respects to figure 2 and the exhibited painting, is more highly detailed and carefully modeled, especially in the definition of the hills. The lower point of view and delicate flecks of

Alexander Keirincx

(Antwerp 1600–1652 Amsterdam)

light and color in the sky resemble earlier du Jardin paintings of the 1660s (see cat. 49, fig. 2).

A.C.

1. Stechow 1966, p. 159; Stechow refers specifically to a painting in the Lugt collection (fig. 3) but does not make clear whether he considers it to have been executed in Holland or Italy.

2. Utrecht 1965, p. 209. For Cerquozzi see Briganti 1950; and Briganti et al. 1983, pp. 133–93.

3. Renate Trnek in Minneapolis 1985, p. 38.

4. Brochhagen 1957. Recent assignments to du Jardin's late period include a landscape sold in London (Christie's), July 5, 1985, no. 52; fig. 2; and another exhibited in New York 1984, no. 41, ill.

5. The consistency of these supposedly late works has been questioned by Salerno (1977–80, vol. 2, p. 740). A painting in Budapest (inv. 322) is strongly influenced by Jan Both; if by du Jardin, it was probably not painted in Italy. In view of their finer handling and somewhat decorative compositions, two other paintings assigned by Brochhagen to du Jardin's Italian period may also have been done earlier in Holland: Musées Royaux des Beaux-Arts, Brussels, inv. 1067 and 1068 (Brochhagen 1957, pp. 251–52, figs. 19, 20).

Born in Antwerp on January 23, 1600, Keirincx (also spelled Keerincx, Kierings, Carings, Cierings, etc.) joined the Antwerp St. Luke's Guild in 1619. His teacher is unknown. In 1622 he married in Antwerp, in 1624 had a student there named Aertus Verhoeren, and was still living in the city in 1626. He must have been in Utrecht by about 1628, when Cornelis van Poelenburch painted staffage figures in his landscapes; Houbraken confirms their collaboration. Other works with staffage by Poelenburch are dated 1631 (Bayerische Staatsgemäldesammlungen, Munich, inv. 723) and 1633 (Kunstmuseum, Bremen, inv. 64). Paulus van Hillegaert (1595/96–1640) also painted staffage in at least one of the artist's landscapes (Museum Boymans-van Beuningen, Rotterdam). Keirincx is mentioned regularly as a resident of Amsterdam from 1636 onward. He probably visited England on several occasions. Walpole mentions two drawings dated 1625 depicting views of London, and in 1630 and 1640–41 the artist was again in the British Isles, employed by Charles I to paint portraits of the monarch and views of his Scottish castles. Keirincx should not be confused with his English namesake Jacob or Johann Carings ([Cierings], c.1590–1646). Keirincx was buried in Amsterdam on October 7, 1652.

Keirincx specialized in landscapes of forest interiors. His *flamisant* landscapes follow in the tradition of Coninxloo, Vinckboons, Abraham Govaerts (1589–1626), and Jan Brueghel (1568–1625). While his later works of c.1635 and onward adopted simpler, more open compositions and a light brown overall tonality under the influence of Jan van Goyen and Salomon van Ruysdael, he never fully abandoned his Flemish legacy of fantasy – great gnarled trees and dense lacy foliage.

P.C.S.

Literature: Houbraken 1718–21, vol. 1, p. 130; Weyerman 1729–69, vol. 1, p. 335; Descamps 1753–64, vol. 1, p. 400; Walpole 1828, vol. 1, p. 345; Nagler 1835–52, vol. 7, p. 4; Immerzeel 1842–43, vol. 2, p. 110; Kramm 1857–64, vol. 3, pp. 842–43; Nagler 1858–79, vol. 1, nos. 776, 1449, vol. 2, no. 224; Riegel 1882, p. 177; Wurzbach 1906–11, vol. 1, pp. 251–52; Plietzsch 1910, p. 68; H. Schneider in Thieme, Becker 1907–50, vol. 20 (1927), p. 77; Bredius 1915–22, vol. 7, pp. 23–30; Martin 1935–36, vol. 1, p. 234; Greindl 1942–47; Thiéry 1953, p. 182; Ogden, Ogden 1955, pp. 20, 33, 41, 57; Stechow 1966, pp. 68–70, 75, 97, 142, 151, 164, 177; Dattenberg 1967, pp. 244–45; Bol 1969, p. 134; Keyes 1978; Haak 1984, p. 301.

Landscape with Cephalus Receiving the Gifts from Procris, c.1620/21

Oil on panel, 18¾ x 31¾ in. (48 x 80.6 cm.)
Virginia Museum of Fine Arts, Richmond, The Williams Fund, 84.77

Provenance: Christophe Janet Gallery, New York; French and Co., New York.

Literature: P. Jeromack, *Tableau* 6 (1983), p. 73, ill.; Briels 1984; P. Near, "European Paintings and Drawings: The Williams Collection and Fund," *Apollo* 122 (1985), p. 441, pl. 1; K. Moxey, "A New Look at Netherlandish Landscape and Still-life Painting," *Arts in Virginia* 26 (1986), p. 18, ill.

This painting is probably a very early work by Keirincx, painted in Antwerp prior to his move to the Netherlands in about 1628. Its design is derived from Coninxloo's compositions and its style from the landscapes of Abraham Govaerts and Jan Brueghel. Many of the compositional elements – the flanking coulisses in the foreground, the massed "island" of form in the middle distance, and stereoscopic vistas to either side – are anticipated by Coninxloo (see cat. 19).[1] Individual motifs, such as the blasted tree and rustic bridge, also recall Coninxloo. The tripartite color division (brown, green, blue) of the landscape is typical of mannerist landscapes, especially those of the Antwerp school, and the particular way in which decorative foliage is treated recalls Govaerts. Keirincx's earliest dated works of 1620 and 1621 share many of these features; compare, as examples, the *Forest Landscape with Water* of 1620, Staatliche Kunstsammlungen, Dresden (fig. 1), the pendant forest scenes also in Dresden (fig. 2; and no. 1144), the *Landscape with Stream*, dated 1621, Herzog Anton Ulrich-Museum, Braunschweig (inv. 182), and the *Landscape with Rest on the Flight into Egypt* of about 1620–21, Staatsgalerie, Aschaffenburg (inv. 6304). A virtual trademark of Keirincx's early works are the silhouetted vines, more pronounced than Govaerts's, that surround the tree stumps in the lower left and right of the Richmond painting.

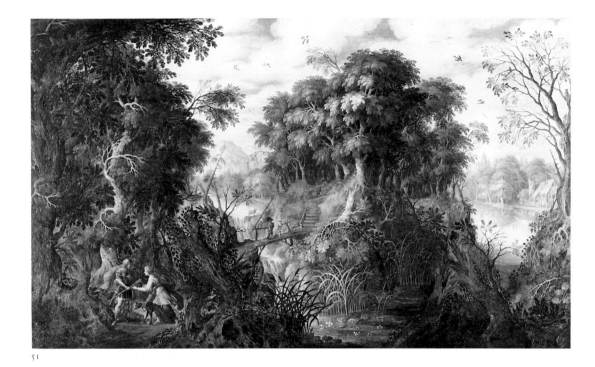

51

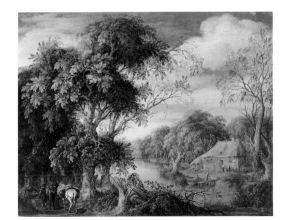

Fig. 1. Alexander Keirincx, *Forest Landscape with Water*, signed and dated 1620, panel, 28 x 35.5 cm., Gemäldegalerie, Staatliche Kunstsammlungen, Dresden, no. 1145.

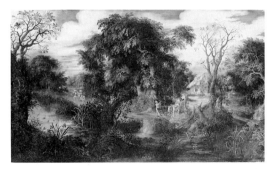

Fig. 2. Alexander Keirincx, *Landscape with Peasants on a Road*, signed, panel, 57 x 99.5 cm., Gemäldegalerie, Staatliche Kunstsammlungen, Dresden, no. 1143.

The story of Cephalus and his wife, Procris, is told in Ovid's *Metamorphoses* (7. 681–865). Only two months after their marriage, Cephalus was provoked by Aurora to test his new bride's constancy by offering her, while disguised, rich gifts. Procris succumbed to temptation, and when he revealed his identity, she fled to join the nymphs of Diana, the chaste goddess of the hunt. Remorseful, Cephalus effected a reconciliation with Procris, who thereupon gave him two presents that she had received from Diana: a wonderful hound, swifter than any other, and an unerring spear that automatically returned to its thrower. This is the specific episode in the story depicted in the Richmond painting. In a later episode Procris mistakenly suspected Cephalus of infidelity; following him when he went hunting, she hid in a bush. Hearing the leaves rustle, Cephalus threw the spear, thus killing his own wife. This episode was depicted by artists more often than the earlier one. Keirincx's own *Landscape with Cephalus and Procris* (fig. 3) in Wilton House, Salisbury, undoubtedly postdates the Richmond painting.[2] Jan Brueghel's *Landscape with Diana and Actaeon* (fig. 4) in the Národní Galerie, Prague, is the type of Flemish painting that would have inspired Keirincx. Ovid's classical story of the dangers of conjugal jealousy was transformed in the Middle Ages into a Christian morality tale about marriage. In the medieval *Ovide Moralisé*, the spear that never misses its mark is a symbol for the divine word of the Holy Spirit that always reaches the heart, and the dog denotes the good preacher who destroys sinners and damns to perdition the wolf of evil.[3] For van Mander, "The gift that Procris received from the chaste Diana, First the spear that is never thrown in vain, with which Cephalus killed the ferocious animal that was destroying the land, signifies just [and] applied reason that eventually triumphs over all and restores again with praise

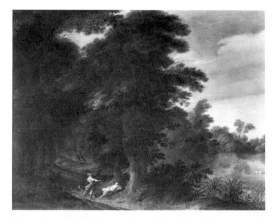

Fig. 3. Alexander Keirincx, *Landscape with Cephalus and Procris*, panel, 49.5 x 63.5 cm., Earl of Pembroke, Wilton House, Salisbury.

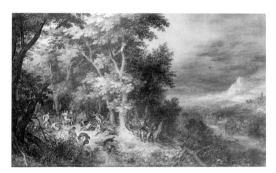

Fig. 4. Jan Brueghel and Hendrick de Clerc, *Landscape with Diana and Actaeon*, panel, 51 x 89.5 cm., Národní Galerie, Prague, inv. 4130.

and honor its own gifts. As for the dog, being a faithful animal, it is understood as the faithfulness which an honorable, chaste wife owes her husband; she must not permit affections that would offend or injure his honor in any way."[4]

P.C.S.

1. Compare also the *Forest Landscape* of 1598 in the Liechtenstein collection, Vaduz, cat. 1980, no. 37.

2. Sidney, Sixteenth Earl of Pembroke, *A Catalogue of the Paintings and Drawings in the Collection at Wilton House, Salisbury, Wiltshire* (London and New York, 1968), no. 151, pl. 61; another version is in the Alte Pinakothek, Munich, inv. 2059.

3. See Irving Lavin, "Cephalus and Procris: Transformation of an Ovidian Myth," *Journal of the Warburg and Courtauld Institutes* 17 (1954), pp. 260–87.

4. Van Mander 1604, *Wtlegghingh*, fols. 67–68.

Landscape with Deer Hunt, c.1640–45

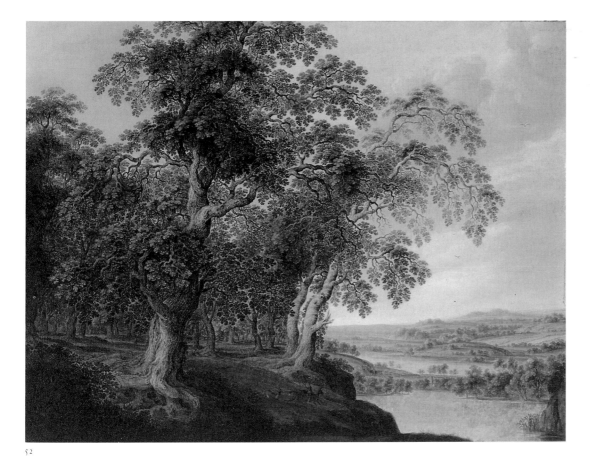

52

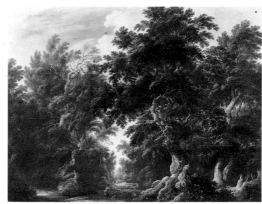

Fig. 1. Alexander Keirincx, *Forest with Deer Hunt*, signed and dated 1630, panel, 68 x 90 cm., Koninklijk Museum voor Schone Kunsten, Antwerp, inv. 902.

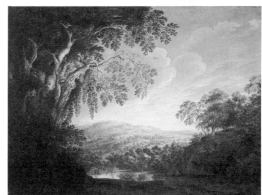

Fig. 2. Alexander Keirincx, *Forest Landscape with Pond and Hills*, signed and dated 1640, panel, 61 x 85 cm., Herzog Anton Ulrich-Museum, Braunschweig, inv. 183.

Oil on canvas, 33⅛ x 43¼ in. (84 x 110 cm.)
Private Collection

Provenance: Private collection, the Netherlands.

Exhibitions: The Hague 1982, no. 48, ill.

On the left, enormous gnarled trees with delicate, lacy foliage rise above the bank of a pond. Low rolling hills recede to the horizon on the right. Deer pursued by a hunter and dogs scamper down the bank in the foreground.

This work is typical of Keirincx's forest landscape style from his mature Amsterdam period, of 1636 onward. Its embroidered foliage, writhing, twisted tree limbs, and blond palette of rust colors are especially characteristic of the artist's works from the early 1640s. Keirincx had painted grand forest views with heavily gnarled trees and hunt scenes by 1630 (fig. 1), but the greater delicacy of the exhibited painting points to a later date. It is close in style and conception,

Philips Koninck

(Amsterdam 1619–1688 Amsterdam)

for example, to the *Forest Landscape with Pond and Hills* of 1640 in Braunschweig (fig. 2) and a similar painting, dated 1644, in the Kunsthalle, Hamburg.[1] It also may be compared with several other wooded river views from these years.[2] Several drawings by Keirincx also depict similar trees and landscape motifs.[3]

P.C.S.

1. Inv. 287, panel, 37 x 52.5 cm.

2. See the *Forest Landscape with Deer*, signed and dated 1643, panel, 86.4 x 63.5 cm., sale, New York (Sotheby-Parke Bernet), June 11, 1981, no. 112, ill.; *Rives boisées*, signed and dated 1645, panel, 83.8 x 69.9 cm., sale, Amsterdam (Muller), June 19, 1913, no. 33, ill.; and *River View*, panel, 201.9 x 121.9 cm., sale, Davell, London (Christie's), May 23, 1924, no. 114; sale, London (Sotheby's), April 21, 1926, no. 65.

3. Compare the trees in the drawings in the Witt Collection, London (48.3 x 27.3 cm., photo RKD, The Hague), and the Kunsthalle, Bremen, inv. 1219 (23.2 x 18.7 cm.), and the vista depicted in Niedersächsisches Landesmuseum, Hannover, inv. N149(68), 19.4 x 30.2 cm.

Jacob Houbraken, *Philips Koninck*, from Arnold Houbraken, *De groote schouburgh*, 1718–21, engraving.

The youngest of six brothers, Philips Koninck (Koning, Coningh, Coninck, and other spellings) was born in Amsterdam on November 5, 1619. His father, Aert de Koninck, was a goldsmith, and his brother, Jacob Koninck (1614/15–after 1690), and cousin, Salomon de Koninck (1609–1656), were painters. Jacob served as Philips's first teacher in Rotterdam; on January 2, 1640 he received payment of thirty guilders for instructing Philips over a period of half a year. Philips had probably begun this instruction around 1637. By 1639, he had painted portraits and head studies as well as executed figure drawings, since works of these descriptions were mentioned in his father's inventory of that year.

In 1640 he married Cornelia Furnerius, daughter of a surgeon and organist and sister of the artist Abraham Furnerius (c.1628–1654), who was also a Rembrandt pupil and whose drawings closely resemble those of Philips. According to Houbraken, Koninck studied with Rembrandt. This probably took place following Koninck's move to Amsterdam in 1641. The following year Koninck's young wife died.

Koninck is not mentioned again in documents until 1653 in Amsterdam, although his works from the latter half of the 1640s and early 1650s show the strong influence of Rembrandt and Hercules Segers. His testimony in 1658/59 that he had received a pearl necklace about seven years earlier from Rembrandt proves that the two artists had met at the latest by around 1651. In several disputes over the authenticity of paintings in Amsterdam, Koninck served as an expert. The fact that his portrait was sought by the Grand Duke of Tuscany for the latter's gallery of artists' self-portraits is proof of his international reputation. His art was praised by the poets Jan de Vos and Vondel, whose portrait Koninck drew and painted (Museum Amstelkring, Amsterdam; dated 1665). Vondel, who also admired Jan Lievens and Juriaen Ovens, spoke only of Koninck's history paintings, not his landscapes. In 1657 Koninck was remarried, to Margaretha van Rijn, on whose portrait by the artist (now lost) Vondel composed a poem. In 1658 Koninck was living on the Prinsengracht, in 1669 and 1672 on the Leidsegracht, while at his death in 1688 he was a resident of the Reguliersgracht. Several documents indicate that later in life Koninck was the owner of the inland shipping line between Rotterdam and Amsterdam. His latest dated landscapes are of 1676 (see Amsterdam, Rijksmuseum, inv. A 206), and he seems to have given up painting entirely thereafter; Gerson could date no paintings to the 1680s.

53 (PLATE 87)

Panorama with Cottages Lining a Road, 1655

A painter and draftsman of portraits, history subjects, low-life genre themes, and panoramic landscapes, Koninck excelled only at the last mentioned. Most of his panoramas are imaginary but evoke the landscape of Gelderland. He had developed his own distinctive style by the early 1650s. By the later 1660s his subjects became more idyllic, often populated by elegant or pastoral figures. Nearly three hundred drawings and eight landscape etchings are known by the artist.

P.C.S.

Literature: Houbraken 1718–21, vol. 1, p. 269, vol. 2, pp. 53–54, 131, vol. 3, p. 79; Weyerman 1729–69, vol. 2, p. 153; Kramm 1866, vol. 3, pp. 901–902; Obreen 1877–90, vol. 1, p. 124; Wurzbach 1906–11, vol. 1, 1906, pp. 323–26; Turner 1908–1909; Bredius 1915–22, vol. 1, pp. 149–69; C. Hofstede de Groot in Thieme, Becker 1907–50, vol. 21 (1927), pp. 271–74; Gustav Falck, "Einige Bemerkungen über Philips de Koninck's Tätigkeit als Zeichner," *Festschrift für M.J. Friedlander* (Leipzig, 1927), pp. 168–80; M.B.H. Molkenboer, "Philips Koninck en Vondel," *Vondelkronijk* 7 (1936), pp. 86–91; Gerson 1936; Maclaren 1960; Gerson 1965; Stechow 1966; Sumowski 1979, vol. 4; Dudok van Heel 1982; Sumowski 1983, vol. 3, pp. 1530–1626.

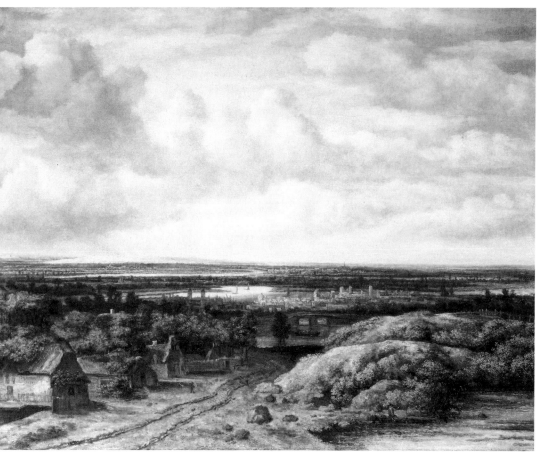

53

Signed and dated: P. Koninck 1655
Oil on canvas, 52⅜ x 66 in. (133 x 167.6 cm.)
Rijksmuseum, Amsterdam, inv. A 4133

Provenance: Possibly sale, Jan Lucas van der Dussen, Amsterdam, October 31, 1774, no. 31 (fl.40 to Pieter Fouquet); Earl of Derby, Knowsley House, probably acquired in late eighteenth century; purchased by the Rijksmuseum in 1967 with aid from the Vereniging Rembrandt, the Prince Bernhard Foundation, and the Photo-Commisie.

Exhibitions: Manchester 1857, no. 868.

Literature: Thoré 1860, p. 253; *A Descriptive Catalogue of Pictures at Knowsley House* (London, 1875), no. 8; Gerson 1936, p. 24, no. 26, pl. 6; van Thiel 1967, figs. 1, 3–5; P.J.J. van Thiel, *Openbaar Kunstbezit* 2, no. 10 (1968); H. Jaffe, "Van Gogh en de 17de eeuw," *Nederlands Kunsthistorisch Jaarboek* 23 (1972), p. 365, fig. 3; Amsterdam, Rijksmuseum cat. 1976, no. A 4133, ill.; E.K.J. Reznicek, "Bruegels Bedeutung für das 17. Jahrhunderts," in *Pieter Bruegel und seine Welt*

(Berlin, 1979), p. 159; Sumowski 1983, vol. 3, p. 1605, no. 1055, ill.

In this very large canvas, a country road passes diagonally by three farmhouses in the lower left toward the right then turns back to the left, where it disappears among trees. Two large hills rise on the right above a pond, where a fisherman has just made a catch. In the middle distance a broad river valley stretches across the picture in dark horizontal bands. A bridge with two arches appears in the center before the profile of a large sunlit city. On the left of the horizon a sand-colored mountain range rises, but the overall effect of the horizon is of an emphatic horizontal separating the land and the cloud-filled sky overhead.

Although Koninck apparently continued to paint low-life genre scenes and portraits throughout his career, he excelled only in landscape and, more specifically, only in the panorama. One-sided as they might seem, the painter's accomplishments are now regarded as the equal in their own terms of those of Ruisdael, Rembrandt, or Segers. Gerson singled out the Rijksmuseum's painting for special praise as "a masterpiece, probably the most brilliant painting that Koninck ever realized through the certainty and freedom of his brushwork."[1] Especially successful is the painterly treatment of the sky and the daubed indications of trees, towers, and flat stretches of water. The palette of yellow and browns is unified by the golden tone overall and accented with deep crimsons and, in the sky, bright blues.

A product of Koninck's best period (c.1654–65), the painting is comparable in execution to that in the Thyssen-Bornemisza Collection (cat. 54) and the panoramas also dated 1655 in the National Gallery, London (no. 6398), at Firle Place (cat. 54, fig. 2), and in the Crawford and Balcarres collection.[2] A painting of

Fig. 1. Philips Koninck, *Panorama with Bridge*, 1651, canvas, 62 x 86 cm., Oskar Reinhardt Collection, Winterthur.

Fig. 2. Rembrandt, *Three Cottages*, 1650, etching.

1651 in the Oskar Reinhardt Collection, Winterthur (fig. 1),[3] anticipates the motif of the bridge and city in the middle distance as well as the road with cottages and a lake in the foreground. This design may descend from works like Rembrandt's *Landscape with Long Arched Bridge* of the late 1630s in the Staatliche Museen Preussischer Kulturbesitz, Berlin (Introduction, fig. 56). But the Reinhardt collection painting has not yet achieved the monumental sweep of the Rijksmuseum's painting, in large part because the city profile disrupts the horizon. A painting in the Carter collection also employs a design comparable in details, such as the use of the road in the foreground with houses at the left.[4] Despite these various correspondences, the site and the city in the Rijksmuseum's painting have not been identified. Koninck executed panoramic drawings of known sites such as Edam, Elten, and the Rhine Valley near Emmerich viewed from Spitzberg; however, the Amsterdam painting, as Pieter van Thiel observed, is probably only an imaginative reconstruction of the type of flat landscape that was encountered around Rhenen.[5]

Van Thiel also called attention to the resemblance of the three farmhouses on the left to those in Rembrandt's etching of 1650 known as the *Three Cottages* (fig. 2).[6] The earth-colored palette and free brushwork of Rembrandt's landscapes probably had an impact on Koninck's color scheme. Koninck executed many drawings of low-lying farm buildings (examples are found in the Ashmolean Museum, Oxford; Teylers Museum, Haarlem; Groningen Museum; Nationalmuseum, Stockholm; and the Bowdoin College Art Museum, Brunswick, Maine), no doubt partly under the influence of Rembrandt's example. A typical drawing of a panorama with buildings is in the Musée Condé, Chantilly,[7] but it is related only in a general way to the Amster-

54 (PLATE 88)

Distant View in Gelderland, 1655

dam painting, for which there are no preparatory studies.

P.C.S.

1. Gerson 1936, p. 24.
2. Ibid., respectively, nos. 57, 56, and 37.
3. Ibid., no. 60.
4. Ibid., no. 9; Los Angeles/Boston/New York 1981–82, no. 16.
5. Van Thiel 1967, p. 111.
6. Ibid. Egbert Haverkamp Begemann (review of O. Benesch, *The Drawings of Rembrandt* [London, 1973], in *Kunstchronik* 14 [1961], p. 57) noted that the etching is based on a motif that Rembrandt sketched in a drawing now in the Kupferstichkabinett, Berlin (West); Benesch 1973, no. 835. The etching and drawing represent the same scene (the print is, of course, reversed) from a different angle.
7. 155 x 230 mm., Gerson 1936, no. 24.

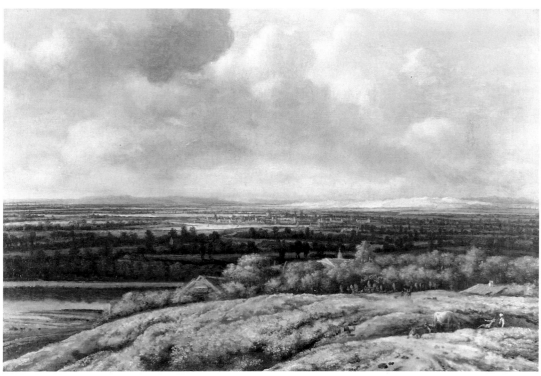

54

Signed and dated on the house in the left foreground: p.koninck/1655
Oil on canvas, 33⅛ x 54 in. (84 x 137 cm.)
Thyssen-Bornemisza Collection, Lugano, no. 156.

Provenance: Sale, Demidoff, Palazzo di San Donato, Florence, March 15, 1880, no. 1131, (frs.9,000); sale, A.J. Bösch, Vienna, April 28, 1885, no. 29 (fl.4,050 to Loescher); sale, J. Simon (Berlin), Amsterdam, October 25, 1927, no. 26 (fl.41,000 to Goudstikker); dealer J. Goudstikker, Amsterdam (cat. 1928, no. 21, ill.); Schloss Rohoncz, by 1930.

Exhibitions: Berlin, Akademie, 1890, no. 162; Berlin, Kaiser-Friedrich-Museums-Verein, 1906, no. 74; Munich, Neue Pinakothek, *Sammlung Schloss Rohoncz*, 1930, no. 180, pl. 58; Neuchâtel, *Semaine Hollandaise*, 1953, no. 23; Rotterdam/Essen 1959–60, no. 86, ill.; London, National Gallery, *From Van Eyck to Tiepolo*, 1961, no. 72, ill.; Moscow/Leningrad/Kiev, *Master Paintings from the Thyssen-Bornemisza Collection*, 1983–84, no. 12, ill. p. 37; Budapest/Szombathely, *Meisterwerke des 15.–20. Jahrhunderts aus der Sammlung Thyssen-Bornemisza*, 1985–86, no. 14, pl. p. 53.

Literature: Henry Thode, *Kunstfreund* 1 (1885), pp. 125, 184; W. Bode, *Jahrbuch der Preussischen Kunstsammlungen* 11 (1890), p. 239; *Kunstchronik* 1 (1890), p. 41; C. Hofstede de Groot in Thieme, Becker 1907–50, vol. 21, p. 272; T. von Frimmel, *Lexikon der Wiener Gemälde-Sammlungen*, vol. 1 (1913), p. 199; Gerson 1936, pp. 25–26, 109, no. 51; Lugano, cat. 1937, no. 226, pl. 55; Lugano, cat. 1969, vol. 1, no. 156; vol. 2, pl. 180.

The panorama is viewed from the slight eleva-
tion of a hill in the foreground. On the left the
land falls away into a river valley. In the middle
distance the flat countryside recedes in darkened
horizontal bands to a lighted city and finally to
mountains on the horizon. This horizon typically
is situated at about the midpoint of the height of
the canvas. Towering above is the cloud-filled
sky. In the right foreground herders tend their
cattle, while a coach appears down a dirt road.

The panorama is more closely associated with
the art of Philips Koninck than with that of any
other Dutch landscapist. Although his paintings
of this type follow the examples of, among
others, Goltzius, Segers, Vroom (see cat. 115),
van Goyen (see commentary to cat. 37), and
Rembrandt, Koninck brought to the panorama
an unprecedented grandeur, both in scale and
design and in the symphonic treatment of
color and light. As Gerson has demonstrated,
his greatest works of this type were painted
between about 1654 and 1665;[1] however,
Koninck had begun painting panoramas by 1647
(see fig. 1) and continued to produce them until
at least 1676.[2] His works progress toward a
comprehensive and majestically peaceful vision
of the land, which stretches away over expansive
parallel strata of painterly passages of light and
shade. Only rarely is the distant horizon in-
terrupted or broken by the superimposition of a
motif. Thus, the broad space seems to extend
almost without limit. The very large size (see,
for example, *Panorama of the River Waal at Beek*,
signed and dated 1654, canvas, 150 x 203 cm.,
Statens Museum for Kunst, Copenhagen, inv.
8376; and cat. 53) and rich freedom of the
brushwork in many of these works also con-
tribute to their compelling evocation of nature's
sweep and atmosphere.

Despite their many similarities, Koninck's
panoramas were never formulaic; they differed
markedly in their variations on his preferred

Fig. 1. Philips Koninck, *Panorama with Travelers*, signed and
(formerly) dated 1647, panel, 38 x 52.5 cm., Victoria and Albert
Museum, London, no. 86.

Fig. 2. Philips Koninck, *Landscape with a Windmill*, signed and dated
1655, canvas, 130 x 165 cm., Firle Place.

designs. These differences are evident even in
the works of the same year. As Gerson has
observed, for example, the Thyssen-Bornemisza
painting is quite different in conception and
style from the other four dated paintings, all of
which are panoramas, of 1655. These include the
landscape owned by Baron Brukenthal (Muzeul
Brukenthal, Sibiu, no. 652),[3] the *River Landscape
with Windmill* at Firle Place (fig. 2), the *River
Landscape with Ruins* in the National Gallery,
London (no. 6398),[4] and the *Distant View, with
Cottages Lining a Road*, formerly owned by the Earl
of Derby and now preserved in the Rijksmuseum
(cat. 53). While the horizon in each of these
works laterally bisects the canvas, the ways in
which the space functions, be it via a winding
road or river, or descending into a valley and
rising again, is different in each case, as is the
painter's touch. The broad rise with the land
falling away in the foreground of the present
painting, for example, is a new development,
only partly anticipated by the Copenhagen
painting, as is its rich profusion of lemony yellow
highlights.

P.C.S.

1. See Gerson 1936, pp. 22–34.

2. See *River Landscape*, signed and dated 1676, canvas,
92.5 x 112 cm., Rijksmuseum, Amsterdam, inv. A 206;
Gerson 1936, no. 2, pl. 15.

3. Canvas, 134 x 163 cm.; Gerson 1936, no. 24.

4. Washington, D.C. 1985–86, no. 322; London, National
Gallery cat. 1973; and Gerson 1936, nos. 56 and 57.

Pieter Lastman

(Amsterdam c.1583–1633 Amsterdam)

Lastman was probably born in Amsterdam around 1583. His father, Pieter Zeegersz, who did not use the surname Lastman, was a courier. In 1604 Karel van Mander claimed that Lastman had studied with Gerrit Pietersz Sweelink (1566–before 1645), the mannerist artist and pupil of Cornelis van Haarlem. Lastman's earliest dated drawing, *Hagar in the Wilderness*, of 1600 or 1601 (Yale University Art Gallery, New Haven), seems to reflect Sweelink's influence. Van Mander (1604) further states that Lastman was, at the time of the author's writing, in Italy. Since the manuscript was probably prepared in the preceding year, Lastman's departure is usually dated to 1603/1604. There is no information about his Italian sojourn apart from a drawing after a Veronese painting in Venice that, however, may have been based on an engraving. Houbraken claims that he was active in Rome with Adam Elsheimer (1578–1610) and Jan Pynas (c.1583/84–1631). Lastman was certainly back in Amsterdam by 1607, when he was mentioned in the catalogue of the estate sale of Gillis van Coninxloo. He lived in Amsterdam with his mother, who died in December 1624.

By 1618 Lastman had gained sufficient reputation as a painter to be mentioned in a poem by Rodenburgh praising the famous artists of Amsterdam. He garnered considerable acclaim from other seventeenth-century chroniclers, including Orlers, Ouddam, Hoogstraeten, and Sandrart. Joost van den Vondel's poem written about Thomas de Keyser's (lost) portrait of Lastman was entitled "On Lastman, the Apelles of Our Century." In 1617 Jan Lievens (1607–1674) became Lastman's pupil; Rembrandt was also a student for about six months in 1623. Lastman apparently was considered a connoisseur of Italian art, since in 1619 he gave a deposition concerning the authenticity of a painting by Caravaggio.

About this time he also received a commission (the only certain one in his oeuvre) for three paintings with New Testament themes intended for the bedchamber at Frederiksborg, the palace of Christian IV, Protestant King of Denmark. Lastman, however, was a Catholic. There is no proof of a hypothesized trip to Denmark. Also included in the Frederiksborg commission were works by Pieter Isaacsz (1569–1625) and his pupils Adriaen van Nieulandt (1587–1658), Werner van den Valckert (c.1585–1627), and Jan Pynas. Lastman's works brought high prices in his own lifetime, and the number of contemporary copies are further proof of his success. During serious illnesses in 1628 and 1629 he made wills. Following his recovery, he made a second deposition, together with his brother-in-law François Venant (c.1591–1636) and van Nieulandt, concerning a copy of a Caravaggio. In 1631 he purchased a home in Amsterdam and the following year had an inventory compiled of his estate, which included a large art collection. Lastman, who remained unmarried his entire life, was buried on April 14, 1633, in Amsterdam.

Lastman was one of the most influential early seventeenth-century painters of biblical and mythological subjects. Though primarily a figural artist, Lastman made landscape a strong feature of his art. He is regarded as a leading figure among the Pre-Rembrandtists, a group of painters who preceded Rembrandt but whose art, contrary to the implications of their group title, was in no way provisional. Lastman was also active as a draftsman and printmaker. Houbraken mentioned in addition to Lievens and Rembrandt, Jan Albertsz Roodtseus (Rootius) (c.1615–1674) and Pieter Pietersz Nedek (d. c.1686) as pupils of Lastman.

P.C.S.

Literature: van Mander 1604, fol. 207b; Rodenburgh 1618; Orlers 1641; Sandrart 1675; Hoogstraeten 1678, p. 257; Houbraken 1718–21, vol. 1, pp. 97, 132, 214, 254, 296; Weyerman 1729–69, vol. 1, pp. 358–61; Descamps 1753–64, vol. 1, pp. 242–43; Nagler 1835–52, vol. 7, p. 323; Immerzeel 1842–43, vol. 2, p. 160; Kramm 1857–64, vol. 3, pp. 954–55; Vosmaer 1863; Nagler 1858–79, vol. 4, nos. 1253, 3108; Bode 1883, pp. 19, 341–43, 392ff., 616ff.; Bredius, de Roever 1886; Wurzbach 1906–11, vol. 2, pp. 16–17, vol. 3, p. 106; Bredius 1911; Freise 1911; Haberditzl 1911; Sandrart, Peltzer 1925, pp. 160, 163, 202, 333, 399; Müller [Hofstede] in Thieme, Becker 1907–50, vol. 22 (1928), pp. 412–14; Müller Hofstede 1929; Ryckevorsel 1934; Martin 1935–36, vol. 1, pp. 142–44; Bauch 1938; Sjtsjerbatsjewa 1940; Boon 1942; Welcker 1947; Bauch 1951; Bauch 1952–53; Bauch 1955; Bauch 1960; Maclaren 1960, pp. 215–17; Stechow 1966, p. 132; Stechow 1969; Sumowski 1970; Sacramento 1974, pp. 47–61; Dudok van Heel 1975; P. Sutton 1975; Bartsch 1978, vol. 53, pp. 217–20; Haak 1984, pp. 190–93; Sluijter 1986, pp. 52–69; A. Tümpel, forthcoming.

55 (PLATE 11)

Landscape with Pastoral Figures, c.1609–14

Signed indistinctly at bottom left: P. Last. . .
Oil on panel, 15 x 21¼ in. (38 x 54 cm.)
Private Collection

Provenance: Sale, London (Sotheby's), December 8, 1986, no. 88; on loan to Montreal Museum of Fine Arts, 1986.

Exhibitions: Atlanta 1985, no. 40, ill.; London 1986, p. 191, no. 84, ill.

Literature: Kettering 1983, pp. 88, 93, fig. 117.

This work more closely approaches a pure landscape than any other painting in Lastman's oeuvre. An undescribed landscape was mentioned in the painter's inventory of July 7, 1632, and other landscapes by the artist are mentioned in seventeenth-century inventories with high appraisals or actually sold for good prices;[1] further, prints by Simon Frisius and Jan van Noordt document lost landscapes by Lastman.[2] But no other known painting by the artist devotes so much of the composition to the landscape relative to the figures.

The diagonal design, picturesque Italian ruins, cauliflower-shaped trees, and idyllic, pastoral tenor of the scene all recall Adam Elsheimer's art. Whether Jacob Pynas played an intermediary role in Lastman's absorption of Elsheimer's inventions is a matter for speculation. Aspects of Elsheimer's landscapes had appeared in Lastman's art by 1608 (see, for example, the *Baptism of the Eunuch*, signed and dated 1608, Staatliche Museen Preussischer Kulturbesitz, Berlin [West], no. 677).

The amorous couple in the right foreground have not been identified with any of the figures from the pastoral literature that was then just gaining popularity. Among the candidates are Angelica and Medoro from the nineteenth canto of Ariosto's *Orlando Furioso* and Granida and Daifilo from P.C. Hooft's *Granida*; as Kettering observed, to certify the former story, the lovers' carved names should appear on the tree, while

55

most representations of the latter episode include a shell full of water.[3] The gesture of the comfortably reclining shepherdess who crowns her lover with a garland of flowers recalls a scene from the story of Amarillis and Mirtillo in Guarini's *Il Pastor Fido*, but the identification can be dismissed;[4] the shepherd Mirtillo was disguised as a woman when the nymph Amarillis awarded him the garland for winning a kissing game. Moreover, Amarillis is usually depicted among her peers. The crowning motif had become a common gesture in love garden and

other amorous subjects by the seventeenth century. Of course the goat is appropriate to a bucolic subject but since pagan antiquity had also been associated with lust, hence serves to emphasize the lovers' physical attraction.

The exhibited work is very similar in conception and details to a painting by Lastman of another shepherd couple in a landscape, signed and dated 1610, and inscribed as if carved into the tree trunk, "Paris [and] Oenone" (fig. 1). Having been warned that his son would one day ruin his country, Priam, King of Troy, sent the

Fig. 1. Pieter Lastman, *Paris and Oenone in a Landscape*, signed and dated 1610, and inscribed "Paris [and] Oenone," panel, 66 x 112 cm., Colnaghi, New York.

Fig. 2. Pieter Lastman, *A Shepherd Girl Crowning a Shepherd Boy with a Garland in a Landscape*, signed and dated 1619, panel, 47 x 68.5 cm., with dealer E. Parsons & Sons, London, 1910.

prince to Mount Ida, where the child was raised as a shepherd. Paris married the lovely nymph Oenone and they had a son. More common than images of the couple embracing or carving their names in the tree are depictions of the Judgment of Paris, when the three goddesses (Hera, Athena, and Aphrodite) miraculously appeared before the shepherd as he was writing Oenone's name on a piece of bark and asked him to make the fateful choice that started the Trojan War.[5] Lastman's painting of 1610 apparently depicts the moment when Paris deserts Oenone for Helen, symbolically disregarding his shepherd's crook and marital wreath, which lie in the foreground. Although Oenone foresaw the wounding of Paris, in her bitterness she refused to cure him. Relenting too late, she killed herself in despair. Despite its many similarities to the work of 1610, the exhibited painting does not depict Paris's departure, nor can it be certified as a depiction of an earlier and more blissful moment in the story without such features as the lovers' carved names in the tree.

Lastman not only seems to have been the first artist to paint the classical story of Paris and Oenone,[6] but also claims the distinction of being one of the first Dutchmen to paint landscapes with pastoral figures from antique and Italian literature. Van Mander had recommended the inclusion of such figures in his discussion of landscape in his *leerdicht* of 1604: "[Of the figures in the landscape] show how the farm girls beside the green banks bring forth fountains of milk with their hands. Show how Tityrus, with his flute, entertains Amaryllis, his beloved among women, as they rest beneath a beech tree and delight in the pleasant sounds of the herd" (*Den Grondt*, chap. 8, verse 42).

Although Kettering did not know its classical subject, she identified *Paris and Oenone* as the earliest dated work by a Dutch artist depicting a pastoral theme. Yet another similarly conceived

lost work by Lastman (fig. 2) is dated 1619, and a painting in the Muzeum Narodowe, Gdansk, is dated 1624.[7] The work exhibited here may postdate the painting of 1610 but is unlikely to have been painted later than the version of 1619. It shares stylistic similarities with Lastman's early works, especially the paintings from around 1609–14.[8]

P.C.S.

1. An otherwise undescribed landscape (Freise 1911, no. 123a) by Lastman in the inventory of Aaltje Gerritsdr, widow of Barendt Jansz van Kippen, was appraised in Amsterdam on March 6, 1657, for fl.42; and an *Italian Landscape with Figures* (Freise 1911, no. 125) sold in Amsterdam, April 11, 1689, for fl.100 together with another undescribed picture by Lastman. See also Hoet 1752, vol. 1, p. 43, no. 6.

2. See Simon Frisius after Lastman, *Landscape with the Angel and Young Tobias* (Hollstein, no. 192), and Jan van Noordt after Lastman, *Landscape with the Temple of the Sybils*, dated 1645 (Hollstein, no. 2).

3. Kettering 1983, p. 88.

4. As noted by Duparc in Atlanta 1985, no. 40, ill.

5. See van Mander 1604, *Den Grondt*, chap. 5, verse 57; *W'tlegghingh*, fol. 92.

6. While George Pencz made an earlier engraving, all the paintings of the theme appear to be later in date; see Pigler 1974, vol. 2, p. 204; and Sluijter 1986, pp. 50, 389, note 50–1, 460, note 128-5. Eric Sluijter notes that Cornelis van Haarlem's design of 1615 (preserved in the print by Jan Saenredam, Hollstein, no. 84, and several dubious painted versions) closely resembles the artist's various treatments of the themes of Mars and Venus, and Venus and Adonis. Later artists who treated the theme include Jan van Bijlert, Christian van Couwenburgh, and Jan and Salomon de Bray.

7. Oil on panel, 53 x 54 cm.

8. Compare the *Odysseus and Nausicaa* of 1609, Herzog Anton Ulrich-Museum, Braunschweig, inv. 210; the *Dismissal of Hagar* of 1612, Kunsthalle, Hamburg, inv. 191; and *Abraham's Vision* of 1614, Hermitage, Leningrad, inv. 8306. A signed but illegibly dated early painting by Lastman of *Apollo and Coronis* (sale, David Arnon, London (Christie's), Dec. 11, 1959, no. 82) employs a similar, diagonal Elsheimerian design.

Pieter de Molijn

(London 1595–1661 Haarlem)

Son of Flemish parents, Pieter de Molijn was baptized in London on April 6, 1595. He became a master in the Haarlem guild in 1616. The date of his move to the Netherlands is unknown, as is the name of his teacher. In 1624 he joined the local militia and was registered as a bachelor from London when he married Mayken Gerards. His earliest dated paintings are of 1625 (*Nocturnal Street Scene*, Musées Royaux des Beaux-Arts, Brussels, inv. 314; *The Stadtholder Going to the Chase*, National Gallery of Ireland, Dublin, no. 8; and *Wooded View with Hunter*, Lord Barnard, Raby Castle [cat. 56, fig. 1]). From 1630 to 1649 he served on the administration of the guild; in 1633, 1638, and 1646 he was a deacon. In the past he has wrongly been considered to be a pupil of Frans Hals (1582/83–1666) on the basis of an inscription on a portrait in the Frans Halsmuseum. He is often confused with the painters Pieter Mulier the Elder (d. 1670) and Younger (c.1637–1701). However, there is probably truth in Houbraken's claim that Allart van Everdingen was his pupil. Van der Willigen also discovered that Christian de Hulst, Jan Nose (in 1655), and the genre painter Gerard Terborch (1617–1681) were de Molijn's pupils. De Molijn was buried in Haarlem on March 23, 1661.

Pieter de Molijn specialized in paintings and drawings of dune landscapes and views of sandy roads; rarer are his forest and, in his later career, mountain landscapes, winter landscapes, and views of nocturnal fires and soldiers plundering. Between 1623 and 1630 he also painted and drew landscape compositions with large figures, which might properly be considered genre scenes. A series of four etched landscapes with genre figures is dated 1626.

P.C.S.

Literature: Schrevelius 1647, p. 294; Houbraken 1718–21, vol. 1, p. 25, vol. 2, pp. 95, 343, vol. 3, p. 183; Weyerman 1729–69, vol. 2, p. 13; Descamps 1753–64, vol. 1, p. 429; Bartsch 1803–21, vol. 4, pp. 7–12; Nagler 1835–52, vol. 9, pp. 382–83; Immerzeel 1842–43, vol. 2, p. 235; Kramm 1857–64, vol. 4, pp. 1139–40; van der Willigen 1870, pp. 18, 21, 27, 225–27, 229; Obreen 1877–90, vol. 1, pp. 231, 235, 291, vol. 5, pp. 57, 182, 212; Granberg 1883; Granberg 1884; Bode 1885b; Wurzbach 1906–11, vol. 2, pp. 178–80; Grosse 1925, pp. 55–63; T.H. Fokker in Thieme, Becker 1907–50, vol. 25 (1931), pp. 49–50; Martin 1935–36, vol. 1, p. 246; Bengtsson 1952; Stechow 1966, pp. 23–28; Bol 1969, pp. 139–43; Haak 1984, pp. 239–40.

56 (PLATE 30)

Dune Landscape with Trees and Wagon, 1626

Signed and dated on fence: PMolyn 1626 [PM ligated]
Oil on panel, 10¼ x 14⅛ in. (26 x 36 cm.)
Herzog Anton Ulrich-Museum, Braunschweig, inv. 338

Provenance: Bildergalerie, Salzdahlem, by 1776; removed to Paris, 1807–15 (the seal of the Musée Napoléon on the reverse).

Exhibitions: Schaffhausen 1949, no. 87; Cologne 1954, no. 14, pl. 9.

Literature: Salzdahlum, cat. 1776, p. 306, no. 88 (as van Goyen); Riegel 1882, p. 350; Granberg 1884, p. 372; Riegel 1885, no. 74; A. Michel 1887, p. 22; Wurzbach 1906–11, vol. 2, p. 179; T.H. Fokker in Thieme, Becker 1907–50, vol. 25 (1931), p. 49; Grosse 1925, pp. 55, 58, pl. 29; Drost 1926, p. 212; Müller 1928, p. 66; Sthyr 1929, p. 11; van Gelder 1933, p. 74; Martin 1935–36, vol. 1, p. 247, fig. 142; Bernt 1948, vol. 2, fig. 547; Würtenberger 1958, p. 50, ill.; Filla 1959, p. 57, fig. 54; Plietzsch 1960, p. 97; Dobrzycka 1966, pp. 33, 62; Rosenberg et al. 1966, p. 149, fig. 123A; Stechow 1966, pp. 23–26, fig. 24; Bol 1969, p. 140, fig. 125; Berlin (West), cat. 1975, p. 281; Bernt 1980, vol. 2, fig. 842; Schmidt 1981, pp. 129, 154; Braunschweig, cat. 1983, pp. 141–42, no. 338, ill.

This small, unprepossessing painting has been characterized by Stechow as "one of the cornerstones of Dutch landscape painting."[1] While features such as the dark foreground strip on the left and the brightly contrasted band of light beyond do not yet achieve a fully unified "tonal" painting, relative to contemporary paintings by Jan van Goyen and Esaias van de Velde, this work makes startling advances in style and technique. The local application of color favored by earlier landscapists is now subordinated to a more limited blond palette of browns and earth colors punctuated with gray-green shadows. The high foreground, rising diagonal of the road, and sloping horizon not only create a sweeping and dramatic effect that belies the panel's tiny scale

56

Fig. 1. Pieter de Molijn, *Wooded View with Hunter*, signed and dated 1625, panel, Lord Barnard, Raby Castle.

Fig. 2. Pieter de Molijn, *Evening*, signed and dated 1627, panel, 30 x 42 cm., Staatliche Museen Preussischer Kulturbesitz, Berlin (West), no. 960B.

but also achieve an unprecedented spatial and aerial unity. Even Pieter van Santvoort's exceptional *Sandy Road* of 1625 (cat. 98) falls short of de Molijn's achievement, although it anticipates his rough, vital technique and daring use of diagonals.

How de Molijn accomplished this leap in advance of artists like van Goyen and Salomon van Ruysdael is not obvious. De Molijn's *Wooded View with Hunter*, dated in the immediately preceding year (fig. 1), is still conceived in the rather mannered *flamisant* style of forest landscapes by Roelandt Savery, Jan Wildens

(1586–1653), and Gerrit Claesz Bleker. De Molijn's two other dated paintings of 1625 in Dublin and Brussels (see biography above) are primarily genre scenes. As Stechow observed, Esaias van de Velde's drawings surely provided de Molijn with a point of departure in his search for simple images of roads with unifying diagonal compositions, but no other artist (aside from Santvoort) had yet attempted these designs in paint or recognized the complementary effect of a muted palette and moist atmosphere.[2] Very similar in conception to the Braunschweig painting but employing a descending diagonal

scheme is the *Evening*, preserved in Berlin, dated the following year (fig. 2). The unelevated subject matter, the raw, direct paint application, and the spareness of the palette are very similar to de Molijn's paintings of 1627 in the Frans Halsmuseum (no. 214a) and of 1628(?) in the Národní Galerie, Prague (inv. DO-4196), which

Frans de Momper

(Antwerp 1603–1660 Antwerp)

57 (PLATE 41)

Valley with Mountains, c.1640–50

Fig. 3. Pieter de Molijn, *Landscape with Cottage*, signed and dated 1629, panel, 37.5 x 55.2 cm., The Metropolitan Museum of Art, New York, no. 95.7.

also depict country roads and employ a similar style and palette but adopt larger motifs, trees, and figures traveling or resting. De Molijn's *Landscape with Cottage* of 1629 (fig. 3) again depicts a sandy road in the dunes set off by a darkened *repoussoir* in the foreground and featuring a rustic fence and cottage beyond, but the artist's touch has become somewhat tighter and more controlled.

With these and similar works from the latter half of the 1620s, de Molijn played an important role in the rise of the indigenous Dutch realist landscape painting. In the 1630s he apparently abdicated this position of leadership, painting in a manner dependent upon van Goyen and Ruysdael, but after 1650 he again exhibited unexpected inventiveness in a series of powerful mountain landscapes.

P.C.S.

1. Stechow 1966, p. 23.
2. Ibid., pp. 22–23.

Born in Antwerp on October 17, 1603, Frans de Momper was the son of the landscape painter Jan de Momper II and brother of the artist Philip de Momper II (d. 1675). In 1629 he became a master in the Antwerp guild and married Catherina Beucker, who died in 1646. Emigrating to the Northern Netherlands, he was first active in The Hague and in 1647 appeared in Haarlem, where he joined the guild the following year. In 1648 he also appeared in Amsterdam, where the following year he was registered as an artist from Antwerp when he remarried. He returned to Antwerp in August 1650 and died there in 1660. On October 6, 1662, Philip de Momper, acting as guardian for the children and heirs of Frans de Momper, authorized a boatman to demand from Dirck Ulbrecht in Hamburg the restitution of all the paintings that Frans de Momper had consigned to him for sale.

A painter of mountainous landscapes, winter scenes, and views of villages, Frans de Momper apparently first worked in the Flemish manner of Joos de Momper (1564–1635) but in the Netherlands developed a more intimate, tonal style under the influence of Jan van Goyen and Hercules Segers.

P.C.S.

Literature: van der Willigen 1870; Frimmel 1905; Bode 1872; Hofstede de Groot 1915–16b; Wurzbach 1906–11, vol. 1, p. 180; Bredius 1916; Hofstede de Groot 1923, pp. 21–23; Grosse 1925, pp. 30, 86; Thieme, Becker 1907–50, vol. 25 (1931), pp. 51–52; Bredius 1939; Laes 1952, pp. 57–67; Stechow 1966, p. 134; van Gelder 1963a; Bol 1969, pp. 182–83; Haak 1984, p. 339; Ertz 1986, pp. 278–95.

Signed, lower center: f momper
Oil on panel, 14¾ x 25⅛ in. (37.5 x 63.8 cm.)
Philadelphia Museum of Art, The Henry P. McIlhenny Collection, in memory of Frances P. McIlhenny, no. 1986-26-276

Provenance: Henry P. McIlhenny.

Exhibitions: Boston, Museum of Fine Arts, "Masterpieces from the Henry P. McIlhenny Collection," 1986.

Literature: Stechow 1966, p. 134, fig. 268.

Towering craggy mountains soar above a wide valley in this imaginary landscape. In the darkened foreground a tiny rider and a second traveler on foot move away from the viewer down into the valley. A blasted, limbless tree trunk on the left counterbalances the thrust of the church spires and mountains on the right. Sailing vessels ply a broad lake in the middle distance. On the shore is the specter of a city with many tall buildings and the suggestion of a port.

One of the relatively few known paintings by Frans de Momper, this landscape reflects the influence of the Flemish landscapist Joos de Momper II (1564–1635). Not only the subject but also the treatment of the mountain, lake, and even details like the denuded tree at the left descend from Joos de Momper (see fig. 1). However, Frans converted Joos's exaggerated, even decorative mannerism and recollections of the *Weltlandschaft* tradition to a more dramatic but at the same time more naturalistic vision. To be sure, the scene is still a fantasy, but the treatment of the landscape motifs is less stylized; the palette, though still composed of the manneristic triad of brown, green, and blue, is tempered by a new tonal harmony. These developments probably reflect not only Frans de Momper's acquaintance with van Goyen and other Dutch "tonal" landscapists but also, as Stechow observed, the influence of Hercules

57

Fig. 1. Joos de Momper II, *Mountain Landscape*, panel, 51.5 x 78 cm., Musées Royaux des Beaux-Arts, Brussels, inv. 6542.

Fig. 2. Frans de Momper?, *Mountain Landscape*, panel, 40 x 56 cm., H.J. Reinink collection, The Hague, 1961.

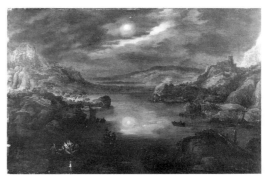

Fig. 3. Frans de Momper, *Mountain Lake by Moonlight*, remnants of a signature, panel, 61 x 97 cm., Museum der bildenden Künste, Leipzig, inv. 1239.

Segers's views (see cat. 100 and 101).[1] Stechow believed that works wrongly attributed to Segers in the past ought to be reassigned to Frans de Momper.[2]

In addition to the works mentioned by Stechow, the *Mountain Landscape* (fig. 2) in the H.J. Reinink collection, The Hague, 1961, has carried an attribution to Segers but closely resembles the Philadelphia painting in design and execution.[3] Mountain views by Frans de Momper (see fig. 3)[4] are not as numerous as his winter scenes and views of cities, villages, and rivers.[5]

P.C.S.

Frederik de Moucheron

(Emden, Germany 1633–1686 Amsterdam)

1. Stechow 1966, p. 134.

2. Ibid., p. 211, note 15; and Stechow 1954.

3. Formerly sale, Enthoven, Oct. 25, 1932, no. 20. Compare also the design of the painting attributed to Segers in the Oskar Reinhardt collection, Winterthur. See also the *Mountain Landscape with River* (D. van Buuren, Brussels) attributed to Segers by Leo van Puyvelde, "Zwei Werke von Hercules Segers," *Pantheon* 12 (1933), pp. 354–56, ill., p. 355.

4. See also the *Mountain Landscape* monogrammed "F.d.m." that was in the collection of Baron Janssen, Brussels (cat. 1923, no. 79), and the unsigned *Mountain Landscape with Peasants beside a Road* (panel, 43.8 x 62.5 cm., Museum of Fine Arts, Boston, 48.505). The unsigned *Mountain Scene with a Metal Factory* (panel, 46 x 72 cm.) in Brussels is a free copy after a work by Lucas van Valckenborch (see Laes 1952, p. 61, fig. 2; and Brussels, Musées Royaux des Beaux-Arts, *Catalogue inventaire* [1984], p. 199, inv. 4710, ill.).

5. See Bol 1969, fig. 174; *City by a River*, panel, 69 x 117 cm., van den Boogaard collection, Beek, near Nijmegen.

Son of French Huguenots, Frederik de Moucheron was born in Emden, Germany, in 1633. The de Moucheron family subsequently settled in Amsterdam, where Frederik became the pupil of Jan Asselijn sometime before the latter's death in 1652. Following this training, de Moucheron spent several years in France, and in 1656 he was residing in Paris and Lyon. It is possible that he may also have visited Italy at this time, although there is no concrete evidence for such a trip. After a brief stay in Antwerp, de Moucheron returned to Amsterdam, where in July 1659 he married Marieke de Jouderville. Between 1660 and 1678 twelve of the couple's offspring were baptized in Amsterdam. Apart from a trip to Rotterdam in the spring of 1671, where he acted as middleman in several art sales, de Moucheron apparently spent the rest of his life in Amsterdam. In 1678–79 de Moucheron and Claes Berchem worked together to complete the several landscapes left unfinished by Willem Schellinks upon his death in 1678. De Moucheron was buried in Amsterdam on January 5, 1686.

De Moucheron's Italianate landscapes – particularly his mountain views – show the clear influence of second-generation Italianates such as Asselijn, Jan Both, and Jan Hackaert. His softer, more atmospheric scenery, silvery tonalities, and predilection for a cultivated, park-like nature are important steps in the transition toward the more delicate landscapes favored in the eighteenth century. De Moucheron painted both cabinet pieces and large-scale decorative ensembles. Johannes Lingelbach (1622–1674), Theodor Helmbreker (1633–1696), Gerard de Lairesse (1641–1711), Adriaen van de Velde, and Claes Berchem contributed the staffage figures to many of his landscape compositions. De Moucheron's son and pupil Isaac (1667–1744) was renowned not only as a painter of decorative Italianate landscapes but also as an architect and designer of formal gardens.

M.E.W.

Literature: Houbraken 1718–21, vol. 2, p. 327; Weyerman 1729–69, vol. 2, pp. 332–33; Descamps 1753–64, vol. 2, pp. 478–80; Nagler 1835–52, vol. 9, pp. 523–24; Immerzeel 1842–43, vol. 2, p. 243; Kramm 1857–64, vol. 4, pp. 1170–71; Siret 1863; A.D. de Vries 1883, p. 156; A.D. de Vries 1885–86, pp. 231, 331; Haverkorn van Rijsewijk 1890, p. 208; Hofstede de Groot 1899, pp. 231–33; Wurzbach 1906–11, vol. 2, pp. 199–200, vol. 3, p. 128; Ledermann 1920; Martin 1935–36, vol. 2, p. 326; Thieme, Becker 1907–50, vol. 25, p. 198; Gerson 1942, pp. 28, 51, 200; Staring 1958, pp. 44, 46; Maclaren 1960, pp. 259–60; Utrecht 1965, pp. 219–24; Stechow 1966, pp. 156, 163, 166; Bol 1969, pp. 270–72; Kaemmerer 1975, pp. 132–41; Blankert 1978, pp. 219–24; Salerno 1977–80, vol. 2, pp. 760–67, vol. 3, p. 1060; Salzburg/Vienna 1986, pp. 144–50.

Italianate Landscape, 1670s

Signed: Moucheron
Oil on canvas, 34⅝ x 37¾ in. (88 x 96 cm.)
Niedersächsisches Landesmuseum, Hannover,
inv. PAM 821

Literature: Hannover, Niedersächsiches
Landesgalerie, *Verzeichnis der ausgestellten Gemälde*,
1980, p. 65.

In a wooded valley with slender streaming trees,
anglers fish in a shadowed pond on the left, and a
herdsman drives his cattle down a lighted path
in the middle distance. Buildings sit atop a hill in
the distance.

Although there is no proof that de Moucheron
traveled to Italy, a painting in Strasbourg (fig.
1), first assigned to the artist by Bode, may
document such a trip;[1] it depicts a view of Rome
from the garden of the Villa Celimontana with S.
Stefano Rotondo basilica on the left, the
Ospedale di S. Giovanni on the right, and Mount
Sabine in the distance. Italian motifs, if not such
specific topographically accurate views, also
frequently appear in his other works. One group
of his works consists of classical landscapes with
architecture and statuary (see, for example, the
Landscape with Narcissus, signed and dated 1668,
Thurkow collection, The Hague),[2] while other
paintings depict park-like settings or imaginary
views of the Italian campagna with classical
ruins and de Moucheron's beloved cypresses.[3]
Houbraken's claim that Asselijn was de
Moucheron's teacher is borne out by the com-
bination of strongly lit architecture and soft
treatment of foliage in de Moucheron's work.
Asselijn's influence may also be detected in such
motifs as peasants fording streams;[4] however, de
Moucheron's taste for tall trees seems to owe
more to Jan Both.

In a group of Italian landscapes to which the
exhibited work belongs, de Moucheron adopted
less structured compositions and a more restless,
atmospheric treatment of the silvery trees and

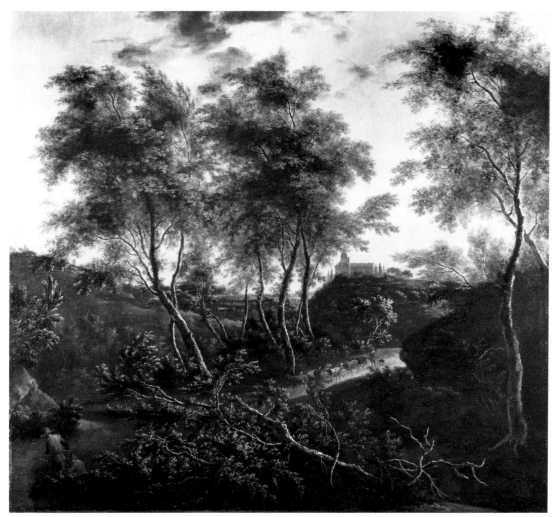

58

Fig. 1. Frederik de Moucheron?, *View of Rome*, canvas 35 x 48 cm., Musée des Beaux-Arts, Strasbourg.

Fig. 2. Frederik de Moucheron, *Wooded Landscape with Sportsmen*, signed, canvas, 177.8 x 144.8 cm., Trafalgar Galleries, London.

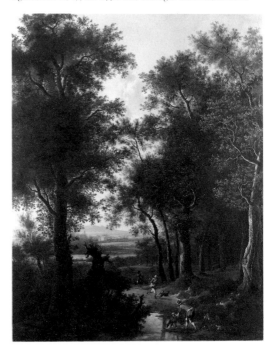

foliage, creating a new decorative animation. The painting is closest in style to a painting in Braunschweig (Herzog Anton Ulrich-Museum, inv. 362), which in the past has been wrongly attributed to both Pijnacker and Both, but which is surely by de Moucheron.[5] Blankert has argued that these developments signal the influence of late works by Pijnacker and thus probably date after about 1670.[6] De Moucheron's works can be readily distinguished from those of the second generation of Dutch Italianate artists (Asselijn, Both, Berchem, et al.) not only by their greater decorativeness and feathery foliage but also by abrupt, sometimes illogical changes in scale and a more casual, less cohesive approach to composition.

The very large scale of some of de Moucheron's works (see, for example, fig. 2) suggests that, like Pijnacker's paintings admired by Verhoek, some of these works must once have been set into the decorative paneling of rooms.[7] An idea of how these wall decorations appeared is provided by the elegant little "Saletkamer" painted by de Moucheron for the elaborate dollhouse of Adam Oortmans and Petronella de la Court and now preserved in the Centraal Museum, Utrecht (inv. 5000).[8] Frederik's son Isaac de Moucheron followed his father's example in painting wall decorations, some of which are still in situ in Amsterdam houses (e.g., Heerengracht nos. 168 and 475).[9]

P.C.S.

1. See Amsterdam, Rijksmuseum, *Hollandse schilderijen uit Franse musea*, 1971, no. 37.

2. See Utrecht 1965, no. 139, ill.

3. See National Gallery, London, nos. 842 and 1352.

4. See *Italian Landscape with Ford*, signed, canvas, 142 x 115 cm., Natale Labia Collection (London, Wildenstein Gallery, *Twenty Masterpieces from the Natale Labia Collection*, May 1978, no. 6), and *Italian Landscape with Herders*, signed, canvas, 68 x 80 cm., Herzog Anton Ulrich-Museum, Braunschweig, inv. 391.

5. See Klessmann in Braunschweig, cat. 1983, pp. 145–46, no. 362.

6. See Utrecht 1965, nos. 140 and 141; however, Duparc (The Hague, Mauritshuis cat. 1980, p. 58) disputed the influence of Pijnacker on de Moucheron's painting in the Mauritshuis, The Hague, inv. 121. Salerno's claim (1977–80, vol. 2, p. 760) that the Braunschweig painting (inv. 362) is "almost a free copy" of the Pijnacker in the Mauritshuis (inv. 132) overstates a case of influence.

7. The Labia painting mentioned in note 4 above is probably the pendant to a painting now in the J. Paul Getty Museum, Malibu. See also the pair of paintings owned by the Duke of Montrose, Brodick Castle, Isle of Arran, *Landscape with Hawking Party* and *Landscape with Figures*.

8. Utrecht 1965, no. 142. See also I.H. van Eeghen, "Het poppenhuis van Petronella de la Court, huisvrouw van Adam Oortmans," *Jaarboek Amstelodamum* 47 (1960), pp. 159–67; P. Sutton 1980, p. 29, note 5, p. 47, fig. 49.

9. See also Hartford, cat. 1978, nos. 96–98. Little has been published on de Moucheron's wall decorations. See A. Staring, "Isaac de Moucheron als ontwerper van gevels en tuinen," *Oud Holland* 65 (1950), pp. 85–104; Zwolle 1973, p. 41.

Aert van der Neer

(Amsterdam 1603/04–1677 Amsterdam)

Aert van der Neer was probably born in 1603 or 1604 in Amsterdam; on May 12, 1642, he was recorded as about thirty-eight years old; on July 22, 1647, "about 43 years old"; on October 20, 1651, "about 48 years old"; and on June 5, 1653, "about 50 years old." According to Houbraken, van der Neer lived in his youth in Arkel near Gorinchem and was the father of Eglon van der Neer (1634?–1703). Houbraken also states that he was a steward (*majoor*) in the service of a family at Gorinchem. Among the leading artists in Gorinchem in van der Neer's youth were Jochem (1601/02–1659) and Raphael Govertsz Camphuysen (b. c.1597/98–1657). Documents and stylistic connections suggest that the latter was van der Neer's teacher; on December 28, 1642, Raphael Camphuysen was a witness at the baptism of van der Neer's daughter Cornelia. Van der Neer married Lysbeth Goverts and around 1632 moved to Amsterdam. His son, the painter Eglon, was born there; Johannes was born in 1637/38 (d. 1665); Pieter was born March 4, 1640; Cornelia, December 28, 1642; Pieter, July 5, 1648; and Alida, July 7, 1650.

On January 24, 1659, and again on June 14, Aert van der Neer was mentioned as a citizen of Amsterdam working as an innkeeper at "de Graeff van Hollant" on the Kalverstraat. Aert and his son Johannes were both *wyntappers* (taverners) in Amsterdam. On January 25, 1662, he again appeared in a list of innkeepers. On December 12 of the same year he went bankrupt, and an inventory of his belongings was drawn up. His paintings were appraised at relatively low values, mostly five guilders and less. At the end of his life he lived in impoverished conditions. His address was given as the Kerkstraat near the Leidsegracht when he died in Amsterdam on November 9, 1677.

The artist's earliest dated painting is a genre scene of 1632 (Národní Galerie, Prague); his earliest landscape is of 1633 (Bachmann 1982,

fig. 2). A painter of winter scenes and moonlit and twilight landscapes, van der Neer developed into one of the most important landscapists of his age. His early landscapes are influenced by the Camphuysen brothers, and the winter landscapes show an interest in Hendrick Avercamp and Esaias van de Velde.

P.C.S.

Literature: Houbraken 1718–21, vol. 3, p. 172; van Eynden, van der Willigen 1816–40, vol. 1, pp. 92–96; Nagler 1835–52, vol. 10, pp. 167–69; Immerzeel 1842–43, vol. 2, pp. 257–58; Kramm 1857–64, vol. 4, pp. 1191–92, Supplement, p. 113; Obreen 1877–90, vol. 2, pp. 25–26, vol. 4, p. 212; Veth 1884, p. 258; Bode 1906, pp. 142–50; Wurzbach 1906–11, vol. 2, pp. 221–23; Thieme, Becker 1907–50, vol. 2 (1931), pp. 374–75; Hofstede de Groot 1908–27, vol. 7, pp. 359–523; Bredius 1921; Kauffman 1923, pp. 106–10; Grosse 1925, pp. 30–32; Martin 1935–36, vol. 2, pp. 283–88; Maclaren 1960, pp. 260–65; Bachmann 1966; Stechow 1966, pp. 96–98, 176–82; Bachmann 1970; Bachmann 1972; Bachmann 1975; Bachmann 1982; Zeldenrust 1983; Haak 1984, pp. 304–05.

Moonlit View on a River, 1647

Monogrammed in ligature and dated: AVDN 1647
Oil on panel, 25⅝ x 35 in. (57.5 x 89 cm.)
Private Collection, Montreal

Provenance: Sale, N.J.W. Smallenburg van Stellendamm et al., Amsterdam, May 6, 1913, no. 73 (fl.23,600 to Muller); Krupp Collection, Villa Hügel, Essen (inv. KH 352); Hoogsteder-Naumann, Ltd., New York.

Exhibitions: Essen, Villa Hügel, *Aus der Gemäldesammlung der Familie Krupp*, April 30–October 31, 1965, p. 32, no. 67.

Literature: Hofstede de Groot 1907–28, vol. 7, no. 431; Stechow 1966, p. 220, note 20; Müllenmeister 1973–81, vol. 1, p. 178, ill.; *Katalog der Gemäldesammlung Hügel* [n.d.], p. 20; Bachmann 1982, pp. 64–65, 85, note 98, p. 106, fig. 60.

Under a night sky with full moon and billowing clouds, a river reminiscent of the Nieuwe Amstel flows back to a distant horizon at the center right. The scene specifically recalls the area known as the "Kalfje." In the immediate foreground is the silhouette of a marshy shore with reeds and, on the right, a darkened tree with a skiff moored beyond. Two men walk along a road on the right bank. The left bank is the larger of the two and has tall, full trees. Beneath them are a little bridge spanning a side canal and a house with stepped gables. A sailing boat lies at anchor just off shore. On the bank in the distance is a castle with a square tower, reminiscent of Castle Kostverloren. In front of it are other sailboats.

Hofstede de Groot wrongly recorded the date as 1643,[1] a reading questioned by Stechow.[2] Bachmann certified the date as 1647.[3] Van der Neer's earliest dated evening landscape is the painting of 1643 in Schloss Friedenstein, Gotha (fig. 1). That work employs a similar composition, with a river rapidly receding between two river banks, a castle on the left, and sil-

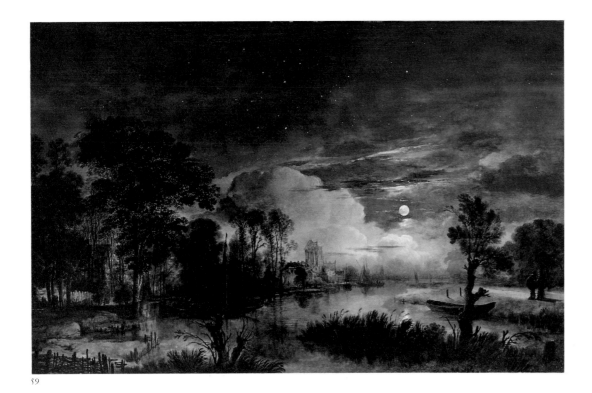

59

Fig. 1. Aert van der Neer, *Evening Landscape with Canal and Gabled Villa*, signed and dated 1643, panel, 72 x 101 cm., Schloss Friedenstein, Gotha.

Fig. 2. Aert van der Neer, *Moonlit Landscape with Castle*, dated 1646, panel, 58 x 82 cm., Israel Museum, Jerusalem, inv. 3561-8-55.

houetted plants, low trees, and bushes in the foreground. The Gotha picture, however, has yet to achieve the comprehensive unity of atmosphere and design that characterizes the exhibited painting. The latter work is one of van der Neer's earliest dated paintings to be illuminated by moonlight; a moonlit landscape with ruined castle in the Israel Museum, Jerusalem, is dated 1646 (fig. 2), as is the *River Landscape with Dam and Bridge* (sale, Göteborg, November 10, 1976, no. 268, panel, 33 x 53 cm.).[4] Works of any type dated after 1647 by Aert van der Neer are scarce. However, it is generally assumed that he was highly productive until 1658, when his financial debacle may have brought a period of

inactivity. From about 1662 onward, he continued to paint despite declining skill and inspiration until his death in 1677.[5]

This work therefore stands at the beginning of his mature period, vindicating his renown as a master of nocturnal effects. This early apogee in van der Neer's nocturnes was achieved in the same year, 1647, that his fellow Amsterdammer Rembrandt painted his *Nocturnal Landscape with the Rest on the Flight into Egypt* (cat. 78), that master's definitive nocturne. Bachmann and others have particularly praised the sensitive and varied treatment of the night sky in van der Neer's work, where the handling of the cumulous and cirrus clouds enhances the effect of

spatial recession; according to Bachmann, this painting is the first nocturne by van der Neer to employ these devices.[6]

Van der Neer's painting is of interest not only for its nocturnal effects but also for its evocation, if not exact record, of the Amstel. Many seventeenth-century Dutch poets eulogized the Amstel, and landscapists from C.J. Visscher

onward depicted scenes along its banks, including Castle Kostverloren (see fig. 3). Among these artists we include Rembrandt, Ruisdael, and Hobbema. Visscher executed and published an entire series of views of Amsterdam's outskirts and the Amstel in about 1607. Simon Frisius also made a print of Kostverloren as early as 1610.[7] Until the second half of the seventeenth century, Kostverloren was the most imposing, grand house on the outer Amstel.[8] Its history can be traced to about 1500, when it was constructed by Jan Jansz Benningh, a jurist and municipal leader of Amsterdam and member of the Provincial Council of Holland. Kostverloren (originally it was called Brillenburg and later, alternatively, Amstelhof or Ruyschenstein) means "lost earnings," a name that arose from the disastrous costs of the building's construction and repairs. The foundation of the building began sinking soon after it was built. Several later additions were made, notably a low stone wall with tower constructed around 1610–30.[9] Van der Neer's painting takes considerable liberties with architectural details but recalls the structure as it appeared before being heavily damaged by a fire around 1650. The disaster left only the central tower-like structure. This later state of the building is familiar to us from paintings and drawings by Jacob van Ruisdael (fig. 4), Meindert Hobbema, Jan van Kessel, and many others.[10] About 1700 these ruins also disappeared, and no trace of the original structure survives today. For van der Neer's painting it is of special interest that in the anonymous *Roemster van den Amstel* (The Eulogist of the River Amstel), the poet goes for a moonlit walk by the Amstel. In his *Hertspieghel* of 1615, the poet Hendrik Laurensz Spiegel also versified on the beauty of the Amstel at night ("flowing softly from the East, with the black Haarlem-meer shimmering in the West . . . Northwards streams the dammed-up river IJ, so rich in fishes, teeming

Fig. 3. C.J. Visscher, *Kostverloren*, 1607, etching.

Fig. 4. Jacob Ruisdael, *The Ruins of Kostverloren*, black chalk and wash, 203 x 291 mm., Teylers Museum, Haarlem, no. Q*52.

with boats; here night falls")[11] and alluded to Kostverloren, referring to it as Ruyschensteen. When van der Neer was active, the building was still owned by the Amsterdam patrician family named Ruysch.

P.C.S.

1. Hofstede de Groot 1908–27, vol. 7, no. 431.

2. Stechow 1966, p. 220, note 20.

3. Bachmann 1982, p. 64, note 85.

4. See respectively Bachmann 1982, figs. 56 and 59. Other undated moonlit landscapes are dated by Bachmann to the 1640s, including works in the Kunsthistorisches Museum, Vienna, inv. 436; Staatliches Museum, Schwerin, inv. 725; Thyssen-Bornemisza Collection, Lugano no. 231; and Städelsches Kunstinstitut, Frankfurt, inv. 507. See respectively Bachmann 1982, nos. 58, 43, 36, and 32.

5. See Stechow 1966, p. 180.

6. See Bachmann 1982, p. 106.

7. Hollstein, vol. 14, p. 141.

8. On Kostverloren and artists' treatment of the subject, see Lugt 1915, pp. 107–112. For Rembrandt's drawings of the site, see Lugt 1915, pls. 65–69. Seymour Slive delivered a lecture on artists' representations of Kostverloren at the meeting of the College Art Association, Boston, 1987.

9. Lugt 1915, p. 110, mentions a drawing by A. Beerstraten (active mid-seventeenth century) and a print by A. Rademaker (b. 1675) that show the structure in this state. See also Rademaker's watercolor, in sale, A.E. van Saber, Amsterdam, February 27–March 3, 1951, no. 148.

10. See Lugt 1915, p. 110, note 1. Ruisdael's other drawings are in the Collection Frits Lugt, Institut Néerlandais (see exh. cat. Brussels/Rotterdam/Paris/Berne, 1968–69, *Dessins de paysagistes hollandais du XVIIe siècle*, no. 126, pl. 118), and the Kunsthalle, Hamburg (inv. 22452; exh. cat. Hamburg, 1976, *Hundert Meisterzeichnungen aus der Hamburger Kunsthalle, 1500–1800*, no. 85, pl. 74). Hobbema's paintings were with Dr. Rittmann, Basel, and M.C.D. Borden, New York (see Broulhiet 1938, nos. 341, 432, 435); van Kessel's work is in the Szépművészeti Múzeum, Budapest, inv. 258 (see also the drawing possibly by van Kessel in Hamburg, inv. 3086); for Ruisdael's four paintings, see Rosenberg 1928a, nos. 68, 69; and Hofstede de Groot, no. 101, and the work attributed to Ruisdael owned by Jhr. J. van Rijckevorsel.

11. Translated by Freedberg 1980, p. 13.

View of a River in Winter, c.1655–60

Signed with double monogram on a tree trunk,
lower left: AV DN
Oil on canvas, 25¼ x 31⅛ in. (64 x 79 cm.)
Rijksmuseum, Amsterdam, inv. C 191

Provenance: Edward Gray, Harringhay; dealer A.
Brondgeest, Amsterdam; bought by A. van der
Hoop, Amsterdam, 1839; bequeathed to the city of
Amsterdam, 1854; Museum van der Hoop; on
permanent loan to the Rijksmuseum from 1885.

Exhibitions: Brussels 1946, no. 72, fig. 46; Paris
1950–51, no. 56, fig. 18; Zurich 1953, no. 93; Cologne
1954, no. 17; Milan 1954, no. 99; Rome 1954, no. 95;
New York/Toledo/Toronto 1954–55, no. 54, ill.; Oslo
1959, no. 43, ill.

Literature: Amsterdam, van der Hoop cat. 1855, no.
104; Thoré 1858–60, vol. 2, pp. 142–43; Amsterdam,
Rijksmuseum cat. 1887, no. 1016; Bredius 1900,
p. 80; Amsterdam, Rijksmuseum cat. 1903 (and later
eds.), no. 1720; Hofstede de Groot 1908–27, vol. 7,
no. 479; Havelaar 1931, p. 160, ill.; A. van Schendel,
Openbaar Kunstbezit 1, no. 5 (1957), ill.; E. van Uitert,
Openbaar Kunstbezit 3, no. 20 (1965), figs. 6–7; Stechow
1966, pp. 93–94, 107, ill. 183; Rosenberg et al. 1966,
p. 512, fig. 128B; Bachmann 1966, pp. 52–53, fig. 13;
Russell 1975, p. 31, fig. 26a; Amsterdam, Rijks-
museum cat. 1976, no. C 191, ill.; Davies 1978,
p. 254, fig. 370; Bachmann 1982, pp. 98, 117–18,
fig. 89; Haak 1969, p. 199, fig. 326.

From almost directly in front of the viewer a
frozen river stretches into the far and hazy
distance. On the left bank are a few houses and
farther back, behind a fortress wall, a large and
distinguished city. The steeples of its many large
and smaller church buildings dominate the
silhouette, and windmills form the distant
outline of the city's edge. The right bank of the
river has a more open and rural character,
defined by a few scattered farms and a small
windmill. The frozen river serves as the setting
for a wide variety of winter entertainment.
Skaters hurry at full speed past several groups of
unperturbed *kolf* players. Others travel across

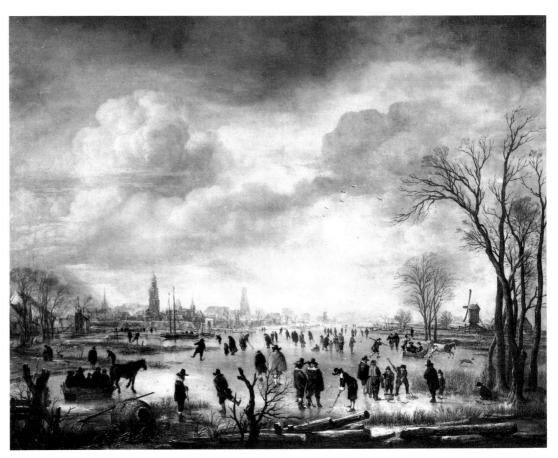

60

the ice by sled, and in the lower right fishermen spear eels as some passers-by from the city watch. In the 1630s and 1640s Aert van der Neer occasionally dated his paintings, but no dates exist after 1650.[1] His later work can be dated only roughly, using the clothing of the figures as an important tool. This *View of a River in Winter* is commonly assigned to around 1655,[2] and Bachmann dates the painting between 1655 and 1660.[3] This means that it was painted when van der Neer, who started his painting career late in life and probably as an amateur, had fully matured in craftsmanship.

Broadly staged in the flat landscape under a high and cloudy sky, and situated near a typically Dutch but imaginary city, this kind of ice scene offered a distinctly personal contribution to the traditional depiction of winter. Van der Neer has reinstated its monumental form, more or less following the old formula introduced by Avercamp but since dropped from usage. However, he did not follow this formula blindly but customized it to accommodate his own view of the subject.

Other mid-seventeenth-century painters of winter scenes, such as Jan van de Cappelle and Isack van Ostade, were inclined to use a more intimate approach, examining the subject within a smaller scope, as a close-up (see cat. 18 and 63). These changes followed logically on the evolution of winter landscape painting effected by Haarlem painters in the 1620s and 1630s (see cat. 107). Aert van der Neer turned away from those developments, choosing a model that may strike one as old-fashioned in some respects. Half a century after Avercamp's works we find many elements of his art in van der Neer's painting: the wide body of a waterway receding perpendicularly, the buildings concentrated mainly on one riverbank, the vertical accents of scattered trees, some of which form the border of the picture in the lower right or left, the barges frozen fast in the ice along the riverbank, one or more obstacles in the foreground, and, finally, scattered throughout the endless space in the center of this static decor, a happy, bustling crowd of people. The all-encompassing character of the scene, its virtually encyclopedic register of every sort of winter activity, and exhaustive furnishing of an unlimited space are aspects of Avercamp's work that are clearly recalled by van der Neer (see cat. 5). Significant in this context is the detail of fishermen spearing eels, treated entirely in the manner of Avercamp. It is as if van der Neer wanted to pay homage to his admired predecessor.

Having acknowledged these similarities, we note the new elements that van der Neer brings to the Dutch winter scene: a great variety of coloristic nuance throughout the painting and well-considered detail in the sky, where several cloud formations are knowledgeably depicted. It is no wonder that this painting has been given a place of honor by several authors, who rank it as a classic work, indeed an apogee in the painter's oeuvre. Bachmann calls it one of the most beautiful winter landscapes[4] and the most important among van der Neer's series of "blue" winter scenes.[5] Stechow discussed it extensively as the paragon of van der Neer's achievement in painting, noting it as an important "discovery" in its richly nuanced depiction of light through a refined and effective use of color and stressing the significance of these inventions for the picture's expression of atmosphere and space.[6] In this landscape one readily notices the attention that the painter has paid to certain laws of nature applying to the diffusion and reflection of winter light. We note how the sky's different blue, gray, and lighter warm tones are reflected successively in the ice, and how the sunlight, breaking in slanted rays through the low clouds above the city, lends a clear, warm glow to some buildings, while others remain covered by a bluish haze. The far distance, where the ice blends into the sky, is also a hazy blue. But a little farther to the right, the roof of a farm is illuminated with a rosy light in the pale sunshine, contrasting sharply with a nearby windmill, which is momentarily covered by a passing cloud. These interrelated, carefully adjusted particularities enliven the scene, setting the details constantly and pervasively in motion on the ice as well as in the sky. The sense of space achieved by the painter through attention to the established laws of perspective is enhanced by the subtle definition of atmosphere. Our admiration for this conscientious achievement is all the greater for the realization that van der Neer's art shows no trace of the flair and ease of, for instance, a Jan van Goyen or Salomon van Ruysdael.

C.J.d.B.K.

1. Bachmann 1982, p. 75.

2. Van Uitert, *Openbaar Kunstbezit* 3, no. 20 (1965); Stechow 1966, p. 93.

3. Bachmann 1982, p. 118.

4. Ibid., p. 98.

5. Ibid., pp. 117–19. Bachmann's remark concerning the blue effect in this painting being toned down by the warm undertone of the oak panel is based on a misunderstanding, since the work is on canvas.

6. Stechow 1966, pp. 93–94.

61 (PLATE 43)

Winter Landscape in a Snowstorm, c.1655–60

Signed lower center with monogram: AVDN [ligated]
Oil on canvas, 24 x 29⅞ in. (61 x 76 cm.)
Private Collection

Provenance: Sale, D. Middeldorp, Leiden, October 21, 1761, no. 7 (to Haazebroek for the brothers Neufville, fl.180); sale, Joan Willem Frank, The Hague, April 5, 1762, no. 85 (to Verschuuring, fl.47); Dale Gallery, London, 1770; Sir Francis Cook, Richmond, Doughty House, 1880, thence by descent; Agnew's, London, 1956; Sidney J. van den Bergh, Wassenaer.

Exhibitions: London 1929, no. 203; London 1938, no. 133; Laren 1959, p. 31; Leiden 1965, no. 8; San Francisco/Toledo/Boston 1966–67, no. 52; Brussels 1971, no. 70, ill.

Literature: Hoet 1752, vol. 1, p. 606, no. 133; Terwesten 1770, p. 247, no. 33; Hofstede de Groot 1907–28, vol. 7, pp. 490–91, no. 531; Thieme, Becker 1907–50, vol. 25 (1931), p. 375; Cook Collection, cat. 1914, vol. 2, p. 63, no. 294, pl. XV; A.B. de Vries 1964, pp. 355, 357, ill.; Bachmann 1966, p. 55; Stechow 1966, p. 204; van den Bergh collection, cat. 1968, pp. 78, 79, ill.; Müllenmeister 1973–81, vol. 1, p. 167; Bachmann 1982, pp. 90, 117, no. 88a, ill.

A frozen canal stretching from the right foreground curves around to recede into the central distance. In the foreground a road leading along the left bank passes several leafless trees. Three men and a boy walk to the left down the road, while a fourth man and a dog move to the right. All are wrapped in heavy cloaks blown by the wind. A village with a church appears on the receding left bank; a windmill and other buildings appear on the right bank. On the ice, figures fish through a hole, push a sledge, or simply bundle themselves against the onslaught of the storm. The entire scene, including threatening sky overhead, is filled with white snowflakes.

Van der Neer had begun painting winter scenes as early as 1641[1] and dated several others in the mid- to later 1640s,[2] but later dates are virtually unknown.[3] The present painting,

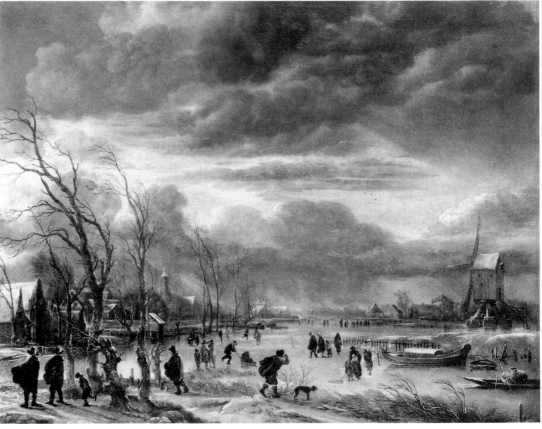

61

however, can probably be dated to about 1655–60 on the basis of the figures' costumes. Thus, it was probably painted about the same time as the Rijksmuseum's painting (cat. 60). Like that work, it represents a central view of a frozen canal seen from a certain remove, with both banks depicted and the ice peopled by skaters. This rather formal design was a composition that van der Neer much favored after about 1645 (see Introduction). A work from van der Neer's best period, the exhibited painting is particularly effective in its evocation of a unifying rose brown and gray atmosphere.

An interesting feature of the work is that it actually depicts snow falling. As Stechow observed,[4] this practice can be traced back at least to sixteenth-century art in paintings by Pieter Brueghel the Younger (*Adoration of the*

Hendrick ten Oever

(Zwolle 1639–1716 Zwolle)

Fig. 1. Lucas van Valckenborch, *Winter Landscape with Snow Falling* (*February?*), monogrammed and dated 1586, canvas, 117 x 198 cm., Kunsthistorisches Museum, Vienna, inv. 1064.

Magi, 1567, panel, 35 x 55 cm., Oskar Reinhardt Collection, Winterthur), Abel Grimmer,[5] and Lucas van Valkenborch (see fig. 1).[6] Van der Neer himself depicted other snowstorms in his paintings in Vienna[7] and the Wallace Collection, London.[8]

P.C.S.

1. See Bachmann 1982, fig. 10.

2. See Bachmann 1982, figs. 25 (dated 1643, Earl of Crawford and Balcarres, panel, 50.8 x 66 cm.), 26 (dated 1643, P. Saltmarshe, canvas, 88 x 116 cm.), and 34 (dated 1645, Corcoran Gallery of Art, Washington, D.C., no. 26.148; see Introduction, fig. 54). A painting dated 1646 was in sale, London (Sotheby's), July 19, 1950, no. 102 (panel, 85 x 73.7 cm.), and one of 1647 appeared in sale, Amsterdam (Muller), October 25, 1927, no. 36 (panel, 31 x 43 cm.).

3. See Hofstede de Groot 1907–28, vol. 7, no. 575, as "1662," but Stechow (1966, p. 93) suggests 1662 or 1665.

4. Stechow 1966, p. 95.

5. See de Boer, Amsterdam, cat. 1972, no. 66, ill.

6. Sale, Frankfurt, May 3, 1932, no. 112 (dated 1575).

7. Canvas, 49.5 x 61 cm., Kunsthistorisches Museum, Vienna, inv. 1259 (Hofstede de Groot 1908–27, vol. 7, no. 534; Stechow 1966, fig. 185).

8. Canvas, 62 x 76 cm., Wallace Collection, London, no. P 159 (Hofstede de Groot 1908–27, vol. 7, no. 508).

Hendrick ten Oever, *Self-Portrait*, pen and ink, from the Album Heyblocq, Koninklijk Bibliotheek, The Hague.

Baptized on April 11, 1639, in Zwolle, Hendrick ten Oever was the son of David ten Oever of Amsterdam and Marijke Molkenbuer, widow of Capt. Marten Roeyer. Hendrick was probably a student of the Zwolle portraitist Eva van Marle (active c.1650), since his first dated painting of 1657 (Provinciaal Overijssels Museum, Zwolle) reflects her influence. Shortly afterward, ten Oever moved to Amsterdam, where he received instruction from his cousin Cornelis de Bie (1621/22–1664). A fellow student was the German landscape and animal painter Johann Heinrich Roos (1631–1685). In 1663 ten Oever drew a self-portrait in the *Album Amicorum* of Professor Jacobus Heyblock, rector of the Amsterdam Gymnasium; Rembrandt, Aert van der Neer, and Jan van de Cappelle also made entries in the album. A painting of the Keizersgracht (Mauritshuis, The Hague, inv.

681) must also date from ten Oever's Amsterdam stay. After de Bie's death in 1664 (several paintings by ten Oever occur in the posthumous inventory), ten Oever moved back to Zwolle.

In Zwolle the artist lived on the Sassenstraat and was a member of the Kerkeraad (church council). On November 16, 1675, he married Geertruidt van der Horst; among their four children was Hieronymous, a silversmith. In the 1680s ten Oever was the most important portraitist in Zwolle, painting its mayors, preachers, and theologians. In 1698 ten Oever was commissioned to paint three large mythological paintings for Rechteren Castle at Delfsen (still in situ). He did several other works for the van Rechteren family, including the painting of clavier covers, for which drawings survive. Ten Oever's last dated painting is from 1705; the artist was buried in Zwolle's Grote Kerk on June 15, 1716.

Ten Oever was an eclectic painter, somewhat isolated from trends in the rest of the Netherlands. Besides the portraits and history pieces mentioned above, ten Oever painted cityscapes, landscapes with Italianate elements, genre scenes, animal paintings, and still lifes. Recently, a group of "pseudo ten Oever" paintings have been identified that are close in style to ten Oever's work but by another as yet unspecified artist.

A.C.

Literature: Kramm 1857–64, vol. 4, pp. 1217–18; Wurzbach 1906–10, vol. 2, p. 250; Thieme, Becker 1907–50, vol. 25 (1931), p. 577; Bredius 1915–22, vol. 1, pp. 89–97; Plietzsch 1942; Zwolle 1957; Stechow 1966, p. 49; Bol 1969, pp. 237–41; The Hague, Bredius cat. 1978, p. 98; Haak 1984, pp. 142, 401.

View of Zwolle, 1675

Signed lower left: Hten Oever/1675
Oil on canvas, 26¼ x 34¼ in. (66.5 x 87 cm.)
Torrie Collection, University of Edinburgh

Provenance: Sir John Erskine of Torrie, by descent to
Sir James Erskine of Torrie, presented in 1835 to
Edinburgh College; loaned to the Board of
Manufacturers, Edinburgh, 1845; on loan to the
National Gallery of Scotland, Edinburgh, 1859 to
1982; returned to the University of Edinburgh,
Talbot Rice Art Gallery.

Exhibitions: Edinburgh, Royal Institution, 1830, no. 98
(as Cuyp); Edinburgh, Royal Institution, 1850, p. 22,
no. 15 (as Cuyp); Zwolle 1957, no. 43, pl. 21.

Literature: Edinburgh, University of Edinburgh cat.
1842, p. 6, no. 15 (as Cuyp); Edinburgh, National
Gallery of Scotland cat. 1859, p. 29, no. 196 (as Jan
Ossenbeck [1627–1678]), and later eds.; Hofstede de
Groot 1893a, pp. 132–33 (as ten Oever); Edinburgh,
National Gallery of Scotland cat. 1896, p. 32, no. 26
(as ten Oever), and later eds.; Wurzbach 1906–10,
vol. 2, p. 250; Thieme, Becker 1907–50, vol. 25
(1931), p. 577; Plietzsch 1942, p. 132, ill.; Stechow
1966, p. 49, pl. 85; Bol 1969, pp. 238–39, pl. 231;
Colin Thompson, *Pictures for Scotland* (Edinburgh,
1972), p. 16; Edinburgh, National Gallery of Scotland
cat. 1978, no. 22, cat. 1980, ill. p. 97; University of
Edinburgh, *The Torrie Collection* (1983), no. 27, pl. 4.

Certainly one of the most striking and un-
orthodox Dutch landscape paintings of the
seventeenth century, Hendrick ten Oever's *View
of Zwolle*, like the work of Aelbert Cuyp, was
conceived and executed in provincial isolation,
far from the mainstream of Dutch landscape art.
Indeed, ten Oever's work was once attributed to
Cuyp and for a long time was thought at least to
be the product of his influence, even though it is
very doubtful that ten Oever could have known
Cuyp's paintings.

By placing the sphere of the setting sun in the
center of the composition and situating nude
bathers before a Dutch town, ten Oever created
a landscape virtually without precedent in the

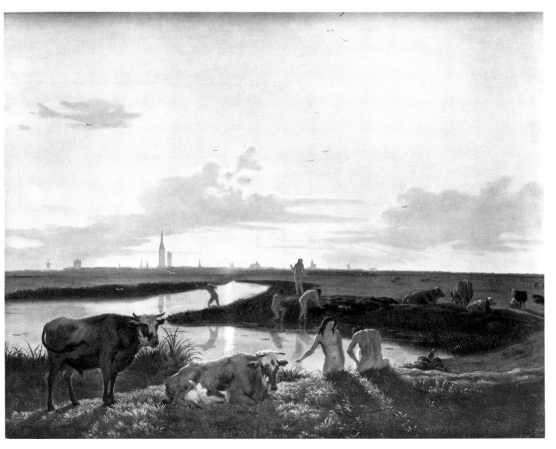

62

seventeenth century. The city seen in the dis-
tance is Zwolle, ten Oever's birthplace and
home at the time of the picture's making, in
1675. The view is from the east. The tallest
tower is that of Michaelskerk, which was almost
totally destroyed by a fire in 1682 (having
already been struck by lightning in 1669). The
smaller tower to the right is the so-called *peperbus*
(pepper mill) of the Onze Lieve Vrouw Church.
At the left is the Sassepoort, to the right the

Dieserpoort. The most common view of Zwolle
before ten Oever's painting was from the north
or west, showing the "Zwarte Water" in front of
the city.[1] Ten Oever has in fact chosen the
topographically correct vantage point that
would show the setting sun directly behind the
city.

The landscape in the exhibited painting was
repeated by ten Oever in a somewhat larger
painting dated 1676 with totally different figures

Fig. 1. Hendrick ten Oever, *View of Zwolle*, signed and dated 1676, canvas, 75 x 100 cm., Gallery Gebr. Douwes, Amsterdam, 1978.

Fig. 2. Hendrick ten Oever, *Fields and Cattle*, canvas, 64 x 99 cm., Museum Bredius, The Hague, inv. 82-1946.

(fig. 1). A man and woman and a different arrangement of cattle have replaced the nude bathers, imparting a typically Dutch but also more prosaic flavor to the scene.[2]

Ten Oever's development as a landscapist can be briefly charted since the artist primarily devoted himself to other types of paintings throughout his career. A landscape with ruins and large trees dated 1660 is from ten Oever's Amsterdam residency (Museum Bredius, The Hague, inv. 187).[3] This intimate sheltered scene does not readily disclose its stylistic sources but indicates ten Oever's already inventive and unorthodox nature. At about the same time, ten Oever depicted the Keizersgracht in Amsterdam (Mauritshuis, The Hague, inv. 681).[4] Sometime afterward, ten Oever painted an open flat landscape (fig. 2) infused with rich golden light in the Italianate manner and showing strong similarities to Pijnacker's early landscapes and the works of Joris van der Haagen. The lighting and composition of this painting, especially its Italianate treatment of sunlight, directly anticipate the greater atmospheric brilliance of the Edinburgh painting.

The nude bathers in the exhibited picture, an uncommon feature in Dutch landscape painting, set it apart from ten Oever's other landscapes. Nudes are found in the landscapes of Poelenburch, Wtenbrouck (cat. 123), and their followers, often included in scenes showing Diana, or nymphs and satyrs. However, these are mythological or idealized figures, and the landscapes themselves include no native Dutch features. More plausibly "everyday" bathers appear in a few Italianate landscapes, such as those by Pieter van Laer,[5] or the clearly foreign scenes of Wouwermans (fig. 3).[6] Nude bathers sometimes figure in traditional representations of Spring or Summer, such as in Herman Saftleven's print of Spring with swimmers before a ruined tower.[7] Ruisdael's painting of

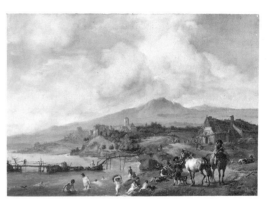

Fig. 3. Philips Wouwermans, *Bathers in a Landscape*, signed, canvas, 55.5 x 81 cm., Schloss Vaduz, Liechtenstein, inv. 432.

Kostverloren (Amsterdams Historisch Museum) also shows nudes before a ruin.[8] However, it is the special combination of such idyllic figures with a modern Dutch town that sets ten Oever's painting apart. A drawing by Rembrandt (Kupferstichkabinett, Berlin, inv. 5212)[9] similarly shows a nude bather climbing out of a canal with the towers of Amsterdam in the distance. Only in Paulus Potter's *Cow Reflected in the Water* in the Mauritshuis (cat. 73, fig. 2) are these motifs otherwise found in painting. Like ten Oever's landscape, the scene is Dutch – Delft is visible in the left distance – and bathers are mingled with cattle in a farm setting. Ten Oever must have been acquainted with Potter's transcriptions of Italianate light while in Amsterdam and certainly was greatly affected by Potter's animal paintings.

Ten Oever's bathers evoke a dreamier lyricism, a more idyllic atmosphere than those in Potter's work. The presence of cattle adds a pastoral, if not rural, note, but the poses and limning of the figures bespeak a classical orientation. We are reminded that ten Oever painted scenes from classical mythology, studied

Isack van Ostade

(Haarlem 1621–1649 Haarlem)

ancient statuary, and sketched nude figures.[10] This pervasive classicism, as imprecise as it is strongly felt and reinforced by what would have been recognized as an Italian, idealizing light, is here linked to civic and national pride. Ten Oever's desire to celebrate and monumentalize the Dutch cities and countryside is echoed in seventeenth-century descriptions of the towns of Holland that stressed their beauty, wealth, nobility, and glorious past. Landscape painters were frequently accomplices in this endeavor. There are strong parallels between ten Oever's painting and the work of Aelbert Cuyp (see his *View of Nijmegen*, cat. 22) in the addition of idyllic or pastoral figures, antique statuary, and golden Italian light to depictions of Dutch towns.

A.C.

1. Two anonymous paintings, one of c.1606 (probably an official city portrait since it is emblazoned with arms), the other from the 1670s, are in the Provinciaal Overijssels Museum, Zwolle; illustrated in K. Boonenburg, *Terugblik op Swol* (Zwolle, 1969), pp. 9, 14.

2. Zwolle 1957, no. 44, pl. 22. Formerly in the collection P. Kramer, Cologne, 1886; with Gallery Gebr. Douwes, 1978.

3. Zwolle 1957, no. 40, pl. 18; The Hague, Bredius cat. 1978, no. 115, ill.

4. This painting, or one very similar to it, was cited in the inventory of ten Oever's teacher in 1664, no. 106; Bredius 1915–22, vol. 1, pp. 89–97.

5. Kunsthalle, Bremen, inv. 69; Utrecht 1965, no. 35, ill.

6. Hofstede de Groot 1907–28, vol. 2, no. 92. Exhibited, New York, The Metropolitan Museum of Art, 1985–86, *Liechtenstein: The Princely Collections*, no. 163, ill.

7. Bartsch no. 22, dated 1650, shows boys pissing into the water.

8. See The Hague 1981–82, pl. 28a.

9. Benesch 1973, vol. 6, no. 1352, pl. 1586, as c.1654. A painting attributed to Nicolas Maes in the Louvre (inv. RF 2132) shows children swimming and jumping off a boat.

10. Classical statuary appears in a painting dated 1674, location unknown (Zwolle 1957, pl. 26). Ten Oever also sketched nude figures, Zwolle Museum, dated 1684 (Zwolle 1957, no. 102, pl. 33; see also pls. 27, 28, 29, 34, 36, 37).

Baptized in Haarlem on June 2, 1621, Isack van Ostade was the youngest child of Jan Hendricks van Eyndhoven and Janneke Hendriksdr. Houbraken stated that Isack was a pupil of his older brother, Adriaen van Ostade (1610–1685). His earliest dated painting is of 1639 (see cat. 63), but he did not enter the Haarlem guild until 1643. In the same year he was mentioned in the guild records when the council arbitrated his three-year dispute with the Rotterdam dealer Leendert Volmarijn concerning payment for and delivery of paintings. At least in these early years he seems to have been paid very little for his works; a contract in 1642 specified thirteen paintings for twenty-seven guilders (hence just over two guilders per painting), while the following year, when he joined the guild, he agreed to deliver nine paintings for fifty-six guilders, theoretically raising his pay per painting to about six guilders. Isack lived in Haarlem until his early death at the age of twenty-eight. He was buried on October 16, 1649, in St. Bavo's Church.

A painter and draftsman of landscapes and genre paintings, Isack van Ostade was active for only about a decade. His early works are strongly dependent on the art of his brother and teacher, Adriaen; indeed, the two painters' hands have often been confused. However, Isack gave landscape greater prominence in his art, while Adriaen stressed figures. Chief among Isack's landscape subjects were winter scenes and the Halt before the Inn theme. In addition to Adriaen van Ostade, other Haarlem artists who may have influenced Isack were Pieter de Molijn and Salomon van Ruysdael.

P.C.S.

Literature: Houbraken 1718–21, vol. 1, p. 347; Weyerman 1729–69, vol. 2, pp. 91–92; Descamps 1753–54, vol. 2, pp. 173–75; Smith 1829–42, vol. 1, pp. 179–98, vol. 9, pp. 121–36; Nagler 1835–52, vol. 10, pp. 409–11; Immerzeel 1842–43, vol. 2, p. 288; Kramm 1857–64, vol. 4, pp. 1234–35; van der Willigen 1870, pp. 29, 239–41; Obreen 1877–90, vol. 1, p. 231; van de Wiele 1893; A. Rosenberg 1900; Wurzbach 1906–11, vol. 2, pp. 287–89; Hofstede de Groot 1908–27, vol. 3, pp. 437–556; Bode 1916, pp. 1–10; Bode 1921, pp. 167–86; R. Fritz in Thieme, Becker 1907–50, vol. 26 (1932), p. 75; Martin 1935–36, vol. 1, pp. 402–406; Scheyer 1939; Klessmann 1960, vol. 2, pp. 92–115; Leningrad 1960; Rosenberg et al. 1966, pp. 113–14; Stechow 1966, pp. 28, 39, 90, 92, 98, 99; Eckerling 1977; Paris 1981; Schnackenburg 1981; Haak 1984, pp. 238–39, 248.

63 (PLATE 45)

A Frozen Canal with Skaters, c.1644–47

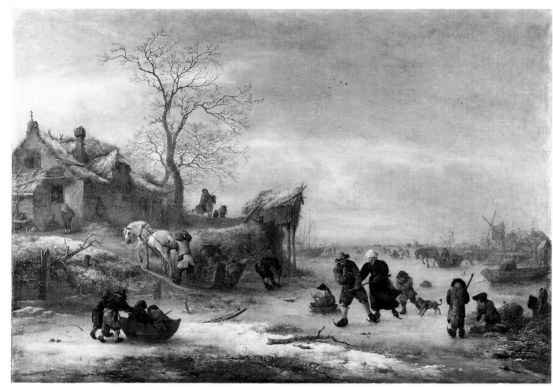

63

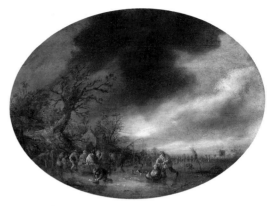

Fig. 1. Isack van Ostade, *Winter Landscape with Ice Skaters*, c.1641, panel, 39 x 52 cm., Staatsgalerie, Schleissheim, inv. 2169.

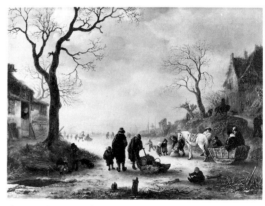

Fig. 2. Isack van Ostade, *Canal in Winter*, canvas, 92.7 x 119.4 cm., the Iveagh Bequest, Kenwood House, London, no. 53.

Signed lower right on boat: Isack Ostade
Oil on canvas, 39¾ x 58⅝ in. (101 x 149 cm.)
Musée du Louvre, Paris, inv. 1688

Provenance: Collection of Louis XVI; acquired in 1784.

Literature: Deperthes 1822, pp. 226–28; Smith 1829–42, vol. 1, no. 66; Paris, Louvre cat. 1852, no. 378; Rosenberg 1900, p. 106, fig. 99; Wurzbach 1906–11, vol. 2, p. 288; Hofstede de Groot 1908–27, vol. 3, no. 258; Paris, Louvre cat. 1922, no. 2510; Eckerling 1977, pp. 31, 40–42, fig. 16; Paris, Louvre cat. 1979, p. 102, inv. 1688, ill.

On a frozen river or canal figures skate or push their sledges. In the center a heavily bundled couple followed by a boy and a dog skate toward the left foreground. In the lower left two boys push a tiny sledge containing two more boys. On the right another boy kneels down to tie his skate while a second stands with his back to the viewer. On a dike in the left middle distance is a cottage with a tall leafless tree. A sledge laden with casks is drawn up the bank by a gray horse as the driver prods the animal. The water stretches away into the distance on the right.

Isack van Ostade dated winter scenes between 1639 and 1647.[1] These paintings first

employ a dark, tonal manner and free, painterly touch reminiscent of van Goyen (see fig. 1), while his paintings from the mid-1640s adopt a lighter overall tonality, a more exacting touch, and stronger local color. He apparently continued to paint small, intimately conceived oils on panel alongside large, more ambitious designs on canvas.[2] With its rich offering of figural anecdote and bright, silvery atmosphere, the Louvre's painting is one of the most successful of the latter group. In design it resembles a painting of 1645 in the Koninklijk Museum voor Schone Kunsten (inv. 467). Another very similar but undated painting is the *Canal in Winter* at Kenwood House (fig. 2), which also employs a distant view down a frozen canal and comparably shadowed and silhouetted figures in the foreground; but the Kenwood painting enlarges the second bank on the right, creating a more enclosed design. With its single-wing design, the Louvre's painting offers an open composition in which the windswept expanse of ice and sky make the skaters' chilled gestures all the more compelling. The painting also has points in common with the Hermitage's undated winter scene[3] in its design and figures.

The motif of the horse drawing the sledge up an incline was one of Isack's favorite details (see cat. 64).[4] Although figure motifs such as this one frequently recur in Isack's winter scenes, only a single sheet has survived of what must once have been many more figure study drawings.[5]

P.C.S.

1. See respectively, Hofstede de Groot 1908–27, vol. 3, no. 280 (panel, 37 x 49 cm.), present location unknown; ibid., no. 98 (panel, 25.4 x 33 cm.), sale, Paris, December 15, 1958, no. 63.
2. Examples of his smaller, more intimately conceived winter scenes on panel are in the Mauritshuis, The Hague, inv. 864; the Gemäldegalerie, Berlin (West), inv. 1709; and the Gemäldegalerie, Staatliche Museen, Dresden, no. 1491.

3. Leningrad, inv. 906, panel, 71.5 x 113.5 cm. See Kuznetsov, Linnik 1982, no. 200, as "painted around 1648."
4. See, in addition to figure 2 and catalogue 64, the winter scene in the National Gallery, London, no. 848.
5. See *Skater Pushing a Sledge*, brown ink and wash, 50 x 85 mm., sale, Ederheimer, New York, April 9, 1919, no. 117 (as A. van Ostade); Schnackenburg 1981, no. 474, fig. 197.

Ice Scene before an Inn, 1644

Signed and dated lower left: Isack van Ostade / 1644
Oil on panel, 26 x 36 in. (63.5 x 88.5 cm.)
Private Collection

Provenance: Royal collection, Munich; Alte Pinakothek, Munich; dealer Walter Andreas Hofer, Berlin, 1940; Adalbert Bella Mangold (Cannes), sale, London (Sotheby's), July 6, 1966, no. 35; dealer H. Terry Engell, London, 1966–67; Gallery Gebr. Douwes, Amsterdam; Herbert Girardet, Kettwig; Cramer, The Hague.

Exhibitions: Cologne/Rotterdam 1970, no. 39, ill.; The Hague 1982, no. 64, ill.

Literature: Munich, Alte Pinakothek cat. 1838, no. 251; Waagen 1862, p. 150; Gaedertz 1869, p. 135; Munich, cat. 1884 (and later eds.), no. 378; Rosenberg 1900, p. 100; Wurzbach 1906–11, vol. 2, p. 288; Hofstede de Groot 1907–28, vol. 3, no. 83; Munich, cat. 1922, no. 1037; Stechow 1928a, p. 173, ill.; Martin 1935–36, p. 404, fig. 244; Eckerling 1977, pp. 5, 14, 61; Kirschenbaum 1977, pp. 35, 168, fig. 23; Braun 1980, p. 86, fig. 11a; Müllenmeister 1973–81, vol. 3, no. 292, ill.

A frozen river and its surrounding banks bustle with the special activities of winter. A carriage has pulled up to an inn at the right. A family in the foreground prepares for a day out on the ice: one boy is already seated in the sled. The whole scene has been arranged around a low, sweeping diagonal ending at the horizon at the left. Only a bare tree silhouetted against the pale sky interrupts this diagonal.

Isack van Ostade painted genre scenes and farm landscapes throughout his career. His early landscapes, such as a work dated 1641 in Basel (fig. 1), resemble those of his brother Adriaen van Ostade[1] and almost contemporary works by Rembrandt (see cat. 76). Beginning in 1642, however, Isack made winter landscapes a speciality, and these in turn may have influenced Rembrandt (see cat. 77).

As Stechow noted, most of Isack van Ostade's

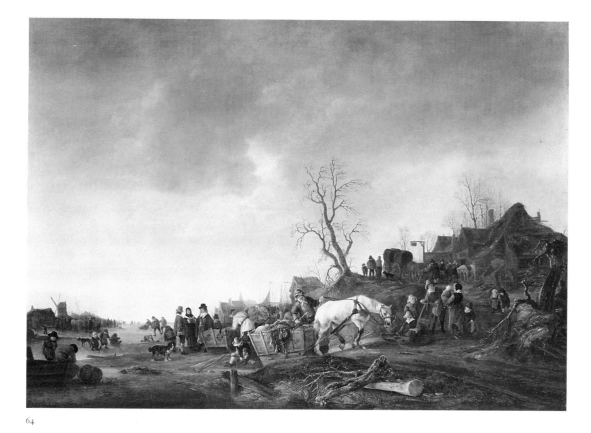

64

Fig. 1. Isack van Ostade, *Landscape*, signed and dated 1641, panel, 28.5 x 41 cm., Kunstmuseum, Basel, inv. 1350.

Fig. 2. Jan Steen, *Winter Landscape*, signed, panel, 67 x 97 cm., Baron Rutger von Essen, Skokloster, Sweden.

winter landscapes conform to a basic diagonal pattern.[2] A quick sketch by Isack van Ostade appears to outline roughly the composition of the exhibited painting.[3] A painting in the Louvre (cat. 63) reverses the structure of the present painting, placing a similar house to the left and likewise reversing the horse struggling up the ramp, while the distant view with a windmill is almost identical. In other respects, the two works are entirely different: the exhibited landscape is more elegant, brighter, and more tightly finished. Many of the figures here are clearly wealthy or engaged in pleasurable activities. Even the horse in the exhibited work is white rather than gray. The work is dated 1644 and seems to immediately postdate the Louvre painting, which is more monochromatic in tone and looser in handling.

In focusing on human activity in a comparatively confined outdoor space, Isack van Ostade showed his debt to pure genre painting, especially village scenes. Indeed, Jan Steen derived a winter landscape of remarkably similar composition and imagery from the present painting (fig. 2).[4] Isack van Ostade continued to inspire later genre winter scenes, in particular Salomon

Adam Pijnacker

(Schiedam c.1620–1673 Amsterdam)

van Ruysdael's *Drawing the Eel (Palingtrekken)* dated 165[0?] (see cat. 120, fig. 1), and Philips Wouwermans's winter landscapes, which often include skaters, tents, inns, and horse-drawn sledges.[5]

A.C.

1. See Adriaen van Ostade's landscape dated 1639 in the Museum Boymans-van Beuningen, Rotterdam, inv. vdv 58. There exist paintings of the *Halt before the Inn* by Isack dated 1643 and 1645 (in the Rijksmuseum, Amsterdam, and the National Gallery of Art, Washington, D.C.; see Schnackenburg 1982, pls. 58, 59).

2. Stechow 1966, p. 90.

3. Schnackenburg 1981, no. 479 verso, ill. vol. 2, p. 200. The cart near the inn at the right of the exhibited painting is derived from another drawing in the van Regteren Altena collection; Schnackenburg 1981, no. 560, ill. vol. 2, p. 237.

4. Painted before 1651, when it was sold in The Hague (Stechow 1928a).

5. See, for example, Nationalmuseum, Stockholm, inv. 709; Bayerische Staatsgemäldesammlungen, Munich, inv. 152.

Jacob Houbraken, *Adam Pijnacker* from Arnold Houbraken, *De groote schouburgh*, 1718–21, engraving.

Adam Pijnacker was born in Schiedam (not Pijnacker, as often thought) about 1620; he is recorded as aged thirty-one in a document of January 22, 1652. His first teacher was probably his father, Christiaen Pijnacker, a glass painter from Kerckhoven. Houbraken reports that Adam spent several years in Italy, but there is no independent confirmation of this trip. The earliest dated work by the artist is an Italianate seaport of 1650 (private collection).

In 1649–51 and 1657, Pijnacker was recorded in Delft, where he was associated with the painter and innkeeper Adam Pick. Several of his paintings appear in Delft inventories from the early 1650s, and Leonaert Bramer (1596–1674) made sketches of three of his landscapes about 1653. However, Pijnacker probably worked frequently in Delft without actually living there.

He is documented in Schiedam in 1651, 1652, and 1658.

In 1654–55 Pijnacker worked at Lenzen in Germany for the Brandenberg court, for which a landscape dated 1654 survives (see p. 113, fig. 13). On September 20, 1658, he married the eldest daughter of the Frisian painter Wijbrand de Geest (1592–after 1660), who portrayed the couple (Leeuwarden Museum). Pijnacker also must have converted to Catholicism at that time (the de Geests were Catholic), since both his son and daughter were baptized as Catholics in Schiedam in 1660 and 1661 respectively.

In 1661 or shortly thereafter Pijnacker moved to Amsterdam, where he is recorded again in 1669 and 1671. In 1670, the year of his last dated painting, he was again in Schiedam. Pijnacker was buried in Amsterdam on March 28, 1673.

Pijnacker's landscape style is a synthesis of motifs borrowed from Jan Asselijn and Jan Both and powerfully independent innovations – complex compositions, a subtle treatment of mountains, and the use of a cool light and clear tonalities.

A.C.

Literature: Félibien 1666–88, vol. 5, p. 44; Houbraken 1718–21, vol. 2, pp. 96–99; Weyerman 1729–69, vol. 2, pp. 180–82; Descamps 1753–64, vol. 2, pp. 317–21; van Eynden, van der Willigen 1816–40, vol. 1, pp. 407–408; Smith 1829–42, vol. 6, pp. 285–300, vol. 9, pp. 750–55; Nagler 1835–52, vol. 12, pp. 125–26; Immerzeel 1842–43, vol. 2, pp. 331–32; Kramm 1857–64, vol. 5, pp. 1326–27; Obreen 1877–90, vol. 5, p. 15; Bredius 1888a, p. 297; Bredius 1890–95, p. 2; Wurzbach 1906–11, vol. 2, p. 366; Hofstede de Groot 1907–28, vol. 9, pp. 521–68; R. Juynboll, in Thieme, Becker 1907–50, vol. 27 (1933), pp. 477–78; Utrecht 1965, pp. 184–94; Rosenberg et al. 1966, p. 179; Stechow 1966, pp. 157, 160–61; Wassenbergh 1969; Salerno 1977–80, vol. 2, pp. 694–705; Montias 1982, pp. 81–82; Harwood 1983; Harwood 1985; Plomp 1986, nos. 50–52.

Barges on a Riverbank, c.1654–57

Signed lower right: APijnacker [AP ligated]
Oil on canvas pasted on panel, 19 x 17 in.
(48.5 x 44.5 cm.)
Gemäldegalerie der Akademie der bildenden
Künste, Vienna, inv. 828

Provenance: Count Anton Lamberg-Sprinzenstein,
Vienna; presented in 1822.

Exhibitions: Amsterdam/Brussels 1947, no. 112;
Utrecht 1965, no. 108, ill.; Brussels 1977–78, no. 64;
Minneapolis/Houston/San Diego 1985, no. 27, ill.;
Salzburg/Vienna 1986, no. 60, ill.

Literature: Vienna, Akademie cat. 1866, no. 428;
Vienna, Akademie cat. 1889, no. 828; Frimmel 1901,
vol. 4, p. 186; Hofstede de Groot 1907–28, vol. 9,
no. 36; Eigenberger 1927, no. 828, pl. 174; Plietzsch
1960, p. 136; Vienna, Akademie cat. 1961, no. 169,
ill.; Stechow 1966, p. 160, fig. 325; Waddingham
1966, ill.; Vienna, Akademie cat. 1972, no. 198, ill.;
Bol 1973, p. 260, fig. 265; Salerno 1977–80, vol. 2,
p. 694; Vienna, Akademie cat. 1982, pp. 77–79,
pl. 25; Harwood 1985, no. 16.

Two barges and a small boat have pulled up to a
bank on a calm river. Golden sunlight saturates
the scene, imparting a glow to the figures and
sails of the boats. Brilliant reflections shimmer in
the river, while the strong light divides the hill
on the opposite bank into two overlapping
forms. Pijnacker's composition is of great sim-
plicity, governed only by a few gentle curves.
Unconfined by traditional framing devices, the
lines of the hills and banks seem to extend
beyond the picture frame. The spareness of this
arrangement shifts attention to the overall
atmosphere – the vast, open sky with brilliant,
diagonal streaks of clouds.
 Although Blankert and Harwood have made
important studies of Pijnacker's work, establish-
ing the artist's chronology remains difficult.[1]
There are six dated paintings by Pijnacker:

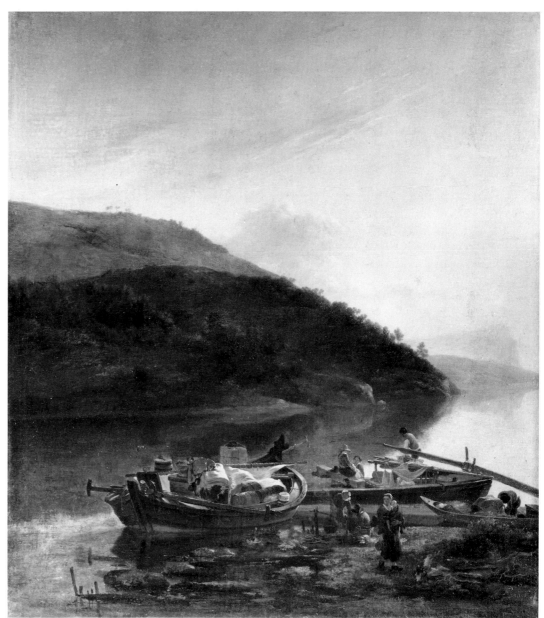

1650, *Italian Seaport*, Charrington collection, Great Britain;[2] 1654, *Landscape with a Hunter*, Staatliche Museen, Berlin (DDR), inv. 897 (see p. 113, fig. 13);[3] 1657, *Hunters and Game*, Leger Galleries (1979);[4] 1659, *Collapsing Bridge*, Schliessheim, inv. 773 (cat. 66, fig. 1);[5] 1661, *Landscape with a Bridge*, version in Rheinisches Landesmuseum, Bonn, inv. 35/541;[6] and 1670, *Landscape with a Rider*, Schloss Vaduz, Liechtenstein, inv. 1200.

To this group can be added three paintings that Leonaert Bramer recorded in sketches made in Delft around 1653.[7] Probably made between 1649–51, when the artist was often recorded in Delft, two of these can be identified: *Harbor Scene* (R. Hanbury Tenison, Abergavenny),[8] and the *Spinning Shepherdess* (Rijksmuseum, Amsterdam, inv. A 322).

The dating of other works on the basis of stylistic and compositional similarities to these paintings remains highly problematic, especially in the case of Pijnacker's early work, since there are no dated river or ferry scenes that might help in ordering Pijnacker's many paintings of that theme. The lack of evidence concerning a possible sojourn in Italy compounds the problem.[9]

Both Blankert and Harwood date the exhibited painting to the early or mid-1650s. Blankert did not definitively decide whether it dated just before or just after the painting in Berlin of 1654. He implied that the work was preceded by views of ferries in Leningrad (inv. 1162) and sold in London (Sotheby's) December 10, 1980 (no. 96); then followed by works in Berlin (inv. 3/58) and a private British collection (fig. 1).[10] Harwood almost precisely reverses the sequence, placing the exhibited work about 1650–53 and ending with the work illustrated in figure 1, which she also believed to be the last of the group.[11] An exact date for Pijnacker's work is impossible to determine, but

Fig. 1. Adam Pijnacker, *The Stone Bridge*, canvas, 77 x 63.2 cm., Earl of Crawford and Balcarres, Scotland.

Fig. 2. Jan Both, *The Ferry*, etching.

the exhibited painting most closely resembles the work sold in 1980 as well as that shown in figure 1, which must immediately follow it.[12] Its freer, more assured technique, in comparison with the dated work in Berlin, suggests that a date between 1654 and 1657 seems most likely. Another ferry scene on a coast (cat. 67) seems to have been done much later.

Many of Pijnacker's river landscapes were created under the influence of Jan Asselijn,[13] although the present painting is more directly affected by ferry scenes of Jan Both, especially as seen in prints (fig. 2).[14] Landscapes with ferries and barges, including those by Asselijn, Both, Wouwermans (cat. 119), and du Jardin, as well as Pijnacker, must have reminded viewers of journeys through Italy.

A.C.

1. Utrecht 1965; Harwood 1983; Harwood 1985. Hofstede de Groot 1907–28, vol. 9, no. 198, a scene with ruins, was reportedly dated 1646.

2. Harwood 1983, p. 112; Harwood 1985, no. 13.

3. Blankert 1978, p. 186, fig. 197; Stechow 1960, fig. 7. Closely related to this Both-influenced landscape are paintings with Waterman, Amsterdam, 1983 (*Tableau* 5 [Nov.–Dec. 1982], p. ii); Nationalmuseum, Stockholm, inv. 575 and 576; Schleissheim, inv. 551.

4. Müllenmeister 1973–81, vol. 3, fig. 315.

5. Utrecht 1965, no. 113.

6. Ibid., no. 114. A larger version (132.5 x 114.5 cm.) of the Bonn painting, sold in London (Christie's), June 30, 1913, no. 98, is reportedly dated 1661 (Hofstede de Groot 1907–28, vol. 9, no. 128). Thus it is possible that the Bonn painting was also done in 1661.

7. Plomp 1986, nos. 50–52. Plomp believes that the drawings were probably made for an auction after the death in October 1652 of Vermeer's father, who was one of the dealers who owned the paintings copied by Bramer.

8. Plomp 1986, fig. 52a.

66 (PLATE 65)

Boats on the Bank of a Lake, c.1660

9. Houbraken (1718–21, vol. 2, p. 96) reported that Pijnacker spent three years in Italy. If this is true, the sojourn must have taken place about 1655–58 (Utrecht 1965, p. 185). Harwood (1985, pp. 28, 95) sees stylistic elements in Pijnacker's work indicating a trip to Italy. However, it seems highly unlikely that Pijnacker went to Rome. His treatment of light is the direct product of contact with Jan Both and Jan Asselijn. The lack of any topographic specificity in his treatment of buildings and ruins of an Italian character further indicates that his knowledge of Italy was secondhand. A painting in the Fitzwilliam Museum, Cambridge (inv. PD 64-1958), cited by Harwood (1985, no. 1) as an early work reflecting direct contact with Italy, perhaps even done in Rome, is topographically generalized and formulaic and betrays a strong debt to Jan Both.

10. Utrecht 1965, nos. 106–107, 110, 111.

11. Harwood 1985, nos. 6, 15, 38, 40.

12. The date Harwood suggests for the Berlin ferry scene, c.1648, is too early. It appears to be more sophisticated in handling than the very early picture in the Fitzwilliam Museum and seems to follow the work dated 1650 (see above), and may indeed have been done after 1654.

13. Pijnacker's river scene in the Schloss Vaduz, Liechtenstein (inv. 4860; ill. in Los Angeles/Boston/New York 1981–82, p. 82, fig. 2), is derived from Asselijn's harbor scene in Schwerin dated 1647 (see cat. 119, fig. 2).

14. Another of Both's prints, Bartsch no. 5, shows ferries with the Ponte Molle.

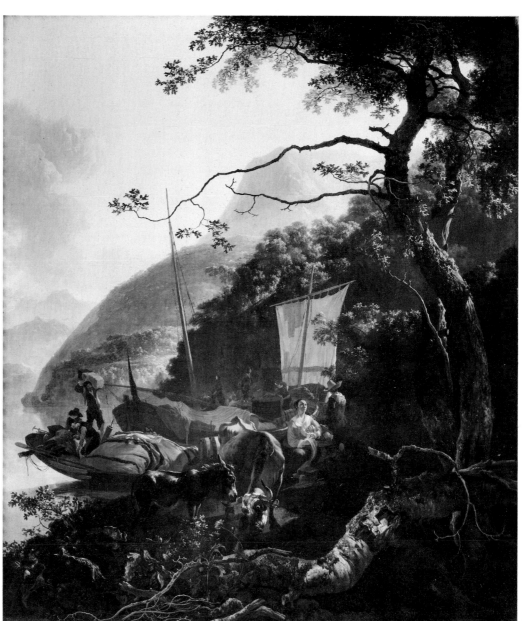

66

Signed lower left: APijnacker [AP ligated]
Oil on canvas pasted on panel, 38 x 33 in.
(96.5 x 83.8 cm.)
Rijksmuseum, Amsterdam, inv. A 321

Provenance: Sale, Amsterdam, June 8, 1763, no. 13
(fl.610 to Neufville); P.L. de Neufville, Rotterdam,
sold in 1786 to the dealer P. Fouquet, who sold it to
G. van der Pot van Groeneveld; van der Pot sale,
Rotterdam, June 6, 1808, no. 105 (fl.1,800 to
A. Stratenus for the Rijksmuseum); loaned to various
departments, 1932–51.

Exhibitions: London 1955, no. 65, ill.; Rome 1956–57,
no. 235; Zutphen 1957, no. 39; Utrecht 1965, no. 116,
ill.; San Francisco/Toledo/Boston 1966–67, no. 75, ill.

Literature: Amsterdam, Rijksmuseum cat. 1809, p. 57,
no. 249; Amsterdam, Rijksmuseum cat. 1821, p. 60,
no. 260, cat. 1827, no. 252; Smith 1829–42, vol. 6,
no. 21; Amsterdam, Rijksmuseum cat. 1885, no. 1147;
Amsterdam, Rijksmuseum cat. 1903, 1960, no. 1926;
Hofstede de Groot 1907–28, vol. 9, no. 18; Moes, van
Biema 1909, pp. 113, 182; Wiersum 1931, p. 211;
Stechow 1966, p. 160; L. Slatkes, *Art Quarterly* 31
(1968), p. 84; Amsterdam, Rijksmuseum cat. 1976,
no. A 321, ill.; Salerno 1977–80, vol. 2, pl. 117.4;
Sarasota, Ringling Museum, cat. 1980, fig. 113b;
Müllenmeister 1981, vol. 3, no. 317, ill.; Harwood
1984, no. 68.

On a lake surrounded by high mountains, two
boats have drawn up to a bank, their diaphanous
sails hoisted aloft. The foreground is a comfor-
ting, cool oasis of shady trees from which the
lake and distant mountains can be viewed.
Various colors and intensities of light differen-
tiate the sections of the hills: lush greens in the
middle distance, paler shades at the end of the
lake, concluding with bluish tints on the highest
peaks. This intensely naturalistic attention to
light is coupled with the artist's almost man-
nerist interest in bold, twisting forms. From the
gnarled, rough tree trunk extend elegant curv-
ing branches over the vista. In the foreground,
the undulating forms of the dead tree and the

large leaves are echoed even by the curving
spine and horns of the ox.
 The exhibited work closely resembles two
paintings dated 1659 and 1661, in Schleissheim
(fig. 1) and Bonn (Rheinisches Landesmuseum,
inv. 35/541),[1] respectively. Highly detailed
foliage in the immediate foreground, crisp
handling of the bark, and the expressive, almost
caricatured beasts are common to all three
paintings. In the Amsterdam landscape, the
brushwork in the sky and leaves of the trees
closely resemble those in figure 1. On the other
hand, the domed shapes of the hills recall an
earlier river scene by Pijnacker (cat. 65).
Blankert places the present painting between
works dated 1661 and 1670;[2] Harwood concurs
with a date of about 1665.[3] However, com-
pared with works that seem unquestionably of
Pijnacker's late period, the exhibited painting
should be placed close to 1659 or 1661.[4]
 While Pijnacker had been dependent on the
work of Asselijn and Both early in his career, he
returned particularly to the work of Both in his
maturity. Jan Both frequently divided his com-
positions with very tall trees or rocky ravines,
often sheltering figures in one area of the land-
scape. The exhibited work is derived from such
compositions (see cat. 15).
 In depicting a woman with a child about to
embark on a ferry, Pijnacker has recast in secular
terms the landscape tradition of the Flight into
Egypt (see cat. 69 and 70).[5] The two animals in
the foreground of Pijnacker's painting, the ox
and the ass, were the traditional beasts of the
Nativity.[6] However, Pijnacker surrounds the
woman and child with figures and objects unre-
lated to the religious story. None of the people,
for example, could be interpreted as Joseph.
Many sixteenth-century landscapes include
figures that would not be interpreted as religious
personages without the help of inscriptions or
labels.[7] Heironymous Cock's series of prints

Fig. 1. Adam Pijnacker, *The Collapsing Bridge*, dated 1659, canvas,
113 x 162 cm., Staatsgalerie, Schleissheim, inv. 773.

Fig. 2. Jan Both, *Travelers in a Landscape*, etching.

after Pieter Bruegel contains a landscape with the Flight into Egypt accompanied by landscapes of a completely secular nature.[8] In a landscape by Bril, the subject of a crowded forum landscape would be unidentifiable without the print's caption; in fact, we do not know whether Bril, the etcher, or the publisher was responsible for the title.[9] Poelenburch's *Flight into Egypt* of 1625 (cat. 69) is also divested of some of its iconographic specificity, while a print by Jan Both (fig. 2), part of a series with no scriptural connections, seems to abandon all references to the biblical. Indeed, women with babies occur with great frequency in the Italianate landscapes of Asselijn, Cuyp,[10] and especially Jan Baptist Weenix.[11] This iconographic erosion – the retention of a visual motif without its original meaning – moves Pijnacker's figures from the realm of religious painting to that of genre.

A poem by Pijnacker's friend Pieter Verhoek (1633–1702) on a set of paintings by Pijnacker provides a rare look at contemporaries' immediate responses to seventeenth-century landscapes. Verhoek wrote his poem about the landscapes decorating a room in the house of the East India Company director Cornelis Backer at 548 Herengracht in Amsterdam.[12] A painting by Pijnacker is known to have originally hung in Backer's house (see Introduction, fig. 59),[13] but Verhoek's impressions are also applicable to the exhibited painting:

Thus the bold brush conquers more fields, now all
 the walls
of the hall are painted with artful parks
and green woods, lit by a morning sun
which shines down brilliantly from the horizon
 upon lush vegetation,
creating the day, so that he who understands art
 stands enraptured,
and believes Italy appears before his eyes.

As Hannibal saw, descending from the Alps,
a golden harvest painted by fair nature.
. .
Here one finds the art of composition correctly
 understood.
The foreground is with plants and trunks richly
 laden
and executed, as it is the first thing the eye sees.
The terrain is seen expanding farther and farther
 into the
vague distance, miles away, to where the pale
 azure
of the mountains is painted with the gleam of the
 sun's fire.
Here the rocks extend their crowns to heaven,
 covered
with hedges, bushes, and bramble, loosely en-
 twined with ivy.
Note how pleasantly nature is blended with colors.
. .
The bark rough with moss here represents the oak,
 which stands
quietly for three centuries and presents itself green
 and lush,
like the birch tree is also known by its bark:
their crowns, brown and thick, laden with leaves,
shadow the ground, and block Phoebus' rays.
. .
I imagine myself already stepping through frolic-
 some wilds
of lush plants, and hear the rustling of leaves.
All that pleases the eye smiles pleasantly at us
 here;
Pynakker's brush thus surpasses tapestries,
which are lame, stiff, hard, their colors soon gone,
like bitter envy in the face of man's insistence.
Here can Heer Backer, when the trees are without
 leaves,
and the grassless field is frosted over, while the
 dunes
are covered with snow drifts, contemplate these
 leafy crowns,
green of foliage, a summer for the eye.
Here, worn out by the affairs of state, he can
unwind again, and enjoy himself in these
 observations.[14]

In addition to offering a close description of Pijnacker's landscapes, Verhoek evoked the simple, almost escapist pleasures that such paintings were meant to provide.[15] The poem suggests that the depictions of Italian scenery and weather that appealed to the art connoisseurs of Dutch Italianate landscapes were appreciated as compellingly plausible representations of Italy. Travel, whether in the guise of Hannibal descending from the Alps, or of a viewer sensuously surrendering himself to unfettered nature, or even of an itinerant artist (see cat. 15), is a recurrent theme in Dutch Italianate landscapes.

A.C.

1. Utrecht 1965, no. 114, ill. Though not dated, the painting is identical in composition to a painting dated 1661 sold in London (Christie's), Feb. 23, 1934, no. 57.

2. Utrecht 1965, no. 116. Blankert notes that similar cloud formations occur in a painting in the Stedelijk Museum, Brussels (ibid., no. 115, ill.).

3. Harwood 1984, no. 68. Harwood's reasons for the dating are not clear.

4. Paintings that are clearly late include one dated 1670 in Schloss Vaduz, Liechtenstein (inv. 1200), and a similar cycle of three landscapes in Rotterdam (Museum Boymansvan Beuningen, inv. 1685 and 1686) and Le Mans (Harwood 1983, p. 116, fig. 12). These, and the painting in the Dulwich Picture Gallery (Introduction, fig. 59), are surely later than the exhibited work.

5. Leonard Slatkes (*Art Quarterly* 31 [1968], p. 84) suggested that the work may indeed represent the Rest on the Flight into Egypt.

6. E. Panofsky, *Early Netherlandish Painting*, vol. 1 (Cambridge, Mass., 1963), p. 470.

7. Augustin Hirschvogel's etching of the *Conversion of Saul* (Bartsch, no. 77) of 1545 in fact shows a landscape with no figures at all. The only indications of the subject are an inscription from the passage in Acts and a beam of sunlight.

8. Lebeer 1979, nos. 1–12, ill.

9. Willem van Nieulandt after Paul Bril, *Forum Landscape with the Flight into Egypt*, etching, part of the series Hollstein, nos. 76–111 (incompletely described).

10. Cleveland Museum of Art, no. 42.637; Reiss 1975, pl. 46.

11. Schloss 1983a.

12. Published by Houbraken 1718–21, vol. 2, pp. 97–99. Pieter Verhoek's brother Gijsbert was a pupil of the artist (ibid., vol. 3, p. 188).

13. Hofstede de Groot 1907–28, vol. 9, nos. 9, 72. The painting was sold by a member of the Backer family in Leiden, Aug. 16, 1775, no. 4, to Delfos for fl.1,310. The description of the painting (canvas, 52 x 74 duim) in the sales catalogue matches the Dulwich painting in all respects. Since Backer's house was completed in 1665, the Dulwich painting should date shortly thereafter (H.F. Wijnman, "Beschrijving van elk pand aan de Herengracht," in *Vier eeuwen Herengracht* [Amsterdam, 1976]; Harwood 1985).

14. My translation of Houbraken 1718–21, vol. 2, pp. 97–99: "Dus wint het kloek penceel meer velds, nu alle wanden / Der zaale, stan bemaald met konstige waranden, / En groene bosschen, van een morgenzon bestraalt, / Die glansryk uit de kim op wilde kruiden daalt, / Den dag schept, dat wie Konst verstaat, staat opgetogen, / En waant Italien t'aanschouwen met zyn oogen. / Zoo zag Vorst Hannibal van d'Alpes neergedaald, / Door d'aardige Natuur een gouden oegst gemaald. / . . . De voorgrond is met kruid en stammen ryk belaân / En uitgevoerd, als 't eerst dat 't oog komt aan te schouwen. / Men ziet de gronden voorts al meer en meer verflouwen / En deinzen, mylen veer, tot daar het bleeke azuur / Der bergen word geverst, met glans van 't zonnevuur. / Hier strekt de rots zyn kruin ten Hemel, woest bedekt / Met heggen, ruigte, en braam, van klimop los omstrengelt. / Met let hoe aardig haar natuur door kleuren mengelt. / . . . De boomschors ruyg van mos verbeeld hier d'eyk, die rustig / Drie eeuwen standhoud, en vertoont zig groen en lustig, / Gelyk de Berkenboom gekent word aan zyn bast: / Hun kruinen, bruin en dicht, met bladeren vermast, / Beschaduwen den grond, en stuiten Phebus stralen. / . . . My dunkt ik stap alree door dart'le wildernissen / Der weel'ge kruiden, en hoor 't ruisschen van de blaân. / Al wat het oog vermaakt, lacht ons hier lieflyk aan; / PYNAKKERS konstpenceel braveert dus de tapyten, / Die lam, en styf, en hart, in kort haar kleuren styten; / Gelyk de bitt're nyd verbleekt op 's mans bestaan. / Hier kan Heer Backer, als 't geboomte, ontbloot van blaân, / En 't grazeloos Veld behyzelt staat, met duinen / Van jachtsneeuw overstolpt, dees bladerryke kruinen, / Beschouwen, groen van loof, een Somer voor het oog. / Hier kan hy afgeslooft door Staatzorg, weer den boog / Ontspannen; zig in dees bespiegeling verlusten."

P.T.A. Swillens's edition of Houbraken (Maastricht, 1944, vol. 2, pp. 77–78) uses the word "perceel" rather than "penceel" in lines 1 and 32, although both the

1718–21 and 1753 editions employ "penceel," as does the 1726 collected edition of Verhoek's poetry.

15. The humanist didactic purposes of Italian travel have surely been overemphasized, for the simple reason that there is much seventeenth-century literature on the issue; see Frank-van Westreinen 1984 on the classical education of upper-class youth in Italy. Economic and religious motivations were also important, no less than the prospect of adventure and pleasure.

67 (PLATE 64)

Barges and Ships on a Coast, c.1665–70

Signed lower left: APijnacker [AP ligated]
Oil on canvas, 17⅛ x 22⅞ in. (43.5 x 58.5 cm.)
Wadsworth Atheneum, Hartford, The Ella Gallup Sumner and Mary Catlin Sumner Collection, 1952.51

Provenance: Possibly sale, Wierman, Amsterdam, August 1, 1762, no. 93 (fl.275); sale, Amsterdam, September 17, 1766, no. 41 (fl.300 to J.M. Kok); sale, Baron E. de Beuronville, Paris, May 9–16, 1881, no. 431; sale, Haemacher and Berré, Amsterdam, November 30, 1897, no. 89 (fl.235 to Fischer); sale, van Lutzen de Voorst, Amsterdam, March 29, 1898, no. 60; sale, Amsterdam, June 30, 1909, no. 135; sale, Amsterdam, November 30, 1909, no. 40a; Lady Cosmo-Bevan, Dorking; dealer David M. Koetser, New York; purchased 1952.

Exhibitions: Atlanta Museum, *Collectors' Firsts*, 1959; New London 1962, no. 23; Ann Arbor 1964, no. 52, pl. 10; Denver 1971, p. 96, ill.; St. Petersburg/Atlanta 1975, no. 25, ill.; Framingham, Danforth Museum, 1975; New York, Wildenstein & Co., *Romance and Reality*, 1978, no. 53, fig. 22.

Literature: Hofstede de Groot 1907–28, vol. 9, no. 46; C.C. Cunningham, *Wadsworth Atheneum Bulletin*, March 1952; Utrecht 1965, pp. 186, 194; Stechow 1966, pp. 160–61, fig. 328; Nash 1972, fig. 61; Salerno 1977–80, vol. 2, p. 694; Hartford, cat. 1978, no. 118, pl. 108; Worcester 1979, p. 89, fig. 26a; Harwood 1985, no. 44.

On a sunny Italian coast three barges laden with goods and passengers hoist sails, presumably to rendezvous with the large sailing ship in the distance. Behind rise gentle hills and steeper mountains.

Coastal landscapes were a specialty of Pijnacker's. When compared with the lighting in earlier barge scenes such as catalogue 65, the sunlight in the exhibited work is still strong but more diffuse and less shadowy. As a group these landscapes are dependent on the coastal views of Jan Asselijn (see cat. 119, fig. 3) and the ferry scenes by Jan Both (cat. 65, fig. 2). Philips

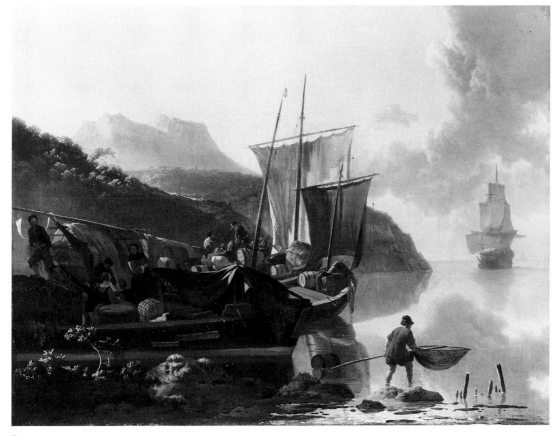

67

Fig. 1. Adam Pijnacker, *Coastal Scene*, signed, panel, 40 x 43 cm., Rijksmuseum, Amsterdam, inv. A 2335.

Wouwermans's *Ferry* (cat. 119) shares compositional features with the exhibited painting and is probably the product of the same influences.

Coastal scenes in Liechtenstein (Schloss Vaduz, inv. 4860),[1] in Amiens (Musée de Picardie),[2] in a private French collection,[3] and in Amsterdam (fig. 1) strongly resemble the exhibited painting. However, the Amsterdam painting employs stronger contrasts and more glistening highlights, especially in the water and sky. A dryer palette as well as a tendency to stylize and make forms and textures smoother indicate a late date for the Hartford painting,[4] although Harwood left open the possibility that it might date as early as 1655–57.[5] A date from the late

Cornelis van Poelenburch

(Utrecht 1594/95–1667 Utrecht)

1660s seems probable because of stylistic similarities to a painting of 1670 in Liechtenstein (Schloss Vaduz, inv. 1200). Another coastal scene of this period in the Museum Boymans-van Beuningen, Rotterdam (inv. 1683), is similarly derived from a much earlier work.[6] Pijnacker painted a closely related scene with a tower (Musée des Beaux-Arts, Nîmes, inv. 287).[7] A close variant of the exhibited painting in a private American collection appears to be a copy by a pupil.[8]

A.C.

1. Hofstede de Groot 1907–28, vol. 9, no. 37; Los Angeles/Boston/New York 1981–82, p. 83, fig. 2 (as c.1645–50). The composition is derived directly from Asselijn's *Harbor Scene with SS. Giovanni e Paolo* in Schwerin (cat. 119, fig. 3), which is signed and dated 1647. For a discussion of Pijnacker's chronology see catalogue 65.

2. Illustrated in Harwood 1983, fig. 11 (as early 1650s).

3. Utrecht 1965, no. 107, ill. (as c.1655).

4. Albert Blankert, in Utrecht 1965, pp. 186 and 194; see also Hartford, cat. 1978, p. 174.

5. Harwood 1985, no. 44. Harwood allows for the possibility that the Hartford painting is a variant of a now lost work of about 1655–57 but also notes that there are features resembling works of 1665–70. She also states that it is "remotely possible" that the painting is a copy by a close follower or imitator.

6. See catalogue 65. A painting that has been thought to date from the same period is an Alpine scene with a variety of animals now in the Louvre (inv. RF 1981–10) (Harwood 1983, figs. 1 and 2). While sharing a certain dryness with the Hartford painting, the Louvre painting is wholly different in handling and composition from Pijnacker's authentic work and must be by a follower. Harwood (1985, B26) considers it questionable.

7. See Harwood 1983, fig. 9.

8. Canvas, 52 x 61 cm., exhibited Worcester 1979, no. 26, ill. Thomas Kren in Hartford, cat. 1978, p. 174, considers it of equal quality to the Hartford painting. Harwood (1985, nos. 43 and 44), while cataloguing it as an authentic work, leaves open the possibility that it and the Hartford painting are copies. A third version was with the dealer Vermolen, The Hague.

P. Jode II after A. van Dyck, *Portrait of Cornelis van Poelenburch,* engraving.

One of the most famous painters of his time, Cornelis van Poelenburch was born in Utrecht in 1594 (or January 1595), the son of Simon van Poelenburch (d. 1596), Catholic canon of the Utrecht cathedral. Poelenburch studied with Abraham Bloemaert, whose influence can be perceived in his earliest paintings and drawings. The artist must have achieved some early success, since his name appears in Rodenburgh's *Lofdicht* enumerating painters famous in Amsterdam in 1618. He was, moreover, the youngest artist listed. Poelenburch was in Rome by 1617; several drawings dated each year from 1619 to 1623 attest to his continued residence in that city. He was a founding member of the

Roman Schildersbent in 1623, using the nickname "Satyr." The artist found patrons among Rome's major families, in particular the Orsini. In addition, sometime before 1621, Poelenburch worked for the Medici court in Florence, where he is reported to have met Jacques Callot (1592–1635). Four landscapes by Poelenburch are recorded in the *guardaroba* of the Pitti Palace in 1638, and a sizable number of early Poelenburch paintings remain in Florentine collections – the legacy of the artist's sojourn in Florence.

Paul Bril (1554–1626) seems to have been Poelenburch's closest associate and mentor in Rome; Italian inventories of the seventeenth century report that the two artists collaborated on paintings. Poelenburch also copied paintings by Adam Elsheimer (1578–1610) and came into contact with landscapists of the Carracci circle. Although Poelenburch's work is sometimes deceptively close to that of Filippo Napoletano (c.1587–1638) and to a certain extent that of Bril and Breenbergh, the influences between the artists were probably mutual.

Poelenburch had probably returned to Utrecht by 1625 (see cat. 69). In April 1627 the Utrecht government purchased from him a painting of the *Banquet of the Gods* as a gift to the stadtholder's wife, Amalia van Solms. In the same year Rubens, who owned several paintings by Poelenburch, visited the artist's studio. In 1628 Poelenburch painted the children of the Winter King, Frederick V of Bohemia. The artist was married on May 30, 1629, to Jacomina van Steenre, daughter of a notary and clerk of the provincial court, in a civil ceremony, as was required of Catholics. Poelenburch visited Paris in 1631, but by 1632 was recorded living on the Winsensteeg in Utrecht. Shortly afterwards Poelenburch was commissioned, along with his teacher Abraham Bloemaert, his pupil Dirck van der Lisse (d. 1669), and Herman Saftleven to paint a cycle based on Guarini's *Il pastor fido* for

the new royal palace at Honselaarsdijk for which Poelenburch also provided a mantelpiece. Indeed, Poelenburch was one of the most popular artists at The Hague court; there are more paintings by him than by any other landscapist in the inventories of the stadtholder's palaces. The painter also worked for Charles I in London between 1637 and 1641. From 1642 Poelenburch lived on the Oude Domplein in Utrecht. He was an officer (*overman*) of the guild in 1656 and its dean in 1657–1658 and 1664. During the 1640s and 1650s, Willem Vincent, Baron von Wyttenhorst, was Poelenburch's major patron.

Important as both a figural artist and a landscapist, Poelenburch painted history, mythological, and religious scenes (including devotional Catholic images), as well as pastoral landscapes and a number of portraits. The artist also painted staffage in the works of Jan Both, Alexander Kierincx, Bartholomeus van Bassen, Dirck van Delen, and Nicolaes de Gijselaer. A recently discovered cabinet (British private collection) contains twenty-four mythological landscapes by Poelenburch along with architectural interiors by van Bassen. Poelenburch had many pupils and appears to have operated a large studio. J.G. van Bronckhorst (c.1603–1661) produced several etchings after the artist's designs.

A.C.

Literature: Rodenburgh 1618; van Dyck 1636; Meyssens 1649, p. 120; de Bie 1661, pp. 256–57; de Monconys 1665–66, vol. 2, p. 181; Félibien 1666–88, vol. 4, p. 149; Sandrart 1675, vol. 2, p. 305; Félibien 1679, p. 51; le Comte 1699, vol. 2, p. 325; de Piles 1699, pp. 420–21; Houbraken 1718–21, vol. 1, pp. 128–30; Weyerman 1729–69, vol. 1, pp. 333–35; Descamps 1753–64, vol. 1, pp. 365–68; van Eynden, van der Willigen 1816–40, vol. 1, pp. 376–77; Nagler 1835–52, vol. 11, pp. 437–41; Immerzeel 1842–43, vol. 2, p. 317; Kramm 1857–64, vol. 5, pp. 1295–97; Obreen 1877–90, vol. 1, p. 157, vol. 2, pp. 72, 82; Bode 1883, pp. 286, 323; Friedländer 1905; Wurzbach 1906–11, vol. 2, pp. 336–38; T.H. Fokker in Thieme, Becker 1907–50, vol. 27, pp. 178–79; Budde 1929, pp. 78–80; de Jonge 1932; Gerson 1942; Hoogewerff 1942–43, pp. 18, 92; Hoogewerff 1952, p. 141; Aschengreen 1953; Schaar 1959; Knab 1960; Utrecht 1965; Stechow 1966, pp. 149–51; Waddingham 1966; Bol 1969, pp. 159–62; Chiarini 1972a; Chiarini 1972b; Waddingham 1975; Salerno 1977–80, vol. 1, pp. 224–37; vol. 3, pp. 1067–69; Rubsamen 1980, pp. 16–24, 36–37, 55, 59, 62, 80–82; Roethlisberger 1981, pp. 14–15, 30–39; Sluijter-Seiffert 1984; Bok 1985; Sluijter 1986, pp. 70–81, 153; Chong 1987.

Waterfalls at Tivoli, c.1622

Monogrammed lower right of center: CP
Oil on copper, 9½ x 13⅛ in. (24.1 x 33.3 cm.)
Bayerische Staatsgemäldesammlungen, Alte Pinakothek, Munich, inv. 5273

Provenance: Royal collection, Schleissheim; transferred in 1781 to the Hofgarten gallery, Munich; transferred c.1810 to the Gemäldegalerie, Augsburg; transferred in 1919 to the Alte Pinakothek, Munich.

Exhibitions: Utrecht 1965, no. 18; Frankfurt 1966–67, no. 81, pl. 67.

Literature: Augsburg, Gemäldegalerie cat. 1869, no. 628; cat. 1899, no. 605; cat. 1912, p. 54, no. 2605; Munich, Alte Pinakothek cat. 1922, p. 124, no. 2573 [*sic*]; cat. 1938, no. 5273; Grosse 1950, fig. 1; Longhi 1957, p. 54, pl. 36; Schaar 1959, p. 28; MacLaren 1960, p. 296; Plietzsch 1960, p. 133, pl. 223; Munich, cat. 1961, p. 52, no. 5273; Nieuwstraten 1965a, p. 272 (as Breenbergh); Roli 1965, p. 107; Briganti 1966, ill. p. 14; *Kindlers Malerei-Lexikon*, vol. 4, (1967), ill. p. 789; Bol 1969, p. 159, fig. 152; Munich, cat. 1969, p. 68, no. 5273; Roethlisberger 1969, p. 21; *Propyläen Kunstgeschichte*, vol. 9 (1970), p. 186, pl. 160; Salerno 1977–80, vol. 1, p. 226 (as Poelenburch); vol. 3, p. 1069, note 17 (as circle of Napoletano or Wals); Fuchs 1978, p. 138, fig. 119; Munich, cat. 1983, pp. 391–92, no. 5273, ill.; Sluijter-Seiffert 1984, pp. 65–67, no. 156.

The composition of this painting is unusual in presenting a low point of view, from far below the town of Tivoli. The river Annio's descent in multiple cascades through a lush screen of leafy green trees fills much of the picture. Cattle water in a pool at the bottom, while two shepherds rest near some rocks. At the left, other figures climb up the steep hills to Tivoli, while the main portion of the town is visible just beyond the ledge of the falls at the upper right.

Virtually no earlier examples show such a close view of a hillside, although the work of Paul Bril may in part have provided a source for Poelenburch. A print by Willem van Nieulandt after a lost painting by Bril (fig. 1)[1] also presents

68

Fig. 1. Willem van Nieulandt after Paul Bril, *View of Tivoli*, etching.

a view looking up at the town of Tivoli, although there the hillside has been truncated and a traditional panorama inserted at the left. The structure of the exhibited landscape is derived directly from Poelenburch's drawings of Tivoli, which occupied the artist from 1619 to about 1623.[2] The same low point of view, buildings silhouetted against the sky, and falls that end in pools in the immediate foreground can be found in two drawings of 1620. One of these (fig. 2) depicts similar dense, billowing foliage and

strong, scattered sunlight striking the rocks and buildings.[3] The exhibited painting closely corresponds to a drawing in the Goethe-Nationalmuseum, Weimar (inv. 851), which appears to date from the period 1622–24.[4]

The composition of the painting in Munich would have been even more striking in its original oval format. Although the copper support was always rectangular, the four corners were painted considerably later by another artist.[5] The sharply angled roofline at the left

would have been silhouetted against an arched sky, strengthening the impact of the watery, verdant hillside below.

Some controversy exists over the attribution of the exhibited work and its pendant (fig. 3). Nieuwstraten and Salerno have suggested alternative attributions for the former painting.[6] Sluijter-Seiffert, while including it among Poelenburch's early works, noted strong resemblances to the work of Filippo Napoletano.[7] She also found some differences in handling between the two pendants, although she accepts figure 3 as well. Schaar attributed the pendant to Breenbergh, Blankert doubted that it was by the same hand, while Chiarini has recently assigned it to Filippo Napoletano.[8]

Although there are no precise parallels in Poelenburch's secure oeuvre, the intense light and handling of paint (especially in the foliage) in the exhibited painting are characteristic of Poelenburch. A similar oval painting of a hillside, attributed to Poelenburch by Roethlisberger, is preserved in Stuttgart.[9] The distinctive rendering of the figures occurs in other Poelenburch paintings.[10] The close links with the artist's

Fig. 2. Cornelis van Poelenburch, *View of Tivoli*, dated 1620, pen and wash, 435 x 318 mm., formerly E. Perman collection, Stockholm.

Fig. 3. Circle of Poelenburch (Filippo Napoletano?), *View of a Hill Town*, copper, 24 x 32 cm., Alte Pinakothek, Munich, inv. 5272.

drawings and the presence of a monogram typical of Poelenburch strengthen the attribution. Except for occasional passages in the foliage, the pendant differs significantly from the exhibited work in conception and handling, particularly in the rocky cliff and the brick wall. Although the two paintings were obviously executed as pendants, figure 3 appears to be by a closely related artist rather than Poelenburch himself.

The dating of the work is equally problematic. Schaar, Blankert, and Sluijter-Seiffert assigned it a very early position in Poelenburch's oeuvre.[11] The *Landscape with Orpheus* (Louvre, Paris, inv. MNR 506), heavily influenced by Paul Bril, represents the earliest known stage of Poelenburch's development. There follow several paintings known to have been made for Cosimo II de' Medici in Florence before his death in early 1621.[12] Further, a landscape in the Louvre (Introduction, fig. 42) is dated 1620, and a similar scene is dated 1621 (Museo del Prado, Madrid, inv. 2130). The *Waterfalls at Tivoli* cannot be convincingly placed within this sequence and certainly cannot be dated before the

drawings of 1620. Instead, it resembles a painting of dancing shepherds dated 1622, which includes a large diagonal hillside of deeply modulated colors (Uffizi, Florence, inv. 1233).[13]

A view of the waterfalls at Tivoli first occurs in the work of Pieter Bruegel the Elder, known through Hieronymus Cock's etching of about 1553, the first print in a series of twelve landscapes.[14] Joaneath Spicer has noted that this image established the waterfall as an appropriate landscape subject, paving the way for the work of Jan Brueghel the Elder, Paul Bril (fig. 1), Roelandt Savery, and eventually Allart van Everdingen.[15] Indeed, van Mander, in praising Pieter Bruegel's landscapes, singled out his "rushing streams," urging landscapists to portray waterfalls that "rush down between weathered rocks."[16]

A.C.

1. The print is no. 48 in a series of prints by Nieulandt after Bril, incompletely described by Hollstein (nos. 76–111).

2. A drawing of 1619 belonging to Keith Andrews shows the bridge at Tivoli. Sixteen drawings bear inscriptions and dates in Poelenburch's handwriting; see Chong 1987, nos. 1–16.

3. A closely related sheet of the same size and style also dated 1620 is in the British Museum, London, inv. 1874-8-8-17 (Hind 1915–31, vol. 3, no. 23, pl. 29). Schaar (1959, p. 28) connected the present painting to views of Tivoli in Poelenburch's sketchbook in the Uffizi, Florence (inv. 772-777), but these are not as close as the drawings of 1620.

4. Roethlisberger 1969, no. 6, ill. (as Poelenburch). This drawing does not seem to be a preparatory study for the Munich painting but may record a sketch from nature now lost. Another view of the Tivoli falls in the same style is in the Kupferstich-Kabinett, Dresden, inv. C 1162.

5. The character of the brushwork in the corners is different from that in the rest of the painting, noticeable especially in the buildings at the upper left. Some of the sky has been blended into Poelenburch's original sections (see Munich, cat. 1983, p. 391). Sluijter-Seiffert (1984, p. 66) leaves open the possibility that the original painting may have been set into an oval frame, damaging the corners. However, the corners are not worn or abraded but simply painted by a

69 (PLATE 23)

The Flight into Egypt, 1625

different hand. Although it is conceivable that the damaged areas were later retouched in the corners only, the composition is enhanced by an oval format.

6. Nieuwstraten 1965a, p. 272 (as Breenbergh); Salerno 1977–80, vol. 3, p. 1069 (as close to Napoletano and Gottfried Wals).

7. Sluijter-Seiffert 1984, p. 66.

8. Schaar 1959, pp. 28, 53; Blankert in Utrecht 1965, pp. 70–71; Chiarini 1984, p. 19.

9. Roethlisberger 1981, no. 29, ill. (not in Sluijter-Seiffert 1984).

10. Pitti Palace, Florence, inv. 1176, 1196, 1197, 1218 (see Roethlisberger 1981, pls. 31, 33, 34).

11. Schaar 1959, p. 28; Utrecht 1965, no. 18; Sluijter-Seiffert 1984, p. 65.

12. Schaar 1959, p. 40, note 15. See also Pitti Palace, Florence, inv. 473, 479, 1176, 1194.

13. Galleria degli Uffizi, *Catalogo generale* (Florence, 1979), p. 420, ill.; Schaar 1959, fig. 16. This is confirmed by the dating of the corresponding drawing in Weimar (inv. 851) based on style.

14. Lebeer 1979, no. 1, inscribed "Prospectus Tyburtinus."

15. Joaneath Spicer, unpublished lecture, New York, 1981. Jan Brueghel the Elder also drew the falls at Tivoli; see Brussels, Palais des Beaux-Arts, *Brueghel*, 1980, nos. 148, 155, ill.

16. Van Mander 1604, *Den Grondt*, chap. 8, verses 25, 34–35.

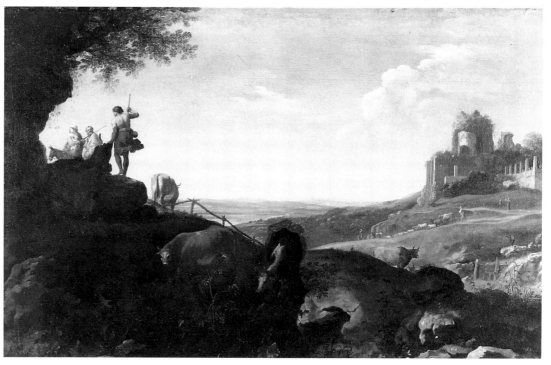

69

Signed and dated lower left: C.P. 1625
Oil on canvas, 18⅞ x 28 in. (48 x 71 cm.)
Centraal Museum, Utrecht, inv. 8391.

Provenance: Marquesses of Bute, Luton Hoo, Mount Stuart; C. Benedict, Paris; Vitale Bloch, The Hague; purchased in 1940.

Exhibitions: London 1883, no. 17: Glasgow 1884; Manchester 1885, p. 10, no. 79 (as Breenbergh, figures by Poelenburch); Utrecht 1941, no. 145, pl. 9; Rome 1954, no. 102, pl. 10; Milan 1954, no. 105; Warsaw 1958, no. 74, ill.; Breda/Ghent 1960–61, no. 50, ill.; Dordrecht 1963, no. 98, ill.; Utrecht 1965, no. 20, ill.; San Francisco/Toledo/Boston 1966–67, no. 71, ill.; Washington, D.C./Detroit/Amsterdam 1980–81, no. 45, ill.

Literature: Waagen 1854–57, vol. 3, p. 476; Utrecht, cat. 1952, p. 94, no. 216; Schaar 1959, pp. 42–43, fig. 22; Nieuwstraten 1963, pp. 226–27; Stechow 1966, p. 149, fig. 290; Bol 1969, p. 159, pl. 151; Burnett 1969, p. 372, fig. 6; Salerno 1977–80, vol. 1, p. 226, vol. 3, p. 1068, note 16; Philadelphia/Berlin/London 1984, p. 297 (under no. 97), fig. 2; Sluijter-Seiffert 1984, pp. 84–86, no. 68, fig. 6.

A dark foreground ridge bisects the painting diagonally. Cool, lush vegetation provides the setting for a group of figures dramatically silhouetted on the ridge. A shepherd with a staff and a woman on a donkey accompanied by a man are all brilliantly lit by the rays of the sun, which

also illuminate the hills and ruins in the distance. The ruins at the right are based on the Roman Palatine as seen from the Circus Maximus, which Poelenburch sketched several times while in Rome.[1]

The painting, executed in Utrecht in 1625, strongly recalls an earlier work by Poelenburch, the *Moses Striking the Rock* in Florence (fig. 1). That landscape, probably painted before 1620,[2] also features a diagonal hill around which figures are disposed, a more brightly lit vista beyond, as well as trees that extend to the top of the composition. However, the exhibited painting not only has fewer figures and is less conspicuously a history painting, but also shows greater dramatic unity in the form and lighting of the foreground slope. Moreover, the transitions from the hillside at the right to the panorama beyond are handled with greater finesse and assurance, in what Waagen called "a most delicately blended execution and soft harmony."[3]

This distant view of overlapping hills reformulates the composition of Adam Elsheimer's *Aurora* of about 1605 in Braunschweig (see p. 94, fig. 16), which Poelenburch probably knew through the work of Paul Bril. In turn, Poelenburch's work had an immediate effect on Bartholomeus Breenbergh, whose version of the *Flight into Egypt*, dated 1634 (fig. 2), employs a similar arrangement of landscape.[4] The contrast of a richly detailed foreground full of plants and cattle with a distant view must have strongly influenced Jan Both and Adam Pijnacker, who developed further the premises of the design (see cat. 15 and 73). Poelenburch's composition also influenced Herman Saftleven (see cat. 96) and Aelbert Cuyp.

Particularly innovative in the Utrecht painting is the treatment of light. Sunlight streams in diagonally from the left distance, rather than directly from the sides. Poelenburch had experimented with strong light effects as early as 1620,

Fig. 1. Cornelis van Poelenburch, *Moses Striking the Rock*, copper, 45 x 63 cm., Pitti Palace, Florence, inv. 1220.

Fig. 2. Bartholomeus Breenbergh, *The Flight into Egypt*, signed and dated 1634, panel, 56 x 80 cm., Alte Pinakothek, Munich, inv. 1647.

Fig. 3. Cornelis van Poelenburch, *Landscape with Tobias and the Angel*, panel, 52.5 x 35 cm., Earl of Jersey, Channel Islands.

in a flat landscape illuminated by brilliant colored light (see Introduction, fig. 42). In the present painting, the light is almost directly behind the figures, anticipating the *contrejour* effects of Jan Both, Claude and Aelbert Cuyp.

In style and conception, the Utrecht painting is close to a *Tobias and the Angel* in the collection of the Earl of Jersey (fig. 3).[5] The rich detailing of the plants in the foreground, which sets off brightly colored figures, is common to both paintings. In figure 3, a rider playing a flute is silhouetted, partially hidden behind a rocky ledge, while Tobias and the Angel are in the distance. Both the *Tobias and the Angel* and the Utrecht *Flight into Egypt* reduce the narrative to the advantage of the landscape and emphasize a single figure that assumes genre-like importance. Of Poelenburch's many depictions of the Flight into Egypt, the exhibited painting is the least specific (see cat. 67).[6] Pieter Bruegel and Paul Bril had begun to shift the emphasis of the Flight into Egypt from the figures to the landscape. Bril's frescoes for the Palazzo Rospigliosi Pallavicini in Rome grouped a landscape based on the Flight into Egypt with secular land-

scapes.[7] The process was continued by Jan Both (cat. 66, fig. 2) and Adam Pijnacker (cat. 66), among others.

Stechow noted that the present landscape shows a return to certain mannerist devices – a hilly foreground, highly detailed foliage, and a brighter palette – which seem to indicate that after spending eight years or more in Rome, Poelenburch had become reacquainted with the landscapes of Abraham Bloemaert. Sluijter-Seiffert does not discuss this theory but believes that the work was done at the end of Poelenburch's stay in Rome.[8] There is good reason to believe, however, that Poelenburch had returned to Utrecht by 1625 and that the landscape was one of his first paintings executed in the Netherlands. It is markedly different from his Italian works dated 1624, which include a scene with Odysseus and Athena set in a cavern,[9] and a landscape with nymphs and satyrs in the British Royal Collection.[10] Poelenburch can be securely documented in Rome in 1623, according to an inscription on a drawing recently acquired by the J. Paul Getty Museum, Malibu. Although Poelenburch is not documented in Utrecht until April 6, 1627, when the States of Utrecht purchased a painting of the *Banquet of the Gods* for 575 guilders as a present for Amalia van Solms, the importance and extravagance of that commission suggest that Poelenburch had been in Utrecht for some time and that his work was well known.

Schaar also connected the Utrecht painting with a *Road to Emmaus*,[11] although the structure of the rocky cliffs there seems much closer to Poelenburch's early work in Italy. Sluijter-Seiffert, concurring with Schaar's analysis, suggests that a painting of *Mercury and Herse* (Mauritshuis, The Hague, inv. 134) is also contemporaneous with the exhibited work.[12] However, in composition and handling that painting resembles Poelenburch's works dated

1624. A copy of the exhibited work was sold in Berlin (Spik), December 8–9, 1977, no. 233.

A.C.

1. Drawings in the Ecole des Beaux-Arts, Paris (inv. M 2064), and the Uffizi, Florence, inv. 785, 790, 791.

2. The painting, along with three others in the Pitti Gallery, inv. 1203 (its pendant, the *Finding of Moses*), 1200, and 1221, is listed in a 1638 inventory of the *guardaroba* of Grand Duke Cosimo II de' Medici (Schaar 1959, p. 40). Because Cosimo died in January 1621, Poelenburch's paintings must have been made before then.

3. Waagen 1854–57, vol. 3, p. 476.

4. Breenbergh's careful detailing of the costumes and accoutrements shows a concern for iconographic specificity very different from Poelenburch.

5. A painting of Lot and His Daughters (de Sejournet collection, Brussels) is also very similar.

6. The present work was included in an exhibition of history painting (Washington, D.C./Detroit/Amsterdam 1980–81, no. 45).

7. Illustrated in T. Pugliatti, *Agostino Tassi: Tra conformismo e libertà* (Rome, 1977), figs. 55–58.

8. Sluijter-Seiffert 1984, pp. 86–87.

9. In two versions, both in private collections; see Roethlisberger 1981, figs. 51 and 52.

10. White 1982, no. 142, pl. 118. A painting representing the Banquet of the Gods is also dated 1624 (Alan Jacobs, London, cat. 1977.)

11. Schaar 1959, p. 43, fig. 23.

12. Sluijter-Seiffert 1984, p. 86; see The Hague, Mauritshuis, cat. 1977, no. 134.

Rest on the Flight into Egypt, 1630s–40s

Monogrammed lower left: C.P.
Oil on copper, 13 x 17 in. (33 x 42 cm.)
Fogg Art Museum, Harvard University, Cambridge, Mass., inv. 1965.523

Provenance: Eric Palmer, Woburn Green, Buckinghamshire; London art market.

Exhibitions: London 1952–53, no. 485; London 1955, no. 59; Utrecht 1965, no. 21, ill.

Literature: Gerson 1950–52, vol. 1, fig. 150; Donahue 1965; Rosenberg et al. 1966, p. 296, fig. 235; Sluijter-Seiffert 1984, pp. 81, 105–106, 141–42, no. 70.

Beneath ruins on the left the Holy Family appears on the Flight into Egypt. Scattered in the foreground are fallen statues and architectural fragments that also figure in several early Poelenburch paintings (see fig. 1). A wider landscape opens in the distance. This type of flat, open landscape first appeared in Poelenburch's early work executed in Italy (see Introduction, fig. 42, dated 1620). The ruins in the middle distance are based on the so-called hippodrome of the eastern part of the Palatine, which Poelenburch sketched and included in several earlier paintings.[1] The undulating, overlapping ridges of the countryside and the limpid light recall Poelenburch's earliest representation of the Flight into Egypt of 1625 (cat. 69).

Poelenburch painted no less than nine representations of the Flight into Egypt, distinguishing it as his favorite subject. The demand for the theme is indicated by the fact that Baron van Wyttenhorst paid Poelenburch two hundred guilders for a depiction of the Flight in 1657. There are no examples of this theme from Poelenburch's Italian residency; his first representation of the subject (cat. 69) is believed to have been executed during his first year back in Utrecht. Sluijter-Seiffert considered a work in Rochefort to be the next treatment of the theme, from before 1630,[2] and dated the exhibited work, with its golden tones and fine details, about

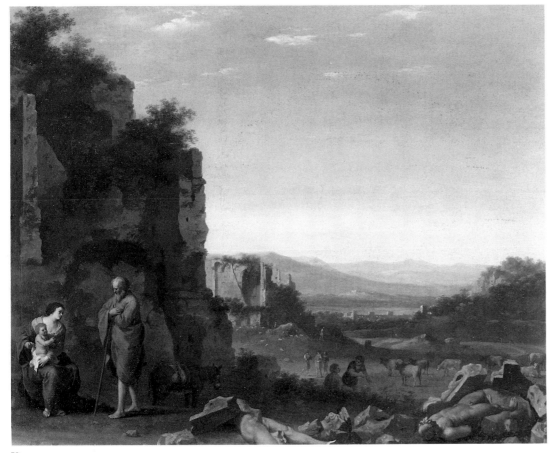

70

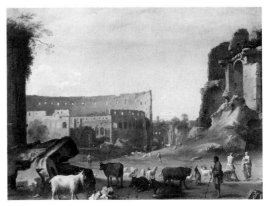

Fig. 1. Cornelis van Poelenburch, *Landscape with Ruins*, panel, 44.5 x 60 cm., Toledo Museum of Art, no. 56.52.

1640. Although very few of Poelenburch's paintings are dated after 1625, the landscape and ruins in the Fogg painting resemble many of Poelenburch's late drawings in gray wash. Further, a painting of the Crowning of Mirtillo (p. 105, fig. 1), which can be dated to about 1638 on documentary evidence, bears general stylistic similarities to the exhibited work.[3]

No specific type of setting seems to have been codified for this popular landscape subject, although Poelenburch often placed the Flight amidst Roman ruins,[4] perhaps in reference to Christ as a successor to the Roman imperium. Sluijter-Seiffert suggested that the fallen statues and fragments in the exhibited landscape may refer to the legend of Christ at Heliopolis, in which he used an idol as a footrest.[5] In another painting of the Rest on the Flight into Egypt of about the same time (British private collection),[6] Poelenburch again placed the scene in a "Forum" landscape with various ruins scattered in the foreground. Exceptional in this case is the depiction of Joseph holding the Christ child,

Frans Post

(Haarlem c.1612–1680 Haarlem)

perhaps, as Sluijter-Seiffert suggested, as a response to the Counter Reformation.[7]

A.C.

1. Drawing in the Uffizi, Florence, inv. 784P. Paintings with the same ruins include a landscape in the British Royal Collection (White 1982, no. 141, ill.).

2. Sluijter-Seiffert 1984, pp. 105–106, no. 76. Sluijter-Seiffert (1984, p. 140, no. 74) placed a work in Milan (Museo d'Arte Antica) in Poelenburch's Utrecht period, although Roethlisberger (1981, no. 41, ill.) implied that it was an Italian work. However, the work appears to be by a follower of Poelenburch.

3. Berlin (DDR), cat. 1976, pp. 66–67; Sluijter-Seiffert 1984, no. 42.

4. A work in the Museum of Fine Arts, Boston (51.2776) is set before the Monumentum Argentariorum; another in the Vassar College Art Gallery contains fragments in the foreground. A work formerly in the Staatliche Kunstsammlungen, Dresden (no. 1239) also contains similar ruins near the Holy Family (Haak 1984, fig. 296). Susan Donahue placed the Dresden painting before the Fogg painting. However, the former is a formulaic composition typical of Poelenburch's late work, perhaps with workshop participation. Other representations of the Flight into Egypt by Poelenburch include a work in the Hermitage, Leningrad (inv. 1063), and in a private Scottish collection.

5. Sluijter-Seiffert 1984, p. 142.

6. Donahue (1965, p. 159, fig. 3) dated it about 1620, although it is very similar to the exhibited landscape and must date from about the same time.

7. Sluijter-Seiffert 1984, p. 141; see also J.B. Knipping, *Iconography of the Counter Reformation in the Netherlands* (Nieuwkoop, 1974), pp. 117–19. For the iconography of the Flight into Egypt generally, see S. Schwartz 1975.

Son of the painter Jan Jansz Post (d. 1614) and brother of the painter and architect Pieter Post (1608–1669), Frans Post was born about 1612 in Haarlem. Together with the artist Albert Eckhout (c.1610–1665), he embarked for Brazil on October 25, 1636, as a member of Prince Jan Maurits of Nassau-Siegen's expedition. The party arrived at Recife in January 1637. A sketchbook survives containing nineteen views made on the voyage and in Brazil (Scheepvaart Museum, Amsterdam). Frans Post executed many paintings and drawings for Prince Jan Maurits, of which only six paintings dated 1638–40 survive. Post returned to Haarlem in 1644 and spent the rest of his career producing Brazilian landscapes for collectors. He was paid substantial sums by the stadtholder Frederik Hendrik in 1644 and 1650 for West Indian landscapes. Post drew designs for prints based on his Brazilian sketches which were published in Caspar van Baerle's description of Brazil in 1647. In 1646 Post joined the Haarlem painters' guild, becoming *vinder* in 1656/57 and *penningmeester* in 1658. On March 27, 1650, he married Jannetje Bogaert in Zandvoort. He was buried in Haarlem's Grote Kerk on February 17, 1680.

Dated paintings exist from almost every year between 1647 and 1670; nearly all are Brazilian landscapes filled with exotic buildings, natives, animals, and plants. Unusual among these is a *Sacrifice of Manoah*, dated 1648 (Boymans-van Beuningen Museum, Rotterdam), with figures by a collaborator.

A.C.

Literature: van Baerle 1647; Houbraken 1718–21, vol. 2, p. 344; Weyerman 1729–69, vol. 2, p. 339; Descamps 1753–64, vol. 3, pp. 8–9; Nagler 1835–52, vol. 11, p. 534; Immerzeel 1842–43, vol. 2, p. 322; Kramm 1857–64, vol. 5, p. 1303–1304; van der Willigen 1870, pp. 245–49; Wurzbach 1906–11, vol. 2, pp. 346–47; Bredius 1915–22, vol. 5, pp. 1691–1718; Combe 1931; J. Held in Thieme, Becker 1907–50, vol. 27 (1933), pp. 296–97; van Schendel 1937; Sousa-Leão 1937; R. Smith 1938; Thomsen 1938; van Gelder 1940; Gerson 1942, pp. 554–55; Rio de Janeiro 1942; Sousa-Leão 1942–43; Sousa-Leão 1948; The Hague 1953; Gudlaugsson 1954; Guimarães 1957; Plietzsch 1960, pp. 112–14; Larsen 1962; van Gelder 1963b; Rosenberg et al. 1966, pp. 152–53; Stechow 1966, pp. 168–69; Rio de Janeiro 1968; Bol 1969, pp. 197–98; Reviglio 1972; Sousa-Leão 1973; Joppien 1979, pp. 299–302; Kleve 1979; The Hague 1979–80; The Hague, Mauritshuis cat. 1980, pp. 72–77; Duparc 1982; Larsen 1982.

The São Francisco River with Fort Maurits, 1638

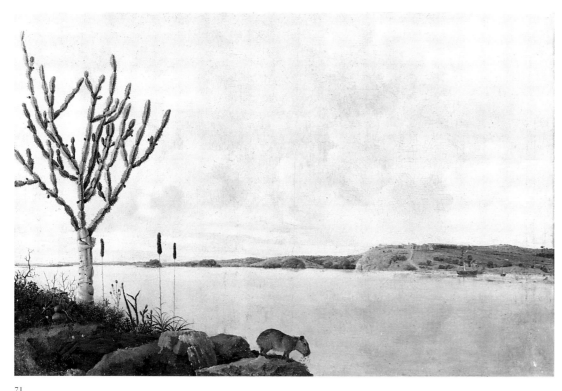

71

Signed at lower left: F. Post A. 1638 [effaced and retouched]
Oil on canvas, 24⅜ x 37⅜ in. (62 x 95 cm.)
Musée du Louvre, Paris, inv. 1727.

Provenance: Painted in Brazil for Prince Johan Maurits of Nassau-Siegen: Mauritshuis, The Hague; presented in 1679 to Louis XIV of France (1681 inventory, no. 443); transferred in 1696 to Chaville; returned to Versailles in 1784; 1802 to Musée de Marine, Paris; Musée de la France d'Outre-Mer, Vincennes; Musée du Louvre.

Exhibitions: Marseilles, "Exposition coloniale," 1922; Paris 1950–51, no. 59, pl. 9; The Hague 1953, no. 13, pl. 7; Amsterdam/Vlissingen, *Herdenking van Michiel de Ruyter*, 1957, no. 36, fig. 5; Rio de Janeiro 1968, no.

11, ill.; Washington/Cleveland 1975–76, no. 76, ill.; Paris 1976–77, no. 76, ill., color pl. 18; The Hague 1979–80, no. 101, ill.

Literature: Jean Destrem, "Le Musée de Marine du Louvre," *Gazette des beaux-arts* 61 (1919), p. 294, ill.; Combe 1931, p. 488; Sousa-Leão 1937, pl. 5; R. Smith 1938, pp. 239–62, no. 2, pl. 4; Thomsen 1938, p. 152, pl. 77; van Gelder 1940, p. 70, fig. 2; Sousa-Leão 1948, p. 99, no. 4, pl. 4; Guimarães 1957, no. 12; Sousa-Leão 1961; Larsen 1962, pp. 96–97, 138–39, no. 4, fig. 24; Rosenberg et al. 1966, p. 153, pl. 129A; Bol 1969, pp. 197–98, fig. 191; Sousa-Leão 1973, pp. 23, 33, no. 2, ill.; Joppien 1979, pp. 299, 300, 330; Lemmens 1979, p. 276, fig. 15; The Hague, Mauritshuis cat. 1980, pp. 73–75.

Frans Post is the only known Dutch painter to have been employed full time to record and depict landscapes. Together with Albert Eckhout, who painted figures and wildlife, Post accompanied Prince Johan Maurits of Nassau-Siegen to Brazil in 1636, returning to Holland in 1644.

Nothing is known of Frans Post's work before his embarkation for the New World.[1] His first painting, dated 1637, shows the island of Itamarca in Brazil (Mauritshuis, The Hague, inv. 915); the painting exhibited here is probably the next surviving work. It shows the broad São Francisco River, which marked the southern border of the Dutch possessions in Brazil. Sharply silhouetted on the near bank are a capybara, a large Brazilian rodent, and a cactus. Across the river is the Dutch Fort Maurits.

Six paintings are known from Post's Brazilian stay, including a view of Fort Keulen (fig. 1) executed in the same year as *The São Francisco River*.[2] These Brazilian-period paintings are remarkably innovative compositions, resembling free sketches in their directness and simplicity of vision. It is tempting to see this almost naive straightforwardness as the product of the exotic Brazilian scenery Post encountered. Indeed, early writers interpreted the bold qualities of Post's work as a proto-Romantic response to the tropics and compared him to "le Douanier" Rousseau.[3] But Frans Post must have been a highly trained artist before his arrival in Brazil, although he was by no means a typical Dutch landscapist; his stylistic sources continue to prove elusive. More recent writers have emphasized the apparent topographical, quasi-scientific aspects of Post's work, believing his drawings and paintings to be objective records.[4]

Since Post was from Haarlem, his landscapes are often seen as products of that city's school of landscape painting. However, the connection with Haarlem panoramic painting exists only in

Fig. 1. Frans Post, *Fort Keulen on the Rio Grande*, signed and dated 1638, canvas, 60 x 88 cm, Musée du Louvre, Paris, inv. 1726.

Fig. 2. Pieter Post, *Hooischelf*, dated 1633, panel, 53.3 x 79.5 cm., Mauritshuis, The Hague, inv. 970.

the most general of terms.[5] Rather, Frans Post's work is very closely tied to that of his older brother, Pieter, and through him to Cornelis Vroom.[6] Pieter Post and Vroom eschewed the rough calligraphic brushwork, monochromatic tonality, and traditional receding compositions of de Molijn, van Goyen, Ruysdael, and their circle in favor of a sharper, crisper pictorialism with more directly observed compositions (see cat. 115 and cat. 115, fig. 2). Pieter Post's *Hooischelf*, dated 1633 (fig. 2), is the clearest source for Frans's work.[7] As in the exhibited painting, the land stretches in a broad, horizontal band across the picture, broken by a few vertical accents. The light in both is strong, and the paint is applied in almost unmodulated blocks of separate colors. Since traditional *repoussoir* devices are not employed in the foreground, the viewer confronts the objects in the painting directly. The clear, linear quality of the exhibited landscape is heightened by the stark simplicity of its forms: a triangular foreground bank, the long, straight lines of the cliffs opposite, and, most remarkable, the silhouetted plants, particularly the reeds, which are boldly superimposed on the horizon.

Although only a handful of paintings survive from Post's Brazilian period, there once were surely many more. In 1679 Johan Maurits presented forty-two paintings by Frans Post and Albert Eckhout to Louis XIV in the hopes of receiving financial support.[8] Most of the paintings had been stored in the prince's residence, the Mauritshuis, in The Hague during his more than thirty-year absence as stadtholder of Kleve. A report by Jacob Cohen of 1678 described a set of Brazilian landscapes intended for the French king, where "the blues looked faded as if they had been rubbed with sand or glass",[9] which may explain the flat whiteness of the skies in some of the Brazilian paintings. The report listed eighteen small Brazilian landscapes of

identical size in black frames, along with five others by Post. Some of these were restored, and nine more paintings by Post were acquired on the open market to complete the shipment. It is very likely that the Louvre painting and its five companions were among the eighteen small landscapes. There were thus at least twelve more Brazilian small landscapes that disappeared from the collections of the French state before 1824.[10] Together, these eighteen paintings must have formed a single series made for Prince Johan Maurits.[11] The extant paintings are identical in size and style, while both the report of 1678 and the Paris inventory of 1681 suggest that they belonged together because of their similar formats and frames.

It is unlikely that the exhibited landscape was painted on the spot, as was once commonly thought. It is probably based on a lost sketch made from nature which also served as the model for a second drawing with a cartouche, used for an illustrative print in Caspar Barlaeus's account of Johan Maurits's Brazilian governorship, published in 1647 (fig. 3).[12] The print, corresponding to the exhibited painting but accompanied by a map of the area around Fort Maurits, was adapted to fit Barlaeus's narrative describing the retreat of the Portuguese in the face of Johan Maurits's advance. The foreground has been simplified and widened, and fleeing soldiers on rafts have been added. In fact, Fort Maurits on the far side had yet to be built at the time of the event described.[13] An eighteenth-century French gouache also duplicates the landscape in the displayed painting, but with different figures.[14]

While Frans Post was the first trained landscape artist to have visited and depicted the New World, images of America achieved a currency in Europe almost from Columbus's arrival. In Netherlandish art before Frans Post, works by Jan Mostaert (1475–1555/56; Haarlem,

Fig. 3. Jan van Brosterhuizen after Frans Post, *Fort Maurits*, etching, from Caspar Barlaeus, *Rerum per octennium in Brasilia* (1647), pl. 17.

Frans Halsmuseum) and Jan van der Straet (print by Theodor Galle, Hollstein, no. 411) presented highly fanciful views of the Americas.[15]

A.C.

1. Larsen attributed a battle scene to Frans Post formerly in the Schönborn collection, Vienna, which, according to an 1830 catalogue, is signed and dated 1631. However, the work more closely resembles the battle paintings of Pieter Post, two of which are dated 1631 (Mauritshuis, The Hague, inv. 765 and 766; Larsen 1962, pl. 22; Sousa-Leão 1973, p. 21).

2. The other dated Brazilian paintings are *Oxen Cart*, dated 1638 (Louvre, inv. 1728), *Porto Calvo*, dated 1639 (Louvre, inv. 1729), *Fort Frederik Hendrik*, dated 1640 (J. de Sousa-Leão collection, Rio de Janeiro). All illustrated in Sousa-Leão 1973, nos. 1–6. A few other paintings have been assigned to Post's Brazilian sojourn: a *View of Mauritsstad* in Schloss Sanssouci, Potsdam (The Hague 1979–80, no. 90, ill.); *Paulo Afonso Waterfall* in the Museu de Arte São Paulo (Joppien 1979, p. 229; Sousa-Leão 1973, no. 7, ill. as 1647); *Mauritsstad and Recife* (Joppien 1979, p. 299 [as 1637 rather than 1657]; Sousa-Leão 1973, no. 25, ill.).

3. Combe 1931.

4. Most recently Joppien (1979, p. 300): "It was this kind of factual, objective recording which was Post's strength."

5. Sousa-Leão 1973, p. 23; Joppien (1979, pp. 300, 335) surprisingly contends that Frans Post possessed "an almost cosmic attitude to aerial extension."

6. Larsen 1962. Sousa-Leão's suggestion (1973, p. 24) that Pieter Post may have been a pupil of de Molijn is difficult to accept.

7. Stechow 1966, p. 169; Sousa-Leão 1973, pp. 23–24; Haverkamp Begemann, Chong 1985, p. 65. On Pieter Post's landscapes see Gudlaugsson 1954; and Larsen 1962, pp. 132, 231.

8. Sousa-Leão 1972, pp. 30–34; The Hague, Mauritshuis cat. 1980, pp. 73–74; Joppien 1979, p. 330.

9. Quoted in Sousa-Leão 1973, p. 32.

10. There were twenty-seven to twenty-nine paintings by Frans Post in the gift to Louis XIV; at least twenty-three were recorded in inventories of the royal collections in 1696 and 1784, eighteen in 1802, but only eight by 1824. Two of the deaccessioned paintings have resurfaced, but the fate of the others is unknown.

11. The serial nature of the Brazilian landscapes is specifically denied in Sousa-Leão (1973, p. 24), although he does note the unusual facts of their uniform size and stylistic consistency.

12. Barlaeus 1647. Thirty-two drawings (British Museum, London) dated 1645 are preparatory studies for prints by Jan van Brosterhuizen (van der Kellen 1866, p. 137). (Larsen's theory that the prints are by Post himself has no foundation; Larsen 1962, p. 126). Larsen's suggestion (1962, pp. 96, 114–130) that the British Museum drawings are preparatory studies for the Brazilian paintings is now universally discounted. Sousa-Leão (1973, p. 37) ventures the possibility that the drawings in the British Museum may be the actual sketches that Post made in Brazil, with additions in a different medium made later to prepare the sheets for the prints. However, the drawings have none of the appearance of sketches from nature. The staffage in the drawing was indeed made later, probably to conform to the demands of Barlaeus or the publisher.

13. Barlaeus 1647, p. 42. The preparatory drawing for the print (British Museum, London; Hind 1915–31, vol. 4, no. 8) is illustrated in Larsen 1962, no. D 8, fig. 85; Sousa-Leão 1973, no. D 30, ill.

14. Bibliothèque Nationale (Cabinet des Estampes), Paris, inv. VD 23, part of a set of eight, one signed and dated "de Thiery Cap Pinx. 1765.") The gouache version of the exhibited painting shows a wider bank in the foreground and Indians in a canoe harpooning a manatee. The caption reads, "du Fort Maurice Situé sur la grande Rivière de Ste François, avec la peche du Lamentin" (ill. in Sousa-Leão 1973, p. 197, fig. D). The other gouaches that repeat known Brazilian-period paintings also show significant variations on the compositions. Sousa-Leão (1973, p. 33–34) believes that these gouaches are free copies after the paintings (some of which are now lost) then at Chaville. Joppien, however (1979, p. 330) argues that the gouaches are copies of the lost drawings that Post made on the spot in Brazil, and believes that the variations between painting and gouaches record topographically significant features of the Brazilian landscape. In particular he notes that the view of Recife is missing the Palace of Vrijburg built in 1642. However, the inscriptions on the gouaches seem to be translations of the Dutch labels placed on the paintings presumably when they were sent to France (see The Hague, Mauritshuis cat. 1980, p. 73), although the gouache related to the present entry contains figures different from those in the painting.

15. See Hugh Honour, *The New Golden Land: European Images of America from the Discovery to the Present Time* (London, 1976); Washington/Cleveland 1975–76; and Paris 1976–77.

Ruins of the Cathedral of Olinda, Brazil, 1662

Signed and dated: F. Post 1662
Oil on canvas, 42⅜ x 68 in. (107.5 x 172.5 cm.)
Rijksmuseum, Amsterdam, inv. A 742

Provenance: C. J. G. Copes van Hasselt, Haarlem; sale, Amsterdam, April 20, 1880, no. 44 (fl.148.50); acquired by the Rijksmuseum in 1881.

Exhibitions: The Hague 1953, no. 25, fig. 17; Amsterdam, Troppenmuseum, *Wonen in de wijde wereld*, 1963–64, no. 102; Rio de Janeiro 1968, no. 36, ill.; Kleve 1979, no. B 33, ill.; The Hague 1979–80, no. 98, ill.; Amsterdam 1984, no. 46, ill.

Literature: Amsterdam, Rijksmuseum cat. 1886, no. 275a; cat. 1887, no. 1128; cat. 1903, no. 1902 (and later eds.); Sousa-Leão 1937, pl. 5; R. Smith 1938, p. 262, no. 20; Sousa-Leão 1948, p. 99, no. 25, pl. 20; Guimarães 1957, no. 98; Larsen 1962, pp. 147–48, no. 65, fig. 69; Sousa-Leão 1973, no. 36, ill.; Amsterdam, Rijksmuseum cat. 1976, no. A 742, ill.; Joppien 1979, p. 336; Haak 1984, fig. 39.

The majority of Frans Post's landscapes are dated, many even with the day and month of completion. This work of 1662 comes from the last years of the artist's career. His last dated painting is of 1669, and he does not appear to have worked at all in the final decade of his life, when he is described as "having fallen to drinking and become shaky."[1] Unlike the paintings that Post executed in Brazil (cat. 71), his work after his return to Holland in 1644 adopted conventions of Dutch landscape painting. The foreground now consists of traditional *repoussoirs*: diagonal slashes of dark foliage stocked with a multitude of Brazilian flora and fauna. The figures have been pushed farther into the distance, and the composition with its framing trees has taken on aspects of more familiar Dutch landscapes, although Post never painted the vast sweeping panoramas with elevated viewpoints and tall skies seen in the work of Segers, van Goyen, Koninck, and Ruisdael.[2] Stechow claimed that Post's later work was like

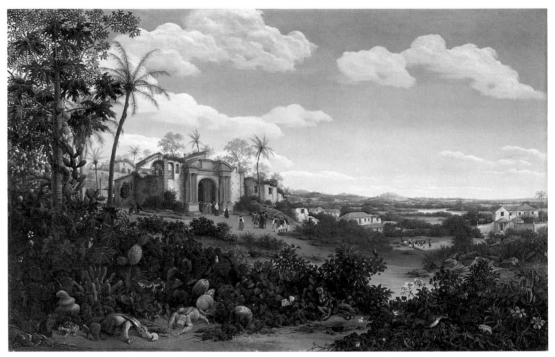

72

Fig. 1. Claes Jansz Visscher, *Battle of Olinda*, 1630, etching (two plates).

an "old bottle . . . filled with new wine," that is, time-honored compositions furnished with marketably exotic ruins, plants, and animals.[3] However, there is no mistaking the clarity and strength of Post's personal landscape style. The highly finished detail as well as the deep, saturated palette, now without a hint of Haarlem monochromaticism, all enhance the Brazilian subject. The crispness of the foliage, especially where it is outlined against the sky at the upper left, betrays the continuing influence of Pieter Post (see cat. 115, fig. 2)[4] and Cornelis Vroom (cat. 114 and 115).

The impact of the painting is heightened by the richly carved seventeenth-century frame, which was probably part of the original commission for the work and perhaps actually designed by Post himself.[5] The exotic fruits and leaves in the picture are echoed in the frame.

The ruins in the exhibited work are those of the sixteenth-century Portuguese cathedral at Olinda, capital of the district of Pernambuco. Frans Post included the building and other views of Olinda in many of his paintings.[6] There exists a variant of the present composition in reverse.[7] Post's panoramic view of Olinda was published in 1647 in Barlaeus's *Rerum per octennium in Brasilia*.[8] Much of the landscape in the present painting is imaginary; the buildings at the right are based on the Franciscan cloister at Igaraçu, in reality some twelve miles north of Olinda.

Olinda was not unfamiliar to the Dutch at the time Frans Post painted his depictions of the town. In 1630 it was the site of a major Dutch victory over the Portuguese, an event extensively reported in books, pamphlets, and prints.[9] Most important of these is a large broadsheet describing the battle of March 1, 1630, accompanied by a map and a view of the area.[10] The landscape print by Claes Jansz Visscher (fig. 1) shows Olinda at the right, including the cathedral (labeled 11) found in the exhibited

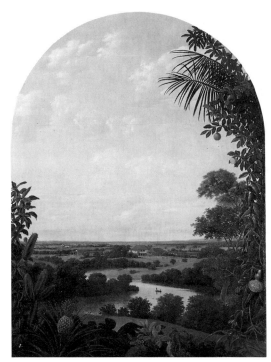

Fig. 2. Frans Post, *Brazilian Landscape*, signed and dated 1652, canvas, 282.5 x 210.5 cm., Rijksmuseum, Amsterdam, inv. A 3224.

painting. The victory at Olinda was crucial to the Dutch in securing Brazil. It was considered doubly significant because it closely followed the defeat of the Spanish at Den Bosch and certified Dutch power over the Spanish, who at the time conducted the affairs of the Portuguese empire. Other victories in the 1630s were similarly reported and illustrated.[11] In 1632 the Dutch burned Olinda when the administrative center of Brazil was transferred to Recife. Post's painting of these ruins, which are conspicuously both Catholic (note the monks in front) and Portuguese, would have brought to mind the Dutch imperial triumphs in the Americas.[12]

Much of Frans Post's work in Holland repre-

sents an effort to celebrate Brazil. In 1648 Post provided a Brazilian landscape as the setting for the *Sacrifice of Manoah*, with figures painted by another artist, perhaps Claes Moeyaert (Museum Boymans-van Beuningen, Rotterdam, inv. 1693).[13] The biblical story itself may be an allegory of the Dutch in Brazil, signifying, as Sousa-Leão puts it, "a new Samson against the Philistines."[14] Another painting, dated 1652, executed in an arched format probably for a large-scale decorative project, lends an element of classical elevation to the Brazilian scene (fig. 2). These two paintings, along with the exhibited work in its elaborate frame, were seemingly intended as grand public statements about Brazil, perhaps commissioned by Dutch patricians associated in some way with the Brazilian colony.

For such potential patrons, as for most seventeenth-century observers, Brazil was not merely another unusual foreign spot. It was a Dutch possession and as such stood for the military and economic power of the nation. Brazilian sugar plantations, also occasionally depicted by Post, represented a potentially lucrative industry; Brazilian forests, a strange new world ripe for development. These imperial aspirations, based on shipping, trade, and naval warfare, were in the spotlight throughout the seventeenth century. Aside from appearing in Post's landscapes, Braziliana figured in official triumphal imagery, most notably in a painting by Jacob van Campen for the Oranjezaal of the stadtholder's palace, Huis ten Bosch.[15] Frans Post's paintings were very popular and often expensive, probably in part because they provided patriotic reminders of Holland's status as a world power.

A.C.

1. Report of Jacob Cohen, January 9, 1679, quoted in Sousa-Leão 1973, p. 32. .

2. Previous authors have overstressed Frans Post's reliance

Paulus Potter

(Enkhuizen 1625–1654 Amsterdam)

on and similarity to Haarlem panorama artists (see Larsen 1962; Joppien 1979, p. 335). In comparison with some of the works of Jan van Goyen and Salomon van Ruysdael, with their vast areas of sky, Post's landscapes are less extensive.

3. Stechow 1966, p. 169.

4. See Pieter Post's panorama dated 1631 in the Institut Néerlandais, Paris, inv. 6331.

5. Amsterdam 1984, no. 46.

6. Sousa-Leão 1973, nos. 41, 43, 46, 74–81.

7. Instituto Historico e Geografico Brasiliero, Rio de Janeiro (Sousa-Leão 1973, no. 78, ill.). A version of the center of the Amsterdam painting, showing only an edge of the cathedral, is also dated 1662 (Kugel collection, Paris; Sousa-Leão 1973, no. 37, ill.).

8. Van Baerle 1647, pl. 10. Post's preparatory drawing for the print is in the British Museum, London (Hind 1915–31, vol. 4, no. 4; Larsen 1964, fig. 64).

9. For pamphlets on the battle of Olinda, see Tiele 1858, nos. 2350–56; and van der Wulp 1866–68, nos. 2113–16. For prints, see F. Muller 1863–82, nos. 1656B, 1657A, 1657.

10. Entitled *Cort verhael van all 't gepasseerde in de victorieus veroveren der Stadt Olinda*, published in 1630 in Amsterdam by Claes Jansz Visscher (F. Muller 1863–82, no. 1656; M. Simon 1958, no. 270).

11. The victory at San Salvador in 1627 and the capture of the Spanish silver fleet in Cuba in 1628 were well reported. For illustrative prints, see F. Muller 1863–82, nos. 1560, 1593, 1594; The Hague 1979–80, nos. 60–68. General accounts of the conquest of Brazil appeared in 1644 by Johannes de Laet and in J. Commelin's biography of Frederik Hendrik (1651–52).

12. R. Joppien (1979, p. 355) suggests that such ruins ennoble the landscape and were an effort to achieve a higher form of landscape art. While this may be the case in some Italianate landscape paintings, it was the contemporary world of Dutch affairs with which these Brazilian ruins were associated.

13. The figures have long been attributed to Ferdinand Bol, although Blankert (Washington, D.C./Detroit/Amsterdam 1980–81, no. 77) suggests Moeyaert.

14. Sousa-Leão 1973, p. 63, no. 9 (first suggested in The Hague 1953, no. 17). Susan Kuretsky (Washington, D.C./Detroit/Amsterdam 1980–81, no. 77) interprets Johan Maurits's return in 1644 as a defeat for the Dutch, although it certainly was not regarded as such at the time.

15. Brenninkmeyer-de Rooij 1979; The Hague 1979–80, no. 271 (also no. 266).

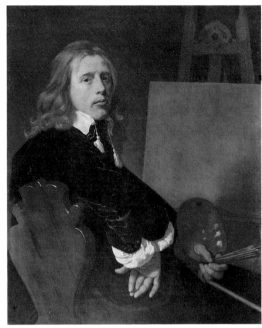

Bartholomeus van der Helst, *Portrait of Paulus Potter*, signed and dated 1654, canvas, 99 x 80 cm., Mauritshuis, The Hague, inv. 54.

Baptized at Enkhuizen on November 20, 1625, Paulus Potter was the son of the painter Pieter Simonsz Potter (c.1600–1652) and Aaltje Paulusdr Bartsius, sister of the painter Willem Bartsius (born c.1612). The family settled in Amsterdam by 1631. According to Houbraken, Potter studied under his father; his first dated works of 1642 reflect the latter's influence. In May of that year a "P. Potter" was student of Jacob de Wet (1610–1671/72) in Haarlem. In August of 1646 Potter joined the guild in Delft. In 1649 he entered the guild at The Hague and was married to Adriana Backen Eynde in that city in July 1650. Potter's wife was the daughter of the city architect Claes Balken Eynde, who worked on the royal palaces and may have

introduced Potter to Amalia van Solms, widow of Frederik Hendrik, for whom the artist painted a picture now in Leningrad (inv. 820). From 1649 to 1652 he lived in the house of the painter Jan van Goyen on the Dunne Bierkade. In 1651 Potter was sued by the royal court for failure to deliver paintings. Houbraken claims that he was persuaded to leave The Hague for Amsterdam by Dr. Nicolaes Tulp. He settled by May 1, 1652, in Amsterdam, where he was still living in January 1653, when he made a will. Potter was buried in the Nieuwezijdskapel on January 17, 1654. He was only twenty-nine years old at the time of his death from tuberculosis. Potter's portrait (reproduced here) by Bartholomeus van der Helst (1613–1670) is dated in the year of his death.

Despite his brief life, Potter was a highly innovative and influential artist. Many of his pictures are cabinet-sized paintings of animals – usually cows – in landscapes, but his well-known *Young Bull* of 1647 (Mauritshuis, The Hague, inv. 136) and equestrian portrait of Prince Johan Maurits of 1653 (Six Collection, Amsterdam) are both lifesize. His paintings are related to those of Karel du Jardin, and the two may have had a mutual influence on each other. In addition to paintings, Potter executed about two dozen etchings of animals.

A.C., P.C.S.

Literature: Houbraken 1718–21, vol. 2, pp. 126–29; Descamps 1753–64, vol. 2, pp. 351–56; Bartsch 1803–21, vol. 1, pp. 41–70; van Eynden, van der Willigen 1816–40, vol. 1, pp. 412–17, vol. 2, p. 153; Smith 1829–42, vol. 5, pp. 113–65, vol. 9, pp. 620–28; Nagler 1835–52, vol. 11, pp. 540–50; Immerzeel 1842–43, vol. 2, pp. 324–26; Kramm 1857–64, vol. 5, pp. 1307–11; Westrheene 1867; van der Kellen 1870; Duplessis 1875; Obreen 1877–90, vol. 1, p. 7, vol. 2, pp. 139–40; A.D. de Vries 1885–86; Cundall 1891, pp. 105–43, 167–72; Bredius

73 (PLATE 77)

Farm near The Hague, 1647

1893; Michel 1906; Wurzbach 1906–11, vol. 2, pp. 349–54, vol. 3, p. 133; Hofstede de Groot 1907–28, vol. 4; Havelaar 1911; Brunt 1912; Zoege von Manteuffel 1924; von Arps-Aubert 1932; R. von Arps-Aubert in Thieme, Becker 1907–50, vol. 27 (1933), pp. 306–307; Martin 1935–36, vol. 2, pp. 328–33; Allhusen 1939; Borenius 1942; C. van Eeghen 1943; Hollstein, vol. 17, pp. 211–24; Maclaren 1960, pp. 298–300; Stechow 1966; ten Doesschate 1966; Müllenmeister 1973–81, vol. 3, pp. 23–27; Müllenmeister 1980; Montias 1982, pp. 102, 178, 342; Walsh 1985.

73

Signed and dated, lower left: Paulus Potter
f 1647
Oil on panel, 15⅝ x 19¾ in. (39.7 x 50.2 cm.)
By the kind permission of His Grace The Duke of Westminster, Eaton Hall, Chester

Provenance: J. van der Linden van Slingeland, Dordrecht, by 1752; sale, J. van der Linden van Slingeland, Dordrecht, August 22, 1785, no. 315, to Hoogstraten (fl.8010); sale, Claude Tolozan, Paris, February 23, 1801 (frs.27,050); Crawford collection, Rotterdam, said to have been bought from Stafford for fl.13,000; sale, van Hoorn, Amsterdam, November 13, 1894, no. 948; sale, London, April 26, 1806, to Campbell (bought in at £1,552); acquired shortly thereafter by the first Marquess of Westminster for £1,000.

Exhibitions: London, British Institution, 1834, no. 120; London, Royal Academy, 1870, no. 127; London, Royal Academy, 1895, no. 91.

Literature: Hoet 1752, vol. 2, p. 490; John Young, *A Catalogue of the Pictures at Grosvenor House* (London, 1821), no. 115, ill.; Smith 1829–42, vol. 5, no. 37; *Catalogue of the Marquess of Westminster's Collection of Pictures at Grosvenor House* (London, 1849); Blanc 1854–90, vol. 2, p. 188; Westrheene 1867, no. 32; Wurzbach 1906–11, vol. 2, p. 352; Hofstede de Groot 1908–27, vol. 4, no. 94; Walsh 1985, pp. 181, 182, 185, 186, 206, 302, 304–305, note 54, 401, fig. B 53.

A row of backlighted willows stretches diagonally across the picture. Before them are sheep, cows, a bull, and a milkmaid conversing with an old man. At the end of the line of willows is a farmhouse in an enclosure. Between the centermost pair of trees, an elegant couple promenades, the woman holding her fan aloft against the bright sun. Green pastures with cows stretch back behind them. On the horizon is the country house Binckhorst near The Hague.

Paulus Potter was chiefly an animal painter; however, the landscape elements of his paintings are always an accomplished feature of his art and often, as in the present work, play a major role. The Duke of Westminster's painting illustrates many characteristics of Potter's landscapes, including a penchant for exact and finely detailed highlights, a clear, crisp light, *contrejour* illumination, and delicate, silver-hued foliage. Despite the compilation of detail, there is nothing fastidious or fussy about the work. Painted in 1647, when the artist was only twenty-two years old, the work already attests to artistic maturity. Gone are the early traces of the influence of his teacher, Claes Moeyaert, and of Gerrit Claesz Bleker. The important effects of Pieter van Laer's prints have also been fully absorbed by 1647. In the same year, Potter executed his most famous painting, *The Young Bull* (Mauritshuis, The Hague, inv. 136), and dated at least eleven other pictures.[1] Potter's painting *Cows Driven to Pasture* of 1647 from the Czernin Collection (fig. 1) may be compared for its similar use of dra-

Fig. 1. Paulus Potter, *Cows Driven to Pasture*, signed and dated 1647, panel, 38.1 x 50.8 cm., Residenzgalerie, Salzburg, inv. 139.

Fig. 2. Paulus Potter, *Cows Reflected in the Water*, signed and dated 1648, panel, 43.4 x 61.3 cm., Mauritshuis, The Hague, inv. 137.

matic backlighting, minute, almost grainy highlights, and bright palette. The Mauritshuis's well-known *Cow Reflected in the Water* of the following year (fig. 2) offers a more spacious, as it were, enlarged variant of the design of the Duke of Westminster's painting.[2] While the animals and milkmaid again appear, a pond with bathers is introduced in the immediate foreground, and the screen of trees has been moved farther back.

Potter's *Great Farm* of 1649 (Hermitage, Leningrad, inv. 820) is a still more ambitiously large variant of the composition, while the *Cows in a Meadow near a Farm* of 1653 (Rijksmuseum, Amsterdam, inv. A 711) returns to the more intimate form and design of the *Farm near The Hague*. In the later Amsterdam painting the row of trees is broken at the right center, to offer a distant view over pastures. The country house Binckhorst (see fig. 3) and the church of Rijswijk that appear in the background of the Westminster painting also appear in the Mauritshuis's two paintings, *The Young Bull* and the *Cow Reflected in the Water*. In 1752, Hoet described the Duke of Westminster's painting when it was in the famous van der Linden van Slingeland Collection in Dordrecht, as "landschap verbeeldende de weg tusschen Ryswyk en de geestbrug na den Haag te zien, met het Huys de Binckhorst, door Paulus Potter."[3] Potter did not register in The Hague guild until 1649, but he had probably moved there in 1647, when his father joined the guild and his sister was baptized in that city. Thus, he was probably living on the Dunne Bierkade, on what was then the southeastern boundary of The Hague, when he painted these pictures and surely was well acquainted with this area and its lovely polders.[4] The author of the 1821 catalogue of the Duke of Westminster's paintings, John Young, wrote, "It is worthy of remark, that after a lapse of nearly two hundred years, the scenery remains in the

Fig. 3. Roeland Roghman, *De Binckhorst*, black chalk and gray wash, 370 x 504 mm., Teylers Museum, Haarlem, inv. o★★16.

state the Artist saw it; and the house with the turret in the distance, is scrupulously preserved unaltered."[5] Houbraken, whose information came from Nicolaes Reenen, a son of the second marriage of Potter's widow, claimed that the artist never went walking in the countryside without taking his sketchbook.[6]

That Binckhorst appears in this picture is of special interest for our understanding of the work.[7] The country estate of Jacob Snouckaert, Binckhorst was immortalized by Philibert van Borselen in *Den Binckhorst ofte het lof des geluck-salighen ende gerust-moedighen Land-levens* (Amsterdam, 1613), which is credited with being the first true *hofdicht* (see Introduction).[8] The poem typically extolls the virtues and happiness of country life with specific descriptions of the estate Binckhorst. *Hofdichten* were composed by many of the most important Dutch literary figures of the period, including Petrus Hondius, Joost van de Vondel, Jacob Wester-baen, Jacob Cats, and Constantijn Huygens. As Walsh has demonstrated, in the Duke of Westminster's painting and the *Great*

Farm in the Hermitage, Potter adopted "a mode of expression" which parallels that of the *hofdichten*.[9] A standard conceit of these poems was the poet's conduct of his visitor, the reader, on an extended stroll through the estate and neighboring countryside. The sophisticated couple that appear in the background of Potter's two paintings are like the promenading poet and his reader.[10] Walsh also points out that the social contrast established between the elegant promenaders and the milkmaid and her rustic neighbor is similar to the juxtaposition implied by the coach that passes the rustic farm scene in the *Cow Reflected in the Water*. Such details are, of course, common in Dutch landscapes (see, for example, cat. 103). However, Walsh has stressed their precedents for Potter in traditional de-pictions of the Seasons in which the activities and diversions of the upper classes are usually isolated from the peasants' Labors of the Months.[11] For a very young artist like Potter, who specialized in painting barnyard animals but was descended from a patrician family and patronized by some of the most wealthy, power-ful, and influential men of his age (Frederik Hendrik, Johan Maurits, Dr. Tulp, and others), social contrasts must have been a familiar re-ality. But Potter's knowledge of farms, as Walsh rightly reminds us, was acquired knowledge,[12] no doubt gained on the walks described by Houbraken and prescribed by van Mander.

The several early copies of this painting attest to its attraction in the seventeenth and eigh-teenth centuries.[13] Further, for Smith it was a "superlative production," and Hofstede de Groot singled it out as one of Potter's "masterpieces."[14]

P.C.S.

1. See Hofstede de Groot 1908–27, vol. 4, nos. 24, 50, 51, 55, 58b, 63, 80, 106, 136, 156, and 169.

2. Ibid., no. 81.

3. Hoet 1752, vol. 2, p. 490. "The landscape depicts the road between Rijswijk and the geestbrug with a view to The Hague, with Binckhorst, by Paulus Potter."

4. W. Martin (1950, p. 73) even suggested that Potter might have painted *The Young Bull* from his own house on the Dunne Bierkade. Petra ten Doeschate improbably suggested in her unpublished thesis "De Stier van Potter" (Utrecht, 1966) that *The Young Bull* is the portrait of the prize bull of Jacob Snouckaert (see below).

5. John Young, *A Catalogue of the Pictures at Grosvenor House, London* (London, 1821), no. 115.

6. Houbraken 1718–21, vol. 2, p. 129.

7. On Binckhorst, see J. Renauld, "Uit de bouwgeschiedenis van Den Binckhorst", *Oudheidkundig Jaarboek* 5 (April 1936), pp. 23–31.

8. On the *hofdicht*, see van Veen 1985.

9. See Walsh 1985, pp. 298–313, especially, p. 304.

10. Ibid., p. 305, "As the reader of the *hofdicht* assumes the role of the visitor to the estate and vicariously enjoys the walk through the countryside, the viewer of Potter's paintings identifies with the strollers in the background."

11. Ibid., pp. 255–56.

12. Ibid., p. 297.

13. Hofstede de Groot 1908–27, vol. 4, under nc. 94, lists four copies. See also the copy, panel, 50.8 x 40 cm., in the collection of E.W. Edwards, Cincinnati, ill. in exh. cat. Indianapolis, Herron Art Museum, 1937, no. 56. Potter's original was also engraved by P.J. Arendzen and J. Scott.

14. Smith 1829–42, no. 37; Hofstede de Groot 1908–27, vol. 4, p. 584.

Herdsmen with Cattle, 1651

Signed and dated, lower left: Paulus Potter f.
1651
Oil on canvas, 32 x 36 in. (81 x 97.5 cm.)
Rijksmuseum, Amsterdam, inv. A 318

Provenance: Snakenburg collection, Leiden; sold on
April 25, 1796, by Jan Danser Nijman to Gerrit van
der Pot van Groeneveld; sale, G. Van der Pot van
Groeneveld, Rotterdam, June 6, 1808, no. 103.

Exhibitions: Cape Town/Johannesburg,
Herdenkingstentoonstelling Jan van Riebeeck, 1952, no. 56;
Norwich Castle Museum, *East Anglia and the
Netherlands*, 1954, no. 10; Warsaw 1958, no. 79, fig. 74.

Literature: Smith 1829–42, vol. 5, p. 140, no. 51;
Immerzeel 1842–43, vol. 2, p. 325; Thoré 1858–60,
vol. 1, pp. 76–77; Westrheene 1867, p. 147, no. 5;
Fromentin 1876, pp. 216–17; Michel 1906a, pp. 77,
92, ill.; Moes, van Biema 1909, pp. 113, nos. 103,
184; Hofstede de Groot 1907–28, vol. 4, no. 118;
E. Wiersum, "Het ontstaan van de verzameling
schilderijen van Gerrit van der Pot van Groeneveld
te Rotterdam," *Oud-Holland* 48 (1931), p. 212; von
Arps-Aubert 1932, no. 50; Müllenmeister 1973–81,
vol. 3, p. 27, no. 309, ill.; Müllenmeister 1980, p. 44,
fig. 5.

In a hilly landscape a man and woman tend their
animals at the edge of a pasture. The woman,
seated on the ground under an old oak tree, is
nursing a baby while a dog sits by her side.
Leaning against the tree behind her, the man
plays his bagpipe. A donkey, an ox, and a horse
stand nearby. In the foreground a cow, a goat, a
ram, two sheep, and a lamb lie together peace-
fully. Next to them, in the center foreground, a
red and white ox – the most prominent motif in
this rural scene – stands sentry, turning his head
curiously toward the spectator. On the left, on
the other side of the field, above a steep slope
with grazing sheep and goats, the edge of the
forest is outlined against the sky. Several trees in
the landscape show fall coloring. On a hill on the
other side of the valley, the tower of an old
castle rises above the trees. Large clouds gather

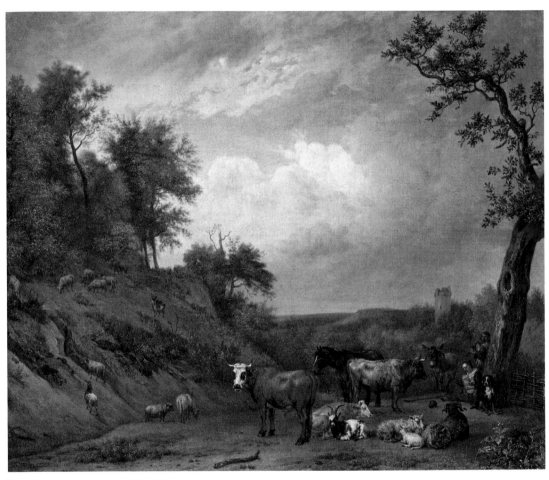

74

overhead; in the distance their leaden masses
suggest a recent or imminent thunderstorm.
 It is appropriate to inventory the variety of
animals in describing a painting by Paulus Potter
since they are central to the nature and meaning
of his work. Animals are not merely the support-
ing cast but are the featured players of his
landscapes. This kind of landscape, whose main

intent is the representation of livestock and
which often displays a pronounced portrait
character, is commonly called an "animal-piece"
(*veestuk*, literally "livestock-piece"). So familiar
has the well-loved and classic theme of the
Dutch animal-piece become, that the time in the
seventeenth century before Paulus Potter when
it did not exist is barely imaginable. Animals had

Fig. 1. Pieter van Laer, *Goats and Sheep with a Woman Spinning*, etching, from a series of eight published in 1636 in Rome.

Fig. 2. Claes Moeyaert, *The Herd*, signed and dated 1638, etching.

The Amsterdam history painter Claes Moeyaert, who is assumed to have been Potter's teacher, depicted cows and other animals with such great devotion, knowledge, and prominence that some of his works are barely distinguishable from the later independent animal-piece.[1] These paintings illustrate how much Potter owed to Moeyaert's example when he introduced the animal-piece as a separate genre of painting.

But another factor came into play. We have seen that new developments in painting often make use of examples in earlier printmaking. This was the case here, where a number of prints from the 1630s influenced the origin of the independent animal-piece. In 1636 a series of eight etchings by Pieter van Laer was published in Rome. This series depicted, for the first time, several kinds of animals entirely for their own sake, but in combination with other motifs, such as a sleeping shepherd boy or spinning shepherdess (fig. 1), a hunter or a buffalo drover, also drawn from life.[2] Blankert has pointed to two painted landscapes with cattle by Pieter van Laer, executed around 1639, when the painter returned to Haarlem.[3] It is not clear, however, whether and when these paintings could have been well enough known to have been of influence. However, the etchings are certain to have been known and, indeed, popular in Holland.

Gerrit Bleker[4] and Moeyaert published etchings of cattle as early as 1638. In these works Moeyaert did not hesitate to treat animals as an independent subject (fig. 2).[5] Potter followed suit in and after 1643 with his now famous etchings, which were soon followed by etched landscapes with cattle by Berchem and du Jardin; in this way the subject consolidated its permanent position in Dutch printmaking.[6] Potter had already awarded cattle an independent stature and meaning in his earliest paintings. A dated example is the *Landscape with*

Fig. 3. Paulus Potter, *A Shepherd Playing the Flute and a Singing Shepherdess with Cattle*, panel, 67 x 114.5 cm., Szépművészeti Múzeum, Budapest, inv. 51.2885.

Cattle of 1643 in the Institut Néerlandais in Paris,[7] while an undated example is *A Shepherd Playing the Flute and a Singing Shepherdess with Cattle* in Budapest (fig. 3). In both paintings Potter has placed the cattle in the foreground. The landscape's diagonal design as well as the decorative treatment of the trees strongly recall the work of the previous generation. A comparison of this early work with the exhibited painting of 1651 shows that Potter perfected the naturalistic rendering of nature in less than ten years' time. Gone are the shepherds' pastoral stage costumes with their references to literature's arcadian idylls. In the later work the shepherds wear plain, everyday clothing that is consistent with the unstylized, directly observed rendering of the landscape.

As in other paintings by Potter from the 1650s, the hilly landscape recalls the region of Gelderland or the area beyond.[8] It replaces the flat farmland of the Dutch polder region where Potter lived and which he repeatedly depicted before 1650 (see cat. 73). In the exhibited painting Potter, in fact, returned to the etching by Moeyaert (fig. 2), in which cattle are also placed between a tall tree on the right and a steep hill covered with woods on the left. Potter's old

certainly been represented earlier but usually in the context of a biblical or mythological scene. Sometimes they were depicted in passing and somewhat carelessly as minor motifs, but there were also painters who seized the historical theme as a pretext to portray the appropriate animals in great detail. It is in their works that the independent animal-piece finds its roots.

Jacob Pynas

(Haarlem c.1585–after 1656 Haarlem)

source of inspiration again proved to be of service to him in this new concept of landscape. The landscape from 1651, painted when Potter was only twenty-five or twenty-six years old, is among the last paintings of his short career. Granted little time for the development and maturation of his art, Potter nonetheless earns our admiration by his passionate diligence. The somewhat fastidiously detailed manner that sometimes threatened the organic unity of his early works was later replaced by a calmer, more ductile and cohesive style. But from beginning to end, Potter was faithful to a loving consideration of common animals and equally caring in his attention to the tranquil countryside that they inhabit. The artistic relationship between Potter and du Jardin is not yet entirely understood, but du Jardin honored the memory of his predecessor in a number of extremely delicate, pastoral landscapes, including those from 1655 in Amsterdam and Paris and from 1656 in London.[9]

C.J.d.B.K.

1. For the life and work of Moeyaert, see A. Tümpel 1974.

2. Hollstein, nos. 1–8, ill.

3. Blankert 1968, figs. 3 and 7.

4. Hollstein, no. 6, ill.; Boston/St. Louis 1980–81, no. 78, ill.

5. Hollstein, nos. 23 and 24, ill.; see de Groot 1979, no. 89, ill., and Boston/St. Louis 1980–81, no. 79, ill.

6. For etchings by Paulus Potter, see Duplessis 1875; Hollstein, nos. 1–20, ill.; de Groot 1979, nos. 201–208, ill.; Boston/St. Louis 1980–81, nos. 122, 142, 143, ill.

7. Paris 1983, no. 65, pl. 31. This landscape depicts a Dutch farmer's wife milking a cow, a motif etched in the same year, 1643, by Gerrit Bleker (Hollstein, no. 9, ill.).

8. Clearly related is the landscape decor in *Orpheus Charming the Beasts*, 1650, Rijksmuseum, Amsterdam, inv. A 317. Hilly terrain can be seen as well in *A Landscape with Cows, Sheep, and Horses by a Barn*, 1651, National Gallery, London, no. 849, and in *The Water Mill*, 1653, A. de Rothschild collection, London (see Müllenmeister 1980, p. 40, fig. 2); the latter depicts the same tower as the exhibited painting.

9. Musée du Louvre, Paris, inv. 1397; Rijksmuseum, Amsterdam, inv. A 195; National Gallery, London, no. 826.

According to Houbraken, Jacob and his brother, the history painter Jan Pynas (c.1583/84–1631), were born in Haarlem. Although his date of birth is unknown, his signature follows his brother's in documents, he outlived Jan, and his works take up at a later point stylistically, suggesting that he was the younger of the two. The two artists were the sons of the wholesale merchant Symon Jansz Pynas. Jan and Jacob were in Rome in 1605 and returned at the latest by 1608, when Jan appeared in Amsterdam. Their relationship with the German expatriate Adam Elsheimer (1578–1610) is still unclear and with the circle of Carlo Saraceni (1585–1620) yet more obscure. Jacob's earliest dated work, the *Adoration of the Magi* of 1613 or 1617 (Wadsworth Atheneum, Hartford, no. 1959.103) was executed long after his return. He was in The Hague in 1622. It is often overlooked that Jacob Pynas probably was active in Leiden in or before 1626. In that year he owed fl.51 to the estate of Aernout Elsevier, a painter and owner of the Leiden inn known as the Gouden Gecroonden Regenbooch; the artists Jan van de Velde (1593–1641) and Paulus van Someren (1576–1621) also owed Elsevier money. In the 1626 inventory of the tavern owner's possessions were four paintings by "Pynas" (no doubt Jacob) respectively valued at 30, 40, 66, and 36 guilders, as well as works by other Pre-Rembrandtists, including Moyses van Wtenbrouck and Jan Tengnagel (c.1584/85–1635). Jacob became a member of the St. Luke's Guild in Delft in 1632 and was still a resident of Delft in 1639. In 1641 and 1643 he was mentioned in Amsterdam. His last dated work is a grisaille of Apollo and Daphne (Lugt Collection, Institut Néerlandais, Paris), which bears the date 1656. The date and place of Jacob's death are unknown. His sister Meynsge married the well-connected history painter Jan Tengnagel, who became the director of the Amsterdam St.

Luke's Guild and a provost in the civic government. According to Houbraken, Rembrandt studied with Jacob Pynas for several months following his half-year tutelage with Pieter Lastman in Amsterdam, hence in or after 1623 or 1624. Houbraken also claims that Rembrandt imitated Jan Pynas's technique in painting brown tones. Rodenburgh mentions Pynas in his 1618 laudatory poem about Amsterdam artists, but it is not known to which brother he refers.

Jacob Pynas is considered a member of the Pre-Rembrandtists in the circle of Pieter Lastman. Although Jan and Jacob both usually signed their works with a monogram or simply "J. Pynas," their styles can be differentiated. Jacob is credited with the landscapes. He painted two distinctive types of pictures: history paintings with prominent figures related in style to those of Lastman and landscapes with historical staffage recalling Bril and Elsheimer. His works are often small in scale and depict ruins with rocky mountains or stylized forests defined by a hard, clear light. Jacob was also active as a draftsman.

P.C.S.

Literature: Rodenburgh 1618; Schrevelius 1648, p. 290; Houbraken 1718–21, vol.1, pp. 214, 254; Weyerman 1729–69, vol. 2, pp. 2–3; Kramm 1857–64, vol. 5, p. 1287; Bode 1883, pp. 19, 343–46, 393; Bredius 1890–95, pt. 1, p. 13; Wurzbach 1906–11, vol. 2, p. 366, vol. 3, p. 133; Bredius 1907; Müller Hofstede 1931; Thieme, Becker 1907–50, vol. 27 (1933), p. 478; Bredius 1935a; Bauch 1936; Bauch 1937; Baldass 1938–43; Cunningham 1959; Bauch 1960; Waddingham 1960; Waddingham 1963; Klessmann 1965; Frankfurt 1966–67, pp. 62–65; Oehler 1967; Ottani Cavina 1968, pp. 16–19, 59–61; Sacramento 1974, pp. 67–77; Salerno 1977–80, vol. 1, pp. 140–45, vol. 3, pp. 1072–73; Keyes 1980.

Landscape with Mercury and Battus, 1618

Monogrammed and dated at lower right: 1618
JCP [in ligature]
Oil on panel, 15¼ x 20¾ in. (38.7 x 52.7 cm.)
Private Collection, New York

Provenance: E. Wright Anderson, 1832; Col. R.
Leathem, by 1938; by descent to M.W.T. Leathem,
Finchampstead, by 1967; French and Co., New York,
1985.

Exhibitions: London 1938, no. 137 (as P. Lastman);
London 1952–53, no. 42 (as P. Lastman); Ghent 1961,
no. 42 (as P. Lastman); Frankfurt 1966–67, no. 82 (as
Jacob Pynas, *Merkur und Battus*), pl. 68; New York
1985b, no. 18, ill.

Literature: J.G. van Gelder 1953a, p. 33; Waddingham
1963, p. 59, fig. 53; Oehler 1967, pp. 159, 168, note 8,
fig. 7; A. Tümpel 1974, fig. 83; Sacramento 1974,
p. 72; Salerno 1977–80, vol. 1, p. 143; Haak 1984,
p. 193, fig. 394, ill. (as *Hermes and Argus*).

Though attributed to Pieter Lastman when
exhibited in London in 1938 and 1952–53, as well
as in Ghent in 1961, the painting was correctly
attributed to Jacob Pynas in 1953 by J.G. van
Gelder, an assignment supported at that time by
Horst Gerson.[1] Previously misunderstood, the
monogram on the painting closely resembles
those on Jacob Pynas's paintings in Hartford and
Dresden.[2]

Jacob's earliest dated landscape is a drawing
of 1608 (fig. 1), depicting a view of the Italian
campagna with steep, rocky hills dotted with
buildings and ruins framing a distant prospect.
The exhibited work is his earliest dated painting
of a landscape subject; his two paintings of 1617
are both history pieces. Characteristic of Pynas
is the use of small mythological staffage, strong
tonal contrasts, deep saturated colors, and a
single-wing coulisse. The last-mentioned takes
the form of a shaded, vine-covered cliff on the
left side and serves to enhance the effect of deep
space. Typically, the meandering road also leads
the eye into the picture, but Pynas shows little

75

concern with aerial perspective; his light is hard,
his touch dry.

Similar in conception are the landscapes in
Pynas's two versions of the *Meeting of Moses and
Aaron*, the *Hagar and the Angel*, and the *Old
Testament Subject (Elijah Sending His Servant to King
Ahab?)* (fig. 2).[3] Oehler has suggested a date for
the last mentioned in the first decade of the
seventeenth century.[4] While we cannot with
certainty date any works earlier than the Berlin

drawing of 1608, the *Old Testament* scenes's
slightly more animated style may point to
earlier origins than those of the present picture.
Pynas's other version of the *Mercury and Battus*,
(fig. 3), an oval painting on copper preserved in
Kassel, probably postdates the present picture;[5]
its wooded vista with Elsheimerian trees is
closer in conception to the landscape in the
Salmacis and Hermaphroditus engraved by
Magdalena de Passe after Jacob Pynas in 1623.

Fig. 1. Jacob Pynas, *Italian Campagna with a Hermitage*, mono-
grammed and dated 1608, pen and ink, 184 x 268 mm.,
Kupferstichkabinett, Staatliche Museen Preussischer Kulturbesitz,
Berlin, no. 12291.

Fig. 2. Jacob Pynas, *Old Testament Subject (Elijah Sending His Servant to
King Ahab?)* panel, 21.1 x 27 cm., Kurhessische Hausstiftung,
Schloss Fasanarie, inv. B 352.

The calm demeanor of Mercury and the de-
monstrative gesture of Battus are similar in both
versions of the subject; indeed, the latter motif
was much favored by Pynas (see fig. 2).

Though sometimes misinterpreted as a
scene of Mercury and Argus,[6] the painting's
subject is another story taken from Ovid's

Metamorphoses (2. 688–705), namely, that of the
peasant Battus, who was petrified as a result of
his attempt to deceive Mercury. Mercury had
stolen Apollo's cattle and hidden them in a cave,
and old Battus was the only one who saw the
theft. While he was watching a herd of blooded
mares at pasture, Mercury accosted him and
offered him a sleek heifer if he would deny to
anyone who asked that he had seen any cattle go
by. The old man took the cow and replied, " 'Go
on, stranger, and feel safe. That stone will tell of
your thefts sooner than I,' and he pointed out a
stone" (2. 696–97). This apparently is the
specific moment in the tale depicted by Pynas.
Mercury thereupon went away but returned in
disguise, offering Battus both a bull and cow if he
would tell. When the peasant greedily accepted
his second offer and disclosed where the cattle
were hidden, Mercury turned him into flint. Van
Mander (*Wtlegghingh*, fol. 20) moralized on the
subject: "The fable of Battus shows us how a
covetous breach of faith rewards its perpetrator:
it is demonstrated by the deadly punishment
suffered by the two-tongued tattle-tale."
Although the stories of Mercury and Argus and
Mercury and Battus were popular and often
represented together (Wtenbrouck, for example,
treated both in print series; see Bartsch 1978,
vol. 6), several details in Pynas's picture certify
that the old man is Battus; for example, the
heifer that stands beside him is brown, not the
white of Io in her bovine transformation. In the
background on the left side there is a well with a
relief of the Rape of Europa that reappears in
Jacob Pynas's late *Virgil's Tomb* of 1628 (formerly
collection of Dr. E. Shapiro, London).[7] It is
unclear whether this detail with its subject also
taken from Ovid's *Metamorphoses* has a symbolic
meaning in the present context.

P.C.S.

Fig. 3. Jacob Pynas, *Mercury and Battus*, oval copper, 16.4 x 22 cm.,
Gemäldegalerie, Schloss Wilhelmshöhe, Kassel, no. 611.

1. J.G. van Gelder 1953a, p. 33. He likened the painting to
Jacob Pynas's *Hagar and the Angel* (of 1620 or 26) in the De
Boer Foundation, Amsterdam. Horst Gerson's opinion,
"probably by Jacob Pynas," is also there recorded.
However, the painting was once again attributed to
Lastman by Gerson in Ghent 1961.

2. *Adoration of the Magi*, monogrammed and dated 1617,
copper, 39.7 x 53.5 cm., Wadsworth Atheneum, Hartford,
no. 1959.103; *Joseph and His Brothers at the Well*, mono-
grammed, copper, 22.3 x 27.5 cm., Gemäldegalerie,
Staatliche Kunstsammlungen, Dresden, no. A 702.

3. Respectively, copper, 21.3 x 27.5 cm., Gemäldegalerie,
Schloss Wilhelmshöhe, Kassel, inv. 1875; copper, 34 x
48.5 cm., De Boer Foundation, Amsterdam (see note 1);
and panel, 21.1 x 27 cm., Kurhessische Hausstiftung,
Schloss Fasanerie, inv. B 352. See Oehler 1967, figs. 1, 3, 4,
and 5. Compare also the *Rest on the Flight into Egypt* in the
Stiftung Kunsthaus Heylshof, Worms (reproduced in
Ottani Cavina 1968, fig. 11), and the *Repentant Magdalen*,
copper, 18 x 24.5 cm., Gemäldegalerie, Staatliche Museen
Preussischer Kulturbesitz, Berlin (West), no. 1973.

4. Oehler 1967, p. 160.

5. Oehler 1967, p. 160, would date it in the period
c.1615–20.

6. See London 1938, no. 137; London 1952–53, no. 42; and
New York 1985b, no. 18.

7. See Bernt 1980, vol. 2, no. 1015.

Rembrandt van Rijn

(Leiden 1606–1669 Amsterdam)

Rembrandt, *Self-Portrait*, signed and dated 1639, etching.

Rembrandt Harmensz van Rijn was born in Leiden on July 15, 1606, a son of the miller, Harmen Gerritsz van Rijn (d. 1603), and Neeltje van Zuytbroeck (d. 1640). According to the Leiden city historian Orlers (1641) he attended the Latin School for seven years. Rembrandt was admitted to the University of Leiden in 1620. Presumably the same year, he began his artistic education with the Leiden painter Jacob van Swanenburgh (c.1571–1638), who taught him the fundamentals of the profession. For six months thereafter Rembrandt was an apprentice to the successful history painter Pieter Lastman in Amsterdam, who strongly affected his development.

After the completion of his training, around 1624, Rembrandt returned to Leiden where he became an independent master. He began his career as a history painter; his earliest dated work is *The Stoning of Stefanus* (Musée des Beaux-Arts, Lyon) of 1625. During this Leiden period he closely collaborated with his friend Jan Lievens and counted Gerard Dou among his first pupils. He also executed his first etchings during these years. The journals of Aernout van Buchell and the poet Constantijn Huygens (the stadtholder's secretary, who actually visited Rembrandt and Lievens in Leiden) prove that Rembrandt achieved renown as a talented and promising artist by the time he was twenty-two years old. In 1629 Robert Kerr, Earl of Ancrum, bought three paintings by Rembrandt and presented them to Charles I of England.

Rembrandt left the town of his birth in 1631 and settled permanently in Amsterdam. He took up residence in the house of the art dealer Hendrick van Uylenburgh in the Sint Anthoniesbreestraat. Initially he prospered. The success of his group portrait *The Anatomical Lesson of Dr. Nicolaes Tulp* of 1632 (Mauritshuis, The Hague) brought numerous portrait commissions, and the stadtholder commissioned him to paint a series of scenes from The Passion. In 1633 he became engaged to Hendrick van Uylenburgh's niece, Saskia, an orphan from a prominent and well-to-do Friesian family. On this occasion he drew his first portrait of his betrothed (Kupferstichkabinett, Staatliche Museen Preussischer Kulturbesitz, Berlin). Rembrandt and Saskia were married on June 22, 1634, in the town of St. Anna-Parochie in Friesland.

A well-run business, Rembrandt's studio also served as a training center for young painters who eventually became his collaborators, often contributing to the products of his enterprise. During the first ten years, that is until about 1642, pupil-collaborators played an important role: Jacob Backer and Govert Flinck from the outset until about 1636, and after, Gerbrand van den Eeckhout and Ferdinand Bol.

After their first child died in 1636 at the age of two months, Rembrandt and Saskia lost two more daughters – one in 1638, after they had moved to the Nieuwe Doelenstraat, and another in 1640. From May 1639 onward, they lived in a large house that they had purchased in the Breestraat (now the Museum Rembrandthuis). This move was the apogee of Rembrandt's career as a successful artist. But this ambitious purchase sowed the seed for financial problems, which, barely twenty years later, would lead to a famous debacle. In this house their son Titus was born; he was the only one of their children who would reach maturity. He was baptized on September 22, 1641. Saskia fell critically ill and died on June 14, 1642.

In the same year Rembrandt completed the *Nightwatch* (Rijksmuseum, Amsterdam). In these years and prior to 1645 Carel Fabritius and Samuel van Hoogstraeten were Rembrandt's most important pupils, while Lambert Doomer and Jurriaen Ovens were also noteworthy. Nicolaes Maes only became a pupil at the end of the 1640s. From the beginning of the 1640s until the 1650s, Rembrandt executed etchings and drawings of views of the flat polderland that surrounds Amsterdam.

After Saskia's death, Geertje Dircks was employed as a nanny in Rembrandt's house and became his lover. When Rembrandt's attention turned to the younger Hendrickje Stoffels, whom he met in 1649, Geertje Dircks sued him for breach of marital promise. Rembrandt disposed of Geertje by forcing her to agree to a settlement. When she did not abide by its conditions, he committed her to a house of correction in 1650. These events, combined with growing financial troubles caused by mismanagement, cast a shadow over Rembrandt's life. Hendrickje

took Geertje's place as Rembrandt's wife. However a formal marriage was out of the question since Saskia had stipulated in her will that, while Titus would inherit her half-share of all that she and Rembrandt owned jointly, Rembrandt was entitled to its usufruct as long as he did not remarry. If he remarried, he forfeited this right and would be obliged to pay Titus his maternal portion. In 1654 Hendrickje was reprimanded by the church council for living in sin with Rembrandt. Four months later, on October 30, their daughter Cornelia was baptized.

In 1656 Rembrandt finally put his affairs in order by requesting a proclamation of his insolvency and permission for cession. An inventory of his property was drawn up, and in 1657 and 1658 all his possessions, including his art collection, were sold at auction. The house in the Breestraat was also sold, but the new owner allowed him to live there for two more years before taking possession. Rembrandt, Hendrickje, Titus, and the six-year-old Cornelia moved to the Rozengracht in December of 1660. He would remain there until his death. A different business arrangement was set up: Hendrickje and Titus became partners in an art dealership, sharing equally in all gains and losses and each owning half of all household goods, equipment, art objects, and so forth. Rembrandt lent his expertise to the venture and received in exchange free room and board. Following diminished production during the immediately preceding years, Rembrandt began to paint more. At about this time Aert de Gelder became his apprentice. Rembrandt painted his most moving works during this late period, such as the *Self-Portrait as the Apostle Paul* of 1661 (Rijksmuseum, Amsterdam). This was one of the latest works in a long and remarkable series of painted, etched, and drawn self-portraits that provide an unprecedentedly complete review of

Rembrandt's appearance in all phases of his career.

Hendrickje Stoffels died in 1663 and was buried in the Westerkerk on July 24. Titus married Magdalena van Loo in 1668 and moved to the Singel. He died approximately half a year later and was buried in the Westerberk on September 7, 1668. On March 22, 1669, Rembrandt's granddaughter Titia van Rijn was baptized. Rembrandt died on October 4 of the same year and was buried in the Westerkerk on October 8.

C.J.d.B.K.

Literature (selected): Orlers 1641, p. 375; Angel 1642, p. 47; de Bie 1661, p. 290; de Monconys 1665–66, vol. 2, p. 132; Sandrart 1675; Hoogstraeten 1678; Félibien 1666–88, vol. 4, p. 150; Félibien 1679, p. 51; Baldinucci 1686, p. 78; de Piles 1699, p. 316; Houbraken 1718–21, vol. 1, pp. 254–55; Gersaint 1751; Bartsch 1797; Smith 1829–42, vol. 9; Blanc 1859–61; Vosmaer 1863; Michel 1893, 1894; Bode, Hofstede de Groot 1897–1906; Hofstede de Groot 1906; Bode 1906b; Valentiner 1906; Baldwin Brown 1907; Hofstede de Groot 1907–28, vol. 6; Valentiner 1908; Holmes 1911, Hind 1912; Weisbach 1926; Hind 1932; Benesch 1935; Bredius 1935b; Bredius 1937b; H.E. van Gelder 1946; Huygens, Kan 1946; Rosenberg 1948; Schaffhausen 1949; A.B. de Vries 1956; Amsterdam/Rotterdam 1956; Kunttel 1956; Boon 1963; Kühn 1965; Bauch 1966; Haverkamp Begemann 1966; Fuchs 1968; Gerson 1968; Hollstein, vols. 18, 19; Bredius, Gerson 1969, Haak 1969; Stechow 1969; White 1969; Chicago/Minneapolis/Detroit 1969–70; White, Boon 1970; Benesch 1973; Lecaldano 1973; Schwartz 1977; *Rembrandt Documents* 1979; Rembrandt Research Project 1982; White 1984; Amsterdam, Rijksprentenkabinet, cat. 1985; Schwartz 1985; C. Tümpel 1986.

On Landscape: Lugt 1915; Eisler 1918; Bode 1925; van Regteren Altena 1954; Stechow 1966; Amsterdam 1983; Larsen 1983; C. Schneider 1984a; C. Schneider 1984b.

The Stone Bridge, late 1630s

Oil on panel, 11⅝ x 16¾ in. (29.5 x 42.5 cm.)
Rijksmuseum, Amsterdam, inv. A 1935

Provenance: Sale, M.L. Lapeyrière, Paris, April 14, 1817, no. 46; Edward Gray; James Gray, Versailles; Marquess of Lansdowne, Bowood, by 1854; James Reiss, London, 1883, sale, Reiss, London (Christie's), May 12, 1900, no. 63; purchased with the assistance of A. Bredius and the Vereeniging Rembrandt.

Exhibitions: London, Royal Academy, *Rembrandt*, 1899, no. 35; Amsterdam, Rijksmuseum, Vereeniging Rembrandt, 1923, no. 31, ill.; Rome, *Capolavori della pittura olandese*, 1928, no. 95, ill.; London 1929, no. 148; Amsterdam, Rijksmuseum, *Rembrandt*, 1932, no. 11; Brussels 1946, no. 84, fig. 100; Paris 1950–51, no. 66; Zurich 1953, no. 111, pl. 18; Rome 1954, no. 111, fig. 19; Milan 1954, no. 114, fig. 30; New York/Toledo/Toronto 1954–55, fig. 3; Stockholm, Nationalmuseum, *Rembrandt*, 1956, no. 19, fig. 13; Moscow/Leningrad, *Rembrandt*, 1956, p. 53, ill.

Literature: Buchanan 1824, vol. 2, p. 298; Smith 1829–42, vol. 7, p. 194, no. 612; Waagen 1854–57, vol. 3, p. 164; Blanc 1859–61, vol. 2, p. 434; Bode 1883, pp. 492, 579, no. 143; Dutuit 1885, p. 13; B.W.F. van Riemsdijk, "Berichten over Nederlandsche Musea," *Bulletin Nederlandsche Oudheidkundige Bond* 1 (1899–1900), p. 199; Wurzbach 1906–11, vol. 2, p. 395; Hofstede de Groot 1907–28, vol. 6, no. 939; Valentiner 1908, p. 135; Lugt 1915, pp. 119–21; Eisler 1918, pp. 192–93, fig. 114; Drost 1926, p. 166; Weisbach 1926, pp. 405–406; Havelaar 1931, p. 176, ill.; Hind 1932, p. 112, pl. 88; F. Schmidt-Degener, *Gedenkboek Vereeniging Rembrandt 1883–1933* (Amsterdam, 1933), p. 60, ill.; Bredius 1935b, no. 440, ill.; Martin 1935–36, vol. 2, p. 46, fig. 22; H.E. van Gelder 1946, pp. 1, 17, 33, 38, ill. p. 7; Hamann 1948, p. 299, fig. 204; Gerson 1950–52, vol. 2, p. 42, fig. 119; Knuttel 1956, pp. 112, 279; H. van de Waal, *Openbaar Kunstbezit* 2, no. 26 (1958), ill.; H.E. van Gelder 1959a, pl. 3; A.B. de Vries 1963, fig. 3; Bauch 1966, no. 543, ill.; Stechow 1966, pp. 42, 57–58, fig. 108; Fuchs 1968, p. 61, fig. 99; Gerson 1968, pp. 306, 496, fig. 196; Haak 1968, p.149, fig. 232; Bredius, Gerson 1969, no. 440, ill.; White 1969, vol. 1, p. 193; R. Charnet, M. Ochse, D. François, "Rembrandt, la

lumière de l'âme," *Jardin des arts* 215 (1972), pp. 24–25, ill.; Russell 1975, p. 37, fig. 47a; J. Bauch and D. Eckstein, "Woodbiological Investigations on Panels of Rembrandt Paintings," *Wood Science and Technology* 15 (1981), pp. 260–61; Amsterdam 1983, p. 6, ill.; Larsen 1983, pp. 63–64, pl. 3; van Thiel 1983; C. Schneider 1984a, pp. 10, 16; C. Schneider 1984b; White 1984, pp. 98–99, fig. 78; Schwartz 1985, p. 249, fig. 281; C. Tümpel 1986, pp. 230–31, 418, no. 260, ill.

A heavy passing thunderstorm has covered much of the flat Dutch landscape in darkness. On the left, beside the water, a rutted country road passes an inn with a coach out front and leads to a stone bridge. In the foreground, near a few sunken planks along the riverside, two men punt a barge. The road continues on the other side of the water past a farm and a haystack surrounded by trees before disappearing into the ominous darkness on the right. Just past the haystack a man drives an ox. Further back, in the thick of the storm, the outline of a church steeple is just barely visible against the black sky. To the far right, in the middle distance of the field, the shapes of a few cows are vaguely distinguishable. Sunlight breaks through an opening in the passing cloud cover, casting a brilliant light on the red-shingled roof of the farm, on part of the trees, and on the wooden fence near the bridge. The arched upper section of the bridge and part of the road to the left are also lit by the sunlight, as are the two men who walk toward the bridge from either side. Underneath the bridge a second barge is outlined against the grayish blue re-flections of the clearing sky.

This small landscape is unique in Rem-brandt's oeuvre. Pure landscapes constitute only a small group of his paintings and consist mainly of mountainous vistas, sometimes recall-ing Hercules Segers, whose work Rembrandt admired. Products of his imagination, these works create a tense mood with their dramatic

76

lighting effects. *The Stone Bridge* is an exception in this small group because of its indigenous Dutch subject. The small winter landscape in Kassel (cat. 77) also has a local character, but as a landscape its aim is more limited, focused chiefly on the mood of winter and the genre-like in-terest of people on the ice. *The Stone Bridge* is the only painting in which Rembrandt treated a view of the typical flat Dutch farmland coursed with water. But he was not satisfied with the clear daylight and atmosphere usually favored by his contemporaries in their depictions of the subject. As an ambitious history painter, Rem-

brandt had a different approach, seeking the expression of an unusual mood or emotion in landscape even when depicting a simple rural scene. To achieve these ends he used a sugges-tive chiaroscuro for which the passing thunder-storm provided a plausible pretext. The result-ing scene achieves a compelling depiction of a very common phenomenon in nature.

The bright sunlight breaking through the clouds has been beautifully incorporated into the composition; the strongest and warmest light is concentrated in the center, contrasting sharply with the gray sky. The dark, slow-moving

fragments of cloud overhead share brown undertones with – but also subtly counterbalance – the shadowed area below. In the diagonal space in between, with its richly nuanced lighter colors and radiant accents, the gloomy atmosphere of the landscape suddenly takes a hopeful, almost festive turn: light will triumph. In this way the history painter sought to express something unusual and more profound, even within the narrow scope of this otherwise ordinary landscape.

Although it is unsigned, there can be no doubt about the authenticity of this painting.[1] The fact that it is also undated requires conjecture about its point of origin in the development of Rembrandt's art. Since most of the other landscape paintings by or attributed to Rembrandt are also undated, a comparison of their stylistic characteristics fails to solve the problem of assigning precise dates. Further, this type of conjecture must be undertaken with caution because it may be expected that the already limited number of Rembrandt landscapes will be further diminished by advancing research in establishing the limits of the artist's personal production.[2] At present, the various dates assigned to *The Stone Bridge* range from about 1635 to 1640. Dendrochronological analysis of the oak panel, requested in 1983 by the Rembrandt Research Project in Amsterdam, has shown that the tree from which the panel was made was cut down no earlier than 1635. This find reinforces the opinion of the group of specialists that *The Stone Bridge* dates from the end of the 1630s.[3]

It is remarkable that the rural environs of Amsterdam did not figure more often in Rembrandt's paintings. The painter was surely familiar with these regions and took a substantial interest in them shortly thereafter. Attesting to Rembrandt's many excursions outside the walls of the city in the 1640s and 1650s are the numerous drawings and etchings in which he depicted the extensive polderland so strikingly. So attentive was he not only to the character and atmosphere but also to the topographical particularities that it is now often possible centuries later to identify the site or localize the scene depicted. On the basis of this work we can follow the draftsman on his trips along the Diemer dike, past the winding Amstel and the many smaller rivers and streams that are connected to it. In 1915 Frits Lugt made a special study of this subject, which still provides the basis of our knowledge of this fascinating aspect of Rembrandt's activity.[4]

In view of all this, *The Stone Bridge* not surprisingly has been considered a reliable depiction of an existing location somewhere outside Amsterdam. Lugt thought he recognized the church steeple of Ouderkerk,[5] prompting some later authors to name the painting *Landscape near Ouderkerk*,[6] while a view near the village of Diemen has also been mentioned as a possibility.[7] Others refrained from naming a specific location but nonetheless were of the opinion that the entire scene or part thereof was or could have been based directly on personal observation from nature.[8] The landscape drawings and etchings offer no direct connection with the painting.[9] The earliest dated etchings are from 1641 and it is probable that all landscapes on paper were created later than *The Stone Bridge*.

Finally, still others have regarded *The Stone Bridge* as completely imaginary, inspired only by Rembrandt's general impressions of a familiar environment.[10] In this view all of his landscapes are, without exception, idealized or, as Gerson put it, "romantic inventions, visions of his imagination."[11]

The latter opinion is preferable to the two mentioned above but still offers insufficient explanation for the origins of *The Stone Bridge*. This painting is more than simply a willed and

Fig. 1. Jan van de Velde, *Skaters on a River*, etching, 1616.

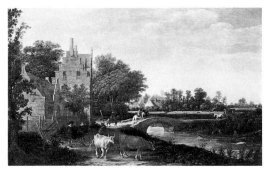

Fig. 2. Esaias van de Velde (attributed to), *Horsemen and Cattle by a Bridge*, panel, 24.4 x 41 cm., Terry-Engell Gallery, London, 1971.

original product of Rembrandt's imagination. The fact has often been studied and extensively published that Rembrandt made repeated and innovative use of earlier works of art in creating his own paintings. We are now familiar with the often derivative nature of Rembrandt's iconography. It is not surprising that the greatest attention has been given to biblical scenes, but mythological subjects, genre scenes, and portraits have also been considered.[12] However,

Ice Scene near Farm Cottages, 1646

the relationship of Rembrandt's landscapes, especially those assumed to depict existing reality, to earlier images potentially influencing their conception has been little studied. In the exhibition at the Rembrandthuis in Amsterdam in 1983, Eva Ornstein and Peter Schatborn compared Rembrandt's landscape drawings and etchings with prints by his predecessors and identified possible connections.[13] It became apparent that Rembrandt's approach to landscape was influenced by, among others, popular series of prints by Claes Jansz Visscher, Esaias and Jan van de Velde, and Willem Buytewech, dating from the second decade of the seventeenth century. These prints played a decisive role in the propagation and development of a new approach to landscape.

The Stone Bridge may also be connected to a print from this well-known repository of images. For a series of sixty small landscapes dating from 1616, Jan van de Velde made an etching of a winter scene of skaters on a frozen river near a stone bridge. This scene has so many similarities to Rembrandt's painting that it cannot be coincidence (fig. 1).[14] In the left foreground a road curves to the right over an arched stone bridge and continues past groups of trees that partially obscure the view of a farmhouse and haybarn; the view to the right into the distance is interrupted by vertical landmarks, and the barges in the foreground, together with the bridge, dominate the left side of the scene. All these motifs have been incorporated into Rembrandt's composition in an approximately similar fashion. He has added the detail of the inn with the stepped gable, but this motif was perhaps influenced by another example. In a painting attributed to Esaias van de Velde that shares a number of motifs with the etching of 1616, there is an inn with a stepped gable to the left of the arched stone bridge (fig. 2).[15] In this instance Rembrandt's familiarity with the image is

difficult to prove. However, Jan van de Velde's etching was certainly known by Rembrandt, and it is highly probable that it affected his conception of *The Stone Bridge*.

C.J.d.B.K.

1. Only Wurzbach (1906–11, vol. 2, p. 395) denigrated *The Stone Bridge* as "Falschung," but his reason for doing so was unexplained.

2. See the case of cat. 29.

3. Statement in 1986 by Ernst van de Wetering of the Rembrandt Research Project in Amsterdam. A previous dendrochronological analysis of the panel, published in 1981 by Bauch and Eckstein, resulted in inaccurately proposing 1643 as the earliest possible year in which the tree could have been cut down. Bauch and Eckstein corrected this in 1983.

4. Lugt 1915.

5. According to Lugt, two small rivers south of Ouderkerk on the Amstel, the Bullewijk and the Waver, had a stone bridge in Rembrandt's day (ibid., pp. 121–22). The former was closest to Ouderkerk.

6. H.E. van Gelder 1948, pp. 7, 17; Fuchs 1968, pp. 61, 74; Russell 1975, p. 37.

7. White 1969, vol. 1, p. 193, without further explanation.

8. Knuttel 1956, p. 112; Weisbach 1926, pp. 405–406; Hind 1932, p. 112.

9. A presumed connection, discussed at one point by F. Schmidt-Degener, was justly rejected as improbable by Henkel, but the latter's alternative suggestion is also unconvincing (M.D. Henkel, *Tekeningen van Rembrandt en zijn school* [The Hague, 1942], p. 40, no. 78).

10. Hamann 1948, p. 299; Larsen 1983, p. 63.

11. Gerson 1950–52, vol. 2, p. 42.

12. For a recent survey, see Amsterdam, Rembrandthuis, *Rembrandt and His Sources*, 1985–86 (by Ben Broos).

13. Amsterdam 1983.

14. Franken, van der Kellen 1883, no. 318. The probability that this etching depicts an existing site near Haarlem is strengthened by comparison with a painting by Jacob van Ruisdael (with dealer X. Scheidwimmer, Munich, 1977; Hofstede de Groot 1907–28, vol. 4, no. 679), which depicts (in reverse) a similar view.

15. Keyes 1984, p. 189, Attr. 20.

Signed lower left: Rembrandt f. 1646
Oil on panel, 6½ x 8¾ in. (16.7 x 22.4 cm.)
Gemäldegalerie Alter Meister,
Staatliche Kunstsammlungen, Kassel, no. GK 241

Provenance:[1] Langrave Wilhelm VIII of Hesse-Kassel, probably acquired in 1752 through Gerard Hoet, from Holland (MS inventory 1749ff., no. 768; inventory 1783, no. 128); removed to Musée Napoléon, Paris, 1807–15; Schloss Wilhelmshöhe, Kassel.

Exhibitions: Amsterdam 1932; Schaffhausen 1949, no. 132; Paris 1950–51, no. 67, pl. 2; Zurich 1953, no. 114; Rome 1954, no. 114, ill.; Milan 1954, no. 117, ill.; Chicago/Minneapolis/Detroit 1969–70, no. 9, ill.

Literature: Smith 1837–54, vol. 7, no. 609; Kassel, cat. 1830, 1877, no. 368; Vosmaer 1963; Parthey 1863–64, vol. 2, p. 340, no. 20; Dutuit 1881–85, p. 27, no. 450; Bode 1883, no. 57; Michel 1886, pp. 319, 552, ill.; Wurzbach 1886, no. 66; Kassel, cat. 1888, no. 219; Michel 1894, vol. 1, pp. 319–20, ill.; Bode, Hofstede de Groot 1897–1906, vol. 5, no. 341; Bell 1899, pp. 78, 167, ill.; Kassel, cat. 1904, pl. 148; Valentiner 1906, pl. 34; Baldwin Brown 1907, p. 251; Hofstede de Groot 1907–28, vol. 6, no. 943; Valentiner 1908, ill. p. 310; Holmes 1911, p. 135; Kassel, cat. 1913, 1929, no. 241; Lugt 1915, pp. 4, 119; Eisler 1918, pp. 267–68, fig. 127; Grosse 1925, p. 108; Weisbach 1926, p. 417; Hind 1932, pp. 114–15, pl. 93; Benesch 1935b, p. 37; Bredius 1935b, no. 452; H.E. van Gelder 1946, pp. 33–34, ill.; Hamann 1948, p. 295, figs. 200, 201; A.B. de Vries 1956, p. 37, fig. 9; Kassel, cat. 1958, no. 241, ill; Kassel, cat. 1965, pl. 15; Kühn 1965, p. 200; Bauch 1966, p. 28, pl. 552; Rosenberg et al. 1966, p. 60, fig. 38B; Stechow 1966, pp. 87, 90–91, fig. 178; Gerson 1968, p. 352, no. 267, ill.; Bredius, Gerson 1969, no. 452, ill.; Haak 1969, p. 199, fig. 325; Herzog 1969, p. 74, pl. XI; Brussels 1971, p. 132; van Straaten 1977, pp. 113–14, pl. xiv; Kitson 1982, no. 25, ill.; Larsen 1983, p. 71, no. 9, pl. 12; Keyes 1984, p. 140; C. Schneider 1984b; White 1984, p. 99, fig. 79; Amsterdam, Rijksprentenkabinet cat. 1985, pp. 70–71, ill.; Schwartz 1985, pp. 249, 253, fig. 289; Paris 1986, pp. 339–41, fig. 1; Tümpel, pp. 230–31, ill., no. 264.

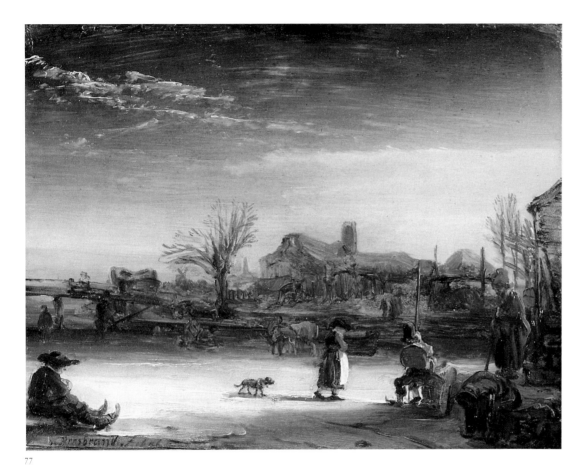

77

Fig. 1. Rembrandt van Rijn, *Cottages in Winter*, drawing, 103 x 108 mm., Rijksprentenkabinet, Amsterdam, inv. 1930:63.

Fig. 2. Dirck Lons, *Winter Scene*, etching, 1622.

Under a deep steel-blue sky streaked with thin clouds, cottages line the banks of a frozen river. Sunlight imparts an intense glow to the white ice in the center of the scene. Several figures, as well as a horse and a dog, appear on the ice, while a man in the right foreground ties on his skates. A leafless tree stands silhouetted beside a bridge at the back. Between this tree and the cottage is what may be the truncated obelisk near Spieringerhorn, outside Amsterdam on the road to Haarlem, which Rembrandt depicted in an etching (Bartsch, no. 227; see cat. 29, fig. 2).

It has often been noted that this work alone among Rembrandt's landscape paintings, and indeed among all seventeenth-century Dutch landscapes, appears to have been executed out of doors on the spot.[2] The panel was painted rapidly in bold, thick brushstrokes. Many areas reveal paint applied "wet into wet," especially the bridge and cottages in the background, where the design has been quickly sketched in dark tones. While some documentary evidence exists to suggest that landscapes were painted out of doors in the seventeenth century,[3] the exhibited work stands alone in bringing the immediacy of drawing to painting. It is likely that Rembrandt made landscape etchings on the spot.[4] Moreover, in Rembrandt's inventory of 1656 there are listed four small landscape paintings made "after nature."[5] Although it cannot be proven that the exhibited painting is one of these works, it shares many characteristics with the artist's sketches of country cottages in the area around Amsterdam, from the early 1640s to

the mid-1650s. Max Eisler in 1918 was the first to compare the painting with a drawing of a few farm cottages in the snow, which Benesch dated around 1648–50 (fig. 1).[6] In these drawings as in the exhibited painting, the scene is enclosed by a row of cottages and a bridge placed parallel to the picture plane and cutting off the view into the distance.

The spontaneity of Rembrandt's landscape thus distinguishes it from other Dutch winter scenes. The simple setting with a few country peasants going about their everyday tasks is very different from the festive crowds often found in expansive ice scenes (see cat. 5–7, 111, 60). Dirck Lons's print of a man dressed for winter (fig. 2) also features farm cottages with a frozen canal, a combination that occasionally appeared in Hendrik Avercamp's work.[7] In many respects, Rembrandt's winter scene very closely resembles Esaias van de Velde's ice scenes from the 1620s (cat. 107), especially a painting in the Mauritshuis, The Hague (fig. 3).[8] Both are simple small-scale scenes, with humble dwellings and figures. In the Kassel painting the painterly technique of the trees set against the sky is similar, as are the bright local colors – so surprising in Rembrandt's work. No less significant are the differences between Rembrandt and Esaias. Rembrandt's composition reflects a different organizational approach. The exhibited painting consists of several broad horizontal strata, beginning with deep blue sky with a lighter area below. The cottages and other structures form a unified group (compare Esaias's large single house), and the frozen river is divided into bands of bright sunlight and shadow.[9] Rembrandt's larger, broadly painted figures frame the design at the left and right.

By 1646, when Rembrandt painted this winter scene, he had almost stopped painting landscapes, although he continued to draw out of doors. The convincing naturalism of this winter-

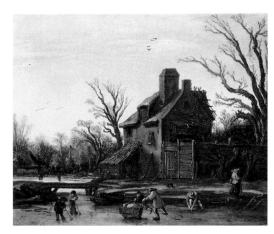

Fig. 3. Esaias van de Velde, *Skaters before a House*, signed and dated 1624, panel, 26 x 32 cm., Mauritshuis, The Hague, inv. 673.

scape is very different from almost all of the artist's other landscape paintings, which are generally fanciful, imaginary scenes with large mountains and dramatic lighting effects (see Introduction, fig. 56). Even the *Stone Bridge* (cat. 76), probably derived from a site near Ouderkerk, is rendered theatrical by a brilliant, dramatic spotlight piercing the storm clouds.

In his earlier landscapes, Rembrandt combined genre-like features and bits of observed natural scenery within an imaginary landscape structure derived from the work of Hercules Segers and the Flemish landscape tradition. However, rather than making a landscape such as that in Braunschweig (see p. 97, fig. 20) more humane and intimate,[10] the contrast between naturalistic and fantastic elements in fact intensifies the sense of awe and brooding in Rembrandt's mysterious landscapes. The expressive effects of Rembrandt's earlier landscape paintings thus were entirely different from the bold, simple naturalism of the exhibited winter landscape.

A.C.

1. Gary Schwartz (1985, pp. 249–53) speculates that this painting may have belonged to Martin van den Broeck in 1647, since he owned another painting dated 1646. However, it seems unlikely that Rembrandt would have sold such a small sketchy landscape, if only because it is so completely different from his other paintings. Only one other landscape painting by Rembrandt is recorded in seventeenth-century inventories, sold from the estate of Boudewijn de Man, Delft in 1644 for fl. 166 (*Rembrandt Documents* 1979, p. 240).

2. Emile Michel (1894, vol. 1, pp. 319–20) wrote that the painting "has all the vivid and sudden quality of a sketch from nature, reproducing with absolute sincerity a simple motive, painted in a few minutes from the scene before the artist's eyes," an opinion shared by Bell (1899, p. 78) and Hind (1932, pp. 114–15).

3. See Introduction, note 65.

4. E.F. Gersaint (*Catalogue raisonné de l'oeuvre de Rembrandt* [Paris, 1751], p. 163, no. 200) says that Rembrandt habitually carried prepared etching plates. Certain landscape etchings, such as Bartsch no. 2221, may well have been done on the spot. The careful arrangement of the figures and strong similarities between Rembrandt's work and other Dutch landscapes, especially Esaias van de Velde's winter landscape (fig. 3), make it unlikely that Rembrandt actually made his painting out of doors. Stechow (1966, pp. 90–91) leaves that possibility open.

5. In the 1656 inventory are listed "een lantschappie nae 't leven" (nos. 69, 291) ["a small landscape after nature"], "eenige huysen nae 't leven" (no. 68) ["some houses after nature"], "een begone lantschappie nae 't leven" (no. 304) ["an unfinished small landscape after nature"]; *Rembrandt Documents* 1979, pp. 355, 379–80.

6. Eisler 1918, pp. 267–68, fig. 127. Benesch 1973, no. 839; see also nos. 833, 1232, 1234, 1241, 1312, 1313. Amsterdam, Rijksprentenkabinet cat. 1985, no. 31, as c.1650.

7. C. Welcker 1979, no. T.62.2, pl. 13. Stechow (1966, p. 90) suggested that Rembrandt's bolder and freer brushwork and stronger and more brillant light may have been influenced by Isack van Ostade's work, particularly in a painting in Berlin (West), inv. 1709.

8. The relationship was suggested by Stechow (1966, p. 87) and developed more fully by Haak (1969, p. 199). Larsen (1983, p. 71) unconvincingly proposed Aert van der Neer as another source for Rembrandt. E.K.J. Reznicek suggests that Rembrandt directly borrowed the motif of a woman with a hat followed by a dog from Esaias and thus actually knew the work illustrated in fig. 3 (Keyes 1984, p. 140).

78 (PLATE 82) *Boston only*

Landscape with the Rest on the Flight into Egypt, 1647

9. Stechow (1966, p. 91) compared this banded composition to an otherwise very different painting of the following year: the *Flight into Egypt*, in Dublin (cat. 78).

10. Schneider has recently stressed the role that naturalistic components play in Rembrandt's landscapes made prior to the exhibited work but may overestimate the effects time has had in darkening and intensifying the contrasts in Rembrandt's landscapes. See C. Schneider 1984b; summarized in a paper delivered at the meeting of the College Art Association, New York, 1986.

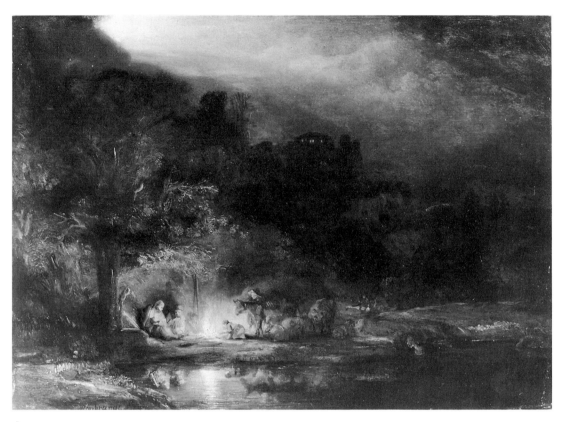

78

Signed and dated bottom left: Rembrandt f.1647
Oil on panel, 13⅜ x 18⅞ in. (34 x 48 cm.)
The National Gallery of Ireland, Dublin, no. 215

Provenance: Henry Hoare, Stourhead, Wiltshire, by 1752; thence by descent; sale, Stourhead, London (Christie's), June 2, 1883, no. 68 (£514), purchased by the National Gallery of Ireland.

Exhibitions: London, Royal Academy, 1870, no. 29; London, Royal Academy, 1894, no. 91; London, Royal Academy, *Rembrandt*, 1899, no. 51; London 1929, no. 140; Amsterdam/Rotterdam, *Rembrandt*, 1932, no. 57; Amsterdam, Rijksmuseum, *Rembrandt*, 1969, no. 8, ill.; London 1985, no. 24, ill.

Literature: Smith 1829–42, vol. 7, no. 603; Burnet 1849, p. 71; Waagen 1854–57, vol. 3, p. 172; Bode 1883, p. 592, no. 261; Dutuit 1883–85, p. 45, no. 55; Wurzbach 1886, no. 197; W. Armstrong, *Magazine of Art*, 1890, p. 286; Michel 1893, pp. 366, 555; Michel 1894, vol. 2, p. 234; Bode, Hofstede de Groot 1897–1906, no. 342; Bell 1899, pp. 78, 141; Wurzbach 1906–11, vol. 2, p. 413; Hofstede de Groot 1908–27, vol. 6, no. 88; Valentiner 1909, ill., p. 290; Eisler 1918, p. 209, fig. 128; Gerstenberg 1923, p. 70, pl. 51; Grosse 1925, pp. 107–108, 123, note 168; H. Walpole, "Journal of Visits to Country Seats," *Walpole Society* 16 (1928), p. 42; Bredius 1935b, no. 576; H.E. van Gelder 1946, p. 166; Knuttel 1956, p. 146; Bauch

1966, no. 80; Stechow 1966, pp. 61, 174, 176; K. Clark, *Rembrandt and the Italian Renaissance*, New York, 1968, p. 216; Gerson 1968, p. 324, no. 220; Bredius, Gerson 1969, p. 487, no. 576, ill.; Haak 1969, p. 205, fig. 335; Hamann 1969, pp. 344–45, fig. 237; Lecaldano 1973, no. 278; Keyes 1975, vol. 2, p. 192; S. Schwartz 1975; Andrews 1977, p. 155, pl. 136; K. Clark, *Introduction to Rembrandt*, New York, 1978, p. 83, fig. 86; Dufey-Haeck 1979; Larsen 1983, pp. 22–24, 71–72, pl. 13; Munich 1983, p. 194; Falkenburg 1985; London 1985, pp. 62–65; Schwartz 1985, p. 246, fig. 276; Dublin, cat. 1986, no. 215, fig. 133; C. Tümpel 1986, pp. 246–47, no. 68, ill.

Among Rembrandt's few landscape paintings this dated work of 1647 is a late work and the only night scene. The artist's other landscapes frequently depict dark, stormy scenes, but none is a proper nocturne. Horace Walpole described the picture in 1762 as simply *A Nightpiece*[1] and in 1854 Waagen called it *Two Gypsies by Moonlight*;[2] Smith in 1836 described it as "a company of travelers at the base of a hill."[3] Bode was then the first author to correctly recognize it as a scene of the *Rest on the Flight into Egypt*.[4]

The subject is not, in fact, mentioned in the Bible (see Matthew 2:13-15), which relates only that King Herod, having been informed that a new king of the Jews had been born, decreed that all male children in Bethlehem under the age of two be killed. An angel warned Joseph, saying, "Rise, take the child and his mother, and flee to Egypt." The episode of the Rest on the Flight is, however, one of the legends that later embellished the tale. Rembrandt etched and drew the subject of the Rest on the Flight, and many of his pupils and followers painted it, but rarely with so much emphasis on the landscape.[5] There was a longstanding visual tradition of depicting the Rest on the Flight (see cat. 66) beginning by 1320 and gaining popularity after Patinir's influential landscapes.[6] However, as Bode was again the first to note,[7] Rembrandt's

Fig. 1. Adam Elsheimer, *Landscape with the Rest on the Flight into Egypt*, signed and dated 1609, copper, 31 x 40 cm., Alte Pinakothek, Munich, inv. 216.

Fig. 2. Hendrick Goudt after Adam Elsheimer, *Landscape with Flight into Egypt*, 1613, engraving.

specific inspiration was Adam Elsheimer's *Landscape with the Rest on the Flight into Egypt* of 1609 (fig. 1), which was engraved by the Utrecht nobleman Hendrik Goudt in 1613 (fig. 2). Rembrandt's great Flemish counterpart, Peter Paul Rubens, had earlier been inspired by Goudt's print after Elsheimer in a landscape of 1614 (hence the year after the print appeared), now preserved in Kassel (Staatliche Kunstsammlungen, Gemäldegalerie, inv. 87). Elsheimer's picture depicts the subject as a night scene with a diagonal composition of silhouetted trees and a still expanse of water illuminated by both moonlight and firelight. While Rembrandt eliminates Elsheimer's central motif of the Holy Family traveling with the aid of a torch, details like the tiny figure crouching by the fire and the livestock standing nearby confirm the connection between the two works.

Although Rembrandt was inspired by Elsheimer both directly and indirectly on several other occasions,[8] his sole concern with landscape and the natural effects of moonlight in the Dublin painting is new. Other, earlier artists had painted, drawn, and etched nocturnal subjects (see Introduction); late mannerist prints often represented the Nativity as a night scene, and Willem Buytewech and Jan van de Velde explored in allegorical and mythological prints the chromatic effects of nocturnal illumination. Further, Esaias van de Velde painted nocturnal scenes of soldiers plundering as early as 1620, and by 1625 Pieter de Molijn painted genre scenes set out of doors and at night.[9] In 1630, Cornelis Vroom painted a night scene with a diagonally receding river bank illuminated by a campfire (see fig. 3). And by the late 1640s, immediately preceding Rembrandt's painting, Jan Asselijn (see cat. 9, fig. 2) and Aert van der Neer had painted night scenes that combine the effects of moonlight and fire or torchlight. But, as Stechow observed, Rembrandt's painting

Fig. 3. Cornelis Vroom, *Nocturnal River Panorama*, signed and dated 1630, panel, 41.5 x 63.7 cm., Staatliches Museum, Schwerin, inv. G 122.

achieves a new synthesis and "poetic climax" in the history of painted nocturnes.[10] The landscape, the glint of the fire, and the sheen of moonlight are fused with an unprecedented effect of mystery. In the Dublin painting Rembrandt achieved a new "coloristic unity . . . the dark browns, gray and dull green of the landscape blend to perfection with the warm orange of the fire and the muted red-brown and gray in the figures."[11]

Inscriptions on early Dutch prints depicting the Rest on the Flight often stressed the role of the Virgin as the mother of God who enabled the "heavenly light" to take refuge in Egypt, or emphasized the sublime purity of the Christ Child who was born to the Virgin Mary and the chaste Joseph.[12] The Latin verses on Goudt's print after Elsheimer recall the former idea in their metaphorical play on Elsheimer's innovative decision to depict the Flight in a nocturnal setting, since they speak of the "Light of the World fleeing into the Darkness." In Rembrandt's landscape the wonder of the spiritual event is manifested in a natural but pointedly exotic landscape setting. By adding the darkened form of a castle with glinting

windows on the hillside, Rembrandt transports the biblical story to a realm more foreign than Elsheimer's setting. For Gerson the background with its fantastic structure and vigorously painted trees recalled Rembrandt's *Landscape with a Castle* (Louvre, Paris, inv. RF 1948-35).[13] Potterton also noted that this "Claudian building" and the composition generally may reflect Rembrandt's early study with Jacob Pynas.[14]

Rembrandt's painting drew early admirers. Among the works by his contemporaries and pupils that seem to reflect its influence, we count Jan Lievens's *Landscape with the Rest on the Flight* in the Thyssen-Bornemisza Collection, Lugano.[15] While in the collection of Henry Hoare of Stourhead, the Dublin painting was engraved by J. Wood in 1752; the print was later reissued by Boydell in 1779.[16]

P.C.S.

1. *Walpole Society* 16 (1928), p. 42.

2. Waagen 1854–57, vol. 3, p. 172.

3. Smith 1829–42, vol. 7, no. 603.

4. Bode 1883, p. 542, no. 261.

5. For Rembrandt's etchings of the subject, see Bartsch 1797, nos. 59 and 58 (dated 1645). Potterton (London 1985, p. 64) saw some resemblance in the latter to the poses of the Holy Family in Dublin's painting. For Rembrandt's drawing of the subject, c.1647–48, see Benesch 1977, no. 600. For the two paintings of the *Flight into Egypt*, see Bredius, Gerson 1969, nos. 532A (rejected by the Rembrandt Research Project 1982, as no. C 5) and 552A.

6. See Knipping 1974, vol. 2, pp. 383–87; Dufey-Haeck 1979; S. Schwartz 1975; Falkenburg 1985, pp. 17–25, 137–47.

7. Bode 1883, p. 292, no. 261.

8. For example, Goudt's print after Elsheimer's lost *Tobias and the Angel* (seventeenth-century copies in Statens Museum for Kunst, Copenhagen [inv. 745], and National Gallery, London [no. 1424]) formed the basis for a print by Hercules Segers that Rembrandt actually reworked from the original plate, substituting figures from the Rest on the Flight for Tobias and the Angel. Further, Goudt's print of 1612 after Elsheimer's nocturnal *Philemon and Baucis* probably inspired motifs in several of Rembrandt's

nighttime interiors (e.g., *Christ at Emmaus*, Musée Jacquemart-André, Paris; Bredius, Gerson 1969, no. 539).

9. See Stechow 1966, p. 175, pls. 347 and 349: respectively, Statens Museum for Kunst, Copenhagen, inv. 735, and Musées Royaux des Beaux-Arts, Brussels, inv. 314.

10. Ibid., pp. 174 and 176.

11. Ibid., p. 177.

12. See Jacob Matham's print of 1589 after Goltzius (Hollstein, nos. 120 and 121).

13. Bredius, Gerson 1969, p. 609, under no. 576.

14. Potterton, in London 1985, p. 64.

15. Lugano, cat. 1969, no. 166, pl. 144.

16. See reproduction in London 1985, p. 65, fig. C.

Roeland Roghman

(Amsterdam 1627–1692 Amsterdam)

Baptized on March 14, 1627, in the Nieuwe Kerk in Amsterdam, Roeland Roghman was the son of the engraver Hendrick Lambertsz Roghman and Maria Savery. Roeland was probably named in honor of his uncle, Roelandt Savery, who also may have given him his first instruction in art. Little is known of Roghman's life. Houbraken informs us that he was a friend of Rembrandt and van den Eeckhout, was the teacher of Jan Griffier, and was blind in one eye. In 1646 and 1647 he executed at least 241 drawings in black and white chalk, many with wash, of the castles and country villas in the provinces of Holland, Utrecht, and Gelderland. These drawings were together as late as 1800 in the Ploos van Amstel collection but now are dispersed. His non-topographical drawings often depict mountainous scenery and woodlands. About fifty etchings by his hand, mostly of Dutch subjects, are also known. He collaborated with his sister, Geertruydt Roghman on a series of landscape prints, *Plaisante lantschappen* (*Pleasant Landscapes*). The absence of dates on his paintings, which are not numerous, has frustrated efforts to trace a chronology in his work. Recollections of Alpine and southern scenery appear in his art, but there is no proof that he traveled south. The influence of Hercules Segers and Rembrandt have been observed in his art, but his personal style is original. In 1661 he made a will in Amsterdam but in 1664 recanted it. He was buried on January 3, 1692, in the Saint Anthonie cemetery in Amsterdam.

P.C.S.

Literature: Houbraken 1718–21, vol. 1, p. 173, vol. 2, p. 8; vol. 3, p. 358; Weyerman 1729–69, vol. 1, p. 397; Descamps 1753–64, vol. 1, p. 424; Bartsch 1803–21, vol. 4, pp. 13–34; van Eynden, van der Willigen 1816–40, vol. 1, p. 378; Nagler 1835–52, vol. 13, p. 313; Immerzeel 1842–43, vol. 3, p. 23; Kramm 1857–64, vol. 5, p. 1380; A.D. de Vries 1885–86, p. 311; Wurzbach 1906–11, vol. 2, pp. 464–65; Thieme, Becker 1907–50, vol. 28 (1934), p. 518; Martin 1935–36, vol. 2, p. 291; Maclaren 1960, p. 353; Rosenberg et al. 1966, p. 95; Stechow 1966, p. 138; Dattenberg 1967, pp. 276–79; Sumowski 1979; Kloek 1975; Haak 1984, p. 375.

Valley with Travelers

Oil on canvas, 44⅞ x 65¾ in. (114 x 167 cm.)
Galerie Bruno Meissner, Zurich

Provenance: Bayerische Staatsgemäldesammlungen, Munich, inv. 12026

Literature: *Münchner Jahrbuch* 8 (1957) p. 238.

A road runs through a darkened valley with a tree-covered hillside on the right and steep mountains on the left. In the foreground a drover with sheep, a steer and a pack animal move along the road toward the viewer. Further back at the left a simple footbridge crosses a rushing stream. The road weaves further back beneath tall trees. In the distance the prospect of mountains and a broad valley takes on a bluish hue.

In the absence of dates on Roghman's paintings, a chronology of his development is hypothetical. The *Dune Landscape with Wagon* (signed, Museum der bildenden Künste, Leipzig, inv. 622) recalls van Goyen's art, and may be an early work by Roghman but the majority of Roghman's paintings are large mountain views in a style derived from Rembrandt. The subject, painterly execution and somber palette of this work are all typical of Roghman's art. Signed or monogrammed mountain valley landscapes by Roghman are in the Rijksmuseum, Amsterdam (inv. A 4218), the Rijksmuseum Twenthe, Enschede (inv. 165), the Gemäldegalerie, Kassel (inv. 227 and 228), Musée Fabre, Montpellier (cat. 1926, no. 273), with S. Nijstad, The Hague in 1972,[1] and in sale, Amsterdam (F. Muller), November 21, 1933, no. 51. Among these works, the paintings in Amsterdam and Kassel (inv. 227) are closest in design to the exhibited painting. The *Cascade with Fishermen* in the Lugt collection (Institut Néerlandais, Paris, inv. 68),[2] the larger but compositionally related *River Landscape with Bridge* now with S. Nijstad, The Hague,[3] *Mountain View with a River*, Statens Museum for Kunst, Copenhagen (no. 589), and the *River Landscape with Shepherds* (fig. 1) are also fully

79

Fig. 1. Roeland Roghman, *River Landscape with Shepherds*, signed, canvas, 81 x 100 cm., Private Collection, on loan to Kunsthaus, Zurich.

Fig. 2. Roeland Roghman, *Forest View with Mountains*, canvas, 134 x 170.5 cm., Statens Museum for Kunst, Copenhagen, no. 590.

Jacob van Ruisdael

(Haarlem c.1628/29–1682 Amsterdam ?)

signed and share similarities in execution. Although unsigned, the large *Forest View with Mountains* (fig. 2) which has correctly been assigned to Roghman since it was purchased for the Danish royal collection in 1759, appears to be an expanded variant of the present work's design.[4] It employs many of the same elements – the wooded hillside on the right, the central roadway, and, farther back, a silhouetted bridge and tall mountain – but in a more open and enlarged composition. Roghman executed drawings and prints of Tirolean mountain views. Several of his sketches of mountain valleys with travelers and bridges, specifically two wash drawings in the Kunsthalle, Hamburg (inv. 1921-73) and the Prentenkabinet der Rijksuniversiteit, Leiden (no. 245, from the collection of C. Hofstede de Groot), share features of the Meissner painting's design but no true preparatory study for the composition is known.

Gerbrand van den Eeckhout's debt to Roghman's landscapes of this type is evident in catalogue 26.

P.C.S.

1. See Musée des Beaux-Arts, Montreal, *Rembrandt et ses élèves*; also shown at Art Gallery of Ontario, Toronto, 1969, no. 107, ill.

2. Paris 1983, no. 68, pl. 21.

3. Canvas 188 x 175.5 cm.

4. See Copenhagen, cat. 1951, p. 261, no. 590. Compare also the design of Roghman's signed painting in the Musée Fabre, Montpellier.

Jacob van Ruisdael was born in Haarlem in 1628 or 1629. Although there is no record of his birth, a document of June 9, 1661, records his age as 32. However, this cannot be taken as unassailable evidence, since the ages given for other painters mentioned in the document are not consistently correct. Jacob's father, Isaack, was born in Naarden (c.1599), as were his uncles Jacob (c.1594), Pieter (c.1596), and Salomon. At that time the family name was still de Goyer. Jacob, a sheriff and "kistemaker" in Naarden, called himself Ruysdael, possibly because his father had resided in Castle Ruisdael (or Ruisschendael) near Blaricum. In early records Isaack and Salomon were known by the surname de Goyer but later also changed their names. Only Pieter, a linen merchant in Alkmaar, retained the family name.

Described as a widower, Isaack married Maycken Cornelisz on November 12, 1628. Jacob may have been a son of this marriage, although the possibility that he was born to an earlier marriage cannot be excluded. While his father and uncles spelled the family name Ruysdael, Jacob consistently used Ruisdael. Isaack was mentioned as an ebony framemaker, an art dealer, and a maker of patterns for tapestries and wall coverings. Apparently he was also a painter, for paintings by him are mentioned in inventories, and according to Houbraken, he was the teacher of Isaack Koene. In a document of 1634, in which Ruisdael's father was fined because Jan van Goyen worked as a painter in his house, Isaack was not mentioned as being a free master painter ("vrij meester schilder") but as an apprentice ("leerknecht").

As an artist, Jacob van Ruisdael made an astonishingly early and impressive start. His earliest dated works are from 1646, thus painted when he was only seventeen or eighteen years old. According to a membership list compiled in the eighteenth century, he joined the Haarlem Saint Luke's Guild in 1648. Although we have no record of his teacher, Jacob was surely familiar with the work of his uncle Salomon. There are also similarities with the work of Cornelis Vroom, which are particularly evident in paintings of 1648 and 1649. It is equally possible that his father gave him his first lessons in the art of painting. Houbraken, Ruisdael's earliest biographer, mentions that at the instigation of his father, Ruisdael had learned Latin in his youth, and had later also practiced the science of medicine, winning great renown for performing assorted "manuale operatien" in Amsterdam. According to a register of Amsterdam doctors, a medical degree was conferred on a "Jacobus Ruijsdael" in Caen on October 15, 1676. This name, however, is the only one on the list that has been crossed out. In addition, a landscape with waterfall was sold in 1720 as by "Doctor Jacob Ruisdael." It is not inconceivable, therefore, that the painter was also active as a doctor.

Jacob made several journeys early in his career, among others to Egmond (near his uncle in Alkmaar) and Naarden (where his uncle Jacob lived). Around 1650, and certainly by 1651, the date of his earliest dated view of Bentheim, he traveled to this area on the Dutch-German border, perhaps together with Claes Berchem, who, according to Houbraken, was a "groot vrint" (great friend). The castle at Bentheim appears in the works of both artists at this time. Their journey probably continued on to Steinfurt, the birthplace of Berchem's father, Pieter Claesz. Steinfurt Castle also appears in several of Ruisdael's paintings. In the 1650s, possibly around 1656, Ruisdael settled in Amsterdam. On June 14, 1657, the painter, originally from a Mennonite family, petitioned the council of the Reformed Church in Amsterdam for permission to be baptized. At that time he lived in the Beursstraat in Amsterdam and was not married. His baptism

took place three days later in Ankeveen. In 1659 Ruisdael obtained the rights of citizenship in Amsterdam. Not long thereafter, on July 8, 1660, he testified that Meyndert Lubbertsz, later known as Hobbema, had worked and studied with him for several years.

Ruisdael drew up two wills, both in 1667. In the first, dated May 23, Ruisdael, "sickly in body but moving and standing" ("sieckelycke van lichaem doch gaende en staende"), appointed his half-sister Maria as heir, with the stipulation that she pay an adequate amount for the support of their father. Four days later Ruisdael revoked all earlier wills and made his father his sole heir. Houbraken's remark that Ruisdael apparently remained unmarried so that he could help his father may, therefore, contain a grain of truth. In addition, the fact that the flood of documents concerning Isaack's financial problems decreased after 1646 probably indicates that Jacob contributed to the support of his father. According to the will, Ruisdael lived in the Kalverstraat near the Dam. Shortly thereafter, from about 1670, he lived on the south side of the Dam, above the book and art dealer Hieronymus Sweerts. Jacob van Ruisdael was buried in the Grote Kerk in Haarlem on March 14, 1682. However, since he filed a document in Amsterdam in January of that year, it is unlikely that he died in Haarlem.

Ruisdael was a painter, draftsman, and etcher of many categories of landscapes. Many of his paintings are dated between 1646 and 1653, but few thereafter. Following his early dunescapes and views of Holland, Ruisdael developed landscapes with large central motifs, such as oaks, ruins, water mills, wooded landscapes, and seascapes. Jan Porcellis (c.1584–1632) and Simon de Vlieger had an influence on his marines. Later in his career he devoted himself to the depiction of waterfalls, panoramic landscapes, winter landscapes, beach scenes, and city views.

Thirteen etchings are known, all of which date from his early career, and numerous drawings. Claes Berchem, Philips Wouwermans, Adriaen van de Velde, and Johannes Lingelbach (c.1624–1674) all painted staffage in Ruisdael's works. Ruisdael collaborated with Thomas de Keyser (1596/97–1667) on a large-scale landscape portrait of the family of Cornelis de Graeff, burgomaster of Amsterdam (National Gallery of Ireland, Dublin, no. 287).

Although Meindert Hobbema was the artist's most important pupil, he had many other followers and imitators, including his cousin Jacob Salomonsz van Ruysdael (1629/30–1681), Cornelis Decker (before 1623–1678), Jan van Kessel (1641/42–1680), Adriaen Verboom (c.1628–c.1670), and Roelof van Vries (c.1631–after 1681). Through the wide variety of his landscape subjects, his unparalleled compositional skill, and careful technique, Ruisdael raised the art of landscape painting from the mere rendering of a "playsante plaats" to classic images of untamed nature.

J.G.

Literature: Houbraken 1718–21, vol. 3, p. 65; Descamps 1753–64, vol. 3, pp. 9–12; Bartsch 1803–21, vol. 1, pp. 307–19; Goethe 1816; Smith 1829–42, vol. 6, pp. 1–107; vol. 9, pp. 680–718; Nagler 1835–52, vol. 14, pp. 92–104; Immerzeel 1842–43, vol. 3, pp. 41–43; Planche 1857; Kramm 1857–64, vol. 5, pp. 1410–12; de Brou 1863; Héris 1865; van der Willigen 1870; Scheltema 1872; Hafed 1876; Viardot 1876; Duplessis 1878; de Besneray 1884; Bredius 1888b; Michel 1888a; Bredius 1890; Michel 1890; Cundall 1891, pp. 5–38, 145–54; Rosenberg 1891; Thieme 1896; D.F.M. 1897; Riegl 1902; Riat 1906; Wurzbach 1906–11, vol. 2, pp. 517–22; Schubring 1908; Hofstede de Groot 1908–27, vol. 4, pp. 1–349; Bredius 1915; Bradley 1917a; Valentiner 1919; Havelaar 1924; Valentiner 1925–26; Weinberger 1925; Rosenberg 1926; Simon 1927; Pina 1928; Rosenberg 1928a; Kauffmann 1929; Martin 1929; Mayer 1929; Rosenberg 1929; Simon 1930; Wijnman 1932; Rosenberg 1933; Gerson 1934; Mottini 1934; Agafonawa 1935; Konradi 1935; Simon 1935; K. Simon in Thieme, Becker 1907–50, vol. 29 (1935), pp. 190–93; Oldewelt 1938; Simon 1939–40; Renaud 1940; Cunningham 1940; Oldewelt 1942a; Beenken 1943; Rosenau 1958; Maclaren 1960, pp. 353–74; de Bruyn Kops 1966; Stechow 1966; Hagels 1968; Stechow 1968; Wiegand 1971; Fuchs 1973; Kuznetsov 1973; Slive 1973; Burke 1974; Kauffmann 1977; Keyes 1977; Korn 1978; Maschmeyer 1978; Giltay 1980; Schmidt 1981; Duparc 1981–82; The Hague/Cambridge 1981–82; Hagens 1982; D. Sutton 1982; P. Sutton 1982; Slive 1983; Walford 1983.

Dune Landscape, c.1651–1655

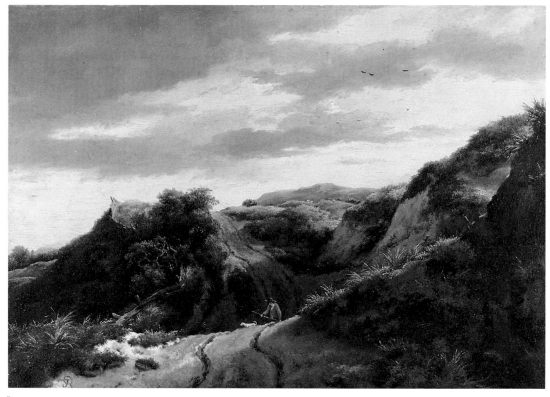

Monogrammed lower left: Jvr
Oil on panel, 13⅜ x 19 in. (34 x 48.3 cm.)
John G. Johnson Collection at the Philadelphia
Museum of Art, no. 563

Provenance: Purchased by J. Smith in Paris for frs.3200,
and sold to Charles Brind; sale, Charles Brind,
London (Christie's), May 10, 1849 (£404 5s to
Rutley); sale, Lynne Stevens, London (Christie's)
May 9, 1895, no. 344 (£315); G. Johnson, 1902.

Exhibitions: London, British Institution, 1840, no. 49;
(lent by Charles Brind); New York, World's Fair,
Masterpieces of Art, 1939, p. 165, no. 340.

Literature: Smith 1829–42, vol. 9, no. 53; Hofstede de
Groot 1908–27, vol. 4, nos. 897, 914; Philadelphia,
Johnson cat. 1913, p. 123; Simon 1927, pp. 26, 76;
Rosenberg 1928a, pp. 33, no. 562, ill. 654;
Philadelphia, Johnson cat. 1941, p. 36; Philadelphia,
Johnson cat. 1972, p. 76, ill. p. 292; p. 117, no. 70;
Paris 1983, p. 117.

A deeply rutted cart track winds through an
area of steeply sloping dunes. Along the left side
of the path is a decrepit wooden fence and some
low undergrowth. Making his way along the
track, a wanderer with his dog toils up out of a
valley. The precipitous drop of the valley is
emphasized by its closeness to the dune in the
right foreground that mounts high in the picture
plane. Strong contrasts in light and shadow
emphasize both the variations in height and
depth and the sequence of planes within the
composition. The irregularity of the forms is also
strengthened by accents of light, such as those
which outline the crest of the first dune. The
imposing landscape that results from these
pronounced contrasts in height and depth and in
light and shade is in some ways reminiscent of
the mountain landscapes of Hercules Segers and
Pieter Bruegel the Elder.

Rosenberg grouped this undated painting
together with some of Ruisdael's other native
Dutch landscapes, of which two are dated 1651

(see fig. 1) and 1652, which originated in the same period as paintings with more exotic themes drawn from the artist's trip to Bentheim.[1] There are three other paintings in which dunes are the central motif, and which are also of comparatively small size. Nihom-Nijstad noted the relationship of the Philadelphia painting to the *Landscape with Herder and Flock* in the Fondation Custodia (Lugt Collection) in Paris.[2] Slive, furthermore, brought the Paris painting together with the *View of the Sea from the Dunes* in the Ruzicka collection, Kunsthaus, Zurich,[3] and the *Dune Landscape with Rabbit Hunt* in the Frans Halsmuseum, Haarlem,[4] and dated these paintings, all fairly sketchily rendered, to the mid-1650s, with the Haarlem painting dating from early or mid-1650s. The Philadelphia *Dune Landscape* also probably originated in the early or mid-1650s.

Although dunes appear regularly in Ruisdael's landscapes, it is mostly as a motif in the fore- or background of a larger composition. Seldom do they form such a central motif as in the exhibited painting, in which trees and cultivation are almost totally absent. Similarly sparse dunescapes occur but rarely in the work of other seventeenth century landscape painters. On the other hand, the motif of the crudely constructed wooden fence is much more frequently encountered (see cat. 90), and sometimes forms an essential part of Ruisdael's composition.[5]

Dunes are a specifically Dutch motif, and one that is particularly associated with the area around Haarlem. In addition to being a popular subject for painters, these areas of virgin nature were also celebrated in seventeenth-century Dutch literature. One early example is in the *lofdichten* of Karel van Mander, poems written in praise of the city of Haarlem: "Long wide and broad the dunes appear, where rabbits run like ants in the grass."[6] At the beginning of the

Fig. 1. Jacob van Ruisdael, *Road in the Dunes*, signed and dated 1651, panel, with dealer E. Slatter, London, c.1945.

eighteenth century (1708) Pieter Vlaming wrote, "I turn toward the dunes, which raise their white crowns above the encircling trees."[7] Iconographic interpretations of the *Dune Landscape* have rarely been put forth, unless one applies Raupp's conclusions (formed in the context of other paintings) that similar paths symbolize the path of life,[8] or that the broken-down wooden fence suggests an allusion to transitoriness.

J.G.

1. Rosenberg 1928a, p. 33.

2. Paris 1983, no. 70, fig. 17, demonstrates that this painting is a fragment of a larger work that may originally have had a vertical format; The Hague/Cambridge 1981–82, no. 25, ill. (mid-1650s).

3. The Hague/Cambridge 1981–82, no. 26, ill. (mid-1650s).

4. Ibid., no. 28, ill. (early- or mid-1650s).

5. Rosenberg 1928a, no. 1.

6. "Lanck, wijt en breet daer de duijnen verschijnen, Daer loopen de konijnen als in 't gras de mieren." Rutgers van der Loeff 1911, p. 21; see also van Mander, Miedema 1973, vol. 2, pp. 536–37, and esp. p. 540, commentary under VIII 3a.

7. "Ik keer my na de duinen, Die uit een reeks van boomen, als een ring, Om hoog het wit verheffen van hun kruinen," quoted in Beening 1963, p. 378.

8. Raupp 1980, p. 103 (with respect to Jan van Goyen).

Two Water Mills with an Open Sluice, 1653

Monogrammed and dated on the stones at left:
JvR 1653
Oil on canvas, 26 x 33¼ in. (66 x 84.5 cm.)
The J. Paul Getty Museum, Malibu, 82.PA.18

Provenance: Sale, J. Goll van Franckenstein, Amsterdam, July 1, 1833, no. 70 (fl.1,980 to Clarke for C.J. Nieuwenhuis); sale, Casimir Périer, London (Christie's), May 5, 1848, no. 13 (£367 10s. to Gardner); sale, J.D. Gardner (Bottisham Hall), London (Christie's), March 25, 1854, no. 71 (£451 10s. to Brown); sold by Brown to Edmund Foster, Clewer Manor, near Windsor; sale, Richard Foster of Clewer Manor, London (Christie's), June 3, 1876, no. 13 (£1,837 10s. to Durlacher); Alfred de Rothschild, 1876; Baroness Mathilde von Rothschild, Frankfurt; dealer Blumenreich, Berlin, 1923; dealer Kleykamp, The Hague (cat. 1927, no. 34, ill.); H.M. Clark, London, c.1930; private collection, Switzerland, 1945; private collection, the Netherlands; sale, Laren (Christie's), October 20, 1980, no. 252, ill.; private collection 1981–82.

Exhibitions: Basel 1945, no. 79; The Hague/Cambridge 1981–82, no. 23, ill.

Literature: Smith 1829–42, vol. 6, p. 78, no. 250 (see also p. 36, no. 111); Waagen 1854–57, vol. 4, p. 287; Hofstede de Groot 1908–27, vol. 4, no. 169d; *Beeldende Kunst* 15 (1927), no. 32, ill.; Rosenberg 1928a, p. 33, no. 102, fig. 62; Simon 1930, p. 81; Maclaren 1960, p. 359, note 7; Walford 1981, p. 164; The Hague/Cambridge 1981–82, no. 23; Hagens 1982, p. 9, ill. p. 8; Schuster 1982, p. 157; *Gazette des beaux-arts* 101, supplement (March 1983), p 37, fig. 205.

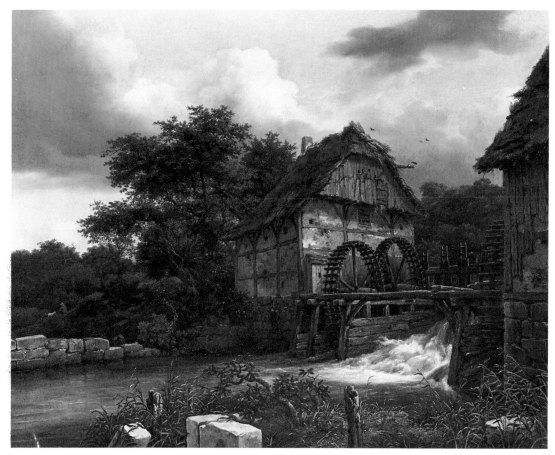

81

The central focus of the painting is the half-timbered water mills and the seething water that passes between them. Of the two mills lying opposite each other, only a portion of the wheel and house of the right-hand mill is visible, framing the composition on that side. The sluice between the two mills is open and lets in the swirling water.

Ruisdael had seen similar water mills during his travels to Bentheim and selected them as the subject for a series of paintings. The exhibited work, of 1653, is the only one with a legible date. The other paintings probably originated shortly before 1653 or about the same period. A painting formerly in the collection of Lord Swaythling shows the same water mills from a similar vantage point.[1] In that painting, the mill on the left is given further emphasis by raising the roof above the level of the treetops. The shape of the building is modified in some respects, the water

is given a more important place, and the right mill is in ruins. In addition, there are other paintings showing the same mills from the opposite side of the water, including a painting in the National Gallery, London (no. 986) from about 1650–52.[2] Finally, there are two paintings in which the mills are seen from the other side.[3]

It is risky to attempt to identify these water mills with existing water mills, as it is seldom known how a particular mill may have appeared

in the seventeenth century. Most important, Ruisdael rarely adhered strictly to a given topographical site but, rather, selected for use such compositional motifs as suited him. Maschmeyer believed that the mills of Haaksbergen were represented in the Getty painting.[4] Slive, on the other hand, supposed that the mills in this entire series of paintings were inspired by those on the Singraven estate near Denekamp and compared them with the mills in two paintings by Hobbema that have been identified as such.[5] There are several differences between the mills of Hobbema and those of Ruisdael: the mill to the left of the stream in Hobbema's paintings has a transverse addition that is consistently absent in Ruisdael's compositions;[6] and the mill on the right in the former has three wheels and in the latter only two. The mills of Singraven, which were sold along with the estate by the Count of Bentheim to an agent in 1651, were the most important mills in Twenthe at this time.[7] Perhaps these mills did indeed serve as a starting point for Ruisdael, but he employed them with great freedom in his compositions.

Although water mills occur frequently in landscapes of the sixteenth and seventeenth centuries, not until Ruisdael were they elevated to the role of the central motif in a painting. It was precisely in this period of the 1650s that Ruisdael showed a preference for portraying the imposing, frequently non-Dutch motifs that gave his landscape painting such a unique character. Only in the seventeenth century were half-timbered houses noteworthy, as is evident from the travel journal of Vincent Laurensz van der Vinne, who together with Guillam du Bois and Dirck Helmbrecker journied to Germany and beyond in 1652–55. Before reaching Cologne, van der Vinne made a sketch of half-timbered farmhouses and noted: "the farm or village houses are drolly ["kluchtich"] constructed of clay and wood, and thatch (and

sufficiently in this manner, which I have drawn from life)."[8] The turbulent spill of the water must also have attracted Ruisdael, for it became a specialty in his later waterfall paintings. Through the skillful composition of this painting, by which the mills are seen more or less from below against dark cloud formations, and through the extremely detailed fall of light, Ruisdael has elevated the half-timbered mill from mere "drollery" to an awesome and imposing motif.

Guided by Wiegand's iconographic interpretations of other Ruisdael landscapes, one can also see the flowing water in the Getty painting as a symbol of the transitoriness of human life.[9] In Jan Luyken, furthermore, we find the water mill as an emblem in which the wheel is a symbol for people who are urged on by the water, the symbol of Christ.[10] A similar reading of the exhibited painting would form a parallel with Kauffmann's vision of the *Mill at Wijk* (cat. 88), which he interpreted as a symbol of people who cannot function without divine inspiration ("ni spiret immota").[11] How valid such interpretations are for the *Two Water Mills with an Open Sluice* cannot be stated with certainty at this time. It seems repeatedly apparent, however, that in general the depiction of earthly nature can be an occasion for mirroring the spiritual world.[12]

J.G.

1. Lord Swaythling, Townhill Park, Southampton, sale, London (Christie's), July 12, 1946, no. 34, ill.; Rosenberg 1928a, no. 107; Maclaren 1960, p. 359, note 8; The Hague/Cambridge 1981–82, p. 81, fig. 36.

2. Rosenberg 1928a, no. 100; Maclaren 1960, pp. 359–60; The Hague/Cambridge 1981–82, no. 22, ill. Variants of this composition are: formerly collection of Sir Audley Neeld, Chippenham, Wiltshire (Rosenberg 1928a, no. 99; Maclaren 1960, p. 359, note 2; The Hague/Cambridge 1981–82, p. 78, fig. 33); a painting known only by a print of 1782 by J.J. de Boissieu (Maclaren 1960, p. 359, note 4; The Hague/Cambridge 1981–82, p. 78, fig. 34); Musée des Beaux-Arts, Strasbourg (Rosenberg 1928a, no. 108; Maclaren 1960, p. 359, note 1; The Hague/Cambridge 1981–82, under no. 22); Collection of Dent Brocklehurst, Sudley Castle, Winchcombe (Rosenberg 1928a, no. 103; Maclaren 1960, p. 359, note 3); Maclaren (1960, p. 359, notes 5 and 6), also mentions a painting in the Museum in Weimar (Hofstede de Groot 1908–27, no. 158) which, according to Simon (1927, p. 74), and Rosenberg (1928a, p. 116, note 7), is a copy; in addition, Maclaren (1960, p. 359, note 9) mentions the painting in the Museum Boymans-van Beuningen, Rotterdam (Rosenberg 1928a, no. 94), as possibly showing the influence of the Swaythling and Getty paintings. Slive (The Hague/Cambridge 1981–82, under no. 22) mentions a weak version (with Lillian Berkman, New York) by another hand.

3. Sale, Edward Habich, Kassel, May 9–10, 1892, no. 125, ill. (Rosenberg 1928a, no. 97; Maclaren 1960, p. 359, note 10; The Hague/Cambridge 1981–82, under no. 22), and sale, A.W.M. Mensing, Amsterdam, November 15, 1938, no. 88, ill. (Maclaren 1960, p. 359, note 11; The Hague/Cambridge 1981–82, under no. 22). This painting is perhaps identical with one sold in Amsterdam (Muller), December 11, 1928, no. 24, ill. (Rosenberg 1928a, no. 102a). Maclaren (1960, p. 359, note 12) also mentions a print by Le Veau, 1781, after a work by Ruisdael then in the Poullain collection. The drawing in the Rijksprentenkabinet, Amsterdam (Giltay 1980, p. 174, no. 4), is accepted neither by Rosenberg (1928a) nor by Slive (in The Hague/Cambridge 1981–82, under no. 22) as by Ruisdael.

4. See Hagens 1982, p. 9; H. Hagens, *Molens, Mulders, Meesters, Negen eeuwen watermolens in de Gelderse Achterhoek, Salland en Twente* (1978), p. 85, reproduces the painting from the Mensing sale and the Amsterdam drawing as of Singraven.

5. The Hague/Cambridge 1981–82, under no. 22, with reference to the identification of the motif in Hobbema's paintings by K. Döhmann and W.H. Dingeldein, *Singraven, de geschiedenis van een Twentsche havezathe* vol. 3 (Brussels, 1934), pp. 144–45.

82 (PLATE 101)

Hilly Landscape with Large Oak, c. 1652–55

6. See Hagens 1982, pp. 9–11; and Döhmann and Dingeldein, *Singraven*, vol. 3, p. 140.

7. See Döhmann and Dingeldein, *Singraven*, vol. 1, p. 150; W.H. Dingeldein, *Singraven* (Enschede, 1969), pp. 93ff.

8. Van de Vinne, Sliggers 1979, p. 50, ill. p. 51. "De boeren of dorp huijsen sijn kluchtich van leem, hout en tieten (en genoech op dees manier, die ick na 't leven geconterfeijt heb) gebouwt."

9. Wiegand 1971, pp. 87ff.

10. Luyken 1711, pp. 18ff.

11. Kauffmann 1977, pp. 379–97.

12. For example, van de Vinne's poem "Rustplaetse en inwendigh gedachten" (van de Vinne, Sliggers 1979, p. 135).

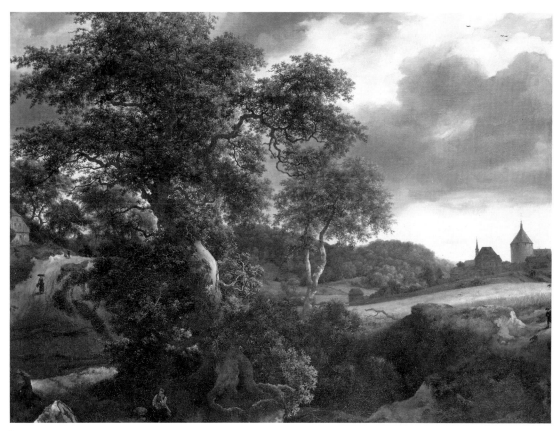

82

Oil on canvas, 41¾ x 54⅜ in. (106 x 138 cm.)
Herzog Anton Ulrich-Museum, Braunschweig, inv. 376

Provenance: Acquired in 1738 by the Duke of Braunschweig for the Gallery at Salzdahlum; removed to Musée Napoléon, Paris, 1807–15.

Exhibitions: Paris 1807, no. 558; Krefeld 1938, no. 107, fig. 19; The Hague/Cambridge 1981–82, no. 17, ill.

Literature: Salzdahlum, cat. 1776, p. 258, no. 16; Ribbentrop 1789, vol. 1, p. 337, no. 16; Filhol 1804–28, vol. 7, no. 442, ill. (engraving by Jean de Saulx); D. Ainé, *Musée Français* (Paris, 1815), ill.

(engraving by Jean de Saulx); Emperius 1816, no. 45; Smith 1829–42, vol. 6, no. 299 (identical with no. 331); Braunschweig, cat. 1836, p. 137, no. 379; Parthey 1863–64, vol. 2, p. 455, no. 13; Riegel 1882, pp. 387ff.; Riegel 1885, no. 83; A. Michel 1887, p. 23; Michel 1890, p. 83; Braunschweig, cat. 1900, p. 276; Michel 1906b, pp. 187, 193; Hofstede de Groot 1908–27, vol. 4, no. 107; Simon 1930, p. 24; Rosenberg 1928a, pp. 23, 76, no. 74, fig. 39; Fink 1954, pp. 54, 90; Braunschweig, cat. 1969, p. 120, fig. 57; Korn 1978, p. 114; Schmidt 1981, p. 52ff., fig. 15; Walford 1981, pp. 158–59; C. Brown 1982, p. 193; Schuster 1982, p. 157; Braunschweig, cat. 1983, pp. 177–78, ill.

The entire composition is dominated by a massive oak tree stretching from the top to the bottom of the picture, its exposed roots clinging tenaciously around a boulder. A ray of sunlight highlights a light-colored patch on the trunk where the bark has been stripped away. Beyond the oak is a young birch tree. At the foot of the oak, by the side of the road at the left, a woman is seated in a meditative pose.

The great tree divides the composition into two parts. To the right is a golden expanse of grain field and a path where a man wanders with a dog. A road in the distance, with two more figures, leads toward a complex of buildings. To the left of the oak a mountain path climbs steeply past a characteristic Westphalian farmhouse; on the path are a woman with a basket on her head and several other figures. In the immediate foreground at the far left is the stump of a birch tree. Recent technical examinations have established that the canvas of the painting has been trimmed on all four sides, most notably on the right. At the right edge of the painting, in fact, parts of a tree have been covered over by the sky.[1]

The stout tower with steeply pitched polygonal roof among the complex of buildings at the right has been identified by Korn as the "Buddenturm" of Steinfurt Castle; a similar tower in the *Landscape with Small Village* (Wallace Collection, London, no. P156)[2] was identified independently by both Korn and Maschmeyer as a view of the same castle.[3] According to Korn, the tower in the Braunschweig painting has been combined with other architectural features of the castle. The identification of this building as Steinfurt Castle indicates that Ruisdael's travels took him farther than Bentheim, once considered the limit of his peregrinations. The still-life painter Pieter Claesz, father of Ruisdael's travel companion Claes Berchem, was born in Steinfurt and perhaps, as Korn has suggested, this was

Fig. 1 Jacob van Ruisdael, *The Great Oak*, signed and dated 1652, canvas, 85.1 x 104.3 cm., collection of Mr. and Mrs. Edward W. Carter, Los Angeles.

sufficient inducement for the two young landscapists to travel there.

Perhaps the most impressive element in the Braunschweig painting is the massive old oak dominating the foreground of the composition. Ruisdael had evinced interest in similar large oak trees from the start of his career, as may be seen in etchings of 1647 and 1649. Following his trip to Westphalia in 1650, these trees with exposed roots often appear set upon a hill or rock, and even more frequently as a foreground motif, as for example in paintings of 1651 and 1652.[4] Ruisdael also etched a landscape view in which a great beech tree clings to a rock in a similar manner. The Braunschweig painting has been dated by Slive to a few years after the *Great Oak* of 1652 (fig. 1).[5]

In the seventeenth century these powerful and uniquely gnarled oaks were probably perceived as *schilderachtig* (picturesque), a concept defined in the theoretical works of Gerard de

Lairesse, among others. Lairesse, in *Het Groot Schilderboek* (1707), contrasted the classical concept of "picturesque" with an older definition of the term, as for example, in "a landscape with perfect and straight-grown trees," which was opposed to "a piece filled with misshapen trees, their branches and leaves wildly and improperly splayed from east to west."[6] In a similar vein, Samuel van Hoogstraeten (1678) also termed Muziano's chestnut trees *schilderachtig*.[7]

The motif of the grain field becomes more frequent in Ruisdael's work and appears as the central motif in some later paintings, such as catalogue 83 and a painting in Rotterdam (Museum Boymans-van Beuningen, inv. 1742).[8] Grain and buckwheat fields were described with obvious pleasure and proprietary delight in seventeenth-century Dutch literature. Vincent Laurensz van der Vinne mentioned them regularly in his travel journal whenever he encountered them;[9] the area of the Gooi east of Amsterdam was especially popular in the summer because of its fragrant buckwheat fields.[10]

The *Hilly Landscape with Large Oak* is thus a compilation of motifs that occur in other contexts throughout Ruisdael's oeuvre and that are here combined with particularly striking effect. Apart from his own direct observation of nature, Ruisdael may also have been inspired by earlier artists in his treatment of colossal trees. Stechow cites Esaias van de Velde, Roelandt Savery, and Jan Lievens as possible precursors;[11] one might also think of landscape studies by or after Pieter Bruegel in which large trees are also prominently featured.[12]

The entire composition of the painting, moreover, is reminiscent of sixteenth-century landscape painting. In Joachim Patinir's *Rest on the Flight into Egypt* (Museo del Prado, Madrid; Introduction, fig. 14), a large tree is placed in the

foreground in front of Mary and the Child, with a grainfield in the right background and a desolate mountain landscape on the left. Falkenburg interprets this contrast between cultivated farmland on one side and wild nature on the other as a reference to the two paths of life, the cultivated landscape symbolizing the sinful world and wild nature the arduous path of the virtuous pilgrim of life.[13] Although it is debatable how far one may presume similar interpretations in the seventeenth century, Ruisdael's compilation of motifs remains intriguing.

J.G.

1. See C. Brown 1982, p. 193, and Braunschweig, cat. 1983, pp. 177–78.

2. Rosenberg 1928a, no. 508; Korn 1978, p. 114.

3. Maschmeyer 1978, pp. 64–66; Korn 1978, p. 114.

4. *View of Bentheim* (private collection, The Hague/ Cambridge 1981–82, no. 12, ill.; and Rosenberg 1928a, no. 15) and *Landscape with Wooden Footbridge* (Frick Collection, New York; Rosenberg 1928a, no. 393).

5. The Hague/Cambridge 1981–82, no. 17, p. 60, with reference to the Birmingham painting, now in the collection of Mr. and Mrs. Edward W. Carter, Los Angeles, (ibid., no. 16); Rosenberg 1928, no. 339.

6. "Een Landschap met gaave en regt opwassende boomen" and "een Stuk vol wanschaapene boomen, welker takken en loof zich woest en ongeschikt van 't oosten na 't westen spreijen," quoted by J. A. Emmems, "Rembrandt en de regels van de kunst," in *Verzameld Werk* (Amsterdam, 1979), vol. 2, p. 158.

7. Hoogstraeten 1678, p. 136.

8. Rosenberg 1928a, no. 92, fig. 123; The Hague/ Cambridge, 1981–82, no. 80, ill.

9. Van de Vinne, Sliggers 1979, pp. 114, 116.

10. Beening 1963, p. 63.

11. Stechow 1966, pp. 71–72.

12. See Berlin (West), Kupferstichkabinett, Staatliche Museen Preussischer Kulturbesitz, *Pieter Bruegel die A. als Zeichner: Herkunft und Nachfolge*, 1975, nos. 42–47.

13. Falkenburg 1985, pp. 144–45.

83 (PLATE 99)

Grainfields, 1660s

83

Signed lower right: JvRuisdael [JvR ligated]
Oil on canvas, 18½ x 22½ in. (47 x 57.2 cm.)
The Metropolitan Museum of Art, New York, bequest of Michael Friedsam, The Friedsam Collection, 32.100.14

Provenance: Louis Viardot, Paris, sold about 1863; sale, G. Rothan, Paris (Petit), May 29, 1890, no. 95 (frs.24,000 to A. Lehmann); sale, Albert Lehmann, Paris (Petit), June 12–13, 1925, no. 282; Michael Friedsam, New York; presented in 1931.

Exhibitions: Paris 1921, no. 90; New York, World's Fair, 1939, no. 90, ill.; The Hague/Cambridge 1981–82, no. 31, ill.

Literature: Blanc, *Chronique des Arts* (Paris, 1863), p. 130; Hofstede de Groot 1907–28, vol. 4, no. 141; Rosenberg 1928a, no. 87; New York, Metropolitan

Museum of Art, *Concise Catalogue*, 1954, p. 87; Stechow 1966, p. 29, fig. 37; New York, Metropolitan cat. 1980, vol. 1, p. 162, vol. 3, ill. p. 441.

Beside a rough road cut through sandy soil, luxuriant fields of grain thrive and ripen. In the distance are low hills, a windmill, and the church tower of a small town. As in most of Ruisdael's mature paintings, gray clouds gather, crowding a turbulent sky and casting changeable patches of shadow and light upon the evenly cropped grain.

Wheat fields form a major theme in Ruisdael's oeuvre, especially in the 1660s, the period to which Slive assigns this work.[1] In a larger, roughly contemporaneous work, Ruisdael similarly depicted a sandy road near grainfields (The Metropolitan Museum of Art, New York, no. 14.40.630) but in a bold gesture, used the road to divide the fields symmetrically. Ruisdael also depicted wheat partially cut or bundled and stacked (fig. 1).[2] A close variation of the exhibited landscape in Basel (fig. 2) contains in the left distance a view of a sea, as is found in most of Ruisdael's landscapes with grainfields. Slive reasons that the more subtle handling of structure, space, and atmosphere in the Metropolitan Museum of Art's picture indicates that it followed the Basel painting by a few years.[3] Thematically, Ruisdael's shift away from the more common (and probably more accurate) view in the distance confirms this. Ruisdael's addition of the windmill to the exhibited work adds a picturesque Dutch element to the scene as well as a reminder that the wheat is cultivated to be ground. The tone of the Basel landscape is brighter, its composition gentler, while the playful dogs in the foreground impart a more carefree atmosphere.

Wheat fields were frequently depicted by Flemish landscape painters of the sixteenth and seventeenth centuries. Representations of the

Fig. 1. Jacob van Ruisdael, *Grainfields on a Hill*, signed, canvas, 66 x 82.6 cm., French and Co., New York.

Fig. 2. Jacob van Ruisdael, *A Grainfield*, canvas, 46 x 56.5 cm., Öffentliche Kunstsammlungen, Basel, inv. 924.

Flight into Egypt, which was one of the first subjects to appear in fully autonomous landscapes, often included wheat fields to illustrate the tale of the Miraculous Wheat Fields,[4] as seen in Patinir's painting in the Prado (Introduction, fig. 14). A more pervasive tradition utilized wheat fields in representations of Summer in cycles of the seasons or months. Pieter Brueghel's painting of *Summer* from a series of six is only the most famous example depicting the harvesting of wheat (fig. 3). Lucas van Valckenborch, Josse de Momper, Abel Grimmer, Sebastian Vrancx, and David Teniers continued the tradition in Flanders;[5] in Holland, wheat fields occur occasionally in early seventeenth-century prints of the seasons such as those by Jan van de Velde.[6]

So common are wheat fields in sixteenth-century landscapes that the motif emerges as an independent theme, particularly in the work of Jan Brueghel the Elder.[7] Martin van Heemskerk used wheat fields to characterize the common people in a design for a print series entitled "Pontifex, Rex et Plebs" which shows workers plowing, sowing and reaping grain.[8] Much the same imagery was employed by David Teniers in the seventeenth century in his depictions of aristocratic estates.[9] These typically contrast elegantly dressed seigneurial figures – their chateaus in the background – with laborers working the fields (fig. 4). However, such class consciousness based on agricultural production is largely absent from Dutch seventeenth-century landscapes. Van Mander in 1604 instructed painters to include grainfields in their landscapes, "corn and wheat, and the useful flax, sky-blue in color. Also plowed fields, with furrows cut through, or occasionally fields with harvested crops . . ." (*Den Grondt*, chap. 8, 30-31). Wheat fields even became a common motif in landscape poetry.[10]

It is strange, given this strong tradition in the

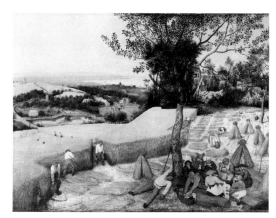

Fig. 3. Pieter Bruegel the Elder, *The Harvesters*, signed and dated 1565, panel, 118 x 160.7 cm., The Metropolitan Museum of Art, New York, no. 19.164.

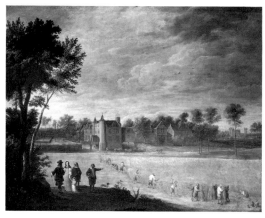

Fig. 4. David Teniers the Younger, *View of Drij Toren*, canvas, 127 x 160 cm., Boughton House, Kettering.

visual and literary arts, that painted representations of wheat fields in seventeenth-century Holland are rare before Ruisdael's paintings. Only a few paintings, such as Pieter van Santvoort's landscape in Berlin (cat. 98) include

the subject.[11] The fact that Dutch and Flemish landscape paintings differed in this regard seems to reflect economic realities that influenced the selection of themes in Dutch landscape paintings. The imagery evoked by Teniers's painting of a large agricultural estate owned by a noble Flemish family became less relevant in Holland after the wars of independence, when the landed aristocracy declined in influence. Furthermore, the growing of wheat and other grains declined steadily in Holland through the sixteenth century until almost none was grown in the mid-1600s; the South continued meanwhile to grow grain in large quantities. Instead, Holland imported the bulk of its grain from Poland and the German Hanseatic states around the Baltic sea.[12] This allowed for a high degree of agricultural specialization: the fertile soils of coastal Holland supported the raising of livestock and the production of milk products for which Holland became world renowned.

After 1650, the grain trade with the Baltic area began to decline, and other sources of grain staples were found in Flanders, England and Germany.[13] More crucially for our purposes, the Netherlands again began to grow grain, particularly in areas not especially suited to the grazing of cattle, such as the regions to the south and east of the Zuider Zee, including western Friesland.[14] Thus the precise setting of the wheat fields in Ruisdael's paintings had special interest for the seventeenth-century observer. Indeed, Ruisdael most commonly shows wheat fields near an inland sea, as in an earlier version of the exhibited painting (fig. 3), which suggests that Ruisdael's original concept was closer to the real situation in nature.

R.H. Fuchs has interpreted a painting of wheat fields in the Museum Boymans-van Beuningen, Rotterdam (inv. 1742), in terms borrowed from semiotic literary criticism, as an accumulation of a vast range of indicators.[16] He

characterizes the painting as a *speculum naturae*, a deliberate selection of elements for contemplation: cut fields next to growing wheat, cultivated crops and wild nature, sun versus shadow, dead tree trunks beside living plants, autumn next to spring. This analysis (expanded by Walford, who reads the sunlight on the grainfields as specifically emblematic of the power of God),[17] is fraught with problems, not least that it seems to be applicable to only one of Ruisdael's paintings of wheat fields and more appropriate to sixteenth-century landscapes such as Bruegel's *Road to Calvary* in Vienna, which is truly a universal composite of opposing natural forces. More important for the contemporary observer, Ruisdael's paintings of grainfields were remarkably specific and resonant: they showed a noteworthy topographic feature of Holland in a recognizable setting. The exhibited work, in showing the cultivation of grain in Holland, not only revives a theme in Dutch painting, but also presents a new feature of the Dutch countryside itself, one with enormous economic and social importance for the Dutch. In his interest in industries of the land – such as bleaching fields and windmills – Ruisdael was unique.

A.C.

1. The Hague/Cambridge 1981–82, p. 97.

2. Other wheat fields include cat. 82, and paintings in Rotterdam (inv. 1742); the Thyssen-Bornemisza collection (The Hague/Cambridge 1981–82, nos. 30, 6); the Carter collection (Los Angeles/Boston/New York 1980–81, no. 21); National Gallery, London (inv. 990), also Rosenberg 1928a, nos. 73a, 85a.

3. Ruisdael also made an etching of grainfields in 1648 (Bartsch no. 5, The Hague/Cambridge 1981–82, p. 97).

4. See H. Wentzel, "Die 'Kornfeldlegende,'" in *Festschrift Kurt Bauch* (Munich, 1957), pp. 177–92; and *Aachener Kunstblatt* 30 (1965), pp. 131–34. The apocryphal legend is also depicted in the work of Patinir (private collection,

Frankfurt) and the Master of the Female Half-lengths (Kunsthistorisches Museum, Vienna, inv. 950); see Koch 1968, pls. 18, 79. Falkenburg (1984, pp. 18–19, 57–59) treats the motif as symbolizing the pilgrimage of life.

5. Lucas van Valckenborch, dated 1585, Kunsthistorisches Museum, Vienna, inv. 1060. For Josse de Momper, see Ertz 1986, pp. 222–30, fig. 241–51. David Teniers, National Gallery, London, inv. 858. The theme even occurs in Italian painting, as in Matteo da Siena's fresco of summer in the Sala Ducale, Vatican, and Paul Bril's frescoes for the Casino of the Palazzo Pallavicini-Rospigliosi, Rome (Mayer 1910, pls. 7, 24a).

6. Franken, van der Kellen 1883, nos. 147 (of 1617) and 157. The latter, like the exhibited work, shows wheat fields to the right of a diagonally placed road.

7. Ertz 1979, no. 281, fig. 45.

8. Martin van Heemskerk, Hollstein, vol. 8, p. 248, nos. 584–87; ill. in van Straaten 1977, fig. 3.

9. See F.P. Dreher, "The Artist as Seigneur: Chateaux and Their Proprietors in the Work of David Teniers II," *Art Bulletin* 60 (1978), pp. 682–703. That grainfields were associated with wealthy landowners is confirmed in a print by Dirck Lons that shows a well-dressed gentleman before wheat fields (Hollstein no. 18).

10. Van Mander, "Boere-clacht" in *Nederduytschen Helicon* (Haarlem, 1610), par. 264 ("West winds sometimes blow the grain as the sea is driven").

11. Claes Moeyaert employed grainfields in a painting of Ruth and Boas (A. Tümpel 1974, no. 68, fig. 118).

12. J. de Vries 1974, pp. 137–53, 169–73; B.H. Slicher van Bath, "The Rise of Intensive Husbandry in the Low Countries," in *Britain and the Netherlands*, ed. J.S. Bromley (London, 1960). A.E. Christensen, *Dutch Trade in the Baltic about 1600* (Copenhagen, 1941).

13. J.A. Faber, "The Decline of the Baltic Grain-trade in the Second Half of the 17th Century," *Acta Historiae Neerlandica* 1 (1966).

14. J. de Vries 1974, p. 171.

15. See Hofstede de Groot 1907–28, vol. 4, no. 124; Fuchs 1973, pp. 287–88 (who suggests that a precise identification of the site would tell us little).

16. Fuchs 1973.

17. Walford 1981. He interprets Santvoort's painting in Berlin (cat. 98) similarly.

84 (PLATE 105)

A Village in Winter, mid-1660s

Signed lower right: JvRuisdael [JvR ligated]
Oil on canvas, 14⅛ x 12¼ in. (36 x 31 cm.)
Bayerische Staatsgemäldesammlungen, Alte Pinakothek, Munich, inv. 117.

Provenance: Gallery, Zweibrücken; transferred to Munich, 1799.

Exhibitions: The Hague/Cambridge 1981–82, no. 41, ill.

Literature: Smith 1829–42, vol. 6, p. 504, no. 338; Michel 1910, ill., p. 163; Hofstede de Groot 1908–27, vol. 4, no. 998; Rosenberg 1928a, no. 618; Stechow 1966, p. 97; Walford 1981, pp. 204–205; Munich, cat. 1983, pp. 446–47, no. 117.

Under a dark, slate gray sky a man and a boy dragging a sledge, walk away from the viewer along a frozen canal that recedes from right to left, with snow-covered houses and a tall tree delicately dusted with snow on the right. Logs, long planks, and an ice-locked boat also line the banks. Overhead the heavily overcast sky soars aloft, with cumulous shapes in the foreground and more stratified clouds beyond. In the left distance the canal turns to the right and disappears.

In the past this dark little picture has wrongly been considered a nocturne. It was formerly catalogued with the title *A Village in Winter by Moonlight*, but there is no evidence of a moon, nor is there anything in the treatment of the subject to support such a romantic title. The threatening clouds overhead are dramatic but unsentimentalized, the village is scarcely picturesque, and the staffage unapologetically anonymous. Indeed, it is Ruisdael's refusal to project human emotion onto this unembellished scene that makes its account of a somber, bone-chilling winter day so compelling. Except for the shifting, velvety clouds overhead, the world is immobilized, frozen in the very dead of winter. A pall has descended on a small, unheroic but exactly observed corner of the world. The

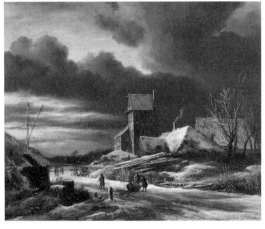

Fig. 1. Jacob van Ruisdael, *Winter Landscape*, canvas, 42 x 49 cm., Rijksmuseum, Amsterdam, inv. A 349.

man and boy who trudge off down the canal seem resigned to the cruelest of seasons, but there is nothing trivial or pathetic about their actions. The subdued mood is nature's own, not man's. Ruisdael's triumph here is one of understatement, creating in an intimately scaled work a powerful effect by the subtle adjustments of atmosphere and a harmony of tone overall.

As Stechow wrote of the closely related winter scene in the Rijksmuseum (fig. 1), "there is no trace here of the traditional gaiety of Avercamp's [see cat. 5, 6, 7] or even van Goyen's and van der Neer's scenes, nor of the lyrical elegance of van der Capelle's [cat. 18]; it would be altogether absurd to think of skaters before this picture; the real topic is the forlorn, tragic mood of a wintry day, with winter interpreted as the corollary of sadness and even death."[1] Stechow goes on to compare these dark moods to the poetry of Pope and Thomson, while the Munich catalogue likened it to Schubert's "Winterreise."[2]

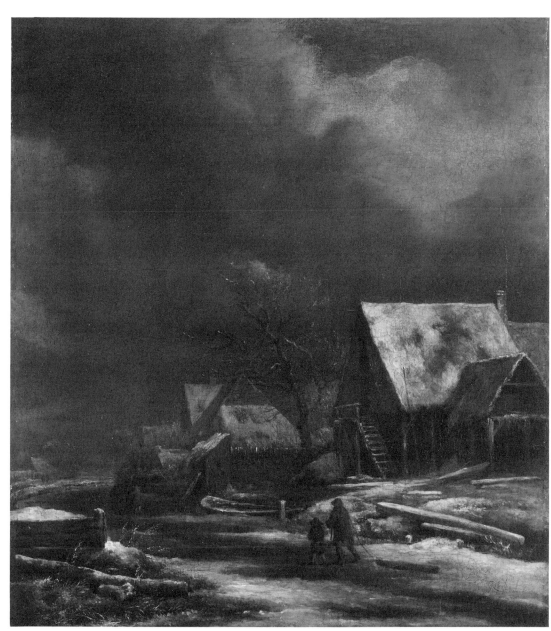

84

Of Ruisdael's only approximately twenty-five winter landscapes none is dated. Supporting Rosenberg's supposition that the subject was taken up only shortly after 1655, Stechow noted that the *Winter View* of 1658 by Jan Beerstraten (1622–1666) in the National Gallery, London (no. 1311) was probably based on Ruisdael's *Winter Landscape* then in the collection of J.C.H. Heldring in Oosterbeek.[3] Stechow dated the present work to the early 1660s, while Slive adjusted it slightly later to the "mid 1660s."[4] Most of the paintings in this group are small in scale, and many are upright in format (compare, for example, Mauritshuis, The Hague, inv. 802). The vertical format, relatively low horizon, and fine atmospheric touch of the Munich painting create spatial effects related to Ruisdael's *haarlempjes* of this same period (see Introduction, fig. 65, and cat. 89).

P.C.S.

1. Stechow 1960b, p. 183.
2. Munich, cat. 1983, p. 477.
3. Stechow 1966, pp. 96, 204, note 50, fig. 187.
4. Slive in The Hague/Cambridge 1981–82, p. 121.

Waterfall with Castle and a Hut, c.1665

Signed lower right on a rock: JvRuisdael [JvR in monogram]
Oil on canvas, 39¼ x 34 in. (99.7 x 86.3 cm.)
Fogg Art Museum, Harvard University, Cambridge, Mass. Gift of Miss Helen Clay Frick, inv. 1953.2

Provenance: Edward R. Bacon; Miss Helen Clay Frick, New York, who gave the painting to the museum in 1953.

Exhibitions: Chapel Hill, 1958, no. 53, ill.; Baltimore 1968, pp. 32–33, no. 16, ill.; The Hague/Cambridge 1981–82, no. 34, ill.

Literature: Rosenberg 1952–53, p. 11; Cambridge, Fitzwilliam Museum cat. 1960, p. 111, Stechow 1966, p. 145, fig. 288; Davies 1978, pp. 216–18, 221, and fig. 274; Walford 1981, p. 158; C. Brown 1982, p. 193; Braunschweig, cat. 1983, p. 178, under no. 377.

A fall of water comes cascading down from about midway up the picture plane, and in the foreground spreads over almost the whole width of the painting, thundering past the viewer as swirling and seething rapids. On the right side looms a mountain, at the top of which a dramatically highlighted castle contrasts sharply against the dark clouds. By the side of the mountain is a half-timbered house, a collapsing plank fence skewed to one side, and tree trunks lying one atop the other. At the left, tall spruces tower almost to the top of the painting.

Rosenberg, who first published this painting, dated it around 1665. From this same period come several other paintings with similar waterfalls, also painted in a vertical format, all impressive variations of the same composition.[1] Waterfalls in a horizontal format occur somewhat later in the late 1660s and early 1670s.[2] The great vertical movement of the composition and the violence of the splashing water in the Cambridge painting make way in these works for a majestic calm and more stately compositions. Landscapes with waterfalls such as

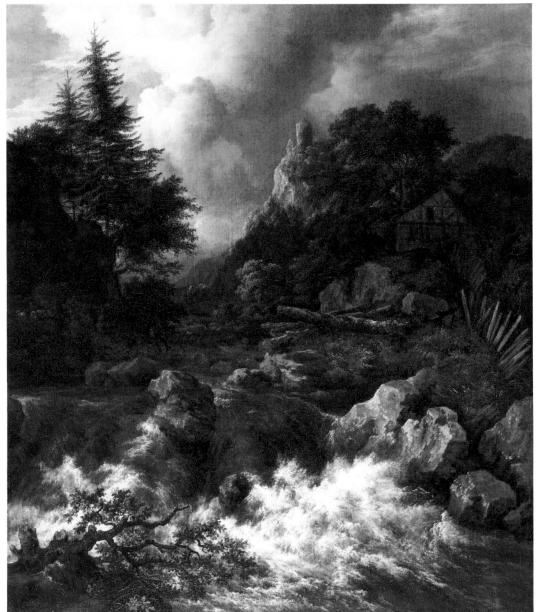

the exhibited painting are often labeled Scandinavian landscapes. From as early as the nineteenth century, however, it has been noted that Ruisdael himself never visited these lands, and was instead inspired to these themes by the works of Allart van Everdingen.[3] Everdingen traveled to Scandinavia in about 1644 and, following his return to Holland, continued to produce landscapes with motifs he had observed there. Although Rosenberg has demonstrated that there are undeniable affinities between Ruisdael's waterfalls of the early 1660s and those of Everdingen,[4] there are important differences which show Ruisdael to be independent of the earlier artists, as Simon has shown.[5] Ruisdael had already been interested in waterfalls in the 1650s; moreover, his waterfalls are not truly Scandinavian, but develop out of motifs he could have observed in Germany and developed independently into a landscape subject.

Both Thoré-Bürger[6] and Rosenberg had little appreciation for Ruisdael's waterfalls, precisely because the painter did not, as in his native Dutch landscapes, conceive these views directly after nature.

As in many of Ruisdael's landscapes, these waterfalls are also an assemblage of motifs that could have been borrowed from Everdingen but may also hark back to earlier artists, such as Roelandt Savery.[7] Ruisdael must have quickly become famous for his waterfall paintings, which form quite a large group in his oeuvre. Houbraken (1721) remarked of Ruisdael that he "painted Dutch and foreign landscape views, but especially those in which the water is seen pouring down from one rock to another, and finally with great noise [geruis] (which seems to be a play upon his name) down through the valleys [dalen] or spraying out. He could depict water splashing and foaming as it dashed upon the rocks, so naturally delicately and transparently that it appears to be real."[8]

This allusion to Ruisdael's name is also found earlier in the writings of Jan Luyken. In an emblem of a waterfall with the motto "Tot verdooving" (Until deafening), the waterfall is used as a symbol of the earthly hubbub as contrasted to the silence of God: "Indeed, tranquility came to this life, / which for so long now and for many days, / inhabited this valley of noise [Ruis-dal], / a place that must displease this life. / Oh valley of noise [Ruis-dal], all vanity, / from the turbulent and teeming life, / that the world gives in the realm of time, / one must flee and forsake you."[9]

This emblem from Luyken is one of the many sources cited by Wiegand to show the waterfall as a symbol of transitoriness. Fleeting human life was repeatedly compared to the rush of water. Finally, the ruined hut and the towers upon the rocks could also be interpreted as *vanitas* symbols.[10]

J.G.

1. Paintings in the Rijksmuseum, Amsterdam (Rosenberg 1928a, no. 121); Herzog Anton Ulrich-Museum, Braunschweig (ibid., nos. 142, 143); formerly in the Girardet collection, Kettwig (see The Hague/Cambridge 1981–82, figs. 44–47); and in Fitzwilliam Museum, Cambridge (Rosenberg 1928a, no. 149).

2. Among others, a painting in the Rijksmuseum Amsterdam (Rosenberg 1928a, no. 120); see The Hague/Cambridge 1981–82, under no. 35.

3. For a discussion of the literature concerning this relationship, see Davies 1978, pp. 217–29.

4. Rosenberg 1928a, pp. 43ff.

5. Simon 1927, pp. 60–62, 137.

6. Thoré 1858–60, vol. 2. pp. 137–38.

7. Simon 1927, p. 64.

8. "Hy schilderde inlandsche en buitenlandsche landgezigten, maar inzonderheid zulke, daar men 't water van d'een op de andere Rots, ziet neder storten, eindelyk met geruis (waar op zyn naam schynt te zinspeelen) in en door de dalen, of laagtens zig verspreid: en wist de sprenkelingen, of het schuimende water door het geweldig geklets op de rotzen, zoo natuurlyk dun en klaardoorschynende te verbeelden, dat het niet anders dan natuurlyk water scheen te wezen" (Houbraken 1718–21, vol. 3, pp. 65–66; translation based on The Hague/Cambridge 1981–82, p. 22).

9. "Wel aan den Leven werd bedaard, / Dat nu zo lange en veelde daagen, / Bewoonder van het Ruis-dal waard, / Een Plaas die 't Leven moest mishaagen. / Ô Ruis-dal, aller ydelheid, / Van 't woelend en krioelend leven, / Der wereld geeft in 't ryk der tyd, / Men moet u vlieden en begeeven" (Jan Luyken, *Beschouwing der Wereld* [1708]). The allusion is also cited by G. Brom, *Schilderkunst en litteratuur in de 16e en 17e eeuw* (Utrecht and Antwerp, 1957), p. 212.

10. Wiegand 1971, pp. 87–98, p. 265, note 491.

The Jewish Cemetery, c.1668–72

Signed on the tomb lower left: JvRuisdael [JvR ligated]

Oil on canvas, 55½ x 72 in. (141 x 182.9 cm.)
The Detroit Institute of Arts, Gift of Julius H. Haass in memory of his brother Dr. Ernest W. Haass, no. 26.3

Provenance: Possibly sale, Amsterdam, September 16, 1739, no. 88, (fl.11.10); probably sale, Amsterdam, May 9, 1770, no. 2; sale, P. Locquet, Amsterdam, September 22, 1783, no. 315 (fl.40, to Vallens); sale, Marin, Paris (Lebrun), March 22, 1790, no. 124 (frs.2,000 to Lebrun); possibly owned by (Féréol) Bonnemaison, Paris, sometime after 1796; sale, Paris, 1802 (frs.3,203); "Huybens" (Huygens?) purchased it for frs.20,000 from a banker in Paris c.1815, imported it into England and sold it to George Gillows; purchased from Gillows's executors by Zachary; sale, M.M. Zachary, London (Phillips), May 31, 1828, no. 51, (£913 10s.); Mackintosh collection, 1835; dealer Anthony Reyre, London, c.1920, who sold it to Romford; sale, Romford, London (Christie's), April 30, 1924, no. 353; dealers Leo Blumenreich and Frantz M. Zatzenstein, Berlin, 1925; Galerie Matthiesen, Berlin; Julius H. Haass, Detroit, who presented it to the Institute in 1926.

Exhibitions: Berlin, Kaiser-Friedrich-Museums-Verein, 1925, no. 339; Detroit Institute of Arts, *Loan Exhibition of Dutch Genre and Landscape Paintings*, 1929, no. 59; Providence 1938, no. 42, ill.; Chicago 1942, no. 35; New York 1942, no. 55; Brooklyn Museum, *An Exhibition of Paintings*, 1946, no. 26; Philadelphia 1950–51, no. 41; New York/Toledo/Toronto 1954–55, no. 71; Seattle, World's Fair, *Masterpieces of Art*, 1962, no. 29, ill.; Leningrad, Hermitage, *Exhibition of Pictures from the United States of America*, 1976, p. 10; The Hague/Cambridge 1981–82, no. 20, ill.

Literature: J.J. Taillasson, *Observations sur quelques grands peintres* (Paris, 1807), p. 49; Smith 1829–42, vol. 6, no. 60; Hofstede de Groot 1908–27, vol. 4, no. 219; Valentiner 1925–26; Rosenberg 1926; Detroit Institute of Arts, cat. 1927, pl. 103; Rosenberg 1928a, no. 153, ill.; Zwarts 1928; Detroit, cat. 1930, no. 196, ill.; Simon 1930, pp. 31ff.; Wijnman 1932b, p. 179; Rosenberg 1933; Gerson 1934, p. 79; Martin

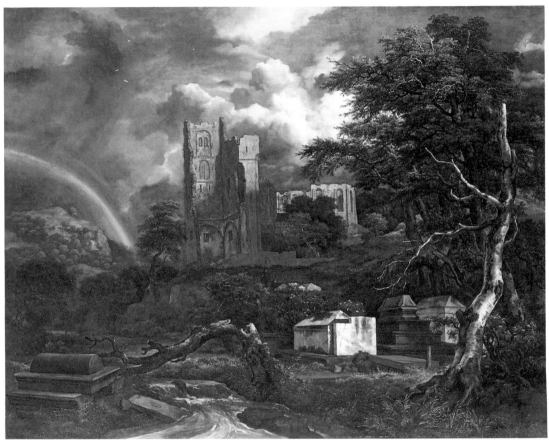

86

1935–36, vol. 2, pp. 300, 516, note 512; Simon 1935; Gerson 1950–52, p. 45; Rosenau 1958; Stechow 1966, p. 139; F.J. Dubiez, "Beth Haim, Huis des Levens: de Portugees Israelietische begraafplaats te Ouderkerk aan de Amstel," *Ons Amsterdam* 19 (1967), pp. 205–12; Wiegand 1971, pp. 57–86; Kuznetsov 1973; L. Alvares Vega, *Het Bet Haim van Ouderkerk* (Assen, 1975); Scheyer 1977; Duparc 1981–82; Sluijter-Seiffert 1984, "stellingen" no. 3; William H. Peck, *One Hundred Masterworks from the Detroit Institute of Arts* (Detroit, 1985), ill.

A wooded hillside is covered with tombs, ruins of a church, a running brook, and, in the foreground, a broken and a dead tree. In the stormy sky overhead on the left a rainbow appears.

Two versions of the subject are known, the exhibited painting and a smaller version in Dresden (fig. 1), while other unverified versions and/or copies are mentioned in sale records.[1] As early as 1739 a painting by Ruisdael, possibly identical with one of those versions, was sold as a

Fig. 1. Jacob van Ruisdael, *The Jewish Cemetery*, signed, canvas, 84 x 95 cm., Staatliche Kunstsammlungen, Dresden, no. 1502.

Fig. 2. Jacob van Ruisdael, *The Portuguese-Jewish Cemetery*, "*Beth-Haim*," *at Ouderkerk on the Amstel*, black chalk and pen with wash, 190 x 283 mm., Teylers Museum, Haarlem, no. Q*48.

depiction of a "Jewish Burial Place" (Een joode Begraafplaats).[2] And in a 1754 inventory (vol. 2, p. 490) of Dresden's collection, that version was described as "Eine dunkele Landschaft, worauf ein Juden-Begräbnis." The assumption that the works depict a Jewish cemetery is supported by the existence of two related drawings (Teylers Museum, Haarlem, no. Q*48 and 49) of the tombs by Ruisdael (see fig. 2), which were identified as early as 1670 in the inscription on Abraham Blooteling's prints after them as the tombs at Ouderkerk on the Amstel near Amsterdam. Land for the cemetery was purchased by the Sephardic communities Beth Jacob and Neweh Shalom in 1614, and the cemetery was put into official use two years later. The early seventeenth-century sarcophagi at Beth Haim (House of Life), the burial place of the Portuguese-Jewish congregation of Amsterdam, can still be seen today and attest to Ruisdael's exact rendering (see fig. 3).

The most prominent white marble tomb is that of Eliahu Montalto, a renowned physician to Ferdinand I, Grand Duke of Tuscany, and later to Marie de' Medici. He died in Tours in 1616 but was buried at Ouderkerk. The dark, bier-like tomb just visible behind and to the left of Montalto's is that of Dr. David Farras (d. 1624). The dark gray marble tomb with a stepped base and sarcophagus with draped "cloth" of red marble, is the grave of Issak Uziel (b. Fez, Barbary, d. 1622), hakam to the Neweh Shalom congregation from 1617 to 1622. To the right of Uziel's tomb is the white marble sarcophagus of Israel Abraham Mendez (d. 1627). The tomb with the half-cylinder stone lid, which appears on the right in the drawings but on the left in the two paintings, is the monument to Melchior Franco Mendez (also known as Franco O. Velho; d. 1614). One of Ruisdael's drawings (fig. 2) suggests that the tombs rest on a hillside, but in fact the actual site is a very gentle slope. The

Fig. 3. Sarcophagi at Beth Haim, photograph.

view looking up from the ground (simulated in a photograph taken only a few centimeters off the ground and published by Duparc)[3] is designed to lend the tombs an imposing monumentality. The hillside is made steeper and a stream is introduced in the paintings, with the low point of view still more exaggerated in the Dresden version but moderated in the Detroit painting.

De Henriques de Castro, who first identified the tombs in the Dresden version in 1883, relating them both to the drawings in the Teylers Museum and the print by Blooteling, correctly observed that the setting of the actual cemetery differed utterly from the scene in the Dresden painting.[4] When the Detroit version reemerged in the 1920s, it affirmed that Ruisdael's setting was imaginary. As the Teylers Museum's drawings indicate, no hill or stream appears in the flat setting of the tombs. Moreover, the two painted versions depict different ruins in the background. The Dresden version's ruins were inspired by (but do not exactly record) the remains of Egmond Castle, of which various paintings and drawings by Ruisdael are known (see under cat. 89). The Detroit version's ruins, on the other hand, recall

the remains of Egmond Abbey, which are also near Alkmaar but many miles from Ouderkerk. The only large building in the vicinity of Beth Haim is St. Urban's church, a Romanesque structure that lost its spire to lightning in August 1674 but, as Slive observed, never lay in ruins.[5] Although the settings then surely juxtapose actual and fantastic elements, two low tombs that appear in the middle distance of the paintings are not visible in the drawings but exist in the actual cemetery.

The extensive literature on the painting has been excellently summarized by Slive.[6] In 1807 the French artist and critic Jean-Joseph Taillasson (1745/46–1809) was one of the first to comment on the paintings, noting that "several times [Ruisdael] painted the tombs of the Jews in Amsterdam," suggesting that the author had firsthand knowledge of both painted versions and very possibly Blooteling's prints.[7] Taillasson stressed the poetic qualities of the pictures and Ruisdael's "sweet melancholy." The most famous essay ever written about the Dresden version, which also includes a discussion of two other Dresden paintings (*The Waterfall*, no. 1495, and *The Monastery*, no. 1494), is Goethe's *Ruysdael als Dichter* (*Ruisdael as Poet*) written in 1813 and first published in 1816.[8] Goethe emphasized not the painting's melancholy aspect but the way "a pure feeling, clear thinking artist, proving himself a poet, achieves perfect symbolism, and, through the wholesomeness of his outer and inner mind, delights, teaches, refreshes and animates us at the same time."[9] For Goethe, *The Jewish Cemetery* was "dedicated to the past." "The graves, even in their ruined state, point to a past beyond the past; they are tombs of themselves."[10] Even though the 1765 catalogue (no. 548) of Dresden had mentioned that Hebraic inscriptions appeared on the tombs, Goethe made no mention of the cemetery's being a Jewish burial ground (the

inscriptions that are now visible on the tombs are only undecipherable pseudo-Hebraic inscriptions). Goethe remained interested in Ruisdael throughout his life, commenting on his art repeatedly; Goethe's posthumous estate included some of the artist's rare etchings, as well as Blooteling's prints.[11]

In his catalogue raisonné of Ruisdael's works of 1835, Smith recorded both painted versions, noting in his preface that these "two pictures . . . of highly classical character, merit particular notice. . . . They are styled 'The Jews' Burying Ground' but are evidently intended as allegories of human life."[12] In his entry (no. 60) on the Detroit painting, Smith also observed that "in this excellent picture, the artist has evidently intended to convey a moral lesson of human life; and in addition to this, there is a sublimity of sentiment and effect . . . worthy of the powers of Nicolo Poussin." The Dresden version he considered "a duplicate . . . differing in size, and inferior in quality having become dark from time." The following year another Englishman, the painter John Constable (1776–1837), also referred in a lecture at the Royal Academy on "Landscape of the Dutch and Flemish Schools" to a Ruisdael painting, which in all likelihood was the Detroit picture: "In a picture which was known, while he was living, to be called 'An Allegory of the Life of Man' (and it may therefore be supposed he so intended it) – there are ruins to indicate old age, a stream to signify the course of life, and rocks and precipices to shadow forth its dangers; – but how are we to discover all this?"[13] Comparing this work with a winter scene by Ruisdael (Johnson Collection, Philadelphia Museum of Art, no. 569), Constable concluded that in the former Ruisdael had "failed because he attempted to tell that which is out of the reach of the art."

There is no proof of Constable's claim that Ruisdael's picture was considered an allegory of

the Life of Man in his own lifetime; however, his belief that the work was a failure has been reiterated in less emphatic terms by several later observers. For example, in 1907, Bode felt that the picture "alludes almost obstrusively to the decrepitude of all things of this earth, to the transience of all works of Man, which nature in her perpetual renewal mercilessly ignores."[14] And Jakob Rosenberg in 1928 remarked, "Today the symbolic burden of the picture no longer appears to be such a remarkable artistic achievement. We respect Ruisdael more when he solely allows the landscape to speak."[15] In 1947 Friedländer also spoke of the Ruisdael symbolism as "insistently bordering on the obstrusive . . . Ruins harping on the decay and transitoriness of all things, storm-tossed trees lying like fallen warriors on the battlefield, graveyards complete with tombstones."[16]

Some authors, including Rosenberg and Martin, have regarded the image as a thoroughgoing allusion to transitoriness, with all the details of the picture, including the fleeting rainbow and passing storm, functioning as *vanitas* symbols.[17] Other writers, however, including Woermann, Valentiner, Stechow, Slive, and Duparc have shared Goethe's belief that "Light (is) about to conquer the rainsquall," regarding motifs such as the rainbow breaking through the clouds and the full, leafy trees rising over the dead and broken beeches as embodying the promise of renewed life and hope.[18] The fullest account of the *vanitas* associations of Ruisdael's motifs has been compiled by Wiegand.[19] He offers an extensive inventory of potential biblical, emblematic, and literary sources, connecting all of the motifs in the pictures (the ruins, brook, rainbow, graves, broken and rotted trees, clouds, even the suggestion of wind) with the ideas of pride, transience, and fallibility. The fact that the tombs are Jewish graves, moreover, prompts Wiegand to offer a more elaborate

interpretation of the work, citing the arguments of theologians such as Frank, Erasmus, and Coornhert, who stressed the difference between inward and outward religion, condemning ceremony and ostentation. Thus, according to Wiegand, the overgrown ruins are symbols of those who do not follow Christian beliefs and are destroyed by their pride;[20] the elaborate marble sarcophagi are symbolic of prideful displays and ceremony;[21] and the bare and broken trees are once again associated with the godless.[22] For Wiegand the painting's overriding message is "Do not trust formalities, ceremonies and ostentatiousness – as the godless and particularly the Jews do – since all these things are as nothing in view of the universality of transience."[23]

While Wiegand's interpretation acknowledged specific theological disputes of the day, Slive rightly cautioned that we have no evidence that Ruisdael "thought Jewish customs and tombs examples *par excellence* of man's vanity. . . . Seventeenth-century warnings against human vanity were delivered by Christian moralists as a much more general message."[24] Although Ruisdael's early religion is unknown, he was probably a Mennonite (his paternal grandfather, uncle Salomon, and cousin Jacob Salomonsz were all Mennonites), a sect sympathetic to the Jews in the seventeenth century. Ruisdael became a member of the Reformed Church in Amsterdam at the age of thirty in 1657. Although we have no knowledge of Ruisdael's relationship to the Jews, as Duparc noted, it may be significant that one of his paintings preserved in the Alte Pinakothek, Munich (inv. 10818), depicts a view from the Kuiperberg of Ootmarsum, where another Jewish burial ground is located.[25] Slive observed that the cemetery at Ouderkerk apparently was something of a tourist attraction;[26] on August 21, 1641, no less distinguished an observer than John Evelyn paid a visit to

"Over-kirk, where [the Jews] had a spacious field assigned them for their dead, which was full of Sepulchers, and Hebrew Inscriptions, some of them very stately, of cost."[27] Romeijn de Hooghe also made two fanciful prints of a burial party and mourners at Ouderkerk in which the middle- and backgrounds are based on Ruisdael's drawings of the tombs.[28] The facts that there was a market for the prints by de Hooghe and Blooteling and that Ouderkerk was regularly visited by gentiles attest to the site's attraction. Perhaps, as Slive suggested, the appeal of Ruisdael's *Jewish Cemetery* was related to the exhortation, clearly expressed by Dirck van Bleyswijck in his account of the city of Delft, to visit tombs every day to consider where one's corpse will lie and to think on the vanity and fragility of life.[29]

The circumstances and date of the origins of Ruisdael's works have not been determined. Martin suggested that the paintings were commissioned as portraits of the tombs.[30] Scheyer further proposed that one of the versions might have been ordered by the family of Eliahu Montalto, the doctor whose white tomb is the most prominent in the picture.[31] But Slive rightly questioned whether pseudo-Hebraic inscriptions (added later?) would appear on works for Jewish patrons.[32] Slive also discredited Zwart's attempts to date both versions after 1674 when St. Urban's was struck by lightning. No consensus has yet emerged in the dating of the two versions;[33] however, Sluijter-Seiffert is probably correct in questioning the traditional assumption (see Rosenberg, Zwarts, and Slive) that the Detroit version was the earlier of the two, and in dating the Dresden painting to the mid-1650s and the much larger Detroit version "at least ten years later."[34] Respective dates of about 1655–58 and 1668–72 are here proposed.

P.C.S.

1. Panel, 47 x 62 cm., see Hofstede de Groot 1908–27, vol. 4, no. 219; a possible fourth version or copy (72 x 91 cm.) is mentioned by Slive (The Hague/Cambridge 1981–82, p. 74) as from the Arthur Kaye Collection, with later sales.

2. See *Provenance*.

3. Duparc 1981–82, p. 228, fig. 6.

4. De Henriques de Castro, *Keur van Grafsteenen op de Nederl.-Portug.-Israël. Begraafplaats te Ouderkerk aan den Amstel* (Leiden, 1883). The history of the cemetery is recounted in Alvares Vega, *Het Bet Haim*, 1975.

5. Slive in The Hague/Cambridge 1981–82, p. 73; see Abraham Jacob van der Aa, *Aardrijkskundig woordenboek der Nederlanden* (Gorinchem, 1839–51), vol. 8, p. 678.

6. See The Hague/Cambridge 1981–82, pp. 68–75.

7. Jean-Joseph Taillasson, *Observations* (1807), p. 49; see also Francis Haskell, *Rediscoveries in Art* (Ithaca, 1979), p. 111.

8. See Goethe 1816.

9. Translation in The Hague/Cambridge 1981–82, p. 68.

10. "Die Grabmale sogar deuten in ihrem zerstörten Zustande auf ein Mehr-als-Vergangenes, sie sind Gräbmaler von sich selbst."

11. The Hague/Cambridge 1981–82, p. 70; see C. Schuchardt, *Goethe's Kunstsammlungen*, vol. 1 (Jena, 1848), p. 183, nos. 379–86.

12. Smith 1829–42, vol. 6, p. 4.

13. C.R. Leslie, *Memoirs of the Life of John Constable, Esq. R.A.*, 2nd ed. (London, 1845), p. 350.

14. Bode 1906b, pp. 126–27. "Hier ist auf die Hinfälligkeit alles Irdischen, auf die Vergänglichkeit alles Menschenwerkes, über das die ewig sich erneuernde Natur erbarmungslos hinweggeht, deutlich, fast aufdringlich hingewiesen."

15. Rosenberg 1928a, p. 30. "Wir empfinden die symbolische Belastung des Bildes heute kaum mehr als eine besondere künstlerische Tat. Ruisdael erscheint uns verehrungswürdiger da, wo er die Landschaft allein für sich sprechen lässt."

16. Friedländer 1950, p. 119.

17. Rosenberg 1928a, p. 30: "Die Vergänglichkeit alles Lebendigen"; Martin 1935–36, vol. 2, p. 302.

18. Karl Woermann, *Die Malerei von der Mitte des 16. Jahrhunderts bis zum Ende des 18. Jahrhunderts* (Leipzig, 1888), p. 632; Valentiner 1925–26, p. 58; Stechow 1966, p. 140 "the rainbow as a sign of promise and resurrection"; and Slive in The Hague/Cambridge 1981–82, p. 68.

19. Wiegand 1971, pp. 57–85.

20. Ibid., pp. 77–78.

87 (PLATE 102)

Oaks beside a Pool, mid-1660s

21. Ibid., pp. 75–76; see Matthew 23:27.

22. Ibid., pp. 80–82; see Psalms 1:3, 52:8, 92:13, Jeremiah 17:7-8, and discussion under cat. 87.

23. Wiegand 1971, p. 82.

24. The Hague/Cambridge 1981–82, pp. 74–75.

25. Duparc 1981–82.

26. The Hague/Cambridge 1981–82, p. 196.

27. E.S. de Bier, ed., *The Diary of John Evelyn*, vol. 2 (1955), p. 43.

28. Hollstein, vol. 9, nos. 260–61; J. Landwehr, *Romeyn de Hooghe the Etcher* (Leiden/Dobbs Ferry, 1973), pp. 299–300; The Hague/Cambridge 1981–82, figs. 72–73.

29. The Hague/Cambridge 1981–82, p. 75; Bleyswijck 1677, p. 271.

30. Martin 1935–36, vol. 2, p. 304.

31. Scheyer 1977, p. 138.

32. The Hague/Cambridge 1981–82, p. 74.

33. The dates suggested by various authors range from the early 1650s to 1678–79 and are summarized by Wiegand 1971, p. 134; and Slive, The Hague/Cambridge 1981–82, pp. 68, 76. Slive (ibid., p. 73) suggests that both works were painted in the mid-1650s, with the Dresden version postdating the Detroit version: "however a long interval of time can hardly separate the two works."

34. Sluijter-Seiffert 1985, "stellingen" no. 3.

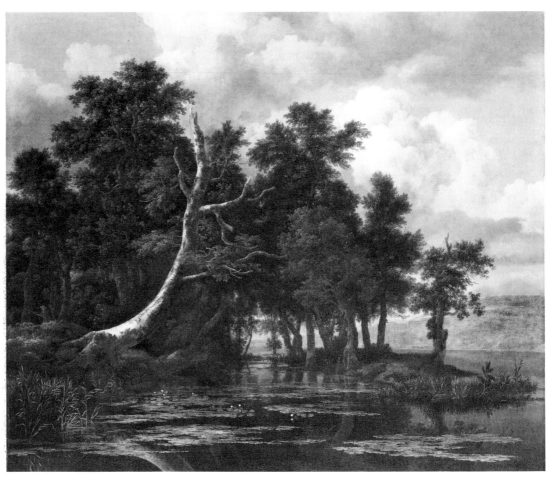

87

Signed lower right: JvRuisdael [JvR ligated]
Oil on canvas, 44⅞ x 55½ in. (114 x 141 cm.)
Gemäldegalerie, Staatliche Museen Preussischer Kulturbesitz, Berlin (West), no. 885G

Provenance: William Wells, Redleaf, 1835; sale, W. Wells, London, May 12, 1848 (£735, bought in); dealer C. Sedelmeyer, Paris, 1898, no. 181; acquired by the Kaiser-Friedrich-Museum, Berlin, in 1901.

Exhibitions: London, British Institution, 1848; Manchester 1857, no. 975.

Literature: Smith 1829–42, vol. 6, no. 313; Berlin, Kaiser-Friedrich-Museum, cat. 1906, no. 885G; Wurzbach 1906–11, vol. 2, p. 520; Hofstede de Groot 1908–27, vol. 4, no. 444; Gerstenberg 1923, p. 34, pl. VIII; Rosenberg 1928a, pp. 51, 88, no. 264, fig. 107; Stechow 1966, p. 75; Berlin (West), cat. 1975, p. 379, no. 885G, ill.; Schmidt 1981, pp. 87, 90, 140, fig. 17; Walford 1981, p. 198.

Rising high above a calm stretch of water with water lilies blooming in the foreground, great oaks line the banks of a lake. In the left foreground a shattered oak with only a few green branches grows out over the inlet, its reflection cast on the water. The broken trunk's light, silvery form contrasts against the lighter greens and browns of the foliage beyond. Behind the tree on the right stretches the broad lake, and, beyond, a misty mountain rises to the right. Overhead a bright sky is filled with billowing clouds.

As Rosenberg outlined the artist's development, Ruisdael had already begun painting forest interiors by the 1640s; but it probably was not until the mid-1650s that these scenes took on a monumental aspect. The huge trees that had dominated Ruisdael's early works were moved back to the middle ground in the interest of more spacious effect but lost little in their imposing presence, still dwarfing the human presence (see cat. 45, fig. 2).[1] Those romantically overgrown, gesticulating giants that appeared in Ruisdael's early etchings were replaced in the 1660s by more majestic trees, the somber regents of the forest. Rosenberg saw in these developments a return to the "heroic" style, in which Ruisdael reconciled the seemingly contradictory formal effects of a near view of large, powerful forms with more open spaces beyond.[2] As Stechow then observed, the Berlin painting well illustrates these formal developments;[3] while it resembles the earlier Worcester picture superficially in its use of a horizontal band of large trees in the middle ground, the trees now function truly as a screen rather than as a wall, the light permeating from behind. Closely related to the Berlin painting is a group of majestic forest pool scenes, the most famous of which are the *Marsh in the Forest* in the Hermitage (fig. 1) and the similarly conceived painting in the National Gallery, London (no.

Fig. 1. Jacob van Ruisdael, *Marsh in the Forest*, signed, canvas, 72.5 x 99 cm., Hermitage, Leningrad, inv. 934.

Fig. 2. Aegidius Sadeler after Roelandt Savery, *Stag Hunt in a Marsh*, engraving.

854).[4] Also close in design is the *Forest Marsh with Stag Hunt* in the Staatliche Kunstsammlungen, Dresden (no. 1492), which, like the paintings in London and Leningrad, has staffage by Adriaen van de Velde.[5] Stechow supported the traditional dating of this entire group to the 1660s by citing the date of 166(?) on a compositionally related forest pool picture in sale, H.A. Clowes, London (Christie's), February 17, 1950, no. 49.[6] Several authors also pointed out that the Leningrad *Marsh in the Forest* recalls a print after a design by Savery (fig. 2).[7] However, as Stechow vividly observed of Ruisdael's grand forest scenes from these years, "The essentially decorative and somewhat grandiloquent busyness of Savery and Keirincx [see cat. 52] is here replaced by a calm grandeur which rests primarily on economy of material, firm structure and impeccable planning, but lacks all artificiality, and bespeaks sustained incorruptible observation of nature."[8]

In the Berlin catalogue of 1975 the shattered oak in the foreground, the reflection of which stretches across the blooming surface of the water, is interpreted metaphorically as an allusion to "the transitoriness of all life."[9] The catalogue cites Wiegand's discussion (1971) of the *vanitas* symbolism of the oak tree in Ruisdael's *Jewish Cemetery* (cat. 86).[10] The Bible refers to the "tree of life" (Revelation 2:14) and specifically to the broken tree as a symbol of the fallibility of things of this earth. The most pertinent passages appear in Job 14, the chapter that famously begins "Man that is born of woman is of few days and full of trouble. He cometh forth like a flower and is cut down." The chapter continues, "For there is hope of a tree, if it be cut down, that it will sprout again, and that the tender branch thereof will not cease. Though the root thereof wax old in the earth, and the stock thereof die in the ground, yet through the scent of water it will bud, and bring forth

boughs like a plant. But man dieth, and wasteth away; yea, man giveth up the ghost, and where is he?"(Job 14:7–10).

The Bible also refers to the pious, metaphorically, as green or fruitful trees (see Psalms 1:3; 52:8; 92:12; Proverbs 11:28; and Jeremiah 17:7–8), while the impious or godless are likened to leafless or ruined trees (Isaiah 1:30; Ezekiel 31:3–4; Jude 12). And juxtapositions of barren and blooming trees also prompted moralizing in seventeenth-century emblem books (see Introduction, fig. 11). Oak trees were traditional symbols of steadfastness, strength, and power, but also of pride, arrogance, and overbearance.[11]

While it is unclear, then, whether the Berlin painting embodies a specific Christian or moral message, the great stricken oak with denuded trunk and a few sprouting leaves offers a universal image of decay and regeneration, of the rotation and cycle of life. In discussing the related painting in London, Levey spoke of Ruisdael's intimation of "the majestic cycle of nature's processes" and of "significance transcending the immediate subject."[12] Evoking nature's ceaseless alteration and renewal, Ruisdael inevitably tinges his scene with transience. Yet the scale and grandeur of the works will not permit of pathetic sentiment. Like the tiny shepherd who passes heedlessly with his flock, man is a marginal unobservant figure in this luxuriant but remorseless realm of still, fathomless lakes, great trees, and relentless change.

P.C.S.

1. Rosenberg 1928a, pp. 45ff.
2. Ibid, p. 50.
3. Stechow 1966, p. 75.
4. Respectively, Rosenberg 1928a nos. 313 and 320.
5. Stechow 1966, p. 200, note 41; Hofstede de Groot no. 548; reproduced in The Hague/Cambridge 1981–82, p. 109, fig. 51.

6. Rosenberg 1928a, no. 285.
7. Roh 1921, p. 331, note to fig. 158; Gerstenberg 1923, p. 34; Rosenberg 1928a, p. 48; Slive in The Hague/Cambridge 1981–82, p. 108.
8. Stechow 1966, p. 75.
9. Berlin (West), cat. 1975, p. 379.
10. See Wiegand 1971, pp. 66–70.
11. See Raupp 1980, pp. 88–89, 106, note 23; and *Reallexikon zur deutschen Kunstgeschichte*, s.v. "Eiche." On the oaks as the Christian tree of life, see M. Levi d'Ancona, *The Gardens of the Renaissance* (Florence, 1979), p. 250.
12. Michael Levey, *Ruisdael: Themes and Painters in the National Gallery* (London, 1977), p. 29.

The Mill at Wijk, c.1670

Signed lower right: Ruisdael
Oil on canvas, 32¾ x 39¾ in. (83 x 101 cm.)
Rijksmuseum, Amsterdam, inv. C 211

Provenance: Sale, J. Juriaans, Amsterdam, August 28, 1817, no. 55 (fl.1,200 to van Heijningen); (possibly) sold in London, 1833; purchased from J. Noé in 1841 for fl.6,300 by A. van der Hoop, Amsterdam; presented to the city of Amsterdam, 1854; Museum van der Hoop; on permanent loan to the Rijksmuseum from 1885.

Exhibitions: Paris 1921, no. 91, ill.; London 1929, no. 207, pl. 61; Rotterdam 1945–46, no. 39; Brussels 1946, no. 91, ill.; Paris 1950–51, no. 75; The Hague/Cambridge 1981–82, no. 39, ill.

Literature: Amsterdam, van der Hoop cat. 1855, no. 124; Thoré 1858–60, vol. 2, pp. 132–36; Fromentin 1876, pp. 244, 254–55; Amsterdam, Rijksmuseum cat. 1885, van der Hoop no. 124, ill.; Amsterdam, Rijksmuseum cat. 1903 (and later eds.), no. 2074; Hofstede de Groot 1907–28, vol. 4, nos. 105, 183; L. Baldass in *Meisterwerke der Kunst in Holland* (1920–21); Rosenberg 1928a, pp. 52–53, no. 70, fig. 111; Simon 1930, p. 41; Martin 1935–36, vol. 1, p. 53, fig. 29; vol. 2, pp. 299–300; Preston 1937, p. 46, fig. 66; Beenken 1943, p. 10, pl. 12; Gerson 1950–52, vol. 2, p. 45, pl. 127; Hijmans 1951, pp. 51–57, fig. 17; H.E. van Gelder 1959, p. 16; *Duits Quarterly* 1 (1963), pp. 11–13; Rosenberg et al. 1966, pp. 154, 157; Stechow 1966, pp. 59–60, 75, fig. 115, 115a; Imdahl 1968; Amsterdam, Rijksmuseum cat. 1976, no. C 211, ill.; Kauffmann 1977; Taverne 1977, p. 65, ill.; Bergvelt 1978, p. 142, fig. 11; Fuchs 1978, pp. 131–35, fig. 109; Kahr 1978, pp. 214–16, fig. 164; Schmidt 1981, pp. 70–73; Walford 1981, pp. 201–203; Haak 1984, p. 142.

Towering above a group of buildings is a tall platform windmill bracketed below by the diagonal sweep of a river bank reinforced by wooden pilings and above by high-blown gray clouds that seem to swirl around the wings of the mill. But it is the sharply angled, dramatically lit windmill that dominates the landscape and forms the primary focus of the painting.

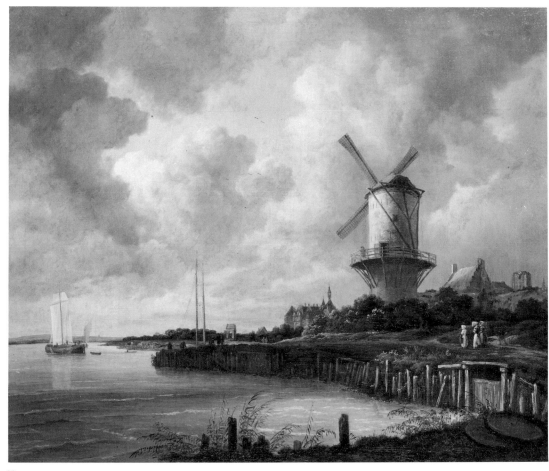

88

The village depicted is Wijk bij Duurstede, southeast of Utrecht on the river Lek, a branch of the Rhine. This view from the south shows the fifteenth-century archbishop's castle to the left of the mill and the tower of the town church on the right.[1] The clock-faces on this tower were installed shortly after 1668, which confirms a dating of the painting based on style to about 1670.[2] Ruisdael's major alteration to the topography is the removal of the Vrouwen Poort (Women's Gate), which should stand about where the three women walk – perhaps a reference, as Imdahl suggests, to the missing structure.[3] In eliminating the gate and wall, Ruisdael greatly emphasizes the height of the mill beyond its appearance in reality and calls special attention to it.

Windmills form the primary subject in a number of drawings and paintings by Ruisdael. At the beginning of his career in 1645–46 Ruisdael frequently sketched windmills[4] and included them in paintings (Cleveland Museum of Art, dated 1646, inv. 67.19; and Buckingham Palace, no. 1170).[5] A composition from the 1650s that exists in two versions (private collection; and Berlin [West], inv. 885)[6] introduced the dramatic foreshortening of a tall mill built on a platform, which Ruisdael would intensify in the exhibited painting. Several winter landscapes with windmills, dated by Slive to the late 1660s or 1670s,[7] especially one in the Institut Néerlandais, Paris (fig. 1), closely echo the composition of *The Mill at Wijk*. Tall windmills occur in other drawings[8] and in some paintings as secondary subjects (see cat. 83).[9]

Surprisingly, windmills rarely contribute the principal motif in Dutch paintings after the first decades of the century. It had been common in Flanders in the late sixteenth and early seventeenth centuries, especially in the work of Jan Brueghel the Elder (see cat. 108, fig. 1); Ruisdael's composition resembles those of

Fig. 1. Jacob van Ruisdael, *Winter Landscape with a Windmill*, canvas, 37.2 x 45.8 cm., Institut Néerlandais, Paris, inv. 6104.

Fig. 2. Jan van de Velde, *Aestas (Summer)* etching.

Brueghel, depicting a tall mill on a bank.[10] Mills occur occasionally in the work of early Dutch landscapists such as Adriaen van de Venne, Esaias van de Velde, and Jan van Goyen (cat. 108, 106, 33), as well as Cuyp and van der Neer. But even these are isolated examples. With the removal of *The Mill* in the National Gallery of Art, Washington, D.C. (no. 1942.9.63) from Rembrandt's oeuvre, Ruisdael is one of the few leading Dutch landscapists at midcentury to have treated the windmill as a major theme in his paintings.[11]

The situation is different in the graphic arts, where many artists, including Rembrandt, made drawings and prints of windmills.[12] Etchings by Esaias and Jan van de Velde (fig. 2), like the exhibited painting, show an enlarged windmill towering over the landscape and form Ruisdael's closest visual precedents.

Recent discussion of Jacob van Ruisdael has centered on the moral and religious symbolism of his landscapes. Wiegand and Kuznetsov offered symbolic interpretations of Ruisdael's paintings, drawing upon emblem books, sermons, and other religious texts.[13] Kauffmann compared Ruisdael's *Mill at Wijk* to an emblem of the windmill with the scriptural caption "The letter kills but the spirit gives life" (print by Jan Sweelincks in Zacharias Heyns's *Emblemata*, 1625).[14] Other religious tracts use wind and other natural forces as symbols for the power of God over man. However, little in Ruisdael's painting, save for a generally somber or "romantic" mood, would reinforce such a scriptural reading. It is, therefore, difficult to prove that these specific interpretations had real currency; indeed, mills could signify many other things (see below). Fuchs suggested more generally that the restless sky and what he perceived as threatening weather reinforced a *vanitas* interpretation.[15]

Walford's recent dissertation on Ruisdael elaborates these earlier iconographic approaches with special sensitivity to Ruisdael's naturalism. He begins cautiously: "The painting can be appreciated on several levels: topographic, aesthetic and intellectual."[16] Walford believes that the play of light on the mill would have reminded the thoughtful observer that God may be perceived in things made by man (Romans 1:20), and that the beams of sunlight "accentuate the notion of man's dependence on providence," a principle he applies generally to sunbeams in landscape paintings. The worn millstones in the foreground are seen as a further *vanitas* element, representing man in a transitory world.

These recent explorations of seventeenth-century emblematic and religious literature are related to studies of earlier Netherlandish art concerning the use of windmills as Christian emblems. Windmills in sixteenth-century landscapes (particularly those of Bosch and Bruegel) have been variously interpreted as representing the mind, man's fortune, the evil world (or Augustine's City of Man), folly, virtue, and temperance.[17] Most convincing are the analyses by James Pierce and Walter Gibson[18] of the grain mill as a symbol of the Eucharist and Redemption, whether in the form of a hand, water, or windmill. That the blades of a windmill could also form a cross increased its symbolic power. Windmills frequently appear in Netherlandish Books of Hours as well as in paintings of *Christ Carrying the Cross* by the Brunswick Monogrammist[19] and Pieter Bruegel the Elder. In Bruegel's *Road to Calvary* (dated 1546, Kunsthistorisches Museum, Vienna, inv. 1025) the monumental mill (also built on a platform), which divides night from day and winter from spring,[20] has clear religious symbolism in the context of the scene represented, although it also functions as a local "picturesque" motif.

While some seventeenth-century observers may have drawn moral or even scriptural interpretations from paintings such as Ruisdael's, these would have been nonspecific, especially compared with the perception of the explicitly religious landscapes of the sixteenth century.[21] No doubt some members of Ruisdael's audience may have made scriptural associations, although very few of Ruisdael's pictures, perhaps only *The Jewish Cemetery* (cat. 86), show clear moralizing intent. Seymour Slive makes the important point that if some of Ruisdael's contemporaries attached such scriptural and *vanitas* meanings to his paintings, they would have interpreted almost all objects in this manner.[22] That the injunction to discover God in all natural things was a literary topos in the seventeenth century diminishes rather than increases its relevance here.[23] The cataloguing of individual religious texts does not elucidate the way most viewers responded, nor does it measure how common or strong such responses were.

A seventeenth-century landscape painting such as *The Mill at Wijk* had significance on several different levels, which may have varied considerably from viewer to viewer. Several models are available to gauge these associations. The travel diary of the landscapist Vincent Laurensz van der Vinne, which was intended for publication, contains characterizations of certain features of the landscape in poetic epigrams that sometimes contain moralizing interpretations. At the sight of men struggling to pull a barge upstream, van der Vinne waxes poetic about the need for Christians to struggle continuously against lust.[24] However, van de Vinne rarely introduces such moralizing mottoes and is more commonly interested in the political, historical, and social aspects of the places he sees, especially when they are connected with Holland. Thus he illustrates the levels of meanings for the seventeenth-century Dutch. Moralizing in-

Fig. 3. Dirck Lons, *Grain Mill*, etching.

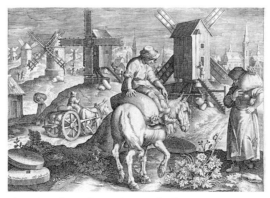

Fig. 4. J.B. Collaert after Stradanus, *Mola Alata*, engraving.

terpretations of places and events occur frequently in seventeenth-century histories and city descriptions, again often in poetry, but they are usually extraneous to the general thrust of the book.[25] The divergence between moralizing epigram and primary subject (which may be regarded as a duality of poetic and prose modes) can also be encountered in prints such as Jan Saenredam's etching of a beached whale (1602).[26] Thus, while moralizing and symbolic meanings play a role in the appreciation of landscape, they are subsidiary, indirect associations.

Rather, Ruisdael has evoked more timely and direct meanings by placing a familiar and commonplace object in a dramatic context. As indicated previously, windmills, though ubiquitous in the Dutch countryside, are less than common in Dutch paintings. It is possible that contemporary viewers would have recognized the site depicted in the painting, since Wijk was situated on a branch of the Rhine that connected Holland and Germany. The castle at Wijk had been the seat of Catholic bishops in previous centuries, and the mill itself may have been a famous landmark along the river.[27] The mill is of an extremely unusual type, consisting of a stone tower mill with a balustraded platform (*torenstellingmolen*). Simple platform mills were common near town walls or other buildings, where a platform served to set the mill high enough to catch the wind without interference from surrounding structures. (Ruisdael eliminated a gate that should have stood in front of the mill.) This particular windmill was used for grinding grain. Seventeenth-century observers would have been interested in the windmill as an industrial structure, with its functions and special features, as seen in Dirck Lons's (c.1599-after 1666) series of four prints of 1631 illustrating various types of mills, with captions noting their purposes (fig. 3). A print by J.B. Collaert (1566–1628) after Stradanus (1523–1605) celebrates the

windmill as an invention essential to the modern age, one that was unknown to the ancient Romans (fig. 4).[28] Such direct associations were probably more common in the seventeenth century than emblematic references were.

As in his paintings of bleaching or grainfields (cat. 83), Ruisdael shows the productivity in the landscape and here celebrates the common windmill, symbol of Holland,[29] and an acknowledged factor in the economic strength of the country. Jan van de Velde's print of *Summer* (fig. 2) shares these associations in showing two giant windmills overshadowing a busy farm. Ruisdael, by enlarging his mill and placing it under a dramatic sky, glorifies and elevates a familiar feature of the Dutch scene as surely as Paulus Potter (*The Bull*, Maurtishuis, The Hague, inv. 136) and Aelbert Cuyp (cat. 21) exalted the ordinary cow. This heightening of the everyday is common to many Dutch seventeenth-century landscape painters, who selected and represented with expressive force the features of their native land.

A.C.

1. The town in the painting was identified in the nineteenth century when the painting was in the van der Hoop collection (Amsterdam, van der Hoop cat. 1855, no. 124). Hijmans (1951, pp. 51–57) specified the exact view and the position of the windmill (see also Imdahl 1968).

2. Imdahl 1968, p. 3; The Hague/Cambridge 1981–82, p. 115.

3. Imdahl 1968, p. 5. See an anonymous drawing of the site from the opposite direction, dated July 19, 1750 (ibid., fig. 14).

4. Kupferstichkabinett, Dresden; Giltay 1980, nos. 39, 41, 42, 43.

5. The Hague/Cambridge 1981–82, no. 10. ill.

6. Ibid., no. 24, ill.; this painting is based on a drawing formerly in Bremen.

7. Ibid., no. 53, figs. 60–62.

8. Giltay 1980, no. 75; and two prints by Abraham Blooteling (1640–1690) after lost drawings by Ruisdael (ill. in The Hague/Cambridge 1981–82, figs. 79, 80).

9. See also The Hague/Cambridge 1981–82, nos. 28, 29.

10. Formerly collection of David M. Koetser, Zurich (Ertz 1979, no. 271, pl. 185, see also pp. 164–69). Rubens also included a large windmill in his *Landscape with a Birdtrap* (Musée du Louvre, Paris, inv. 1800).

11. The work is probably by Aert de Gelder (1645–1727). Slive noted that windmills are rare in Ruisdael's work, occurring only about fifteen times. While this is true in relation to Ruisdael's large oeuvre, it is even rarer in the work of other artists (The Hague/Cambridge 1981–82, p. 115). Under Ruisdael's influence, Jan van Kessel depicted large windmills (see Bergvelt 1978, p. 148, fig. 20).

12. Rembrandt drew windmills around Amsterdam on many occasions, from the early 1640s to the mid-1650s (Benesche 1973, nos. 789, 802, 813, 1217, 1260, 1308, 1333, 1335, 1356), and made a print of a mill, dated 1641 (Bartsch, no. 233).

13. Wiegand 1971; Kuznetsov 1973. Certain aspects of Wiegand's dissertation have drawn criticism (see Raupp 1980; Walford 1981, pp. 45–48; Stone-Ferrier 1985), but other recent writers have not questioned the basic iconographic method (Kauffman 1977 and Raupp 1980). This type of emblematicism parallels the similar treatment of Dutch genre painting pioneered by Eddy de Jongh, who has also commented on landscapes (Brussels 1971, pp. 150–52). De Klijn 1982 and Walford 1981 (the latter drawing upon Fuchs 1973) have specifically focused on the religious symbolism of Ruisdael's paintings. For example, Walford writes, "Nature continued to be a primary means by which man might know through its beauty and order the wisdom of God" (p. 51).

14. Kauffmann 1977, fig. 3.

15. Fuchs 1978, pp. 131–34; Fuchs uses as support the lines from Jacob Cats quoted here in note 23.

16. Walford 1981, p. 202.

17. C.G. Stridbeck, *Bruegelstudien* (Stockholm, 1956), pp. 108, 124; M.N. Sokolov, "Christ under the Mill of Fortune," *Konsthistorisk Tidskrift* 52 (1983), pp. 59–63; C.D. Bax, *Hieronymous Bosch* (Rotterdam, 1979), pp. 159–61; Falkenburg 1985, pp. 85–97, 99–101; De Tolnay 1965, pp. 29, 63. Generally, see Kauffmann 1977, pp. 384–85; and H.D. Brumble, "Pieter Brueghel the Elder: The Allegory of Landscape," *Art Quarterly* 2 (1979), pp. 125–39.

18. James Pierce, "Memling's Mills," *Studies in Medieval Culture* 2 (1966), pp. 111–19; Walter Gibson, "Bosch's *Boy with a Whirligig*: Some Iconographical Speculations," *Simiolus* 8 (1976), pp. 12–13; James Pierce, "The Windmill on the Road to Calvary," *New Lugano Review* 11–12 (1976), pp. 48–55.

19. P. and N. de Boer Foundation, Amsterdam, ill. in Gibson, *Simiolus* 8 (1976), fig. 7.

20. This type of sixteenth-century landscape is more conducive to Fuchs's analysis (1973) than Ruisdael's paintings are.

21. See D. Zinke, *Patinirs "Weltlandschaft"* (Frankfurt, 1977) and Falkenburg 1985.

22. The Hague/Cambridge 1981–82, pp. 16, 116. Bob Haak also doubted the religious significance of Ruisdael's mill (Haak 1984, p. 142).

23. Jacob Cats wrote, "Whatever may be said, one can learn from trees / honor the great Creator wherever things grow, / wherever the eye turns, one finds things to laud his name" ("Men kan van boomen leeren, / men kan, waer groente wast, den grooten Schepper eeren. / Al waer het ooge draeyt, daer vintmen stage stof / te roemen sijnen naam"). "Ouderdom en Buytenleven," in *Alle Wercken* (Amsterdam, 1712), pp. 565–66. This is echoed in the writings of Spiegel and Huygens. Walford relates these evocations of God in nature to van Mander's discussion of landscape, although significantly van Mander does not mention God at all. In many respects, praises of nature are derived from secular ancient poetry, especially Virgil's *Georgics* and Horace's *Epodes*, most evident in the Dutch *hofdicht* (see Introduction).

24. Van de Vinne, Sliggers 1979, pp. 93–94; discussed in Haverkamp Begemann, Chong 1985, pp. 56–57.

25. City descriptions provide important indications of how contemporaries thought of their surroundings. The most widely circulated were Joan Blaeu's maps and descriptive texts of Dutch cities (Blaeu 1649). See also Ampzing (1626) on Haarlem; Balen (1677) on Dordrecht; Bleyswijck (1674) on Delft; and Orlers (1641) on Leiden.

26. Bartsch, no. 11 (see also Boston/St. Louis 1980–81, no. 24). The view and the Dutch text are concerned with carefully describing the details of the event. An additional text in Latin by Schrevelius (already abstruse by its linguistic inaccessibility) draws a moralizing message. Later illustrations of beached whales leave out such morals; see Buytewech's print of 1617 (Haverkamp Begemann 1959, fig. 61).

27. Though not perfectly accurate, Ruisdael's view was recognizable to those who knew Wijk. The town is depicted in only a handful of topographic prints before Ruisdael's time. Besides an anonymous view of the early 1600s, there is an etching of the castle made by I. Hilverdink in 1640 (Imdahl 1968, fig. 16). Jan van Goyen included the castle at Wijk (but not the windmill) in a few of his paintings (Beck 1972–73, vol. 2, nos. 637, 697). Roeland Roghman also

89 (PLATE 100)

View of Alkmaar, c.1670–75

sketched the building. On the history of the castle, built by Philip of Burgundy (1396–1467), see J. Sterk, *Philips van Bourgondië* (Zutphen, 1980), pp. 55–60.

28. Several different types of mills are shown, and mill stones are seen in the foreground, just as in Ruisdael's landscape. The print is from a series (with some prints by Thomas Galle) "Nova Reperta" (New Discoveries) illustrating things unknown to the ancients, including America, printing, mechanical clocks, distillation, oil paint, optical lenses, and the magnetic poles (Thomas Galle, Hollstein, nos. 410–30).

29. Peter Schatborn (Amsterdam, Rijksprentenkabinet cat. 1985, p. 68) noted that Rembrandt added a windmill to the background of an etching in transferring a composition from drawing to print (Bartsch, no. 232) in order to add a more picturesque element to the scene. On the history and popular culture of the Dutch windmill, see A. Bicher Caarten, *De molen in ons volksleven* (Leiden, 1958); and A. Bicher Caarten, ed., *Noordhollands molenboek* (Haarlem, 1964).

Signed lower left: J Ruisdael [JR ligated]
Oil on canvas, 17½ x 17⅛ in. (44.4 x 43.5 cm.)
Museum of Fine Arts, Boston, Ernest Wadsworth Longfellow Fund. 39.794

Provenance: Eugene, Duke of Leuchtenberg, Munich; Maximilian, Duke of Leuchtenberg, Munich and St. Petersburg: Leuchtenberg family, Seeon Castle, Bavaria [inventory c.1920, no. 250]; with dealer Arnold Seligmann, Rey and Co., London; acquired 1939.

Exhibitions: St. Petersburg 1904, ill.; Boston, Museum of Fine Arts, "One Thousand Years of Landscape, East and West," autumn 1945; St. Louis 1947, no. 35, ill.; Toronto 1950, no. 41; Hartford 1950–51, no. 9, pl. ii.

Literature: Leuchtenberg coll., cat. 1830, no. 108; Leuchtenberg coll., cat. 1895, no. 166; Passavant 1851, p. 29, no. 151 (engraved by H. Adam); Leuchtenberg coll. cat. 1886, no. 129 (wrongly as a panel); Michel 1890b, p. 87; Hofstede de Groot 1908–27, vol. 4, no. 77; Rosenberg 1928a, no. 61a; Simon 1930, p. 53; Cunningham 1940; Luttervelt 1949; Lugano, cat. 1969, p. 298; Burke 1974, p. 10; Boston, MFA cat. 1985, p. 254; P. Sutton 1986, p. 29.

The vault of a towering sky stretches above a panoramic plain, with the skyline of a city on the horizon. Weaving back from the foreground, a sandy road passes through a watery hollow to a darkened stand of trees surrounding cottages and a tall building in the shadows of the left middle distance. To the right, a sunny meadow with windmill and cottages bordered by a minutely observed fence stretches back to the city on the shadowed horizon. The cloud-dappled sky, which dominates nearly four-fifths of the composition, mottles the countryside.

This painting is closely related to a series of about fifteen panoramic views of the city of Haarlem that Ruisdael had begun by 1669 and that probably date mostly from about 1670–75.[1] The paintings of this group (see, for example, Introduction, fig. 65) are customarily called

Ruisdael's *haarlempjes*; "een Haerlempje van Ruysdael" (a little [view of] Haarlem by Ruisdael) appeared in an Amsterdam inventory of 1669.[2] Important innovations in the history of the panorama, Ruisdael's *haarlempjes* incorporate features of the profile town view, part of the familiar schema of the topographical print tradition, with the recent advances of artists like van Goyen, Rembrandt, and Philips Koninck in achieving a more comprehensive, unified panoramic vista. Employing for the most part a vertical format, Ruisdael's works adopt a high viewpoint, an emphatic horizon, and a soaring, cloud-filled sky, which reiterates the complex patterning of light and shade in the land below. Their upright design, as Stechow observed, gives the works an "erect stateliness,"[3] which enables the sky to complement the countryside's seemingly endless projection into space. The counterpoint of the vaulted heavens and the rayed and dappled earth below creates an extraordinarily monumental effect even in works, like the present one, of a modest scale. Ruisdael's *haarlempjes* are generally considered the pinnacle and culmination of the Dutch panorama. Burke has proved in a systematic study of the series in relation to the topography in and around Haarlem (Bloemendaal, Overveen, and other sites) that despite their apparent naturalism they are never an exact representation of a specific prospect, and the viewing point is rarely an identifiable spot.[4]

The Boston painting has always been labeled and catalogued as a depiction of Haarlem, with the form of Saint Bavo's church on the horizon.[5] It was also regarded as such when in the Leuchtenberg collection and when published by Rosenberg in his monograph of 1928. However, in 1940 in an unpublished opinion, Horst Gerson and E.H. ter Kuile correctly suggested that the city was not Haarlem but Alkmaar and that the building in the left foreground was Egmond

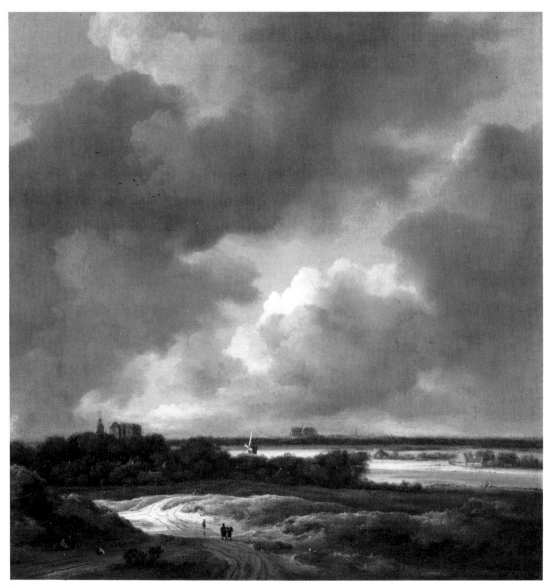

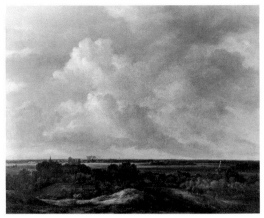

Fig. 1. Jacob van Ruisdael, *View of Alkmaar with Castle Egmond*, signed, canvas, 50.8 x 63.5 cm., Thyssen-Bornemisza Collection, Lugano, no. 272.

Fig. 2. François Knibbergen, *View of Alkmaar with Castle Egmond*, canvas, 105 x 144 cm., Krupp von Bohlem und Halbach collection.

Castle.[6] They further argued that in addition to the Boston painting, the closely related paintings now in the Thyssen-Bornemisza Collection (fig. 1),[7] Viscount Bearsted's collection, Upton House, Banbury,[8] the Duke of Sutherland's collection,[9] and the painting formerly in the Huldschinsky sale, Berlin, May 10, 1928 (no. 30; later with Etienne Nicolas, Paris, 1968),[10] all depict Alkmaar and should be removed from the proper group of *haarlempjes*. Without discussing the matter in detail, Burke also listed the Boston, Lugano, and Upton House paintings as depicting Alkmaar from southwest of the city.[11] However, in 1949 van Luttervelt upheld the identification of the Boston painting as Haarlem, rejecting the identification of the building on the left with Egmond Castle (as well as ruling out the castle of Heemstede and Brederode), arguing instead that it depicts the Huis te Kleef with Haarlem viewed from the north, possibly from nearby the Huis te Zanen.[12] Despite van Luttervelt's argument that Ruisdael has fantasized the Huis te Kleef, prints of the ruins by Willem Buytewech, Jan van de Velde (after Pieter Saenredam) (see Introduction, fig. 29), and Willem Akersloot show no compelling resemblance to the structure in the foreground of the Ruisdaels.[13] Indeed, Ruisdael himself depicted the Huis te Kleef twice in panoramic settings (Musée Jacquemart-André, Paris, no. 416; and Musée des Beaux-Arts, Montreal, no. 920).

In the Boston painting the spire of the church on the horizon is too low for Saint Bavo's, but it closely resembles the Grote Kerk in Alkmaar. Further, not one of the other familiar landmarks of Haarlem appears on the horizon. The van Goyen follower François Knibbergen painted Alkmaar from virtually the same angle as Ruisdael's paintings, including the Egmond Castle and the village Egmond op den Hoef in the left foreground (fig. 2).[14] Two drawings by

Fig. 3. Roeland Roghman, *Egmond Castle*, chalk and wash drawing, 310 × 465 mm., Teylers Museum, Haarlem, no. o**6.

Roeland Roghman (see fig. 3) offer close views of Egmond Castle in ruins, surrounded by trees but viewed from an angle opposite the one in the panoramas by Ruisdael and Knibbergen.[15] Ruisdael himself had earlier depicted close views of Egmond Castle repeatedly (see Art Institute of Chicago, no. 47.475; John G. Johnson Collection, Philadelphia Museum of Art, no. 564 and five drawings of the ruins),[16] but dramatized the site and building, adding a hilly setting and greatly attenuating the castle's turrets.

The castle was the seat of the counts of Egmond. Spanish troops occupied it during the invasion of Holland in 1573–74. When they departed, the Prince of Orange ordered the troops of Diederik Sonoy, governor of the northern quarter of Holland, to destroy the castle to prevent the Spanish from again camping there. Since then the castle has remained in ruins.

P.C.S.

1. See the discussion in Rosenberg 1928a, pp. 56–59; Stechow 1968, pp. 45–49; and The Hague/Cambridge 1981–82, pp. 127–31.

2. See Bredius 1915–22, vol. 3, p. 425. Four drawings by Ruisdael of Haarlem seen from the west are preserved, one in the Rijksprentenkabinet in Amsterdam (inv. 1961:43) and three in the Bredius Museum, The Hague (inv. T 94-1946, T 95-1946, T 96-1946).

3. Stechow 1968, p. 46.

4. Burke 1974, pp. 4–11.

5. Rosenberg 1928a, no. 61a.

6. Letter to C.C. Cunningham, March 21, 1940.

7. Hofstede de Groot 1908–27, vol. 4, no. 57; Rosenberg 1928a, no. 57; Lugano cat. 1969, no. 272, as a *View of Haarlem with the Huis te Kleef* (see below).

8. *Le Coup de Soleil*, canvas, 40.5 x 40.6 cm., Hofstede de Groot 1908–27, vol. 4, no. 70; Rosenberg 1928a, no. 55.

9. Hofstede de Groot 1908–27, no. 67.

10. Ibid., no. 58; Rosenberg 1928a, no. 41.

11. Burke 1974, p. 10.

12. Van Luttervelt 1949.

13. See Willem Buytewech's *Ruins of the Huis te Kleef*, no. 3 from the "Various Landscapes" series of c.1616, etching (van der Kellen 1866, no. 23); Claes Jansz Visscher, *Ruins of the Huys te Kleef*, about 1611–12, no. 12 from the "Pleasant Places around Haarlem" series, etching (Wurzbach 1906–11, vol. 3, p. 796, no. 23; ill. respectively in Boston/St. Louis 1980–81, nos. 37 and 36); and *Siege of Haarlem 1572–73* (van Luttervelt 1949, fig. 2). Van Luttervelt also refers to the engravings of Hendrick Spilman and illustrations in F. de Witt Huberts, *Haarlem Heldenstrijd* (1943).

14. Sale, Moll, Amsterdam (F. Muller), December 15, 1908, no. 63. On the photo at the Rijksmuseum voor Kunsthistorische Documentarie George Keyes suggests an attribution to Jan van Kessel.

15. For the Roghman drawing, see also Teylers Museum, Haarlem, inv. o**5 (334 x 480 mm.).

16. See, respectively, Hofstede de Groot 1982, nos. 51 and 766; Rosenberg 1928a, no. 34 and 479; for discussion, see Slive in The Hague/Cambridge 1981–82, pp. 64–66.

Salomon van Ruysdael

(Naarden 1600-03–1670 Haarlem)

Landscape with a Fence, 1631

Salomon Jacobsz van Ruysdael was born in Naarden in Gooiland. He was originally called Salomon de Gooyer (Goyer), but he and his brother Isaack (1599–1677), who was also an artist, adopted the name Ruysdael from Castle Ruisdael (or Ruisschendaal), near their father's home town. Salomon spelled his name Ruysdael (or occasionally Ruyesdael), as distinguished from his nephew Jacob, who used Ruisdael. In 1623 Salomon entered the painters' guild in Haarlem (as Salomon de Gooyer), was named a *vinder* of the guild in 1647, a deacon the following year, and a *vinder* again in 1669. His earliest known dated painting is of 1626, and he was praised as a landscapist as early as 1628 by the chronicler of Haarlem, Samuel van Ampzing. He was called a merchant in 1651 and dealt in blue dye for Haarlem's bleacheries. His wife, Maycken Buysse, was buried in Saint Bavo's Church in Haarlem on December 25, 1660. Like his father, Salomon was a Mennonite and in 1669 was listed among the members of the "Vereenigde Vlaamsche, Hoogduitsche en Friesche Gemeente" when he was living on the Kleyne Houtstraat. As a Mennonite, he could not bear arms but contributed to Haarlem's civic guard. Although Salomon seems to have lived and worked in Haarlem his entire life, he probably made several trips through the Netherlands, making views of, among other places, Leiden, Utrecht, Amersfoort, Arnhem, Alkmaar, Rhenen, and Dordrecht. The artist was buried in Saint Bavo's Church in Haarlem on November 3, 1670.

Although Salomon's teacher is unknown, his earliest works of about 1626–29 recall the art of Esaias van de Velde, who worked in Haarlem from 1609 to 1618. In addition to van de Velde's influence, these early works reveal many parallels with Jan van Goyen's work. Together with Pieter de Molijn, Salomon van Ruysdael and Jan van Goyen were the leading "tonal" landscapists of their generation and seem to have influenced each other. They laid the foundation for the great "classical" period of Dutch landscape painting that followed. In addition to landscapes and numerous river and seascapes of a calm, never stormy, type, he painted a few still lifes in his later years. Salomon was the father of Jacob Salomonsz van Ruysdael (c.1629/30–1681), also a painter.

P.C.S.

Literature: Ampzing 1628; Houbraken 1718–21, vol. 2, p. 124, vol. 3, p. 66; Descamps 1753–64, vol. 3, p. 11; Nagler 1835–52, vol. 14, pp. 104–5; Immerzeel 1842–43, vol. 3, p. 41; Kramm 1857–64, vol. 5, p. 1412; Nagler 1858–79, vol. 5, nos. 265, 418; von Frimmel 1905; Wurzbach 1906–11, vol. 2, pp. 524–25; K.E. Simon, in Thieme, Becker 1907–50, vol. 29, pp. 189–90; Dülberg 1922; Grosse 1925, pp. 79–87; Wijnman 1932; Martin 1935–36, vol. 1, pp. 250–51, 426, vol. 2, pp. 280–83; Amsterdam 1936; Beerends 1936; van Gelder 1936; Heppner 1936; Stheeman 1936; Stechow 1938a; Stechow 1938b; Trautscholdt 1938; van Regteren Altena 1939; Stechow 1939; Stechow, Hoogendoorn 1947; Niemeijer 1959; Maclaren 1960, pp. 377–78; Scholtens 1962; Stechow 1966, 23–28, 38–43, 54–62, 90–91, 103, 113–16; Bol 1973, pp. 148–56; van Gelder 1976; Bengtsson 1977; The Hague, Mauritshuis cat. 1980, pp. 94–99.

Signed and dated lower left: S.W.R VYESDAEL 1631
Oil on panel, 14⅞ x 21⅜ in. (37.8 x 54.3 cm.)
Kunsthistorisches Museum, Vienna, inv. 6972

Provenance: Dealer P. Cassirer, Berlin, about 1926; L. Lobmeyr, Vienna; acquired in 1939 from the Galerie Sanct Lucas, Vienna.

Exhibition: Zurich 1947, no. 401.

Literature: Stechow 1938a, p. 18, no. 230; Ludwig von Baldass, "Neue Erwerbungen der Wiener Gemäldegalerie," *Belvedere* 23 (1938–43), p. 173; Vienna, Kunsthistorisches cat. 1972, p. 83, ill.

A road in the dunes passes through a diagonally receding backlighted fence that extends from the left foreground to the right distance. On the left the fence is composed of wattles and planks, while on the right it has a more open structure of split rails and tree branches. A large tree with two naked limbs rises on the left, and low hills appear in the distance. Light streams through a gate in the right center of the picture. In the shadow of this crude fence, four peasants, including one woman, rest by the roadside. A fifth seated figure is silhouetted by the gate. In the distance on the right stretch open fields.

This unembellished view of a crudely demarcated boundary line and rural highway is typical of Salomon van Ruysdael's earliest paintings of roads in the dunes. The palette is restricted to earth colors, but the contrasts of light and shadow are dramatically juxtaposed. The use of a darkened repoussoir in the foreground with bright sunlight raking across the scene from the broken cloud-cover low on the left, had already appeared in Salomon van Ruysdael's daringly composed *Dunescape* of 1628 (see p. 67, fig. 3)[1] and in an even earlier painting said to be dated 1626 (Introduction, fig. 48). There the design of the Vienna painting is applied, as it were, in close focus; the lighted roadway is again hidden by the silhouetted mass

90

Fig. 1. Salomon van Ruysdael, *Gate in the Dunes*, monogrammed and dated 1633, panel, 33.5 x 44 cm., Fürst Salm-Salm, Museum Wasserburg, Anholt.

1. Stechow 1938a, no. 227.

2. Ibid., no. 233.

3. See also Salomon's other paintings dated 1631, ibid., nos. 180, 229A, 229B, 231, 321, and 435.

4. In the RKD's photograph files, Horst Gerson assembled a group of misattributed works that employ this design and assigned them collectively to de Neyn: sale, Munich, June 15, 1909, no. 89 (as P. Nolpe); sale, Munich, Dec. 10, 1907, no. 6 (as P. Nolpe); sale, G.R. Hoscher, Vienna, Mar. 24, 1909, no. 45; sale, Vienna, Feb. 26, 1918, no. 265 (as P. de Molijn); and sale, Paris (Drouot), Nov. 29, 1950, no. 32 (as Jan van Goyen).

of the dune on the left, and two figures in a small horsecart are just disappearing behind this darkened foil. In the Vienna painting the artist steps back, offering a broader view of the dunes, but the informal immediacy remains. Bristling with late afternoon highlights, the makeshift gate and ramshackle fence capture the careless, unaffected beauty of the countryside. A further remove from the original near view of the sandy road and the next development from the sidelit composition with aperture of light is the *Gate in the Dunes*, dated 1633, in the collection of Fürst Salm-Salm (fig. 1).[2] Also dated 1631 are Salomon van Ruysdael's dune landscapes in Budapest (cat. 91), Berlin (cat. 91, fig. 1), and Warsaw.[3] Ruysdael's composition with the sidelighted gate was adopted by later artists, notably Pieter de Neyn (1597–1639), who used it repeatedly.[4]

P.C.S.

Road in the Dunes with a
Passenger Coach, 1631

Monogrammed and dated lower right: SVR 1631
Oil on panel, 22 x 34 in. (56 x 86.4 cm.)
Szépművészeti Múzeum, Budapest, inv. 260

Provenance: Prince Nikolaus Esterházy von Galantha
(at Laxenburg before 1815; in Vienna 1813–1865
[1820 inventory, no. 989]; in Pest Academy of
Sciences, from 1865); purchased by the Hungarian
government in 1870; National Gallery, Pest, 1872;
transferred to the Szépművészeti Múzeum, 1906.

Literature: Esterházy, cat. 1869, p. 44; Bode 1872,
p. 169; Tschuchi, Pulszky 1883, p. 19; Wurzbach
1885, p. 155; Frimmel 1892, p. 167; Budapest, cat.
1906, no. 515; Wurzbach 1906–11, vol. 2, p. 523;
Stechow 1938a, pp. 19, 89, no. 181; Bernt 1948, vol. 3,
pl. 700; Stechow 1966, p. 26, fig. 30; Czobor 1967,
no. 17; Budapest, cat. 1968, p. 604, no. 260, pl. 270;
Bernt 1980, vol. 3, pl. 1068.

A coach crowded with passengers approaches a
house nestled in the dunes beside a sandy road
and surrounded by tall trees. On the left is the
silhouette of a haywagon, and hogs wallow in the
mud beside two wooden barrels. On the right
the shadow of a horseman appears before other
cottages. A cloudy sky rises overhead.

This painting is one of Salomon van
Ruysdael's earliest paintings of dunes and
country roads employing a diagonal compo-
sition. The orientation is from the right fore-
ground to the left distance with a low horizon.
The movement into depth is counterbalanced by
the opposing diagonal of the road in the fore-
ground. As Stechow demonstrated,[1] this schema
is applied in its most orthodox form in the
painting in Berlin (fig. 1), dated the same year as
Budapest's picture and again depicting a sandy
road in the dunes with wagon and farmhouse.
Also similar in conception is a third work of
1631, the *Country Road in the Dunes* in the Muzeum
Narodowe, Warsaw (inv. 1121),[2] where, how-
ever, the darkened *repoussoir* zone in the fore-
ground is enlarged. Of the three closely related
works, the Budapest painting displays the

91

Fig. 1. Salomon van Ruysdael, *Dune Landscape with Farmhouse and
Wagon*, signed and dated 1631, panel, 68.5 x 105.5 cm., Staatliche
Museen Preussischer Kulturbesitz, Berlin (West), no. 901C.

92 (PLATE 49)

Travelers before an Inn, 1645

greatest diversity in the effects of light, movement, and atmosphere. It also boasts the most variegated motifs. Not only the design but also the palette of grayish greens and tawny browns are related to contemporary and slightly earlier works by Pieter de Molijn (cat. 56) and van Goyen (cat. 35). In the Budapest Museum's catalogue the painting is titled *After the Rain*, and, indeed, the greenish cast to the skies and the moist earth below vividly evoke the passing of a shower.

Although it is not certain that the building approached by the open coach is a roadside tavern, this work anticipates one of Ruysdael's favorite themes in the mid-1640s and afterward, namely, the Halt before the Inn (compare cat. 92, of 1645). Individual motifs, such as the silhouetted sow, which recurs in an identical position in the later work of 1645, confirm that Salomon used a repertory of figure and animal studies for his staffage.

P.C.S.

1. Stechow 1938a, p. 19; Stechow 1966, p. 26.
2. Stechow 1966, p. 26, note 31.

92

Signed and dated lower right:
S.vRUYSDAEL[vR ligated]/1645
Oil on panel, 27¼ x 36½ in. (69.5 x 92.5 cm.)
Private Collection

Provenance: Mevr. A.M.A. Ijssel de Schepper-Dumbar, Deventer, by 1901; sale, Ijssel de Schepper, Amsterdam, May 20, 1919, no. 97; sale, Bringenberg et al., Amsterdam (Muller), June 17, 1925, no. 237; G.J. Willink, Winterswijk (d. 1934); by descent to H.E. ter Kuile, Enschede; sale, London (Sotheby's), July 5, 1984, no. 262, ill.

Exhibitions: Deventer, Sociëteit "de Vereeniging," *Oude Kunst*, 1901, no. 3; Enschede, Rijksmuseum Twenthe, 1935, no. 40.

Literature: Stechow 1938, pp. 21, 24, 28–29, 41, 44, 91, no. 153, pl. 20, fig. 29; ter Kuile 1976, p. 149, ill.

On a curving country road flanked by tall trees, travelers have halted before an inn. The moist ground suggests the passing of a recent shower, the silvery foliage the advent of spring. Cattle

Fig. 1. Salomon van Ruysdael, *Halt before the Inn*, signed and dated 1643, canvas, 62 x 92 cm., Norton Simon Museum of Art, Pasadena.

Fig. 2. Jan van de Velde, *White Cow*, 1617, etching.

and pigs stand on a muddy road in the foreground, while on the right a crowd of drovers, horsemen and other travelers are accosted by gypsies. Further along the road in the middle distance two more elegant, covered carriages have stopped beneath the wreath-covered signboard of the inn.

The subject of the halt before the inn was one of Salomon van Ruysdael's favorite landscape themes. While the elements of the subject – travelers stopped before a building on a country road – were treated by Salomon as early as 1630/31 in his first investigations of diagonal designs in "tonal" paintings (see cat. 91), Salomon's nearly twenty dated paintings of the halt before the inn range in date from 1635 to 1667.[1] Around 1643, as Stechow has observed, this subject assumed a new importance in Ruysdael's art as he treated fewer watery subjects – river views and marines – turning instead to subjects on dry land with variations on the diagonal designs of his "tonal" works but stressing more compositional structure.[2] In the *Halt before the Inn* of 1643 (fig. 1),[3] for example, where once the diagonal thrust would have swept rapidly from right to left, it now is tempered by a second, counterbalancing diagonal and a large band of shadow serving as a *repoussoir* in the immediate foreground. In the exhibited painting of two years later, a similar darkened foreground zone appears, as well as bisecting diagonals. But now additional stabilizing elements in the design – including a group of massive trees on the left, the greater clarity of tone overall, and a new emphasis on bright local color – announce the advent of Ruysdael's mature style. Indeed, the work is particularly precocious in its return to a greater concern with form and structure. Clearly, Stechow felt that the painting constituted a milestone and highpoint in Ruysdael's career.[4]

The season depicted here is certainly spring. We deduce this not simply from the muddy roads suggesting a recent shower and the silvery, young leaves (a favorite detail in Ruysdael's work that recalls van Mander's prescription to observe foliage carefully, even the lighter underbellies of leaves [*Den Grondt*, chap. 8, verse 40]) but also from the cows in the

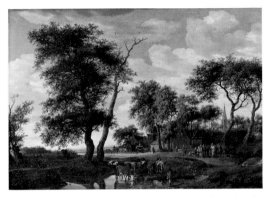

Fig. 3. Salomon van Ruysdael, *View in a Village*, signed and dated 1663, canvas, 105 x 150.5 cm., Rijksmuseum, Amsterdam, inv. A 2571.

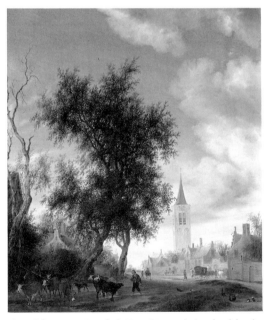

Fig. 4. Salomon van Ruysdael, *View of Beverwijk*, signed and dated 1646, panel, 75.2 x 65.6 cm., Museum of Fine Arts, Boston, 1982.396.

93 (PLATE 47)

River View, 1645

foreground. Cattle drives were traditionally held in spring. An allegorical print of Spring (*Ver*) by Jan van de Velde or Gillis van Scheyndel after Willem Buytewech (Franken, van der Kellen 1883, no. 518) depicts a landscape prominently featuring cows at pasture. Another print by van de Velde, depicting a farmer driving his cows and goats to market at dawn (see fig. 2), bears a Latin inscription referring to the monetary value of the livestock: "The heavy work is light for him as long as he comes home later loaded down with the money he has earned." But the gullible might not always return with a full purse, as the gypsies in Ruysdael's painting serve to remind us.

The relationship of the staffage figures in Ruysdael's landscape may recall contemporary genre paintings by Isack van Ostade. Gypsies appear elsewhere in Salomon's art, including a late painting in the Rijksmuseum, Amsterdam (fig. 3) that employs a variation on the present work's design.[5] Other variants of the design include the upright format *View of Beverwijk*, dated 1646 (fig. 4), and the horizontally disposed *Landscape with a Watchtower* (the Plompetoren in Utrecht?) of about 1660 (Alte Pinakothek, Munich, inv. 4526),[6] two works that incorporate actual structures into the composition and further attest to the fictitious origins of Salomon's views.

P.C.S.

1. See Stechow 1938a, nos. 145–166, and the undated works, nos. 166–176.
2. See Stechow 1938a, pp. 21–22; Stechow 1966, pp. 27–28.
3. Stechow 1938a, no. 147.
4. Ibid., p. 22, where he speaks of the work as a masterpiece of the new "composed (*komponierenden*) style."
5. Ibid., no. 163.
6. Müllenmeister 1973–81, vol. 3, fig. 347.

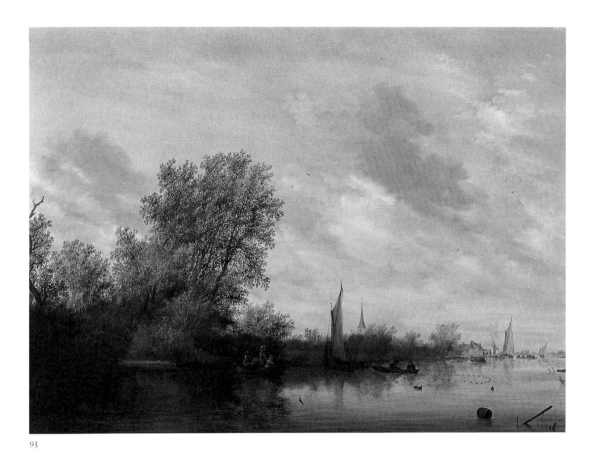

93

Monogrammed and dated on the largest boat: SVR 1645
Oil on canvas, 38½ x 52 in. (98 x 132 cm.)
Mr. and Mrs. George M. Kaufman

Provenance: Sale, Schamp van Aveschoot, Ghent, September 14, 1840, no. 171 (frs.1,050 or 2,050 to Mme. Durray); sale, Lord Aldenham, London (Sotheby's), February 24, 1937, no. 121 (£1,050 to R. MacConnal); dealer D. Katz, Dieren (1938 cat., no. 93); dealer Dr. H. Schaeffer, New York (1939 cat., no. 343); sale, New York (Christie's), January 15, 1985, no. 98; Richard Green Gallery, London.

Exhibitions: Providence 1938, no. 47; New York, Knoedler Gallery, 1945, no. 14.

Literature: Stechow 1938a, p. 149, no. 517.

A river recedes diagonally from the left foreground. A group of tall trees ascends to the left of center while the remainder of the bank is covered with bushes and trees that extend out over the water. On the left a narrow clearing appears. A boat with four fishermen, one standing with his back to the viewer, is situated to the

River Landscape with Ferry, 1649

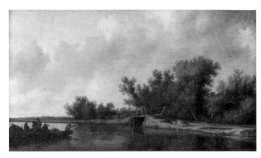

Fig. 1. Salomon van Ruysdael, *River Landscape*, monogrammed and dated 1631, panel, 36.6 x 65.5 cm., National Gallery, London, no. 1439.

Fig. 2. Salomon van Ruysdael, *River Landscape*, monogrammed and dated 1632, panel, 35.5 x 50.5 cm., Kunsthalle, Hamburg, inv. 627.

Fig. 3. Salomon van Ruysdael, *River View with Fishermen*, monogrammed and dated 1645, panel, 64 x 92.5 cm., Kunsthalle, Hamburg, inv. 322.

left of center. On the right a second rowboat with two fishermen has set out nets. In the center the line of the bank is divided by the sails of boats anchored along shore. In the distance a church spire rises, and on the horizon are other boats and houses.

This large, fully resolved canvas from Salomon's mid-career takes up a theme and design that he had first investigated more than a dozen years earlier. As Stechow observed, Ruysdael initially addressed the subject of river landscapes in 1631.[1] The *River Landscape* in the National Gallery, London, of that year (fig. 1), employs a conspicuously linear schema with the diagonally retreating banks to the right moving ineluctably into the left distance, its rapid retreat counteracted only by the static shadow of a fishing boat in the left foreground.[2] Notable advances in the atmospheric unity of the work and the evocative use of reflections on the water appear in the *River Landscape*, dated only one year later in the Kunsthalle, Hamburg (fig. 2).[3] This precocious painting exhibits all of the elements, even down to the barrel floating on the stream in the foreground, that Ruysdael would perfect in the Kaufman painting. In the latter work, however, the touch has become more assured and subtly descriptive, and the gray-green palette is supplemented with accents of yellow and a bold sky-blue. Short, stabbing strokes enliven the work's foliage with an impressionistic flicker. A close variant of the design of the Kaufman painting appears in the *River View with Fishermen*, also dated 1645, in the Kunsthalle, Hamburg (fig. 3).[4] Compare also his painting of the *Halt before the Inn* theme of this year (cat. 92).

P.C.S.

1. Stechow 1938a, p. 19.
2. Ibid., no. 435.
3. Ibid., no. 498.
4. Ibid., no. 514.

Signed and dated: S.vRuysDAEL [vR ligated]/1649
Oil on panel, 35⅞ x 49⅝ in. (91 x 126 cm.)
Private Collection

Provenance: Capt. Webb, Woodford, Ashford, Kent; dealer W.E. Duits, London, 1934; dealer G. Douwes, Amsterdam, 1934; private collection, England, by 1938; sale, Trustees of the Mendel Furniture Settlement, London (Sotheby's), November 30, 1983, no. 89; ill.

Exhibitions: Amsterdam, Douwes, 1934, no. 58, ill.

Literature: Stechow 1938a, p. 123, no. 357.

A river landscape depicts a wooded bank and screen of tall trees on the right and a distant prospect on the left. Many boats enliven the scene. Heavily laden with three mounted riders, cattle, farmers, and dogs, a ferry poles toward the near bank, its darkened form serving as a *repoussoir*. Beyond, a trio of boats moves rapidly downstream under full sail while other smaller rowboats, also weighted down with passengers, ply the more sheltered waters of a small bend in the river. In the distance, a church, a castle, and buildings punctuate the horizon.

As Wolfgang Stechow has demonstrated, Salomon van Ruysdael had begun painting river views with rustic ferry boats as early as 1631 (see cat. 93, fig. 1).[1] Thus, he followed on the heels of Jan Brueghel (see fig. 1), Jan van de Velde (Franken, van der Kellen 1883, no. 406), Esaias van de Velde (see cat. 106), and van Goyen (see cat. 33). During the 1640s Ruysdael painted variations on the river view (see commentary to cat. 93) and by about 1650 had made the subject a personal specialty. This painting is among the largest and most successful of Salomon's mature river views. It adopts a compositional scheme, which he had developed by 1645, that fills the foreground with water but mitigates the strict diagonal recession of the river bank with a series of sharp curves (see cat.

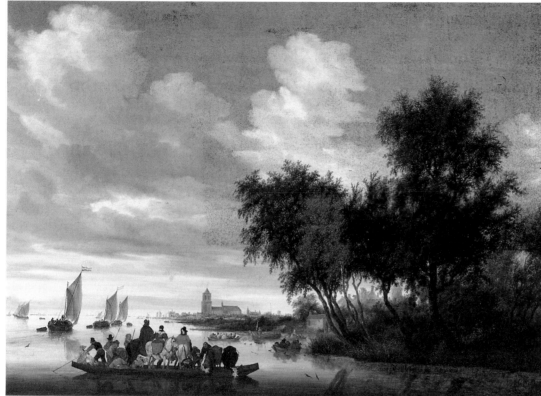

94

Fig. 1. Jan Brueghel, *River Landscape*, signed and dated 1603, panel, 39 x 60 cm., Koninklijk Museum voor Schone Kunsten, Antwerp, inv. 910.

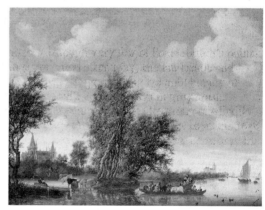

Fig. 2. Salomon van Ruysdael, *River Landscape with Ferry*, signed and dated 1649, canvas, 99.5 x 133.5 cm., Rijksmuseum, Amsterdam, inv. A 3983.

93, fig. 3).[2] In these designs the prominent motifs of the near shore overlap those of the middle distance, and a similar series of super-impositions is reiterated into the distance. Counterbalancing the banks is the charming line of sailing vessels on the left. The latter detail was a compositional device anticipated by Jan Brueghel (fig. 1) and much favored by Ruysdael.[3]

Characteristic of Ruysdael's mature works of the later 1640s and the 1650s are the sharper contrasts of value and stronger color accents.

The trees and foliage, the surface of the water, even the details of the boats and architecture are observed with a new precision. Overhead the windswept clouds, so distinct against the bright blue sky, reiterate the forms of the softly mottled trees on the near bank. A variant of this work's composition, which is dated the same year but reverses its design, is in the Rijksmuseum (fig. 2).[4] Also very close in design is the painting dated the following year, 1650, in the collection of Mr. and Mrs. Edward W. Carter.[5] With variations to its site and structure, the

95 (PLATE 50)

Winter View outside Arnhem, 1653

church in the distance reappears elsewhere in Ruysdael's art (see, for example, cat. 93, fig. 3) but has not been identified. Like Ruysdael's repeated variations on his designs, this structure and the castle with turret and crenelated battlements partially hidden by the trees may be the artist's invention. It is a testament to Ruysdael's extraordinary creativity, however, that his river scenes are always naturalistically plausible, never formulaic.

P.C.S.

1. Stechow 1938a, pp. 19ff., 41ff.; Stechow 1966, pp. 55–57.

2. Stechow 1938a, no. 514. See also *River Landscape with Fishermen*, dated 1645, panel, 64 x 88 cm., sale, London (Sotheby's), July 6, 1983, no. 74, ill.

3. See, for example, *Sailboats near Rhenen*, Barnes Foundation, Merion, Penn.; Stechow 1938a, no. 309, fig. 46.

4. Ibid., no. 358. Compare also the *River Landscape with View of Nijenrode Castle*, dated 1649 (ibid., no. 355, fig. 27).

5. Ibid., no. 363A, pl. 36; Walsh and Schneider, in Los Angeles/Boston/New York 1981–82, no. 22, ill.

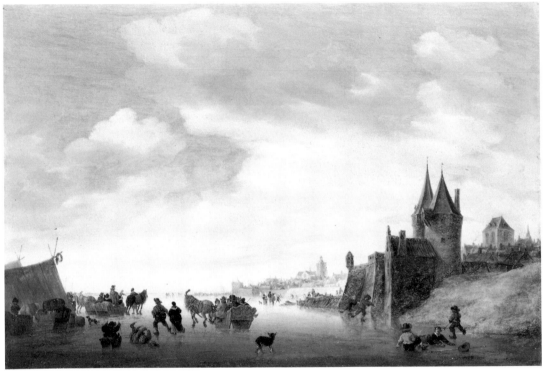

95

Monogrammed and dated on the sledge at bottom left: S.VR. 1653
Oil on panel, 22 x 31½ in. (56 x 80 cm.)
Dutch Private Collection

Provenance: François-Joseph, 2nd Duc de Caylus; dealer E. Slatter, London, 1950; Señora Diaz Estévez; sale, London (Sotheby's), July 6, 1983, no. 78.

Exhibition: Atlanta 1985, no. 49, ill.

Literature: Stechow 1938a, p. 69, no. 5B; F.J. Duparc, "Dutch Masters from Private Collections in Atlanta," *Tableau* 7, no. 6 (summer 1985), p. 45, ill.

Skaters frolic on the ice outside the city walls of a town resembling Arnhem. The painting is not topographically correct but depicts the Grote Kerk (Saint Eusebius) in the distance, and, in the double-turreted port in the right foreground, possibly the imaginatively reformed Saint Janspoort. Figure skaters play games and take a tumble on the ice in the foreground while a horse-drawn sleigh moves off down the river. Another sleigh stops before tents on the left advertising refreshments with a sign and wreath hung on one of the poles out front. Billowing clouds sweep past overhead.

Herman Saftleven

(Rotterdam 1609–1685 Utrecht)

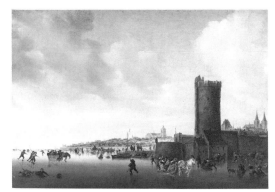

Fig. 1. Salomon van Ruysdael, *Skating outside Arnhem*, signed and dated 165(3), canvas, 75 x 105 cm., private collection.

With the prominent church towers of the squat Grote Kerk and the double-spired Saint Walpurgis standing out above the broad plain of the Rhine, Arnhem in Gelderland was a favored subject for landscapists. Van Goyen alone painted at least seventeen views of the city in and after 1633.[4] Ruysdael painted a second winter view of Arnhem with ice skaters, also dated 165[3] (fig. 1), which in characteristic fashion reshuffles the city's monuments and landmarks.[5] A painting of *Ice Skating in Utrecht*, dated 165[8?], employs a diagonal composition with church spires on the right that recalls the general design of his winter scenes of 1653.[6] Ruysdael apparently continued to paint winter landscapes in the 1660s, but his total production probably never exceeded about twenty works.

P.C.S.

In his early career Ruysdael painted three winter landscapes in 1627 under the influence of Esaias van de Velde and possibly van Santvoort.[1] He did not return to the subject for more than twenty years, dating his *Drawing the Eel* in 165[0?] (cat. 120, fig. 1), a village landscape in winter. The exhibited painting of 1653 was executed in the year he again took up skating scenes. As Stechow observed, these works employ the diagonal design that Salomon had perfected in his river scenes of the 1630s but add a new interest in topographic and genre-like details.[2] These compositions seem to reflect the influence of Jan van Goyen's designs for skating scenes from about 1638 and later,[3] as do motifs like the tents on the ice. But Salomon's palette is much more colorful, his figures more solidly conceived, and his architecture more stately and substantial. The skies in his winter scenes also offer far greater meteorological variety than do those of van Goyen or Salomon's more celebrated nephew, Jacob van Ruisdael (see cat. 84). The latter's paintings of winter's darker moods held no interest for Salomon.

1. Stechow 1938a, nos. 1–3.
2. Ibid.; Stechow 1966, p. 99.
3. Compare, for example, Beck 1972–73, vol. 2, nos. 52 and 53, both dated 1638.
4. See Beck 1972–73, vol. 2, nos. 272–89.
5. Stechow 1938a, no. 12.
6. Ibid., no. 13, fig. 36; Stechow 1966, fig. 6.

Anonymous after D. Saftleven, *Herman Saftleven*, c.1660, etching.

Born in 1609 in Rotterdam to an artistic family, Herman Saftleven III was the son and grandson of painters of the same name (by whom no works are known); his mother was Lijntge Cornelisdr Moelants (d. 1625). His brothers, Abraham (b. 1612/13) and Cornelis (c.1607–1681), were also artists. The painter's father (d. 1627) may have also been an art dealer; paintings by Cornelis van Haarlem (1562–1638), Esaias van de Velde, Roelandt Savery and Hercules Segers were listed in his estate. Herman III and Cornelis were registered as pupils in the Saint Luke's Guild when Abraham enrolled on June 12, 1627. In 1632 Herman moved to the Korte Jansstraat in Utrecht. On May 15, 1633, he married Anna van Vliet (d. October 10, 1684),

daughter of Dirck van Vliet and Levina van Westhuyse. The couple lived near Saint Pieter's Church and had two sons and two daughters; Sara Saftleven later became a flower painter. On December 21, 1639, Saftleven bought a house behind Saint Pieter's Church, which remained his Utrecht residence until his death. Shortly thereafter, he purchased a section of small houses at the entrance to the Maliebaan. Between 1655 and 1667 he held offices in the Utrecht painters' guild. He traveled along the Moselle and Rhine as far as Basel and in 1667 may have been living in Elberfeld. However, on January 5, 1684, he was buried in the Buurkerk in Utrecht.

Saftleven was primarily a painter and etcher of landscapes. His paintings before 1650 reflect a wide variety of styles, including a brief period around 1634–37, when he executed barn interiors with still lifes in the manner of his brother Cornelis. His early landscapes of the 1630s recall the art of Bloemaert, van Goyen, and de Molijn. Following his move to Utrecht he abandoned the indigenous Dutch naturalistic landscape style. Around 1640 Breenbergh's art had a brief period of influence on his work; after 1643 Jan Both's impact is even more noticeable. During the later 1640s his works become smaller in scale, and in 1650 he began to specialize in panoramic and Rhineland river landscapes with many small details. Saftleven's etchings date from 1640 to 1669.

The poet Joost van den Vondel praised the artist's works, and among his patrons was Lady Althea Talbot, widow of Thomas Howard, Earl of Arundel. According to Houbraken, the landscape painters Johannes Vorstermans (1643–c.1699) and Jan van Bunnik (1654–1727) were his pupils. Willem van Bemmel (1630–1708) is also documented as his student.

P.C.S.

Literature: de Bie 1661, p. 275; de Monconys 1665–66, p. 132; Houbraken 1718–21, vol. 1, pp. 340–42, vol. 3, pp. 138, 198, 293, 339, 360; Weyerman 1729–69, vol. 2, pp. 83–86; Descamps 1753–64, vol. 2, pp. 146–49; Bartsch 1803–21, vol. 2, pp. 247–326; Nagler 1835–52, vol. 14, p. 183–92; Immerzeel 1842–43, vol. 3, pp. 51–52; Weigel 1843, p. 31; Wap 1852; Wap 1853; Kramm 1857–64, vol. 5, p. 1435; Nagler 1858–79, vol. 3, p. 1219; Thoré 1858–60, pp. 149, 151; Thoré 1860, pp. 142, 209, 355; Obreen 1877–90, vol. 2, pp. 71–93, 266, vol. 5, pp. 48, 115–28; S. Muller 1880, pp. 129, 131, 168; Dutuit 1881–88, vol. 4, pp. 4, 285; Blanc 1888, vol. 3; Wurzbach 1906–11, vol. 2, pp. 549–51; Erasmus 1909; Sterck 1924–25; Grosse 1925, pp. 88–92; Sandrart, Peltzer 1925, pp. 190, 216; Molkenboer 1926–27; Swillens 1931; Martin 1935–36, vol. 2, pp. 291–93; W. Stechow in Thieme, Becker 1907–50, vol. 29 (1935), pp. 310–11; van Campen 1937; Heppner 1946; Hollstein, vol. 23, pp. 119–48; Maclaren 1960, pp. 382–83; Nieuwstraten 1965b; Stechow 1966; Dattenberg 1967, pp. 287–342; Bol 1969, pp. 183–84; Bolten 1970; Klinge-Gross 1977; Schulz 1977; Bartsch 1978, vol. 1, pp. 240–66; Schulz 1978; Boston/St. Louis 1980–81, pp. 167–68, 171–72, 196–97; Schulz 1982; Haak 1984, pp. 321–22.

96 (PLATE 76)

Hunter Sleeping on a Hillside, 164[2]

Signed and dated lower right: Saft/Levens 164[?]
Oil on panel, 14½ x 20½ in. (36.8 x 52 cm.)
Collection of Maida and George Abrams, Boston

Provenance: Sale, Brussels, December 13, 1774, no. 37; sale, The Hague, September 27, 1791, no. 30 (to Coclers); sale, London (Christie's), April 25, 1952, no. 83 (as A. Lievens); Walter Chrysler, Provincetown, Massachusetts.

Exhibitions: St. Petersburg/Atlanta, 1975, no. 10, pl. 10; Philadelphia/Berlin/London 1984, no. 97, pl. 91.

Literature: Schulz 1978, p. 28, no. 646, fig. 29; Schulz 1982, p. 132, no. 28, fig. 10.

On a darkened hillside with an overarching oak silhouetted against the sky, sleeps a hunter. Beside him are his dogs, a gutted hare, and a dead mallard. In the distant valley at the right, a mounted hunt passes.

No doubt through a misreading of its signature, the painting was misattributed in a 1952 sale to Jan Andries Lievens (1644–1680), the son of the painter Jan Lievens (1607–1674). The painting, in fact, is signed in the plural "Saft Levens," confirming that it is a rare instance of collaboration between the two brothers, Cornelis and Herman Saftleven.[1] Cornelis painted the hunter, while Herman executed the landscape. A preparatory drawing by Cornelis for the hunter, also in the Maida and George Abrams Collection, is dated 1642,[2] thus providing the final digit of the partly legible date on the painting. Also dated 1642 are Saftleven's *Christ Preaching on the Shore of the Sea of Galilee* (National Gallery of Scotland, Edinburgh, no. 1508) and *Panorama of Tall Mountains* (sale, Stockholm, November 16, 1965, no. 781, ill.).[3]

Herman Saftleven was apparently living in Utrecht when he painted this work. As Nieuwstraten observed,[4] the artist began a series of broad views of Friesian-looking valleys with wooded slopes in about 1641 (see fig. 1). These seem to reflect the influence not only of

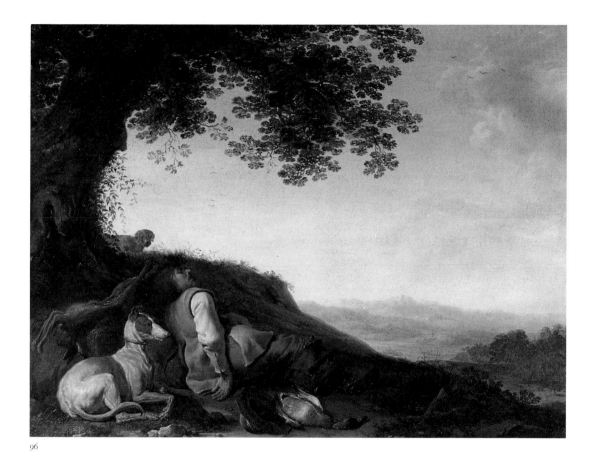

96

Fig. 1. Herman Saftleven, *Mountain Valley*, signed and dated 1641, panel, 40 x 62 cm., Kunsthistorisches Museum, Vienna, inv. 434.

Fig. 2. Herman Saftleven and Cornelis van Poelenburch, *Wooded Landscape with Arcadian Figures*, monogrammed by Saftleven and dated 1643, panel, 73.5 x 102.7 cm., Herzog Anton Ulrich-Museum, Braunschweig, inv. 343.

mountain views by Roelandt Savery (who died in Utrecht in 1641) but also, in design, tonality, and the treatment of foliage, paintings by Flemish artists such as Kerstiaen de Keuninck (d. 1635) and the expatriate Alexander Keirincx (cat. 52). Though not documented in Utrecht, Keirincx, then active in Amsterdam, is known to have collaborated with the Utrecht painter Cornelis van Poelenburch, as did Saftleven in these years (fig. 2).[5] The silhouetted hillside in the Abrams collection painting recalls com-

positions favored by Poelenburch (cat. 69), and the lacy, carefully outlined foliage of the oak and delicately rendered prospect at the right recall Keirincx. The theme of the hunter resting in a wooded landscape can also be traced back to Coninxloo's painting of 1598 in Vaduz (see Introduction, fig. 25) and reappears in Saftleven's painting of 1647 (fig. 3).

In this painting, which is unusually successful for a collaborative effort, the poetic effect is seamless. The subtlest and most consistent of

counterpoints is established: the sleeping hunter and his alert hound harkening to the distant hunt and the dramatic juxtaposition of the darkened hillside and the lightening tones of the distant prospect.

P.C.S.

97 (PLATE 92)

Rhineland Fantasy View, 1650

Fig. 3. Herman Saftleven, *Riders Resting in a Wood*, monogrammed and dated 1647, canvas, 78 x 68 cm., Museum Bredius, The Hague, inv. 145.

1. According to Schulz (1978, p. 27, no. 643), the two brothers collaborated as early as around 1634–35 in the *Van Reede Family Portrait* (Stichting Slot Zuilen, Maarsen), although only Cornelis signed the work.
2. Black chalk and wash; Schulz 1978, no. 56, fig. 64.
3. See, respectively, Schulz 1982, nos. 26 (fig. 12) and 27 (panel, 41 x 62 cm.).
4. Nieuwstraten 1965b, pp. 92–95; see also Schulz 1982, pp. 28–29.
5. Klessmann (Braunschweig, cat. 1983, p. 185) notes that on the back of this panel appear the initials "AC" and the mark of the painters' guild of Antwerp, perhaps indicating that Saftleven visited the Flemish city in 1643, during this period when Flemish influences are most apparent in his work.

Signed and dated lower left: Hermanus Saftleuen Fec. 1650.
Oil on canvas. 21 x 28 in. (53.3 x 71 cm.)
Private Collection, New York

Provenance: Dealer van der Meer, Amsterdam, cat. November 1963, no. 14, ill.; R. van Loo–van Ryckevorsel van Kessel, Amsterdam.

Exhibitions: Dordrecht 1964, no. 69, fig. 62.; New York 1985a, no. 16, ill.

Literature: *Weltkunst*, November 1, 1963, ill. p. 100; Schulz 1982, pp. 33, 141, no. 64.

Though strongly reminiscent of scenes along the Rhine, this river valley is a fantasy view. The rocky banks rise steeply above the broad, meandering water. Cottages, churches, and a walled monstery perch upon the cliffs and nestle among the trees. Peasants and traders move along sandy roads or rest by the wayside. Vessels laden with cargo ply the river or are upturned for mending in dry dock. In the distance are the turrets and walls of other fortified cities.

In his early career, Herman Saftleven adopted an unusually wide variety of styles as well as subjects, painting forests, river views, winter scenes, mountains, imaginary subjects, and panoramas.[1] However, at the end of the 1640s he developed a theme and manner – namely, the panorama river view with miniature-like detail – that would absorb his interests almost without distraction until his death more than 30 years later. Dated 1650, the year in which Saftleven first perfected this painting type, the exhibited painting is typical of this group in its use of a high point of view depicting vaguely Rhenish scenery but not an exact site, with a bright palette, exactingly perceived landscape motifs, and anecdotal staffage. It may be compared with a painting dated the same year in Frankfurt (fig. 1), where a similar elevated view of a valley is combined with a multitude of detail.[2] As

Fig. 1. Herman Saftleven, *River Landscape*, signed and dated 1650, panel, 33.6 x 45 cm., Städelsches Kunstinstitut, Frankfurt, inv. 67.

Nieuwstraten has observed, only the coulisse of the tree on the left still links the Frankfurt painting with Saftleven's paintings of the forties, when he favored more monumental motifs.[3] The panoramic river views are the fruition in Saftleven's work of a progressive diminishment in the scale of form.

His works of this type descend ultimately from Pieter Bruegel the Elder's mountain views and river valleys (see Introduction, fig. 15), especially as they were interpreted by Jan Brueghel (see, for example, the *River Landscape* of 1602, Staatsgalerie, Aschaffenberg, inv. 829; and cat. 39, fig. 1). Roelandt Savery's mountain landscapes also impressed Saftleven, especially their composite use of actual sites, but the increasingly emphatic palette and minute detail of Saftleven's Rhine views more clearly recall Jan Brueghel and his followers (Jan the Younger, Pieter Gysels, Bouts, and Boudewijns).

Around 1650, following closely on the signing of the Treaty of Munster and the official end of hostilities, many Dutch artists took the opportunity to travel through Gelderland to the

Fig. 2. Herman Saftleven, *View of Rolandseck*, monogrammed and inscribed by a later hand "Roelan Seek", black chalk, 310 x 400 mm., Nationalbibliothek, Vienna, Atlas Blaeu.

97

Brandenburgian Lower Rhine. Among those who went that way were Aelbert Cuyp, Gerbrand van den Eeckhout, Jacob Esselens, Lambert Doomer, Authonie Waterloo, Joris van der Haagen, V.L. van de Vinne, Roeland Roghman, and Rembrandt.[4] Herman Saftleven had begun painting the Rhine valley at least by 1641 (see Rheinisches Landesmuseum, Bonn, inv. 60–72) and apparently traveled out from Utrecht in the 1640s and 1650s to draw. Many of his topo-graphical drawings of the Rhine are preserved in the Atlas van der Hem, or Atlas Blaeu, National-bibliothek, Vienna, and depict such sites as Remagen, Unkel, Linz, Koblenz, Braubach, Pfalz bei Kaub, Saint Goar, and the Mäuseturm near Bingen (see, for example, fig. 2);[5] some of these drawings carry his monogram and original or later-day inscriptions identifying the sites, but not one is dated. We know from the publication in the *Hollantse Parnas* of Joost van den Vondel's poem praising Saftleven's drawings of Rhine views that they predate 1660 and must have been much admired.[6] One can only conjecture whether seventeenth-century viewers recognized that Saftleven's paintings, unlike his drawings, were usually fantasy views or composites of existing sites. As Stechow noted, for example, Saftleven's *Rhine Fantasy* of 1653 in the Mittelrheinisches Landesmuseum, Mainz (inv. 99), employs an impossible combination of the Zollburg at Bonn, the Round Tower of Ander-nach, the Godesberg, and the Drachenfels.[7]

The legacy of Saftleven's Rhineland view was perpetuated by, among others, Jan Griffier (see cat. 39) and the eighteenth-century German artist Christian Georg Schultz.

P.C.S.

1. On Saftleven's development, see, above all, Nieuwstraten 1965b.

Pieter van Santvoort

(Amsterdam 1604/05-1635 Amsterdam)

98 (PLATE 29)

Landscape with a Road and Farmhouse, 1625

2. Compare also the two other Rhineland fantasy views that are signed and dated 1650, in a private collection (canvas, 68 x 95.5 cm.; Schulz 1982, no. 63, fig. 24), and in the Statens Museum for Kunst, Copenhagen (canvas, 100.5 x 130 cm., no. Sp. 420; Schulz 1982, no. 62; however, previously also deciphered as "1659"). On Saftleven's Rhineland fantasies, see Schulz 1982, pp. 33–47.

3. Nieuwstraten 1965b, p. 106.

4. See the exhibition catalogues Krefeld 1938; Dusseldorf 1953; Bonn 1960–61; see also Stechow 1966, pp. 167–69; and Dattenberg 1967.

5. See Schulz 1982, nos. 680–734.

6. Vondel's verses play poetically on Saftleven's name: "Lust het iemant zacht te leven, lucht te scheppen naar zijn wil, die blijf t'huis, gerust en stil: Hij kan stil den Rijn opstreven." See *De Werken van J. van den Vondel*, ed. J. van Lennep, p. 341.

7. Stechow 1966, p. 167; Schulz 1982, no. 78, fig. 25.

Son of the painter Dirck Pietersz Bontepaert (1578–1642), Pieter van Santvoort was probably born in 1604 or 1605 in Amsterdam. Born into an artistic family, he was the great-nephew of the influential Flemish genre and still-life painter Pieter Aertsen (1508–1575) and the nephew of Pieter Pietersz (1540–1603). While his father used the family name Bontepaert, Pieter and his brothers, Abraham and Dirck, adopted the surname "Santvoort," presumably after the fishing village Zandvoort, near Haarlem. On June 3, 1633, Santvoort married twenty-eight-year-old Marretje Coerten. His teacher is un-identified, but the style of his landscapes (see especially cat. 98 below) relates his art to the early indigenous Dutch realist school of Esaias van de Velde, Pieter de Molijn, and Jan van Goyen. As both a painter and draftsman (a series of fourteen sheets in the Rijksprentenkabinet, Amsterdam, signed "Bontepaart," includes several drawings dated 1623), Santvoort spe-cialized in dune landscapes and winter scenes. He was buried in Amsterdam on November 19, 1635.

P.C.S.

Literature: Nagler 1835-52, vol. 16, p. 7; Kramm 1857–64, vol. 5, p. 1443; van der Willigen 1870, p. 262; Harvard 1879-81, vol. 4, pp. 185–90; de Roever 1889, pp. 32–34; Wurzbach 1906–11, vol. 2, p. 560; Müller 1928; W. Stechow in Thieme, Becker 1907–50, vol. 29 (1935), p. 454; Stechow 1966, pp. 24–25, 90; Bol 1969, p. 142; Haak 1984, p. 240.

Signed and dated lower left: P v Santvoort 1625
Oil on panel, 11⅞ x 14⅝ in. (30 x 37 cm.)
Gemäldegalerie, Staatliche Museen Preussischer Kulturbesitz, Berlin, no. 1985

Provenance: Gift from Julius Böhler, Munich, 1926.

Literature: Müller 1928, pp. 64–67; Kauffmann 1931, p. 229; W. Stechow in Thieme, Becker 1907–50, vol. 29 (1935), p. 454; Stechow 1966, pp. 24–25; Bol 1969, p. 142, fig. 131; Berlin (West), cat. 1975, p. 385, ill.; Walford 1981, p. 84.

This painting is among the earliest products of the indigenous Dutch realist school of landscape painting; though related by its simple subject matter and diagonal composition to the graphic works of Esaias van de Velde, it chronologically precedes similar paintings by Santvoort's con-temporaries Pieter de Molijn, Jan van Goyen, and Salomon van Ruysdael.

The theme could scarcely be more com-monplace: a road converging with a second sandy thoroughfare in an open field, and a darkened farmhouse and trees silhouetted beneath a threatening sky. The chevron of the lighted roadway is reiterated in the pattern of clouds overhead. Anonymous peasants make their way into the distance past rustic fences, and birds fleck the sky. The palette is estab-lished by the cloudy, lowering atmosphere, rather than by the incidentals of local coloration.

This reduced range of value and hue laid the groundwork for the "tonal" painting that followed. In Santvoort's direct approach to his subject, "diagonal-triangular composition, and crude but daring application of paint," Stechow has seen a decisive step in the evolution of Dutch landscape painting.[1] While the painting clearly anticipates the achievements of Pieter de Molijn's dune landscape of the following year in Braunschweig (cat. 56), Santvoort's picture is an isolated statement; no other work by the artist affirms his precociousness. *Country Road* of

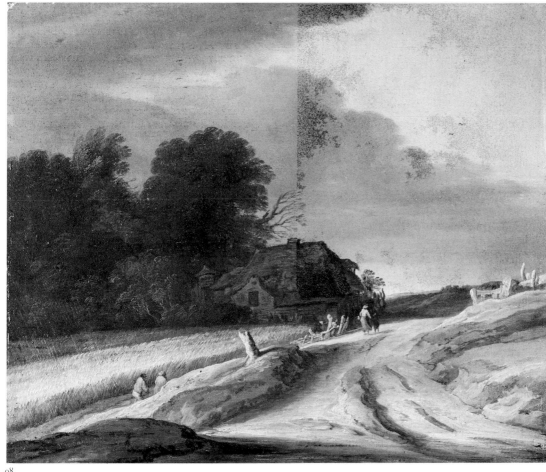

Fig. 1. Pieter van Santvoort, *Country Road*, indistinctly signed and dated 1629(?), panel, 32 x 45.5 cm., Rijksdienst Beeldende Kunst, The Hague, inv. NK 2650.

1629(?) (fig. 1), for example, harkens back to a more contrived compositional system of overlapping and strongly contrasted diagonals. Thus, the legitimacy of Santvoort's claim to a pioneering role may be questioned.

P.C.S.

1. Stechow 1966, p. 24.

Roelandt Savery

(Kortrijk c.1576/78–1639 Utrecht)

G. Roghman after P. Moreelse, *Portrait of Roelandt Savery*, 1647, engraving.

Born about 1576–78 in Kortrijk (Courtrai), Flanders, Roelandt Savery was the son of Maerten Savery and Catelyne van der Beecke and the youngest brother of the painters Hans I (1564/65–1622) and Jacob I (1565/67–1603). With the fall of Kortrijk to the Spanish in 1580, the family moved to Brugge, then, around 1585, to Haarlem, where the family joined the Anabaptist community. Roelandt's mother died in 1586, and his father remarried a year later. Roelandt was taught by his brother Jacob, who joined the Haarlem guild in 1587. In 1591 Jacob moved to Amsterdam, probably accompanied by Roelandt. Roelandt's earliest works are dated 1600: a watercolor and a painting of village scenes, both in the Hermitage, Leningrad.

After the death of Jacob Savery in April 1603, Roelandt traveled to Prague, where he worked for Emperor Rudolf II (d. 1612). A drawing signed "Roelandt Savery fe in Praga 1605" (Berlin [West], inv. 4461) is the first secure record of Savery's presence in Prague. The artist also made large numbers of drawings of Prague and its surroundings and probably visited the Tirol around 1606. In 1613 Savery was called "kamermaler" to the Emperor Mathias. The same year, Savery returned to Amsterdam, where in 1614 he invested for his brother's children in the East India Company. Savery is again listed among the court painters in Prague in 1615, but there is no indication that he ever returned to the service of the emperor. In January 1616 Roelandt was a witness at the wedding of his nephew Salomon (1594–1678), who was also a successful painter and printmaker. Roelandt was in Haarlem in 1618, probably on a visit.

In 1619 Savery moved to Utrecht and entered the guild there. His nephew Hans II (1597–c.1655) lived and worked with him, probably as a primary assistant. In December 1626 the Utrecht government paid Savery 700 guilders for a painting of "all the animals of the air and earth" as a present to Amalia van Solms. Several more works by Savery are recorded in the stadtholder's collections. In 1628 the Prince of Liechtenstein commissioned two paintings from the artist for 1,000 guilders. Savery also sold at least one painting to Charles I of England. On February 25, 1639 Savery was buried in the Buurkerk, Utrecht.

Savery remained an essentially Flemish painter who reflected his training with his brother Jacob and his contact with the group of artists at the Prague court, in particular, Jan Brueghel the Elder and Pieter Stevens. The influence of Gillis van Coninxloo and more generally of Pieter Bruegel the Elder can also be felt. He painted flower pieces, still lifes, genre and animal paintings. His landscapes range from simple naturalistic forest views to scenes filled with religious and historical staffage or with animals and birds. Allart van Everdingen was a pupil, while Savery inspired a whole generation of landscape painters, including Gillis de Hondecoutre, Esaias van de Velde, and Adam Willaerts.

A.C.

Literature: van Mander 1604, fol. 260v.; Rodenburgh 1618; die Bie 1661, pp. 125–26; Sandrart 1675, vol. 2, p. 305; Houbraken 1718–21, vol. 1, pp. 56–60, vol. 2, p. 95; Félibien 1666–88, vol. 3, p. 326; Félibien, 1679, p. 46; de Piles 1699, p. 410; Descamps 1753–64, p. 293–95; Nagler 1835–52, vol. 16, pp. 47–49; Kramm 1857–64, vol. 5, pp. 1296, 1446–1447; Obreen 1877–90, vol. 5, pp. 117, 126, 299; S. Muller 1880, p. 113; Immerzeel 1842–43, vol. 1, pp. 55–56; Fetis 1858; Thieme, Becker 1907–50, vol. 29, p. 507; Erasmus 1908; Plietzsch 1910, pp. 70–72; Erasmus 1911, vol. 1, pp. 5–8; Hirschmann 1920, p. 111; Buchelius 1928, pp. 60, 87; Laes 1931; Martin 1935–36, vol. 1, pp. 233–34, 292; Raczyński 1937, pp. 55–56; Ghent 1954; Thiéry 1953, pp. 27–29, 199; Białostocki 1958; Boon 1961; Fechner 1966–67; Briels 1967; Bol 1969, pp. 123–28; Franz 1970; van Leeuwen 1970; Sip 1970; Spicer 1970a; Spicer 1970b; Schulz 1971; Sip 1973; Kortrijk 1976; Briels 1976, pp. 281–301; Gerszi 1976b; Bartsch 1978, vol. 53, pp. 359–66; Spicer 1979; Franz 1979–80; Bol 1980–81; Spicer 1981; Segal 1982; Buysschaert 1983; Haak 1984, p. 214; da Costa Kaufmann 1985, pp. 268–87; Cologne/Utrecht 1985–86; da Costa Kaufmann 1986; Thiéry 1986; Müllenmeister 1987; Spicer, forthcoming.

Forest Scene with Hunters
c.1617–20

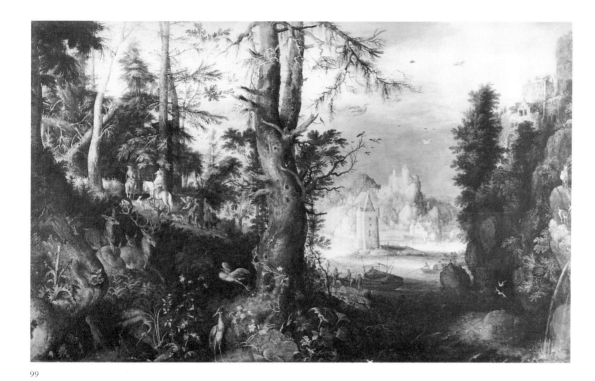

99

Fig. 1. Roelandt Savery, *Landscape with the Temptation of Saint Anthony*, dated 1617, panel, 49 x 94 cm., private collection, London.

Fig. 2. Roelandt Savery, *Clearing in a Forest*, signed, panel, 42 x 78 cm., Kunsthalle, Hamburg, inv. 163.

Oil on panel, 20½ x 33⅝ in. (52 x 85.3 cm.)
Private Collection, The Netherlands

Provenance: Comtesse A. Mniszech, Zomoyska (Poland); sale, Paris (Drouot), May 9–10, 1910, no. 88 (frs.800 to Margossian); sale, Margossian, Paris (Drouot), November 21–22, 1935, no. 19; P. de Boer, Amsterdam, Th. Niemeijer, Laren, 1954–64.

Exhibitions: Ghent 1954, no. 14; Laren 1959, no. 130; Delft, Prinsenhof, *De jacht in de kunst*, 1964, no. 45.

Literature: Spicer 1979, p. 701.

Savery presents a vast, multifarious view divided into several individual sections and studded with highly detailed figures, animals, foliage, and rocks. Like many sixteenth-century man-

nerist landscapes, the picture has been partitioned into two large sections by a tall tree that stretches to the top of the picture. But Savery has made this traditional "double-wing" structure even more complex; deer hunters on horseback with their retainers proceed on a mountain path at the left, while their quarry huddles just below in front. The immediate foreground is full of birds, insects, frogs, even an owl in the trunk of the tree. Such rich profusion, especially in the finely painted plants and leaves, recalls landscape techniques of the previous century. In the right distance a tower is set in a lake, with a castle behind. This is a free transcription of the Mäuseturm at Binger Loch

on the Rhine, with the Castle Ehrenfels behind it, a site Savery no doubt passed on the way to or from Prague, although his drawings after nature do not survive.[1] Also on the right is a group of houses set on the hill above a waterfall, which flows into a pool and the lake beyond.

The division of the landscape into two views, the abrupt transition from enclosed space to distant panorama, and above all the concern with finely painted detail are all retardataire elements in Savery's work, developed almost a century before by Flemish landscape painters. Rather than simplifying the motifs and handling, as Gillis de Hondecoutre, Keirincx (cat. 51, 52), and Gillis van Coninxloo (cat. 19) did, Savery

makes them more complicated and richer. Indeed, Savery's painted landscapes became increasingly encyclopedic as his career progressed.

The present painting probably dates from Savery's Amsterdam period, after he had returned from Prague in 1613. The structure of the composition can be compared to a double-winged landscape with a waterfall and Saint Anthony dated 1617 (private collection, Great Britain, fig. 1)[2] and a very similar work, dated 1618, in a Dutch private collection. The exhibited painting is very close in handling to these examples and must date from approximately this time. Within the artist's oeuvre, the landscape represents a compilation and development of types of paintings that Savery had perfected during his Prague residency. For example, he had often depicted waterfalls, deer hunts, and Alpine forests in separate pictures.[3] Many of these themes also occur in Savery's sketches, although no precise connections can be made with the present painting.[4] Savery employed this general landscape composition as early as 1608, in a landscape with a tower in Schleissheim (Staatsgalerie, inv. 2162)[5] and another in Hamburg (fig. 2), where a tall fir tree in a sunlit clearing in the back plays the same role as the tower in the exhibited painting.

The variety of objects and views in Savery's painting prevents any single motif from dominating, although the deer hunt, with hunters and prey dramatically juxtaposed, forms an important theme. With its various animals, figures, boats, and architectural elements, the landscape recalls the "world view" paintings of sixteenth-century Flanders.

A.C.

1. A drawing attributed to Savery, but perhaps a copy after him, also shows the Mäuseturm, although the castle behind has been considerably altered. The sheet, in Kurt Erasmus's collection, Berlin, c.1932, is rightly rejected by Spicer (1979, p. 701).

2. London 1986, no. 27. In that exhibition a drawing attributed to Savery (no. 28) is indeed a late copy, as Spicer suggested (1979, no. C47), while a drawing assigned to Wilem van Nieulandt, as perhaps after Savery (no. 26), is also doubtful.

3. See, for example, Savery's early painting of waterfalls in Hannover, dated 1608 (Cologne/Utrecht 1985–86, no. 8, ill.).

4. See Savery's drawings: a single tree in the Kupferstichkabinett, Berlin (West), inv. 3226 (Cologne/Utrecht 1985–86, no. 102, ill.); rocky waterfalls in the Institut Néerlandais, Paris (da Costa Kaufmann 1985, ill. p. 120) and in the National Library, Vienna (Atlas Blaeu, fol. 9).

5. Cologne/Utrecht 1985–86, no. 7, ill.

Hercules Segers

(Haarlem 1589/90–1633-38 The Hague?)

One of the most innovative printmakers and landscapists, Hercules Segers is a somewhat shadowy figure to whom legends have been attached. Samuel van Hoogstraeten in 1678 wrote a highly dramatic, topos-filled account of Segers's life: a tale of unrecognized talent, deep poverty, and death from a fall downstairs while drunk. While much of his account may have been fabricated, Hoogstraeten seems to have been well acquainted with Segers's rare work, reporting accurately on the great demand for his art, and offering the telling observation that Segers attempted to "print paintings."

At the publishing of his marriage banns in December 1614, Segers was said to be twenty-four years old; in 1623 he was referred to as about thirty-four. His father, Pieter Segers, may have been a Mennonite from Flanders. A cloth merchant, he moved his family from Haarlem to Amsterdam by 1596. There Hercules Segers (also often known simply as Hercules Pieters) studied with Gillis van Coninxloo before that artist's death in December 1606. At the sale of Coninxloo's estate, Segers bought a number of drawings and a mountainous landscape painting; his father purchased several objects as well. This early instruction with Coninxloo was crucial for Segers's artistic formation because it introduced Segers to the work of a wide range of Flemish landscapists, such as Joos de Momper, Paul Bril, and Pieter Bruegel.

In 1612 Segers's father died. Within a year or two Segers entered the Haarlem guild along with Willem Buytewech (1591/92–1624) and Esaias van de Velde. In December 1614, again in Amsterdam, he made a settlement with the mother of his illegitimate daughter, gaining custody of the child. In January 1615 he married Anneken van der Brugghem from Antwerp, who was sixteen years his senior. In 1618 the couple made a will. He bought a house on the Lindengracht the following year, which he sold

in 1631, perhaps in the face of mounting debts, to move to Utrecht. In 1632 the royal court in The Hague acquired two paintings by Segers, and he is again recorded as living there in 1633. In 1638 a Cornelia de Witte is mentioned as the widow of Hercules Pieters, which probably indicates that Segers had remarried and died before that date.

Segers's paintings seem to have been widely appreciated, despite Hoogstraeten's claims. Besides the paintings owned by the stadtholder, several Segers paintings are recorded in Amsterdam inventories during his own lifetime, and one landscape by the artist was offered to the King of Denmark. Rembrandt, who was strongly influenced by Segers's work, owned no less than eight landscapes in 1656, including a large landscape now in the Uffizi, Florence, which he partially reworked (see Introduction, fig. 46). The Amsterdam art dealer Johannes de Renialme owned twenty-one paintings by Segers and twelve rolled pieces – prints or unframed canvases. Segers's few prints were apparently collected in large groups by a handful of admirers in the seventeenth century.

Although Segers's prints cover a wide range of subjects, including religious scenes, marines, and still lifes, the artist concentrated his energies on mountainous and panoramic landscapes. Segers treated individual impressions as autonomous works of art and printed impressions on linen as well as paper, in variously colored inks and on colored grounds, often working up images with wash. Even more unusual, Segers frequently cropped his prints on all sides in order to obtain different compositions. From 54 plates, there survive 183 impressions, almost all of them significantly different. One etching, however, was printed at least twenty-one times in various colors and combinations of media.

Only two drawings and eleven paintings survive, none of which are dated. Segers's

mountainous landscapes, whether printed or painted, present images of vast rocky wildernesses inspired by late sixteenth-century Flemish painting, especially the work of Joos de Momper, but create a greater sense of desolation and human frailty. Many of these aspects were adopted by Rembrandt in his landscapes. In addition, Segers influenced Frans de Momper, Philips Koninck, Allart van Everdingen, and Johannes Ruyscher, who was called Young Segers.

A.C.

Literature: Hoogstraeten 1678, p. 312; Houbraken 1718–21, vol. 2, p. 136; Frenzel 1829–30; Bredius 1881–82; de Roever 1885; Bredius 1898; Bode 1903; Bode 1906, pp. 103–120; Springer 1910–12; Pfister 1921; Fraenger 1922; Steenhoff 1924; Grosse 1925, pp. 99–104, 121–22; E. Trautscholdt in Thieme, Becker 1907–50, vol. 30 (1936), pp. 444–48; Knuttel 1941; Kannegieter 1942; van Gelder 1950; Amsterdam 1951–52; Collins 1953; van Gelder 1953; Rotterdam 1954; Stechow 1954; Trautscholdt 1954–55; van Regteren Altena 1955; Houplain 1957; Boon 1960; van Leusden 1961; Schneebeli 1963; Trautscholdt 1963; Stechow 1966; Amsterdam 1967a; Amsterdam 1967b; van Gelder 1967; van Eeghen 1968; Haverkamp Begemann 1968; Haverkamp Begemann 1973; Rowlands 1979; Gerzi 1981; Filedt Kok 1982.

Landscape with a Lake and a Round Building, 1620s

Signed lower left: herkeles segers
Oil on canvas pasted on panel, 11½ x 18 in. (29.3 x 45.7 cm.)
Museum Boymans-van Beuningen, Rotterdam, inv. 2383.

Provenance: Sale, London (Sotheby's), May 9, 1951, no. 69 (as de Vos); dealer D. Hoogendijk, Amsterdam; acquired in 1953 with the assistance of the Vereeniging Rembrandt.

Exhibitions: Delft, 1953; Rotterdam 1954, no. 5, ill.

Literature: Ebbinge Wubben 1953; van Gelder 1953; *Kroniek van Kunst en Kultur* 13 (1953), p. 157, ill.; *Weltkunst* 23 (September 1, 1953), p. 7; B. Nicolson, *Burlington Magazine* 96 (1954), p. 21, fig. 22; Trautscholdt 1954; Stechow 1954, p. 244; Trautscholdt 1954–55; H.E. van Gelder 1959a, pl. 29; Rotterdam, cat. 1962, p. 130, no. 2383; Amsterdam 1967, p. 25; Haverkamp Begemann 1968, pp. 13–14, fig. 10; Rotterdam, cat. 1972, p. 222, no. 2383, ill.; Haverkamp Begemann 1973, pp. 34–36, 54, 85; Rowlands 1979, p. 33, pl. 41.

Extensive wet lowlands are framed by a rugged, overgrown bluff to the right, and spiky, shaggy trees in the left foreground. Rather formally dressed figures and riders appear on the sunlit shore of the lake, their relationship to the round building and tower on the opposite bank undefined. These structures are not clearly recognizable as having ancient, medieval or seventeenth-century origins; Haverkamp Begemann thought they looked like a displaced bapistry and campanile.[1] In spite of these buildings and the sailboats on the sea in the farthest distance, untamed nature predominates. The figures might be wandering in a strange, pre-lapserian paradise of waterways, exotic foliage, shimmering light, and dramatic outcroppings of rock. Alternating bands of sunlight and shadow divide the various features of the landscape and enhance the sense of change and mystery.

100

Fig. 1. Hercules Segers, *Old Oak Tree*, etching.

Fig. 2. Philips Koninck, *Wide River Landscape*, canvas, 41.3 x 58 cm., The Metropolitan Museum of Art, New York, no. 63.43.2.

The application of paint is equally rich and varied. Segers scatters bright flecks of paint that are restricted to a narrow range of color, but an overall matrix of reds, browns, and yellows develops. The trees on the hills at the right edge are rendered with a pattern of dots, dabs, and circles, a technique analogous to that found in Segers's prints (see fig. 1) which anticipates the "pointillism" of Vermeer's paintings.

Only eleven paintings by Segers survive, although several others have been attributed to him.[2] Segers's chronology is difficult to establish, especially for his prints, since there are neither dated works nor external clues. Haverkamp Begemann suggests that Segers's earliest surviving paintings are those of the most pronounced Flemish character, which were produced under the influence of Joos de Momper and other Flemish landscapists.[3] Two such landscapes

probably made before 1620, in the Mauritshuis, The Hague (inv. 1033), and the Rijksmuseum, Amsterdam (Introduction, fig. 45),[4] show vast panoramas with travelers dwarfed by tall rocky mountains. The rounded, bumpy shapes of the peaks are complemented by the peculiar forms of the trees, still found in the exhibited painting. Also similar in composition are a painting in the Schloss Herdringen,[5] a lost work recorded in a drawing by Leonaert Bramer,[6] as well as numerous prints by Segers. In a painting preserved in the Uffizi (Introduction, fig. 46), desolate rocky wastelands give way to a broad, flat valley framed by steep cliffs. Partially reworked by Rembrandt,[7] this less forbidding scene with a warmer palette directly precedes the exhibited work and catalogue 101. A painting now in the Thyssen-Bornemisza Collection[8] is also very similar in composition, while a view of Brussels

in Cologne (cat. 101, fig. 2) resembles catalogue 101 in technique. Segers's last paintings are a closely related group of panoramas: a view of Rhenen and a similar vista, both in Berlin (cat. 37, fig. 1 and no. 806B),[9] and a view in the Borthwick Norton collection, England.[10]

The view presented in the exhibited work closely resembles that found in a print, although there a large tree in the foreground splits the view (fig. 1). In other respects, the round build-ing with its tower, the distant lake, and the hill to one side (somewhat lower in the print) are the same as in the painting, but in reverse. The same buildings are found in another print that also contains a large tree.[11] This group of images suggests that prints rather than paintings were the focus of Segers's creative and experimental energies.

Landscapes such as this one and catalogue 101 must have greatly influenced Rembrandt (who owned eight of Segers's paintings)[12] and Philips Koninck. The vast, expansive plains that lead to distant lakes and towns, as well as the vigorous brushwork, are common to the work of all three artists. However, Rembrandt typically gave his landscapes of the 1630s a dominant central element: ruins, dramatic rocks, or a large tree. Koninck's broad, flat landscapes (fig. 2) are closer to Segers's work and suggest that Koninck knew Segers's work firsthand, probably through Rembrandt's collection.

A.C.

1. Haverkamp Begemann 1968, p. 14.

2. Among recent attributions to Segers is a painting of a skull in a private collection, now on loan to the Fogg Art Museum, Cambridge, Mass. (Rowlands 1979, pl. 1). A painting of the same subject was given to the surgeons' guild in 1663 and later sold in Amsterdam in 1873, but it was of a different size (E. Trautscholdt in Thieme, Becker 1907–50, vol. 30, p. 446). See also, E. Trautscholdt, "Der 'Seghers ten Cate,'" in *Pantheon* 30 (1972), pp. 144–50. Neither attribution can be regarded as plausible.

3. Haverkamp Begemann 1968, pp. 9–10; Haverkamp Begemann 1973, pp. 31–32. Kerstiaen de Keuninck may also have been a direct source for Segers, while, more generally, Segers's mountain landscapes are variations on Pieter Bruegel (Amsterdam 1967b; Gerzi 1981).

4. Trautscholdt 1954–55; Stechow 1966, p. 132; Filedt Kok 1982.

5. Collins 1953, fig. 84.

6. Plomp 1986, no. 55, ill.

7. The cart and figures at the left and some passages of heavy impasto on the valley cliffs (the profile of which has also been changed) are by Rembrandt; Haverkamp Begemann 1968, pp. 12–13. This is probably the large landscape by Segers in Rembrandt's 1656 inventory, hanging in the large rear room.

8. Haverkamp Begemann 1968, pp. 15, 25; Rowlands 1979, pl. 45.

9. Rotterdam 1954, nos. 9, 8. They must date from before 1631, because the Winter King's palace, built in that year, does not appear in no. 808A.

10. Rotterdam 1954, no. 10. Van Gelder noted that all three have additions in the sky (van Gelder 1950). Berlin (West), cat. 1975 reports that the addition to no. 808A is of a later date (1637 plus or minus 5 years) than the painting itself, according to dendrochronological research.

11. Haverkamp Begemann 1973, no. 34.

12. Rembrandt's inventory of 1656 includes 17 "a small landscape," 40 "a small wood," 70 "some small houses by Herculus Seghersz," 93 "two small landscapes", 104 "a large landscape," 124 "a landscape ingrisaille," 292 "a small landscape" (Fuchs 1968, pp. 76–80; *Rembrandt Documents* 1979, pp. 349–88).

Houses near Steep Cliffs, 1620s

Oil on canvas, 27½ x 34⅛ in. (70 x 86.6 cm.) Museum Boymans-van Beuningen, Rotterdam, inv. 2525

Provenance: Private collection, England; James Simon, Berlin (acquired 1901–1903); sale, Amsterdam (Muller), October 25–26, 1927, no. 46; D.G. van Beuningen, Vierhouten; incorporated in the Museum Boymans-van Beuningen, 1958.

Exhibitions: London, New Gallery, 1901 (as Jan Vermeer van Haarlem); Berlin, Kaiser-Friedrich-Museums-Verein, 1906, no. 126; Rotterdam, Museum Boymans, 1927–28, no. 13, pl. 8; Brussels, *Cinq siècles d'art*, 1935, no. 772; Rotterdam, Museum Boymans, *Meesterwerken uit vier eeuwen*, 1938, no. 136, fig. 141; Paris 1950–51, no. 86; Paris 1952, no. 120, fig. 32; Rotterdam 1954, no. 6, ill., Rotterdam 1955, no. 117.

Literature: Bode 1903, pp. 180–81, ill.; Bode 1906b, pp. 113–14, ill.; Bode 1917, pp. 154–55, ill.; Holmes 1928, p. 221; A. Welcker 1932–36, vol. 51, pp. 88–89, fig. 48; E. Trautscholdt in Thieme, Becker 1907–50, vol. 30 (1936), p. 446, no. 18; Trautscholdt 1940, p. 85, pl. 86; Knuttel 1941, pp. 42–43, ill.; Bernt 1948, vol. 3, pl. 752; van Beuningen collection, cat. 1949, no. 66, figs. 73–75; Bode, Plietzsch 1951, pp. 206–07, ill.; Ebbinge Wubben 1953, pp. 36–44, figs. 6, 10; Collins 1953, pp. 62–64, fig. 74; van Gelder 1953, p. 156; Trautscholdt 1954, p. 3; Trautscholdt 1954–55, p. 80, fig. 14; Leymarie 1956, p. 80, ill.; Rotterdam, cat. 1962, p. 131, no. 2525; Amsterdam 1967, p. 25; Haverkamp Begemann 1968, pp. 7, 13–14, figs. 12, 14; Rotterdam, cat. 1972, no. 2525, ill.; Haverkamp Begemann 1973, p. 88; Rowlands 1979, pp. 15, 33, pl. 2; Bernt 1980, vol. 3, pl. 1139; Filedt Kok 1982, p. 173; Haak 1984, p. 201, fig. 414.

Nestled beneath almost vertical cliffs is a group of houses in a grove, while other buildings are scattered on the broad plain or close by a lake. Patches of sunlight and shade, interrupted by occasional outcroppings of rock, punctuate the marshy lowlands. Segers's thick impasto and rich though restricted blond palette enliven the painting, especially in the expressive brushwork of the cliffs at the right. Derivative of Joos de

101

Fig. 1. Hercules Segers, *View of the Noorderkerk, Amsterdam*, etching on cloth, Rijksprentenkabinet, Amsterdam, inv. OB 857.

Fig. 2. Hercules Segers, *View of Brussels from the North*, panel, 24.5 x 39 cm., Wallraf-Richartz-Museum, Cologne, inv. 249.

Momper's work, this technique anticipates the work of Jan van Goyen, Pieter de Molijn, and Salomon van Ruysdael.

Branches and foliage are silhouetted on the face of the rocky cliff reaching to the top of the picture, while the houses in the center appear almost immediately below the viewer, as in Pieter Bruegel's *The Gloomy Day* of 1565

(Kunsthistorisches Museum, Vienna, inv. 1837). These variations on the traditional panorama landscape differ considerably from the forms developed by Goltzius (see Introduction, fig. 28), Pieter Post (cat. 115, fig. 2), and Cornelis Vroom (cat. 115), or even from Segers's earlier essays on the theme (cat. 100 and cat. 100, fig. 1). Sheer cliff faces occur in several prints by Segers,[1] as

well as in a slightly earlier painting in the Uffizi, Florence (Introduction, fig. 46). Segers combined this kind of expansive river valley bordered by cliffs with a topographically accurate view from a window of the second floor of his own house. The same buildings, with the window frame through which he saw them, occur in an etching on linen that exists in a single impression (fig.

Herman van Swanevelt

(Woerden? c.1600–1655 Paris)

1).[2] In the exhibited painting, Segers eliminated Amsterdam's Noorderkerk and the distant view of the city. The innovative window frame in the print has been replaced compositionally by the rectilinear cliffs in the painting. Segers thus derived his unusual vertical cliffs not only from his own earlier landscapes but also from the framing aperture of the print.

Despite their close connection, Segers's painting lacks the urban atmosphere of his etching. Indeed, no human figures are visible in the forests or among the dwellings. Like much of his work, Segers's landscape contrasts civilized and untamed nature. A view of Brussels in Cologne (fig. 2),[3] close in technique and coloring to the exhibited work, especially in the geometric array of reddish roofs, is a more accurate transcription of a real site. Segers's later panoramic views of towns (fig. 3 and cat. 37, fig. 1)[4] are even more typically Dutch in theme as well as less fantastic.

A.C.

1. Haverkamp Begemann 1973, nos. 6, 14, 19, 22, 27.
2. De Roever first established that the view is from Segers's house on the Lindengracht (de Roever 1885, p. 52; Haverkamp Begemann 1973, p. 37, no. 41). Only a few changes were made to the church (which may then have been under construction) and to the distant view at the right, which shows fields and trees rather than the center of Amsterdam. A painting described as "De Noorder Kerk" by Segers was sold from Allart van Everdingen's collection, Amsterdam, April 19, 1704, no. 54.
3. The relative dating of the Brussels and Rotterdam paintings is impossible to determine. See E. Trautscholdt, "Hercules Seghers 'Blick auf Brussel' in Köln," *Wallraf-Richartz-Jahrbuch* 25 (1963), pp. 263–68.
4. Paintings in Berlin (nos. 808A and 806B; cat. 37, fig. 1) and the Borthwick Norton collection (Rotterdam 1954, nos. 8, 9) and several prints (see Haverkamp Begemann 1973, nos. 29, 30, 31, the latter two, views of Amersfoort and Wageningen).

The date of Swanevelt's birth is unknown, although he was probably from Woerden. His first signed and dated works – two drawings in the Herzog Anton Ulrich-Museum, Braunschweig – indicate that he was in Paris in 1623. He is recorded as having been almost continuously in Rome between 1629 and 1641, although he probably arrived in Italy earlier. His first dated painting is a landscape of 1630 (Bredius Museum, The Hague, inv. 115). A member of the Bentvueghels, Swanevelt was given the nickname "Eremiet" (hermit). In 1632–34, he was recorded living with French painters in Rome. Swanevelt was imprisoned by an ecclesiastical tribunal in 1634 for failing to observe a fast day. While incarcerated, he painted two lunettes for the sacristy of S. Maria sopra Minerva.

Swanevelt's work in Rome was crucial for the development of Italianate landscape painting; his work often parallels that of the early Claude. The French artist, for example, derived a composition (Louvre, Paris, inv. 4712) from Swanevelt's *Campo Vaccino*, dated 1631 (Fitzwilliam Museum, Cambridge, no. 367).

In the late 1630s Swanevelt was commissioned by the Spanish court to paint landscapes for the Buen Retiro Palace in Madrid, a project shared among the major landscapists in Rome, including Claude, Nicolas Poussin, Gaspard Dughet, and Jan Both. The artist contributed four horizontal landscapes with anchorite saints, as well as three upright landscapes for another cycle (Museo del Prado, Madrid). Swanevelt worked for many of the most important patrons in Rome. He received a payment from the Vatican in 1632 for paintings done for the Vatican Loggie and at Monte Cassino; eight landscapes were recorded in the Pamphili collection in 1666 (still in the Galleria Doria-Pamphili, Rome), another painting (Staatliche Museen, Berlin [DDR], inv. 432; see p. 114, fig. 15) was cited in the

Giustiniani inventory of 1638. Further, in 1640 the Duke of Modena commissioned Swanevelt and Salvator Rosa (1615–1673) to paint a pair of landscapes. Most important among Swanevelt's Italian commissions, however, is a series of thirty paintings, mostly of mythological subjects, that was in the collection of Cardinal Antonio Barberini by 1644 (eight are still in the Palazzo Barberini, Rome); Swanevelt was paid by the cardinal for two of these paintings in 1641.

Almost all of the remainder of his career was spent in Paris. In 1644 he was "peintre ordinaire" to the King of France. About 1645/46, he worked on the decoration of the Cabinet de l'Amour of the Hôtel Lambert (along with Jan Asselijn, Pierre Patel, and Giovanni Francesco Romanelli). Swanevelt became a member of the Academie in 1651. There are paintings done in Paris dated 1644, 1645, 1646, and 1649. In 1653 Swanevelt issued a series of etchings of Roman views, some of which had been previously printed in Rome. At this time, he sometimes signed his name Suanevelt.

Swanevelt made periodic visits to his native Woerden, where he was recorded in 1643 and 1649. He presented a painting to Baron van Wyttenhorst in Utrecht in 1650 and sold him a second one the following year. Swanevelt died in Paris in 1655.

A.C.

Literature: de Bie 1661, p. 259; Félibien 1666–88, vol. 5, p. 44; Sandrart 1675, p. 316; Félibien 1679, p. 59; de Piles 1699, p. 418; Houbraken 1718–21, vol. 2, p. 352; Dézallier d'Argenville 1745–52, vol. 3, pp. 396ff., vol. 4, p. 156ff.; Descamps 1753–64, vol. 2, pp. 296–97; Bartsch 1803–21, vol. 2, pp. 249–326; van Eynden, van der Willigen 1816–40, vol. 1, pp. 138–40; Nagler 1835–52, vol. 18, pp. 35–54; Immerzeel 1842–43, vol. 3, p. 124; Kramm 1857–64, vol. 5, p. 1593; Nagler 1858–79, vol. 3, nos. 885,

102 (PLATE 51)

Landscape with Tall Rocks, 1643

1661; Obreen 1877–90, vol. 3, p. 213; Bertolotti 1880–85, pp. 125–38; Venturi 1882, pp. 218, 249–50; Wurzbach 1906–11, vol. 2, pp. 680–81; Hoogewerff 1913–17, vol. 1, pp. 48, 50, 53, 97, 127; Henkel 1924–25; Martin 1935–36, vol. 2, pp. 451, 458; Hoogewerff 1938, pp. 71, 73; Thieme, Becker 1907–50, vol. 32 (1938), pp. 339–41; Hoogewerff 1942–43, pp. 235–37; Hollstein, vol. 29, pp. 49–106; Hoogewerff 1952, p. 92; Gerson 1956; Kitson 1958; Stechow 1960d; Waddingham 1960; Utrecht 1965, pp. 98–105; Stechow 1966, pp. 151–52, 155; Bodart 1971; Rosenberg, Schnapper 1971; Burke 1972, pp. 81–84; Paris 1972; Lavin 1975, pp. 41, 159–61, 165; Salerno 1977–80, vol. 2, pp. 410–23; von Barghahm 1979, pp. 314–28; Brown, Elliott 1980, pp. 125–27, 270; Rome, Doria Pamphili cat. 1982, nos. 318–40; Brown, Elliott 1987.

102

Signed lower right: HVSWANEVELT FS / WOERDEN. 1643 [HVS ligated]
Oil on canvas, 22 x 27⅛ in. (56 x 69 cm.)
Rijksmuseum, Amsterdam, inv. A 2497

Provenance: Sale, "A.G. in B." Munich (Helbing), May 12, 1910, no. 57 (850 marks to the Rijksmuseum).

Exhibitions: Bolsward 1964, no. 54; Utrecht 1965, no. 41, ill.

Literature: Amsterdam, Rijksmuseum cat. 1918, supplement no. 2280a; Stechow 1960, p. 84, fig. 301; Amsterdam, Rijksmuseum cat. 1976, no. A 2497, ill.

While Herman Swanevelt's explorations of warmly colored sunlight and misty effects had considerable influence on the development of Roman landscape painting in the 1630s, this

painting was executed much later, on one of the artist's infrequent visits to Holland. It is one of his most successful compositions. The high rocks, with the light and figures distributed about the crevices, provide a strong diagonal framework for the distant view and the richly illuminated sky. Such idyllic figures gesturing into the distance were also much favored by Claude, Swanevelt's closest colleague in Rome. Indeed, Claude's development was paralleled by that of Swanevelt, and influences between the two are best characterized as mutual. Swanevelt knew other French artists and patrons well and eventually took up residence in Paris in 1640.

Although this painting was done in 1643 in Woerden, Swanevelt's hometown, it could as readily be a product of Swanevelt's Parisian period. It reveals a considerable development from the artist's Italian paintings, in which he had experimented with deep sunset colors and hazy atmospheric effects. After arriving at a functional composition early in his career, already seen in his first dated work of 1630 (fig. 1), Swanevelt employed it with only minor variations throughout his Roman career. A low, flat foreground is typically framed by rocks or trees, with hills some distance beyond. Ruins only occasionally disturb the symmetry. This basic arrangement, derived from Poelenburch and also commonly encountered in Claude's work, was well suited to the mythological and historical paintings that made up the vast majority of Swanevelt's Roman commissions (see p. 114, fig. 15).

In several of the landscapes for the Buen Retiro palace in Madrid, Swanevelt began to employ high rocky cliffs, a device borrowed directly from Poelenburch's Italian landscapes. Many of Swanevelt's etchings also presage the composition of the exhibited painting.[1] Especially similar are paintings made for the Pamphili family (now in the Galleria Doria

Fig. 1 Herman van Swanevelt, *Landscape with Figures*, signed and dated 1630, copper, 56.5 x 76 cm., Museum Bredius, The Hague, inv. 115-1946.

Fig. 2 Herman van Swanevelt, *Landscape with Rocks*, signed and dated 1643, canvas, 50.8 x 61 cm., sale, London (Sotheby's), March 24, 1976, no. 71.

Pamphili), which probably date from the end of the artist's Roman residency.[2] Several paintings inscribed "Paris 1641" continue this development.[3] The landscape closest in composition to the exhibited work is inscribed "Paris 1643" (fig. 2), which indicates that the artist was in both France and Holland that year. Through the 1640s Swanevelt painted landscapes with similar large rocky outcroppings, which capture sunlight at various angles and enliven and vary his compositions.[4] Related works are inscribed "Calais 1647" and "Woerden 1648."[5]

A.C.

1. Bartsch, nos. 49, 77, 97.

2. Rome, Doria Pamphili cat. 1982, nos. 318, 319.

3. Sale, London (Sotheby's), June 23, 1976, no. 41. Other dated paintings from the 1640s include one of 1644 in City Art Gallery, Glasgow (inv. 280), and one of 1645 in the Kunsthalle, Bremen (inv. 830). A painting inscribed "HVS FP 1646" (i.e., fecit Paris 1646) was with the dealer Cramer, The Hague, cat. 1960; another dated "1646 Paris" is in the Akademie, Vienna, inv. 864.

4. Especially notable is a landscape with large rocks in the center of the composition extending almost to the top of the picture plane; sale, London (Christie's), May 4, 1979, no. 60.

5. A landscape with the temple of Minerva Medica, signed and dated "1647 a Calais," was sold in London (Christie's), June 28, 1974, no. 102. A similarly composed landscape done in Woerden in 1648 was sold London (Sotheby's), July 13, 1977, no. 265. Paintings from 1649 include one done in Paris, at Uppark (Waddingham 1960, fig. 296), another done in Woerden, in a private collection, New York. Two paintings inscribed "Paris 1645" are in the Louvre, Paris (invs. 1874 and 1875).

Adriaen van de Velde

(Amsterdam 1636–1672 Amsterdam)

Adriaen van de Velde from Arnold Houbraken, *De groote schouburgh*, 1718–21.

Baptized on November 30, 1636, in Amsterdam's Oude Kerk, Adriaen van de Velde was the son of Willem van de Velde I (1611–1693) and the younger brother of Willem van de Velde the Younger (1633–1707), both noted marine painters. According to Houbraken, Adriaen was taught by his father, then by Jan Wijnants in Haarlem. It is sometimes thought that he went to Rome about 1653–56, but there is no evidence for this; Adriaen's occasional Italian motifs are no doubt derived from other artists. Adriaen's first dated works are several etchings of 1653. His first paintings, of 1654, are landscapes with animal staffage. On April 5, 1657, he married Maria Ouderkerk in Amsterdam, where the artist seems to have remained for the rest of his career. Several paintings dated 1671 indicate that he was active to the end of his life. On

January 21, 1672, Adriaen was buried in the Nieuwe Kerk, Amsterdam. Later that year, his brother and father emigrated permanently to Britain.

Adriaen van de Velde was strongly influenced by Paulus Potter, Philips Wouwermans, and Claes Berchem in his treatment of figures, landscapes, and, above all, animals. Italianate elements such as ruins are frequently found in the artist's pastoral landscapes. Some of his landscapes include aristocratic portraits. Adriaen also painted beach scenes and winter landscapes, as well as genre, still-life, and history paintings. Houbraken wrote of him in 1721, "He zealously drew and painted cows, bulls, sheep and landscapes and carried his equipment each day out to the countryside – a practice that he maintained until the end of his life once per week." The grandly conceived *Allegory of Life* dated 1663 (Pushkin Museum, Moscow) suggests that the painter received official commissions in Amsterdam. Adriaen was also one of the most popular staffage painters of his time; his figures can be found in landscapes by Ruisdael, Hobbema, Frederik de Moucheron, Jan van der Heyden, and Willem van de Velde the Younger.

A.C.

Literature: Sandrart 1675, p. 314; Houbraken 1718–21, vol. 1, pp. 275, 355; vol. 2, pp. 128, 132, 328; vol. 3, pp. 48, 53, 81, 90–91, 181, 286, 288, 358; Weyerman 1729–69, vol. 2, pp. 395–97; Descamps 1753–64, vol. 3, pp. 72–77; Bartsch 1803–21, vol. 1, pp. 209–28; van Eynden, van der Willigen 1816–40, vol. 1, pp. 424–26; Smith 1829–42, vol. 5, pp. 167–226; vol. 9, pp. 629–37; Immerzeel 1842–43, vol. 3, pp. 162–63; Nagler 1835–52, vol. 20, pp. 28–36; Kramm 1857–64, vol. 6, pp. 1686–87; Nagler 1858–79, vol. 1, no. 1474; Havard 1879–81, vol. 1, pp. 116ff.; A.D. de Vries 1885–86, pp. 143–44; Michel 1892a; Michel 1892c, pp. 74–123; Haverkorn van Rijsewijk 1901, p. 62; Bode 1906a; Wurzbach 1906–11, vol. 2, pp. 748–50; vol. 3, p. 172; Hofstede de Groot 1908–27, vol. 4, pp. 452–581; Zoege von Manteuffel 1927, pp. 55–83; Martin 1935–36, vol. 1, pp. 334–40; Richardson 1939–40; K. Zoege von Manteuffel in Thieme, Becker 1907–50, vol. 34 (1940), pp. 198–99; Hoogewerff 1952, pp. 77, 96–97, 99–100; Maclaren 1960, pp. 413–17; Rosenberg et al. 1966, p. 161; Stechow 1966, pp. 31–32, 60–61, 80, 98–99, 107–109, 160–62; Schatborn 1975; Salerno 1977–80, vol. 2, pp. 750–53; Robinson 1979; Haak 1984, pp. 471–72.

Beach View, c. 1664

Signed and dated lower left: Av Velde f/166(3 or
5?) [Av ligated]
Oil on panel, 16½ x 21¼ in. (42 x 54 cm.)
Koninklijk Kabinet van Schilderijen,
Mauritshuis, The Hague, inv. 198

Provenance: Sale, Jeronimus Tonneman, Amsterdam
(Leth), October 21, 1754, no. 23; sale, Conraad van
Heemskerck, The Hague (Franken), October 7, 1765,
no. 38; sale, Govaert van Slingelandt, The Hague
(Venduhuis), May 18, 1768, no. 36 (auction canceled):
Willem V of the Netherlands, who acquired the
G. van Slingelandt collection *en bloc*; 1795–1815,
Musée du Louvre, Paris ("Inventaire et état," 1795,
no. 172); King Willem I, The Hague, 1815;
Mauritshuis, 1822.

Exhibitions: Rotterdam 1945–46, no. 47, ill.;
Brussels/Antwerp 1946, no. 108, fig. 45; Paris
1950–51, no. 91; Dordrecht 1964, no. 79, fig. 95; Paris
1986, no. 49, ill.

Literature: Terwestern 1770, p. 716; Smith 1829–42,
vol. 5, p. 219, no. 149; Thoré 1858–60, vol. 1, p. 265;
Gaver 1875, p. 36; Hofstede de Groot 1908–27,
vol. 4, no. 356; Zoege von Manteuffel 1927, p. 69,
fig. 71; Preston 1937, fig. 37; Martin 1950, no. 129,
pp. 74–75, fig. 129; Frerichs 1966; Stechow 1966,
pp. 107–108, fig. 214; Bol 1973, p. 246, fig. 252;
Drossaers, Lunsingh Scheurleer 1974–76, vol. 3,
p. 234, no. 165; Brenninkmeyer–de Rooij 1976, p. 173,
no. 165, ill.; The Hague, Mauritshuis cat. 1980, pp.
108–109, no. 198, ill.; Los Angeles/Boston/New York,
1981–82, p. 100, fig. 4; White 1982, p. 130;
Haverkamp Begemann, Chong 1985, p. 59, pl. 92.

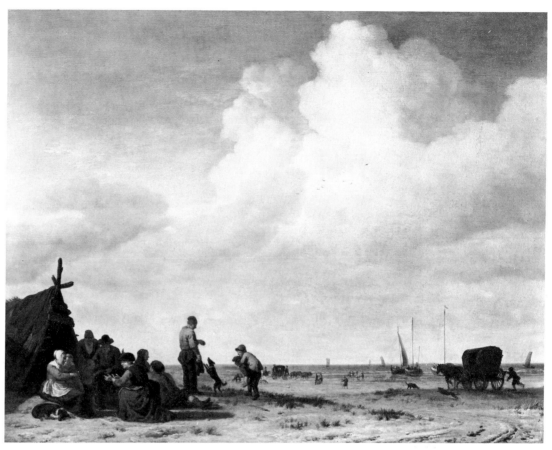

103

On a beach with a low horizon and a bright,
towering sky, a group of eight fisherfolk have
gathered before a wooden, tent-shaped hut. The
light-hearted party before this crude cabana
includes an old woman seated and reaching
toward a child held by its mother, a man playing
with a dog, and a boy carrying a second young-
ster on his back. The boots and apron worn by
the standing man are the attire of a fisherman.
On the right, a sandy track curves down to the
ocean, and farther to the right a covered wagon
makes its way toward the sea. In the distance an
elegant coach moves along the water's edge, and
fishing boats have been drawn up on shore. In
the calm of the shallows, tiny figures wade in to
hunt for shellfish.

The date on the painting was deciphered by
Hofstede de Groot as probably 1665 but has also
been read as 1663.[1] It is one of only five beach
scenes that van de Velde painted, all of which
date between 1658 and 1670. The earliest of the
group is *The Beach at Scheveningen* in Kassel (fig. 1),
which moves the viewer closer to the water and
depicts figures of various classes taking their
ease on a bright, clear afternoon. The relaxed
mood of this work, in which the foremost figure
has rolled up his trousers, waded into the low
surf, and stares off to sea, is very similar to that
of the painting in the Mauritshuis. The latest of
van de Velde's beach scenes is the painting of
1670 in the Carter collection, Los Angeles, which

Fig. 1. Adriaen van de Velde, *The Beach at Scheveningen*, signed and dated 1658, canvas, 50 x 72 cm., Staatliche Kunstsammlungen, Kassel, inv. GK 374.

Fig. 2. Adriaen van de Velde, *The Beach at Scheveningen with a Carriage*, signed and dated 1660, panel, 37 x 49 cm., Musée du Louvre, Paris, inv. 1915.

exhibits a slightly darker tonality but, like the exhibited painting, depicts an elegant coach passing in the distance.[2] In the Louvre's beach scene of 1660 the carriage is the central motif among the staffage (fig. 2).[3]

After about 1658–60 the genre figures in van de Velde's paintings play a more prominent role in his landscapes. Evidence of van de Velde's practice of reusing drawings of such motifs is provided by the fact that the same carriage appears in both The Hague and Kassel paintings. While it cannot be certified by any identifiable landmark or edifice, as in the other works from this group, the Mauritshuis's painting also probably depicts the long, flat beach that stretches between the dunes and the sea at Scheveningen, the coastal town near The Hague. As Broos observed, the time of day can be determined as early morning from the direction of the shadows, with the sea at the right, hence looking south.[4] Carriages must have been a relatively common sight in the landscape around the courtly city of The Hague.[5] And like several of van de Velde's other beach scenes, the Mauritshuis's painting makes a point of social contrast, juxtaposing the group of simple folk in the foreground with the implicit aristocracy of the coachowner in the distance. In the Carter painting, an elegant couple strolling on the beach draws sidelong glances from a fisherman with his catch, and in the Louvre painting classes are once again contrasted.

Seventeenth-century descriptions of The Hague characterize the beach at Scheveningen as a place for holiday amusements, strolling, and buying fish.[6] Offering more than simply fresh air and recreation, Scheveningen for city dwellers was probably associated with a simpler, purer life, notions expressed by the moralizing poet Jacob Cats in his poem published in 1655 entitled "On the Situation of a Young Woman of Scheveningen with a Basket of Fish on her Head" ("Op de gelegenheyt van een Scheveninghs vroutje dat een benne mit visch op haer hooft draeght").[7] The poem proclaims that life and work at the seashore, where one can be happy and free, is preferable to the pomp of town life. Ironically, the idyllic quiet of van de Velde's views of the beach at Scheveningen was thunderously interrupted only eight years after he painted the Mauritshuis's painting when, in 1673, the famous Admiral de Ruyter engaged and defeated the combined naval forces of France and England just offshore.

As Stechow has observed, depictions of beaches were first inspired by special events, such as a prominent embarkation or landing, or some popular spectacle, such as the beaching of a whale.[8] One of the later masters of the beachscape, van de Velde followed earlier artists, like Adam Willaerts (1577–1664), Jan van Goyen (see cat. 38), Salomon van Ruysdael, Simon de Vlieger, and Jan van de Cappelle, in the depiction of the beach as a place for everyday activities and a subject with its own intrinsic beauty. For van de Velde, that beauty took a form different from the chilly overcast beach scenes of van Goyen, the still, monochromatic shores of de Vlieger, or the more luminous, delicately nuanced images of Jan van der Cappelle. Unlike these masters of atmospheric effects, van de Velde celebrates those all too rare Dutch beach days when the sun breaks through the leaden skies, flooding the scene with light and infusing colors with a special clarity and intensity. For van de Velde, value is of more concern than atmospheric tone, but he retains just enough moisture in the air to take the edge off contours and the sun's harshest glare.[9] In 1834 Smith called the picture "a little gem of art." "This simple scene," he continued, "is rendered highly interesting by the admirable truth of its aerial perspective, and local tints of colour."[10]

Winter Scene c. 1668–69

Adriaen van de Velde's beach scenes are often very close in style to those of his brother, the marine painter Willem van de Velde the Younger (1633–1707), who was three years his senior. Indeed, Adriaen may have painted the figures in several of Willem's beach scenes (see, for example, *The Shore at Scheveningen*, National Gallery, London, no. 873). Adriaen and Willem's works are also prophetic for the designs and conception of scenes that Jacob van Ruisdael painted in the 1670s.

A copy of the Mauritshuis's painting was in sale, Bergman et al., New York, May 12, 1949, no. 24, ill. The work was also engraved by Hulk for the Musée Français, about 1800.

P.C.S.

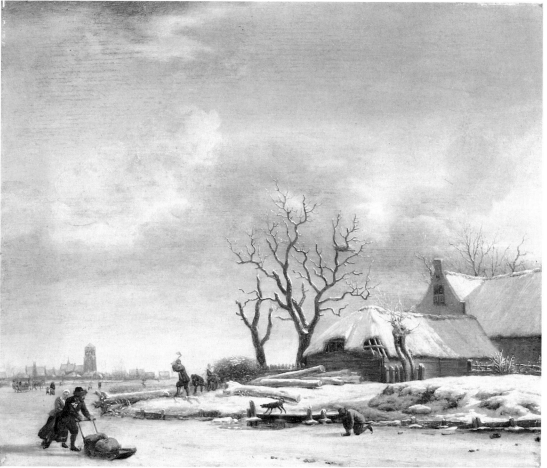

104

1. Hofstede de Groot 1908–27, vol. 4, no. 356; Martin 1950, no. 129 (1665?); Frerichs 1966, p. 16a (1663); Bol 1973, p. 246 (1665); The Hague, Mauritshuis cat. 1980, p. 108 (166[5?]); B. Broos, in Paris 1986, p. 333 (166[3?]).
2. See Los Angeles/Boston/New York 1981–82, cat. no. 24.
3. *The Beach at Scheveningen*, signed and dated 1670, canvas, 39.3 x 50.1 cm. See also the *Coast near Scheveningen*, also dated 1660, canvas, 43.2 x 54.6 cm., Royal Collection, London (White, 1982, p. 129, no. 203, pl. 180).
4. B. Broos, in Paris 1986, p. 333. Frerichs 1966, p. 16a, and in The Hague, Mauritshuis cat. 1980, p. 109, assume, however, that the sun is setting.
5. See, for example, Salomon van Ruysdael's *View of The Hague* (Introduction, fig. 53); Stechow 1938a, p. 90, no. 193.
6. See the accounts of Jacob van der Does (1668) and Gijsbrecht de Cretser (1711), as quoted by Haverkamp Begemann, Chong 1985, p. 59.
7. Cited by Julius Held and Seymour Slive in relation to Frans Hals's fisher children (see S. Slive, *Frans Hals*, vol. 1 [London, 1972], p. 144), and further related by Walsh and Schneider (Los Angeles/Boston/New York 1981–82, p. 100) to Adriaen van de Velde's beach scenes.
8. See Stechow 1966, pp. 101–109.
9. Stechow (1966, p. 108) has written especially sensitively of these achievements.
10. Smith 1829–42, vol. 5, p. 219, no. 149.

Oil on panel, 12 x 14½ in. (30.5 x 36.8 cm.)
John G. Johnson Collection at the Philadelphia Museum of Art, no. 603

Provenance: John G. Johnson, Philadelphia, by 1912.

Literature: Hofstede de Groot 1908–27, vol. 4, p. 568, no. 373; Philadelphia, Johnson cat. 1913, vol. 2, p. 138; Stechow 1966, p. 98; Philadelphia, Johnson cat. 1972, p. 89, ill.

On the right bank of a frozen canal are snow-covered cottages and several leafless trees. In the left foreground a man and a woman skating in tandem push a sledge; on the right a man kneels

Fig. 1. Adriaen van de Velde, *Skaters near a Town Wall*, signed and dated 1669, canvas on panel, 33 x 40.5 cm., Staatliche Kunstsammlungen, Dresden, no. 1659.

Fig. 2. Adriaen van de Velde, *Winter Landscape*, signed and dated 166[8?], canvas, 23 x 30 cm., Musée du Louvre, Paris, inv. 1920.

to put on his skates, while nearby an excited dog barks. On the bank a man chops wood. On the ice in the left distance are a horse-drawn sleigh and other skaters; on the horizon is the profile of a village with a tall church spire.

Adriaen van de Velde painted very few winter landscapes, and most seem to date from the two-year period 1668–69. As Stechow has observed,[1] these winter scenes may be divided into two groups: those, like the *Golfers on the Ice near Haarlem* of 1668 (National Gallery, London, no. 869)[2] and the *Skaters near a Town Wall* of 1669 (fig. 1), in which the genre figures loom large and the landscape plays a more subsidiary role; and those in which the landscape is of greatest interest. The latter group includes the Johnson collection's painting as well as the Louvre's painting of 166(8?) (fig. 2). Of the Johnson picture, Stechow has written evocatively, "The horizon is low and unencumbered by large figures, the filigree of bare trees displayed against the sky with consummate tact and delicacy. The picture is . . . painted in rose brown tints, [its] mood . . . harmonious and of subdued gaiety."[3] Their light tonality and cheerful mood – note the charming detail of the skating couple – link them more readily to Berchem's winter scenes than to Ruisdael's (see cat. 84). Van de Velde's other scarce winter landscapes are found in the Manchester City Art Gallery (Assheton Bennett Collection, no. 103) and the Nicolaes collection, Paris.

A copy of the Johnson painting has been tentatively assigned by S.J. Gudlaugsson to H. Dubbels.[4]

P.C.S.

1. Stechow 1966, p. 98.

2. Panel, 30.3 x 36.4 cm.; see also the *Winter Landscape with Snowballers*, of which two versions exist: Hofstede de Groot 1908–27, vol. 4, no. 374, sale, Viscount Chandos et al. (G.W. Macalpine), London (Sotheby's), March 19, 1975, no. 10, ill. (ex-Cook collection); and Berlin, cat. 1931, no. 1999.

3. Stechow 1966, p. 98.

4. Panel, 26 x 38.5 cm., sale, ten Bos et al., Amsterdam (Brandt), June 24, 1959, no. 28, ill.; with dealer R. Lamm, Neuilly, 1960. Notation on photo in the RKD.

Esaias van de Velde

(Amsterdam 1587–1630 The Hague)

Esaias van de Velde (he most commonly used "van den Velde") was baptized in Amsterdam's Oude Kerk on May 17, 1587. His father, Hans van de Velde (1552–1609), was a Protestant artist and art dealer who fled religious oppression in Antwerp and settled in Amsterdam in 1585. Esaias was a second cousin of the landscape etcher and draftsman Jan van de Velde (c.1593–1641). This van de Velde family was unrelated to that of the painters Adriaen and Willem van de Velde from Leiden. Presumably Esaias first studied with his father and may also have been a pupil of Gillis van Coninxloo, whose death in 1607 provides a *terminus ante quem* for this earliest period of training; in an entry of 1621 from his *Res Pictoriae*, Arnout van Buchell cites a landscape by Coninxloo with figures by Esaias van de Velde. Hans van de Velde also is known to have bought some of Coninxloo's drawings at the sale following the latter's death. Esaias may also have studied with David Vinckboons, whose work his art acknowledges. The influence of Jan van de Velde and Claes Jansz Visscher is also evident in Esaias's landscapes.

Esaias was in Haarlem in 1609 and had settled there by 1610. On April 10, 1611, he married Catelijn Maertens of Ghent; the couple had three children, including the artists Esaias the Younger (b. 1615) and Anthonie the Younger (1617–1672). Esaias was admitted to the Haarlem Guild of Saint Luke in 1612, the same year as Willem Buytewech (1591/92–1624) and Hercules Segers. His earliest dated works are of 1614. He was a member of the Haarlem rhetoricians' chamber "De Wijngaertranken" in 1617 and 1618. In 1618 he moved to The Hague and joined the guild there; he became a citizen in 1620. Constantijn Huygens singled out Esaias's landscapes for special praise in his private memoirs. On January 3, 1626, the treasurer of the Prince of Orange accused Esaias of maligning

him in public concerning a payment of 200 guilders for one of the artist's paintings; two days later Esaias testified that he had been paid in full, adding that he had never intended any offense. Esaias died in The Hague and was buried in the Grote Kerk there on November 18, 1630.

Esaias van de Velde was a draftsman, painter, and etcher of landscapes, cavalry battles, and genre scenes. He played a pioneering role in the development of a more naturalistic and indigenously Dutch landscape style. Further, he often contributed staffage to the architectural paintings of Bartolomeus van Bassen (c.1590–1652) and the landscapes of other painters. His pupils included Jan van Goyen and Pieter de Neyn (1597–1639).

P.C.S.

Literature: Orlers 1641, pp. 373–74; van Bleyswijck 1667, vol. 2, p. 847; Sandrart 1675, p. 310; Houbraken 1718–21, vol. 1, pp. 171, 173, 275, 303; Weyerman 1729–69, vol. 2, p. 45; Descamps 1753–64, vol. 1, p. 396; Nagler 1835–52, vol. 20, pp. 37–39; Immerzeel 1842–43, vol. 3, p. 159; Blanc 1854–90, vol. 4, p. 99; Kramm 1857–64, vol. 6, p. 1687; Nagler 1858–79, vol. 2, no. 1806; van der Willigen 1870, p. 305; Bode 1872; Obreen 1877–90, vol. 3, pp. 260, 298, vol. 5, pp. 117, 126, 178, 306, vol. 6, p. 172; Michel 1888b; Worp 1891, p. 117; Michel 1892; Wurzbach 1906–11, vol. 2, pp. 751–52; K. Zoege von Manteuffel, in Thieme, Becker 1907–50, vol. 34 (1940), pp. 199–200; Burchard 1912; Bradley 1917b; Blok 1917–18; Poensgen 1924; Grosse 1925, p. 44–45; Zoege von Manteuffel 1927; Buchelius 1928, pp. 50, 67; van Gelder 1933; Martin 1935–36, vol. 1, pp. 247–48, 359; Siwajew 1940; Stechow 1947; Bengtsson 1952; Gerson 1955; Rotterdam 1959; Maclaren 1960, pp. 418–19; Plietzsch 1960, pp. 94–97; Rosenberg et al. 1966, pp. 104–05, 145–46; Stechow 1966, pp. 19–23, 25–27, 34–36, 51–56, 84–88; Bol 1969, pp. 135–39; Briels 1976; Gerszi 1978; Boston/St. Louis 1980–81; Amsterdam 1981; Amsterdam/Washington, D.C. 1981–82, p. 43; Haak 1984, pp. 186–87; Keyes 1984; Philadelphia/Berlin/London 1984, pp. 328–32; Hellerstedt 1985.

105 (PLATE 15)

Riders Resting on a Wooded Road, 1619

Signed and dated on a branch, lower left:
E V VELDE 1619
Oil on panel, 15 x 19⅝ in. (38 x 50 cm.)
Private Collection, Boston

Provenance: Sale, A. Grossmann, Munich (Helbing), October 30, 1902, no. 150, ill.; Brambach collection; Albrecht Grossmann; sale, A. Grossmann, Munich (Helbing), May 12, 1910, no. 72, ill.; Duschnitz, Vienna; Colnaghi's, London.

Literature: Keyes 1984, pp. 161, 266, no. 156, pl. 84.

A road through a wood winds from the left foreground along a swamp and around a large tree, forming an arch that sweeps into the left distance. In the left foreground, shrubs and a slender tree form a coulisse; a screen of swamp reeds in the middle distance enhances the recession of the highlighted road beyond. A group of horsemen and two footsoldiers rest in the foreground. Further down the road other mounted horsemen stand at angled intervals.

In 1618 Esaias van de Velde moved permanently from Haarlem to The Hague. This painting of 1619 is characteristic of his work of the period in its consolidation and fulfillment of ideas about the naturalistic treatment of landscape, notions first formulated four or five years earlier in Haarlem. As Keyes has observed, the composition recalls that (in reverse) of a 1616 chalk drawing by the artist depicting riders in a forest, now preserved in Kassel (fig. 1); but the painting creates a more intimate effect by eliminating the left third of the original design.[1] A painting in Besançon (fig. 2), also of 1619, similarly depicts resting horsemen and soldiers on a wooded, arc-shaped road; however, the composition is more open and the effect grander.[2] Still another painting in a private collection in Aachen depicts a broad road with a larger troop of cavalry and soldiers resting, some reiterating the figural motifs in the exhibited painting.[3]

105

Fig. 1. Esaias van de Velde, *Riders in a Forest*, signed and dated 1616, black chalk on blue paper, 268 x 418 mm., Kupferstichkabinett, Staatliche Kunstsammlungen, Kassel, no. KII 5061.

Fig. 2. Esaias van de Velde, *Landscape with Riders beside a Pond at the Edge of a Wood*, signed and dated 1619, panel, 34 x 54 cm., Musée des Beaux-Arts, Besançon, inv. 899.1.10.

In comparison with the paintings in Besançon and Aachen, the scene is drawn into closer focus and the human presence enlarged. The painting still employs spatial devices favored by the earlier mannerist artists – the coulisse and compositional screens – but now the space recedes continuously; any picturesque elements, such as a decorative treatment of the foliage, have been replaced by a more literally descriptive conception of the forest and its

travelers. In no pejorative sense, Esaias's new conception of landscape is deliberately prosaic. Scarcely glamorous adventurers, the soldiers loll on the roadside or rest their sturdy mounts, which relieve themselves openly. Even the tall, slender tree silhouetted against the sky on the left – a motif recollecting Esaias's famous so-called *Square Tree Landscape* etching[4] – is stripped of ornament, its graphic beauty restrained and understated. The excellent state of this panel

The Ferryboat, 1622

enables us to study van de Velde's sure tech-
nique and strong palette of deep greens and
browns accented with vivid local colors: rusty
orange, tawny yellow, and white.

This painting is one of Esaias's earliest land-
scapes with military staffage and is typical of his
early works in depicting the soldiers taking their
ease. It was only after 1620 that van de Velde
began to paint cavalry skirmishes, pitched
military battles, wagon hold-ups, and ambushes
of convoys. No doubt, as Keyes has speculated,[5]
this sudden new interest may be explained in
part by the end of the Twelve-Year Truce in
1621, which brought renewed hostilities be-
tween the United Provinces and Spain. Esaias
continued, however, to paint anonymous
military episodes rather than identifiable battles.

P.C.S.

1. Keyes 1984, p. 161, no. 156. At the time of his writing,
Keyes knew the work only from a photograph that had
been cropped (see his pl. 84), leading him to conclude
wrongly that the panel had been cut down.
2. Keyes (1984) notes the stylistic resemblance of the
Besançon picture as well as the painting of a *Landscape with
Courtly Procession* (ibid., no. 18), also of 1619, now in the
Minneapolis Art Institute. Other paintings by Esaias van de
Velde dated 1619 include *Riders by a Pool and Ruined Tower*,
private collection, New York (Keyes 1984, no. 131, pl. 83);
Gallows on a Rise in a Panorama, Konstmuseum, Göteborg
(ibid., no. 15, pl. 114); *Merry Company by a River*, Gallery
Houthakker, Amsterdam (ibid., no. 67, pl. 136); and
Banquet in a Garden, Frans Halsmuseum, Haarlem (ibid.,
no. 62, pl. 137).
3. Keyes 1984, no. 21, pl. 77 (panel, 38 x 52 cm.).
4. Ibid., no. E8.
5. Ibid., p. 105.

106

Signed and dated lower right: E.V. Velde 1622
Oil on panel, 29¾ x 44½ in. (75.5 x 113 cm.)
Rijksmuseum, Amsterdam, inv. A 1293.

Provenance: Sale, P. VerLoren van Themaat,
Amsterdam, October 30, 1885, no. 100.

Exhibitions: Rotterdam 1946, no. 49, ill.; Amsterdam,
Rijksmuseum, *Spiegelingen in het water*, 1977, no. 3, ill.
of detail.

Literature: Roh 1921, p. 72, fig. 121; Grosse 1925, p.
46; Zoege von Manteuffel 1927, p. 16, fig. 9; Havelaar
1931, p. 77, ill.; Martin 1935–36, vol. 1, pp. 100, 247,
fig. 56; Boon 1942, p. 31, fig. 13; Bernt 1948, vol. 3,
pl. 884; Bengtsson 1952, p. 69, ill.; H.E. van Gelder
1959, pp. 10, 13, fig. 19; Plietzsch 1960, p. 96; H.P.

Baard, *Openbaar Kunstbezit* 7, no. 12 (1963), ill.;
Dobrzycka 1966, p. 30, fig. 4; Stechow 1966, pp.
52–53, fig. 91; Haak 1968, p. 18, fig. 13; Bol 1969,
p. 139; Bergvelt 1978, p. 144, fig. 16; Haak 1984,
p. 187, fig. 381; Keyes 1984, pp. 33, 35, 66–67, 74,
104, no. 104, pl. 116.

A ferry carries some countryfolk, a horse-drawn
wagon, and two cows across a river whose banks
are occupied by houses and closely planted trees.
This river village exudes a sense of calm and
good-natured activity. To the left, the ferryman
has just pushed off from the landing, villagers are
coming and going, and behind a large tree in the

foreground there is an inn. Under the awning customers sit drinking contentedly while chatting with the landlady, who stands in the doorway. There is a pigeon house high on the facade of the tower-like structure. To the right, across the river, a bench marks the ferry's point of disembarkation, where three countryfolk are waiting to be taken across the river, and a horseman rides away along the riverbank. The road beyond leads past the fenced-in grounds of a house to a shipyard, where craftsmen are working on a boat. Near the slipway, which juts out into the water, a fisherman sits quietly in his little boat. A bit farther back, near the windmill, the river curves to the right. The line of trees hides the view beyond, except for the roof and steeple of the village church. Originally conceived on a narrower, oblong format, the panel has a 14 cm.-high extension on the top that increases the expanse of cloudy sky. Some of the original sky was overpainted below the join. The addition was probably added around the middle of the seventeenth century. As of this writing, it has not been decided whether the addition should be removed.

This large river landscape is an important milestone in the evolution of Dutch landscape painting during the second and third decades of the seventeenth century. One of the pioneers, Esaias van de Velde played a significant role in these developments. His first contributions were mainly with his small etchings and drawings, in which he shaped a new vision of his own rural surroundings in an original manner, at once plain but evocative. Later he took up the themes in small painted landscapes. He shared this interest with his fellow Haarlemmers Willem Buytewech and Jan van de Velde, but their groundbreaking work was limited to drawings and etchings. As a painter, Esaias undertook the experiment alone. By 1618, when he moved to The Hague, he was in full command of the new

Fig. 1. Esaias van de Velde, *Mountainous Landscape with a Rider Attacked by Bandits*, signed and dated 1622, panel, 61.5 x 87.5 cm., whereabouts unknown.

Fig. 2. Esaias van de Velde, *Bandits Robbing a Carriage at the Edge of a Forest*, signed and dated 1623, panel, 26.5 x 38 cm., Herzog Anton Ulrich-Museum, Braunschweig, inv. 785.

formula. He packed all the achievements of the new Haarlem realism into his luggage, transported them to his new home, and perfected a more mature form of his landscape art.

In The Hague his attention also turned to a different kind of work. There he encountered a great demand for more conventional mountainous and wooded landscapes with robberies, mounted battles, plunderings, and the like. Esaias had painted a number of these scenes in Haarlem and was fully prepared to satisfy the taste for them.[1] A good example is *Mountainous Landscape with a Rider Attacked by Bandits* (fig. 1).[2] With a ruined castle on a cliff, a ravine with a stream, and tall spruces in the foreground, this painting offers an entirely different kind of landscape, far more traditional in design than *The Ferryboat* painted in the same year. *Bandits Robbing a Carriage at the Edge of a Forest*,[3] dating from the following year, 1623, illustrates the variety of these fashionable scenes that Esaias created in The Hague (fig. 2). The significance of *The Ferryboat* is better understood when viewed against this undoubtedly successful aspect of Esaias's activity.

The Ferryboat is Esaias's exemplary and comprehensive expression of what he must have viewed as the preeminent Dutch landscape in its most typical and essential form. It was the first time that this subject had been treated in such a grand fashion. The large size, still very unusual if not completely unprecedented for the new native landscape subjects, attests to the work's ambitious conception. During the previous years, the painter compiled a repertoire of more or less finished drawings of various subjects, studied and sketched from nature. These drawings would later serve as models for different components of his paintings. We can document this process with the many drawings that have survived. Keyes has identified fifteen drawings, now separated, which originally were part of a

sketchbook dating from 1618 to 1620 and which must have had great significance for the development of Esaias van de Velde's painted landscapes.[4] One of these drawings, Keyes noted, anticipates both the composition and the still, reflected water of *The Ferryboat*.[5] The ferry with cattle in the center of the drawing also presages the painting (fig. 3). There is a second drawing (fig. 4) reproduced almost literally in the right-hand side of the painting, although this is not apparent at first glance since the motif appears as a reversed image.[6]

Traditional artistic means endow this river scene with its peacefulness, balance, and clarity of organization. The space is organized following a proven scheme; buildings and trees are placed in the lower left, the right middle distance, and the left background. The space in between – in this case, the river – recedes with a zigzag motion. Esaias's devotion to this principle – learned as a young artist and applied repeatedly, as, for example, in the two conventional landscapes mentioned earlier (figs. 1 and 2) – attests to his well-recognized role as a transitional figure. His trees, especially those in the foreground and the middle distance, appear old-fashioned, with their peculiarly shaped foliage treated in a more decorative than realistic fashion. The same is true of the dark horizontal band spreading along the lower edge of the painting. This time-honored technique for defining the foreground casts the water in shadow in a manner that bears no relationship to the light depicted. Despite these many ties to the past, *The Ferryboat* points to the new direction in which Dutch landscape painting would develop.

New and surprising is the work's monumentality, especially given the painter's affectionate renditions of something as plain and simple as everyday village life. The diversity of motifs is enlivened by all sorts of small details and color-

Fig. 3. Esaias van de Velde, *Path before a Village on a River*, black chalk, 137 x 177 mm., van Regteren Altena collection, Amsterdam.

Fig. 4. Esaias van de Velde, *River View with Farms*, black chalk, 129 x 170 mm., Institut Néerlandais, Fondation Custodia, collection Frits Lugt, Paris, inv. 451.

istic accents but creates a harmonious scene within a strong composition; no doubt this was what Stechow had in mind when he described the painting as "a piece for full orchestra."[7] New as well is the way in which the water dominates the scene. In this respect *The Ferryboat* is actually a rarity in Esaias van de Velde's work. But water as the vital element in Dutch landscape could scarcely have been depicted more compellingly. The long and glorious tradition of the Dutch river landscape found its origin here. It was to become a classic theme in the work of Esaias's pupil, Jan van Goyen, and of Salomon van Ruysdael, both of whom would use the ferryboat motif repeatedly (see cat. 33 and 94).

C.J.d.B.K.

1. In 1616 he painted *The Robbery*, Rijksmuseum, Amsterdam, inv. c 1533, and *River Landscape with Bandits Plundering a Village*, private collection, the Netherlands (see Keyes 1984, no. 44, pl. 78, and no. 122, pl. 81). In the latter painting the robbers use a ferry to transport their booty.

2. Ibid., no. 186, pl. 148.

3. Ibid., no. 45, pl. 285.

4. Ibid., pp. 34–35, no. D 78, citing the fourteen other nos., pls. 97–111.

5. Ibid., no. D 92, pl. 100.

6. Ibid., no. D 116, pl. 99.

7. Stechow 1966, p. 53.

Landscape with Cottages and a Frozen River, 1629

Signed and dated lower left: E.V. VELDE 1629
Oil on paper mounted on panel, 8⅜ x 13¼ in.
(21.2 x 33.5 cm.)
From the private collection of Mr. and Mrs. Edward William Carter, Los Angeles

Provenance: With dealer D. Hoogendijk, Amsterdam; private collection, Groningen, c.1948–80; private collection, Wassenaar, 1980; dealer S. Nystad, The Hague, 1980–81.

Exhibitions: Los Angeles/Boston/New York 1981–82, no. 25, ill.

Literature: Keyes 1984, p. 142, pl. 258, color pl. XXIV.

As many authors have noted, the winter scenes of Esaias van de Velde were extraordinarily progressive.[1] His works advance the efforts of his immediate predecessors in the painting of winter scenes – above all Vinckboons, Avercamp, and van de Venne – by eliminating any vestiges of picturesque detail and anecdote. Even in his earliest dated paintings, for example, the *Winter Landscape* of 1614 in the Fitzwilliam Museum, Cambridge (fig. 1), Esaias's commitment to an unprepossessing naturalism is clear.[2] In the wide view of frozen fields flanked by bristling trees in the Cambridge painting, the colors are muted, the tiny figures purposeful and unheroic, and the weather raw. Other early winter scenes by Esaias recall Avercamp's designs in their use of a tondo format or ample horizontal stage setting with central river, high horizon, and skaters; but Esaias consistently employs fewer staffage figures, which are absorbed rather than set off by their environment. Anecdotal merriment gives way to a more somber mood in his image of winter.

The Carter collection's *Landscape with Cottages and a Frozen River* of 1629 is a later work from Esaias's years in The Hague, but, as Walsh and Schneider observed, it recalls the artist's early Haarlem period designs, particularly the paint-

107

Fig. 1. Esaias van de Velde, *Winter Landscape*, signed and dated 1614, panel, 21 x 40.6 cm., Fitzwilliam Museum, Cambridge, no. M79.

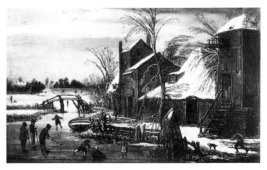

Fig. 2. Esaias van de Velde, *Frozen Canal and Farm Buildings*, signed and dated 1615, panel, 28.5 x 46.5 cm., Museum der bildenden Künste, Leipzig, inv. 359.

Adriaen van de Venne

(Delft 1589–1662 The Hague)

ing of 1615 in Leipzig (fig. 2), in its juxtaposition of a frozen expanse of water on one side and buildings on the other.[3] Characteristically the subject is unembellished, nature at its most quotidian; a denuded tree rises above the crude shapes of cottages and a rustic fence on the left, while on the right a frozen river with skaters extends to a village church spire in the distance. Typically, human incident is recorded matter-of-factly: a dog barks at a man with a basket, and a peasant with a sledge heaped with firewood gestures to his companion who leans on a *kolf* stick. Other winter scenes by Esaias in Kassel and Cologne are also dated 1629,[4] but in these works snow covers the riverbanks and rooftops. The wintry damp is all the more palpable in the Carter picture for the contrast between the barren ground and the trees already showing a hint of spring.

P.C.S.

1. See, above all, Stechow 1966, p. 21; and Keyes 1984, pp. 47–51.
2. See also Esaias's other winter scenes of 1614: the *Frozen River with Skaters*, private collection, Cologne (Keyes 1984, no. 73, pl. 4); and *Farms Flanking a Frozen Canal*, North Carolina Museum of Art, Raleigh, no. 52.9.61 (ibid., no. 89, pl. 9). The latter has a large addition to its panel in the upper half of the sky.
3. Walsh and Schneider, in Los Angeles/Boston/New York 1981–82, no. 25, ill.
4. See Schloss Wilhelmshöhe, Kassel, no. 384 (panel, 41 x 59 cm.), and Wallraf-Richartz-Museum, Cologne, inv. 2623 (panel, 11.2 x 15 cm.); respectively, Keyes 1984, nos. 79 and 72, pls. 256 and 257. For other landscapes dated 1629, see Keyes 1984, nos. 133, 138, 221B, and 105. The last mentioned – the painting in the Rijksmuseum, Amsterdam (inv. A 1764), of a *Dune Panorama* – is also a winter scene, to judge from its leafless tree.

W. Hollar after A. van Veen, *Portrait of Adriaen van de Venne*, etching.

Toward the end of the sixteenth century Adriaen van de Venne's parents moved from Lier in Brabant (Flanders), to Delft, where Adriaen was born in 1589. His parents sent him to Leiden University, and he studied with the Leiden goldsmith, Simon Valck. Later he was a pupil of Hieronymous van Diest (active c.1600) in The Hague. His father, Pieter van de Venne, moved there in 1608. Adriaen van de Venne presumably moved to Middelburg in 1605, and his older brother, Jan Pietersz, who later established a publishing business and book and art dealership, moved there in 1608. Adriaen van de Venne presumably moved to Middelburg about the same time as his brother. One of the town residents at this time was Jacob Cats, the Zeeland poet whose works the van de Venne

brothers, respectively, published and illustrated. Adriaen also illustrated the poetic works of Johan de Brune and wrote poetry himself. His book of poems entitled *Zeeusche Nachtegael ende des selfs dryderley gesang* (Middelburg, 1623) expresses van de Venne's artistic credo. Active in Middelburg from 1608 or 1614 to 1625, van de Venne painted historical and mythological subjects as well as landscapes. His grisaille and polychrome paintings illustrate proverbs and sayings, often in the guise of genre. In 1614 he married Elisabeth de Pours in Middelburg, and the couple had at least two children, including the painters Huybregt (c.1634/35–c.1675) and Pieter (d. 1657). Following his brother's death in 1625, van de Venne moved to The Hague. Registered as a member of the Saint Luke's Guild in 1625, he was appointed dean in 1637. In 1656 he was one of the founders of Confrerie Pictura. Van de Venne died in The Hague on November 12, 1662. His successes in his own lifetime are confirmed by commissions from the House of Orange and the King of Denmark.

Adriaen van de Venne's landscapes are not nearly as numerous as his paintings and drawings of genre, history, and proverbial subjects but prove him to be an important figure in the transmission and reformation of a Flemish landscape style (Jan Brueghel and Coninxloo) to the Northern Netherlands.

P.C.S.

Literature: de Bie 1661, pp. 234–36; van Bleyswijck 1667, p. 857; Houbraken 1718–21, vol. 1, pp. 136–37; Weyerman 1729–69, vol. 1, pp. 340–41; Descamps 1753–64, vol. 1, pp. 374–75; Nagler 1835–52, vol. 20, pp. 70–72; Immerzeel 1842–43, vol. 3, p. 165; Kramm 1857–64, vol. 6, p. 1696–98, supplement, p. 150; Obreen 1877–90, vol. 3, p. 258, vol. 4, pp. 59, 128, vol. 5, p. 68, vol. 7, p. 37; Franken 1878; Ising 1889; van Loo 1899; Wurzbach 1906–11, vol. 2, pp. 758–60; Bredius 1915–22, vol. 2, pp. 374–93, vol. 7, pp. 240–44; Knuttel 1917; Henkel 1934; Martin

1935–36, vol. 1, pp. 251–56, 350, 372; Mulder 1937; Thieme, Becker 1907–50, vol. 34 (1940), p. 213; Bol 1958; Plietzsch 1960, pp. 91–94; Laansma 1965; Rosenberg et al. 1966, p. 104; Stechow 1966; Bol 1969, pp. 116–21; Amsterdam 1976, pp. 250–61; Braunschweig, cat. 1978, pp. 160–63; Boston/St. Louis 1980–81, pp. 105–106; Bol 1982–83; Haak 1984, pp. 206–207, 331–32; Philadelphia/Berlin/London 1984, pp. 333–34; Plokker 1984; van Thiel 1986.

108 (PLATE 6) *Amsterdam only*

Summer Landscape, 1614

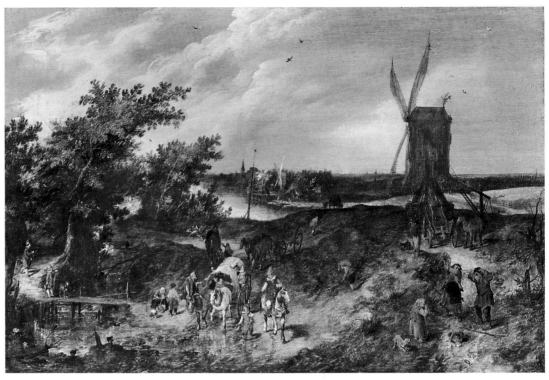

108

Signed and dated in the lower center: AvVenne 1614
Oil on panel, 16⅞ x 26¾ in. (42.2 x 68 cm.)
Gemäldegalerie, Staatliche Museen Preussischer Kulturbesitz, Berlin (West), no. 741A

Provenance: B. Suermondt, Aaachen; acquired in 1874.

Literature: Franken 1878, no. 1; Wurzbach 1906–11, vol. 2, p. 759; Roh 1921, fig. 118; Bernt 1948, pl. 896; Stechow 1966, p. 202, note 9; Bol 1969, p. 116; Berlin (West), cat. 1975, p. 452, no. 741A; Bol 1982–83, part 1, pp. 169–70, 175, fig. 3.

A summer landscape is divided laterally by a shadowed rise of ground in the middle distance, with trees on the left and a windmill on the right. In the distance a village appears on the banks of a river. In the foreground a covered wagon about to ford a stream is accosted by beggars. In the woods on the left are hunters; on the right, peasants quarrel over a spilled basket of eggs.

As Jan Kelch noted in Berlin's catalogue of 1975, this painting is clearly influenced in both style and individual motifs by the art of Jan Brueghel (1568–1625).[1] The composition with a

Fig. 1. Jan Brueghel, *Landscape with a Windmill and Travelers*, signed and dated 1607, panel, 30.3 x 47.4 cm., Palazzo Spada, Rome, inv. 138.

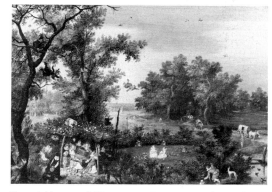

Fig. 2. Adriaen van de Venne, *Merry Company in an Arbor*, panel, 16 x 26 cm., J. Paul Getty Museum, Malibu, no. 83.PB.364.1.

central road in the woods or open country traversed by a covered wagon moving toward the viewer and surrounded by anecdotally conceived staffage figures was one of "Velvet" Brueghel's favorite designs.[2] The large silhouetted windmill was also one of Jan Brueghel's preferred devices (see fig. 1).[3] Even the minor incidents of the staffage – beggars receiving alms, weary tradesfolk seated with their wares at the side of the road, and hunters stalking their prey – recall Jan Brueghel's art. However, van de Venne's touch is freer, his palette moderated and less shrill. The effects of atmosphere are more pervasive in his works, his figures more pliant and nimbler than Brueghel's. The overall effect, so typical of the Dutch transformations of the Flemish landscape tradition, is of an increased naturalism. Yet the ties to the earlier tradition remain strong. Together with its pendant of *Winter* (see cat. 109), the painting stands firmly in the time-honored medieval landscape tradition of representing seasonal typologies (see Introduction, and commentary to cat. 109).

The earliest dated summer landscape by van de Venne, this work may be compared with several later works by the artist in the J. Paul Getty Museum, Malibu (c.1614–17); the Schloss Wilhelmshöhe, Kassel (dated 1617); the Hermitage, Leningrad (dated 1621); the Rijksmuseum, Amsterdam (dated 1625); and formerly in the American art trade (c.1615–20).[4] As Bol observed,[5] all these later works present a very different view of the summer landscape, namely, as a land of pleasure and relaxation, of upper-class diversions free of toil. No summer Elysium, the Berlin landscape is still the province of laborers, peasants, and beggars. Travelers and tradesmen make their way between towns, the corn is gathered and milled, alms are requested and received. Country life thus harkens back to Pieter Bruegel the Elder's

realm of the peasant rather than anticipating the elegant *fêtes champêtres* of Vinckboons, Esaias van de Velde, or van de Venne in his own later, no doubt allegorical, summer landscapes. Compare, for example, the charming little painting of women playing music in an arbor as men – including figures in cap and bells plummeting from trees! – spy on them (fig. 2).

P.C.S.

1. Berlin (West), cat. 1975, p. 452.

2. Compare the wooded highway scenes by Brueghel in the Galleria Sabauda, Turin, dated 1613, inv. 234; Gemäldegalerie, Dresden; the Wellington Museum, London; the Hermitage, Leningrad; and the David Koetser Collection, Zurich, dated 1611 (respectively, Ertz 1979, nos. 272, 127, 241, 242, and 232, figs. 306, 293, 167, 168, and 165); and the single-wing open landscapes attributed to Jan Brueghel in the Minneapolis Institute of Arts and an English private collection (respectively, Ertz 1979, nos. 117, 260, figs. 117 and 260).

3. Compare also the landscapes with windmills in the Palazzo Spada, Rome, the Alte Pinakothek, Munich, and the Gemäldegalerie, Dresden (respectively, Ertz 1979, nos. 151 [dated 1607], 237 [dated 1611], and 162, figs. 36, 38, and 179).

4. See, respectively, Bol 1982–83, pt. 2, figs. 12, 14, 16, 17, 18, and 15. Compare also the smaller *Summer Landscape*, copper, 24 x 33 cm. (in the sale, Crespi, Paris [Drouot], June 6, 1914, no. 81), which varies the Berlin painting's design.

5. Bol 1982–83, pt. 2, p. 260.

Winter Landscape, 1614

Signed and dated lower right: AvVenne 1614
Oil on panel, 16½ x 26¾ in. (42 x 68 cm.)
Gemäldegalerie, Staatliche Museen Preussischer
Kulturbesitz, Berlin (West), no. 741B

Provenance: B. Suermondt, Aachen; acquired in 1874.

Literature: Franken 1878, no. 2; Wurzbach 1906–11,
vol. 2, p. 759; Roh 1921, fig. 151; Plietsch 1960,
fig. 151; Stechow 1966, p. 85; Bol 1969, p. 116; Berlin
(West), Gemäldegalerie, cat. 1975, p. 453, no. 741B;
Bernt 1980, pl. 1333; Bol 1982–83, pt. 1, pp. 169–70,
175, fig. 4.

A frozen river flanked by tall, barren trees on
either bank recedes into the central distance.
On the ice are many tiny figures, including ice
fishermen, skaters, iceboats, and horse-drawn
sleighs. On the left a skater passes beneath a
stone bridge. In the distance there is a castle on
the left at the end of a tree-lined canal and a
village with a church spire in the center right.

Together with its pendant – the *Summer
Landscape*, also exhibited here (cat. 108) – this
work is van de Venne's earliest dated landscape.
It is close in conception, design, and technique to
the smaller *Winter Landscape*, dated the following
year, in the Worcester Art Museum (fig. 1),
where one again encounters a multitude of tiny
skaters on a frozen river, a tree-lined path on the
left, and castles and other buildings in the
distance. The later *Winter Landscape with a
Hunting Party* (with Prince Maurits?; panel,
74 x 114 cm., English private collection) of 1620
offers a further variation on this design but
adopts the slicker style that van de Venne
developed at that time.[1]

As Bol has observed, van de Venne's Berlin
painting and other early winter landscapes
resemble paintings by his contemporary
Middelburg landscapists, Christoffel van den
Berghe (c.1590–after 1642) and Mattheus
Molanus (c.1590–1645).[2] However, van de
Venne achieved a "greater naturalism in the

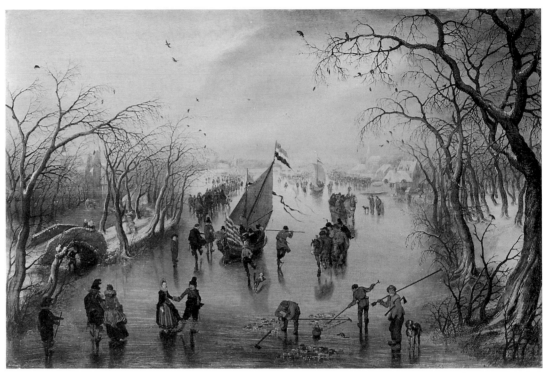

109

figuration and coloration, as well as in the atmos-
phere and light effects."[3] In these regards, he
was more successful in freeing himself from the
artistic conventions of his Flemish forerunners,
above all Jan Brueghel (see commentary to the
pendant, cat. 108).

In painting two landscapes embodying Winter
and Summer, van de Venne acknowledged a
pictorial tradition that can be traced back at
least as early as medieval manuscript illumi-
nations and that surely reflects universal human
ideas. Seasonal typologies also continued to
enjoy great popularity among early seventeenth-
century draftsmen, printmakers (see, for

example, Jan van de Velde series of 1617), and
painters (see van Goyen's *Winter* and *Summer*,
cat. 31 and 32). Adriaen van de Venne also
treated the Four Seasons in a later series of
small, oblong landscapes that he executed in The
Hague in 1625 and are now preserved in the
Rijksmuseum, Amsterdam.[4] A lost series by the
artist of the Four Seasons is known from an
eighteenth-century sale catalogue to have been
dated 1620 and 1623.[5] Van de Venne also re-
turned to the Four Seasons themes in landscape
when he illustrated Jacob Cats's famous poetic
treatise on marriage, women's roles and proper
conduct, *Houwelyck* (1625). The four major

David Vinckboons

(Mechelen 1576–c.1632 Amsterdam?)

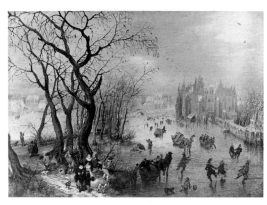

Fig. 1. Adriaen van de Venne, *Winter Landscape*, signed and dated 1615, panel, 16 x 23 cm., Worcester Art Museum, no. 1951.30.

1. Bol 1982–83, pt. 1, fig. 6.

2. Bol 1969, p. 116; Bol 1982–83, pp. 169–70. Compare, respectively, van den Berghe's *Winter Landscape* in the Mauritshuis, The Hague (inv. 671), and Molanus's *Winter Landscape* (with dealer P. de Boer, Amsterdam, 1935).

3. Bol 1982–83, p. 175.

4. Rijksmuseum, Amsterdam, inv. A 1771–A 1774, respectively, *Spring: "The Meeting," Summer: "The Salute," Autumn: "The Conversation,"* and *Winter: "Frolicking on the Ice,"* panel, each 25.5 x 42.5 cm.

5. Sale Isaäc Hermansen, Middelburg, March 4, 1767: "De Vier Getijden des Jaars, zijnde de Vier Lusthoven van Zijne Hoogh, Willem den Eersten, Prince van Oranje en Nassau, welker Pourtrait of Beeltenisse zich ook in ieder stuk vertoont, zeer rijk van ordinantie en extra uitvoerig geschildert door Adr. van de Venne, zijnde van zijn allerbeeste werk en getekant 1620 en 1623. H. 29½ d., Br. 45½ d." (panels, 75 x 115 cm.).

6. See Bol 1982–83, p. 9, pp. 54–55, figs. 115–116. Three of the original drawings (104 x 139 mm.), all dated 1622, are in the Kupferstichkabinett, Berlin (West), while *Spring* is in a Dutch private collection.

7. Berlin (West), cat. 1975, p. 243.

8. As panel, 49 x 79 cm., but in sale, Paris (Charpentier), April 25, 1951, no. 82, as 53 x 74 cm. Compare also the design of *Winter Landscape* in sale, Paris, Nov. 8, 1940, no. 11 (panel, 75 x 39 cm.) as by A. van der Neer but attributed by S.J. Gudlaugsson on the photo mat at the RKD to A. van de Venne.

9. Sale, L. Behr, Munich, June 27, 1933, no. 241, panel, 29 x 18 cm.

subdivisions of this book – "Bruyt" (Bride), "Vrouwe" (Wife), "Moeder" (Mother), and "Weduwe" (Widow) – were illustrated by van de Venne with title prints depicting couples standing, respectively, before spring, summer, fall, and winter landscapes and accompanied by other emblematic details referring to the progressive stages of one's life.[6] The authors of the Berlin catalogue of 1975, however, were probably correct in regarding the pair of Winter and Summer paintings exhibited here as relatively "neutral" in the sense that they do not juxtapose the seasons for purposes of moral commentary.[7]

A *Winter Landscape*, which varies aspects of the Berlin painting's design and motifs, was in the sale, Boissonas, Lucern (Fischer), November 24, 1959, no. 2281;[8] and another upright panel, possibly a fragment, repeats the motif of the man skating beneath the stone bridge on the left side of the Berlin painting.[9]

P.C.S.

David Vinckboons was born on August 13, 1576, in the Flemish town of Mechelen. His father, Philip (1545–1601), was an artist and had entered the Mechelen guild in 1573; David's mother, Cornelia Carré, was the widow of the painter Philip Loemans of Leipzig. The couple had five children. In 1579 they moved to Antwerp, where Philip entered the guild and David became his pupil. According to van Mander, David's earliest training was in watercolors, a medium in which his father specialized. He later studied oils with an unidentified master. When Antwerp came under Spanish control in 1586, the Protestant Vinckboons family emigrated north, first briefly to Middelburg and in 1591 to Amsterdam. David was married in Leeuwarden on October 8, 1602 to Agnieta van Loon, whose brother Willem (b. c.1591) was a painter. Soon after their wedding the couple moved to Amsterdam, where they had ten children. Vinckboons was present at the auction of the goods of Gillis van Coninxloo. He bought a house on the Sint Anthoniesbreestraat in Amsterdam on January 28, 1611. His pupil Willem Helmung of Zeeland was a boarder. Vinckboons's place and date of death are unknown; however, his wife was listed in Amsterdam as a widow with eight underage children on January 12, 1633.

Vinckboons's landscapes are often populated by historical or genre figures and reflect the strong influence of Coninxloo. His low-life genre scenes descend from Pieter Bruegel. Vinckboons was also active as a draftsman and designer of prints. In 1618 the German art lover Gottfridt Müller proclaimed him one of the greatest painters in Amsterdam. The many prints after his paintings and designs also attest to his success and renown. Among Vinckboons's students were the little-known artists Helmung,

IIO (PLATE 2)

Forest with a Hunt, 1602

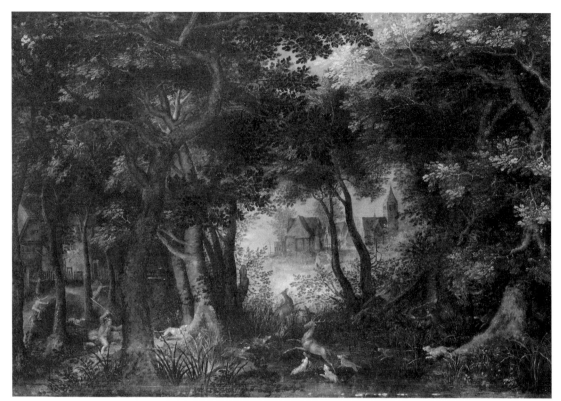

110

Jacob Quina, and Jacques van der Weyden, and possibly Esaias van de Velde.

P.C.S.

Literature: Van Mander 1604; Sandrart 1675, pp. 289–90; Houbraken 1718–21, vol. 3, p. 69; Descamps 1753–64, vol 1, pp. 327–28; Nagler 1835–52, vol. 20, pp. 350–53; Immerzeel 1842–43, vol. 3, p. 194; Kramm 1857–64, vol. 1, p. 122, vol. 6, pp. 1756–57; Michiels 1870; Obreen 1877–90, vol. 6, p. 52; Wurzbach 1906–11, vol. 2, pp. 790–92; Coninckx 1907; Coninckx 1908; Plietzsch 1910, pp. 67–68; Springer 1910; Verburgt 1916; Martin 1935–36, vol. 1, p. 233; Raczyński 1937, pp. 56–57; C. van Balen 1939; Vermeulen 1939; Sthyr 1939–40; de Luynsche 1940; K. Zoege von Manteuffel in Thieme, Becker 1907–50, vol. 34 (1940), pp. 387–88; Held 1951; van Eeghen 1952; Thiéry 1953; Goossens 1954a; Goossens 1954b; Slive 1957; Czobor 1963; Goossens 1966; Rosenberg, et al. 1966, pp. 103–104; Briels 1976; Wegner, Pée 1980; Haak 1984, p. 175; Bartsch 1978, vol. 53, pp. 395–402; Genaille 1983; Philadelphia/Berlin/London 1984, pp. 348–52.

Signed and dated 1602, lower right
Oil on panel, 20⅛ x 22⅝ in. (51 x 57.5 cm.)
Private Collection

Provenance: Dr. Einar Perman, Stockholm; dealer
P. de Boer, Amsterdam.

Literature: Goossens 1954a, p. 21, fig. 8.

In a dense forest with cottages and a church
glimpsed in the distance, hunters and their dogs
converge on a stag and hind that have been
driven into a pool in the immediate foreground.
Rising to the top of the picture are great, un-
dulating tree trunks supporting boughs covered
with delicate, lacey foliage.

As Goossens observed, Vinckboons had begun
designing forest interiors with elegant com-
panies picnicking and making music by 1601;[1]
see Nicolas de Bruyn's print after Vinckboons's
design (Introduction, fig. 26) and the related
painting *Merrymakers at the Edge of a Wood*, in the
Gräfliche Schönbornsche Gemäldegalerie,
Pommersfelden.[2] The exhibited painting of the
following year is the earliest dated painting of a
forest interior by Vinckboons. Like the roughly
contemporary (see cat. 19) and earlier works of
Gillis van Coninxloo (see Introduction, fig. 25,
dated 1598), it depicts a dense wood with vistas
funneling through the embroidered foliage of
enormous trees. No doubt Coninxloo's pre-
cedent was important for Vinckboons, but so,
too, were Hans Bols's forest interiors (see fig. 1),
which precede in date both artists' wooded
scenes and constitute some of the most impor-
tant works in the "Bruegel Renaissance" – the
landscape movement that revived interest in
Pieter Bruegel's forest landscapes.[3] Goossens
discussed the differences between the paintings
of forest interiors by Coninxloo and
Vinckboons.[4] While Coninxloo's works evoke
the forest primeval with greater naturalistic
detail but a lyrical overall conception,
Vinckboons's forests are less mysterious and

Fig. 1. Hans Bol, *Forest Interior*, signed and dated 1588, pen and wash drawing, Museum Boymans-van Beuningen, Rotterdam.

Fig. 3. David Vinckboons, *Forest with Abraham and the Angels*, panel, 39 x 64 cm., Museum Wiesbaden, Wiesbaden, inv. M 14.

Fig. 2. David Vinckboons, *Landscape with Hunt*, panel, 51.7 x 67.5 cm., Gemäldegalerie, Dresden, no. 3529.

commensurately more idyllic. The human
presence of the staffage is more assertive, and
glimpses of villages usually appear in the dis-
tance. Coninxloo's hunters are secreted deep in
the woods, but Vinckboons's stay close to the
forest's edge.

Vinckboons must have regarded the exhibited
work's design as one of his most successful since
he repeated it several times in paintings with
both secular and religious staffage. It recurs in a
close variant of the exhibited painting in Dres-
den (fig. 2), in the *Forest with Abraham and the
Angels* in Wiesbaden (fig. 3),[5] the *Forest Scene with
the Baptism of the Eunuch*,[6] and the *Forest with
Elegant Couple*, formerly in Berlin (Gemälde-
galerie; destroyed in World War II).[7]

P.C.S.

1. Goossens 1954a, pp. 11–24.

2. Ibid., fig. 7.

3. See Gerszi 1976a, pp. 201–29.

4. Goossens 1954a, pp. 21–22.

5. The Dresden and Wiesbaden paintings are not men-
tioned in Goossens 1954a.

6. Panel, 98 x 135 cm., formerly Semenow-Tianskansky
Collection, Leningrad; see Goossens 1954a, pp. 24, 139,
fig. 9, as "c. 1603."

7. Canvas, 64 x 105 cm.; see Goossens 1954a, pp. 25, 44,
142, fig. 10, as "c. 1610."

Landscape with Frozen Canal, Skaters, and Iceboats, c.1610

Oil on panel, 20½ x 39⅜ in. (52 x 100 cm.)
Private Collection

Provenance: Galerie Hoogsteder, The Hague; private collection, The Netherlands; dealer Hoogsteder-Naumann, New York.

Exhibitions: The Hague 1982, no. 89, ill.; Amsterdam/Zwolle 1982, no. 26, ill.; New York 1983, pp. 95–98, ill.; Caracas, Museo de Bellas Artes, *Invierno en Holanda*, 1983, ill.

Literature: Bol 1982–83, p. 173, figs. 9–11; Haverkamp Begemann, *Burlington Magazine* (1983), p. 386 (as possibly by Vinckboons); Terri James-Kester, "Art of the Winter Landscape," *Holland Herald* 19, no. 2 (1984), p. 16, ill.

On a frozen canal a crowd of agile skaters, a horse-drawn sleigh, and picturesque iceboats fill a winter landscape. The scene recedes to a high horizon with a central vanishing point. Lining the banks of the canal are buildings, barren trees, and, on the right, an elaborate castle.

This painting had always been attributed to Adriaen van de Venne until Egbert Haverkamp Begemann tentatively reattributed it to David Vinckboons.[1] J. Bruyn and Martin Royalton-Kisch both privately and independently came to the same conclusion. The attribution is based primarily on the figure types, which closely resemble those in Vinckboons's genre scenes. Compare, for example, the elegant figures in Vinckboons's *Merry Company* of 1610 (tempera and oil on panel, 41 x 68.3 cm., Akademie der bildenden Künste, Vienna, inv. 592). Winter scenes are exceedingly rare in Vinckboons's oeuvre. Indeed, no other such paintings by his hand exist, although there are prints after his designs for winter subjects in a series of the Four Seasons by Hessel Gerritsz and Simon Frisius (fig. 1).[2] Additional support for the attribution to Vinckboons is provided by infrared reflectography, which reveals extensive underdrawing in the composition. Comparisons with drawings

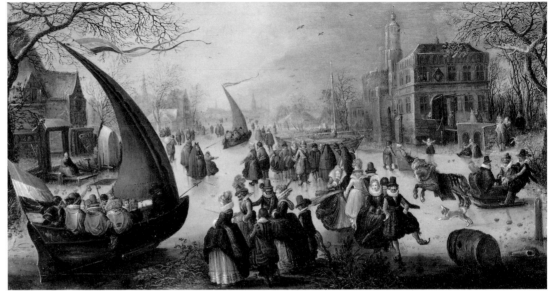

111

on paper by Vinckboons in Berlin, the British Museum, and elsewhere present many points of similarity in the handling of the figures, the animals, trees, and architecture.[3] Several complete or partial copies or variants of the work exist, which attest to its popularity.[4] One of these variants, the *Winter Landscape* by Adam van Breen (active c.1611–46) in the Rijksmuseum (fig. 2), bears the date 1611, providing us with a *terminus ante quem* for the origin of Vinckboons's prototype. This date suggests that Vinckboons preceded Adriaen van de Venne in the painting of winter views of this type, since the latter's winter landscapes of 1614, in Berlin (cat. 109), and 1615, in the Worcester Art Museum (cat. 109, fig. 1), both postdate the present painting.

As Otto Naumann has observed, the early seventeenth-century print by Christoffel van

Sichem (c.1546–1624) describes iceboats as a new invention and notes that no less important a figure than Prince Maurits took a ride in one in 1610 (fig. 3).[5] The winters of 1610 and 1611 were famously harsh, no doubt ensuring ice of a solidity rarely known today in Holland's moderated climate. Already by 1655, Parival claimed that iceboats were falling out of favor because of the unevenness of the ice.[6] However, they apparently had a revival; as late as 1799, the former French ambassador de Langres commented on their popularity, great speed, and difficulty of handling.[7]

P.C.S.

Simon de Vlieger

(Rotterdam? c.1601–1653 Weesp)

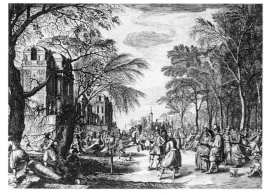

Fig. 1. Simon Frisius after David Vinckboons, (HYEMS) *Winter*, etching.

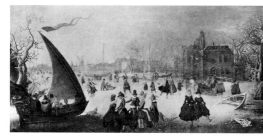

Fig. 2. Adam van Breen, *Winter Landscape*, signed and dated 1611, panel, 52.5 x 90.5 cm., Rijksmuseum, Amsterdam, inv. A 2510.

Fig. 3. Christoffel van Sichem, *Iceboat*, engraving.

1. Haverkamp Begemann, in *Burlington Magazine* 125 (1983), p. 386.

2. For Hessel Gerritsz's print, see Hollstein, vol. 7, p. 107, no. 20, *Hyems*, in "The seasons [with] views of the castles in the vicinity of Amsterdam," including respectively Nyenroy, Loenersloot, Maersen, and Zuylen. Although the castle in the exhibited painting has not been identified, it may recall an actual site. Royalton-Kisch (letter of May 21, 1986) first observed the connection with the figure style of Gerritsz's winter print. The Frisius print is inscribed "D. Vinckboons inv. Symon frisius fecit. Hondius [H. Hondius II] excud." See Hollstein, vol. 7, p. 39, no. 233. Although the print is not dated, the *Autumnus* print etched by A. Stock after Vinckboons for the same series bears the date 1618.

3. Otto Naumann (privately) compares the horse pulling the sleigh with the treatment of horses in Vinckboons's drawing *Hunting Scene with Fox*, which is part of the series of hunting scenes in the Kupferstichkabinett, Berlin (nos. 2217–2228), and in the *Return of the Prodigal Son* in the British Museum, London (inv. 1848-11-25-4). He also likens the underdrawing of the architecture to the sketchy technique in known drawings by Vinckboons; see *Peasants outside Tavern* (British Museum, inv. 1946-7-13-183) and *Genre Scene* (British Museum, inv. 1895-9-15-1030).

4. Copies: (1) panel, 55 x 104 cm., Muzeum Narodwe, Warsaw, inv. 181830, as A. van de Venne; (2) panel, 48 x 97 cm., Goudstikker Gallery, Amsterdam (Amsterdam 1932, no. 21); (3) panel, 48 x 96 cm., Slatter Gallery, London, 1957, and sale, London (Sotheby's), June 25, 1969, no. 129 (ill. in New York 1983, p. 96, fig. 1); (4) by Adam van Breen (fig. 2).

5. New York 1983, p. 98; see also van Straaten 1977, p. 60. However, there is no reason to believe the people in Vinckboons's iceboat or any of the skaters are identifiable.

6. Quoted by Naumann (New York 1983); see Nicolaes Parival, *Les délices de la Hollande* (Leiden, 1655), p. 16.

7. Vincent-Lombard de Langres, *Mémoires anecdotiques pour servir à l'histoire de la révolution française* (Paris, 1823), p. 309; quoted in R. Murris, *La Hollande et les hollandais au XVIIe et au XVIIIe siècles vus par les français* (Paris, 1925), pp. 135–36.

According to a document dated May 16, 1648, Simon Jacobsz de Vlieger was about forty-seven years old, hence born about 1601, probably in Rotterdam. His sister Neeltje de Vlieger became a still-life painter. On January 10, 1627, he married Anna Gerridts van Willige in Rotterdam, where he is also mentioned in 1628, 1630, 1632, and 1633. On February 25, 1634, he rented the house known as "Kranenburch" in Delft and on October 18 of that year became a member of the guild. On December 14, 1637, he bought a house on De Schilderstraat in Rotterdam but on March 12, 1638, was still living in Delft in the house known as "Houttuyn." On July 19, 1638, he was described in a document as an artist living in Amsterdam and probably moved to that city sometime between this date and the preceding March 12, when he was still residing in Delft.

De Vlieger executed two designs for decorations for the festivities honoring Queen Maria de Medici's entry into Amsterdam on August 31, 1638. On December 2, 1640, and March 10, 1641, he was paid for unspecified works by the city of Delft. In 1642 he received a commission to paint organ doors for the Grote Kerk in Rotterdam, for which he was paid the considerable sum of 2,000 guilders on January 7, 1645. (The doors, depicting King David and other figures, were destroyed in 1788). On January 5, 1643, he became a citizen of Amsterdam and on September 17, 1644, sold his house in Rotterdam. On January 4, 1648, he was commissioned to decorate the windows on the south side of the Nieuwe Kerk in Amsterdam for 6,000 guilders. He was still living in Amsterdam on November 20, 1648, but on January 13, 1649, bought a house in Weesp. His daughter, Cornelia, was married to the Amsterdam painter Paulus van Hillegaert the Younger (1631–1658) in that city in 1651. On February 2, 1652, he was again mentioned in Rotterdam as a widower, but

he died in Weesp, probably early in March 1653. His death was lamented in verses by the poet Joost van den Vondel.

A varied artist, Simon de Vlieger painted and drew seascapes, beach scenes, and landscapes, as well as a few genre scenes and portraits. His earliest dated works are of 1624. The early paintings are strongly influenced by Jan Porcellis (1584–1632) and chiefly depict ships and fantastic rocky coasts. Around 1630 he painted his first beach scenes and from 1650 onward executed mostly coastal views and marines with calmer seas and a few forest scenes. Landscapes proper form a small portion of his oeuvre. De Vlieger was also active as a printmaker. According to Houbraken, de Vlieger was the teacher of the seascapist Willem van de Velde the Younger (1633–1707).

P.C.S.

Literature: Houbraken 1718–21, vol. 2, p. 325; Bartsch 1803–21, vol. 1, pp. 19–36; Nagler 1835–52, vol. 20, pp. 461, 463; Immerzeel 1842–43, vol. 3, p. 202; Blanc 1854–90, vol. 4, p. 164; Kramm 1857–64, vol. 6, p. 1780, supplement p. 163; Obreen 1877–90, vol. 1, pp. 6, 30, vol. 7, p. 22; Dutuit 1881–85, vol. 4, p. 532; Haverkorn van Rijswijk 1891–93; Wurzbach 1906–11, vol. 2, pp. 803–804; Thieme, Becker 1907–50, vol. 34 (1940), pp. 462–63; Heppner 1930, pp. 78–91; Martin 1935–36, pp. 264–66; van Hall 1936–49, p. 648; no. 17388; Rosenberg 1953–54, p. 8; Maclaren 1960, pp. 442–44; Dattenberg 1967, pp. 344–45; Kelch 1971; Preston 1974, pp. 60–63; The Hague, Mauritshuis cat. 1980, pp. 119–21; Ruurs 1983, p. 189; Haak 1984, pp. 150, 308–309.

112 (PLATE 79)

Wooded Landscape with Sleeping Peasants (The Parable of the Tares of the Field), 1650–53

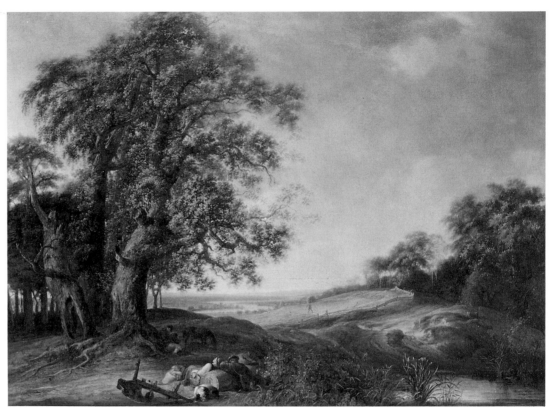

112

Signed and dated on the plow in the lower left: S. DE VLIEGER 165[?]
Oil on canvas, 35⅝ x 51⅛ in. (90.4 x 130.4 cm.)
The Cleveland Museum of Art, Mr. and Mrs. William H. Marlatt Fund, 75.76

Provenance: The Hon. Frederick Lindley Meynell; Capt. Charles Meynell; sale, London (Sotheby's), March 27, 1974, no. 7, pl. 7; dealer Frederick Mont, New York; acquired in 1975.

Literature: *Bulletin of the Cleveland Museum of Art* 63 (1976), p. 40, fig. 64; Cleveland, cat. 1978, p. 156, ill.; Cleveland, cat. 1982, pp. 284–85, no. 126, ill.

In a summer landscape with tall, gnarled trees on the left and a pond, a dirt road, and enclosed fields on the right, peasants doze beside a plow in the lower left foreground. In the distance, the tiny figure of the devil confirms the painting's biblical subject; like Bloemaert's earlier work of 1624 (see cat. 12), de Vlieger's painting illustrates the Parable of the Tares of the Field (Matthew 13:24–30, 36–39). On the subject's meanings and associations, see the commentary to Bloemaert's painting.

Fig. 1. Jacques de Gheyn, *Parable of the Tares of the Field*, signed and dated 1603, pen and ink, 256 x 417 mm., Kupferstichkabinett, Staatliche Museen Preussischer Kulturbesitz, Berlin (West), inv. 3102.

Fig. 3. Herman Saftleven, *Wooded View with Pond*, monogrammed and dated 1645, canvas, 129 x 183 cm., Kunsthistorisches Museum, Vienna, inv. 0228.

Fig. 2. Unknown sixteenth-century artist, *Landscape with the Parable of the Tares of the Field*, signed and dated "H. Bol 1573(?)," pen and wash drawing, 194 x 301 mm., Rijksprentenkabinet, Amsterdam, inv. A 3353.

De Vlieger offers a more naturalistic depiction of the subject, exchanging Bloemaert's nudes for the fully clothed peasants and eschewing picturesque motifs like Bloemaert's tumbledown cottage and dovecote in favor of a more straightforward account of the farm country. He also devotes more of the scene to the landscape, diminishing the scale of the figures. But like Bloemaert and unlike Jacques de Gheyn (fig. 1), de Vlieger depicts the devil as a tiny figure in the distance, also omitting the supernatural apparitions that appear in de Gheyn's drawing. His conception and design nonetheless recall still earlier treatments of the subject, such as the sixteenth-century drawing inscribed "H. Bol" and dated 1573(?) in the Rijksprentenkabinet, Amsterdam (fig. 2);[1] compare details, such as the foremost peasant on the left.

Few of de Vlieger's paintings are dated, and his landscapes are not as numerous as his marines. Indeed, the Cleveland picture, which must date from the last three years of de Vlieger's life, is the only wooded landscape by the artist to bear a date. It may be compared with his few other painted landscapes of this type, including the horizontally disposed *Entrance to the Forest* in the Museum Boymans-van Beuningen, Rotterdam (inv. 1924),[2] and two upright compositions depicting wooded landscapes with hunters, in the Nationalmuseum, Stockholm (inv. NM 682), and the Szépművészeti Múzeum, Budapest (inv. 323). In the catalogue of the Cleveland Museum of Art, the composition is also compared with de Vlieger's drawings in the Kunsthalle, Hamburg (inv. 22657), and the Kupferstichkabinett, Staatliche Museen Preussischer Kulturbesitz, Berlin (West).[3]

All probably late works by de Vlieger, his wooded views owe a debt, as Stechow observed,[4] to Cornelis Vroom, Salomon van Ruysdael, and, above all, to his fellow Rotterdamer Herman Saftleven. The Cleveland painting, for example, is anticipated by Saftleven's large canvas *Wooded View with Pond*, dated 1645, in the Kunsthistorisches Museum, Vienna (fig. 3).

P.C.S.

1. Not in K.G. Boon, *Netherlandish Drawings of the Fifteenth and Sixteenth Centuries, Rijksmuseum, Amsterdam*, 2 vols. (1978).

2. Stechow 1966, fig. 133.

3. Cleveland, cat. 1982, p. 284, fig. 126a.

4. Stechow 1966, pp. 69–70.

Landing Party on a Rugged Coast, 1651

Signed and dated lower left: S. DE / VLIEGER / 1651
Oil on panel, 30 x 43 in. (76 x 109 cm.)
Private Collection, Montreal

Provenance: Sale, London, Christopher York, London (Christie's), December 8, 1972, no. 63 (to Leadbeater); dealer J. Hoogsteder, The Hague.

Exhibitions: The Hague 1982, no. 91, ill.

This painting, dated 1651, is the product of Simon de Vlieger's last years. As early as about 1630, de Vlieger had painted similar scenes of ships landing on rocky coasts, occasionally in heavy sea storms. A painting in the Rijksmuseum, Amsterdam, contains similar steep cliffs,[1] while another work at Greenwich shows hunters landing on a rocky shore with fir trees (fig. 1).[2] However, the exhibited work is bolder and more dramatic than either of these two much earlier examples. The high, steep cliffs form a cohesive diagonal unit, while the weathered and dead trees, together with the waterfall, present a formidable, almost threatening, prospect for the landing party. Like the painting in Greenwich, the present work apparently depicts hunters, although they may be a group of explorers landing on some uncharted shore; either would be an appropriate activity for northern adventurers.

While it is tempting to see this painting as a Scandinavian landscape influenced by Allart van Everdingen, who had returned to Holland in 1644, the dating of de Vlieger's early coast scenes makes this impossible. The exhibited painting and its predecessors in de Vlieger's oeuvre are directly inspired by paintings of Adam Willaerts (1577–1664), such as a coast scene dated 1620 showing warships and a landing party of explorers or hunters armed with rifles (fig. 2). That coast, as in de Vlieger's painting, is clearly Northern, with high rocky cliffs and evergreen trees. Willaerts executed

113

Fig. 1. Simon de Vlieger, *Hunters Landing on a Rocky Coast*, remains of a signature, panel, 54.6 x 99 cm., National Maritime Museum, Greenwich, inv. 62-62.

Fig. 2. Adam Willaerts, *Landing Party on a Rocky Coast*, dated 1620, panel, 62 x 104 cm., Staatliche Kunstsammlungen, Dresden, no. 936.

many such coast scenes between 1619 and 1622, varying the figures to include deer hunters, fish markets, and even the Winter King and Queen of Bohemia.[3] Willaerts was strongly influenced by the Alpine landscapes of Roelandt Savery. De Vlieger's painting is equally reminiscent of Savery's work (see cat. 99) in its expansive monochromatic cliffs, silhouetted trees, and scattering of light on the rocks, particularly around the waterfall, which appears to be back-lit. It is likely that de Vlieger came into direct contact with Savery's paintings and drawings of Alpine scenery.[4]

The exhibited painting clearly demonstrates de Vlieger's concern with the problems of linear perspective in landscape and marine painting. The sharp diagonal of the cliffs, echoed on the opposite side by the warships, leads to a vanishing point in the right distance. The positioning of figures at various levels on the cliffs further enhances the clarity of this exercise. These elements can be compared with a drawing by de Vlieger dated 1645 (fig. 3), which is made up of a number of landscape compositions demonstrating various systems of perspective.[5] The sketch at top right, for example, shows figures placed on an elevated platform; the second from the top on the left shows a ship in the distance set off by a large cliff in the foreground.[6] Generally, such concern with perspectival systems is rare in Dutch seventeenth-century landscape painting, although van Mander and P.C. Ketel exhorted the landscape artist to pay close attention to recession.[7]

The associations that a seventeenth-century Dutch observer would have made when viewing a landscape such as de Vlieger's would no doubt have reflected Holland's role as a nation of seafarers, traders, and explorers. Numerous paintings of storms at sea also depict ships being driven toward strange and exotic coasts – Northern European or even American land-

Fig. 3. Simon de Vlieger, *Perspective Sketches*, signed and dated 1645, pen and brown ink, 320 x 210 mm., British Museum, London, inv. 1874.8.8.99.

scapes – again conjuring up images of exploration and discovery.[8] A painting by Bonaventura Peeters (1614–1652) even shows explorers encountering a polar bear (Rijksmuseum, Amsterdam, inv. 2518). The landing party in de Vlieger's picture, seen drawn up on the shore, with armed men investigating the coast and scrambling over the rocks, would presumably have reminded viewers of Dutch adventurers in the Northern regions. Numerous travel journals kept by captains who sailed to little-known regions were published to satisfy a curious seventeenth-century public. The coast seen in de Vlieger's work may have recalled voyages to Scandinavia and Greenland, which were described in the diaries of J.H. van Linschoten, Gerrit de Veer, Dirck Raven, P. de la Martinière, and others.[9] Like the Brazilian

views of Frans Post (cat. 71), Scandinavian mountains of Allart van Everdingen (cat. 27), or Italian landscapes, de Vlieger's scene shows the viewer not only exotic foreign scenery but also a place where the Dutch had a real presence.

A.C.

1. Inv. A 2086, dated about 1630 by Jan Kelch (Kelch 1971, p. 16, no. 80).

2. National Maritime Museum, Greenwich, inv. 62–65, dated by Kelch to the mid-1630s (Kelch 1971, p. 30, no. 81).

3. Other similar compositions by Adam Willaerts include *Frederik V van Palts on a Rocky Coast*, dated 1619, Nederlands Scheepvaart Museum, Amsterdam (Stechow 1966, fig. 199); *Deer Hunters on a Coast*, dated 1620, Kunsthalle, Hamburg, inv. 336 (Bol 1973, pl. 65); *A Landing Party on a Coast*, dated 1621 (Rijksmuseum, Amsterdam, inv. A 1927).

4. Some of de Vlieger's drawings may have been inspired by Savery's sketches; see a black chalk drawing in Albertina, Vienna, inv. 9167. Kelch also relates de Vlieger's coast scenes to Joos de Momper, for example, a landscape in Rijksmuseum, Amsterdam, inv. A 3100 (Kelch 1971, p. 29). However, Savery seems a stronger and more immediate source.

5. See Hind 1915–31, vol. 4, no. 14. M.S. Robinson (*A Catalogue of Drawings in the National Maritime Museum by Willem van de Velde*, Cambridge, 1974, vol. 2, p. 9, no. 822) questions the attribution of the sheet to de Vlieger, saying the artist did not seem to employ rules of perspective in his paintings. However, the exhibited painting clearly demonstrates de Vlieger's concern with perspective. Ruurs (1983, pp. 189–94) accepts the attribution to de Vlieger and suggests that the sheet was used primarily for instruction, although there is no evidence for this.

6. This type of ship occurs frequently in de Vlieger's work; see paintings in the Prinsenhof, Delft (Bol 1973, pl. 189), and in Statens Museum for Kunst, Copenhagen (Copenhagen, cat. 1951, no. 779).

7. Van Mander 1604, fol. 35v–r. P.C. Ketel, in the "Landschap-Schilder-Liedt," urges the landscapist, "Mark how everything even in the extreme distance meets at a single point." See also Angel 1642, p. 53.

8. See Goedde 1986, esp. figs. 7, 8, 9. The associations with exotic lands, seafaring, and exploration are by no means confined to depictions of ships in storms, as the present painting indicates.

9. J.H. Linschoten, *Twee journalen van twee verscheyde voyagien . . . van bij Noorden om langes Noorwegen* (Amsterdam, 1594,

Cornelis Vroom

(Haarlem c.1591–1661 Haarlem)

and eds. of 1595, 1601, 1624). Gerrit de Veer's description of Norway and Russia was published in 1598. Others include Dirck Albertsz Raven's journals of trips to Spitsbergen and Greenland (1646) and P.M. de la Martinière's *De noordsche wereld* (1671 and 1685). Several accounts of voyages around the world were published in the seventeenth century, including those of Oliver van Noort (1601 and later eds.), J.J. Struijs (1676), and Nicolaus de Graaff (1683).

Cornelis Vroom was the son of the Haarlem marine painter Hendrick Cornelisz Vroom (1566–1640). A notarial act of February 1649 declared him to be "about 58 years old." Samuel Ampzing mentioned Cornelis briefly in a poem about Haarlem in 1621 and praised him more fully in 1628. In 1647 Schrevelius ranked Cornelis Vroom above all other Haarlem landscapists.

Vroom's earliest known work is a marine painting in the style of his father dated 1615 (National Maritime Museum, Greenwich); his earliest landscape painting is from 1622 (Paynhurst collection, London). In 1628 a "Vroom" received a payment from Charles I of Great Britain. This probably refers not to Cornelis but to his brother Frederick. In 1630 Cornelis and his sister left their family, probably because of quarrels with their brother, and spent several months in Beverwijk before returning to Haarlem. Cornelis is first recorded as a member of the Haarlem guild in 1635 but probably joined much earlier. In 1638 Vroom was paid 450 guilders for landscapes to decorate the Honselaarsdijk palace, and he continued through the mediation of Constantijn Huygens to work for the stadtholder's court. A painting, *The Finding of Moses*, with figures by Paulus Bor (c.1600–1669), seems to have been made for Huygens (Rijksmuseum, Amsterdam, inv. A 852). Vroom also collaborated with Jacob van Campen (1595–1657) and Caesar van Everdingen (c.1616/17-1678). In 1639 Vroom donated part of the value of a painting to the city of Haarlem and was exempted from military service. By 1642 Vroom had left the guild, possibly because court patronage enabled him to work outside the guild's jurisdiction.

Vroom's earliest landscape paintings show a debt to Esaias van de Velde and Willem Buytewech. His works in the 1630s, simple views of rivers and woods, stand remarkably outside the tonal phase of Haarlem landscape painting and are paralleled by the landscapes of Pieter Post (1608–1669). Some of Vroom's landscapes incorporate ruins and arcadian staffage, and it is possible that he was influenced by Italianate artists. In the 1640s Vroom's landscapes had considerable influence on other Haarlem artists, including Guillaum Dubois (d. 1680), Jan Lagoor (active c.1645–1671), and Jacob van Ruisdael.

Vroom seems to have become wealthy primarily through real estate transactions and from inheritance, although his paintings were widely known and highly valued in his own lifetime. His will divided his estate between his brother, a niece and a nephew, and a natural son, Jacob. Vroom was buried in the Saint Bavo Church, Haarlem, on September 16, 1661.

A.C.

Literature: Ampzing 1621; Ampzing 1628, p. 368; Schrevelius 1647; van der Willigen 1870, pp. 321–23; Moes 1900, p. 217; Wurzbach 1906–11, vol. 2, p. 833; Bredius 1915–22, vol. 2, pp. 643–67; vol. 7, pp. 281–84; Rosenberg 1928b; Martin 1935–36, vol. 1, pp. 258–59; vol. 2, p. 295; van Gelder 1962; Stechow 1966, pp. 69–73; Haverkamp Begemann 1967; Bol 1969, pp. 144–48; Biesboer 1972; Keyes 1975; Biesboer 1978–79; Biesboer 1979; Keyes 1982; Russell 1983, pp. 105–11, 160, 187–89, 198, 202; Zwollo 1983; Haak 1984, pp. 240–41.

River Landscape with Imaginary Ruins, c. 1622–30

Signed lower center to right of tree stump:
CVROOM [CVR ligated]
Oil on panel, 11⅝ x 23⅝ in. (29.5 x 60 cm.)
Frans Halsmuseum, Haarlem, inv. 499

Provenance: D.C.E. Erskine; sale, Erskine, London (Sotheby's), December 5, 1922, no. 87 (£50 to Abraham); acquired in 1923 by the Vareiniging tot Uitbreiding van de Verzameling van Kunst en Oudheden op het Frans Halsmuseum.

Exhibition: New Brunswick 1983, no. 130, ill.

Literature: Rosenberg 1928a, pp. 102–103, no. 11, ill. no. 1; Simon 1930, p. 11; Thieme, Becker 1907–50, vol. 34 (1940), p. 581; Baard 1955, no. 499; Stechow 1966, pp. 58, 168; Bol 1969, p. 146, pl. 135; Biesboer 1972, pp. 37–38, cat. pp. 7–9; Keyes 1975, vol. 1, pp. 67–68, vol. 2, no. P 19, fig. 24; Paris 1983, p. 158; Haak 1984, p. 241, fig. 505.

114

On a still stretch of river with lush banks of carefully observed, silhouetted foliage, a skiff carrying exotically diverse figures (one wearing a turban, the others elegantly attired in plumed hats) rows away from an imaginary Mediterranean river mooring. Dominating the architecture in the distance is a medieval Italian structure reminiscent of a Roman mausoleum but constructed of alternating limestone and *pietro rosso* bands. On the far horizon a southern baroque church with elaborate pediment appears. A botanical potpourri complements the architectural mélange; northern and southern plants and trees mix freely with imaginary specimens. Beneath the oaks on the far bank, a quotidian note: a woman strikes the lower branches to shake down acorns for her swine.

This haunting river scene creates an effect not unlike a dream. Neither Dutch nor Italian in its scenery, neither a depiction of classical antiquity nor an imagined seventeenth-century world, the landscape defies specifications of place and time. Even the weather and hour of the day are indeterminate. Keyes has suggested that this painting may predate Vroom's earliest dated landscape of 1622 (fig. 1).[1] However, as Biesboer suggests, the crisp, exacting treatment of the foliage would seem to point to a later date, possibly even later than the *River Landscape*, dated 1626, in the National Gallery, London (no. 3475).[2] As Keyes himself notes, the coulisse in the right foreground of a tree and river bank covered with "prickly foliage" resembles similar motifs in Schwerin's *River Panorama*, dated 1630 (see cat. 78, fig. 3), and other later works.[3] Indeed, the work anticipates Frans Post's manner in its exacting account of foreground plants and more distant trees.

The legacy of Elsheimer is evident in the hushed serenity, diagonal design, and vaguely Italianate flavor of this river scene, but as Keyes notes, the influence was probably absorbed via Jan van de Velde's etchings, particularly the long horizontal prints from the series *Amoenissimae*

Fig. 1. Cornelis Vroom, *River Landscape with Boats*, signed and dated 1622, panel, 45 x 65 cm., Frederick Paynhurst, London.

aliquot Regiumculae et Antiquorum Monumentorum ruinae.[4] In addition to Jan van de Velde, the Pre-Rembrandists – Lastman, Pynas and Wtenbrouck – also may have piqued Vroom's

interest in pseudo-Tuscan architectural details. Biesboer observed that Wtenbrouck's hybrid landscapes, which are part Italian, part Dutch, with a liberal admixture of imaginary arcadian elements, are the closest to Vroom's vision.[5] Vroom's building is also surely imaginary;[6] on it is a relief of an unidentified historical scene, possibly of judgment or obeisance, including a horseman and kneeling figures.

As Keyes has observed, the motif of the woman feeding her pigs descends from activities depicted in calendar illustrations of the Labors of the Month of November, while the idyllic quality of the scene could recall the *luxuria* theme often depicted in the guise of the month of May.[7] However, the painting embodies no single allegory; rather, like its contradictory but artfully combined components, it evokes a whole spectrum of poetic emotion. Likening the work to Giorgione's haunting landscapes, Keyes characterized the work as "an idyll with no ulterior subject, . . . possibly the first of its type in Dutch art."[8]

An autograph variant of the left side of the Haarlem painting's composition is preserved in the Lugt Collection, Institut Néerlandais, Paris.[9]

P.C.S.

1. Keyes 1975, vol. 2, p. 182, no. P 19.

2. Biesboer 1972, cat. p. 8. Without specifying her reasoning, Hofrichter (in New Brunswick 1983, no. 130) dated the work "ca. 1622–26."

3. Keyes 1975, vol. 2, p. 182, no. P 19. The author contends that these motifs descend from a group of seven drawings (Keyes 1975, nos. D 2, 9–11, 25, 28, 29, figs. 9–15) that Vroom made of sites in the Rhône Valley.

4. Keyes 1975, vol. 1, p. 67. Compare, for example, Franken, van der Kellen 1883, no. 228, *Castle Ruins*.

5. Biesboer 1972, p. 36; Biesboer 1979.

6. Hofrichter (in New Brunswick 1983, no. 130) even compared the shape of the monument to a Dutch barn silo.

7. Keyes 1975, vol. 2, p. 183, and vol. 1, p. 68.

8. Ibid., vol. 1, p. 68.

9. Paris 1983, no. 95, ill.

115 (PLATE 20)

Estuary Viewed through a Screen of Trees, c. 1638

115

Signed at bottom right: CVROOM [CVR ligated]
Oil on panel, 19¾ x 26½ in. (50 x 67.3 cm.)
Private Collection, on loan to the Frans Halsmuseum, Haarlem

Provenance: Private collection; dealer S. Nijstad, The Hague.

Exhibitions: Brussels 1971, no. 117, ill.; The Hague 1982, no. 94, ill.; Atlanta 1985, no. 58, ill.; London 1986, no. 79, ill.

Literature: Keyes 1975, vol. 1, pp. 85–86, 88, 89, 107; vol. 2, no. 39, ill. no. 48.

Tall trees with filigreed foliage are silhouetted above a broad panorama. Beyond the wooded slope stretches a large river estuary or bay, with smaller misty inlets. While deep blackish tones accent the trees, muted gray-green hues color the distance. Dwarfed by the towering trees and the vast panorama, tiny hunters and a dog make their silent way over the land.

Fig. 1 Cornelis Vroom, *Panorama*, drawing in brown ink, 292 x 448 mm., Yale University Art Gallery, New Haven, inv. 1961.64.56.

Fig. 2. Pieter Post, *Panorama*, signed and dated 1631, panel, 43.7 x 61.5 cm., Institut Néerlandais, Paris, inv. 6331.

Fifteenth- and sixteenth-century Northern landscapists had produced panoramic views, both of mountains and plains (see Introduction, figs. 15 and 22). However, the panorama assumed a new importance in Dutch seventeenth-century art through Hendrick Goltzius's drawings of 1603 (Introduction, fig. 28)[1] and the paintings of Hercules Segers (cat. 37, fig. 1) and Esaias van de Velde. As the exhibited work attests, Vroom also made important contributions to the tradition.

A pair of drawings dated 1631 are Cornelis Vroom's earliest surviving panoramic landscapes.[2] Some years later, he executed two sheets with identical compositions that depict a panorama with a country house and an estuary beyond. One of these (fig. 1), a large-scale presentation drawing with the remnants of a date, must be approximately contemporary with the exhibited painting.[3] At the same time that Vroom made his drawings of 1631, Pieter Post (1608–1669) painted a panoramic landscape similar in composition and handling to Vroom's work (fig. 2).[4] The strong similarities between Pieter Post and Vroom may in part be the result of their common source in the work of Esaias van de Velde. Moreover, Vroom and Post moved in similar circles in Haarlem and The Hague.

Closely related to the present painting is another panorama in the Stichting Hannema-de Stuers, Heino (Introduction, fig. 47). Keyes believed that this painting must have been executed after the exhibited work because of its greater refinement and the fact that the treetops are no longer cut off.[5] However, the opposite seems more likely. The present landscape is more innovative in its placement of the view behind a screen of richly differentiated trees. (Keyes noted that these trees range from young saplings, to aged giants, to a dead tree stump at the left but declined to speculate "whether this life cycle consciously affirmed an authentic vision

Fig. 3. Cornelis Vroom, *Idyllic Landscape*, signed and dated 1638, panel, 40.7 x 67.5 cm., Frans Halsmuseum, Haarlem, inv. 499.

of nature.")[6] The exhibited composition represents a significant departure from the Heino painting, which is more closely related to Vroom's earlier drawings and Pieter Post's panorama, all of which are dated 1631.[7] Vroom's screen of trees atop a hill overlooking a panorama marks a return to Flemish sixteenth-century compositions employed by Pieter Bruegel the Elder, Jan Brueghel,[8] and Gillis de Hondecoutre. A deliberate revival, this traditional composition enables the viewer to gaze on the vast landscape and the patterned sky through the trees. Vroom's arrangement of the trees as well as his evocation of an idyllic mood anticipate the work of artists like Jan Both and Adam Pijnacker. Stylistically related to Vroom's two panoramic paintings is the *Waterfall above a River*, dated 1638, in the Frans Halsmuseum, Haarlem (fig. 3).[9] The exhibited work would seem to just predate the painting of 1638.

As Biesboer has observed, Vroom's mature works evoke poetic idylls of the sort encountered in seventeenth-century arcadian literature, which was inspired by the classical writings of Virgil and Horace.[10] Vroom was acquainted with Constantijn Huygens, a leading exponent of neoclassical poetry, including paeans to country

Jan Baptist Weenix

(Amsterdam 1621–1660/61 Utrecht)

living. Indeed, Vroom is known to have worked for Huygens. The haunting appeal of his painting arises from its highly personal interpretation of the classical landscape tradition, an interpretation that parallels Dutch poets' translations of Latin *bucolica* into their own native tongue and recasting of arcadian themes into evocatively Dutch locales with familiar Dutch characters.

A.C., P.C.S.

1. Two drawings in the Louvre, Paris, and the Museum Boymans-van Beuningen, Rotterdam, both dated 1603 (Reznicek 1959, nos. 400, 404).
2. In the Kupferstichkabinett, Berlin (West) (inv. 8501) and the Abrams collection, Boston, both dated 1631 (ill. in Keyes 1975, vol. 2, figs. 43, 44).
3. The sheet at the Yale University Art Gallery contains the remains of a date read variously as 1636, 1639, 1640, or 1649 (Haverkamp Begemann, Logan 1970, no. 441; Keyes 1975, no. D 26). It is based on a smaller drawing in the Institut Néerlandais, Paris (Keyes 1975, vol. 2, no. D 31, fig. 45).
4. Biesboer 1972, pp. 47–48. Bol 1969, pp. 147–48, noted similarities between Pieter Post's painting and Vroom's landscape in Heino.
5. Keyes 1975, pp. 88, 186. In somewhat contradictory fashion, Keyes also suggests that the painting has been cropped at the left and top edges, although there is no evidence to support this; see also Christopher Brown, in London 1986, no. 79.
6. Keyes 1975, p. 86.
7. Pieter Biesboer agrees with this conclusion (letter, October 28, 1986).
8. Ertz 1979, nos. 223, 282.
9. Biesboer 1972, pp. 47–48; Keyes 1975, vol. 1, p. 85; Biesboer 1979. A painting very similar to the one dated 1638 is in the Niedersächsisches Landesmuseum, Hannover, inv. PAM 902 (Keyes 1975, vol. 2, fig. 56). A painting of similar composition with a distant panorama at the right appeared in a recent exhibition (London 1986, no. 77, ill.). However, it is clearly the work of a follower of Vroom, perhaps Jan Lagoor.
10. Biesboer 1979, pp. 106–107.

Jacob Houbraken, *Jan Baptist Weenix*, from Arnold Houbraken, *De groote schouburgh*, 1718–21, engraving.

Born in Amsterdam in 1621, Weenix was the son of an architect, Johannes Weenix. He was first apprenticed in Amsterdam to the little-known artist Jan Micker (c.1598–1664), subsequently studied with the Utrecht painter Abraham Bloemaert, and completed his training with two years in the Amsterdam studio of Claes Moeyaert (1592/93–1655). At eighteen, Weenix married the daughter of the landscape painter Gillis de Hondecoutre. The couple had two sons, one of whom, Jan (1640–1719), became a well-known still life, landscape, and portrait painter. Weenix traveled to Italy in late 1642 or early 1643. In the words of the will that he drafted before departing, he made the trip to "experi-

ment with his art." In Rome he joined the Netherlandish artists' society, "De Schildersbent," where he became known as "Ratel" (rattle) because of a speech defect. According to Houbraken, Weenix remained in Italy for four years, spending most of this time in Rome, where, around 1645, he entered the service of a "Kardinaal Pamfilio." Most writers have assumed that this patron was Cardinal Giovanni Battista Pamphili, who became Pope Innocent X in 1644; however, it is more likely that he was the Pope's nephew, Cardinal Camillo Pamphili, who took greater interest in the arts than the pontiff. Nonetheless, in using the Italian translation of his name "Giovanni Battista" (the form of signature he invariably used after returning from Italy), the artist may have wished to honor Innocent X, who commissioned at least one work from him. Weenix was back in Amsterdam by June 1647, when Bartholomeus van der Helst (1613–1670) painted his portrait (now lost but known through a print by Jan Houbraken). By 1649 he had settled in Utrecht, where he was elected an officer of the painters' guild. Documents from 1653 show that he was closely involved, as both painter and dealer, with the collector Baron van Wyttenhorst. In 1657 Weenix moved to the Huis ter Mey(e), near Utrecht. According to Houbraken, he died there in 1660 or 1661 at the age of thirty-nine.

Together with Jan Asselijn, Jan Both, and Karel du Jardin, Jan Baptist Weenix was a leader of the second generation of the seventeenth-century Dutch Italianate painters. In addition to painting and drawing genre and history subjects set in the Italian campagna, he executed fanciful views of Mediterranean seaports and still lifes with dead game. His son Jan carried on his art, attracting followers well into the eighteenth century.

P.C.S.

116 (PLATE 62)

River View with a Ferry, c. 1647–50

Literature: de Bie 1661, p. 277; Houbraken 1718–21, vol. 2, pp. 77–83, 111, 113, 131, vol. 3, pp. 70, 72; Weyerman 1729–69, vol. 2, pp. 163–70; Descamps 1753–64, vol. 2, pp. 306–12; Bartsch 1803–21, vol. 1, pp. 389–94; Nagler 1835–52, vol. 21, pp. 199–204; Immerzeel 1842–43, vol. 3, pp. 223–24; Blanc 1854–90, vol. 4, p. 197; Kramm 1857–64, vol. 6, pp. 1835–7; Obreen 1877–90, vol. 2, p. 72; S. Muller 1880, pp. 3, 129; Dutuit 1881–85, vol. 6, p. 622; Bode 1883, p. 174; Wurzbach 1906–11, vol. 2, pp. 846–47; Bredius 1928; Martin 1935–36, vol. 2, pp. 460–62; Thieme, Becker 1907–50, vol. 35, pp. 246–47; Stechow 1948; Hoogewerff 1952, pp. 19, 93, 146, 153, 165; Maclaren 1960, pp. 448–49; Plietzsch 1960, pp. 138–40; Utrecht 1965; Chudzikowski 1966; Stechow 1966, pp. 156, 159–60; Ginnings 1970; Duparc 1980; Rubsamen 1980, pp. 7–10, 14, 58–59; Schloss 1982; Kettering 1983; Schloss 1983a; Schloss 1983b; Plomp 1986, pp. 145–47.

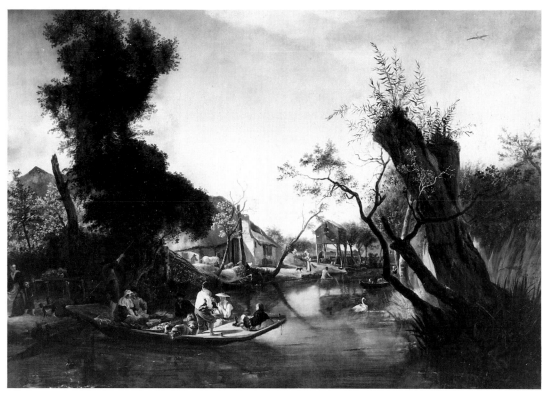

116

Remnants of a signature lower right: . . . Batt. . .
Oil on canvas, 60 x 80 in. (152.4 x 203.2 cm.)
French & Company, New York.

Provenance: Van Diemen, Amsterdam; Gerolamo Parensi, who married Anna Maria van Diemen, September 1, 1675; by descent to Mansi, Lucca; dealer Bernhard Houthakker, Amsterdam, 1973; Patrick Gallagher, Ireland; sale, Gallagher, London (Sotheby's), November 17, 1982, no. 100; dealer Noortman and Brod, London, New York, and Maastricht; sale, New York (Christie's), June 5, 1985, no. 154 (bought in).

Literature: Hofstede de Groot 1908–27, vol. 9, no. 81 (as Adam Pijnacker); Harwood 1985, no. C 13.

In a sunny landscape a river recedes centrally between two banks covered with trees, marshy reeds, and, in the left distance, a farmhouse and dovecote. In the left foreground a heavily laden ferry is being pushed from shore. Its passengers include seven people, three sheep, and a wriggling pig held precariously by a standing man spotlit in the sunshine with his chemise falling off one shoulder. Remaining behind on the left

Fig. 1. Jan Baptist Weenix, *Hunting Party Resting among Ruins*, signed and dated 1648, canvas, 99 x 129 cm., Private Collection.

are a mother, a child, and a dog. The trunks of a tall pollard willow on the right shore form angled silhouettes. In front of the farmhouse a woman sweeps as a man bathes in the river. A skiff and a white swan also ply the river.

Although the painting once carried an attribution to Pijnacker,[1] it bears the remnants of the signature that Jan Baptist Weenix (Gio Batta [or Bata] Weenix) favored after his return from Italy in 1647. Prior to this date he used a Dutch spelling of his name: "J Weenincks" or "Weeninxs." Weenix dated paintings as early as 1642 (see the *Sleeping Tobias*, signed "Jo. Weenincks," Museum Boymans-van Beuningen, Rotterdam, inv. 1204),[2] but no dated or datable paintings are known from his years, 1644–47, in Italy. The landscapes that Weenix painted immediately following his return mostly depict imaginary southern scenery with ruins and relatively large genre figures. The *Ford* of 1647 (Leningrad, Hermitage, inv. 820) and the *Hunting Party Resting among Ruins* of 1648 (fig. 1)[3] are typical of these early works and employ the figure types that, as Blankert has shown,[4] recall

those of Pieter van Laer.[5] The relatively loosely painted, pliant figures in *River View with a Ferry* are closer to those of Weenix's early works of about 1647–50 than to those of the 1650s. A much tighter, more polished style, for example, appears in his last dated painting of 1658, the *Italian Landscape with Figures and Animals before an Inn*, signed and dated 1658 (panel, 68 x 87 cm., Mauritshuis, The Hague, inv. 901).

Netherlandish scenery of the type seen in the exhibited painting is rarer in Weenix's work than Italianate subjects, but he painted a handful of other scenes of Dutch dunes and beaches.[6] No other river scenes of this type, however, are known by Weenix. More commonly he painted imaginary Mediterranean harbor views. In the present work the picturesque treatment of the trees and motifs, like the distant farmhouse with dovecote, may recall the art of Weenix's teacher, Abraham Bloemaert (see cat. 12), while the heavily laden skiff, or ferry, which no doubt accounts for the work's earlier misattribution to Pijnacker (see cat. 72 and 74), has a long history in both the indigenous Dutch landscape painting tradition and among Dutch Italianate artists: Jan and Esaias van de Velde (see cat. 106), van Goyen (cat. 33), Salomon van Ruysdael (cat. 94), Jan Both (*View on the Tiber*, etching),[7] Jan Asselijn (*Marshy Landscape with Boat*, formerly Cook Collection, Richmond),[8] and, after Weenix, Adriaen van de Velde (see *Italian Landscape with Ferry*, signed and dated 1667, canvas 62 x 75 cm., Staatsgalerie, Schleissheim, inv. 1853). Weenix himself may also have painted an imaginary Mediterranean port scene with a heavily laden ferry shoving off from shore (Marquess of Bath, Longleat, Warminster); however, that work has also been attributed to Johannes van der Bent (c.1640–1690), one of J.B. Weenix's followers. Although it seems unlikely that Weenix conceived of the exhibited work in allegorical terms, landscapes with ferries and

passenger barges and river views with bathers were earlier depicted in print series depicting *Ver* (Spring) in Four Seasons series.[9]

P.C.S.

1. See Hofstede de Groot 1908–27, vol. 9, no. 81, as Pijnacker.

2. Ginnings 1970, no. 3.

3. Respectively, Utrecht 1965, nos. 96 and 97; Ginnings 1970, nos. 11a and 20.

4. Blankert, in Utrecht 1965, p. 174; and Blankert 1968, pp. 129–30. See also Ginnings 1970, p. 34.

5. Compare the figures, for example, in Pieter van Laer's *Bathers by a Stream*, Kunsthalle, Bremen, inv. 752, and *Peasants by a Stream*, Rijksmuseum, Amsterdam, inv. A 1945.

6. See, for example, *Seacoast with Dunes and Figures*, signed "J B Weenix," canvas, 43 x 61.5 cm., Girardet collection, Kettwig (Ginnings 1970, no. 54; ill. in Brussels 1971, no. 118); and *Dunescape with Various Figures*, signed "Gio. Ba. Weenix," canvas, 34.5 x 41 cm., with dealer J. Hoogsteder, The Hague.

7. Burke 1974, no. 7; ill. in de Groot 1979, no. 115.

8. Steland-Stief 1971, no. 108, pl. XXXIX.

9. See Jan van de Velde's etching dated 1617 (Franken van der Kellen 1883, no. 146), depicting a *trekschuit* (tow barge) laden down with passengers and freight, with the Latin text: "The harsh winter departs, the cattle return to the meadow. The trees are green, the birds sing their song over the resonant water. The youth frolic playfully; Cupid fires his love-full arrows at the crowd" (translated in de Groot 1971, no. 71). For Saftleven's depiction of *Ver* as an etching of bathers, see Bartsch, no. 22; de Groot 1979 no. 141, inscribed "spring opens up the earth, fires the ships from their retirement, tempts young men into the water, [where] they piss to their hearts' delights."

Jan Wijnants

(Haarlem? 1631/32–1684 Amsterdam)

Although the precise date of Wijnants's birth is unknown, the painter gave his age as twenty-eight at the time of the publication of the banns on December 18, 1660. If correct, he must have been born in 1632 or in late 1631.

The son of the Haarlem art dealer of the same name, Jan Wijnants was sometimes designated "the Younger" to distinguish him from his father. When the elder Wijnants made his will in August 1653, Rotterdam was given as the residence of his son. He returned to Haarlem and was certainly living there by 1657, since a notarized document of January 1658 states that the recently born son of a Haarlem woman, Guertgen Claesdr, was fathered by the painter Jan Wijnants the Younger. Wijnants made an agreement with the family of the woman (who died shortly thereafter) that he would adopt the child and educate him. He was in Amsterdam by the spring of 1660. Probably early in 1661 he married nineteen-year-old Catharina van der Veer, who, like him, was Catholic and also lived in the Runstraat. All available documents indicate that Wijnants lived continuously in Amsterdam until his death.

Apparently business matters did not go well for Wijnants. More than once there is mention of unpaid debts. For years, in spite of repeated warnings and efforts to collect payment, he was in default of a debt of forty guilders, lent to him by the painter Nicolaes van Helt Stockade (1614–1669). Time and again Wijnants kept his creditor on a string, appeasing him "met een soopie brandewijn" (with a little brandy). When van Helt Stockade died in 1669, this debt still had not been paid. In 1670, at the request of his widow, a notary recorded the account of a witness to this painful business.

The "brandewijn" that Wijnants dispensed probably refers to the inn that the painter ran; in a document dated April 16, 1672, he is called a "painter and publican." At that time he lived on the Looiersgracht and was perhaps at the same address when he gave his wife power of attorney in November 1667. Difficult financial circumstances apparently compelled Catharina to work cleaning paintings, as recorded in July 1680. When Wijnants died, he was living on the Baangracht near the Reguliersgracht. He was buried on January 23, 1684, leaving a widow and four children.

Throughout his entire career Wijnants relied on motifs taken from the dunes near Haarlem for his paintings, which vary only slightly from a set pattern and chiefly conform to an idealized arrangement. He gave to these indigenous dunescapes a classical form and dignity that endow his best paintings with a certain allure and monumentality.

Wijnants never seems to have painted the hunters, herders, and other countryfolk with animals in his paintings. Among the artists who provided his staffage was Adriaen van de Velde, who, according to Houbraken, was Wijnants's pupil. Although Wijnants's teacher is unidentified, he probably studied in Haarlem about 1646–50, when he was in his teens. Wijnants's earliest paintings feature farmhouses of weathered brick under heavy trees and sometimes poultry painted by Dirck Wijntrack (c.1625–1678). His later dune landscapes reflect Jacob van Ruisdael's influence, particularly where gnarled and barren trees or fallen tree trunks dominate the foreground. It is equally true that Philips Wouwermans's characteristic rendering of the dunes has points in common with Wijnants's later work. Exceptional in Wijnants's oeuvre is *The Herengracht in Amsterdam* (Cleveland Museum of Art, no. 64.419).

C.J.d.B.K.

Literature: Houbraken 1718–21, vol. 3, p. 90; van Eynden, van der Willigen 1816–40, vol. 1, pp. 120–22; Nagler 1835–52, vol. 1, p. 207; Immerzeel 1842–43, vol. 3, p. 253; Kramm 1857–64, vol. 6, p. 1891; Nagler 1858–79, vol. 1, p. 47; A.D. de Vries 1885–86, vol. 4, p. 302; Wurzbach 1906–1911, vol. 2, pp. 907–908; Hofstede de Groot 1907–28, vol. 8, pp. 463–586; Bredius 1911a; Martin 1935–36, vol. 2, pp. 318–19; H. Wolff in Thieme, Becker 1907–50, vol. 36, pp. 329–31; Maclaren 1960, pp. 471–72; Stechow 1965a; van Eeghen 1966; Stechow 1966, pp. 30–31, 163; Bol 1969, pp. 213–14; The Hague, Mauritshuis cat. 1980, p. 123; Haak 1984, pp. 387, 483.

117 (PLATE 117)

Dune Landscape with Hunters, 1665–70

Signed bottom right: J.W
Oil on canvas, 14⅝ x 13⅜ in. (37 x 34 cm.)
Rijksmuseum, Amsterdam, inv. A 490

Provenance: Probably purchased from J.B. de Lega,
January 15, 1801; Nationale Konstgallery, The
Hague, 1801; transferred to the Koninklijk Museum,
Amsterdam, 1808.

Exhibitions: IJzendijke, Raadhuis, *De jacht in de kunst*,
1953, no. 48.

Literature: Amsterdam, Koninklijk Museum,
cat. 1809, no. 365; van Eynden, van der Willigen
1816–40, vol. 1, p. 122; Amsterdam, Rijksmuseum
cat. 1885 (and later eds.), no. 2737; Moes, van Biema
1909, pp. 35, 51, 71, 116, 167, 223; Hofstede de Groot
1908–27, vol. 8, no. 213; Amsterdam, Rijksmuseum
cat. 1976, no. A 490, ill.

A road with deep cart tracks winds over gently
undulating terrain, around the base of a dune,
and past a pair of trees. Where the road vanishes
from sight behind a slope and a stand of trees, a
herd of cows marshaled by a man jogs briskly
along; one of the cows is being mounted by a
steer. Farther on is a country house amidst some
trees; in the distance a row of dunes fades into
the haze. In the foreground a hunter approaches
on foot over the road. He gestures to another
hunter walking over the dune along the edge of
the woods, who with one hand answers the
gesture and in the other carries two hares. A dog
walks before him and a third man follows over
the crest of the dune. A second dog explores
with his nose along the slope of the dune, while a
third dog runs to the road below. Sunlight passes
over the rugged surface of the sandy dune and
models the clouds, which fill most of the sky.

 Here, as in other paintings by Wijnants, the
people and animals have been added by a col-
league more skilled in figure painting. In this
instance it was Adriaen van de Velde, who,
according to Houbraken, was a former pupil.[1]
Van de Velde frequently assisted Wijnants in
this way, as did Johannes Lingelbach. This

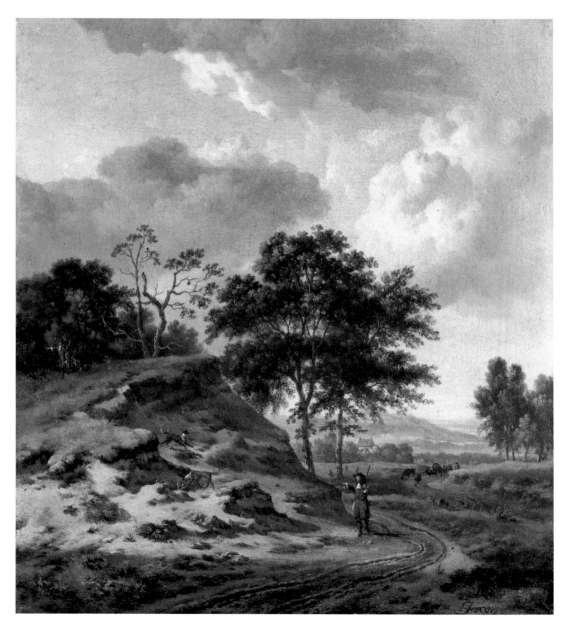

117

Wooded Landscape with a River, c.1668–75

professional cooperation is almost never confirmed by a dual signature. Thus, the identification of van de Velde's hand, or elsewhere that of Lingelbach, depends on discerning the artist's distinctive stylistic characteristics.[2] Undoubtedly, all Wijnant's landscapes were intended to be completed with the addition of such figures. This could have come about well after Wijnants had affixed his signature (and sometimes the date) to the painting. Thanks to a rare instance of double signing and dating by Wijnants in 1661 and Lingelbach in 1664, we know that considerable time could elapse between the moment the painting left Wijnants's easel and its final completion with staffage figures.[3] We must be careful, therefore, in assigning a date to undated works on the basis of the figures' costumes, which may have been added much later. Judging only from the hunters' dress, we cannot be certain that this painting was completed by van de Velde in or shortly before 1670.

Wijnants was obviously successful with this composition because there is a second version of the painting, identical in even the smallest details.[4] Although such literal repetitions were probably exceptional, Wijnants often repeated one chosen theme, raising it to the status of a classic image. This was the Dutch dunescape, which must have been very familiar to a native of Haarlem. Despite variations in the arrangement of the composition, in the form of dunes, trees, and wooded areas, in the placement of roads and waterways, and despite his indulgence at times in such details as an exotic building in the distance or a distinctive rock formation, Wijnants repeatedly painted essentially the same type of painting. Sometimes a great withered tree or fallen tree trunks in the foreground will echo Ruisdael's pathos, but the latter's feeling for monumentality was alien to Wijnants (fig. 1).[5] Wijnants's landscapes are

Fig. 1. Jan Wijnants, *Landscape with Dead Tree and Peasant Driving Oxen and Sheep*, signed and dated 1659, canvas, 80 x 99.4 cm., National Gallery, London, no. 883.

never threatening and seldom awe-inspiring; they are neither deserted nor inhospitable but always friendly and inviting. Invariably, the scene is bathed in clear sunlight, probably influenced by the painting of the Dutch Italianates, and dominated by an aura of imperturbable repose and detachment.

C.J.d.B.K.

1. Houbraken 1718–21, vol. 3, p. 90.
2. Adriaen van de Velde's contribution in this instance was noted at the time of purchase in 1801 and has been repeatedly mentioned ever since.
3. *A Hilly Landscape with Figures*, sale, London (Christie's), April 5, 1963, no. 6.
4. Hofstede de Groot 1908–27, vol. 8, p. 480, no. 214, canvas, 37 x 34.5 cm., location unknown.
5. Some other examples of paintings in Wijnants's oeuvre dominated by a withered tree or fallen tree trunks in the foreground are *Landscape with Two Dead Trees*, canvas, 29 x 36.8 cm., National Gallery, London, no. 972; *Lisière de forêt*, 1668, canvas, 116 x 144 cm., Musée du Louvre, Paris, inv. 1967; and *Landscape with Peddler and Woman Resting*, 1669, canvas, 29.5 x 35 cm., Rijksmuseum, Amsterdam, inv. C 227.

Signed bottom left: J Wynants F.
Oil on canvas, 37 x 45⅝ in. (94 x 116 cm.)
The National Gallery of Ireland, Dublin, no. 508

Provenance: Sale, J. Wiltsen, Amsterdam, August 16, 1790, no. 85 [to Yver]; sale, Marquis de Montcalm, London, May 4, 1849, no. 113 [to Farrer]; Sir Hugh Hume Campbell, Marchmont House, Berwickshire, by 1856; sale, C.J. Nieuwenhuys, London (Christie's), July 17, 1886, no. 118 [bought in]; sale, C.J. Nieuwenhuys, London (Christie's), June 25, 1887, no. 99, to Sir Henry Page Turner Barron, who bequeathed it to the National Gallery of Ireland in 1901.

Exhibitions: London, British Institution, 1856, no. 12.

Literature: Waagen 1854–57, vol. 4, p. 442; Hofstede de Groot 1908–27, vol. 8, no. 458; Thieme, Becker 1907–50, vol. 36 (1947), p. 330; Dublin, cat. 1986, no. 508, fig. 186.

A road curves around the sandy bank of a river on the right. On the left a large, gnarled, and broken oak stands amidst smaller trees. Behind them and beyond a sandy rise are other trees. The travelers on the road include a woman riding a pack horse and a man, who have stopped to speak to a seated woman with a water vessel on her back. Before them a small boy pats a dog, and to the right an angler stands beside the river, which weaves back to a distant view of buildings and herdsmen watering their livestock.

In 1857 Waagen characterized the painting as "a fine specimen of the master in his free manner." Hofstede de Groot attributed the figures to Johannes Lingelbach (1622–1674), who, like Adriaen van de Velde often painted Wijnants's staffage. Indeed, Lingelbach apparently painted the figures in most of Wijnants's landscapes. A similar style of painting staffage figures, including virtually the same seated woman, appears in a dune landscape by Wijnants (the figures again assigned by Hofstede de Groot to Lingelbach) dated 1669 in the British royal collection.[1]

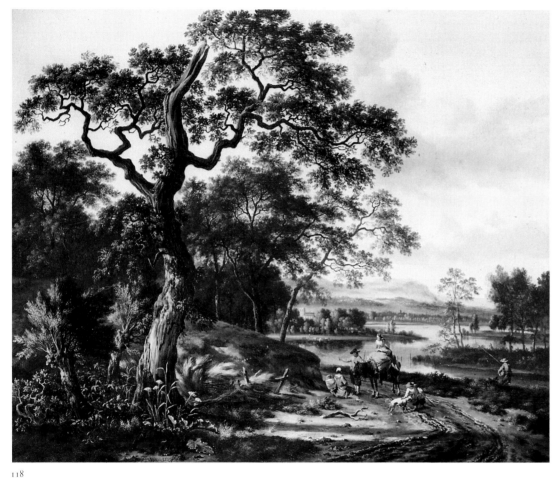

118

Fig. 1. Jan Wijnants, *Lisière de forêt*, signed and dated 1668, canvas, 117 x 144 cm., Musée du Louvre, Paris, inv. 1967.

Potterton correctly surmised that Dublin's painting was probably a late work by Wijnants, noting that the signature was in the form that appeared on a document of 1679.[2] However, the style of the painting suggests that it may not be so late. The general elements of the work's design had already been worked out in a painting of 1659 in Dresden (Gemäldegalerie, inv. 1941A; Hofstede de Groot, no. 587). Moreover, the design is similar to that of a painting in Budapest (inv. 507; Hofstede de Groot, no. 218) of 1667, and both the technique and composition closely resemble those of the *Lisière de forêt*, signed and dated 1668 in the Louvre (fig. 1).[3] However, notwithstanding his many dated paintings, Wijnants's later work changes little; hence his development is difficult to chart.

As Stechow has observed, the earliest certain date on Wijnants's painting is 1649.[4] His early development seems to have been influenced in Haarlem by the youthful works of Jacob van Ruisdael and Philips Wouwermans. His treatment of sandy roads and dunes and his penchant for large, gnarled trees, as in the present work,

Philips Wouwermans

(Haarlem 1619–1668 Haarlem)

descend from paintings executed in the late 1640s and early 1650s by Ruisdael and Wouwermans. Wijnants's small, minutely executed paintings of dunes, resembling the works of Karel du Jardin, have been more admired than his large, more decorative later works. However, the freshness and fluidity of the present work distinguish it from the hard, decoratively formulaic quality of some of his later paintings.

P.C.S.

1. White 1982, no. 264; Hofstede de Groot 1908–27, vol. 8, no. 219a.
2. Potterton 1986, p. 185, no. 508; see the facsimiles of signatures reproduced in Bredius 1911a, p. 184.
3. Hofstede de Groot 1908–27, vol. 8, no. 147.
4. Stechow 1966, p. 193, note 50; see Hofstede de Groot 1908–27, vol. 8, no. 457.

Philips Wouwermans, *Self-Portrait*, red and black chalk, 175 x 147 mm., British Museum, London, inv. 1836.8.11.586.

Baptized in Haarlem on May 24, 1619, Wouwermans was the eldest son of the painter Pauwels Joostens Wouwermans from Alkmaar (d. 1642); his brothers Pieter (1623–1682) and Jan (1629–1666) were also painters. According to Cornelis de Bie, Wouwermans trained with Frans Hals. Because his family objected to his marrying a Catholic, Wouwermans moved in 1638 to Hamburg. There he worked with the painter Evert Decker (d. 1647). By 1640 he had returned to Haarlem and had entered the Saint Luke's Guild, becoming a *vinder* in 1646. Kort Withold and Nicolaes Fikke were his pupils in 1641–42. In 1645 and 1647 Wouwermans was recorded buying houses in Haarlem. The artist was a wealthy man by the time of his death on

May 19, 1668; he was buried four days later in Haarlem's Nieuwe Kerk. In 1670 his daughter married the painter Hendrik de Fromantiou with a dowry from her father of 20,000 guilders.

Wouwermans's earliest dated painting is from 1639 (sale, London [Christie's], October 10, 1972, no. 13). Three paintings are dated 1646 (National Gallery, London, no. 6263; Museum der bildenden Künste, Leipzig, inv. 823; City Art Gallery, Manchester, Assheton-Bennett collection). According to Houbraken, Wouwermans acquired sketches by Pieter van Laer after that artist's death. Wouwermans's handling of figures shows a strong debt to the Italianate artist. He probably had a successful career as a painter, although his works, especially his horse paintings, enjoyed greater popularity in the eighteenth century among aristocratic collectors. Wouwermans painted Italianate landscapes with genre figures (recalling those of the *bamboccianti*) and religious scenes, as well as with battles, hunts, and riding schools. He also painted staffage in the landscapes of Jacob van Ruisdael, Jan Wijnants, and Cornelis Decker. Wouwermans had numerous pupils, and his considerable influence on Adriaen van de Velde is recognized.

A.C.

Literature: De Bie 1661, p. 281; Houbraken 1718–21, vol. 2, pp. 70, 102, 128, 131, 132; Weyerman 1729–69, vol. 2, pp. 157–63; Moyreau 1737; Descamps 1753–64, vol. 2, pp. 286–95; Bartsch 1803–21, vol. 1, pp. 395–400; Smith 1829–42, vol. 1, pp. 199–358, vol. 9, pp. 137–233; Kramm 1857–64, vol. 6, pp. 167–171; van der Willigen 1870, pp. 338–340, 351; Hofstede de Groot 1891; Wurzbach 1906–11, vol. 2, pp. 902–903; Thieme, Becker 1907–50, vol. 36 (1947), pp. 265–68; Hofstede de Groot 1908–27, vol. 2, pp. 249–650; Kalff 1920; Bode 1921, pp. 236–43; Maclaren 1960, pp. 462–71; Stechow 1966, pp. 29–31; The Hague, Mauritshuis cat. 1980, pp. 124–30; Haak 1984, p. 387.

Travelers Awaiting a Ferry, 1649

Monogrammed and dated lower left:
PHILS.W.1649
Oil on canvas, 26 x 32 in. (66 x 81.3 cm.)
Private Collection, New York

Provenance: Probably sale, Amsterdam, August 9,
1739, no. 4 (fl.160; "het Volk wagt om overgezet te
worden, met Paarden, Koeyen en Schaapen, extra
geschildert 1659"); Catherine II, St. Petersburg;
Hermitage, Leningrad (deaccessioned by 1928, when
it was omitted from a guide to the Dutch paintings);[1]
sale, Frankfurt (Helbing), May 3–4, 1932, no. 122,
ill.; sale, London (Sotheby's), June 23, 1982, no. 10;
Gallery Gebr. Douwes, Amsterdam.

Exhibitions: New York 1985, no. 17, ill.

Literature: Hoet 1752, vol. 1, p. 596; Leningrad,
Hermitage cat. 1774, no. 531; Lacrois 1861–62,
vol. 13, p. 246; Waagen 1864, p. 217; Leningrad,
Hermitage, cat. 1870, no. 1016 (and eds. of 1895,
1901, and 1916); Thieme, Becker 1907–50, vol. 36,
p. 267, Hofstede de Groot 1908–27, vol. 2, nos. 362
and 363.

In a mountainous landscape along a river or
inland sea a group of travelers and riders awaits
a ferry. Farther along the coast, below the high
peaks, is a castle approached by a winding path.
The swirl of dark clouds echoes the complex
richness of the terrain: brightly lit patches
alternate with dark crevices, interspersed among
bridges and wind-tossed trees.

The landscape would undoubtedly have been
recognized as foreign, evoking as it does a north
Italian or Alpine site. While this type of fjord
scene is almost unique in Wouwermans's oeuvre,
he frequently employed the theme of peasant
travelers and mounted figures waiting for a
ferry. Such scenes of travelers and boats first
gained currency in the Italian landscapes of Jan
Both and were continued by Asselijn and es-
pecially Pijnacker (cat. 65, fig. 2 and cat. 65–67).
Wouwermans also painted at least one Italian
port scene depicting the loading of barges, as

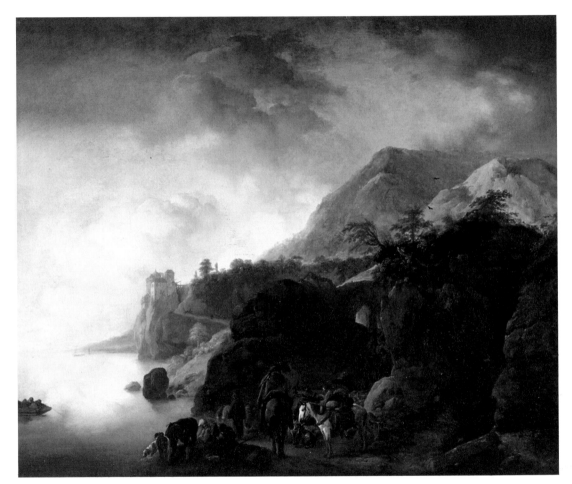

119

Fig. 1. Justus Danckerts, after Philips Wouwermans, *Italian Seaport*, etching.

Fig. 2. Jan Asselijn, *Italian Bay with SS. Giovanni e Paolo*, signed and dated 1647, canvas, 77.5 x 103 cm., Staatliche Gemäldegalerie, Schwerin, inv. 2219.

recorded in an etching by Justus Danckerts (fig. 1).[2]

Wouwermans was strongly influenced by Italianate landscape painting, especially in a relatively early work such as the exhibited painting. A battle scene dated 1646 set on a shore nestled below high cliffs (National Gallery, London, no. 6263) shows the influence of Pieter van Laer and anticipates the deeply saturated palette and intense shadows of the present painting. Wouwermans's later work is distinguished by delicate coloring and a pervasive, silvery light (see cat. 122). Although the treatment of the mountains in *Travelers Awaiting a Ferry* is similar to that by Jan Both in *Italian Landscape* (cat. 15), it was the work of Jan Asselijn that had the most importance for Wouwermans. The profile of the landscape, with its sharp descent from the mountain peaks to the water, appears in many Asselijn landscapes (see fig. 3), including two painted in 1647 in Amsterdam.[3]

A.C.

1. The Russian provenance is presumed, since no Hermitage catalogue mentions the signature or date. Hermitage, inv. 835, is reported to be a landscape very similar to the present entry. A copy of the exhibited work was sold in London (Christie's), April 13, 1984, no. 182.

2. Hollstein, no. 20; Hofstede de Groot 1908–27, vol. 2, no. 999, which exists in several versions. This work is influenced by a painting by Jan Asselijn and Jan Baptist Weenix in the Akademie, Vienna, inv. 761 (Steland-Stief 1971, no. 212, pl. 160).

3. One sold in Cologne (Lempertz), October 29, 1941, no. 1 (Steland-Stief 1971, no. 211, pl. 44), the other is in the Mauritshuis, The Hague, inv. 950 (ibid., no. 206, pl. 63). Claes Berchem painted similar views of bays (cat. 9, fig. 3).

Riding at the Herring, c. 1650

Signed with the monogram lower center: PHILS.W.
Oil on canvas, 25⅜ x 32¼ in. (64.5 x 82 cm.)
Private Collection

Provenance: Lubbeling Collection, Amsterdam (according to Blanc); sale, Randon de Boisset, Paris (Chariot), February 27, 1777, no. 87; sale, Claude Tolozan, Paris (Paillet, Delaroche), February 23, 1801, no. 42; Duchesse de Berri, Paris, 1834; purchased by R.S. Holford, London, in 1839, from Woodbury; sale, G.L. Holford, London (Christie's), May 17, 1928, no. 75; Thos. Agnew and Sons, London; Algernon Firth; Mrs. M. Dewar; Lt. Col. T. Marshall Brooks; sale, London (Christie's), December 12, 1980, no. 84; with R. Noortman, London and Hulsberg.

Exhibitions: London, British Institution, 1851, no. 58; Manchester 1857, no. 988; London, Royal Academy, 1876, no. 48; London, Burlington Fine Arts Club, 1900, no. 51; Bristol, *Dutch Old Masters*, 1946, no. 14; Manchester, City Art Gallery, *Works of Art from Private Collections*, 1960, no. 88; Atlanta 1985, no. 61, ill.

Literature: Smith 1829–42, vol. 1, no. 130, vol. 9, no. 46; Waagen 1854–57, vol. 2, p. 202; Blanc 1857–58, vol. 1, p. 256, vol. 2, p. 189; Hofstede de Groot 1907–28, vol. 2, no. 1030; F.J. Duparc, *Tableau 7* (1985), pp. 42–43.

In the foreground of a landscape with a village in winter, a crowd plays a game known as "Riding at the Herring." A herring is tied to a rope fastened across the road between an inn and a leafless tree. A man on horseback with a woman behind him ride under the line and try to catch the herring in their teeth. In the foreground other contestants wait their turn or mount up. A colorful crowd of spectators enlivens the scene.

Wouwermans and other landscape artists depicted various popular seventeenth-century sports played on horseback, such as Riding at the Herring. Salomon van Ruysdael, for example, painted a winter landscape (fig. 1) of about

120

the same date and very similar in design to the Wouwermans painting but depicting "Drawing the Eel," a game that is played by couples on horseback who try to yank a slippery eel from a line. Among the other games that Wouwermans depicted was "Tilting at the Ring," a contest still occasionally practiced in Holland today, in which men on horseback riding at a gallop attempt to hit a ring fastened to a tub of water that hangs from a pole projecting over the road.[1] Crude as these entertainments might seem, they scarcely rivaled "Kattrekken," or "Riding at the Cat" (fig. 2), for cruelty, which offered a feline substitute for the herring or eel.[2] All these themes obviously provided Wouwermans with opportunities to demonstrate his unrivaled skill at painting horses.

Duparc has plausibly dated the painting to "the beginning of the 1650s," when the artist achieved a happy synthesis between landscape and paintings of equestrian subjects.[3] For example, the painting may be compared in execution and conception with the left side of the village panorama dated 1653 in the Minneapolis Institute of Art (fig. 3). Whereas the latter painting is a summer scene, in *Riding at the Herring* Wouwermans is particularly successful at rendering the chill atmosphere and blank sky of a winter day. A complementary palette sparkles with crisp color accents of red and blue.

Wouwermans's great popularity in the eighteenth century, reflected in the large holdings of his works still preserved in the museums in Dresden and Leningrad, and in the Mauritshuis, is borne out by the high price of 12,000 francs that *Riding at the Herring* brought at the Randon de Boisset sale in Paris in 1777. In 1834 Smith also commended the painting as a "capital picture . . . of the most esteemed quality."[4]

P.C.S.

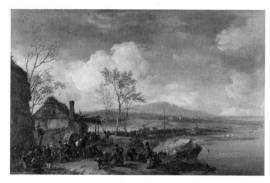

Fig. 3. Philips Wouwermans, *Festive Peasants before a Panorama*, signed and dated 1653, canvas, 69.9 x 118.8 cm., Minneapolis Institute of Art, Gift of Margaret L. Sweatt, no. 81.107.

Fig. 1. Salomon van Ruysdael, *Drawing the Eel*, signed and dated 165[?], panel, 74.9 x 106 cm., The Metropolitan Museum of Art, New York, no. 71.75.

Fig. 2. Philips Wouwermans, *Riding at the Cat (Kattrekken)*, canvas, 67.3 x 96.5 cm., The Hague, inv. NK 3123.

1. Panel, 44.5 x 52 cm., with P. and D. Colnaghi and Co., London, 1908; Hofstede de Groot 1907–28, vol. 2, no. 1029. See also Hofstede de Groot 1907–28, vol. 2, no. 1034. A painting of horsemen playing a game with lances and dummies was in the sale, Stroganoff (Leningrad), Berlin, May 12, 1931, no. 98.

2. Formerly in the Hermitage, Leningrad (Leningrad, cat. 1901, no. 995); Hofstede de Groot 1907–28, vol. 2, no. 1031.

3. Atlanta 1985, p. 135.

4. Smith 1829–42, vol. 1, p. 239, no. 130.

Rest by a Stream with a Wooden Bridge, c. 1655–60

Monogrammed lower right: PHILS W. [PHILS ligated]
Oil on canvas, 22⅞ x 26¾ in. (58 x 68 cm.)
Musée du Louvre, Paris, inv. 1952

Provenance: Collection of Louis XVI; acquired in 1784.

Literature: Paris, Louvre cat. 1852, no. 566; Hofstede de Groot 1908–27, vol. 2, no. 350; Paris, Louvre cat. 1922, no. 2622; Paris, Louvre cat. 1979, inv. 1952, ill.

A group of horsemen, a hay wagon with four horses, and travelers on foot have stopped beside a rushing stream to rest and water their animals. A wooden bridge crosses the stream high above on the left. On the bridge are a woman, with a basket on her head, and a boy. Fording the stream, with clothes drawn up above their ankles are another woman with a child on her back and a young boy. Masonry frames the scene on the right, and on the left is the doorway of a house built into the pier supporting the bridge.

In light of the artist's specialization in equestrian themes, the subject of the rest beside a stream with riders watering their horses was naturally one of Wouwermans's favorites (see, for example, Rijksmuseum, Amsterdam, inv. C 271). It can be traced to earlier landscapes by, among others, Esaias van de Velde and Pieter van Laer (see the latter's *Landscape with Bathers and Horsemen*, Kunsthalle, Bremen, inv. 690. 1). Although they number more than one thousand (!), Wouwermans's paintings are not easily dated because he himself did not make a habit of dating paintings. A mature work with an exact, even minute touch and a bright, clear palette with a silvery tonality, the Louvre's painting surely postdates Wouwermans's early work, such as cat. 119, as well as paintings from the early 1650s, such as the Sweatt collection painting of 1653 (cat. 120, fig. 3). However, it is not clear that it postdates the finely executed little dune landscape of 1660 in Rotterdam (Introduction, fig. 66). A smaller version of the subject

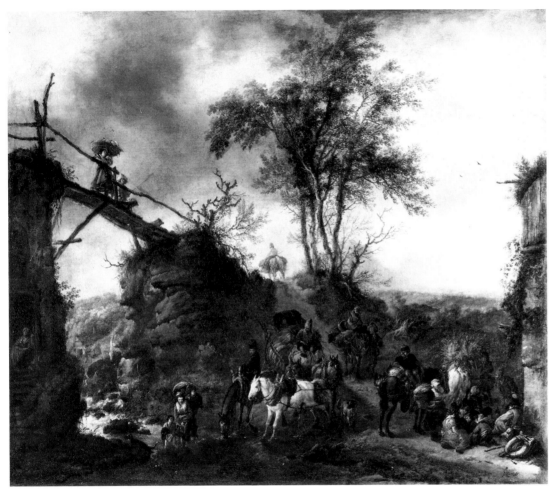

121

employing a simpler variant of the same design, complete with a bridge and virtually the same figures fording the stream, was formerly in the Hermitage and later in the van Aalst collection, Hoevelaken (fig. 1).[1] It apparently represents Wouwermans's first conception of the subject, later elaborated with additional figures and a taller, more picturesque bridge in the Louvre's painting.

The motif of the narrow and precarious bridge, silhouetted against the sky, had earlier roots in Flemish landscape painting and the widely disseminated prints after Roelandt Savery and Pieter Stevens (see, for example, fig. 2).[2] Esaias van de Velde took up the motif in his painting *Wooden Bridge over Waterfalls* of 1623 in the Smith College Museum of Art (fig. 3) and a later, more naturalistically conceived little painting of 1629 (panel, 9 x 13 cm., private collection, West Germany), in which the bridge is much lower and the landscape free of any drama or foreign exoticism;[3] the latter work has more in common with Wouwermans's own more simplified version of the subject (fig. 1). However, in the Louvre painting Wouwermans deliberately recalled the earlier mannerist composition in the exaggerated linear elegance of the bridge and trees and the up-and-down complexity of the design. Yet there is nothing *retardataire* about the painting's style; indeed, its delicacy of execution, airy lightness of touch, and the charming gaiety and piquant incident of the figures make clear why Wouwermans was the darling of the eighteenth-century rococo.

A copy of the Louvre's painting was in the sale, J. Niessen et al., Cologne, May 9, 1911, no. 327 (canvas, 56 x 66 cm.).

P.C.S.

Stag Hunt, c. 1665

Fig. 3. Esaias van de Velde, *Wooden Bridge over Waterfalls*, signed and dated 1623, panel, 14 x 20.7 cm., Smith College Museum of Art, Northampton, Mass., no. 1964:4.

Fig. 1. Philips Wouwermans, *Landscape with a Horse being Watered*, canvas, 49 x 55.5 cm., formerly Hans M. Cramer, The Hague.

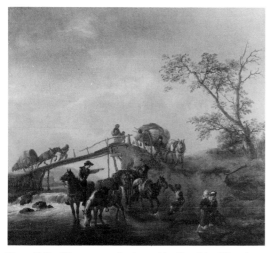

Fig. 2. Aegidius Sadeler after Pieter Stevens, *Landscape with Bridge*, etching.

1. Hofstede de Groot 1908–27, vol. 2, no. 1082; Hermitage, Leningrad, inv. 1005; W.R. Valentiner and J.W. von Moltke, *Dutch and Flemish Old Masters in the Collection of Dr. C.J.K. van Aalst* (1939), p. 326, ill.

2. Wurzbach 1906–11, vol. 2, p. 537, no. 107, 1; Hollstein, vol. 21, no. 226.

3. Keyes 1984, no. 133, fig. 255. Compare also Esaias's drawing of 162(?) in the Institut Néerlandais, Paris (ibid., no. D 117 bis).

Monogrammed lower right: PHILS. W.
Oil on canvas, 32¼ x 55⅛ in. (82 x 140 cm.)
Bayerische Staatgemäldesammlungen, Munich, Staatsgalerie, Schleissheim, inv. 408

Provenance: Gallery Mannhiem; transferred to Munich 1798.

Literature: Smith 1829–42, vol. 1, no. 322, vol. 9, no. 123; Munich, cat. 1904, no. 496; Hofstede de Groot 1908–27, vol. 2, no. 625; Martin 1935–36, vol. 2, p. 365, fig. 197; Schleissheim, cat. 1980, p. 49, ill.

In a broad river valley a hunting party chases a stag and a hind into the river. In the center left foreground dogs, two men with hunting horns on horseback, and an elegant lady dressed in yellow and riding sidesaddle follow their prey into the water. On the right bank figures in fine attire rest beside a monument and near a road traveled by a coach drawn by four white horses. A lady in a red dress and two gentlemen sit on the ground while a page serves them a *tazza*. Beneath the stone statue musicians play and a couple dance. A lady with a hawk on her wrist sits on a white horse while a groom holds a roan horse. On the left shore the terrace of a large garden rises above a mooring with an elegant passenger barge. In the distance are swimmers, fishing boats, and farther back, riverside cities and a mountain range in airy tints of blue.

Nearly two hundred hunting scenes are recorded as by Wouwermans. This is probably a later work, the figures' costumes suggesting a date of about 1660 or thereafter. Wouwermans had begun to paint hunting scenes early in his career and had certainly treated the traditional landscape theme of the stag hunt by 1651.[1] Though recently incorrectly catalogued as a work of about 1665,[2] Wouwermans's *Stag Hunt* in Raleigh (fig. 1) was already recognized by Smith as an early picture.[3] It may date from about 1650 and includes many of the elements of the Schleissheim painting, such as the stag

122

Fig. 1. Philips Wouwermans, *Stag Hunt in a River*, monogrammed, canvas, 135 x 195 cm., North Carolina Museum of Art, Raleigh, no. 52.9.64.

Fig. 2. Philips Wouwermans, *Stag Hunt by a River*, monogrammed, canvas, 115 x 129 cm., Staatliche Kunstsammlungen, Dresden, no. 1449.

chased into the river, the elegantly uninterested party on the bank, and the mountainous landscape beyond — all treated on a comparably monumental scale. Typically, in the later painting Wouwermans has adopted a more fanciful, vaguely Italianate setting, as well as more diminutive figures and brighter local colors. With its lowered horizon, brilliantly fresh sky, and longer shape, the composition has a new panoramic sweep that is characteristic of the artist's mature hunt scenes on a large scale.

Wouwermans painted several other large stag hunts, including works in the Hermitage, Leningrad (inv. 1034), and the Prado, Madrid.[4] However, the work that is closest in conception to the Schleissheim picture is the *Stag Hunt* in Dresden (fig. 2), which is set once more in a broad river valley with a villa on the far shore.[5] In that case the hunters spear the animals just before they enter the water but again send innocent bystanders scurrying for safety; at the water's edge in the Schleissheim painting two small boys with toy boats just escape being trampled, and at the same point in the Dresden painting a shepherdess hustles her flock out of harm's way while a fisherman quickly draws in his nets. Stag hunts (see also cat. 11 and 52) can be traced back to medieval manuscripts illuminating the Months, where one often encountered juxtapositions of peasant labors and aristocratic diversions, including a similar disregard by the latter for the former.

P.C.S.

1. See Hofstede de Groot 1908–27, vol. 2, no. 633d, *Horsemen Hunting a Stag*, dated 1651, J.J. von Hirsch collection, 1863.

2. See North Carolina Museum of Art, Raleigh, *Introduction to the Collections* (1983), p. 110, ill.

3. Smith 1829–42, vol. 1, no. 229, vol. 9, no. 87, "an early production." See Hofstede de Groot 1908–27, vol. 2, no. 635.24.

4. See respectively, Hofstede de Groot 1908–27, vol. 2, nos. 628 and 624.

5. See Hofstede de Groot 1908–27, vol. 2, no. 620. The painting is the pendant to *Camp by a River*, also in Dresden, no. 1450 (ibid., no. 838).

Moyses van Wtenbrouck

(c.1590?–c.1647 The Hague)

Moyses van Wtenbrouck, *Self-Portrait*, c.1645, etching.

Both the date and place of Moyses Matheusz van Wtenbrouck's birth are unknown. The artist also spelled his name Wttenbroeck but never Uytenbroeck, which later generations used; his brother Jan (1585–1651), also a painter, sometimes used Vuytenbrouck. Moyses married Cornelia van Wijck sometime before December 10, 1624. One of his sons, the artist Matheus van Uytenbroeck, made prints after his father's designs.

Moyses' first dated work is an etching of 1615. He entered the painters' guild in The Hague in 1620, was named a deacon in 1627, and is known to have had pupils in 1631. Wtenbrouck sold two houses in The Hague in 1631 and 1642. In 1638

he was paid for a number of paintings made for Frederik Hendrik's palace at Honselaarsdijk (of which only one survives: Schloss Grunewald, Berlin, inv. 6302). Wtenbrouck sold other paintings to the court through 1646 and also had connections with the Delft art market. In February 1645 the artist was recorded in The Hague, but in July 1647 his wife was called a widow.

Félibien claims that Wtenbrouck lived in Rome, but there is no proof of such a trip. Wtenbrouck's combination of mythological or historical subjects with Italianate landscapes is derived from Jacob Pynas and Adam Elsheimer (1578–1610) and related to works by Cornelis van Poelenburch and Claes Moeyaert (1590/91–1655). His later works incorporate more typically Dutch landscape themes. Wtenbrouck also produced some portraits and a number of landscape and animal prints. Dirk Dalens the Elder (d. 1676) was probably a pupil.

A.C.

Literature: Félibien 1666–88, vol. 4, p. 148; Félibien 1679, p. 51; Dézallier d'Argenville 1745–52, vol. 3, p. 25; Bartsch 1803–21, vol. 5, pp. 79–119; Nagler 1835–52, vol. 19, pp. 272–82; Immerzeel 1842–43, vol. 3, pp. 151–52; Kramm 1857–64, vol. 6, pp. 1663–64; Obreen 1877–90, vol. 3, pp. 262, 271, vol. 4, p. 4, vol. 5, p. 72, vol. 7, p. 190; Bode 1883, pp. 337–41; Worp 1891, p. 117; Wurzbach 1906–11, vol. 2, pp. 729–30; Thieme, Becker 1907–50, vol. 34, pp. 17–18; Bredius 1915–22, vol. 3, pp. 921–35, vol. 7, p. 237; Huygens, Kan 1946; Weisner 1963; Weisner 1964; Bol 1969, pp. 166–71; Sacramento 1974, pp. 41–43, 115–25; Salerno 1977–80, vol. 1, pp. 282–85, vol. 3, p. 1095; Bartsch 1978, vol. 6; van Thiel 1978, pp. 7–42; Keyes 1980, pp. 156–58; Sluijter 1986, pp. 70–81, 153.

123 (PLATE 13)

Forest Pool with Hermaphroditus and Salmacis, 1627

Signed lower right: mo v WB 1627 [WB ligated]
Oil on panel, 17 x 26 in. (43 x 66 cm.)
Rijksdienst Beeldende Kunst, The Hague, inv. NK 2532

Provenance: Vitale Bloch, The Hague; J.H. Gosschalk, The Hague; Stichting Nederlands Kunstbezit, 1945; loaned to Kunsthistorisch Instituut, Utrecht, 1965; Schilderijenzaal Prins Willem V, The Hague.

Exhibitions: The Hague, Gemeentemuseum, 1935, no. 35; Bolsward 1964, no. 67, fig. 2; Leiden 1972, no. 9, pl. 3.

Literature: G. Poensgen, *Holland zwischen Kindheitserinnerungen und Kunstgeschichte: Das Kunstwerk*, vol. 1 (1949) p. 31, ill.; Weisner 1963, no. 57; Weisner 1964, no. 55; Haak 1984, p. 335, fig. 716; Sluijter 1986, p. 67.

Rich green trees with an open landscape glimpsed beyond surround a dark pool of water in the immediate foreground. Wtenbrouck has assembled a landscape of great variety, full of alternating dark and light passages, enclosed and open spaces. On the ledges of the pool, he depicts the story of Hermaphroditus and Salmacis.[1] According to Ovid (*Metamorphoses* 4. 341–57), Hermaphroditus, son of Hermes and Aphrodite, repulsed the affections of the nymph Salmacis. In the painting Salmacis watches Hermaphroditus enter her pool; in a moment she will embrace him and pull him into the water, praying that the gods make their body one.

Nearly half of Wtenbrouck's surviving oeuvre illustrates passages from Ovid's *Metamorphoses*, probably known to the artist from Karel van Mander's Dutch translation and commentary.[2] Certain subjects from Ovid had always been popular, such as the story of Io and Argus, but the Pre-Rembrandtist history painters, including Pieter Lastman, Jan and Jacob Pynas, as well as Wtenbrouck, made a specialty of Ovid's tales and Old Testament subjects.

Weisner divided Wtenbrouck's development

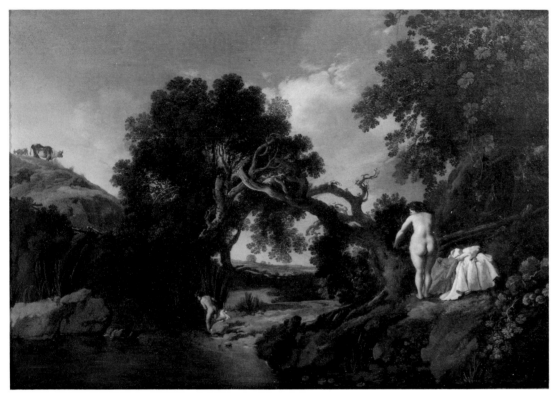

123

1. Jan Londerseel after Gillis de Hondecoutre, *Landscape with Rebecca and Eliezer*, etching.

into four distinct periods: "fantasy Italian" landscapes, executed before 1622; "heroic Italian" (from around 1623–1630); "arcadian Dutch" landscapes produced in the 1630s; and "ideal" landscapes from the artist's final period.[3] The exhibited painting belongs to the "heroic Italian" landscapes, a category consisting of a wide variety of landscape types. For example, the only other dated painting of 1627, *The Triumph of Bacchus* (Herzog Anton Ulrich-Museum, Braunschweig, inv. 2161),[4] employs as a backdrop a hilly landscape derived from Jacob Pynas.

It is doubtful that Wtenbrouck ever went to Italy, and although the artist is often connected with Elsheimer,[5] there is little specific affinity with the work of the older artist. More important as early sources for Wtenbrouck are the landscapes of Pieter Lastman and Jacob Pynas (cat. 55 and 75), who were themselves under Elsheimer's influence. In addition, Paul Bril's hilly arcadian landscapes with trees, which were widely disseminated through prints, seem to have been especially important for Wtenbrouck.[6]

By 1627, the date of the exhibited painting,

Wtenbrouck had begun to depict and compose his landscapes in innovative ways. His interest in trees was probably piqued by paintings of forests by Coninxloo and his followers, such as Roelandt Savery[7] and Gillis de Hondecoutre. For example, the right portion of a landscape by de Hondecoutre (fig. 1) shows a pool encircled by twisting trees, dead trunks, the whole flecked with patches of light. To this tradition Wtenbrouck brought a new Dutch naturalism in his treatment of details (especially in the foliage) and depiction of light. Cornelis van Poelenburch, who returned to Utrecht from Italy in 1625, must also have played a role in the formation of Wtenbrouck's landscape style. Wtenbrouck's treatment of the distant hills in *Landscape with Mythological Figures* of 1628 (fig. 2), for example, is similar to Poelenburch's in *The Flight into Egypt* of three years earlier (cat. 69); in other paintings Wtenbrouck, like Poelenburch, used expressively twisted trees to frame his figures near pools.[8] In the exhibited painting Wtenbrouck's delicate little nudes, which differ from the larger, more vigorous Lastmanian staffage found in his earlier works, are also a response to

2. Moyses van Wtenbrouck, *Landscape with Mythological Figures*, signed and dated 1628, panel, 55.9 x 77 cm., National Gallery, London, no. 6476.

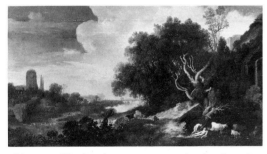

3. Moyses van Wtenbrouck, *Mercury, Argus, and Io*, signed, panel, 39 x 72.2 cm., Institut Néerlandais, Paris, inv. I, 492.

Poelenburch. The motif of a crouching figure near a sheltered pool can be found in Wtenbrouck's etchings (Bartsch, nos. 38, 39). Like these prints, the exhibited landscape represents a lush arcadian world: the setting for mythological events or idyllic pastoral figures. But the scene is not completely foreign, since Wtenbrouck has incorporated native Dutch elements observed from nature.

A painting in Budapest (inv. 248) with a similar collection of lush trees and dead branches around a pool, with hills in the distance, probably dates from about the same time. The more open landscape with ruins (fig. 2) again shows Wtenbrouck's exceptional ability to balance the foreground and background in his paintings; the silhouetted cattle on the hill at the left also closely resemble their counterparts in the present painting. Wtenbrouck continued to explore the expressive possibilities of the twisting trunks of dead or dying trees. In a later painting in the Lugt collection (fig. 3), figures are again framed by dead trees suspended at unexpected angles and bathed in a bright light.

The possible influence of Wtenbrouck's paintings of forests and hills, especially on Cornelis Vroom and Jacob van Ruisdael, has been overlooked. For example, Ruisdael's landscape with a pool in Berlin (cat. 87)[9] is similar to Wtenbrouck's painting in depicting a variety of trees, dead trunks, and reeds around a pool with hills in the distance.

A.C.

1. A print by Wtenbrouck depicting Salmacis embracing Hermaphroditus is also set around a forest pool. Weigel, no. 59; ill. in Bartsch 1978, vol. 6 (commentary), p. 93, no. 59.

2. Karel van Mander, "Wtleggingh op den Metamorphosis," in van Mander 1604; reprinted in Amsterdam, 1616. On van Mander's treatment of Ovid and Ovidian subjects in Dutch painting, see Sluijter 1986.

3. Weisner 1964, pp. 204–207. Weisner's somewhat opaque categories do not denote clear divisions, since the dating of Wtenbrouck's work is often confusing.

4. Weisner 1964, no. 15, fig. 4; Haak 1984, fig. 715.

5. Weisner 1964, pp. 190, 210. Weisner does not otherwise discuss Wtenbrouck's sources.

6. Willem van Nieulandt (1584–1635), a pupil of Bril and etcher of many of his designs, arrived in Amsterdam sometime after 1620; see Utrecht 1965, pp. 56–57.

7. See Aegidius Sadeler's print after Savery (cat. 87, fig. 2).

8. See Schaar 1959, figs. 17, 19; Utrecht 1965, no. 17.

9. See also a painting by Ruisdael at Worcester College, Oxford (cat. 45, fig. 2).

Agafanowa 1935
 K.A. Agafanowa. "Ruisdael Drawings in the Hermitage" (in Russian). *Iskusstvo* 3 (1935), pp. 177–84.

Alfassa 1903
 Paul Alfassa. "L'exposition van Goyen." *Revue de l'art ancien et moderne* 14 (1903), pp. 255–57.

Allhusen 1939
 E.L. Allhusen. "The Etchings of Paul Potter." *Print Collector's Quarterly* 26 (1939), pp. 209–23, 335–47.

Alpers 1983
 Svetlana Alpers. *The Art of Describing: Dutch Art in the Seventeenth Century.* Chicago, 1983.

Ampzing 1621
 Samuel Ampzing. *Het lof der stadt Haerlem in Hollandt.* Haarlem, 1621.

Ampzing 1628
 ———. *Beschrijvinge ende lof der stad Haerlem in Holland.* Haarlem, 1628.

Amsterdam 1903
 Amsterdam, Stedelijk Museum. *Jan van Goyen.* Catalogue by Frits Lugt. 1903.

Amsterdam 1932
 Amsterdam, Kunsthandel J. Goudstikker. *Hollandsche winterland-schappen uit de 17de eeuw.* Introduction by J.G. van Gelder. 1932.

Amsterdam 1936
 Amsterdam, Kunsthandel J. Goudstikker. *Salomon van Ruysdael.* Introduction by J. Goudstikker. 1936.

Amsterdam 1937
 Amsterdam, Amsterdams Historisch Museum. *Jan van der Heyden.* Introduction by I.Q. van Regteren Altena. 1937.

Amsterdam 1951–52
 Amsterdam, Rijksmuseum. *Hercules Segers.* Introduction by I.Q. van Regteren Altena. 1951–52.

Amsterdam 1967a
 Amsterdam, Rijksmuseum. *Graphiek van Hercules Seghers.* Catalogue by K.G. Boon and J. Verbeek. 1967.

Amsterdam 1967b
 Amsterdam, Rijksprentenkabinet. *Hercules Seghers en zijn voorlopers.* Catalogue by K.G. Boon and J. Verbeek. 1967.

Amsterdam 1970
 Amsterdam, Amsterdams Historisch Museum. *17e-eeuwse schilderijen uit de verzameling Willem Russell.* Catalogue by Bob Haak. 1970.

Amsterdam 1976
 Amsterdam, Rijksmuseum. *Tot lering en vermaak.* Catalogue by E. de Jongh et al. 1976.

Amsterdam 1981a
 Amsterdam, Gallery Gebr. Douwes. *Esaias van de Velde, schilder, 1590/91–1630; Jan van Goyen, tekenaar, 1596–1656.* Catalogue by Evert J.M. Douwes. 1981.

Amsterdam 1981b
 Amsterdam, Waterman Gallery. *Jan van Goyen, 1596–1656: Conquest of Space.* Catalogue by Hans-Ulrich Beck, M.L. Wurfbain, and W.L. van de Watering. 1981.

Amsterdam 1983
 Amsterdam, Rembrandthuis. *Landschappen van Rembrandt en zijn voorlopers.* 1983.

Amsterdam 1984
 Amsterdam, Rijksmuseum. *Prijst der lijst.* Catalogue by P.J.J. van Thiel and C.J. de Bruyn Kops. 1984.

Amsterdam 1985
 Amsterdam, Nederlands Scheepvaart Museum. *Ludolf Bakhuizen, 1631–1708.* 1985.

Amsterdam/Brussels 1947
 Amsterdam, Rijksmuseum. *Kunstschatten uit Wenen.* 1947. Also shown at Brussels, Palais des Beaux-Arts.

Amsterdam/Rotterdam 1956
 Amsterdam, Rijksmuseum. *Rembrandt.* 1956. Also shown at Rotterdam, Museum Boymans.

Amsterdam/Toronto 1977
 Amsterdam, Amsterdams Historisch Museum. *The Dutch Cityscape in the 17th Century and Its Sources.* 1977. Also shown at Toronto, Art Gallery of Ontario.

Amsterdam/Washington, D.C. 1981–82
 Amsterdam, Rijksprentenkabinet. *Dutch Figure Drawings from the Seventeenth Century.* Catalogue by Peter Schatborn. 1981–82. Also shown at Washington, D.C., National Gallery of Art, 1982.

Amsterdam/Zwolle 1982
 Amsterdam, Waterman Gallery. *Hendrick Averkamp, 1584–1634; Barent Averkamp, 1612–1679: Frozen Silence.* 1982. Also shown at Zwolle, Provinciaal Overijssels Museum.

Amsterdam, van der Hoop cat. 1855
 Amsterdam, Museum van der Hoop. *Catalogus der schilderijen van het Museum van der Hoop.* 1855 (and rev. eds. 1865, 1876).

Amsterdam, Rijksmuseum cat. 1976
 ———. *All the Paintings of the Rijksmuseum in Amsterdam.* Catalogue by P.J.J. van Thiel et al. 1976.

Amsterdam, Rijksprentenkabinet cat. 1985
 Amsterdam Rijksprentenkabinet. *Tekeningen van Rembrandt (Drawings by Rembrandt).* Catalogue by Peter Schatborn. 1985.

Andrews 1977
 Keith Andrews. *Adam Elsheimer: Paintings, Drawings, Prints.* Oxford, 1977.

Angel 1642
 Philips Angel. *Lof der schilder-konst.* Leiden, 1642. Reprint. Utrecht, 1969.

Ann Arbor 1964
 Ann Arbor, University of Michigan Museum of Art. *Italy through Dutch Eyes.* 1964.

Antal 1928–29
 Friedrich Antal. Review of G. Delbanco, *Der Maler Abraham Bloemaert* (Strasbourg, 1928). *Kritische Berichte zur kunstgeschicht-lichen Literatur* 2 (1928–29), pp. 207–56.

Antwerp, cat. 1948
 Antwerp, Koninklijk Museum voor Schone Kunsten. *Beschrijvende catalogus: oude meesters.* Antwerp, 1948. (Rev. ed. in French, 1958.)

Arndt 1965–66
 Karl Arndt. "Pieter Bruegel als Vorlaufer Coninxloos: Bemerkungen zur Geschichte der Waldlandschaft." *Kunstgeschichtliche Gesellschaft zu Berlin. Sitzungsberichte* 14 (1965–66), pp. 9–11.

Arndt 1966
 ———. "Unbekannte Zeichnungen von Pieter Bruegel d. Ä." *Pantheon* 24 (1966), pp. 207–16.

Arndt 1967
———. "Frühe Landschaftszeichnungen von Pieter Bruegel d. Ä." *Pantheon* 25 (1967), pp. 97–104.

von Arps-Aubert 1932
R. von Arps-Aubert. *Die Entwicklung des reinen Tierbildes in der Kunst des Paulus Potter*. Dissertation. Halle, 1932.

Aschengreen 1953
Kirsten Aschengreen. "The Italianate School of Dutch Landscape Painting in the First Half of the 17th Century." Thesis. Courtauld Institute, London, 1953.

Atlanta 1985
Atlanta, High Museum of Art. *Masterpieces of the Dutch Golden Age*. Catalogue by Frits J. Duparc. 1985.

Bachmann 1966
Fredo Bachmann. *Die Landschaften des Aert van der Neer*. Neustadt, 1966.

Bachmann 1970
———. "Die Brüder Rafael und Jochem Camphuysen und ihr Verhältnis zu Aert van der Neer." *Oud Holland* 85 (1970), pp. 243–50.

Bachmann 1972
———. *Aert van der Neer als Zeichner*. Neustadt, 1972.

Bachmann 1975
———. "Die Herkunft der Frühwerke des Aert van der Neer." *Oud Holland* 89 (1975), pp. 213–22.

Bachmann 1982
———. *Aert van der Neer, 1603/4–1677*. Bremen, 1982.

Baer 1930
Rudolf Baer. *Paul Bril*. Munich, 1930.

van Baerle 1647
Caspar van Baerle. *Rerum per octennium in Brasilia*. Amsterdam, 1647.

Baglione 1642
G.B. Baglione. *Le vite de' pittori, scultori, architetti, ed intagliatori*. Rome, 1642.

Baldass 1938–43
Ludwig von Baldass. "Studien über Jacob Pynas." *Belvedere* 13 (1938–43), pp. 154–59.

Baldinucci 1686
Filippo Baldinucci. *Cominciamento e progresso dell'arte dell'intagliare in rame*. Florence, 1686.

Baldwin Brown 1907
G. Baldwin Brown. *Rembrandt: A Study of His Life and Work*. London, 1907.

C. van Balen 1939
C.L. van Balen. "Het probleem Vinckboons-Vingboons opgelost." *Oud Holland* 56 (1939), pp. 97–112, 273.

van Balen 1677
Matthys van Balen. *Beschryvinge der stad Dordrecht*. Dordrecht, 1677.

Baltimore 1968
Baltimore Museum of Art. *From El Greco to Pollock: Early and Late Works by European and American Artists*. 1968.

Barghahm 1979
Barbara von Barghahm. "The Pictorial Decoration of the Buen Retiro Palace." Dissertation. New York University, 1979.

Bartsch 1797
Adam von Bartsch. *Catalogue raisonné de toutes les estampes qui forment l'oeuvre de Rembrandt*. Vienna, 1797.

Bartsch 1803–21
Le peintre graveur. 21 vols. Vienna, 1803–21.

Bartsch 1978
———. *The Illustrated Bartsch*. General editor, Walter L. Strauss. New York, 1978–.

Basel 1945
Basel, Kunstmuseum. *Meisterwerke holländischer Malerei: Ausstellung aus Privatbesitz in der Schweiz*. 1945.

van Bastelaer 1908
René van Bastelaer. *Les estampes de Peter Bruegel l'Ancien*. Brussels, 1908.

Bauch 1936
Kurt Bauch. "Beiträge zum Werk der Vorläufer Rembrandts: Die Gemälde der Jakob Pynas." *Oud Holland* 53 (1936), pp. 79–88.

Bauch 1937
———. "Beiträge zum Werk der Vorläufer Rembrandts: Handzeichnungen van Jakob Pynas." *Oud Holland* 54 (1937), pp. 241–52.

Bauch 1938
———. "Beiträge zum Werk der Vorläufer Rembrandts, V: Gerrit Pietersz. Sweelinck, der Lehrer Lastmans." *Oud Holland* 55 (1938), pp. 254–65.

Bauch 1951
———. "Frühwerke Pieter Lastman." *Münchner Jahrbuch der bildenden Kunst* 2 (1951), pp. 225–37.

Bauch 1952–53
———. "Handzeichnungen Pieter Lastman." *Münchner Jahrbuch der bildenden Kunst* 3–4 (1952–53), pp. 220–32.

Bauch 1955
———. "Entwurf und Komposition bei Pieter Lastman." *Münchner Jahrbuch der bildenden Kunst* 6 (1955), pp. 213–21.

Bauch 1960
———. *Der frühe Rembrandt und seine Zeit: Studien zur geschichtlichen Bedeutung seines Frühstils*. Berlin, 1960.

Bauch 1966
———. *Rembrandt: Gemälde*. Berlin, 1966.

Beck 1957
Hans-Ulrich Beck. "Jan van Goyens Handzeichnungen als Vorzeichnungen." *Oud Holland* 72 (1957), pp. 241–50.

Beck 1960
———. "Jan van Goyen: The Sketchy Monochrome Studies of 1651." *Apollo* 71 (1960), pp. 176–78.

Beck 1966a
———. "Jan van Goyen am Deichbruch von Houtewael (1651)." *Oud Holland* 81 (1966), pp. 20–33.

Beck 1966b
———. *Ein Skizzenbuch von Jan van Goyen*. The Hague, 1966.

Beck 1972–73
———. *Jan van Goyen, 1596–1656*. 2 vols. Amsterdam, 1972–73.

Beening 1963
Theo Jan Beening. *Het landschap in de Nederlandse letterkunde van de Renaissance*. Dissertation. Nijmegen, 1963.

Beenken 1943
Hermann Beenken. "Die Landschaftsschau Jakob van Ruisdaels." In *Neue Beiträge deutscher Forschung: Wilhelm Worringer zum 60. Geburtstag*. Königsberg, 1943.

Bell 1899
Malcolm Bell. *Rembrandt van Rijn and His Work*. London, 1899.

Bellori 1672
G.P. Bellori. *Le vite de' pittori, scultori e architetti moderni*. Rome, 1672.

du Belloy 1844
Auguste du Belloy. *Karel du Jardin: Comédie en un acte et en vers*. Paris, 1844.

Benesch 1935
Otto Benesch. *Rembrandt: Werk und Forschung*. Vienna, 1935 (rev. ed., Lucerne, 1970).

Benesch 1973
———. *The Drawings of Rembrandt*. 6 vols. London, 1973. (1st ed. 1953.)

Bengtsson 1952
Åke Bengtsson. *Studies on the Rise of Realistic Landscape Painting in Holland, 1610–1625*. (*Figura* 3) Stockholm, 1952.

Bengtsson 1977
———. Review of W. Stechow, *Salomon van Ruysdael* (Berlin, 1975). *Konsthistorisk Tidskrift* 46 (1977), pp. 96–97.

Bentkowska 1982
A. Bentkowska. "'Navigatio vitae': Elements of Emblematic Symbolism in 17th-Century Dutch Seascapes." *Bulletin du Musée National de Varsovie* 23 (1982), pp. 25–43.

van den Berg 1942
H.M. van den Berg. "Willem Schellinks en Lambert Doomer in Frankrijk." *Oudheidkundig Jaarboek* 11 (1942), pp. 1–31.

van den Bergh collection, cat. 1968
Verzameling Sidney J. van den Bergh. Catalogue by A.B. de Vries. Wassenaar, 1968.

Bergstrom 1956
Ingvar Bergstrom. *Dutch Still-Life Painting*. New York, 1956.

Bergvelt 1978
Ellinoor Bergvelt. "Het Hollandse landschap in de kunst." In Amsterdams Historisch Museum, *Het land van holland*, 1978, pp. 135–60.

Berlin (DDR), cat. 1976
Berlin (DDR), Gemäldegalerie, Staatliche Museen. *Holländische und flämische Gemälde des 17. Jahrhunderts im Bode-Museum*. Catalogue by Irene Geismeier. 1976.

Berlin (West), cat. 1975
———. *Katalog der ausgestellten Gemälde des 13. bis 18. Jahrhunderts*. 1975. (English ed. 1978.)

Bernt 1948
Walther Bernt. *Die niederländischen Maler des 17. Jahrhunderts*. 3 vols. Munich, 1948. (Rev. eds. 1960–62, 1970.)

Bernt 1980
———. *Die niederländischen Maler und Zeichner des 17. Jahrhunderts*. 5 vols. Munich, 1980.

Bertolotti 1880–85
A. Bertolotti. *Artisti belgi ed olandesi a Roma nei secoli XVI e XVII*. Florence and Rome, 1880–85.

de Besneray 1884
Marie de Besneray. *Les grandes époques de la peinture: Le Poussin, Ruisdael, Claude Lorrain*. Paris, 1884.

Bettink 1937
G.J. Bettink. "Van een schilder en zijn buiten." *Haerlem Jaarboek*, 1937, pp. 92–98.

van Beuningen collection, cat. 1949
Catalogue of the D.G. van Beuningen Collection. By D. Hannema. Rotterdam, 1949.

Białostocki 1958
Jan Białostocki. "Les bêtes et les humains de Roelant Savery." *Bulletin des Musées Royaux des Beaux-Arts* (Brussels) 7 (1958), pp. 69–92.

Białostocki 1961
———. "Das Modusproblem in den bildenden Künsten: Zur Vorgeschichte und zum Nachleben des 'Modusbriefes' von Nicolaes Poussin." *Zeitschrift für Kunstgeschichte* 24 (1961), pp. 128–41.

de Bie 1661
Cornelis de Bie. *Het gulden cabinet vande edele en vry schilder-const*. Antwerp, 1661. Reprint. Soest, 1971.

Biesboer 1972
Pieter Biesboer. "Cornelis Vroom of Haarlem, 1598–1661." Dissertation. Bryn Mawr, 1972.

Biesboer 1978–79
———. Review of G. Keyes, *Cornelis Vroom* (Amsterdam, 1975). *Simiolus* 10 (1978–79), pp. 207–10.

Biesboer 1979
———. "Cornelis Vroom, idyllisch landschap: Een nieuwe aanwinst voor het Frans Halsmuseum." *Haerlem Jaarboek*, 1979, pp. 104–112.

Biesboer 1983
———. *Schilderijen voor het stadhuis Haarlem: 16e en 17e eeuwse kunstopdrachten ter verfraaiing*. Haarlem, 1983.

Bille 1960
Clara Bille. "Een dijksdoorbraak te Amsterdam ruim 400 jaar geleden." *Maandblad Amstelodamum* 47 (1960), pp. 204–11.

Birkmeyer 1954
Karl M. Birkmeyer. "Three Dutch Landscapes of the 17th Century." *Bulletin of the California Palace of the Legion of Honor* 12 (May–June 1954).

Blaeu 1649
Joan Blaeu. *Toonneel der steden der vereenighde Nederlanden, met hare beschrijvingen*. Amsterdam, 1649. Reprint. Amsterdam, 1968.

Blanc 1854–90
Charles Blanc. *Manuel de l'amateur d'estampes*. 4 vols. Paris, 1854–90.

Blanc 1857–58
———. *Le trésor de la curiosité*. 2 vols. Paris, 1857–58.

Blanc 1859–61
———. *L'oeuvre complet de Rembrandt*. 2 vols. Paris, 1859–61.

Blankert 1967–68
Albert Blankert. "Stechow: Addenda." *Simiolus* 2 (1967–68), pp. 103–108.

Blankert 1968
———. "Over Pieter van Laer als dier- en landschapschilder." *Oud Holland* 83 (1968), pp. 117–34.

Blankert 1978
———. *Nederlandse 17e eeuwse Italianiserende landschapschilders*. Soest, 1978. (Rev. ed. of Utrecht 1965).

Blankert 1982
———. "Hendrik Avercamp als schilder van winters." *Tableau* 4 (1982), pp. 604–15.

Bleyswijck 1667
Dirck van Bleyswijck. *Beschryvinge der stadt Delft*. 2 vols. Delft, 1667. Supplement, 1674.

Bloemaert 1740
Oorspronkelyk en vermaard konstryk tekenboek van Abraham Bloemaert, geestryk getekent, en meesterlyk gegraveert bij Frederik Bloemaart. Amsterdam, 1740.

Blokhuis 1917–18
K. Blokhuis. "Hobbemas Laan van Middelharnis." *Oude Kunst* 3 (1917–18), pp. 277–84, 315.

Blunt 1967
Anthony Blunt. *Nicolas Poussin*. 2 vols. New York, 1967.

Bock, Rosenberg 1931
Elfried Bock and Jakob Rosenberg. *Staatliche Museen zu Berlin. Die Zeichnungen alter Meister im Kupferstichkabinett: Die niederländischen Meister*. 2 vols. Frankfurt, 1931.

Bodart 1970
Didier Bodart. *Les peintres des Pays-Bas Méridionaux et de la Principauté de Liége à Rome au XVIIème siècle*. 2 vols. Brussels and Rome, 1970.

Bodart 1971
———. "La biografia di Herman van Swanevelt scritta da Giovanni Battista Passeri." *Storia dell'arte* 12 (1971), pp. 327–31.

Bode 1872
Wilhelm von Bode. "Die Künstler von Haarlem, II." *Zeitschrift für bildende Kunst* 7 (1872), pp. 164–77.

Bode 1883
———. *Studien zur Geschichte der holländischen Malerei*. Braunschweig, 1883.

Bode 1885a
———. "Das Geburtsjahr der Maler Albert Cuyp und Ferdinand Bol." *Repertorium für Kunstwissenschaft* 8 (1885), p. 136.

Bode 1885b
———. Review of O. Granberg, *Pieter de Molijn och sparen af hans konst* (Stockholm, 1883). *Repertorium für Kunstwissenschaft* 8 (1885), pp. 243–46.

Bode 1903
———. "Der Maler Hercules Segers." *Jahrbuch der königlich Preussischen Kunstsammlungen* 34 (1903), pp. 179–96.

Bode 1906a
———. "Adriaen van de Velde." *Die graphische Künste* 29 (1906), pp. 14–24.

Bode 1906b
———. *Rembrandt und seine Zeitgenossen*. Leipzig, 1906.

Bode 1915
———. "Jan van der Heyden." *Zeitschrift für bildende Kunst* 26 (1915), pp. 181–87.

Bode 1916
———. "Die beiden Ostade." *Zeitschrift für bildende Kunst* 27 (1916), pp. 1–10.

Bode 1921
———. *Die Meister der holländischen und flämischen Malerschulen*. Leipzig, 1921. Revised ed. by E. Plietzsch. Leipzig, 1956.

Bode 1925
———. "Rembrandt Landschaft mit der Brücke." *Jahrbuch der Preussischen Kunstsammlungen* 46 (1925), p. 159.

Bode, Hofstede de Groot 1897–1906
Wilhelm von Bode and C. Hofstede de Groot. *The Complete Works of Rembrandt*. 8 vols. Paris, 1897–1906.

Bodkin 1929
Thomas Bodkin. "Two Unrecorded Landscapes by Abraham Bloemaert." *Oud Holland* 46 (1929), pp. 101–103.

Bol 1957
Laurens J. Bol. "Een Middelburgse Breughel-groep, VI: Jacob Jacobsz. van Geel." *Oud Holland* 72 (1957), pp. 20–40.

Bol 1958
———. "Een Middelburgse Brueghel-groep, VII–VIII: Adriaen Pietersz. van de Venne, schilder en teyckenaer." *Oud Holland* 73 (1958), pp. 59–79, 128–47.

Bol 1969
———. *Höllandische Maler des 17. Jahrhunderts nahe den grossen Meistern: Landschaften und Stilleben*. Braunschweig, 1969.

Bol 1973
———. *Die holländischen Marinemalerei des 17. Jahrhunderts*. Braunschweig, 1973.

Bol 1980–81
———. "Goede onbekenden, IX: Roelandt Savery." *Tableau* 3 (1980–81), pp. 753–759. Reprint. Utrecht, 1982.

Bol 1982–83
———. "Adriaen Pietersz. van de Venne, schilder en teyckenaer." *Tableau* 5 (1982–83), pp. 168–75, 254–61, 276–83, 342–47, 416–21; 6 (1983–84), pp. 54–63.

Bolsward 1964
Bolsward, Raadhuis. *Italië in de toets der gouden eeuw*. 1964.

Bolten 1970
Jaap Bolten. "Een landschaptekening van Herman Saftleven." In *Opstellen voor H. van de Waal*. Amsterdam, 1970.

Bonn 1960–61
Bonn, Rheinisches Landesmuseum. *Rheinische Landschaften und Städtebilder, 1600–1850*. Catalogue by F. Goldkuhle and H.P. Hilger. 1960–61.

Bonn, cat. 1959
Bonn, Rheinisches Landesmuseum. *Verzeichnis der Gemälde*. By Franz Rademacher. 1959.

Bonn, cat. 1977
———. *Auswahlkatalog 4: Kunst und Kunsthandwerk Mittelalter und Neuzeit*. 1977.

Bonn, cat. 1982
———. *Gemälde bis 1900*. 1982.

Boon 1942
K.G. Boon. *De schilders voor Rembrandt*. Antwerp, 1942.

Boon 1960
———. "Een notitie op een Segers-prent uit de verzameling Hinloopen." *Bulletin van het Rijksmuseum* (Amsterdam) 8 (1960), pp. 3–11.

Boon 1961
———. "Roelandt Savery te Praag." *Bulletin van het Rijksmuseum* (Amsterdam) 9 (1961), pp. 145–48.

Boon 1963
———. *Rembrandt de etser: Het volledige werk*. Amsterdam, 1963. (Also published in English, London, 1963.)

Borenius 1942
Tancred Borenius. "Paul Potter." *Burlington Magazine* 81 (1942), pp. 290–94.

Boston, MFA cat. 1985
Boston, Museum of Fine Arts. *European Paintings in the Museum of Fine Arts, Boston: An Illustrated Summary Catalogue.* By Alexandra R. Murphy. 1985.

Boston, Gardner cat. 1974
Boston, Isabella Stewart Gardner Museum. *European and American Paintings.* Catalogue by Philip Hendy. 1974. (1st ed. 1931.)

Boston/St. Louis 1980–81
Boston, Museum of Fine Arts. *Printmaking in the Age of Rembrandt.* Catalogue by Clifford S. Ackley. 1980–81. Also shown at St. Louis Art Museum, 1981.

Bowron 1973
Edgar Peters Bowron. "A Landscape by Bloemaert." *Walters Art Gallery Bulletin* 25 (December 1973).

Boydell 1769
John Boydell. *A Collection of Prints, Engraved after the Most Capital Paintings in England.* London, 1769.

Bradley 1917a
William A. Bradley. "The Etchings of Jacob Ruisdael." *Print Collector's Quarterly* 7 (1917), pp. 153–74.

Bradley 1917b
———. "The Van de Veldes." *Print Collector's Quarterly* 7 (1917), pp. 55–89.

van den Branden 1883
F.J. van den Branden. *Geschiedenis der Antwerpsche schilderschool.* Antwerp, 1883.

Braun 1980
Karel Braun. *Alle tot nu toe bekende schilderijen van Jan Steen.* Rotterdam, 1980.

Braun, Hogenberg 1572–1617
George Braun and Franz Hogenberg. *Civitates orbis terrarum.* Cologne, 1572–1617. Reprint. Amsterdam, 1967.

Braunschweig 1978
Braunschweig, Herzog Anton Ulrich-Museum. *Die Sprache der Bilder: Realität und Bedeutung in der niederländischen Malerei des 17. Jahrhunderts.* 1978.

Braunschweig, cat. 1836
———. *Verzeichnis der Gemälde-Sammlung des Herzoglichen Museums zu Braunschweig.* By Ludwig Pope. 1836. (Rev. ed. 1868.)

Braunschweig, cat. 1900
———. *Beschreibendes und kritisches Verzeichnis der Gemälde-Sammlung.* By Herman Riegel. 1900.

Braunschweig, cat. 1969
———. *Verzeichnis der Gemälde.* By Gert Adriani. 1969.

Braunschweig, cat. 1983
———. *Die holländischen Gemälde.* Catalogue by Rüdiger Klessmann. 1983.

Breda/Ghent 1960–61
Breda, De Beyerd. *Het landschap in de Nederlanden 1550–1630.* 1960–61. Also shown at Ghent, Museum voor Schone Kunsten, 1961.

Bredius 1881–82
Abraham Bredius. "Iets over Hercules Segers." *Obreen's Archief* 4 (1881–82), pp. 314–15.

Bredius 1886
———. "Italiaanse schilderijen in 1672 door Amsterdamsche en Haagsche schilders beoordeelt." *Oud Holland* 4 (1886), pp. 279–80.

Bredius 1888a
———. "Drie Delftsche schilders: Evert van Aelst, Pieter Jansz. van Asch, en Adam Pick." *Oud Holland* 6 (1888), pp. 289–98.

Bredius 1888b
———. "Het geboortejaar van Jacob van Ruisdael." *Oud Holland* 6 (1888), pp. 21–24.

Bredius 1890
———. Review of E. Michel, *Jacob van Ruisdael et les paysagistes de l'école de Haarlem* (Paris, 1890). *Nederlandsche Spectator*, 1890, pp. 282–85.

Bredius 1890–95
———. "Het schildersregister van Jan Sysmus, Stads Doctor van Amsterdam." *Oud Holland* 8 (1890), pp. 1–17, 207–34, 298–313; 9 (1891), pp. 137–49; 12 (1894), pp. 160–71; 13 (1895), pp. 112–20.

Bredius 1892
———. "De schilder Johannes van de Cappelle." *Oud Holland* 10 (1892), pp. 26–40, 133–37.

Bredius 1893
———. "Pieter Symonsz. Potter, glaseschrijver, ooc schilder." *Oud Holland* 11 (1893), pp. 34–46.

Bredius 1896
———. "Jan Josephsz. van Goyen: Nieuwe bijdragen tot zijne biographie." *Oud Holland* 14 (1896), pp. 113–25.

Bredius 1898
———. "Hercules Seghers." *Oud Holland* 16 (1898), pp. 1–11.

Bredius 1900
———. "Aernout (Aert) van der Neer." *Oud Holland* 18 (1900), pp. 70–82.

Bredius 1905–1906
———. "Johannes Porcellis." *Oud Holland* 23 (1905), pp. 69–73; 24 (1906), pp. 129–38, 248.

Bredius 1906
———. "De nalatenschap van Carel du Jardin." *Oud Holland* 24 (1906), pp. 223–32.

Bredius 1907
———. "Aernout Elsevier: Een Nalezing." *Oud Holland* 25 (1907), pp. 57–60.

Bredius 1910–15
———. "Uit Hobbema's laatste levensjaren." *Oud Holland* 28 (1910), pp. 93–106; 29 (1911), pp. 124–28; 33 (1915), pp. 193–98.

Bredius 1911a
———. "Een en ander over Jan Wijnants." *Oud Holland* 29 (1911), pp. 179–84.

Bredius 1911b
———. Review of K. Freise, *Pieter Lastman* (Leipzig, 1911). *Monatshefte für Kunstwissenschaft* 4 (1911), pp. 129–30.

Bredius 1912
———. "De nalatenschap van Jan van der Heyden." *Oud Holland* 30 (1912), pp. 129–51.

Bredius 1913a
———. "Twee schilderijen op glas van Jan van der Heyden." *Oud Holland* 31 (1913), pp. 25–26.

Bredius 1913b
———. "Wie wurde Cuyp während seines Lebens geschätzt?" *Kunstchronik* 24 (1913), pp. 409–11.

Bredius 1915
———. "Twee testamenten van Jacob van Ruisdael." *Oud Holland* 33 (1915), pp. 19–25.

Bredius 1915–22
———. *Künstler-Inventare: Urkunden zur Geschichte der holländischen Kunst des XVI., XVII., und XVIII. Jahrhunderts.* 8 vols. The Hague, 1915–22.

Bredius 1916
———. "Het juiste sterf-datum van Jan van Goyen." *Oud Holland* 34 (1916), pp. 158–59.

Bredius 1917
———. "The Still-Life Painter Abraham Calraet." *Burlington Magazine* 30 (1917), pp. 172–79.

Bredius 1919
———. "Heeft van Goyen te Haarlem gewoond?" *Oud Holland* 37 (1919), pp. 125–27.

Bredius 1921
———. "Waar is Aermont van der Neer begraven?" *Oud Holland* 39 (1921), p. 114.

Bredius 1928
———. "Een testament van Jan Baptist Weenicx." *Oud Holland* 45 (1928), pp. 177–78.

Bredius 1935a
———. "Aanteekeningen omtrent de schilders Jan en Jacob Symonsz. Pynas." *Oud Holland* 52 (1935), pp. 252–58.

Bredius 1935b
———. *Rembrandt: Schilderijen.* Utrecht, 1935. (Also published in German and English, 1937.)

Bredius 1937
———. "Gegevens omtrent Abraham Bloemaert." *Oud Holland* 54 (1937), pp. 177–78.

Bredius 1939
———. "Archiefsprokkelingen." *Oud Holland* 56 (1939), pp. 47–48.

Bredius, Gerson 1969
———. *Rembrandt: The Complete Edition of the Paintings.* Revised by Horst Gerson. London, 1969.

Bredius, de Roever 1886
Abraham Bredius and N. de Roever. "Pieter Lastman en François Venant." *Oud Holland* 4 (1886), pp. 1–23.

Bredius et al. 1897–1904
Abraham Bredius et al. *Amsterdam in de zeventiende eeuw.* 3 vols. The Hague, 1897–1904.

Breek 1910
Joseph Breek. "L'art hollandais à l'exposition Hudson-Fulton à New York." *L'art flamand et hollandais* 13 (January–June 1910), p. 59.

Breen 1912
Joh. C. Breen. "Jan van der Heijden." *Eigen Haard,* 1912, pp. 196–202, 215–20.

Breen 1913
———. "Jan van der Heyden." *Jaarboek Amstelodamum* 11 (1913), pp. 29–92, 93–108, 109–18.

Bregenz 1984
Bregenz, Vorarlberger Landesmuseum. *Die schweizer Ansichten, 1653–1656, von Jan Hackaert*. Catalogue by G. Solar. 1984.

Bremmer 1920–21
H.P. Bremmer. "Jan van Goyen: Stadje aan de vaart." *Maandblad voor beeldende kunsten* 16 (1939), pp. 40–43.

Brenninkmeyer-de Rooij 1976
Beatrijs Brenninkmeyer-de Rooij. "De schilderijen galerij van Prins Willem V op het Buitenhof te Den Haag (2)." *Antiek* 11 (1976), pp. 138–76.

Brenninkmeyer-de Rooij 1979
———. "Indische Exotika auf einem Gemälde des Jacob van Campen im Oraniersaal des 'Huis ten Bosch'." In Kleve 1979, pp. 57–60.

Briels 1967
J.G.C.A. Briels. "De Zuidnederlandse bijdrage tot het ontstaan van de Hollandse landschapschilderkunst circa 1600–1630." Thesis. Louvain, 1967.

Briels 1976
———. *De Zuidnederlandse immigratie in Amsterdam en Haarlem omstreeks 1572–1630*. Dissertation. Utrecht, 1976.

Briels 1984
———. *Painting in the Northern Netherlands 1580–1630*. Utrecht, 1984.

Brière-Misme 1946
Clothilde Brière-Misme. Review of G. Broulhiet, *Meindert Hobbema* (Paris, 1938). *Oud Holland* 61 (1946), p. 174.

Briganti 1950
Giuliano Briganti. "Pieter van Laer e Michelangelo Cerquozzi." *Proporzioni* 3 (1950), pp. 185–98.

Briganti 1966
———. *Gaspar van Wittel e l'origine della veduta settecentesca*. Rome, 1966.

Briganti et al. 1983
Giuliano Briganti, Ludovica Trezzani, and Laura Laureati. *The Bamboccianti: The Painters of Everyday Life in Seventeenth Century Rome*. Rome, 1983.

Brochhagen 1957
Ernst Brochhagen. "Karel Dujardins späte Landschaften." *Bulletin des Musées Royaux des Beaux-Arts* (Brussels) 6 (1957), pp. 236–55.

Brochhagen 1958
———. *Karel Dujardin: Ein Beitrag zum Italianismus in Holland im 17. Jahrhundert*. Dissertation. Cologne, 1958.

Brochhagen 1965
———. Review of Utrecht 1965. *Kunstchronik* 18 (1965), pp. 177–85.

Broos 1979
Ben Broos. "De oudheid in een nieuw licht." *Openbaar Kunstbezit* 23, no. 2 (1979).

de Brou 1862
C. de Brou. "Acte de marriage de M. Hobbema." *Revue universelle des arts* 15 (1862), pp. 178–84.

de Brou 1863
———. "Quelques notes concernant David Teniers le jeune, Jacob van Ruysdael, et Nicolas Berghem." *Bulletin des commissions royales d'art et d'archéologie* 2 (1863), pp. 508–22.

Broulhiet 1938
Georges Broulhiet. *Meindert Hobbema*. Paris, 1938.

Brown, Elliott 1980
Jonathan Brown and J.H. Elliott. *A Palace for a King: The Buen Retiro and the Court of Philip IV*. New Haven, 1980.

Brown, Elliott 1987
———. "The Marquis of Castel Rodrigo and the Landscape Paintings in the Buen Retiro." *Burlington Magazine* 129 (1987), pp. 104–107.

C. Brown 1982
Christopher Brown. "Jacob van Ruisdael at the Fogg." *Burlington Magazine* 129 (1982), pp. 190–94.

C. Brown 1984
———. *Images of a Golden Past: Dutch Genre Painting of the 17th Century*. New York, 1984.

J.C. Brown 1961
J. Carter Brown. "Jan van Goyen: A Study of His Early Development." Thesis. New York University, 1961.

Bruinvis 1899
C.W. Bruinvis. "De van Everdingens." *Oud Holland* 17 (1899), pp. 216–22.

Bruinvis 1903
———. "Nadere berichten over de familie van Everdingen." *Oud Holland* 21 (1903), pp. 56–60.

Brunt 1912
Aty Brunt. "Paulus Potter en zijn schilderijen in Hollandsche musea." *Morks' Magazin* 14, no. 2 (1912), pp. 1–11.

Brussels 1946
Brussels, Palais des Beaux-Arts. *De Hollandsche schilderkunst van Jeroen Bosch tot Rembrandt*. 1946.

Brussels 1971
———. *Rembrandt en zijn tijd*. 1971.

Brussels 1977–78
Brussels, Musées Royaux des Beaux-Arts. *Personnages et paysages dans la peinture hollandaise du XVIIème siècle*. Catalogue by Renate Trnek. 1977–78.

de Bruyn 1952
Lia de Bruyn. "Het geboortejaar van Jan Both." *Oud Holland* 67 (1952), pp. 110–12.

de Bruyn Kops 1965
C.J. de Bruyn Kops. "Kanttekeningen bij het nieuw verworven landschap van Aelbert Cuyp." *Bulletin van het Rijksmuseum* (Amsterdam) 13 (1965), pp. 162–75.

de Bruyn Kops 1966
———. "Salomon van Ruysdael and Jacob van Ruisdael." In *Encyclopedia of World Art*, vol. 12 (New York, 1966), pp. 609–15.

Buchanan 1824
William Buchanan. *Memoirs of Painting, with a Chronological History of the Importation of Pictures by the Great Masters into England since the French Revolution*. 2 vols. London, 1824.

Buchelius 1928
[Arend van Buchell]. *Arnoldus Buchelius, "Res Pictoriae," 1583–1639*. Ed. G.J. Hoogewerff and I.Q. van Regteren Altena. The Hague, 1928.

Budapest 1967
Budapest, Szépművészeti Múzeum. *Holland Mesterművek a XVII századból*. 1967.

Budapest, cat. 1906
———. *Tableaux anciens du Musée des Beaux-Arts de Budapest*. Catalogue by G. de Térey. 1906.

Budapest, cat. 1954
———. *A régi képtár: Katalógusa*. By A. Pigler. 2 vols. 1954. (1st ed. 1937.)

Budapest, cat. 1968
———. *Katalog der Galerie alter Meister*. By A. Pigler. 1968.

Budde 1929
Illa Budde. *Die Idylle im holländischen Barock*. Cologne, 1929.

Burchard 1912
Ludwig Burchard. *Die holländischen Radierer vor Rembrandt*. Halle, 1912. (Rev. ed. Berlin, 1917.)

Burke 1974
James D. Burke. "Ruisdael and His Haarlempjes." *M: A Quarterly Review of the Montreal Museum of Fine Arts* 6, no. 1 (1974), pp. 3–11.

Burke 1976
———. *Jan Both: Paintings, Drawings and Prints*. Dissertation. Harvard, 1972. New York, 1976.

Burnet 1849
John Burnet. *Rembrandt and His Works*. London, 1849.

Burnett 1969
D.G. Burnett. "Landscapes of Aelbert Cuyp." *Apollo* 89 (1969), pp. 372–80.

Busiri Vici 1974
Andrea Busiri Vici. *Jan Frans van Bloemen "Orizzonte" e l'origine del paesaggio romano settecentesco*. Rome, 1974.

Buysschaert 1983
A.-C. Buysschaert. "Roelandt Savery: Les oeuvres peintes du Musée Communal de Courtrai." Dissertation. Louvain, 1983.

Caffin 1911
Charles H. Caffin. "Allart van Everdingen." *Print Collector's Quarterly* 1 (1911), pp. 562–72.

van Campen 1937
J.W.C. van Campen. "Vondels relaties met Utrechtsche kunstenaars." *Jaarboekje van Oud-Utrecht*, 1937, pp. 29–55.

Cardiff 1960
Cardiff, National Museum of Wales. *Ideal and Classical Landscape*. 1960.

Chiarini 1964
Marco Chiarini. "Appunti sulla pittura di paesaggio a Roma fra il 1620 e il 1650." *Paragone* 175 (1964), pp. 74–79.

Chiarini 1972a
———. "Ipotesi sugli inizi di Cornelis van Poelenburgh." *Nederlands Kunsthistorisch Jaarboek* 23 (1972), pp. 203–12.

Chiarini 1972b
———. "Filippo Napoletano, Poelenburgh, Breenbergh e la nascita del paesaggio realistico in Italia." *Paragone* 269 (1972), pp. 18–34.

Chiarini 1984
———. "The Importance of Filippo Napoletano for Claude's Early Formation." *Studies in the History of Art* 14 (1984), pp. 13–26.

Chicago 1942
The Art Institute of Chicago. *Paintings by the Great Dutch Masters of the Seventeenth Century*. 1942.

Chicago/Minneapolis/Detroit 1969–70
The Art Institute of Chicago. *Rembrandt after Three Hundred Years*. Catalogue by J.R. Judson, E. Haverkamp Begemann, and A.-M.

Logan. 1969. Also shown at Minneapolis Institute of Arts and Detroit Institute of Arts. 1969–70.

Chong 1987
Alan Chong. "The Drawings of Cornelis van Poelenburch." *Master Drawings* 25 (1987).

Chong, forthcoming
————. "Social Meanings in the Paintings of Aelbert Cuyp." Dissertation. New York University. Forthcoming.

Chudzikowski 1966
Andrzej Chudzikowski. "Jan Baptist Weenix, peintre d'histoire." *Bulletin du Musée National de Varsovie* 7 (1966), pp. 1–10.

Cincinnati, Taft cat. 1920
A Catalogue of Paintings in the Collection of Mr. and Mrs. Charles P. Taft. By Maurice Brockwell. New York, 1920.

Cincinnati, Taft cat. 1945
Cincinnati Institute of Fine Arts, Taft Museum. *The Taft Museum Catalogue.* 1945.

Clark 1976
Kenneth Clark. *Landscape into Art.* Rev. ed. London, 1976. (1st ed. 1949.)

A. Clark 1961
Anthony M. Clark. "A Supply of Ideal Figures." *Paragone* 12 (1961), pp. 51–58.

Cleveland, cat. 1978
Cleveland Museum of Art. *Cleveland Museum of Art Handbook.* 1978.

Cleveland, cat. 1982
————. *European Paintings of the 16th, 17th, and 18th Centuries.* 1982.

Collins 1953
Leo C. Collins *Hercules Seghers.* Chicago, 1953. Reprint. New York, 1978.

Cologne 1954
Cologne, Wallraf-Richartz-Museum. *Meisterwerke holländischer Landschaftsmalerei des 17. Jahrhunderts.* May–June 1954.

Cologne/Rotterdam 1970
————. *Sammlung Herbert Girardet: Holländische und flämische Malerei.* Catalogue by Horst Vey. 1970. Also shown at Rotterdam, Museum Boymans-van Beuningen.

Cologne/Utrecht 1985–86
————. *Roelant Savery in seiner Zeit.* 1985. Also shown at Utrecht, Centraal Museum, 1985–86.

Combe 1931
Jacques Combe. "Un douanier Rousseau au XVIIe siècle: Franz Post (1612–1680)." *Amour de l'art* 12 (1931), pp. 481–89.

le Comte 1699
Florent le Comte. *Cabinet des singularitez d'architecture, peinture, sculpture, et gravure.* 3 vols. Paris, 1699.

Coninckx 1907
H. Coninckx. "David Vinckboons, peintre, et son oeuvre et la famille de ce nom." *Annales de l'Académie royale d'archéologie de Belgique* 59 (1907), pp. 405–52.

Coninckx 1908
————. *David Vinckboons, peintre, et son oeuvre et la famille de ce nom.* Antwerp, 1908.

Cook collection cat. 1914
A Catalogue of the Paintings at Doughty House, Richmond, and Elsewhere in the Collection of Sir Frederick Cook, Bt. By J.O. Kronig. 2 vols. London, 1914.

Copenhagen, cat. 1951
Copenhagen, Statens Museum for Konst. *Royal Museum of Fine Arts. Catalogue of Old Foreign Paintings.* 1951.

da Costa Kaufmann 1985
Thomas da Costa Kaufmann, *L'école de Prague: La peinture à la cour de Rodolphe II.* Paris, 1985.

da Costa Kaufmann 1986
————. Review of Cologne/Utrecht 1985–86. *Simiolus* 16 (1986), pp. 249–53.

Cundall 1891
Frank Cundall. *The Landscape and Pastoral Painters of Holland.* London, 1891.

Cunningham 1940
C.C. Cunningham. "'View of Haarlem from the Dunes' by Jacob van Ruisdael (1628–1682)." *Bulletin of the Museum of Fine Arts, Boston* 38 (1940), pp. 15–17.

Cunningham 1959
————. "Jacob Pynas' *Adoration of the Magi.*" *Wadsworth Atheneum Bulletin,* winter 1959, pp. 10–13.

Czobor 1963
Agnes Czobor. "Zu Vinckboons Darstellung von Soldatenszenen." *Oud Holland* 78 (1963), pp. 151–53.

Czobor 1967
————. *Dutch Landscapes.* Budapest, 1967.

D. F. M. 1897
D. F. M. "Le peintre Ruisdael, a-t-il fait des études médicales?" *La chronique médicale* 4 (1897), p. 505.

Dattenberg 1940
Heinrich Dattenberg. "Wassertor zu Emmerich: Ein unveröffentliches Gemälde von Jan van der Heyden." *Die Heimat* 19 (1940), pp. 198–201.

Dattenberg 1967
————. *Die Niederrheinansichten holländischer Künstler des 17. Jahrhunderts.* Dusseldorf, 1967.

Davies 1972
Alice Ingraham Davies. "Allart van Everdingen's Drawings of the Twelve Months." *Register of the University of Kansas Museum of Art* 4 (1972).

Davies 1978
————. *Allart van Everdingen.* Dissertation. Harvard University, 1973. New York, 1978.

Delbanco 1928
Gustav Delbanco. *Der Maler Abraham Bloemaert.* Strasbourg, 1928.

Denver 1971
Denver Art Museum. *Baroque Art: Era of Elegance.* 1971.

Deperthes 1822
J.B. Deperthes. *Histoire de l'art du paysage.* Paris, 1822.

Descamps 1753–64
Jean Baptiste Descamps. *La vie des peintres flamands, allemands, et hollandois.* 4 vols. Paris, 1753–64.

Desenfans 1802
Noel Desenfans. *A Descriptive Catalogue of Some Pictures of the Different Schools, Purchased for H.M. the late King of Poland.* 2 vols. London, 1802.

Detroit, cat. 1930
Detroit Institute of Arts. *Catalogue of Paintings.* 1930.

Deys 1981
H.P. Deys. *Achter Berg en Rijn: Over boeren, burgers en buitenlui.* Rhenen, 1981.

Dézallier d'Argenville 1745–52
A.N. Dézallier d'Argenville. *Abrégé de la vie des plus fameux peintres.* 3 vols. Paris, 1745–52.

DIAL
Rijksbureau voor Kunsthistorische Documentatie. *Decimal Index of the Art of the Low Countries.* The Hague, 1958–.

Diedenhofen 1973
W. Diedenhofen. "Trophäen im Park: Zu einer Zeichnung des Anthonie van Borssum." *Bulletin van het Rijksmuseum (Amsterdam)* 21 (1973), pp. 117–26.

Dobrzycka 1966
Anna Dobrzycka. *Jan van Goyen, 1596–1656.* Poznan, 1966.

Dodgson 1918
Campbell Dodgson. "A Dutch Sketchbook of 1650 (by Jan van Goyen)." *Burlington Magazine* 32 (1918), pp. 234–40.

Dohmann 1958
A. Dohmann. "Les événements contemporains dans la peinture hollandaise du XVIIe siècle." *Revue de l'histoire moderne et contemporain* 5 (1958), pp. 265ff.

Donahue 1965
Susan Donahue. "*The Rest on the Flight into Egypt* by Cornelis van Poelenburgh." *Fogg Art Museum: Acquisitions,* 1965, pp. 155–60.

Doorninck 1883–86
J.I. van Doorninck. "Bartholomeus Breenborch." *Bijdragen tot de geschiedenis van Overijssel* 7 (1883), p. 184; 8 (1886), p. 368.

Dordrecht 1963
Dordrechts Museum. *Nederlandse landschappen uit de zeventiende eeuw.* Catalogue by L.J. Bol. 1963.

Dordrecht 1964
————. *Zee-, rivier-, en oevergezichten.* 1964.

Dordrecht 1977–78
————. *Aelbert Cuyp en zijn familie, schilders te Dordrecht.* Catalogue by J.M. de Groot, J.G. van Gelder, and W. Veerman. 1977–78.

Dresden 1972
Dresden, Albertinum. *Europäische Landschaftsmalerei, 1550–1650.* 1972.

Drossaers, Lunsingh Scheurleer 1974–76
S.W.A. Drossaers and Th. H. Lunsingh Scheurleer. *Inventarissen van de inboedels in de verblijven van de Oranjes en daarmede gelijk te stellen stukken 1567–1795.* 3 vols. The Hague, 1974–76.

Drost 1921
Willy Drost. "Über Wesensdeutung von Landschaftsbildern, gezeigt an der holländischen Landschaftsmalerei des 17. Jahrhunderts." *Zeitschrift fur Ästhetik und allgemeine Kunstwissenschaft* 15 (1921), pp. 272–304.

Drost 1926
————. *Barockmalerei in den germanischen Landern.* Potsdam, 1926.

Drost 1933
————. *Adam Elsheimer und sein Kreis.* Potsdam, 1933.

Drugulin 1873
W. Drugulin. *Allart van Everdingen: Catalogue raisonné de toutes les estampes qui forment son oeuvre gravé.* Leipzig, 1873.

Dublin, cat. 1986
Dublin, National Gallery of Ireland. *Dutch Seventeenth Century*

Paintings in the National Gallery of Ireland. Catalogue by H. Potterton. 1986.

Dudok van Heel 1975
S.A.C. Dudok van Heel. "Waar woonde en werkte Pieter Lastman." *Maandblad Amstelodamum* 62 (1975), pp. 31–36.

Dudok van Heel 1982
———. "Het 'Schilderhuis' van Govaert Flinck en de kunsthandel van Uylenburgh te Amsterdam." *Jaarboek Amstelodamum* 24 (1982), pp. 70–90.

Dufey-Haeck 1979
M.L. Dufey-Haeck. "Le thème du repos pendant la fuite en Egypte dans la peinture flamande de la seconde moitié du XVᵉ au milieu du XVIᵉ siècle." *Revue belge d'archéologie et d'histoire de l'art* 48 (1979), pp. 45–76.

Dulberg 1922
Franz Dulberg. *Die drei Ruysdael.* Leipzig, 1922.

Duparc 1980
Frits J. Duparc, Jr. "Een teruggevonden schilderij van N. Berchem en J.B. Weenix." *Oud Holland* 94 (1980), pp. 37–43.

Duparc 1981–82
———. "'Het Joodse kerkhof' van Jacob van Ruisdael." *Antiek* 16 (1981–82), pp. 225–30.

Duparc 1982
———. "Frans Post and Brazil." *Burlington Magazine* 124 (1982), pp. 761–72.

Duplessis 1875
Georges Duplessis. *Eaux-fortes de Paul Potter.* Paris, 1875.

Duplessis 1878
———. *Eaux-fortes de J. Ruysdael.* Paris, 1878.

Dusseldorf 1953
Dusseldorf, Kunstmuseum. *Niederrheinansichten holländischer Künstler des 17. Jahrhunderts.* 1953. Also shown at Mönchengladbach.

Dusseldorf 1981
———. *Gaspard Dughet und die ideale Landschaft.* Catalogue by Ch. Klemm. 1981.

Dutuit 1881–85
E. Dutuit. *Manuel de l'amateur d'estampes.* 6 vols. Paris, 1881–85.

Dutuit 1883–85
———. *L'oeuvre complet de Rembrandt.* Paris, 1883–85.

van Dyck 1636
Anthonie van Dyck. *Iconographie.* Antwerp, 1636. 2nd ed. 1646. Ed. M. Mauquoy-Hendrickx. 2 vols. Brussels, 1956.

van Dyke 1914
J.C. van Dyke. *Critical Notes on the Imperial Gallery and Budapest Museum.* New York. 1914.

Ebbinge Wubben 1953
J.C. Ebbinge Wubben. "Het nieuw verworven landschap van Hercules Seghers." *Bulletin Museum Boymans* 4 (1953), pp. 29–44.

Eberle 1980
M. Eberle. *Individuum und Landschaft: Zur Entstehung und Entwicklung der Landschaftsmalerei.* Dissertation. Giessen, 1980.

van Eck 1937
A.C. van Eck. "Jan van der Heyden." *Maandblad Amstelodamum* 24 (1937), pp. 33–36.

Eckering 1977
Lea Eckerling. "Isack van Ostade in the Literature: A Study of

His Artistic Reputation." Thesis. University of California, Los Angeles, 1977.

Edinburgh 1949
Edinburgh, National Gallery of Scotland. *Dutch and Flemish Paintings from the Collection of the Marquess of Bute.* 1949.

C. van Eeghen 1943
Chr. P. van Eeghen. "Paulus Potter's 'Groote ossendrift': De veiling-de Wacker van Son te Londen aangekondigd." *Oud Holland* 60 (1943), pp. 14–28.

van Eeghen 1952
I.H. van Eeghen. "De familie Vinckboons-Vingboons." *Oud Holland* 67 (1952), pp. 217–32.

van Eeghen 1953
———. "Een stadsgezicht van Hobbema." *Oud Holland* 68 (1953), pp. 120–26.

van Eeghen 1966
———. "De vier huizen van Cromhoult." *Maandblad Amstelodamum* 53 (1966), pp. 52–59.

van Eeghen 1968
———. "De ouders van Hercules Segers." *Maandblad Amstelodamum* 55 (1968), pp. 73–76.

van Eeghen 1973a
———. Review of H. Wagner, *Jan van der Heyden* (Amsterdam and Haarlem, 1971). *Maandblad Amstelodamum* 60 (1973), pp. 23–24.

van Eeghen 1973b
———. "Archivalia betreffenden Jan van der Heyden." *Maandblad Amstelodamum* 60 (1973), pp. 29–36, 54–61, 73–79, 99–106, 128–34.

Egger 1931–32
Hermann Egger. *Römische Veduten: Handzeichnungen aus dem XV. bis XVII. Jahrhundert zur Topographie der Stadt.* 2 vols. Vienna, 1931–32.

Eigenberger 1927
Robert Eigenberger. *Die Gemäldegalerie der Akademie der bildenden Künste in Wien.* 2 vols. Vienna and Leipzig, 1927.

Eindhoven 1948
Eindhoven, Van Abbe Museum. *Nederlandse landschapkunst in de 17e eeuw.* 1948.

Eisler 1918
Max Eisler. *Rembrandt als Landschafter.* Munich, 1918.

Ekkart 1983
R.E.O. Ekkart. "Bartholomeus Breenbergh en Dirck Metius." *Bulletin van het Rijksmuseum* (Amsterdam) 31 (1983), pp. 248–54.

Emmens 1968
J.A. Emmens. *Rembrandt en de regels van de kunst.* Utrecht, 1968. (Reprinted J.A. Emmens, *Verzameld Werk.* Amsterdam, 1979.)

Emperius 1816
J.F.F. Emperius. "Über die Wegführung und die Zurückkunft der Braunschweigischen Kunst- und Bücherschätze." *Braunschweigisches Magazin* 28 (1816), pp. 1–64.

Enschede 1980
Enschede, Rijksmuseum Twenthe. *Oost-Nederland model: Landschappen, stads- en dorpsgezichten.* 1980.

Erasmus 1908
Kurt Erasmus. *Roelandt Savery: Sein Leben und seine Werke.* Dissertation. Halle, 1908.

Erasmus 1909
———. "Die Hermann Saftleven-Ausstellung im Rijksprentenkabinet." *Der Cicerone* 1 (1909), pp. 611–12.

Erasmus 1911
———. "De teekeningen van Roelandt Savery." *Kunst en Kunstleven* 1 (1911), pp. 5–8.

Ertz 1979
Klaus Ertz. *Jan Brueghel der Ältere (1568–1625): Die Gemälde.* Cologne, 1979.

Ertz 1986
———. *Josse de Momper der Jüngere: Die Gemälde.* Freren, 1986.

Eskridge 1979
Robert William Eskridge. "Attitudes toward Seventeenth-Century Landscape Painting in Rome." Thesis. Oberlin, 1979.

Esterházy, cat. 1812
Catalog der Gemälde-Gallerie des durchlauchtigen Fürsten Esterházy von Galantha zu Laxenburg bey Wien. By J. Fischer. Vienna, 1812.

Esterházy, cat. 1869
Catalog der Gemälde-Gallerie seiner Durchlaucht des Fürsten Nicolaus Eszterházy von Galantha in Pest, Academie-Gebäude. Pest, 1869.

van Eynden, van der Willigen 1816–40
Roeland van Eynden and Adriaan van der Willigen. *Geschiedenis der vaderlandsche schilderkunst sedert de helft der XVIII eeuw.* 4 vols. Haarlem, 1816–40.

Faggin 1965
G.T. Faggin. "Per Paolo Bril." *Paragone* 185 (July 1965), pp. 21–35.

Falkenburg 1985
R.L. Falkenburg. *Joachim Patinir: Het landschap als beeld van de levenspelgrimage.* Dissertation. Amsterdam, 1985.

Farington [1793–1821]
Joseph Farington. *The Diary of Joseph Farington.* 16 vols. New Haven, 1978–84.

Fechner 1963
Jelena Fechner. *Le paysage hollandais du XVIIe siècle à l'Ermitage* (in Russian). Leningrad, 1963.

Fechner 1966–67
———. "Die Bilder von Roelant Savery in der Eremitage." *Jahrbuch des Kunsthistorischen Instituts der Universität Graz* 2 (1966–67), pp. 93–100.

Feinblatt 1949
Ebria Feinblatt. "Note on Paintings by Bartholomeus Breenbergh." *Art Quarterly* 12 (1949), pp. 266–71.

Félibien 1666–88
André Félibien. *Entretiens sur les vies et sur les ouvrages des plus excellens peintres anciens et modernes.* 5 vols. Paris, 1666–88.

Félibien 1679
———. *Noms des peintres les plus célèbres et les plus connus, anciens et modernes.* Paris, 1679. Reprint. Geneva, 1972.

Fetis 1858
E. Fetis. "Roelandt Savery." *Bulletins de l'académie royale des sciences, des lettres et des beaux-arts de Belgique* 4 (1858), pp. 344–59.

Filedt Kok 1982
J.P. Filedt Kok. "'Riverdal' van Hercules Segers

schoongemaakt." *Bulletin van het Rijksmuseum* (Amsterdam) 30 (1982), pp. 169–76.

Filhol 1804–1828
A.M. Filhol. *Galerie du Musée Napoleon*. 11 vols. Paris, 1804–28. (2nd ed. 1810–28.)

Filla 1959
Emil Filla. *Jan van Goyen*. Prague, 1959.

Fink 1954
A. Fink. *Geschichte des Herzog Anton Ulrich-Museums in Braunschweig*. Braunschweig, 1954.

Floerke 1905
Hanns Floerke. *Studien zur niederländischen Kunst- und Kulturgeschichte: Die Formen des Kunsthandels, das Atelier und die Sammler in den Niederlanden vom 15.–18. Jahrhundert*. Munich and Leipzig, 1905. Reprint. Soest, 1972.

Florence 1967
Florence, Palazzo Pitti. *Paesisti, bamboccianti e vedutisti nella Roma seicentesca*. Catalogue by Marco Chiarini. 1967.

Flugi van Aspermont 1899
C.H.C. Flugi van Aspermont. "Carel Cornelisz. de Hooch." *Oud Holland* 17 (1899), pp. 223–27.

Fraenger 1922
Wilhelm Fraenger. *Die Radierungen des Hercules Seghers: Ein physiognomischer Versuch*. Munich, 1922.

Franken 1878
Daniel Franken. *Adriaen van de Venne*. Amsterdam, 1878.

Franken, van der Kellen 1883
D. Franken and J.P. van der Kellen. *L'oeuvre de Jan van de Velde*. Amsterdam, 1883. Reprint. Amsterdam, 1968.

Frankfurt 1966–67
Frankfurt, Städelsches Kunstinstitut. *Adam Elsheimer: Werk, künstlerische Herkunft und Nachfolge*. 1966–67.

Franz 1963
Heinrich Gerhard Franz. "De boslandschappen van Gillis van Coninxloo en hun voorbeelden." *Bulletin Museum Boymans-van Beuningen* 14 (1963), pp. 66–85.

Franz 1968
———. "Das niederländische Waldbild und seine Entstehung im 16. Jahrhundert." *Bulletin des Musées Royaux des Beaux-Arts* (Brussels) 17 (1968), pp. 1–2, 15–38.

Franz 1968–69
———. "Meister der spätmanieristischen Landschaftsmalerei in den Niederlanden." *Jahrbuch des Kunsthistorischen Instituts der Universität Graz* 3–4 (1968–69), pp. 19–72.

Franz 1969
———. *Niederländische Landschaftsmalerei im Zeitalter des Manierismus*. 2 vols. Graz, 1969.

Franz 1970
———. "Niederländische Landschaftsmaler im Künstlerkreis Rudolf II." *Umění* 18 (1970), pp. 224–45.

Franz 1979–80
———. "Zum Werk der Roelandt Savery." *Jahrbuch des Kunsthistorischen Instituts der Universität Graz* 15–16 (1979–80), pp. 175–86.

Freedberg 1980
David Freedberg. *Dutch Landscape Prints of the Seventeenth Century*. London, 1980.

Freise 1911
Kurt Freise. *Pieter Lastman: Seine Leben und seine Kunst*. Leipzig, 1911.

Frenzel 1829–30
J.G.A. Frenzel. "Hercules Zegers." *Kunst-Blatt* 10, nos. 18, 19, 32 (1829); 11, no. 10 (1830).

Frenzel 1855
———. "Albert oder Aldert van Everdingen." *Archiv für die zeichnenden Künste* 1 (1855), pp. 104–22.

Frerichs 1966
L.C.J. Frerichs. "Adriaen van de Velde (1636–1672): Strandgezicht." *Openbaar Kunstbezit* 10 (1966), p. 16 a–b.

Friedländer 1905
Max J. Friedländer. "Das Inventar der Sammlung Wyttenhorst." *Oud Holland* 23 (1905), pp. 63–68.

Friedländer 1950
———. *Landscape, Portrait, Still-Life*. Oxford and New York [1950]. (Originally published in German, The Hague, 1947.)

Frimmel 1892
Theodor von Frimmel. *Kleine Galeriestudien*. vol. 1. Vienna, 1892.

Frimmel 1899–1901
———. *Geschichte der Wiener Gemäldesammlungen*. 4 vols. Leipzig, 1899–1901.

Frimmel 1905
———. "Zu Frans de Momper." *Blätter für Gemäldekunde* 1 (1905), pp. 64–66.

Frimmel 1906
———. "Bemerkungen über den polychromen Frühstil des Jan van Goyen." *Blätter für Gemäldekunde* 2 (1906), pp. 71–76.

Fritz 1932
Rolf Fritz. *Stadt- und Strassenbild in der holländischen Malerei des 17. Jahrhunderts*. Dissertation. Berlin, 1932.

Fromentin 1876
Eugène Fromentin. *Les maîtres d'autrefois: Belgique – Hollande*. Paris, 1876.

Fromentin 1963
———. *The Old Masters of Belgium and Holland*. Introduction by Meyer Schapiro. New York, 1963. (Translation of Fromentin 1876.)

Fuchs 1968
R.H. Fuchs. *Rembrandt en Amsterdam*. Rotterdam, 1968.

Fuchs 1973
———. "Over het landschap: Een verslag naar aanleiding van Jacob van Ruisdael, 'Het Korenveld'." *Tijdschrift voor Geschiedenis* 86 (1973), pp. 281–92.

Fuchs 1978
———. *Dutch Painting*. New York, 1978. (Also published in Dutch.)

Gaedertz 1869
Theodor Gaedertz. *Adriaen van Ostade: Sein Leben und seine Kunst*. Lübeck, 1869.

Garas 1977
Klára Garas. *The Budapest Gallery*. Budapest, 1977.

Gaver 1875
Ronald Gaver. *A Pocket Guide to the Public and Private Galleries of Holland and Belgium*. London, 1875.

van Gelder 1933
J.G. van Gelder. *Jan van de Velde*. The Hague, 1933.

van Gelder 1934
———. Review of C. Welcker, *Hendrik Avercamp and Barent Avercamp, "schilders tot Campen"* (Zwolle, 1933). *Zeitschrift für Kunstgeschichte* 3 (1934), pp. 78–79.

van Gelder 1936
———. "Salomon van Ruysdael in den Kunsthandel J. Goudstikker." *Elsevier's geïllustreerd maandschrift* 91 (1936), pp. 201–202.

van Gelder 1937a
———. "Pennetengninger af Jan van Goyen." *Kunstmuseets Aarskrift* 24 (1937), pp. 31–45.

van Gelder 1937b
———. "Het werk van Jan van der Heyden in de Waag te Amsterdam." *Elsevier's geïllustreerd maandschrift* 93 (1937), pp. 360–61.

van Gelder 1940
———. "Post en van Eckhout, schilders in Brazilie 1637–1644." *Beeldende Kunst* 26 (1940), pp. 65–72.

van Gelder 1950
———. "Hercules Seghers erbij en eraf." *Oud Holland* 65 (1950), pp. 216–26.

van Gelder 1953a
———. "Dutch Pictures at the Royal Academy." *Burlington Magazine* 95 (1953), p. 33.

van Gelder 1953b
———. "Hercules Seghers, Addenda." *Oud Holland* 68 (1953), pp. 149–57.

van Gelder 1958
———. *Prenten en tekeningen: De schoonheid van ons land*. Amsterdam, 1958.

van Gelder 1962
———. "Cornelis Vroom: Een onbekend landschap." *Oud Holland* 77 (1962), pp. 56–57.

van Gelder 1963a
———. "Huiswaarts kerend landvolk." *Openbaar kunstbezit* 7 (1963), pp. 27a–b.

van Gelder 1963b
———. Review of E. Larsen, *Frans Post* (Amsterdam, 1962). *Oud Holland* 78 (1963), pp. 77–79.

van Gelder 1976
———. Review of W. Stechow, *Salomon van Ruysdael* (Berlin, 1975). *Oud Holland* 90 (1976), pp. 135–36.

van Gelder, Jost 1969
J.G. van Gelder and Ingrid Jost. "Vroeg contact van Aelbert Cuyp met Utrecht." In *Miscellanea I.Q. van Regteren Altena*. Amsterdam, 1969.

van Gelder, Jost 1972
———. "Doorzagen op Aelbert Cuyp." *Nederlands Kunsthistorisch Jaarboek* 23 (1972), pp. 223–39.

van Gelder, Jost, forthcoming
———. *The Drawings of Aelbert Cuyp*. Ed. E. Haverkamp Begemann. Forthcoming.

H.E. van Gelder 1946
H.E. van Gelder. *Rembrandt*. Amsterdam [1946].

H.E. van Gelder 1959a
———. *Holland by Dutch Artists*. Amsterdam, 1959.

H.E. van Gelder 1959b
———. "Ruisdaels 'Wijk bij Duurstede.'" *Openbaar Kunstbezit* 3, no. 13 (1959).

Genaille 1983
R. Genaille. "De Breugel à G. van Coninxloo: Remarques sur le paysage maniériste à la fin du 16e siècle." *Jaarboek van het Koninklijk Museum voor Schone Kunsten, Antwerpen*, 1983, pp. 129–68.

Gerson 1934
Horst Gerson. "The Development of Ruisdael." *Burlington Magazine* 45 (1934), pp. 76–80.

Gerson 1936
———. *Philips Koninck: Ein Beitrag zur Erforschung der holländischen Malerei des XVII. Jahrhunderts*. Berlin, 1936. Reprint. Berlin, 1980.

Gerson 1942
———. *Ausbreitung und Nachwirkung der holländischen Malerei des 17. Jahrhunderts*. Haarlem, 1942. Reprint. Amsterdam, 1983.

Gerson 1947a
———. "Een Hobbema van 1665." *Kunsthistorische Mededeelingen* 2 (1947), pp. 43–47.

Gerson 1947b
———. "De Meester P.N." *Nederlandsch Kunsthistorisch Jaarboek* 1 (1947), pp. 95–101.

Gerson 1948
———. "Landschappen van Jan Steen." *Kunsthistorische Mededeelingen* 3 (1948), pp. 51–56.

Gerson 1950–52
———. *De Nederlandse schilderkunst*. 2 vols. Amsterdam, 1950–52.

Gerson 1953
———. Review of London 1953. *Burlington Magazine* 95 (1953), pp. 47–52.

Gerson 1955
———. "Enkele vroege werken van Esajas van de Velde." *Oud Holland* 70 (1955), pp. 131–35.

Gerson 1956
———. "Twee tekeningen van Herman van Swanevelt." *Oud Holland* 71 (1956), pp. 113–15.

Gerson 1963
———. "Dutch Landscapes at Dordrecht." *Burlington Magazine* 105 (1963), pp. 461–62.

Gerson 1964a
———. "Aelbert Cuyps gezichten van het 'Wachthuis in de Kil'." In *Opus musivum: Een bundel studies aangeboden aan Prof. Dr. M.D. Ozinga*. Assen, 1964.

Gerson 1964b
———. "Italy through Dutch Eyes." *Art Quarterly* 27 (1964), pp. 342–52.

Gerson 1965
———. "Bredius 447." In *Festschrift Dr. h.c. Eduard Trautscholdt*. Hamburg, 1965.

Gerson 1968
———. *Rembrandt Paintings*. Amsterdam, 1968.

Gerstenberg 1923
Kurt Gerstenberg. *Die ideale Landschaftsmalerei: Ihre Begründung und Vollendung in Rom*. Halle, 1923.

Gerszi 1976a
Teréz Gerszi. "Bruegels Nachwirkung auf die niederländischen Landschaftsmaler um 1600." *Oud Holland* 90 (1976), pp. 201–29.

Gerszi 1976b
———. Un problème de l'influence réciproques des paysagistes Rodolphins." *Bulletin du Musée Hongrois de Beaux-Arts* 46–47 (1976), pp. 105–28.

Gerszi 1978
———. "Zur Zeichenkunst Esaias van de Veldes." *Actae Historiae Artium* 24 (1978), pp. 273–77.

Gerszi 1981
———. "Landschaftdarstellungen von Pieter Bruegel und Hercules Seghers." *Pantheon* 39 (1981), pp. 133–39.

Ghent 1954
Ghent, Museum van Schone Kunsten. *Roelandt Savery*. Catalogue by P. Eeckhout. 1954.

Ghent 1961
———. *Le paysage aux pays-bas de Bruegel à Rubens (1550–1630)*. Catalogue by Horst Gerson. 1961.

Giltay 1980
Jeroen Giltay. "De tekeningen van Jacob van Ruisdael." *Oud Holland* 94 (1980), pp. 141–86.

Ginnings 1970
Rebecca J. Ginnings. "The Art of Jan Baptist Weenix and Jan Weenix." Dissertation. University of Delaware, 1970.

Goedde 1986
Lawrence Goedde. "Convention, Realism, and the Interpretation of Dutch and Flemish Tempest Paintings." *Simiolus* 16 (1986), pp. 139–49.

Goethals 1837
F.V. Goethals. "Nicolas Berchem." In F.V. Goethals, *Lectures relatives à l'histoire des sciences, des arts, des lettres . . . en Belgique*, vol. 1. Brussels, 1837.

Goethe 1816
Johann Wolfgang von Goethe. "Ruysdael als Dichter" (1816). In *Goethes Werke*, 7th ed., vol. 12, ed. E. Trunz. Munich, 1973.

Goldschmidt 1939
Adolph Goldschmidt. "The Style of Dutch Painting in the Seventeenth Century." *Art Quarterly* 2 (1939), pp. 3–21.

Gombrich 1953
E.H. Gombrich. "The Renaissance Artistic Theory and the Development of Landscape Painting." *Gazette des beaux-arts* 41 (1953), pp. 335–60.

Gombrich 1966
———. *Norm and Form*. London, 1966.

Gombrich 1971
———. *Meditations on a Hobby Horse*. London, 1971.

van Gool 1750–51
Johan van Gool. *De nieuwe schouburg der Nederlantsche kunstschilders en schilderessen*. 2 vols. The Hague, 1750–51.

Goossens 1954a
Korneel Goossens. *David Vinckboons*. Antwerp and The Hague, 1954. Reprint. Soest, 1977.

Goossens 1954b
———. "David Vinckboons." *Bulletin des Musées Royaux des Beaux-Arts* (Brussels) 3 (1954), pp. 33–43. Reprint. Soest, 1977.

Goossens 1966
———. "Nog meer over David Vinckboons." *Jaarboek van het Koninklijk Museum voor Schone Kunsten te Antwerpen*, 1966, pp. 59–106.

Gorissen 1964
Friedrich Gorissen. *Conspectus Cliviae: Die klevische Residenz in der Kunst des 17. Jahrhunderts*. Kleve, 1964.

Göthe 1903
Georg Göthe. "Har Allart van Everdingen varit i Norge?" *Nordisk Tidskrift for Vetenskap, Konst och Industri* 26 (1903), pp. 315–19.

Gottsched 1752
Johann Christoph Gottsched, trans. *Reinekeder Fuchs*. Illustrated by Allart van Everdingen. Leipzig and Amsterdam, 1752.

ter Gouw 1872
J. ter Gouw. "Jan van der Heyden." In *Nederlands geschiedenis en volksleven*, vol. 4 (1872), no. 90.

Granberg 1883
Olof Granberg. *Pieter de Molijn och sparen af hans konst: En konsthistorisk studie*. Stockholm, 1883.

Granberg 1884
———. "Pieter de Molijn und seine Kunst." *Zeitschrift für bildende Kunst* 19 (1884), pp. 369–77.

Granberg 1902
———. *Allaert van Everdingen och hans "Norska" landskap. Det Gamla Julita och Wurmbrandts Kanoner*. Stockholm, 1902.

Grautoff 1936
Otto Grautoff. "Remarques sur le classement des oeuvres de Hobbema." In *Actes du XIVe congrés international d'histoire de l'art*, vol. 1, pp. 105–107; vol. 2, p. 86. Basel, 1936.

Greindl 1942–47
Edith Greindl. "La conception du paysage chez Alexandre Keirincx." *Jaarboek van het Museum voor Schone Kunsten te Antwerpen*, 1942–47, pp. 115ff.

Gronau 1923
Georg Gronau. "Neuerwerbungen der Casseler Galerie, 1912–22." *Berliner Museen* 44 (1923), pp. 60–72.

de Groot 1979
Irene de Groot. *Landscape Etchings by the Dutch Masters of the Seventeenth Century*. Maarssen, 1979. (Also published in Dutch.)

de Groot, Vorstman 1980
Irene de Groot and Robert Vorstman. *Sailing Ships: Prints by the Dutch Masters from the Sixteenth to the Nineteenth Century*. New York, 1980. (Also published in Dutch.)

Grosse 1925
Rolph Grosse. *Die holländische Landschaftskunst, 1600–1650*. Berlin and Leipzig, 1925.

Grosse 1950
———. "Zum Werk Adam Elsheimers." *Zeitschrift für Kunstwissenschaft* 4 (1950), pp. 173–82.

Gudlaugsson 1953
S.J. Gudlaugsson. "Landschappen van Gerrit Claesz. Bleeker en Jan Looten tot 'Hercules Seghers' vervalst." *Oud Holland* 68 (1953), pp. 182–84.

Gudlaugsson 1954
———. "Aanvullingen omtrent Pieter Post's werkzaamheid als schilder." *Oud Holland* 69 (1954), pp. 59–70.

Guimarães 1957
Argeu Guimarães de Segadas Machado, "Na Holanda com Frans Post." *Revista do Instituto Historico e Geografico Brasileiro* 235 (1957), pp. 85–295.

F. van der Haagen 1915
F.W. van der Haagen. "Joris van der Haagen, Kunstschilder." *Gelre, Bijdragen en Mededeelingen* 18 (1915), pp. 129–45.

J. van der Haagen 1932
J.K. van der Haagen. *De schilders Van der Haagen en hun werk.* Voorburg, 1932.

M. van der Haagen 1917
M.J.F.W. van der Haagen. "De samenwerking van Joris van der Haagen en Dirck Wijntrack." *Oud Holland* 35 (1917), pp. 43–48.

M. van der Haagen 1932
———. *Het geslacht van der Haagen 1417–1932.* The Hague, 1932.

Haak 1969
Bob Haak. *Rembrandt: His Life, His Work, His Time.* New York, 1969. (Also published in Dutch, Amsterdam, 1968.)

Haak 1972–73
———. Review of H. Wagner, *Jan van der Heyden 1637–1712* (Amsterdam and Haarlem, 1971). *Antiek* 7 (1972), pp. 53–54.

Haak 1973
———. Review of London 1973. *Antiek* 7 (1973), pp. 713–19.

Haak 1984
———. *The Golden Age: Dutch Painters of the Seventeenth Century.* New York, 1984.

Haarlem, cat. 1955
Haarlem, Frans Halsmuseum. *Catalogue of the Frans Halsmuseum.* By F. Baard. 1955.

Haarlem, cat. 1960
———. *Frans Halsmuseum: Municipal Art Gallery at Haarlem.* 1960.

Haberditzl 1911
F.M. Haberditzl. Review of K. Freise, *Pieter Lastman* (Leipzig, 1911). *Kunstgeschichtliche Anzeigen,* 1911, pp. 120–25.

Hafed 1876
Hafed, Prince of Persia: His experiences in earth-life and spirit-life . . . With an appendix containing communications from the spirit artists Ruisdael and Steen. London, 1876.

Hagels 1964
Herman Hagels. "Die Gemälde der niederländischen Maler Jacob van Ruisdael und Nicolaas Berchem von Schloss Bentheim im Verhältnis zur Natur des Bentheimer Landes." *Jahrbuch des Heimatvereins der Grafschaft Bentheim,* 1968, pp. 41ff.

Hagens 1982
H. Hagens. "Jacob van Ruisdael, Meindert Hobbema en de identificatiezucht." *'t inschrien* 14 (1982), pp. 7–12.

The Hague 1881
The Hague, Gothisch Paleis. *Catalogus van oude meesters te 's Gravenhage ten behoeve der waternoodlijdenden.* 1881.

The Hague 1929
The Hague, Koninklijke Kunstzaal Kleycamp. *Oud Hollandschen en Vlaamsche Meesters.* 1929.

The Hague 1953
The Hague, Mauritshuis. *Maurits de Braziliaan.* Catalogue by A.B. de Vries. 1953.

The Hague 1979–80
———. *Zo wijd de wereld strekt: Tentoonstelling naar aanleiding van de 300ste sterfdag van Johan Maurits van Nassau-Siegen.* 1979–80.

The Hague 1981–82
———. *Jacob van Ruisdael 1628/29–1682.* 1981–82. (Exhibition album for The Hague/Cambridge 1981–82.)

The Hague 1982
———. *Terugzien in bewondering (A Collector's Choice).* 1982.

The Hague/Cambridge 1981–82
The Hague, Mauritshuis. *Jacob van Ruisdael.* 1981–82. Also shown at Cambridge, Mass., Fogg Art Museum, 1982. Catalogue by Seymour Slive. (See also The Hague 1981–82.)

The Hague/London 1971
The Hague, Mauritshuis. *The Shock of Recognition.* 1971. Also shown at the Tate Gallery, London.

The Hague, Bredius cat. 1978
The Hague, Museum Bredius. *Catalogus van de schilderijen en tekeningen.* By Albert Blankert. 1978. (Rev. ed. 1980.)

The Hague, Mauritshuis cat. 1980
———. *Hollandse schilderkunst: Landschappen 17de eeuw.* Catalogue by F.J. Duparc. 1980.

The Hague, Mauritshuis cat. 1985
———. *The Royal Picture Gallery.* 1985.

Hamman 1948
R. Hamman. *Rembrandt.* Berlin, 1948. Reprint. Berlin, 1969.

Hardenberg 1960
H. Hardenberg. *Tussen zeerovers en Christenslaven: Noord-Afrikaanse reisjournalen.* Leiden, 1960.

Hartford 1950–51
Hartford, Wadsworth Atheneum. *Life in Seventeenth Century Holland.* Introduction by C.C. Cunningham. 1950–51.

Hartford, cat. 1978
Hartford, Wadsworth Atheneum. *Catalogue I: The Netherlands and German-Speaking Countries.* Hartford, 1978.

Harwood 1983
Laurie Harwood. "Les Pynacker du Louvre, à propos d'une récente acquisition." *Revue du Louvre* 33 (1983), pp. 110–18.

Harwood 1985
———. "Adam Pynacker." Dissertation. Courtauld Institute, London, 1985.

Havard 1879–81
Henry Havard. *L'art et les artistes hollandais.* 4 vols. Paris, 1879–81.

Havelaar 1911
Just Havelaar. "Iets over Paulus Potter en zijn 'Stier'." *Elsevier's geïllustreerd maandschrift* 42 (1911), pp. 176–85.

Havelaar 1924
———. *Jacob van Ruisdael en Meindert Hobbema.* Amsterdam, 1924.

Havelaar 1931
———. *De Nederlandsche landschapskunst tot het einde der zeventiende eeuw.* Amsterdam, 1931.

Havelaar 1942
———. *Hoogtepunten der oud-Hollandsche landschapskunst.* Bilthoven, 1942. (1st ed. *Oude Kunst,* 1915–18.)

Haverkamp Begemann 1959
Egbert Haverkamp Begemann. *Willem Buytewech.* Amsterdam, 1959.

Haverkamp Begemann 1966
———. "Rembrandt." In *Encyclopedia of World Art,* vol. 9 (New York, 1966), pp. 916–40.

Haverkamp Begemann 1967
———. "Cornelis Vroom aan het Meer van Como." *Oud Holland* 82 (1967), pp. 65–67.

Haverkamp Begemann 1968
———. *Hercules Seghers.* Amsterdam, 1968.

Haverkamp Begemann 1972
———. "Nicolaes Berchem in honore Horst Gerson propter artem navigandi." *Nederlands Kunsthistorisch Jaarboek* 23 (1972), pp. 273–74.

Haverkamp Begemann 1973a
———. *Hercules Segers: The Complete Etchings.* The Hague, 1973.

Haverkamp Begemann 1973b
———. "Review of H. Wagner, *Jan van der Heyden 1637–1712* (Amsterdam and Haarlem, 1971). *Burlington Magazine* 115 (1973), pp. 401–402.

Haverkamp Begemann 1978
———. "Jan van Goyen in the Corcoran: Exemplars of Dutch Naturalism." In Washington, D.C., Corcoran Gallery of Art, *The William A. Clark Collection,* 1978, pp. 51–59.

Haverkamp Begemann, Chong 1985
Egbert Haverkamp Begemann and Alan Chong. "Dutch Landscape and Its Associations." In *The Royal Picture Gallery, Mauritshuis.* New York, 1985.

Haverkamp Begemann, Logan 1970
Egbert Haverkamp Begemann and Anne-Marie Logan. *European Drawings in the Yale University Art Gallery.* 2 vols. New Haven, 1970.

Haverkorn van Rijsewijk 1890
P. Haverkorn van Rijsewijk. "Eenige aanteekeningen betreffende schilders, wonende buiten Rotterdam, uit het Archief te Rotterdam." *Oud Holland* 8 (1890), pp. 203–14.

Haverkorn van Rijsewijk 1891–93
———. "Simon Jacobsz. de Vlieger." *Oud Holland* 9 (1891), pp. 221–24; 11 (1893), pp. 229–35.

Haverkorn van Rijsewijk 1901
———. "Korte mededeelingen." *Oud Holland* 19 (1901), pp. 60–64.

Heidrich 1913
Ernst Heidrich. *Vlämische Malerei.* Jena, 1913.

Held 1937
Julius S. Held. "Ett bidrag till kannedomen om Everdingens skandinaviska resa." *Konsthistorisk Tidskrift* 6 (1937), pp. 41–43.

Held 1951
———. "Notes on David Vinckboons." *Oud Holland* 66 (1951), pp. 241–44.

Heldring collection cat. 1955
Catalogue Raisonné of the Pictures in the Collection of J.C.H. Heldring. By D. Hannema. Rotterdam, 1955.

Hengeveld 1865–70
G.J. Hengeveld. *Het rundvee.* 2 vols. Haarlem, 1865–70.

Henkel 1924–25
M.D. Henkel. "Swanevelt und Piranesi in Goethescher Beleuchtung." *Zeitschrift für bildende Kunst* 34 (1924–25), pp. 153–58.

Henkel 1931
———. *Le dessin hollandais.* Paris, 1931.

Henkel 1934
———. "Van-de-Venne-Ausstellung, Amsterdam." *Pantheon* 13 (1934), p. 154.

Hennus 1945
M.F. Hennus. "Hendrick Avercamp als teekenaar." *Maandblad voor Beeldende Kunsten* 25 (1949), pp. 1–10.

Heppner 1930
A. Heppner. "Simon de Vlieger en der 'Pseudo van de Venne'." *Oud Holland* 47 (1930), pp. 78–91.

Heppner 1936
———. "Salomon van Ruysdael." *Die internationale Kunstwelt* 3 (1936), pp. 31–32.

Heppner 1937
———. "Der Maler und Erfinder Jan van der Heyden im Amsterdam Historischen Museum." *Internationale Kunstrevue*, 1937, pp. 99–100.

Heppner 1940
———. "Nicolaes Berchem als illustrator van het Nieuwe Testament." *Het Gildeboek* 23 (1940), pp. 81–85.

Héris 1839–40
H.J. Héris. "Sur la vie et les ouvrages de Mindert Hobbema." *La Renaissance* 1 (1839–40), pp. 5–7.

Héris 1854
———. *Notice raisonnée sur la vie et les ouvrages de Mindert Hobbéma.* Paris, 1854. (Reprinted in *Journal des beaux-arts et de la littérature* 6 [1864], pp. 163–68.)

Héris 1865
———. "Note sur la vie et des ouvrages de Jacques Ruisdael." *Journal des beaux-arts et de la littérature* 7 (1865), pp. 175–76.

Herzog 1969
Erich Herzog. *Die Gemäldegalerie der Staatliche Kunstsammlungen Kassel.* Kassel, 1969.

Hijmans 1951
H. Hijmans. *Wijk bij Duurstede.* Rotterdam, 1951.

Hind 1912
Arthur M. Hind. *Rembrandt's Etchings.* London, 1912.

Hind 1915–31
———. *Catalogue of Drawings by Dutch and Flemish Artists in the British Museum.* 4 vols. London, 1915–31.

Hind 1932
———. *Rembrandt.* Oxford, 1932.

Hoet 1752
Gerard Hoet. *Catalogue of naamlyst van schilderyen met derzelver pryzen.* The Hague, 1752. Reprint. Soest, 1976.

Hofmann 1906
Julius Hofmann. "Die Radierungen von Aelbert Cuyp." *Mitteilungen der Gesellschaft für vervielfältigende Kunst,* 1906, pp. 14–16.

Hofmann 1920
Johannes Hofmann. "Allart van Everdingen und Goethes Reineke Fuchs." *Zeitschrift für Bücherfreunde* 12 (1920), pp. 188–91.

Hofstede de Groot 1891
Cornelis Hofstede de Groot. "Die Malerfamilie Wouwerman." *Kunstchronik* 2 (1891), pp. 1–5.

Hofstede de Groot 1893a
———. *Arnold Houbraken und seine "Groot Schouburgh," kritisch beleuchtet.* The Hague, 1893.

Hofstede de Groot 1893b
———. "Hobbema's Laantje van Middelharnis." *Nederlandsche Spectator,* 1893, pp. 61–62.

Hofstede de Groot 1893c
———. "Hollandse Kunst in Schotland." *Oud Holland* 11 (1893.)

Hofstede de Groot 1895
———. "Nogmaals: Een merkwaardige verzameling teekeningen." *Oud Holland* 13 (1895), pp. 238–40.

Hofstede de Groot 1907–28
———. *Beschreibendes und kritisches Verzeichnis der Werke der hervorragendsten holländischen Maler des XVII. Jahrhunderts.* 10 vols. Esslingen and Paris, 1907–28. Reprint. Vols. 9–10, Cambridge, 1976.

Hofstede de Groot 1908–27
———. *A Catalogue Raisonné of the Works of the Most Eminent Dutch Painters of the Seventeenth Century.* Translated by Edward G. Hawke. 8 vols. London, 1908–27. Reprint. Cambridge, 1976.

Hofstede de Groot 1915–16a
———. "Aelbert Cuyp of Abraham van Kalraet?" *Oude Kunst* 1 (1915–16), pp. 143–45, 241–43, 314, 386.

Hofstede de Groot 1915–16b
———. "Inedita IX: François de Momper." *Oude Kunst* 1 (1915–16), pp. 213ff.

Hofstede de Groot 1917–18
———. "Een landschap van Meindert Hobbema." *Oude Kunst* 3 (1917–18), p. 70.

Hofstede de Groot 1923
———. "Jan van Goyen and His Followers." *Burlington Magazine* 42 (1923), pp. 4–27.

Hollstein
F.W.H. Hollstein. *Dutch and Flemish Etchings, Engravings, and Woodcuts.* Vol. 1–. Amsterdam, 1949–.

Holmes 1911
C.J. Holmes. *Notes on the Art of Rembrandt.* London, 1911.

J. Holmes 1930
Jerrold Holmes. "The Cuyps in America." *Art in America* 18 (1930), pp. 165–85.

J. Holmes 1933
———. "Aelbert Cuyp als Landschaftsmaler." Dissertation. Innsbruck, 1933.

't Hooft 1912
C.G. 't Hooft. *Amsterdamsche stadsgezichten van Jan van der Heyden.* Amsterdam, 1912.

Hoogendorn 1946
Annet Hoogendorn. "Hendrick Avercamp of Arent Arentsz.?" *Kunsthistorische Mededeelingen* 1 (1946), pp. 49–50.

Hoogewerff 1931
G.J. Hoogewerff. "Wanneer en hoe vaak was Berchem in Italië?" *Oud Holland* 48 (1931), pp. 84–87.

Hoogewerff 1932–33
———. "Pieter van Laer en zijn vrienden." *Oud Holland* 49 (1932), pp. 1–17, 205–20; 50 (1933), pp. 103–17, 250–62.

Hoogewerff 1933a
———. "Een schilderij en een teekening van Jan Both." *Oudheidkunding Jaarboek* 2 (1933), pp. 35–37.

Hoogewerff 1933b
———. "Uittreksel uit de 'Libri relationum barberiorum' (1550–1650)." *Mededeelingen van het Nederlandsch Historisch Instituut te Rome* 3 (1933), pp. 197–219.

Hoogewerff 1938
———. "Nederlandsche Kunstenaars te Rome, 1600–1725." *Mededeelingen van het Nederlandsch Historisch Instituut te Rome* 8 (1938), pp. 49–125.

Hoogewerff 1940
———. "Karel Dujardins schilderijen met gewijde voorstellingen." *Mededeelingen van het Nederlandsch Historisch Instituut te Rome* 10 (1940), pp. 107–21.

Hoogewerff 1941
———. "Het spokend ruiterstandbeeld." *Maandblad voor Beeldende Kunsten* 18 (1941), pp. 257–66.

Hoogewerff 1942–43
———. *Nederlandsche kunstenaars te Rome (1600–1725): Uittreksels uit de parochiale archieven.* The Hague, 1942–43.

Hoogewerff 1952
———. *De Bentvueghels.* The Hague, 1952.

Hoogewerff 1954
———. *Het landschap van Bosch tot Rubens.* Antwerp, 1954.

Hoogstraeten 1678
Samuel van Hoogstraeten. *Inleyding tot de hooge schoole der schilderkonst, anders de zichtbaere werelt.* Rotterdam, 1678. Reprint. Utrecht, 1969.

de Hoop Scheffer 1976
D. de Hoop Scheffer. "Onbeschreven staten in het etswerk van Jan Both." *Bulletin van het Rijksmuseum* (Amsterdam) 24 (1976), pp. 177–82.

Hos 1961
H.A.J. Hos. "A. van Everdingen in de Ardennen." *Oud Holland* 76 (1961), pp. 208–209.

Houbraken 1718–21
Arnold Houbraken. *De groote schouburgh der Nederlantsche konstschilders en schilderessen.* 3 vols. Amsterdam, 1718–21; 2nd printing, Amsterdam, 1753. Reprint. 1976.

Houplain 1957
Jacques Houplain. "Sur les estampes d'Hercules Seghers." *Gazette des beaux-arts* 49 (1957), pp. 149–64.

Hughes 1984
Anthony Hughes. Review of Freedberg 1980. *Burlington Magazine* 126 (1984), pp. 578–80.

Huizinga 1933
J. Huizinga. *Holländische Kultur des siebzehnten Jahrhunderts: Ihre soziale Grundlagen und nationale Eigenart.* Jena, 1933.

Huizinga 1948
———. *Nederlands beschaving in de zeventiende eeuw.* In *Verzamelde Werken,* vol. 2. Haarlem, 1948. English translation: *Dutch Civilization in the Seventeenth Century,* London, 1968.

Hull 1981
Hull, Ferens Art Gallery. *Scholars of Nature: The Collecting of Dutch Paintings in Britain 1610–1857.* Catalogue by Christopher Brown. 1981.

Huygens, Kan 1946
Constantijn Huygens. *De jeugd van Constantijn Huygens door hemzelf beschreven.* Ed. A.H. Kan. Rotterdam, 1946. Reprint. 1971.

Ilchester collection, cat. 1883
Catalogue of the Pictures Belonging to the Earl of Ilchester. By A. Fox Strangways. 1883.

Imdahl 1958
Max Imdahl. "Baumstellung und Raumwirkung." In *Festschrift Martin Wackernagel.* Cologne, 1958.

Imdahl 1961
———. "Ein Beitrag zu Meindert Hobbemas Allee von Middelharnis." In *Festschrift Kurt Badt zum 70. Gerburtstag.* Berlin, 1961.

Imdahl 1968
———. *Jacob van Ruisdael: Die Mühle von Wijk.* Stuttgart, 1968.

Immerzeel 1842–43
J. Immerzeel. *De levens en werken der Hollandsche en Vlaamsche kunstschilders, beeldhouwers, graveurs en bouwmeesters van het begin der 15e eeuw tot heden.* 3 vols. Amsterdam, 1842–43.

Isarlov 1936
George Isarlov. "Rembrandt et son entourage." *La Renaissance* 19 (1936), pp. 1–50.

Ising 1889
Arnold Ising. "Een schilder-dichter uit de zeventiende eeuw [Adriaen van de Venne]." *De Gids,* 1889, pp. 129–56.

Israel 1977
J.I. Israel. "Spain and the Netherlands: A Conflict of Empires, 1618–1648." *Past and Present* 76 (1977), pp. 45–47.

Jameson 1844
Mrs. [Anna B.] Jameson. *Companion to the Most Celebrated Private Galleries of Art in London.* London, 1844.

Janeck 1968
A. Janeck. *Untersuchung über den holländischen Maler Pieter van Laer, genannt Bamboccio.* Dissertation. Würzburg, 1968.

Jansen 1985
Guido Jansen. "Berchem in Italy: Notes on an Unpublished Painting." *Mercury* 2 (1985), pp. 13–17.

Jantzen 1910
Hans Jantzen. "De ruimte in de hollandsche zeeschildering." *Onze Kunst* 18 (1910), pp. 105–17.

Jegenstorf 1955
Schloss Jegenstorf. *Alte Meister aus der Sammlung E. Bührle.* 1955.

de Jonge 1932
C.H. de Jonge. "Utrechtsche schilders der XVIIde eeuw in de verzameling van Willem Vincent, Baron van Wyttenhorst." *Oudheidkundig Jaarboek* 1 (1932), pp. 120–34.

E. de Jongh 1967
E. de Jongh. *Zinne- en minnebeelden om de schilderkunst van de zeventiende eeuw.* 1967.

J. de Jongh 1903–1904
Johanna de Jongh. "Een verbetering [Over de Handteekening van Hendrick Avercamp]." *Bulletin van den Nederlandsche Oudheidkundigen Bond* 5 (1903–1904), pp. 151–52.

J. de Jongh 1905
———. *Die holländische Landschaftsmalerei.* Dissertation. Berlin, 1903. Berlin, 1905. (Published in Dutch, 1903.)

Joppien 1979
R. Joppien. "The Dutch Vision of Brazil: Johan Maurits and His Artists." In *Johan Maurits von Nassau-Siegen 1604–1679: Humanist Prince in Europe and Brazil: Essays on the Occasion of the Tercentenary of his Death.* Ed. E. van den Boogaart. The Hague, 1979.

Juynboll 1933
R. Juynboll. Review of C. Welcker, *Hendrick Avercamp en Barent Avercamp, "Schilders tot Campen"* (Zwolle, 1933). *Oudheidkundig Jaarboek* 2 (1933), pp. 149–50.

Juynboll 1935
———. Review of G. Naumann, *Die Landschaftszeichnungen des Bartholomeus Breenbergh* (Wertheim, 1933). *Oudheidkundig Jaarboek* 4 (1935), p. 31.

Kaemmerer 1975
Christian Kaemmerer. *Die klassisch-heroische Landschaft in der niederländischen Landschaftsmalerei.* Dissertation. Berlin, 1975.

Kahr 1978
Madlyn Millner Kahr. *Dutch Painting in the Seventeenth Century.* New York, 1978.

Kalff 1920
S. Kalff. "De gebroeders Wouwerman." *Elsevier* 30 (1920), pp. 96–103.

Kamenskaja 1937
T. Kamenskaja. "Unveröffentlichte Zeichnungen Abraham Bloemaerts in der Ermitage." *Oud Holland* 54 (1937), pp. 145–63.

Kampen 1949
Kampen, Oude Raadhuis. *Avercamp tentoonstelling.* 1949.

Kannegieter 1942
J.Z. Kannegieter. "Het huis van Hercules Segers op de Lindengracht te Amsterdam." *Oud Holland* 59 (1942), pp. 150–57.

Kassel, cat. 1783
Verzeichniss der nochfürstlich-heissischen Gemälde-Sammlung in Cassel. 1783. (Rev. ed. 1830.)

Kassel, cat. 1888
Katalog der königlichen Gemälde-Galerie zu Cassel. By Oscar Eisenmann. 1888. (Rev. ed. 1913.)

Kassel, cat. 1904
Die Meisterwerke der König. Gemälde-Galerie zu Cassel. Catalogue by Karl Voll. 1904.

Kassel, cat. 1958
Kassel, Staatliche Kunstsammlungen, Gemäldegalerie. *Katalog der Staatliche Gemäldegalerie zu Kassel.* By Hans Vogel. 1958.

Kassel, cat. 1965
Holländische Meister des 17. Jahrhunderts. Kassel, 1965.

Kauffman 1923
Hans Kauffman. "Die Farbenkunst des Aert van der Neer." In *Festschrift für Adolph Goldschmidt zum 60. Geburtstag.* Leipzig, 1923.

Kauffmann 1929
———. Review of J. Rosenberg, *Jacob van Ruisdael* (Berlin, 1929). *Kunst und Künstler* 27 (1929), pp. 404–406.

Kauffmann 1977
———. "Jacob van Ruisdael: 'Die Mühle von Wijk bei Duurstede'." In *Festschrift für Otto von Simson zum 65. Geburtstag.* Frankfurt, 1977.

Kelch 1971
Jan Kelch. *Studien zu Simon de Vlieger als Marinemaler.* Dissertation. Berlin, 1971.

Keleti 1871
G. Keleti. *Az Esterházy-Keptar eredeti feny kepekben.* Budapest, 1871.

van der Kellen 1866
J.Ph. van der Kellen. *Le peintre-graveur hollandais et flamand.* Utrecht, 1866.

van der Kellen 1870
———. "De studieboeken van Paulus Potter in het museum te Berlijn en de Callot's te Venetië." *Nederlandsche Spectator,* 1870, pp. 62–63.

van der Kellen 1928
———. *Teekeningen door Jan van Goyen uit het Rijksprentenkabinet te Amsterdam.* Amsterdam, 1928.

Kettering 1983
Alison McNeil Kettering. *The Dutch Arcadia: Pastoral Art and Its Audience in the Golden Age.* Montclair, N.J., 1983.

Keyes 1975
George S. Keyes. *Cornelis Vroom, Marine and Landscape Artist.* 2 vols. Dissertation. Utrecht, 1975.

Keyes 1977
———. "Les eaux-fortes de Ruisdael." *Nouvelles de l'estampe* 36 (Nov.–Dec. 1977), pp. 7–20.

Keyes 1978
———. "Landscape Drawings by Alexander Keirincx and Abraham Govaerts." *Master Drawings* 16 (1978), pp. 293–302.

Keyes 1980
———. "Jacob Pynas as a Draughtsman." *Bulletin des Musées Royaux des Beaux-Arts* (Brussels) 23–29 (1974–80), pp. 147–70.

Keyes 1982
———. "Hendrick and Cornelis Vroom: Addenda." *Master Drawings* 20 (1982), pp. 115–24.

Keyes 1984
———. *Esaias van den Velde 1587–1630.* With a biographical chapter by J.G.C.A. Briels. Doornspijk, 1984.

Kirschenbaum 1977
Baruch D. Kirschenbaum. *The Religious and Historical Paintings of Jan Steen.* New York, 1977.

Kitson 1958
Michael Kitson. "Claude Lorrain et le Campo Vaccino." *Revue des arts* 8 (1958), pp. 215–20, 259–66.

Kitson 1982
———. *Rembrandt.* London, 1982. (1st ed. 1969.)

Klessmann 1960
Rüdiger Klessmann. "Die Anfänge des Bauerninteriors bei den Brüdern Ostade." *Jahrbuch der Berliner Museen* 2 (1960), pp. 92–115.

Klessmann 1965
———. "Die Landschaft mit der büssenden Magdalena von Jacob Pynas." *Berliner Museen* 15 (1965), pp. 7–11.

Kleve 1979
Kleve, Städtisches Museum Haus Koekkoek. *Soweit der Erdkreis reicht: Johann Moritz von Nassau-Siegen 1604–1679.* 1979.

Kleyn 1944
A.R. Kleyn. "Jan van der Heyden." *Sibbe* 4 (1944), pp. 33–45.

de Klijn 1982
M. de Klijn. *De invloed van het Calvinism op de Noord-Nederlandse landschapsschilderkunst 1570–1630.* Apeldoorn, 1982.

Klinge-Gross 1977
Margaret Klinge-Gross. "Herman Saftleven als Zeichner und Maler bäuerlicher Interieurs." *Wallraf-Richartz-Jahrbuch* 38 (1977), pp. 68–91.

Kloek 1975
W. Th. Kloek. "Een berglandschap door Roelant Roghman." *Bulletin van het Rijksmuseum* (Amsterdam) 23 (1975), pp. 100–101.

Knab 1960
Eckhart Knab. "Die Anfänge des Claude Lorrain." *Jahrbuch der kunsthistorischen Sammlungen in Wien* 56 (1960), pp. 63–164.

Knab 1962
————. "Bij een landschap van Jan Both." *Bulletin van het Museum Boymans-van Beuningen* (Rotterdam) 13 (1962), pp. 46–58.

Knab 1969
————. "De genio loci." In *Miscellanea I.Q. van Regteren Altena.* Amsterdam, 1969.

Knuttel 1917
G. Knuttel. *Das Gemälde des Seelenfischfangs von Adriaen Pietersz. van de Venne.* The Hague, 1917.

Knuttel 1938
————. *De nederlandsche schilderkunst van van Eyck tot van Gogh.* Amsterdam, 1938.

Knuttel 1941
————. *Hercules Seghers.* Amsterdam [1941].

Knuttel 1956
————. *Rembrandt: De meester en zijn werk.* Amsterdam, 1956.

Knuttel 1962
————. *Adriaen Brouwer.* The Hague, 1962.

Koch 1968
Robert A. Koch. *Joachim Patinir.* New York, 1968.

Konradi 1935
V. Konradi. *Jacob van Ruisdael.* Moscow, 1935. (In Russian.)

Koppius 1839–40
P.A. Koppius. "Meindert Hobbema." *Drentsche Volksalmanak* 3 (1839), pp. 114–28; 4 (1840), pp. 120–30.

Korevaar-Hesseling 1944
E.H. Korevaar-Hesseling. *Het landschap in de Nederlandse en Vlaamse schilderkunst.* Amsterdam [c.1944].

Korn 1978
U.D. Korn. "Ruisdael in Steinfurt." *Westfalen: Hefte für Geschichte, Kunst und Volkskunde* 56 (1978), pp. 111–14.

Kramm 1857–64
Christiaan Kramm. *De levens en werken der Hollandsche en Vlaamsche kunstschilders, beeldhouwers, graveurs en bouwmeesters, van den vroegsten tot op onzen tijd.* 6 vols. Amsterdam, 1857–64.

Krautheimer 1948
Richard Krautheimer. "The Tragic and Comic Scene of the Renaissance." *Gazette des beaux-arts* 33 (1948), pp. 327–46.

Krefeld 1938
Krefeld, Kaiser-Wilhelm-Museum. *Deutsche Landschaften und Städte in der niederländischen Kunst des 16.–18. Jahrhunderts.* 1938.

de Kruyff 1882–83
C.A. de Kruyff. "Iets over Abr. Blommaert of Bloemaert." *Obreen's Archief* 5 (1882–83), pp. 333–35.

ter Kuile 1976
O. ter Kuile. *500 Jaar Nederlandse Schilderkunst.* Amsterdam, 1976.

Kühn 1965
Hermann Kühn. "Untersuchungen zu den Malgründen Rembrandts," *Jahrbuch der staatlichen Kunstsammlungen in Baden-Württemberg* 2 (1965), pp. 189–210.

Kurtz 1958
G.H. Kurtz. "Nog eens: Bodding (Van Laer)." *Oud Holland* 73 (1958), pp. 231–32.

Kunstreich 1959
J.S. Kunstreich. *Der geistreiche Willem: Studien zu Willem Buytewech 1591–1624.* Cologne, 1959.

Kuznetsov 1960
Y. Kuznetsov. "Claes Berchem and His Works in the State Collections Hermitage." In *Iz istorii russkogo i zapadnoevropeiskogo iskusstva (Sbornik posvyashchen 40 – letiyu nauchnoi deyatel'nosti V. N. Lazarev).* Moscow, 1960. (In Russian.)

Kuznetsov 1973
————. "Sur le symbolisme dans les paysages de Jacob de Ruisdael." *Bulletin du Musée National de Varsovie* 14 (1973), pp. 31–41.

Kuznetsov, Linnik 1982
Y. Kuznetsov and I. Linnik. *Dutch Paintings in Soviet Museums.* New York, 1982.

Laansma 1965
S. Laansma. "Adriaan van de Venne en het 'Tabacksuygen.'" *Amstelodamum* 52 (1965), pp. 40–47.

Lacrois 1861–62
P. Lacrois. "Musée du palais de l'Ermitage sous le règne de Catherine II." *Revue universelle des arts* 13–15 (1861–1862).

Laes 1931
Arthur Laes. "Le peintre courtraisien Roelant Savery." *Revue belge d'archéologie et d'histoire de l'art* 1 (1931), pp. 315–37.

Laes 1939
————. "Gillis van Coninxloo, rénovateur du paysage flamand au XVIe siècle." *Annuaire des Musées Royaux des Beaux-Arts* (Brussels) 2 (1939), pp. 109–22.

Laes 1954
————. "Paysages de Josse et Frans de Momper." *Bulletin des Musées Royaux des Beaux-Arts* (Brussels) 1 (1952), pp. 57–67.

Lairesse 1707
Gerard de Lairesse. *Het groot schilderboek.* Amsterdam, 1707. Reprint. Soest, 1969.

Laren 1958
Laren, Singer Museum. *Kunstbezit rondom Laren.* 1958.

Laren 1959
————. *Kunstschatten: Twee Nederlandse collecties schilderijen.* 1959.

Larsen 1962
Erik Larsen. *Frans Post, interprète du Brésil.* Amsterdam, 1962.

Larsen 1982
————. "Supplements to the Catalogue of Frans Post." *Burlington Magazine* 124 (1982), pp. 339–43.

Larsen 1983
————. *Rembrandt, peintre de paysage: Une vision nouvelle.* Louvain-la-Neuve, 1983.

Lavin 1975
Marilyn A. Lavin. *Seventeenth-Century Barberini Documents and Inventories of Art.* New York, 1975.

Lebeer 1979
Louis Lebeer. *Beredeneerde catalogus van de prenten naar Pieter Bruegel de Oude.* Brussels, 1979.

Lecaldano 1973
P. Lecaldano. *The Complete Paintings of Rembrandt.* London, 1973. (Originally published in Italian, 1969.)

Ledermann 1920
Ida Ledermann. "Beiträge zur Geschichte des romanistischen Landschaftsbildes in Holland und seines Einflusses auf die nationale Schule um die Mitte des XVII. Jahrhunderts." Dissertation. Berlin, 1920.

Leeuwen 1970
F. van Leeuwen. "Iets over het handschrift van de 'naar het leven' tekenaar." *Oud Holland* 85 (1970), pp. 25–32.

Lehmann 1976
Jürgen M. Lehmann. "Kasseler Bacchanales." In *Festschrift für Gerhard Kleiner.* Tübingen, 1976.

Leiden 1965
Leiden, Stedelijk Museum "de Lakenhal". *17de eeuwse meesters uit Nederlandse particulier bezit.* 1965.

Leiden 1972
————. *Het Hollandse 17de eeuwse landschap.* 1972.

Leiden/Arnhem 1960
————. *Jan van Goyen.* 1960. Also shown at Arnhem, Gemeentemuseum.

Lemmens 1979
Gerard Th. M. Lemmens. "Die Schenkung an Ludwig XIV. und die Auflösung des brasilianischen Sammlung des Johann Moritz 1652–1679." In *Kleve 1979,* pp. 265–93.

Leningrad 1960
Leningrad, Hermitage. *Adrian van Ostade.* 1960. Catalogue by Y. Kuznetsov.

Leningrad, cat. 1870
St. Petersburg, The Hermitage. *Ermitage Impérial. Catalogue de la galerie de tableaux.* vol. 2. 1870. (Rev. eds. 1895, 1901, 1916.)

Leningrad, cat. 1904
————. *Les trésors d'art en Russie.* 1904.

Leningrad, cat. 1958
Leningrad, Hermitage. *Hermitage State Museum, Department of Western Art. Catalogue of Painting.* 2 vols. 1958.

Leuchtenberg coll., cat. 1830
Catalogue des tableaux de la Galerie le Prince Eugène, Duc de Leuchtenberg. Munich, 1830. (Rev. ed. 1845.)

Leuchtenberg coll., cat. 1886
Leuchtenberg Galerie. St. Petersburg, 1886.

van Leusden 1961
Willem van Leusden. *The Etchings of Hercules Segers and the Problems of His Graphic Technique.* Utrecht, 1961. (Dutch ed. 1960.)

Lewinson-Lessing 1963
W.F. Lewinson-Lessing. *Meisterwerke aus der Eremitage: Malerei des 17. und 18. Jahrhunderts.* Leningrad, 1963.

Leymarie 1956
Jean Leymarie. *Dutch Painting.* Trans. by Stuart Gilbert. New York, 1956.

Lille 1972
Lille, Musée des Beaux-Arts. *Trésors des musées du Nord de la France: I. Peinture hollandaise.* Catalogue by Jacques Foucart. 1972. Also shown at Arras and Dunkirk.

London 1883
London, Bethnal Green Museum. *Collection of Paintings Lent for Exhibition by the Marquess of Bute.* 1883.

London 1929
London, Royal Academy of Arts. *Exhibition of Dutch Art, 1450–1900*. 1929.

London 1938
———. *Catalogue of the Exhibition of 17th Century Art in Europe.* 1938.

London 1946–47
———. *The King's Pictures at the Royal Academy of Arts.* 1946–47.

London 1952–53
———. *Dutch Pictures 1450–1750.* 1952–53.

London 1955
London, Wildenstein and Co. *Artists in 17th Century Rome.* 1955.

London 1971
London, Queen's Gallery. *Dutch Pictures from the Royal Collection.* Introduction by Oliver Millar. 1971.

London 1973
London, National Gallery. *Aelbert Cuyp in British Collections.* 1973.

London 1976a
———. *Art in Seventeenth Century Holland.* 1976.

London 1976b
London, Alan Jacobs Gallery. *Jan van Goyen.* 1976.

London 1978
London, Thos. Agnew and Sons. *Dutch and Flemish Pictures from Scottish Collections.* 1978.

London 1985
London, National Gallery. *Masterpieces from the National Gallery of Ireland.* Catalogue by Homan Potterton. 1985.

London 1986
———. *Dutch Landscape: The Early Years, Haarlem and Amsterdam 1590–1650.* Catalogue by Christopher Brown et al. 1986.

London, National Gallery cat. 1973
London, National Gallery. *Illustrated General Catalogue.* 1973.

London, Royal Collection cat. 1841
Catalogue of Her Majesty's Pictures in Buckingham Palace. By W. Seguier. 1841.

London, Royal Collection cat. 1852
Catalogue of the Pictures in Her Majesty's Gallery at Buckingham Palace. By T. Unwins. 1852.

London, Wallace cat. 1968
London, Wallace Collection. *Wallace Collection Catalogues: Pictures and Drawings.* 1968.

Longhi 1957
Roberto Longhi. "Una traccia per Filippo Napoletano." *Paragone* 8 (1957), pp. 33–62.

van Loo 1899
A.W. Sanders van Loo. "Iets over A.P. van de Venne." *De Vlaamsche School* 3 (1899), pp. 347–53.

von Lorck 1936
C. von Lorck. "Goethe und Lessings 'Klosterhof im Schnee'." *Westdeutsches Jahrbuch für Kunstgeschichte (Wallraf-Richartz-Jahrbuch)* 9 (1936), pp. 205ff.

Lorenzetti 1934
C. Lorenzetti. *Gaspar Vanvitelli.* Milan, 1934.

Los Angeles/Boston/New York 1981–82
Los Angeles County Museum of Art. *A Mirror of Nature: Dutch Paintings from the Collection of Mr. and Mrs. Edward William Carter.* Catalogue by John Walsh and Cynthia P. Schneider. 1981–82.

Also shown at Boston, Museum of Fine Arts, 1982; New York, The Metropolitan Museum of Art, 1982.

Lugano 1985
Lugano, Thyssen-Bornemisza Collection. *Capolavori da musei ungheresi.* 1985.

Lugano, cat. 1937
Sammlung Schloss Rohoncz. 1937. (Rev. ed. 1958.)

Lugano, cat. 1969
Lugano, Thyssen-Bornemisza Collection. *The Thyssen-Bornemisza Collection.* Catalogue by J.C. Ebbinge Wubben. 2 vols. 1969.

Lugano, cat. 1986
———. *Catalogue Raisonné of the Exhibited Works of Art.* 1986.

Lugt 1915
Frits Lugt. *Wandelingen met Rembrandt in en om Amsterdam.* Amsterdam, 1915. (German ed. *Mit Rembrandt in Amsterdam.* Berlin, 1920.)

Lugt 1927
———. *Les dessins des écoles du Nord de la collection Dutuit.* Paris, 1927.

H. van Luttervelt 1955
H. van Luttervelt. "Ein nieuwe aanwinst voor de historische afdeling van het Rijksmuseum: Een schilderij van J.B. Weenix." *Bulletin van het Rijksmuseum* (Amsterdam) 2 (1955), pp. 9–16.

R. van Luttervelt 1949
R. van Luttervelt. "Een gezicht op Haarlem van Jacob van Ruysdael." *Historia: Maandschrift voor geschiedenis en kunstgeschiedenis* 14 (1949), pp. 223–25.

Lützeler 1950
Heinrich Lützeler, "Vom Wesen der Landschaftsmalerei." *Studium Generale* 3 (1950), pp. 210ff.

Lützow 1875
C. von Lützow. "Ein Stadtbild von Hobbema." *Kunstchronik* 10 (1875), pp. 193–95.

Luyken 1711
Jan Luyken. *De bykorf des gemoeds.* Amsterdam, 1711.

de Luynsche 1940
Th. H. de Luynsche. "David Vinckboons en het Kastell van Verneuil." *Oud Holland* 57 (1940), pp. 206–11.

Maclaren 1938
Neil Maclaren. Review of G. Broulhiet, *Meindert Hobbema* (Paris, 1938). *Burlington Magazine* 74 (1939), pp. 43–44.

Maclaren 1960
———. *National Gallery Catalogues: The Dutch School.* London, 1960.

Manchester 1857
Manchester. *Catalogue of the Art Treasures of the United Kingdom, Collected at Manchester in 1857.* Ed. J.B. Waring. 1857.

Manchester 1885
Manchester, Queen's Park Museum and Art Gallery. *The Bute Collection of Pictures.* Catalogue by J.P. Richter. 1885.

van Mander 1604
Karel van Mander. *Het Schilderboeck.* Haarlem, 1604. Reprint. Utrecht, 1969.

van Mander, Miedema 1973
Hessel Miedema. *Karel van Mander. Den grondt der edel vry schilderconst.* 2 vols. Utrecht, 1973.

Mannheim 1962
Mannheim, Städtisches Reiss-Museum. *Die Frankenthaler Maler.* Catalogue by H. Wellensiek. 1962.

Mantz 1875
Paul Mantz. "Jan van Goyen." *Gazette des beaux-arts* 12 (1875), pp. 138–51, 298–311.

Marguery 1925
Henri Marguery. "Les animaux dan l'oeuvre de Karel Du Jardin." *Amateur d'estampes* 4 (1925), pp. 80–86.

Marguery 1926
———. "Quelques paysages gravés d'Aldert van Everdingen." *Amateur d'estampes* 5 (1926), pp. 117–23.

Martin 1905–1908
Willem Martin. "The Life of a Dutch Artist in the Seventeenth Century." *Burlington Magazine* 7 (1905), pp. 125–28, 416–27; 8 (1905–1906), pp. 13–24; 10 (1906–1907), pp. 144–54, 363–70; 11 (1907), pp. 357–69.

Martin 1908
———. "Über den Geschmack des holländischen Publikums im XVII. Jahrhundert mit Bezug auf die damalige Malerei." *Monatshefte für Kunstwissenschaft* 1 (1908), pp. 727–53.

Martin 1929
———. Review of J. Rosenberg, *Jacob van Ruisdael* (Berlin, 1928). *Repertorium für Kunstwissenschaft* 50 (1929), pp. 164–68.

Martin 1935–36
———. *De Hollandsche schilderkunst in de zeventiende eeuw.* 2 vols. Amsterdam, 1935–36. (2nd ed. 1942.)

Martin 1950
———. *De schilderkunst in de tweede helft van de zeventiende eeuw.* Amsterdam, 1950. (English ed. 1951.)

Maschmeyer 1978
D. Maschmeyer. "Jacob Isaackszoon van Ruisdael und Meindert Hobbema malen Motive aus der Grafschaft Bentheim und ihrer Umgebung." *Jahrbuch des Heimatvereins der Grafschaft Bentheim, Das Bentheimer Land* 92 (1978), pp. 61–71.

Mayer 1910
Anton Mayer. *Das Leben und die Werke der Brüder Matthäus und Paul Bril.* Leipzig, 1910.

Meyssens 1649
Jan Meyssens. *Images du divers hommes d'esprit sublime.* Antwerp, 1649.

Michalkowa 1971
Janina Michalkowa. "Quelques remarques sur Pieter van Laer." *Oud Holland* 86 (1971), pp. 188–95.

A. Michel 1887
André Michel. "Le Musée de Brunswick." *Gazette des beaux-arts* 35 (1887), p. 22.

Michel 1886
Emile Michel. "Meindert Hobbema." *L'Art* 40 (1886), pp. 257–63; 41 (1887), pp. 3–9.

Michel 1888a
———. "Jacob van Ruisdael." *Revue des deux mondes* 86 (1888), pp. 835–69.

Michel 1888b
———. "Les van de Velde." *Gazette des beaux-arts* 37 (1888), pp. 177–96, 397–406, 490–501; 38 (1888), pp. 265–84.

Michel 1890a
———. *Hobbema et les paysagistes de son temps en Hollande.* Paris, 1890.

Michel 1890b
———. *Jacob van Ruisdael et les paysagistes de l'école de Haarlem.* Paris, 1890.

Michel 1892a
———. "Adriaen van de Velde." *L'Art* 53 (1892), pp. 54–58.

Michel 1892b
———. "Une famille d'artistes hollandais: Les Cuyps." *Gazette des beaux-arts* 34 (1892), pp. 5–23, 107–17, 225–38.

Michel 1892c
———. *Les van de Velde.* Paris, 1892.

Michel 1893
———. *Rembrandt: Sa vie, son oeuvre et son temps.* Paris, 1893.

Michel 1894
———. *Rembrandt: His Life, His Work and His Time.* 2 vols. London, 1894.

Michel 1906
———. *Paulus Potter.* Paris, 1906.

Michiels 1865–76
Alfred Michiels. *Histoire de la peinture flamande.* 10 vols. Paris, 1865–76.

Michiels 1870
———. "David Vinckboons." *Kunstkronijk* 11 (1870), pp. 13–15.

Miedema 1980
Hessel Miedema. *De archiefbescheiden van het St. Lukasgilde te Haarlem.* Alphen aan den Rijn, 1980.

Milan 1954
Milan, Palazzo Reale. *Pittura olandese del seicento.* 1954.

Minneapolis/Houston/San Diego 1985
Minneapolis Institute of Arts. *Dutch and Flemish Masters: Paintings from the Vienna Academy of Fine Arts.* Catalogue by George S. Keyes and Renate Trnek. 1985. Also shown at Houston, Museum of Fine Arts, and San Diego Museum of Art.

Moes 1894a
E.W. Moes. "Een te weinig opgemerkte bron over het leven van Pieter van Laer." *Oud Holland* 12 (1894), pp. 95–106.

Moes 1894b
———. "Een brief van kunsthistorische betekenis." *Oud Holland* 12 (1894), pp. 234–40.

Moes 1895
———. "Een merkwaardige verzameling teekeningen." *Oud Holland* 13 (1895), pp. 182–92.

Moes 1900
———. "Brieven van oud Hollandsche kunstenaars." *Oud Holland* 18 (1900), pp. 217–25.

Moes, van Biema 1909
E.W. Moes and E. van Biema. *De Nationale Konst-Gallery en Het Koninklijk Museum.* Amsterdam, 1909.

Molkenboer 1925–27
B.H. Molkenboer. "Vondel en de kunst." *Studia Catholica* 2 (1925–26), pp. 472–87; 3 (1926–27), pp. 94–118.

Molkenboer 1926–27
———. "Utrecht, Vondel, Zachtleven en Booth." *Verslagen vereeniging het Vondelmuseum* 13 (1926–27), pp. 16–27.

Moltke 1965
J.W. von Moltke. *Govaert Flinck, 1615–1660.* Amsterdam, 1965.

de Monconys 1665–66
Balthasar de Monconys. *Journal des voyages de Monsieur de Monconys.* Vol. 2: *Voyage de Pays-Bas, zomer 1663.* Lyons, 1665–66.

Montias 1982
John Michael Montias. *Artists and Artisans in Delft in the Seventeenth*

Century: *A Socio-Economic Study of the Seventeenth Century.* Princeton, 1982.

Montreal/Toronto 1969
Montreal Museum of Fine Arts. *Rembrandt and His Pupils.* 1969. Also shown at Toronto, Art Gallery of Ontario.

Moyreau 1737
Jean Moyreau. *Oeuvres de Ph.pe Wouwermens hollandois.* Paris, 1737.

Mulder 1937
Adriana W.J. Mulder. "De huwelijksloterij: Grisaille door Adriaan van de Venne." *Vereeniging Oranje-Nassau Museum,* 1937, pp. 24–25.

Müllenmeister 1973–81
Kurt Müllenmeister. *Meer und Land im Licht des 17. Jahrhunderts.* 3 vols. Bremen, 1973–81.

Müllenmeister 1980
———. "Charme der Tieridylle: Ein Blick auf das Werk des Malers Paulus Potter." *Kunst und Antiquitäten* 4 (1980).

Müllenmeister 1987
———. *Roelandt Savery: Die Gemälde.* Freren, 1987.

Müller 1927
Cornelis Müller. "Abraham Bloemaert als Landschaftsmaler." *Oud Holland* 44 (1927), pp. 193–208.

Müller 1928
———. "Neuerworbene holländische Landschaften im Kaiser Friedrich Museum, II: Pieter van Santvoort." *Berliner Museen* 49 (1928), pp. 64–67.

Müller Hofstede 1929
Cornelis Müller Hofstede. "Studien zu Lastman und Rembrandt." *Jahrbuch der Preussischen Kunstsammlungen* 50 (1929), pp. 45–83.

Müller Hofstede 1931
———. "Jacob Pynas." *Jahrbuch der Preussischen Kunstsammlungen* 54 (1931), pp. 199–200.

F. Muller 1863–82
Frederik Muller. *De Nederlandsche geschiedenis in platen.* 4 vols. Amsterdam, 1863–1882.

S. Muller 1880
Samuel Muller. *De Utrechtsche Archieven.* I: *Schildersvereenigingen te Utrecht.* Utrecht, 1880.

Münch 1960
Ottheinz Münch. "Ein Spätwerk des Gillis van Coninxloo." *Mitteilungen des Historisch Vereins der Pfalz* 58 (1960), pp. 275ff.

Munich 1983
Munich, Haus der Kunst. *Im Lichte von Claude Lorrain: Landschaftsmalerei aus drei Jahrhunderten.* Catalogue by Marcel Roethlisberger. 1983.

Munich, cat. 1961
———. *Kataloge I: Deutsche und Niederländische Malerei zwischen Renaissance und Barock.* 1961. (Rev. eds. 1963, 1973.)

Munich, cat. 1983
———. *Erläuterungen zu den ausgestellten Gemälden.* 1983.

Münz 1952
Ludwig Münz. *A Critical Catalogue of Rembrandt's Etchings.* London, 1952.

Münz 1961
———. *Bruegel: The Drawings.* London, 1961.

Nagler 1835–52
G.K. Nagler. *Neues allgemeines Künstler-Lexikon.* 22 vols. Munich, 1835–52.

Nagler 1858–79
———. *Die Monogrammisten und die jenigen bekannten und unbekannten Künstler.* 5 vols. Munich, 1858–79. Reprint. Nieuwkoop, 1977.

Nalis 1972–73
H. Nalis. "Bartholomeus Breenbergh." *Vereeniging tot Beoefening van Overijsselsch Regt en Geschiedenis, Verslagen en Mededelingen,* 1972, pp. 62ff; 1973, pp. 51ff.

Nanninga Uitterdijk 1879–80
J. Nanninga Uitterdijk. "Een en ander over Hendrik Avercamp, den Stomme van Kampen, en zijne werken." *Obreen's Archief* 2 (1879–80), pp. 195–234, 270–71.

Nash 1972
J.M. Nash. *The Age of Rembrandt and Vermeer.* New York, 1972.

Naumann 1931
Gertraut Naumann. *Die Landschaftzeichnungen des Bartholomeus Breenbergh.* Dissertation. Heidelberg, 1931. (Published Wertheim, 1933.)

New Brunswick 1983
New Brunswick, N.J. The Jane Voorhees Zimmerli Art Museum. *Haarlem: The Seventeenth Century.* Catalogue by Frima Fox Hofrichter et al. 1983.

New London 1962
New London, Lyman Allyn Museum. *The Golden Age of Dutch Painting.* 1962.

New York 1909
New York, The Metropolitan Museum of Art. *Loan Exhibition of Paintings by Old Dutch Masters Held in Connection with the Hudson-Fulton Celebration.* 1909.

New York 1942
New York, Duveen Galleries. *Paintings by the Great Dutch Masters . . . in Aid of the Queen Wilhemina Fund.* 1942.

New York 1959
New York, Wildenstein Gallery. *Masterpieces of the Corcoran Gallery of Art.* 1959.

New York 1983
New York, Hoogsteder-Naumann Ltd. *A Selection of Dutch and Flemish Seventeenth-Century Paintings.* Catalogue by Otto Naumann. 1983.

New York 1985a
New York, Minskoff Cultural Center. *The Golden Ambience: Dutch Landscape Painting in the Seventeenth Century.* Catalogue by Walter Liedtke. 1985.

New York 1985b
New York, Richard L. Feigen & Co. *Landscape Painting in Rome 1595–1675.* Catalogue by Ann Sutherland Harris et al. 1985.

New York/Paris 1977–78
New York, The Pierpont Morgan Library. *Rembrandt and His Century: Dutch Drawings of the Seventeenth Century from the Collection of Frits Lugt.* 1977–78. Also shown at Paris, Institut Néerlandais, 1978.

New York/Toledo/Toronto 1954–55
New York, The Metropolitan Museum of Art. *Dutch Painting: The Golden Age.* 1954–55. Also shown at Toledo Museum of Art, and Art Gallery of Toronto.

New York, Metropolitan cat. 1980
———. *European Paintings in the Metropolitan Museum of Art: A Summary Catalogue.* By Katherine Baetjer. 3 vols. 1980.

Newcastle-upon-Tyne 1983
Newcastle-upon-Tyne, Laing Art Gallery. *Dutch Landscape Painting.* Catalogue by Christopher Wright. 1983.

Nicolson 1979
Benedict Nicolson. *The International Caravaggesque Movement: Lists of Pictures by Caravaggio and His Followers throughout Europe from 1590–1650.* Oxford, 1979.

Niemeijer 1959
J.W. Niemeijer. "Het topografisch element in enkele riviergezichten van S. van Ruysdael nader beschouwd." *Oud Holland* 74 (1959), pp. 51–56.

Niemeijer 1960
———. "Johannes op Patmos door Abraham Bloemaert." *Oud Holland* 75 (1960), pp. 240–42.

Nieuwstraten 1963
J. Nieuwstraten. "Dutch Landscapes at Dordrecht." *Apollo* 19 (1963), pp. 226–27.

Nieuwstraten 1965a
———. "Netherlandish Italianising Landscape Painters at Utrecht." *Burlington Magazine* 107 (1965), pp. 271–75.

Nieuwstraten 1965b
———. "De ontwikkeling van Herman Saftlevens kunst tot 1650." *Nederlands Kunsthistorisch Jaarboek* 16 (1965), pp. 81–117.

Nieuwstraten 1965c
———. "Een ontlening van Cuyp aan Claude Lorrain." *Oud Holland* 80 (1965), pp. 192–95.

Noack 1929
F. Noack. "Kunstpflege und Kunstbesitz der Familie Borghese." *Repertorium für Kunstwissenschaft* 50 (1929), pp. 191–231.

Novotny 1948
Fritz Novotny. *Die Monatsbilder Pieter Bruegels des Älteren.* Vienna, 1948.

Obreen 1877–90
Fr. D.O. Obreen, ed. *Archief voor Nederlandsche Kunstgeschiedenis.* 7 vols. Rotterdam, 1877–90. Reprint. Soest, 1976.

Oehler 1967
Lisa Oehler. "Zu einigen Bildern aus Elsheimers Umkreis." *Städel-Jahrbuch* 1 (1967), pp. 148–70.

Offerhaus 1960
J. Offerhaus. "Gezicht op Casteel van Rome." *Bulletin van het Rijksmuseum* (Amsterdam) 8 (1960), pp. 97–103.

Ogden, Ogden 1955
Henry V.S. Ogden and Margaret S. Ogden. *English Taste in Landscape in the Seventeenth Century.* Ann Arbor, 1955.

Oldewelt 1939
W.F.H. Oldewelt. "Meindert Hobbema." *Maandblad Amstelodamum* 26 (1939), pp. 25–28.

Oldewelt 1942a
———. "Jacob Ruisdael en zijn Damgezichten." In W.F.H. Oldewelt, *Amsterdamsche archiefvondsten.* Amsterdam, 1942.

Oldewelt 1942b
———. "De landschapschilder Hobbema als wijnroeier." In W.F.H. Oldewelt, *Amsterdamsche archiefvondsten.* Amsterdam, 1942.

Orbaan, Hoogewerff 1911–17
J.A.F. Orbaan and G.J. Hoogewerff. *Bescheiden in Italië omtrent Nederlandsche kunstenaars en geleerden.* 3 vols. The Hague, 1911–17.

Orlers 1641
J.J. Orlers. *Beschrijvinge der stadt Leydens.* 3 vols. Leiden, 1641. (1st ed. Leiden, 1614.)

Ottani Cavina 1968
Anna Ottani Cavina. *Carlo Saraceni.* Milan, 1968.

Ottani Cavina 1976
———. "On the Theme of Landscape." *Burlington Magazine* 118 (1976), pp. 82–87, 139–44.

Panofsky 1954
Erwin Panofsky. *Galileo as a Critic of the Arts.* The Hague, 1954.

Paris 1921
Paris, Orangerie. *Exposition hollandaise: Tableaux, aquarelles et dessins anciens et modernes.* 1921.

Paris 1950–51
———. *Le paysage hollandais au XVIIe siècle.* Introduction by A.B. de Vries. 1950–51.

Paris 1955
Paris, Hôtel de Rohan. *France et Brésil.* 1955.

Paris 1970–71
Paris, Petit Palais. *Le siècle de Rembrandt.* 1970–71.

Paris 1972
Paris, Musée du Louvre. *Le cabinet de l'amour de l'Hôtel Lambert.* Catalogue by Jean-Pierre Babelon et al. 1972.

Paris 1976–77
Paris, Grand Palais. *L'Amérique vue par l'Europe.* 1976–77.

Paris 1981
Paris, Institut Néerlandais. *Le monde paysan d'Adriaen et Isack van Ostade.* Catalogue by Bernhard Schnackenburg. 1981.

Paris 1983
———. *Reflets du siècle d'or: Tableaux hollandais du dix-septième siècle. Collection Frits Lugt.* Catalogue by Saskia Nihom-Nijstad. 1983.

Paris 1986
Paris, Grand Palais. *De Rembrandt à Vermeer: Les peintres hollandais au Mauritshuis de la Haye.* Catalogue by Ben Broos. 1986.

Paris, Louvre cat. 1852
Paris, Musée du Louvre. *Notice des tableaux dans les galeries du Musée National du Louvre, pt. 2: Ecoles allemande, flamande et hollandaise.* By F. Villot. 1852.

Paris, Louvre cat. 1922
———. *Musée National du Louvre, catalogue des peintures exposées dans les galeries, 3: Ecoles flamande, hollandaise, allemande et anglaise.* By L. Demonts. 1922.

Paris, Louvre, cat. 1979
———. *Catalogue sommaire illustré des peintures du Musée du Louvre, no. 1: Ecoles flamande et hollandaise.* Paris, 1979.

Parthey 1863–64
Gustav Parthey. *Deutscher Bildersaal: Verzeichnis der in Deutschland vorhandenen Oelbilder verstorbener Maler aus allen Schulen.* 2 vols. Berlin, 1863–64.

Passavant 1851
Johann David Passavant. *Gemäldesammlung der Herzog von Leuchtenberg in München.* Munich, 1851.

Passerei, Hess 1934
G.B. Passerei. *Vite de' pittori, scultori ed architetti che hanno lavorato in Roma* [Rome, 1772]. Ed. J. Hess. Leipzig, 1934.

Peltzer 1903
Alfred Peltzer. *Über Malweise und Stil in der holländischen Kunst.* Heidelberg, 1903.

K. Pfister 1921
Kurt Pfister. *Herkules Segers.* Munich, 1921.

Pfister 1972
Max Pfister. "Trasimenischer See oder Zürichsee?" *Bulletin van het Rijksmuseum* (Amsterdam) 20 (1972), pp. 177–81.

Pfister 1973
———. "Ein unbekanntes Zürichsee-Gemälde des 17. Jahrhunderts." *Unsere Kunstdenkmäler* 24 (1973), pp. 262–66.

Philadelphia 1950–51
Philadelphia Museum of Art. *Masterpieces in America: Diamond Jubilee Exhibition.* 1950–51.

Philadelphia/Berlin/London 1984
Philadelphia Museum of Art. *Masters of Seventeenth-Century Dutch Genre Painting.* Catalogue by Peter C. Sutton et al. 1984. Also shown at Berlin (West), Staatliche Museen Preussischer Kulturbesitz, and London, Royal Academy of Arts.

Philadelphia, Elkins cat. 1900
Catalogue of Paintings in the Private Collection of W.L. Elkins. 2 vols. By William L. Elkins. Paris, 1900.

Philadelphia, Johnson cat. 1913
Philadelphia, John G. Johnson Collection. *Flemish and Dutch Paintings.* Catalogue by W.R. Valentiner. 1913.

Philadelphia, Johnson cat. 1972
———. *Catalogue of Flemish and Dutch Paintings.* By Barbara Sweeney. 1972.

Philadelphia, Museum of Art cat. 1965
Philadelphia Museum of Art. *Checklist of Paintings in the Philadelphia Museum of Art.* 1965.

Philipsen 1957–59
J.P.W. Philipsen. "Abraham Bloemaert en zijn omgeving." *Oud Gorcum Varia,* 1957–59, pp. 31–32.

Pigler 1974
A. Pigler. *Barockthemen.* 3 vols. Budapest, 1974. (1st ed. Berlin and Budapest, 1956.)

de Piles 1699
Roger de Piles. *Abrégé de la vie des peintres.* Paris, 1699.

Pina 1928
M. Pina. "Centenari di grandi artisti: Jacob van Ruisdael." *Emporium* 67 (1928), pp. 195–206.

Planche 1857
Gustave Planche. "Les paysages et les paysagistes: Jacob van Ruisdael, Claude Lorrain, Nicolas Poussin." *Revue des deux mondes* 9 (1857), pp. 756–87.

Plietzsch 1910
Eduard Plietzsch. *Die Frankenthaler Maler.* Leipzig, 1910. Reprint. Soest, 1972.

Plietzsch 1942
———. "Hendrick ten Oever." *Pantheon* 29 (1942), pp. 132–38.

Plietzsch 1960
———. *Holländische und flämische Maler des XVII. Jahrhunderts.* Leipzig, 1960.

Plokker 1984
A. Plokker. *Adriaen Pietersz. van de Venne (1589–1662): De grisailles met spreukbanden.* Louvain and Amersfoort, 1984.

Plomp 1986
M. Plomp. "'Een merkwaardige verzameling Teekeningen' door Leonaert Bramer." *Oud Holland* 100 (1986), pp. 81–153.

Poensgen 1923–24
Georg Poensgen. "Arent Arentsz. (gennant Cabel) und sein Verhältnis zu Hendrick Avercamp." *Oud Holland* 41 (1923–24), pp. 116–35.

Poensgen 1924
———. "Der Landschaftstil des Esaias van de Velde." Dissertation. Freiberg, 1924.

Poggioli 1957
Renato Poggioli. "The Oaten Flute." *Harvard Library Bulletin* 11 (1957), pp. 147–84.

Ponce, cat. 1965
Ponce, Museo de Arte. *Catalogue I: Paintings of the European and American Schools.* By Julius S. Held. 1965.

Poortenaar 1944
Jan Poortenaar. *Schilders van het Hollandsche landschap.* Naarden [1944].

Preston 1937
Lionel Preston. *Sea and River Painters of the Netherlands in the 17th Century.* London, 1937.

Preston 1974
R. Preston. *The Seventeenth Century Marine Painters in the Netherlands.* Leigh-on-Sea, 1974.

Providence 1938
Providence, Rhode Island School of Design. *Dutch Painting in the Seventeenth Century.* 1938.

Puyvelde 1950
Leo van Puyvelde. *La peinture flamande à Rome.* Brussels, 1950.

Quarles van Ufford 1978
C.C.G. Quarles van Ufford. "Een der vier ontbrekende bladen uit het Dresdense schetsboek van Jan van Goyen teruggevonden." *Oud Holland* 92 (1978), pp. 207–11.

Raczyński 1937
J.A. Raczyński. *Die flämische Landschaft vor Rubens.* Dissertation, Berlin, 1937. Frankfurt, 1937.

Rammelman Elsevier 1861–62
W.J.C. Rammelman Elsevier. "De geboorteplaats van den schilder Meijndert Hobbema." *Algemeene Konst- en letter-bode* 73 (1861), pp. 345–46. (Reprinted in *Kunstkronijk* 3 [1862], pp. 87–88.)

Raupp 1980
H.J. Raupp. "Zur bedeutung von Thema und Symbol für die holländische Landschaftsmalerei des 17.Jahrhunderts." *Jahrbuch der Staatlichen Kunstsammlungen in Baden-Württemberg* 17 (1980), pp. 85–110.

van Regteren Altena 1926
I.Q. van Regteren Altena. "I. van Moscher." *Oud Holland* 43 (1926), pp. 18–28.

van Regteren Altena 1936
———. *The Drawings of Jacques de Gheyn.* Vol. 1. Amsterdam, 1936.

van Regteren Altena 1939a
———. Review of G. Broulhiet, *Meindert Hobbema* (Paris, 1938). *Tijdschrift voor geschiedenis* 54 (1939), pp. 274–75.

van Regteren Altena 1939b
———. Review of W. Stechow, *Salomon van Ruysdael* (Berlin, 1938). *Tijdschrift voor geschiedenis* 54 (1939), pp. 276–77.

van Regteren Altena 1954
———. "Retouches aan ons Rembrandt-beeld, III: Het landschap van den Goudweger." *Oud Holland* 69 (1954), pp. 1–17.

van Regteren Altena 1955
———. "Herkules Seghers en de topographie." *Bulletin van het Rijksmuseum* (Amsterdam) 3 (1955), pp. 3–8.

van Regteren Altena 1974
———. Review of H. Beck, *Jan van Goyen* (Amsterdam, 1972–73). *Oud Holland* 88 (1974), pp. 242–44.

van Regteren Altena 1983
———. *Jacques de Gheyn: Three Generations.* 3 vols. The Hague, 1983.

Reiss 1953
Stephen Reiss. "Aelbert Cuyp." *Burlington Magazine* 95 (1953), pp. 42–47.

Reiss 1975
———. *Aelbert Cuyp.* London, 1975.

Reiss 1978
———. "The Old Guardhouse by Aelbert Cuyp." *Burlington Magazine* 120 (1978), pp. 87–88.

Rembrandt Research Project 1982
Stichting Foundation Rembrandt Research Project. *A Corpus of Rembrandt Paintings.* The Hague and Dordrecht, 1982– .

Rembrandt Documents 1984
The Rembrandt Documents. Ed. W.L. Strauss and M. van der Meulen. New York, 1979.

Renaud 1940
J.G.N. Renaud. "De iconographie van het slot te Egmond." *Maandblad voor beeldende kunsten* 17 (1940), pp. 338–45.

Renckens 1951
B.J.A. Renckens. "Jan van Goyen en zijn Noordhollandse leermeester." *Oud Holland* 66 (1951), pp. 23–34.

Reviglio 1972
Laura Reviglio. "Frans Post, o primeiro paisagista do Brasil." *Revista do Instituto de Estudos Brasileiros* 13 (1972), pp. 7–33.

Reynolds 1781
Sir Joshua Reynolds. "A Journey to Flanders and Holland in the Year MDCCLXXXI." In *The Literary Works of Sir Joshua Reynolds,* vol. 2. Ed. H.W. Beechey. London, 1851.

Reznicek 1961
E.K.J. Reznicek. *Die Zeichnungen von Hendrick Goltzius.* 2 vols. Utrecht, 1961.

Riat 1906
Georges Riat. *Jacob van Ruisdael.* Paris, 1906.

Ribbentrop 1789
P.C. Ribbentrop. *Beschreibung der Stadt Braunschweig.* 2 vols. Braunschweig, 1789.

Richardson 1939–40
E.P. Richardson. "A Painting by Jan van der Heyden and Adriaen van de Velde." *Bulletin of the Detroit Institute of Arts* 19 (1939–40), pp. 24–27.

Richardson 1940
———. "The Romantic Prelude to Dutch Realism." *Art Quarterly* 3 (1940), pp. 40ff.

Richardson 1950–51
———. "Jan Hackaert's *Landscape with a Stag Hunt.*" *Bulletin of the Detroit Institute of Arts* 30 (1950–51), pp. 66–68.

Riegel 1882
Herman Riegel. *Beiträge zur niederländische Kunstgeschichte, II: Die niederländischen Schüler im herzoglichen Museum zu Braunschweig.* Berlin, 1882.

Riegel 1885
———. *Die vorzüglichsten Gemälde des Herzoglichen Museums zu Braunschweig.* Berlin, 1885.

Riegl 1902
Alois Riegl. "Jacob van Ruisdael." *Graphische Künste* 25 (1902), pp. 11–20. (Reprinted in A. Riegl, *Gesammelte Aufsätze* [Augsburg, 1929].)

Rijckevorsel 1933
J. van Rijckevorsel. "Jan van der Heyden in Nijmegen." *Oud Holland* 50 (1933), p. 249.

Rijckevorsel 1934
———. "Lastmaniana." *Oud Holland* 51 (1934), pp. 166–70.

Rijnbach 1944
A.A. van Rijnbach. *Groot lied-boeck van G.A. Brederode.* Bilthoven and Antwerp, 1944.

Rio de Janeiro 1942
Rio de Janeiro, Museu Nacional de Belas Artes. *Exposição Frans Post.* Introduction by Ribeiro Couto. 1942.

Rio de Janeiro 1968
Rio de Janeiro, Museu de Arte Moderna. *Os pintores de Mauricio de Nassau.* 1968.

Robinson 1979
William W. Robinson. "Preparatory drawings by Adriaen van de Velde." *Master Drawings* 17 (1979), pp. 3–23.

Rodenburgh 1618
Theodore Rodenburgh. "Lofdicht op de Rederijkerskamer de Eglentier." In *Amstels Eglentier,* vol. 2. Amsterdam, 1618. (Reprinted in A. Tümpel 1974.)

Roethlisberger 1958
Marcel Roethlisberger. "Les pendants dans l'oeuvre de Claude Lorrain." *Gazette des beaux-arts* 51 (1958), pp. 215–28.

Roethlisberger 1961
———. *Claude Lorrain: The Paintings.* 2 vols. New Haven, 1961.

Roethlisberger 1967
———. "Abraham Bloemaert." In *Katalog der 14. Ausstellung in Wien der Galerie Friederike Pallamar.* Vienna, 1967.

Roethlisberger 1968a
———. *Claude Lorrain: The Drawings.* 2 vols. Berkeley, 1968.

Roethlisberger 1968b
———. "Da Bril a Swanevelt: Tondi olandesi di paesaggio, 1600–1650." *Palatino* 4 (1968), pp. 387–93.

Roethlisberger 1969
———. *Bartholomäus Breenbergh: Handzeichnungen.* Berlin, 1969.

Roethlisberger 1977
———. "Breenbergh and Barata." *Los Angeles County Museum of Art Bulletin* 23 (1977), pp. 8–21.

Roethlisberger 1981
———. *Bartholomeus Breenbergh: The Paintings.* Berlin, 1981.

Roethlisberger 1985
———. "New Works by Bartolomeus Breenbergh." *Oud Holland* 99 (1985), pp. 57–66.

Roethlisberger, forthcoming
———. *The Paintings of Abraham Bloemaert*. Forthcoming.

de Roever 1882
N. de Roever. *Meindert Hobbema*. Amsterdam, 1882.

de Roever 1883–85
———. "Meindert Hobbema." *Oud Holland* 1 (1883), pp. 81–85; 3 (1885), p. 151.

de Roever 1885a
———. "De Coninxloo's." *Oud Holland* 3 (1885), pp. 33–53.

de Roever 1885b
———. "Hendrik Averkamp, de Stomme van Kampen." *Oud Holland* 3 (1885), p. 53.

de Roever 1889
———. "Pieter Aertsz., gezegd Lange Pier, vermaard schilder." *Oud Holland* 7 (1889), pp. 1–38.

Roh 1921
Franz Roh. *Holländische Malerei*. Jena, 1921.

Roh 1923
———. *Holländische Landschaftsmalerei des XVII. Jahrhunderts*. Leipzig, 1923.

Roli 1965
P. Roli. Review of Utrecht 1965. *Arte Antica e Moderna* 29 (1965), p. 107.

Romanow 1936
N.I. Romanow. "A Landscape with Oaks by Jan van Goyen." *Oud Holland* 53 (1936), pp. 187–92.

Rombouts, van Lerius 1961
Ph. Rombouts and Th. van Lerius. *De liggeren en andere historische archieven der Antwerpsche Sint Lucasgilde*. Antwerp and The Hague, 1961.

Rome 1950
Rome, Palazzo Massimo alle Colonne. *Catalogo della mostra degli Bamboccianti*. By Guiliano Briganti. 1950.

Rome 1954
Rome, Palazzo delle esposizioni. *Pittura olandese del seicento*. 1954.

Rome 1954–55
Rome, Palazzo Barberini. *Fiamminghi e olandesi del 600*. 1954–55.

Rome 1956
———. *Paesisti e vedutisti a Roma nel 600 e nel 700*. 1956.

Rome 1956–57
Rome, Palazzo delle esposizioni. *Il seicento europeo*. 1956–57.

Rome, Doria Pamphili cat. 1982
La Galleria Doria Pamphili a Roma. Catalogue by E. Safarik and G. Torselli. 1982.

Rooses 1894
Max Rooses. "De Hollandsche meesters in den Louvre. Meyndert Hobbema: De watermolen." *Elsevier's geïllustreerd maandschrift* 8 (1894), pp. 419–23.

Rosenau 1958
Helen Rosenau. "The Dates of Jacob van Ruisdael's 'Jewish Cemeteries'." *Oud Holland* 73 (1958), pp. 241–42.

A. Rosenberg 1891
Adolf Rosenberg. "Ein neuer Ruisdael im Berliner Museum." *Kunstchronik* 2 (1891), pp. 385–87.

A. Rosenberg 1900
———. *Adriaen and Isack van Ostade*. Bielefeld and Leipzig, 1900.

Rosenberg 1926
Jakob Rosenberg. "'The Jewish Cemetery' by Jacob van Ruisdael." *Art in America* 14 (1926), pp. 37–44.

Rosenberg 1927
———. "Hobbema." *Jahrbuch der Preussischen Kunstsammlungen* 48 (1927), pp. 139–51.

Rosenberg 1928a
———. *Jacob van Ruisdael*. Berlin, 1928.

Rosenberg 1928b
———. "Cornelis Hendricksz. Vroom." *Jahrbuch der Preussischen Kunstsammlungen* 49 (1928), pp. 102–10.

Rosenberg 1933
———. "Notizen und Nachrichten: 'Jacob van Ruisdael'." *Zeitschrift für Kunstgeschichte* 2 (1933), pp. 237–38.

Rosenberg 1940
———. "Rembrandt's Technical Means and Their Stylistic Significance." *Technical Studies in the Field of the Fine Arts* 8 (1940), pp. 193–206.

Rosenberg 1964
———. *Rembrandt*. 2nd ed. London, 1964. (1st ed. Cambridge, Mass., 1948.)

Rosenberg 1952–53
———. "A Waterfall by Jacob van Ruisdael." Fogg Art Museum, Harvard University, *Annual Report*, 1952–53, p. 11.

Rosenberg 1953–54
———. "The Wreckers by Simon de Vlieger." Fogg Art Museum, Harvard University, *Annual Report*, 1953–54, p. 8.

Rosenberg et al. 1966
Jakob Rosenberg, Seymour Slive, and E.H. ter Kuile. *Dutch Art and Architecture, 1600–1800*. Harmondsworth and Baltimore, 1966. (Rev. eds. 1972, 1977.)

P. Rosenberg, Schnapper 1971
Pierre Rosenberg and Anthonie Schnapper. "Le cabinet de l'amour de l'Hôtel Lambert." *Revue du Louvre* 21 (1971), pp. 157–64, 375–78.

Roth 1945
Alfred G. Roth. *Die Gestirne in der Landschaftsmalerei des Abendlandes*. Bern, 1945.

Rotterdam 1943–44
Rotterdam, Museum Boymans. *Het landschap in de nederlandsche prentkunst*. Catalogue by J.C. Ebbinge Wubben. 4 vols. 1943–44.

Rotterdam 1945–46
———. *Het nederlandsche zee- en riviergezicht in de 17de eeuw*. 1945–46.

Rotterdam 1954
———. *Hercules Seghers*. Catalogue by E. Haverkamp Begemann. 1954.

Rotterdam 1955
———. *Kunstschatten uit Nederlandse verzamelingen*. 1955.

Rotterdam 1959
Rotterdam, Museum Boymans-van Beuningen. *Esaias van de Velde, Jan van de Velde: Grafiek*. 1959.

Rotterdam/Essen 1959–60
———. *Collectie Thyssen-Bornemisza*. 1959–60. Also shown at Essen, Museum Folkwang, 1960.

Rotterdam/Paris 1974–75
———. *Willem Buytewech 1591–1624*. 1974–75. Also shown at Paris, Institut Néerlandais, 1975.

Rotterdam, cat. 1962
———. *Schilderijen tot 1800*. 1962.

Rotterdam, cat. 1972
———. *Old Paintings 1400–1900: Illustrations*. 1972.

Rowlands 1979
John Rowlands. *Hercules Segers*. New York, 1979.

Roy 1972
Ranier Roy. "Studien zu Gerbrand van den Eeckhout." Dissertation. Vienna, 1972.

Rubsamen 1980
Grisela Rubsamen. *The Orsini Inventories*. Malibu, Calif., 1980.

Russell 1975
Margarita A. Russell. *Jan van de Capelle, 1624/26–1679*. Leigh-on-Sea (Eng.), 1975.

Russell 1983
———. *Visions of the Sea: Hendrik C. Vroom and the Origins of Dutch Marine Painting*. Leiden, 1983.

Rutgers van der Loeff 1911
J.D. Rutgers van der Loeff. *Drie lofdichten op Haarlem: Het middelnederlandsch gedicht van Dirk Mathijszen en Karel van Mander's Twee Beelden van Haarlem*. Haarlem, 1911.

Ruurs 1983
Rob Ruurs. "'Even if it is not architecture': Perspective Drawings by Simon de Vlieger and Willem van de Velde the Younger." *Simiolus* 13 (1983), pp. 189–200.

Sacramento 1974
Sacramento, E.B. Crocker Art Gallery. *The Pre-Rembrandtists*. Catalogue by Astrid Tümpel, Christian Tümpel, and Wolfgang Stechow. 1974.

St. Louis 1947
St. Louis Art Museum. *Forty Masterpieces*. 1947.

St. Petersburg/Atlanta 1975
St. Petersburg, Museum of Fine Arts. *Dutch Life in the Golden Century*. Catalogue by Franklin W. Robinson. 1975. Also shown at Atlanta, High Museum of Art, 1975.

Salerno 1977–80
Luigi Salerno. *Pittori di paesaggio del seicento a Roma (Landscape Painters of the Seventeenth Century in Rome)*. 3 vols. Rome, 1977–80.

Salzburg/Vienna 1986
Salzburg, Residenzgalerie. *Die Niederländer in Italien: Italianisante Niederländer des 17. Jahrhunderts aus Österreichischem Besitz*. Catalogue by Renate Trnek. 1986. Also shown at Vienna, Akademie der bildenden Künste, 1986.

Salzdahlum, cat. 1776
Schloss Salzdahlum. *Verzeichniss der Herzoglichen Bilder-Galerie zu Salzthalen*. By Christian Nicolas Eberlein. 1776.

Sander 1958
C.A.L. Sander. "Het dulhuys of dolhuys aan de vesten of de Kloveniersburgwal." *Maandblad Amstelodamum* 45 (1958), pp. 229ff.

Sandrart 1675
Joachim von Sandrart. *L'Academia todesca della architectura, scultura*

e pittura; oder, Teutsche Academie der edlen Bau-, Bild- und Mahlerey-Künste. 2 vols. Nuremberg, 1675.

Sandrart, Peltzer 1925
————. *Joachim von Sandrarts Akademie der Bau-, Bild- und Mahlerey-Künste von 1675.* Edited with a commentary by A.R. Peltzer. Munich, 1925.

San Francisco/Toledo/Boston 1966–67
San Francisco, California Palace of the Legion of Honor. *The Age of Rembrandt.* 1966. Also shown at the Toledo Museum of Art, 1966–67, and the Museum of Fine Arts, Boston, 1967.

Schaar 1954
Eckhard Schaar. "Berchem und Begeijn." *Oud Holland* 67 (1954), pp. 241–45.

Schaar 1956a
————. "Zeichnungen Berchems zu Landkarten." *Oud Holland* 69 (1956), pp. 239–43.

Schaar 1956b
————. "Zu den Berchem-Zeichnungen in den Musées Royaux des Beaux-Arts zu Brüssel." *Bulletin des Musées Royaux des Beaux-Arts* (Brussels) 5 (1956), pp. 209–20.

Schaar 1957
————. *Studien zu Nicolaes Berchem.* Dissertation. Cologne, 1957.

Schaar 1959
————. "Poelenburgh und Breenbergh in Italien und ein Bild Elsheimers." *Mitteilungen des kunsthistorischen Instituts in Florenz* 9 (1959), pp. 25–46.

Schaffhausen 1949
Schaffhausen, Museum zu Allerheiligen. *Rembrandt und seine Zeit.* 1949.

Schapelhouman 1982
Marijn Schapelhouman. "Twee tekeningen van Nicolaes Berchem." *Oud Holland* 96 (1982), pp. 123–26.

Schatborn 1974
Peter Schatborn. "Figuurstudies van Nicolaes Berchem." *Bulletin van het Rijksmuseum* (Amsterdam) 22 (1974), pp. 3–16.

Schatborn 1975
————. "'De Hut' van Adriaen van de Velde," *Bulletin van het Rijksmuseum* (Amsterdam) 23 (1975), pp. 159–65.

Scheltema 1853
P. Scheltema. *Rembrandt: Redevoering over het leven en de verdiensten van Rembrandt van Rijn.* Amsterdam, 1853.

Scheltema 1863
————. "Meindert Hobbema." *Aemstel's oudheid* 5 (1863), pp. 45–64. (Reprinted in *Gazette des beaux-arts* 16 [1864], pp. 214–26.)

Scheltema 1872
————. "Jacob van Ruijsdael." *Aemstel's oudheid* 6 (1872), pp. 95–112.

Scheltema 1876
————. "De geboorteplaats van Meindert Hobbema." *Nederlandsche Kunstbode* 3 (1876), pp. 11–12. (Reprinted in *Aemstel's oudheid* 7 [1885], pp. 77–80.)

Schendel 1937
A. van Schendel. "Frans Post, le brésilien." Dissertation. Paris, 1937.

Scheyer 1939
Ernst Scheyer. "Portraits of the Brothers van Ostade." *Art Quarterly* 2 (1939), pp. 134–41.

Scheyer 1977
————. "The Iconography of Jacob van Ruisdael's *Cemetery.*" *Bulletin of the Detroit Institute of Arts* 55 (1977), pp. 133–46.

Schleissheim, cat. 1980
Schleissheim, Staatsgalerie. *Verzeichnis der Gemälde.* 1980.

Schloss 1982
Christine Skeeles Schloss. *Travel, Trade, and Temptation: The Dutch Italianate Harbor Scene, 1640–1680.* Ann Arbor, 1982. (Revision of Dissertation, Yale University, 1978.)

Schloss 1983a
————. "The Early Italianate Genre Paintings by Jan Weenix." *Oud Holland* 97 (1983), pp. 69–97.

Schloss 1983b
————. "A Note on Jan Baptist Weenix's Patronage in Rome." In *Essays in Northern Art Presented to Egbert Haverkamp Begemann on His Sixtieth Birthday.* Doornspijk, 1983.

Schmidt 1873a
Wilhelm Schmidt. "Bemerkungen über verschiedene Bilder der Galerien zu München und Schleissheim." *Jahrbücher für Kunstwissenschaft* 5 (1873), pp. 46ff.

Schmidt 1873b
————. "Zwei Bilder von Jan van Goyen und A. van Ostade in Braunschweig." *Jahrbücher für Kunstwissenschaft* 6 (1873), pp. 188–89.

Schmidt 1883
————. "Zur Braunschweiger Galerie." *Zeitschrift für bildende Kunst* 18 (1883), p. 103.

Schmidt 1981
Winfried Schmidt. *Studien zur Landschaftskunst Jacob van Ruisdaels: Frühwerke und Wanderjahre.* Dissertation. Hildesheim, 1981.

Schnackenburg 1981
Bernhard Schnackenburg. *Adriaen van Ostade, Isack van Ostade: Zeichnungen und Aquarelle.* 2 vols. Hamburg, 1981.

Schneebeli 1963
Hans R. Schneebeli. *Hercules Seghers: Die Radierungen.* Dissertation. Zurich, 1963.

Schneider 1933
Arthur von Schneider. *Caravaggio und die Niederländer.* Marburg, 1933. Reprint, with new introduction. Amsterdam, 1967.

C. Schneider 1984a
Cynthia Schneider. "A New Look at 'The Landscape with an Obelisk.'" *Fenway Court*, 1984, pp. 6–21.

C. Schneider 1984b
————. "Rembrandt's Landscape Paintings." Dissertation. Harvard, 1984.

H. Schneider 1925
Hans Schneider. "Govaert Flinck en Juriaen Ovens in het Stadhuis te Amsterdam." *Oud Holland* 42 (1925), pp. 215–23.

H. Schneider 1933
————. *Jan Lievens: Sein Leben und seine Werke.* Haarlem, 1932. Reprint, with supplement by R.E.O. Ekkart. Amsterdam, 1973.

Scholtens 1962
H.J.J. Scholtens. "Salomon van Ruysdael in de contreien van Holland's landengte." *Oud Holland* 77 (1962), pp. 1–10.

Schöne 1954
Wolfgang Schöne. *Über das Licht in der Malerei.* Berlin, 1954.

Schrevelius 1647
Theodoor Schrevelius. *Harlemum, sive urbis Harlemensis incunabula, incrementa, fortuna varia, in pace, in bello.* Leiden, 1647.

Schrevelius 1648
————. *Harlemias; ofte, De eerste stichtinghe der stadt Haerlem.* Haarlem, 1648.

Schulz 1971
Wolfgang Schulz. "Doomer and Savery." *Master Drawings* 9 (1971), pp. 25–29.

Schulz 1977
————. "Blumen Zeichnungen von Herman Saftleven d. J." *Zeitschrift für Kunstgeschichte* 40 (1977), pp. 135–153.

Schulz 1978
————. *Cornelis Saftleven.* Berlin, 1978.

Schulz 1982
————. *Herman Saftleven.* Berlin, 1982.

Schulz 1983
————. Review of G. Solar, *Jan Hackaert* (Dietikon, 1981). *Zeitschrift für Kunstgeschichte* 46 (1983), pp. 450–55.

Schwartz 1983
Gary Schwartz. "Jan van der Heyden and the Huydecopers of Maarsseveen." *The J. Paul Getty Museum Journal* 2 (1983), pp. 197–220.

Schwartz 1985
————. *Rembrandt: His Life, His Paintings.* Harmondsworth (Eng.), 1985. (Published in Dutch, 1984.)

S. Schwartz 1975
S. Schwartz. "The Iconography of the Rest on the Flight into Egypt." Dissertation. New York University, 1975.

Schwerin, cat. 1982
Schwerin, Staatliches Museum. *Holländische und flämische Malerei des 17. Jahrhunderts.* 1982.

Segal 1982
Sam Segal. "The Flower Pieces of Roelandt Savery." *Leids Kunsthistorisch Jaarboek*, 1982, pp. 309–37.

Seifertova-Korecka 1962
Hana Seifertova-Korecka. "Das Genrebild des Aert van der Neer in Liberec." *Oud Holland* 77 (1962), pp. 57–58.

Seilern 1955
Antoine Seilern. *Flemish Paintings and Drawings at 56 Princes Gate.* London, 1955.

von Sick 1930
Ilse von Sick. *Nicolaes Berchem, ein Vorläufer des Rokoko.* Dissertation. Berlin, 1930.

Simon 1927
Kurt Erich Simon. "Jacob van Ruisdael." Dissertation. Berlin, 1927.

Simon 1930
————. *Jacob van Ruisdael: Eine Darstellung seiner Entwicklung.* Berlin, 1930.

Simon 1935
————. "Wann hat Ruisdael die Bilder des Judenfriedhofs gemalt?" In *Das siebente Jahrzehnt: Festschrift zum 70. Geburtstag von Adolph Goldschmidt.* Berlin, 1935.

M. Simon 1958
Maria Simon. "Claes Jansz. Visscher." Dissertation. Freiburg im Breisgau, 1958.

Šíp 1970
J. Šíp. "Roelandt Savery in Prague." *Umění* 18 (1970), pp. 276–83.

Šíp 1973
———. "Savery in and around Prague." *Bulletin du Musée National de Varsovie* 14 (1973), pp. 69–75.

Siret 1863
Ad. Siret. "La date du décès de F. de Moucheron." *Journal des beaux-arts et de la littérature* 5 (1863), p. 69.

Siwajew 1940
M. Siwajew. "Esajas van de Velde als Schlachtenmaler." *Travaux du département de l'art européen. Musée de l'Ermitage* 1 (1940), pp. 67–77.

Sjtsjerbatsjewa 1940
M. Sjtsjerbatsjewa. "Pieter Lastmans Gemälde in der Ermitage." (In Russian; German summary.) *Travaux du département de l'art européen Musée de l'Ermitage* 1 (1940), pp. 31–54.

Slive 1956
Seymour Slive. "Notes on the Relationship of Protestantism to Seventeenth-Century Dutch Painting." *Art Quarterly* 19 (1956), pp. 3–15.

Slive 1957
———. Review of K. Goossens, *David Vinckboons* (Antwerp, 1954). *Art Bulletin* 39 (1957), pp. 311–16.

Slive 1962
———. "Realism and Symbolism in Seventeenth-Century Dutch Painting." *Daedalus* 91 (1962), pp. 469–500.

Slive 1973
———. "Notes on Three Drawings by Jacob van Ruisdael." In *Album Amicorum J. G. van Gelder*. The Hague, 1973.

Slive 1983
———. "An Unpublished Drawing by Jacob van Ruisdael." In *Essays in Northern Art Presented to Egbert Haverkamp Begemann on His Sixtieth Birthday*. Doornspijk, 1983.

Sluijter 1973
Eric Jan Sluijter. Review of H. Wagner, *Jan van der Heyden 1637–1712* (Amsterdam and Haarlem, 1971). *Oud Holland* 87 (1973), pp. 244–52.

Sluijter 1986
———. *De 'heydensche fabulen' in de Noordnederlandse schilderkunst, circa 1590–1670*. Dissertation. Leiden, 1986.

Sluijter-Seijffert 1982
Nicolette Sluijter-Seijffert. Review of M. Roethlisberger, *Bartholomeus Breenbergh: The Paintings* (Berlin, 1981). *Oud Holland* 96 (1982), pp. 69–72.

Sluijter-Seijffert 1984
———. *Cornelis van Poelenburch, ca. 1593–1667*. Dissertation. Leiden, 1984.

Smith 1829–42
John A Smith. *A Catalogue Raisonné of the Works of the Most Eminent Dutch, Flemish, and French Painters*. 9 vols. London, 1829–42.

R. Smith 1938
R.C. Smith, Jr. "The Brazilian Landscapes of Frans Post." *Art Quarterly* 1 (1938), pp. 239–67.

Snoep 1968–69
D.P. Snoep. "Een 17de eeuws liedboek met tekeningen van Gerard ter Borch de Oude en Pieter en Roeland van Laer." *Simiolus* 3 (1968–69), pp. 77–134.

Snoep 1970
———. "Gerard Lairesse als plafond- en kamer-schilder." *Bulletin van het Rijksmuseum* (Amsterdam) 18 (1970), pp. 159–220.

Snoep 1983
———. "Het Trippenhuis, zijn decoraties en inrichting." In *Het Trippenhuis te Amsterdam*. Edited by R. Meischke and H.E. Reeser. Amsterdam, 1983.

Snoep-Reitsma 1967–68
Ella Snoep-Reitsma. "Een beperkt uitzicht op het Hollandse landschap." *Simiolus* 2 (1967–68), pp. 100–103.

Solar 1981
Gustav Solar. *Jan Hackaert: Die schweizer Ansichten 1653–55: Zeichnungen eines niederländischen Malers als frühe Bilddokumente der Alpenlandschaft*. Zurich, 1981.

Solar 1984
———. "Zur Datierung von Hackaerts Rheinfall ansichten." *Schaffhauser Beiträge zur Geschichte* 61 (1984), pp. 229–40.

Somerville 1973
John Somerville. "The World of Aelbert Cuyp." *Country Life*, July 3, 1973, pp. 32–34.

Sousa-Leão 1948
Joaquim de Sousa-Leão. *Frans Post*. Rio de Janeiro, 1948. (1st ed. 1937.)

Sousa-Leão 1942–43
———. "Frans Post in Brazil." *Burlington Magazine* 80 (1942), pp. 59–61; 83 (1943), pp. 216–17.

Sousa-Leão 1973
———. *Frans Post 1612–1680*. Amsterdam, 1973.

Spicer 1970a
Joaneath Spicer. "The 'naer het leven' Drawings: By Pieter Bruegel or Roelandt Savery?" *Master Drawings* 8 (1970), pp. 3–30.

Spicer 1970b
———. "Roelandt Savery's Studies in Bohemia." *Umění* 18 (1970), pp. 270–75.

Spicer 1979
———. "The Drawings of Roelandt Savery." Dissertation. Yale, 1979.

Spicer 1983
———. "'De Koe voor d'aerde statt': The Origins of the Dutch Cattle Piece." In *Essays in Northern European Art Presented to Egbert Haverkamp Begemann on His Sixtieth Birthday*. Doornspijk, 1983.

Spicer, forthcoming
———. *Roelandt Savery*. Forthcoming.

Spickernagel 1979
Ellen Spickernagel. "Holländische Dorflandschaften in frühen 17. Jahrhunderts." *Städel-Jahrbuch* 7 (1979), pp. 133–48.

Springer 1910
Jaro Springer. "Vinckboons als Zeichner für den Kupferstich." *Amtliche Berichte aus den Königlichen Kunstsammlungen* 31 (1910), pp. 295–97.

Springer 1910–12
———. *Die Radierungen des Herkules Seghers*. Berlin, 1910–12. (Introduction, Berlin, 1916.)

Starcke 1898
E. Starcke. "Die Coninxloo's." *Oud Holland* 16 (1898), pp. 129–46.

Staring 1953
A. Staring. "De ruiterportretgroep van Albert Cuyp in het Metropolitan Museum te New York." *Oud Holland* 48 (1953), p. 117.

Staring 1958
———. *Jacob de Wit, 1695–1754*. Amsterdam, 1958.

Stechow 1928a
Wolfgang Stechow. "Bemerkungen zu Jan Steens kunstlerischer Entwicklung." *Zeitschrift für bildende Kunst* 62 (1928), pp. 173–79.

Stechow 1928b
———. Review of I. Budde, *Die Idylle im holländischen Barock* (Cologne, 1929). *Kritische Berichte zur kunstgeschichtlichen Literatur*, 1928, pp. 181ff.

Stechow 1930
———. "Bartholomaeus Breenbergh, Landschafts- und Historienmaler." *Jahrbuch der Preussischen Kunstsammlungen* 51 (1930), pp. 133–40.

Stechow 1938a
———. *Salomon van Ruysdael: Eine Einführung in seine Kunst*. Berlin, 1938. Reprint. Berlin, 1975.

Stechow 1938b
———. "Die 'Pellekussenpoort' bei Utrecht auf Bildern von Jan van Goyen und Salomon van Ruysdael." *Oud Holland* 55 (1938), pp. 202–208.

Stechow 1939
———. "Salomon van Ruysdael's Paintings in America." *Art Quarterly* 2 (1939), pp. 251–63.

Stechow 1947
———. "Esajas van de Velde and the Beginnings of Dutch Landscape Painting." *Nederlands Kunsthistorisch Jaarboek* 1 (1947), pp. 83–94.

Stechow 1948
———. "Jan Baptist Weenix." *Art Quarterly* 11 (1948), pp. 181–86.

Stechow 1953
———. "Jan Both and Dutch Italianate Landscape Painting." *Magazine of Art* 46 (1953), pp. 131–36.

Stechow 1954
———. Review of L. Collins, *Hercules Seghers* (Chicago, 1953). *Art Bulletin*, 36 (1954), pp. 240–44.

Stechow 1955
———. "Jan Both and the Re-evaluation of Dutch Italianate Landscape Painting." In *Actes du XVIIe Congrès International d'Histoire de l'Art*, pp. 425–32. The Hague, 1955.

Stechow 1959
———. "The Early Years of Hobbema." *Art Quarterly* 22 (1959), pp. 3–18.

Stechow 1960a
———. "Cuyp's 'Valkhof at Nijmegen.'" *John Herron Art Institute Bulletin* 47 (1960), pp. 4–11.

Stechow 1960b
———. "The Winter Landscape in the History of Art." *Criticism*, 1960, pp. 175–89.

Stechow 1960c
———. "Landscape Paintings in Dutch Seventeenth Century Interiors." *Nederlands Kunsthistorisch Jaarboek* 11 (1960), pp. 165–84.

Stechow 1960d
———. "Significant Dates on Some Seventeenth Century Dutch Landscape Paintings." *Oud Holland* 75 (1960), pp. 79–92.

Stechow 1965a
———. "Jan Wijnants, View of the Heerengracht, Amsterdam." *Bulletin of the Cleveland Museum of Art* 52 (1965), pp. 164–73.

Stechow 1965b
———. "Über das Verhältnis zwischen Signatur und Chronologie bei einigen holländischen Künstlern des 17. Jahrhunderts." In *Festschrift Dr. h.c. Eduard Trautscholdt*. Hamburg, 1965.

Stechow 1966
———. *Dutch Landscape Painting of the Seventeenth Century*. London, 1966.

Stechow 1967
———. "A Painting and a Drawing by Adriaen van de Velde." *Bulletin of the Cleveland Museum of Art* 54 (1967), pp. 30–35.

Stechow 1968
———. "Ruisdael in the Cleveland Museum." *Bulletin of the Cleveland Museum of Art* 55 (1968), pp. 250–61.

Stechow 1969
———. "Some Observations on Rembrandt and Lastman." *Oud Holland* 84 (1969), pp. 148–62.

Stechow, Hoogendoorn 1947
Wolfgang Stechow and Annet Hoogendoorn. "Het vroegst bekende werk van Salomon van Ruysdael." *Kunsthistorische Mededeelingen* 2 (1947), pp. 36–39.

Steenhoff 1903
W. Steenhoff. "Van Goyen: Tentoonstelling in Amsterdam." *Onze kunst* 2, no. 2 (1903), pp. 65–72.

Steenhoff 1922–23
———. "Jan van Goyen." *Wil en weg* 1 (1922–23), pp. 462–65.

Steenhoff 1924
———. *Hercules Seghers*. Amsterdam, 1924.

Steenhoff 1930
———. "Jan van Goyen." *De ploeg* 8 (1930), pp. 318–24.

Steinmetz et al. 1854–60
F.F.C. Steinmetz, H.M.C. van Oosterzee, et al. "Meindert Hobbema." *De Navorscher* 4 (1854), pp. 30, 329–30; 10 (1860), pp. 231, 376.

Steland-Stief 1963
Anne Charlotte Steland-Stief. "Jan Asselijn." Dissertation. Freiburg im Breisgau, 1963.

Steland-Stief 1964
———. "Jan Asselyn und Willem Schellinks." *Oud Holland* 79 (1964), pp. 99–110.

Steland-Stief 1967
———. "Jan Asselijn und Karel Dujardin." *Raggi* 7 (1967), pp. 99–107.

Steland-Stief 1970
———. "Drei Winterlandschaften des Italianisten Jan Asselyn und ihre Auswirkungen." In *150 Jahre Hessisches Landesmuseum in Darmstadt*. 1970.

Steland-Stief 1971
———. *Jan Asselijn, nach 1610 bis 1652*. Amsterdam, 1971.

Steland-Stief 1980
———. "Zum zeichnerischen Werk des Jan Asselijn: Neue Funde und Forschungsperspektiven." *Oud Holland* 94 (1980), pp. 213–58.

Stelling-Michaud 1937
Sven Stelling-Michaud. *Unbekannte schweizer Landschaften aus dem XVII. Jahrhunderts: Zeichnungen und Schilderungen von Jan Hackaert und anderen holländischen Malern*. Zurich and Leipzig, 1937.

Stelling-Michaud 1979
———. "Routes commerciales et itinéraires d'un peintre hollandais en Suisse au XVII⁰ siècle." *Schweizerische Zeitschrift für Geschichte* 29 (1979), pp. 607–37.

Steneberg 1953
Karl Erik Steneberg. "Allart van Everdingen." In *Svenskt Konstnarslexikon*, vol. 2 (1953), pp. 168–69.

Steneberg 1955
———. *Kristinatidens Måleri*. Malmö, 1955.

Stheeman 1935
A. Stheeman. "De evolutie van het Vlaamsche en Hollandsche landschap." *Maandblad voor beeldende kunsten* 12 (1935), pp. 11–18, 39–47.

Stheeman 1936
———. "Salomon van Ruysdael (1602–1670) bij den Kunsthandel Goudstikker, Amsterdam." *Op de hoogte* 33 (1936), pp. 35–39.

Sthyr 1929
Jorgen Sthyr. *Nederlandsk landskabsmaleri i danske samlinger*. Copenhagen, 1929.

Sthyr 1939–40
———. "David Vinckboons: 'Die Boere cermis'." *Old Master Drawings* 14 (1939–40), pp. 8–10.

Stone-Ferrier 1985
Linda Stone-Ferrier. *Images of Textiles: The Weave of Seventeenth-Century Dutch Art and Society*. Ann Arbor, 1985. (Revision of Dissertation, University of California, Berkeley, 1980.)

van Straaten 1977
Evert van Straaten. *Koud tot op het bot: De verbeelding van de winter in de zestiende en zeventiende eeuw in de Nederlanden*. The Hague, 1977.

Sullivan 1984
Scott Sullivan. *The Dutch Gamepiece*. Montclair, N.J., 1984.

Sumowski 1962
Werner Sumowski. "Gerbrand van den Eeckhout als Zeichner." *Oud Holland* 77 (1962), pp. 11–37.

Sumowski 1970
———. "Rötelzeichnungen von Pieter Lastman." *Jahrbuch des Hamburger Kunstsammlungen* 14–15 (1970), pp. 129–32.

Sumowski 1979
———. *Drawings of the Rembrandt School*. 9 vols. New York, 1979–85.

Sumowski 1983
———. *Gemälde der Rembrandt-Schüler*. London and Pfalz, 1983–.

D. Sutton 1982
Denys Sutton. "Jacob van Ruisdael, Solitary Wanderer." *Apollo* 115 (1982), pp. 182–85.

P. Sutton 1975
Peter C. Sutton. "The Early Works of Pieter Lastman." Thesis, Yale University, 1975.

P. Sutton 1982
———. "Ruisdael Retrospective." *Art Journal* 42 (1982), pp. 147–51.

P. Sutton 1986
———. *Dutch Art in America*. Grand Rapids, 1986.

P. Sutton 1987
———. "'The Noblest of Livestock,'" *The J. Paul Getty Museum Journal* 15 (1987.)

Swillens 1931
P.T.A. Swillens. "Het kunstboek van Herman Saftleven." *Vondel-kroniek* 2 (1931), pp. 18–23.

Swillens 1935
———. *Pieter Janszoon Saenredam*. Amsterdam, 1935.

Swillens 1949
———. "Een schilderij van Willem Schellinks." *Kunsthistorische Mededeelingen* 4 (1949), pp. 19ff.

Taverne 1977
Ed Taverne. *58 miljoen Nederlanders en de mooie natuur*. Amsterdam, 1977.

Terwesten 1770
Pieter Terwesten. *Catalogus of naamlyst van schilderyen, met derzelver prysen, zedert den 22. Augusti 1752 tot den 21. November 1768*. The Hague, 1770. (Supplement to Hoet 1752.) Reprint. The Hague, 1976.

van Thiel 1967
P.J.J. van Thiel. "Philips Konincks vergezicht met hutten aan de weg." *Bulletin van het Rijksmuseum* (Amsterdam) 5 (1967), pp. 109–15.

van Thiel 1968
———. "Vergezicht met Hutten aan de Weg: Philips Koninck (1619–1688)." *Openbaar Kunstbezit* 2, no. 10 (1968).

van Thiel 1978
———. "Houtsneden van Werner van de Valckert en Mozes van Uyttenbroeck." *Oud Holland* 92 (1978), pp. 7–42.

van Thiel 1983
———. "Verkregen met steun van de Vereniging Rembrandt, 1900: Rembrandt, De stenen brug," *Bulletin van het Rijksmuseum* (Amsterdam) 31 (1983), p. 203.

van Thiel 1986
———. Review of A. Plokker, *Adriaen Pietersz. van de Venne (1589–1662), de grisailles met spreuckbanden* (Louvain and Amersfoort, 1984). *Oud Holland* 100 (1986), pp. 66–71.

Thieme 1896
Ulrich Thieme. "Ruisdael und Hobbema." *Das Museum* 1 (1896), pp. 17–19.

Thieme, Becker 1907–50
Ulrich Thieme and Felix Becker, eds. *Allgemeines Lexikon der bildenden Künstler von der Antike bis zur Gegenwart*. 37 vols. Leipzig, 1907–50.

Thiéry 1953
Yvonne Thiéry. *Le paysage flamand au XVIIe siècle*. Paris and Brussels, 1953.

Thiéry 1986
———. *Les peintres flamands de paysage au XVIIe siècle*. Brussels, 1986.

Thomsen 1938
T. Thomsen. *Albert Eckhout*. Copenhagen, 1938.

Thoré 1858–60
E.J.T. Thoré [W. Bürger]. *Les musées de la Hollande*. 2 vols. Paris, 1858–60.

Thoré 1859
———. "Hobbema." *Gazette des beaux-arts* 4 (1859), pp. 28–44.

Thoré 1860
———. *Trésors d'art en Angleterre*. Brussels, 1860. (Originally *Trésors d'art exposés à Manchester en 1857* [Paris, 1857].)

Thuillier 1977
Jacques Thuillier. "Le paysage français du XVIIe siècle: De l'*imitation naturae* à l'esthétique des 'belles idees.'" *Cahiers de l'association internationale des études françaises*, 1977, pp. 45–64.

Tilanus 1975
J.L.L. Tilanus. *Het graphisch werk van drie Italianisanten: Jan Both, Nicolaes Berchem, and Karel Dujardin*. Dissertation. Ghent, 1975.

Timm 1961
Werner Timm. "Der gestrandete Wal: Eine motivkundliche Studie." *Staatliche Museen zu Berlin, Forschungen und Berichte* 3–4 (1961), pp. 76ff.

Timmers 1959
J.J.M. Timmers. *A History of Dutch Life and Art*. London, 1959.

de Tolnay 1952
Charles de Tolnay. *The Drawings of Pieter Bruegel the Elder*. London, 1952. (1st ed. 1925.)

Toronto 1950
Art Gallery of Toronto. *Fifty Paintings by Old Masters*. 1950.

Trautscholdt 1940
Eduard Trautscholdt. "Der Maler Herkules Seghers." *Pantheon* 35 (1940), pp. 81–86.

Trautscholdt 1954–55
———. "Neues Bemühen um Hercules Seghers." *Imprimatur* 12 (1954–55), pp. 78–85.

Tschudi, Pulszky 1883
H. Tschudi and K. Pulszky. *Landes-Gemälde-Gallerie in Budapest*. Vienna, 1883.

A. Tümpel 1974
Astrid Tümpel. "Claes Cornelisz. Moeyaert: Katalog der Gemälde." *Oud Holland* 88 (1974), pp. 1–63, 245–90.

A. Tümpel, forthcoming
———. *Pieter Lastman*. Forthcoming.

C. Tümpel 1986
Christian Tümpel. *Rembrandt*. Antwerp and Amsterdam, 1986. (Published in German and English.)

Turner 1908–1909
J.M. Turner. "Philips and Jacob de Koninck." *Burlington Magazine* 14 (1908–1909), pp. 360–65.

Upmark 1900
G. Upmark. "Ein Besuch in Holland 1687." *Oud Holland* 18 (1900), p. 125.

Utica 1963
Utica (N.Y.), Munson-Williams-Proctor Institute, Museum of Art. *Masters of Landscape: East and West*. 1963. Also shown at Rochester Memorial Art Gallery, 1963.

Utrecht 1941
Utrecht, Centraal Museum. *Catalogus van schilderijen der Utrechtsche school*. Utrecht, 1941.

Utrecht 1965
———. *Nederlandse 17e eeuwse Italianiserende landschapschilders*. 1965. (Revised edition, see Blankert 1978.)

Utrecht/Braunschweig 1986–87
———. *Nieuw licht op de Gouden Eeuw: Hendrick ter Brugghen en tijdgenoten*. 1986–87. Also shown at Braunschweig, Herzog Anton Ulrich-Museum, 1987.

Utrecht, cat. 1952
Utrecht, Centraal Museum. *Centraal Museum Utrecht: Catalogus van schilderijen*. Utrecht, 1952.

E. Valentiner 1930
Elisabeth Valentiner. *Karel van Mander als Maler*. Strasbourg, 1930.

Valentiner 1906
Wilhelm R. Valentiner. *Rembrandt in Bild und Wort*. Berlin, 1906.

Valentiner 1908
———. *Rembrandt: Des Meisters Gemälde*. Klassiker der Kunst. Stuttgart and Leipzig, 1908. (2nd ed. 1922.)

Valentiner 1919
———. "Jacob van Ruisdael." In W.R. Valentiner, *Zeiten der Kunst und der Religion*, pp. 291–356. Berlin, 1919.

Valentiner 1925–26
———. "'The Cemetery' by Jacob van Ruisdael." *Bulletin of the Detroit Institute of Arts* 7 (1925–26), pp. 55–58.

Valentiner 1941
———. "Jan van de Cappelle." *Art Quarterly* 4 (1941), pp. 272–96.

Vancouver 1986
Vancouver Art Gallery. *The Dutch World of Painting*. Catalogue by Gary Schwartz. 1986.

Veegens 1860
D. Veegens. "Nog iets over Hobbema." *Kunstkronijk* 1 (1860), pp. 89–90.

Veen 1985
P.A.F. van Veen. *De soeticheydt des buyten-levens vergheselschapt met de boucken*. Dissertation, Leiden, 1960. Utrecht, 1985.

Verburgt 1916
J.W. Verburgt. "De vier jaargetijden van David Vinckboons." *Jaarboekje van het Oudheidkundig Genootschap "Niftarlake,"* 1916, pp. 25–35.

Vermeulen 1939
Frans Vermeulen. "Enkele aanteekeningen betreffende het probleem Vingboons." *Oud Holland* 56 (1939), pp. 268–73.

Vertue 1929–42
George Vertue. "Vertue Note Books." *The Walpole Society* 18, 20, 22, 24, 26, 29 (1929–42).

Veth 1884
G.H. Veth. "Aelbert Cuyp, Jacob Gerritsz. Cuyp en Benjamin Cuyp." *Oud Holland* 2 (1884), pp. 30–282.

Veth 1888
———. "Aanteekeningen omtrent eenige Dordrechtsche schilders." *Oud Holland* 6 (1888), pp. 131–48.

Viardot 1876
Louis Viardot. "La date de la naissance de Ruisdael." *La chronique des arts et de la curiosité*, 1876, pp. 118–19, 127–28.

Vienna 1951
Vienna, Akademie der bildenden Künste. *Meisterwerke der holländischen Landschafts- und Architekturmalerei des XVII. Jahrhunderts*. Catalogue by L. Münz. 1951.

Vienna, Akademie cat. 1866
Vienna, Akademie der bildenden Künste. *Verzeichnis der Gemäldesammlung der K.K. Akademie der bildenden Künste in Wien*. By H. Schwemminger. 1866. (Rev. ed. 1873.)

Vienna, Akademie cat. 1889
———. *Katalog der Gemäldegalerie*. By C. von Lützow. 1889. (Rev. ed. 1900.)

Vienna, Akademie cat. 1961
———. *Katalog der Gemäldegalerie der Akademie der bildenden Künste in Wien*. 1961. (Rev. eds. 1968, 1972.)

Vienna, Akademie cat. 1982
———. *Niederländer in Italien: Italianisante Landschafts- und Genremalerei von Niederländern des 17. Jahrhunderts*. Catalogue by Renate Trnek. 1982.

Vienna, Kunsthistorisches cat. 1972
Vienna, Kunsthistorisches Museum. *Katalog der Gemäldegalerie: Holländisch Meister des 15., 16., und 17. Jahrhunderts*. 1972.

Vipper 1957
B.R. Vipper. *The Origin of Realism in Dutch Painting of the Seventeenth Century*. Moscow, 1957. (In Russian.)

van de Vinne, Sliggers 1979
Vincent Laurensz van de Vinne. *Dagelijcke aentekeninge van Vincent Laurensz van der Vinne*. Edited by B. Sliggers. Haarlem, 1979.

van Vloten 1875
J. van Vloten. "Een stadsgezicht van Hobbema." *Nederlandsche Kunstbode* 2 (1875), pp. 12–13.

Volhard 1927
Hans Volhard. *Die Grundtypen der Landschaftsbilder Jan van Goyens und ihre Entwicklung*. Dissertation. Frankfurt, 1927.

Vollmer 1909
Hans Vollmer. "Die alte Gemäldegalerie in Kopenhagen." *Monatshefte für Kunstwissenschaft* 2 (1909), pp. 558–60.

Vosmaer 1863
Carel Vosmaer. *Rembrandt Harmensz. van Rijn, ses précurseurs et ses années d'apprentissage*. The Hague, 1863.

Vosmaer 1874a
———. "Johan Josefsz. van Goyen." *Kunstkronijk* 15 (1874), pp. 49–53.

Vosmaer 1874b
———. "Johan Josefszoon van Goyen." *Zeitschrift für bildende Kunst* 9 (1874), pp. 12–20.

A.B. de Vries 1956
A.B. de Vries. *Rembrandt*. Baarn, 1956.

A.B. de Vries 1963
———. "Het landschap." *Openbaar Kunstbezit* 1, no. 15 (1963).

A.B. de Vries 1964
———. "Old Masters in the Collection of Mr. and Mrs. Sidney van den Bergh." *Apollo* 80 (1964), pp. 352–59.

A.D. de Vries 1883
A.D. de Vries. "Willem Schellinks, schilder-tekenaar-etser-dichter." *Oud Holland* 1 (1883), pp. 150–63.

A.D. de Vries 1885–86
———. "Biografische aanteekeningen betreffende voornamelijk Amsterdamsche schilders, plaatsnijders, enz." *Oud Holland* 3 (1885), pp. 55–81, 135–60, 223–40, 303–12; 4 (1886), pp. 71–80, 135–44, 215–40, 295–304.

J. de Vries 1974
Jan de Vries. *The Dutch Rural Economy of the Golden Age*. New Haven, 1974.

L. de Vries 1976
Lyckle de Vries. "Post voor Jan van der Heyden." *Oud Holland* 90 (1976), pp. 267–75.

L. de Vries 1984
———. *Jan van der Heyden.* Amsterdam, 1984.

Waagen 1854–57
G.F. Waagen. *Treasures of Art in Great Britain.* 4 vols. London, 1854–57.

Waagen 1862
———. *Handbuch der Geschichte der deutschen und niederländischen Malerschulen.* Stuttgart, 1862.

Waagen 1864
———. *Die Gemäldesammlung in der Kaiserlichen Ermitage zu St. Petersburg.* Munich, 1864.

van de Waal 1941
H. van de Waal. *Jan van Goyen.* Amsterdam [1941].

van de Waal 1952
———. *Drie eeuwen vaderlandsche geschied-uitbeelding, 1500–1800: Een iconologische studie.* 2 vols. The Hague, 1952.

Waddingham 1960
Malcolm R. Waddingham. "Herman van Swanevelt in Rome." *Paragone* 11, no. 121 (1960), pp. 37–50.

Waddingham 1963
———. 'Bologna in Retrospect: Some Northern Aspects." *Paragone* 14, no. 159 (1963), pp. 57–66.

Waddingham 1964
———. "Andries and Jan Both in France and Italy." *Paragone* 15, no. 171 (1964), pp. 13–34.

Waddingham 1966
———. *I paesaggisti nordici italianizzanti del XVII secolo.* 2 vols. Milan, 1966.

Waddingham 1975
———. "A Poelenburgh in the National Gallery of Canada." *National Gallery of Canada Bulletin* 26 (1975), pp. 3–10.

Waetzoldt 1927
Wilhelm Waetzoldt. *Das klassische Land.* Leipzig, 1927.

Waetzoldt 1943
———. "Okeanos: Bemerkungen zur Geschichte der Meeresmalerei." In *Wilhelm Worringer zum 60. Geburtstag.* Königsberg, 1943.

Wagner 1970
Helga Wagner. "Jan van der Heyden als Zeichner." *Jahrbuch der berliner Museen* 12 (1970), pp. 111–50.

Wagner 1971
———. *Jan van der Heyden 1637–1712.* Amsterdam and Haarlem, 1971.

Walford 1981
E.J. Walford. "Jacob van Ruisdael and the Perception of Landscape." Dissertation. Cambridge, 1981.

Walpole 1828
Horace Walpole. *Anecdotes of Painting in England.* 5 vols. 5th ed., with additions by James Dallaway. London, 1828.

Walsh 1985
Amy Walsh. "Imagery and Style in the Paintings of Paulus Potter." Dissertation. Columbia University, 1985.

Wantage collection, cat. 1905
Catalogue of Pictures Forming the Collection of Lord and Lady Wantage. London, 1905.

Wap 1852
J.J.F. Wap. "Herman Saftleven en de rokaan van 1674." In *Utrechtsche volks-almanak,* pp. 140–77. Utrecht, 1852.

Wap 1853
———. "Herman Saftleven en de rokaan van 1674." *Astrea: Maandschrift voor schone kunst* 2 (1853), pp. 42–52, 83–84.

Warsaw 1958
Warsaw, Museum Norodowe. *Krajobraz Holenderski XVII Wieku.* 1958.

Washington, D.C. 1985–86
Washington, D.C., National Gallery of Art. *The Treasure Houses of Britain.* Edited by Gervase Jackson-Stops. 1985–86.

Washington, D.C./Cleveland 1975–76
———. *The European Vision of America.* Catalogue by Hugh Honour. 1975–76. Also shown at the Cleveland Museum of Art, 1976. (See also Paris 1976–77.)

Washington D.C./Detroit/Amsterdam 1980–81
Washington, D.C., National Gallery of Art. *Gods, Saints and Heroes: Dutch Painting in the Age of Rembrandt.* 1980–81. Also shown at the Detroit Institute of Arts and the Rijksmuseum, Amsterdam, 1981. (Also published in Dutch.)

Washington, D.C., Corcoran cat. 1932
Washington, D.C., Corcoran Gallery of Art. *Illustrated Handbook of the W.A. Clark Collection.* 1932.

Washington, D.C., Corcoran cat. 1955
———. *A Handbook of Dutch and Flemish Paintings in the William Andrews Clark Collection.* By James D. Breckenridge. 1955.

Wassenbergh 1969
A. Wassenbergh. "Het huwelijk van Adam Pijnacker en Eva Maria de Geest." *De Vrije Fries* 49 (1969), pp. 93–96.

Weber 1974
Bruno Weber. "Der Zürichsee von Jan Hackaert." *Zeitschrift für Schweizerische Archäologie und Kunstgeschichte* 31 (1974), pp. 230–41.

Wedmore 1874
Frederick Wedmore. *Rembrandt: Seventeen Masterpieces in the Cassel Gallery.* London, 1894.

Wegner 1967
Wolfgang Wegner. "Zeichnungen Gillis van Coninxloo und seiner Nachfolge." *Oud Holland* 82 (1967), pp. 203–24.

Wegner, Pée 1980
Wolfgang Wegner and Herbert Pée. "Die Zeichnungen des David Vinckboons." *Münchner Jahrbuch der bildenden Kunst* 31 (1980), pp. 35–128.

Weigel 1843
Rudolph Weigel. *Suppléments au peintre-graveur de Adam Bartsch.* Leipzig, 1843.

Weinberger 1925
Martin Weinberger. *Ruisdael, der Maler der Landschaft.* Munich, 1925.

Weiner 1923
P.P. van Weiner. *Meisterwerke der Gemäldesammlung in der Eremitage zu Petrograd.* Munich, 1923.

Weisbach 1926
Werner Weisbach. *Rembrandt.* Berlin and Leipzig, 1926.

Weisner 1963
Ulrich Weisner. "Moyses van Uyttenbroeck: Studien und kritischer Katalog seiner Gemälde und Zeichnungen." Dissertation. Kiel, 1963.

Weisner 1964
———. "Die Gemälde des Moyses van Uyttenbroeck." *Oud Holland* 79 (1964), pp. 189–228.

Welcker 1940
A. Welcker. "Schildersportretten: I. Govaert Flinck." *Oud Holland* 57 (1940), pp. 115–122.

Welcker 1942–47
———. "Pieter Boddink alias Pieter van Laer." *Oud Holland* 59 (1942), pp. 80–89; 62 (1947), pp. 206–208.

Welcker 1947
———. "Pieter Lastman als tekenaar van landschap en figuur." *Oud Holland* 62 (1947), pp. 165–76.

C. Welcker 1950
Clara J. Welcker. "Hendrick Avercamp of Arentsz.?" *Oud Holland* 65 (1950), p. 206.

C. Welcker 1979
———. *Hendrick Avercamp (1585–1634), bijgenaamd "De Stomme van Campen" en Barent Avercamp (1612–1679), "Schilders tot Campen".* Revised edition by D.J. Henbroek-van der Poel. Doornspijk, 1979. (1st ed. Zwolle, 1933.)

Wellensiek 1954a
Hertha Wellensiek. *Gillis van Coninxloo: Ein Beitrag zur Entwicklung der niederländischen Landschaftsmalerei um 1600.* Dissertation. Bonn, 1954.

Wellensiek 1954b
———. "Das Brüsseler 'Elias-Bild', ein Werk des Gillis van Coninxloo?" *Bulletin des Musées Royaux des Beaux-Arts* (Brussels) 3 (1954), pp. 109–16.

Westrheene 1866
Tobias van Westrheene. "Twee en misschien nog meer kunsthistorische vliegen in één klap." *Nederlandsche Spectator,* 1866, pp. 236–37.

Westrheene 1867
———. *Paulus Potter: Sa vie et ses oeuvres.* The Hague, 1867.

Wetering 1938
Cornelis van der Wetering. *Die Entwicklung der niederländischen Landschaftsmalerei.* Dissertation. Bonn, 1938.

Weyerman 1729–69
Jacob Campo Weyerman. *De levens-beschryvingen der Nederlandsche konst-schilders en konst-schilderessen.* 4 vols. The Hague, 1729–69.

White 1969
Christopher White. *Rembrandt as an Etcher: A Study of the Artist at Work.* 2 vols. London, 1969.

White 1982
———. *The Dutch Pictures in the Collection of Her Majesty The Queen.* Cambridge, 1982.

White 1984
———. *Rembrandt.* London, 1984. (1st ed. 1964.)

White, Boon 1969
Christopher White and K.G. Boon. *Rembrandt's Etchings: An Illustrated Critical Catalogue.* Amsterdam, 1969.

Wiegand 1971
Wilfred Wiegand. "Ruisdael-Studien: Ein Versuch zur

Ikonologie der Landschaftsmalerei." Dissertation. Hamburg, 1971.

van de Wiele 1893
Marguerite van de Wiele. *Les frères van Ostade, les artistes célèbres*. Paris, 1893.

Wiersma 1985
H. Wiersma. *Hendrik Averkamp 1585–1634, de Stomme van Kampen*. Kampen, 1985.

Wijnman 1932a
H.F. Wijnman. "Dr. Jacob van Ruisdael, landschapschilder en medicus (1629–1682)." *Maandblad Amstelodamum* 19 (1932), pp. 40–42.

Wijnman 1932b
———. "Het leven der Ruysdaels." *Oud Holland* 49 (1932), pp. 46–60, 173–81, 258–75.

Willemsen 1946
J. Willemsen. "Jan van Goyen." *Constghesellen* 1 (1946), pp. 4–7.

van der Willigen 1831–32
[A. van der Willigen.] "Iets wegens de schilderijen, door M. Hobbema." *Algemeene Konst- en letter-bode*, 1831, pp. 302–304, 361–64, 409–10, 460, 474; 1832, pp. 24–25.

van der Willigen 1870
———. *Les artistes de Haarlem: Notices historiques avec un précis sur la Gilde de St. Luc*. Haarlem and The Hague, 1870.

Willis 1911
Fred C. Willis. *Die niederländische Marinemalerei*. Leipzig [1911].

Willnau 1952
C. Willnau. "Die Zusammenarbeit des Nikolaus Knüpfer mit anderen Künstlern." *Oud Holland* 67 (1952), pp. 210–17.

de Winter 1767
Hendrik de Winter. *Beredeneerde catalogus van alle de prenten van Nicolaas Berchem*. Amsterdam, 1767.

Woermann 1920
Karl Woermann. *Geschichte der Kunst*. Leipzig, 1920.

Woodall 1935
Mary Woodall. "A Note on Gainsborough and Ruisdael." *Burlington Magazine* 66 (1935), pp. 40–45.

Worcester 1979
Worcester Art Museum. *17th Century Dutch Painting: Raising the Curtain on New England Private Collections*. 1979.

Worcester, cat. 1974
Worcester Art Museum. *European Paintings in the Collection of the Worcester Art Museum*. 2 vols. 1974.

Worp 1891
J.A. Worp. "Constantyn Huygens over de schilders van zijn tijd." *Oud Holland* 9 (1891), pp. 106–36, 307–308.

Worp 1897
———. "Fragment eener autobiographie van Constantijn Huygens." *Bijdragen en Mededelingen van het Historisch Genootschap Utrecht* 18 (1897).

Worp 1911–13
———. *De Briefwisseling van Constantijn Huygens*. The Hague, 1911–13.

Wright, forthcoming
Christopher Wright, *Meindert Hobbema*. Forthcoming.

Würtenberger 1958
F. Würtenberger. *Weltbild und Bilderwelt von der Spätantike bis zur Moderne*. Vienna and Munich, 1958.

Wurzbach 1885
Adolf von Wurzbach. *Geschidenis der hollländischen Malerei*. Leipzig, 1885.

Wurzbach 1886
———. *Rembrandt Galerie*. Stuttgart, 1886.

Wurzbach 1906–11
———. *Niederländisches Künstler-Lexicon*. 3 vols. Vienna and Leipzig, 1906–11.

Yarborough, cat. 1851
Catalogue of the Earl of Yarborough's Collection of Pictures at 17, Arlington Street, London. London, 1851.

Zeldenrust 1983
Manja Zeldenrust. "Aert van der Neers 'Rivier landschap bij maanlicht opgehelderd'." *Bulletin van het Rijksmuseum* (Amsterdam) 31 (1983), pp. 99–104.

Zoege von Manteuffel 1924
Kurt Zoege von Manteuffel. *Paulus Potter*. Leipzig, 1924.

Zoege von Manteuffel 1927
———. *Die Künstlerfamilie van de Velde*. Bielefeld and Leipzig, 1927.

Zurich 1953
Zurich, Kunsthaus. *Holländer des 17. Jahrhunderts*. 1953.

Zurich 1958
———. *Sammlung Emil G. Bührle*. 1958.

Zurich 1979
Zurich, Zentralbibliothek. *Alpenreise 1655: Conrad Meyer und Jan Hackaert*. Catalogue by Gustav Solar. 1979.

Zurich, Bührle cat. 1973
Stiftung Sammlung Emil G. Bührle. Zurich, 1973.

Zutphen 1957
Zutphen, Stadhuis. *17e eeuwse Nederlandse landschapkunst*. 1957.

Zwarts 1928
Jacob Zwarts. "Het motief van Jacob van Ruisdael's 'Jodenkerkhof'." *Oudheidkundig Jaarboek* 8 (1928), pp. 232–49.

Zwolle 1957
Zwolle, Provinciaal Overijssels Geschiedkundig Museum. *Hendrik ten Oever, een vergeten Overijssels meester uit de zeventiende eeuw*. Catalogue by J. Verbeek and J.W. Schotman. 1957.

Zwollo 1973
An Zwollo. *Hollandse en Vlaamse veduteschilders te Rome (1675–1725)*. Assen, 1973.

Zwollo 1983
———. "De Tombe van de Horatii en de Curiatii, getekend door Cornelis Vroom." In *Essays in Northern European Art Presented to Egbert Haverkamp Begemann on His Sixtieth Birthday*. Doornspijk, 1983.

An exhibition of this magnitude inevitably incurs a multitude of debts. Rather than inventory that debt imperfectly, I thank all of my colleagues, the lenders, and our supporters and friends collectively. Special thanks are reserved for Jan Fontein, under whose directorship much of the work on this project was completed, for my fellow organizers, P.J.J. van Thiel of the Rijksmuseum and Joseph Rishel of the Philadelphia Museum of Art, and for the contributing authors listed on the title page. Expert advice during the early stages of the conception of the show was offered by Egbert Haverkamp-Begemann, Albert Blankert, Frits Duparc, David Freedberg, Eddy de Jongh, Otto Naumann, and Seymour Slive. To the core of workers, including Marjorie Elizabeth Wieseman, Alan Chong, Priscilla Myrick Diamond, Judy Weinland, Fennelies Kiers, and Irma Lichtenwagner, who applied themselves most consistently to the project, my admiration for your care, resolve, and stamina. Linda Thomas, Suzy Wells, Irene Taurins, and Pat Loiko also performed essential administrative roles. Translations were ably and swiftly tendered by Michael Armstrong Roche and Monique van Dorp. Margaret Jupe and Holly Elliot deftly edited the manuscript, and Stella Gelboin and Elizabeth Stouffer read galley proofs with attention. The catalogue was expertly designed and produced by Carl Zahn, assisted by Nancy Robins. The research facilities and amenable staffs of the Rijksbureau voor Kunsthistorische Documentatie (RKD) in The Hague and the Frick Art Reference Library in New York were, as always, invaluable to the preparation of the catalogue. Thanks, too, to the following individuals, who contributed in many diverse ways to the show's realization: Robert Aarsse, George and Maida Abrams, Clifford S. Ackley, Rita Albertson, Jonathan Albutt, Nancy Allen, Peter Ashton, Katherine Baetjer, Pieter Biesboer, Elizabeth Ann Bond, Edgar Peters Bowron, John Brealey, Richard Brettell, Peter Cannon-Brookes, M.J. Broos, Christopher Brown, Hortense Anda-Buhrle, James D. Burke, Marigene Butler, Marco Chiarini, Sean Clarkin, Joop Coevoerden, Alfred Cohen, Bernice Davidson, Pamela J. Delaney, Ilana Dreyer, Peter Eikemeir, Ildiko Ember, Roy Fisher, S.D. Fletcher, Jacques Foucart, Christopher Gatiss, Alain Goldrach, J.M. de Groot, Bob Haak, Helen Hall, Jane Hankins, John Herrmann, Hans Hoetink, Francis Hogan, John Hoogsteder, Evelyn Joll, Lilian Joyce, Jan Kelch, George Keyes, Martin Royalton-Kisch, Rudiger Klessmann, Olaf Koester, Gerbrand Kotting, Thomas Lang, Ronald Laskin, Walter Liedtke, Iva Lisikewycz, Ann Tzeuthschler Lurie, Hugh Macandrew, Duncan MacMillan, Thomas McGrath, Jean Patrice Mandell, Ruth Meyer, Sir Oliver Millar, Charles Moffett, John Michael Montias, Wendy Moran, Michael Morano, Kristin Mortimer, Larry W. Nichols, Bonnie Porter, Margaret Quigley, Pierre Rosenberg, Gary Ruuska, Eric van Santen, Scott Schaefer, Herman Shickman, Nicolette Sluijter-Seiffert, Eric Jan Sluijter, Robert and Clarice Smith, Janice Sorkow, Anthony Speelman, Joaneath A. Spicer, Carl Strehlke, Anthony Crichton-Stuart, Hollister Sturges, Susanne Thesing, Renate Trnek, John Walsh, Amy Walsh, K.V. Waterman, Arthur Wheelock, Martin Zimet, Amalyan Zipkin. And to Bug, Page, and Burns, as ever, much love.

P.C.S.